LUXUS CODEX

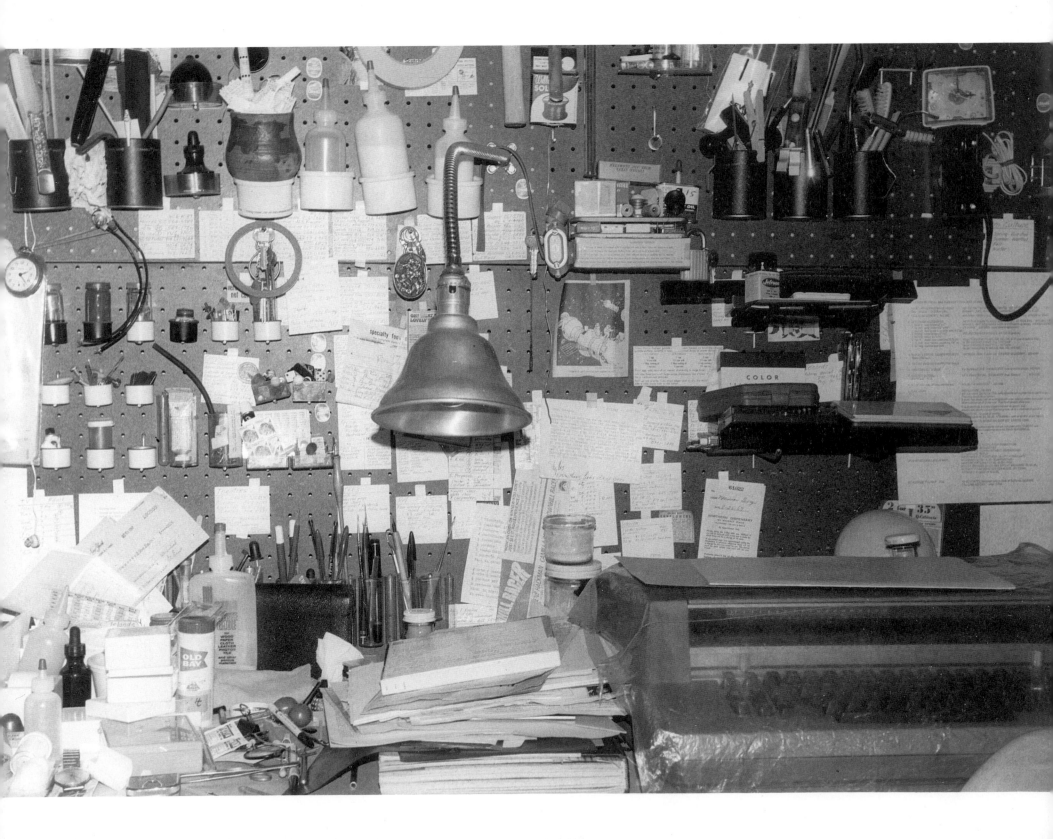

Recto and above, George Maciunas' workbench at 349 West Broadway, New York City, photographed in December, 1969 by Hanns Sohm. Maciunas' IBM composer is visible on the bench. Many of the Fluxus publications, labels, and scores were typeset with this machine. Also visible are some of the tools and components which Maciunas used in assembling Fluxus product. Courtesy of Archiv Hanns Sohm, Staatsgalerie Stuttgart

FLUXUS CODEX

JON HENDRICKS

with an introduction by **Robert Pincus-Witten**

The Gilbert and Lila Silverman Fluxus Collection, Detroit, Michigan

in association with

Harry N. Abrams, Inc., Publishers, New York

Library of Congress Cataloging-in-Publication Data

Hendricks, Jon.
 Fluxus codex / [compiled by] Jon Hendricks ; with an introduction
by Robert Pincus-Witten.
 p. cm.
 Bibliography: p.
 Includes index.
 ISBN 0 – 8109 – 0920 – 0
 1. Fluxus (Group of artists)—Catalogs. 2. Art, Modern—20th
century—Catalogs. 3. Avant-garde (Aesthetics)—History—20th
century—Catalogs. 4. Silverman, Gilbert—Art collections—
Catalogs. 5. Silverman, Lila—Art collections—Catalogs. 6. Art—
Private collections—Michigan—Detroit—Catalogs. I. Gilbert and
Lila Silverman Fluxus Collection II. Title.
N6494.F55H4 1988
709'.046—dc19 87 – 33432
 CIP

ACKNOWLEDGMENTS

This book is the result of several years of research and compilation by a devoted group of individuals, each of whom has contributed significantly to the project.

Alice Weiner is my associate and worked on most aspects of the book, including editing my comments and questioning my conclusions. She has made a major contribution to the book.

Melanie Hedlund has worked with me on The Gilbert and Lila Silverman Fluxus Collection since its inception. Besides her enormous task of typesetting the book, she participated in other areas of the work. Fatima Bercht compiled the List of References and Bibliographic Information, which was edited by Paula Baxter, Head, Art and Architecture Collection, New York Public Library.

The research team that painstakingly extracted information from the mass of Fluxus reference material included Fatima Bercht, Nancy Bialic, Eva Lee, Alice Weiner and Trevor Winkfield. The initial design of FLUXUS CODEX was done by Sara Seagull, Panama Design Studios, New York.

Subsequent design, mechanicals and production were done by Peter Downsbrough.

Their production assistants were: Marijke Bontinck, Angela Carlino, Candice Crawford, Leslie Johnson, Leslie Kamen, and Larry Miller. Additional proofreading was done by Dana Lloyd. Additional typesetting was done by Concord Typographic Service. Thanks to O & J Design for their photostat facilities.

I would like to express my gratitude to Margaret Kaplan, Senior Vice President and Executive Editor of Harry N. Abrams, Inc., for her sustained belief in and encouragement of this book, and for her many wise suggestions and insightful comments. FLUXUS CODEX would not have been realized without her support.

Sam Antupit, Vice President and Director of Art and Design of Harry N. Abrams, Inc. unsparingly offered time and expertise on questions of design and production for FLUXUS CODEX.

I would also like to thank Linda L. Cathcart, Director of the Contemporary Arts Museum, Houston, Texas, for her early support for this project. Marti Mayo, now Director of the Blaffer Gallery, University of Houston, Texas, and Dana Friis Hanson, now Assistant Curator, List Visual Arts Center, Massachusetts Institute of Technology in Cambridge, gave encouragement and support for this book at its inception.

Special thanks are due Nijole Valaitis who generously shared information about her brother, George Maciunas. Dr. Thomas Kellein, Curator of the Archiv Hanns Sohm, Staatsgalerie Stuttgart, made valuable suggestions regarding the Index and Foreword, and made material from the archive available to us for research. Clive Phillpot, Librarian of the Museum of Modern Art, New York, was always available for consultation and advice. I appreciate Jaap Rietman's suggestions about cover design. Harry Ruhe, Director of Galerie "A" in Amsterdam provided me with valuable information about Fluxus in Holland. I am very grateful to Dr. Manfred Leve for the use of his photographs and information on Fluxus in Düsseldorf. Rolf Jährling graciously agreed to my taping hours of his recollections about Fluxus and the Galerie Parnass. He also provided us with photographs and other documentation of the seminal events at his gallery. Coosje van Bruggen and Claes Oldenburg gave advice and encouragement, and especially, gave documentation on Oldenburg's Fluxus projects. I am indebted to Mrs. Aagard Andersen, Charlotte Christiansen, Finn Falkersby, Knud and Bodil Pedersen for many kindnesses and information on Fluxus in Copenhagen. Nori Sato provided us with extensive photographic and other information about the Fluxfest at and/or in Seattle, 1977. I am also very grateful to Karen Kvernenes, René Block, Michel Oren, and Vytautas Landsbergis.

Dan Morganstern, Director, Institute of Jazz Studies at Rutgers University, and Maxwell T. Cohen, Esq., shared information about cabaret cards required by jazz musicians in New York in the 1950s. Dieter Froese generously provided a translation of the sign above the *Fluxlabyrinth* entrance at the Akademie der Künste in Berlin, 1976. And Rimma Gerlovina translated selections from the Soviet avant-garde magazine, LEF. I am grateful to Jonas Mekas and Rick Stanbery and Anthology Film Archives.

I also wish to express my thanks and affection to Jean Brown.

Numerous Fluxus artists spent many hours with me discussing Fluxus and their involvement with the movement. I would especially like to thank those artists I interviewed, and those who helped in other ways, such as loaning photographs or sharing documentation: Eric Andersen, Copenhagen, Denmark; George Brecht, Cologne, West Germany; Philip Corner, New York City; Christo and Jean-Claude Christo, New York City; Willem de Ridder, Amsterdam, Holland; Lette Lou Eisenhauer, New York City; Robert and Marianne Filliou, Les Eyzies, France; Henry Flynt, New York City; Bici Forbes, Brattleboro, Vermont; Ken Friedman, New York City; Geoffrey Hendricks, New York City; Dick Higgins, Barrytown, New York; Alice Hutchins, New York City; Scott Hyde, New York City; Joe Jones, Düsseldorf, West Germany; Per Kirkeby, Copenhagen, Denmark; Milan and Maria Knizak, Prague, Czechoslovakia; Alison Knowles, New York City; Tut Koepcke, Copenhagen, Denmark; Shigeko Kubota, New York City; Carla Liss, New York City; Jackson Mac Low, New York City; Larry Miller, New York City; Kate Millett, New York City; Barbara and Peter Moore, New York City; Serge Oldenbourg, Nice, France; Claes Oldenburg, New York City; Yoko Ono, New York City; Nam June Paik, New York City; Benjamin Patterson, New York City; James Riddle, Richmond, Virginia; Takako Saito, Düsseldorf, West Germany; Tomas Schmit, Berlin, West Germany; Sara Seagull, New York City; Paul Sharits, Albany, New York; Yasunao Tone, New York City; Mrs. Frank Trowbridge, Switzerland; Annie and Ben Vautier, Nice, France; Robert Watts, Bangor, Pennsylvania; La Monte Young, New York City; and Marian Zazeela, New York City.

Since 1978, when they first started collecting Fluxus, Gilbert and Lila Silverman have travelled extensively, doing research and studying the movement, meeting many Fluxus artists, collectors and publishers. They would like to thank those artists they visited, enriching their knowledge of the artists' work: Genpei Akasegawa and Jiro Takamatsu of the Hi Red Center Group, Tokyo, Japan; Ay-O, New York City; George Brecht, Cologne, West Germany; Brian Buczak, New York City; Giuseppe Chiari, Florence, Italy; Ken Friedman, New York City; Geoffrey Hendricks, New York City; Dick Higgins, Barrytown, New York; Ray Johnson, Locust Valley, New York; Joe Jones, Asolo, Italy and Düsseldorf, West Germany; Bengt af Klintberg, Stockholm, Sweden; Milan and Maria Knizak, Prague, Czechoslovakia; Alison Knowles, New York City; Shigeko Kubota, New York City; Nam June Paik, New York City; Benjamin Patterson, New York City; Takako Saito, Düsseldorf, West Germany; Mieko (Chieko) Shiomi, Osaka, Japan; Paul Sharits, Buffalo, New York; Annie Vautier (Ben wasn't home), Nice, France; Robert Watts, Bangor, Pennsylvania; Emmett Williams, Asolo, Italy.

Gilbert and Lila Silverman are very grateful to those Fluxus collectors who opened their collections and generously shared information with them: Eric and Dorothy Andersch, Düsseldorf, West Germany; Mats B., Stockholm, Sweden; Hermann and Marietta Braun, Remscheid, West Germany; Rosanna Chiessi, Reggio Emilia, Italy; Gino Di Maggio, Milan, Italy; Sara Fox Pitt, The Tate Gallery, London, England; Dr. Thomas Kellein, Staatsgalerie Stuttgart, Stuttgart, West Germany; Billie Maciunas, Pittsfield, Massachusetts; Victor Musgrave, London, England; Arturo Schwarz, Milan, Italy; Hanns Sohm, Markgröningen, West Germany.

The Silvermans also wish to extend their appreciation to the several innovative publishers and critics they visited, and who have a close relationship with Fluxus, and as well to the museum directors and curators who have exhibited the Silverman Fluxus Collection: Simon Andersen, London, England; Jay Belloli, former Director, The Baxter Art Gallery, California Institute of Technology, Pasadena, California; Manon Blanchette, former Director, Walter Phillips Gallery, The Banff Centre, Banff, Alberta, Canada; Linda Cathcart, Director, Contemporary Arts Museum, Houston, Texas; Francesco Conz, Asolo, Italy; Suzanne Delehanty, Director, The Neuberger Museum, State University of New York, Purchase, New York; Wolfgang Feelisch, Remsheid, West Germany; Peter Frank, New York City; Walther König, Cologne, West Germany; Jaap Rietman, New York City; Roy Slade, Director, The Cranbrook Academy of Art Museum, Bloomfield Hills, Michigan.

J.H.

During the 1960s, when curious and radical art activities took place, one would gather up a batch of posters and snapshots and other little bits and mail them off to Dr. Hanns Sohm in Markgröningen, West Germany. It was a ritual repeated hundreds of times in numerous countries. I think many of us were not too clear who the addressee was, except that he was someone who cared as deeply and passionately about the activities as those who did them. What to most was junk and a candidate for the dust bin was to Sohm a treasure. One even heard rumors that he organized and filed the bits in a coherent manner, rather than just dropping them in a box to accumulate dust as most did. Then, in 1969 artists received nicely printed cards asking that they list all their performance activities, publications, reviews, etc. There was going to be a show in Cologne and he needed the information for a catalogue. What appeared the next year was the landmark HAPPENING & FLUXUS, a book of extraordinary value chronicling the decade. For the first time, one realized that like activities were taking place all over the world. A typical page of the book listed: Bengt af Klintberg's "Orangerimusik" in Stockholm and Uppsala; Allan Kaprow's "Bon Marché" in Paris; "Fluxus Festival of Total Art" in Nice; Ken Dewey's "A.C.T. of San Francisco Yliopplasteatteri" in Helskinki; Al Hansen's "Parisol 4 Marisol" in New York; Hi Red Center Group's "Por Rogy" in Tokyo; "New Music at the Pocket Theater" with many Fluxus artists participating in New York; "1st Festival of Avantgarde" organized by Charlotte Moorman in New York; and Robert Whitman's "Water" in Los Angeles.

In the summer of 1978, when we were just beginning the Silverman Fluxus Collection, two seemingly simple but troubling questions came up that had unforeseen consequences. The first question was what constitutes a Fluxus work? And the second, what were these works? Out of curiousity I prepared a group of pages for each Fluxus artist, listing all the works I could find in various Fluxus newspapers, putting works already in the Silverman Collection above a line and others below the line. That next year, Gilbert and Lila Silverman travelled to West Germany and stopped in Markgröningen, a small village near Stuttgart. There, the Silvermans paid a visit to Hanns Sohm. The visit extended to several days as Sohm carefully went over the list of Fluxus works, marking each, indicating whether it was known to exist or not, or that he had seen it but it wasn't in his collection, and showing the Silvermans the works in his magnificent Fluxus collection. Always sharing a contagious passion for the material, his hospitality knew no limits as days extended into nights.

That, then, was the beginning of this book. The lists expanded ten fold as more references were located and the definition of Fluxus product became clearer. It was that initial visit which was the catalyst.

Hanns Sohm, over the years, has furthered the knowledge of Fluxus and other radical art movements, sharing information with scholars and students, and especially artists, helping many with purchases and numerous other encouragements. A few years ago Dr. Sohm placed his invaluable collection in the Staatsgalerie Stuttgart where it will permanently be available to study and to learn from. He continues his work, devoting many days each month to the archive and sharing his knowledge with others.

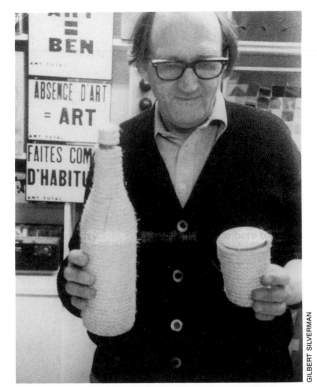

Hanns Sohm demonstrating George Maciunas' OBJECTS WRAPPED IN ROPE to Gilbert and Lila Silverman on their visit to Markgroningen, West Germany. 1979

This book is dedicated to HANNS SOHM who has devoted the past twenty-five years to preserving the fragile record of Fluxus and other experimental art forms. In his quiet, meticulous and generous way, he has shared that record with a generation hungry for that knowledge.

Lila and Gilbert Silverman

Joanne and Jon Hendricks

FLUXUS and the SILVERMANS: An INTRODUCTION
by ROBERT PINCUS-WITTEN

Two mismated descriptions are in order, a contrast that does not share a reasonable sector of overlap as, say, when we compare apples and oranges. There, at least, the assumed category is fruit. No such credible bridge is to be found between Fluxus and Silverman. There's the rub, to reasonably bridge these wildly disparate entities. Differing *taxonomies* is the beginning; how they got together, an ongoing story.

Fluxus is a complex manifestation of the high Conceptual tide of the 1960s and 1970s. While seen as a movement, Fluxus' anarchic and idealist stance argue against conventional embodiments for the work of art, so that its monuments fall between the artistic and bibliographic. There are, of course, Fluxus works that do correspond to traditional painting and sculpture, works perhaps best realized in the genial efforts of the reclusive George Brecht, who, in addition to the pioneering game box *Water Yam*, also created several other major if underestimated constructions. Here, too, the subversive constructions of Ben Vautier of the Nice School should be noted. Beyond these examples and the occasional refined painting of Ay-O, there is little to make the case for the studio side of Fluxus.

By contrast, the movement is bibliographic and bibliophilic though anticerebral and a smidge anti-intellectual. The lion's share of Fluxus work assumes the form of transient pieces of paper—handbills and broadsides or boxed thematic accumulations. By contrast, Schwitters' tramway tickets and valueless German currency dating to Hanover Dada are virtual Sistine Ceilings of Merzification when compared to the ephemeral notebook pages typical of Fluxus flourish.

The numerous strands of Fluxus plait into a thick braid entwining amazing brainstorms, a politic of liberation, parareligious asceticism as well as the pratfall of the burlesque stooge who slips on the banana peel of life, an elliptical humor much in debt to Marcel Duchamp, the jokey side of Dadaism traceable to the music hall of Alfred Jarry's Pataphysics. Last, Fluxus' political bias is strongly primitive-Christian and pro worker.

The theatrical nutrient in which Fluxus first appeared was the experimental workshop of the Black Mountain College of legend—John Cage, Robert Rauschenberg, Merce Cunningham, and Buckminster Fuller—though the Black Mountain group provided more than that; the effects of Cage were sensible across the apologetics of La Monte Young.

Despite the celebrity of many Fluxus participants, Joseph Beuys, say, or Nam June Paik, or John and Yoko, Fluxus' resident genius was George Maciunas, whose core effort and organizational skill proved of greater import than the occasional object or transient event or happening or action which included the *pro tem* allegiance of a famous personality. A catalytic figure though still virtually unknown, George Maciunas' organizational talents and charisma kept Fluxus afloat beyond all reason though it is certainly true that many of its original participants continue to make art.

Fluxus begins with the foundation of the Fluxus press in the Winter of 1961-1962, abruptly terminating in May of 1978 when Maciunas dies, an untimely victim to cancer. This is the position taken by Lila and Gil-

bert Silverman, and by Jon Hendricks, the Curator of the Silverman Collection. Purists about the matter, they admit as authentic Fluxus only those works, actual or conceived even if unrealized, of which Maciunas knew or to which he made reference in the Fluxus newsletters—works, that is, to which Maciunas' awareness grants imprimatur. Other material, for all that it may be Fluxus-associated, falls outside this stringent canon. That Maciunas was the impresario of Fluxus, whose Diaghilev-like persona more than anything else carried the day, is the fundamental premise of the Silverman Collection.

Owing to the period context of Fluxus, the movement was strongly inflected by an unequivocal opposition to the imperial note being struck in the conduct of American foreign policy then crowned by the misadventure of Vietnam. That political backdrop can no more be stripped away from Fluxus than the operatic fustian from a Cecil B. DeMille movie. The irony is the short life of historical memory as contrasted to the stability of the period object. As the intonation provided by the backdrop dissipates, so do Fluxus works assume an aesthetic integrity, an autonomy at odds with the intentions of its makers. This process is true of all artistic production, that which was anti-governmental as much as that which was official and academic. Much Fascist art today, for example, seems as neutral and as laundered as work addressed to the Left Wing during the Great Depression. Short historical memory and dissociation are the culprits.

For Fluxus, the political arena also addressed the revulsion for high formalist abstraction, the successful abstract art of the day. For Fluxus, those field painters and late Constructivist sculptors covered by the term formalist abstraction were inculpated insofar as their art was perceived, rightly or wrongly, as co-relative to a misguided political agenda. In this perception, formalist abstraction provided not only art but preferred shares, not art but capital.

Fluxus indicted the strutting of later American Abstract Expressionist values and its internal drift, its exclusionary theory of pure and visual systems, all that we ultimately came to discard in Clement Greenberg's theories when, during the 1970s, the Women's Movement, Black Power, Gay Pride, etc., set new priorities for an art of a putatively purist nature, an agenda that already had been tested in the Fluxus crucible.

But even as a manifestation of the Conceptual, Fluxus drifted toward the expressive end of Conceptualism rather than toward the Minimalist or cerebral side of things. Closed seriality and the solipsism characteristic of the Minimalist/Conceptualist continuum were anathematic to the anarchic embrace of Fluxus theatricality.

Fluxus artists waged a campaign that subverted the inherited abstract value system—large, heroic, ambitious, and sexist—favoring an art that was intimate, ephemeral, and highly poetic. Fluxus is an art jammed chock-a-block with minute containers of all shapes and sizes, little wooden and plastic boxes found in the "for sale" street-side cartons of the Canal Street supply houses—corrugated cardboard, mailing tubes, scraps of paper,

plastic indecencies from the local joke or tourist shop, miniaturized Pop gew gaws of prepossessing verisimilitude—cucumbers, fried eggs—ball-bearing puzzles that tax manual skill, articulated plastic and wooden take-apart puzzles and games, meaningless gadgets displaced from household and hobbyist needs, the tiny paraphernalia of the home workshop and playroom—all these and more were subject to the ordering premise of the Fluxus board game cum encyclopedia, from Lotto to the rebus to the child's mineral set.

Fluxus grabbed at absurd categories—all the effluvia of human aperture, say, or all forms of carefully categorized, vaguely repulsive organic substance. The lust for the encyclopedic was perhaps the only worthy sin in the movement, even if the categories and thematic groupings of Fluxus tend to the loony. Encyclopedia in small scale dedicated to the transient aspects of human enterprise: as the months turn to years since they were made, Fluxus works, apt to be temporal, sour and spoil, crumble and crack, go limp as the plastic or rubber leaks liquid or air and the cheap acid papers on which the broadsides are printed cannibalize themselves or metastasize into shallow mounds of the ink with which these handbills and posters were first printed. One of the clear stylistic sources for Fluxus is traceable to American letterpress—letterpress into litter press—an impression reinforced by the typographer's love of the stray hand-carved nineteenth-century woodblock letter. Maciunas' designer orientation was susceptible to the self-reliance coded in this pre-linotype, pre-computer American face, a responsiveness that was in certain measure characteristic of advanced graphic design in the 1950s and 1960s.

Fluxus was a real alternative to the exclusionary esthetic of high modernism. Its vocabulary of naughty words and calendar of sensuous events carried Fluxus participants to new states of keen experience within the shortest passing instant. In that sense Fluxus was ambitiously experiential and unabashedly existential, a fusion that grew to the proportions of a comic cliché. Zen and archery became Zen and the motorcycle, according to the Buddhism of these newer Dharma Bums.

Fluxus focused on Happening-derived theatrical events that stressed the communal and the democratic. The ephemeral achievements of Fluxus were inflected by an idealist anarchy that stressed the participatory and the self-reliant. This strain invokes a political history reaching back to the Wobblies, the Patterson Strike, and the Feminist model of Emma Goldman, not to say the theatre of Futurism.

Because Fluxus was resistant to a formalist agenda, the movement keyed into the anti-American bias of the Left both here and abroad, quite as it appealed to European artists and intellectuals who were determined to resist the American ascendancy over art that marked the period following World War II through the advent of Conceptualism. The late Joseph Beuys' transformation of his autobiographical art into a grassroots participational political movement resulting in the present-day party of the Greens in Germany may be one of the few measurable successes of Fluxus.

Fluxus was also resistant to our own Eurocentricity, one that suffuses American Formalism. The internationalism of Fluxus is one of its most attractive features, one flavored by the technological detritus of the Global Village. McLuhanist catchphrases abound in Fluxus Cinematic Utopianism.

As part of Fluxus' politics of liberation a strong erotic pitch was inescapable. Libido reaffirmed the Surrealist continuum of the political and the unconscious. Repression continued to be understood in the light cast by Freud's description of social and personal dysfunction as a manifestation of infantile sexual repression. Surrealist references in the formulation of Fluxus value are paramount considering its acceptance of Freud. Fluxus period paradigms would be Grotowski, Julian Beck, Judith Malina, the Living Theater, as well as Antonin Artaud's Theatre of the Cruel, although of course none of these figures ever participated in Fluxus performance.

Then there are Gilbert and Lila Silverman, self-effacing and straightforward. They easily serve as emblems of the good citizen. Still, there is a deep obsessiveness too. They are at ease with their Midwestern lot, and would not consider moving from Detroit, although they travel widely and maintain a *pied-à-terre* in New York. Neither has a gift for subterfuge. What you see is what you get, a kind of terrifying honesty. The Silverman's frank and open mode can be alarmingly tonic.

Lila's sense of duty has cushioned her against the exploitative aspects of volunteerism and good service. Still, being one with skill and dispatch, she assumes myriad duties in the Detroit cultural community, notably for The Detroit Institute of Arts and for The Cranbrook Academy of Art. She takes on responsibilities as recompense for, as she sees it, her life of privilege. Both Silvermans are Detroit Art World Good Citizens, assuming, more often than not, the less than glamorous but more than necessary service and organizational responsibilities—treasurer, fund raiser, and so forth.

When the Silvermans are drawn to art, they are attracted to work which affords an immediate jolt of paradox. Pop Art and its affinites. In this light, their Duane Hanson, John DeAndrea, Howard Kanowitz are less than unexpected *jeux d'esprit*. The scale of their house precludes large works or installations, so the art it contains tends to be intimate—such as the hoard of preparatory drawings for sculpture and environmental projects that Gilbert simply calls Instruction Drawings. This is a fascinating collection of studies for large works generally of a sculptural nature, site-specific, fanciful, outscale, impractical, marked by the Conceptual basis of the 1970s for which Gilbert, as a civil engineer and builder, has a peculiar sympathy and patience, granting that his workday was once shot through with projects to be realized over long stretches of time and with which he was first engaged in the blueprint stage. So the Instruction Drawings might be said to answer a virtually genetic predisposition.

What is intriguing about the businessmen of Gilbert's generation and place is just how many of his schoolmates have risen to prominent place in the arts. One prep school roommate was the co-founder of the Archives of American Art and is today the president of a leading gallery of American art; another fraternity brother recently became president of Sotheby's International.

In terms of the Silverman household collection, the intimate tends to meld with the archeological, partially because the Silvermans are great travellers. A vitrine, for example, is filled with numerous small pieces of ancient iridescent glass. The most compelling wall is covered by prints, drawings, and watercolors of small scale and associated with artists whose names are textbook familiar—a Degas monotype of a nude, a De Kooning watercolor of good date, a Pissarro landscape.

In the last decade or so, the Silverman political trajectory has moved from a Democratic left of center to a carefully considered centrism. They are, in this course, representative citizens who knew the great Depression and World War II at first hand. They appear middle class versions of virtually any presidential couple in the White House during this past half century excepting the Roosevelts, who were American aristocracy. I also omit the dowdy First Ladies, leaving only the men in each couple and Jackie O.

So why Fluxus? What grievance mars the shimmer of the Silverman's happy and positive lives? Why does this couple respond so to a rebellious and spirited avant-gardism? *Ressentiment* might explain it. Nietzsche advanced this category of feeling to explain the moral excellence of the early Christians over the crass and crude later Romans. In our time the theory has been taken up by the philosopher Max Scheler. *Ressentiment* addresses a nonspecific grievance founded in real or imagined affront, free-floating anger at the accidental station of one's birth—all this is theory, of course—an ambiguous and vague nugget of resentment capable of spurring the moderate and balanced to acts of willful overcompensation.

In the past this has led to vast building campaigns; in recent days to the construction of research centers, university theatres, and libraries. This feeling, founded in a fictive sense of inadequacy, has surely inspired many collections of modern art as a means of asserting excellence in the face of conventional derision and indifference.

In the late 1970s when the Silvermans began to collect Fluxus, there were two other collectors of note: Hanns Sohm, whose collection eventually was acquired by the Stuttgart Museum and Jean Brown, whose collection went to the Getty. Another large Fluxus accumulation, put together by David Mayor in England, went to the Tate. By degrees, the Silverman holding surpassed the others in terms of quality and in number of items, although after a certain moment the filling-in of the interstices forecloses preoccupations with quality—always a thorny issue anyway for Fluxus artists whose work rejected the idea of quality from the outset. So the Silverman holding is now the grandest hoard of Fluxus as well as the only one still in private hands.

Fluxus monuments and ephemera—a collection that is one of the grand repositories of one of the most subversive intellectual and imaginative

achievements of the late twentieth century—is tended by people of the most even keel. If there is drama at all, it is measurable in the sharp discrepancy between possessor and possessed—though it is telling that in English the term possession may refer to that which is collected as well as suggest obsessiveness if not outright madness.

Perhaps I feel all this so keenly as in a small measure I bear responsibility for the anomaly. The Detroit Scene of the 1970s was of fascination to me and I wrote one of the first pieces addressing the artists of the Cass Corridor to be published in a national circulation magazine. I was fascinated by the interest that The Detroit Institute of Arts manifested in contemporary art and was also awed by Cranbrook's acres and by its Master of Sculpture, Michael Hall—one of whose sprawling Constructivist Gates is to be found on the Silverman grounds. So, when on a trip to Detroit in March of 1978 I lectured to the Friends of Modern Art on recent shifts in Conceptualism and Performance Art, Body Art and auto-referentiality (a pun in Detroit), the lecture included a slide of the notorious can of tinned excrement, by the Italian nihilist artist Piero Manzoni.

The lecture was approximately coincidental with the imminent death of George Maciunas, a notable event although one not picked up in the general press at the time. But the Silvermans knew of it. They were then considering a first tentative foray into the world of Fluxus, and the Manzoni of my lecture led Gilbert to inquire whether I had ever heard of Fluxus—I had— and whether or not I thought it an interesting area of collecting. "Yes," I said. Fatal words or beneficent ones? The present volume gives pause, confidence, and, I hope, justification to my absence of hesitation and the Silvermans' subsequent audacious dedication.

For not only is theirs the incontestably great collection of Fluxus material, theirs is also the referential language, the logical renumeration by which Fluxus work will henceforth be identified. Three volumes have already been published on the Silverman holding and now this, the *Fluxus Codex*, the most luxurious overview, with a perfected identification system incorporating concordances with the earlier catalogues. We speak of Koechel for Mozart, Bartsch for Rembrandt, Zervos for Picasso, Schweitzer for Bach, the Dewey Decimal System for the precomputerized library, Schwann for discography, Scott for postage stamps, and on and on. Now the interested party must cite the Silverman Numbers by way of identifying even the most transient waft of a hairsbreadth of a harebrained Fluxus broadside and handbill. If this is so, then whatever *ressentiment* there was, if ever there was any, must be richly appeased if not laid to rest with this publication.

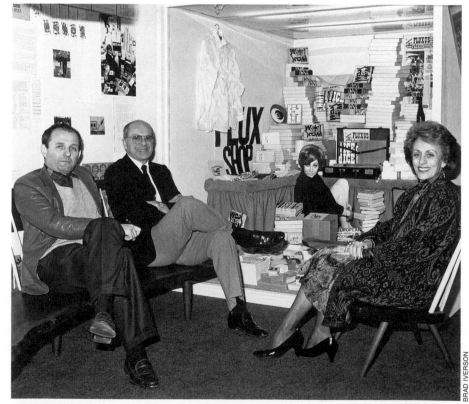

Robert Pincus-Witten with Gilbert and Lila Silverman in front of Willem de Ridder's EUROPEAN MAIL-ORDER WAREHOUSE/FLUXSHOP. Detroit, Michigan. January, 1986

BRAD IVERSON

FOREWORD
by JON HENDRICKS

To understand Fluxus as an art movement, it is helpful to consider the contextuality of the phenomenon. Its primary concerns fall outside those of most other art movements, challenging preconceived notions about art, the function of art, and the role of the artist in society.

Unquestionably, there were precedents for Fluxus earlier in the twentieth century. These precursors, in broad terms, were Futurism, Dada, and Russian Constructivism. Though elements of each had become generally accepted, the essence of each remained taboo in the late 1950s and early 1960s, when several experimental movements were struggling against the high tide of academic abstraction. It was a time of very rapid change, a time to try things out, a time when artists were unhooking the corsets of art and pushing ideas to whatever limits imagination and resources could make them go.

Fluxus begins before it begins and ends, one hopes after it ends.

The 1950s were a time of political conservatism. A period in art of abstraction, individualism, and nationalism. By the late 1950s, Abstract Expressionism had run its course. Senator Joseph McCarthy had finally been discredited and isolationism was temporarily dissolving in the mist of a new internationalism, the world was preparing for the 1960s, which, in retrospect, appear as one of the most tumultuous, creative, and vibrant periods that Western culture has ever seen, certainly rivaling the first decades of the twentieth century in Europe. Fluxus was in the center of this maelstrom.

Clearly, Dada was a precursor to Fluxus. Both sought to unnerve a complacent, militaristic, decadent society by bringing art into direct confrontation with triviality and aesthetics, and to controvert the idea that art is incapable of affecting social or political change.

George Maciunas sought to make Fluxus an important part of the new revolution:

> I know how you feel about involving Fluxus politically with the party (you know which one). Our activities lose all significance if divorced from socio-political struggle going on now. We must *coordinate* our activities or we shall become another "new wave," another dada club, coming and going.
> From a letter by George Maciunas to Emmett Williams, June 1963. The Jean and Leonard Brown Collection, The Getty Center.

Fluxus was begun in late 1961 by George Maciunas. Born in Kaunas, Lithuania, in 1931, Maciunas emigrated to the United States in 1948 and studied art, architecture, and graphic arts at The Cooper Union in New York City until 1952. In 1954 he received a degree in architecture from The Carnegie Institute of Technology in Pittsburgh. Returning to New York, he commenced postgraduate studies at The Institute of Fine Arts, New York University, studying, according to his own account, "European and Siberian Art of Migrations." During this period, from 1955 to 1960, he read extensively, developed art history and architecture charts, and

pursued his love of Renaissance music and ancient instruments. Simultaneously, he continued an interest in avant-garde music like that of John Cage, and developed architectural prefabrication systems. George Maciunas' sister Nijole Valaitis, recalls his receiving thirty or forty patents pertaining to these prefabrication systems when he worked at the Olin Corporation in the late 1950s. Maciunas later worked at the architectural firm of Skidmore, Owings & Merrill, and at the Knoll Design Company, among other jobs.

Radical changes in music, dance, and poetry, as well as in the visual arts, were taking place in the United States, Europe, and Japan in the late 1950s. Central to these changes in the United States were John Cage and Merce Cunningham; Black Mountain College Utopianism; Lawrence Ferlinghetti and his City Lights Bookstore; George Wittenborn's Documents of Modern Art Series directed by Robert Motherwell; Alan Kaprow's defining the concept of Happenings; cooperative art galleries; poetry readings at cafes. In Europe there were the Situationists; COBRA (perhaps more the publication than the product); Gruppo Nucleare; and the stirring of the Nouveaux Réalistes. In Japan there was the Gutai Group.

It was a time of great possibilities. Artists no longer felt confined to canvas, no longer felt bound by definitions imposed by critics and historical precedent. Language could be music, music could be dance, dance could be a political tract, a political statement could be a poem, a poem could be a scream. . . . La Monte Young had made an extremely important discovery, which was as he so happily calls it, the "short form." A musical score or script for an event no longer had to be pages long. It could be reduced to a very short sentence or group of words. Stripped of unnecessary instructions and overbearing constraints, the score was reduced to the idea, to the concept. It was the invention of Concept Art.

In the late 50s and early 60s, Piero Manzoni was working with lines, air, signing human beings as living sculptures, canning his own excrement and offering it as a work of art. Yves Klein was working with the Void, removing everything from a room. Ben Vautier was working with ready-mades, ego, signing ideas as art. George Brecht was working with chance and indeterminacy and "short form" events. Nam June Paik was cutting off John Cage's necktie, Robert Rauschenberg was erasing a de Kooning drawing.

The 1950s were a time of discongruent possibilities and impossibilities. A neo-fascistic element was stifling dissent and destroying some of the most creative careers—exiling film directors, writers, musicians, artists, and poets. Self-appointed anti-Communist watchdogs effectively destroyed the Weavers and many others; malevolent licensing boards in New York made it impossible for Billie Holiday, Thelonius Monk, Art Pepper, Chet Baker, and numerous others to perform, denying required cabaret cards for many jazz greats and comedians, preventing them from working in clubs, a primary outlet for their music and satire. The ostensible reason for these denials were arrest records, but underlying the intent was racism and distrust of non-European music and a fear of the butt of the jokes. Some artists chose exile, like Dexter Gordon; others, like Lenny Bruce and Thelonius Monk, were ostracized in their own society.

Factors that stifle expression also work to counteract their intended purpose. America, having mortgaged its moral values, opted for materialism and was ready to belly flop into an aesthetic pool of jello. Sure enough, some artists in current vogue were more than willing to soften the fall. But a subversive counter culture was building on the radical footing laid in the 1950s. New York, especially, was the fermentation vat. It is hard to pinpoint specific catalysts, but several disparate occurrances coalesced. Among them was the availability of simple printing devices, at first the ditto machine, then the mimeograph. The notion that "Vanity Press" meant mediocrity was reversed with such landmark publications as the "Ray Gun Comics" of Claes Oldenburg, Jim Dine, Robert Whitman, Richard Tyler, Dick Higgins, and Red Grooms in 1960; Ben Patterson's *Methods and Processes* in 1962; Ben Vautier's *Ben Dieu* 1960-63, to name only a few. Indeed, artist control of the publication, presentation, or exhibition of work was essential to its survival and content. Lack of money had little if any bearing on quality. Of equal importance was the opportunity to work outside the traditional venues. Coffee houses had served as the stage for a generation of Beat poets. Suddenly artists found that they could work free of commercial and censored restraint in parking garages, church cellars, lofts, the street—groups could form and rent a storefront to open a gallery or produce events.

In 1960, George Maciunas opened the AG Gallery with his friend Almus Salcius at 925 Madison Avenue in New York, with the idea of showing abstract art and selling ancient musical instruments. However when he met Richard Maxfield and La Monte Young late in 1960, Maciunas was suddenly confronted with the most radical ideas in art. Overnight he transformed the AG Gallery into a colloquium for the germination of Fluxus, sponsoring events by Dick Higgins, Toshi Ichiyanagi, Jackson Mac Low, Jonas Mekas, Yoko Ono, Henry Flynt, La Monte Young, Richard Maxfield, Walter De Maria, Ray Johnson, and others. Maciunas later called this period "proto Fluxus."

These artists and others were realizing works elsewhere in the city as well: at Yoko Ono's loft on Chambers Street, in a series organized by La Monte Young; at the Living Theatre; and at the Reuben Gallery, for example. Maciunas was acquainted with the work of European and Japanese artists through La Monte Young, who had gathered material for *An Anthology*, which was to have been a special issue of *Beatitude*, the Beat poetry magazine. In the summer of 1961, after the AG Gallery went broke and closed, Maciunas started making plans for a magazine of very new music to be called *Fluxus*—modeled in part on Young's *An Anthology*, which Maciunas had agreed to design and get printed. Taking these plans for the magazine, along with many scores and tapes from artists, Maciunas left for Europe with his mother in the late summer or early fall of 1961. He settled in Wiesbaden, West Germany, where he had a freelance design job with the U.S. Army. That winter, Maciunas

developed several preliminary plans for the first issues of *Fluxus* and a series of concerts of new music to be held in various European cities. The evolution of these "Fluxus Yearboxes," as they came to be called, can be seen in the Collective section of this volume. On June 9, 1962, Maciunas held the first public manifestation of Fluxus at Rolf Jährling's Galerie Parnass in Wuppertal, West Germany, and distributed the first Fluxus publication: *Brochure Prospectus for Fluxus Yearboxes, version A*. The evening was called Kleinen Sommerfest—in the tradition of a European garden party. The guests were dressed accordingly, unsuspecting that this was to be the initiation of an important movement. Maciunas titled the events "Apres John Cage," and his lecture, "Neo-Dada in the United States." Beneath his name on the program it said "Editor-in-chief of the new art magazine *Fluxus*," and on the cover of the brochure handout was printed "Fluxus." Fluxus was beginning. Maciunas' lecture, delivered in German by C. Caspari, stakes out the perimeters of the new phenomenon:

> What one might call neo-Dada in the United States, or what in any case we would like to view as such a renewed Dadaism, is manifesting itself in a number of areas. It extends to the spatial and temporal arts, or more precisely, it reaches from the literary—temporal art—over the graphic-literary—temporal-spatial art—to graphics—spatial art—and then again over graphically recorded music—spatio-temporal art—to signless music, not determined by a score—temporal art—, and over theatrical music and the theater—spatio-temporal art—to those spatial arrangements without goal-oriented intention called environments—spatial art. ...These...artists...are almost without exception heavily influenced either by the concept of concrete art or that of artistic nihilism. The concrete artists are, in contrast to the illusionists, opponents of the unity of form and content. They prefer the world of concrete realities to that of artistic abstractions... Thus, a concrete artist in the plastic sphere conceives of a rotten tomato as a rotten tomato, and depicts it as such, without subjecting the reality of its form of appearance to any change. In the end the formal expression remains indistinguishable from the content of the thing and the perception through the artist, namely the rotten tomato instead of an artificially and illusionistically produced image or symbolic representation. In music. . .for example, a tone which arises through the striking of a hammer on a piano or someone stumbling into it is material and concrete, because the hardness of the hammer, the hollow quality of the echo in the piano, as well as the resonance of the strings makes this tone much more clearly perceptible. For the same reason, human language or eating noises are more concrete phenomena than art song.... In concrete theater the artificially mounted action and/or the predetermined play of the actors is usually replaced by a set of naturally unfolding, unrehearsed and mostly completely indeterminate events such as result from spontaneous and improvised actions of a certain group which has merely been set specific, or even very vague, general limits by the author. The concept of indeterminacy or of things not prescribed by artistic intent represents a further turn from the artificial world of abstractions.... Through non-prescribed composition an even more significant concretism is attained, in which nature is charged with developing its own form in its own way.... The actual contribution of the concrete artist (if he really is one) lies in the creation of a draft or rather in a method through which a form can create itself independently of him, and not really in the creation of this form or structure itself.... Many indeterminate artworks of this sort can be understood or received without one having to hear the final result. As in a mathematical problem, the beauty of such a composition lies solely in the method. The second view now dominant among American artists, designers, or composers is that of an artistic nihilism, which in a way does more justice to concretism and the rejection of artificiality than the orientation of the so-called concretists. An art nihilist rejects art and fights it solely for the reason that its intention or intentionality inevitably includes the character of the artistic either with regard to design or the stamp of its method. In order to arrive at a closer connection with concrete reality, the art nihilist either creates an anti-art or only produces the banal. The anti-art forms are primarily directed against art as a profession, against the artificial separation of producer or performer, of generator and spectator or against the separation of art and life. They oppose forms artificial in themselves, models or methods of composition, of artificially constructed phenomena in the various areas of artistic practice, against intentional, conscious formalism and against the fixation of art on meaning, against the demand of music to be heard and that of plastic art to be seen; and finally against the thesis that both should be acknowledged and understood. Anti-art is life, nature; true reality is the one and all. The bird song is anti-art. The pouring rain, the chattering of an impatient audience, sneeze noises, exhibitions like George Brecht's "4 walls with floor and ceiling" or compositions like "letting a butterfly caught in a net fly away," or "what an audience left to its own devices does for amusement"—all of these examples may be viewed in this sense as anti-art. A still more radical step in the direction of art nihilism would be the rejection of any activity which, though not intimately bound with artistic production, still bore some connection with it (its recognition or rejection) along with the practice of nothingness. One could place the intentional and total artistic or anti-artistic activity of Henry Flynt in this category.
>
> *Excerpts from George Maciunas, "Neo-Dada in the United States," translated by Peter Herbo, courtesy of Michel Oren.*

During this period of 1962, George Maciunas made detailed plans for a series of Fluxus concerts throughout Europe and conceived the idea of publishing some of the scores used in these concerts as individual Fluxus publications, separate from the Fluxus Yearboxes. He had access to a blueprint machine at his job, and proceeded to draw and type the scores on translucent masters (usually rubberstamping a Fluxus copyright) which were then printed as needed either as translucent blueprint negatives or positives. The system was basically the same as that used by John Cage's publishers, Edition Peters, in New York. A fairly large number of these scores was published, and those that could be identified appear in this book.

It was only a short step from publishing individual scores to producing collections of an individual's scores. These first collections appeared in 1963, starting with La Monte Young's *Compositions 1961* and George Brecht's *Water Yam*, with many more collected works planned. Simultaneously, Maciunas designed and published Daniel Spoerri and François Dufrêne's *l'Optique Moderne* and Nam June Paik's *Monthly Review of the University for Avant-Garde Hinduism*—two quite different works, not only in content but also in presentation and concept. And indeed, the list of Fluxus Yearboxes 1963-65 (nine in all) and Fluxus Special Editions planned for 1963-64 on the advertising page of *l'Optique Moderne* varies from the collected scores to films of Stan Vanderbeek, *Sound Diaries* of Nam June Paik, *Requiem for Wagner the Criminal Mayor* on tape by Dick Higgins and Paik's "Review" (unlike any other review). Maciunas saw this publishing activity, in part, as an extension of performance, a way to propagandize the movement and undercut the existing art structure. For the most part, the editions were cheap and mass-produceable. By holding the copyright in the name of Fluxus, the intent of the collective was insured. This intent is spelled out in George Maciunas' *Fluxus Manifesto* thrown to an audience in Feburary, 1963, at the Festum Fluxorum Fluxus in the Art Academy in Düsseldorf.

The first Fluxus exhibit was held in a most unlikely location—the kitchen of the Galerie Parnass, Wuppertal—during Nam June Paik's "Exposition of Music/Electronic Television," March 11-20, 1963. In fact, the Fluxus exhibit was so inconspicuous that only one photograph, by Manfred Leve

Spectators looking at BROCHURE PROSPECTUS FOR FLUXUS YEARBOXES, Version A, during Kleinen Sommerfest at the Galerie Parnass, Wuppertal, West Germany, June 9, 1962

ROLF JÄHRLING

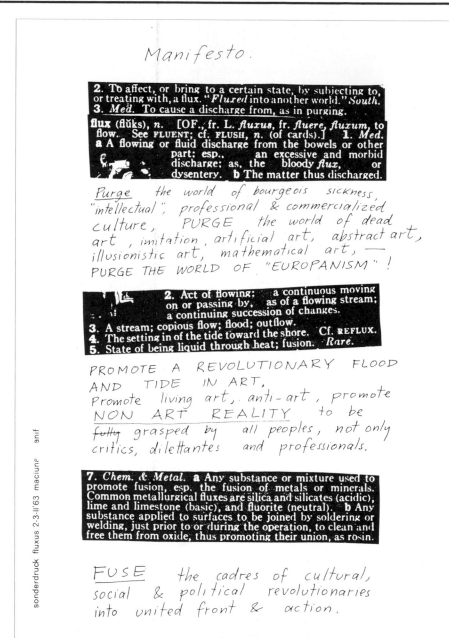

George Maciunas. FLUXUS MANIFESTO. February, 1963

is known to exist. The significance of the show is considerably larger than its location would suggest. It can be determined from the photograph, and from contemporary letters, that the works exhibited were non-precious, and for the most part reproduceable or replaceable, and were participatory—inviting viewers participation though not necessarily be-

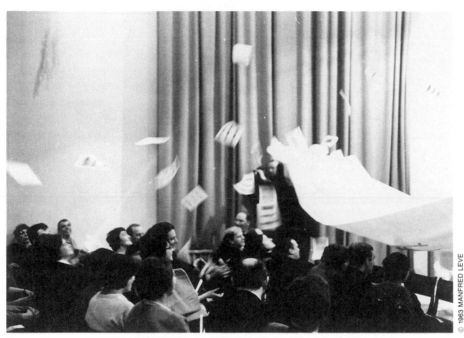

George Maciunas' FLUXUS MANIFESTO being thrown to the audience during Festum Fluxorum Fluxus, Düsseldorf, West Germany. February, 1963

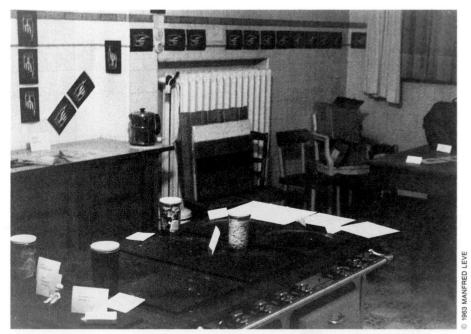

The first Fluxus exhibition—in the kitchen of the Galerie Parnass, Wuppertal, West Germany. March 11-20, 1963

ing performance pieces. There were works by several artists, and the show could be put up quickly and as quickly abandoned. The form of future Fluxus product and exhibitions was set.

Fluxus product took many forms, with Maciunas' return to New York in the fall of 1963, as this book demonstrates. Works as varied as George Maciunas' *Transparent Coffee,* Chieko Shiomi's *Spatial Poem No. 1,* Alison Knowles' *Bean Rolls,* Joe Jones' *Violin in a Bird Cage,* Ben Vautier's *Flux Holes* are all Fluxus works. Then why not Joseph Beuys' *Intuition*? Ben Vautier's *Rien*? Or George Brecht's *History of Fluxus—Part Two*? Works by three artists intimately associated with Fluxus. The question is more than just rhetorical or academic. One could say that these three randomly chosen works are all Fluxus-like, made in the spirit of Fluxus, are works by Fluxus artists, but *not* Fluxus works. The criteria we have chosen have nothing to do with quality; quite simply, they have to do with two conditions: either a work must have been listed or described in a Fluxus publication or it must have been mentioned in correspondance by George Maciunas as being planned as a Fluxus work. In determining these criteria, it is hoped that a much clearer picture of the movement will emerge. Fluxus will be seen to have a particular time frame and a specially stated intent which can be considered when studying Fluxus works. Characteristics of Fluxus become apparent.

Fluxus makes ideas reachable through gags. You can get it quickly, directly, without beating around the bush. It is what it says it is. Not a metaphor for something else necessarily—just the thing itself. Such simple actions as flushing the toilet or turning on the light switch become art. Humor is a very important element. *Exit,* for example, a piece by George Brecht, has some metaphorical meanings to it, but it is also just "the way out," the door through which you leave the room. It is an act, it is a thing that you do at the end of something—you exit, you leave. Maciunas' *Smile Box* forces a smile. Put a little machine in your mouth and your mouth opens up in a smile. You get it right away, it is a smile machine. It makes us smile against our will, the stereotypical movie star smile. Grin and bear it. "America—love it or leave it!" Throughout Fluxus product and Fluxus performance, the element of humor, gag, joke, is frequently essential to the work.

By definition, a Fluxus work must be cheap, and mass-producible. There are exceptions, as this book will show. If there is a stylistic thread that runs through Fluxus, it is the idea of directness, of concreteness, of simplicity, which Maciunas imposes on the work through his control of production.

Although every known published Fluxus document was used as reference material in preparation of *Fluxus Codex,* it was inevitable that others would be found—adding works and even artists to the body of Fluxus. Such a publication, *Press Release for Flux Orchestra at Carnegie Recital Hall,* N.Y., ca. September 1965, turned up recently, too late to be included in this volume. Most works listed in the document do appear in *Fluxus Codex* and its omission in this particular context is not especially signifi-

PUBLISHING, MASSPRODUCING & PERFORMING WORKS BY:	PUBLICATIONS:	FLUXUS FESTIVALS, CONCERTS
GENPEI AKASEGAWA ERIC ANDERSEN AYO GEORGE BRECHT STANLEY BROUWN GIUSEPPE CHIARI PHILIP CORNER ANTHONY COX WALTER DE MARIA WILLEM DE RIDDER ROBERT FILLIOU HI RED CENTER DICK HIGGINS TOSHI ICHIYANAGI JOE JONES ALISON KNOWLES JIRI KOLAR ARTHUR KOPCKE TAKEHISA KOSUGI SHIGEKO KUBOTA FREDRIC LIEBERMAN GYORGI LIGETI JACKSON MAC LOW GEORGE MACIUNAS JONAS MEKAS ROBERT MORRIS LADISLAV NOVAK CLAES OLDENBURG YOKO ONO BENJAMIN PATTERSON JAMES RIDDLE DITER ROT TAKAKO SAITO WILLEM T. SCHIPPERS TOMAS SCHMIT CHIEKO SHIOMI DANIEL SPOERRI BEN VAUTIER ROBERT WATTS EMMETT WILLIAMS LA MONTE YOUNG	Periodical newspaper: V TRE (4 times per year) Periodical yearbox Complete works: (supplemented yearly) of: George Brecht, Takehisa Kosugi, Chieko Shiomi and Robert Watts. Individual compositions by: Eric Andersen, Giuseppe Chiari, Dick Higgins, Hi Red Center, Alison Knowles, Gyorgi Ligeti, Jackson Mac Low, Yoko Ono, Benjamin Patterson, James Riddle, Tomas Schmit, Daniel Spoerri, Ben Vautier, Emmett Williams, La Monte Young. Films by: Eric Andersen, Ayo, George Brecht, Walter de Maria, Dick Higgins, Joe Jones, Alison Knowles, Arthur Kopcke, Takehisa Kosugi, Shigeko Kubota, George Maciunas, Yoko Ono, Benjamin Patterson, James Riddle, Chieko Shiomi, Robert Watts, La Monte Young. **MASS PRODUCED OBJECTS BY:** Ayo, George Brecht, Joe Jones, Shigeko Kubota, George Maciunas, Yoko Ono, Claes Oldenburg, Benjamin Patterson, James Riddle, Takako Saito, Tomas Schmit, Chieko Shiomi, Daniel Spoerri, Ben Vautier, Robert Watts, La Monte Young. boxes, cards, chess & checkers, clocks, clothes, fingerprints, flags, food, ,holes, machines, music boxes, organs, postage stamps, puzzles, rocks, signs, sporting goods, suitcases, tablecloths, etc. art, amusements, circus, compositions, concerts, events, everything, films, gags, games, jokes, music, non-art, nothing, objects, paintings, plans, poetry, theatre, vaudeville, etc. **FLUXSHOPS & WAREHOUSES** New York, P.O. Box 180, New York, N.Y. 10013 Amsterdam, Postbox 2045, Holland Nice, 32 rue tondutti de l'escarene, France La Cedille qui Sourit, 12 rue de May, Villefranche-sur-Mer, France c/o Akiyama, 3-814 Matsubaracho, Setagayaku, Tokyo, Japan.	WIESBADEN, W.Germany, Sept.1962, at state museum, 14 concerts. COPENHAGEN, Denmark, Nov.23 to 28, 1962 6 concerts. PARIS, France, Dec.1962, 7 concerts. DUESSELDORF, W.Germany, Feb.2 & 3,1963, at Academy of Art. AMSTERDAM, Holland, June 1962, 2 concerts. HAGUE, Holland, June 1962, 1 concert. NICE, France, July 27 to 30, 1963, 1 concert & 7 street events. COPENHAGEN, "2 internationale koncerter for nyeste instrumental teater og antiart," Sept.1963 AMSTERDAM, "Internationaal programma nieuste muziek, nieuwste literatur, nieuwste theater," Dec. 1963. AMSTERDAM, "16th.Fluxus Film Festival", 24 Feb.1964 NEW YORK, "Fully Guaranteed 12 Fluxus Concerts", at Fluxhall, April 11 to May 23, 1964 NEW YORK, Fluxus Symphony Orchestra Concert, June 27,1964, at Carnegie Recital Hall. MILAN, Italy, Nov.16,1964 at Galleria Blue. ROTTERDAM, Nov.23, 1964 AMSTERDAM, Holland, Dec.6, 1964 WARS COPENHAGEN, Dec.3 to 23,1964 NEW YORK, Sept.1964 to Jan.1965, at Washington Sq.Gallery. NICE, France, 7 concerts Oct.31, to Nov.7,1964 MARSEILLES, France, Mar.8,1965 at Marseille University theatre NICE, 1965 perpetual Fluxfest NEW YORK, Perpetual Fluxus Festival, weekly concerts since June 27'65 at Cinematheque. NEW YORK, the 83rd.Fluxus concert: Fluxorchestra at the Carnegie Recital Hall, Sept.25,1965

ART	FLUXUS ART-AMUSEMENT
To justify artist's professional, parasitic and elite status in society, he must demonstrate artist's indispensability and exclusiveness, he must demonstrate the dependability of audience upon him, he must demonstrate that no one but the artist can do art.	To establish artist's nonprofessional status in society, he must demonstrate artist's dispensability and inclusiveness, he must demonstrate the selfsufficiency of the audience, he must demonstrate that anything can be art and anyone can do it.
Therefore, art must appear to be complex, pretentious, profound, serious, intellectual, inspired, skillfull, significant, theatrical, it must appear to be valuable as commodity so as to provide the artist with an income. To raise its value (artist's income and patrons profit), art is made to appear rare, limited in quantity and therefore obtainable and accessible only to the social elite and institutions.	Therefore, art-amusement must be simple, amusing, unpretentious, concerned with insignificances, require no skill or countless rehearsals, have no commodity or institutional value. The value of art-amusement must be lowered by making it unlimited, massproduced, obtainable by all and eventually produced by all. Fluxus art-amusement is the rear-guard without any pretention or urge to participate in the competition of "one-upmanship" with the avant-garde. It strives for the monostructural and nontheatrical qualities of simple natural event, a game or a gag. It is the fusion of Spikes Jones, Vaudeville, gag, children's games and Duchamp.

Fluxus Broadside Manifesto. [New York, ca. September, 1965]

Saturday, September 25th 8 PM. Fluxus in its 83rd concert will present 20 world premieres performed by two orchestras at Carnegie Recital Hall in a Festival of Avant Tongue music.
The Fluxorchestra of 20 musicians will perform in the first part and Joe Jones orchestra of 20 instruments without musicians in the second part.
The first part will consist of first performances of compositions by the following:

George Brecht – two most recent works by this composer first to forgo distinction between art and nonart: Symphony no.3 subtitled "on the floor" for orchestra and slippery chairs, Octet for wind instruments and toy sailboat, subtitled "in the water".

La Monte Young – one of the first composers to go beyond and away from Cage school conducting the fluxorchestra and also performing his most recent composition : "1965 $ 50" in which the fee for performing the composition and the composition is the same.

Robert Watts – designer of orchestra costume will have his most recent work "c/s trace for orchestra" performed in darkness and also give a solo performance of his c/t trace for cannon and french horn, a classic of flux-humor.

Yoko Ono – Sky Piece to Jesus Christ, the most recent composition by this first counterpart in Japan of George Brecht and Ben Vautier, and first performance of 4 pieces for orchestra to La Monte Young, 1962.

Ben Vautier – 2 most recent audience performance pieces by this European proponent of musical "ready mades".

Anthony Cox – Tactical pieces for orchestra, a symphonic missile tournament between wind and string sections; and presenting a guest performer in his Sword piece, for "Samurai" conductor, performed simultaneously with Music for late afternoon by Chieko Shiomi and 2" by Robert Watts.

Chieko Shiomi – Disappearing music for face, the classic of quiet visual diminuendo by this gentle Japanese composer.

Stan Vanderbeek – this humorous film maker to make his first appearance with fluxorchestra performing his Movieee Music.

Olivetti Adding Machine – In Memoriam to Adriano Olivetti, performed in its 4th. newest version by 20 smacking lips.

The second part will consist of :

Joe Jones – mechanical orchestra, the latest construction by this builder of automatic musical machines, music boxes, mechanical instruments, robots, mechanical jokes etc.

An exhibit of various Fluxus mass produced products and publications will be presented by Fluxshop at the Carnegie Recital Reception Room. It will consist of the following:
Fluxyearboxes, Fluxus newspapers, Fluxkit (containing entire set of Fluxus publications), Fluxchess and Musical chairs by Takako Saito, Finger hole set by Ayo, Games and Puzzles by George Brecht and Robert Watts, Fluxmusicmachine by Joe Jones, Fluxorgan, Fluxtablecloths by Daniel Spoerri, Fluxclothing by Robert Watts, Spacial Poem by Chieko Shiomi, Touch poems by Yoko Ono, Peep show box by Anthony Cox, Fluxfilms (which can be viewed by eye viewers). These products will be offered for sale.

PRESS RELEASE FOR FLUX ORCHESTRA AT CARNEGIE RECITAL HALL, New York City. [ca. September, 1965.]

cant. However, two works, Yoko Ono's *Touch Poems* and Anthony Cox's *Peep Show Box* do not appear in the book and the inclusion of the press release would have added both another artist, Cox, and two identifiable Fluxus works.

Fluxus product started with Maciunas' idea of making a series of anthologies or compendiums of very new art to be called *Fluxus*. These were based on La Monte Young's *An Anthology* which Maciunas had designed and produced. George Maciunas was to be the publisher and editor-in-chief of *Fluxus* as well as designer and distributor etc., then "Chairman" of the "Editorial Committee." He designated various artists (and non-artists) to be on the "Editorial Committee" as co-editors and to be contributors on various subjects. The *Fluxus*es were to come in two editions—regular and "luxus." There were to be fold-outs, scores, records, and in the "Luxus" *Fluxus*es, original inserts.

FLUXUS YEARBOOK-BOX

Enclosed is the latest plan for the forthcoming issues of Fluxus. Please note revised contents and revised list of co-editors.

1. It was decided to utilize instead of covers a flat box to contain the contents so as to permit inclusion of many loose items: records, films, "poor man's films-flip books," "original art," metal, plastic, wood objects, scraps of paper, clippings, junk, raggs [sic]. Any composition or work that cannot be reproduced in standard sheet form or cannot be reproduced at all.

2. Fluxus will be issued in 2 editions.
 a) 1000 copies of standard edition which will contain only reproducible sheet or printable matter. This will consist of 150 8″ x 8″ bound pages and 12 loose sheets, fold outs or boards and will sell for $4.00 or its equivalent.
 b) 200 copies of luxus-fluxus, which in addition of [sic] standard edition will contain several original solid-nonreproducible works: films, pieces of 2 dimensional or 3 dimensional art, "ready mades," "found objects," junk, records. This edition will sell for $8.00 to $10.00, depending on quantity of non-reproducible matter or solids.
 Excerpt from Fluxus News-Policy-Letter No. 1, *May 21, 1962.*

About the same time as Maciunas was planning the Fluxus Year Boxes, he devised a scheme to publish scores based on a system of C. F. Peters, the music publishers, by making a master and using a "free" blueprint machine at the Wiesbaden U.S. Military Base where he worked.

As the movement exploded on Europe with more than thirty concerts in Wuppertal, Düsseldorf, Paris, Wiesbaden, Amsterdam, London, and Copenhagen in the last six months of 1962, publication of the first issue of *Fluxus* became delayed. Plans for them kept being developed and Maciunas had begun distributing scores done up in his clandestine print shop, when he had the idea to expand Fluxus production to include separate editions of the complete works and "special items" by many of the central Fluxus artists.

A. It has been decided to publish in addition to FLUXUS YEAR-BOXES (which are of an encyclopedic-anthological character) also special collections of single authors and special items—works of single authors.

1. Special collections will comprise whenever possible, the complete works of a single author, to be contained in a box which will be perpetually renewable and expandable as long as the author is living and constantly producing new works. A basic box will be issued containing works up to 1962 and supplements will be issued every coming year or less frequently depending on quantity of new works produced. New boxes will

be added to first issues as the first ones are filled up.

2. Special items will consist of films, magnetic tape, objects, etc., that will be reproduced or produced by authors themselves or Fluxus and sold through Fluxus distribution system in USA, West and East Europe and Japan.
 80% of the profits from the sale of such collections and items will be assigned to the authors. The remainder will be retained by Fluxus.
 Excerpt from Fluxus Newsletter No. 5, *January 1, 1963.*

The "complete works" and "special items" (based on the original idea for inserts in "luxus" *Fluxus*) evolved into a massive body of work which this book covers. To a large extent, Maciunas kept control of Fluxus production, receiving ideas from artists and, in a unique relationship, feeling free to alter and interpret these works—designing the labels and packagings—even varying the contents from copy to copy. Maciunas devised a distribution system through artist-run Fluxshops and mail order houses in several countries, through the Fluxus newspapers and handbills, and at impromptu exhibits during concerts and Fluxfests. Even the copyright had a political and philosophical basis:

Reasons for our copyright arrangements;

1. Eventually we would destroy the *authorship* of pieces & make them totally anonymous—thus eliminating artists "ego"—Author would be "FLUXUS." We can't depend on each "artist" to destroy his ego. The copyright arrangement will eventually force him to it if he is reluctant.

2. When we hold copyright collectively we propagandize the collective rather than the individual.

3. When FLUXUS is noted after each FLUXUS copyrighted composition it helps to propagandize the broader—collective aspect of the composition....

From a letter by George Maciunas to Tomas Schmit. [ca. January, 1964].

The exceptions to the Maciunas-produced works were pieces made by the artists and distributed through Fluxus—many of these appear on the early lists of things for sale. Works such as George Brecht's pennants, flags, signs, hardware, suitcases, etc. were unique (but reproduceable works) by Brecht. Eventually, some of these do evolve into Maciunas-produced Fluxus Editions. Some Fluxus works, such as Chieko Shiomi's *Endless Box*, were complicated to make and were always made by the artists.

Parameters used for this book extend further to include those elements of Fluxus environments, sports events, and performances which were altered ready-mades. Props, say, for a Fluxus sports event—like ping-pong rackets which have a hole cut in the middle are included, in contrast to objects from these activities like sports equipment just used in an uncon-

ventional way have been excluded—for example priests' vestments worn by atheists, or big shoes worn on little feet. An environmental work is considered both in its entirety and its altered components. Foods are included that were altered in a peculiar way. The permanence of a work was not a determining factor for exclusion or inclusion. A work does not have to have been made to be included in this book. Fluxus production ceased with George Maciunas' death, May 9, 1978.

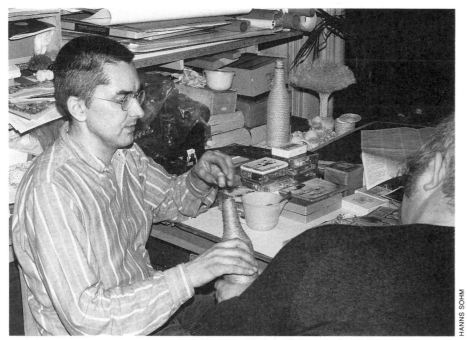

George Maciunas demonstrating an OBJECT WRAPPED IN ROPE to Wolf Vostell. New York City, December, 1969. In the background are numerous Fluxus Editions which Maciunas produced

HANNS SOHM

EXPLANATION OF THE BOOK ITSELF, THE WAY IN WHICH THE WORKS HAVE BEEN TRACED

Using a system of file cards and sheets, a group of researchers isolated each identifiable Fluxus work from extensive correspondence of George Maciunas in the Silverman collection as well as original documents and all known Fluxus publications. For example, George Brecht's *Water Yam*: all mentions of the work in available correspondance and Fluxus publications were copied out in exact reference to *Water Yam,* leaving out extraneous other works mentioned in the same paragraphs. Deletions are indicated by three dots. The job of identifying works was complicated by Maciunas' frequently casual way of referring to works. *Water Yam,* in Fluxus documents, is variously referred to as "The Complete Works of George Brecht," "The Collected works of George Brecht," "Works 1959-61," and so on. Also, in the case of *Water Yam,* the intention of the work was to add new pieces as they were written, and which were to be inserted into

the box. So, later pieces were still part of *Water Yam.* It was decided to include references to those additions within the *Water Yam* entry, and to use cross references so that in looking for "1965 scores of George Brecht," one is referred to *Water Yam.*

At times, it was very difficult to determine exactly what a work was. We decided to deal with concepts where possible, so that the idea of collected works, collected scores, collected writing, in the instance of Brecht, are conceptually the same, and become the work *Water Yam.* There were other scores or event pieces by Brecht that were issued as separate Fluxus publications, such as *Iced Dice,* so those are not included in *Water Yam* listings, but are given separate entries even though *Iced Dice* was sometimes included in the Fluxus Edition of *Water Yam.* Individual scores from *Water Yam* which were known to have been used as separate works in a Fluxus context, are also given separate entries. In the case of Ay-O's *Finger Boxes,* it was impossible to determine all the various tactile elements used in the many realizations of the work, so conceptually, the work is sticking a finger in a little hole and feeling the unexpected but not seen. We have grouped all of the tactile finger boxes into one entry even though there are fifteen finger holes in an attache case with variations from case to case, some finger holes were issued individually or in other forms. But the idea was the same, so the entries for *Finger Holes* in the book are numerous. Some entries are minuscule, such as *Perham's Opera House Ticket,* a facsimile ticket by George Maciunas. We could have grouped tickets together as "tickets," but that would have been a generalization as the tickets were usually available as individual tickets or in small groupings. So we have made separate entries for each identifiable ticket.

The book is arranged alphabetically by individual artists, after starting with Collective and then, Anonymous. Within each artist's section, the works are arranged alphabetically by word, except entries with titles starting with "Flux" or Fluxus." Those works are alphabetized by letter. The references to a work are arranged chronologically so that it is possible to study the development and alteration of a single work, respecting the original typography and spelling idiosyncrasies in the original texts. Minor misspellings in George Maciunas' letters were corrected.

Where possible, works are illustrated. Within a given work there are sometimes great differences in assemblings and interpretations, and an attempt has been made to illustrate as many variations as possible. I have provided a brief commentary to the entries as an aid to understanding the works, and frequently make reference to other related works.

FLUXUS CODES

". . . In regards to Fluxus copyrights etc. on your works. I think no one will object to your special publications of 100 copies of some works. In fact, you could note that they are Fluxus SSS or SSSS or SSSSS publication. Assuming we assign letter "S" to all your works, publications, etc. For instance Nam June Paik has "g" for his first

publication, then "gg" for 2nd, ggg for 3rd, gggg, ggggg, ggg-etc.—Under same system you could send out original texts, objects to limited mailing list. You could choose various letter combinations starting with S—ad infinitum. Say—1st mailing to be Fluxus SMXOV then SXMVO then SVOMX etc., etc. infinite number of combinations. Anything starting with S (or any other letter, maybe you prefer "V"?) would indicate as your Fluxus number (or rather letter)...
From a letter by George Maciunas to Ben Vautier [late May or early June, 1963].

In 1963, George Maciunas began a system of letter codes for Fluxus artists and their works. Immediately it got messed up.

FLUXUSa Monthly Review of the University of Avant-Garde
 Hinduism, edited by Nam June Paik...
FLUXUSb L'OPTIQUE MODERNE...par Daniel Spoerri...
FLUXUSc WATER YAM arranged by George Brecht...
FLUXUSd La Monte Young: Compositions 1961
FLUXUSe EMMETT WILLIAMS: COMPLETE WORKS...
FLUXUSf ROBERT FILLIOU: COMPLETE WORKS...
FLUXUSg N. J. PAIK: Experimental Television...
List in Fluxus Preview Review

FLUXUSg NAM JUNE PAIK: EXHIBITS & COMPOSITIONS...
Advertising page in LY 1961.

FLUXUSd CHIEKO SHIOMI: "Endless box"...
FLUXUSg NAM JUNE PAIK: list of publications by special request
Price list in Fluxus Newspaper No. 1, January 1964.

The code does settle down a bit: George Brecht is usually FLUXUSc with various works of his given more "c"s or other letters after the "c". Willem de Ridder made a free adaptation of the Maciunas code and added numbers as well for his *European Mail-Order Warehouse/Fluxshop price lists.*

THE SILVERMAN NUMBERING SYSTEM

Some years ago, when we were preparing *Fluxus etc. The Gilbert and Lila Silverman Collection* for publication by The Cranbrook Academy of Art Museum, it seemed sensible to attach a number to the works included in the catalogue. The book was arranged alphabetically by artist, with works within sections listed chronologically. Collective works, such as *Fluxkit,* were included in a section titled Fluxus, with periodicals and performance documents coming toward the end of the book. Therefore:
Eric Andersen's *50 Opera* is Silverman No. 1
Fluxkit ("A" copy) is Silverman No. 120
La Monte Young's *Compositions 1961* is Silverman No. 529

Fluxus 3 newspaper eVenTs for the pRicE of $1 (Fluxus Newspaper No. 7) is Silverman No. 568
"Flux Game Fest" flyer, 1973, is Silverman No. 681
As more works were added to the collection, it was necessary to expand the Silverman numbers based on the original system as follows:
>100.I=the new catalogue entry that comes chronologically after Silverman No. 100.
<100.I=the new catalogue entry that comes chronologically before Silverman No. 100.
<100.II=the entry which falls between Silverman No. 100 and No. 101 but follows >100.I.
<100.Ia=a new catalogue entry either identical to or a slight variant of <100.I.
>100.101=work of an artist not in *Fluxus* etc.
So, as Silverman No. 72 is George Brecht's *Closed on Mondays,* when we added Brecht's *Entrance and Exit Music,* an earlier work, it was assigned the Silverman No. <72.I. Silverman No. 201 is Milan Knizak's *Flux Dreams.* When we added Knizak's *Flux Snakes,* a slighty later work, it was assigned the Silverman No. >201.I. Silverman No. 82 is a score of John Cage's. When we added *Fluxfilms* (long version) Silverman No. >123.IV, including John Cale's *Police Car,* it was necessary to designate John Cale as >82.100 and his film, Silverman No. >82.101.

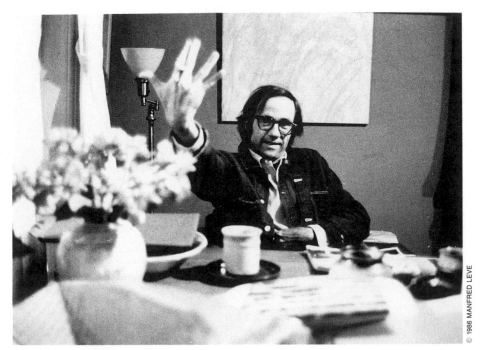

Jon Hendricks

FLUXUS HQ P.O.BOX 180 NEW YORK 10013
FLUXSHOPS AND FLUXFESTS IN NEW YORK
AMSTERDAM NICE ROME MONTREAL TOKYO
V TRE-FLUXMACHINES-FLUXMUSICBOXES
FLUXKITS-FLUXAUTOMOBILES-FLUXPOST
FLUXMEDICINES-FLUXFILMS-FLUXMENUS
FLUXRADIOS - FLUXCARDS - FLUXPUZZLES
FLUXCLOTHES-FLUXORGANS-FLUXSHIRTS
FLUXBOXES-FLUXORCHESTRA-FLUXJOKES
FLUXGAMES-FLUXHOLES-FLUXHARDWARE
FLUXSUITCASES-FLUXCHESS-FLUXFLAGS
FLUXTOURS-FLUXWATER-FLUXCONCERTS
FLUXMYSTERIES-FLUXBOOKS-FLUXSIGNS.
FLUXCLOCKS-FLUXCIRCUS-FLUXANIMALS
FLUXQUIZZES-FLUXROCKS-FLUXMEDALS
FLUXDUST-FLUXCANS-FLUXTABLECLOTH
FLUXVAUDEVILLE-FLUXTAPE-FLUXSPORT
BY ERIC ANDERSEN - AYO - JEFF BERNER
GEORGE BRECHT-GIUSEPPE CHIARI- ANT-
HONY COX - CHRISTO -WALTER DE MARIA
WILLEM DE RIDDER - ROBERT FILLIOU
ALBERT FINE-HI RED CENTER-JOE JONES
H.KAPPLOW-ALISON KNOWLES-JIRI KOLAR
ARTHUR KØPCKE-TAKEHISA KOSUGI-SHIGE-
KO KUBOTA-FREDRIC LIEBERMAN- GYORGI
LIGETI-GEORGE MACIUNAS-YOKO ONO-BEN-
JAMIN PATTERSON-JAMES RIDDLE- DITER
ROT-TAKAKO SAITO-TOMAS SCHMIT-CHIEKO
SHIOMI-DANIEL SPOERRI-STAN VANDER-
BEEK - BEN VAUTIER - ROBERT M. WATTS
EMMETT O. WILLIAMS- LA MONTE YOUNG
FLUX-ART-NONART-AMUSEMENT FORGOES
DISTINCTION BETWEEN ART AND NONART,
FORGOES ARTIST'S INDISPENSABILITY,
EXCLUSIVENESS,INDIVIDUALITY,AMBITION,
FORGOES ALL PRETENSION TOWARDS SIG-
NIFICANCE,RARITY,INSPIRATION, SKILL,
COMPLEXITY, PROFUNDITY, GREATNESS,
INSTITUTIONAL AND COMMODITY VALUE.
IT STRIVES FOR MONOSTRUCTURAL,NON-
THEATRICAL, NONBAROQUE, IMPERSONAL
QUALITIES OF A SIMPLE NATURAL EVENT,
AN OBJECT, A GAME,A PUZZLE OR A GAG.
IT IS A FUSION OF SPIKES JONES, GAGS,
GAMES, VAUDEVILLE, CAGE AND DUCHAMP

George Maciunas. Fluxus Manifesto. 1966.
Reproduced from an original photostatic negative

FLUX SHOP & MAIL ORDER WAREHOUSE

George Maciunas. Mechanical for "Flux Shop & Mail Order Warehouse" graphic used in Fluxus Newspaper No. 5, March, 1965

COLLECTIVE

There are two not so parallel directions in twentieth century art. One, better known and eagerly sought by collectors and museums, is usually identified with a particular school of aesthetic concern. The other direction tends to be on the outs with society. Called "experimental" or "marginal" art, I would prefer to call it "central" or "essential" art. Any art has to be experimental; if it's a sure thing, it's not art. Essential art concerns itself with primary art considerations: concepts, social injustice, behavior, production, environment, and the failure of aesthetic art to address essential art concerns. Essential art uses provocations, denouncements, publications, humor...as its palette. It frequently comes from a group of artists who have formed a collective. Sometimes the latter precedes the former, but in their pure form the two stay aloof.

A dictionary meaning of collective is, "a group of individuals taken together" — collectivism is, "the principle of centralized economic control especially of all means of production." In art, these principles have, for the most part, been scorned where individuality and uniqueness are the hallmarks of the artist and a public's esteem. Movements abound where a common aesthetic concern is expounded, but artists involved with these movements never abandon their individual identities and we are left with a body of works of varying quality examining a particular aesthetic, usually ignoring essential art concerns.

An alternative was presented early in this century by artists who gathered in groups and had as their base a utopian ideology with the objective of social and political change. This art was characterized by a threatened, complacent public as being anti-art or non-art. And indeed it was if one views the function of art as simply decoration or aesthetic renderings.

Fluxus was an essential art movement intentionally alienated from a society it disagreed with. The idea of collectivism which was so central to Fluxus objectives and philosophy, was, George Maciunas stated, based in part on the 1920s Soviet group and publication, LEF (Levyi Front Iskusstv — Left Front of the Arts), 1923-25, which became NOVYI LEF (Novyi Levyi Front Iskusstv — New Left Front of the Arts) in 1927, and in 1929, changed its name to REF (Revolyvtsionnyi Front — Revolutionary Front).

In the first issue of **LEF**, a manifesto titled "Who is LEF Alerting," the collective calls on various progressive groups: proclaiming:

To itself: It characterized LEF as "Master craftsmen...the best workers in today's art." Before the Revolution, it continues, they laid correct plans, brilliant theories, and clever formulas for the "forms of the new art." However, they realized that the worldwide bourgeosie was a bad place to lay a foundation to build upon. Their thinking had been changed by truths they saw during the Revolution and the urgencies of the moment. With the success of the Revolution it was now the time to start "big things," that the "seriousness of our attitude toward ourselves is the one solid foundation for our work."

To the Futurists: It commends them for their great services to art,

but warns them not to rest on their laurels, that they must demonstrate that their revolutionary art was not just "the desperate wailing of the wounded intelligentsia," but part of a true revolution working toward "the victory of the commune."

To the Constructivists: It warns them against "becoming just another aesthetic school," and goes on to say that as an aesthetic, Constructivism is "nothing," rather Constructivism must confront all areas of life and become its "supreme formal engineers," and be based on present day reality.

To the Production Artists: It warns against becoming "applied-art handicraftsmen," and continues that as teachers of the workers, they must learn from the workers.

To the Formalists: It states that the "formal method is the key to the study of art" but that they must avoid working or thinking in an ivory tower, and that only by working together with the "sociological study of art" will their work become essential.

To students: It warns against striving for the new, just for the sake of its being the latest thing in art — an attitude characterized as dilettantism; "only in craftsmanship have you the right to throw out the old."

To everyone together: As you shift from "theory to practice," maintain high technical skill and craftsmanship. "The very greatest idea will perish if we do not mold it skillfully." And it concludes:

LEF is on guard.
LEF is the defender for all inventors.
LEF is on guard.
LEF will throw off all the old fuddy-duddies, all the ultra-aesthetes, all the copiers.
From an editorial, **LEF** *No. 1, March 1923, Moscow.*

LEF's position is stated further in three excerpts from LEF No. 3:

We — workers of Left culture — intend to ruin the attic. The Revolutionary affair is not a six-hour job, not only from 10 to 4. It is ridiculous, and nonsensical, absurd and impossible:

To reveal the method in politics and economy, veiling them in culture and life...

To bring up yourself for the World Revolution, keeping reverential respect to the absolutes, chevalet [shibbolets], dales and taboo...

To oppose a compromise in the middle of the square, reserving your afternoon attic for the conciliation...

To be a maximalist in time — and a minimalist on the bottom...

To bristle up the earth — crawling on all fours...

For the realms of politics-culture-life are not separated as the attic and the auditorium.

They are communicating vessels; interlaced riverbeds [channels]; crossing planes; interchanged ways. The Left policy imperiously demands the left culture, the left life.

In the end the road of the revolution is a road to the organized man...
"From 10 to 4 and From 4 to 10" by M. Levidov. **LEF** *No. 3 June - July 1923, Moscow. Translated by Rimma Gerlovina.*

...I am kino-eye. I am a mechanical eye. As a machine, I show the world as only I can see it.

I release myself today of human immobility, I am non-stop motion, I bring myself nearer and move myself off things, I creep under them, I get inside them, I move along the muzzle of a riding horse, I crash into the crowd, I run together with soldiers, I tipple over my back, I take off with airplanes, I fall down and fly up with falling down and flying up bodies.

Because this road is very hard and connected with the searches new and new skill (mastership);

Because it demands certain estrangement of pity, individual methods, i.e. "yourself";

It demands reconstruction of all your psychological orientation towards the masses;

Because, at last, the art itself is estimated under the new circumstances, not as separated from life, buffoonery, but as direct, inventive skillful penetration in regular life;

It was outrageously difficult to follow this road for the guild artisan.
"Kinoki Overturn" by Dziga Vertov. **LEF** *No. 3 June-July 1923, Moscow. Translated by Rimma Gerlovina.*

...[Our] job is ridiculously simple:

We need such [LEF] art, which could organize our day. The proletariat is chief organizer of today. Therefore, the art of the day can be built only with the active participation of the proletariat...

In this moment the idea of direct building of things through the art was born among the left wing of art circles, mainly Futurists, as a result of an instinct for self-preservation of art and indirect influence of the necessities of the new class-dictator. The art is proclaimed as a simple production of values and the practical art follows this road.
"Pluses and Minuses" by N. Chuzhak. **LEF** *No. 3 June-July 1923, Moscow. Translated by Rimma Gerlovina.*

Vladimir Mayakovsky later stated that the "de-aestheticization of the productional arts, constructivism," was one of LEF's achievements. Maciunas picked up on Mayakovsky's assessment of LEF and drew parallels with the group when he defined the ideology of Fluxus to Tomas Schmit:

...Fluxus objectives are social (not aesthetic). They are connected to the group of LEF group of 1929 [sic] in Soviet Union (ideologically) and concern itself with: Gradual elimination of fine arts (music, theatre, poetry, fiction, painting, sculpture etc. etc.) This is motivated by desire to stop the waste of material and human resources ... and divert it to socially constructive ends. Such as applied arts would be (industrial design, journalism, architecture, engineering, graphic-typographic arts, printing etc.).

...Thus Fluxus is definitely against art-object as non-functional commodity — to be sold & to make livelihood for an artist. It could temporarily have the pedagogical function of teaching people the needlessness of art including the eventual needlessness of itself. It should not be therefore permanent....

Fluxus therefore is ANTIPROFESSIONAL (against professional art or artists making livelihood from art or artists spending their full time, their life on art.). Secondly FLUXUS is against art as medium or vehicle promoting artist's ego, since applied art should express the objective problem to be solved not artist's personality or his ego. Fluxus therefore should tend towards collective spirit, anonymity and ANTI-INDIVIDUALISM — also ANTI-EUROPANISM (Europe being the place supporting most strongly — & even originating the idea of — professional artist, art — for art ideology, expression of artist's ego through art etc. etc.)....

These FLUXUS concerts, publications etc — are at best transitional (a few years) & temporary until such time when fine art can be totally eliminated (or at least its institutional forms) and artists find other employment....

Letter: George Maciunas to Tomas Schmit, [January, 1964].

Maciunas' concern for the collective versus individualism:

...In future all Fluxus concerts (concerts consisting of predominantly Fluxus materials) MUST be called Fluxus concerts. This is purely for propaganda purposes. If newspapers do not mention Fluxus, their reviews are totally worthless for publicity here in New York. That's why we copyright compositions, so we can FORCE mention of FLUXUS (collective) rather that individuals. This is all part of the anti-individualism-campaign....

Letter: George Maciunas to Tomas Schmit, January 24, 1964.

SOME HYSTERICAL OUTBURSTS HAVE RECENTLY RESULTED FROM PEOPLE WHO FAILED TO READ THE ATTACHED SHEET AND YET INTERPRETED WHAT WAS NOT WRITTEN. ALL THE SHEET STATES IS THAT PERMISSION IS GRANTED TO ANYONE, ANYWHERE, ANYTIME TO PERFORM ANY FLUXUS PIECE AT NO COST WHATEVER, PROVIDED PUBLICITY IS GIVEN TO THE FLUXUS GROUP. CHARGE IS MADE ONLY AS A NEGATIVE INCENTIVE. NO PROHIBITION OF ANY KIND IS WRITTEN OR IMPLIED. ANYONE NOT WISHING TO PUBLICIZE FLUXUS SHOULD NOT HAVE INTEREST IN PERFORMING PIECES FROM THAT GROUP. THE RULES WERE ESTABLISHED FOR THE SOLE PURPOSE OF PROMOTING WORKS OF PEOPLE FROM FLUXUS GROUP. EVEN WHEN A SINGLE PIECE IS PERFORMED ALL OTHER MEMBERS OF THE GROUP WILL BE PUBLICIZED COLLECTIVE—LLY [sic] AND WILL THUS BENEFIT FROM IT. ANYONE OBJECTING TO SUCH A SCHEME SETS HIMSELF IN OPPOSITION TO COLLECTIVE ACTION AND THUS HAS NO BUSINESS BEING ASSOCIATED WITH FLUXUS, WHICH IS A COLECTIVE [sic] NEVER PROMOTING PRIMA DONAS [sic] AT THE EXPENCE [sic] OF OTHER MEMBERS.

[**Fluxus Newsletter**, *by George Maciunas, ca. 1965]. Written in response to the reaction to "Conditions for Performing Fluxus Published Compositions, Films & Tapes," [ca. 1965].*

...By anticollectivism & individualism I meant — absence of any effort or desire to promote Fluxus as a group. This applies to Emmett [Williams] when he did his Paris fest ["Poesie Etcetera Americaine," Paris, October 9, 1963]. I just assumed that if he was not interested in promoting Fluxus as a Collective why should Fluxus promote him? Fluxus is not an individual impresario & if each does not help another collectively by promoting each other, the Collective would lose its identity as a Collective and become individuals again, each needing to be promoted individually. and I think I have written on this theme too many times, on the point of becoming

tiresome. Emmett should know it well. Ben Vautier and Jeff Berner I think illustrate very well what I mean by a collective attitude. Whenever they organize events or publish material (and Ben does a lot of it) he does it as part of a Fluxus activity. In other words he promotes Fluxus group (meaning some dozen other people) at the expense of his own name. He has done this at his own free will, just because he feels he is just as much a part of it as I am. In fact he spends as much money on Fluxus as I do, I think — that is indication of Collectivism. But when people expect me to be the spender and themselves the beneficiaries only, then I assume they consider me to be Fluxus & not a collective, thus anticollectivism. *Letter: George Maciunas to Dick Higgins, [ca. July, 1966].*

It was the original intent of Fluxus to produce collective works, as can be seen in the plans for the Fluxus Yearboxes and concerts, like LEF using its publications to propagandize the ideas and aims of the group. On January 1, 1963, George Maciunas announced in **Fluxus Newsletter** No. 5 that, "it has been decided to publish...special collections of single authors and special items — works of single authors"... justifying this and exclusive Fluxus copyright of these works, as a means of "centralization of new art and anti-art activities" to "strengthen 'propaganda'."

Fluxus collective works grew to take two basic forms: publications such as the yearboxes and newspapers which were anthological gatherings of writings, scores, adoptable objects, etc. used as inexpensive propaganda vehicles for the movement; and kits which packaged a number of individual Fluxus works, and some collective publications as well — more expensive but intended for the same purpose. Environments and participation structures such as the **Flux Amusement Center** and **Flux-labyrinth,** extensions of the idea of Anthologies inherent in both publications and kits, contained ideas specifically adapted to their structure, lying in that nebulous ground between product and performance, and are always collective works.

A distinction must be made between collective and collaborative. A great deal of Fluxus product was a collaboration between one or more artists and George Maciunas. An artist would give Maciunas an idea for a work or a prototype to produce as a Fluxus Edition. He would take the idea and interpret it in his own special and distinctive way, usually designing the label, choosing the contents and packaging of the work, sometimes consulting the artist, other times not. An example of Maciunas' collaboration can be seen in Per Kirkeby's "Boxed Solids" series originally suggested by Kirkeby as **Flux Wood** "This box contains wood," a titled metal box containing sawdust. Maciunas interpreted the work into an announced series of solids in containers of the same material: **Sol-id Clay in Ceramic Box; Solid Glass in Glass Jar; Solid Leather in Leather Box; Solid Metal in Metal Box; Solid Plastic in Plastic Box; Solid Wood in Wood Box.** Another example of this collaboration is John Chick's **Flux-Food,** a work which seems to have endless variations and interpretations. This artistic collectivism — centralization of production and control of product — was a unique aspect of Fluxus, and is central to an understanding of the work.

This section is concerned solely with the following collective works:

AN ANTHOLOGY
CASH REGISTER
COMPLETE FLUXUS PIECES
DISPENSERS
EKSTRA BLADET
FLUX AMUSEMENT CENTER
FLUX CABINET
FLUX CLINIC
FLUX ENVELOPE PAPER EVENTS
FLUX FEST KIT 2
FLUXFEST SALE
FLUXFILMS
FLUXFILMS ENVIRONMENT
FLUXFILMS LOOPS
FLUX FOOD
FLUXFURNITURE
FLUX GIFT BOX
FLUX HISTORY ROOM
FLUXKIT
FLUX LABYRINTH
FLUX LIBRARY
FLUX MEDICAL KIT
FLUX PAPER GAMES: ROLLS AND FOLDS
FLUX-PHONE ANSWERING MACHINE
FLUXPOST KIT 7
FLUXSTAMPS
FLUX TATTOOS
FLUX TOILET
FLUXTRAIN
FLUX TV PROGRAM
FLUXUS [BROCHURE PROSPECTUS FOR
 FLUXUS YEARBOXES] version A
FLUXUS [BROCHURE PROSPECTUS FOR
 FLUXUS YEARBOXES] version B

FLUXUS NEWSLETTERS

FLUXUS NEWSPAPERS:
 No. 1 January, 1964
 Fluxus cc V TRE Fluxus

 No. 2 February, 1964
 Fluxus cc V TRE Fluxus

 No. 3 March, 1964
 Fluxus cc Valise e TRanglE

 No. 4 June, 1964
 Fluxus cc fiVe ThReE

 No. 5 March, 1965
 Fluxus Vacuum TRapEzoid

 No. 6 July, 1965
 Fluxus Vaudeville TouRnamEnt

 * Sept. 1965-1970*
 Fluxus Vague TREasure

 No. 7 Feb. 1, 1966
 Fluxus 3 newspaper eVenTs for the pRicE
 of $1

 No. 8 May, 1966
 Fluxus Vaseline sTREet

 * 1966-June 1970*
 [Fluxus] VerTical pRaguE

 * 1967*
 Fluxus VauTieR nicE

 No. 9 1970
 JOHN YOKO & FLUX all photographs copy-
 right nineteen seVenty by peTer mooRE

 * 1973*
 Flux amusement center V TRE

 No. 10 May 2, 1976
 FLUXUS maciuNAS V TRE FLUXUS lau-
 datio SciPTa pro GEoRge [published in
 honor of Maciunas]

 No. 11 March 24, 1979
 a V TRE EXTRA [Posthumus tribute to
 Maciunas by Fluxus artists]
 * not published

FLUXUS PREVIEW REVIEW
FLUXUS YEARBOXES:
 FLUXUS 1
 FLUXUS NO. 2 WEST EUROPEAN
 YEARBOX I
 FLUXUS NO. 3 JAPANESE YEARBOX
 FLUXUS NO. 4 HOMAGE TO THE PAST
 FLUXUS NO. 5 WEST EUROPEAN
 YEARBOX II
 FLUXUS NO. 6 EAST EUROPEAN
 YEARBOX
 FLUXUS NO. 7 HOMAGE TO DADA
 FLUX YEAR BOX 2
 FLUXPACK 3
FLUX WEST ANTHOLOGY
LAUDATIO SCRIPTA PRO GEORGE
PORTRAIT OF JOHN LENNON AS A
 YOUNG CLOUD
TICKET DISPENSER
TIME CLOCK WITH PUNCH CARDS
WEIGHING MACHINE

a V TRE EXTRA see:
FLUXUS NEWSPAPERS

AFTER EFFECT MEALS see:
FLUX FOOD

AGIT PROP TRAIN see:
FLUXTRAIN

all photographs copyright nineteen seVenty by peTer mooRE see:
JOHN YOKO & FLUX all photographs copyright nineteen seVenty by peTer mooRE

AMERICAN YEARBOX see:
FLUXUS 1

amusement center V TRE see:
Flux amusement center V TRE

AMUSEMENT PLACE see:
FLUX AMUSEMENT CENTER

AN ANTHOLOGY
Silverman No. 539

AN ANTHOLOGY Subscriptions $2.98 TO: La Monte Young 119 Bank Street, N.Y. 14, N.Y. U.S.A.
Advertisement insert in Neo-Dada in der Musik program. [ca. June 16, 1962].

An Anthology of lively work, edited by La Monte Young, is soon to appear. Order from him ($2.98) at 119 Bank St, NYC
Yam Festival Newspaper, [ca. 1963].

AN ANTHOLOGY of work by Brecht Bremer Brown Byrd Cage Degener DeMaria Flynt Ono Higgins Ichiyanagi Jennings Johnson Dong Johnson Mac Low Maxfield Morris Morris Paik Riley Rot Waring Williams Wolff Young
La Monte Young, Editor, George Maciunas, Designer
AN ANTHOLOGY $3.98 checks payable to Jackson Mac Low 965 Hoe Ave. Bronx 59 N.Y. or La Monte Young 275 Church St. New York N.Y.
Sissor Bros. Warehouse Newspaper, [1963].

"...Did you get Anthology?..."
Letter: George Maciunas to Tomas Schmit, August 9, 1963.

AN ANTHOLOGY AN ANTHOLOGY AN ANTHOLOGY $3.98 Now available at bookstores and Smolin Gallery or checks payable to La Monte Young, P.O. Box 190, New York 10013, or to Jackson Mac Low, 965 Hoe Ave., Bronx 59
cc V TRE (Fluxus Newspaper No. 1) January 1964.

5-1 AN ANTHOLOGY of chance operations, concept art, anti art, indeterminacy, plans of action, diagrams, music, dance constructions, improvisation, meaningless work, natural disasters, compositions, mathematics, essays, poetry by George Brecht, Claus Bremer, Earle Brown, Joseph Byrd, John Cage, David Degener, Walter de Maria, Henry Flynt, Hans Helms, Dick Higgins, Toshi Ichiyanagi, Terry Jennings, Dennis Johnson, Ray Johnson, Jackson Mac Low, Richard Maxfield, Robert Morris, Simone Morris, Nam June Paik, Terry Riley, Diter Rot, James Waring, Emmett Williams, Christian Wolff, La Monte Young. (editor: La Monte Young) $3.98.
European Mail-Orderhouse: europeanfluxshop, Pricelist. [ca. June 1964].

"...Do you have Anthology I designed?. I am sending some 30 of these books. Sell each for $4...."
Letter: George Maciunas to Willem de Ridder, [end of July, 1964].

[identical to first pricelist]
Second Pricelist - European Mail-Orderhouse. [Fall 1964].

did you receive the 2nd catalog of THE EUROPEAN MAIL-ORDERHOUSE & FLUXSHOP? [advertising] ...anthology etc.
How to be Satisfluxdecolanti?... [ca. Fall 1964].

COMMENTS: *This seminal pre-Fluxus anthology was edited by La Monte Young in 1961, and finally published in 1963 by Young with assistance from Jackson MacLow. It can be considered a Fluxus work on several fronts: George Maciunas designed the book; he helped with its distribution by advertising it in Fluxus publications; he sent it to Europe for distribution there; it was included in some assemblings of Fluxkit, and is a component of the European Mail-Order Warehouse/ Fluxshop; it contains works by many artists who became part of Fluxus; some works published by Fluxus in 1962 and 1963 are included in An Anthology; but most important, it was the model and catalyst for a series of seven planned Fluxus anthologies (only one, FLUXUS 1, was actually produced) which led directly to a number of collective Fluxus anthologies which were actually realized. Their evolution was:*

1. *Fluxus Preview Review, 1963*
2. *FLUXUS 1, ca. 1963 - 1977 or 1978*
3. *Fluxus Newspapers Nos. 1 to 9, 1964-1970 (plus several not produced)*

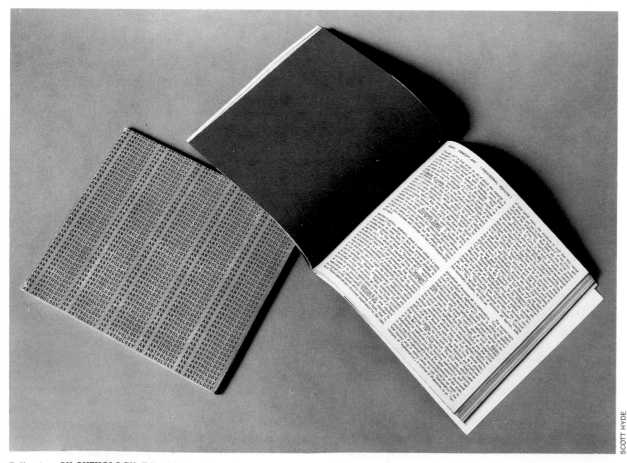

Collective. AN ANTHOLOGY. Edited by La Monte Young

SCOTT HYDE

4. Fluxkit, *1964-ca. 1969*
5. *Hi Red Center* Bundle of Events, *1965*
6. Fluxfilms, *1966-ca. 1972*
7. Fluxfest Sale, *1966*
8. Flux Year Box 2, *1966-1977*
9. Flux Fest Kit 2, *1969*
10. Flux Pack 3, *ca. 1973*
11. Flux Cabinet, *1977*

For An Anthology, Maciunas designed a graphic characterization of its contents, which is similar to one he designed about the same time for the two Brochure Prospectuses for Fluxus Yearboxes in order to characterize the intent and content of Fluxus.

An Anthology	Brochure Prospectus
natural disasters	*happenings*
chance operations	*automatism*
concept art	*concept art*
indeterminacy	*indeterminacy*
improvisation	*theater*
essays	*Brutalism*
stories	*prose*
music	*music*
anti-art	*anti-art*
diagrams	*philosophy*
meaningless work	*plastic arts*
mathematics	*cinema*
compositions	*concretism*
dance constructions	*dance*
plans of action	*Dada(ism)*
poetry	*poetry*
	Bruitisme
	Lettrism
	Nihilism

ANSWERING MACHINE see:
FLUX-PHONE ANSWERING MACHINE
ANTHOLOGY OF FILM LOOPS see:
FLUX YEAR BOX 2
ARCHIVES see:
FLUX HISTORY ROOM
ATHLETICS see:
FLUX AMUSEMENT CENTER
ATTACHE CASE see:
FLUXKIT
AUSTRIA see:
FLUXUS NO. 5 WEST EUROPEAN YEARBOX II
BELGIUM see:
FLUXUS NO. 5 WEST EUROPEAN YEARBOX II
BROCHURE PROSPECTUS FOR FLUXUS YEARBOXES see:
FLUXUS [BROCHURE PROSPECTUS FOR FLUXUS YEARBOXES]
cc fiVe ThReE see:
fluxus cc fiVe ThReE
cc V TRE see:
Fluxus cc V TRE Fluxus

cc V TRE Monthly newspaper see:
FLUXUS NEWSPAPERS
cc Valise e TRanglE see:
Fluxus cc Valise e TRanglE
CABINETS see:
FLUX CABINET
FLUXFURNITURE
CAPSULE see:
FLUXFILMS ENVIRONMENT

CASH REGISTER

"...I hear you are sick & have nothing to do...you could build a cash register — very important! — for fluxus shop OK?/Build one where instead of sum in $ funny pictures come out & objects, and maybe sounds —OK? — Get well with cash register..."
Letter: George Maciunas to Robert Watts, March 13, 1964.

"...We may get backing from a man with lots of $ to open a real Fluxshop in some fancy place like Madison Ave....If this works out we can set up an elaborate shop. I got an antique cash register, which we could connect to various events. i.e. each key (there are 100 keys) would be electrically connected to some events, like snow falling, lights off, sounds, visual events, etc. etc. smells, think of something and let me know, we are making this cash register a collective piece (like medieval cathedrals) Up to now we got Bob Watts, Joe Jones, myself with ideas for cash register. Another 50 keys left - unused. ..."
Letter: George Maciunas to Ben Vautier, March 29, 1966.

"...We plan to make the Fluxshop as a continuous event mechanism. Cash register keys would be connected electrically to all kinds of events; sounds of all kinds or movements, such as falling artificial snow, or shutting off lights, etc, etc. Every time a sale is made and appropriate keys pushed, some different combination of events would occur. It could have amusing effects. We would also try to display all the Fluxus objects (about 100 different objects) in some funny way. You could help us design and prepare this shop during August."
Letter: George Maciunas to Milan Knizak, May 19, 1966.

FLUX-PROJECTS PLANNED FOR 1967...Collective projects: (All are invited to submit ideas and participate, ideas can be either ready pictorial material or just specified material which we have to find, produce or obtain otherwise)...Cash register (most likely for 1968 flux-shop) about 100 keys, each will be electrically or mechanically connected to switch on events, sounds, or small panels (on price indicators on machine itself)....cash register will be used as exit event (different according to price of object bought)...
Fluxnewsletter, March 8, 1967.

FLUXPROJECTS FOR 1969...At 16 Greene st. 2nd floor 16' x 85' space. Similar arrangement as per enclosed for gallery 669 (never realized), with addition of:...FLUXSHOP A cash register, each key (total 36) mechanically or electrically connected to activate some action or event. (snowfall, lights off, loud sound, blast of spice, other smells, trap door, etc. suggestions welcome)...PROPOSALS WILL BE WELCOMED FOR:...cash register key events FLUXPROJECTS FOR 1969...PROPOSALS WILL BE WELCOMED FOR:...cash register key events
Fluxnewsletter, December 2, 1968.

COMMENTS: *The whereabouts of this wonderous Stanley Steamer of performance is unknown.*

CLINIC see:
FLUX AMUSEMENT CENTER
COLORED MEAL see:
FLUX FOOD

COMPLETE FLUXUS PIECES

"...Regarding your idea of printing all performance pieces with possible variations, yes I agree. To make more economical, I would print maybe 10 pieces on a sheet of paper. Or single composer on one sheet (or one year - one composer on a sheet, so each supplement would be for a year & separate. I will start printing them this fall. Check with George Brecht whether it is ok with him because he is very particular about how his scores are printed. 21½cm x 16½cm is OK, since it is close to standard 8½ x 11in in U.S.A. paper sizes. Could you translate into French?"
Letter: George Maciunas to Ben Vautier, [possibly Fall, 1966].

COMMENTS: *The* Complete Fluxus Pieces *was never published as such.* Fluxfest Sale *and* Flux Fest Kit 2 *contain many Fluxus scores and descriptions of scores. Ben Vautier has spoken with me of the need to publish such a work, and I have started the process of identifying and collecting Fluxus scores for the Silverman Collection. Perhaps someday, a book of scores will be published.*

CZECH ISSUE see:
[FLUXUS] VerTical pRaguE
DADA see:
FLUXUS NO. 7 HOMAGE TO DADA
DIE GAME ENVIRONMENT see:
FLUX AMUSEMENT CENTER
FLUXFURNITURE

DISPENSERS

PROPOSED R & R EVENINGS...Food & drink event,

(drink dispenser dispensing various strange drinks or food)
Fluxnewsletter, January 31, 1968.

PROPOSED FLUXSHOW FOR GALLERY 669 ... AUTOMATIC VENDING MACHINES – DISPENSERS (coin operated)
a. drink dispenser dispensing water.
b. dispenser dispensing pennies (one for a dime)
c. dispenser dispensing loose sand or dust or glue.
d. cigarette dispenser dispensing prepared cigarettes (with flash paper, with smoke powder, with tea leaves etc)
e. dispenser dispensing an endless string (one end only).
Fluxnewsletter, December 2, 1968.

PROPOSED FLUXSHOW...AUTOMATIC VENDING MACHINES – DISPENSERS (coin operated)
a. drink dispenser dispensing water with cup missing or into water soluble cup.
b. change dispenser dispensing pennies (one for a dime)
c. nut dispenser dispensing into the palm loose sand, or glue.
d. cigarette dispenser dispensing prepared cigarettes: with flash paper, with smoke powder, with tea leaves, etc.
e. dispenser dispensing an endless string.
Fluxnewsletter, December 2, 1968 (revised March 15, 1969).

FLUXFEST INFORMATION...
P.O. BOX 180, NEW YORK, N.Y. 10013
Many fluxpieces are described and listed in the Expanded Arts issue of FILM CULTURE magazine. A reprint can be obtained for $1. Any of the fluxpieces can be performed anytime, anyplace and by anyone, without any payment to Fluxus provided the following conditions are met:
1. if fluxpieces outnumber numerically or exceed in duration other compositions in any concert, the whole concert must be called and advertised as FLUXCONCERT or FLUXEVENT. A series of such events must be called a FLUXFEST.
2. if fluxpieces do not exceed non-fluxpieces, each such fluxpiece must be identified as a FLUXPIECE. Such credits to Fluxus may be omitted at a cost of $50 for each piece announced or performed....flux-vending machines...

ibid.

PROPOSED CATEGORIES ... FLUXFOODS & DRINKS Cafeteria Vending machines...PROPOSED CATEGORIES ... VENDING MACHINES ... LOCATION...Dormitories etc...
Fluxfest at Stony Brook, Newsletter No. 1, August 18, 1969. versions A & B

AUTOMATIC VENDING MACHINES
1. Drink dispenser dispensing drink with cup missing, or with cup coming after drink, or with water soluble cup.
2. Change machine dispensing penny for dime.
3. Nut dispenser dispensing into the palm loose sand or glue.
4. Cigarette dispenser dispensing prepared cigarettes: with flash paper, with smoke powder, with rope or rubber in tobacco, etc.
5. Dispenser of an endless string.
[Fluxfest Information...on "flux-vending machines" is identical to Fluxnewsletter, December 2, 1968 (revised March 15, 1969).]
Flux Fest Kit 2. [ca. December 1969].

FLUXFEST PRESENTATION OF JOHN LENNON & YOKO ONO...MAY 30-JUNE 5: THE STORE BY JOHN & YOKO + FLUXFACTORY Coin operated vending machines:
1. machines devouring deposited objects,
2. crying machine dispensing tears,
3. machines dispensing sky (air) (all 3 by Yoko Ono),
4. change machine dispensing metal slugs (fake coins for a penny) (John Lennon),
5. change machine dispensing penny for a dime (G. M. 1951),
6. drink dispenser dispensing drink with water soluble or leaking cup (G.M.),
7. nut dispenser dispensing into palm loose sand or glue or an endless string (G. Maciunas),
8. Cigarette dispenser dispensing cigarettes with rope, dried fruit, sawdust & other filling,
9. perfume dispenser dispensing various strange scents and smokes (Yoshimasa Wada),
10. rain machine (Ayo)...
Schedule of events for Fluxfest presentation of John Lennon and Yoko Ono. [ca. April 1970]. version B

FLUXFEST PRESENTS YOKO ONO ... MAY 30 - JUNE 5: THE STORE BY YOKO + FLUX-FACTORY Vending machines (coin operated):
machine receiving deposited objects and making them disappear, crying machine dispensing tears, machine dispensing sky, air, (by Yoko Ono); drink dispenser dispensing drink with cup missing, or with cup coming after drink, with water soluble cup, change machine dispensing penny for a dime, nut dispenser dispensing into the palm loose sand or glue, dispenser of an endless string (by G. Maciunas); cigarette dispenser dispensing prepared cigarettes, with rope, tobacco, dried fruit skins, etc. mixed in the tobacco, machine dispensing incence [sic] and smoke of various mixtures (by Yoshimasa Wada); rain machine (Ayo).
Schedule of events for Fluxfest presentation of John Lennon and Yoko Ono. April 1, 1970. version C

"...If something is still needed for the Rome exhibit

... you could also install a few vending machines, which you could obtain locally, since it would not pay to ship them..."
Letter: George Maciunas to Giancarlo Politi, n.d. Reproduced in Fluxnewsletter, April 1973.

...This Fall, we shall publish V TRE no. 10, which shall consist of a plan for Flux-Amusement-Center, to contain the following:...Vending machines, drink, food, nut type dispensers (dispensing glue, endless string, holy relics, drink before cup, or perforated cup, air etc.)
Fluxnewsletter, April 1973.

JULY 30 & 31 FUNNY WEEKEND...Flux show & vending machines
Proposal for Flux Fest at New Marlborough. April 8, 1977.

COMMENTS: Although planned, a collective Fluxus vending machine arcade was not realized. Individual dispensers were produced by Fluxus or produced by others and used for Fluxus purposes. The idea for artist adapted dispensers evidently came independently from three artists: in 1961, Yoko Ono wrote "Chewing Gum Machine Piece" which proposed putting word cards for a penny in gum machines and placing them next to Coca-Cola machines. She realized Sky Dispenser in 1966 based on the 1961 score, and proposed three others on her 1965 sales list – a Crying Machine, Disappearing Machine, and Danger Box. Word Machine and Sky Machine also appear on that list and are combined in Sky Dispenser. Robert Watts constructed a Pen Dispenser and several Stamp Dispensers starting in 1963. And also around 1963, Knud Pedersen produced for the Kunstbibliotek in Copenhagen, several different sets of 12 three-minute records for juke boxes. They were, Robert Filliou's Whispered Art History, 12 stories about eggs by Daniel Spoerri, 12 records of applause by Bazon Brock; a 12 part story about worms in the brain by Arthur Koepcke; water music (music of water) by Henning Christiansen and possibly a work by Eric Andersen. The jukebox was placed in a coffee shop for half a year, and then at the entrance of Nikolai Kirke where the Art Lending Library was situated. People could select either a hit tune, or a Pedersen production by putting money in the slot.

EKSTRA BLADET

FREDAG 23. november 1962 - 59. årgang - Nr. 239
Rådhuspladsen 33 - Kbh. V - C. 8511 - 65 øre

Kulturen skal i skraldespanden

Ud med det hele

I aften starter Fluxus-festivalen i Nikolaj Kirke i København

I aften lægges det store kanonslag under kunsten og kulturen.

FLUXUS-festivalen starter i Nikolaj Kirke.

Ingen kommer til at føle sig snydt. Fjernsynet vil være til stede på premiereaftenen, og på onsdag får seerne de fleste af begivenhederne på skærmen.

Bliver der ballade?

Fjernsynet regner med det. Man har oprettet et nærligt protest-telefonnummer på radioen, for at seerne kan få afløb for deres eventuelle vrede.

Hvad er der al blive vred over? En mange, forandentlig. Fluxusfolkene — en halv snes mand med kvenanteren Nam June Paik i spidsen — går hårdt til tagen i aften. De vil provokere os, for „verdens er rådden, borgerlig og reaktionær", og der må ruskes op i den. De mener, at musikken og al anden kunst har overlevet sig selv. Det hele kan stige i skraldespanden. Og hvor mange vil finde det så arbet og hære det ske?

På programmet for „koncerten" aften står der ti numre. Titlerne på

Syv fløjtekedler, syv balloner, en halv liter blæk, en natpotte, en pressefotograf, en flaske vand, en tom spand, en stige, et gadeskilt, otte hulte, en sæk tomater, en sæk salat, en sæk løg en sæk gulerødder, masser af papir, en rulle med papir og et skilt med ordet „UD«.

Alt det er med i aften, når der i Nikolaj Kirke i København lægges kanonslag under kunsten og kulturen. — Læs om fluxus-festivalen inde i bladet.

(further columns of Danish text)

LØRDAG 24. november 1962 - 59. årgang - Nr. 240 EKSTRABLADET 29

Det er Fluxus

Sådan som De skal opleve det i TV på onsdag aften

Ved indgangen fik vi at vide, at man burde beholde frakken på og smøge kraven godt op om ørerne.

Det skyldtes ikke, at der var koldt i kirken.

Tværtimod. Dei var FLUXUS, der kom til byen. Premieren foregik i aftes i Nikolaj Kirke i København.

Tre TV-kameraer vogtede på FLUXUS. Hvad el par hundrede københavnere i aftes så, kan millioner se på onsdag hjemme i dagligstuen.

Råeb er spontant

(further columns of Danish text)

Nulpunktet

Lørdag 24. november 1962

FLUXUSTID I KIRKE

POLITIKEN

KØBENHAVN, LØRDAG 24. NOVEMBER 1962

og kaffe-kande-dut

Hatten af — efter noder

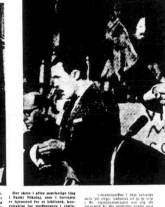

Collective. EKSTRA BLADET. Detail

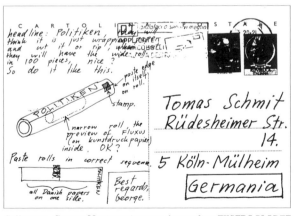

Collective. George Maciunas' system for mailing EKSTRA BLADET with FLUXUS PREVIEW REVIEW inside

EKSTRA BLADET
Silverman No. 543, ff.

"...could you prepare a dozen or so fluxus long rolls. [Fluxus Preview Review] (paste them carefully! straight!) maybe some Koeln printer can do them for you quickly. & send a few out.(as drucksache by boat to few N.Y. people: Higgins, Flynt, Mac Low, Brecht, La Monte, Watts, Mekas, etc.)...send them this way: take small, narrow roll & wrap it in wide - newsprint

roll [Ekstra Bladet] then paste edge on itself, so that when they get it they will just read headline: Politiken, they will think it is just wrapping paper and cut it or rip, when cut they will have the wide roll in 100 pieces, nice? so do it like this...."
Letter: George Maciunas to Tomas Schmit, [August 1963].

COMMENTS: *The title* Ekstra Bladet *is a Fluxus pun, being both the name of a Danish newspaper, meaning literally extra leaf. The "newspaper roll" was a montage of articles on Fluxus from different newspapers that appeared primarily in European newspapers between September and November, 1962. The two-sided work is printed on newsprint, and was used to publicize the movement.*

FLUX YEAR BOX 2
FILM WALLPAPER ENVIRONMENT see:
FLUXFILMS ENVIRONMENT
fiVe ThReE see:
Fluxus cc fiVe ThReE
FLUX AMUSEMENT ARCADE see:
FLUX AMUSEMENT CENTER

FLUX AMUSEMENT CENTER

PROPOSAL

The principal business of this Company (to be known as The Greene Street Precinct, Inc.) will be twofold:
1. The operation of a unique entertainment and game environment, including a multi-level discotheque with both live and canned music and related environmental spaces fitted with specialty shops, concessions, and featuring a specially designed automated food, drink and game lounge. New rock and roll and rock & blues groups will be featured, as well as occasional performances of jazz and new music.
2. The development, distribution, and sale of a new product line utilizing the talents of new and well known artists and designers. Products will be of low cost, mass produced and distributed to mass markets here and abroad. Certain more expensive items may be of limited production considered unique and for conspicuous consumption. The product line will embrace certain existing lines of Flux-group and Implosions, Inc. which have proven sales value and/or potential for immediate production.

Concept.

The company is to be organized around the unique concept of providing two potentials in investment growth, both of which are intimately related. One, expanding upon the discotheque idea and presenting it to a new market in a new location, and two, a new product line presented to a proven market.

The discotheque is a proven success, even ones which do not appear to have much to offer. Recently, however, the existing market in uptown Manhattan has become over saturated with dull establishments and the operation is suffering from inflated real estate values and high operating costs. Most of the new places uptown are banal, lack imagination, and are not open to rapidly changing tastes in music and entertainment. We believe our location is ideal for future developments in this kind of enterprise. It is a strategic location just south of New York University and is centrally located with respect to both the East and West Village markets. From these areas it is easy walking distance; from uptown it is accessible by any subway. The Greene street Precinct will be the first and easily could become the most important "place" in the area. Our location will draw a new market, namely the more than 1000 artists who have recently moved here. As our "underground" reputation gets around we will draw from both the East and West Village [sic]. New York University is a potential hot market. There are two new theatres one block away, the Film-Maker's Cinematheque and the Performance Group. The Greene Street Precinct would be a natural place to go for after-theater audiences. We believe our location to be the best possible choice as we develop from new underground into a preferred establishment.

We further believe we have the capability to provide the best value in real entertainment. The management has proven experience and reputation in providing the best for underground and avant-garde audiences over the past ten years. Both the President and Vice-President are internationally renowed [sic] artists who have been leaders in the field of happenings, avant-garde theatre, and environmental works since their inception in 1958. Each have had business experience with the preferred audience and potential market. Each have unequalled reputations in NYC among the young sophisticated art audience and persons who are "known" in the arts. Even more important The Greene Street Precinct will provide an outlet to chan-nel their newest ideas to the audience.

The Greene Street Precinct will function as a total entertainment environment with dancing on the ground floor. The 2nd floor will contain shops, booths, and concessions devoted to merchandise in demand by the audience. It will feature aspects of pop culture heretofore not associated with a discotheque such as a historically oriented jazz record section, a palmist, an astrologer, and an underground press booth. New items will be dispenced [sic] from machines which together with play-game machines will constitute a new concept in audience — environment participation. Roughly half of this floor will contain another machine environment — the latest in food and drink dispensing oriented around a lounge for reading and relaxation.

The first and second floors will be treated as a complete environment with built-in flexibility for experiment and change. They are to be interconnected by a mezzanine arrangement which will provide experimental areas for placing both musicians and audience. Booths and shops can be easily rearranged and their appearance can be changed at will. The electrical ceiling installation will be flexible to provide power to any location and the ultimate in lighting nuance. Creative artists will be given the opportunity to work within the spaces to provide new and changing environmental situations, including new possibilities for presentation of live entertainment.

An intimate part of the Greene Street Precinct will be the new product line together with a new merchandizing method - Shopping will become an entertainment — adventure combining both existing products and the "house" line. The Greene Street Precinct line will consist of low cost imaginative items (such as Implosions presents) to offset competitors together with a more avant-garde offering including the Flux-line. Both groups have unique appeal, one geared to mass consumption, the other to a sophisticated audience. As the reputation and financial growth of the Company becomes a reality there are many avenues for expansion; such as tapes and records of live performances which eventualy [sic] could become collectors items, new records in conjuction [sic] with the introduction of new music, etc. Royalties from successful records and successful new groups are not to be ignored.

Because of the intimate association of Management with artists, designers, and the art world the newest ideas and best known artists are available to create new products, some of which are already part of the Flux- and Implosions lines; others are now ready for production. Flux-objects are already highly regarded by the new underground audience and the sophisticated art audience. Implosions products such as the stick-on tattoos have proven successful on a small

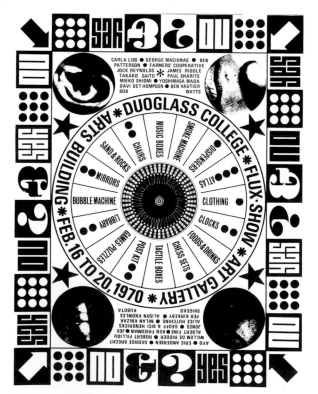

Collective. Detail of a poster for a **FLUX AMUSEMENT CENTER** held at Douglass College, New Brunswick, New Jersey, February 16-20, 1970

scale and are now ready for mass distribution. The success of both lines depends upon publicity and merchandising. We believe that a merchandising campaign skillfully directed having as "underground" appeal is the best way to develop a market for most of the new Greene Street line.

MANAGEMENT

George Maciunas (36) President & Treasurer - Educated at Cooper Union, Carnegie Inst. of Technology, New York University. Product development at Olin Mathieson Chemical Corp., architectural design at Skidmore, Owings & Merrill and Knoll Assoc., graphic design for private accounts (Film Culture Magazine, etc.) Developed a synthetically prefabricated building system now in pilot production. Organizer and agitator of Flux-group, the first organization of artists to produce objects for mass production and to bring experimental theatre to new audiences. Enterpreneur [sic] in avant-garde events such as those presented this year for the Contemporary Crafts Museum, NYC, sponsored by the Container Corp. of America.

Robert Watts (44) Vice-President. Artist, engineer, and Associate Professor of Art at Rutgers University. Numerous one-man and group shows here and abroad. First artist to introduce random electric circuitry into multi-media sculpture and environments. Research and development in multi-media concepts sponsored by research grants from Rutgers University and the Carnegie Foundation, NYC. Consultant to the Arts Councils of America and appointed Lecturer in Art and Consultant to University of California Santa Cruz, under a grant from the Carnegie Foundation. International reputation as a leading artist in the avant-garde movement. A.M. 1951, Columbia University; B.M.E., 1944, University of Louisville.

STAFF

1. Two persons intimately connected to the pop music establishment to be selected to act as co-managers, retained on salary and/or commission.
2. One person, director of merchandising and business manager, retained on commission basis.
3. Corporation counsel, on retainer or fee basis.
4. Outside consultants, on retainer or exchange basis.
5. Additional personnel such as door-man. bouncer, bar tender, waitresses, and janitor to be determined as need arises, on nominal salary and/or tips.

BUDGET

Plumbing (2 public toilets)	$3000
Electrical (new 300amp service & circuits)	$6000
Carpentry (public toilets, stair enclosure, mezzanines)	$8000
Terrazzo Floor (first floor only)	$6000
Masonry (opening up arches)	$2000
Fascade [sic] (doors, signs, lights etc.)	$2000
Heating and 30ton air conditioning & duct system	[$] 15000

Sound system (5 speakers, mike imputs, 4 channel ampl.)	$3000
Initial promotion (radio, newspaper, posters)	$2000
Initial operating expence [sic]	$2000
TOTAL	$49,000

OPERATING EXPENCES[sic]	Daily	Weekly	Yearly
Managers ($100/week each)	50	200	10000
Musicians	200	800	40000
Advertising	100	400	20000
Janitor, doorman	40	160	8000
Misc. (utilities, supplies)	40	160	8000
TOTAL	450	1800	90000

INCOME

Estimated on the basis of $2 per person admission charge, operating from 10PM to 4AM. 300 persons per day.

	Daily	Weekly	Yearly
Admission charge	600	2400	120000
Income from shops, $1 per person average	300	1200	60000
TOTAL	900	3600	180000
Operating costs	450	1800	90000
GROSS PROFIT	450	1800	90000

TOTAL NUMBER OF SHARES 100 at $1000 each, 90% interest/divident [sic] or 900 per $1000 share.

BUDGET - PRODUCT LINE

Initiating production of the following new products:

8 sunglass band	$10,000
Vinyl aprons, place mats & table cloths	$ 5,000
Stick-on and transfer decal - tattoos	$ 5,000
Bathing suit & dresses	$ 5,000
Egg boxes	$ 1,000
4 designs of playing cards	$ 5,000
4 poster designs	$ 500
Furniture	$ 5,000
Paper products, napkins, cups, dishes	$ 8,000
Flux-products	$ 3,500
TOTAL	$49,000

APPENDIX
GREENE STREET PRECINCT SHOPS:
Flux-shop
Palmist
Astrologer
Instant photo-mural
Record shop
Book shop (newspapers, posters, etc.)
Apparel, dress, jewelry
AUTOMATIC MACHINES
Food & drink (hot & cold, candy, desert [sic], ice cream etc.)
Juke box
Cigarettes, cigars
Toiletries (wash room)
Drugs & funny objects, postcards, etc. (washroom)
Game machines
Photo machine
Plastic sealer

Xerox
Stamps & postcards
Movie viewing machine
Weighing scale (with fortune telling cards)
ATHLETIC EQUIPMENT
See-saw
Swing
Trampoline
[George Maciunas and Robert Watts], Proposal for the Greene Street Precinct, Inc. [ca. December 1967].

NEWS FROM FLUX-HOUSES. This project spread byond [sic] all projected plans or expectations outlined in the 1967 flux-newsletter. 7 buildings were purchased, 4 or 6 more to be purchased in very near future. The buildings already purchased are at: 80 Wooster st where a large (50' x 100') theatre is already in operation as the "Film-Makers' Cinematheque", 16-18 Greene st., which will end up to be truly a Flux-house, with flux-shop, theatre, flux-masters residing there, flux-hotel, (totally flux-owned). The theatre there incidentally [sic] will also feature weekly Rock & Roll events (see attached supplement 2), and will be called 16 GREENE ST. PRECINCT. 4 buildings at 64-66-68-70 Grand st. and 31 Wooster st. which will house a theatre to be called THE GARAGE (operated by Implosions). That space is nearly 20 feet high, and 50' x 36'. The audience will be seated in 3 stacks against the wall or on 3 balcony tiers all around the perimeter, leaving the central space uncluttered and open for performances. Various events will be planned there like the FLUX-OLYMPIAD (see supplement 2). Both theatres should be ready April or May, and the FLUX-SHOP in June. The first 2 or 3 floors at 16-18 Greene st. will be interconnected by openings and intermediate platforms, so that the space will have the feeling of being 3 storeys [sic] high, with the shop & theatre interconnected spatially. A time clock and cash register mentioned in previous flux-letter (item 8 & 9) will be set up there at the flux-shop to perform various events when activated (by punch-card or cash).
Fluxnewsletter, January 31, 1968.

PROPOSED FLUXOLYMPIAD
1. RACKET GAMES:
a) prepared badminton: rackets with balloons instead of netting, balloons for shuttlecock.
b) prepared ping pong: rackets with attached cans filled with water, rackets with holes in center, rackets with faceted surface, rackets with extremely soft surfaces, rackets with 3ft. long handles (to be played on floor), etc.
2. TRACK & FIELD GAMES:
a) balloon javelin,...
c) ...race on stilts, etc....

6. BOARD GAMES:
a) chess tournament with: smell chess, sand timer pieces, sound pieces, etc....
c) card games with loaded decks, missing cards, duplicate cards etc....

PROPOSED R&R EVENINGS:
Flux-film-walls (loops by Paul Sharits, Albert Fine, George Maciunas, Wolf Vostell, Yoko Ono, etc.)
Foam rubber floor impregnated with detergent foaming suds, (Ayo)
Snow event (continuous drizzle of artificial snow or one drop in quantity)
Mirror floor event (Ayo), wood block floor event (Ayo), knee height streched [sic] rope (Ayo)
St. Valentine day massacre event, (machine guns with blanks, water, peas, spices, smoke, etc.)
Costume event, Tattoo event, Hat event, etc.etc.
Automobile event (musicians inside car), rubber tire floor, or floor made from junked car roofs, etc.
Feather event, Floor covered with feathers activated by dancers and fan-blown wind.
Food & drink event, (drink dispencer [sic] dispensing various strange drinks or food)
Roller skating event, water event, (musicians in bathtub), ball event, (floor covered with marbles, balls
Swinging event (dancers suspended from ceiling by harness)

ibid.

SUMMARY OF LAST NEWSLETTER (Jan.31, 1968)
...c) proposed Fluxolympiad (to be incorporated in the 1969 Spring Fluxfest at 18 Greene st.)
FLUXFEST
a 20 evening fluxfest will be held at 16 Greene st. theatre (25' x 100' space) sometimes during March and April. It will consist of Fluxolympiad & orchestra (from last newsletter proposals), flux-film environment, mechanical concerts, etc. (proposals from all will be welcomed).
Fluxnewsletter, December 2, 1968.

ENCLOSURES:...
proposed fluxshow for gallery 669 - to be adapted by fluxshop in 1969...
PROPOSED FLUXSHOW FOR GALLERY 669, LOS ANGELES. OPENING NOV. 26, 1968
1. STREET EVENTS.
a. Snowstorm no. 2, by Milan Knizak: a quantity of crushed expanded white polystyrene is dumped from roof.
b. Street cleaning event by Hi Red Center: Performers dressed in white coats (like laboratory technicians) clean a designated area of sidewalk very thoroughly with various devices not usually used in street cleaning, such as dental picks, toothbrushes, steel wool. cotton balls with alcohol, etc.
c. Sanitas no.13 by Tomas Schmit: telephone time

service is relaid to street via loudspeaker.
d. Sanitas no. 35 by Tomas Schmit: blank sheets are handed out to passers by.
e. Two inches by Bob Watts: 2 inch paper ribbon is stretched across entry to gallery each time it is torn by previous passer.

2. VESTIBULE VARIATIONS, by Ayo
Portions of vestibule filled with streched [sic] rope at knee height, other portion, floor covered with foam rubber impregnated with soap suds, other floor portion covered with upwardly protruding nails, except for a few areas in the shape of footprints, other floor portion covered with wood blocks of various shapes, other floor portion sloped upward and downward 30°. These floor variations can also be set up in the main gallery space if no vestibule is available.

3. FOOD CENTER:
a. Distilled (clear) coffee, tea, prune juice, tomato juice dispenced [sic] in test tubes. (a still may be set up to dispence fresh distilled drinks). by George Maciunas
b. 4 flux-teas by Per Kirkeby: tea bags filled with ground aspirin, another with salt, another with citric acid, and another with sugar.
c. Fish-meal: clear fish drink (distilled), clear fish jello, fish bread (from fish bone flour), fish pudding etc.
d. Empty egg shells: filled with water, jello, plaster etc.

4. SPORTS-GAME CENTER
a. prepared pin-pong [sic]: rackets with attached cans filled with water, rackets with holes in center, rackets with faceted surface, rackets with extremly soft surfaces, rackets with 3ft. long handles (to be played on floor
b. jousting on bicycles with leaking feather stuffed pillows.
c. chess sets with: smell pieces, sand timer pieces, sound pieces, etc.
d. balloon javelin.
e. slow-speed bicycle race (slowest winns [sic]).

5. CLINIC by Hi Red Center
An area is set up as a clinic where various measurments [sic] are taken of each visitor such as: head volume, mouth capacity, shoe and foot difference, finger strength, saliva production, extended tongue length, inflated cheek width, etc. (required equipment: scales, rulers, fluid volume measures.)

6. AUTOMATIC VENDING MACHINES - DISPENSERS (coin operated)
a. drink dispenser dispensing water.
b. dispenser dispensing pennies (one for a dime)
c. dispenser dispensing loose sand or dust. or glue.
d. cigarette dispenser dispensing prepared cigarettes (with flash paper, with smoke powder, with tea leaves etc.)

e. dispenser dispensing an endless string (one end only).

7. FILM WALLPAPER ENVIRONMENT
A booth must be set up in a fairly dark area, the walls of which are of white vinyl or cotton sheets (about 12ft. wide) hanging as curtains and creating a 12ft x 12ft or smaller room. Four 8mm loop projectors (with wide angle lenses) must be set up, one on front of each wall (on the outside) and projecting an image the frame of which is to cover entire wall. 20 sets of loops are available, such as vertical lines moving left (like a carousel), or single frame exposures of Sears catalogue etc.etc. Visitors, a few at a time, must enter this booth to observe the film environment around them.

8. SOUND ENVIRONMENT (may be within film environment)
a. relay of telephone time service.
b. street sounds are picked up by microphones placed outside and amplified to speakers inside (by Richard Maxfield)
c. Night Music by Richard Maxfield (loop) played with Artype film loop environment.
d. Requiem for Wagner by Dick Higgins played with eating mouth film loop.
e. paper sound loop, mouth sound loop etc.

9. SOUND MACHINES
a. Flux-quartet by Joe Jones: 4 automatically playing instruments (violin, duck call, bells, 2 reeds)
b. Flux-music-box by Joe Jones: 10 simultaneusly [sic] playing music movements
c. Flux-music-box by Joe Jones: wind-up noise making machines.
d. Paper noise machine

10. OBJECTS, FURNITURE
a. tabletops: desk, crossed legs, dinner setting, (by Watts, Moore, Spoeri [sic] Maciunas)
b. tabletop for displaying small objects will be like a gaming table with locations for displays marked like in a stamp album. All table tops are photographs laminated between wood table top and vinyl surface. They require stands or legs as shown: These pedestal type stands can be obtained from New York for $12 each, plus shipping charges. Additional table tops are in the form of photographs (unlaminated) which should be placed over a table of same size and covered with glass.
c. music-chairs by Takako Saito (bell & rolling ball)
d. clocks: 25 clockface clock by Jim Riddle, clock with face showing direction, or distance or degrees by Per Kirkeby; moire clock face by Bob Watts; faceless clock by George Maciunas; fast turning face (without arms); backward turning arms; etc.
e. Boxed events & objects (see supplement list A)
f. Boxed events & objects - one of a kind: time kit by Bob Watts, large rock by Bob Watts, game box

by George Brecht, boxed solid (leather in leather box, wood in wood box, glass in glass box, metal in metal box by Per Kirkeby; fingerhole by Bob Watts; A Question or more (3 wall hangings) by g. Brecht; jewelry kit by Alice Hutchins; Flux-adder by George Maciunas;

11. WALL OF POSTERS, PAST NEWSPAPERS (V TRE), (one of a kind)

12. TOILET OBJECTS
a. roll of used paper towels (dirty)
b. thin coat of real soap over a plastic soap (washes off in first use) by Bob Watts.
c. picture scale by Bob Watts.
d. toilet seat covered with pressure sensitive adhesive (or double faced adhesive tape)
e. sink faucet turned upward with sprayer or fountain [sic] head attached.
f. convex - 49 facet mirror (reflects face 49 times) by George Maciunas
g. photo-collage mirror (photo of Luis [sic] 14th head with face cut off to reflect face of onlooker)
h. toilet paper with dollar bills printed on it.
ibid.

FLUXSHOP
At 16 Greene st. 2nd. floor 16' x 85' space. Similar arrangement as per enclosed proposal for gallery 669 (never realized), with addition of:
a) time punch clock, printing on visitors cards anything but time (suggestions from all will be welcomed)
b) cash register, each key (total 36) mechanically or electrically connected to activate some action or event (snowfall, lights off, loud sound, blast of spice, other smells, trap door, etc. suggestions welcomed).
ibid.

PROPOSED FLUXSHOW
1. STREET EVENTS
a. Snowstorm no. 2 by Milan Knizak: a quantity of crushed expanded white polystyrene is dumped from roof or passing car.
b. Street cleaning by Hi Red Center: performers dressed in white coats (like laboratory technicians) clean a designated area of sidewalk very thoroughly with various devices not usually employed for street cleaning: such as dental picks, toothbrushes, steel wool, cotton balls with alcohol etc.
c. Sanitas no. 13 by Tomas Schmit: telephone time service is relaid [sic] to street via loudspeaker.
d. Sanitas no. 35 by Tomas Schmit: blank sheets are handed out to passers by.
e. Two inches by Bob Watts: 2 inch paper ribbon is stretched across entry to show each time it is torn by previous passer.

2. VESTIBULE VARIATIONS, by Ayo
Portions of vestibule, stair or main gallery space prepared as follows:
1. streched [sic] rope web at knee height
2. floor covered with foam rubber impregnated with detergent suds
3. floor sloping upward and downward 30°
4. floor covered with upwardly protruding nails, except for a few foot-shape areas,
5. floor covered with blocks of various shapes
6. floor covered with balloons that burst upon contact,
7. mirror floor, photo-mural floor, etc.etc.

3. FOOD CENTER
a. Distilled (clear) coffee, tea, prune juice, tomato juice etc. dispenced [sic] in test tubes. A still may be set up to dispence [sic] fresh distilled drinks. By George Maciunas
b. 4 flux-teas by Per Kirkeby: tea bags filled with ground aspirin, another with salt, another with citric acid and another with sugar.
c. Fish-meal: clear fish drink (distilled), clear fish jello, fish bread (from fish bone flour), fish pudding, fish ice cream, fish pastry etc.
d. Empty egg shells filled with water, or jello, or plaster etc.

4. SPORTS - GAME CENTER
a. Prepared table tennis: rackets (1) with attached cans filled with water, (2) with holes in center, (3) faceted surface, (4) with extremely soft surfaces, (5) with 3ft. long handles (to be played on the floor, etc.
b. Jousting on bicycles with leaking feather stuffed pillows, jousting from suspended swings etc, etc.
c. Chess tournament with: smell pieces, sand-timer pieces, sound pieces, weight pieces, etc.
d. Track & field games: balloon javelin, slow speed bicycle race (slowest is winner), race on adhesive floor or with adhesive soled shoes, etc.
e. Team games: soccer game with ball suspended from ceiling by elastic string, race of clusters of people tied together, etc.
f. Relay and obstacle games: transporting very large objects (could be show advertizement [sic]) through subways, buses, post offices etc. eating races at food center, obstacle race through Ayo's Vestibule or stair variations, etc.

5. CLINIC by Hi Red Center
An area is set up as a clinic where various measurments [sic] are taken by white coated attendants of each visitor such as: head volume, mouth, palm, pocket capacity; shoe and foot difference, hair strength, forefinger punch, saliva production, extended tongue length, inflated cheek width, distance to blow out candle, X-ray vision, temperature inside shoe, pocket; hand grip strength (crushing egg, fruit, etc.) weight

with one foot off the scale, etc.etc. Required equipment: scales, rulers, thermometer, graduated cylinders etc.

6. AUTOMATIC VENDING MACHINES - DISPENSERS (coin operated)
a. drink dispenser dispensing water with cup missing or into a water soluble cup.
b. change dispenser dispensing pennies (one for a dime)
c. nut dispenser dispensing into the palm loose sand, or glue.
d. cigarette dispenser dispensing prepared cigarettes: with flash paper, with smoke powder, with tea leaves etc.
e. dispenser dispensing an endless string.

7. TOILET OBJECTS
a. toilet seat variations: covered with double faced adhesive tape, brush mat, sandpaper, inflated rubber, rubber bag with hot water or iced water, corrugated surface, highly waxed & polished slippery surface, etc.
b. mirrors: continuously undulating (motor driven) surface - by Bob Watts; photo-collage mirror (photo of a head with baroque hairdo and face cut off revealing mirror reflecting face of onlooker) by Robert Filliou; convex - 49 facet mirror reflecting face 49 times - by George Maciunas.
c. plastic soap with thin coat of real soap that washes off in first use - by Bob Watts.
d. sink faucet turned upward with sprayer or fountain head attached.
e. roll of used paper towels, or new ones with dirt and hand marks printed on.

8. FILM WALLPAPER ENVIRONMENT
a booth must be set up in a fairly dark area, the walls of which are of white vinyl or cotton sheets (about 12ft. wide) hanging as curtains and creating a 12ft. x 12ft. or smaller room. Four 8mm loop projectors (with wide angle lenses) must be set up, one in front of each wall on the outside and projecting an image the frame of which is to cover entire wall. 20 sets of loops are available, such as: vertical lines moving carousel fashion clockwise, single frame exposures of Sears catalogue, blinking polka dots, slow motion blinking eyes, etc.

9. SOUND ENVIRONMENT (may be simultaneously and within film environment)
a. street sounds are picked up by microphones placed outside and amplified to speakers inside - by Richard Maxfield.
b. Night Music - by Richard Maxfield, (can be played as loop with Artype film loops.
c. Requiem for Wagner by Dick Higgins, (can be played with his eating mouth film loop).
d. paper sound loop, mouth & lip sound loop, water sound loop, etc.

e. automatically playing instruments: violin, bells, reeds, flutes, duck call, gong etc. - by Joe Jones

f. music box with 10 simultaneously playing music movements - by Joe Jones

g. paper noise machine - by George Maciunas, wind-up noise making machines, etc.

Fluxnewsletter, December 2, 1968 (revised March 15, 1969).

Fluxshop, festival-hall etc. at 16 Greene st. had to be abandoned due to objections from other cooperative members. 18 Mercer is being bought therefore without any other cooperative members to avoid such interference in the future. This means further delay starting the planned fluxfest since 18 Mercer will have to be renovated as 16 Greene st. was.
ibid.

FLUXFEST AT STONY BROOK, STATE UNIVERSITY OF N.Y. NOV. 13 TO DEC. 12, 1969

PROPOSED CATAGORIES	LOCATION /DATES/	IN CHARGE IN NYC STUDENT LIASON
...		
FLUXFOODS & DRINKS	Cafeteria Vending machines	Bici Hendricks? 331 W 20 st 924-9298
VENDING MACHINES	Dormitories etc.	Ken Greenleaf 331 W. Broadway 925-5123
FLUXCLINIC	Science laboratories	Frank Rycyk? Rockaway Valley.Rd.R.D.2 Box 136 Boonton,N.J.07005 (201)627-4691
FLUXTRAIN	L.I.Railroad	Milan Knizak
FLUXBUS...		
FLUXSHOW Lobby Washroom Film environment Exhibit area	Art Gallery	Yoshimasa Wada 15 Greene st. 925-4237
FLUXPHONE	Answering machine	Ely Raman...

Fluxfest at Stony Brook, Newsletter No. 1, August 18, 1969. version A

FLUX FEST INFORMATION

P.O. BOX 180, NEW YORK, N.Y. 10013

Any of the Flux-pieces can be performed anytime, any place and by anyone, without any payment to Fluxus provided the following conditions are met:

1. if flux-pieces outnumber numerically or exceed in duration other compositions in any concert, the whole concert must be called and advertised as FLUXCONCERT or FLUXEVENT. A series of such events must be called a FLUXFEST.

2. if flux-pieces do not exceed non-fluxpieces, each such fluxpiece must be identified as a FLUX-PIECE.

3. Such credits to Fluxus may be omitted at a cost of $50 for each piece announced or performed.

Flux-theatre, dance and operas; flux-orchestra and solo concerts; flux-mechanical concerts, events & environments; flux-film, TV, radio or phone programs; flux-sports, games and tournaments; flux-quiz, lectures & schools; flux-boat, bus, train or air trips; flux-parades; flux-swimming pools; flux-discotheques; flux-meals, drinks and smells; flux-toilets; flux-clinics; flux-church services; flux-funerals; flux-cemeteries; flux-environments; flux-workshop; flux-shops; flux-snowhouses; flux-vending machines; flux-phone answering service; flux-jokes; flux-wars and riots; flux-street events; flux-work and cleaning; flux-jails...or entire flux-fests may be arranged by the flux-collective for a fee of $40 per performer, per day and on condition:

1. travel costs of flux-performer(s) or single supervisor is reimbursed and lodging provided

2. large equipment such as pianos, ladders, tubs, sporting equipment, facilities supplied

3. local performers and helpers mobilized.

AUTOMATIC VENDING MACHINES

1. Drink dispenser dispensing drink with cup missing, or with cup comming [sic] after drink, or with water soluble cup.

2. Change machine dispensing penny for dime.

3. Nut dispenser dispensing into the palm loose sand or glue.

4. Cigarette dispenser dispensing prepared cigarettes: with flash paper, with smoke powder, with rope or rubber in tobacco, etc.

5. Dispenser of an endless string.

TOILET OBJECTS & ENVIRONMENT

1. Toilet seat variations: double faced adhesive tape cover, brush mat, sandpaper, rubber bag with hot or cold water, corrugated surface, inflated rubber, highly waxed slippery surface, squeaking rubber toy seat, etc.

2. Mirrors: motorized undulating surface by Bob Watts, convex multi faceted by George Maciunas, photo collage (funy [sic] head photo with mirror face) by Robert Filliou.

3. Plastic soap with thin coat of quickly washable soap by Bob Watts.

4. Sink faucet turned upward or with sprayer attached.

5. Roll of used paper towels, or new ones but imprinted with dirt & hand marks.

FLUX SHOW: DICE GAME ENVIRONMENT

ENTIRE FLOOR AS DICE HAZARD TABLE DIE CUBES, 15" CUBES ON FLOOR.

Marked on sides, top open or closed with clear plastic.

Consisting or containing

1. Spice, sound, grinder, timer chess sets.
2. Glass bottle chess & light table.
3. Flux sport accessories.
4. Paper games by Sharits, Grimes, Thompson.
5. Ayo's finger box kit.
6. Ayo's rain machines.
7. Smoke machine by Yoshimasa Wada.
8. Soap bubble machine.
9. Automatic dispenser of loose sand or glue.
10. Flux organ by Ben Patterson
11. Flux organ by George Maciunas.
12. Flux trio by Joe Jones
13. Mechanical sound box by Joe Jones.
14. Musical chair by Takako Saito (bells)
15. Musical chair by Takako Saito (balls)
16. Flux record player. (Bob Watts & Shiomi)
17. Flux film loop viewers.
18. Flux clocks by P. Kirkeby & G. Maciunas.
19. Flux clock cabinet by James Riddle.
20. Flux time kit by Bob Watts.
21. Undulating surface mirror by Bob Watts.
22. Multi faceted mirror by George Maciunas.
23. Flux post office.
24. Flux meals and drinks.
25. Flux sand box game by Bob Watts.
26. Water light box by George Maciunas.
27. Flux water pieces. (Liss, Shiomi, Vautier)
28. Flux rocks by Bob Watts.
29. Chrome objects by Bob Watts.
30. Endless box by Chieko Shiomi.
31. Spatial poem no.1 by Chieko Shiomi.
32. Flux library.
33. Flux gift box (give aways)
34. Flux clothing chest by Bob Watts.
35. Flux archives
36. to 38. Small flux boxes.

SOME FLOOR COMPARTMENTS WITH:

1. Flags & signs by George Brecht.
2. Floor photo murals by Peter Moore.
3. Table tops by Moore, Watts and Spoerri.
4. Floor variations by Ayo: sloping floor, area covered with blocks of various shapes, mirror floor, foam rubber carpet impregnated with suds, floor with upwardly protruding nails, floor with raised rope web, etc.

FLUX HI RED CENTER CLINIC

An area is set up as a clinic where various measurmnts [sic] are taken by white coated attendants of each visitor such as: head volume, mouth, palm, between fingers or pocket capacity; shoe and foot difference, extended tongue length, inflated cheek width, hair strength, forefinger punch strength, vision above fore-

head, X-ray vision, saliva or tear production, kick strength, hand grip strength (crushing egg, fruit etc.), temperature inside shoe, pocket; distance to blow out candle, number of hairs in nostril, weight of pocket fuzz, weight with one foot off the scale, maximum and minimum kick or step, blind finger aim, breathing speed, maximum drinking capacity, pulse rate before and after excitation, vision with wrong spectacles, smell sensitivity, pain sensitivity, electrical conductivity, stomach elasticity, capacity to shrink or expand, etc. Required equipment: scales, rulers, thermometers, graduated cylinders, chronometer, volt meter, spring scale, various spectacles, candle, fruit, polistrene [sic] foam board, spices, etc.

FLUX FOODS AND DRINKS
FLUX-EGGS:
Emptied egg shells filled with one of the following: plaster, urethane foam, shaving cream, liquid white glue, white paint, ink, water, white jellatin [sic], coffee, bad smell (rotten food), good smell (spices, perfumes), string, spagetty [sic], etc. (George Maciunas)
MONO-MEALS: FISHMEAL
Fish soup, vinaigrette, pate, pancakes, cutlets, dumplings, bread (from fish bone flour), clear fish carbonated drink, fish jello, pudding, ice cream, pastry, candy, tea etc. (G. Maciunas)
MONO-MEALS: POTATOMEAL
Potato salad, pate, vinaigrette, moonshine, soup, pancakes, dumplings, cake, cutlets, bread, chips, fried, broiled, boiled, baked potatoes, creamed mashed potatoes, potato jello, parfait, ice cream, marzipan, yam jam, cream of yam, yam pastry, sweet potato pie. (Robert Watts)
MONO-MEALS: WHITE MEAL
White drink (milk), white potatoes, rice, white cheese, white creamed salad, white jello, white cake, ice cream etc. (Bici Hendricks)
MONO-MEALS: BLACK MEAL
Black drink (coffee), black beans, black meat and sauce, black bread, chocolate etc. (B.H.)
MONO-MEALS: OTHER COLORS
MONO-MEALS: TRANSPARENT MEAL
Clear coffee, tea, prune juice, tomato juice, (all distilled) clear butter (jello with butter flavor), clear fish, beef, onion (clear jellatin [sic] with appropriate flavours), clear ice cream, etc. (George Maciunas)
AFTER EFFECT MEALS:
URINE COLORS: food with drug giving color to the urine of person eating it. (red, blue, green, orange etc.) (Robert Watts)
LAXATIVE SANDWICH (G. Maciunas)
SLEEPING PILL SANDWICH (G. Maciunas)
NON-EDIBLES
SOUPS: gravel, nail, hardware. (B. Hendricks)
TURKEY STUFFINGS: Concrete stuffing, (Milan Knizak), squeaking rubber toy turkey inside real turkey. (George Maciunas)

TEA VARIATIONS:
Tea bags with: salt, or sugar, or aspirin, or citric acid. (Per Kirkeby)
Tea made from boiling: wood, or rope (sisal, jute, manila), or leather, or wool, or paper, or moss, or grass etc. (George Maciunas)
DUMPLING VARIATIONS:
One of the fillings: hot pepper, garlic, sugar, salt, cotton, chalk, water, coffee, rum, etc. (G.M.)
FILM AND SOUND ENVIRONMENT
A booth must be set up in a fairly dark area, the walls of which are of white vinyl or cotton sheets (about 12' wide x 8' high) hanging as curtains, creating thus a 12' x 12' or smaller room. Four 8mm wide angle lense loop projectors must be set up in front of each wall on the outside, projecting an image the frame of which is to cover entire wall. Spectators may enter the booth through corners.

1. Night Music by Richard Maxfield together with Artype loops by George Maciunas.
2. Paper sound loop with paper punched tape projected loop by G. Maciunas.
3. Paul Sharits film & tape loops.
4. Requiem for Wagner (tape) by R. Higgins with his eating mouth film loop.
5. Buttock movement (film loop) by Yoko Ono with lip & tube sound by Maciunas.
6. Black to white film by George Brecht with his Sinus tone to white noice [sic] tape.
7. Slow motion blinking eyes with audience or street sounds picked up by microphone.
8. Word Movie by Paul Sharits with lip and tongue sound tape loop.
9. Sound and film flicker by J. Cavanaugh.
10. TV distortions by Wolf Vostell with sound static and distortions from radio.

Fluxfest Kit 2. [ca. December 1969].

DOUGLASS COLLEGE * FLUX-SHOW * ART GALLERY * ARTS BUILDING * FEB. 16 TO 20, 1970 * MUSIC BOXES, SMOKE MACHINE, DISPENSERS, ATLAS, CLOTHING, CLOCKS, FOODS & DRINKS, CHESS SETS, TACTILE BOXES, POST KIT, GAMES -PUZZLES, LIBRARY, BUBBLE MACHINE, MIRRORS, SAND & ROCKS, CHAIRS
Poster/program for Flux-Mass, Flux-Sports and Flux-Show. February, 1970.

DETAILS OF FLUXFEST PRESENTATION OF JOHN LENNON & YOKO ONO +* 1 TO 8PM, AT JOE JONES STORE, 18 N. MOORE ST. 2 BLOCKS SOUTH OF CANAL ST. IND STATION.
OPENING: APR. 11, 4PM. COME IMPERSONATING JOHN & YOKO, (photo-masks will be provided to anyone not impersonating.)
GRAPEFRUIT FLUX-BANQUET: grapefruit hors d'oeuvre, marinated grapefruit, grapefruit seed soup,

grapefruit dumplings, grapefruit mashed potatoes, grapefruit pancakes, grapefruit wine. (by Bici & Geoff Hendricks, G. Maciunas, Y. Wada)
APR. 11-17: DO IT YOURSELF, BY JOHN & YOKO + EVERYBODY (by Yoko Ono unless marked otherwise)
1. Painting to be stepped on, (ink pad as door mat, floor covered with paper or paintings by other artists)
2. 2 Eggs (by John Lennon) combined with Add Colour painting, (eggs filled with ink or paint, to be thrown against a wall)
3. Draw Circle painting.
4. Painting to hammer a nail, (each on 6' x 9' wall)
5. Smoke painting (paintings by other artists burned by cigarettefire)
6. Chess Set, (each chess piece hidden in look-alike container)
7. Wash painting (paintings by other artists or rags to be used to wash street)
8. Osmosis (drop of india ink into water contained in hollow slide projected by slide projector, or on pudle [sic] of water, by G.M.)
WINDOW DISPLAY: window covered with paper for graffiti marks of passers and visitors, markers suspended by string.
APR. 18-24: TICKETS BY JOHN LENNON + FLUX-TOURS (by John Lennon unless marked otherwise)
Selling to the public various tickets: desolate, unknown & distant places ($1 to $300), miserable shows ($5), street corners (10¢), tickets to visit famous people ($1 to 10¢), by Y. Wada, 100 tickets to

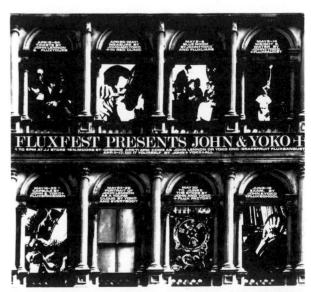

Collective. Poster for the Fluxfest Presentation of John Lennon & Yoko Ono, New York, 1970, which contained aspects of FLUX AMUSEMENT CENTER

same seat, same day show (10¢) by Ben Vautier, Outdated tickets, 19century train tickets, (10¢) by G. Maciunas

WINDOW DISPLAY: travel and theatre posters, as in ticket agency windows.

APR. 25-MAY 1: MEASURE BY JOHN & YOKO + HI RED CLINIC, (by Hi Red Center unless marked otherwise)

Various measurements are taken of each visitor by white coated attendants in a clinic environment: head volume, mouth, palm, between fingers, pocket capacity, shoe/foot difference (Watts), extended tongue length, inflated cheek width, hair strength, forefinger punch strength, kick strength, hand grip strength (crushing egg etc), distance to blow out candle (Brian Lane), vision above forehead, X-ray vision (B. Lane), saliva or tear production (G.M.), vision with wrong spectacles (G.M.), smell sensitivity, pain sensitivity (G.M.), electrical conductivity (G.M.), temperature inside shoe or pocket (Bob Watts), number of hairs in nostril (G.M.), weight of pocket fuzz (Watts), weight with one foot off the scale (G.M.), maximum and minimum kick, minimum sway (G.M.), blind finger aim, stomach elasticity (G.M.), capacity to shrink or expand (G.M.), Measurements taken by visitors: Measure from the store to the nearest water (Yoko Ono), Measure from the nearest water to the store (John Lennon).

WINDOW DISPLAY: photo-mural of distionary page & table of meaure and/or electric chair to measure electric conductivity, to be actually used in the window display.

MAY 2-8: BLUE ROOM BY JOHN & YOKO + FLUXLIARS (by Yoko Ono unless marked otherwise)

Entire room (floor, walls, ceiling), exterior (door and window), interior furnishings to be white.

1. soft rubber ball with sign: This sphere will be a sharp point when it gets to the far side of the room in your mind. Yoko Ono 1964
2. A standing needle somewhere in the room with sign: Forget it. Another one with sign: Needle, John Lennon 1970.
3. A cup on a table with sign: Not to be appreciated until it's broken, Yoko Ono 1966. Another one with sign: Mend, Y.O. 1966
4. Window sign: This window is 2000ft. long, Y.O. 1967, also This window is 6ft wide, John Lennon, 1970
5. A very large box with sign: This is not here, Y.O. 1967
6. Long straight line with sign: This line is a part of a large sphere, a straight line exists only in your mind, Y.O. 1966 & 70
7. Other interior signs: Stay until the room is blue Y.O. 1966; Do not disturb (J. Lennon 1970); Use ashtray for ashes (Y.O. 1966) No Smoking, Exit

(at wrong door or on blank wall), Entry (on the exit), forget this, listen (no sound), location, middle (at edge of room), day/night (at night/day), silence (at exit door), all by George Brecht 1961
8. Exterior signs: Spring, rain, sky, wind, etc. (according to the weather of the day) by Yoko Ono 1967.

WINDOW DISPLAY: 2 sets of 4 spoons in the shop window, one set with sign: 3 spoons, Yoko Ono, 1967, another with sign: 4 spoons, John Lennon 1970. Balance of unused window painted white.

MAY 9-15: WEIGHT & WATER BY JOHN & YOKO + FLUXFAUCET

Store floor flooded with water to about 1" height (either by waterproofing floor or laying 2' x 3' pans edge to edge) Visitors would be provided with rubber boots weighted down to up to 20lbs. (By Yoko + G. Maciunas). Various objects would be floating or sunk:
1. A dry sponge (by Yoko & John, 1970) this can be made to float by waterproofing the bottom of the sponge.
2. A wet sponge (by Yoko & John, 1970)
3. Three Aqueous Events: ice, water, steam (by George Brecht, 1960);
4. Symphony no.3: in the water (by G. Brecht, 1964)
5. 12 look-alike boxes of different weights, from light, floating on the surface, to heavy ones glued to the floor, (Yoko & Takako Saito)
6. Giant 8' x 8' x 8' styrofoam block with imitation brick wall on its surface, floating. plus additional contributions by Flux members

WINDOW DISPLAY: Drip Music (by G. Brecht, 1959) Continuous drip with amplified sound of the drip.

MAY 16-22: CAPSULE BY JOHN & YOKO + FLUX SPACE CENTER

A 3ft cube enclosure (capsule) having various film loops projected on its walls, ceiling and floor to a single viewer inside, total time: 6min
1. transition from small to large screens, single frame exposures of Sears Catalogue pages (Pauls Sharits)
2. transition from white to black (George Brecht, 1965) combined with: transition from smile to no smile, 20,000 frames/sec. (Shiomi '66)
3. linear fall, or turn (carrousel [sic] fashion), slide projection of diffusion, osmosis of liquids, dancing cockroaches (G. Maciunas)
4. transition through color scale (Ayo, 1969)
5. Elephants crowding in, (?)
6. Flicker (J. Cavanaugh, 1965)
7. fly (top, bottom, front and side views shot simultaneously from airoplane [sic] without showing any parts of the plane, projection will give sensation of Bird flight) by Yoko Ono, (realized 1970) No. 4 (close up of walking nude buttock) Yoko Ono. 1966

WINDOW DISPLAY: replica of space capsule or aeroplane control panel.

Schedule of events for Fluxfest presentation of John Lennon and Yoko Ono. [ca. April 1970]. version A

FLUXFEST PRESENTATION OF JOHN LENNON & YOKO ONO+*1 TO 8PM, AT JOE JONES STORE, 18 N. MOORE ST. (AT CANAL)

OPENING: APR. 11, 4PM. GRAPEFRUIT FLUX-BANQUET: grapefruit hors d'oeuvre, grapefruit soup, grapefruit dumplings, grapefruit mashed potatoes, grapefruit rice stuffing, grapefruit pancakes, grapefruit ice cream, grapefruit wine, grapefruit cocktail, etc. (by Flux-chefs)

APR. 11-17: DO IT YOURSELF, BY JOHN & YOKO + EVERYBODY
1. Painting to be stepped on, (Yoko Ono '61) ink pad as door mat.
2. Painting to hammer a nail (Yoko Ono '61)
3. 2 Eggs (John Lennon '70)
4. Flux-eggs (G.M.) eggs filled with paint & to be thrown against wall.
5. Draw Circle painting (Yoko Ono '64)
6. Graffiti wall
7. Kitchen Piece (Yoko Ono '60) painting to wipe hands and floor with.
8. Osmosis (G.M. '60) india ink onto puddle of water.

APR. 18-24: TICKETS BY JOHN LENNON + FLUX-TOURS

Selling to the public various tickets: desolate, unknown, funny 7 distant places ($1 to $300 [for Siberia]), Chinese theatre, sky tours, abandoned buildings & narrow street (10¢) (John Lennon); tickets to visit famous people (Y. Wada); 100 tickets to same seat, same day show (10¢) (Ben Vautier); tickets to locked up theatre (ben Vautier); outdated tickets (10¢)(G.M.). Also available will be lottery tickets to win tickets.

APR. 25-MAY 1: MEASURE BY JOHN & YOKO + HI RED CLINIC + FLUXDOCTORS (by Hi Red Center unless noted otherwise)

Various measurements are taken of each visitor by white coated attendants in a clinic environment: head volume, mouth, palm, pocket capacity, extended tongue length, hair strength, maximum kick; by Bob Watts: shoe/foot difference, inflated cheek width, temperature inside shoe or pocket, weight of pocket fuzz; by G. Maciunas: forefinger punch strength, kick strength, hand grip strength (crushing egg), vision above forehead, saliva or tear production, vision with wrong spectacles, smell, pain sensitivity, number of hairs in nostril, weight with one foot off the scale, minimum sway, stomach elasticity, capacity to shrink or expand; by Brian Lane: distance to blow out candle, X-ray vision; by Joe Jones: electric chair to measure electric conductivity and sound sensitivity (in window); by Yoko Ono: distance from the store to the nearest water; by John Lennon: distance from

the nearest water to the store. ($! ADMISSION CHARGE)

MAY 2-8: BLUE ROOM BY JOHN & YOKO + FLUXLIARS (visitors should be dressed in white)
Entire room (floor, walls, ceiling), exterior (door & window), and interior furnishings are to be white.

1. soft rubber ball with sign: This sphere will be a sharp point when it gets to the far side of the room in your mind. (Yoko Ono '64)
2. an upright needle with sign: Forget it (Yoko Ono) another one with sign: Needle (John Lennon, 1970)
3. A cup on a table with sign: Not to be appreciated until it's broken, (Yoko Ono '66). another one with sign: Mend, (Yoko Ono '66)
4. A very large box with sign: This is not here (Yoko Ono '67)
5. window sign: This window is 2000ft wide (Yoko Ono '67), also This window is 5ft wide (John Lennon '70)
6. Long straight line with sign: This line is a part of a large sphere, a straight line exists only in your mind, (Yoko Ono, 1966 & 70)
7. Other interior signs: Stay until the room is blue (Yoko Ono '66); Do not disturb (John Lennon '70); Use ashtray for ashes (Yoko Ono '66)
8. Signs by George Brecht (1961): No Smoking, Exit (on blank wall), Entry (on exit), forget this, listen, location, silence (at exit), middle (at edge of room), day/night (at night/day).
9. Exterior signs: spring, rain, sky, wind, etc. (according to weather) (Yoko Ono '67)

Window display: 2 sets of 4 spoons, one set with sign: 3 spoons (Yoko Ono '67). and another with sign: 4 spoons (John Lennon, 1970)

MAY 9-15: WEIGHT & WATER BY JOHN & YOKO + FLUXFAUCET
Store floor flooded with water to about 1" height. Visitors either barefooted or provided with rubber boots with weights (Yoko + Maciunas) Various objects floating or sunk to the floor:

1. A dry sponge (Yoko + John, 1970);
2. A wet sponge (Yoko + John, 1970)
3. Three Aqueous Events: ice, water, steam (George Brecht '60);
4. Symphony no.3: in the water (George Brecht, 1964)
5. 10 look-alike boxes of different weights, from light, floating on the surface, to heavy ones glued to the floor. (Yoko + Takako Saito)

Window display: Drip Music (George Brecht, 1959) Automatic drip with amplified sound of the drip, (realized by Joe Jones)

MAY 16-22: CAPSULE BY JOHN & YOKO + FLUX SPACE CENTER ($1 ADMISSION CHARGE)
A 3ft cube enclosure (capsule) having various film loops projected on its 3 walls, ceiling and floor to a single viewer inside, about 8 minutes.

1. transition from small to large screens;
2. single frame exposures of Sears Catalogue pages (both by Paul Sharits, 1966)
3. transition from white to black (George Brecht, 1965)
4. linear fall;
5. linear turn (carrousel [sic] fashion) (both by G. Maciunas, 1966)
6. transition through color scale (Ayo, 1969);
7. No. 4 (close up of walking nude buttock) (Yoko Ono, 1966)
8. Flicker (J. Cavanaugh, 1965)
9. clouds (Geoff Hendricks, 1970);
10. slide projection of: diffusion and osmosis of solvents (G. Maciunas, 1969)

MAY 23-29: PORTRAIT OF JOHN LENNON AS A YOUNG CLOUD BY YOKO ONO + EVERYPARTICIPANT
A 6ft x 10ft wall of 100 drawers (containing more boxes), and doors, all empty inside except one with a microscope entitled: John's smile. Musical portrait of John Lennon (by Joe Jones) when one of the doors is opened.

MAY 23, 7PM. PORTRAIT OF MALKA SAFRO, by Henry Flynt, performed by him on violin.

MAY 30-JUNE 5: THE STORE BY JOHN & YOKO + FLUXFACTORY
Coin operated vending machines:

1. machine devouring deposited objects,
2. crying machine dispensing tears,
3. machine dispensing sky (air) (all 3 by Yoko Ono),
4. change machine dispensing metal slugs (fake coins for a penny) (John Lennon),
5. change machine dispensing penny for a dime (G. M. 1951),
6. drink dispenser dispensing drink with water soluble or leaking cup (G.M.),
7. nut dispenser dispensing into palm loose sand or glue or an endless string (G. Maciunas),
8. Cigarette dispenser dispensing cigarettes with rope, dried fruit, sawdust & other filling,
9. perfume dispenser dispensing various strange scents and smokes (Yoshimasa Wada),
10. rain machine (Ayo)

Sale of body accessories: halos, horns, 3rd eyes, tails, hoofs, skin blemishes, scars, etc. (Yoko Ono)
Sale of Flux-shop products: games, puzzles, jokes, gags, relics, foods, drinks, drugs, sports, playing cards, furniture, films, music boxes and machines, postage stamps, envelopes, maps, atlases, tattoos, posters, boxes, clocks, etc.

JUNE 6-12: EXAMINATION BY JOHN & YOKO + FLUXSCHOOL
Various questions, lectures and other possible and impossible tasks submitted to participants in a classroom environment. (George Brecht, Robert Filliou, Bici

Hendricks, Geoff Hendricks, Henry Flynt, John Lennon, George Maciunas, Yoko Ono, Ben Patterson, Mieko Shiomi, Ben Vautier, Bob Watts.)
FOR FURTHER INFORMATION CALL: 966 6986 OR 925 7360
Schedule of events for Fluxfest presentation of John Lennon and Yoko Ono. [ca. April 1970]. version B

PRESS RELEASE — APRIL 1, 1970 JOINT YOKO ONO, JOHN LENNON & FLUXGROUP PROJECT FLUXFEST PRESENTS YOKO ONO+* 1 TO 8PM, AT JOE JONES STORE, 18 N.MOORE ST. CANAL IND STATION.

OPENING: APR. 11, 4PM. COME IMPERSONATING JOHN LENNON & YOKO ONO, GRAPEFRUIT BANQUET
Banquet will feature: grapefruit wine, grapefruit hors d'oeuvre, marinated grapefruit, grapefruit soup, grapefruit pancakes, grapefruit dumplings, grapefruit mashed potatoes, various grapefruit deserts; (by G. Maciunas, Yoshimasa Wada, Bici & Geoff Hendricks, Bob Watts.)

APR. 11-17: DO IT YOURSELF, BY YOKO + EVERYBODY
Cutting paintings of other artists, braking [sic] & restoring objects, producing paintings by walking on them, wearing them, washing floor with them, throwing food, garbage on them; shadow painting, driving nails into various objects & materials, watering, burning, various objects, making objects and events from various Flux-kits (suicide kit, jewelry kit, medical kit, etc.)

APR. 18-24: TICKETS BY JOHN LENNON + FLUX-AGENTS
Selling to the public various tickets to desolate places, miserable show, distant places via difficult passage, to street corners, buildings, tickets to visit famous people (Y. Wada), many tickets to same seat, same day show (Ben Vautier), Outdated tickets (G. Maciunas)

APR. 25-MAY 1: CLINIC BY YOKO ONO + HI RED CENTER
Various measurements are taken of each visitor by white coated attendants. Measurments [sic] of head volume, mouth, palm, between fingers or pocket capacity; shoe & floor difference, extended tongue length, inflated cheek width, hair strength, forefinger punch strength, kick strength, hand grip srength (crushing egg etc.), distance to blow out candle, hair strength; vision above forehead, X-ray vision, saliva or tear production, vision with wrong spectacles, smell sensitivity, pain sensitivity, electrical conductivity, temperature inside shoe, pocket; number of hairs in nostril, weight of pocket fuzz, weight with one foot off the scale, maximum and minimum kick, minimum sway, blind finger aim, stomach elasticity, capacity to shrink or expand, etc. etc.

MAY 2-8: BLUE ROOM BY YOKO + FLUXMAS-
TERLIARS
Room, windows, doors, sidewalk etc. to be imagined
to be something other than what they are; absent ob-
jects to be imagined as present, imaginary entertain-
ment: food, music and company, etc.

MAY 9-15: WEIGHT & WATER BY YOKO + FLUX-
FIREMEN
Objects characterized by weight rather than shape
(very large & light, very small & heavy etc) Water sup-
plied to flux-participants giving it variety of shapes
and movements.

MAY 16-22: CAPSULE BY YOKO + FLUX SPACE
CENTER
A 3' x 3' x 3' enclosure (capsule) having various film
loops projected on its walls and ceiling to a single
viewer inside: fall, carrousel [sic] (G.Maciunas); screen
transition, single frame exposures (Paul Sharits); tran-
sition from white to black (George Brecht) transition
through chromatic color scale (Ayo); crowding-in,
compressing (Yoko Ono); flight, swim etc. (Bob
Watts); slide projection of diffusion in liquid (Maciu-
nas); projection of moving cockroaches; flicker (J.
Cavanaugh) etc.

MAY 23-29: PORTRAIT OF JOHN LENNON AS A
YOUNG CLOUD BY YOKO + EVERYBODY
A wall of many drawers, and doors, all empty inside
except one with a microscope titled: "John's smile"

MAY 30 - JUNE 5: THE STORE BY YOKO +
FLUXFACTORY
Vending machines (coin operated): machine receiving
deposited objects and making them disappear, crying
machine dispensing tears, machine dispensing sky, air
(by Yoko Ono); drink dispenser dispensing frink [sic]
with cup missing, or with cup comming [sic] after
drink, with water soluble cup, change machine dis-
pensing penny for a dime, but dispenser dispensing in-
to the palm loose sand or glue, dispenser of an endless
string (by G. Maciunas); Cigarette dispenser dispens-
ing prepared cigarettes, with rope, tobacco, dried
fruit skins etc. mixed in the tobacco, machine dis-
pensing incence [sic] and smoke of various mixtures
(by Yoshimasa Wada); rain machine (Ayo).
Sale of body accessories: halos, horn, 3rd eyes, tails,
hoofs, skin, blemishes, scars, etc. (by Yoko Ono)
Sale of Flux-shop products: games, puzzles, kits,
jokes, gags, events, relics, foods, drugs, sports, clocks,
playing cards, furniture, etc. etc. films, music boxes,
music machines, postage stamps, maps, atlases, tat-
toos etc.

JUNE 6-12: EXAMINATION BY YOKO + FLUX-
SCHOOL
Various questions and other tasks submitted to partici-
pants in a classroom environment. (Yoko Ono, Geoff
Hendricks, Bob Watts, Mieko Shiomi, Robert Filliou).
For further information contact: George Maciunas,
349 W. Broadway apt.11, New York 10013, tel: (212)
966-6986
*Schedule of events for Fluxfest presentation of John Lennon
and Yoko Ono. April 1, 1970. version C*

"... Bob Watts told me that Gino Di Maggio was ex-
pecting something from me for an exhibit this Sept. in
Rome ??? I thought I made it clear that I was not en-
thusiastic about exhibits in galleries or institutions. If
something is still needed for the Rome exhibit, I could
send a selection of Fluxobjects, plus my One Year,
which is a large panel or wall of empty containers
stuck together of all the food I ate within the year.
You could also do my Kinesthesis slide pieces. You
need a magnifying (microscopic) slide projector and
few hollowslides (I could send the hollow slides) then
you can fill slides with water containing plankton, or
place small bugs or cockroaches inside these hollow
slides and you will have a continuous live show. With
the microscopic slide projector you can also show
crystallization of barium chloride in sulfuric acid, or
alka seltzer in water, etc. etc. All you need is hollow
slides. If there is room, you could set up a ping pong
table with various prepared rackets, such as rackets
with hole, corrugated or concave or covex [sic] sur-
face, racket with can of water attached to it, oversized
racket, racket with very soft surface, very heavy rack-
ets, etc. public must play of course. I could send
these rackets by mail if you can arrange the table. You
could also install a few vending machines, which you
could obtain localy [sic] since it would not pay to ship
them. One machine could dispence [sic] cat shit,
with the label saying: Fluxrelics: holy shit from the
diners of the Last Supper, by Geoff Hendricks.
Another dispencer [sic] could dispence [sic] a con-
tinuous string, or glue (into the palm of the hand) etc.
Another very easy item to arrange is the Fluxclinic,
which is fully described in the FLUXFESTKIT 2,
which I gave you. In fact that paper is full of propos-
als, you should read it carefully and use any idea you
like for the Rome exhibit. I could not come this Sep-
tember, since I will be still producing the Fluxpack 3,
but I could come to Italy in Spring, and so could Bob
Watts, Takako Saito, Ben Vautier, Geoff Hendricks,
Paul Sharits, etc...."

*Letter: George Maciunas to Giancarlo Politi, n.d. Reproduced
in Fluxnewsletter, April 1973.*

"...I am planning to come to Europe this Summer or
Fall, most likely together with Bob Watts and stop-
ping in England, Holland, Nice at Ben, could stay in
Italy if you could arrange a worthwhile flux-fest. I
still think best is to do an amusement place with toi-
let being one amusement, then a game room, Ayo
walking obstacles, a clinic, flux-food eating place, a
chapel, or funeral place, vending machine place, "flux-
history" room with exhibit of all original prototypes
of objects produced, interesting documents, etc. like
my chart like calender [sic], or I made now a wall of
all containers of all food I ate in a year, 2 meters x 2
meters. maybe a film-loop or some continuous film
and sound room, etc. could use some 4 or 6 rooms.
Simultaneously we could do street parades, events,
concert in a railroad station or meat market or some
interesting building, preferably not concert hall. Water
events in sea, Mass in church, sports in sports hall or
field, and special events specially composed for a spe-
cific town or location. Since such an affair would take
some time to plan and organize I would suggest not
earlier than Autumn, maybe November? or October?
is the wheather [sic] good then??? Could also do train
or boat events, special events that have to be on mov-
able objects. Generally, I prefer to organize and do
things that we have not done yet, rather than repeat
over and over same things, like so many other artists
do. This applies to objects, printed matter, events,
concerts, environments etc.

Financial conditions: we would pay our way to Italy
and would need only a cheap or free place to stay,
but that is not critical. I can stay in 50 cent hotels.
We would bring most of the small and medium ob-
jects, like vending machines, boxes etc. but would
need money for shipping costs. We would need the
following from local sources in Italy or whereever [sic]
we go: money or labor and materials for special cos-
tructions [sic] such as toilet, floor obstacles, larger
games like ping-pong tables, billiard table, pin-ball
machine, [] age a number of musical instruments,
etc. a great number of helpers and participants espe-
cially for sports events and parades, students, bums,
anybody, also would need all kinds of permits from
churches, railroad stations, sports fields, police, cem-
etaries [sic], ships, etc. also would need a place for
the amusements, such as rented store, loft, warehouse,
tents, catacombs, any kind of cheap place, preferably
not galleries or museums. Also would need posters, an-
noucements or some kind of advertisements. I believe
a place together with $2000 should be enough to fi-
nance the whole affair, which could last a month or
more. I and Bob would be interested in something
like this, maybe also Ayo, Takako, Yoshi, Joe Jones,
Alison, Nam June Paik, Shigeko, Geoff, I would have
to find out who could afford to pay own way, al-
though Takako has to return to Europe this Fall any-
way. Ben Vautier of course could join us and prob-
ably George Brecht, Fillou [sic], and some other
Europeans like new flux-people in England: Carla
Liss, David Mayor, etc. I would have to ask them all.
We could all sleep in a cemetary [sic] if permission
could be obtained, or monasteries??? abandoned
churches, roman ruins, under bridges, inside boxes, in
zoos, in bordelos, etc. The main requirement is a place

for amusements and materials for costructions [sic].
Let me know what you find in backers etc...."
Letter: George Maciunas to Daniela Palazzoli, n.d. Reproduced in Fluxnewsletter, April 1973.

...3. This Fall, we shall publish V TRE no. 10, which shall consist of a plan for Flux-Amusement-Center, to contain the following:

a) Fluxtoilet (variations on toilet flushing, seats, stall doors, sinks, mirrors, toilet paper, towels)

b) Vending machines, drink, food, nut type dispensers (dispensing glue, endless string, holy relics, drink before cup, or perforated cup, eir [sic] etc.)

c) Stamp, postcard machines, coin operated game machines (pin-ball, target, driving test, etc)

d) weighing machines, photo machine, movie (loop) machine, juke box, etc.

e) film-environment with sound, (capsule having related films projected on 4 walls, floor and ceiling)

f) Joe Jones instrument machines,

g) Ben Vautier's suicide room

h) Ayo's floor obstacles (foam, mirror, upright nails, steep slopes, water, tunnel, trap doors, rainfall, wood blocks etc.—

i) Bill Tarr's closets for people (being inundated in ping-pong balls, being pressed by growing air bag, or lowered ceiling, etc.)

j) Clinic and test room (must be familiar to all by now)

k) Athletics, games, vehicles, rides: (swing tournament, ping-pong variations, hot cockles, dart target, chess variations, and any other game not requiring large space for its performance.

Any suggestions for listed categories or new ones, written or drawn, should be forwarded to George Maciunas not later than July 4th,...
Fluxnewsletter, April 1973.

PROPOSED DATE: NOVEMBER OR DECEMBER
PROPOSED PARTICIPANTS: Eric Andersen, Ayo, George Brecht, Robin Crozier, Ken Friedman, Geoff Hendricks, Dick Higgins, Davi Det Hompson, Joe Jones, Alison Knowles, Carla Liss, George Maciunas, Larry Miller, Peter Moore, Nam June Paik, Shigeko Kubota, Jock Reynolds, James Riddle, Takako Saito, Paul Sharits, Mieko Shiomi, Bill Tarr, Ben Vautier, Bob Watts, Yoshimasa Wada,

FLUX AMUSEMENT ARCADE

1. Vending machines, dispensers of holy relics (Hendricks,) endless string, prepared eggs, drinks before cups etc. (Maciunas)

2. Stamp & postcard dispensers (Watts & Vautier)

3. Ticket dispenser (tickets by John Lennon, Vautier, Ayo, Maciunas, Wada)

4. Weighing scale (Watts), Pin-ball game (Maciunas), movie-loop machine (flux-films from Flux-box 2), target.

5. Bill Tarr's closet for people (being inundated in ping-pong balls) 3 x 3ft x 6ft high

6. Ben Vautier's suicide booth, 3 x 6ft x 6ft high

7. Nam June Paik prepared piano

8. Clini [sic] & test booth (Hi Red Center, Watts, Maciunas, etc.) 6 x 6 x 6ft cubicle (need one or two full-time attendants, I could supply)

9. Joe Jones automatic trio with Maciunas aerophone (coin activated)

10. Ayo's floor obstacles (either in staircase or a maze (12 x 12ft x 6ft high cubicle)

11. cabinets, chests and trunks with collection of past & current flux-boxes, objects (have about 8 antique cabinets for such purpose)

12. Flux toilet (3 prepared toilets will be constructed at 80 Wooster st. basement, could be completed by December)

FLUX GAME ROOM

1. Swing tournament (Maciunas)

2. Floor billiards with paper boxes (Takako Saito)

3. prepared ping-pong (Maciunas)

4. Hot cockles (Robin Crozier)

BUDGET:

At present I have or could supply objects & machines for items: 2, 3, 4 (pin-ball), 7, 9, 11, 12, & all game items at no cost. You would have to purchase vending machines, movie loop machine, weighing scale, which should cost about $1000, and construct item 5 ($1000), item 6, 8, 10 ($1000), I would supply objects & instruments for items' 6 & 8, but you would have to buy about $1000 worth of ping-pong or similar balls. A TOTAL OF $4000 should be contemplated. Vending machines and flux-objects could be sold, but everything else would be of no monetary value. Furthermore you would have to carry some sort of insurance to cover damage of objects and constructions. If this proposal is acceptable including the new proposed date, I would submit a more detailed plan & list of objects.

George Maciunas, 80 Wooster st.

P.S. I would not be interested in participating in an exhibit before November, because I would not have the time during the Summer to prepare or produce anything, and furthermore in the past, all exhibits that were rushed did not succeed. I would also not be interested in participating in an exhibit of objects and documents, because such exhibits were done already many times.
Preliminary Proposal for a Flux Exhibit at Rene Block Gallery. [ca. 1974].

DATE: JULY 30 & 31 FUNNY WEEKEND:
EVENTS, SAT.: Flux clinic (in barn)...
EXHIBITS: Flux show & vending machines
FOOD EVENTS, SUN: Funny foods...
Proposal for Flux Fest at New Marlborough. April 8, 1977.

FLUXFEST SAT., SEPT. 24 — SUN., OCT. 2, 1977
FLUXFEST FLUXFEST 77 at and/or 1525 Tenth Ave. Seattle, WA 98122 324-5880
FLUXFEST INFORMATION
All events will be at and/or 1525 10th Avenue, unless otherwise listed. For information call FluxPhone or 324-5880
FluxPhone 329-6759
Daily event listings and updates and messages about the Fluxfest from Sat. Sept. 24 - Sun. Oct. 2.
Visa TouRistE
The FLUXPASSPORT with the special VisaTouRistE is the special entry card to Fluxus events during this FluxFest. A photo is needed to affix to the passport and then it will be validated. Each event will have a special entry stamp. $2.00
On Going Events

* Store: Mon-Fri 3-7 pm
 At 111 Bell St. Call 622-9993 for details.

* SCIENCE EXHIBIT: Sun-Sun 11-6 pm

* GAMES EXHIBIT: Sun-Sun 11-6 pm

* PUBLIC TOILETS: Wed-Sun 9-5 pm
 At Triangle Studios, 83 Columbia, 4th Floor. Knock loudly.

* FLUXCLINIC: Mon-Thu 10 am, 1 pm and 4 pm
 Events and clinics according to day. Planned around streets and problems with V T R E letters.

* FLUXUS CORNER: Daily
 Summit and E. Republican

* FLUXUS AUTOBIOGRAPHY: all events
 Record your autobiography.

Special Events/ Calendar
Sat. 24

* FLUXFEST KICKOFF: 1:00 pm
 Initial issue of VisaTouRistE.
 Meet at Woolworth's Downtown at the photobooth for passport photos or bring your own. Other city events will follow.
 $2.00 plus photo costs if any.

Sun. 25...
 OPENING: 7-10 pm
 Science exhibit, Game show and Fluxfilms included in the opening. Animal Shit Anthology, Chess and card games, films in the Flux Anthology and many other pieces.

Mon. 26

* STORE GRAND OPENING: 3-7
 Open the FluxusStore at 111 Bell St. Call for det [ails] at 622-9993....

Tue. 27

* TOILET INAUGURATION: 4:30-7 pm
 Inaugurate the "prepared" toilets at Triangle Studios, 4th Floor of 83 Columbia. Drink a lot before you come!...

Wed. 28...

* GAME NIGHT: 8:30 pm

Play the games on exhibit. Included are Brecht decks, games by Robert Watts, Sally Whitton, George Maciunas and others. Some surprise events.
...
Sat. 01 ...
* FLEECE MART: 12-6 pm
 Find or make things to exchange with other traders. Possibly browse the store for raw materials during the week. At 1st & Bell.
* FLUXFILMS: 8:30 pm
 Re-run of Flux Film Anthology. Films by Brecht, Maciunas, Yoko Ono, and others. $1.00
Sun. 02 ...
* FLUX CLINIC: 4:00 pm onward
 Last stop of the mobile clinic to De-flux participants and cure of FluxFever, if possible....
* RECORD-A-FLUXEVENT:
 Events not listed here or ones you see which may be Flux Events may be recorded at the Store, through the FluxPhone or by calling and/or, 324-5880.
FLUXPASS:
Make a passport with a VisaTouRistE to Flux Events. Make the entry stamps out of vegetables. Make a salad from the stamps.
STORE:
A STORE established, where nothing is available for cash but may be traded for, on an approximate weight or other arbitrary value basis. H.R.
SPORTS:
PING PONG is played with "prepared" rackets: convex, corrugated rackets, rackets with water containers, rackets with hole in center, inflated or soft rackets. G.M.
CLINIC:
Medically MEANINGLESS MEASUREMENTS of bodily functions such as length of tongue, distance between toes, capacity to drink water, etc., is made at a Fluxus Clinic.
FLUXFILMS:
FLEECEMART:
A FLEA MARKET is organized where merchandise may be traded, but not sold or bought.
PUBLIC TOILETS:
A toilet is inSTALLed in which the TOILET is a high platform with a hole cut out in a stall, in which the door doesn't open. USERS may view their own activity through a periscope provided on the platform. G.M.
a TOILET is ALTERED so that a laughing or clapping noise is heard as it is flushed. R.W.
a TOILET is ALTERED so that the door to the stall may be opened only when the outer door to the bathroom is opened or when one sits on the toilet seat. R.W.
GAMES:
CARD GAME is played with cards that are all the

same. G.M.
A TIME PUZZLE in which as many as 100 objects are arranged on a board according to time, is played. R.W.
CHESS is played with pieces which are sand timers. G.M.
a CHESS game is played with a set made of SPICES in test tubes. T.S.
SCIENCE EXHIBIT:
an ANTHOLOGY of ANIMAL SHIT is displayed, from over 40 creatures. Include a wide range and type, from insects, mammals to extinct creatures. Label them in Latin and display as in a science museum. G.M.

Flux fest 77 at and/or, Seattle. September 1977. [selected entries]

COMMENTS: *Flux Amusement Center was the Fluxus alternative to exhibitions. As early as March 11-20, 1963, George Maciunas had organized an impromptu Fluxus exhibition in the kitchen of the Galerie Parnass during Nam June Paik's "Exposition of Music Electronic Television" in Wuppertal, West Germany. In June of that year, he gave instructions to Tomas Schmit to put up a Fluxus exhibit during the Fluxus Festival in Amsterdam. The exhibit there was in Willem de Ridder's Amstel 47 space, and included Paik's prepared pianos. In general, however, Maciunas resisted straight gallery exhibits of Fluxus works, preferring to set up Fluxshops and small displays for selling objects during concerts. With the purchase of several New York buildings in 1967 to be used as Flux House Cooperatives, Maciunas and Robert Watts wrote a prospectus for a commercial Fluxus-oriented amusement center, to be known as "the Greene Street Precinct, Inc.," which would have been in a space they were purchasing on Greene Street. That plan did not work out, but with most future invitations to Fluxus shows, Maciunas would counter with plans for a Flux Amusement Center. Elements of the "Amusement Arcades" were realized in 1970 at the Douglass College "Flux Show" in New Jersey; the "John & Yoko Fluxfest" in New York; and the "Happening & Fluxus" exhibition in Cologne, West Germany. George Maciunas also built aspects of the arcade for Yoko Ono's "This Is Not Here" exhibition at the Everson Museum in Syracuse, New York in 1971. Later realizations were the "Fluxlabyrinth" in Berlin, 1976, and the Fluxfest at and/or in Seattle, 1977. Audience participation was always required. The following is a quote from Hindsight 2, the documentary publication of and/or events: "September 27 - October 2*
Over 25 events took place during the week of the Fluxfest beginning with the Fluxpass VisaTREsspass and tour of the City. The FluxStore managed by H. Ramsay opened with considerable fanfare and was open every day during the Flux-Fest with items offered not for sale, but trade by weight. The FluxClinic, operated by Bill Woods and Shash Slettebak, visited locations around town daily, with streets beginning with letters V, T, R and E (the traditional Fluxus letters) covered first. The exhibition consisted of FluxScience and Flux Games and included many objects by George Maciunas, George Brecht, Ben Vautier, Robert Watts, Takako Saito and local artists as well. Also included were FluxToilets, Fluxus Films, Tour of Bellevue, Fluxus Sports & Games Night, the Flux Concert and talks by George Maciunas."

Flux amusement center V TRE see:
 FLUXUS NEWSPAPERS
FLUX ANTHOLOGY see:
 FLUXUS 1
FLUX ARCHIVES see:
 FLUX HISTORY ROOM

FLUX CABINET
Silverman No. > 131.II

"In January I will mail...my - 24 drawer event cabinet — Each drawer contains some event like spring jumping out or making sound, etc. etc. May cost $400?"
Letter: George Maciunas to Dr. Hanns Sohm, November 30, 1975.

"...I am making a cabinet now with 20 drawers each artist to have one or more drawers. Would be nice if your chess sets or any other games you could think would fit into 12" x 12" interior drawer size. You would not have to make boards either, because drawers would be boards. Write me how large are the cubes that you are making. Also please think of new games to fit 12"x12" - any height 2" to 4"..."
Letter: Geroge Maciunas to Takako Saito, May 30, 1977.

"...I prefer to do now cabinets with 20 drawers about 30 cm x 30 cm - various depths. I have made one already with 2 drawers of yours - one mystery drawer (all covered, rolling balls inside) another large suicide version..."
Letter: George Maciunas to Ben Vautier, October 18, 1977.

COMMENTS: *Flux Cabinet is the final Fluxus Anthology. The 1977 work is a culmination of George Maciunas' desire to present work collectively from the Fluxus group. Maciunas was strongly influenced by Marcel Duchamp's Boit en Valise, and La Monte Young's An Anthology which he designed and helped produce in 1963. The latter collective work led to a large number of planned Fluxuses, and the production of FLUXUS 1, nine Fluxus newspapers, Fluxkit, Flux Year Box 2, and Fluxfilms, etc. Flux Cabinet has the exterior simplicity of Shaker furniture, which Maciunas admired, and took its form from En Bloc, produced by Galerie Rene Block, 1969-72. Flux Cabinet is a unique work. In 1978 George Maciunas listed its contents for Susan Reinhold who had purchased it from him in 1977:*
 Fluxus Cabinet
 Assembled by George Maciunas 1977

Drawer No. 1	Jean Dupuy & John Lennon - each independently
Drawer No. 2	George Brecht
Drawer No. 3	Mystery Drawer Ben Vautier
Drawer No. 4	Maze George Maciunas
Drawer No. 5	Time Flux Kit Bob Watts
Drawer No. 6	Flux Atlas Robert Watts
Drawer No. 7	Suicide Flux Kit Ben Vautier
Drawer No. 8	Flux Reliquary Geoff Hendricks and George Maciunas

Collective. George Maciunas' instruction drawing for the contents of FLUX CABINET

Collective. George Maciunas' instruction drawing for FLUX CABINET

Collective. **FLUX CABINET.** see color portfolio

56

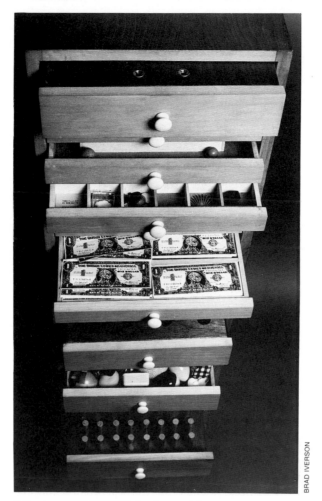

Collective. **FLUX CABINET** showing partial contents. see color portfolio

Drawer No. 11 *Takako Saito* Sound Chess, *and simultaneously,* Weight Chess
Drawer No. 12 *George Maciunas* Excreta Fluxorum
Drawer No. 13 *Chieko Shiomi* Spatial Poem No. 1
Drawer No. 14 *Larry Miller* Orifice Flux Plugs
Drawer No. 15 *Ay-O* Finger Box
Drawer No. 16 *Claes Oldenburg* False Food Selection *with a pop-up stem glass from* Rubber Dinner Setting Kit
Drawer No. 17 *George Brecht* Valoche/A Flux Travel Aid
Drawer No. 18 *George Maciunas* Time Chess, Sand Timer Pieces
Drawer No. 19 *Takako Saito* Spice Chess
Drawer No. 20 *Joe Jones* Fluxmusic

FLUX-CHRISTMAS-MEAL-EVENT see:
FLUX FOOD

FLUX CLINIC

"...The Flux Clinic, operated by Bill Woods, and Shash Slettebak, visited locations around town daily, with streets beginning with letters V, T, R and E (the traditional fluxus letters) covered first..."
Hindsight 2. and/or, Seattle, 1978.

COMMENTS: The mobile unit version of Hi Red Center's "Flux Clinic," was realized during "Fluxfest 77" at and/or, Seattle, September, 1977. Although a Flux Clinic was realized first in July, 1966 as part of the Hi Red Center Hotel Event at the Waldorf Astoria Hotel in New York City, and later during other Fluxus festivals, it was always considered an event. In Seattle, by making a van into a Flux Clinic it crossed over to being object - like. See also Hi Red Center Fluxclinic Record of Features and Feats.

FLUX DRINKS & FOODS see:
FLUX FOOD
FLUX EGGS see:
FLUX FOOD

FLUX ENVELOPE PAPER EVENTS
Silverman No. < 131.I, ff.

FLUXPROJECTS REALIZED IN 1967:...Flux-envelope-paper events (included) for Paper show of the

Collective. **FLUX ENVELOPE PAPER EVENTS**

Collective. FLUX CLINIC. Mobile unit version, realized for the Fluxfest at and/or. Seattle, 1977

NORIE SATO

Mus. of Contemporary Crafts
Fluxnewsletter, January 31, 1968.

COMMENTS: *This is a separate collective Fluxus Edition of participatory paper pieces. The work appeared in some later assemblings of* Fluxkit *and* Flux Year Box 2. *Made for (or simultaneously with) "A Paper Event by the Fluxmasters of the Rear-Garde," New York, November 15, 1967;* Flux Envelope Paper Events *is also related to* Flux Paper Games: Rolls and Folds; *the special Fluxus issue of* Art & Artists; *and Maciunas' own* Flux Paper Events. *Its basic concept incorporates Chieko Shiomi's* Disappearing Music for Envelopes, *and develops from there.*

FLUXFEST see:
FLUX AMUSEMENT CENTER
FLUX-FEST CATALOGUE see:
FLUX FEST KIT 2
FLUXFEST SALE

FLUX FEST KIT 2
Silverman No. 593, ff.

FLUX-PROJECTS PLANNED FOR 1967...Collective projects: (All are invited to submit ideas and participate, ideas can be either ready pictorial material or just specified material which we have to find, produce or obtain otherwise)...Flux-fest catalogue: (1st. edition already published) list and description of performance pieces.
Fluxnewsletter, March 8, 1967.

"...Today I am sending package of printed material - from last 2 years -...Fluxfest-kit-2 - some new pieces..."
Letter: George Maciunas to Ben Vautier, November 9, 1971.

"...Another very easy item to arrange is the Fluxclinic, which is fully described in the FLUXFESTKIT 2, which I gave you. In fact that paper is full of proposals, you should read it carefully and use any idea you

like for the Rome exhibit...."
Letter: George Maciunas to Giancarlo Politi, n.d. Reproduced in Fluxnewsletter, April 1973.

PROPOSED FLUXANNIVERSARYFEST PROGRAM 1962-1972 SEPT & OCT. For detailed description of each proposed piece see FLUXFESTKIT 2, 1969
Fluxnewsletter, April 1973.

COMMENTS: *The publication,* Flux Fest Kit 2, *was the second collection of Fluxus scores and festival information. The first was* Fluxfest Sale. *More than a lecture bureau's guide to Fluxus, anyone could use it to put on their own Fluxfest, and if funds were available, order objects, buy films, rent a fluxorchestra, or even hire Fluxus artists to perform. Some of the scores reproduced are complete, others are abbreviated descriptions of scores. In 1966, George Maciunas had hoped to publish* Complete Fluxus Pieces. *Together,* Fluxfest Sale *and* Flux Fest Kit 2 *with various Fluxus newsletters form a very good representation of Fluxus scores.*

FLUXFEST SALE
Silverman No. 570, ff.

"finally completed the giant 'Expanded Arts' catalogue..."
Letter: George Maciunas to Ken Friedman, November 23, 1966.

"We are very involved in the production of the 'Expanded Arts' Catalogue Deadline — New Years. — A mountain of work..."
Letter: George Maciunas to Ken Friedman, December 29, 1966.

"Please forgive my rude delay in writing you or replying to your letters. My obligations to my friends kept being postponed, while I was being buried by a huge pile of work....then a huge catalogue - special issue of 'Film Culture' magazine on 'Expanded Arts' (events, action music, happenings etc.) which I produced & which took a whole month of my entire time. Fluxus has about 15% of the whole issue. In a few days I will mail by air Flux-page of one issue and few full issues by surface mail...."
Letter: George Maciunas to Milan Knizak, January 30, 1967.

"I got hold of a few $ & shipped out by REA a package to you: with:...100 or so Fluxfest catalogues..."
Letter: George Maciunas to Ken Friedman [ca. February 1967].

"...Did not include Paik in Fluxfest sheet, because most of his pieces don't have scores or texts or descriptions. In fact he does not like to describe them, because like all prima donas and like Kaprow, he likes & insists that his pieces be performed by HIMSELF ONLY. This Flux sheet is actually a reprint from 2 pages of Film Culture magazine - special issue on ex-

Collective. Front side of FLUX FEST KIT 2

Collective. Front side of FLUXFEST SALE

panded arts. on other pages were included Paik, Higgins, La Monte, etc. etc. I will mail you a copy of this Film Culture issue, which I designed & printed as a newspaper...."
Letter: George Maciunas to Ben Vautier [ca. March 1967].

FLUX-PROJECTS PLANNED FOR 1967... Collective projects: (All are invited to submit ideas and participate, ideas can be either ready pictorial material or just specified material which we have to find, produce or obtain otherwise)...Flux-fest catalogue: (1st edition already published) list and description of performance pieces.
Fluxnewsletter, March 8, 1967.

fluxfest s-a-l-e 50¢
Fluxshopnews. [Spring 1967].

FLUXPROJECTS REALIZED IN 1967: Flux-fest-sale (sample included)
Fluxnewsletter, January 31, 1968.

**FLUXFEST INFORMATION,
P.O BOX 180, NEW YORK, N.Y. 10013**

Many fluxpieces are described and listed in the Expanded Arts issue of FILM CULTURE magazine. A reprint can be obtained for $1. Any of the fluxpieces can be performed anytime, anyplace and by anyone, without any payment to Fluxus provided the following conditions are met:

1. if fluxpieces outnumber numerically or exceed

in duration other compositions in any concert, the whole concert must be called and advertised as FLUXCONCERT or FLUXEVENT. A series of such events must be called a FLUXFEST.

2. if fluxpieces do not exceed non-fluxpieces, each such fluxpiece must be identified as a FLUXPIECE. Such credits to Fluxus may be omitted at a cost of $50 for each piece announced or performed.

Flux-theatre, dance and opera; flux-orchestra and solo concerts; flux-mechanical concerts & events; flux-film, TV, radio or phone programs; flux-sports, games and tournaments; flux-quiz, contemplation booths, sky events; flux-boat, bus or air trips; flux-discotheques; flux-meals, drinks and smells; flux-toilets; flux-clinics; flux-church, flux-funerals; flux-environments; flux-shops and workshops; flux-snow-houses; flux-vending machines; flux-phone answering service; flux-jokes; flux-wars and riots; flux-work and cleaning...or entire fluxfest may be arranged by the flux-collective for a fee of $25 per performer, per day and on condition:

1. travel costs of fluxus performer(s) or single supervisor is reimbursed and lodging provided,
2. large equipment such as pianos, ladders, sporting equipment, tubas, boxes etc. are supplied,
3. local performers and helpers mobilized.

Fluxnewsletter, December 2, 1968 (revised March 15, 1969).

FLUX-PRODUCTS 1961 TO 1969 V TRE FLUX-NEWSPAPERS...Fluxfest Sale 1967 Compositions by: Ayo, Bozzi, Brecht, Fine, Heflin, Hi Red Center, Joe Jones, Knizak, Maciunas, Patterson, Sharits, Schmit, Shiomi, Vautier, Watts, Williams, Flux-history-chart by Maciunas $1
ibid.

FLUX-PRODUCTS 1961 TO 1970 [listed as above, without prices]
Flux Fest Kit 2. [ca. December 1969].

COMMENTS: *Fluxfest Sale is a simultaneous reprint of the Fluxus section of* Film Culture — *"Expanded Arts Special Issue," No. 43, Winter 1966. The publication contains numerous Fluxus scores, descriptions of scores, information on organizing a Fluxfest, and George Maciunas' "Expanded Arts Diagram." Together,* Flux Fest Kit 2, *several Fluxus newsletters, and* Fluxfest Sale *form a comprehensive collection of scores of Fluxus performances.*

FLUXFILM PACKAGE see:
FLUXFILM

FLUXFILMS
Silverman No. > 123.IV, ff.

It has been decided to publish in addition to FLUXUS

YEARBOXES (which are of an encyclopedic-anthological character) also special collections of single authors and special items-works of single authors.... Special items will consist of films,...that will be reproduced or produced by authors themselves or Fluxus and sold through Fluxus distribution system in USA, West and East Europe and Japan....
Fluxnewsletter No. 5, January 1, 1963.

FLUXUS 1964 EDITIONS, AVAILABLE NOW ... FLUXUS 1 Anthology of yet unpublished works ... LUXUS edition, with film...no 2 boxes alike $12
cc Valise e TRanglE (Fluxus Newspaper No. 3) March 1964.

NEW! FLUXFILMS
FLUXUSdde CHIEKO SHIOMI: disappearing music
 for face, 16mm film, 1 min. $20
FLUXUS gzz NAM JUNE PAIK: zen for film
 16mm, 20 min. b.&w. no sound, $50
Vacuum TRapEzoid (Fluxus Newspaper No. 5) March 1965.

"...This Fall, we...intend to visit Prague...We could bring with us...a 2 hour film program of some 15 films..."
Letter: George Maciunas to Milan Knizak, (possibly January, 1966).

"...Too bad I can't send a fluxfilm program, we made up a nice 2 hour film program of about 15 various films, but I can't afford to make a print of it which for 16mm costs $200 and 8mm about $70. by April. I will send you an 8mm version, but it will be too late for Milan..."
Letter: George Maciunas to Ben Vautier, March 5, 1966.

FLUXFILM

Collective. An original title board for FLUXFILMS

"...Regarding film festival. — I will send you the following:...
1. Disappearing music for face by Chieko Shiomi - 20 min.
2. Fluxfilm - my own - 20 min.
3. James Riddle - 10 minutes - 10 min.
4. Entrance - Exit by George Brecht 6½ min.
5. Blink by Yoko Ono, or her "walk"
6. Smoking by Joe Jones, -20 min.
If this is too much, let me know, I will send fewer. They and another 6 films make up the whole 2 hour flux film program, I will send later (when I can afford) the other 6, so you will have a complete program to show around. Incidentally, loops from these films will go into Fluxus II Yearboxes. Fluxfilm program was shown at Ann Arbor film fest & won critics award...."
Letter: George Maciunas to Ben Vautier, March 29, 1966.

"...I ran out of money completely and thoroughly, so I was not able to make prints of films I wanted to send you. (it costs $200 for 1 hour 30 min. program of some 15 films.) But I will send them to you during summer when my finances will improve...fluxus II is all ready but production of 100 copies (of film loops) also held up by money shortages..."
Letter: George Maciunas to Ben Vautier, May 19, 1966.

FLUXFILMS
FLUXFILM 3 END AFTER 9, 1 min $6
FLUXFILM 4 CHIEKO SHIOMI:
 disappearing music for face,
 15min $60
FLUXFILM 5 JOHN CAVANAUGH: blink,
 10min $40
FLUXFILM 6 JAMES RIDDLE: 9 minutes,
 9min $36

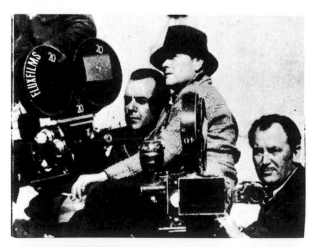

Collective. FLUXFILMS label, designed by George Maciunas

FLUXFILM 7	10 FEET, 16sec	$4
FLUXFILM 8	1000 FRAMES, 40sec	$6
FLUXFILM 9	ONE, 1 min	$6
FLUXFILM 10	GEORGE BRECHT: entrance-exit 6.5min, with sound	$50
FLUXFILM 11	ROBERT WATTS: swallowing,	$20
FLUXFILM 12	ROBERT WATTS: hot dog 3min	$20
FLUXFILM 13	ROBERT WATTS;	$20
FLUXFILM 14	YOKO ONO: no.1, 10min	$40
FLUXFILM 15	EYE BLINK, 5min	$20
FLUXFILM 16	YOKO ONO: no. 4, 4min	$16
FLUXFILM 17	PIETER VANDERBEEK 5 o'clock in the morning, 5min	$20
FLUXFILM 18	JOE JONES: smoking,15min	$60
FLUXFILM 19	ERIC ANDERSEN: opus 74, 4sec	$5
FLUXFILM 20	ALBERT FINE: 1min	$5

Vaseline sTREet (Fluxus Newspaper No. 8) May 1966.

"...I received the...film loops. All were great, terrific and in time for Fluxus II yearbook...If you have any longer films, we can produce them (make prints) and then distribute them as part of a 2 hour Fluxfilm program we distribute through Film Coop & other sources overseas..."
Letter: George Maciunas to Paul Sharits, June 29, 1966.

"...We will include your long films in our next package, since now we have lost our shirts in various film projects. Very expensive thing those films. Yes, we would be interested in your Word Film. All Fluxfilms are numbered. so credit runs like this.
FLUXFILM NO. 29—this would be the next number-

© copyright by Film maker or FLUXUS 1966/ depending on who pays for 2 prints to be deposited in copyright office. then title, filmmaker...copyright is not really necessary. some filmmakers insist on it then we get it..."
Letter: George Maciunas to Paul Sharits, July 11, 1966.

"...Some of the Fluxus people are coming to Prague this fall. They will bring a 2 hour Fluxfilm (some 20 short films)..."
Letter: George Maciunas to Milan Knizak, August 15, 1966.

"...We put your 4 loops both in Fluxus II and Fluxfilm program. We would like to send you at least 8mm print of the entire 1½ hour film package...Will wait with anticipation the 'word movie' & 'nothing' for next fluxfilm edition. I think the 1st (actually 2nd) version will be printed into 4 of 16mm and about 20-8mm before we make 3rd program. Early in 1967 we will rent again the 10,000 frames per second camera, so that we could shoot any film you would propose if you send us detailed instructions (or visit us in N.Y. yourself)..."
Letter: George Maciunas to Paul Sharits [ca. Fall 1966].

"...Re: FLUXFILMS, the only print in U.S.A. is booked up to Nov. 26 at La Jolla, Unicorn Film Society — Cal. 92037, P.O. Box 868. I will ask them to send films directly to you. So you could plan something for mid December. After you are through, send the films back to me, unless I ask you to ship it to some other booked address. OK?...I have asked Greg Sharits at Boulder Colo. to send you Joe Jones duet (bells & Violin) to you after he is through with it. It

is good to use them as sound background with Flux films..."
Letter: George Maciunas to Ken Friedman, November 14, 1966.

"...In regards to film — I have seen no programs or announcements. or payments. Any problem?..."
Letter: George Maciunas to Ken Friedman, November 23, 1966.

"...In 3 weeks we will finally have a completed Flux film program of about 20 films—1 hour 20 min. length, 8mm & 16mm versions..."
Letter: George Maciunas to Ben Vautier, [ca. Fall 1966].

"...Meanwhile please send the film reels—as soon as possible! —to me at N.Y.C. box 180. I have to make some revisions..."
Letter: George Maciunas to Ken Friedman, December 29, 1966.

EVENT NO. 6 FLUXFILMS To be brought 16mm, about 2 hour program.
Proposed program for a Fluxfest in Prague, 1966.

FLUXFEST INFORMATION ... Flux-film package containing 24 films. 1 hr. 40 min. $60 per show...
Fluxfest Sale. [Winter 1966].

FLUXFILMS
SHORT VERSION, 40 MIN AT 24 FRAMES/ SEC. 1400FT. [listed as follows] flux-number, author, title, duration, method of production

9	Anonymous	EYEBLINK 1' High-speed camera, 2000fr/sec. view of one eyeblink *
20	George Maciunas	ARTYPE 4'20'' Artype patterns on clear film, intended for loops.
19	Eric Andersen	OPUS 74, VERSION 2 1'20'' Single frame exposures, color
4	Chieko Shiomi	DISAPPEARING MUSIC FOR FACE 10' High-speed camera, 2000fr/sec. transition from smile to no-smile *
7	George Maciunas	10 FEET 0'45'' Prestype on clear film measuring tape, 10ft. length.
11	Robert M. Watts	TRACE 1'15'' X-ray sequence of mouth and throat: salivating, eating.
24	Albert Fine	READYMADE 0'45'' Produced in developing tank, color.
26	Paul Sharits	SEARS CATALOGUE 1–3 2' Single frame exposures, page from Sears Catalogue
27	''	DOTS 1 & 3 2' Single frame exposures of dot-screens
28	''	WRIST TRICK 2' Single frame

Collective. Two long version, three reel, 16mm FLUXFILMS. In center are two packagings of FLUXFILMS LOOPS and a FLUX YEAR BOX 2 containing FLUXFILMS LOOPS. see color portfolio

BRAD IVERSON

exposures of hand held rasor-blade [sic]

29 " UNROLLING EVENT 2' Single frame exposures of toilet paper event

16 Yoko Ono NUMBER 4 5'30'' Sequences of buttock movement as various performers walked. Filmed at constant distance.

31 John Cale POLICE CAR 1' Underexposed sequence of blinking lights on a police car.

18 Joe Jones SMOKE 6' High-speed camera, 2000fr/sec. sequence of cigarette smoke.

30 Paul Sharits WORD MOVIE 4' Single frame exposures of works, color

25 George Landow THE EVIL.......... 0'30''

3 Anonymous END AFTER 9 2' word & numeral film (a gag).

LONG VERSION, ADDITIONAL FILMS TO SHORT VERSION

5 John Cavanaugh BLINK 1' Flicker: white and black alternating frames.

6 James Riddle 9 MINUTES 9' Time counter, in seconds and minutes.

10 George Brecht ENTRY-EXIT 6'30'' A smooth linear transition from white, through greys to black, produced in developing tank.

12 Robert Watts TRACE
13 " TRACE
14 Yoko Ono NUMBER 1 6' High-speed camera, 2000fr/sec. match striking fire.*

17 Pieter Vander-beek 5' O'CLOCK IN THE MORNING 6' High-speed camera, 2000fr/sec. walnuts and rocks falling.*

23 Wolf Vostell SUN IN YOUR HEAD 6' Various TV screen distortions & interferences

*camera: Peter Moore
Editing and titles by George Maciunas
Fluxfilms are distributed by FILM - MAKERS' CO-OPERATIVE, 175 LEXINGTON AVE. NEW YORK, N.Y. & FLUXFILMS, P.O. B. 180 NEW YORK, N.Y. 10013, also in Australia and England.
Fluxfilms catalogue, [ca. 1966].

"...1st an observation about your posters — I see no mention of Fluxfilms...OK, you can keep films till Christmas, but ship them back right after Christmas..."
Letter: George Maciunas to Ken Friedman, February 28, 1967.

PAST FLUX-PROJECTS (realized in 1966)...Flux-films: total package: 1 hr. 40 min. opus 74 by Eric Andersen, disappearing music for face by Chieko Shiomi, 10 feet by G. Maciunas, blink—anonymous, blink by John Cavanaugh, entrance—exit by George Brecht, artype by G. Maciunas, police car by John Cale, dance—anonymous, loop by Albert Fine, 9 minutes by James Riddle, sears, dotts, wrist trick (3 loop films) by Paul Sharits, 3 films by R.Watts, 5 o'clock in the morning by Pieter Vanderbeek, sun in your head by Wolf Vostell, no.1 and no. 4 by Yoko Ono, no. 25 by George Landow, smoke by Joe Jones, end after 9 by G.Maciunas. Fluxfilm package was already exhibited in several places in U.S.A. (New York, Los Angeles, San Francisco, Boulder, Ann Arbor etc.) France and Czechoslovakia. (It won some bizzare prize Milwaukee Art Center.)
Fluxnewsletter, March 8, 1967.

FLUX-PROJECTS PLANNED FOR 1967...Collective projects: (All are invited to submit ideas and participate, ideas can be either ready pictorial material or just specified material which we have to find, produce or obtain otherwise)...Flux-films (loops or continuous camera shot films up to 8,000 f/sec. speed, hand made or collaged) films should be in 16mm original positives, we will make 16mm Master negs, double 8mm Master negs from which we can make 8mm prints at ¼ the cost of 16mm. Originals if made by you would be returned to you. We can make all titles as we did with the first anthology (mostly kinetic titles related to subject matter).
ibid.

OTHER NEWS: Ken Friedman is establishing a FLUX-WEST center, H.Q. etc. at: 1640 Kirkham, San Francisco, Cal. 94122. He will stock various flux-items for distribution and coordinate...flux-film screenings, etc. in the west coast.
Milan Knizak, Novy svet 19, Prague, Czechoslovakia, established a FLUX-EAST center, H.Q.
Ben Vautier of course is the West European coordinator. All these centers will have stock of Flux-items, flux-film 16mm 1 hr. 40min. program and parts of the automatic flux-orchestra.
ibid.

15 films 35 min. 8mm $30
Fluxshopnews. [Spring 1967].

"...Films - Word Movie is great. Could use color version too, Flux-package has 2 short color films, which we print separately & then splice-in. Though all are silent. At least for a while they will to save on costs. Maybe by Summer we can do something about sound & then include your sound version. On second thought, why not include your present color - sound

version & specify the whole 1200 ft. reel to be played through sound system, so there will be lots of white noise and then suddenly a bit of sound and color. May liven up the entire package this way...."
Letter: George Maciunas to Paul Sharits, [after March 18, 1967].

"...I will send entire flux-film package (3 reels- 1200' ea) about 1 hour 40 min. to you in a week..."
Letter: George Maciunas to Ben Vautier, March 25, 1967.

"...Fluxfilms had to be diverted to Europe. In April I should get another print made, will ship a permanent copy for Westcoast HQ...."
Letter: George Maciunas to Ken Friedman, March 27, 1967.

"...Film coop sent a travelling film library to Europe, in which was included a re-edited Flux-film package - 1200' version. —has all the best material including your 4 loop films. (Dots, Sears, Wrist Trick & Unrolling.) I am finally doing the 8mm print of that 1200ft. Fluxfilm version. It will be good for straight viewing or loop viewing, ..."
Letter: George Maciunas to Paul Sharits, June 21, 1967.

"Quick reply in regards to cost of Fluxfilms (for buyer):...We have a nice condensed one reel program with the best pieces in them, or all short pieces plus the smile to no smile film as the only long film. That also has 3 color films spliced-in. Sale cost $200 for 1200 ft reel. Absolute minimum $120. The 3 reel program-complete with all films, latest version - $500, absolute minimum $360 (that leaves hardly any profit.) When selling, we must ask 75% of cost in advance to cover our costs, since I could not lay out the money for printing cost. Deliver - one week from time of order with deposit. We also will have 8mm film version, which really for our type of film is just as good. Cost is half that of 16mm. In other words one reeler, minimum is $60, rather cheap, I think..."
Letter: George Maciunas to Ken Friedman, July 17, 1967.

"...I should be able to ship to you the 8mm fluxfilm package in a few weeks,...cut up the first package into loops and then i will send second package for uncut version. could use a few dollars for all these films. can't you get some over from all that stuff i shipped to you????..."
Letter: George Maciunas to Ken Friedman, [ca. August 1967].

"...By parcel post I am sending you...8mm film program (1 hour)...The films I am sending contain in beginning material for loops which should be cut up & used for film environments. The actual Fluxfilm program starts with 1st title since loops are untitled...."
Letter: George Maciunas to Ken Friedman, [ca. Winter 1967/68].

FLUXPROJECTS REALIZED IN 1967...Fluxfilm
8mm version...
Fluxnewsletter, January 31, 1968.

"...Re: film fest at your school. Most fluxfilms are
1966 so would disqualify. I could have the Co-op
send you a reel as a non-entry. Also have a 8mm ver-
sion 30min. 20 films - for yourself. Will send you very
soon..."
Letter: George Maciunas to Paul Sharits, February 9, 1968.

"...Received your Word Movie — GREAT! You are
getting expert on single frame sequences, they really
work! Effect is terrific! I would like to include this in
our flux package of 16mm & 8mm versions, except
8mm would be without sound, & 16 with sound, OK?
...I mailed to you a pack with Flux year box 2 (one
with film loops), also our 8mm film program (about
hour long)...."
Letter: George Maciunas to Paul Sharits, [ca. Spring 1968].

"...8mm film pack on way to you in 2 weeks..."
Letter: George Maciunas to Ken Friedman, November 8, 1968.

FLUXPROJECTS FOR 1969 PRODUCTS — PUBLI-
CATIONS...Fluxfilms: by Milan Knizak, Paul Sharits,
George Maciunas.
Fluxnewsletter, December 2, 1968.

FLUXFEST INFORMATION
P.O. BOX 180, NEW YORK, N.Y. 10013
Many fluxpieces are described and listed in the Ex-
panded Arts issue of FILM CULTURE magazine. A
reprint can be obtained for $1. Any of the fluxpieces
can be performed anytime, anyplace and by anyone,
without any payment to Fluxus provided the follow-
ing conditions are met:
1. if fluxpieces out number numerically or exceed in
 duration other compositions in any concert, the
 whole concert must be called and advertised as
 FLUXCONCERT or FLUXEVENT. A series of
 such events must be called a FLUXFEST.
2. if fluxpieces do not exceed non-fluxpieces, each
 such fluxpiece must be identified as a FLUXPIECE.
 Such credits to Fluxus may be omitted at a cost of
 $50 for each piece announced or performed...flux-
 films...
Fluxnewsletter, December 2, 1968 (revised March 15, 1969).

FLUX-PRODUCTS 1961 TO 1969...
FLUXFILMS, short version Summer 1966 40 min.
1400ft: Eyeblink; Artype - by G. Maciunas, Opus 74,
 version 2 - by Eric Andersen; Disappearing
 music for face - Chieko Shiomi; 10ft. - by
 Maciunas; Trace - by Bob Watts; Readymade -
 by Albert Fine; Wrist Trick, Sears Catalogue,
 Dots, Unrolling event - 4 films by Paul Sharits;
 Number 4 - by Yoko Ono; Police Car - by

John Cale; Smoke - by Joe Jones; Word Mov-
ie - by Paul Sharits; The Evil...by George
Landow; End After 9.
 16mm [$] 180
 8mm version [$] 50
FLUXFILMS, long version, Winter 1966. Short ver-
sion plus addition of:
 Flicker by John Cavanaugh, 9 minutes - by
 James Riddle, Entry-Exit - by George Brecht,
 2 Traces - by Bob Watts; No.1- by Yoko Ono;
 5 o'clock in the morning - by Pieter Vander-
 beek; Sun in your head - by Wolf Vostell,
total: 1hr.40min. 16mm only: [$] 400
ibid.

...PROPOSED CATEGORIES...SLIDE-FILM FLUX-
SHOW...FLUXFILM PROGRAM
Fluxfest at Stony Brook, Newsletter No. 1, August 18, 1969. version B

FLUX FEST INFORMATION
P.O. BOX 180, NEW YORK, N.Y. 10013
Any of the Flux-pieces can be performed anytime,
anyplace and by anyone, without any payment to
Fluxus provided the following conditions are met:
1. If flux-pieces outnumber numerically or exceed in
 duration other compositions in any concert, the
 whole concert must be called and advertised as
 FLUXCONCERT or FLUXEVENT. A series of
 such events must be called a FLUXFEST.
2. If flux-pieces do not exceed non-fluxpieces, each
 such fluxpieces must be identified as a FLUX -
 PIECE.
3. Such credits to Fluxus may be omitted at a cost of
 $50 for each piece announced or performed. ...
 fluxfilm...FILM FLUXSHOW...
MILAN KNIZAK: INDETERMINATE MOVIE, 1969
Slow transition from out-of-focus to focus of a pro-
jected piece of rope....
MILAN KNIZAK: INTERMISSION...
ANONYMOUS: EYEBLINK
High-speed camera, 2000fr/sec. view of one eyeblink.
Camera: Peter Moore. 1min.
GEORGE MACIUNAS: ARTYPE
Various artype patterns (screens, wavy lines, parallel
lines etc.) on clear film. No camera.
ERIC ANDERSEN: OPUS 74, VERSION 2
Single frame exposures, color, 1'20".
CHIEKO SHIOMI:
DISAPPEARING MUSIC FOR FACE
Transition from smile to no-smile, 10min. Shot at
2000fr/sec. Camera: Peter Moore.
Simultaneously with:
BEN VAUTIER:
MONOCHROME FOR Y. KLEIN
FLUXVERSION I
Performer paints a movie screen with non-reflective

black paint while a favorite movie is being shown.
GEORGE MACIUNAS: 10 FEET
Projection of clear measuring 10ft. tape. 1'15"
No camera.
ROBERT WATTS: TRACE
X-ray sequence of mouth and throat: eating, salivat-
ing, speaking. 0'45"
ALBERT FINE: READYMADE
Color test strip from developing tank.
PAUL SHARITS:
SEARS CATALOGUE 1 - 3
Pages from Sears catalogue, single frame exp.
DOTS 1 & 3
Single frame exposures of dot-screens.
WRIST TRICK
Various gestures of hand held rasorblade [sic], single
frame exposures.
UNROLLING EVENT
Toilet paper event, single frame exposures.
YOKO ONO: NUMBER 4
Sequences of buttock movement of various walking
performers. 5'30"
JOHN CALE: POLICE CAR
Underexposed sequence of blinking lights on police
car. Color. 1'
JOE JONES: SMOKE
Sequence of cigarette smoke shot with high speed
camera, 2000fr/sec. Camera: P. Moore.
PAUL SHARITS: WORD MOVIE
Single frame exposures of words & colors. 4'
GEORGE BRECHT: ENTRY — EXIT
A smooth linear transition from white, through greys
to black, accompanied by sound transition from white
noise to sinus wave tone. 6'30"
WOLF VOSTELL: SUN IN YOUR HEAD
TV screen distortions and interferences. 6'
AYO: RAINBOW MOVIE, 1969-1970
Smooth transition through chromatic color scale:
yellow to orange to red to violet to blue to turquoise
to green to yellow.
GEORGE MACIUNAS: ROPE MOVIE
Rope in sprocketless projector, together with:
ROBERT WATTS: ROPE RECORD
Coiled rope record played with various replacements
for needle (feather, wire, spring, etc)
Flux Fest Kit 2. [ca. December 1969].

FLUX-PRODUCTS 1961 TO 1970...
FLUXFILMS, short version, Summer 1966.
40min. 1400ft.: Eyeblink, Artype by George Maciunas,
Opus 74 by Eric Andersen, Disappearing music for
face by Chieko Shiomi, 10' by Maciunas, Trace by
Bob Watts, Ready-made by Albert Fine, Wrist Trick,
Sears Catalogue, Dots, Unrolling event by Paul Sharits,
Number 4 by Yoko Ono, Police Car by John Cale,
Smoke by Joe Jones, Word Movie by P. Sharits, The

Evil...by George Landow, End After 9.

16mm version	$180
8mm version	$ 50

FLUXFILMS, long version, Winter 1966. Short version plus addition of: Flicker by J. Cavanaugh, 9 min. by James Riddle, Entry — Exit by George Brecht, 2 Traces by R. Watts, No. 1 by Yoko Ono, 5 o'clock in the morning by Pieter Vanderbeek, Sun in your head by Wolf Vostell, total: 1 hr. 40min. 16mm $400
ibid.

FLUXFILMS, 1974 VERSION
[listed as follows:] flux number, author, title, year, method of production

9 Anonymous EYEBLINK 1966 Hi-speed camera, 2000fr/sec. view of one eyeblink *

20 George Maciunas ARTYPE 1966 Transfer patterns directly on clear film, no camera used

19 Eric Andersen OPUS 74, VERSION 2 1966 Single frame exposures, color

4 Mieko Shiomi DISAPPEARING MUSIC FOR FACE 1966 High-speed camera, 2000fr/sec. view of transition from smile to no-smile *

2 Dick Higgins INVOCATIONS 1966 loop of mouth, eating motion

7 George Maciunas 10 FEET 1966 Numerals on clear film measuring 10 feet, no camera used.

11 Robert M. Watts TRACE 1966 X-ray sequence of mouth and throat: salivating, eating, etc.

24 Albert Fine READYMADE 1966 Found object, test strip from film lab. color.

26 Paul Sharits SEARS CATALOGUE 1 - 3 1966 Single frame exposures, pages from Sears Catalogue

27 '' DOTS 1 & 3 1966 Single frame exposures of various dot-screens

28 '' WRIST TRICK 1966 Single frame exposures of hand held razorblade

29 '' UNROLLING EVENT 1966 Single frame exposures of toilet paper event

16 Yoko Ono NUMBER 4 1966 Sequences of buttock movement as various performers walked. Filmed at constant distance

36 Peter Kennedy & Mike Parr [no title] 1970 tips of feet walking at the very edge of frame, with sound

37 [no title] 1970 face going out

of focus by layering sheets of plastic between camera and subject. with sound

10 George Brecht ENTRY-EXIT 1966 A transition from white, through grey to black, produced in developing tank, sound: sinus tone to white noise.

18 Joe Jones SMOKE 1966 High-speed camera, 2000fr/sec. sequence of cigarette smoke.*

31 John Cale POLICE CAR 1966 Underexposed sequence of blinking lights on a police car.

1 Nam June Paik ZEN FOR FILM 1964 Clear film, accumulating in time dust and scratches.

3 Anonymous END AFTER 9 1966 word & number gag, no camera.

Total length: 2300ft.
PRICE FOR FIRST PRINT: $600
*camera: Peter Moore
Editing and titles by George Maciunas
Fluxfilms Catalogue. 1974.

FLUX-OBJECTS...03.1965...
FLUXFILMS:
ERIC ANDERSEN: opus 74
SHIOMI: disappearing music for face
MACIUNAS: 10ft, artype (dots, lines) end after 9, 1000frames, etc.
G. BRECHT: entrance/exit
A. FINE: color readymade
JOHN CALE: police car blinking
JAMES RIDDLE: 9 minutes
PAUL SHARITS: sears, dotts,
BOB WATTS: traces
YOKO ONO: no. 4 (walking buts [sic])
JOE JONES: smoking
George Maciunas, Diagram of Historical Developments of Fluxus... [1973].

OBJECTS AND EXHIBITS...1965:...edited, designed titles (using various animation and camera techniques) of some 20 films into Flux-film anthology, contributed: films made without camera (using various adhesive patterns on clear film stock): Artype, 10 feet, end after 9, eyeblink (high speed camera)
George Maciunas Biographical Data. 1976.

PERFORMANCE COMPOSITIONS, PERFORMANCES, FILM SCREENINGS, EVENTS ... shown at Cologne, Turin, Perugia, Como, Savona, Zurich, Belgrade, Zagreb, Sarajevo, several U.S. colleges, Flux films awarded Milwaukee Art Center Award, 4th Ann Arbor film Festival Award.
ibid.

COMMENTS: *Although Fluxus planned to include film in special "luxus" editions of FLUXUS 1, and packaged individual film loops such as Nam June Paik's Zen for Film by 1964, it was in 1965 that George Maciunas adopted the term Fluxfilms and started producing films in sufficient numbers to be able to plan a "two hour program." Most of the films that make up the first Fluxfilms package were probably made in 1966. That package was offered for rent and later for sale in either a 40 minute "short version" or a "long version" lasting approximately 75 minutes. A 3 reel 16mm "long version" was produced and sent to Prague in 1966 which matches the Fluxfilms catalogue of that year. That print is now in the Silverman Fluxus Collection and is being used to compare with other prints which vary in contents over the years, as Maciunas edited, added or subtracted films from the packaging of Fluxfilms.*

George Maciunas' notes from around 1970 list the following films produced by Fluxus and their "Fluxfilm" number. Various groupings of some, but never all, of these films make up the Fluxfilms packages:

1	Nam June Paik [Zen for Film]
2	[Dick] Higgins [Invocation of Canyons and Boulders]
3	Anonymous [George Maciunas] End After 9
4	Chieko Shiomi Disappearing Music For Face
5	John Cavanaugh Blink
6	James Riddle 9 Minutes
7	Anonymous [George Maciunas] 10 Feet
8	" [" "] 1000 Frames
9	" [Yoko Ono] One Blink
10	George Brecht Entry Exit
11	Robert Watts Trace [No. 22]
12	" Trace [No. 23]
13	" Trace [No. 24]
14	Yoko Ono No. 1
15	Anonymous [Yoko Ono] Eye Blink
16	" [Yoko Ono] No. 4
17	Pieter Vanderbeek 5 O'Clock in the Morning
18	Joe Jones Smoking
19	Eric Andersen Opus 74, version 2
20	Anonymous [George Maciunas] Artype
21	Alison Knowles []
22	Jeff Perkins Shout
23	Wolf Vostell Sun In Your Head
24	Albert Fine "loop" [Readymade]
25	George Landow [The Evil Faerie]
26	Paul Sharits Dots 1 & 2
27	" Sears Catalogue 1-3
28	" Wrist Trick
29	" "Word Film" [Word Movie]
30	Albert Fine Dance
31	John Cale Police Car
32	Milan Knizak Intermission
33	" Indeterminate Movie
34	Ay-O [Rainbow Movie]
35	[Geoffrey] Hendricks [Moon Landing]
36	Peter Kennedy & Mike Parr [Fluxfilm No. 36, untitled]
37	[Fluxfilm No. 37, untitled]
38	Ben Vautier ["seeing, Hearing, Saying Nothing"]
39	" ["swimming across Nice harbor fully clothed]
40	" ["lifting and holding up a chest of drawers"]
41	.. ["sitting on a promenade in Nice with a sign: Watch me, that's all"]

FLUXFILMS ENVIRONMENT

"...Film Coop sent a traveling film library to Europe, in which was included a re-edited Flux-film package - 1200 ft. version. - has all the best material including your 4 loop films....I am finally doing the 8mm print of that 1200 ft. Fluxfilm version. It will be good for straight viewing or loop viewing, some 40 loops that could do a nice Flux-wallpaper event. (for instance all dotted wall, or moving vertical lines or walking behinds etc. etc.) Will mail this 8mm package to you in a few weeks...."
Letter: George Maciunas to Paul Sharits, June 2, 1967.

"Very quick additional note on films for potential buyer. We have some 20 loops, which he could buy each 4 feet on 16mm say for 20 dollars or 8mm for half that price. With these loops he can have a flux wall paper show since many are patterns like dots or lines, from the artype film. Incidentally, I should be able to ship to you the 8mm fluxfilm package in a few weeks, this pack contains all the loop material for flux wallpaper show, you need some 10 to 20 8mm projectors, and of course white walls and ceilings if you project it on them. You could show say 20 loops of Yoko Ono's walking behinds of 20 different people, or numbers so arranged you have them shift in numerical order, etc. etc., improvise your own arrangement..."
Letter: George Maciunas to Ken Friedman, [ca. August 1967].

Flux-film-walls (loops by Paul Sharits, Albert Fine, George Maciunas, Wolf Vostell, Yoko Ono, etc.)
Proposed R & R Evenings. [ca. 1967].

"...The films I am sending contain in beginning material for loops which should be used for film environments. The actual Flux film program starts with 1st title - since loops are untitled...."
Letter: George Maciunas to Ken Friedman, [ca. Winter 1967/68].

"...You have so many films now, you should have solo evening at Cinematheque - suggest during Flux-Fest in Sept when we will have films, film environments (wall, ceiling, floor), sport events, concerts, etc. - So a few days could be devoted to your films or film environments...."
Letter: George Maciunas to Paul Sharits, [ca. Spring 1968].

PROPOSED R & R EVENINGS: Flux film-walls (loops by Paul Sharits, Albert Fine, George Maciunas, Wolf Vostell, Yoko Ono, etc.)...
Fluxnewsletter, January 31, 1968.

FLUXPROJECTS REALIZED IN 1967:...Fluxfilm 8mm version, also 20 loop version for flux-film-wall-paper-event...
ibid.

FLUXPROJECTS FOR 1968 (in order of priority)... 12. Film projects, film-wall-paper events in "the garage", fluxshop opening.
ibid.

PROPOSED FLUXSHOW FOR GALLERY 669, LOS ANGELES...FILM WALLPAPER ENVIRONMENT A booth must be set up in a fairly dark area, the walls of which are of white vinyl or cotton sheets (about 12ft. wide) hanging as curtains and creating a 12ft x 12ft or smaller room. Four 8mm loop projectors (with wide angle lenses) must be set up, one on front of each wall (on the outside) and projecting an image the frame of which is to cover entire wall. 20 sets of loops are available, such as vertical lines moving left (like a carousel), or single frame exposures of Sears catalogue etc. etc. Visitors, a few at a time, must enter this booth to observe the film environment around them.... SOUND ENVIRONMENT (may be within film environment) a. relay of telephone time service. b. street sounds are picked up by microphones placed outside and amplified to speakers inside (by Richard Maxfield) c. Night Music by Richard Maxfield (loop) played with Artype film loop environment. d. Requiem for Wagner by Dick Higgins played with eating mouth film loop. e. paper sound loop, mouth sound loop etc.
Fluxnewsletter, December 2, 1968.

FLUXFEST, a 20 evening fluxfest will be held at 16 Greene st. theater (25' x 100' space) sometimes during March and April. It will consist of...flux-film environment...(proposals from all will be welcomed).
ibid.

FLUXPROJECTS FOR 1969 ... PROPOSALS WILL BE WELCOMED FOR:...new films and film loops for film environment...
ibid.

PROPOSED R & R EVENINGS: Flux-film-walls (loops by Paul Sharits, Albert Fine, George Maciunas, Wolf Vostell, Yoko Ono, etc.)
ibid.

PROPOSED FLUXSHOW...FILM WALLPAPER ENVIRONMENT...[as above]...20 sets of loops are available, such as: vertical lines moving carousel fashion clockwise, single frame exposures of Sears catalogue, blinking polka dots, slow motion blinking eyes, etc. ...SOUND ENVIRONMENT (may be simultaneously and within film environment) a. street sounds are picked up by microphones placed outside and amplified to speakers inside - by Richard Maxfield. b. Night Music - by Richard Maxfield, (can be played as loop with Artype film loops.) c. Requiem for Wagner by Dick Higgins, (can be played with his eating mouth film loop). d. paper sound loop, mouth & lip sound

loop, water sound loop, etc. e. automatically playing instruments: violin, bells, reeds, flutes, duck call, gong etc. - by Joe Jones .f. music box with 10 simultaneously playing music movements - by Joe Jones g. paper noise machine - by George Maciunas, wind-up noise making machines, etc.
Fluxnewsletter, December 2, 1968 (revised March 15, 1969).

PROPOSED CATEGORIES ... FLUXSHOW ... Film environment ... LOCATION ... Art Gallery ... IN CHARGE IN NYC...Yoshimasa Wada...
Fluxfest at Stony Brook, Newsletter No. 1, August 18, 1969. version A

PROPOSED CATEGORIES ... FLUXSHOW ... Film environment...LOCATION...Art Gallery...
Fluxfest at Stony Brook, Newsletter No. 1, August 18, 1969. version B

FLUXFEST INFORMATION
P.O. BOX 180, NEW YORK, N.Y. 10013
Any of the Flux-pieces can be performed anytime, anyplace and by anyone, without any payment to Fluxus provided the following conditions are met:
1. If flux-pieces outnumber numerically or exceed in duration other compositions in any concert, the whole concert must be called and advertised as FLUXCONCERT or FLUXEVENT. A series of such events must be called a FLUXFEST.
2. If flux-pieces do not exceed non-fluxpieces, each such fluxpiece must be identified as a FLUX-PIECE.
3. Such credits to Fluxus may be omitted at a cost of $50 for each piece announced or performed. ... flux-film,...flux-environments;...

FILM AND SOUND ENVIRONMENT
A booth must be set up in a fairly dark area, the walls of which are of white vinyl or cotton sheets (about 12' wide x 8' high) hanging as curtains, creating thus a 12' x 12' or smaller room. Four 8mm wide angle lense loop projectors must be set up in front of each wall on the outside, projecting an image the frame of which is to cover entire wall. Spectators may enter the booth through corners.
1. Night Music by Richard Maxfield together with Artype loops by George Maciunas.
2. Paper sound loop with paper punched tape projected loop by G. Maciunas.
3. Paul Sharits film & tape loops.
4. Requiem for Wagner (tape) by R. Higgins with his eating mouth film loop.
5. Buttock movement (film loop) by Yoko Ono with lip & tube sound by Maciunas.
6. Black to white film by George Brecht with his Sinus tone to white noice [sic] tape.
7. Slow motion blinking eyes with audience or street sounds picked up by microphone.

8. Word movie by Paul Sharits with lip and tongue sound tape loop.
9. Sound and film flicker by J. Cavanaugh.
10. TV distortions by Wolf Vostell with sound static and distortions from radio.
Flux Fest Kit 2. [ca. December 1969].

"Regarding Capsule. It will be a suspended 3 x 3 x 3 booth with translucent panels, so we can project on all 4 sides, top & bottom. Get all kinds of effects. I thought projecting your dots & sears separately of course. If you have any other suggestions, ideas, etc. let me know. Maybe your students would like to contribute. Also the color spectra was nice, but not smooth enough - my fault. the roll - color sheet is smoother, could you have it reshot - (no need to make loops. - just one of each.) I will pay expenses of the past & future versions. I would appreciate a lot. Do you have access to airplane? would be nice to shoot simultaneously front, top, bottom & one side. we can get back by reversing front, & flipping sides. Or at least from moving car - top, side, front — facing towards sky. Then we can show top also on bottom."
Letter: George Maciunas to Paul Sharits, [ca. April 1970].

...MAY 16 - 22: CAPSULE BY JOHN & YOKO + FLUX SPACE CENTER A 3ft cube enclosure (capsule) having various film loops projected on its walls, ceiling and floor to a single viewer inside, total time: 6 min. 1. transition from small to large screens, single frame exposures of Sears Catalogue pages (Paul Sharits) 2. transition from white to black (George Brecht, 1965) combined with: transition from smile to no smile, 20,000 frames/sec. (Shiomi '66) 3. linear fall, or turn (carousel fashion), slide projection of diffusion, osmosis of liquids, dancing cockroaches (G.Maciunas) 4. transition through color scale (Ayo, 1969) 5. Elephants crowding in, (?) 6. Flicker (J. Cavanaugh, 1965) 7. fly (top, bottom, front and side views shot simultaneously from airoplane [sic] without showing any parts of the plane, projection will give sensation of Bird flight) by Yoko Ono, (realized 1970) No.4 (close up of walking nude buttock) Yoko Ono, 1966
Schedule of events for Fluxfest presentation of John Lennon and Yoko Ono. [ca. April 1970] version A

...MAY 16-22: CAPSULE BY JOHN & YOKO + FLUX SPACE CENTER ($1 ADMISSION CHARGE) A 3ft cube enclosure (capsule) having various film loops projected on its 3 walls, ceiling and floor to a single viewer inside, about 8 minutes. 1. transition from small to large screens; 2. single frame exposures of Sears Catalogue pages (both by Paul Sharits, 1966) 3. transition from white to black (George Brecht, 1965) 4. linear fall; 5. linear turn (carousel fashion)

(both by G. Maciunas, 1966) 6. transition through color scale (Ayo, 1969); 7. No. 4 (close up of walking nude buttock) (Yoko Ono, 1966) 8. Flicker (J. Cavanaugh, 1965) 9. clouds (Geoff Hendricks, 1970); 10. slide projection of: diffusion and osmosis of solvents (G. Maciunas, 1969)
Schedule of events for Fluxfest presentation of John Lennon and Yoko Ono. [ca. April 1970] version B

FLUXFEST PRESENTS YOKO ONO...MAY 16-22 CAPSULE BY YOKO + FLUX SPACE CENTER... A 3'x3'x3' enclosure (capsule) having various film loops projected on its walls and ceiling to a single viewer inside: fall, carousel (G. Maciunas); screen transition, single frame exposures (Paul Sharits); transition from white to black (George Brecht) transition through chromatic color scale (Ayo); crowding-in compressing (Yoko Ono); flight, swim etc. (Bob Watts); slide projection of diffusion in liquid (Maciunas); projection of moving cockroaches; flicker (J.Cavanaugh) etc.
Schedule of events for Fluxfest presentation of John Lennon and Yoko Ono. April 1, 1970. version C

FLUXFEST PRESENTATION OF JOHN LENNON & YOKO ONO+*...MAY 16-22: CAPSULE BY JOHN & YOKO + FLUX SPACE CENTER, A 6 x 6 ft enclosure having various films projected on its wall to a single viewer inside. 1. transition from small to large dot-screens (Paul Sharits '66) 2. single frame exposures of Sears Catalogue pages (Paul Sharits '66) 3. lines falling or rising (G.Maciunas '66) 4. transition through color scale (Ayo '69) 5. No.4 (Yoko Ono '66) close up of walking buttock 6. Moon landing (Geoff Hendricks '70) 7. Word movie (Paul Sharits '66) 8. Dots in squares (G. Maciunas '66)
all photographs copyright nineteen seVenty by peTer mooRE (Fluxus Newspaper No. 9) 1970.

... This Fall, we shall publish V TRE no. 10, which shall consist of a plan for Flux-Amusement-Center, to contain the following:...film-environment with sound, (capsule having related films projected on 4 walls, floor and ceiling)
Fluxnewsletter, April 1973.

"...I am planning to come to Europe this Summer or Fall...could stay in Italy if you could arrange a worthwhile fluxfest. I still think best is to do...maybe a film-loop or some continuous film and sound room, etc. could use some 4 or 6 rooms simultaneously."
Letter: George Maciunas to Daniela Palazzoli, n.d. Reproduced in Fluxnewsletter, April 1973.

11.04-29.05.1970 FLUX FEST OF JOHN LENNON & YOKO ONO...16-22.05: FILM ENVIRONMENT 4 wall projection of dots, ascending lines, rainbow colors, etc. by sharits, maciunas, ono, ayo, etc.
George Maciunas, Diagram of Historical Developments of Fluxus... [1973].

PERFORMANCE COMPOSITIONS...1970:...Organized a flux festival in collaboration with Yoko Ono & John Lennon at 80 Wooster st. ... film capsule-environments...
George Maciunas Biographical Data. 1976.

COMMENTS: *George Maciunas had the idea to do environments using looped films (short repetitions) initially as continuously moving wallpaper. He expanded on this by producing printed wallpaper of Yoko Ono's* Film No. 4, *which he credited to Ben Vautier as* Asses Wallpaper, *and planned other wallpapers as well. Then, perhaps in response to Stan Vanderbeek's cinematic multi-projection dome built in Stony Point, New York, Maciunas devised a plan for a film and sound capsule, again using loops. The only recorded film environment that I have located was "4 wall projections..." for the "Fluxfest of John Lennon and Yoko Ono" in New York City, May 16 to 22, 1970. Paul Sharits evidently used looped fluxfilms as background for at least one performance, and other environments might have been realized.*

FLUXFILMS LOOPS
Silverman No. > 123.II, ff. and component of No. 125, ff.

...FLUXUS 2 1965 ANTHOLOGY, 8mm film loops with eye film projector...by: Ayo, George Brecht, James Riddle, Walter de Maria, Willem de Ridder, Dick Higgins, Joe Jones, Frederic Lieberman, Yoko Ono, Ben Patterson, Chieko Shiomi, Ben Vautier, Robert Watts. Limited edition of 100. available by Sept. In partitioned wood box, hinged top, $20
Vacuum TRapEzoid (Fluxus Newspaper No. 5) March 1965.

"...Fluxus 2 to come out in June or July. That yearbox will have 8mm film loops (about 10) and an eye viewer-projector to view those films...Film loops should be 2 feet long. You can send one original and I will make copies. Original can be 8mm or 16mm...."
Letter: George Maciunas to Ben Vautier, May 11, 1965.

"... Did I mention of our 8mm film loops for Fluxus II? (You will have your 50 cards in Flux II) but maybe you would like to do a film loop also? 2 ft long/ 8mm (or 4ft/16mm). You can just send me 'script' or tell what to do and I can have the film made. OK?..."
Letter: George Maciunas to Ben Vautier, January 10, 1966.

"...Incidentally, loops from these films will go into fluxus II Yearboxes, Everything is ready, but I got short on $ & can't produce these boxes in quantity, since making film copies is rather expensive. Maybe in a month or so I will issue that yearbox..."
Letter: George Maciunas to Ben Vautier, March 29, 1966.

"...fluxus II is all ready but production of 100 copies (of Film loops) also held up by money shortages..."
Letter: George Maciunas to Ben Vautier, May 19, 1966.

... will appear late in 1966 ... FLUXUS 2 1966 ANTHOLOGY, 8mm film loops with film eye viewer ...

by: Eric Andersen, Jeff Berner, George Brecht, John Cale, Christo, John Cavanaugh, Albert Fine, Joe Jones, Milan Knizak, Shigeko Kubota, Frederic Lieberman, George Maciunas, Claes Oldenburg, Yoko Ono, Willem de Ridder, James Riddle, Bob Sheff, Chieko Shiomi, Ben Vautier, Robert Watts. Limited edition of 100, in partitioned box, hinged top: $30
Vaseline sTREet (Fluxus Newspaper No. 8) May 1966.

"Thank you very much for the books...We like them very much. We distribute however only Fluxus publications. But we would like to publish any future work of yours (printed matter or production of objects) and would like to offer you participation in our yearbox which contains 8mm 2 ft. film loops, with film viewer, card games and any other kind of game. Our distribution is slow, but wide: 4 outlets in Europe (England, Denmark, France, Holland) one in Japan, one San Francisco, and we may open a formal Fluxshop in N.Y.C. But we noticed that these "neodada" objects don't sell like hotcakes yet. We are mailing you our 1964 yearbook, & our pricelist. which will give you an idea of the kind of publications we do."
Letter: George Maciunas to Paul Sharits, April 6, 1966.

"...I received the...film loops. All are great, terrific and in time for Fluxus II yearbook..."
Letter: George Maciunas to Paul Sharits, June 29, 1966.

"... Re: Fluxus II yearbook. Since you contributed films for it you will get 2 free copies, one you can sell..."
Letter: George Maciunas to Paul Sharits, July 11, 1966.

"I mailed to you a pack with flux year box 2 (one with film loops)..."
Letter: George Maciunas to Paul Sharits, [Summer 1966].

"...We put your 4 loops both in Fluxus II and Fluxfilm program...."
Letter: George Maciunas to Paul Sharits [ca. Fall 1966].

FLUX-PROJECTS PLANNED FOR 1967...Collective projects: (All are invited to submit ideas and participate, ideas can be either ready pictorial material or just specified material which we have to find, produce or obtain otherwise) ... Flux-films (loops or continuous, camera shot films up to 8,000 f/sec. speed, handmade or collaged) films should be in 16mm original positives, we will make 16mm Master negs, double 8mm prints at ¼ the cost of 16mm. Originals if made by you would be returned to you. We can make all titles as we did with the first anthology (mostly kinetic titles related to subject matter).
Fluxnewsletter, March 8, 1967.

"...Film Coop sent a travelling film library to Europe, in which was included a re-edited Flux-film package

— 1200 ft. version. — has all the best material including your 4 loop films. (Dotts [sic] , Sears, wrist trick & unrolling. I am finally doing the 8mm print of that 1200 ft. Fluxfilm version. It will be good for straight viewing or loop viewing, some 40 loops that could do a nice Flux-wallpaper event. for instance all dotted wall, or moving vertical lines or walking behinds etc. etc. Will mail this 8mm package to you in a few weeks....."
Letter: George Maciunas to Paul Sharits, June 21, 1967.

"Very quick additional note on films for potential buyer. We have some 20 loops, which he could buy each 4 feet on 16mm say for 20 dollars or 8mm for half that price. With these loops he can have a flux wall paper show since many are patterns like dots or lines, from the artype film. incidentally, I should be able to ship to you the 8mm fluxfilm package in a few weeks, this pack contains all the loop material for flux wallpaper show,...cut up the first package into loops and then i will send second package for uncut version. could use a few dollars for all these films. can't you get some over from all that stuff i shipped to you????..."
Letter: George Maciunas to Ken Friedman, [ca. August 1967].

"...By parcel post I am sending you flux-year-box 2 (one with loops) 8mm film program (1 hour)...The films I am sending contain in beginning material for loops which should be cut up & used for film environments. The actual Fluxfilm program starts with 1st title — since loops are untitled...."
Letter: George Maciunas to Ken Friedman, [ca. Winter 1967/1968].

FLUXPROJECTS REALIZED IN 1967:...Fluxfilm 8mm...20 loop version for...flux-year-box-2 (finally)
Fluxnewsletter, January 31, 1968.

FLUXPROJECTS FOR 1968 (In order of priority) ... 4. Flux-year-box 2 (20 8mm film loops...)
ibid.

"...I mailed to you a pack with Flux year box 2 (one with film loops), also our 8mm film program (about hour long) & few new things. Have labels for many new boxes (enclosed) yet have to print your cards for word-wall poem. RAZOR BLADES for loops — very good idea - splice them & I will get boxes & labels...."
Letter: George Maciunas to Paul Sharits, [Spring 1968].

FLUX-PRODUCTS 1961 TO 1969...FLUXYEAR-BOX 2, May 1968...19 film loops by: Eric Andersen, George Brecht, John Cale, John Cavanaugh, Albert Fine, Dan Lauffer, Maciunas, Yoko Ono, Paul Sharits, Stan Vanderbeek, Wolf Vostell, Bob Watts. $40
Fluxnewsletter, December 2, 1968 (revised March 15, 1969).

FLUX-PRODUCTS 1961 TO 1970...[as above, but without price listed]
Flux Fest Kit 2. [ca. December 1969].

FLUX SHOW: DICE GAME ENVIRONMENT ENTIRE FLOOR AS DICE HAZARD TABLE DIE CUBES, 15" CUBES ON FLOOR, Marked on sides, top open or closed with clear plastic. Consisting or containing...Flux film loop viewers.
ibid.

FLUXUS-EDITIONEN...[Catalogue no.] 716 FLUX-YEARBOX 2, 1968...19 film loops by: Eric Andersen, John Cale, John Cavanaugh, G. Brecht, Albert Fine, Dan Lauffer, G. Maciunas, Yoko Ono, Paul Sharits, Stan Vanderbeek, Wolf Vostell, Watts.
Happening & Fluxus. Koelnischer Kunstverein, 1970.

05.1966 FLUXYEARBOX 2 anthology of film loops games & paper events by: andersen, brecht, john cale, john cavanaugh, a. fine, joe jones, knizak, kubota, lieberman, maciunas, oldenburg, yoko ono, w. de ridder, riddle, sheff, shiomi, vautier, watts.
George Maciunas, Diagram of Historical Developments of Fluxus... [1973].

OBJECTS AND EXHIBITS ... 1966: edited & published Fluxyearbox 2, anthology of film loops...Contributed 4 film loops.
George Maciunas Biographical Data. 1976.

COMMENTS: Loops were made from a number of Fluxfilms by cutting strips from longer films and splicing the ends together. These were packaged in a Fluxus Edition labeled simply, Fluxfilms and sold with a separate hand held viewer. Others were packaged as components of Flux Year Box 2. The number of loops and titles can vary in each packaging. George Maciunas also used the idea of loops for various Fluxfilms Environments (see preceding entry in this section).

FLUX FILM WALLS see: FLUXFILM ENVIRONMENT

FLUX FOOD

PROPOSED PRELIMINARY CONTENTS OF NYC FLUXUS IN NOV....Banquet on last day of Nov. giving distinguished guests food prepared with strong enema producing medicines - ending Nov. Fluxus with a grand fluxus. (possibly arranged by D. Spoerri)
Fluxnewsletter No. 6, April 6, 1963.

FLUX-PROJECTS PLANNED FOR 1967...Collective projects: (All are invited to submit ideas and participate, ideas can be either ready pictorial material or just specified material which we have to find, produce or obtain otherwise)...Flux-meal feast (late 1967), any ideas for food or drink or table setting event.
Fluxnewsletter, March 8, 1967.

Food & drink event, (drink dispencer [sic] dispensing various strange drinks or food)...MEAL EVENTS
Proposed R & R Evenings. [ca. 1967].

FLUXPROJECTS REALIZED IN 1967:...
Flux-Christmas-meal-event, participants:
Ayo: tactile food - sea grass (textured like stewed rubber bands)
Barbara Moore - intact egg shells (except for tiny hole) containing jello instead of egg
Per Kirkeby - 4 fluxdrinks (tea bag with ground aspirin, another with salt, another with citric acid, & sugar)
Takako Saito - Echizengami (paper, after being "cooked" over a low flame revealed drawing of various foods)
Herman Fine - wine dispensed from an enema container and tubes
Bob Watts - 12 jello eggs molded in an egg box

Collective. FLUX FOOD. A "Colored Meal" for Flux New Year's Eve in New York. 1974. see color portfolio

© 1974 LARRY MILLER

Geoffrey Hendrics[sic] - sky desert (sky blue cake with blue layers, blue cream, blue dishes, blue napkins)
Frank K. Rycyk jr. - Origami-difficult-to-open-food-containers
George Maciunas - distilled coffee, tea, prune juice, tomato juice (all like clear water but retaining the taste)
Fluxnewsletter, January 31, 1968.

FLUX-CHRISTMAS MEAL EVENT all are invited to participate by bringing a prepared meal or drink event. Notify me in advance what you will prepare. See last newsletter for examples.
Fluxnewsletter, December 2, 1968.

PROPOSALS WILL BE WELCOMED FOR:...meal or drink for christmas party (place & time to be announced)
ibid.

PROPOSED FLUXSHOW FOR GALLERY 669, LOS ANGELES. OPENING NOV. 26, 1968...
FOOD CENTER:
a. Distilled (clear) coffee, tea, prune juice, tomato juice dispenced [sic] in test tubes. (a still may be set up to dispence fresh distilled drinks). by George Maciunas
b. 4 flux-teas by Per Kirkeby: tea bags filled with ground aspirin, another with salt, another with citric acid and another with sugar.
c. Fish-meal: clear fish drink (distilled), clear fish jello, fish bread (from fish bone flour), fish pudding etc.
d. Empty egg shells: filled with water, jello, plaster etc.
ibid.

FLUXFEST INFORMATION,
P.O. BOX 180, NEW YORK, N.Y. 10013
Many fluxpieces are described and listed in the Expanded Arts issue of FILM CULTURE magazine. A reprint can be obtained for $1. Any of the fluxpieces can be performed anytime, anyplace and by anyone, without any payment to Fluxus provided the following conditions are met:
1. if fluxpieces outnumber numerically or exceed in duration other compositions in any concert, the whole concert must be called and advertised as FLUXCONCERT or FLUXEVENT. A series of such events must be called a FLUXFEST.
2. if fluxpieces do not exceed non-fluxpieces, each such fluxpiece must be identified as a FLUXPIECE. Such credits to Fluxus may be omitted at a cost of $50 for each piece announced or performed...flux-meals, drinks and smells;...
Fluxnewsletter, December 2, 1968 (revised March 15, 1969).

PROPOSED FLUXSHOW...FOOD CENTER
a. Distilled (clear) coffee, tea, prune juice, tomato juice, etc. dispenced [sic] in test tubes. A still may

be set up to dispence fresh distilled drinks. By George Maciunas
b. 4 flux-teas by Per Kirkeby: tea bags filled with ground aspirin, another with salt, another with citric acid and another with sugar.
c. Fish-meal: clear fish drink (distilled), clear fish jello, fish bread (from fish bone flour), fish pudding, fish ice cream, fish pastry etc.
d. Empty egg shells filled with water, or jello, or plaster etc.
ibid.

PROPOSED CATEGORIES ... PROPOSED FLUX-DRINKS & FOODS
FLUX EGGS emptied egg shells filled with one of the following: plaster, urethane foam, shaving cream, liquid white glue, white paint, ink, water, white jellatin [sic], coffee, bad smell (rotten), good smell (spices), dead bug, etc.
FISHMEAL clear fish carbonated drink, fish jello, fish bread (from fish bone flour), fish pudding, fish ice cream, fish pastry, fish candy, etc.
TRANSPARENTMEAL clear coffee (distilled), clear tea (distilled), clear butter (with butter flavor) clear onions (jello with onion flavor) clear fishes (fish flavor jello) clear pankakes [sic] with clear syrup, clear beef (beef flavor jello), clear icecream etc. etc.
DISTILLED DRINKS coffee, tea, tomato juice, prune juice, milk, etc.
TEA VARIATIONS tea bags with: salt, or sugar or aspirin, or citric acid.
WHITE MEAL white drink (milk), white potatoes, rice, cheese, spagetti [sic], salad etc.
BLACK MEAL black drink (coffee), black beans, black meat & sauce, black bread, black chocolate etc.
OTHER COLORS
Fluxfest at Stony Brook, Newsletter No. 1, August 18, 1969. versions A & B

You may participate by contributing either a food or drink of your own invention, or make something up from the list below (except what is marked with *, since these will already be made up)
Please verify and indicate piece to be contributed so as to avoid having too much of the same or similar. Write: George Maciunas, POB 180, Canal St. Sta. New York 10013
FLUX DRINKS & FOODS
FLUX EGGS * emptied egg shells filled with one of the following: plaster, urethane foam, shaving cream, liquid white glue, white paint, ink, water, white jellatin [sic], coffee, bad smell (rotten), good smell (spices, perfumes), dead bug, etc.(G.Maciunas)
MONO-MEALS:
FISHMEAL clear fish carbonated drink, fish jello,

fish bread (from fish bone flour), fish pudding, fish ice cream, fish salad, fish pastry, fish candy etc. (G. Maciunas)

POTATOMEAL potato salad, potato pate, potato vinaigrette, potato moonshine, potato soup, potato pancakes, potato dumplings, potato cake, fried, boiled, baked potatoes, potato chips, creamed potatoes, mashed potatoes with sauce, potato cutlets, potato bread, potato jello, potato parfait, sweet potato pie, yam jam, cream of Yam, potato ice cream, potato parzipan [sic]. (Bob Watts)

MONO-COLORS:

WHITE MEAL white drink (milk), white potatoes, rice, white cheese, spagetti [sic], white creamed salad, white jello etc. white cake, white ice cream (Bici Hendricks)

BLACK MEAL black drink (coffee), black beans, black meat & sauce, black bread, black chocolate etc. (Bici Hendricks)

OTHER COLORS blue, red, green etc. (Bici Hendricks)

TRANSPARENT clear coffee, tea, prune juice, tomato juice (distilled), clear butter, onion, fish, beef etc. (clear jellatin with appropriate flavours), clear ice cream etc. (G. Maciunas)

TEA VARIATIONS * tea bags with: salt, or sugar, or aspirin, or citric acid. (Per Kirkeby)
tea made from boiling: wood, or rope (sisal, jute, manila), or leather, or wool, or paper etc. (G. Maciunas)

SOUPS gravel soup, nail soup, hardware soup etc. (Bici Hendricks)

TURKEY with concrete filling (Milan Knizak), with squeaking rubber toy turkey (G. Maciunas)

SANDWICHES crunched ice hamburger (frozen beef nouillon [sic] (Bici Hendricks), Novocain [sic] sandwich (Joe Cammerata [sic]) sleeping pill sandwich (G. Maciunas) etc.

URINE COLORS food with invisible drug giving color to the urine of the person eating it (red, blue, green, orange) (Bob Watts)

Invitation to Participate in New Year Eve's Flux-Feast. [ca. December 1969].

FLUXFEST INFORMATION...
Any of the Flux-pieces can be performed anytime, anyplace and by anyone, without any payment to Fluxus provided the following conditions are met:
1. If flux-pieces outnumber numerically or exceed in duration other compositions in any concert, the whole concert must be called and advertised as FLUXCONCERT or FLUXEVENT. A series of such events must be called a FLUXFEST.
2. If flux-pieces do not exceed non-fluxpieces, each such fluxpiece must be identified as a FLUX-PIECE.
3. Such credits to Fluxus may be omitted at a cost of

$50 for each piece announced or performed....flux-meals, drinks and smells;...

FLUX FOODS & DRINKS FLUX-EGGS: Emptied egg shells filled with one of the following: plaster, urethane foam, shaving cream, liquid white glue, white paint, ink, water, white jellatin [sic], coffee, bad smell (rotten food), good smell (spices, perfumes), string, spagetty [sic], etc. (George Maciunas)

MONO-MEALS: FISHMEAL
Fish soup, vinaigrette, pate, pancakes, cutlets, dumplings, bread (from fish bone flour), clear fish carbonated drink, fish jello, pudding, ice cream, pastry, candy, tea etc. (G. Maciunas)

MONO-MEALS: POTATOMEAL
potato salad, pate, vinaigrette, moonshine, soup, pancakes, dumplings, cake, cutlets, bread, chips, fried, broiled, boiled, baked potatoes, creamed mashed potatoes, potato jello, parfait, ice cream, marzipan, yam jam, cream of yam, yam pastry, sweet potato pie. (Robert Watts)

MONO-MEALS: WHITE MEAL
White drink (milk), white potatoes, rice, white cheese, white creamed salad, white jello, white cake, ice cream etc. (Bici Hendricks)

MONO-MEALS: BLACK MEAL
Black drink (coffee), black beans, black meat and sauce, black bread, chocolate etc. (B.H.)

MONO-MEALS: OTHER COLORS
MONO-MEALS: TRANSPARENT MEAL
Clear coffee, tea, prune juice, tomato juice, (all distilled), clear butter (jello with butter flavor), clear fish, beef, onion (clear jellatin with appropriate flavours), clear ice cream, etc. (George Maciunas)

AFTER EFFECT MEALS:
URINE COLORS: food with drug giving color to the urine of person eating it. (red, blue, green, orange etc.) (Robert Watts)
LAXATIVE SANDWICH (G. Maciunas)
SLEEPING PILL SANDWICH (G. Maciunas)
NON-EDIBLES
SOUPS: gravel, nail, hardware. (B. Hendricks)
TURKEY STUFFINGS: Concrete stuffing, (Milan Knizak), squeaking rubber toy turkey inside real turkey (G. Maciunas)

TEA VARIATIONS:
Tea bags with: salt, or sugar, or aspirin, or citric acid. (Per Kirkeby)
Tea made from boiling: wood, or rope (sisal, jute, manila), or leather, or wool, or paper, or moss, or grass etc. (George Maciunas)
DUMPLING VARIATIONS:
One of the fillings: hot pepper, garlic, sugar, salt, cotton, chalk, water, coffee, run, etc. (G.M.)
Flux Fest Kit 2. [ca. December 1969].

FLUX SHOW:DICE GAME ENVIRONMENT

ENTIRE FLOOR AS DICE HAZARD TABLE DIE CUBES, 15" CUBES ON FLOOR, Marked on sides, top open or closed with clear plastic. Consisting or containing...Flux meals and drinks.
ibid.

NEW YEAR EVE'S FLUX-FEAST, DEC. 31, 1969 AT CINEMATHEQUE, 80 WOOSTER ST.
Henry Flynt performed his violin compositions; Joe Jones: prepared beer cans; Geoff Hendricks: clouds — mashed potatoes in 10 flavors (vanilla, almond, orange, mint etc.) Bici Hendricks: colored bread (purple etc.); Dick Higgins: gentle jello — tasteless jello (gelatin & water); Milan Knizak: sausage log cabin; Alison Knowles: shit porridge and Shit Manifesto; Elaine Allen: eel soup (with whole eel in fish bowl); George Maciunas (with Barbara Moore): eggs containing: vodka, fruit brandy, wine, noodles, cheese and coffee jello; George Maciunas: wood, jute & manila rope, pine cone tea; match flag (burnt 12:05AM); Joan Mathews: black foods; Hala & Veronica Pietkiewicz: shit cookies; Frank Rycyk Jr.: unopenable nuts in openable paper enclosures; chocolate inside nut shells; Paul Sharits: jello in their own paper packs and wrappings; Yoshimasa Wada: vitamin platter and salad soup; Bob Watts: shooting with gun candies into guests' mouths.
Fluxnewsletter, January 8, 1970.

OPENING: APR. 11, 4PM. COME IMPERSONATING JOHN & YOKO, (photo-masks will be provided to anyone not impersonating.) GRAPEFRUIT FLUX-BANQUET: grapefruit hors d'oeuvre, marinated grapefruit, grapefruit seed soup, grapefruit dumplings, grapefruit mashed potatoes, grapefruit pancakes, grapefruit wine. (by Bici & Geoff Hendricks, G. Maciunas, Y. Wada)
Schedule of events for Fluxfest presentation of John Lennon and Yoko Ono. [ca. April 1970]. version A

OPENING: APR. 11, 4PM. GRAPEFRUIT FLUX-BANQUET: grapefruit hors d'oeuvre, grapefruit soup, grapefruit dumplings, grapefruit mashed potatoes, grapefruit rice stuffing, grapefruit pancakes, grapefruit ice cream, grapefruit wine, grapefruit cocktail, etc. (by Flux-chefs)
Schedule of events for Fluxfest presentation of John Lennon and Yoko Ono. [ca. April 1970]. version B

1 TO 8PM, AT JOE JONES STORE, 18 N. MOORE ST. CANAL IND STATION.
OPENING: APR. 11, 4PM. COME IMPERSONATING JOHN LENNON & YOKO ONO, GRAPEFRUIT BANQUET Banquet will feature: grapefruit wine, grapefruit hors d'oeuvre, marinated grapefruit, grapefruit soup, grapefruit pancakes, grapefruit dumplings, grapefruit mashed potatoes, various grapefruit deserts;

(by G. Maciunas, Yoshimasa Wada, Bici & Geoff Hendricks, Bob Watts.)
Schedule of events for Fluxfest presentation of John Lennon and Yoko Ono. April 1, 1970. version C

FLUXFEST PRESENTATION OF JOHN LENNON & YOKO ONO+* AT 80 WOOSTER ST. NEW YORK —1970 OPENING: APR. 11, 4PM. COME IMPERSONATING JOHN & YOKO (Photo-masks were provided) GRAPEFRUIT FLUX-BANQUET
APR. 11-17: DO IT YOURSELF — BY JOHN & YOKO + EVERYBODY... [numbers refer to photos]

6 Flux-egg (George Maciunas '70) egg filled with paint & thrown against wall...
10 Jonas Mekas filming GRAPEFRUIT FLUX-BANQUET
11-14 Grapefruit delivery event (Yoko Ono & John Lennon '70...
17 stuffed grapefruit, grapefruit mashed potatoes by Bici & Geoff Hendricks
18 grapefruit drink by Hala Pietkiewicz
19 grapefruit dumplings by G. Maciunas, grapefruit hors d'oeuvre, soup...
21 2 Eggs (John Lennon) at right, grapefruit flower in center...
23 stuffed grapefruit
24 grapefruit wine by G. Maciunas

all photographs copyright nineteen seVenty by peTer mooRE (Fluxus Newspaper No. 9) 1970.

NEW YEARS EVE'S FLUX-FEST, DEC. 31, 1969

100 shit cookies by Hala & Veronica Pietkiewicz
101 whole eel soup in fish bowl by Elaine Allen
102 wood, jute & manila rope, pine cone teas by George Maciunas
103 sausage log cabin by Milan Knizak
104 egg shells stuffed with vodka, wine, coffee jello, noodles, cheese, etc....
107 clouds (mashed potatoes in 10 flavors) by Geoff Hendricks
108 Yoshimasa Wada eating stuffed egg by George Maciunas
109 flux-eaters eating black foods by Joan Mathews
110 Bici Hendricks (center) serving her colored bread...
113 Yoshimasa Wada serving his salad soup to Alison Knowles...
116 Jonas Mekas & G. Maciunas eating shit porridge by Alison Knowles
117 Donna & Joe Jones eating gentle jello (water jello) by Dick Higgins
118 George Maciunas serving his pine cone tea
ibid.

"...I am planning to come to Europe this Summer or Fall ... could stay in Italy if you could arrange a worthwhile flux-fest. I still think best is to do an amusement place with...flux-food eating place..."
Letter: George Maciunas to Daniela Palazzoli, n.d. Reproduced in Fluxnewsletter, April 1973.

FLUX-OBJECTS:...
03.1964...
1ST FOOD OBJECTS:
GEORGE BRECHT: bread
BOB WATTS: FIRE ALARM CAKE
BOB WATTS: egg making kit...
02.12.1965 FLUXFEST
steamed vegetable pie los angeles...
31.12.1968 NEW YEAR EVE'S FLUX-FEAST (FOOD EVENT)
Takako Saito: rice paper food
Ayo: rainbow noodles
G. Hendricks: blue cake & clouds
G. Maciunas: distilled coffee, tea, etc....
31.12.1969 NEW YEAR EVE'S FLUX-FEAST (FOOD EVENT)
G. Hendricks: potatoes in 10 flavors
Bici Hendricks: colored bread
Dick Higgins: tasteless jello
Milan Knizak: sausage log cabin
Alison Knowles: shit porridge
G. Maciunas: inside eggs: vodka, noodles, cheese etc. wood, jute, pine cone tea.
Joan Mathews: black foods
H. & V. Pietkiewicz: shit cookies
F. Rycyk: unopenable nuts
Paul Sharits: jello mixed with own wrap.
Y. Wada: vitamin platter & salad soup.
Bob Watts: candy bullets,
...1970 FLUX FEST OF JOHN LENNON & YOKO ONO: 11.04 GRAPEFRUIT FLUX-BANQUET several grapefruit dishes such as wine, pancakes, stuffings, etc. (collaborative)
George Maciunas, Diagram of Historical Developments of Fluxus... [1973].

FLUX NEW YEAR EVE, 1974 — COLORED MEAL:
Charteuse [sic], by Vytas Bakaitis
Yellow, by Yasunao Tone, Peter Van Ripper, Simone Forti
Orange, by Amy Taubin
Red, by Ayo, Francene Keery
Violet, by Barbara Moore, Larry Miller, Sarah Seagull
Blue, by Geoff Hendricks
Turqoise [sic], by Callie Angell, Mike Cooper, Jonas Mekas, Hollis Melton
Green, by Jean Brown, Shirley Smith
White, by Alison Knowles
Grey, by Almus & Nijole Salcius
Charcoal, by Shigeko Kubota & Nam June Paik
Black, by Barbara Stewart & Yoshimasa Wada
Transparent, by George Maciunas
Fluxnewsletter, May 3, 1975.

It is proposed that all participants submit time-pieces, which could be either time or clock objects, or time events or time foods.
SOME PROPOSED OBJECTS/EVENTS:...
FOODS:
1. 1 minute egg, 2 min, 3 min, 4 min, 5 min, 6 min, 7 min, 8 min, 9 min, 10 min. eggs, or potatoes.
2. food that continuously expands, or changes color, or shrinks, or melts,
3. food or drink that is dispenced [sic] very slowly or very fast
4. food that takes very long time to chew etc.
Please submit any proposed pieces, events or foods before DEC. 1 to: George Maciunas, 80 Wooster st.
Proposal for 1975/76 Flux-New Year's Eve Event. [ca. November 1975].

Bring food or drink (cold food: apetizer [sic], desert or fruit etc.) from [country] All food will be set up on a giant map. Arrive about noon of Dec. 31 and plan to stay through Jan. 1.
Instructions for Flux-New Year Eve Event. [December 1976].

PERFORMANCE COMPOSITIONS, PERFORMANCES,...EVENTS...
1968:...Organized and contributed to first flux-food events.
1969: 2nd flux-food event (funny foods) contributed egg pieces, rope, cone & wood tea, distilled juices, etc. transparent coffee, etc.
1970:...Organized a flux festival in collaboration with Yoko Ono & John Lennon at 80 Wooster St. grapefruit banquet...
1975: ... Organized ... Rainbow food event (+ transparent)
George Maciunas Biographical Data. 1976.

PARTICIPANTS:	food or drink for food atlas
Peter & Barbara Moore	Australian fruit, Greek apetizer [sic]
Dick Higgins	Vermont bread
Alison Knowles	Arabian bean dish
Geoff Hendricks	Swedish apetizers
Jon Hendricks	
Jean Dupuy	Algerian cous-cous
Olga Adorno	?
Nam June Paik	Korean something
Joan Mathews	?
Hala Pietkiewicz	Polish
Yasunao & O. Tone	Chinese (Peking dust?)
Larry Miller	?
Sara Seagul [sic]	?
Joe Jones	Austrian soup
Yoshimasa Wada	Japanese
Barbara Stewart	Indonesian?
Bob Watts	Turkish apetizer [sic]

Stuart Sherman — Bulgarian drink
Charles Bergengren — ?
John Bourgeois — Greek stuffed vine leaves?
Rena — ?
Peter Frank — Dutch
Bici Forbes — Russian
Adolfas & Pola Mekas, — ?Lithuanian bread?
Susan Rheinholt &
Bob Brown — ?
Emmett Williams (?) — ?
Jean Brown — Flemish fruit tart
J & A. Baal-Teshuva — Near Eastern desert?
George Maciunas — French,
boeuf Bourguignonne
Mary Beth Petit — Indian fish curry
John Lennon & Yoko Ono (?) — ?

INSTRUCTIONS:...Each participant should bring either food or drink from a different country, preferably already prepared but it could also be prepared on the premises. (do not bring foods requiring heating or cooking by oven)....To avoid duplicating countries in food atlas, coordinate food proposals with George Maciunas or follow his suggestions.
Announcement for Flux Snow Event: January 22-23, 1977. [January 1977].

DATE	FOOD EVENTS, SUN
JULY 4 & 5	July 4th soup by
FLUX DAY	Jean Dupuy
	(ingredients native to
	American continent)
JULY 9 & 10	Rainbow food
NATURE	
JULY 16 & 17	Daniel Spoerri
FOREIGN VISITORS	
JULY 23 & 24	Cloud food by
SKY & WATER	Geoff Hendricks
JULY 30 & 31	Funny foods
FUNNY WEEKEND	
AUGUST 6 & 7	Potatoe [sic] dinner
AUDIENCE	contributed and
PARTICIPATION	prepared by audience
AUG. 13 & 14	1450 Dinner by
HISTORIC WEEKEND	George Maciunas
AUG. 20 & 21	Edible clothing fashion
	by John Lennon

Proposal for Flux Fest at New Marlborough. April 8, 1977.

COMMENTS: *Flux Food is one of the more problematic conceptual categories for inclusion in a book on Fluxus product. On one hand, many of the menus for Fluxus meals could be considered participatory performance. On the other hand, most of the foods and configurations of food undergo such change that they fit into the perimeters of alteration to be considered "products." In respect for the extraordinary preoccupation with food in Fluxus, I have chosen to gather all*

references to meals into one entry, so Flux Food contains several collective menus of quite different sorts.

FLUX-FOOD EATING PLACE see:
FLUX FOOD

Collective. **FLUXFURNITURE** label, designed by George Maciunas

FLUXFURNITURE

...items are in stock, delivery within 2 weeks...

FLUXFURNITURE & ACCESSORIES

FLUXUSbo DANIEL SPOERRI: tabletops in multiples of 21" x 25", each multiple with laminated full size photoreproduction of one variation from his "31 Variations on a meal".
any combination of variations available.

tabletop with single variation	$30
tabletop with two variations	$60
tabletop with four variations	$120
metal table legs,	$20

FLUXUSfl PETER MOORE, photo-rug $300

photoreproduction on canvas of an inverse panoramic portrait of any human subject, (photo of all sides flatened [sic] out)

FLUXUSf2 PETER MOORE: photo-venetian blinds, any human subject, $300
FLUXUSf3 PETER MOORE: photo-floor tiles, in multiples of 4ft.x4ft. in following $80
downward view from a tall building $80
view down an elevator shaft $80
FLUXUSai TAKAKO SAITO: musical chairs,ea.$40

Vaseline sTREet (Fluxus Newspaper No. 8) May 1966.

"...Another new development: We are working on FLUXFURNITURE.
Peter Moore: Venetian blinds; you pull one way - girl all dressed (full size photo) pull another way - nude.
Rug - nude girl all spread out (photo reproduction) like a bear rug
Tables: laminated full size photos (Spoerri's 35 variations)
Bob Watts - a disorderly desk (all photographic). or one top with full size photo of girls crossed legs, so when you sit on correct side it looks as if these legs belong to you. very funny effect. Then many chairs and cabinets with various kinds of doors. 15" x 15" One has 25 clock faces printed, but one has real clock arms moving, although from distance they all look alike. Another is like medicine cabinet, 1st. door has photo of squeezed front face. 2nd. door has photo dish (like radar screen) so you see 50 faces of yourself. etc. etc.
 N.Y. Times photographed them all for a special Furniture feature for September Sunday magazine should give us finally our 1st. publicity here. If you like, think up new furniture ideas, and I will manufacture them. I will also ship some of them to you as soon as I have some money."
Letter: George Maciunas to Ben Vautier, August 7, 1966.

"...I would like to send you all new Flux items such as furniture, but it is rather bulky—too large for post, would have to ship in a crate as freight. Costs about $50 100lbs. crate. Can I ship it collect? (you would pay for shipment on arrival.) I could include Spoerri's table, Bob Watts table, musical chairs, chess table, cabinets, etc. Please send furniture ideas to me, so we can start producing them. If you will keep furniture then I will send you prototype furniture which we already have but can't sell because they are prototypes..."
Letter: George Maciunas to Ben Vautier, August 22, 1966.

"I don't know whether I mentioned our involvement now in making furniture - Mostly utilizing 15" wood cubes as cabinets, lamps, tables "musical chairs" (sitter activates some event inside the chair, like rolling balls, squirting water etc.). Also using photo laminations on table tops - like table after meal, or a messy desk top, or photo of girls crossed nude legs - same size, so any sitter behind legs looks like the crossed legs were part of the sitter. If you have any furniture ideas, let us know."
Letter: George Maciunas to Paul Sharits, [ca. Fall 1966].

"...I will ship furniture to you on Oct 8th. — so they should arrive to you about Mid-November..."
Letter: George Maciunas to Ben Vautier, [ca. October, 1966].

"Please forgive my rude delay in writing you or replying to your letters. My obligations to my friends keep being postponed while I was being buried by a huge pile of work. At first it was Flux-furniture project, then the cooperative both of which are still in the process...."
Letter: George Maciunas to Milan Knizak, January 30, 1967.

PAST FLUX-PROJECTS (realized in 1966)
Fluxfurniture: table tops by Daniel Spoerri, Robert Watts & Peter Moore, venetial [sic] blinds by Peter Moore, modular cabinets by: James Riddle, Robert Watts and George Maciunas, lamps and luminous ceilings by Robert Watts, chess tables and lamps by George Maciunas, chairs by Takako Saito. Flags by George Brecht. Fluxchess by Takako Saito and George Maciunas....
FLUX-PROJECTS PLANNED FOR 1967...Collective projects: (All are invited to submit ideas and participate, ideas can be either ready pictorial material or just specified material which we have to find, produce or obtain otherwise)...Flux furniture: photo-laminate table tops, cabinet doors for modular cubical cabinets 15"x15"x15",rugs, lamps, chairs...
IMPLOSIONS INC. PROJECTS...Projects to be realized through Implosions: (all are invited to participate & submit ideas)...Low cost furniture (like the stool of Kate Millet [sic])
Fluxnewsletter, March 8, 1967.

FLUXFURNITURE
TABLETOPS, photo-laminates, vinyl surface, ¾" board, formica edging, metal pedestal.
Daniel Spoerri: from "31 variations on a meal": single variation per top, following variations available: Arman, Duchamp, Ferro, M. Kyrby, Billy Lennick, Ben Patterson, Youngerman, 21" x 25" size, 2 to 4 week delivery, $ 80.00

Robert Watts &
Peter Moore: desk top and crossed legs, 21" x 25", 4 weeks, $ 80.00
Kate Millet: dinner setting for 2, 24" x 28", 4 weeks, $ 90.00
Robert Filliou: "Monsters are Inoffensive" montage, dinner setting for 4, 4 variations, 36" x 36", 4 weeks, $160.00
MODULAR CABINETS, 15" cubes, walnut sides and back, locked corners, variations on doors.
George Maciunas: 49 mirrors set in concave door, multiplying any image 49 times, $100.00
George Maciunas
& James Riddle: 25 clock faces, one operable, photo-laminate, $100.00
George Maciunas: photo-laminate, medieval door-hardware (hinges, locks etc.) $60.00
LAMPS, 15" cubes, walnut sides, locked corners, translucent front and back,
Robert Watts: fountain, a water fall over luminous photo of water, with pump, $200.00
Robert Watts: clouds, $80.00
CUBE TABLES, 15" cubes, walnut sides, locked corners,
George Maciunas: chess table, lamp, glass bottle top, 4 weeks, $100.00
George Maciunas: chess table, lamp, spice chest, (bottled spices as chess pieces) $100.00
Robert Watts: sand table, thin layer of sand over photo transparency of sand, lamp, $80.00
CHAIRS
Kate Millet: 2 legged stool with shoes, $40.00
Takako Saito: "musical chairs" "event chairs", 15" cubes, leather tops, 12 variations, sitting down activates mechanism producing event, $60 to 160
RUGS
George Brecht: arrow, "middle", "exit", "room", "location", "top", woven,
George Brecht &
Robert Filliou: 12 human footsteps and 1 dogs footstep, woven rug,
Peter Moore: downward view of elevator shaft, photo-emulsion rug,
4ft. x 4ft. $150,
8ft. x 8ft. $300.
VENETIAN BLINDS, photo-laminates, any subject, custom made, 8 weeks
Peter Moore, $300.00

FLUX H.Q. P.O. BOX 180, NEW YORK, N.Y. 10013 Available in N.Y.C. at Multiples and late in 1967 at FLUXSHOP, 18 GREENE ST.
Fluxfurniture, pricelist. [1967].

PROPOSED FLUXSHOW FOR GALLERY 669, LOS ANGELES...Nov. 26, 1968...FURNITURE
a. tabletops: desk, crossed legs, dinner setting, (by Watts, Moore, Spoeri [sic], Maciunas)
b. tabletop for displaying small objects will be like a gaming table with locations for displays marked like in a stamp album. All table tops are photographs laminated between wood table top and vinyl surface. They require stands or legs as shown: These pedestal type stands can be obtained from New York for $12 each, plus shipping charges. Additional table tops are in the form of photographs (unlaminated) which should be placed over a table of same size and covered with glass.
c. music-chairs by Takako Saito (bell & rolling ball)
d. clocks: 25 clockface clock by Jim Riddle....
Fluxnewsletter, December 2, 1968.

MAY 30-JUNE 5: THE STORE BY YOKO + FLUX-FACTORY...sale of Flux-shop products:...furniture...
Schedule of events for Fluxfest presentation of John Lennon and Yoko Ono. [ca. April 1970]. versions B & C

COMMENTS: *Influenced by the Bauhaus example and his own work with Knoll Associates, George Maciunas laid plans for an extensive line of Fluxfurniture, inviting ideas from all members of the group. Some pieces were to be adaptations of existing works, such as the Spoerri tables. Others, such as Peter Moore's Venetian Blinds, were designed specifically for the project. A number of pieces did actually get produced, although none were mass produced as had been hoped. Toward the late 1960s the idea shifted away from individually produced furniture pieces to a system of Modular Cabinets or 15" Die Cube display cases which were adaptable to either individual or group displays of objects for exhibitions. Fluxfurniture culminated in 1977 with Flux Cabinet, a 20 drawer anthological chest of Fluxus works.*

FLUX GAME ROOM see:
FLUX AMUSEMENT CENTER

FLUX GIFT BOX

FLUX SHOW: DICE GAME EVNIRONMENT ENTIRE FLOOR AS DICE HAZARD TABLE DIE CUBES, 15" CUBES ON FLOOR, Marked on sides, top open or closed with clear plastic. Consisting or containing...Flux gift box. (give aways)
Flux Fest Kit 2. [ca. December 1969].

COMMENTS: *"Give aways" were always present in Fluxus in order to promote the movement and emphasize its attitude against precious art. I don't know if an actual Flux Gift Box was ever made for a Fluxfest, but if it was, its contents would*

have leaned towards ready-mades and overstock Fluxus items. The principle of selling Fluxus Editions was always continued at public Fluxus events even though some sold for as little as a dollar or two.

FLUX HISTORY ROOM

FLUX SHOW: DICE GAME ENVIRONMENT
ENTIRE FLOOR AS DICE HAZARD TABLE
DIE CUBES, 15'' CUBES ON FLOOR, Marked on
sides, top open or closed with clear plastic. Consisting
or containing...Flux archives
Flux Fest Kit 2. [ca. December 1969].

''...I am planning to come to Europe this Summer or Fall...could stay in Italy if you could arrange a worthwhile flux-fest. I still think best is to do ...'flux-history' room with exhibit of all original prototypes of objects produced, interesting documents, etc. like my chart-like calendar, or I made now a wall of all containers of all food I ate in a year, 2 meters x 2 meters...''
Letter: George Maciunas to Daniela Palazzoli, n.d. Reproduced in Fluxnewsletter, April 1973.

FLUX AMUSEMENT ARCADE...cabinets , chests and trunks with collection of past & current flux-boxes, objects (have about 8 antique cabinets for such purpose)
Preliminary Proposal for a Flux Exhibit at Rene Block Gallery. [ca. 1974].

The Centre is being created in recognition of the great contribution made by Bauhaus and Black Mountain as a think-tank and training ground for the future avant garde. The acquisition of a beautiful ''village'' of a group of some 12 buildings in the township of New Marlborough presents the possibility of creating a similar center that could devote itself to:
1) study, research, experimentation and development of various advanced ideas and forms in art, history of art, design & documentation,
2) teaching small groups of apprentices in subjects and through proceedures [sic] not found in colleges,
3) production and marketing of various products, objects and events developed at the centre,
4) organization of events and performances by residents and visitors of the centre.
The Centre would be structured as follows:...Library, archives and exhibit space (buildings 1a, 2, 13) It would contain reference material on past & present avant garde, original documents, prototypes, possibly contain archives of photo-documentation (Peter Moore's), exhibit new works in sound, graphics, objects, video etc. and would contain the ''learning machine'' being developed by G. Maciunas.
Prospectus for the New Marlborough Centre for the Arts. [ca. 1976].

COMMENTS: George Maciunas was impressed with the pioneering work of Dr. Hanns Sohm in Markgroningen, West Germany, who was forming his great archive of Fluxus and other post war experimental art. Maciunas' interest in documenting and preserving Fluxus history was reinforced by his close association with Jean Brown, who in the 1970s was also gathering a major archive in her home in Tyringham, Massachusetts. It was through his friendship with Jean Brown that Maciunas moved from New York City to New Marlborough, Massachusetts, and started plans for a Centre for the Arts. The Fluxus archives are now dispersed and housed in the Archiv Hanns Sohm, Staatsgalerie Stuttgart; the Getty Museum, Malibu, California; and the Gilbert and Lila Silverman Fluxus Collection, Detroit, Michigan.

FLUXKIT
Silverman Nos. 120, ff. and < 122.I, ff.

NEWNEWNEWNEWNEWNEWNEWNEWNEW !
FLUXKIT	containing following fluxus - publications: (also available separately)	
FLUXUS c	WATER YAM, arranged by George Brecht (complete set of GB events, including the 1964 events) in plastic box,	$5
FLUXUS cc	V TRE newspaper, edited by the Fluxus Editorial Council, each issue	25¢
FLUXUS c/1	BALL PUZZLE, by George Brecht,	$3
FLUXUS d	CHIEKO SHIOMI: ''endless box''	$20
FLUXUS dd	CHIEKO SHIOMI: events in box	$2
FLUXUS gz	NAM JUNE PAIK: ZEN FOR FILM 16mm loop, in special plastic box	$3
FLUXUS h	LA MONTE YOUNG: compositions 1961	$1
FLUXUS hhh	LA MONTE YOUNG: remains from Composition 1961 no. 2, in jar,	$2
FLUXUS ii	BEN PATTERSON: poem-puzzle	25¢
FLUXUS ii	BEN PATTERSON: INSTRUCTION 1	50¢
FLUXUS iii	BEN PATTERSON: INSTRUCTION 2	$3
FLUXUS iiii	BEN PATTERSON: questionaire	10¢
FLUXUS jam	DICK HIGGINS: ''Invocation of Canyons & Boulders'', 16mm color film loop, each loop different, boxed	$6
FLUXUS jak	DICK HIGGINS: Instructions & events	25¢
FLUXUS k1	ROBERT WATTS: complete set of events, dollar bill and stamps, in box,	$5

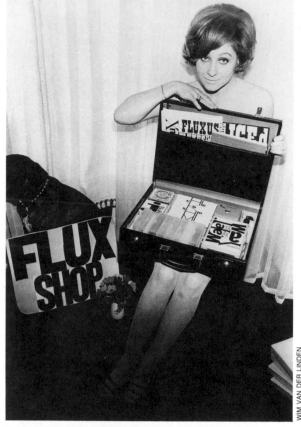

WIM VAN DER LINDEN

Collective. Dorothea Meijer presenting FLUXKIT for the European Mail-Order Warehouse/Fluxshop. Amsterdam, Winter 1964-65

FLUXUS kw	ROBERT WATTS: rocks in compartmented plastic box, marked by their weight	$3
FLUXUS L1	EMMETT WILLIAMS: long poem,	25¢
FLUXUS L2	EMMETT WILLIAMS: opera,	25¢
FLUXUS L3	EMMETT WILLIAMS: ''Four directional song of doubt for 5 voices,'' no 2 alike	$3
FLUXUS mx	JOE JONES: mechanical music box titled: ''my favorite song'' (not sold separately).	
FLUXUS naa	BEN VAUTIER: mystery envelopes	25¢
FLUXUS ni	BEN VAUTIER: dirty water, 2oz. bottle	$1
FLUXUS no	BEN VAUTIER: ''holes'', photos & obj.	$5
FLUXUS p	ALISON KNOWLES: canned bean rolls	$3
FLUXUS qq	AYO: FINGER BOX, each different, in wood box,	$6

FLUXUS r TAKEHISA KOSUGI: events in wd.
box $2
TAKEHISA KOSUGI: Theatre
music, performed on handmade
Japanese paper, $1
FLUXUS s JAMES RIDDLE:
mind event in bottle $4
FLUXUS zaz BOX FROM THE EAST,
each different $2

FLUXKIT all listed items in specially parti-
tioned suitcase, with silkscreen
imprint, $100
cc fiVe ThReE (Fluxus Newspaper No. 4) June 1964.

"...I will send one attache case to De Ridder, which
will contain miniature FLUXSHOP. If you think you
may sell this attache case also, I will send you one. It
should sell for $100...."
Letter: George Maciunas to Ben Vautier, June 12, 1964.

"...Also I include the latest list of items which also
lists contents of FLUX-KIT (suitcase). I have circled
items being shipped to you. You will also get two
FLUX-KITS (suitcase) You can sell these for $100 or
more. They are worth it. Suitcases are being shipped
in 2 days. It will be a rather large crate—so be pre-
pared to receive it...If you sell suitcases send me $60
and I will replace them (send you 2 more). It costs
me $60 to make up each suitcase, so I must get at
least $ for each...."
*Letter: George Maciunas to Willem de Ridder, n.d., [pos-
sibly end of June or July, 1964].*

"...Next week I am sending a large box with: one at-
tache case - to be sold for $100...De Ridder will receive
also attache case plus 100 of each publication (that's
the dose for all Europe) so you can take from him any-
thing you think you can sell. But most important keep
your accounts organized!!! Don't lose things!..."
Letter: George Maciunas to Ben Vautier, July 21, 1964.

"...Also put on your mailing list of important people.
Peter & Barbara Moore 4 E 36 St, New York, (best
and most loyal Fluxus friends up here) and the only
owners of a Fluxkit up here..."
*Letter: George Maciunas to Willem de Ridder, October 7,
1964.*

FLUXKIT containing following flux - publications:
WATER YAM, arranged by George Brecht (complete
set of george brecht events, including the 1964 events)
in plastic box + all cc V TRE's, newspapers
SECOND PRICELIST of the EUROPEAN MAIL-
ORDERHOUSE by the Fluxus Editorial Council +
ball puzzle by George Brecht + endless box by
Chieko Shiomi + events in box by Chieko Shiomi +
Nam June Paik's zen for film (16 mm loop, in special

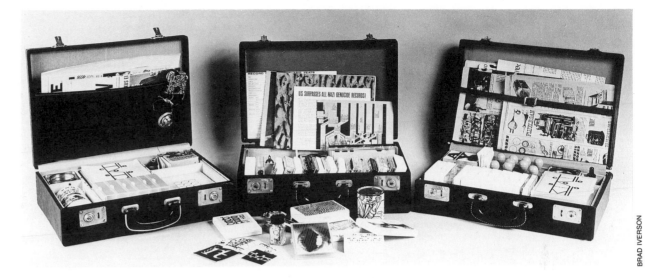

BRAD IVERSON

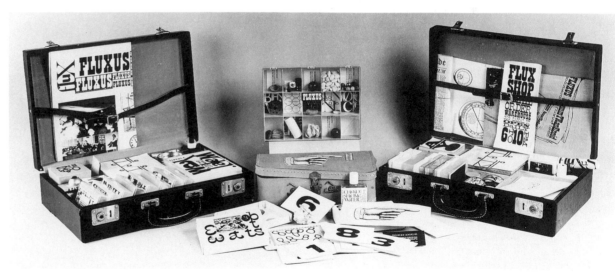

BRAD IVERSON

Collective. FLUXKIT. Seven different assemblings of the work, including two from the European Mail-Order Warehouse/Fluxshop. see color portfolio

plastic box) + compositions 1961 of La Monte Young
+ remains from composition 1960 no. 2 (in jar) of La
Monte Young + poem puzzle, instruction 1, instruc-
tion 2, questionaire [sic] of Ben Patterson + Invoca-
tion of Canyons & Boulders, 16 mm color film loop,
each loop different, boxed, of Dick Higgins + events
& instructions of Dick Higgins + complete set of
events dollar bill and stamps (in box), rocks in com-
partmented plastic box, marked by their weight of
Robert Watts + long poem, opera, four directional
song of doubt for 5 voices of Emmett Williams +
mechanical music box titled: "my favorite song" of

Joe Jones + mystery envelopes, dirty water, 2 oz. bot-
tle, holes (Photos & objects) of Ben Vautier + canned
bean rolls of Alison Knowles + Finger Box of Ayo (in
wood box) + events in wood box, theatre music, per-
formed on handmade japanese paper of Takehisa Ko-
sugi + mind event in bottle of James Riddle + box
from the east.

ALL THIS LISTED ITEMS IN SPECIALLY PARTI-
TIONED SUITCASE, WITH SILKSCREEN IMPRINT,
$100.

Second Pricelist - European Mail-Orderhouse. [Fall 1964].

did you receive the 2nd catalog of THE EUROPEAN MAIL-ORDERHOUSE & FLUXSHOP? [advertising] fluxkit...
How to be Satisfluxdecolanti?... [ca. Fall 1964].

"...Also will send a Fluxkit suitcase in one week. (must have only partitions made)..."
Letter: George Maciunas to Ben Vautier, January 5, 1965.

"... I will send attache case as soon as return from Arizona (by mid Feb. or end of Feb). I could not send it now, because Chieko Shiomi did not make 'endless boxes' Everything else was ready..."
Letter: George Maciunas to Ben Vautier, January 23, 1965.

"...As soon as I return from Arizona, I will ship you a Fluxkit, which will have all new compositions including Gius. Chiarri—La Strada..."
Letter: George Maciunas to Ben Vautier, February 1, 1965.

FLUXKIT	containing following fluxus-publications: (also available separately)	
FLUXUS c	WATER YAM, arranged by George Brecht (complete set of GB events through 1964) in plastic box,	$5
FLUXUS cc	V TRE newspaper, edited by the Fluxus Editorial Council,	
	past issues, ea.	$1
	future issues, ea.	25¢
FLUXUS c1	GEORGE BRECHT: ball puzzle ea	$3
FLUXUS c2	GEORGE BRECHT: name kit	$4
FLUXUS ccc	GEORGE BRECHT: cloud scissors,	$1
FLUXUS cccc	GEORGE BRECHT: iced dice, event prospectus (menu cards)	$3
FLUXUS ax	FLUXCHESS or FLUXORGAN	$20
FLUXUS dd	CHIEKO SHIOMI: events in box	$3
FLUXUS ddd	CHIEKO SHIOMI: water music, bottled,	$1
FLUXUS gz	NAM JUNE PAIK: zen for film 16mm loop, in plastic box	$3
FLUXUS h	LA MONTE YOUNG: compositions 1961	$1
FLUXUS iii	BEN PATTERSON: instruction 2	$3
FLUXUS JA	DICK HIGGINS: "Invocation of Canyons & Boulders", 16mm color film loop,	$6
FLUXUS kd	ROBERT WATTS: playing cards, set of 12 (4 suites of J,Q,K,)	$1
FLUXUS ke	ROBERT WATTS: postcards, ea.	10¢
FLUXUS kf	ROBERT WATTS: fluxpost stamps, sheet of 100 different stamps,	$1
FLUXUS kg	ROBERT WATTS: fingerprint in box	$2
FLUXUS kl	ROBERT WATTS: complete set of events, in plastic box,	$5
FLUXUS kw	ROBERT WATTS: rocks in	

	compartmented box, marked by their weight in grams	$3
FLUXUS mx	JOE JONES: mechanical music box,	$6
FLUXUS ni	BEN VAUTIER: dirty water, 2oz. bottle	$1
FLUXUS no	BEN VAUTIER: collection of holes,	$3
FLUXUS p	ALISON KNOWLES: canned bean rolls	$3
FLUXUS qq	AYO: finger box,	$6
FLUXUS r	TAKEHISA KOSUGI: events in box	$2
FLUXUS u	GIUSEPPE CHIARI: La Strada, score	$1
FLUXUS v	ERIC ANDERSEN: 50 opera,	$4
FLUXUS zaz	BOX FROM THE EAST, ea. different	$2
FLUXUS ziz	MYSTERIOUS ANIMAL, in bottle	$1
FLUXKIT	all items in partitioned suitcase	$100

Vacuum TRapEzoid (Fluxus Newspaper No. 5) March 1965.

"Replies to your questions...Name kit, swim puzzle, black ball puzzle, Bread puzzle — go into game & puzzle boxes (like one in Fluxkit)...Very nice of you to sell Flux-kit to Stedelk! I am sending to you 2 more Flux-kits. If you sell kit for $100, you can keep $40 and send me $60, because I must pay others...I will mail you a sample together with 2 Fluxkits..."
Letter: George Maciunas to Willem de Ridder, March 2, 1965.

"...Send money only if you sell Fluxkit. I mailed to you about 10 days ago a Fluxkit. Keep that as your own example to show. When someone orders, I will send you another..."
Letter: George Maciunas to Ben Vautier, May 11, 1965.

"...I had to mark value of suitcase because it was insured for $100. I will mail next one uninsured and will mark 'worthless gift' OK?..."
Letter: George Maciunas to Ben Vautier, [ca. June, 1965].

"...Fluxkit now has also object by Christo and Oldenburg + Hi Red Center..."
Letter: George Maciunas to Ben Vautier, January 10, 1966.

"...I am worried that you have not received the FLUXKIT (suitcase) for such a long time. We shall try to trace it through the post office and if does not show-up, we shall send another one or let you take one back if you visit us..."
Letter: George Maciunas to Milan Knizak, [ca. January, 1966].

"...I got a letter from Arch do, re Appolinaire show, in which they asked a complete Fluxus collection, which with major, large objects, some dozen different attache case-kits, would cost us some $400 in materials alone, so obviously we just can't afford to make such gifts

or even send it on consignment. I just don't have such money. So I wrote them that we can ship them slowly during the next 3 or 4 months our complete collection. But since you have concert in March, & there is no time to ship entire collection to Milan I suggest the following:...Take all Fluxus objects that you own, Fluxkit, Fluxus 1, etc. privately including all your own creations. I will replace any Fluxus objects you or the gallery sells. The new Fluxkit besides is better than the old one. It has Oldenburg rubber cows udders, also Christo object, but I still have not begun to mass produce it. (out of $)..."
Letter: George Maciunas to Ben Vautier, March 5, 1966.

"...In a few days I will ship to you our newest FLUXKIT which now has some 30 small boxes, 25 of them entirely new, and 4 bottle events. Would like to include some of your paper events in the KIT. OR - best of all, after you receive the kit - study carefully the spaces involved, boxes available, bottles, flat spaces, and maybe you can propose some object or event to fit a plastic box or an available space, then I could reproduce it, so there would be no cost to you. Also can design label unless you have particular label ideas. Maybe you can share the FLUXKIT with your brother, since we are sort of short of kits, them being rather expensive to produce. I mean, you could lend the kit to your brother for his November Fluxfilm plans. Next year we could spare a kit for him too...."
Letter: George Maciunas to Paul Sharits, [ca. Fall 1966].

FLUXKIT	containing following fluxus-publications: (also available separately)	
FLUXUS c	WATER YAM, arranged by George Brecht (complete set of GB events through 1966) in plastic box:	$6
FLUXUS cn	GEORGE BRECHT: deck plastic coated playing cards, boxed	$8
FLUXUS c1	GEORGE BRECHT: ball puzzles, each	$4
FLUXUS c2	GEORGE BRECHT: name kit	$5
FLUXUS ccc	GEORGE BRECHT: cloud scissors	$1
FLUXUS cccc	GEORGE BRECHT: iced dice, event prospectus (menu cards)	$3
FLUXUS cc	V TRE newspaper, 5 issues, each first 3 issues - out of print	$1
FLUXUS dd	CHIEKO SHIOMI: events in box	$5
FLUXUS ddd	CHIEKO SHIOMI: water music, bottles	$1
FLUXUS e	CHRISTO: package	$15
FLUXUS g	CLAES OLDENBURG, rubber udder not sold separately	
FLUXUS h	YOKO ONO: self portrait	$1
FLUXUS iii	BEN PATTERSON: instruction 2	$4
FLUXUS kf	ROBERT WATTS: fluxpost stamps, sheet of 100 different stamps,	$1

FLUXUS kg ROBERT WATTS: fingerprint in box, $4

FLUXUS kl ROBERT WATTS: events, complete set through 1966 $6

FLUXUS kw ROBERT WATTS: rocks in compartmented box, marked by their weight in grams $5

FLUXUS mx JOE JONES: mechanical music box $8

FLUXUS ni BEN VAUTIER: dirty water, 2oz. bottle $1

FLUXUS no BEN VAUTIER: collection of holes $4

FLUXUS o SHIGEKO KUBOTA: fluxmedicines $4

FLUXUS oo SHIGEKO KUBOTA: set of napkins $1

FLUXUS p ALISON KNOWLES: canned bean rolls $4

FLUXUS qq AYO: finger box $6

FLUXUS r TAKEHISA KOSUGI: events in box $4

FLUXUS s HI RED CENTER: a bundle of events and exhibits, wrapped in rope, edited by Shigeko Kubota $5

FLUXUS u JAMES RIDDLE: mind events, boxed $5

FLUXUS w ALBERT FINE: piece for fluxorchestra $4

FLUXUS v ERIC ANDERSEN: 50 opera, boxed $4

FLUXUS ziz MYSTERY ANIMAL, in bottle $1

choice of one of the three:

FLUXUS a2 FLUXCHESS, smell pieces, spices $40

FLUXUS d CHIEKO SHIOMI: endless box $35

FLUXUS x FLUXORGAN: 12 sounds, not sold separately.

FLUXKIT all items in partitioned suitcase $150

Vaseline sTREet (Fluxus Newspaper No. 8) May 1966.

"...As soon as I get $10, will ship to you FLUXKIT & whatever $10 will carry..."

Letter: George Maciunas to Ken Friedman, November 14, 1966.

fluxkit $150

Fluxshopnews. [Spring 1967].

"...Next month we will be able to ship to you more items:... new Fluxkit..."

Letter: George Maciunas to Milan Knizak, January 30, 1967.

"...You still must have a quantity of original (Fluxkit, Flag, musicbox, etc.) consignment. Since you paid about $10 for them, I assumed the rest was unsold. That's why I was in no hurry to ship to you next consignment. You still must have $100 worth of

stuff, No?..."

Letter: George Maciunas to Ken Friedman, [ca. February 1967].

FLUX-PRODUCTS 1961 TO 1969...

FLUXKIT with objects marked *, some of which are available only in the kit [$] 200

V TRE FLUX-NEWSPAPERS

V TRE no. 1 Jan. 1964 *

V TRE no. 2 Feb. 1964 *

Valise eTRanglE, no. 3 Mar. 1964 Flynt, Vautier, Fluxshop & Fluxfest poster, River Wax by George Brecht *

fiVe ThReE, no. 4 June 1964 Nam June Paik, Fluxpage by Bob Watts, Fluxorchestra poster no. 1, fluxfest *

Vacuum TRapEzoid, no. 5 Mar. 1965 Science River Wax page by G.Brecht, Fluxshop catalogue, Fluxfest poster, *

Vaudeville TouRnamEnt, no. 6 July 1965 Perpetual Fluxfest wheel, Fluxfest news, Fluxorchestra poster no. 2 *

3 newspaper eVenTs for the pRicE of $1 no. 7, Feb. 1966. Fluxorchestra news, Do it yourself dance series by Yoko Ono & Co.* One hout [sic] by Jim Riddle, 58 propositions for one page by Ben Vautier.

Vaseline sTREet, no. 8 May 1966 Waldorf Astoria Hotel event, action page by Wolf Vostell, Fluxshop list no. 2 *

FLUXTATTOOS Winter 1967 Campaign ribbons, medals, nipples, navels by Bob Watts,* fasteners, buttons, zippers, symbols by Maciunas, 6 - 5x6" stick-on sheets, boxed 5

FLUXPOST KIT 1968 100 stamp sheet - by Bob Watts, 2 postcards by Bob Watts, 3 post cards by Ben Vautier, rubber stamp by Ken Friedman, Ben Vautier, Jim Riddle, * 8

SOLO OBJECTS & PUBLICATIONS

AYO Finger tactile box, wood 3x3x3" * 8

GEORGE BRECHT Water Yam, complete set of Brecht events, boxed cards, 1959 to 1966 * 20

Ball puzzle, swim puzzle, bead puzzle, bread puzzle, inclined plane puzzle, direction, each:* 3

Black ball puzzle, name kit, closed on Mondays, boxed* 5

Iced Dice, (menu cards) *

Deck, playing cards, (inven-your-self game) * 8

JOHN CHICK Flux-food, (forest found objects or synthetic food-like objects) in partitioned box* 5

FARMER'S COOPERATIVE, Find the end, a rope trick, boxed, 4

ROBERT FILLIOU Fluxdust or fluxhair, boxed, each * 3

ALBERT M. FINE Piece for fluxorchestra, instructions on 24 cards for performers among audience, boxed * 3

KEN FRIEDMAN Flux-corsage, (boxed packet of sunflower seeds) * 3

Cleanliness kit, (miniature cleaning devises) in partitioned box * 5

JOE JONES Music box & mechanical event *

HI RED CENTER Clinical record, folder * .50

ALICE HUTCHINS Jewelry fluxkit, do-it-yourself kit containing springs, bolts, magnets, jingles, etc. Apr. 1969 * 6

PER KIRKEBY 4 flux-drinks, 1st tea bag with sugar, 2nd with salt, 3rd with ground aspirin, 4th with citric acid * 5

Boxed solid, solid plastic in plastic box * 3

MILAN KNIZAK Flux white meditation, in clear box * 3

Flux dreams, 12 colored small boxes in larger partitioned box, * 6

Flux snakes, in clear box * 3

Events and games, in pocketed bag, late 1969, * 40

ALISON KNOWLES Canned bean rolls, can containing rolled paper (all about beans) *

SHIGEKO KUBOTA Flux napkins, set of 4 napkins with printed eyes or lips, noses, boxes * 4

Flux medicine, (empty capsules, vials, wrappers etc.) boxed * 4

GEORGE MACIUNAS	Snow game, boxed *	3
	Same card deck, deck of 52 same cards, *	4
MOSSET	Flux-dots, in plastic box *	3
SERGE OLDEN-BOURG	Flux contents, bottle full of solid plaster *	1
JAMES RIDDLE	E.S.P. Fluxkit, boxed, also included in Fluxyearbox 2 *	3
PAUL SHARITS	Wall poem, boxed, May 1969 *	3
MIEKO SHIOMI	Events & games, boxed cards *	4
	Water music, bottled *	1
BEN VAUTIER	Mystery food, canned; or mystery box, 10lbs. carton,*	1
	Suicide fluxkit, partitioned box *	5
	Dirty water, bottled *	2
	Postcards, 3 different kinds, each: *	.2
YOSHIMASA WADA	Smoke fluxkit, in partitioned box *	.2
ROBERT WATTS	Finger print, boxed *	3
	Events, boxes cards & rubber veggetable [sic] *	8
	Rocks, marked by weight or volume, small pebbles in partitioned box *	6
	Time kit (various time measuring or telling devices) in partitioned box *	8

Fluxnewsletter, December 2, 1968 (revised March 15, 1969).

FLUX-PRODUCTS 1961 TO 1970...FLUXKIT, with objects marked * $200 [in this publication, no objects are marked *]
Flux Fest Kit 2. [ca. December 1969].

[Catalogue no.] 719 FLUXUS-EDITIONEN...FLUX-KIT (koffer mit objekten und publikationen)
Happening & Fluxus. Koelnischer Kunstverein, 1970.

FLUX-OBJECTS...03.1965 FLUXKIT, attache case with all current fluxobjects...
George Maciunas, Diagram of Historical Developments of Fluxus... [1973].

OBJECTS AND EXHIBITS...1965: edited and published Fluxkit, an attache case with various flux objects produced up to that date.
George Maciunas Biographical Data. 1976.

COMMENTS: Fluxkit is an anthology of 2-dimensional and 3-dimensional Fluxus product, packaged in a businessman's attache case. Its earliest assembling in 1964 followed FLUXUS 1 (the first Fluxus anthology to be realized), and three or four Fluxus newspapers. By this time, Maciunas had produced

a number of 3-dimensional works by Fluxus artists, and needed a format to distribute them collectively. It is certain that Maciunas borrowed this format from Marcel Duchamp's Boite en Valise. Through the years, the contents of Fluxkit changed as new works were produced, and as Maciunas devised special built-in works exclusively for Fluxkit.

Willem de Ridder assembled his own versions of Fluxkit (Silverman No. < 122.1, ff.) for the European Mail-Order Warehouse/Fluxshop. Ken Friedman has told me of a miniature Fluxshop — in fact a grand version of Fluxkit — which Maciunas made in the mid-60s for Friedman to carry around the country in his car and display like a travelling salesman's wares case. Friedman states that the work was disassembled and the case lost. No known photos or other documentation exist of that work.

By the late 60s and early 70s Maciunas devised other systems to display and distribute the growing numbers and changing shapes of Fluxus works. These systems consisted of Modular Cabinets or 15" Die Cubes, and Tabletop for Displaying Small Objects marked off like pages of a stamp catalogue. Then in 1977 Maciunas designed and assembled Flux-cabinet, the final Fluxus anthology, a museum in drawers with each work adopted and built in.

FLUXLABYRINTH

FLUX-MAZE

GM, Paik, Ayo floor, Alison, Watts + Larry
send to Ben, Brecht, Takako[:]
Take off shoes!
Handle on wrong end.
to spring door floor.
ball booth. Bill Tarr balls
squeeking whistles & horns
spring steps up.
see saw.
foam rubber steps.
rubber bridge
shoes on posts.
Paik Piano - one key unlocks door
one way door.
water. stilt over water
strings
soapy foam [changed to] glass balls
Adhesive
blindfold-food Alison
walls: wet paint.
* Watts
roll inside tank. Musical roll. Joe Jones bells + gongs inside & out.
roll with dolly?
smell chamber
doors
door like steps, with roof. or clg.

George Maciunas. Preliminary Instruction Drawing for Flux-Maze. [New York 1974]. (Silverman No. 297.IVa). List of works transcribed from drawing. This information is not used elsewhere in Fluxus Codex.

FURTHER PROPOSAL FOR FLUX-MAZE AT RENE BLOCK GALLERY, JANUARY 1975
Any proposals from participants should fit the maze format, 3 foot wide x 8ft high walls, 11 ft high ceiling, 35ft long passage. Ideas should relate to passage through doors, steps, floor, obstacles, booths. Proposals from participants should be submitted to George Maciunas, POB 180, New York 10013, before November 15th, 1974[:]
door with knob at hinges
door hinged at ceiling
Bill Tarr's ball booth
G.M.:
spring steps
see saw
foam rubber steps
rubber bridge
shoe steps
N.J. Paik piano activating door
vertical rubber strings
footsteps in water
knee high strings & obstacles
slipery [sic] balls
AYO
adhesive
blindfold food by Alison K.
wet paint on walls
walk inside 6ft drum with bells
Watts: spiderwebs
fog box
smell box
step like door hinged at floor

George Maciunas, Plan for Flux-Maze, New York. [1974]. List of works transcribed from instruction drawing. This version was not used elsewhere in the book.

Any proposals from participants should fit the maze format, 3 foot wide x 8ft high walls, 11 ft high ceiling, 35ft long passage. Ideas should relate to passage through doors, steps, floor, obstacles, booths. Proposals from participants should be submitted to George Maciunas, POB 180, New York 10013, before November 15th, 1974[:]
door with knob at hinges
door hinged at ceiling
Bill Tarr's ball booth
spring steps
see saw
foam rubber steps
rubber bridge
shoe steps
N.J. Paik piano activating door
blocks
footsteps in water
knee high strings
slipery [sic] balls
adhesive

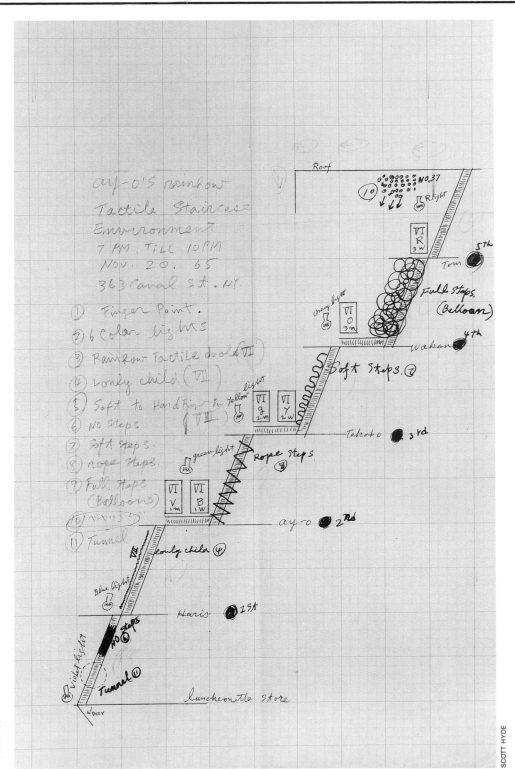

Ay-O's instruction drawing for his RAINBOW STAIRCASE ENVIRONMENT. New York, 1965. It is the precursor of the collective FLUXLABYRINTH

SCOTT HYDE

blindfold food
wet paint on walls
walk inside 6ft drum with bells
smell box
step like door hinged at floor
George Maciunas, Further Proposal for Flux-maze at Rene Block Gallery, New York, [ca. Fall 1974]. List of works transcribed from instruction drawing.

sign release at entry.
boxing glove
— this door is pivoted along vertical axis at center of door.
fogg machine
Watts: spiderweb machine
smell room
regular doors or new ideas
Geoff Hendricks: upside down forest
this revolving or 270 degree door must be opened 270 degrees to permit anyone to enter
G.M. [:] foam steps
steps made from foam rubber covered at top with thin plywood to prevent damage to foam (30" or so [width of steps])
see saw pivot 2' high 8' [long]
shoe steps[:]
Various shoes steps: slipper type shoe rest made from leather attached to wood sole, oversized to fit largest shoe, held on top of wood post.
sloping sideways sloping upward sloping downward toward heel
rubber bridge or trampoline type bridge (canvas held by springs at perimeter)
see above [below:]
compartments. steps made up of 3 boxes filled with crumpled paper, styrofoam balls, tennis balls
rubber edge protectors
slipery [sic] floor[:] glass balls black glass balls
door with knob at hinges
adhesive[:] liquid contact adhesive
N.J. Paik[:] piano activates door[:]
One key on piano is electrically switched to activate an electrical door opener.
Ayo section[:] starts with a forest of vertical rubber bands, rods, followed by mattress like foam bent into U shape. soft enough to permit passage. To facilitate it the foam should be covered with slippery vinyl film or cloth. followed by a forest of horizontal rubber bands, rods.
whitewashed, covered with film
clothes line rope? mixed, pencil thick
Ayo
Joe Jones[:] steel drum with bells attached walk inside drum up slight incline
Brecht[:] floor
Larry Miller's section[:]
door with many knobs[:] only one opens door

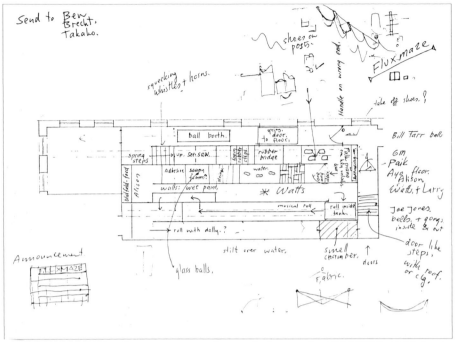

George Maciunas' 1974 preliminary instruction drawing for the unrealized FLUXMAZE which led to the collective FLUXLABYRINTH

George Maciunas' preliminary drawing for the collective FLUXLABYRINTH

YOSHI WADA SECTION [deleted]
Ben.
Brecht.
This door is actually a steep stair which must be climbed upon for it to lower down permitting passage. Counterweight would slow down the movement.

may be omitted
this door has a small door in it. to open it one has to open small door and find the door kn[ob] on other side which opens the large door.
ambulance strecher [sic] on end. + First Aid Station.
Instruction drawing for Fluxlabyrinth, Berlin. [ca. August 1976]. version A. Transcribed list of works from the drawing.

This door has a small door in[:] to open it one has to open small door and find the door on other side which opens the large door.
this door is pivoted along ver[tical] axis at center of door.
fogg machine
Watts: spiderweb machine
smell room
Geoff Hendricks: upside down forest
G.M.[:] this revolving or 270 degree door[:] must be opened 270 degrees to permit anyone to enter
foam steps[:]
steps made from foam rubber covered at top with

thin plywood to prevent damage to foam
see saw
shoe steps[:]
Various shoe steps: slipper type shoe rest made from leather attached to wood sole, oversized to fit largest shoe, held on top of wood post.
sloping sideways sloping upward sloping downward toward heel
rubber bridge or trampoline type bridge (canvas held by springs at perimeter)
see above [see below:]
steps made up of 3 boxes filled with crumpled paper, styrofoam balls, tennis balls
slipery [sic] floor[:] glass balls
door with knob at hinges
adhesive
N.J. Paik[:] piano activates door[:] One key on piano is electrically switched to activate an electrical door opener.
Ayo section[:] starts with a forest of vertical rubber bands, rods, followed by mattress like foam bent into U shape. soft enough to permit passage. To facilitate it the foam should be covered with slippery vinyl film or cloth. followed by a forest of horizontal rubber bands, rods. Ayo
Joe Jones[:] steel drum with bells attached[:] walk inside drum up slight incline
Larry Miller's section[:] door with many knobs only

one opens door
YOSHI Wada [deleted]
Ben Vautier section[:]
this area for George Brecht. He has submitted very nice idea: walking on exploding pistons —
this door is actually a steep stair which must be climbed upon for it to lower down permitting passage. Counterweight would slow down the movement.
Instruction drawing for Fluxlabyrinth, Berlin. [ca. August 1976]. version B. Transcribed list of works from the drawing.

"Enclosed is the final plan of labyrinth with a few details which I will describe starting from entry. General remarks: All doors should be openable from entry side only. the reverse of them should have no knobs so as not to allow some of the people to return. Anyone entering MUST go through the whole labyrinth. First door at entry is one with a small (about 10cm square) door with its own knob. one has to open it and pass the hand through, looking for the knob of the big door on other side that will open door. This way only smart people will be able to enter. Anyone passing that door will be able to pass all obstacles. Idiots will be prevented from entering. There should be no instruction written on the door. Next door is like a revolving door, revolving along a vertical axis at center and preferably revolving one way. One enters then the room with fogg machine. That room should have a roof and should be quite dark. Incidentally,

the money ($1000) arrived too late to have the machine delivered in time for container, so that now we have to mail it or bring it with ourselves or with Larry. The next door could have a sticky knob or very soft one (rubber bulb) and one enters the room with spider webb machine. This should also have a ceiling but not be as dark. The next door could have a hot knob (one with an electric heating element) or without knob but with push plate that is being heated. We will think of something else if that is too complicated to realize. the third Watts room will be with some smell, it should also have a roof. The smell could be either burning tar, or sulfur or hashish, we will think of something. It could be a different smell for each day. The next door could be pivoted horizontally at center, so that one has to stoop under to get through. The following room is by Geoff Hendricks which is a kind of upside down forest. The floor should be a photomural of clouds, could be black and white, and you should order one locally right away. (one meter wide by whatever length you can get, like 3 or 4 meters). A number of dry branches should be attached to the ceiling. This room should also have a ceiling. You will notice, that I bunched up all rooms that require a ceiling. The ceiling could have a plastic grass. They make a kind of grass rug. I hope you can get it in Berlin, otherwise we will have to bring it with ourselves. To protect the photomural on the floor from wear, it should be covered with clear plastic or glass. The sides could have thicker evergreen branches attached to the wall (but always upside down). The next door I call 270 degree door. To open it, or rather to pass through it, one has to walk back 270 degrees, because otherwise there is no room to pass it, through it one enters my own passage way. 1) one climbs a foam stair. the foam should be covered with thin plywood or masonite to protect the foam from wear but be thin enough to allow some bending. It will be a kind of springy step. [2)] at the top of it or about 50cm height one steps at the raised part of a see-saw. To prevent a sudden fall, the see-saw should be kept in that position with a counterweight or heavy automobile type spring. as one slowly walks foreward [sic], the see-saw will tip the other way bringing the walker back to floor level. 3) next, one proceeds upward again by way of shoe steps. These will need some more explanation. Slipper like shoe rests should be made from leather or canvas uppers nailed to wood or plywood soles, big enough to allow another shoe slip in and out easily. these slippers should be mounted on wood posts continuously rising to 50cm height at the end of the run. They should be placed in various contorted positions, toes sloping down or up, sideways, so as to make the "walk" awkward and difficult but not impossible. There should be something like either water, or upward facing nails or some other

dangerous material on the ground below to prevent the walker from just walking on the ground. 4) next, one enters on a rubber bridge, which could be either from heavy rubber sheet held like suspended bridge or from perimeter by being wrapped around wood frame or a trampoline type canvas held around perimeter by springs as shown on drawing. this bridge should be at 50cm. height. 5) to step down one would step into 3 descending boxes, first filled by crumpled newspapers to the total height of 50cm, next with styrofoam balls or just plain crushed styrofoam to the height of about 34cm, next with rubber balls to the height of about 17cm. 6) then one enters upon "slippery floor" covered by small glass balls that I shipped from New York. 7) the last panel should be an adhesive floor that could be either covered with liquid adhesive that dries to be an adhesive or with double adhesive faced tape. I dont' know if the liquid type is available in Berlin. this ends my section. One enters then a space of Paik which contains a piano. One of the keys (preferably a black, sharp key) should be fixed to switch on electrical momentary switch which would buzz open the door lock (standart [sic] magnetic door opener used in apartments), the door should be self closing, and the key near enough to allow the same person to press the key and hold or push the door open. This door would lead to Ayo's section which would start with a vertical forest of thick rubber bands (rods) You will have to experiment to find best thickness. My guess would be about 5mm round, bought in a drum as a continuous rubber rod. It could be "woven" between a perforated floor and ceiling panel without ever cutting it. The next obstacle would be two mattresses or foam rubber sheets bent as shown touching each other, but soft enough to permit one to squeeze between them. But since foam is a very non-slippery material, they should be covered with slippery fabric or vinyl or other plastic film. These covers could be painted with white wash (liquid chalk) which would smear all people passing between the mattresses. Next would come a "horizontal" rubber band forest, which could be constructed same way as the vertical, except the perforated panels would be at both facing walls. Next one enters the steel drum, about 2m diameter and 1m wide, welded from steel plate about 3mm thick. little bels [sic] and other noise makers should be attached on the inside near the perimeter not to be in the way of the person walking. The person would step inside and walk, making the drum roll forward. There should be rails on both walls to make this walk easier. The floor should be just enough inclined upward to allow the drum return to starting position by itself, but not too steep to make walk impossible. Exiting Joe Jones musical drum, one faces Larry Miller's door, which would contain many door knobs, maybe as many as 20 or

30, all turning, but only one actually opening the door. He is still designing his section. I know that he wants to build a perspective stair (one geting [sic] smaller and narrower,) also was thinking of floor covered with rubber nails, which may be difficult to ob-

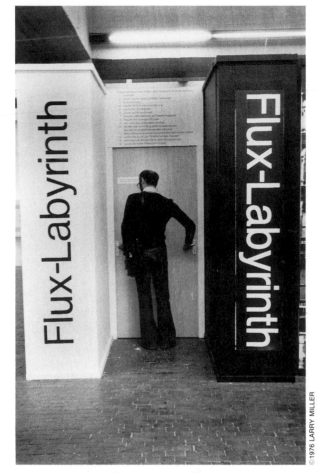

© 1976 LARRY MILLER

Collective. FLUXLABYRINTH entrance. The text above the CENTRAL VERTICAL AXIS DOOR reads:

the following visitors should not enter the Flux-Labyrinth
1. *Invalids*
2. *People who are prone to accidents*
3. *Sickly people*
4. *People without accident insurance*
5. *People with wooden legs*
6. *People on roller skates*
7. *Women (or men) in high heels*
8. *Women with skirts that are too tight*
9. *Gorillas escaped from the zoo*
10. *Idiots (who are not capable of finding out how to open doors)*
11. *Drunks and people who had too many beers*
12. *People who have to run to the toilet too often*
13. *Representatives of the Department of Buildings and Insurance*
14. *People who don't like elephants*

Translation by Dieter Froese

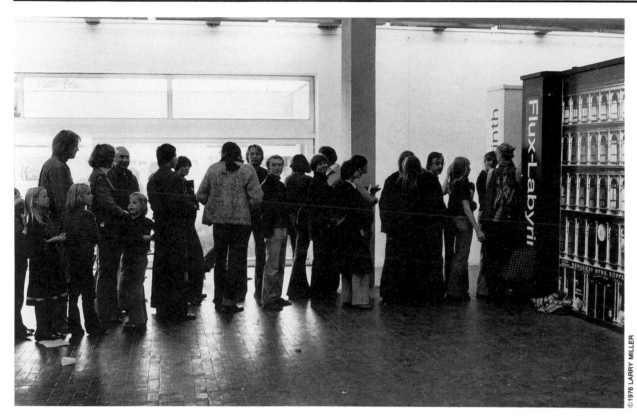

Collective. Entrance to FLUXLABYRINTH

rubber bridge or trampoline type bridge (canvas held by springs at perimeter)

see above [below:]

steps made up of 3 boxes filled with crumpled paper, styrofoam balls, tennis balls

slipery [sic] floor[:] glass balls

door with knob at hinges

adhesive

N.J. Paik[:] piano activates door[:] One key on piano is electrically switched to activate an electrical door opener.

Ayo section[:] starts with a forest of vertical rubber bands, rods, followed by mattress like foam bent into U shape. soft enough to permit passage. To facilitate it the foam should be covered with slippery vinyl film or cloth. followed by a forest of horizontal rubber bands, rods. Ayo

Joe Jones[:] steel drum with bells attached[:] walk inside drum up slight incline.

George Maciunas blocking the entrance to FLUXLABYRINTH until the authorities returned the elephant excrement for the final door

tain. I am leaving the rest of the corridor as reserve for people who may respond yet, people I have asked to contribute: George Brecht, Yoshi [Wada], Ben Vautier. The last door would be a sort of step like fire escapes used in New York. At first it would look like a steep stair leading into the ceiling, but would slowly lower itself when person starts stepping on it. The stair would require a counterweight to permit it to come down not too suddenly. You should have someone start the construction now, especially of things that are easily understood, since Larry will not have enough time to do the whole labyrinth. His function should be to do difficult things or items that are designed too late. Our or my function will be to solve design problems that neither your worker or Larry could solve. I hope there will be very few of those."
Letter: George Maciunas to Rene Block. [ca. Summer 1976].

FLUXLABYRINTH
at Berlins 26th Arts Festival, Sept. 1976
in the Art Academy
designed and installed by
George Maciunas & Larry Miller
with assistance from Joe Jones, Ayo, Bob Watts.

Entry[:]
this door has knobs on each side; to open it, one has to turn them simultaneously. The door turns along its central vertical axis.
fogg machine
Watts: spiderweb machine

Maciunas section[:] this door releases a catch causing a beach ball to swing on a pendulum and hit the face of visitor.
this door swinging 270 degrees, must be opened 270 degrees to permit anyone to enter. while opening it, the beach ball is lifted and set in a magnetic catch to be released by the next visitor.

foam steps[:]
steps made from foam rubber covered at top with thin plywood to prevent damage to foam
see saw

shoe steps[:]
Various shoe steps: slipper type shoe rest made from leather attached to wood sole, oversized to fit largest shoe, held on top of wood post.
sloping sideways sloping upward sloping downward toward heel

This door has 20 knobs, but only one will open door; door is pivoted along a horizontal central axis.
Larry Miller's section: Labyrinth within a labyrith [sic], vertical and horizontal passages, all in total darkness except on passing one portion a strobe flash is switched on.
slit rubber gates containing a room full of balloons.
this door has a small door in it. to open it one has to open the small door and find the door knob for the large door, which is contained in a box filled with elephant shit.
EXIT
Plan of completed Fluxlabyrinth, Berlin. [ca. September 1976]. version C

Release table or shelf at Entrance.
needed:
Compose release (& signs to explain) form & have printed. (should be given to attendant or put in a box before entry)

1. Door — (Central Axis)
 This door is installed except for knobs. Hinges are hidden by trim. To enter person must turn both knobs + enter clockwise. It springs back to place. All doors will have thin padding to buffer continuous closing. I made this 1st for intelligence test as entry instead of boxing glove.
 needed: padding to buffer closing.
2. Door (Boxing Glove)
 materials yet needed: Boxing Glove
 Bob or you should design this. If we must buy 2 gloves to get one, then we should design it to use both gloves. Maybe one for head + one for groin. I suggest left handed door — pulling to open bringing gloves into position. Perhaps they should stop at door plane so no one with glasses or soft groin is hurt.
3. Fog Machine — I assume we will want a ceiling. There are materials at Academie ready + easy for this.
4. Door - (to spider web room) 5. Door (to smell room)
 we need idea for this and next door perhaps:
 1. loud noise when opened (maybe siren or whoopee cushion or Joe Jones style
 2. narrow door (hard for fat people)
 3. Triangular doors or eccentric shape — easy to make (no curves)
 or could be fairly narrow with strong spring — hard to open. But unfair to weak people.
6. Smell room
 needed: smells
 Perhaps the entry door here could be whoopee cushion or whoopee cushions somewhere on floor to make a fart sound. Then we could have sulphur smell. I will have assistant locate a novelty and gag store to inquire.

also: we could have unmarked aerosol cans with various smells so people could spray.

7. Door (to Hendricks room)
8. Cloud room needed: photo + twigs
 Here I suggest we make a horizontal axis door — with knob near normal position. This makes people go in squatting position which is a good transition to upside down room. Re: photo. I was unable so far to locate or get someone to locate suitable clouds in Hendricks style. They should be easily distinguished in figure/ground relationship. Rene offered Gerhard Richter painting reproduction of clouds but I declined — I felt Geoff would not like using another artists' clouds — so I requested by telegram Hendricks postcards. If you did not bring them, I have a slide by Rene that is suitable — so in either case we deliver to the photo lab as a priority 1st thing Monday. This would be good thing for Bob or myself to do. I am told it takes a week — so timing is O.K. I am also told the Academie has plexiglass available for covering the photo. I suggest we authenticate that Monday. In case of cutting: we have table saw.
 Re: Twigs Today I have arranged to look for some. Also there are Academie grounds I am told. And weeds outside of doors in Academie Patio.
 P.S. Twigs seem abundant — low priority
9. Door (270°)
 I have materials + solutions for this. Installation on Monday.
10. Foam Steps (these are completed) needed: thin covering (possibly) wood [supports]
 These are completed except gluing. There were many kinds of foam available. I picked a substantial kind. They may not need a covering - if so I suggest thin rubber found at the same store as rubber found at the same store as rubber bridge material. We should use a pliable covering instead of masonite etc.
11. See Saw needed: spring or cushion system
 This is nearly completed. Perhaps instead of springs, we can use foam again.
 Monday, we can experiment with foam at hand. I located a firm with a wide variety of foams and they cut to size.
12. Shoe Steps waits for you
14. I held on this until your arrival to determine volumes and expense of filling materials.
 wood on hand.
13. on following page
13. Rubber Bridge
 needed: Rubber
 This too, I held to wait for your consultation. There is a firm we visited that has a variety of sheet and tube rubbers as well as a collection of

Canal Street type rubber products. I suggest this method instead of spring
It would be easy.
[sketch with materials and measurements]
For a significant experience, I suggest above dimensions [1m x 2.5m x 1cm]. Rubber firm suggested approx. 1cm. thickness, but they have many choices. Above dimensions equal about 130 MARKS (60 - 70 $)

15. Glass Balls waits for you
 I have not had a chance to unpack the container you shipped
16. Adhesive: must be located.
 On Monday, an assistant can inquire by phone.
17. Piano and electric door
 needed: system to activate buzzer-latch.
 We have the piano in the building, I am told. We can bring it in place Monday. I have the buzzer-latch, and wire at Academie, but did not buy switch. I wait for Bob — is a good job for him.
18. Ayo
 needed: rubber tubing
 Again here, I located at the rubber firm many possibilities. The best was silicone rubber, but it is not so cheap. They also have other tubing that is pretty elastic. I delayed these selections until your arrival. We can discuss money, etc. I suggest we go here together since I have scouted the place somewhat.
 This I have bought. 2 soft foam pieces of pink color. I thought Ayo would like pink as a vagina-like birth experience. Also I have ordered 2 kilos of foam scraps at 20 marks only to stuff inside. It may be sufficient as is without poly-urethane + white wash. We can introduce white wash elsewhere.
 I have brush example available — it is very good — soft — again I only located until we alot budget. This would cost about 80-90 MARKS.
 also: at Rubber firm they have soft gloves that are easily inflated for 1M per pair. They could be introduced somewhere.
19. Rolling Drum:
 This was ordered at the time of my arrival. It will be about $850 and is 2 meters diameter. Also we get rails provided. We should only have to shim the rails.
 Delivery date is to be this Thursday, I am told. I suggest a foam or spring buffer at the track's downhill end.
20.*Door — Many Knobs we have all materials
 *ask me — I have additional idea.
21. Dark Maze
 Materials needed: Strobe Flash + Switching design
 They have some novaply and masonite at Academie that can be used.

22. Balloon Room —
needed: Balloons by quantity and inflation method.
Today an assistant should locate this and price.
We must figure volume. Balloons should be various colors + sizes. Plastic doors (2 Poly-Urethane sheets) I have + wire for above.
23. -Ben- no word yet
24. -Brecht- '' '' ''
26. Door — Small door inset materials available.
Notes: Larry Miller to George Maciunas concerning the Flux-labyrinth, Berlin. [ca. August 1976].

OBJECTS AND EXHIBITS...1976: Sept. initiated collaborative flux-labyrinth project, major contribution, to be exhibited at US. Centennial Exhibition, Berlin.
George Maciunas Biographical Data. 1976.

COMMENTS: *The concept for* Fluxlabyrinth, *realized September 1976 at Berlin's 26th Arts Festival in the Art Academy, evolved from a combination of Ay-O's* Rainbow Staircase, *a "Fluxfest Presentation" November 20, 1965 in New York, (elements and variations of that event appeared on a number of plans for Fluxfests, R&R evenings and Fluxshows), and the collective* Portrait of John Lennon as a Young Cloud, *a maze of 8 doors built by George Maciunas for the "Fluxfest Presentation of John Lennon & Yoko Ono" May 23-29, 1970 in New York. The concept of that work was altered to become* Amaze *by Yoko Ono for her One Woman Show at the Everson Museum in Syracuse New York in 1971.*
Fluxlabyrinth *was preceded by a plan for an unrealized* Fluxmaze *that was to have been constructed at the Rene Block Gallery in New York, January 1975, and George Maciunas' own* Flux-Combat Between Attorney General of New York 1975-76. *Elements of all these works appear in* Fluxlabyrinth. *The idea of maze was also explored in three individual Fluxus Editions: Takako Saito's ca. 1965* Ball Games; *Robert Watts' 1970* Maze; *and George Maciunas' 1977* Maze.

FLUX LIBRARY

FLUX SHOW: DICE GAME ENVIRONMENT
ENTIRE FLOOR AS DICE HAZARD TABLE
DIE CUBES, 15'' CUBES ON FLOOR, Marked on sides, top open or closed with clear plastic. Consisting or containing...Flux library.
Flux Fest Kit 2. [ca. December 1969].

COMMENTS: Flux Library *would have consisted of Fluxus publications, and is a concept related to* Flux History Room.

FLUX-MAZE see:
FLUXLABYRINTH
FLUX-MEAL FEAST see:
FLUX FOOD
FLUX-MEALS, DRINKS, AND SMELLS see:
FLUX FOOD

FLUX MEDICAL KIT

FLUXPRODUCTS PRODUCED IN 1972 & 1973 ... by George Maciunas:...fluxsyringe (part of fluxmedical kit)
Fluxnewsletter, April 1973.

by George Maciunas:...flux syringe (part of flux-medical kit)...
Fluxnewsletter, April 1975.

COMMENTS: *There are only two references to* Flux Medical Kit. *Apart from George Maciunas'* Fluxsyringe, *its planned contents are not recorded.*

FLUXOLYMPIAD see:
FLUX AMUSEMENT CENTER
FLUX 1 see:
FLUXUS 1
FLUXPACK 3 see:
FLUXUS YEARBOXES

FLUX PAPER GAMES: ROLLS AND FOLDS
Silverman Nos. 131, ff.

"...Just received your collection of paper events-in-a-box. ABSOLUTELY SUPERB—FIRST RATE...We will certainly distribute them, $10 is fine. Maybe $15 list price, so $10 would be to Galleries etc....or better still, send about 10 to us, we will build nice wood boxes for them...In a few days I will ship to you our newest FLUXKIT...would like to include some of your paper events in the KIT..."
Letter: George Maciunas to Paul Sharits, [ca. Fall 1966].

"Furthermore Fluxus still publishes...printed paper events— Sharits etc.—..."
Letter: George Maciunas to Ben Vautier, [ca. October, 1966].

"...Other going projects:...Sharits-Thompson-Grimes — paper event jar..."
Letter: George Maciunas to Ken Friedman, [ca. February 1967].

FLUX-PROJECTS PLANNED FOR 1967 ... Paul Sharits, Greg Sharits, David Thompson, Bob Grimes, collective edition: paper events (rolls in a jar)
Fluxnewsletter, March 8, 1967.

"...Incidentally your paper event box, (rolls, folds, etc.) we are putting in a 9''x3'' ∅ jar, so it will be a "jar of rolls," label showing people folding or doing something with rolls..."
Letter: George Maciunas to Paul Sharits, [ca. March 8, 1967].

fluxpaper games $20 by greg & paul sharits, thompson & grimes
Fluxshopnews. [ca. Spring 1967].

Collective. **FLUX PAPER GAMES: ROLLS AND FOLDS.** Mechanical by George Maciunas for the label

FLUXPROJECTS FOR 1968 (in order of priority) ...
3.Boxed events & objects (all ready for production):... Paul Sharits, Greg Sharits, D.Thompson, Bob Grimes - paper events (rolls in jar)
Fluxnewsletter, January 31, 1968.

FLUX-PRODUCTS 1961 TO 1970...PAUL SHARITS ...with Greg Sharits, Bob Grimes, Dave Thompson: Paper Games; & Rolls & Folds, wd. box [$] 16
Fluxnewsletter, December 2, 1968 (revised March 15, 1969).

FLUX SHOW: DICE GAME ENVIRONMENT
ENTIRE FLOOR AS DICE HAZARD TABLE
DIE CUBES, 15'' CUBES ON FLOOR, Marked on sides, top open or closed with clear plastic. Consisting

SCOTT HYDE

Collective. FLUX PAPER GAMES: ROLLS AND FOLDS. Mechanical by George Maciunas for an unused label

or containing...Paper games by Shartis, Grimes, Thompson.
Flux Fest Kit 2. [ca. December 1969].

FLUX-PRODUCTS 1961 TO 1970...PAUL SHARITS ...Paper Games, Rolls & Folds, with Greg Sharits, Bob Grimes, D. Thompson [$] 20
ibid.

SPRING 1969...SHARITS, GRIMES, THOMPSON: paper games, events, music, etc.
George Maciunas, Diagram of Historical Developments of Fluxus... [1973].

COMMENTS: *The following individual pieces are contained in* Flux Paper Games: Rolls and Folds: Pull Fold *by Bob Grimes;* Bag Trick, Roll Fold, *and* Roll Trick *by Greg Sharits;* Pull/Glue, Sound Fold *and* Unrolling Screen Piece *by Paul Sharits;* Un Roll *by David Thompson. The works were designed, printed and assembled by Paul Sharits and David Thompson. George Maciunas designed the label and packagings for the collective work, and distributed it through Fluxus. A related Fluxus work is* Flux Envelope Paper Events.

FLUX-PHONE ANSWERING MACHINE

FLUX-PROJECTS PLANNED FOR 1967...Collective projects: (All are invited to submit ideas and participate, ideas can be either ready pictorial material or just specified material which we have to find, produce or obtain otherwise) ... Flux-phone answering messages (through automatic answering device over advertised tel. number.)
Fluxnewsletter, March 8, 1967.

FLUXFEST INFORMATION
P.O.BOX 180, NEW YORK, N.Y. 10013
Many fluxpieces are described and listed in the Expanded Arts issue of FILM CULTURE magazine. A reprint can be obtained for $1. Any of the Fluxpieces can be performed anytime, anyplace and by anyone, without any payment to Fluxus provided the following conditions are met:
1. If flux-pieces outnumber numerically or exceed in duration other compositions in any concert, the whole concert must be called and advertised as FLUXCONCERT or FLUXEVENT. A series of such events must be called a FLUXFEST.
2. If fluxpieces do not exceed non-fluxpieces, each such fluxpiece must be identified as a FLUX-PIECE. Such credits to Fluxus may be omitted at a cost of $50 for each piece announced or performed...flux...phone programs...flux-phone answering service...
Fluxnewsletter, December 2, 1968 (revised March 15, 1969).

FLUXFEST INFORMATION...
Any of the Flux-pieces can be performed anytime, anyplace and by anyone, without any payment to

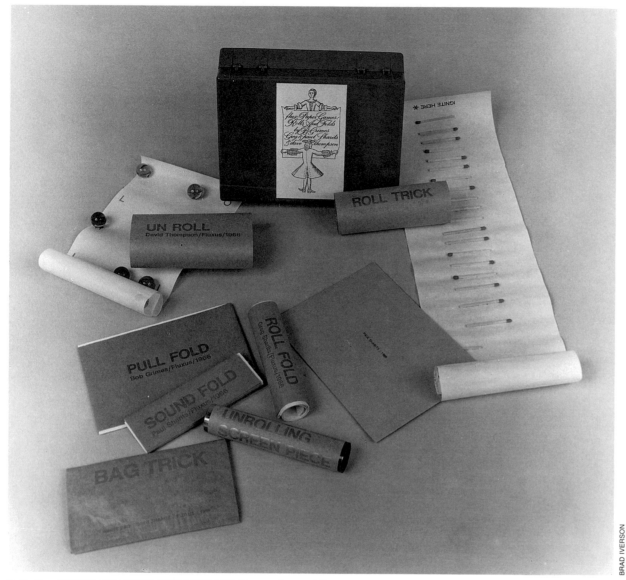

BRAD IVERSON

Collective. FLUX PAPER GAMES: ROLLS AND FOLDS. see color portfolio

FLUX POST KIT 7
Silverman No. > 130.I

FLUX-PROJECTS PLANNED FOR 1967...Collective projects: (All are invited to submit ideas and participate, ideas can be either ready pictorial material or just specified material which we have to find, produce or obtain otherwise)...Flux-postal kit: containing postcards, stamps, cancellation stamps, passport etc. stamps sizes: 7/8" x 1" (25mm x 22mm wide) or 1" x 1.5" (25mm x 39mm), images can be either photographs (any size) or screened clippings (from magazines, veloxes) to size, image size: 1/4" smaller than stamp size (5/8" x 3/4" etc.) (or 6mm smaller). We will issue a 100 stamp sheet, each row (10 stamps) designed by different participant. Images can also be drawings, prints, engravings, letters, etc. etc.
Fluxnewsletter, March 8, 1967.

IMPLOSIONS INC. PROJECTS...Postcards, stamps (same as Flux-postal kit)
ibid.

flux post kit $7
Fluxshopnews. [ca. Spring 1967].

FLUX-PRODUCTS 1961 TO 1969...FLUXPOST KIT 1968 100 stamp sheet—by Bob Watts, 2 postcards by Bob Watts, 3 postcards by Ben Vautier, rubber stamp by Ken Friedman, Ben Vautier, Jim Riddle, [$] 8 Version without rubber stamps [$] 2
Fluxnewsletter December 2, 1968 (revised March 15, 1969).

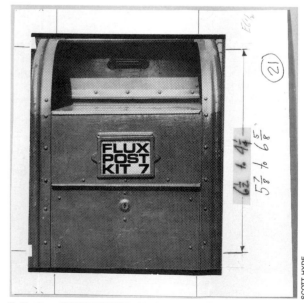

SCOTT HYDE

Collective. FLUX POST KIT 7. Mechanical by George Maciunas for the label

Fluxus provided the following conditions are met:
1. If flux-pieces outnumber numerically or exceed in duration other compositions in any concert, the whole concert must be called and advertised as FLUXCONCERT or FLUXEVENT. A series of such events must be called a FLUXFEST.

2. If flux-pieces do not exceed non-fluxpieces, each such fluxpiece must be identified as a FLUX-PIECE.

3. Such credits to Fluxus may be omitted at a cost of

$50 for each piece announced or performed ... flux-...phone programs...flux-phone answering service...
Flux Fest Kit 2. [ca. December 1969].

COMMENTS: Flux Phone Answering Machine *was initially listed in Fluxnewsletter, March 8, 1967, as both an individual work by Ely Raman and a collective project. Although the idea is very suitable for group participation, only Raman's tapes are known to exist. The idea pre-dates John Giorno's Dial-a-Poem which he started in November 1968 and lead the way to a mass utilization of the concept.*

FLUX-PRODUCTS 1961 TO 1970 ... FLUXPOST KIT, 1968: 100 stamp sheet by Bob Watts, 3 post cards by Ben Vautier, rubber stamp by Ken Friedman, Ben Vautier, Jim Riddle. boxed: $8
Flux Fest Kit 2. [ca. December 1969].

FLUX SHOW: DICE GAME ENVIRONMENT ENTIRE FLOOR AS DICE HAZARD TABLE DIE CUBES, 15'' CUBES ON FLOOR, Marked on sides, top open or closed with clear plastic. Consisting or containing...Flux post office.
ibid.

[Catalogue no.] 718 FLUXUS-EDITIONEN...FLUX-POST KIT, 1968 (b.watts, b.vautier, k.friedman, j.riddle)
Happening & Fluxus. Koelnischer Kunstverein, 1970.

FLUX-PRODUCTS 1961 TO 1970 ... FLUXPOST KIT, 1968: 100 stamp sheet by Bob Watts, 3 post cards by Ben Vautier, rubber stamp by Ken Friedman, Ben Vautier, Jim Riddle. Boxed: $15
[Fluxus price list for a customer]. September 1975.

COMMENTS: *The contents of Flux Post Kit 7 are both a packaging of existing material such as Watts' stamps, and postcards of Watts and Vautier. To that, three rubberstamps were added: Friedman's* Inconsequential is Coming; *Riddle's* Everything; *and Vautier's,* Ben Vautier Certifies this to be a work of Fluxart. *A separate collective sheet of stamps and passport were never done for* Flux Post Kit 7, *although the passport was most likely Ken Friedman's* Flux-Passport, *which was conceived at that time but not made until 1977.*

FLUXSHOP see:
 FLUX AMUSEMENT CENTER
 EUROPEAN MAIL-ORDER WAREHOUSE/
 FLUXSHOP
FLUXSHOW FOR GALLERY 669 see:
 FLUX AMUSEMENT CENTER
FLUX SNOW EVENT see:
 FLUX FOOD

FLUXSTAMPS

''...We will also come out with 100 fluxstamps - collective designs, by various people - so let me know your ideas. All you need to do is send drawing, picture, anything. If it is halftone (dotted) it should be about same size as stamp, because dots can't be reduced to over 120 lines per inch...''
Letter: George Maciunas to Ben Vautier, March 29, 1966.

''...You could do the following yet: Collective projects...Postage stamps will have 100 stamp sheet, each row of 10 by different Flux-man...I figure about 4 projects per person as yearly quota in addition to unlimited participation in collective projects... postage stamps...''
Letter: George Maciunas to Ken Friedman, [ca. February 1967].

FLUX-PROJECTS PLANNED FOR 1967...Collective projects: (All are invited to submit ideas and participate, ideas can be either ready pictorial material or just specified material which we have to find, produce or obtain otherwise)...Flux-postal kit: containing ... stamps,...etc. stamps sizes: 7/8'' x 1'' (25mm x 22mm wide) or 1'' x 1.5'' (25mm x 39mm), images can be either photographs (any size) or screened clippings (from magazines, veloxes) to size, image size: 1/4'' smaller than stamp size (5/8'' x 3/4'' etc.) (or 6mm smaller). We will issue a 100 stamp sheet, each row (10 stamps) designed by different participant. Images can also be drawings, prints, engravings, letters, etc. etc.
Fluxnewsletter, March 8, 1967.

COMMENTS: *This collective sheet of stamps was never produced by George Maciunas as a Fluxus Edition.*

FLUX TATTOOS
Silverman Nos. 130, ff.

''...Other going projects:...Collective:...Stick-ons... I figure about 4 projects per person as yearly quota in addition to unlimited & participation in collective projects: ...stick-ons, etc...''
Letter: George Maciunas to Ken Friedman, [ca. February 1967].

IMPLOSIONS INC. PROJECTS...Triple partnership was formed between Bob Watts, Herman Fine and myself [George Maciunas] to introduce into mass market ...money producing products...This business will be operated in commercial manner, with intent to make profits...connection between Fluxus collective and Implosions Inc. has not been clarified yet...we could consider at present Fluxus to be a kind of division or subsidiary of Implosions. Projects to be realized through Implosions:(all are invited to participate &

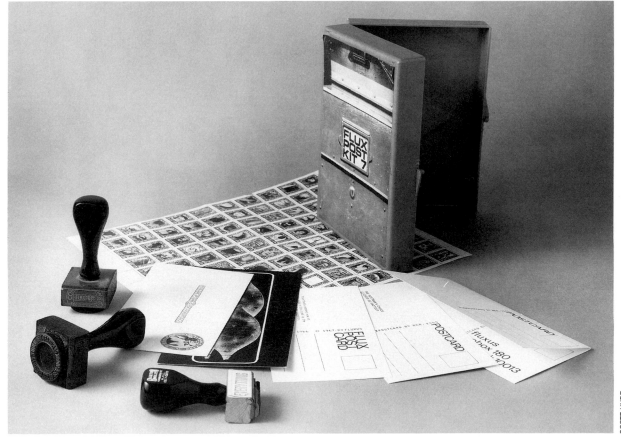

Collective. FLUX POST KIT 7

SCOTT HYDE

submit ideas) Stick-ons (disposable jewelry): printed on clear acetate or vinyl 9" x 11¾" (image size), images may be photographs (will be screened) or drawings, engravings, words etc. any color. Plastic sheets will have self-adhesive backs that will permit them to be stuck on skin or clothing. Sheets will also be die cut or contain partly die cut (snap-out) shapes in the shape of the image or anything else.
Fluxnewsletter, March 8, 1967.

stick-on tattoos $1
Fluxshopnews. [Spring 1967].

"...By separate mail I am sending some of the new stick-on tattoos we produced...There are 4 other new sheets we are doing now: with zippers, hinges, screw heads, medals, etc.- to be stuck on skin or clothing..."
Letter: George Maciunas to Paul Sharits, June 21, 1967.

NEWS FROM IMPLOSIONS, INC. Various items were produced as planned & the listed in the past news-letter: Stick-ons, samples included...Planned in 1968: ...More stick-ons (some 8 designs)...
Fluxnewsletter, January 31, 1968.

Collective. FLUX TATTOOS. Mechanical by George Maciunas for an unused label

FLUXPROJECTS FOR 1969...PROPOSALS WILL BE WELCOMED FOR:...new ideas for...stick-ons...
fluxnewsletter, December 2, 1968.

FLUX-PRODUCTS 1961 TO 1969 ... FLUXTATTOOS WINTER 1967 Campaign ribbons, medals, nipples by Bob Watts, Fasteners, buttons, zippers, symbols by Maciunas. 6 different — 5x6" stick on sheets, boxed* [indicated as part of FLUXKIT] [$] 5
Fluxnewsletter, December 2, 1968 (revised March 15, 1969).

FLUX-PRODUCTS 1961 TO 1970 ... FLUXTATTOOS 1967: [as above]
Flux Fest Kit 2. [ca. December 1969].

COMMENTS: *Usually seven sheets of stick-ons produced by George Maciunas for Implosions are included in the collective*

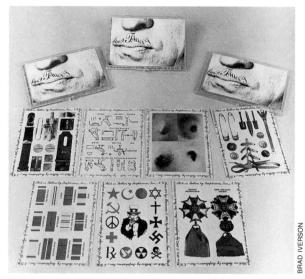

Collective. FLUX TATTOOS

Collective. FLUX TATTOOS. Mechanical by George Maciunas for the label

Fluxus Edition of Flux Tattoos. *Implosions was an attempted commercialization of Fluxus ideas organized by Maciunas, Herman Fine and Robert Watts. The idea of producing stick-ons by Fluxus preceded the creation of Implosions and the lines between the two are frequently blurry. The tattoo sheets that were produced are: Archeology 900 (hieroglyphs) by Anonymous; George Maciunas'* Fluxwear 303 *(primarily hardware fasteners),* Fluxwear 304) *(primarily clothing fasteners), Hero 603 (medals), Hero 604 (emblems or symbols); Robert Watts'* Biology 704 *(navels and nipples), and Hero 601 (campaign ribbons). Other sheets of stick-ons were planned in this format but were not produced.*

FLUX TOILET

FLUXPROJECTS FOR 1969...PROPOSALS WILL BE WELCOMED FOR:...new toilet room objects...
Fluxnewsletter, December 2, 1968.

PROPOSED FLUXSHOW FOR GALLERY 669, LOS ANGELES. OPENING NOV. 26, 1968...
TOILET OBJECTS
a. roll of used paper towels (dirty)
b. thin coat of real soap over a plastic soap (washes off in first use) by Bob Watts.
c. picture scale by Bob Watts.
d. toilet seat covered with pressure sensitive adhesive (or double faced adhesive tape)
e. sink faucet turned upward with sprayer or fountain [sic] head attached.
f. convex - 49 facet mirror (reflects face 49 times) by George Maciunas
g. photo-collage mirror (photo of Louis 14th head with face cut off to reflect face of onlooker)
h. toilet paper with dollar bills printed on it.
ibid.

FLUXFEST INFORMATION
P.O. BOX 180, NEW YORK, N.Y. 10013
Many fluxpieces are described and listed in the Expanded Arts issue of FILM CULTURE magazine. A reprint can be obtained for $1. Any of the Fluxpieces can be performed anytime, anyplace and by anyone, without any payment to Fluxus provided the following conditions are met:
1. if fluxpieces outnumber numerically or exceed in duration other compositions in any concert, the whole concert must be called and advertised as FLUXCONCERT or FLUXEVENT. A series of such events must be called a FLUXFEST.
2. if fluxpieces do not exceed non-fluxpieces, each such fluxpiece must be identified as a FLUXPIECE. Such credits to Fluxus may be omitted at a cost of $50 for each piece announced or performed...flux-toilets...
PROPOSED FLUXSHOW...
TOILET OBJECTS
a. toilet seat variations: covered with double faced

adhesive tape, brush mat, sandpaper, inflated rubber, rubber bag with hot water or iced water, corrugated surface, highly waxed & polished surface, etc.

b. mirrors: continuously undulating (motor driven) surface - by Bob Watts; photo-collage mirror (photo of a head with baroque hairdo and face cut off revealing mirror reflecting face of onlooker) by Robert Filliou; convex - 49 facet mirror reflecting face 49 times - by George Maciunas.

c. plactic soap with thin coat of real soap that washes off in first use - by Bob Watts.

d. sink faucet turned upward with sprayer or fountain head attached.

e. roll of used paper towels, or new ones with dirt and hand marks printed on.

Fluxnewsletter, December 2, 1968 (revised March 15, 1969).

FLUXFEST INFORMATION...

Any of the Flux-pieces can be performed anytime, anyplace and by anyone, without any payment to Fluxus provided the following conditions are met:

1. If flux-pieces outnumber numerically or exceed in duration other compositions in any concert, the whole concert must be called and advertised as FLUXCONCERT or FLUXEVENT. A series of such events must be called a FLUXFEST.
2. If flux-pieces do not exceed non-fluxpieces, each such fluxpiece must be identified as a FLUX-PIECE.
3. Such credits to Fluxus may be omitted at a cost of $50 for each piece announced or performed ...

flux-toilets;...or entire flux-fests may be arranged by the flux-collective for a fee of $40 per performer, per day and on condition:

1. travel costs of flux-performer(s) or single supervisor is reimbursed and lodging provided
2. large equipment such as pianos, ladders, tubs, sporting equipment, facilities supplied
3. local performers and helpers mobilized.

TOILET OBJECTS & ENVIRONMENT

1. Toilet seat variations: double faced adhesive tape cover, brush mat, sandpaper, rubber bag with hot or cold water, corrugated surface, inflated rubber, highly waxed slippery surface, squeaking rubber toy seat, etc.
2. Mirrors: motorized undulating surface by Bob Watts, convex multi faceted by George Maciunas, photo collage (funy [sic] head photo with mirror face) by Robert Filliou.
3. Plastic soap with thin coat of quickly washable soap by Bob Watts.
4. Sink faucet turned upward or with sprayer attached.
5. Roll of used paper towels, or new ones but imprinted with dirt & hand marks.

Flux Fest Kit 2. [ca. December 1969].

	Toilet no.1 Bob Watts	Toilet no.2 Paul Sharits	Toilet no.3 Joe Jones	Toilet no.4 G. Maciunas	Toilet no.5 Ayo	Toilet no.6 collective
Doors - method of opening	*(diagram)* No handle, elec. push-switch behind target. To get in: throw super ball to target on door. hitting center will activate switch & open door. To get out: sit down on seat.	*(diagram)* only small door with handle on outside. large door with handle on inside. Access via small door with arm to open door from inside.	*(diagram)* hinge on top.	*(diagram)* 2 separate doors on top of each other.	*(diagram)* pivot in center	*(diagram)* pivot in center vertical axis.
Doors display on interior side of door	Game-ball rolling down a maze.	paper sound (delaminating acordion) when small door opened. Inside display: Flux clocks *	Wind-up movements. * Electric String trio on side wall of stall, switched on when flushed *	Bird organ * & other bulb activated tricks.	Finger holes *	Chess boards can be played by 2 people swinging door around. One person inside, another outside the stall. (Takako Saito)
Toilet seat	Seat with elec. switch controlling door. Door with spring, held in closed position with lock. lock opens by solenoid switch. When seat sat upon- door opens, when seat empty door closes.	Adhesive-Covered daily with double-face adhesive tape)	Hot- with electric coil inside seat.	Inflated & squeaking.	Stiff brush bristles facing upward. *(hatching)*	Corrugated ~~~~ Wet Paint sign. (John Lennon)
Toilet flushing	Releases mist of smells: lysol, chlorox, moth flakes, coffee, turpentine, cloves, alcohol, vanilla.	Starts recorded laugh or toilet sounds like farts.	activates electric string trio.	starts fine drizzle of rain over head.	detergent suds in tank when flushed foam comes out the bowl.	starts faucet in sink.
Toilet bowl display	colored water from tank Blue, then clear then blue again.	Floating rubber shit. secured by string.	George Brecht ball puzzle: Balls secured by string. Instructions on bottom.	Mirrors in periscope fashion to show action, must have elec. illumination in bowl.	foam -	Boiling water (John Lennon)
Toilet paper	Mylar- * metalic finish	stuck together	$ bills *	perforated with large holes	Rainbow colors	De Ridder paper games printed.
Paper towels	dirty - 2nd. hand with foot prints.	stuck together	fragile	with chemical making hands dirty.		
Sink faucet water	soapy water	flushes toilet no. 5	upwards spray	thick mud or thin glue.		
Mirror	undulating * motorized	covered with opaque window cleaner. Must be wiped off ea. time.	Filliou-collage mirror	faceted *		
Medicine cabinet	Rocks * marked by volume in c.c. Time kits.	cleanliness kit Suicide kit * etc. behind glass	Foods * Drinks napkins behind glass.	various * flux-boxes behind glass.	Vending * machine-dispensing Relics- holy shit, by Geoff Hendricks	Vending * machine dispensing air capsules by Yoko ono.
Soap	thin coat on plastic facsimile					

Collective. George Maciunas' plan for FLUX TOILET, published in Fluxnewsletter April 1973

©1970 HENRY MAITEK

Wolf Vostell sent George Maciunas this photograph of a portable toilet in planning for the collective FLUX TOILET for Happening & Fluxus. Koeln. 1970

ENVIRONMENT...George Maciunas FLUX-TOILET - TRAILER [a drawing by Wolf Vostell of the Flux-Toilet trailer credited to George Maciunas and Bob Watts is reproduced on the cover of the catalogue].
Happening & Fluxus. Koelnischer Kunstverein, 1970.

"...I still think best is to do an amusement place with toilet being one amusement..."
Letter: George Maciunas to Daniela Palazzoli, n.d. Reproduced in Fluxnewsletter, April 1973.

This Fall, we shall publish V TRE no. 10, which shall consist of a plan for Flux-Amusement-Center, to contain the following: Fluxtoilet (variations on toilet flushing, seats, stall doors, sinks, mirrors, toilet paper, towels)
Fluxnewsletter, April 1973.

[A complete plan for six Flux Toilets was included with Fluxnewsletter April 1973 and is reproduced in this section.]

6.11.1970—6.01.1971
HAPPENING & FLUXUS
koelnischen [sic] kunstverein,
FLUX-TOILET:
WATTS: toilet seat when sat upon opens door, colored water in tank, metalic [sic] toilet paper, mirror, soap.
SHARITS: adhesive toilet seat, stuck-glued toilet paper, etc.
MACIUNAS: squeaking toilet seat, flushing starts rain, toilet bowl persicope [sic], ½ door, prepared sink.
AYO: brush seat, suds in tank.
LENNON: boiling water in tank.
George Maciunas, Diagram of Historical Developments of Fluxus... [1973].

FLUX AMUSEMENT ARCADE...Flux toilet (3 prepared toilets will be constructed at 80 Wooster st. basement, could be completed by December)
Preliminary Proposal for a Flux Exhibit at Rene Block Gallery. [ca. 1974].

OBJECTS AND EXHIBITS...1970:...initiated collaborative flux-toilet project, major contribution. exhibited at Happening & Fluxus, Koelnischer Kunstverein, Cologne.
George Maciunas Biographical Data. 1976.

...A Toilet is inSTALLed in which the TOILET is a high platform with a hole cut out in a stall, in which the door doesn't open. USERS may view their own activity through a periscope provided on the platform. G.M.
...a TOILET is ALTERED so that a laughing or clapping noise is heard as it is flushed. R.W.
...a TOILET is ALTERED so that the door to the stall may be opened only when the outer door to the bathroom is opened or when one sits on the toilet seat. R.W.
...On Going Events...
*PUBLIC TOILETS: Wed-Sun 9-5pm
At Triangle Studios, 83 Columbia, 4th floor. Knock loudly....
Special Events/Calendar...
Tue. 27
*TOILET INAUGURATION: 4:30-7 pm
Inaugurate the "prepared" toilets at Triangle Studios, 4th Floor of 83 Columbia. Drink a lot before you come!
Fluxfest 77 at and/or, Seattle. September 1977.

COMMENTS: *Flux Toilet was first proposed in 1968, but was not built until two years later for the Happening and Fluxus Exhibition in Cologne, West Germany at the Koelnischer Kunstverein. It never officially opened because of bureaucratic interference and inter-artist bickering. A second Flux Toilet was constructed for the Fluxfest at and/or in Seattle, 1977. This collective environmental work ranks with Fluxlabyrinth in its assault on the senses. It was a successful realization of a participatory form of Fluxus work that is at the same time distinct from performance.*

FLUXTRAIN

"...There is no need for you to come to Duesseldorf or Wiesbaden. There is no one in Duesseldorf anyway. We have postponed all East European tours for maybe Summer 1965, since we want to combine it with tour through Siberia, which we would like to do with a freightcar to the audience standing in front in the rail yards. (free audience). But such arrangement will take time to formalize, since we must obtain approval from Soviet government...."
Letter: George Maciunas to Ben Vautier, [May 1963].

PROPOSED CATEGORIES...FLUXTRAIN...LOCATION...L.I. Railroad...IN CHARGE IN NYC...Milan Knizak
Fluxfest at Stony Brook, Newsletter No. 1, August 18, 1969. versions A & B

COMMENTS: *The idea for a Fluxtrain, though never realized, was derived from the Soviet Avant-Garde Agit-prop vehicles —such as trains, street cars, boats and carts — decorated with bold constructivist design and used as a come-on and backdrop for performance and political consciousness raising.*

FLUX TV PROGRAM

"...Please think up some TV events. We will have a special TV performance late Feb. Program will be only 1 hour long, so event should not be too long. We will do your 2", &. Event 13...."
Letter: George Maciunas to Robert Watts, [December 1962].

"...keep thinking on TV ideas..."
Letter: George Maciunas to Tomas Schmit, [end of December 1962 or early January 1963].

"...Compose pieces for Television!!! De Ridder needs them..."
Letter: George Maciunas to Tomas Schmit, [late June, early July 1963].

"...De Ridder wrote TV may offer some time for Fluxus broadcast. So I have mailed him some special TV pieces (Brecht, Higgins, La Monte, my Olivetti for 4 TV cameras aimed at some other place, 1 performer at switchboard, etc). So, please think! think up quickly special TV pieces & send them to De Ridder!!!!!! (pieces that would not be filmed but rather pieces for their equipment, studio, technicians etc, you understand? Not 'artificial' pieces, but more like your Sanitas with numbered seats. OK?..."
Letter: George Maciunas to Tomas Schmit, [August 1963].

"De Ridder wrote (the letter you got) that Amsterdam Television may broadcast a Fluxus program — so WORK FAST — on special TV compositions, — I mean pieces that can not be done anywhere else but in TV studio, OK? Think, think!!! We can adapt Higgins constellation (just a 'bip') also La Monte's 2 tones — interference sound for 10 minutes and picture in horizontal lines (out of tune) & several other pieces easily adapted for TV, but they must be special TV pieces. When you have composed some send them to: Fluxus. Willem de Ridder Amstel 47, Amsterdam, Holland. Hurry...."
Letter: George Maciunas to Ben Vautier, [early August 1963].

"...I have more exact information as regards my availability for Amsterdam 2nd. Fluxus (TV) if it comes off. I could be in Amsterdam anytime between Aug.

27 and Sept. 2....I forgot what I wrote to you for inclusion in TV program, so I will write again, with more detail since I have more time now & more space. Such program can be carried out by you alone (with local assistance only), in other words we are not indispensable.

FLUXUS

1. Announcer can say a few words about fluxus: International organization with intent to FLUX (purge) the world of various bourgeois sicknesses; intellectual, professional & commercialized culture, abstract art, dodecaphonic music, art for art, art-art etc. Purge the world of Europanism. Promote living, nonartificial art, or other non-art reality grasped & experienced as art by social & political revolutionaries into a united front & action. These 3 points are all related to word FLUX & can be considered as FLUXUS Manifesto. Mention can be made of various publications & the Fluxus branch in your shop, represented by you as co-editor.

2. During the last few seconds of his talk, the light is turned off, when he ends talking, light is on again showing the announcer, then off again, (silence). for few seconds, then on and the announcer announces, that 'the first piece just performed was light event by George Brecht.' (From here on pieces can be announced before they are performed).

3. Emmett Williams — voice piece for La Monte Young. the announcer asks: 'If La Monte Young is watching this program would he please telephone......' (maybe Queen's telephone number, or one in Kremlin).

4. Nam June Paik: 'Zen for TV'. He did this in Wuppertal as one of his 'prepared' TV sets — (this can be announced). I don't know how it was prepared but the technicians probably would know what signal to feed the transmitter (no camera needed). Result is this. [drawing] screen —white thin line on a blank screen. Hold this line for 2 minutes at least or more if time is available.

5. Dick Higgins — constellation no. 7. Just a very, very short loud noise (electronic signal) and screen all in jumble during this short period. No microphone or camera needed, all signals to be fed directly to transmitter.

6. Ben Patterson — Paper piece. Paper stretched in front of camera so no edges are seen. [drawing indicating:] 1 meter visibility. [on a] screen. Performers start by making little holes, sticking their fingers or just looking through hole with one eye at camera, then a hand can be stuck through hole, or a bare foot, foot can be moved about, also hands, then 2 fingers can start ripping a narrow ribbon from top to bottom [drawing]. Performers

always hidden behind paper. Someone can tap paper with fingers from behind, or just move hand across it. Then when all movement and small penetration possibilities are exhausted, camera runs through paper — blank screen as soon as camera shoots through paper, so performers are never actually seen.

7. Announcer comes from off screen walks towards camera so only his face is seen and announces: George Brecht — Direction. (this whole episode must be filmed and made into a continuous loop, because the performance is showing this announcer coming towards camera & announcing 4 times — (4 times loop is shown) and then it is shown once backwards (he says it backwards and walks backwards.

8. George Maciunas — In Memorium to Adriano Olivetti. I remember having explained the variation for TV. One performer at switches, Metronome always audible,
 1. One camera may be turned on announcer,
 2. another on his shoes,
 3. another on studio
 4. another on street through window,
 5. another on 1st camera,
 6. another on metronome,
 0. and then one blank. Now an adding machine tape may give the following:

2 & 4 = one tact of metronome
2 = feet
1 = announcer
0 = blank
0 = blank
7 = still blank because there is nothing assigned for 7.
5 = show camera
9 = show camera
8 = show camera
6 = show camera
8 & 6 = when unassigned numbers follow an assigned one, you just continue showing what was being shown in last assigned number. Picture changes on tact of next assigned number, like in this case no. 4 all clear?
4 = street
8 = street
1 = announcer
etc. etc.

It must be a very rhythmic piece. Metronome speed can be set to the proficiency of performer. the faster the better.

6. I just thought of a better variation for Ben Patterson — paper piece — do it instead of one I described under no. 6. Set 8 paper screens about 1 meter apart: [drawing] run camera through all these stretched screens, all 8 screens. Edges of

these screens must never be within vision of camera, so all it sees is blank sheets, then WHAM! through the sheet, and another approaches, WHAM! again. etc.

9. La Monte Young — Composition no. 13, 1960. Two tones. major 5th. apart are played for about 5 minutes. Signals must be sinus tones — continuous

10. Dick Higgins — Danger Music no. 17. Terrible loud noise on all sets of people watching this program. Screen all in jumble, like when you get interference from some drill next door or something like that. Must last 2 minutes. People will turn their dials trying to set their TV sets right. very nice piece.

11. George Brecht — word event — blank screen until the next program on the station. No announcement must be made that the program has ended. Just announce the piece, don't even say it is the last one, and then blank. Like station was off.

Within this program you should insert your own TV pieces & any pieces specially adapted for TV that maybe sent by Tomas Schmit, Emmett Williams & Ben Vautier. (if they are well adapted). Use your own judgement. I think the pieces should not show any performers. TV is not same as theatre, it should utilize the technical aspects of TV, especially natural events, so that people would tend not even to notice some pieces. In this respect my Olivetti is the worst piece, most artificial, least Fluxus.

12. Just thought of another piece:
 Robert Watts: Hospital event for GM. take picture of De Gaulle or Kennedy or Adenauer. Best to show Kennedy (president). Show picture so no edges are seen. Picture stretched over frame. Performer from behind with finger, in fast sequence pierces one eye (goes with finger through it) then second eye, mouth, & then middle of forehead. Make little holes beforehand so finger will be able to pierce neatly without ripping-up picture. Practice with another paper. Sequence must be fast, like one, two, three, four. OK?

13. this must be the very first piece, before the announcer says anything about Fluxus, — Picture is inverted — everything upside down, the announcer comes and talks — all upside down. Brecht's light event performed, then announced — all still upside down, then announcer is turned rightside up — or rather the camera & he announces: '2nd piece just performed was — 'prelude' by Nam June Paik'. Many people probably will have turned their sets upside down to see the announcer rightside up & will have to turn it back again after he announces Paik. Nice??
Let me know how this TV comes out. It would

be good to have the whole version on TV tape so we could take it to New York. (or on film)...."

Letter: George Maciunas to Willem de Ridder, [early August 1963].

"...Have you sent TV compositions to De Ridder?..."

Letter: George Maciunas to Tomas Schmit, [late Summer 1963].

"I got the telegram from you, but did not reply because:

1. I did not have any fluxus film for TV (and just sound material would not be suitable for TV.

2. I did send you long time ago a program for TV presentation & I hope you did not lose it!! You should present that material. It is much better than doing another theatre and televising theatre pieces. What I sent you were special pieces for TV. OK?

If you do want also to do a Fluxus theatre performance for TV, it is perfectly alright. You know many pieces already from our 1st. FLUXUS festival. I will include also some others:

1. Takehisa Kosugi — Organic Music:
"Breath by oneself or have something breathed for the number of times which you have decided at the performance. Each number must contain breath-in-hold-out. Instruments may be used. I suggest you do this in one of these ways:
a)-a group play accordions without producing any tones — just breathing sound — you all pump accordion bellows rhythmically with open dampers.
b)-a group (like string quartet come out to sit down, set the instructions on music stands, place violins in playing position and breath rhythmically (without playing)!

2. Takehisa Kosugi — Anima 2
Enter a chamber which has windows. Close all windows and doors. Put out each different part of body through each window. Then leave chamber. Chamber may be made of large cloth bag with "doors" and "windows" made of zippers.

3. Chieko Shiomi — Wind Music 1963.
One version I suggest. String quartet comes on stage, sits down in front of music stands, sets instructions (on large sheets of paper) on music stands — and just when they are ready to begin playing a strong wind is raised (with very large fan) which blows all instructions over audience.
—instructions read:
"Raise wind. Be blown by wind, Let anything be blown by wind".

4. Chieko Shiomi — portrait piece
Crumple portrait of famous man (like De Gaulle), then smooth it, crumple again, then smooth it, Look at the face (let TV camera look at face

5. Dick Higgins — Music for Stringed instruments, Nov. 1963
Lots of extra strings may be attached to conventional stringed instruments for the performance of this piece. Each performer has a dull knife. A lovely lady acts as referee. At a signal from lovely lady each performer cuts and removes the strings from his instrument as noisily and as rapidly as possible, using nothing else but his hands and his knife. The first to finish gets a kiss from the lovely lady, which is the signal for all to stop.

These are some of the more recent pieces.
You have complete works of Brecht also you have Fluxus roll with short pieces, & Tomas Schmit & Emmett may come to you, they know the complete Fluxus repertory. So you have big choice for theatre performances. I suggest you do the following:

Tomas Schmit — piano no. 1 piece.
Emmett Williams — 4 directional song or alphabet symphony.
Toshi Ichiyanagi — piano no 5 (maybe is not good for TV.).
Brechts — drip event,
" piano piece 1963 (vase of flowers)
" comb music.
Robert Watts — 2 inches.
Dick Higgins — constellation 7 (short one).
Your own clown piece — man in rubber tub. + mask piece.
Ben Patterson — paper piece
solo for dancer.
Higgins — Bubble music (instructions in fluxus roll.)
my — piano piece no 11. (polishing piano)
Paik — one for violin solo —Tomas knows it I think.

Emmett & Tomas will give you more suggestions. Give them my regards when you see them in Amsterdam.
In addition you should do the special TV pieces I wrote you long time ago — THAT IT MOST IMPORTANT. I will add small revisions: In Paik's Prelude where I wrote that TV camera sometimes would shoot announcer upside down — the volume at transmitting station should be sometimes very loud, then very low (every 10 or 20 seconds it should change, so that listener would have to keep adjusting his TV volume all the time! (you see it is a piece for the listener — he must work!)

Always end program with George Brecht's Exit!...Do propaganda for FLUXUS publications....Send me news about how TV event went. Present the TV event as FLUXUS."

Letter: George Maciunas to Willem de Ridder, December 26, 1963.

"...In future all Fluxus concerts (concerts consisting of predominately Fluxus materials MUST be called Fluxus concerts. This is purely for propaganda purposes. If newspapers do not mention Fluxus, their reviews are totally worthless for publicity here in New York. That's why we copyright compositions, so we can FORCE mention of FLUXUS (collective) rather than individuals. This is all part of the anti-individualism - campaign. As it is now we can sue Holland Television for performing Fluxus materials without our permission. See to it that this never happens again. We will absolutely refuse permission to perform any Fluxus materials on any other arrangement...."

Letter: George Maciunas to Tomas Schmit, January 24, 1964.

ENCLOSURES:...flux-radio & TV pieces (new pieces from all will be welcomed)...FLUXPROJECTS FOR 1969...PROPOSALS WILL BE WELCOMED FOR: radio-TV pieces...

1962 FLUX-RADIO PIECES	1966 FLUX-VIDEO VERSIONS
Anonymous[:] While a long-winded announcement or comment is made, the broadcasting volume is set to the minimum, requiring the receiving (radio) volume to be set at a maximum. After a short while, the broadcasting volume is set at a maximum.	Same volume settings as for radio, plus announcer is shot with upside down video camera, so receiving set would get the image upside down. After a while the camera is turned right side up, requiring the viewer to adjust his receiver again, (by turning his tv set right side up).
Ben Vautier[:] Efforts are broadcast of a telephone operator trying to make a telephone connection to president Johnson, or some other high offical.	no video version
La Monte Young[:] Announcement is made while a loud interfering static noise is broadcast.	Announcement is made simultaneously with all kinds of electronic interferences such as: ghosts, rolling, picture slipping, distortion, snow storms, etc.
Tomas Schmit[:] Telephone time service is broadcast.	no video version
George Brecht[:] Entrance-Exit. A smooth linear transition from white noise to sinus wave tone is broadcast. An-	A smooth linear transition from white, through all greys to white is broadcast together with radio sound

nouncement is made also at the end but backward (tape played backward).

Anonymous[:]
Applause, laughter and other audience sounds are broadcast for a long while. | same, but broadcast also in video.

Anonymous[:]
Various studio sounds are broadcast in a pattern of inter-mix determined by a metronome. Studio sounds may be also inter-mixed with other sounds, such as ones from public toilet etc. | Various views of the studio are broadcast in a pattern of inter-mix determined by a metronome.

Nam June Paik[:]
Several news broadcasts are given simultaneously. | Several video broadcasts of news are superimposed and given simultaneously.

Takehisa Kosugi[:]
Live microphone is wrapped with a large piece of paper. | Video camera broadcasting the program is wrapped in a very large sheet of celophane or polyethylene.

Milan Knizak[:]
Snowstorm is broadcast. | same

Fluxnewsletter, December 2, 1968.

FLUXFEST INFORMATION
P.O.BOX 180, NEW YORK, N.Y. 10013
Many fluxpieces are described and listed in the Expanded Arts issue of FILM CULTURE magazine. A reprint can be obtained for $1. Any of the Fluxpieces can be performed anytime, anyplace and by anyone, without any payment to Fluxus provided the following conditions are met:

1. if fluxpieces outnumber numerically or exceed in duration other compositions in any concert, the whole concert must be called and advertised as FLUXCONCERT or FLUXEVENT. A series of such events must be called a FLUXFEST.

2. if fluxpieces do not exceed non-fluxpieces, each such fluxpiece must be identified as a FLUX-PIECE. Such credits to Fluxus may be omitted at a cost of $50 for each piece announced or performed ...TV...flux-...TV, radio...programs

Fluxnewsletter, December 2, 1968 (revised March 15, 1969).

[Identical to plan presented in Fluxnewsletter, December 2, 1968, with the following variations:]
FLUX-RADIO AND TV PIECES, 1965
FLUX-RADIO PIECES FLUX-VIDEO VERSIONS
Tomas Schmit[:]
Telephone time service is broadcast for an hour. | View of a ticking clock.

Anonymous[:]
Applause, laughter and other audience sounds are broadcast for a long while. | same, but with a view of the audience.

Fluxfest at Stony Brook, Newsletter No. 1 August 18, 1969. version B

FLUXFEST INFORMATION...
Any of the Flux-pieces can be performed anytime, anyplace and by anyone, without any payment to Fluxus provided the following conditions are met:

1. If flux-pieces outnumber numerically or exceed in duration other compositions in any concert,the whole concert must be called and advertised as FLUXCONCERT or FLUXEVENT. A series of such events must be called a FLUXFEST.

2. If flux-pieces do not exceed non-fluxpieces, each such fluxpiece must be identified as a FLUX-PIECE.

3. Such credits to Fluxus may be omitted at a cost of $50 for each piece announced or performed.

...TV, radio...programs...flux-fest may be arranged by the flux-collective for a fee of $40 per performer, per day and on condition:

1. travel costs of flux-performer(s) or single supervisor is reimbursed and lodging provided

2. large equipment such as pianos, ladders, tubs, sporting equipment, facilities supplied.

3. local performers and helpers mobilized.

FLUX-RADIO & TV
While a long-winded announcement or comment is made, the broadcasting volume is set to the minimum, requiring the receiving radio volume to be adjusted to maximum. After a short while, the broadcasting volume is set to a maximum, blasting the receiver.
Video version: broadcast with upside down video camera, then right side up. (G. Maciunas)
Announcement is made while a loud interfering static noise is broadcast. (L.M. Young)
Applause, laughter and other audience sounds are broadcast for a while. (Joe Byrd)
Various studio sounds are broadcast in a pattern of inter-mix determined by a metronome. Studio sounds may be also intermixed with other sounds, such as ones from public toilet. (George Maciunas)
Several news broadcasts are given simultaneously. (Nam June Paik)
Live microphone is wrapped with large piece of paper. (Takehisa Kosugi)
Video version: broadcasting camera is wrapped in a large sheet of celophane.

Flux Fest Kit 2. [ca. December 1969].

COMMENTS: *Willem de Ridder and Wim T. Schippers' T.V. program for* Signalement *was broadcast on Dutch television December 29, 1963, produced by Henk de Bÿ. Although it contained elements of Fluxus, such as Emmett Williams'*

"Voice Piece for La Monte Young," *glimpses of Chieko Shiomi's* Endless Box *and gave a plug for the European Mail-Order Warehouse/Fluxshop, it could not be considered a Flux TV Program as envisioned by George Maciunas. His was a program consisting of works specifically for T.V. equipment and technicians, rather than filmed events. The program as it was produced, also explored Zero, Nul, Pop, New Realist and Kinetic Art, as well as de Ridder's PK's and his and Schippers' "Mars Door Amsterdam" [March Through Amsterdam], Daniel Spoerri's "Tableau Piece," and Stanley Brouwn's "Street Event." In sum, an overview of art of the day. In 1968, Maciunas revived the idea of a Flux TV Program and radio variations, but neither is known to have been done.*

FLUXUS see:
FLUXUS 1

FLUXUS [BROCHURE PROSPECTUS FOR FLUXUS YEARBOXES] VERSION A
Silverman No. < 541.I, ff.

COMMENTS: *This first version of the* Brochure Prospectus *was printed in time for distribution to the audience at "Kleinen Sommerfest," Galerie Parness, Wuppertal, West Germany, June 9, 1962. The four page work is printed black on orange paper, staple-bound in a stiff olive green folder with the word "Fluxus" on the cover. A dictionary definition of Fluxus appears on page 1. Page 2 lists the editorial commitee, information on ordering Fluxus, and a graphic characterization of its contents. Pages 3 and 4 list the supposed contents of the seven Fluxuses. This was the first public presentation of the plans for Fluxus, following the three versions of Fluxus...Tentative Plan for Contents of the First 6 [and 7] Issues and News-policy-Letter No. 1 which were distributed to contributing artists and supporters.*

SCOTT HYDE

Collective. FLUXUS [BROCHURE PROSPECTUS FOR FLUXUS YEARBOXES] VERSIONS A & B

FLUXUS [BROCHURE PROSPECTUS FOR FLUXUS YEARBOXES] VERSION B
Silverman No. 541, ff.

COMMENTS: *This second version of the* Brochure Prospectus *was printed around October 1962. Although bound identically to the first version, the contents are printed black on white newsprint and contain significant changes in the text.*

FLUXUS 1 see:
FLUXUS YEARBOXES

FLUXUS 1 1964 ANTHOLOGY see:
FLUXUS 1

FLUXUS 1 1964-5 ANTHOLOGY see:
FLUXUS 1

FLUXUS 1 YEARBOOK see:
FLUXUS 1

FLUXUS II see:
FLUXUS NO. 2 WEST EUROPEAN YEARBOX I
FLUX YEAR BOX 2

FLUXUS II...FRENCH see:
FLUXUS NO. 5 WEST EUROPEAN YEARBOX II

FLUXUS 2. FRENCH YEARBOX see:
FLUXUS NO. 5 WEST EUROPEAN YEARBOX II

FLUXUS 2 1965 ANTHOLOGY see:
FLUX YEAR BOX 2

FLUXUS 2 1966 ANTHOLOGY see:
FLUX YEAR BOX 2

FLUXUS 3. SCANDINAVIAN YEARBOX see:
FLUXUS NO. 2 WEST EUROPEAN YEARBOX I

FLUXUS 4. JAPANESE YEARBOX see:
FLUXUS NO. 3 JAPANESE YEARBOX

FLUXUS 5. EAST EUROPEAN YEARBOX see:
FLUXUS NO. 6 EAST EUROPEAN YEARBOX

FLUXUS 6. GERMAN YEARBOX see:
FLUXUS NO. 2 WEST EUROPEAN YEARBOX I

FLUXUS 7. HOMAGE TO DADA see:
FLUXUS NO. 7 HOMAGE TO DADA

FLUXUS 8. HOMAGE TO THE PAST see:
FLUXUS NO. 4 HOMAGE TO THE PAST

FLUXUS 9. ITALIAN-ENGLISH-AUSTRIAN YEARBOX see:
FLUXUS NO. 5 WEST EUROPEAN YEARBOX II

FLUXUS ANTHOLOGY see:
FLUXUS 1

FLUXUS BOX NO. 1 (U.S. ISSUE) see:
FLUXUS 1

FLUXUS CABINET see:
FLUX CABINET

Fluxus cc fiVe ThReE see:
FLUXUS NEWSPAPERS

Fluxus cc V TRE Fluxus see:
FLUXUS NEWSPAPERS

Fluxus cc Valise e TRanglE see:
FLUXUS NEWSPAPERS

FLUXUS 1st YEARBOX see:
FLUXUS 1

FLUXUS ISSUE see:
FLUXUS 1

FLUXUS maciuNAS V TRE FLUXUS laudatio ScriPTa pro GEoRge see:
FLUXUS NEWSPAPERS

FLUXUS NEWSLETTERS

COMMENTS: *Starting in late 1961 or early 1962 in Weisbaden, West Germany, George Maciunas produced a large number of communications intended only for Fluxus artists and close associates, rather than for public distribution. These* Fluxus Newsletters *carried a variety of titles and served as a diving board for ideas, and as a bailing wire for the Fluxus group. There was no set format for the newsletters, and usually little effort to design them — rather they were communications of information which could vary from an address list with mention of a few new Fluxus editions, to a complete plan, including scores, for a Fluxus Festival in Prague.*

It has not been possible to identify every Fluxus Newsletter *— several important ones turned up during research, and I suspect more exist. Most are reproduced in* Fluxus etc./ *Addenda I. Those, and others which have been identified since publication of that book, are included in the Bibliography of this book, as are several hand-outs, broadsides, and press releases which were intended for a larger audience than were the* Fluxus Newsletters.

FLUXUS NEWSPAPER ROLL see:
EKSTRA BLADET

FLUXUS NEWSPAPERS

COMMENTS: *The newspaper format was used by the Dadaists as a cheap, immediate form of propaganda for their movement. Legendary publications such as* Neue Jugend, *Berlin, 1917;* Jedermann sein eigner Fussball, *Berlin, 1919; and* Der Blutige Ernst, *Berlin, 1919 were but a few of the periodicals produced by radical artists in this century. Seemingly each movement and group did some. The frustration Maciunas felt at the delay in producing* FLUXUS 1 *due to costly printing and complex collation of the anthology led him to abandon plans for the six or seven other* FLUXUSES *and start a rapid production of Fluxus newspapers, four appearing in the first six months of 1964. The title for the Fluxus newspapers comes from George Brecht's earlier newspaper,* V TRE. *Maciunas added the code "cc" to signify Brecht before the letters, repeated Fluxus profusely on the masthead, and after*

the first two issues, started to play with words containing "VTRE" and using these for the titles.

*Fluxus newspapers organized by date of publication or * planned publication:*

No. 1	January, 1964	Fluxus cc V TRE Fluxus
No. 2	February, 1964	Fluxus cc V TRE Fluxus
No. 3	March, 1964	Fluxus cc Valise e TRanglE
No. 4	June, 1964	Fluxus cc fiVe ThReE
No. 5	March, 1965	Fluxus Vacuum TRapEzoid
No. 6	July, 1965	Fluxus Vaudeville TouRnamEnt
*	Sept. 1965-1970	Fluxus Vague TREasure
No. 7	Feb. 1, 1966	Fluxus 3 newspaper eVenTs for the pRicE of $1
No. 8	May, 1966	Fluxus Vaseline sTREet
*	1966-June 1970	[Fluxus] VerTical pRaguE
*	1967	Fluxus VauTieR nicE
No. 9	1970	JOHN YOKO & FLUX all photographs copyright nineteen seVenty by peTer mooRE
*	1973	Flux amusement center V TRE
No. 10	May 2, 1976	FLUXUS maciuNAS V TRE FLUXUS laudatio ScriPTa pro GEORGE, [published in honor of Maciunas]
No. 11	March 24, 1979	a V TRE EXTRA [Posthumus tribute to Maciunas by Fluxus artists]

Besides the identifiable newspapers, Fluxus also published several newspaper-like works which appear in the collective section. Listed here successively:
Extra Bladet
Fluxus Preview Review
Fluxfest Sale
Flux Fest Kit 2
and Hi Red Center's Bundle of Events.

Fluxus cc V TRE Fluxus
No. 1 January, 1964
Silverman No. 549, ff.

"Brecht now is editing Fluxus newspaper, need short pieces, so rush short new pieces to me!!! (like your Sanitas pieces)...We shall also have some 12 exhibits set up - all in Canal Street area...Each area of activity has been subdivided to get things done more actively - in organized manner....Newspaper - Geo. Brecht...."
Letter: George Maciunas to Tomas Schmit, October 21, 1963.

FLUXUS 1963 EDITIONS, AVAILABLE NOW FROM FLUXUS P.O. Box 180, New York 10013, N.Y. or FLUXUS 359 Canal St. New York. C07-9198 ...FLUXUS cc V TRE, monthly newspaper, edited by George Brecht, $6 per year, 80¢ per issue..."
Film Culture No. 30, Fall 1963.

FLUXUS 1963 EDITIONS, AVAILABLE NOW ... FLUXUS cc V TRE, monthly newspaper, edited by George Brecht, $6 per year, 80¢ per issue...Most materials originally intended for Fluxus yearboxes will be included in the FLUXUSccV TRE newspaper

or in individual boxes.
cc V TRE (Fluxus Newspaper No. 1) January 1964.

"We are printing a MONTHLY NEWSPAPER now (edited by new Fluxus Council - Brecht, Dick & Alison Higgins & myself.) I am sending to you a pack of January issues (50 copies) by sea and one by printed-matter air mail. You will note that 1st page is totally anonymous (no "compositions" of any sort - only "ready-mades.") Please distribute it in Germany only, since we are sending separately to all other countries. Send all German contributions to Fluxus P.O. Box 180. OK?"
Letter: George Maciunas to Tomas Schmit, [January 1964].

"Got your virulent letter few days ago. I don't mind it at all. What I mind is sending one like that to George Brecht & calling various compositions (including Brecht essay) - junk. That is a judgement that would be disagreed to by all Fluxus people. Incidentally — I thought your serial poem to be your best work & so does every one else here think. We would be very interested to see some of these student papers & "bier-zeitungen". We will pay for them and for mail costs if you can find at least one copy. (You will get $4 for it). OK? I have no time to answer in detail all your

Collective. Fluxus cc V TRE Fluxus, Fluxus Newspaper No. 1, January, 1964. Page 1

suggestions, except am writing to instruct you not to add any remarks on paper when distributing. Better do NOT DISTRIBUTE PAPER. When you get some money for Brecht boxes mail newspapers (the same roll that you will receive) to Arthur Koepcke, OK? We found another distributor for Germany. We will not send next issues to you since the format has not changed. Your proposals were (unanimously) rejected by the 'council'."
Letter: George Maciunas to Tomas Schmit, February 1, 1964.

FLUXUS 1963 EDITIONS, AVAILABLE NOW ... FLUXUS cc V TRE, monthly newspaper, edited by George Brecht, $6 per year, 80¢ per issue
cc V TRE (Fluxus Newspaper No. 2) February 1964.

FLUXUS 1964 EDITIONS, AVAILABLE NOW ... FLUXUS cc B TRE, monthly newspaper, co-edited by George Brecht & Fluxus Editorial Council $6 per year, 60 cents per single issue.
cc Valise e TRanglE (Fluxus Newspaper No. 3) March 1964.

FLUXKIT containing following fluxus-publications: (also available separately)...FLUXUS cc V TRE newspaper, edited by the Fluxus Editorial Council, each issue 25¢
cc fiVe ThReE (Fluxus Newspaper No. 4) June 1964.

ccV TRE Monthly newspaper, co-edited by GEORGE BRECHT and FLUXUS-Editorial Council, $6 per year. 60¢ per single issue.
European Mail-Orderhouse: europeanfluxshop, Pricelist. [ca. June 1964].

cc V TRE monthly newspaper, edited by Fluxus Editorial Council 25¢ per single issue.
Second Pricelist - European Mail-Orderhouse. [Fall 1964].

FLUXKIT containing following flux-publications: ... all cc V TRE's newspaper by the Fluxus Editorial Council...
ibid.

FLUXKIT containing following fluxus-publications: (also available separately)...FLUXUS cc V TRE newspaper, edited by the Fluxus Editorial Council, past issues, ea. $1, future issues, ea. 25¢
Vacuum TRapEzoid (Fluxus Newspaper No. 5) March 1965.

FLUXKIT containing following fluxus-publications: (also available separately) FLUXUS cc V TRE newspaper, 5 issues, each $1, first 3 issues - out of print
Vaseline sTREet (Fluxus Newspaper No. 8) May 1966.

PROPOSED FLUXSHOW FOR GALLERY 669, LOS ANGELES. OPENING NOV. 26, 1968 ... WALL OF POSTERS, PAST NEWSPAPERS (V TRE), (one of a kind)
Fluxnewsletter, December 2, 1968.

FLUX-PRODUCTS 1961 TO 1969, V TRE FLUX-NEWSPAPERS, V TRE no. 1, Jan. 1964 * [indicated as part of Fluxkit]
Fluxnewsletter, December 2, 1968 (revised March 15, 1969).

FLUX-PRODUCTS 1961 TO 1970, V TRE FLUX-NEWSPAPERS, V TRE no. 1, Jan. 1964
Flux Fest Kit 2. [ca. December 1969].

COMMENTS: *The first of the Fluxus newspapers,* Fluxus cc V TRE Fluxus, *was published in New York, January, 1964. Edited by "George Brecht and the Fluxus Editorial Council" (George Maciunas was certainly a dominant presence of that "council"). It contains works by an international array of artists, breaking away from the more geographical isolation of the planned Fluxus Yearboxes.*
It contains:

page 1

Advertisement:	*"Fluxus 1963 Editions"*
	"Fluxus 1964 Editions"
Announcement:	*"Fluxus Festival in NY March - May [1964]*
Anonymous:	*found texts and images, some of which relate to other Fluxus pieces.*

page 2

George Brecht:	*"Events: scores and other occurrences (Editorial)"*
Tatu Izumi:	*"Events July 7 - 13, 1963... Naigua Gallery"*
Takahisa Kosugi:	*"Chironomy 1"*
Ruth Krauss:	*"Weather"*
Ben Patterson:	*"New York Public Library Event"*
Chieko Shiomi:	*"Mirror"*
Robert Watts:	*"Swimming pool event no. 3"*
pages 2 and 3	
Anonymous:	*found texts and images*
George Brecht:	*"Recipe"*
Congo:	*photo of the artist at work*
Willem de Ridder:	*"Card piece no. 1"*
	"Card piece no. 2"
Carolyn Fozznick:	*"Earthquake Event"*
Dick Higgins:	*"Constellation No. 4"*
	"New Constellation (constellation No. 7)"
	"iv-Two Copper Histories"
	"Music for Stringed Instruments"
	"Non-Performance Pieces from Twenty Sad Stories'" Nos. v; xviii
Alison Knowles:	*"Child Art Piece"*
	"bean" [excerpt from Bean Rolls]
Philip Krumm:	*"List"*
Jackson Mac Low:	*"Piano Suite for David Tudor & John Cage"*
	"Tree Movie"*
Tomas Schmit:	*"Poeme Serielle"*
Daniel Spoerri:	*photo of the artist by Erismann*
Ben Vautier:	*"Time Certificate"*
Emmett Williams:	*"Ten Arrangements for Five Performers"*
	"Voice Piece for La Monte Young"

Advertisement:	An Anthology
	Angus Mac Lise, Year
	Stan Van Der Beek, want ad for used film
Anonymous:	list of names
	found texts and images
Christo:	photograph of "L'Empaquetage D'Edifice Public"
Eugen Gomringer:	"Ping Pong"
Arthur Koepcke:	images
George Maciunas:	reproduction of announcement card for An Anthology
Nam June Paik:	reprint of article about the artist
Jean Tinguely:	photo-portrait by Christer Christian
Bill Wilson:	"Envelope Event"

Fluxus cc V TRE Fluxus
No. 2 February, 1964
Silverman No. 550, ff.

FLUXUS 1963 EDITIONS, AVAILABLE NOW ...
FLUXUS cc V TRE, monthly newspaper, edited by
George Brecht, $6 per year, 80¢ per issue
cc V TRE (Fluxus Newspaper No. 2) February 1964.

FLUXUS 1964 EDITIONS, AVAILABLE NOW ...
FLUXUS cc V TRE, monthly newspaper, co-edited

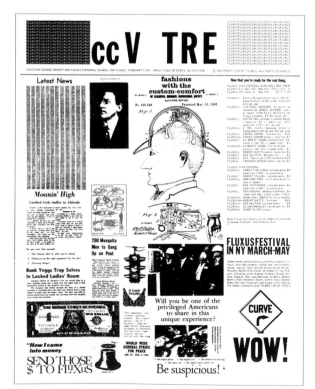

Collective. Fluxus cc V TRE Fluxus. Fluxus Newspaper No. 2,
February 1964. Page 1

by George Brecht & Fluxus Editorial Council $6 per
year, 60 cents per single issue.
cc Valise e TRanglE (Fluxus Newspaper No. 3) March 1964.

FLUXKIT containing following fluxus-publications:
(also available separately)...FLUXUS cc V TRE news-
paper, edited by the Fluxus Editorial Council, each
issue 25¢
cc fiVe ThReE (Fluxus Newspaper No. 4) June 1964.

cc V TRE Monthly newspaper, co-edited by GEORGE
BRECHT and FLUXUS-Editorial Council, $6 per
year. 60¢ per single issue.
*European Mail-Orderhouse: europeanfluxshop, Pricelist.
[ca. June 1964].*

cc V TRE monthly newspaper, edited by Fluxus Edi-
torial Council 25¢ per single issue.
Second Pricelist - European Mail-Orderhouse. [Fall 1964].

FLUXKIT containing following flux-publications: ...
all cc V TRE's newspaper by the Fluxus Editorial
Council...
ibid.

FLUXKIT containing following fluxus-publications:
(also available separately)...FLUXUS cc V TRE news-
paper, edited by the Fluxus Editorial Council, past
issues, ea. $1, future issues, ea. 25¢
Vacuum TRapEzoid (Fluxus Newspaper No. 5) March 1965.

FLUXKIT containing following fluxus-publications:
(also available separately) FLUXUS cc V TRE news-
paper, 5 issues, each $1, first 3 issues - out of print
Vaseline sTREet (Fluxus Newspaper No. 8) May 1966.

PROPOSED FLUXSHOW FOR GALLERY 669, LOS
ANGELES. OPENING NOV. 26, 1968 ... WALL OF
POSTERS, PAST NEWSPAPERS (V TRE), (one of a
kind)
Fluxnewsletter, December 2, 1968.

FLUX-PRODUCTS 1961 TO 1969, V TRE FLUX-
NEWSPAPERS...V TRE no. 2, Feb. 1964 * [indicated
as part of FLUXKIT]
Fluxnewsletter, December 2, 1968 (revised March 15, 1969).

FLUX-PRODUCTS 1961 TO 1970, V TRE FLUX-
NEWSPAPERS, V TRE no. 2, Feb. 1964
Flux Fest Kit 2. [ca. December 1969].

COMMENTS: *The second Fluxus newspaper, Fluxus cc
V TRE Fluxus, was published in New York, February, 1964,
and followed the format of the first, also edited by "George
Brecht and the Fluxus Editorial Council." Again, George
Maciunas' design and editorial presence is strongly felt.
It contains:*
page 1

Advertisement:	*Fluxus 1963 Editions*
	Fluxus 1964 Editions
Announcement:	*Fluxus Festival in NY March-May [1964]*

Anonymous:	*World Wide General Strike for Peace*
[Ruth Krauss]:	*found texts and images*
Robert Watts:	*"This measure..."*
	$ Bill
page 2	
Anonymous:	*found texts and images*
Elaine Bloedow:	*"'I don't know'..."*
George Brecht:	*"Drip Music (Drip Event)"*
	"Piano Piece, 1962"
	"Ten Rules: No Rules (Editorial)"
	"Poem for George Brecht's Dog"
Ray Johnson:	*Anonymous photograph of the artist*
Joe Jones:	*wearing his mechanical monkey hat*
Ruth Krauss:	*"Weather"*
Jackson Mac Low:	*"Punctuation Mark Numbers"*
	"Why did Bodhidharma come..."
[Peter Moore]:	*photograph of George Brecht, Lette Eisenhauer, Alison Knowles, Robert Watts for "Blink" show*
news item:	*"Ray Johnson's photograph..."*
Hans Nordenstroem:	*"Plug-out' motor"*
Benjamin Patterson:	*"Pond"*
Emmett Williams:	*"A German Chamber Opera for 38 Marias"*
La Monte Young:	*"Composition 1961 No. 4, February 9"*
page 3	
Advertisement:	*Yoko Ono "Collection of Works"*
	George Brecht "Relocation"
Anonymous:	*found texts and images*
Dick Higgins:	*"Solo for Brass"*
Alison Knowles:	*2 excerpts from Bean Rolls*
Takehisa Kosugi:	*"Theatre Music"*
Yoko Ono:	*"Instructions for Poem No. 86"*
Benjamin Patterson:	*untitled collage*
Chieko Shiomi:	*"Event for the Midday in the Sunlight"*
Ben Vautier:	*"Coups De Pieds: Creations (1961)"*
	"Terrain Vague"
Robert Watts:	*"Event: 13"*
	"Event: Washroom"
	found text
page 4	
Anonymous:	*found texts and images*
Carol Berge:	*":from a richard maxfield concert: elektrahnik nachtmusick"*
[George Brecht]:	*"Direction"*
Diter Rot:	*Photo by Christer Christian*
Walter De Maria:	*"Portrait of John Cage/Portrait of the School of Cage, caged"*
M. Feldman:	*found cartoon*
Raymond Hains and Jacques de la Villegle:	*photo of a 1950 Decollage*
Jackson Mac Low:	*"One Hundred"*
Diter Rot:	*"Poem Machine"*

Fluxus cc Valise e TRanglE
No. 3 March, 1964
Silverman No. 551, ff.

FLUXUS 1964 EDITIONS, AVAILABLE NOW ...

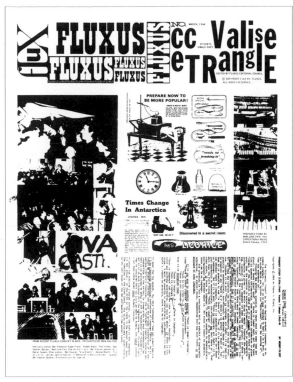

Collective. Fluxus cc Valise e TRanglE, Fluxus Newspaper No. 3, March 1964. Page 1

FLUXUS cc V TRE, monthly newspaper, co-edited by George Brecht & Fluxus Editorial Council $6 per year, 60 cents per single issue.
cc Valise e TRanglE (Fluxus Newspaper No. 3) March 1964.

FLUXKIT containing following fluxus-publications: (also available separately)...FLUXUS cc V TRE newspaper, edited by the Fluxus Editorial Council, each issue 25¢
cc fiVe ThReE (Fluxus Newspaper No. 4) June 1964.

cc V TRE Monthly newspaper, co-edited by GEORGE BRECHT and FLUXUS-Editorial Council, $6 per year. 60¢ per single issue.
European Mail-Orderhouse: europeanfluxshop, Pricelist. [ca. June 1964].

cc V TRE monthly newspaper, edited by Fluxus Editorial Council 25¢ per single issue.
Second Pricelist - European Mail-Orderhouse. [Fall 1964].

FLUXKIT containing following flux-publications: ... all cc V TRE's newspaper by the Fluxus Editorial Council...
ibid.

FLUXKIT containing following fluxus-publications: (also available separately)...FLUXUS cc V TRE news-

paper, edited by the Fluxus Editorial Council, past issues, ea. $1, future issues, ea. 25¢
Vaccum TRapEzoid (Fluxus Newspaper No. 5) March 1965.

FLUXKIT containing following fluxus-publications: (also available separately) FLUXUS cc V TRE newspaper, 5 issues, each $1, first 3 issues - out of print
Vaseline sTREet (Fluxus Newspaper No. 8) May 1966.

PROPOSED FLUXSHOW FOR GALLERY 669, LOS ANGELES. OPENING NOV. 26, 1968 ... WALL OF POSTERS, PAST NEWSPAPERS (V TRE), (one of a kind)
Fluxnewsletter, December 2, 1968.

FLUX-PRODUCTS 1961 TO 1969, V TRE FLUX-NEWSPAPERS...Valise eTRanglE no. 3, Mar. 1964 Flynt, Vautier, Fluxshop & Fluxfest poster, River Wax by George Brecht * [indicated as part of FLUX-KIT]
Fluxnewsletter, December 2, 1968 (revised March 15, 1969).

FLUX-PRODUCTS 1961 TO 1970, V TRE FLUX-NEWSPAPERS...Valise eTRanglE, no. 3, Mar., 1964: Vautier, Flynt, Fluxshop & Fluxfest Poster, River Wax by George Brecht.
Flux Fest Kit 2. [ca. December 1969].

COMMENTS: The third newspaper, Fluxus cc Valise e TRanglE, *New York, March, 1964, was edited by the "Fluxus Editorial Council" with George Brecht contributing a distinct section titled "River Wax." George Maciunas' anonymous editorial presence is felt with the powerful centerfold advertising Fluxus Editions and concerts, and the inclusion on page one of Henry Flynt's landmark "Primary study..." essay. It contains:*

page 1

Anonymous:	*found texts and images*
Henry Flynt:	*"Primary study (1956-1964) version 7 (Winter 1963-64)"*
Nam June Paik:	*photographs of his prepared pianos "from Exposition of Music..."*
Photographs:	*"from recent Fluxus Concert in Nice, presented by Ben Vautier"*

pages 2 and 3

Advertisement:	*"Fluxus 1964 Editions"*
	"Flux Shop & Mail Order Warehouse..." [collaged photo, found texts & images] and photograph of Fluxus Objects
Announcement:	*"12 Fluxus Concerts...at Fluxhall 359 Canal St. New York April 11-May 23, 1964"*

page 3

Announcement:	*Dick Higgins "Lecture Series" New York, April 2 - May 1, 1964*
	"[Fluxus] Street Events" New York, March to May 1964 — Photo ad by George Maciunas of Higgins, Eisenhauer, Filliou, Knowles, Ay-O

page 4

Anonymous:	*found texts and images*

George Brecht:	*"River Wax" includes found texts and images and Heinz Gappmayr's "from 'zeichen'"*
Robert Filliou:	*"Poeme invalide"*
From "Culture" to Veramusement:	*"press release for March-April, 1963" "statement of November 1963" by Henry Flynt 2 photographs of FCTV action*
Heinz Gappmayr:	*see George Brecht: "River Wax"*
Ben Vautier:	*"Holes" from FLUXUS ni [Flux Holes]*
Marian Zazeela:	*"Message"*

Fluxus cc fiVe ThReE
No. 4 June, 1964
Silverman No. 552, ff.

FLUXKIT containing following fluxus-publications: (also available separately)...FLUXUS cc V TRE newspaper, edited by the Fluxus Editorial Council, each issue 25¢
cc fiVe ThReE (Fluxus Newspaper No. 4) June 1964.

cc V TRE Monthly newspaper, co-edited by GEORGE BRECHT and FLUXUS-Editorial Council, $6 per year. 60¢ per single issue.
European Mail-Orderhouse: europeanfluxshop, Pricelist. [ca. June 1964].

Collective. Fluxus cc fiVe ThReE, Fluxus Newspaper No. 4, June, 1964. Page 1

cc V TRE monthly newspaper, edited by Fluxus Editorial Council 25¢ per single issue.
Second Pricelist - European Mail-Orderhouse. [Fall 1964].

FLUXKIT containing following flux-publications: ... all cc V TRE's newspaper by the Fluxus Editorial Council...
ibid.

FLUXKIT containing following fluxus-publications: (also available separately)...FLUXUS cc V TRE newspaper, edited by the Fluxus Editorial Council, past issues, ea. $1, future issues, ea. 25¢
Vacuum TRapEzoid (Fluxus Newspaper No. 5) March 1965.

FLUXKIT containing following fluxus-publications: (also available separately)...FLUXUS cc V TRE newspaper, 5 issues, each $1, first 3 issues - out of print
Vaseline sTREet (Fluxus Newspaper No. 8) May 1966.

PROPOSED FLUXSHOW FOR GALLERY 669, LOS ANGELES. OPENING NOV. 26, 1968 ... WALL OF POSTERS, PAST NEWSPAPERS (V TRE), (one of a kind)
Fluxnewsletter, December 2, 1968.

FLUX-PRODUCTS 1961 TO 1969, V TRE FLUX-NEWSPAPERS...fiVe ThReE, no. 4 June 1964 Nam June Paik, Fluxpage by Bob Watts, Fluxorchestra poster no. 1, fluxfest * [indicated as part of FLUX-KIT]
Fluxnewsletter, December 2, 1968 (revised March 15, 1969).

FLUX-PRODUCTS 1961 TO 1970, V TRE FLUX-NEWSPAPERS...fiVe ThReE, no. 4 June 1964: Nam June Paik, Fluxpage by Bob Watts, Fluxorchestra poster No. 1, fluxfest news.
Flux Fest Kit 2. [ca. December 1969].

COMMENTS: *The fourth Fluxus newspaper,* Fluxus cc fiVe ThReE, *New York, June 1964, was edited by the "Fluxus Editorial Council." George Maciunas clearly designed the newspaper and had a big say in its contents. George Brecht contributed a major essay on Fluxus, which could be considered an editorial. An important innovation of this issue was printing the poster for "Fluxus Symphony Orchestra In Fluxus Concert" which served as an ad for the concert and, by tearing the sheet apart from the first pages, was used as a wall poster. The one printing served two purposes.*
It contains:
page 1

George Brecht:	*"Something About Fluxus"*
George Brecht and Allan Kaprow:	*"Excerpts from a discussion between George Brecht and Allan Kaprow entitled: 'Happenings and Events' Broadcast Sometimes during May"*
Nam June Paik:	*"afterlude to the Exposition of Experimental Television 1963, March. Galerie Parnass."*
page 2	
Robert Watts:	*untitled collage*

page 3

Poster:	*"Fluxus Symphony Orchestra in Fluxus Concert" June 27th at Carnegie Recital Hall. New York.*
page 4	
Advertisement:	*"Flux Shop & Mail Order Warehouse" 359 Canal Street. New York "Flux Horn Handy Order" form "New Fluxus items"*
Peter Moore:	*20 photographs "From Fluxus Concerts in Fluxhall — April & May, part 1" [1964]*

Fluxus Vacuum TRapEzoid No. 5 March, 1965
Silverman No. 557, ff.

"I am making now 5th. Fluxus newspaper with big price list (with photos). Some new items are Chess pieces and musical chairs by Takako Saito. Chess pieces are recognizable by their sound, or weight, or smell, etc. I will mail you a sample...."
Letter: George Maciunas to Willem de Ridder, March 2, 1965.

FLUXKIT containing following fluxus-publications: (also available separately)...FLUXUS cc V TRE newspaper, edited by the Fluxus Editorial Council, past issues, ea. $1, future issues, ea. 25¢
Vacuum TRapEzoid (Fluxus Newspaper No. 5) March 1965.

"...Do you have all Fluxus pieces?? The last Fluxorchestra pieces? Did I send you a newsletter? Let me know, so I can send you all pieces. The last newspaper (which I sent to you) describes several pieces.... Let me know as soon as possible if you have 1965 Fluxpieces."
Letter: George Maciunas to Ben Vautier, March 5, 1966.

FLUXKIT containing following fluxus-publications: (also available separately)...FLUXUS cc V TRE newspaper, 5 issues, each $1, first 3 issues - out of print
Vaseline sTREet (Fluxus Newspaper No. 8) May 1966.

"... I mailed 5 V TRE No. 5 wholesale cost to you 25¢, suggested selling price 50¢. ...Incidently No. 5 newspaper's back page is by George Brecht (he likes anonymity, & calls himself Longazzo."
Letter: George Maciunas to Ken Friedman. August 19, 1966.

flux newspaper $1 no. 5 to 8
Fluxshopnews. [Spring 1967].

PROPOSED FLUXSHOW FOR GALLERY 669, LOS ANGELES. OPENING NOV. 26, 1968 ... WALL OF POSTERS, PAST NEWSPAPERS (V TRE), (one of a kind)
Fluxnewsletter, December 2, 1968.

FLUX-PRODUCTS 1961 TO 1969, V TRE FLUX-NEWSPAPERS...Vacuum TRapEzoid, no. 5 Mar.

Collective. Fluxus Vacuum TRapEzoid. Fluxus Newspaper No. 5. March, 1965. Page 1

1965 Science River Wax page by G. Brecht, Fluxshop catalogue, Fluxfest poster, * [indicated as part of FLUXKIT]
Fluxnewsletter, December 2, 1968 (revised March 15, 1969).

FLUX-PRODUCTS 1961 TO 1970, V TRE FLUX-NEWSPAPERS...Vacuum TRapEzoid, no. 5, Mar. 1965: Science River Wax page by George Brecht, Fluxshop catalogue, Fluxfest poster.
Flux Fest Kit 2. [ca. December 1969].

COMMENTS: *The fifth newspaper,* Fluxus Vacuum TRapEzoid, *New York, March 1965, has no editorial credit, but was edited and designed by George Maciunas with a page given to George Brecht. Continuing a system introduced in the previous newspaper, Maciunas uses an entire page for a dual purpose poster, and another for a catalogue/advertisement for Fluxus Editions.*
It contains:
page 1
Anonymous

[George Maciunas]	*Graphic Cover*
page 2	
poster:	*"Perpetual Fluxfest" at Cinematheque, 85 E. 4th St., NYC*
page 3	
Advertisement:	*for Fluxus Editions at Flux Shop & Mail Order Warehouse*

page 4
"Peter Longazzo"
[George Brecht] *"Science River Wax Science"*

Fluxus Vaudeville TouRnamEnt
No. 6 July, 1965
Silverman No. 561, ff.

"...Do you have all Fluxus pieces?? The last Fluxorchestra pieces? Did I send you a newsletter? Let me know, so I can send you all pieces. The last newspaper (which I sent to you) describes several pieces. Also Vaudeville Tournament newspaper describes last years pieces. Let me know as soon as possible if you have 1965 Fluxpieces."
Letter: George Maciunas to Ben Vautier, March 5, 1966.

FLUXKIT containing following fluxus-publications: (also available separately) FLUXUScc V TRE newspaper, 5 issues, each $1, first 3 issues - out of print
Vaseline sTREet (Fluxus Newspaper No. 8) May 1966.

"I mailed by parcel post...5 VTRE No. 6, wholesale cost to you 25¢ each., suggested selling prices 50¢ ... Also in past newspapers you can read on front pages descriptions of some pieces we performed..."
Letter: George Maciunas to Ken Friedman. August 19, 1966.

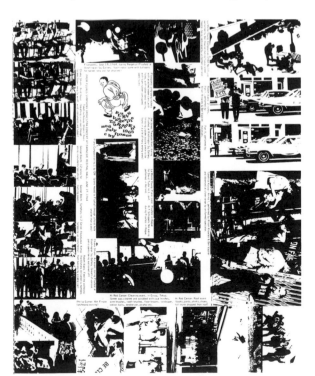

Collective. Fluxus Vaudeville TouRnamEnt, Fluxus Newspaper No. 6, July, 1965. Page 1

flux newspaper $1 no. 5 to 8
Fluxshopnews. [Spring 1967].

PROPOSED FLUXSHOW FOR GALLERY 669, LOS ANGELES. OPENING NOV. 26, 1968... WALL OF POSTERS, PAST NEWSPAPERS (V TRE), (one of a kind)
Fluxnewsletter, December 2, 1968.

FLUX-PRODUCTS 1961 TO 1969, V TRE FLUX - NEWSPAPERS...Vaudeville TouRnamEnt, no. 6 July 1965, Perpetual Fluxfest wheel, Fluxfest news, Fluxorchestra poster no. 2 * [indicated as part of FLUX-KIT]
Fluxnewsletter, December 2, 1968 (revised March 15, 1969).

FLUX-PRODUCTS 1961 TO 1970, V TRE FLUX - NEWSPAPERS...Vaudeville TouRnamEnt, no. 6, July 1965: Perpetual Fluxfest wheel, Fluxfest news, Fluxorchestra poster no. 2
Flux Fest Kit 2. [ca. December 1969].

COMMENTS: Fluxus Vaudeville TouRnamEnt, published in New York, July 1965, was the sixth Fluxus newspaper and by now entirely edited by George Maciunas — anonymously. A propaganda vehicle for Fluxus performance, it contains many photographs of past events and two posters for Events later that year:
It contains:
page 1
photo-documentation
from past Fluxus
performances: *"Fluxus Symphony Orchestra at Carnegie Recital Hall [NY]." June 27, 1964*
 Hi Red Center, "Cleaning event," in Ginza, Tokyo and "Roof event"
 "Perpetual Fluxfest" at Washington Sq. Gallery, New York, 1964...
 "Fluxus Street Events" Canal St., N.Y. May 23, 1964
 Fluxfest in the Hague. June 28, 1963
pages 2 & 3
poster: *"Perpetual Fluxfest at New Cinematheque 85 E 4th St." N.Y.C. Sept-December [1965]*
page 4
poster: *"Flux Orchestra at Carnegie Recital Hall September 25, 1965"*

Fluxus Vague TREasure
* September 1965-1970

FLUX-PROJECTS PLANNED FOR 1967...Collective projects: (All are invited to submit ideas and participate, ideas can be either ready pictorial material or just specified material which we have to find, produce, or obtain otherwise)...V TRE action pages or paper events.
Fluxnewsletter, March 8, 1967.

FLUX-PROJECTS PLANNED FOR 1967...V TRE no. 9 with page event by Eric Andersen...
ibid.

FLUXPROJECTS FOR 1968 (in order of priority)... 14. V TRE issue
Fluxnewsletter, January 31, 1968.

FLUXPROJECTS FOR 1969, PRODUCTS—PUBLICATIONS...V TRE no. 10: Eric Andersen page, announcement for Fluxshop * Fluxfest, Fluxclinic record etc.
Fluxnewsletter, December 2, 1968.

FLUX-PRODUCTS 1961 TO 1969, V TRE FLUX - NEWSPAPERS...Vague TREasure, no. 9 Apr. 1969 Vautier Litany, Filliou autobiography, Ayo's list, Gherasim Lux-litany, Eric Andersen-fluxpage, Fluxclinic record, news of past 3 years, $1
Fluxnewsletter, December 2, 1968 (revised March 15, 1969).

FLUX-PRODUCTS 1961 TO 1970 ... Vague TREasure, no. 9, 1970: Vautier Litany, Filliou autobiography, Ayo's List, Gherasim Luca Litany, Eric Andersen fluxpage, Fluxclinic record, news of past years.
Flux Fest Kit 2. [ca. December 1969].

1970 - Vague TREasure (Vautier Litany, Eric Andersen page, news of past years, etc.)...
Fluxnewsletter, January 8, 1970.

COMMENTS: Fluxus Vague TREasure was originally planned for September, 1965 and was to have been Fluxus Newspaper No. 7. Plans for it continued until 1970, its number changing to 9 and then 10, then back to 9 again. It was never published. The seventh came out in February, 1966 titled Fluxus 3 newspaper eVenTs for the pRicE of $1.

Fluxus 3 newspaper eVents for the pRice of $1
No. 7 February 1, 1966
Silverman No. 568, ff.

"The story about Dick Higgins, is that he is trying to fight me not I - him. Since he started his publishing venture he has tried as hard as he could to duplicate my efforts by asking Fluxus people whom Fluxus publishes to publish with him not me. Now, that is not very ethical. He has so pirated Ben Patterson, Filliou, tried unsuccessfully to pirate Barbara Moore, who is collecting a Flux-cook-book. I don't mind at all when he publishes people like Tomas Schmit, Al Hansen, Ray Johnson, Mac Low, who are not planned for Fluxus publications. There are enough unpublished people around he could use. There is no need for piracy. It is the technique of Wolf Vostell all over again. Now, your sending the 50 different ways to read a page disturbs me just as much as if George Brecht had sent him something. After all, I do not ask on the sly

people like Ray Johnson or Al Hansen to send me things, because I know how Dick Higgins would feel and I have no reason to fight him, or aggravate or sabotage him. I got your material from Kubota for Flux page. I will use it. If you have any other newspaper page ideas - send it. Especially newspaper page-events (like 50 diff. ways to read a page). In other words, not events of something else, but events related to paper page, OK?''
Letter: George Maciunas to Ben Vautier, [ca. Summer 1965].

"...I am just ready to print your 50 cards. They are slightly different...Do you prefer the card version to that of book version? Let me know as soon as possible. I will print in 10 days...(You will have your 50 cards in Flux II)..."
Letter: George Maciunas to Ben Vautier, January 10, 1966.

"...I mailed last V TRE no. 7 about a month ago. But will mail another 50 tomorrow...."
Letter: George Maciunas to Ben Vautier, March 29, 1966.

"You are doing superb FLUXWORK! Paris & Nice concerts sound terrific ... They are described in the V TRE I mailed, same newspaper that has your 50

Collective. Fluxus 3 newspaper eVenTs for the pRicE of $1. Fluxus Newspaper No. 7. February 1. 1966. Page 1

propositions on a page..."
Letter: George Maciunas to Ben Vautier, May 19, 1966.

FLUXKIT containing following fluxus-publications: (also available separately) FLUXUScc V TRE newspaper, 5 issues, each $1, first 3 issues - out of print
Vaseline sTREet (Fluxus Newspaper No. 8) May 1966.

"I mailed by parcel post...5 V TRE No. 7, wholesale cost to you 25¢, suggested selling price 50¢...Also in past V TRE newspapers you can read on front pages descriptions of some pieces we performed..."
Letter: George Maciunas to Ken Friedman, August 19, 1966.

PAST FLUX-PROJECTS (realized in 1966) 3 newspaper eVenTs for the pRicE of $1 (V TRE no. 7) Newspaper events by: Yoko Ono, Ben Vautier, J. Riddle...
Fluxnewsletter, March 8, 1967.

flux newspaper $1 no. 5 to 8
Fluxshopnews. [ca. Spring 1967].

PROPOSED FLUXSHOW FOR GALLERY 669, LOS ANGELES. OPENING NOV. 26, 1968 ... WALL OF POSTERS, PAST NEWSPAPERS (V TRE), (one of a kind)
Fluxnewsletter, December 2, 1968.

FLUX-PRODUCTS 1961 TO 1969, V TRE FLUX-NEWSPAPERS...3 newspaper eVenTs for the pRicE of $1, no. 7, Feb. 1966. Fluxorchestra news, Do it yourself dance series by Yoko Ono & Co. One hour by Jim Riddle, 58 propositions for one page by Ben Vautier * [indicated as part of FLUXKIT]
Fluxnewsletter, December 2, 1968 (revised March 15, 1969).

FLUX-PRODUCTS 1961 TO 1970, V TRE FLUX-NEWSPAPERS...3 newspaper eVenTs for the pRicE of $1, no. 7 Feb. 1966: Fluxorchestra news, Do it yourself dance series by Yoko Ono & Co. One hour by Jim Riddle, 58 Propositions for one page by Ben Vautier.
Flux Fest Kit 2. [ca. December 1969].

COMMENTS: *Fluxus Newspaper No. 7,* Flux 3 newspaper eVenTs for the pRicE of $1, *New York, February 1, 1966, was the most innovative of all the Fluxus newspapers. George Maciunas, its editor and designer, invited Fluxus artists to devise events for the page — that is, not just reproducing a pre-existing collage or whatever, but, as he wrote in a letter to Ben Vautier, "events related to paper page." Maciunas had the printer produce both the newspaper version and each page separately on white sheets of stiff card stock, enabling him to cut the works into cards to box as three separate editions.*
It contains:
page 1
Photographs

4 photographs of Shigeko Kubota performing "Vagina Painting."
16 photographs "from Fluxorchestra

Concert at Carnegie Recital Hall" New York, 1965
page 2
Yoko Ono Do It Yourself Fluxfest
page 3
Ben Vautier Fifty eight Propositions For One Page
page 4
Jim Riddle One Hour

Fluxus Vaseline sTREet No. 8 May, 1966
Silverman No. 569, ff.

"I mailed by parcel post — one carton with following: ...5 V TRE No. 8 Free..."
Letter: George Maciunas to Ken Friedman, August 19, 1966.

FLUXKIT containing following fluxus-publications: (also available separately) FLUXUScc V TRE newspaper, 5 issues, each $1, first 3 issues - out of print
Vaseline sTREet (Fluxus Newspaper No. 8) May 1966.

PAST FLUX PROJECTS (realized in 1966)...Vaseline sTREet (V TRE no. 8) Newspaper event (action page) by Wolf Vostell.
Fluxnewsletter, March 8, 1967.

Collective. Fluxus Vaseline sTREet. Fluxus Newspaper No. 8. May. 1966. Page 1

flux newspaper $1 no. 5 to 8
Fluxshopnews. [Spring 1967].

PROPOSED FLUXSHOW FOR GALLERY 669, LOS ANGELES. OPENING NOV. 26, 1968...WALL OF POSTERS, PAST NEWSPAPERS (V TRE), (one of a kind)
Fluxnewsletter, December 2, 1968.

FLUX-PRODUCTS 1961 TO 1969, V TRE FLUX-NEWSPAPERS...Vaseline sTREet, no. 8 May 1966 Waldorf Astoria Hotel event, action page by Wolf Vostell, Fluxshop list no. 2 * [indicated as part of FLUXKIT]
Fluxnewsletter, December 2, 1968 (revised March 15, 1969).

FLUX-PRODUCTS 1961 TO 1970, V TRE FLUX-NEWSPAPERS...Vaseline sTREet, no. 8, May 1966: Waldorf Astoria Hotel Event, action page by Wolf Vostell, Fluxshop list no. 2
Flux Fest Kit 2. [ca. December 1969].

"...Today I am sending package of printed material — from last 2 years — read it carefully — some are duplicates. I am mailing — ... V TRE no. 8 — many photos...."
Letter: George Maciunas to Ben Vautier, November 9, 1971.

COMMENTS: *Fluxus Newspaper No. 8, Fluxus Vaseline sTREet, New York, May, 1966, continues a format Maciunas used in previous newspapers — with posters, an "action page" by a Fluxus artist, and a catalogue of Fluxus Editions. It contains:*

page 1	
poster	*"Flux fest presents Hi Red Center Street Cleaning event at Grand Army Plaza 58th St. & 5th Av." N.Y. June 11th (raindate June 25th)1966*
page 2	
poster	*"Fluxfest presents Hi Red Center Hotel Event at Waldorf Astoria 50 & Park" N.Y. [June 11, 1966]*
page 3	
Wolf Vostell	Yellow Pages or An Action Page
page 4	
Advertisement	*Fluxshop price list of Fluxus Editions*

[Fluxus] VerTical pRaguE
* 1966-June 1970

"...Incidentally, our next issue of V-TRE newspaper will be devoted in its entirety to Czech composition. It will be titled VerTical pRaguE. Maybe we should hold-up this issue till your arrival, so that you could edit it yourself..."
Letter: George Maciunas to Milan Knizak, [ca. January 1966].

"...As regards special Fluxus V TRE newspaper issue on Prague-Fluxus, it may be best to wait until you

are able to come to New York..."
Letter: George Maciunas to Milan Knizak, January 30, 1967.

FLUX-PROJECTS PLANNED FOR 1967...V TRE no. 10, special Czech issue, edited by Milan Knizak
Fluxnewsletter, March 8, 1967.

Milan Knizak:...also special V TRE issue
ibid.

FLUXPROJECTS FOR 1969, PRODUCTS-PUBLICATIONS...Milan Knizak, V TRE issues no. 9 (Jan.)
Fluxnewsletter, December 2, 1968.

FLUX-PRODUCTS 1961 TO 1969, V TRE FLUX-NEWSPAPERS...Viscous TRumpEt, no. 10 June 1969 special issue by Milan Knizak $1
Fluxnewsletter, December 2, 1968 (revised March 15, 1969).

COMMENTS: *Fluxus VerTical pRaguE, planned between 1966 and 1969, was never published. It was to have been a special issue on the activities of the Czechoslovakian artist group, Aktual and edited by Milan Knizak, the Fluxus artist and one of the originators of Aktual. The newspaper would have been modeled on the contents of Hi Red Center's Bundle of Events. see Milan Knizak; Complete Works.*

Fluxus VauTieR nicE
* 1967

FLUX-PROJECTS PLANNED FOR 1967 ... Ben Vautier:...special issue of V TRE...
Fluxnewsletter, March 8, 1967.

COMMENTS: *Fluxus VauTieR nicE was never published. The title used here is conjecture. The issue would have focused on Ben Vautier, the Group de Nice, and their Fluxus activities. The publication would have been modeled on the contents of Hi Red Center's, Bundle of Events, although certainly formated differently. George Maciunas greatly admired Vautier, and had also planned to publish his complete works as a Fluxus Edition.*

JOHN YOKO & FLUX all photographs copyright nineteen seVenty by peTer mooRE
No. 9 1970
Silverman No. 592, ff.

COMMENTS: *Fluxus Newspaper No. 9 (misnumbered 8) consists entirely of photographs by Peter Moore, with a 2-sided insert identifying the contents. It contains:*

page 1	*"Fluxfest Presentation of John Lennon & Yoko Ono +*" at 80 Wooster St. New York — 1970*
page 2	- as above -
page 3	- as above -
	"Flux-Mass" at Douglass College. February 17, 1970
	"Flux-Sports" at Douglass College

Collective. JOHN YOKO & FLUX all photographs copyright nineteen seVenty by peTer mooRE, Fluxus Newspaper No. 9, 1970. Page 1 and the title page insert detail (enlarged)

no.8 all photographs copyright nineteen seVenty by PeTer MooRE

FLUXFEST PRESENTATION OF JOHN LENNON & YOKO ONO + *
AT 80 WOOSTER ST. NEW YORK – 1970

OPENING: APR.11, 4PM. *COME IMPERSONATING JOHN & YOKO* (Photo-masks were provided) GRAPEFRUIT FLUX-BANQUET

APR.11–17: DO IT YOURSELF – BY JOHN & YOKO + EVERYBODY

1,2	*Draw Circle painting (Yoko Ono '64)*
3,4,5	*Do It Yourself painting (Yoko Ono)*
6	*Flux-egg (George Maciunas '70)* egg filled with paint & thrown against wall
7,8	*Painting to be stepped on (Yoko Ono '61)* ink pad as door mat
9	*Kitchen Piece (Yoko Ono '60)* painting to wipe floor and street with
10	Jonas Mekas filming GRAPEFRUIT FLUX-BANQUET
11-14	*Grapefruit delivery event (Yoko Ono & John Lennon '70)*
15	John Lennon mask
16	left to right: George Maciunas, Emmett Williams, Alison Knowles
17	stuffed grapefruit, grapefruit mashed potatoes by Bici & Geoff Hendricks
18	grapefruit drink by Hala Pietkiewicz
19	grapefruit dumplings by G.Maciunas, grapefruit hors d'oeuvre, soup
20	*Painting to hammer a nail (Yoko Ono)* in background
21	*2 Eggs (John Lennon)* at right, grapefruit flower in center
22	Yoko Ono mask
23	stuffed grapefruit
24	grapefruit wine by G.Maciunas
25	APR.18–24: TICKETS BY JOHN LENNON + FLUXTOURS

100 tickets to same numbered seat, same day show *(Ben Vautier)*
Audience piece no.5 (Ben Vautier) tickets to locked up theatre
One way trip to Wharton Tract, N.J. *(Tomas Schmit)* out 8hrs. by foot
Unauthorized tickets to visit famous people *(Yoshimasa Wada)*
tickets to visit Lauren Bacall through stage door of Palace theater

page 4 *"Fluxfest Presentation of John Lennon & Yoko Ono +*"*
"New Years Eve's Flux-fest," 80 Wooster St. New York, December 31, 1969

Flux amusement center V TRE
* 1973

This Fall, we shall publish V TRE no. 10, which shall consist of a plan for Flux-Amusement-Center, to contain the following:

a) Fluxtoilet (variations on toilet flushing, seats, stall doors, sinks, mirrors, toilet paper, towels)

b) Vending machines, drink, food, nut type dispensers (dispensing glue, endless string, holy relics, drink before cup, or perforated cup, eir [sic] etc.)

c) Stamp, postcard machines, coin operated game machines (pin-ball, target, driving test, etc)

d) weighing machines, photo machine, movie (loop) machine, juke box, etc.

e) film-environment with sound, (capsule having related films projected on 4 walls, floor and ceiling)

f) Joe Jones instrument machines,

g) Ben Vautier's suicide room

h) Ayo's floor obstacles (foam, mirror, upright nails, steep slopes, water, tunnel, trap doors, rainfall, wood blocks, etc.—

i) Bill Tarr's closets for people (being inundated in ping-pong balls, being pressed by growing air bag, or lowered ceiling, etc.)

j) Clinic and test room (must be familiar to all by now)

k) Athletics, games, vehicles, rides: (swing tournament, ping-pong variations, hot cockles, dart target, chess variations, and any other game not requiring large space for its performance.

Any suggestions for listed categories or new ones, written or drawn, should be forwarded to George Maciunas not later than July 4th,...
Fluxnewsletter, April 1973.

COMMENTS: Planned as Fluxus Newspaper No. 10 for Fall, 1973, the issue was never published. It would have been a compilation of ideas similar to Flux Fest Kit 2. George Maciunas' concept of an exhibition was consistently that of an amusement center, from his first Fluxus show in the kitchen of the Galerie Parnass in 1963, to the Fluxfest at and/or, Seattle, 1977. More plans for an amusement center are described in Flux Amusement Center.

FLUXUS maciuNAS V TRE FLUXUS laudatio ScriPTa pro GEoRge
No. 10 May 2, 1976
Silverman No. 603, ff.

COMMENTS: *Fluxus Newspaper No. 10,* Fluxus maciuNAS

V TRE FLUXUS laudatio ScriPTa pro GEoRge *came about at the suggestion of George Brecht. He, Geoffrey Hendricks and several other Fluxus artists were organizing a Festschrift to honor George Maciunas, which included original contributions for a collective box,* Laudatio Scripta Pro George. *Robert Watts and Sara Seagull were given these contributions to reproduce, from which they edited and designed a newspaper published in time for the Festschrift in New York, May 2, 1976. Geoffrey Hendricks served as producer of both the box and the newspaper.*
It contains:

page 1
Anonymous *"No Smoking"* collage
Ay-O *"A Poem for George Maciunas"*
Henry Flynt *"The Politics of 'Native' or Ethnic Music"*

Dick Higgins *"Piece for Maciunas"*
Alice Hutchins *"Bicentennial Magnetic Flux"*
Alison Knowles *"Aroostook Bush Lima, single specimen"*

Larry Miller *"Outer Space Sign"*
Yasunao Tone *"Container for used sandpaper"*
Wolf Vostell *"Please kiss Maciunas..."* telegram
pages 2 & 3
Anonymous
[Robert Watts] *"The Septic Tank News"*
George Brecht *"A Physiochemical Analysis of Maciunas"*

Collective. FLUXUS maciuNAS V TRE FLUXUS laudatio scriPTa pro GEoRge, Fluxus Newspaper No. 10, May 2, 1976. Page 1

page 4
Anonymous newspaper clipping
Joseph Beuys cryptographic letter on *"Organization fuer Direkte Demokratie ..."* stationery
Geoffrey Hendricks *"Twenty-Eight Tasks for George Maciunas"*
Larry Miller *"1957 Cadillac Bumper-Bra"*
Peter Moore *"Outline of Peter Moore's Polaroid photo of all the Particpants [sic] present May 2, 1976"*
Nam June Paik *"Fluxus is Mainliner"*
Takako Saito *"If you want a Talking Machine"*
Mieko Shiomi *"Fantastic event for George Maciunas"*
Daniel Spoerri *"My laudatio for George will appear in AQ..."* postcard

a V TRE EXTRA
No. 11 March 24, 1979
Silverman No. 608, ff.

COMMENTS: *A VTRE EXTRA was edited by the "Fluxus Editorial Council," in this case, it was Geoffrey Hendricks who initiated the project and actually edited it. Sara Seagull was its designer. The newspaper is a posthumus tribute to George Maciunas. Numbered 11, it can be considered the final Fluxus newspaper.*
It contains:

page 1
Anonymous *"Maciunas Dies"* photomontage and altered texts
page 2
Anonymous *"California Posse Hunts Woman Reported Carried Off by 'Big Foot'"*
 "Cook Meets Untimely Death" photomontage
 "Man Gives Birth to Gorilla Twins"
 "Mysterious Telegram Received"
 "Paik Fluxfire"
 "Philadephia Court Voids Maciunas Terms"
Colophon
Larry Miller *"from an interview with George Maciunas March 24, 1978"*
Peter Moore Photograph of George Maciunas
Robert Watts *"George Maciunas: Life Span Data"* with a *"correction"* insert
page 3
Henry Flynt *"George Maciunas and My Work With Him"*
Camille Gordon
[Dick Higgins] *"George Maciunas Retired Train Conductor,"* altered obituary
Peter Moore photograph of George Maciunas
Wolf Vostell *"Musica Morta"*
page 4
Mieko Shiomi *"The Last Event For George in Another World"*
Ben Vautier *"Fill up some names and place the arrows"* photomontage
Yoshimasa Wada *"...The Death of Culture..."*

a V TRE EXTRA

No. 11 | COPYRIGHT **1979** by the FLUXUS Editorial Council | *Unsettled* | Saturday, March 24, 1979 | TV Page 18 | $2.00

Hart attack kills him at summer palace

MACI UNAS DIES

George Maciunas in one of his many disguises to elude the Attorney General.

Flux Pope George Maciunas died last year after collapsing with a heart attack at his summer palace in New Marlborough. Earlier doctors fought to save the 92 years old spinster after being beaten and gang raped. He was given the last rites and the Flux Council appealed for world-wide prayers for his life.

'With deep anguish' Sobbing aide breaks news to the world

Collective. α V TRE EXTRA, Fluxus Newspaper No. 11, March 24, 1979. Page 1

FLUXUS PREVIEW REVIEW

Silverman No. 542, ff.

"...Enclosed many things etc. etc....enclosed [Vautier's] kick in the pants piece — please type it with margin (standard) & send me back (also Alison's, Mekas & JML short pieces.) OK? So I will have complete text for prospectus. Oh yes, need for prospectus the editorial board text spaced differently. As it is, it does not fit. So can you type it without any spaces between the lines...."
Letter: George Maciunas to Tomas Schmit, [between May 15 - 26, 1963].

"...Also enclosed a last batch of compositions for the prospectus. I will print foto of a poem of yours, so write titles of them all, so I can choose. OK? This prospectus should be good enough to sell for $.25 or so. Like miniature fluxus magazine ... I will write

Eric Andersen, April 1963
Sit down during Dec. 11, 1963 from 7 PM to 8.03 PM (Danish time) and think about the people over the whole world, who may be performing this composition.

WORD EVENT

● EXIT

G. Brecht
Spring, 1961

John D. Cale: from Outdoor pieces for Robin Page, Summer 62
2. Make love to a piano without arms.
8. Follow the wind and listen to it.

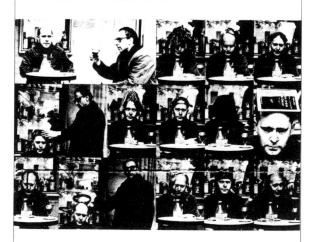

Robert Filliou: 13 Facons d'Employer le Crane de Emmett Williams, 1963

Dick Higgins: Danger Music No. 28, Koeln 2/10/63.
Not-smile for some days.

Collective. **FLUXUS PREVIEW REVIEW.** Detail of the publication

again when I find I need something, some text for Prospectus...."
Letter: George Maciunas to Tomas Schmit, May 26, 1963.

"In 10 days I will mail several copies of the new Fluxus prospectus — which includes past press reviews, photos of performances, several short fluxus compositions (including your own — kick in the posterior certificate), plus Fluxus schedule of publications and the make-up of the committee — a separate prospectus together with your own materials & tracts for press releases. I will bring about 1000 of these prospectuses with me (they are like posters & can be pasted about the town)...."
Letter: George Maciunas to Ben Vautier, [late May or early June, 1963].

"...I will take some...2000 prospectuses...London, Amsterdam, Paris, Nice, Florence. 400 prospectuses in each. This will be quite a load to dispose..."
Letter: George Maciunas to Tomas Schmit, June 1, 1963.

"...It would have been better to have Amsterdam on 29th. & Hague on 30th so that I would have Fluxus with me for sure, but it's OK. to have Amsterdam on June 23 & Haag on 30th. I will have prospectus,..."
Letter: George Maciunas to Tomas Schmit, [early June 1963].

"...I will stay in Wiesbaden till Printer completes... prospectus...(2 printers are working now). They should have it completed by June 15...Question — please let me know whether you can come to pick Citroen on say June 7th? I can give Fluxus prospectuses then..."
Letter: George Maciunas to Tomas Schmit, [before June 8 1963].

"...photos of all your poems came out VERY WELL! Even poem VII which was difficult to photograph.... So I will have both poems printed VI & VII in newspaper-preview-prospectus...Let me know your address in Amsterdam so I can mail some prospectuses. I will bring many prospectuses...on 21 June. —OK?..."
Letter: George Maciunas to Tomas Schmit, [mid June 1963].

"...Could you write letters to: F.Becker & Co. Wiesbaden - Biebrich, Wiesbadenerstr. 43. Asking them in my name (sign for me) to print all matters that I have requested for July 16th. plus...1000 of the prospectus: long on kunstdruckpapier and also the one on zeitungspapier. (the item of Rechnung Nr. 23-822, 3 & 4) Ask them to glue the 3 kunstdruckpapier sheets into long strip and the 2 Zeitungspapier also into one long strip..."
Letter: George Maciunas to Tomas Schmit, [end of June beginning of July 1963].

"...Go to the Becker printer & pick up...Long prospectuses. (Printer should paste them up. Take 400 to Nice...Leave in Paris all prospectuses...if you can't fit them though it would be good to have them..."
Letter: George Maciunas to Tomas Schmit, [ca. 2nd week of July 1963].

"...could you prepare a dozen or so Fluxus long rolls. (paste them carefully! straight!) maybe some Koeln printer can do them for you quickly. & send a few out. (as drucksache by boat to few N.Y. people: Higgins, Flynt, Mac Low, Brecht, La Monte, Watts, Mekas, etc.)...Send them this way: take small, narrow roll & wrap it in wide-newsprint roll then paste edge on itself, so that when they get it they will just read headline: Politiken, they will think it is just wrapping paper and cut it or rip, when cut they will have the wide roll in 100 pieces, nice? So do it like this...."
Letter: George Maciunas to Tomas Schmit, [August 1963].

"...Send...Fluxus roll (preview) to J.P. Wilhelm OK? Did you take Fluxus rolls to Copenhagen when you went there??? Otherwise some must be mailed to them..."
Letter: George Maciunas to Tomas Schmit, [end of August/ early September, 1963].

"...Have you distributed in Copenhagen the Fluxus rolls?... & few rolls to J.P. Wilhelm? These are things you could do for Fluxus in your spare time (after you have done your 8 hrs work or study). OK?..."
Letter: George Maciunas to Tomas Schmit, November 8, 1963.

"...Did you try to sell things I sent you?...Fluxus rolls...????? I will send you many new things we printed IF you can sell or sold or are selling the things you have...You have...big choice for theatre performances..."
Letter: George Maciunas to Willem de Ridder, December 20, 1963.

"...Answers to your specific questions:
1. your most recent card — inserting fluxus-review-preview roll into Decollage 4 could be done ONLY if it is done as advertisement or as a separate item not put inside book but outside (maybe used as wrapper). It could not be included as part of book since the roll was copyrighted & that would be illegal. But your statement that it is the 'best and only way to get the 850 copies off' is at best ambiguous. Did you distribute the rolls to the audiences in Amsterdam & Copenhagen?????!! I can't believe that you did not (that would be sabotage on your part) so I assume that you did, since you are still part of Fluxus and not cast-out by any means. The reason I don't think including Fluxus

roll in Decollage is good idea is that our mailing lists are very similar (in fact I have Vostell's list) & it would be a waste to mail to same people 2 rolls. So my advice is: DO NOT INCLUDE FLUXUS ROLL IN DECOLLAGE!...Instructions. (VERY IMPORTANT)...would you please...mail the following quantities:...100 Fluxus rolls (rolled) to Gallerie Parnass...500 Fluxus rolls (glued in strips but not rolled) to: Gallery One...one roll to each [11 names]...200 rolls to Karl-Erik-Welin —...and 20 rolls to each: Galerie Niepel,...Galerie Schmela ...That will relieve you of 800 rolls..."
Letter: George Maciunas to Tomas Schmit, [January 1964].

COMMENTS: *Fluxus Preview Review, a preview of the "Review" (Anthology) Fluxus, served as a kind of first Fluxus newspaper and propaganda vehicle. It contains a definition of the word FLUXUS, a list of the Editorial committee, advertisements for Fluxus Yearboxes and Fluxus product, scores by a number of Fluxus artists and photographs of performances. George Maciunas, who edited and designed the work, took its format from the November 1961 publication Kalender Rolle, edited by Ebeling and Dietrich in Wuppertal, West Germany.*

FLUXUS ROLL see:
FLUXUS PREVIEW REVIEW
FLUXUS 2ND YEARBOX see:
FLUX YEAR BOX 2
Fluxus 3 newspaper eVenTs for the pRicE of $1 see:
FLUXUS NEWSPAPERS
Fluxus Vacuum TRapEzoid see:
FLUXUS NEWSPAPERS
Fluxus Vague TREasure see:
FLUXUS NEWSPAPERS
Fluxus Vaseline sTREet see:
FLUXUS NEWSPAPERS
Fluxus Vaudeville TouRnamEnt see:
FLUXUS NEWSPAPERS
Fluxus VauTieR nicE see:
FLUXUS NEWSPAPERS
[Fluxus] VerTical pRaguE see:
FLUXUS NEWSPAPERS
FLUXUS YEARBOOK-BOX NO. 1 U.S. see:
FLUXUS 1

FLUXUS YEARBOXES

COMMENTS: *In 1961 George Maciunas started to design and produce* An Anthology, *a remarkable collection of very new work that La Monte Young had edited and eventually published in 1963. It was Young's idea of anthology that was the catalyst for Maciunas' ambitious plans for a series of Fluxus anthologies or yearboxes. He initially planned six, then seven: American; Northern European; Japanese; Homage to the Past;*

Southern European; Eastern European; and Homage to Dada, dividing the world, past and present, into centers of like experimental activity.

Only the first, FLUXUS 1, was completed, and though dominated by American Fluxus, contains works by European and Japanese Fluxus artists as well. With the production of individual Fluxus editions starting in 1963, the character and interests of the movement shifted away from ideas that would have fit into a yearbox as envisioned for the first seven. In 1965, Maciunas started work on Flux Year Box 2, which was a reflection of this change in Fluxus. Years later, Maciunas produced the material for Fluxpack 3 which was conceived initially as Flux Year Box 3. Had that sold successfully, a Fluxpack 4 was contemplated.

The idea of yearboxes derives from Almanacs popular in the first part of the 20th century. Richard Huelsenbeck's Dada Almanach is an example. These works served as moderately priced anthologies of a movement's current work, requiring more preparation than a newspaper or magazine, but less than the expensive and complex portfolio anthologies.

In the first three tentative plans for Fluxus Yearboxes, George Maciunas used the following definition of Fluxus as a manifesto for the movement:

FLUXUS
1. To purge. A fluid discharge, esp. an excessive discharge, from the bowels or other part.
2. A continuous moving on or passing, as of a flowing stream,
3. a stream; copious flow,
4. the setting of the tide toward the shore,
5. Any substance or mixture, as silicates, limestone, and fluorite, used to promote fusion, esp. the fusion of metals or minerals.

Then, in Fluxus Newsletter No. 1, Maciunas put forward a specific description of the seven planned Fluxus Yearboxes:

FLUXUS YEARBOOK-BOX

Enclosed is the latest plan for the forthcoming issues of Fluxus. Please note revised contents and revised list of co-editors.
1. It was decided to utilize instead of covers a flat box to contain the contents so as to permit inclusion of many loose items: records, films, "poor man's films-flip books", "original art", metal, plastic, wood objects, scraps of paper, clippings, junk, raggs. Any composition or work that cannot be reproduced in standard sheet form or cannot be reproduced at all.
2. Fluxus will be issued in 2 editions.
 a) 1000 copies of standard edition which will contain only reproducible sheet or printable matter. This will consist of some 150 8" x 8" bound pages and 12 loose sheets, fold outs or boards and will sell for $4.00 or its equivalent.
 b) 200 copies of luxus-fluxus, which in addition of standard edition will contain several original solid-nonreproducible works: films, pieces of 2 dimensional or 3 dimensional art, "ready-mades"

"found objects", junk, records. This edition will sell for $8.00 to $10.00 depending on quantity of non-reproducible matter or solids.

3. Those recipients who have not been formally invited to submit for the fluxus-year-box:

a) critical or noncritical, rational or irrational essays, and/or literal compositions — letters, notes, statements, prose, poetry etc.

b) news items regarding art or non-art events of interest (festivals, exhibits, publications, scandals, revolutions etc.)

c) compositions: scores, instructions or magnetic tape for reproduction into records

d) visual compositions for reproduction: drawings, collages, photographs, reliefs for vacuum formed plastic, perforated sheets for die cutting etc. or

e) 200 original aural, visual or literary compositions: solid objects, scraps, collages, smears, junk, garbage, rags, ready-makes [sic], found objects etc. These can be either whole objects or an object (like a flat painting) cut to 200 parts.

f) kinetic compositions: whole films or parts, series of photographic prints (of at least 100 successive frames) to be printed into flip-books or "poor mans movie". Original drawings for flip books. Instructions for happenings, film or photo essay of happenings, original "equipment" for happenings (200 or them) etc.

4. All co-editors are urged to submit proposed contents and plans as soon as possible but not later than August 1 (for all 7 issues) since contents' plan of all 7 issues will be included in the 1st. issue and a prospectus of same date. The proposed materials by co-editors themselves and contributors personally known to them should be submitted by the schedule. Materials from contributors, whose addresses are known to us can be requested and obtained directly by us if the co-editors so desire.

5. Please send with every material submitted for Fluxus, especially that of a co-editor, a photograph or drawing of the person submitting, or representative substitute if so desired.

6. Publication of issues no. 1 and 2 have been delayed due to:

a) very late receipt of materials from contributors.

b) extremely high printing costs here in Germany

c) acquisition by us for long range economy of an offset printing press by July, which will be utilized for printing all Fluxus issues, festival programs and individual publications such as collections of prose, poetry, music scores, graphs etc.

The remaining information regarding the schedules for each issue can be found listed in each yearbox.

Then in the two Brochure Prospectuses for Fluxus Yearboxes, Maciunas publicly characterized the contents for the series:

Anti art	*Happenings*
Concept art	*Theatre*
Indeterminacy	*Prose*
Dada	*Poetry*

Brutalism	*Philosophy*
Automatism	*Plastic arts*
Bruitisme	*Music*
Concretism	*Dance*
Lettrism	*Cinema*
Nihilism	

and reproduced a different dictionery definition of Fluxus:

We have grouped all of the Fluxus yearboxes into this section. They are listed successively so that their development might be studied.

FLUXUS 1
FLUXUS NO. 2 WEST EUROPEAN YEARBOX I
FLUXUS NO. 3 JAPANESE YEARBOX
FLUXUS NO. 4 HOMAGE TO THE PAST
FLUXUS NO. 5 WEST EUROPEAN YEARBOX II
FLUXUS NO. 6 EAST EUROPEAN YEARBOX
FLUXUS NO. 7 HOMAGE TO DADA
FLUX YEAR BOX 2
FLUXPACK 3

FLUXUS 1
Silverman Nos. 117, ff. and 119, ff.

FLUXUS...NO.1 U.S. ISSUE, English edition only. Feb.1962

SCOTT HYDE

Collective. Mask used for rubberstamping the cover of some FLUXUS 1s

Essays:

George Brecht	Events
''	Experiences, Fixations, Focus
Joseph Byrd	Modern Music and the Emotion Aesthetic.
Walter De Maria	*
''	*
Henry A.Flynt, jr	The Exploitation of Cultural Revolutionaries in Present Societies.
Philip Corner	Projections of Indeterminacy.
Dick Higgins	Some Thoughts on Politics in Art.
R. Maxfield	Music without Score.
Jonas Mekas	Experiments in cinema - U.S.A.
'' ed.	Anthology of statements.
Robert Morris	Environments or *
Simone Morris	Dance constructions or *
A.Kaprow	Historical precedents of "Environment-happenings" or *
La Monte Young	*
George Maciunas	The grand fakers of architecture: M.v.d. Rohe, Saarinen, Bunshaft, F.L.Wright.
all editors	Atlas-index of new art, music, literature, cinema, dance in U.S.

Anthology:

George Brecht	6 Exhibits, 3 Telephone Events
Philip Corner	Chirographic...(score)
L.Dlugoszewski	Glass Identity (score)
Dick Higgins	*
Alison Knowles	a glove
Jackson Mac Low	Letters for Iris Numbers for silence and *
R.Maxfield	*(record)
* to be determined	

...

EDITORS:

Publisher & editor-in-chief: George Maciunas

U.S. SECTION:

Walter De Maria - art, sculpture
Jackson Mac Low - poetry
Dick Higgins - happenings, theatre, politics
Philip Corner - music
Simone Morris - dance
Jonas Mekas - cinema

...

CANADIAN SECTION:
Pierre Mercure
HEADQUARTERS: FLUXUS, J.S. Bach Strasse, Wiesbaden, West Germany

Fluxus... Tentative Plan for Contents of the First 6 issues. [before February 1962]. version A

FLUXUS...NO. 1 U.S. YEARBOOK, English and German editions, Feb.1962

George Brecht	Events: scores and other occurrences.
Joseph Byrd	Modern Music and the Emotion Aesthetic.

Philip Corner	Projections of Indeterminacy - **
Walter de Maria	
L.Dlugoszewski	Is Music Sound?
Henry A. Flynt, jr.	The Exploitation of Cultural Revolutionaries in Present Societies.
	Some Thoughts on Politics in Art. *
Dick Higgins	
A.Kaprow	
George Maciunas	The grand frauds of architecture: M.v.d. Rohe, Saarinen, Bunshaft, F.L.Wright.
R.Maxfield	Music without Score.
Jonas Mekas	Experiments in cinema - U.S.A.
" ed.	Anthology of statements.
Robert Morris	Environments, happenings or *
Simone Morris	Dance constructions or *
La Monte Young	*
all editors	Atlas - index of new art, music, literature, cinema and dance in U.S.

Anthology:

George Brecht	6 Exhibits, 3 Telephone Events (inserts)
Philip Corner	Chirographic...(score fold out)
L. Dlugoszewski	Glass Identity (score)
Dick Higgins	Inroads Rebuff'd & At Least Two Events for One or More Performers.
Alison Knowles	a glove (insert)
Jackson Mac Low	Letters for Iris Numbers for silence and *(card)
R.Maxfield	Night Music (?)* (record)
La Monte Young	*

Walter De Maria *
others to be determined
*to be determined
...
EDITORIAL COMMITTEE:
Chairman: George Maciunas

U.S. SECTION:

Walter De Maria - art, sculpture
Jackson Mac Low - poetry
Dick Higgins - happenings, theatre, politics
Philip Corner - music
Simone Morris - dance
Jonas Mekas - cinema for all sections
...

CANADIAN SECTION:
Pierre Mercure
TEMPORARY ADDRESS:
FLUXUS, J.S. Bach Str. 6, Wiesbaden, Germany.
SUBSCRIPTIONS: for each yearbook including all inserts & records:
16 NF, 16DM, $4.50
Format: 25cm. x 25cm.
150 to 250 pages
Printed in Japan, Germany and U.S.A.

Fluxus... Tentative Plan for Contents of the First 7 issues. [before January 18, 1962]. version B

"...I will appease you and we will have German edition of 1st. issue, that will appear 2 months later, OK?..."
Letter: George Maciunas to Dick Higgins, January 18, 1962.

[Identical to Fluxus... Tentative Plan for Contents of the First 7 Issues. [before January 18, 1962]. version B]
Fluxus... Tentative Plan for Contents of the First 7 Issues. [before February 1962]. version C

FLUXUS YEARBOOK — BOX Enclosed is the latest plan for the forthcoming issues of Fluxus. ... New "dead line schedule for each issue is as follows: [Fluxus] No. 1 U.S. ... Submitting Materials June 15 ...Final proofs to authors May 15 to July 15...Submitting 200 originals for Luxus-Fluxus July 30 ... Printing & Binding July 1 to July 30...Issuance Aug. 15...Full efforts should be exerted to issue No. 1 and 2 for festivals starting September and No. 3 in time for December festival in Paris....
George Maciunas
for Fluxus administration
(62) Wiesbaden (temporary)
J.S. Bach Str. 6 (even more temporary)
Fluxus Newsletter No. 1, [before May 21, 1962].

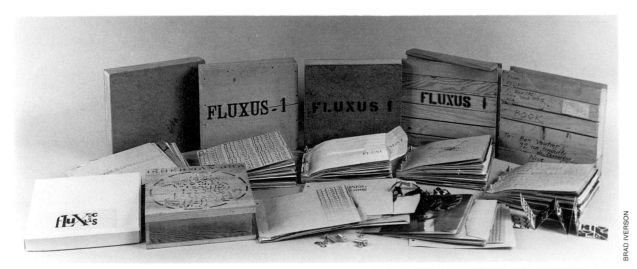

BRAD IVERSON

Collective. Seven examples of FLUXUS 1, including a version assembled for the EUROPEAN MAIL-ORDER WAREHOUSE/FLUXSHOP, lower left, and a mailed copy upper right. The box was intended to serve simultaneously as cover and mailing carton. see color portfolio

EDITORIAL COMMITTEE:
CHAIRMAN: George Maciunas
U.S. SECTION: La Monte Young
Jackson Mac Low
Dick Higgins
Philip Corner
Jonas Mekas

...

CANADIAN SECTION:
Pierre Mercure
SUBSCRIPTIONS: for each yearbox
standard fluxus
20 NF. 16 DM. $4.00
luxus fluxus
(with inserts of originals)
40 NF. 32 DM. $8.00
FORMAT: 150 to 200 pages
20 cm x 20 cm x 3 cm
ADDRESS: FLUXUS J.S. Bach Str. 6
62 Wiesbaden Germany

FLUXUS NO. 1, U.S. YEARBOX - AUG. 15, 1962
English & German Editions

George Brecht	Events: scores and other occur-rances
Joseph Byrd	Modern Music and the Emotion Aesthetic
Philip Corner	Lecture for Sunday Performance
L. Dlugoszewski	Is Music Sound?
Henry A. Flynt, Jr.	The Exploitation of Cultural Rev-olutionaries in Present Societies
Dick Higgins	Some Thoughts on Politics in Art
George Maciunas	The grand frauds of architecture: M.v.d.Rohe, Saarinen, Bunshaft F. L. Wright
R. Maxfield	Music without Score
Simone Morris	Dance constructions
all editors	Atlas-index of new art, music, lit-erature, cinema and dance in U.S.

COMPOSITIONS:

George Brecht	6 Exhibits, 3 telephone events
Jerry Bloedow & Diane Wakoski	Conversation between Diane & Jerry stimulated by one hundred ones
Jerry Bloedow	Lopsiglyphs, Sestina
Philip Corner	Chirographic piano piece, Tower Music etc.
Walter De Maria	Portrait of John Cage
	Portrait of the school of Cage, Caged
	(to be determined)
Al Hansen	
Larry Eigner	Poems
Henry Flynt	Linact: Incongruities, Audact Composition
	A way of Enjoying a non-Con-trolled Acoustical Environment
	My New Concept of General Acognitive Culture
Dick Higgins	More danger music, Inroads Re-buff'd
	At least Two Events for One or More Performers
Dick Higgins, ed	Visuals (collection of inserts)
Spencer Holst	Sections from ''The Hunger of the magicians''
Terry Jennings	Poems
Dennis Johnson	Items, score, scraps
Allan Kaprow	Happenings:Chapel.Stockroom. Happening for Ann Arbor
Alison Knowles	A glove to be worn while exam-ining (insert) Rats (dwg.)
Jackson Mac Low	Letters for Iris numbers for si-lence
	From Nuclei III. Puncuation mark numbers
	Tree movie. Rush Hour. One Hundred.
	A little Dissertation Concerning Mississippi & Tennessee for Iris
	A story for Iris Lezak. 3 Drawing-Asymmetries
Claes Oldenburg	(to be determined)
Ben Patterson	Variations for double-bass
Larry Poons	Baltimore Seaside Zephyr (graph-ic)
Griffith [sic] W. Rose	Squares, 2nd Ennead, Bass Clari-net piece
Stanley Vanderbeek	film flip book (to be determined
Emmett Williams	Universal & generative poems
La Monte Young	String Trio, Death Chant (scores)
Diane Wakoski	Poems (2)

...

Brochure Prospectus for Fluxus Yearboxes. [before June 9, 1962]. version A

FLUXUS NR.1 US Yearbook $4 16 DM Wiesbaden J.S. Bach Str. 6
Advertisement insert in Neo-Dada in der Musik program. [ca. June 16, 1962].

''Very nice postage stamps. — send more of these, — will mail fluxus with them or some. Very interested in your things. Send — quickly clear instructions ''scores'' etc. of your pieces for fest & Fluxus issue...''
Letter: George Maciunas to Robert Watts, [ca. June 1962].

''...We will include in Fluxus: your $ bill, playing cards (VERY NICE), Old writing, bills etc. pres. The cattle branding signs & the ''branded'' womans thigh right behind it...We will include in Fluxus I, all events you sent. You can still send for Fluxus I till Aug. 25th. Ones you send later — we can include in other editions ...Send also the clippings & accessories...In Luxus Fluxus we will include accessories...Luxus Fluxus has no dead line — since it will be assembled only when an order comes for it...''
Letter: George Maciunas to Robert Watts, [Summer 1962].

EDITORIAL COMMITTEE:
CHAIRMAN:
U.S. SECTION: George Maciunas
La Monte Young
Jackson Mac Low
Dick Higgins
Benjamin Patterson
Jonas Mekas

...

CANADIAN SECTION:
Pierre Mercure
SUBSCRIPTIONS: for each yearbox
(unless noted otherwise)
standard fluxus
20 NF. 16 DM. $4.00
luxus fluxus
(with inserts of originals)
40 NF. 32 DM. $8.00
ADDRESS: FLUXUS
6241 Ehlhalten
Grafliche str. 17
West Germany

...

FLUXUS NO. 1, U.S. YEARBOX
ESSAYS

George Brecht	Events: scores and other occur-ances
	Ten Rules: no rules
Joseph Byrd	Modern Music and the Emotion Aesthetic
L. Dlugoszewski	Is Music Sound?
Henry A. Flynt, Jr.	The Exploitation of Cultural Rev-olutionaries in Present Societies
	My new Concept of General Acognitive Culture
Dick Higgins	Some Thoughts on Politics in Art
George Maciunas	The grand frauds of architecture: M.v.d.Rohe, Saarinen, Bunshaft F. L. Wright
''	The zoological precursor of Ab-stract Expressionism
Jackson Mac Low	On the concern with the new
R. Maxfield	Music without Score
Jonas Mekas	A press release
''	American Film poets
George Maciunas	Atlas of new art, music, litera-ture, dance etc.

COMPOSITIONS:

George Brecht	exhibits and events
Joseph Byrd	2 pieces for R. Maxfield
Bloedow & Wakoski:	Conversation between Diane & Jerry stimulated by one hundred ones

Jerry Bloedow	Lopsiglyphs, Sestina, Sword Poem
Philip Corner	Chirographic, Piano Activites
Walter De Maria	Portrait of John Cage
	Portrait of the school of Cage, Caged
Larry Eigner	Poems
Henry A. Flynt, Jr.	Linact: Incongruities, Audact Composition
"	A way of Enjoying a non-Controlled Acoustical Environment
Brion Gysin	Basic statement on cut-up method & permutated poems (cut card)
Ann Halprin	Five legged stool (dance score & photographs)
" & workshop	Lanscape [sic] score for a 45 Minute Environment
Dick Higgins	Complete Danger musics
"	Constellations & Contributions
"	Stacked Deck (photographs)
"	Some Aspects of Content & Ideation in Inroads Rebuff'd or the disdainfull evacuation.
"	Inroads Rebuff'd (text and photographs)
"	The Tart or Miss America
"	Legend of the Antidancers
"	Collection of ready mades
Spencer Holst	Sections from the Hunger of the Magicians
Terry Jennings	Poems
Dennis Johnson	Items, score, scraps
Allan Kaprow	Happenings: Chapel, Stockroom (text & photo)
	Happening for Ann Arbor & An Apple Shrine.
Alison Knowles	A glove to be worn while examining (glove)
"	Bats [sic?] (drawing)
George Maciunas	Tactile composition for skin (molded paper)
	Music for Everyman (luxus fluxus only)
"	Infinite poem
"	In Memoriam to Adriano Olivetti (score)
Richard Maxfield	Night music (record) (luxus fluxus only)
Angus Mac Lise	Calender, The Doubletake Walk
Ch. Mac Dermed	Letters (luxus fluxus only)
Jackson Mac Low	Letters for Iris numbers for silence
"	From Nuclei III
"	Punctuation mark numbers
"	One Hundred
"	Machault
"	the 3rd biblical poem & foreword
"	Rush Hour & introduction
"	Tree Movie
"	Thanks I & II
"	Piano Suite for David Tudor & John Cage
Robert Morris	Words & Actions - A Polemic
"	Sculpture (photographs)
Rochelle Owens	Poems
Ben Patterson	Variations for double bass
"	Second solo dance from "Lemons"
"	Overture
"	Septet from "Lemons"
"	Traffic Light - A Very Lawful Dance
"	Collage poem
Larry Poons	Baltimore Seaside Zephyr (drawing)
Margaret Randall	poems
Ron Rice	portrait of an artist with a bad tooth
M. C. Richards	poems & foreword by Jackson Mac Low
Grifith Rose	Squares, 2nd. Ennead (score)
Ed Sanders	Prayer-wheel & vision
Stan Vanderbeek	film flip books
"	16mm film sections (luxus fluxus only)
Diane Wakoski	poems
James Waring	formal comic and chance poems
Robert Watts	Theatre Events for intermission
"	Playing cards, postage stamps, dollar bill,
"	Collection of ready mades
Emmett Williams	a german chamber opera for 38 marias
"	litany and response
"	4-directional song of doubt for 5 voices (luxus)
La Monte Young	String Trio, Death Chant (scores)
Marian Zazeela	Scribbles

...

standard fluxus $6.00 luxus fluxus $12.00

Brochure Prospectus for Fluxus Yearboxes. [ca. October 1962]. version B

"...Questions....Would you care to have all your past & future works published under one cover or in box — a kind of special fluxus edition...This could be sold separately or as part of Fluxus yearbox...Fluxus I deadline now is closed, (all works are at printer who is scratching his head to the bone.) It should be out in Jan. will send you a few copies..."
Letter: George Maciunas to Robert Watts, [December 2, 1962].

"...Still heard nothing from your $ $ givers. Don't they trust Fluxus??? As soon as Fluxus is out I will send one to you air mail so you could give them a copy — that might help...."
Letter: George Maciunas to Robert Watts. [ca. January 1, 1963].

"Could you send me all your works (they do not have to be in english translations): the complete Sanitas, etc., etc. OK? Would you be interested to offer me exclusive rights to publish your works (which may mean all your works, if the rest of Sanitas is as good as other things you sent me). I have similar arrangement with Ben Patterson, Filliou, George Brecht, Robert Watts, La Monte Young. (the kind of arrangement Cage has with Peters editions). The advantage of such arrangement is that such works can be combined with fluxus year-boxes (them being boxes), or sold separately, or parts combined with fluxus. The works will be copyrighted when published, which means their performances will be controlled by yourself through fluxus, and indiscriminate copy prohibited. Besides Paik and Filliou, you are the only European (Paik is not European anyway) whom I offered such arrangement, because I think, next after Paik and possibly Nordenstroem you are the best European composer of events & action music. — My one condition however (like that of any other serious publisher) is that once you agree or decide to offer your works for publication and they are accepted, they can not be offered to and published by any other publisher. This is necessary to protect my investment in printing and distribution. I lost a few hundred marks already, by printing Ligeti & Flynt and then eliminating the works because of Vostell's fast dealings. Since fluxus will be copyrighted as a whole I can not legally include materials that already appeared in print. Such 'preview' type appearance of fluxus materials in other publications like Decollage is therefore very harmful to me financially and I must insist thus on 'conventional' publishers conditions. OK? If you offer to me exclusive rights to publish your works, I am bound of course to publish all that you submit (once I agree initially) just as you are bound to submit the works to no one else but me (once you agree initially) it is as sort of 'Faust' arrangement. Let me know your thoughts on this. I will hold on printing the things you sent me until I hear from you.
Letter: George Maciunas to Tomas Schmit, [end of December 1962 or early January 1963].

"I am presently hospitalized...but as soon as I am released I will send you Fluxus box no. 1, (U.S. issue) which is now completed and also much information on our 'festivals' & 'concerts' — programs, photographs etc. etc. With a wild 'concert' in Dusseldorf (which we ended in a pissing contest) we completed

our 'winter offensive' against all the bourgeois reactionaries, dogmatists & Stockhausen...We did one ending piece in which we shut the lights off and left (all performers left) leaving the audience in darkness waiting for that 'last piece' which we performed by walking out & leaving them alone. You will read all that in Fluxus 1.''
Letter: George Maciunas to Ben Vautier, March 5, 1963.

"...In few weeks I will mail to you via parcel post a case of FLUXUS 1's to you can distribute them — I won't describe my homages, since they are in Fluxus so you will see them there..."
Letter: George Maciunas to Robert Watts, [before March 11, 1963].

"Fluxus 1 $2000 (now 400 pages thick) is 80% completed — very slow printer! but I think I will have them ready end of March — so I can mail several copies to you for possible Yam May — distribution. Quota in US is 200. I will send 40 each to you, G. Brecht, Jackson M.L, Dick Higgins & J.Mekas."
Letter: George Maciunas to Robert Watts, [March 11 or 12th, 1963].

"...Fluxus I, still at printer & printer getting very confused with dozen different kind of papers, page sizes, shapes, loose cards, sheets, foldouts, so will delay another 3 weeks, but I think it will get to N.Y. by May 11th. which is when Yam day takes place?...By Fall I should have some 6 Fluxus issues: US Fluxus... Eventually I will acquire a press myself, for dealing with those stupid printers drains my patience...I will send fluxuses as soon as they come out the other end of the idiot printer...Mekas has several things in Fluxus I...Good Man..."
Letter: George Maciunas to Robert Watts, [possibly early April 1963].

PROPOSED PROPAGANDA ACTION FOR NOV. FLUXUS IN N.Y.C. (during May — Nov. period) ... Propaganda through sale of fluxus publications (fluxus I...): to be dispatched by end of April to N.Y.C.
Fluxus Newsletter No. 6, April 6, 1963.

"We shall bring to Nice lots of Fluxus publications (fluxus yearbox...)"
Letter: George Maciunas to Ben Vautier, May 26, 1963.

"...In few days I will mail you various fluxus compositions (by printed matter mail), not all of course that would be difficult, since many are still being only prepared for printing. Fluxus 1st. yearbox (400 pages) has many works from New York. I will mail this book — box in 2 or 3 weeks and bring some 100 copies to Nice. (also other works)..."
Letter: George Maciunas to Ben Vautier, [late May or early June 1963].

"...I will take some 500 of each book...100 books each: London, Amsterdam, Paris, Nice, Florence ... This will be quite a load to dispose. (also 100 books in your place.)..."
Letter: George Maciunas to Tomas Schmit, June 1, 1963.

"...I will stay in Wiesbaden till Printer completes Fluxus 1,... (2 printers are working now). They should have it completed by June 15..."
Letter: George Maciunas to Tomas Schmit, [before June 8, 1963].

"...It would have been better to have Amsterdam on 29th. & Hague on 30th. so that I would have Fluxus with me for sure, but it's OK. to have Amsterdam on June 23 & Haag on 30th...Then after Amsterdam I will drive same day to pick-up Fluxus I for Hague..."
Letter: George Maciunas to Tomas Schmit, [early June 1963].

"...After Hague or maybe after London I will go to Wiesbaden to pick up Fluxus I (still not ready!)..."
Letter: George Maciunas to Tomas Schmit, [ca. June 1963].

FLUXUS No.1 - U.S. Yearbox. Essays and compositions by Byrd, Dlugoszewski, Flynt, Higgins, Mekas, Bloedow, Corner, DeMaria, Halprin, Holst, Knowles, Maxfield, Mac Lise, Morris, Young, Vanderbeek, Owens, Patterson, Poons, Richards, Watts, Waring and others too nomerus [sic] Info: Fluxus, 6241 Ehlhalten Gräfliche str.17 West Germany
Yam Festival Newspaper, [ca. 1963].

FLUXUS YEARBOXES 1963-5 FLUXUS 1. U.S. YEARBOX $6 - luxus fluxus (with tape, film loops, objects, originals, each edition different) $12
Fluxus Preview Review, [ca. July] 1963.

[as above]
Daniel Spoerri, L'Optique Moderne. List on editorial page. 1963.

[as above]
La Monte Young, LY 1961. Advertisement page. [1963].

FLUXUS 1963 EDITIONS, AVAILABLE NOW FROM FLUXUS P.O. Box 180, New York 10013, N.Y. or FLUXUS 359 Canal St. New York. CO7-9198 ...Most materials originally intended for Fluxus yearboxes, will be included in the FLUXUSccV TRE newspaper or in individual boxes...
Film Culture No. 30, Fall 1963.

"Please accept our belated acknowledgement of your order for Fluxus 1 yearbook. Due to financial difficulties, this fat book will not be issued but the contents will be included in the monthly Fluxus newspaper, 2 issues of which have already appeared. We are also concentrating our effort more on Fluxus solo

editions of which 4 more will be issued in the next 2 weeks...."
Letter: George Maciunas to Philip Kaplan, November 19, 1963.

FLUXUS 1964 EDITIONS, AVAILABLE NOW ... FLUXUS 1 Anthology of yet unpublished works by: Ayo, George Brecht, Congo, Philip Corner, Dick Higgins, Joe Jones, Allan Kaprow, Alison Knowles, Takehisa Kosugi, Gyorgi Ligeti, Bob Morris, Robert Filliou, George Maciunas, Jackson Mac Low, Tomas Schmit, Chieko Shiomi, Ben Patterson, Nam June Paik, Ben Vautier, Robert Watts, Emmett Williams, La Monte Young. Loose leaf binding (nonperiodically renewable), with objects in wood box $6 LUXUS edition, with film, tape, objects and accessories, no 2 boxes alike $12
cc Valise e TRanglE (Fluxus Newspaper No. 3) March 1964.

FLUXUS 1: anthology of yet unpublished works by: Ayo, George Brecht, Congo, Philip Corner, Dick Higgins, Joe Jones, Allan Kaprow, Alison Knowles, Takehisa Kosugi, Gyorgi Ligeti, Bob Morris, Robert Filliou, George Maciunas, Jackson Mac Low, Chieko Shiomi, Ben Patterson, Nam June Paik, Ben Vautier, Robert Watts, Emmett Williams, La Monte Young, and others. in wood box (loose leaf binding) with objects $6. LUXUS— edition, with film, tape, objects, accessories $12.
European Mail-Orderhouse: europeanfluxshop, Pricelist. [ca. June 1964].

"...Soon I will send additional box with Fluxus I, unbound pages. You could bind them in Holland. There will be 250 copies..."
Letter: George Maciunas to Willem de Ridder, August 12, 1964.

fluxus I anthology of yet unpublished works by: Ayo, George Brecht, Congo, Philip Corner, Dick Higgins, Joe Jones, Allan Kaprow, Alison Knowles, Takehisa Kosugi, Gyorigi Ligeti, Bob Morris, Robert Filliou, George Maciunas, Jackson Mac Low, Chieko Shiomi, Ben Patterson, Nam June Paik, Ben Vautier, Robert Watts, Emmett Williams, La Monte Young, and others. in wood box (loose leaf binding) with objects $6. luxus edition, with film tape, objects, accesoires [sic] etc. $12.
Second Pricelist - European Mail-Orderhouse. [Fall 1964].

did you receive the 2nd catalog of THE EUROPEAN MAIL-ORDERHOUSE & FLUXSHOP? [advertising] ...american yearbox...
How to be Satisfluxdecolanti?...[ca. Fall 1964].

"...I am mailing 2 copies of Fluxus 1 (Free copies) you can sell one for $10, since that's what we sell them for here. I NEED MORE MATERIALS FROM

YOU TO PUT IN FLUXUS 1, (like the printed bag or booklets.) I mean some printed materials, like we discussed. Remember? You would send me 100 copies of your materials so I could incorporate in Fluxus book. OK?..."
Letter: George Maciunas to Ben Vautier, January 5, 1965.

"First to reply to your questions...Very good that you have sent anthologies to the East...(I will send you more anthologies as soon as I receive that material you got from them.)...I have mailed to you 4 copies of Fluxus anthology.— which is a limited edition (total 100 copies) mostly hand made and therefore expensive — sort of between Fluxus and Luxus Fluxus. We sell it for $12, you could sell for $10 ... I also mailed one Fluxus anthology in wood box and with contents — harmonica on back. This is the way we sell it (in wood box). I suggest that you have similar boxes made up (like little crates). If you think harmonica on back is nicer than cards in front envelope, let me know, I will make next ones with harmonicas. Make about 30 boxes. I can send you a total of 30 Fluxus anthologies. My essay and portrait is there & you can reprint it. I will send separate sheets, so you don't have to take the book apart. Sell the books to people who order both regular and luxus edition, because we combined them. ... Ben Vautier ... I have mailed to him Flux-anthologies directly, so you don't have to give him any..."
Letter: George Maciunas to Willem de Ridder, January 21, 1965.

"I have mailed to you: 5 — Fluxus no. 1 anthology, without boxes & with cards in front envelope instead of back harmonica...I have mailed to you:...1 — Fluxus no. 1 in wood box and armonica type contents. Let me know if you want armonicas for the other 5 books. I can send them separately...but you will have Fluxus I book meanwhile. These books are limited in number (total only 100), because they are all hand made. And it takes a few hours to make each one. So we sell them for $12, but you can sell them for less. You do not have to send me money. ... ONLY PLEASE! send 100 copies of your part in the book. We ran out of your 'bag over the head' then ran out of small booklets you sent, then ran out of record labels, so now we have NOTHING FROM YOU TO PUT IN FLUXUS I !!! So please send a quantity of your contribution. Send anything you like."
Letter: George Maciunas to Ben Vautier, January 23, 1965.

"...I will ship to you a Fluxkit, which will have all new compositions, including Gius Chiarri-La Strada. (that's in Fluxus I incidentally)..."
Letter: George Maciunas to Ben Vautier, February 1, 1965.

"...The gray pages were sent to be incorporated into European Fluxbox. So hold them for your own edition...I will send...soon more material for your own Fluxus box editions — some photos, and Jackson Mac Low cards for 'Letters for Iris'..."
Letter: George Maciunas to Willem de Ridder, February 4, 1965.

"... Replies to your questions. Once you receive Fluxus I yearbook, you will know the contents....I will mail to you soon white and translucent pages for Flux yearbook, plus cards — yellow piece, questionnaire, rich man piece, but not 250, I don't have that many. I will send all that I have OK? Envelopes you can obtain yourself...Let me know if you wish more Fluxus I yearbooks from me...."
Letter: George Maciunas to Willem de Ridder, March 2, 1965.

YEARBOXES FLUXUS 1 1964 ANTHOLOGY, book events, objects, compositions, essays by: Ayo, George Brecht, congo, Robert Filliou, Dick Higgins, Joe Jones, Alison Knowles, Takehisa Kosugi, Shigeko Kubota, Gyorgi Ligeti, George Maciunas, Jackson Mac Low, Ben Patterson, Tomas Schmit, Chieko Shiomi, Ben Vautier, Robert Watts, Emmett Williams, La Monte Young. Limited edition of 100, hand assembled & bound with bolts $12
Vacuum TRapEzoid (Fluxus Newspaper No. 5) March 1965.

"...Very good of you to mail Fluxus 1 to important people. I will send you 5 more copies. Do not send me money for them. Keep...for Fluxus activities...."
Letter: George Maciunas to Ben Vautier, May 11, 1965.

"...Incidentally, next week I will make up revised edition of Flux 1 (with some additions) & send you maybe 6 copies. OK?..."
Letter: George Maciunas to Ben Vautier, January 10, 1966.

"...Have you received Fluxus I yearbox?..."
Letter: George Maciunas to Milan Knizak, [possibly January, 1966].

"...But since you have concert in March, & there is no time to ship entire collection to Milan [for Apollinaire show]. I suggest the following: Take all Fluxus objects that you own...Fluxus I, etc..."
Letter: George Maciunas to Ben Vautier, March 8, 1966.

"...Should I send Fluxus I yearbook to Lebel?..."
Letter: George Maciunas to Ben Vautier, May 19, 1966.

"...Incidentally — do you need more Fluxus I books? I could send some new versions (additional object — Christo & A. Fine)...."
Letter: George Maciunas to Ben Vautier, November 14, 1966.

... items are in stock, delivery within 2 weeks. ... FLUXUS 1 1964-5 ANTHOLOGY, book events, objects, compositions, essays by: George Brecht, Christo, congo, Willem de Ridder, Robert Filliou, Dick Higgins, Ann Halprin, Joe Jones, Alison Knowles, Shigeko

Kubota, Gyorgi Ligeti, Jackson Mac Low, George Maciunas, Yoko Ono, Ben Patterson, Chieko Shiomi, Tomas Schmit, Ben Vautier, Robert Watts, Emmett Williams, La Monte Young. Limited edition of 100, hand assembled, bound with bolts and boxed: $20
Vaseline sTREet (Fluxus Newspaper No. 8) May 1966.

flux year box no.1 $20
Fluxshopnews. [Spring 1967].

FLUX-PRODUCTS 1961 TO 1969...FLUXYEARBOX 1962-4 Book events, objects, essays, compositions by: Ayo, George Brecht, Congo, Dick Higgins, Joe Jones, Alison Knowles, T.Kosugi, S.Kubota, G.Ligeti, Maciunas, Jackson Mac Low, Ben Vautier, Bob Watts, Emmett Williams & La Monte Young. $30
Fluxnewsletter, December 2, 1968 (revised March 15, 1969).

FLUX-PRODUCTS 1961 TO 1970...FLUXYEARBOX 1, 1962-4: Book events, objects, essays, compositions by: Ayo, George Brecht, Congo, Dick Higgins, Joe Jones, Alison Knowles, T. Kosugi, S. Kubota, G. Ligeti, G. Maciunas, Jackson Mac Low, Ben Patterson, Tomas Schmit, Chieko Shiomi, Ben Vautier, Bob Watts, Emmett Williams & La Monte Young. $30
Flux Fest Kit 2. [ca. December 1969].

[catalogue no.] 715 FLUXUS-EDITIONEN FLUXYEARBOX 1, 1962-1964 (buch in kasten)
Happening & Fluxus. Koelnischer Kunstverein, 1970.

FLUX-OBJECTS ... 03.1964 ... FLUXYEARBOX 1 anthology of flat objects in envelopes by: brecht, ayo, knowles, higgins, joe jones, kosugi, kubota, maciunas, mac low, patterson, t. schmit, shiomi, vautier, watts, e. williams, l.m. young
George Maciunas, Diagram of Historical Developments of Fluxus... [1973].

FLUX-PRODUCTS 1961 TO 1970...FLUXYEARBOX 1, 1962-4: Book events, objects, essays, compositions by: Ayo, George Brecht, Congo, Dick Higgins, Joe Jones, Alison Knowles, T. Kosugi, S. Kubota, G. Ligeti, G. Maciunas, Jackson Mac Low, Ben Patterson, Tomas Schmit, Chieko Shiomi, Ben Vautier, Bob Watts, Emmett Williams & La Monte Young. $80
[Fluxus price list for a customer]. September 1975.

Fluxyearbook 1 $80
[Fluxus price list for a customer]. January 7, 1976.

OBJECTS AND EXHIBITS ... 1964: edited & published Fluxyearbox 1, anthology of flat objects in envelopes. Contributed a chart on architectural criticism.
George Maciunas Biographical Data. 1976.

"Tried to reach you by phone when I was in NYC. I heard from Jean that you may be interested to take Flux boxes for the $800 I owe you. That would be wonderful! I could suggest the following:...Flux 1

yearbox — $100... Backworks has them..."
Letter: George Maciunas to Peter Frank, [ca. March 1977].

COMMENTS: *Plans for the U.S. issue of Fluxus kept changing and expanding as Maciunas expanded the movement and the movement itself became more defined. As it finally appeared,* FLUXUS 1 *contained not only American material but works that would have appeared in several of the other Fluxus anthologies as well.* FLUXUS 1 *combined the printed sheets that had been planned for the standard edition with original and multiple inserts of "Luxus Fluxus."*

It is difficult to ascertain just when Maciunas assembled the first copies of FLUXUS 1. *Much of the material was printed in Europe starting in 1962, and extending well into 1963. Some copies might have been assembled there, or late in 1963 when Maciunas returned to New York. His letters to various artists in Europe seem to indicate that it was not fully assembled until some time in 1964. The United States copyright registration information states:*

FLUXUS 1
No. A748678
Oct. 2, 1964
following publication
George Maciunas Editor and Book designer
Registered in the name of Fluxus, soley owned by George Maciunas.

He also gave Willem de Ridder a mass of printed material for assembling FLUXUS 1s *in Amsterdam, and to add to a European Fluxus that they had planned to produce. De Ridder did use much of the material in a boxed edition (Silverman No. 119, ff.) However, a European Fluxus was never completed.*

There are a number of variations in FLUXUS 1 *because it was assembled by hand over a period of perhaps 13 years. During this time Maciunas' attitude toward certain artists and/or works in the anthology changed, some works got lost or misslaid, and others ran out of stock. An early copy of* FLUXUS 1 *(Silverman No. 117), probably assembled in 1964, has the following contents:*

Ay-O	Finger Envelope
George Brecht	2 sided photo-portrait by George Maciunas
	Direction
	Five Places
Stanley Brouwn	untitled, inserted 5 times throughout
Guisseppe Chiari	La Strada
Congo	photo of the artist painting
	reproduction of two untitled works
Robert Filliou	Whispered Art History (incomplete)
Brion Gysin	"Basic Statement On Cut-up Method & Permutated Poems (cut card)"
Sohei Hashimoto	"Composition for Rich Man"
Dick Higgins	photomontage-portrait
	"Inroads Rebuff'd"
	"Yellow Piece"
Joe Jones	A Favorite Song
Alison Knowles	Glove to be Worn While Examining
Takehisa Kosugi	Theatre Music (with score)
Shigeko Kubota	Flux Napkin
Gyorgy Ligeti	"Trois Bagatelles"
George Maciunas	Editor card
	2-sided photo-portrait work
	The Grand Frauds of Architecture

Jackson Mac Low	2 photo-portraits by George Maciunas
	Letters for Iris Numbers for Silence
	"Thanks II"
	Two "Vocabularies"
Benjamin Patterson	Overture (Version II)
	Overture (Version III)
	Poems in Boxes
	Questionnaire
	Septet from "Lemons"
	"Solo Dance from 'Lemons'"
	Traffic Light
	"Variations for Double Bass"
	4 photographs of Patterson performing "Variations for Double Bass"
Takako Saito	Magic Boat
Tomas Schmit	"Floor and Foot Theatre"
	"Sanitas 2"
	"Sanitas 13"
	"Sanitas 22"
	"Sanitas 35"
	"Sanitas 107"
	"Sanitas 165"
	"Zyklus for Water Pails"
Chieko Shiomi	Disappearing Music for Face [Disappearing Music for Envelopes]
Ben Vautier	Je Signe Tout
	Turn This Page
	[missing contents, could have been:]
	Disque De Musique Total
	No Art
	Untitled Booklet
Robert Watts	Brands
	Hospital Events
	photomontage self-portrait
Emmett Williams	2 identical photo-portraits
	abcdefghijklmnopqrstuvwxyz
	An Opera
	"B Song for Five Performers"
	"Counting Song No. 1-6"
	"Duet for Performer(s) and Audience"
	"Litany & Response No. 2 for Alison Knowles"
	"Litany & Response for female and male voices"
	"Song of Uncertain Length"
	"Tag"
	"10 Arrangements for 5 Performers"
	two untitled poems
	"Voice Piece for La Monte Young"
La Monte Young	5 part photo-portrait work by George Maciunas
	"Death Chant"
	Trio for Strings

Photo-documentation of Fluxus Performances
Incomplete index of artist's monogram cards, designed by George Maciunas
Fluxus Copyright label, designed by George Maciunas
Packaged in wooden "dust jacket" and mailing box branded Fluxus 1, designed by George Maciunas

Although in somewhat different order, the contents of a late FLUXUS 1 *(Silverman No. > 118.II) assembled ca. 1977, are similar to Silverman No. 117, but with the following differences. It is missing:*

Giuseppe Chiari	La Strada
Brion Gysin	"Basic Statement On Cut-up Method & Permutated Poems (cut card)"
Sohei Hashimoto	"Composition for Rich Man"
Dick Higgins	photo-portrait
	"Inroads Rebuff'd"
	"Yellow Piece"
Takehisa Kosugi	score for Theatre Music
George Maciunas	editor card
Takako Saito	Magic Boat
Chieko Shiomi	Disappearing Music for Face [Disappearing Music for Envelopes]
Ben Vautier	Je Signe Tout
Robert Watts	Hospital Events
Emmett Williams	1 photo-portrait
	abcdefghijklmnopqrstuvwxyz
	An Opera
La Monte Young	Trio for Strings

The following lists works included in Silverman No. > 118.II that were not in Silverman No. 117:

George Brecht	"Impossible Effort"
	"Incidental Music"
	"2 Exercises"
Stanley Brouwn	untitled, inserted 12 times throughout
Ann Halprin	"Landscape Event"
Hi Red Center	Bundle of Events
Allan Kaprow	"Stockroom"
Yoko Ono	Self Portrait
Ben Vautier	Mystery Envelope
	Untitled Booklet
Robert Watts	Dollar Bill
	"Event for Guggenheim"
	Fluxpost 17-17
	"keyhole"
La Monte Young	Remains from Composition 1960 No. 2

Over the years, FLUXUS 1 *was listed or referred to in many different ways. We have found the following titles all refer to it. The list is arranged chronologically:*

FLUXUS NO. 1 U.S. ISSUE
FLUXUS NO. 1 U.S. YEARBOOK
FLUXUS NO. 1 U.S. YEARBOX
FLUXUS NO. 1 U.S. YEARBOOK-BOX NO. 1 U.S.
FLUXUS 1
Fluxus Issue
Fluxus Box No. 1, (U.S. issue)
Fluxus 1st. yearbox
Fluxus anthology
Fluxus no. 1 anthology
Fluxus 1 U.S. yearbook
1964 Anthology
1964-65 Anthology
FLUXYEARBOX 1962-4
FLUXYEARBOX 1, 1962-4
FLUXYEARBOX 1
FLUXYEARBOOK 1
LUXUS FLUXUS
U.S. FLUXUS
FLUXUS
AMERICAN FLUXUS
FLUX ANTHOLOGY
FLUXUS 1 1964 ANTHOLOGY

FLUXYEARBOX NO. 1
FLUXYEARBOX 1
FLUXYEARBOOK 1
fluxus yearbox

FLUXUS NO. 2 WEST EUROPEAN YEAR-BOX I

...
FLUXUS...No. 2 WEST EUROPEAN ISSUE 1.
(Germany, Scandinavia, Holland, Switzerland)
English, German editions. May 1962
A. ARS AUTOMATICA MACHINARUM

K. Wiggen	Music Machine
Diter Rot	Poetry Machine
G. Maciunas	Hydrokinetic - osmotic painting
Fehn	Sonorealization of City

B. ARS RATIONALIS (et irrationalis) MACHINIS

K.O. Goetz	Electronic painting and its programming
Øyrind [sic] Fahlstrøm	Possibilities of Electronic Television (plans for electronic TV studio in Stockholm.)
M. Koenig ed.	Anthology of Electronic Music record & comment) — Stockhausen, Elmert, Koenig, Kagel, Boemer etc.
C. Bremer & E. Williams	Anthology of serial poetry
Kirchgässer	Experimental Film with Ossirograph (painting with printing press)
J. Mekas ed.	Experiments in cinema - West Europe I

C. ARS AUTOMATICA ET RATIONALIS PERSONARUM

K. Stockhausen	"Originale"paar" etc...
H.K. Metzger	Cage, Marx, Stirner ... Is Anarchism anachronized?
M. Bauermeister	Towards the new Onthology of Painting
Nam June Paik	Towards the New Onthology of Music
''	several studies (compositions)
Karl-Erik Welin	New possibilities in the interpretation of Cage and his followers.
Nam June Paik	Apology of John Cage

D. ANTHOLOGY OF NEW LITERATURE
H.G. Helms, F. Kriwet,
D. Huelsmanns, Franz Mon.

E. PAINTING, ARCHITECTURE, PHILOSOPHY

J.P. Wilhelm	W. Gaul
M. de la Motte	Bruning and Twombly
Franz Mon	Bernard Schultze
W. Gaul	Color in new art
Gunter Bock	* (architecture)

Jörn Janssen	* ('')
C. Caspari	LABYR. ...no more Bauhaus
H.K. Metzger	German philosophy after and against Heideggar [sic] .
'' ed.	digests of Adorno and Suzuki in Culture/Nature
Anonymous	Critique contre critique/ critique pour critique
Anonymous	The militant art politic — a brutalist manifesto
Editors	Atlas-index of new art, music, literature, cinema, theatre in West Europe I.

[* to be determined]

...
EDITORS: Publisher & editor-in-chief: George Maciunas
...
WEST EUROPEAN SECTION I:
M. de la Motte - art, sculpture
J.P. Wilhelm - literature, theatre
Hans G. Helms - poetry
Nam June Paik - music, happenings
Heinz Klaus Metzger - Scandinavian sub-section
Karl Erik Welin - Philosophy
HEADQUARTERS: FLUXUS, J.S.Bach Strasse, Wiesbaden, West Germany

Fluxus... Tentative Plan for Contents of the First 6 Issues. [before February 1962]. version A

...
NO. 2 WEST EUROPEAN YEARBOOK 1. (Germany, Scandinavia, Holland) English, German editions. May 1962.

T.W. Adorno	being consulted
H.K. Metzger	Marx, Stirner, Cage...Is Anarchism anachronized?
J.P. Wilhelm	Thoughts
'' ed.	Anthology of new poetry
Emmett Williams	Universal and generative poems(?)
Dr. Eimert	being consulted
M. Kagel	*
M. Koenig	Automation in electronic music production
Nam June Paik	Apology of John Cage
''	Towards the New Onthology of Music
''	Several Studies
	A Sound collage (record)
K. Stockhausen	being consulted
Karl-Erik Welin	New possibilites in the interpretation of cage and his followers.
K. Wiggen	Music Machine.
M. Bauermeister	Towards the new Onthology of Painting

''	molded plastic relief composition (insert)
Øyrind [sic] Fahlstrøm	Possibilities of Electronic Television (plans for electronic TV studio in Stockholm)
W. Gaul	Color in new art.
K.O. Goetz	Electronic painting and its programming.
Kirchgässer	Experimental Film with Ossirograph (painting with printing press) (fold out)
Montovani	long scroll (fold out)
J. Mekas ed.	Experiments in cinema — West Europe I
M. de la Motte	Bruning and Twombly
Franz Mon	Bernard Schultze
G. Maciunas	Hydrokinetic - osmotic painting (miniature insert)
Gunter Bock	* (architecture)
C. Caspari	Labyr... absolute architecture
Jorn Janssen	* (architecture)
Fehn	Sonorealization of City
Heussner	Indeterminate theatre

Programme of FLUXUS festival of new music (insert)
Newspaper fold out:
Chronicle - calendar of events
Index - directory of new art, music, literature & cinema
Reviews - books, magazines, etc.
...
EDITORIAL
COMMITTEE: Chairman: George Maciunas
...
WEST EUROPEAN SECTION 1:
Manfred de la Motte - art, sculpture, architecture
Jean-Pierre Wilhelm - literature, theatre
Heinz Klaus Metzger - philosophy, (music)
Nam June Paik - music, happenings
Karl Erik Welin - Scandinavian sub-section
...
TEMPORARY ADDRESS:
FLUXUS, J.S. Bach Str. 6, Wiesbaden, Germany

SUBSCRIPTIONS: for each yearbook including all inserts & records:
16 NF, 16DM, $4.50
format: 25cm. x 25cm.
150 to 250 pages
Printed in Japan, Germany and U.S.A.

Fluxus... Tentative Plan for the Contents of the first 7 Issues. [before January 18, 1962]. version B

"...I also met Bussotti and Metzger (both same age as Paik - about 28). Also unpretentious. They all will be of tremendous help for the magazine and festival. Also met Maderna who looks like a fat butcher, and Helms who (very much like Flynt) is absurdly arrogant and with pretentions towards world shattering originality and genuis bordering on megalomania. I met also other people like Mary Bauermeister, whose work I suppose you know, Kagel, Boemer + others whose names I now forget. They showed me some diagrams + perform. instructions of new composers which seem very good. (especially a group of Sicilians doing good work) - Also quite a few doing concrete compositions...."

Letter: George Maciunas to Dick Higgins. January 18, 1962.

[Identical to Fluxus...Tentative Plan for Contents of the First 7 Issues. [before January 18, 1962]. version B]

Fluxus...Tentative Plan for Contents of the First 7 Issues. [before February 1962]. version C

FLUXUS YEARBOOK - BOX Enclosed is the latest plan for the forthcoming issues of Fluxus....New "dead line schedule for each issue is as follows: [Fluxus] ...No. 2 German...Submitting Materials July 10...Final proofs to authors July 15 to Aug. 1 ...Submitting 200 originals for Luxus-Fluxus Sept. 1 ...Printing & Binding Aug. 15 to Sept. 15...Issuance Sept. 15 ?...Full efforts should be exerted to issue No. 1 and 2 for festivals starting September and No. 3 in time for December festival in Paris.
George Maciunas
for Fluxus administration
(62) Wiesbaden (temporary)
J.S. Bach Str. 6 (even more temporary)

Fluxus Newsletter No. 1, [before May 21, 1962].

EDITORIAL COMMITTEE:
CHAIRMAN George Maciunas
...
GERMAN SECTION:
 Manfred de la Motte
 Jean-Pierre Wilhelm
 Heinz Klaus Metzger
 Nam June Paik
 Wolf Vostell
SCANDINAVIAN SECTION:
 Karl Erik Welin
...
SUBSCRIPTIONS: for each yearbox
 standard fluxus
 20 NF. 16 DM. $4.00
 luxus fluxus
 (with inserts of originals)
 40 NF. 32 DM. $8.00

FORMAT:	150 to 200 pages
	20 cm x 20 cm x 3 cm
ADDRESS:	FLUXUS J.S. Bach Str. 6
	62 Wiesbaden, Germany

...

FLUXUS NO. 2 GERMAN & SCANDINAVIAN YEARBOX German & English Editions

T.W. Adorno	being consulted
H.K. Metzger	Marx, Stirner, Cage ... is Anarchism anachronized?
J.P. Wilhelm	Winfred Gaul - Dialogue avec le neant
Diter Rot	poetry machine & essay
Prof. Bense	poetry machine (being consulted)
Dieter Hulsmanns	La Sacrification S'Alanguit dans le centre
M. Kagel	being consulted
M. Koenig	Automation in electronic music production
Nam June Paik	Apology of John Cage
	Towards the New Ontology of Music
	Several studies
	Ode to Chen-chu or to Dmitri Karamazov and
	Zen exercises (record)
Dieter Schnebel	being consulted
K. Stockhausen	being consulted
Karl-Erik Welin	New possibilities in the interpretation of Cage and his followers
K. Wiggen	Music Machine
M. Bauermeister	Towards the new Ontology of Painting
	molded plastic relief composition (insert)
Öyvind Fählstrom	Possibilities of Electronic Television (plans for electronic TV studio in Stockholm)
W. Gaul	Color in new art
K.O. Goetz	Electronic painting and its programming
Kirchgässer	Experimental Film with Ossirograph (painting with printing press) (fold out)
J. Mekas ed.	Experiments in cinema
to be determined	Swedish art machines
H.K. Metzger	Horst Egon Kalinowski
M. de la Motte	Bruning and Twombly
Franz Mon	Bernard Schultze
Wolf Vostell	Decollage (inserts, originals)
Wolf Vostell, ed.	collected visuals
G. Maciunas	Hydrokinetic-osmotic painting (original insert)
Gunter Bock	to be determined
C. Caspari	Labyr...absolute architecture
Jörn Janssen	Anthology of possible architec-

	tural critique
Fehn	Sonorealization of City
Heusser	Indeterminate theatre
Werner Ruhnau	indeterminate & immaterial theatre

Programme of FLUXUS festival of new music (insert)
Newspaper fold out:
Chronicle - calendar of events
Index - directory of new art, music, literature & cinema
Reviews - of books, magazines, etc.
...

Brochure Prospectus for Fluxus Yearboxes. [before June 9, 1962] version A

EDITORIAL COMMITTEE:
CHAIRMAN:
U.S. SECTION: George Maciunas
...
GERMAN SECTION:
 Jean-Pierre Wilhelm
 Heinz Klaus Metzger
 Nam June Paik
 Arthur Koepcke
SCANDINAVIAN SECTION:
 Karl Erik Welin
...
SUBSCRIPTIONS: for each yearbox
 (unless noted otherwise)
 standard fluxus
 20 NF. 16 DM. $4.00
 luxus fluxus
 (with inserts of originals)
 40 NF. 32 DM. $8.00
ADDRESS: FLUXUS
 6241 Ehlhalten
 Gräfliche str. 17
 West Germany
...

FLUXUS NO. 3 GERMAN & SCANDINAVIAN YEARBOX

H.K. Metzger	Marx, Stirner, Cage ... Is Anarchism anachronized?
J.P. Wilhelm	Winfred Gaul - Dialogue avec le neant
Diter Rot	Poetry machine & essay
Gerhard Rühm	
Tomas Schmit	Action music, audience compositions
F. Trowbridge	
Dieter Hulsmanns	La Scarification S'Alanguit dans le centre
Gyorgy Ligeti	Die Zukunft der Music Eine Kollektive Komposition
M. Koenig	Automation in electronic music production

Nam June Paik	Apology of John Cage
	New compositions
	Towards the New Ontology of Music
	Ode to Chen-chu or to Dmitri Karamazov and
	Zen exercises (record)
Tomas Schmit	Action music & audience compositions
Karl-Erik Welin	New possibilities in the Interpretation of Cage and his followers
K. Wiggen	Music Machine
Öyvind Fählstrom	Possibilities of Electronic Television
W. Gaul	Color in new art
K.O. Goetz	Electronic painting and its programming
Kirchgässer	Experimental Film with Ossiograph
Arthur Kopcke ed.	Collected visuals
"	Works, compositions
Harry Kramer	Kinetics
Franz Mon	Bernard Schultze
Andre Thompkins	Osmotic painting
Wolf Vostell	Decollage (originals in luxus fluxus only)
Per olof Ultvedt	to be determined
C. Caspari	Theatralisches BYL
Jörn Janssen	Anthology of possible architectural critique
Fehn	Sonorealization of City
Heussner	Indeterminate theatre
Werner Ruhnau	Indeterminate & immaterial theatre

...
Brochure Prospectus for Fluxus Yearboxes. [ca. October, 1962]. version B

The new Fluxus Hq. will also house...All administrative and technical work regarding Fluxus publications ...The German-Scandinavian Fluxus will be No. 3 or 4. Since the deadline was not met by 80% of the contributors, new deadline for submitting materials is set for January 1st. 1963. No further extensions will be made. It will be issued in January 1963 with contents as planned or with reduced contents, depending on how the contributors meet this new deadline.
Fluxus Newsletter No. 4, fragment, [ca. October 1962].

PROPOSED PROPAGANDA ACTION FOR NOV. FLUXUS IN N.Y.C. (during May - Nov. period) ... Propaganda through sale of fluxus publications (fluxus ...II...): to be dispatched by end of April to N.Y.C.
Fluxus Newsletter No. 6, April 6, 1963.

FLUXUS YEARBOXES 1963-5 ... FLUXUS 3.

SCANDINAVIAN YEARBOX (1963)...FLUXUS YEARBOXES 1963-5 ... FLUXUS 6. GERMAN YEARBOX (1964)
Fluxus Preview Review, [ca. July] 1963.

[as above]
Daniel Spoerri, L'Optique Moderne. List on editorial page. 1963.

[as above]
La Monte Young, LY 1961. Advertisement page. [1963].

"...Please send new compositions (& old ones) to me c/o Dick Higgins OK? Also anything you collect for Dutch - Scandinavian Fluxus. We shall print all future fluxus issues in New York on our own press."
Letter: George Maciunas to Willem de Ridder, [Fall, 1963].

FLUXUS 1963 EDITIONS, AVAILABLE NOW FROM FLUXUS P.O. BOX 180, New York 10013, N.Y. or FLUXUS 359 Canal St. New York. CO7-9198 ...Most materials originally intended for Fluxus yearboxes, will be included in the FLUXUScc V TRE newspaper or in individual boxes...
Film Culture No. 30, Fall 1963.

in preparation: -- EUROPEAN YEARBOX -- cardboard box containing small cardboard boxes with pieces, events, works, photographs, etc. of: eric andersen, tomas schmit, ben vautier, emmett williams, willem de ridder, addi koepcke, ludwig gosewitz, stanley brouwn, wim t. schippers & others
How to be Satisfluxdecolanti?... [ca. Fall 1964].

did you receive the 2nd catalog of THE EUROPEAN MAIL-ORDERHOUSE & FLUXSHOP? [advertising] ...european yearbox...
ibid.

"...I think you should certainly include in European Fluxus Stanley Brouwn. Try to pull him out of the bearhug of Vostell. Ben Vautier will get in touch with you directly and probably contribute some money for European Fluxus box....Japanese Fluxus festival will be March — May 1965 So you may plan on this date. But don't use any Fluxus money for making a trip. The money should be spent on European Fluxus book. OK? Send 100 of this book to N.Y.C. & 100 to Japan. Official address of Fluxus in Japan is FLUXUS c/o Kuniharu Akiyama."
Letter: George Maciunas to Willem de Ridder. [ca. June 1964].

"...In regards to De Ridder I asked him to prepare Fluxus book for North Europe, since I thought you wanted to do one for South Europe (France & Italy). But of course it would be better to combine — one Fluxus book for all Europe which you should co-edit with Willem de Ridder. It is much cheaper to print in

Holland than France (or anywhere else in Europe)..."
Letter: George Maciunas to Ben Vautier, June 12, 1964.

"...On other side I marked following symbols:
1 — people could be included in European Fluxus if you want very fat book — but not important works....
2 — especially suitable for European Fluxus.
You should not include too many names in European Fluxus, becasue it will end up very thick, without character, and not at all avant-garde. Only true Fluxus-type avant-garde (or rear-garde) should be included I think. Also I would not suggest duplicating too many works already published I marked 3 — already published. not complete works. 100 copies sent to you. You may use some material (choose yourself from published materials) so as to propagandize their complete works. If too many are reprinted, you will never be able to sell the stuff I am shipping to you.
4 — I am sending their materials, many already typeset, ready for offset plates, many negatives even sent. Ready for publication
I have added a few important names...
We may print complete works of Yoko Ono who is coming to New York. if not I will send you all typeset prints for you to print.
The type set sheets I am sending to you (marked 4) are all ready for offset negatives & printing. I suggest you use offset printing method to print.
You will get from me some 100 pages of such ready to print materials therefore I suggest you don't waste time writing to not very important people marked 1 without 4 You will save money this way.
When you have to type set new material, I suggest you don't try to match my type but use some contrasting type. Also change papers. Use nice glossy for photos and rough like wrapping paper for text. Will be cheaper this way. It is less boring when a thick book has various kinds of papers. Do you have Anthology I designed?...
You may get some 50 pages from Ben Vautier.
We shall print a few Hi - Red Center things in New York. You could print some more of their things. That's the best group in Japan (besides Fluxus people: Shiomi - Kosugi - Yoko Ono).
European Fluxbook must be copyrighted. I can do it very easily in New York (for international copyright) or you can do it. In either case it should be: © copyright by Fluxus, all rights reserved. In copyright office they may have on record that I and you are copyright holders....
Add these names:
Giuseppe Chiari 2, 4
Juan Hidalgo & Walter Marchetti 2
Piero Manzoni, 1...
Japanese addresses:
Toshi Ichiyanagi 1

Yasunao Tone 1
Takehisa Kosugi, 2
Chieko Shiomi, 2
Yoriaki Matsudaira 1
Katsuhiro Yamaguchi, 1
Yoshiaki Tono, 1
High Red Center 2 (they dont write English)
Genpei Akasegawa 2
Natsuyuki Nakanishi 2, !
Jiro Takamatsu 2

...

eric andersen 2	DENMARK
sylvano busotti 1, 4	ITALY
joseph byrd 1, 4	USA
jerry bloedow 1, 4	USA
stanley brouwn 2	HOLLAND
bazon brock 1	GERMANY
Pol Bury 2	[FRANCE]
caspari 1	GERMANY
paolo castaldi 2, 4	ITALY
philip corner 1, 4	ENGLAND
john d cale 1	ENGLAND
henning christiansen 2	DENMARK
francois dufrene 1	FRANCE
henry flynt 2	USA
robert filliou 2, 4, 4	FRANCE
øvind fahlstrøm 1	SWEDEN
l gosewitz 1	GERMANY
eugen gomringer 1	SWITZERLAND
dieter hülsmann 1?,4	GERMANY
raoul haussmann 1	GERMANY
Toshi ichiyanagi 1	JAPAN
tatu izumi 1	JAPAN
dennis johnson 1	USA
joe jones c/o Fluxus. 2	USA
kirchengässer 1?	GERMANY
arthur køpcke 2, 4	DENMARK
vaclav kaslik 1	
alison knowles 2	USA
shigeko kubota 2, 4	JAPAN
bengt af klintberg 1	SWEDEN
jackson mac low 1, 4, 3	USA
j.c. lambert 1, 4	FRANCE
gherasim luca 2, 4, 4	FRANCE
gyorgi ligeti 2, 3	POLAND
yoriaki matsudeira[sic] 1, 4	JAPAN
george maciunas 3, 4	USA
walter de maria 2	[USA]
richard maxfield 1, 4	USA
simone morris 1	USA
bob morris 2, 4, 3	USA
miroslav miletic 1	YUGOSLAVIA
heinz klaus metzger 1	
misja mengelberg ?	HOLLAND
franz mon 1	GERMANY
yevgeni murzin 1	

pierre mercure 1	CANADA
jonas mekas 1	USA
Bruno Munari 2	
very important	Milan
Hans Nordenstroem 2	[SWEDEN]
staffan olzon 1	SWEDEN
nam june paik c/o Fluxus 3, 2	KOREA
benjamin patterson 2, 4, 3	USA
joseph patkowski 1	POLAND
k penderecki 2	POLAND
robin page ? 1	ENGLAND
diter rot 2, 1, 4	ICELAND
gerhard rühm 2, 4	GERMANY
alexis rannit 1	GERMANY
grifith rose 1, 4	USA
m.c. richards 1, 4	USA
ron rice 1, 4	USA
terry riley 1	USA
willem de ridder 2	HOLLAND
frederic rzewski 2	
hashimoto sohei 1, 3	JAPAN
daniel spoerri 2, 4	FRANCE
wim t schippers 2	HOLLAND
tomas schmit	
[name deleted] 2, 4	GERMANY
print him at least we shall hold copyright	
jasuano [sic] tone 1, 4	JAPAN
jaap spek 1	HOLLAND
frank trowbridge 2, 4	USA
andre thomkins 4	
tori takemitsu 1	JAPAN
yuri takahashi 1	JAPAN
per olof ultvedt 1	SWEDEN
stanley vanderbeek 2	USA
ben vautier 2, 4, 3	FRANCE
jean pierre wilhelm 1	GERMANY
karl erik welin 2	SWEDEN
knut wiggen 1	SWEDEN
emmett williams 2, 4, 4, 3	USA
james waring 1	USA
diane wakowski 1	USA
la monte young 2, 4, 3	USA
marian zazeela 1, 4	USA
more names?	

congo is a monkey in London Zoo. 2, 4, 3

[This list of names has been edited to exclude addresses and individuals not intended for European Fluxus. We have substituted a numerical code for Maciunas' original graphic code.]

Letter: George Maciunas to Willem de Ridder. [end of July 1964].

"Some more names:
 1 C. Caspari,
 1 Bazon Brock,
 1 Hugo Gosewitz

 1 Henning Christiansen,
 1 Frederic Rzewski
 1 Piero Manzoni
 4 Jean - Pierre Wilhelm
 2 Pol Bury,
 2 Gyorgi Ligetti,
 1 Robin Page
4, 2 Andre Thomkins,
 (All these pages I shipped with his piano pieces.)
 1—suitable for Flux-book
 2—very suitable for Fluxus.
 4—I mailed-shipped his pieces....

You can't include East Europe-Fluxus, because we want that to be printed in East Europe. That's the only basis upon which we get their co-operation...

Don't make Europe-Flux too thick. Its cost will be too high. Be more selective. Don't include all the second-rate things."

[This list of names has been edited to exclude addresses and individuals not intended for European Fluxus. We have substituted a numerical code for Maciunas' original graphic code.]

Letter: George Maciunas to Willem de Ridder, August 12, 1964.

We hope you will co-operate with the european-yearbox we are going to print this winter here in Holland. A 1000 copies (200 for Japan, 200 for U.S.A. and the rest for Europe). The plan is to print your copy on cards (paper etc.) having the size of a box (looking like a cardboard cigarbox) or ½ that size, or ¼, or 1½ etc.
It should be wonderfull [sic] if you have already print copy (size 18 x 15 cm.)
Of course we send you some free copies.
We hope to receive the works, essays, photographs etc. as soon as possible because it is our intention to be ready before january 1965. If we already have all the copy you like to publish, then you can send us instructions wich [sic] works we may use and how you like them to be printed. Special wishes, plans, money etc. for the box are welcome. When you miss some important names on the list, please send us name and address. Write us too, when you don't wish to co-operate. (to flux or not to flux, that's not the question)
We sent this letter to:

Eric Andersen	Arthur Køpcke
Henning Christiansen	Bengt Af Klintberg
Emmett Williams	Robert Filliou
Wolf Vostell	Tomas Schmit
Pol Bury	Paolo Castaldi
Gyorgi Ligeti	Gherasim Luca
Wim T. Schippers	Bruno Munari
Hans Nordenström	K. Penderecki
Diter Rot	Gerhard Rühm
Frederic Rzewski	Daniel Spoerri
Guiseppe Chiari	Juan Hidalgo

Walter Marchetti Ben Vautier
Stanley Brouwn Andre Thomkins
Hugo Gosewitz Willem de Ridder
Form letter: Lydia Mercedes Luyten for the European Mailorder Warehouse/Fluxshop. ca. August 1964.

did you receive the 2nd catalog of THE EUROPEAN MAIL-ORDERHOUSE & FLUXSHOP [advertising]?
...european yearbox...
How to be Satisfluxdecolanti?... [ca. Fall 1964].

"I agree most of French material is no good. Best to limit to some Emmett, Robert, Ben Vautier....
Cards with comic cartoon? I think Stan Vanderbeek, but I don't remember having sent it to you.
Zen priest — painters — we don't have that essay, ignore it.
Robert Morris box with a switch in it is his cabinet. Do you have that photo?
Left hand book etc — throw it away
Carol Berge " " "
un eden + pr 2 cox " " "
nails on german dictionary " " "
Grifith Rose " " "
Cards with short scores — Philip Corner, but to make sure, please describe a few other cards.
My essay and portrait is there & you can reprint it. I will send separate sheets, so you don't have to take the book apart....
We are very pleased to hear of your activities & energetic efforts — Please push — on —"
Letter: George Maciunas to Willem de Ridder, January 21, 1965.

"Reply to your questions: — Fluxyearbox in complete form has been mailed to you. The grey pages were sent to be incorporated into European Fluxbox. So hold them for your own edition..."
Letter: George Maciunas to Willem de Ridder, February 4, 1965.

"...— I am designing cards for you, Schippers, Andersen & Filliou...."
Letter: George Maciunas to Willem de Ridder, March 2, 1965.

"...Do not send me money for [FLUXUS 1]. Keep that money for Fluxus activities & your own contribution for Fluxus...3 etc..."
Letter: George Maciunas to Ben Vautier, May 11, 1965.

COMMENTS: *Fluxus No. 2 West European Yearbox 1 was never produced. Some early planned contributions were used elsewhere, such as Nam June Paik's "Towards the New Ontology of Music" which appeared in Paik's* Monthly Review of the University for Avant-Garde Hinduism *and Diter Rot's "poetry machine," published in Fluxus Newspaper No. 2. Many others were left by the wayside. By 1964, after various attempts to define regions for the first West European Fluxus, Maciunas gave the project to Willem de Ridder to produce as*

a "European Fluxus" from material already printed for FLUXUS 1, plus other manuscripts, scores and works that Maciunas had collected and de Ridder solicited. "European Fluxus," which would have contained work by both Europeans and non-Europeans alike, was never produced either, although some of its probable contents found their way into Randstad No. 11-12, Amsterdam, 1966. The issue was devoted to "Manifestations 1916-1966" and edited by the prominent dutch poet, Simon Vinkenoog. De Ridder was also behind the special Fluxus issue of Kunst Van Nu (Amsterdam: Sept/Oct 1966, No. 11, 3rd Year) which also contains material that would have gone into "European Fluxus."
Between 1962 and 1965, when Fluxus No. 2 West European Yearbox 1 was being planned, George Maciunas gave the following titles for the work in this sequence:
FLUXUS NO. 2 WEST EUROPEAN ISSUE 1. (Germany, Scandinavia, Holland, Switzerland)
FLUXUS NO. 2 WEST EUROPEAN YEARBOOK 1. (Germany, Scandinavia, Holland)
FLUXUS NO. 2 GERMAN YEARBOOK-BOX
FLUXUS NO. 2 GERMAN & SCANDINAVIAN YEARBOX
GERMAN-SCANDINAVIAN FLUXUS NO. 3 or 4
SCANDINAVIAN FLUXUS BOX
FLUXUS II
FLUXUS 3. SCANDINAVIAN YEARBOX (1963)
FLUXUS 6. GERMAN YEARBOX (1964)
DUTCH-SCANDINAVIAN FLUXUS
EUROPEAN YEARBOX
EUROPEAN FLUXUS
NORTH EUROPEAN FLUXUS YEARBOOK
EUROPEAN FLUXBOX

FLUXUS NO. 3 JAPANESE YEARBOX

...
FLUXUS...NO. 3 JAPANESE ISSUE, Japanese & English editions, Aug. 1962
S. Morita or * Abstract chirography (origins, aesthetics) essay & folio
* Brutalist architecture
J. Mekas & * Experiments in Cinema - Japan
Toshi Ichiyanagi *
George Brecht Hakuin, Haiku - Assemblages, Events
* The Gutai theatre
Yoko Ono Kinetics (essay and anthology)
* Japanese electronic music (essay and record)
Ayo or * Sculpture from inside
Nam June Paik Zen Priest training
Philip Corner Of modern times and ancient sounds
[* to be determined]

...
EDITORS: Publisher & editor-in-chief: George Maciunas

...
JAPANESE SECTION:
 Toshi Ichiyanagi - music

...
HEADQUARTERS: FLUXUS, J.S.Bach Strasse, Wiesbaden, West Germany
Fluxus...Tentative Plan for Contents of the First 6 Issues. [before February 1962]. version A

...
FLUXUS...NO.3 JAPANESE YEARBOOK, Japanese & English editions, Aug. '62
Kuniharu Ariyama being consulted
Yoshiaki Tono "
Y. Nakahara "
S. Morita " for Abstract chirography (essay & fold-out folio)
Toshi Ichiyanagi ***
* The Gutai happenings
George Brecht Hakuin, Haiku - Assemblages, Events
Yoko Ono Kinetics (essay and anthology of inserts)
* Japanese electronic music (essay & record)
Ayo or * Sculpture from inside
— Zen Priest training (translation)
Philip Corner Of modern times and ancient sounds
Hidekazu Joshida I hate Japanese modern art *
other essays & anthologies to be determined
[* to be determined]

...
EDITORIAL COMMITTEE:
 Chairman: George Maciunas

...
JAPANESE SECTION:
 Toshi Ichiyanagi - music, happenings

...
TEMPORARY ADDRESS:
 FLUXUS, J.S. Bach Str. 6, Wiesbaden, Germany.
SUBSCRIPTIONS: for each yearbook including all inserts & records:
 16 NF, 16 DM, $4.50
Format: 25 cm. x 25 cm.
 150 to 250 pages
 Printed in Japan, Germany and U.S.A.
Fluxus...Tentative Plan for Contents of the First 7 Issues. [before January 18, 1962]. version B

[as above]
Fluxus...Tentative Plan for Contents of the First 7 Issues. [before February 1962]. version C

FLUXUS YEARBOOK-BOX Enclosed is the latest plan for the forthcoming issues of Fluxus.... New "dead line schedule for each issue is as follows:

[FLUXUS] ...No. 4 Japanese...Submitting Materials Dec. 1...Final proofs to authors Jan. 2...Submitting 200 originals for Luxus-Fluxus Feb. 1...Printing & Binding Feb. 1-30...Issuance Mar. 15 1963...
George Maciunas
for Fluxus administration
(62) Wiesbaden (temporary)
J.S. Bach Str. 6 (even more temporary)
Fluxus Newsletter No. 1 [before May 21, 1962].

EDITORIAL COMMITTEE:
CHAIRMAN: George Maciunas
...
JAPANESE SECTION:
 Toshi Ichiyanagi
...
SUBSCRIPTIONS: for each yearbox
 standard fluxus
 20 NF. 16 DM. $4.00
 luxus fluxus
 (with inserts of originals)
 40 NF. 32 DM. $8.00
FORMAT: 150 to 200 pages
 20 cm x 20 cm x 3 cm
ADDRESS: FLUXUS J.S. Bach Str. 6
 62 Wiesbaden, Germany
...
FLUXUS NO. 4 JAPANESE YEARBOX
Japanese & English Editions

Kuniharu Ariyama	being consulted
Yoshiaki Tono	being consulted
Y. Nakahara	being consulted
S. Morita	Abstract chirography (being consulted)
Toshi Ichiyanagi	new instrumental music (record)
	musical happenings (record)
	Japanese electronic music (essay & record)
	The Gutai happenings
George Brecht	Hakuin, Haiku - Assemblages, Events
Yoko Ono	Kinetics (essay and anthology of inserts)
Ayo	Sculpture from inside (being consulted)
to be determined	Zen Priest training (translation)
Philip Corner	Of modern times and ancient sounds
Hidekazu Joshida	I hate Japanese modern art (consulted)

other essays & anthologies to be determined
...
Brochure Prospectus for Fluxus Yearboxes. [before June 9, 1962]. version A

"...keep sending goodies! It is never too late. We can include them in other issues, like Japanese or East European or French. You are not particular about nationalities?..."
Letter: George Maciunas to Robert Watts, [Summer 1962].

EDITORIAL COMMITTEE:
CHAIRMAN: George Maciunas
...
JAPANESE SECTION:
 Toshi Ichiyanagi
 Yoko Ono
...
SUBSCRIPTIONS: for each yearbox
 (unless noted otherwise)
 standard fluxus
 20 NF. 16 DM. $4.00
 luxus fluxus
 (with inserts of originals)
 40 NF. 32 DM. $8.00
ADDRESS: FLUXUS
 6241 Ehlhalten
 Gräflich str. 17
 West Germany
...
FLUXUS NO. 4 JAPANESE YEARBOX
Japanese & English Editions. Contents to be determined.
...
Brochure Prospectus for Fluxus Yearboxes. [ca. October 1962]. version B

The new Fluxus Hq. will also house...All administrative and technical work regarding Fluxus publications ...Japanese issue is scheduled for March. Material already has been collected by the respective co-editors.
Fluxus Newsletter No. 4, fragment, [ca. October 1962].

FLUXUS YEARBOXES 1963 - 5 ... FLUXUS 4. JAPANESE YEARBOX (1964)
Fluxus Preview Review, [ca. July] 1963.

[as above]
Daniel Spoerri, L'Optique Moderne. List on editorial page. 1963.

[as above]
La Monte Young, LY 1961. Advertisement page. [1963].

FLUXUS 1963 EDITIONS, AVAILABLE NOW FROM FLUXUS P.O. BOX 180, New York 10013, N.Y. or FLUXUS 359 Canal St. New York. CO7-9198 ...Most materials originally intended for Fluxus yearboxes, will be included in the FLUXUSccV TRE newspaper or in individual boxes..."
Film Culture No. 30, Fall 1963.

COMMENTS: In the 1950s and early 1960s, significant avant-garde work was being done in Japan. The Gutai and Hi Red Center groups were particularly prominent. George Maciunas and several of the other American Fluxus artists, such as La Monte Young, George Brecht and Philip Corner, were influenced as well by Zen philosophy, Haiku poetry and traditional Japanese music forms. Fluxus No. 3 Japanese Yearbox was never produced. Various copies of FLUXUS 1 contain contributions by Japanese artists: Ay-O, Sohei Hashimoto, Shigeko Kubota, Takako Saito, Chieko Shiomi, Takehisa Kosugi, Yoko Ono, and Hi Red Center. In 1965, Shigeko Kubota edited Hi Red Center's Bundle of Events for Fluxus. It could be considered an abridged "Japanese Yearbox" although it covers only the actions of one group which weren't included at all in the plans for the Japanese Fluxus.
 Fluxus No. 3 Japanese Yearbox was variously referred to in Fluxus publications as:
FLUXUS NO. 3 JAPANESE ISSUE
FLUXUS NO. 3 JAPANESE YEARBOOK
FLUXUS NO. 4 JAPANESE YEARBOX

FLUXUS NO. 4 HOMAGE TO THE PAST

...
FLUXUS ... NO. 4 HOMAGE TO THE DISTANT PAST, English, German, French editions. Nov. 1962

R. Maxfield	Oscillographic studies of some ancient musical instr.
Don Smithers	Renaissance instrumentation. essay & record)
Philip Corner	The radicals of 14th cent.secular music.
*	Ying Yuch Chieh, the ink splasher of Chan painters.
Alexis Rannit	Byzantine abstract - lettristic poetry.
Dick Higgins	Nonsense poetry of E. Lear
Prof. Nomura (?)	Zen monk music (essay & record)
G. Maciunas or *	Moussorgsky — first concretism in Nursery Cycle.
*	Machine music of Athanasius Kircher
G. Maciunas	Development of abstraction in Animal Style 7-9 cent.
Nam June Paik	Oriental Nihilism in the Past

[* to be determined]
...
EDITORS: Publisher & editor-in-chief:
 George Maciunas
HEADQUARTERS: FLUXUS, J.S. Bach Strasse,
 Wiesbaden, West Germany
Fluxus... Tentative Plan for Contents of the First 6 Issues. [before February 1962] version A

...
FLUXUS...NO. 4 HOMAGE TO THE PAST, English, German, French ed. Nov. '62

Paulo Castaldi	Italian Futurist noise music
Philip Corner	Medieval musical extremeties [sic] of Avignon.
Dick Higgins	Tradition of experimental literature in English.

Fumio Koizumi	Cosmology of Indian Music, ("Musical"study of Indian Music)
George Maciunas	early concretism in Moussorgsky's Nursery Cycle.
''	China's & Europe's cultural debt to Siberia.
R. Maxfield	Oscillographic studies of some ancient musical instr.
H.K. Metzger	Machine music of Athanasius Kircher.
''	Moritz Hauptmann and the musical time.
Prof. Nomura	being consulted for: Zen monk music (essay & record)
Nam June Paik	Indeterminism in Korean Medieval Art.
Alexis Rannit	Byzantine abstract - lettristic poetry.
Don Smithers	Renaissance instrumentation (essay & record)
Isan Yun	Stone instruments of Korean court.
*	Ying Yuch Chieh, the ink splasher of Chan painters.
*	3 newly discovered Japanese medieval Zen painters.

other essays and inserts to be determined.
[* to be determined]

...

EDITORIAL COMMITTEE: Chairman:
George Maciunas

...

TEMPORARY ADDRESS:
FLUXUS, J.S.Bach Str. 6,
Wiesbaden, Germany.
SUBSCRIPTIONS: for each yearbook
including all inserts & records:
16 NF, 16 DM, $4.50
Format: 25cm. x 25 cm.
150 to 250 pages
Printed in Japan, Germany and
U.S.A.

*Fluxus... Tentative Plan for Contents of the First 7 Issues.
[before January 18, 1962]. version B*

"...I will include in Fluxus — your Inroads Rebuff'd and at least 2 Events etc. But the _____ I did not understand all this grammar you were throwing at me. You will notice from revised contents, that Metzger undertook to do Kircher, which will be excellent — much better than if I did it. ...I changed name of 'distant past' to just 'Past' so 19th. and early 20th. cent. can be included...."
Letter: George Maciunas to Dick Higgins, January 18, 1962.

[Identical to Fluxus... Tentative Plan for Contents of

the First 7 Issues. [before January 18, 1962]. version B]

Fluxus... Tentative Plan for Contents of the First 7 Issues. [before February 1962]. version C

FLUXUS YEARBOOK — BOX Enclosed is the latest plan for the forthcoming issues of Fluxus....7. New "dead line schedule for each issue is as follows:...No. 5 Special issue...Submitting Materials Mar. 1 1963... George Maciunas
for Fluxus administration
(62) Wiesbaden (temporary)
J.S. Bach Str. 6 (even more temporary)
Fluxus Newsletter No. 1, [before May 21, 1962].

EDITORIAL COMMITTEE:
CHAIRMAN: George Maciunas

...

SUBSCRIPTIONS:	for each yearbox standard fluxus 20 NF. 16 DM. $4.00 luxus fluxus (with inserts of originals) 40 NF. 32 DM. $8.00
FORMAT:	150 to 200 pages 20 cm x 20 cm x 3 cm
ADDRESS:	FLUXUS J.S. Bach Str. 6 62 Wiesbaden Germany

...

FLUXUS NO. 5 HOMAGE TO THE PAST
English, German, French Editions

M. von Biel	Chance methods in musical compositional methods of past centuries
Paolo Castaldi	Italian Futurist noise music
Philip Corner	Medieval musical extremeties [sic] of Avignon
Dick Higgins	Tradition of experimental literature in English
Fumio Koizumi	Cosmology of Indian Music ("Musical"study of Indian Music)
G. Maciunas	Early concretism in Moussorgsky's Nursery Cycle
G. Maciunas	China's & Europe's cultural debt to Siberia
Dr. P.G. Heike	Overtone structure of ancient wind musical instruments
H.K. Metzger	Machine music of Athanasius Kircher
H.K. Metzger	Moritz Hauptmann and the musical time
Prof. Nomura	Zen monk music (essay & record) (being consulted)
Nam June Paik	Indeterminism in Korean Medieval Art
Alexis Rannit	Byzantine abstract - lettristic poetry

Don Smithers	Renaissance instrumentation (essay & record)
Isan Yun	Stone instruments of Korean court
to be determined	Ying Yuch Chieh, ink splasher of Chan painters
to be determined	Newly discovered Japanese medieval Zen painters

other essays and inserts to be determined
...

Brochure Prospectus for Fluxus Yearboxes. [before June 9, 1962]. version A

EDITORIAL COMMITTEE:
CHAIRMAN:

U.S. SECTION:	George Maciunas

...

SUBSCRIPTIONS:	for each yearbox (unless noted otherwise) standard fluxus 20 NF. 16 DM. $4.00 luxus fluxus (with inserts of originals) 40 NF. 32 DM. $8.00
ADDRESS:	FLUXUS 6241 Ehlhalten Gräfliche str. 17 West Germany

...

FLUXUS NO. 5 HOMAGE TO THE PAST

M. von Biel	Chance methods in musical compositions of the past
Paolo Castaldi	Italian Futurist noisemmusic[sic]
Philip Corner	Medieval musical extremeties [sic] of Avignon
Dick Higgins	Tradition of experimental literature in English
Fumio Koizumi	Cosmology of Indian Music
G. Maciunas	Early concretism in Moussorgky's Nursery Cycle
''	China's & Europe's cultural debt to Siberia
Dr. P.G. Heike	Overtone structure of ancient wind musical instruments instruments [sic]
H.K. Metzger	Machine music of Athanasius Kircher
''	Moritz Hauptmann and the musical time
Prof. Nomura	Zen monk music (essay & record) (being consulted)
Nam June Paik	Indeterminism in Korean Medieval Art
Alexis Rannit	Byzantine abstract - lettristic poetry
Don Smithers	Renaissance instrumentation (essay & record)

Isan Yun	Stone instruments of Korean court
to be determined	Ying Yuch Chieh, ink splasher of Chan painters

...

Brochure Prospectus for Fluxus Yearboxes. [ca. October 1962]. version B

FLUXUS YEARBOXES 1963-5 ... FLUXUS 8. HOMAGE TO THE PAST (1965)

Fluxus Preview Review, [ca. July] 1963.

[as above]

Daniel Spoerri, L'Optique Moderne. List on editorial page. 1963.

[as above]

La Monte Young, LY 1961. Advertisement page. [1963].

FLUXUS 1963 EDITIONS, AVAILABLE NOW FROM FLUXUS P.O. BOX 180, New York 10013, N.Y. or FLUXUS 359 Canal St. New York. CO7-9198 ...Most materials originally intended for Fluxus yearboxes, will be included in the FLUXUScc V TRE newspaper or in individual boxes..."
Film Culture No. 30, Fall 1963.

COMMENTS: Fluxus No. 4 Homage to the Past *was never published. Its plan was a reflection of George Maciunas' intense interest in art history, early music, and the roots of experimentalism, an interest which appears in various works of his:* Diagram of Historical Development of Fluxus...; Historical Boxes; History of Art *etc.*

Fluxus No. 4 Homage to the Past *was successively referred to in Fluxus publications as:*
FLUXUS NO. 4 HOMAGE TO THE DISTANT PAST
FLUXUS NO. 5 HOMAGE TO THE PAST
FLUXUS NO. 5 SPECIAL ISSUE
FLUXUS 8. HOMAGE TO THE PAST

FLUXUS NO. 5 WEST EUROPEAN YEAR-BOX II

...

FLUXUS...NO. 5 WEST EUROPEAN ISSUE II. (France, Italy, England, Belgium, Spain), French, English editions Feb. 1963
A ARS AUTOMATICA MACHINARUM

Tinguiley [sic] (?)	Painting machine
N. de St. Phalle	Shot-gun painting

B. ARS RATIONALIS MACHINIS

p. Schaeffer ed.	Anthology of Musique Concrete: Schaeffer, Henry, Arthuy, Philippot, Ferrari, Mache, Xenakis, Boucourechliev, Vandelle, Chamass, Sauguet, Barrague...(essay & record)
L. Berio (?) ed.	Anthology of Italian Electronic music: Berio, Ligeti, Maderna,

	Nono, Castiglioni ... (essay and record)
J. Siclier or *	Experiments in Cinema — W. Europe II

C. ARS AUTOMATICA PERSONARUM

G. Maciunas	Abstract chirography (essay & folio) in France
D. Higgins or *	Lettrism since Isidore Isou (essay & anthology)
*	Junk and garbage art
S. Bussotti	Graphic music
S. Bussotti	New Music in Italy
C. Cardew (&) or*	Neo Dada in England

...

EDITORS:	Publisher & editor-in-chief: George Maciunas

...

WEST EUROPEAN SECTION II
Sylvano Bussotti - music

...

HEADQUARTERS:
FLUXUS, J.S. Bach Strasse, Wiesbaden, West Germany

Fluxus...Tentative Plan for Contents of the First 6 Issues. [before February 1962]. version A

...

FLUXUS...NO. 5 WEST EUROPEAN YEARBOOK II, (France, Italy, England, Belgium, Spain) French, English editions. Feb.1963

S. Bussotti	Graphic music (a false anthology)
"	South Avant Garde (open letter to Maderna)
" , ed.	Anthology of magnetic-tape music from Italy.
Enrico Crispolti	Being consulted for: new Italian art & literature
Julien Alvard	being consulted for: new French art & literature
P. Schaeffer	being consulted for anthology of Musique Concrete (essay and record)
Isidore Isou	being consulted for: Lettrism since Isou
*	Abstract chirography in France (essay & folio)
G. Maciunas	Motivations of abstract chirographist
Restany	being consulted for: The garbage artists in France (Tinguiley [sic], Arman, Klein, Cezar [sic] etc.)
N. de St. Phalle	Shot-gun painting.
Mekas & *	Experiments in Cinema — W. Europe II

other essays, inserts, anthologies and records to be determined.
[* to be determined]

...

EDITORIAL COMMITTEE: Chairman:
George Maciunas

...

WEST EUROPEAN SECTION II:
Sylvano Bussotti - music (Italy)
Enrico Crispolti - being consulted for Italian art & lit.
Julien Alvard - being consulted for French art & lit.
P. Schaeffer & Bayle - being consulted for French music

...

TEMPORARY ADDRESS:	FLUXUS J.S. Bach Str. 6, Wiesbaden, Germany.
SUBSCRIPTIONS:	for each yearbook including all inserts & records: 16 NF, 16 DM, $4.50
Format:	25cm. x 25cm. 150 to 250 pages Printed in Japan, Germany and U.S.A.

Fluxus...Tentative Plan for Contents of the First 7 Issues. [before January 18, 1962] version B

"...I will ask French editor, (possibly Alvard) to request Isou to write about lettrism. By abstract chirography I was thinking of the very speedy handwriting (like signatures) closer to Japanese 'grass style' (Morita, Equchi etc.) Or in France people like Degottex, few things of Viseaux, Mathieu, and some scribbles of Hidai (not his paintings)...."
Letter: George Maciunas to Dick Higgins, January 18, 1962.

[Identical to Fluxus...Tentative Plan for Contents of the First 7 Issues. [before January 18, 1962]. version B]
Fluxus...Tentative Plan for Contents of the First 7 Issues. [before February 1962]. version C

FLUXUS YEARBOOK-BOX Enclosed is the latest plan for the forthcoming issues of Fluxus....7. New "dead line schedule for each issue is as follows: ... No. 3 French...Submitting Materials Sept. 15...Final proofs to authors Sept. 15-30...Submitting 200 originals for Luxus-Fluxus Nov. 15...Printing & Binding Oct. 15 to Nov. 15...Issuance Dec. 1...No. 6 Italian English Spanish...Submitting Materials April 1, 1963 ...Full efforts should be exerted to issue No. 1 and 2 for festivals starting September and No. 3 in time for December festival in Paris.
George Maciunas
for Fluxus administration
(62) Wiesbaden (temporary)
J.S. Bach Str. 6 (even more temporary)
Fluxus Newsletter No. 1, [before May 21, 1962].

EDITORIAL COMMITTEE
CHAIRMAN: George Maciunas
...

FRENCH SECTION:
 Daniel Spoerri
 François Bayle
ITALIAN SECTION:
 Sylvano Bussotti
 Enrico Crispolti*
AUSTRIAN SECTION:
 Schwertzik
ENGLISH SECTION:
 Michael von Biel
 Michael Horowitz
...
 * being consulted
SUBSCRIPTIONS for each yearbox
 standard fluxus
 20 NF. 16 DM. $4.00
 luxus fluxus
 (with inserts of originals)
 40 NF. 32 DM. $8.00
FORMAT: 150 to 200 pages
 20 cm x 20 cm x 3 cm
ADDRESS: FLUXUS J.S. Bach Str. 6
 62 Wiesbaden Germany
...

FLUXUS NO. 3 FRENCH YEARBOX
French & English Editions
Daniel Spoerri, ed. New Realist art (essays, original, inserts)
 Art in motion
 Neo-dada
 Abstract chirography (inserts, essay)
 Other subjects to be determined
Francois Bayle, ed. New magnetic tape music (record)
 New instrumental music (record)
 happenings
 computer music
 tradition of lettrism since Isou
 experiments in Cinema (flip books)
other subjects, anthologies, inserts, records to be determined
...

FLUXUS NO. 6 ITALIAN, ENGLISH, AUSTRIAN
YEARBOX English & French Editions
S. Bussotti Graphic Music (a false anthology)
 South Avant Garde (open letter to Maderna)
S. Bussotti, ed. Anthology of magnetic tape music (record)
 Italian happenings
Enrico Crispolti being consulted for: new Italian art & literature

to be determined Italian experiments in Cinema
Michael Horowitz compressed anthology of abstract & concrete sounds (Burroughs Themerson Hollo Pete Brown, Horowitz, Tom Raworth, David Sladen, C. Cardew)
Michael Von Biel essay against concretism
Michael Von Biel other subjects to be determined
Schwertzik (to be determined)
other subjects to be determined
...

Brochure Prospectus for Fluxus Yearboxes. [before June 9, 1962]. version A

"...KEEP SENDING GOODIES! It is never too late. We can include them in other issues, like...French... You are not particular about nationalities?..."
Letter: George Maciunas to Robert Watts, [Summer 1962].

The new Fluxus Hq. will also house...All administrative and technical work regarding Fluxus publications ... The Fluxus II will be an issue devoted to new French Art and Music — almost all materials for this having been collected by the co-editors.
Fluxnewsletter No. 4, fragment, [ca. October 1962].

EDITORIAL COMMITTEE:
CHAIRMAN:
U.S. SECTION: George Maciunas
...

FRENCH SECTION:
 Daniel Spoerri
 Jean Clarence Lambert
 Francois Bayle
ITALIAN SECTION:
 Sylvano Bussotti
AUSTRIAN SECTION:
 Kurt Schwertsik
ENGLISH SECTION:
 Michael Horowitz
...
SUBSCRIPTIONS: for each yearbox
 (unless noted otherwise)
 standard fluxus
 20 NF. 16 DM. $4.00
 luxus fluxus
 (with inserts of originals)
 40 NF. 32 DM. $8.00
ADDRESS: FLUXUS
 6241 Ehlhalten
 Gräfliche str. 17
 West Germany
...

FLUXUS NO. 2 FRENCH YEARBOOK-BOX
Daniel Spoerri, ed. Works by Arman, Cesar, Christo, Dufrene, Yves Klein, Arthur Kopcke, Rotella, Spoerri, Benja-

min Vautier, Jacques de Villegle [sic], Jean Tinguely.
J.C. Lambert, ed.: F [sic]
F. Dufrene Tango, Comptines and other poems
Robert Filliou Poems, compositions
 Biography in cards
J.C. Lambert ALEA poesie, Liste Aleatoire
Gherasim Luca Le secret du vide et du plein
 " " Proportion, Coupable ou non.
Emilio Villa Un eden Precox
Sonderborg &
Gastone Novelli scribbles
Kumi Sugai calligraphy
...
[FLUXUS NO. 6 omitted in original]
Brochure Prospectus for Fluxus Yearboxes. [ca. October 1962]. version B

"...We are now in process of printing the French FLUXUS which includes many of your very nice pieces — the 'holes' terraine vague — vomit bottles, a box of god, etc. etc..."
Letter: George Maciunas to Ben Vautier, March 5, 1963.

"...I have several of your things you sent for French Fluxus via Spoerri who is editing it. I can reuse this material for your 'solo' edition. So please send your other compositions etc. as soon as possible, since I will not be Wiesbaden during the Summer. We would print your works in New York where we are acquiring offset press and plate making equipment...."
Letter: George Maciunas to Ben Vautier, [April 1963].

"...Right now Tomas Schmit stays in my place & puts full time on putting together...French Fluxus (2)...By Summer we should be ready to work on next projects..."
Letter: George Maciunas to Robert Watts, [March 11 or 12th, 1963].

"... By fall I should have some 6 Fluxus issues ... French fluxus..."
Letter: George Maciunas to Robert Watts, [ca. April 1963].

"...I will go to New York 2nd week of September... Dec. to March — we should print lots of materials in Dicks shop. (...French Fluxus..."
Letter: George Maciunas to Tomas Schmit, [before June 8, 1963].

FLUXUS YEARBOXES 1963-5 ... FLUXUS 2. FRENCH YEARBOX $4 (1963) — luxus fluxus (with tape, fluxus b & fluxus f) $10...FLUXUS 9. ITALIAN —ENGLISH—AUSTRIAN YEARBOX
Fluxus Preview Review, [ca. July] 1963.

[as above]
Daniel Spoerri, L'Optique Moderne. List on editorial page. 1963.

[as above]
La Monte Young, LY 1961. Advertisement page. [1963].

FLUXUS 1963 EDITIONS, AVAILABLE NOW FROM FLUXUS P.O. BOX 180, New York 10013, N.Y. or FLUXUS 359 Canal St. New York. CO7-9198 ...Most materials originally intended for Fluxus yearboxes, will be included in the FLUXUSccV TRE newspaper or in individual boxes...''
Film Culture No. 30, Fall 1963.

COMMENTS: *This Fluxus was never published. The first plans called for a varied look at the Anglo-Latin avant-garde, touching on the New Realists, Musique Concrete, Lettrism and British Neo-Dadaism etc. Then, in the Spring of 1962, plans were altered to produce a solely French Fluxus edited by Daniel Spoerri. Though never published, the manuscript for it exists, and is in the Archiv Hanns Sohm at the Staatsgalerie Stuttgart. Concurrent plans for a separate Italian, English, Austrian, and for an Italian, English, Spanish Yearbox were never realized, and are included here as conceptual groupings of more or less Southern European vs. Northern or Eastern European Yearboxes.*

Fluxus No. 5 West European Yearbox II *was successively referred to the Fluxus publications as:*

FLUXUS NO. 5 WEST EUROPEAN ISSUE II. (France, Italy, England, Belgium, Spain)
FLUXUS NO. 5 WEST EUROPEAN YEARBOOK II. (France, Italy, England, Belgium, Spain)
FLUXUS NO. 5 WEST EUROPEAN YEARBOX II (France, Italy, England, Belgium, Spain)
FLUXUS NO. 6 Italian, English, Spanish
FLUXUS NO. 6 ITALIAN, ENGLISH, AUSTRIAN YEARBOX
FLUXUS NO. 3 French
FLUXUS NO. 3 FRENCH YEARBOOK-BOX
FRENCH FLUXUS
FLUXUS II...FRENCH
FLUXUS NO. 2 FRENCH YEARBOOK-BOX
FLUXUS 2. FRENCH YEARBOX
FLUXUS 9. ITALIAN-ENGLISH-AUSTRIAN YEARBOX

FLUXUS NO. 6 EAST EUROPEAN YEAR-BOX

...
FLUXUS...NO. 6 EAST EUROPEAN ISSUE, English, Russian editions, May 1963

Dr. Zofia Lissa	Polish experimental cinema - music
*	New Polish concrete and electronic music
J. Patkowski	*
V. Zavalishin or *	Abstract sound poetry in Russia 1900-1921: Annenskii, Kruchionych, Shurshun, Klebnikov, etc.
Akosh Csernus	Sound poetry at present (essay & anthology)
G.Chukhrai (?)	* or Film making procedures in

	Soviet studios.
*	Principles of Dialectic Materialism in concrete art.
J. Mekas & *	Experiments in cinema — East Europe
*	Potentialities of concrete prefabrication in USSR
G. Maciunas	Dostoyevski - the unsuspected champion of the Party. a letter
Editors	Atlas-index of new art, music, cinema in E. Europe

[* to be determined]

...
EDITORS:
Publisher & editor-in-chief: George Maciunas

...
EAST EUROPEAN SECTION:
Jozef Patkowski - music
Akosh Csernus - poetry

...
HEADQUARTERS: FLUXUS, J.S. Bach Strasse, Wiesbaden, West Germany
Fluxus... Tentative Plan for Contents of the First 6 Issues. [before February 1962]. version A

...
FLUXUS...NO. 6 EAST EUROPEAN YEARBOOK, English, Russian editions.

M. Joudina & A. Volkonski	being consulted for: experimental music in USSR
Dr. Zofia Lissa	Polish experimental cinema-music.
*	New Polish concrete and electronic music.
J. Patkowski	*
V. Zavalishin	being consulted for: Abstract sound poetry in Russia 1900 - 1921: Annenskii, Kruchionych, Shurshun, Klebnikov etc.
Akosh Csernus	Sound poetry at present (essay and anthology)
J. Mekas & *	Experiments in cinema - East Europe
G. Maciunas	Principles of Dialectic Materialism & concrete art.
''	Dostoyevski - the unsuspected champion of the Party.
**	Potentialities of concrete prefabrication in USSR.

other essays, anthologies, inserts and records to be determined.
[*to be determined]

...
EDITORIAL COMMITTEE:
Chairman: George Maciunas

...
EAST EUROPEAN SECTION:
Jozef Patkowski - music
Akosh Csernus - poetry
M. Joudina & Andrei Volkonski being consulted for USSR

...

TEMPORARY ADDRESS:	FLUXUS, J.S. Bach Str. 6, Wiesbaden, Germany.
SUBSCRIPTIONS:	for each yearbook including all inserts & records: 16 NF, 16DM, $4.50
Format:	25cm. x 25cm. 150 to 250 pages Printed in Japan, Germany and U.S.A.

Fluxus... Tentative Plan for Contents of the First 7 Issues. [before January 18, 1962]. version B

[as above]
Fluxus... Tentative Plan for Contents of the First 7 Issues. [before February 1962]. version C

FLUXUS YEARBOOK-BOX Enclosed is the latest plan for the forthcoming issues of Fluxus....7. New ''dead line schedule for each issue is as follows: ... No. 7 East Europe...Submitting Materials Dec. 1 1963...
George Maciunas
for Fluxus administration
(62) Wiesbaden (temporary)
J.S. Bach Str. 6 (even more temporary)
Fluxus Newsletter No. 1, [before May 21, 1962].

EDITORIAL COMMITTEE:
CHAIRMAN: George Maciunas

...
E. EUROPEAN SECTION:
Henry Flynt
Josef Patkowski
Marie Joudina *
Andrei Volkonski *
Akosk [sic] Csernus

...

	* being consulted
SUBSCRIPTIONS:	for each yearbook standard fluxus 20 NF. 16 DM. $4.00 luxus fluxus (with inserts of originals) 40 NF. 32 DM. $8.00
FORMAT:	150 to 200 pages 20 cm x 20 cm x 3 cm
ADDRESS:	FLUXUS J.S. Bach Str. 6 62 Wiesbaden Germany

...

FLUXUS NO. 7 EAST EUROPEAN YEARBOX
English & Russian Editions

M. Joudina & A.Volkonski	experimental music in USSR (being consulted)
Dr. Zofia Lissa	Polish experimental cinema-music
to be determined	New Polish concrete and electronic music
J. Patkowski	to be determined
V. Zavalishin	being consulted for: Abstract sound poetry in Russia 1900 - 1921: Annenskii, Kruchionych Shurshun, Klebnikov etc.
Akosh Csernus	Sound poetry at present (essay and anthology)
J. Mekas	Experiments in cinema - East Europe
G. Maciunas	Principles of Dialectic Materialism in concrete art
G. Maciunas	Potentialities of concrete prefabrication in USSR
to be determined	"Zamek" group of concretists in Lublin
to be determined	ballet without gravity
to be determined	junk architecture
to be determined	Soviet machine music
to be determined	Soviet glass electronic music of Muzzin

...

Brochure Prospectus for Fluxus Yearboxes, [before June 9, 1962]. version A

"...KEEP SENDING GOODIES! It is never too late. We can include them in other issues, like...East Europe...You are not particular about nationalities?..."
Letter: George Maciunas to Robert Watts, [Summer 1962].

EDITORIAL COMMITTEE:
CHAIRMAN:
U.S. SECTION: George Maciunas

...

E. EUROPEAN SECTION:
 Henry Flynt
 Josef Patkowski

...

| SUBSCRIPTIONS: | for each yearbox (unless noted otherwise) standard fluxus 20 NF. 16 DM. $4.00 luxus fluxus (with inserts of originals) 40 NF. 32 DM. $8.00 |
| ADDRESS: | FLUXUS 6241 Ehlhalten Gräflich str. 17 West Germany |

...

FLUXUS NO. 7 EAST EUROPEAN YEARBOX
English & Russian Editions

A. Volkonski (*)	Experimental music in USSR (being consulted)
Dr. Zofia Lissa	Polish experimental cinema-music
K. Penderecky	Polish concrete music
J. Patkowski	to be determined
V. Zavalishin	Abstract sound poetry in Russia 1900-1921: Annenskii, Kruchionych, Shurshun, Klebnikov etc. (being consulted)
G. Maciunas	Potentialities of concrete prefabrication in USSR
Miroslav Miletić	New music in Yugoslavia
W. Borowski	Cybernetics in Concrete Art
Yevgeni Murzin	Photoelectric Machine automatically playing pitch-time graphs
to be determined	ballet Without Gravity (In orbital space stations)
to be determined	junk architecture
Henry Flynt	Analysis of Communist Culture
"	The Fraud of "Western Artistic Freedom": Culture for a Decadent Alienated Elite
"	New Culture for Fully Industrialized Communist Society
Vaclav Kaslik "Zamek"	Czech musique concrete (record) works (photographs)
Soviet composers	glass electronic music (record)
Joseph Byrd	Critical analysis of the theories of Zhdanov
"	Critical analysis of current Marxists estheticians (in regard to lack of dialectic approach)
Anthology of Soviet Realism:	Bertolt Brecht, El Lissitzsky, V. Mayakovsky, Yury Pimenov, A. Korneichuk, Y. Evtushenko

...

Brochure Prospectus for Fluxus Yearboxes. [ca. October 1962]. version B

FLUXUS YEARBOXES 1963-5...FLUXUS 5 EAST EUROPEAN YEARBOX (1964)
Fluxus Preview Review, [ca. July] 1963.

[as above]
Daniel Spoerri, L'Optique Moderne. List on editorial page. 1963.

[as above]
La Monte Young, LY 1961. Advertisement page. [1963].

FLUXUS 1963 EDITIONS, AVAILABLE NOW

FROM FLUXUS P.O. BOX 180, New York 10013, N.Y. or FLUXUS 359 Canal St. New York. CO7-9198 ...Most materials originally intended for Fluxus yearboxes, will be included in the FLUXUSccV TRE newspaper or in individual boxes..."
Film Culture No. 30, Fall 1963.

"...You can't include East Europe-Fluxus, because we want that to be printed in East Europe. That's the only basis upon which we get their co-operation..."
Letter: George Maciunas to Willem de Ridder, August 12, 1964.

COMMENTS: *Although never produced, the desire to publish an East European Fluxus was, in part, a reflection of the revolutionary intent of the Fluxus movement. Plans went beyond doing just a Fluxus anthology — there were to be Fluxus agit-prop tours of Eastern Europe as well, and in 1966 some Fluxus members travelled to Prague and performed two Fluxus concerts with Milan Knizak (see: Proposed Program for a Fluxfest in Prague, 1966, reproduced in* Fluxus etc. Addenda I, *pp. 162-169). Maciunas also planned to publish a Fluxus newspaper,* [Fluxus] VerTical pRaguE *on the activities of the Aktual Group.*

Fluxus No. 6 East European Yearbox was successively referred to in Fluxus publications as:
FLUXUS NO. 6 EAST EUROPEAN ISSUE
FLUXUS NO. 6 EAST EUROPEAN YEARBOOK
FLUXUS NO. 7 EAST EUROPE
FLUXUS NO. 7 EAST EUROPEAN YEARBOX
EAST EUROPE FLUXUS
FLUXUS 5. EAST EUROPEAN YEARBOX

FLUXUS NO. 7 HOMAGE TO DADA

...

FLUXUS...NO. X HOMAGE TO DaDa, no date, English, French, German ed.

*	Origins of garbage - junk art
*	Noise music of Futurists & Dada: Russolo, Ball, Tzara...
*	Poemes simultanes (essay & anthology)
*	Dada happenings - (corpus)
*	Abstract sound poetry: anthology of Tzara, Ball, Arp, Housmann [sic], Schwitters,
*	Significance of Dada political orientation.
K. Schwitters	a Theatre piece.

[* to be determined]

...

EDITORS:
Publisher & editor-in-chief: George Maciunas

...

HEADQUARTERS: FLUXUS, J.S. Bach Strasse, Wiesbaden, West Germany
Fluxus... Tentative Plan for Contents of the First 6 Issues. [before February 1962]. version A

...
FLUXUS...NO. 7 HOMAGE TO DaDa, no date, English, French, German ed.

*ed.	Corpus of Dada happenings — festivals.
*	Dada noise music
*	Significance of Dada political orientation.
*	Anthology of Dada sound poetry.
K. Schwitters	A Theatre piece.
Hans Richter	Anti Dada notes of notes.

other essays, inserts and anthologies to be determined.
* to be determined

...
EDITORIAL COMMITTEE:
Chairman: George Maciunas

...
TEMPORARY ADDRESS:
 FLUXUS, J.S. Bach Str. 6,
 Wiesbaden, Germany.
SUBSCRIPTIONS: for each yearbook including all
 inserts & records:
 16 NF, 16 DM, $4.50
Format: 25 cm. x 25 cm.
 150 to 250 pages
 Printed in Japan, Germany and
 U.S.A.

Fluxus...Tentative Plan for Contents of the First 7 Issues. [before January 18, 1962]. version B

[as above]
Fluxus...Tentative Plan for Contents of the First 7 Issues. [before February 1962]. version C

FLUXUS YEARBOXES 1963-5 ... FLUXUS 7. HOMAGE TO DADA (ed. by Raoul Hausmann)
Fluxus Preview Review, [ca. July] 1963.

[as above]
Daniel Spoerri, L'Optique Moderne. List on editorial page. 1963.

[as above]
La Monte Young, LY 1961. Advertisement page. [1963].

FLUXUS 1963 EDITIONS, AVAILABLE NOW FROM FLUXUS P.O. BOX 180, New York 10013, N.Y. or FLUXUS 359 Canal Str. New York. CO7-9198 ...Most materials originally intended for Fluxus yearboxes, will be included in the FLUXUSccV TRE newspaper or in individual boxes..."
Film Culture No. 30, Fall 1963.

COMMENTS: It is unfortunate that Fluxus No. 7 Homage to Dada *was never published. There was an early linkage by the movement to Dada in the characterization of activities as "Neo Dada in der Musik" and in George Maciunas' first lecture/ manifesto on Fluxus at "Kleinen Sommerfest," June 9, 1962, Galerie Parnass, Wuppertal, West Germany. It was titled, "Neo-Dada in Den Vereinigten Staaten" (Neo-Dada in the* United States), *and was an essay in which Maciunas first put forward his ideas of concretism and anti-art that are basic to Fluxus.*

Fluxus No. 7 Homage to Dada *was* successively referred to in Fluxus publications *as:*
FLUXUS NO. X HOMAGE TO DaDa
FLUXUS NO. 7 HOMAGE TO DaDa
FLUXUS 7. HOMAGE TO DADA

FLUX YEAR BOX 2
Silverman No. 125, ff.

"...Please send me some of your compositions (preferably 'Book events' — events that are enacted by reader looking through a Fluxus book — such as film flip-books etc. — We are now preparing Fluxus no. 2 yearbox and would like to include your pieces..."
Letter: George Maciunas to Willem de Ridder, January 21, 1965.

"...Another request: FLUXUS 2 yearbox is now in planning stage & I am requesting various people to contribute Book events. Especially flip book films ... Also more things like your Hosp. event, trace or Vautier's 'turn page'...Fluxus 2, will be a more selected collection of people: Ayo, Brecht, Akasegawa, Brouwn, De Maria, Kubota, Kosugi, Bob Morris, Ben Patterson, Yoko Ono, Shiomi, Vautier, Watts, La Monte Young, & Saito."
Letter: George Maciunas to Robert Watts, January 21, 1965.

"...Now we are preparing Fluxus no. 2 which will be not a book like no. 1 but a box like drawing, with various small items in it, like flip-books (movies) bottles, small games, — all kinds of loose items, a kind of GAME BOX. So please send me also anything you think will fit into such miniature Flux-kit ... Maybe you can make flip-book movies? They should be at least 60 pages to work well. We also will issue only 100 copies. For this you have time till mid Summer. OK?"
Letter: George Maciunas to Ben Vautier, January 23, 1965.

"...Also think about contributions for Fluxus 2...."
Letter: George Maciunas to Ben Vautier, February 1, 1965.

"...When you have time, drop in to discuss festival & Fluxus 2nd yearbox plans..."
Postcard: George Maciunas to Robert Watts, February 25, 1965.

"We are also planning a second yearbox — Fluxus 2 — which will be limited to book events only, i.e. events that are enacted by the reader automatically as he inspects the book or box. This does not include instructions for theatre pieces, poetry or music scores, or events requiring more than one performer. It may include flip books, solo games, or puzzles made of paper or other materials.

Fluxus 1 items of the type that may be included are:
1. Ben Vautier — 'turn the page'
2. Bob Watts — hospital events
3. George Brecht — five places
4. Ay-O — finger envelope
5. the magic boat
6. Shigeko Kubota — dinner napkin
7. Alison Knowles — glove
8. Chieko Shiomi — endless envelope
9. Ben Patterson — questionnaire

Fluxus 2 will be financed collectively as follows:
1. Each contributor will prepare 100 copies of his event (which may be flat or 3-dimensional) and ship them to the address below not later than June 1, 1965.
2. All flip books will be printed very economically by Fluxus and will be charged to contributors, unless they wish to print these themselves.
3. Fluxus will assemble all contributions into an 8 x 8 x 2 inch box (8 x 8 inch side to open).

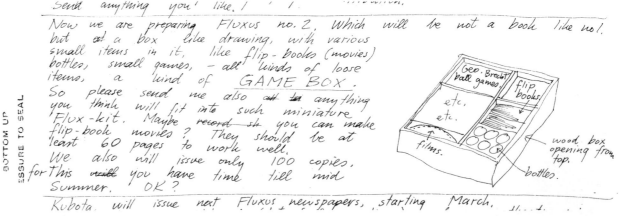

Preliminary instruction drawing by George Maciunas for the collective FLUX YEAR BOX 2, in a January 23, 1965 letter to Ben Vautier

4. Fluxus will distribute 4 free boxes to each contributor
[Fluxus Newsletter] , unnumbered, [ca. March 1965] .

FLUXUS 2 1965 ANTHOLOGY, 8mm film loops with eye film projector, sound objects, puzzles, ball games, paper events, toys, by: Ayo, George Brecht, James Riddle, Walter de Maria, Willem de Ridder, Dick Higgins, Joe Jones, Frederic Lieberman, Yoko Ono, Ben Patterson, Chieko Shiomi, Ben Vautier, Robert Watts. Limited edition of 100. available by Sept. In partitioned wood box, hinged top, $20
Vacuum TRapEzoid (Fluxus Newspaper No. 5) March 1965.

"... Do not send me money for them. Keep that money for Fluxus activities & your own contribution for Fluxus 2...Some time ago I received many matchboxes from you which will be included in Fluxus 2 to come out in June or July. That yearbox will have 8mm film loops (about 10) and an eye viewer - projector to view those films. Also there will be various games & your matches. If you wish to include anything else, please send me 100 copies..."
Letter: George Maciunas to Ben Vautier, May 11, 1965.

"...Did I mention of our 8mm film loops for Fluxus II?? (You will have your 50 cards in FluxII) but maybe you would like to do a loop also? 2ft long/8mm (or 4ft/16mm). You can just send me 'script' or tell what to do and I can have the film made. OK? Let me know soon!..."
Letter: George Maciunas to Ben Vautier, January 10, 1966.

"...the whole 2 hour Fluxfilm program...I will send later...Incidentally, loops from these films will go into Fluxus II Yearboxes. Everything is ready, but I got short on $ & can't produce these boxes in quantity, since making film copies is rather expensive. Maybe in a month or so I will issue that yearbox..."
Letter: George Maciunas to Ben Vautier, March 29, 1966.

"...shortage of $ still delays reproduction of FLUXUS II, but should be able to do in November..."
Letter: George Maciunas to Paul Sharits, [probably after April 6, 1966].

"...Fluxus II is all ready but production of 100 copies (of film loops) also held up by money shortages. The difficulty is that we have now many outlets...but they all want...items on consignment, which means I must invest in them with all these objects, kits, etc, which are expensive to produce, and then I must wait and wait and wait till these outlets start selling. But when they will begin to sell, I think matters will improve and I will be able to produce more objects."
Letter: George Maciunas to Ben Vautier, May 19, 1966.

...will appear late in 1966..FLUXUS 2 1966 ANTHOLOGY, 8mm film loops with film eye viewer,

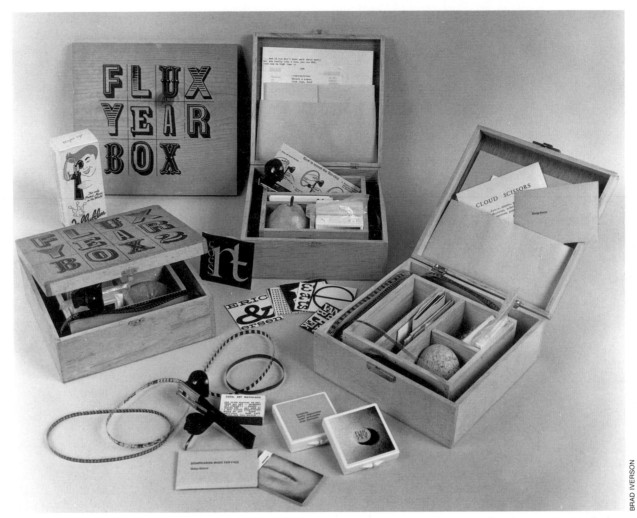

Collective. **FLUX YEAR BOX 2. Three examples and a cover proof, upper left, which is behind an extraneous box that once contained a loop film viewer. see color portfolio**

BRAD IVERSON

playing cards, card games, puzzles, paper events, toys by: Eric Andersen, Jeff Berner, George Brecht, John Cale, Christo, John Cavanaugh, Albert Fine, Joe Jones, Milan Knizak, Shigeko Kubota, Frederic Lieberman, George Maciunas, Claes Oldenburg, Yoko Ono, Willem de Ridder, James Riddle, Bob Sheff, Chieko Shiomi, Ben Vautier, Robert Watts. Limited edition of 100, in partitioned box, hinged top: $30
Vaseline sTREet (Fluxus Newspaper No. 8) May 1966.

"...I received the book, the 'pull apart' book events & film loops. All are great, terrific and in time for Fluxus II yearbook..."
Letter: George Maciunas to Paul Sharits, June 29, 1966.

"... Re: Fluxus II yearbook, since you contributed

films for it you will get 2 free copies, one you can sell..."
Letter: George Maciunas to Paul Sharits, July 11, 1966.

"...We put your 4 loops both in Fluxus II and Fluxfilm program:..."
Letter: George Maciunas to Paul Sharits [ca. Fall 1966].

flux year box no. 2 $30
Fluxshopnews, [Spring 1967] .

FLUXPROJECTS REALIZED IN 1967: ...Fluxfilm 8mm version, also 20 loop version for flux-film-wall-paper-event and flux-year-box-2 (finally)
Fluxnewsletter, January 31, 1968.

FLUXPROJECTS FOR 1968 (in order of priority)...

4. Flux-year-box 2 (20 8mm film loops, jewelry kit by Alice Hutchins, ESP kit by J. Riddle, card games) *ibid.*

''I mailed to you a pack with flux year box 2 (one with film loops), also our 8mm film program (about hour long) & few new things...''
Letter: George Maciunas to Paul Sharits, [Spring 1968].

''...By parcel post I am sending you...flux-year-box 2 (one with loops) 8mm film program (1 hour)...''
Letter: George Maciunas to Ken Friedman, [ca. Winter 1967/68].

FLUX-PRODUCTS 1961 TO 1969...FLUXYEAR-BOX 2 May 1968 Games by: George Brecht, Jim Riddle, Willem De Ridder, Frederic Lieberman, Ken Friedman, Paul Sharits, Bob Sheff, Ben Vautier, Bob Watts.
19 film loops by: Eric Andersen, George Brecht, John Cale, John Cavanaugh, Albert Fine, Dan Lauffer, Maciunas, Yoko Ono, Paul Sharits, Stan Vanderbeek, Wolf Vostell, Bob Watts. $40
Fluxnewsletter, December 2, 1968 (revised March 15, 1969).

FLUX-PRODUCTS 1961 TO 1970 [as above, but without price listed]
Flux Fest Kit 2. [ca. December 1969].

[Catalogue no.] 716 FLUXUS-EDITIONEN...FLUX-YEARBOX 2, 1968 (Holzkasten mit objekten usw.)
Happening & Fluxus. Koelnischer Kunstverein, 1970.

05.1966 FLUXYEARBOX 2 anthology of film loops, games & paper events by: andersen, brecht, john cale, john cavanaugh, a.fine, joe jones, knizak, kubota, lieberman, maciunas, oldenburg, yoko ono, w. de ridder, riddle, sheff, shiomi, vautier, watts.
George Maciunas, Diagram of Historical Developments of Fluxus... [1973].

FLUX-PRODUCTS 1961 TO 1970...FLUXYEAR-BOX 2, May 1968 $80 Games by: George Brecht, Jim Riddle, Paul Sharits, Willem De Ridder, Frederic Lieberman, Ken Friedman, Bob Sheff, Ben Vautier, Bob Watts. 19 film loops by: Eric Andersen, John Cale, John Cavanaugh, G. Brecht, Albert Fine, Dan Lauffer, G. Maciunas, Yoko Ono, Paul Sharits, Stan Vanderbeek, Wolf Vostell, Watts.
[Fluxus price list for a customer]. September 1975.

Fluxyearbox 2 $80
[Fluxus price list for a customer], January 7, 1976.

OBJECTS AND EXHIBITS...1966: edited & published Fluxyearbox 2, anthology of film loops, games and paper events. Contributed 4 film loops.
George Maciunas Biographical Data. 1976.

COMMENTS: *After producing* FLUXUS 1 *and* Fluxkit,

George Maciunas wanted to expand the potentials for a boxed collective anthology to include film, as well as games and small publications. This, and de Ridder's failure to produce European Fluxus *led to* Flux Year Box 2. *It was also during this period, 1965, that plans were being made to produce a number of films for a* Fluxfilms *package. Although a long version of* Fluxfilms *was completed in 1966,* Flux Year Box 2 *was delayed until late 1967, or possibly 1968, because of production costs. The films in* Flux Year Box 2 *are short loops packaged with a hand held viewer, many taken from* Fluxfilms. *The idea of loops led to other possible uses which are discussed in* Fluxfilms Loops.

Maciunas' assemblings of Flux Year Box 2 *vary from copy to copy. An early example (Silverman No. 125). assembled around 1968, contains:*

Anonymous	*film loops*
Eric Andersen	Opus 74, Version 2
George Brecht	Games & Puzzles/ Swim Puzzle/ Bead Puzzle/ Ball Puzzle
George Brecht/ Ben Vautier	"Statement on the otherside..."
John Cale	Police Car
John Cavanaugh	Blink
Willem de Ridder	Paper Flux Work
Albert Fine	"clothespin spring"
	Ready Made
Ken Friedman	A Flux Corsage
Shigeko Kubota	Flux Medicine
Fred Lieberman	Divertevents One
George Maciunas	Artype
	Dots in Squares
	Linear Turn
	Lines Falling or Rising
Claes Oldenburg	False Food Selection
Yoko Ono	Film No. 4
Benjamin Patterson	*[part of]* Poems in Boxes
James Riddle	E.S.P. Fluxkit
Paul Sharits	Flux Music
	Dots 1 & 3
	Sears Catalogue
	Wrist Trick
	Unrolling Event
Bob Sheff	Hum
Stanley Vanderbeek	*untitled film loop*
Ben Vautier	Theatre D'Art Total
	Fold/Unfold
	Total Art Matchbox
	The Postman's Choice
	Your Thumb Present
Wolf Vostell	Sun In Your Head
Robert Watts	Events *[two scores, Watts printing]*
	Playing Cards *[printed on back of six programs for Flux Orchestra at Carnegie Recital Hall]*
	Trace No. 22
Monogram Cards:	*Eric Andersen, George Brecht, John Cavanaugh, Albert Fine, Fred Lieberman, George Maciunas, Yoko Ono, Benjamin Patterson, James Riddle (2x), Chieko Shiomi, Stanley Vanderbeek, Ben Vautier, Robert Watts, unknown*

Also contains:	*loop film viewer*
	instructions for using film viewer

A later assembling of Flux Year Box 2 *(owned by Fluxus artist Larry Miller), although containing many of the works in the earlier version, has numerous differences. It does not contain:*

George Brecht	Games & Puzzles/ Swim Puzzle/ Bead Puzzle/ Ball Puzzle
John Cale	Police Car
Shigeko Kubota	Flux Medicine
Claes Oldenburg	False Food Selection
Benjamin Patterson	*[part of]* Poems in Boxes
Ben Vautier	Fold/Unfold
	The Postman's Choice

but in addition contains:

Anonymous	*[three film loops:]*
	"penguins walking"
	"black film with pin holes"
	"hand in front of lense"
	Outdated London to Dublin Tickets
	Outdated London Underground Tickets
	Ticket
	Facsimile Ticket to New York Zoological Society, 1947
George Brecht	*[10 scores from]* Water Yam
	Nut Bone
Filliou, Spoerri, Topor	*[one card from]* Monsters Are Inoffensive
Hi Red Center	Record of Features and Feats
John Lennon	Tickets to Cortland Alley
George Maciunas	Facsimile Ticket to Grolier Club Exhibition, 1893
	Facsimile Ticket to Visit House of Commons, 1885
	Perham's Opera House Ticket
Claes Oldenburg	Light Bulb
Paul Sharits	*solid black film loop, possibly* N:O:T:H:I:N:G
Mieko Shiomi	Disappearing Music for Face
Ben Vautier	Flux Holes *[plastic straws]*
	100 Tickets to Same Seat, Same Day Show
	To Look At
Yoshimasa Wada	Smoke Fluxkit
	Unauthorized Ticket to Visit James Stewart
	Unauthorized Ticket to Visit Jonas Mekas
	Unauthorized Ticket to Visit Lauren Bacall
	Unauthorized Ticket to Visit La Monte Young
Robert Watts	Playing Cards *[3]*
	[23 scores from] Events
Monogram cards:	*Hi Red Center, Paul Sharits, Anonymous [woman's breast]*

FLUXPACK 3
Silverman No. > 131.I

FLUXPROJECTS FOR 1969...PROPOSALS WILL

BE WELCOMED FOR:...new games for Flux-year-box 3.
Fluxnewsletter, December 2, 1968.

PROPOSED CONTENTS FOR FLUXPACK 3
TO BE PUBLISHED BY FLASH ART

Vinyl aprons	stomach by Maciunas
	Venus de Milo by Maciunas
Table covers	nude crossed legs by Watts
	cluttered desk by Peter Moore
Napkins	face parts by Shigeko Kubota
Dance steps	floor poster by Ben Patterson
gloves	plastic-hand-Watts
Posters 24 x 34	ladder by Watts
	assholes by Ben Vautier
	safe door by Maciunas
Flag	NO SMOKING sign by George Brecht
	Target.
	window —
Game board	by Takako Saito
Map	by Mieko Shiomi
	by Nam June Paik
Stick-ons	parking meter decal by Watts
	bugs, spiders, worms by Maciunas
	jewelry by Maciunas
Stationery	envelope with giant stamp imprint, letter paper with signatures of Decl. of American Independence, by Watts
	envelope with shoe imprint, letter paper with naked foot inprint, [sic] by Maciunas
	envelope with furcoat or dress imprint, letter paper with nude body imprint, by Maciunas

Collective. Unused label designed by George Maciunas for "Flux Shop List Box 3," a work that evolved into **FLUXPACK 3**

Postage stamps	moonscape or other, by Watts
	members of some church synod by Maciunas
Postcards	by Vautier, Filliou, Brecht, Watts, Saito, Paik, Hendricks, Maciunas, Sharits
$ bill	by Watts
Clinic chart	by Hi Red Center, Watts, Maciunas,
Paper Events	hitting explosive charges hidden in picture, by Watts
	paper music by Paul Sharits
Something	by Simonetti
Flip book	rainbow by Ayo
Multi-sun-glasses	by Maciunas
Necklace	by Watts.

100 copies signed by: Watts, Maciunas Saito, Moore, Kubota, Ayo, Vautier, Filliou, Brecht, Shiomi, Hendricks, Simonetti

Cost Estimates:	for 1000 copies
aprons	$500
table covers	$500
posters, games	$700
stick-ons	$500
stationery	$150
postage stamps	$100
postcards	$100
paper events	$500
flip book	$300
sun glasses	$600
packaging	$1000
TOTAL about	$5000

[George Maciunas] Proposed Contents for Fluxpack 3 [ca. 1972].

...Flash Art editor, Giancarlo Politi, proposed to publish the 3rd Fluxyearbook, maybe to be called FLUX-PACK 3, with the following preliminary contents:

Household items: Table covers (crossed nude legs by Bob Watts, cluttered desk by Peter Moore); napkins (face parts by Shigeko Kubota); posters, signs or wallpaper (ladder by Watts, window by Watts, assholes by Ben Vautier, safe door by G.Maciunas, No Smoking sign or flag by George Brecht); parking meter decal by Watts;

Wear items: vinyl aprons (stomach anatomy by Maciunas, Venus de Milo torso by Maciunas); body stick-ons (bugs, spiders by Maciunas, jewelry by Maciunas); paper jewelry (string of pearls by Watts); paper or vinyl gloves by Watts; hats by anyone?;

Stationery: envelope with giant stamp imprint, letter paper with imprint of signatures of Decl. of American Independence, by Watts; envelope with shoe imprint, letter paper with naked foot imprint, by Maciunas; envelope with furcoat imprint, letter paper with nude body imprint;

An advertisement for the collective **FLUXPACK 3**, which appeared in the magazine, *a-beta*, No. 3-4, Milano, October 1975

Postage stamps: moonscape by Watts, members of a church synod by Maciunas;

Postcards: by Ben Vautier, George Brecht, Watts, anyone else?;

Games: dance step floor sheet by Ben Patterson; game board by Takako Saito; map by Mieko Shiomi, and by George Brecht; clinic chart by Hi Red Center, Watts & Maciunas; paper events: (hitting explosive discs hidden in picture by Watts, paper music by P. Sharits) targets by Watts, Maciunas, anyone else?; flip books by Ayo, Shiomi, Brecht, Dick Higgins, anyone else?

Something expected from: Simonetti, Ayo, Wada, Carla Liss, and any recipient of this news letter. Any new proposals fitting any of above listed category should be forwarded to me not later than May 15th. Instead of money, will [sic] shall receive from the publishers 5 copies of the Fluxpack 3 for every item included, or a total of about 200 copies. If number of proposals exceed the projected quantity of items, we shall have the flux-games published as a separate package. All items shall be packed into a set of various size envelopes, the set of envelopes to be boxed

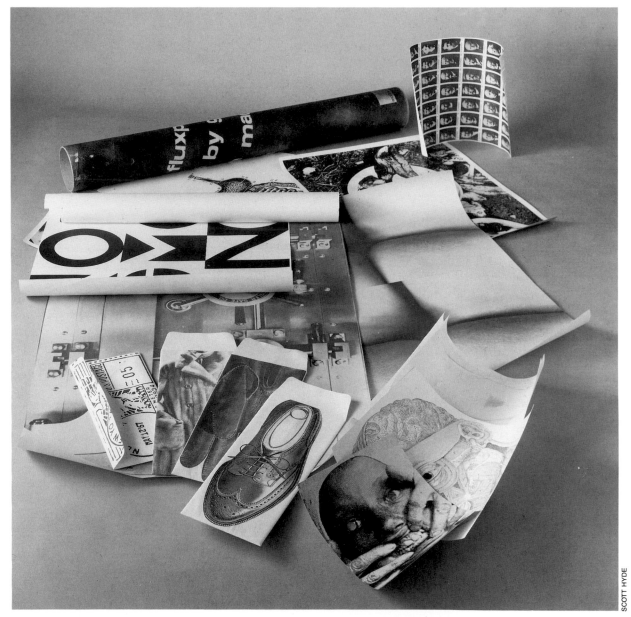

SCOTT HYDE

Collective. **FLUXPACK 3**

Brecht, ladder by Watts, Stick-ons, decals, parking meter decal by Watts, bugs, flies, spiders by Maciunas, pearl necklace by Watts;

Stationery: hand in glove by Maciunas, torso in fur coat by Maciunas, signers of D. of I. in giant stamp by Watts.

Postage stamps: moonscape by Watts, church synod by Maciunas

Postcards: one side with adhesive by Maciunas, specifications about itself (after Bob Morris)

Aprons: anatomy of stomach by Maciunas, Venus de Milo by Maciunas

Masks: sleepmask for dining by Alison Knowles, diseased face by Ben Vautier, face anatomy by Maciunas

Hats: with clouds by Geoff Hendricks, with hair by Watts.

I can still include anything I receive within August. The whole package may have to be a large roll, since I don't think folding of large items would be a good idea. The completion should be end of September.

I am not including any games in this package but saving them for the next package of games only. This package would be household-wear items. By end of August I may need another $2000...I could not come this September, since I will be still producing the Fluxpack 3...."

Letter: George Maciunas to Giancarlo Politi, n.d. Reproduced in Fluxnewsletter, April 1973.

"...Regarding Flux-magazine. As I said before, I am not too enthusiastic about it, since we would be just repeating ourselves. However I could edit one if you insist. I would still like to put together a paper event-game box with maybe a newspaper for text material. Could you find out about the allowable format, allowable budget, whether it could be printed and manufactured it Italy, if you know box makers, die cutters, suppliers of small film viewers, card (playing card) makers, film loop makers etc. also rubber molders. We would like to produce two nice soft objects, a round-ball like dice and cube tennis ball or some such thing. Another object: a soap covered plastic soap shape, so that real soap would wash off instantly, I keep thinking or remembering of other new objects so that I better put it down in more systematic way. These objects I think could be produced cheaper in Italy:

1. rubber dip moulded objects: cube tennis ball, round dice, cows udder (as cream or coffee dispenser or a hat)

2. real soap thin cover of fake plastic soap, dissolvable toilet paper, paper cup made from paper that dissolves in water.

3. towel with dirty hand prints, carpet with foot prints or animal foot prints (elephant prints?)

somehow. The proposed items therefore should be flat, or collapsible into a flat form, so that they could be inserted into an envelope. They should also be possible to be produced in a quantity of 1000.
Fluxnewsletter, April 1973.

"I have received the $2000 some times [sic] ago and proceeded to produce the Flash Art FLUXPACK 3. So

far the response to my newsletter has been very poor. For instance Simonetti has not submitted any project. The contents at present will be as follows:

Tablecloths: crossed legs by Bob Watts, picnic ground by Geoff Hendricks, Napkins (all stuck together) by Paul Sharits

Posters, wallpaper: safe (vault) door by Maciunas, ass holes by Ben Vautier, No Smoking by George

4. vinyl fabric aprons with various fronts (did I show them to you?, Napolean, Venus de Milo, intestants [sic] etc.)

5. shirts with similar subjects, such as baroque engraved pictures of shirt fronts etc.

6. some new stick-ons that we did not have a chance to produce such as various insects (full size), stamps, moustaches, .

7. a sun-glass 'hat' or like a crown, which has actualy [sic] 4 pairs of sun glasses each different like some through fresnel lense, or half sphere lense, box like lense, you can turn it around the head to view through different lenses, could be easely [sic] produced by stamping single plastic sheet and dieing and shaping afterwards.

8. stationery (envelopes with writing paper in such forms as: envelope printed to look like glove, paper like hand or envelope printed like fur coat, paper as nude body, all simple screened photos.

9. playing cards, we have several very good projects. We have already projects, photos etc. of all products, so that only manufacturers and backers are needed. I should have shown them to you, but did not think about them. I am working on the chart, but very slowly. Could finish probably in a year, because I have more time now. That could be [sic] conceivably be included in such an anthology as a wall-paper...."
Letter: George Maciunas to Daniela Palazzoli, n.d. Reproduced in Fluxnewsletter, April 1973.

"The story on the other side is self explanatory. As a result of which I have to have eye surgery, since I hardly see anything with the left eye. In one sense, these hospital expenses to me are a windfall to any collectors of flux-objects. Now with high cost of surgery, I must make more objects and begin to respond to various orders and requests for them. Thus I am sending by mail to you the following...Fluxpack 3 items...aprons, place mats, envelopes, stamps etc.— no charge — this will be sent separately in a tube..."
Letter: George Maciunas to Dr. Hanns Sohm. November 30, 1975.

OBJECTS AND EXHIBITS ... 1975: ... edited Fluxpack 3, contributed 3 stationery designs, 2 aprons, postage stamps, published by Multipla, Milan.
George Maciunas Biographical Data 1976.

COMMENTS: Fluxpack 3, *conceived at first as* Flux Year Box 3, *was edited by George Maciunas and contains both preexisting Fluxus works and material specifically produced by Maciunas for the collective work. The contents were produced in New York and shipped to Gino Di Maggio, publisher of Multipla in Milan, Itlay. There, they were assembled and packaged in a tube as Maciunas had suggested, but the stenciled titled reads "Fluxpack 3 by George Maciunas." Evidently very few examples were assembled. I have only seen one, which is now in the Silverman Collection. It is not clear why the project was shifted from Giancarlo Politi's* Flash Art

which had published a facsimile edition of the nine Fluxus Newspapers. Di Maggio and Politi were friends, and perhaps Politi felt that the work was more in the direction of Di Maggio's activities as a book publisher, gallerist and producer of limited editions.
As produced, Fluxpack 3 contains:

George Brecht:	No Smoking *(typography by George Maciunas)*
Geoffrey Hendricks:	Picnic Garbage Placemat
George Maciunas:	Face Anatomy Mask
	Fluxpost (Aging Men)
	Flux Stationery: Foot In Shoe
	Flux Stationery: Hand In Glove
	Flux Stationery: Torso In Fur Coat
	Grotesque Face Mask
	Safe Door
	Stomach Anatomy Apron
	Venus De Milo Apron
Ben Vautier:	Assholes Wallpaper
Robert Watts:	Crossed Nude Legs Table Cloth
	Giant Stamp Imprint Envelope: Signers of the Declaration of Independance Letter Paper

Contingent on sales of Fluxpack 3, Fluxpack 4 *was to have been produced by George Maciunas for distribution by Gino Di Maggio, possibly for Multipla in Milan. It was to have contained altered ping pong rackets, board and card games, etc. However, because* Fluxpack 3 *was not successfully distributed, no serious work was done on* Fluxpack 4.

FLUX WALLPAPER EVENT see:
FLUXFILM ENVIRONMENT

FLUX-WEST ANTHOLOGY

NEWS FROM FLUX-WEST:...Flux-West Anthology has been postponed. Shortage of $$.
Fluxnewsletter, January 31, 1968.

COMMENTS: *Fluxus never published a* Flux-West Anthology. *We have found no mention of the work in George Maciunas' correspondance with Ken Friedman and can only assume that it would have contained works of the artists associated with Fluxus West.*

JAPANESE YEARBOX see:
FLUXUS NO. 3 JAPANESE YEARBOX
JOHN YOKO & FLUX all photographs copyright nineteen seVenty by peTer mooRE see:
FLUXUS NEWSPAPERS
LABYRINTH see:
FLUX AMUSEMENT CENTER
FLUX LABYRINTH
PORTRAIT OF JOHN LENNON AS A
YOUNG CLOUD

LAUDATIO SCRIPTA PRO GEORGE

FESTSCHRIFT FOR GEORGE MACIUNAS

Last year I proposed to Bob Watts and Geoff Hendricks that it might be nice if all the "Flux-people" (anyone ever connected, closely or remotely, with Maciunas) got together to make a Festschrift for him. In a December '75 letter Bob Watts wrote: "This has been a rugged fall time. G.M. was mugged in a building in Mercer St. by Mafia types over a $2000 misunderstanding with an Italian electrician. He had 4 broken ribs, punctured lung, 8 stitches in scalp, and damage to one eye." There is still some question about recovery of the eye." Geoff wrote that he thought this might be an especially good time to do the Festschrift. Bob, Geoff, Dick Higgins, Alison Knowles, and I came up with the list below of people to invite. They are contacting those in the States and Japan, and I those who live in Europe.

The Festschrift itself might take the form of a printed book, or a box for objects, in book-format, or a combination of both. The Stateside feelings at present are reflected in the following quote from Geoff's most recent letter: "What seems to be cooking in the pot is a meal on Easter for the presentation to George, kept a secret until then, with the Fluxfeast taking place in the printshop of Zacar [sic], right around the corner from Maciunas, where George has had many things printed and where Dick at one time worked. Dick is going to speak to Zacar [sic]. The Box, sure why not lion-skin, containing the original material sent in. (Dick — "who will distribute and publish the special delux edition", Bob — "why not just let it be the box for George",) but it struck me that it might be nice to get the material sent in, into a V TRE-like newspaper form for the rest of us — the "specialdeluxedition" beyond the special copy/box for George. What do you think? That would be something we could put together quickly in the week or so before Easter."

George Brecht
14 Jan 76

Eric Andersen
Ayo
Joseph Beuys
Takehisa Kosugi
Jackson Mac Low
Walter Marchetti

George Brecht
Robert Filliou
Henry Flynt
Bici Forbes
Ken Friedman
Geoff Hendricks
Juan Hidalgo
Dick Higgins
Alice Hutchins
Joe Jones
Alison Knowles
Shigeko Kubota
Addi Koepcke
Yoko Ono (+ John L.)
Nam June Paik
Benjamin Patterson
Takako Saito
Tomas Schmit
Chieko Shiomi
Daniel Spoerri
Yasunao Tone
Ben Vautier
Wolf Vostell
Yoshi Wada
Robert Watts
Emmett Williams
La Monte Young

Formletter: George Brecht to Fluxus Artists. January 14, 1976.

LAUDATIO SCRIPTA PRO GEORGE MACIUNAS CONCEPTA HOMINIBUS FLUXI — MAY 2, 1976, 7:30 P.M. at Mike Zaccar Offset printing plant, 134-6 Spring st. to complete surprise and amazement of George Maciunas....
CONTENTS OF BOX AND V TRE ISSUE:
1. Eric Andersen — circuits
2. Ayo — poem for GM
3. J. Beuys — letter, the script of which even Rene Block could not decifer
4. George Brecht — Physicochemical properties of GM
5. Robert Filliou — false fingerprints of Tristan Tzara, Andre Breton and GM
6. Bici Forbes — fluxerection for GM (made in Denmark) and Dollar bill montage with signatures [sic] of all participants
7. Peter Frank — 10 Ping pong tables for GM
8. Ken Friedman — homage to GM
9. Henry Flynt — Politics of "Native" or ethnic music (essay)
10. Geoff Hendricks — Box for entire contents, also flux soap and 28 tasks for GM
11. Dick Higgins — Flux — George — Us! also sanuicaM piece
12. Alice Hutchins — Bicentennial magnetic flux for GM
13. Joe Jones — No Smoking (sign)
14. Alison Knowles — More (bean book) and Aroostook Bush Lima, single specimen.
15. Larry Miller — Mona Lisa fan blades, and bumper bra, and "Outer Space" road sign
16. Barbara Moore —
17. Peter Moore — group portrait
18. Nam June Paik — Fluxus is always 6AM
19. Takako Saito — drawing of a bull (or an ox?)
20. Mieko Shiomi — Fantastic event for GM (bird organ for collective performance)
21. Daniel Spoerri — piece for GM in June issue of AQ
22. Anne Tardos — clock face
23. Wolf Vostell — Derriere L' Arbre (Duchamp didn't understand Rembrandt)
24. Yasunao Tone — Container for used sandpaper
25. Robert Watts — special issue of V TRE, also photo-film of July 4, 1975 and American Sky
26. Yoshimasa Wada — laminated flux
27. Emmett Williams — portrait of GM
28. Mike Zaccar — "The Living End Catalogue"
[Fluxnewsletter] Laudatio Scripta Pro George Maciunas, [May 1976].

"Thanks a lot for your pieces for the Laudatio...great pieces! You are humorous as ever. Some day we should publish the entire laudatio book..."
Letter: George Maciunas to Ben Vautier, August 11, 1976.

May 2, 1976: recipient of "Laudatio scripta pro George Maciunas concepta hominibus fluxi", organized by all flux-members (27)
George Maciunas Biographical Data. 1976.

COMMENTS: Laudatio Scripta Pro George is a unique box of pieces by Fluxus artists gathered by George Brecht and Geoffrey Hendricks and others to honor George Maciunas. The work was presented to Maciunas as part of a Festschrift in New York City May 2, 1976. Maciunas evidently later considered producing a Fluxus Edition of the work, however this was never done. The original work is now in the Staatsgalerie Stuttgart. Simultaneously with assembling material for the unique box, Geoffrey Hendricks suggested making an issue of V TRE using texts and images from the box. The job of editing and designing the newspaper was done by Robert Watts and Sara Seagull with Hendricks taking on the role of producer.

LIBRARY see:
FLUX LIBRARY
FLUX HISTORY ROOM
LOOPS see:
FLUXFILMS LOOPS
FLUXKIT
FLUX YEAR BOX 2
LUXUS FLUXUS see:
FLUXUS 1
FLUXUS YEARBOXES
maciuNAS V TRE FLUXUS laudatio ScriPTa pro GEoRge see:
FLUXUS maciuNAS V TRE FLUXUS laudatio ScriPTa pro GEoRge
MAZE see:
LABYRINTH
MEAL EVENTS see:
FLUX FOOD
MEDICAL KIT see:
FLUX MEDICAL KIT

PORTRAIT OF JOHN LENNON AS A YOUNG CLOUD

MAY 23-29: PORTRAIT OF JOHN LENNON AS A

YOUNG CLOUD BY YOKO ONO & EVERY PARTICIPANT
A maze with 8 doors each opening in a different manner:
door openable through a small trap door, with knob on other side
door hinged at center of horizontal axis
door split in separate top and bottom halfs [sic]
door hinged at ceiling
door hinged at center of vertical axis
door with missing knob
door hinged at the floor
door with adhesive knob
all photographs copyright nineteen seVenty by peTer mooRE (Fluxus Newspaper No. 9) 1970.

11.04 - 29.05.1970 FLUXFEST OF JOHN LENNON & YOKO ONO:...
23-29.05. PORTRAIT OF LENNON by ono & flux carpenters: 8 doors in a maze, each opening different way (pivoted, hinged at top, door in door, etc.).
George Maciunas, Diagram of Historical Developments of Fluxus... [1973].

PERFORMANCE COMPOSITIONS ... EVENTS ... 1970 Organized a flux festival in collaboration with Yoko Ono & John Lennon at 80 Wooster st. ... maze of difficult doors...
George Maciunas Biographical Data. 1976.

COMMENTS: A precursor to the idea of Flux Maze and Flux-labyrinth, Portrait of John Lennon as a Young Cloud was constructed by George Maciunas from a suggestion by Yoko Ono for the "Fluxfest of John Lennon and Yoko Ono" in New York, 1970. The work incorporated various artists' concepts applied by Maciunas to a maze of doors. A different work of the same title was announced in press releases B and C for the 1970 Fluxfest and was later constructed by George Maciunas for Ono's "This Is Not Here" exhibition at the Everson Museum in Syracuse, New York, 1971. Another work by Ono in the Everson show was titled AMAZE and consisted of plexiglass doors.

TICKET DISPENSER

FLUX AMUSEMENT ARCADE...Ticket Dispenser (tickets by John Lennon, Vautier, Ayo, Maciunas, Wada)
Preliminary Proposal for a Flux Exhibit at Rene Block Gallery. [ca. 1974].

COMMENTS: A "Ticket Window Display" was made for "Fluxfest Presentation of John Lennon & Yoko Ono" in

New York, 1970 (see photograph No. 25 by Peter Moore in Fluxus Newspaper No. 9). However, a dispenser for the various artists' tickets is not known to have been used. I recall seeing a display apparatus at George Maciunas' farm in the mid-1970s that he used to store Robert Watts' Events cards which could conceivably have been originally used for tickets.

TIME CLOCK WITH PUNCH CARDS

FLUX-PROJECTS PLANNED FOR 1967...Collective projects: (All are invited to submit ideas and participate, ideas can be either ready pictorial material or just specified material which we have to find, produce or obtain otherwise)...Time clock with punch cards (most likely for 1968 flux-shop) as cash register will be used as exit event...time clock will be used as entrance event in flux-shop, different according to time entered. Time indicator on drum, may be changed to contain text, symbols, etc. which would be imprinted instead of time, when card is inserted into punch clock. Both machines incidentally are about 60 years old.
Fluxnewsletter, March 8, 1967.

FLUXPROJECTS FOR 1969 ... FLUXSHOP ... At 16 Greene st. 2nd. floor 16' x 85' space. Similar arrangement as per enclosed proposal for gallery 669 (never realized) with addition of:...time punch clock, printing on visitors cards anything but time (suggestions from all will be welcomed)...
Fluxnewsletter, December 2, 1968.

PROPOSALS WILL BE WELCOMED FOR:...time punch clock dies (for printing on cards)
ibid.

COMMENTS: Time Clock with Punch Cards *is now lost. We have found no evidence that it was ever actually used or completed.*

TIME FOODS see:
 FLUX FOOD
TOILET see:
 FLUX AMUSEMENT CENTER
 FLUX TOILET
TRAIN see:
 FLUXTRAIN
24 DRAWER EVENT CABINET see:
 FLUX CABINET
U.S. FLUXUS see:
 FLUXUS 1
V TRE see:
 Fluxus cc V TRE Fluxus
V TRE see:
 FLUXUS NEWSPAPERS

V TRE EXTRA see:
 a V TRE EXTRA
Vacuum TRapEzoid see:
 Fluxus Vacuum TRapEzoid
Vague TREasure see:
 Fluxus Vague TREasure
Valise e TRanglE see:
 Fluxus cc Valise e TRanglE
Vaseline sTREet see:
 Fluxus Vaseline sTREet
Vaudeville TouRnamEnt see:
 Fluxus Vaudeville TouRnamEnt
VauTieR nicE see:
 Fluxus VauTieR nicE
VENDING MACHINES see:
 DISPENSERS
 FLUX AMUSEMENT CENTER
 TICKET DISPENSER
VerTical pRaguE see:
 [Fluxus] VerTical pRaguE
Viscous TRumpEt see:
 [Fluxus] VerTical pRaguE
WALLPAPER ENVIRONMENT see:
 FLUXFILMS ENVIRONMENT

WEIGHING MACHINE

This Fall, we shall publish V TRE no. 10, which shall consist of a plan for Flux-Amusement-Center, to contain the following:...weighing machines...
Fluxnewsletter, April 1973.

COMMENTS: *In 1963, Robert Watts had proposed a scale which Maciunas or Tomas Schmit constructed in Germany for a Fluxus exhibit. Watts' design replaced the weight numbers with cut-outs of women's breasts etc. I would think that the 1973 idea of a* Weighing Machine *would have been based on Watts' earlier idea, but in keeping with the collective spirit, like* Cash Register *or* Time Clock with Punch Cards *he would have used various artists' ideas over the numbers, or on cards if it were that type of machine. The work is not known to have been made.*

WEST EUROPEAN YEARBOX see:
 FLUXUS NO. 2 WEST EUROPEAN YEARBOX I
WEST EUROPEAN YEARBOX II see:
 FLUXUS NO. 5 WEST EUROPEAN YEARBOX II

ANONYMOUS and UNDETERMINED AUTHORS

In the early developmental period of Fluxus, 1962 and 1963, George Maciunas envisaged a movement where the individual identities of artists were secondary to the ideas and goals of the movement. He stated in early tracts that the aim was to eventually achieve anonymity. However, aside from Maciunas, only one or two other artists seemed to agree with this concept, and as a result, the authorship of most works were attributed to individuals. Maciunas himself was inconsistent in this regard, at times giving himself credit for a particular work, at other times crediting "anonymous," or leaving authorship out altogether.

The Fluxus attitude toward anonymity is reflected in a letter from George Maciunas to Ben Vautier, dated March 16, 1964: "...I notice with disappointment your GROWING MEGALOMANIA. Why not try Zen method — Curb & eliminate your ego entirely. (if you can) don't sign anything — don't attribute anything to yourself — depersonalize yourself! that's in true Fluxus collective spirit. De-europanize yourself! No one can succeed to do this here either. (although in Japan they can)..."

This attitude is expanded further in Maciunas' 1965 manifesto for the Fluxus group:

> FLUXMANIFESTO ON FLUXAMUSEMENT-VAUDE-VILLE-ART? TO ESTABLISH ARTISTS NONPRO-FESSIONAL, NONPARASITIC, NONELITE STATUS IN SOCIETY, HE MUST DEMONSTRATE OWN DIS-PENSIBILITY, HE MUST DEMONSTRATE SELFSUF-FICIENCY OF THE AUDIENCE, HE MUST DEMON-STRATE THAT ANYTHING CAN SUBSTITUTE ART AND ANYONE CAN DO IT. THEREFORE THIS SUB-STITUTE ART-AMUSEMENT MUST BE SIMPLE, AMUSING, CONCERNED WITH INSIGNIFICANCES, HAVE NO COMMODITY OR INSTITUTIONAL VAL-UE. IT MUST BE UNLIMITED, OBTAINABLE BY ALL AND EVENTUALLY PRODUCED BY ALL. THE ARTIST DOING ART MEANWHILE, TO JUSTIFY HIS INCOME, MUST DEMONSTRATE THAT ONLY HE CAN DO ART. ART THEREFORE MUST APPEAR TO BE COMPLEX, INTELLECTUAL, EXCLUSIVE, INDIS-PENSABLE, INSPIRED. TO RAISE ITS COMMODITY VALUE IT IS MADE TO BE RARE, LIMITED IN QUANTITY AND THEREFORE ACCESSIBLE NOT TO THE MASSES BUT TO THE SOCIAL ELITE.

We have kept the anonymous section in respect for this original concept. When a work was initially listed anonymously and later credited to an individual, we have put a cross reference for the work in this section to refer the reader to that individual's section. In most remaining cases, it's even been possible to determine stylistically which concepts belong to whom, and this is noted in the comments.

A QUESTION OR MORE see:
George Brecht

ADHESIVE FLOOR see:
George Maciunas

ADHESIVE KNOB DOOR see:
George Maciunas

ADHESIVE PROGRAMS see:
George Maciunas

ADHESIVE SOLED SHOES see:
George Maciunas

ADHESIVE TOILET SEAT see
Paul Sharits

AIR CONDITIONED see:
George Brecht

AIR DISPENSER see:
Yoko Ono

ALL INCLUSIVE 4 DAY STAY IN GREEN-LAND TICKET

FLUXFEST PRESENTATION OF JOHN LENNON & YOKO ONO +* AT 80 WOOSTER ST. NEW YORK —1970...APR. 18-24: TICKETS BY JOHN LENNON + FLUXTOURS...all inclusive 4 day stay in Greenland $340...

all photographs copyright nineteen seVenty by peTer mooRE (Fluxus Newspaper No. 9) 1970.

COMMENTS: *Probably by John Lennon who had two other ideas for tickets to inaccessible Northern places.*

ALL OTHER THINGS see:
George Maciunas

APRONS see:
EMPEROR ALEXANDER II HOLDING A BEER CAN, APRON
MEDIEVAL ARMOR APRON
NAPOLEON'S FRONT APRON
NUDE BACK APRON
PAPER APRONS
POPE MARTIN V APRON
ROMAN EMPEROR APRON
VENUS DE MILO APRON
VIRGIN MARY APRON
WASHINGTON'S FRONT APRON

ARCHAEOLOGY 900

Silverman No. > 130.I

COMMENTS: *Included in the collective Fluxus Edition of Flux Tattoos, Archaeology 900 was produced by Implosions, a project of Herman Fine, George Maciunas and Robert Watts that overlapped with Fluxus.*

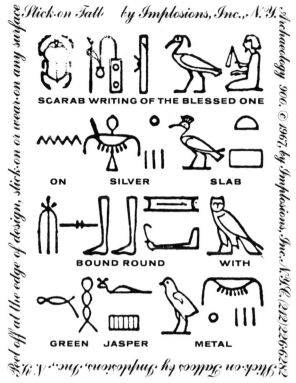

Anonymous. ARCHAEOLOGY 900

ARCHITECTURAL MONUMENTS OF THE WORLD, ATLAS OF MAPS see:
George Maciunas

ARCTIC BIBLIOGRAPHY see:
George Maciunas

ARTYPE see:
George Maciunas

ARM-PIT HAIR OF A CHIGAGOAN NEGRO PROSTITUTE see:
Nam June Paik

ASSHOLES WALLPAPER see:
Ben Vautier

ASSORTED TOOLS see:
Robert Watts

BACK SWEAT SHIRT

IMPLOSIONS, INC. PROJECTS...Triple partnership was formed between Bob Watts, Herman Fine and myself [George Maciunas] to introduce into mass market ...money producing products...This business will be operated in commercial manner, with intent to make profits...connection between Fluxus collective and Implosions Inc. has not been clarified yet...we could consider at present Fluxus to be a kind of division or subsidiary of Implosions. Projects to be realized through Implosions:...Sweat shirts (printed front and back, or front alone), may have images or statements like:..."back";...
Fluxnewsletter, March 8, 1967.

COMMENTS: *This is probably one of Robert Watts' sweat shirt ideas. The work is not known to have been produced either by Implosions or Fluxus.*

BACKWARD CLOCK see:
George Maciunas

BAD SMELL EGGS see:
George Maciunas

BALL see:
Robert Watts

BALL CHECKERS see:
George Maciunas

BALLOON JAVELIN see:
George Maciunas

BALLOON OBSTACLE see:
Ay-O

BALLOON RACKET see:
George Maciunas

BAROQUE ENGRAVED PICTURE SHIRT

"...These objects I think could be produced cheaper in Italy:...shirts with similar subjects, such as baroque engraved pictures of shirt fronts, etc...."
Letter: George Maciunas to Daniela Palazzoli, n.d. Reproduced in Fluxnewsletter, April 1973.

COMMENTS: *This work was never produced. Baroque pictures that might have been used for the shirt were found in George Maciunas' Estate, and are now in the Silverman Collection.*

BEGONIA

28/w BY SPECIAL ORDER...a-4/9 begonia $10.
European Mail-Orderhouse: europeanfluxshop, Pricelist. [ca. June 1964].

COMMENTS: *Begonia was probably a ready-made fake flower assigned by Willem de Ridder.*

BELL CHESS see:
SOUND CHESS

BILLIARD TABLE

"...I am planning to come to Europe this Summer or Fall...could stay in Italy if you could arrange a worth-

while flux-fest...We would need the following from local sources...money or labor or materials for special constructions such as...billiard table..."
Letter: George Maciunas to Daniela Palazzoli, n.d. Reproduced in Fluxnewsletter, April 1973.

COMMENTS: *Presumably this would be an altered billiard table, such as Maciunas' altered ping-pong table. Otherwise, there would be no need to have someone construct one. The work is probably by George Maciunas.*

BIRD ORGAN & OTHER BULB ACTI-VATED TRICKS DOOR see:
George Maciunas
BLEEDING DOG'S CADAVER see:
Nam June Paik
BLIND DATE see:
Robert Watts
BLINK see:
Yoko Ono
BOLTS see:
George Brecht
BOOK see:
Robert Watts
BOOKS see:
ARCTIC BIBLIOGRAPHY
INDEX

BOUNCING BALLS TIME MACHINE

OBJECTS:...Bouncing balls time machine,
Proposal for 1975/76 Flux-New Year's Eve Event. [ca. November 1975].

COMMENTS: *The work was never made.*

BOUNCING SHOES see:
Robert Watts
BOX FROM THE EAST see:
George Maciunas

BOX WITH NO LABEL
Unnumbered, in the Silverman Collection

COMMENTS: *We have not yet determined whether this work is:* Cough, *by Yoshimasa Wada,* Air Sculpture, *by Ay-O,* Flux-Nothing, *by Ben Vautier, or an unknown, anonymous work. All indications are that the work is as Maciunas intended it. It was sent by him, with another identical copy, and other Fluxus items, to Armin Hundertmark in 1970. There were no instructions or identification with the order, no loose labels or suggestions that the work was anything but complete.*

BOXES see:
George Brecht

Anonymous. BOX WITH NO LABEL.

NANCY ANELLO

BOXING GLOVE DOOR see:
George Maciunas and Larry Miller

BREAKABLE BASEBALL FILLED WITH FLUID

FLUX-OLYMPIAD...TEAM...baseball breakable ball filled with fluid
Fluxfest at Stony Brook, Newsletter No. 1, August 18, 1969. version A

FLUX-OLYMPIAD ... by G. Maciunas ... TEAM ... baseball with breakable ball (egg?)
Fluxfest at Stony Brook, Newsletter No. 1, August 18, 1969. version B

COMMENTS: *When first listed, this work appeared anonymously. We have just discovered another reference, included above, which credits the work to George Maciunas, and it should belong in his section. The references demonstrate Maciunas' sometimes casual attitude toward credit.*

BRIEFCASE see:
Robert Watts
BROOMS see:
George Brecht
BRUSH OBSTACLE see:
Ay-O
BRUSH TOILET SEAT see:
Ay-O
BRUSHES see:
George Brecht
BURGLARY FLUXKIT see:
George Maciunas

BUTTER GUIDE see:
George Brecht
BUTTONS see:
George Maciunas
CAN OF WATER RACKET see:
George Maciunas
CARD GAMES see:
LOADED DECK
SAME CARD FLUX DECK

CARDBOARD BOX PROGRAM

PROGRAMS (given out at entry to auditorium) ... printed on large (about 2' x 3') carton boxes...large boxes could conceivably be used also as seats.
[Fluxus Newsletter] Proposal for Fluxus Paper Concert. [ca. Fall 1967].

COMMENTS: *Probably an idea of George Maciunas,* Cardboard Box Programs *were not made. They are related in some ways to Ben Vautier's* Mystery Box, *and Andy Warhol's* Brillo Boxes.

CARDBOARD PROGRAMS

PROGRAMS (given out at the entry to auditorium) printed on 22"x34" unfolded cardboard (about 20mil)
[Fluxus Newsletter] Proposal for Fluxus Paper Concert. [ca. Fall 1967].

COMMENTS: *Cardboard Programs were not made. Related to* Cardboard Box Programs, *and although less awkward, were not intended to serve the dual purpose of program and seat, but rather put the audience in the awkward position of dealing with an enormous sheet of cardboard.*

CEILING HINGED DOOR

FLUXFEST PRESENTATION OF JOHN LENNON & YOKO ONO +* AT 80 WOOSTER ST. NEW YORK —1970...MAY 23-29: PORTRAIT OF JOHN LENNON AS A YOUNG CLOUD BY YOKO ONO & EVERY PARTICIPANT A maze with 8 doors each opening in a different manner...door hinged at ceiling
all photographs copyright nineteen seVenty by peTer mooRE (Fluxus Newspaper No. 9) 1970.

Any proposals from participants should fit the maze format...Ideas should relate to passage through doors, steps, floor, obstacles, booths ... door hinged at ceiling...
George Maciunas, Further Proposal for Flux-Maze at Rene Block Gallery. [ca. Fall 1974].

COMMENTS: *This door variation is reminiscent of George Maciunas'* Trick Ceiling Hatches, *devised for his "Flux Combat with New York State Attorney (& Police)."*

©1976 LARRY MILLER

Anonymous. CENTRAL VERTICAL AXIS DOOR at entrance to FLUXLABYRINTH. Berlin, 1976

CENTRAL VERTICAL AXIS DOOR

FLUXFEST PRESENTATION OF JOHN LENNON & YOKO ONO +* AT 80 WOOSTER ST. NEW YORK —1970...MAY 23-29: PORTRAIT OF JOHN LENNON AS A YOUNG CLOUD BY YOKO ONO & EVERY PARTICIPANT A maze with 8 doors each opening in a different manner...door hinged at center of vertical axis...
all photographs copyright nineteen seVenty by peTer mooRE (Fluxus Newspaper No. 9) 1970.

Toilet no. 5 Ayo...Doors - method of opening: pivot in center Toilet no. 6 Collective Doors - method of opening...pivot in center vertical axis.
Fluxnewsletter, April 1973.

"Enclosed is the final plan of labyrinth...All doors should be openable from entry side only...Next door is like a revolving door, revolving along a vertical axis at center and preferably revolving one way..."
Letter: George Maciunas to Rene Block, [ca. Summer 1976].

this door is pivoted along vertical axis at center of door.
Instruction drawing for Fluxlabyrinth, Berlin. [ca. August 1976]. version A

"Door — (Central axis) This door is installed except for knobs. Hinges are hidden by trim. To enter person must turn both knobs & enter clockwise. It springs back to place. All doors will have thin padding to buffer continuous closing. I made this first for intelligence test as entry instead of boxing glove. needed: padding to buffer closing."
Notes: Larry Miller to George Maciunas concerning the Fluxlabyrinth, Berlin. [ca. August 1976].

this door automatically has knobs on each side; to open it, one has to turn them simultaneously. The door turns along its central vertical axis.
Plan of completed Fluxlabyrinth, Berlin. [ca. September 1976].

COMMENTS: *In the* Fluxlabyrinth, *the work is presented as a collaboration between George Maciunas and Larry Miller, and is a two-handled door at the entrance.*

CHANGE MACHINE DISPENSING PENNY
FOR DIME see:
George Maciunas
CHECKERS see:
BALL CHECKERS
CHESS see:
COLOR BALLS IN BOTTLE-BOARD CHESS
FRUIT AND VEGETABLE CHESS
GRINDER CHESS
JEWEL CHESS
NUT & BOLT CHESS
SMELL CHESS
SOUND CHESS
SPICE CHESS
TIME CHESS, SAND TIMER PIECES
TIME CHESS WITH CLOCKWORK PIECES
WEIGHT CHESS
CHESS TABLE WITH LAMP AND GLASS
BOTTLE TOP see:
George Maciunas

CHICKEN

BY SPECIAL ORDER...a-4/6 chicken $50.
European Mail-Orderhouse: europeanfluxshop, Pricelist. [ca. June 1964].

COMMENTS: *Probably a work by Willem de Ridder. It was never produced by George Maciunas as a Fluxus Edition.*

CHICKEN see:
EARTHENWARE CHICKEN

CIGARETTE BURNS STICK-ONS

"...jewelry design. — printed on self adhesive clear or opaque plastic, die-stamp-out. You stick-on your body or clothing these...die cut items. Got already: ...cigarette burns..."
Letter: George Maciunas to Ken Friedman, [ca. February 1967].

COMMENTS: *See also entries for* Flux Tattoos *under Collective, George Maciunas, and Robert Watts. The work is probably an idea of Watts', but is not known to have been realized.*

CIGARETTE DISPENSER see:
Yoshimasa Wada
CLEAR BEEF see:
TRANSPARENT BEEF
CLEAR BUTTER see:
TRANSPARENT BUTTER
CLEAR ICE CREAM see:
TRANSPARENT ICE CREAM
CLEAR ONION see:
TRANSPARENT ONION
CLOCKS see:
BACKWARD CLOCK
BOUNCING BALLS TIME MACHINE
COLOR WHEEL FACE CLOCK
DECIMAL FACE CLOCK
FAST TURNING FACE (WITHOUT ARMS) CLOCK
12 MOVEMENT FLUX CLOCK
CLOTHING see:
APRONS
BACK SWEAT SHIRT
BAROQUE ENGRAVED PICTURE SHIRT
FLUXWORKER
FRONT SWEAT SHIRT
MADE FROM 100% COTTON SWEAT SHIRT
NECKTIE
PASS ON THE LEFT NOT ON THE RIGHT SWEAT SHIRT
SOCKS
CLOUD SCISSORS see:
George Brecht
COFFEE EGGS see:
George Maciunas

COLD TOILET SEAT

PROPOSED FLUXSHOW ... TOILET OBJECTS ... toilet seat variations:...rubber bag with...iced water...
Fluxnewsletter, December 2, 1968 (revised March 15, 1969).

TOILET OBJECTS & ENVIRONMENT ... Toilet seat

variations:...rubber bag with...cold water...
Flux Fest Kit 2. [ca. December 1969].

COMMENTS: *George Maciunas had a fascination with toilets and gags, and this is possibly his idea. See* Hot Toilet Seat.

COLOR BALLS IN BOTTLE-BOARD CHESS see:
George Maciunas
COLOR WHEEL FACE CLOCK see:
George Maciunas
THE COMING REVOLUTIONS IN CULTURE see:
Henry Flynt
COMPLETE DOORS see:
George Brecht
CONFETTI INVITATIONS see:
George Maciunas
CONTINUOUS STRING DISPENSER see:
George Maciunas

CORRUGATED SURFACE TOILET SEAT

PROPOSED FLUXSHOW ... TOILET OBJECTS ... toilet seat variations:...corrugated surface...
Fluxnewsletter, December 2, 1968 (revised March 15, 1969).

TOILET OBJECTS & ENVIRONMENT...Toilet seat variations:...corrugated surface...
Flux Fest Kit 2. [ca. December 1969].

Toilet no. 6 Collective...Toilet seat:...corrugated...
Fluxnewsletter, April 1973.

COMMENTS: *The original idea of corrugated surfaces seems to come either from Ay-O or George Maciunas. There are corrugated surfaces in some of Ay-O's* Tactile Boxes. *Maciunas made* Corrugated/Undulating Rackets *for Fluxsport games as early as 1964, and later used corrugated surfaces in the interiors of modular furniture cases which were built for Sean Ono Lennon's room in the mid-1970s.*

CORRUGATED/UNDULATING RACKET
see: George Maciunas
CORTISONE BOTTLE OF G. MACIUNAS
see: Nam June Paik
CRUSHED ICE FILLED SHOES see:
ICE FILLED SHOES
CUBE TENNIS BALLS see:
George Maciunas
CURTAINS see:
George Brecht

DANCE

PAST FLUX-PROJECTS (realized in 1966)...Flux-films: total package: 1 hr. 40min [including] ...dance — anonymous...
Fluxnewsletter, March 8, 1967.

COMMENTS: *I don't know this work. There is an unidentified film loop in a* Flux Year Box 2 *which is a stop-motion film of car hoods opening and closing which could be* Dance.

DEAD BUG EGGS see:
George Maciunas
DECIMAL FACE CLOCK see:
George Maciunas
DIAGRAM OF HISTORICAL DEVELOPMENT OF FLUXUS AND OTHER 4 DIMENTIONAL, AURAL, OPTIC, OLFACTORY, EPITHELIAL AND TACTILE ART FORMS see:
George Maciunas
DICE see:
ROUND DICE

DIRTY HAND PRINTS TOWEL

"...These objects I think could be produced cheaper in Italy...towel with dirty hand prints..."
Letter: George Maciunas to Daniela Palazzoli, n.d. Reproduced in Fluxnewsletter, April 1973.

COMMENTS: *This might be a combination of ideas from Ben Patterson's* Instruction No. 2, *Takehisa Kosugi's* Theater Music *and Robert Watts'* Dirty Paper Towels.

DIRTY NAILS OF JOHN CAGE see:
Nam June Paik
DIRTY PAPER TOWELS see:
Robert Watts
DIRTY WATER see:
Ben Vautier
DISEASED FACE MASK see:
Ben Vautier

DISEASES STICK-ONS

FLUXPROJECTS FOR 1969 PRODUCTS - PUBLICATIONS...Stick-ons:...diseases.
Fluxnewsletter, December 2, 1968.

COMMENTS: *Not known to have been produced as a Fluxus or Implosions Edition. See George Maciunas and Ben Vautier,* Scar Stick-ons.

DISINTEGRATING SHOES see:
Robert Watts
DISPENSERS see:
AIR DISPENSER

CHANGE MACHINE DISPENSING PENNY FOR DIME
CIGARETTE DISPENSER
CONTINUOUS STRING DISPENSER
DRINK BEFORE CUP DISPENSER
DRINK WITH CUP MISSING DISPENSER
GLUE DISPENSER
HOLY RELICS DISPENSER
LOOSE DUST DISPENSER
LOOSE SAND DISPENSER
MOVIE-LOOP MACHINE
POSTCARD MACHINE
STAMP DISPENSER
WATER DISPENSER
WATER SOLUBLE CUP DISPENSER
DISPOSABLE DISHES & CUPS see:
Kate Millet

DISSOLVABLE TOILET PAPER

"...These objects I think could be produced cheaper in Italy:...dissolvable toilet paper..."
Letter: George Maciunas to Daniela Palazzoli, n.d. Reproduced in Fluxnewsletter, April 1973.

COMMENTS: *Sounds like a Maciunas idea: see his* Treated Paper Towels *and* Water Soluble Cup Dispenser.

DISTILLED COFFEE see:
George Maciunas
DISTILLED MILK see:
George Maciunas
DISTILLED PRUNE JUICE see:
George Maciunas
DISTILLED TEA see:
George Maciunas
DISTILLED TOMATO JUICE see:
George Maciunas
DOLLAR BILL TOILET PAPER see:
Robert Watts
DOOR WITHIN A DOOR see:
George Maciunas
DOOR OPENABLE THROUGH A SMALL TRAP DOOR, WITH KNOB ON OTHER SIDE see:
SMALL DOOR IN DOOR
DOOR SPLIT IN SEPARATE TOP AND BOTTOM HALVES see:
SEPARATE DOOR IN DOOR
DOORKNOBS see:
George Brecht
DOORS see:
ADHESIVE KNOB DOOR
BOXING GLOVE DOOR

CEILING HINGED DOOR
CENTRAL VERTICAL AXIS DOOR
COMPLETE DOORS
DOOR WITHIN A DOOR
ECCENTRIC SHAPE DOOR
FLOOR HINGED DOOR
HARD TO OPEN DOOR
HORIZONTAL AXIS DOOR
HOT KNOB DOOR
KNOB AT HINGES DOOR
LOUD NOISE DOOR
MANY KNOBS DOOR
MISSING KNOB DOOR
NARROW DOOR
PIANO ACTIVATED DOOR
PORTRAIT OF JOHN LENNON AS A YOUNG
 CLOUD
SEPARATE DOORS DOOR
SMALL DOOR IN DOOR
STEEP STAIR DOOR
TRIANGULAR DOOR
270 DEGREE DOOR

DRINK BEFORE CUP DISPENSER see:
George Maciunas

DRINK WITH CUP MISSING DISPENSER
see: George Maciunas

DUST see:
LOOSE DUST DISPENSER

EARTHENWARE CHICKEN

28/w BY SPECIAL ORDER a-4/5 chicken (earthen-ware) $10
European Mail-Orderhouse: europeanfluxshop, Pricelist. [ca. June 1964].

COMMENTS: Probably a work by Willem de Ridder. Not known to have been produced by George Maciunas as a Fluxus Edition.

ECCENTRIC SHAPE DOOR

Door - (to spider web room)...Door (to smell room) we need idea for this and next door perhaps:...eccentric shape - easy to make (no curves)...
Notes: Larry Miller to George Maciunas concerning the Flux-labyrinth, Berlin. [ca. August 1976].

COMMENTS: Eccentric Shape Door, a suggestion by Larry Miller was not made for the Fluxlabyrinth.

EGG KIT see:
Robert Watts

EGG WHITE EGGS see:
George Maciunas

8 LENS SUN GLASSES see:
George Maciunas

ELASTIC RACKET see:
George Maciunas

EMPEROR ALEXANDER II HOLDING A BEER CAN, APRON

"...You could do the following yet:...Collective projects...Apron design — on paper disposable apron. That's a project we may make some money, by selling it to large beer company, to be used as premium. Got already some designs:...Emperor Alexander II holding beer can [engraving & collage] ...all...are full size to match wearer of apron."
Letter: George Maciunas to Ken Friedman, [ca. February 1967].

COMMENTS: This idea is probably by Robert Watts who designed other aprons that incorporate beer cans. This one was not made.

END AFTER 9 see:
George Maciunas

ENTRANCE AND EXIT MUSIC see:
George Brecht

ENTRY see:
George Brecht

EYEBLINK see:
Yoko Ono

EXCRETA FLUXORUM see:
George Maciunas

EXIT see:
George Brecht

FACETED SURFACE RACKET see:
George Maciunas

FACSIMILE TICKET TO NEW YORK ZOO-LOGICAL SOCIETY, 1947
Silverman No. > 135.I

Anonymous. FACSIMILE TICKET TO NEW YORK ZOOLOGICAL SOCIETY, 1947

COMMENTS: This uncredited ticket was printed on the same sheet with other tickets for the "Fluxtours" aspect of the "Fluxfest Presentation of John Lennon and Yoko Ono" April 18-24, 1970. The ticket is probably a toss-off by George Maciunas.

FACT/FICTION see:
George Brecht

FAST TURNING FACE (WITHOUT ARMS) CLOCK see:
George Maciunas

FILMS see:
ARTYPE
BLINK
DANCE
END AFTER 9
EYEBLINK
LINEAR TURN
NUMBER 4
ONE
1000 FRAMES
POLICE CAR
RAINBOW MOVIE
REQUIEM FOR WAGNER THE CRIMINAL
 MAYOR
SEARS CATALOGUE
SMOKING
SUN IN YOUR HEAD
10 FEET
TRACE
TRANSITION FROM SMALL TO LARGE
 SCREENS
TREE MOVIE
ZEN FOR FILM

FINGERPRINT see:
Robert Watts

FISH BREAD see:
George Maciunas

FISH CANDY see:
George Maciunas

FISH DRINK see:
George Maciunas

FISH ICE CREAM see:
George Maciunas

FISH JELLO see:
George Maciunas

FISH PASTRY see:
George Maciunas

FISH PUDDING see:
George Maciunas

FISH SALAD see:
George Maciunas

FLAG POSTER see:
U.S.A. SURPASSES ALL THE GENOCIDE
RECORDS
FLAGS see:
FLUX

FLOOR HINGED DOOR

FLUXFEST PRESENTATION OF JOHN LENNON
& YOKO ONO +* AT 80 WOOSTER ST. NEW YORK
—1970…MAY 23-29: PORTRAIT OF JOHN LEN-
NON AS A YOUNG CLOUD BY YOKO ONO &
EVERY PARTICIPANT A maze with 8 doors each
opening in a different manner:…door hinged at floor…
*all photographs copyright nineteen seVenty by peTer mooRE
(Fluxus Newspaper No. 9) 1970.*

Any proposals from participants should fit the maze
format…Ideas should relate to passage through doors,
steps, floor, obstacles, booths…step like door hinged
at floor…
*George Maciunas, Further Proposal for Flux-Maze at Rene
Block Gallery. [ca. Fall 1974].*

COMMENTS: *The reverse of* Ceiling Hinged Door, *this work
is probably by George Maciunas.*

FLUSHING ACTIVATES LAUGHTER OR
CLAPPING TOILET see:
Robert Watts

FLUSHING STARTS FAUCET IN SINK,
TOILET

Toilet no. 6 Collective…Toilet flushing…starts faucet
in sink.
Fluxnewsletter, April 1973.

COMMENTS: *Many of the collective* Flux Toilet *works are
by George Maciunas, who designed this "House of Horrors —
Temple of Relief and Contemplation."*

FLUSHING STARTS RAIN TOILET see:
George Maciunas
FLUX see:
George Maciunas
FLUXADDER see:
George Maciunas
FLUXCHAIRS see:
FLUXFURNITURE
FLUXCHESS see:
CHESS
FLUX CLOCKS see:
CLOCKS

FLUX CONTENTS see:
Serge Oldenbourg
FLUXFILMS see:
FILM
FLUXFURNITURE see:
CHESS TABLE WITH LAMP AND GLASS
BOTTLE TOP
MUSICAL CHAIRS
UNDULATING SURFACE MIRROR
FLUX HISTORY CHART see:
DIAGRAM OF HISTORICAL DEVELOPMENT
OF FLUXUS AND OTHER 4 DIMENSIONAL,
AURAL, OPTIC, OLFACTORY, EPITHELIAL
AND TACTILE ART FORMS
FLUX HOLES see:
Ben Vautier
FLUXLABYRINTH see:
ADHESIVE FLOOR
BALLOON OBSTACLE
BOXING GLOVE DOOR
BRUSH OBSTACLE
DOORS
FOAM STEPS
FOG BOX
RUBBER BRIDGE
SEE SAW
SHOE STEPS
SLIPPERY FLOOR
SMELL ROOM
SPIDER WEB ROOM
SPRING STEPS
TACTILE ENTRANCE
UPSIDE DOWN FOREST
WEB OBSTACLE
WOOD BLOCKS OBSTACLE
FLUXLABYRINTH see:
Collective
FLUX MEDICINE see:
Shigeko Kubota
FLUXPAPEREVENTS see:
ADHESIVE PROGRAMS
CARDBOARD BOX PROGRAMS
CARDBOARD PROGRAMS
CONFETTI INVITATIONS
PAPER HAT PROGRAMS
THIN PAPER INVITATIONS
FLUX-PASSPORT see:
Ken Friedman
FLUXORGANS see:
BIRD ORGAN & OTHER BULB ACTIVATED
TRICKS DOOR
FLUXORGAN, CONSOLE
FLUXORGAN, PORTABLE CONSOLE
FLUXORGAN, 12 SOUNDS

FLUXORGAN, 15 SOUNDS
FLUXORGAN, 20 SOUNDS, ELECTRICAL
FLUXORGAN, 20 SOUNDS, MANUAL
FLUXORGAN, 40 SOUNDS, ELECTRICAL
FLUXORGAN, 50 SOUNDS, MANUAL
FLUXORGAN, CONSOLE see:
George Maciunas
FLUXORGAN, PORTABLE CONSOLE see:
George Maciunas
FLUXORGAN, 12 SOUNDS see:
George Maciunas
FLUXORGAN, 15 SOUNDS see:
George Maciunas
FLUXORGAN, 20 SOUNDS, ELECTRICAL
see: George Maciunas
FLUXORGAN, 20 SOUNDS, MANUAL see:
George Maciunas
FLUXORGAN, 40 SOUNDS, ELECTRICAL
see: George Maciunas
FLUXORGAN, 50 SOUNDS, MANUAL see:
George Maciunas
FLUXPOST (AGING MEN) see:
George Maciunas
FLUX POST KIT 7 see:
Collective
FLUXPOST 17-17 see:
Robert Watts
FLUXPOST (SMILES) see:
George Maciunas
FLUX SNOW GAME see:
George Maciunas
FLUX SPORT EQUIPMENT see:
ADHESIVE SOLED SHOES
BALLOON JAVELIN
BALLOON RACKET
BILLIARD TABLE
BOUNCING SHOES
BREAKABLE BASEBALL FILLED WITH FLUID
CAN OF WATER RACKET
CORRUGATED/UNDULATING RACKET
CUBE TENNIS BALL
DISINTEGRATING SHOES
ELASTIC RACKET
FACETED SURFACE RACKET
GIANT INFLATED BOXING GLOVES
HOLE IN CENTER RACKET
ICE FILLED SHOES
INCLINED PLANE SHOES
LONG HANDLE RACKET
MUSICAL SHOES
NAIL SHOES
PREPARED HAMMER THROW HAMMER
SHAVING CREAM FILLED SHOES

FLUXUS, OR
FLUXATLAS
FLUXBOOKS
FLUXBOXES
FLUXCARDS
FLUXCHESS
FLUXCLOCK
FLUXCURES
FLUXDANCE
FLUXESTRA
FLUXFAKES
FLUXFESTS
FLUXFILMS
FLUXGAMES
FLUXGROUP
FLUXHOUSE
FLUNITURE
FLUXJOKES
FLUX-KITS
FLUXMEALS
FLUXMUSIC
FLUXORGAN
FLUXPAPER
FLUXPOEMS
FLUX-POST
FLUX-QUIZ
FLUXSHOPS
FLUXTHING
FLUXV-TRE
FLUXWATER
FLUX-WEAR
FLUX-WORK
FLUXMIDST
(FLUX-HQ)
PO BOX:180
NEW YORK,
N.Y. 10013
FLUX-WEST
K.FRIEDMAN
6361 ELM-
HURST DR.
SAN DIEGO
CAL.92120
FLUX-EAST
M. KNIZAK
NOVY SVET
19, PRAGUE
C. S. S. R.
FLUXSOUTH
B. VAUTIER
32 RUE TON-
DUTTI DE
L'ESCARENE
NICE A.M.
FRANCE
FLUXNORTH
KIRKEBY 40
BULOWSVEJ
KØBENHAVN
V DENMARK

Anonymous. FLUX STATIONERY

SLIPPERY FLOOR
10 FOOT LONG CIGARETTE
VERY SOFT RACKET

FLUX STATIONERY
Silverman No. 136

NEWS FROM FLUX-WEST:...Flux-stationary [sic]
printed by FW & FE, available to any flux-master re-
questing it ($1 per 100 sheets).
Fluxnewsletter, January 31, 1968.

COMMENTS: *George Maciunas designed the Fluxus
stationery.*

FLUX TATTOOS see:
STICK-ONS
FLUX TOILET see:
ADHESIVE TOILET SEAT
BRUSH TOILET SEAT
COLD TOILET SEAT
CORRUGATED SURFACE TOILET SEAT
DIRTY HAND PRINTS TOWEL
DIRTY PAPER TOWELS
DISSOLVABLE TOILET PAPER
DOLLAR BILL TOILET PAPER
FLUSHING ACTIVATED LAUGHTER OR
 CLAPPING TOILET

FLUSHING STARTS FAUCET IN SINK TOILET
FLUSHING STARTS RAIN TOILET
HOT TOILET SEAT
INFLATED RUBBER TOILET SEAT
LOUIS THE 14TH MIRROR
SANDPAPER TOILET SEAT
SINK
SLIPPERY TOILET SEAT
SQUEAKING TOILET SEAT
TOILET PAPER PERFORATED WITH LARGE
 HOLES
UNDULATING SURFACE MIRROR
UPWARD TURNED FAUCET

FLUX TOUR TICKETS see:
TICKETS
FLUXUS COMES TO NEW YORK see:
PREPARED NEWSPAPERS
FLUXUS MACHINE see:
George Maciunas

FLUXUS 301 see:
George Maciunas
FLUXWEAR 303 see:
George Maciunas
FLUXWEAR 304 see:
George Maciunas

FLUXWORKER
Silverman No. > 659.I

"...8 performers dressed in white coats like doctors,
will clean a sidewalk with all kinds of unusual devices
such as toothbrush + toothpaste; cotton balls & alco-
hol, steel wool, hair brush, etc. etc..."
Letter: George Maciunas to Milan Knizak, May 19, 1966.

APR. 25-MAY 1: MEASURE BY JOHN & YOKO +
HI RED CLINIC...Various measurements are taken
of each visitor by white coated attendants in a clinic
environment...
*Schedule of events for Fluxfest presentation of John Lennon
and Yoko Ono. [ca. April 1970]. version A*

APR. 25-MAY 1: MEASURE BY JOHN & YOKO +
HI RED CLINIC + FLUXDOCTORS...Various meas-
urements are taken of each visitor by white coated
attendants in clinic environment...
*Schedule of events for Fluxfest presentation of John Lennon
and Yoko Ono. [ca. April 1970]. version B*

APR. 25-MAY 1: CLINIC BY YOKO ONO + HI RED
CENTER Various measurements are taken of each
visitor by white coated attendants...
*Schedule of events for Fluxfest presentation of John Lennon
and Yoko Ono. April 1, 1970. version C*

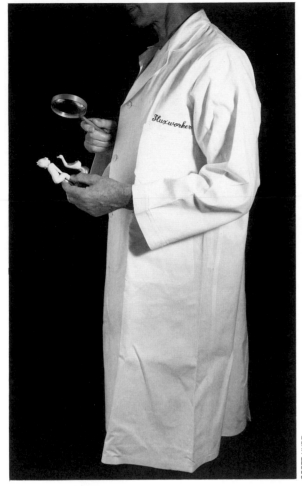

SCOTT HYDE

Anonymous. FLUXWORKER

COMMENTS: *An altered ready-made lab coat with "Flux-worker" embroidered on the pocket. A performance prop, probably by George Maciunas, the work is not known to have been offered for sale.*

FOAM STEPS see:
George Maciunas

FOG BOX see:
Robert Watts

FOOD see:
BAD SMELL EGGS
COFFEE EGGS
DEAD BUG EGGS
DISTILLED COFFEE
DISTILLED MILK
DISTILLED PRUNE JUICE
DISTILLED TEA

DISTILLED TOMATO JUICE
EGG WHITE EGGS
FISH BREAD
FISH CANDY
FISH DRINK
FISH ICE CREAM
FISH JELLO
FISH PASTRY
FISH PUDDING
FISH SALAD
GIANT BREAD FILLED WITH SAWDUST
GOOD SMELL EGGS
INK EGGS
JELLO EGGS
LAXATIVE COOKIES
LIQUID WHITE GLUE EGGS
PAINT EGGS
PLASTER EGGS
SHAVING CREAM EGGS
TRANSPARENT BEEF
TRANSPARENT BUTTER
TRANSPARENT ICE CREAM
TRANSPARENT ONION
TRANSPARENT PANCAKES & SYRUP
TWELVE JELLO EGGS MOLDED IN AN EGG
 BOX
URETHANE FOAM EGGS
WATER EGGS
WHITE GELATIN EGGS

FRESH GOODS FROM THE EAST see:
George Maciunas

FRONT SWEAT SHIRT

IMPLOSIONS INC. PROJECTS...Triple partnership was formed between Bob Watts, Herman Fine and myself [George Maciunas] to introduce into mass market ...money producing products...This business will be operated in commercial manner, with intent to make profits...connection between Fluxus collective and Implosions Inc. has not been clarified yet...we could consider at present Fluxus to be a kind of division or subsidiary of Implosions. Projects to be realized through Implosions:...Sweat shirts (printed front and back, or front alone), may have images or statements like: "front",...
Fluxnewsletter, March 8, 1967.

COMMENTS: *Like* Back Sweat Shirt, *this was also probably an idea of Robert Watts, but is not known to have been made.*

FRUIT & VEGETABLE CHESS see:
Larry Miller

FURNITURE see:
FLUXFURNITURE

FURNITURE see:
George Brecht

FUTILE BOX see:
Robert Filliou

GAMES & PUZZLES/BOARD GAMES see:
George Brecht

GAMES & PUZZLES/CARD GAMES see:
George Brecht

GAMES & PUZZLES/PUZZLES see:
George Brecht

GENUINE WATER FROM DUNKERQUE
see: Nam June Paik

GIANT BREAD FILLED WITH SAWDUST

FEB. 17, 1970: FLUX-MASS BY GEORGE MACIU-NAS...Elevation of the host: giant bread filled with sawdust is brought in by assistants in gorilla outfits...
all photographs copyright nineteen seVenty by peTer mooRE (Fluxus Newspaper No. 9) 1970.

COMMENTS: *Because of the scarcity of food during World War II, bread was frequently made with flour and sawdust. As a child in Europe during the war, George Maciunas must have experienced these hardships.*

GIANT INFLATED BOXING GLOVES see:
George Maciunas

GIANT TICKETS

FLUX-ORCHESTRA CONCERT...TICKETS: giant 2' x 3' sheets...
Flux Fest Kit 2. [ca. December 1969].

COMMENTS: *George Maciunas wanted the audience to get right into the act, or at least make it awkward for them during Fluxus concerts. The idea for* Giant Tickets *was in this spirit; however, they were never made.*

GLASS see:
George Brecht

GLUE DISPENSER see:
George Maciunas

GOOD SMELL EGGS see:
George Maciunas

GRINDER CHESS see:
Takako Saito

GUINEA PIG

28/w BY SPECIAL ORDER...a-4/6 guinea pig $15
European Mail-Orderhouse: europeanfluxshop, Pricelist. [ca. June 1964].

COMMENTS: *Probably a work by Willem de Ridder. It's not known to have been produced by George Maciunas as a Fluxus Edition, and I don't know what* Guinea Pig *could have been, except a live guinea pig.*

HAMMER see:

PREPARED HAMMER THROW HAMMER

HARD TO OPEN DOOR

"Door - (to spider web room) [and] ...Door (to smell room) we need idea for this and next door perhaps: ...could be fairly narrow with strong spring - hard to open. But unfair to weak people."
Notes: Larry Miller to George Maciunas concerning the Flux-labyrinth, Berlin. [ca. August 1976].

COMMENTS: *Not done. The idea of this work seems to be a suggestion from Larry Miller to George Maciunas for solving a problem in the progression of the labyrinth. The closest Fluxus boxed edition to this concept is George Brecht's* Closed on Mondays *(Silverman No. 72, ff) which is a plastic box containing adhesive that makes the work impossible to open more than a small bit. To realize this concept in the* Flux Cabinet, *Maciunas used a system of tied elastic, which would permit only a small opening of the drawer.*

HARDWARE see:
ASSORTED TOOLS
BOLTS
DOORKNOBS
LATCHES
LOCKS
NAILS
SCREWS
TOILET FLOATS
TOOLS

HERO 603 see:
George Maciunas

HERO 604 see:
George Maciunas

HOLE IN CENTER RACKET see:
George Maciunas

HOLY RELICS DISPENSER see:
Geoffrey Hendricks

HORIZONTAL AXIS DOOR

FLUXFEST PRESENTATION OF JOHN LENNON & YOKO ONO +* AT 80 WOOSTER ST. NEW YORK —1970...MAY 23-29: PORTRAIT OF JOHN LENNON AS A YOUNG CLOUD BY YOKO ONO & EVERY PARTICIPANT A maze with 8 doors each opening in a different manner...door hinged at center of horizontal axis...
all photographs copyright nineteen seVenty by peTer mooRE (Fluxus Newspaper No. 9) 1970.

©1976 LARRY MILLER

Anonymous. **HORIZONTAL AXIS DOOR,** an aspect of Larry Miller's **MANY KNOBS DOOR,** installed in **FLUXLABYRINTH.** Berlin, 1976.

"Door (to Hendricks room) Here I suggest we make a horizontal axis door with near normal position. This makes people go in squatting position which is a good transition to upside down room..."
Notes: Larry Miller to George Maciunas concerning the Flux-labyrinth, Berlin. [ca. August 1976].

"Enclosed is the final plan of labyrinth...The next door could be pivoted horizontally at center, so that one has to stoop under to get through..."
Letter: George Maciunas to Rene Block, [ca. Summer 1976].

This door has 20 knobs, but only one will open door; door is pivoted along a horizontal central axis
Plan of completed Fluxlabyrinth, Berlin. [ca. September 1976].

COMMENTS: *Although containing a function of Larry Miller's* Many Knobs Door *as it had been constructed in the* Fluxlabyrinth, *Berlin, 1976, this work was probably an idea of George Maciunas'.*

HOT KNOB DOOR

"Enclosed is the final plan of labyrinth...The next door could have a hot knob (one with an electric heating element) or without knob but push plate that is being heated. We will think of something else if that is too complicated to realize..."
Letter: George Maciunas to Rene Block, [ca. Summer 1976].

COMMENTS: *Many of the ideas for Fluxus derive from practical jokes or gags. This is similar to a hot-foot, and is probably Maciunas' idea.*

HOT TOILET SEAT

PROPOSED FLUXSHOW...TOILET OBJECTS toilet seat variations:...rubber bag with hot water...
Fluxnewsletter, December 2, 1968 (revised March 15, 1969).

TOILET OBJECTS & ENVIRONMENT...Toilet seat variations:...rubber bag with hot water...
Flux Fest Kit 2. [ca. December 1969].

COMMENTS: *Related to* Hot Knob Door *in the sense of practical jokes, and a variation of the whoopie cushion gag. Probably an idea of Joe Jones. See also:* Loud Noise Door *and Joe Jones'* Hot Seat Toilet Seat.

ICE FILLED SHOES see:
Robert Watts
ICED DICE see:
George Brecht
INCLINED PLANE SHOES see:
Robert Watts
INCONSEQUENTIAL IS COMING see:
Ken Friedman
INDEX see:
George Maciunas
INFLATED RUBBER TOILET SEAT see:
George Maciunas

INK BLOTS STICK-ONS

"...jewelry designs. — printed on self adhesive clear or opaque plastic, die-stamp-out. You stick-on your body or clothing these...die cut items. Got already: ...Ink blots..."
Letter: George Maciunas to Ken Friedman, [ca. February 1967].

COMMENTS: *This work does not seem to have been realized, although Maciunas could have done the preparatory work for the piece. Francis Picabia used ink blots as an illustration in his Dada magazine, 391, no. XII (March 1920).*

INK EGGS see:
George Maciunas

INSECT STICK-ONS see:
George Maciunas

**INVERSE PANORAMIC PORTRAIT OF
ANY HUMAN SUBJECT** see:
Peter Moore

INVITATIONS see:
CONFETTI INVITATIONS
THIN PAPER INVITATIONS

JELLO EGGS see:
Barbara Moore

JEWEL CHESS see:
Takako Saito

JOHN LENNON MASK see:
George Maciunas

KNOB AT HINGES DOOR see:
George Maciunas and Larry Miller

LAB COAT see:
FLUXWORKER

LADDERS see:
George Brecht

LATCHES see:
George Brecht

LAXATIVE COOKIES

FEB. 17, 1970: FLUX-MASS BY GEORGE MACIU-NAS...COMMUNION: priest with chasuble front as Venus de Milo offers to congregation cookies prepared with laxative and blue urine pills...
all photographs copyright nineteen seVenty by peTer mooRE (Fluxus Newspaper No. 9) 1970.

17.02.1970 FLUXMASS...COMMUNION: laxative cookies...
George Maciunas, Diagram of Historical Developments of Fluxus... [1973].

COMMENTS: *Although this work is probably an idea of George Maciunas', related to his* Excreta Fluxorum *and other anal interests,* Laxative Cookies *also bears an association with Robert Watts'* Pee Kit *(Silverman No. 506. ff.), Hala and Veronica Pietkiewicz's* Shit Cookies, *and Alison Knowles'* Shit Porridge. *I don't believe this work was realized. See also George Maciunas'* Laxative Sandwich.

LIGHTER see:
Robert Watts

LINEAR TURN see:
George Maciunas

LIQUID WHITE GLUE EGGS see:
George Maciunas

LOADED DECK

PROPOSED FLUXOLYMPIAD...BOARD GAMES: card games with loaded decks...
Fluxnewsletter, January 31, 1968.

COMMENTS: *This could be a reference to George Maciunas'* Same Card Flux Deck *and Ben Vautier's* Flux Missing Card Deck. *I don't know of any other Fluxus card decks that* Loaded Deck *could refer to.*

LOCATOR SIGNS see:
George Brecht

LOCKS see:
George Brecht

LONDON TO DUBLIN TICKETS see:
OUTDATED LONDON TO DUBLIN TICKETS

LONDON UNDERGROUND TICKETS see:
OUTDATED LONDON UNDERGROUND
TICKETS

LONG HANDLE RACKET see:
George Maciunas

LOOSE DUST DISPENSER

PROPOSED FLUXSHOW FOR GALLERY 669 ... AUTOMATIC VENDING MACHINES - DISPENSERS (coin operated)...dispenser dispensing loose...dust...
Fluxnewsletter, December 2, 1968.

COMMENTS: *Robert Filliou had worked with dust, and Fluxus produced an edition of his titled* Fluxdust. *The idea for a* Loose Dust Dispenser *would have come from that work.*

LOOSE SAND DISPENSER see:
George Maciunas

LOUD NOISE DOOR

"Door - (to spider web room...Door (to smell room) ...perhaps:...loud noise when opened (maybe siren or whoopee cushion or Joe Jones style)..."
Notes: Larry Miller to George Maciunas concerning the Flux-labyrinth, Berlin. [ca. August 1976].

COMMENTS: *Although probably George Maciunas' idea, Robert Watts' performance wurks at times employ loud noises. The whoopie cushion would refer to Maciunas' interest, but I don't know how a Joe Jones sound would produce the loud noise described, unless a whole Jones orchestra was employed.*

LOUIS THE 14TH MIRROR see:
Robert Filliou

MACHINES see:
BOUNCING BALLS TIME MACHINE
DISPENSERS
MOVIE-LOOP MACHINE
PAPER NOISE MACHINE
PIN BALL MACHINE
POSTCARD MACHINE
SOAP BUBBLE MACHINE
STAMP MACHINE

MADE FROM 100% COTTON SWEAT SHIRT

IMPLOSIONS INC. PROJECTS...Triple partnership was formed between Bob Watts, Herman Fine and myself [George Maciunas] to introduce into mass market ...money producing products...This business will be operated in commercial manner, with intent to make profits...connection between Fluxus collective and Implosions Inc. has not been clarified yet...we could consider at present Fluxus to be a kind of division or subsidiary of Implosions. Projects to be realized through Implosions:...Sweat shirts (printed front and back, or front alone), may have images or statements like:..."made from 100% cotton etc.etc."
Fluxnewsletter, March 8, 1967.

COMMENTS: *This sweat shirt was never made.*

MAGAZINE see:
Robert Watts

MAGIC BOAT see:
Takako Saito

MANY KNOBS DOOR see:
Larry Miller

MASKS see:
JOHN LENNON MASK
YOKO ONO MASK

MASS OF SWIMMERS WALLPAPER

NEWS FROM IMPLOSIONS, INC. Planned in 1968: ...More posters, including "Wall-paper poster" or poster that can be posted in multiples like wall-paper:...poster of a mass of swimmers or bathers crowded in a pool...
Fluxnewsletter, January 31, 1968.

COMMENTS: *In Fluxus Newspaper No. 1, January, 1964, there is a found photograph of a mass of bathers with the caption, "Robert Watts: Swimming Pool Event No. 3." I'm quite certain the idea for the wallpaper comes from this striking photograph, although the image considered in 1968 might have been a different one. Not known to have been realized as wallpaper.*

SCOTT HYDE

Anonymous. The idea to make MASS OF SWIMMERS WALLPAPER comes from Robert Watts' "Swimming Pool Event No. 3," reproduced in Fluxus Newspaper No. 1

MECHANICAL DOVE see:
Joe Jones
MECHANICAL FLUXORCHESTRA see:
Joe Jones
MEDICINE (PILL) JAR see:
Nam June Paik
MEDIEVAL ARMOR APRON see:
George Maciunas and Robert Watts
MIRROR see:
LOUIS THE 14TH MIRROR

MISSING KNOB DOOR

FLUXFEST PRESENTATION OF JOHN LENNON & YOKO ONO +* AT 80 WOOSTER ST. NEW YORK —1970...MAY 23-29: PORTRAIT OF JOHN LENNON AS A YOUNG CLOUD BY YOKO ONO & EVERY PARTICIPANT A maze with 8 doors each opening in a different manner:...door with missing knob...
all photographs copyright nineteen seVenty by peTer mooRE (Fluxus Newspaper No. 9) 1970.

COMMENTS: *Some of the Fluxus door ideas stem from Marcel Duchamp's* Door, 11 Rue Larrey, *1927.*

THE MONTHLY REVIEW OF THE UNIVERSITY FOR AVANT-GARDE HINDUISM see:
Nam June Paik

MOUSTACHE STICK-ONS

FLUXPROJECTS FOR 1969 PRODUCTS - PUBLICATIONS...Stick-ons: moustaches...
Fluxnewsletter, December 2, 1968.

"...These projects I think could be produced cheaper in Italy:...some new stick ons that we did not have chance to produce such as...moustaches"
Letter: George Maciunas to Daniela Palazzoli, n.d. Reproduced in Fluxnewsletter, April 1973.

COMMENTS: *The idea for this work, never made, comes from Marcel Duchamp's moustached Mona Lisa, L.H.O.O.Q., a rectified ready-made from 1919.*

MOVIE-LOOP MACHINE

FLUX AMUSEMENT ARCADE ... movie-loop machine (flux-films from Flux-box 2)
Preliminary Proposal for a Flux Exhibit at Rene Block Gallery. [ca. 1974].

COMMENTS: *This could be any 8mm projector capable of projecting loops, so in a strict sense, this is not a Fluxus work. However, the concept here is like a dispenser of Fluxus film loop images and therefore has been treated as a work.*

MUSICAL CHAIRS see:
Takako Saito
MUSICAL SHOES see:
Robert Watts
MYSTERY FLUX ANIMAL see:
George Maciunas
MYSTERY MEDICINE see:
George Maciunas
NAIL SHOES see:
Robert Watts
NAILS see:
George Brecht
NAPOLEON'S FRONT APRON see:
George Maciunas

NARROW DOOR

"Door - (to spider web room)...Door (to smell room) we need idea for this next door, perhaps:...narrow door (hard for fat people)..."
Notes: Larry Miller to George Maciunas concerning the Flux-labyrinth, Berlin. [ca. August 1976].

COMMENTS: *This door was not made.*

NECKTIE see:
Robert Watts
NEWSPAPERS see:
PREPARED NEWSPAPERS
NIGHT TELEGRAMME see:
Nam June Paik
NO SMOKING see:
George Brecht
NO VACANCY see:
George Brecht
NUDE BACK APRON see:
George Maciunas
NUMBER 4 see:
Yoko Ono
NUT & BOLT CHESS see:
Takako Saito

ONE

FLUXFILMS...FLUXFILM 9 ONE 1 min. $6
Vaseline sTREet (Fluxus Newspaper No. 8) May 1966.

COMMENTS: This is Eyeblink *by Yoko Ono. See comments regarding the confusion of title, length and Fluxfilm number in Yoko Ono's section.*

1 CENT COIN IN ENVELOPE see:
Nam June Paik
1000 FRAMES see:
George Maciunas
ONE WAY TICKET TO SIBERIA see:
George Maciunas

OUTDATED LONDON TO DUBLIN TICKETS

Silverman No. < 262.IV

FLUXFEST PRESENTATION OF JOHN LENNON & YOKO ONO +* AT 80 WOOSTER ST. NEW YORK —1970...APR. 18-24: TICKETS BY JOHN LENNON + FLUXTOURS ... London to Dublin tickets (outdated)...
all photographs copyright nineteen seVenty by peTer mooRE (Fluxus Newspaper No. 9) 1970.

COMMENTS: This facsimile of an old ticket is certainly a work of George Maciunas, and is a specific of the general work, Outdated 19th Century Train Tickets, *listed in George Maciunas' section.*

Anonymous. OUTDATED LONDON TO DUBLIN TICKETS

OUTDATED LONDON UNDERGROUND TICKETS

Silverman No. < 262.V

FLUXFEST PRESENTATION OF JOHN LENNON & YOKO ONO +* AT 80 WOOSTER ST. NEW YORK —1970...APR. 18-24: TICKETS BY JOHN LENNON + FLUXTOURS...London Underground tickets...
all photographs copyright nineteen seVenty by peTer mooRE (Fluxus Newspaper No. 9) 1970.

COMMENTS: Although not credited to him, this ticket could

Anonymous. OUTDATED LONDON UNDERGROUND TICKETS

be a realization of the general work, Outdated 19th Century Train Tickets *by George Maciunas.*

PAINT EGGS see:
George Maciunas
PAPER APRONS see:
George Maciunas

PAPER HAT PROGRAMS

PROGRAMS (given out at the entry to the auditorium)...printed on paper hats
[Fluxus Newsletter] Proposal for Fluxus Paper Concert. [ca. Fall 1967].

COMMENTS: The idea for this unrealized program variation was based on Milan Knizak's 1965 action in Prague, "Soldier's Game," where participants wore paper hats.

PAPER NOISE MACHINE see:
George Maciunas
PAPER TOWELS see:
FLUX TOILET
PARAKEETS see:
3 COLORED PARAKEETS

PASS ON THE LEFT NOT ON THE RIGHT SWEAT SHIRT

IMPLOSIONS INC. PROJECTS...Triple partnership was formed between Bob Watts, Herman Fine and myself [George Maciunas] to introduce into mass market ...money producing products...This business will be operated in commercial manner, with intent to make profits...connection between Fluxus collective and Implosions Inc. has not been clarified yet...we could consider at present Fluxus to be a kind of division or subsidiary of Implosions. Projects to be realized through Implosions:...Sweat shirts (printed front and back, or front alone), may have images or statements like:..."pass on the left not on the right" etc. etc.
Fluxnewsletter, March 8, 1967.

COMMENTS: This sweat shirt was never made, either by Fluxus or Implosions.

PEEKER WALLPAPER

NEWS FROM IMPLOSIONS INC....Planned in 1968: ...More posters, including "Wall-paper poster" or poster that can be pasted in multiples like: wall-paper: ...peeker through small window or hole in wall, etc.
Fluxnewsletter, January 31, 1968.

COMMENTS: In one sense this work derives from Ben Vautier's Flux Holes. *However, George Maciunas seems to have had something much more specific in mind. Maciunas designed a Fluxus label using an old image of a peeking boy. I think the wallpaper, which was never made, would have had the unstated sexual implications of a "Peeping Tom."*

PENS see:
Robert Watts
PHOTO-COLLAGE MIRROR see:
LOUIS THE 14TH MIRROR
PHOTOGRAPHS see:
Robert Watts
PHOTO-MASKS see:
MASKS
PIANO ACTIVATED DOOR see:
Nam June Paik
PIECE FOR FLUXORCHESTRA see:
Albert Fine
PIN BALL MACHINE see:
George Maciunas
PIVOT IN CENTER VERTICAL AXIS DOOR see:
CENTRAL VERTICAL AXIS DOOR
PLASTER EGGS see:
George Maciunas
POEM V see:
Tomas Schmit
POEM VI see:
Tomas Schmit
POEM VII see:
Tomas Schmit
POEM VIII see:
Tomas Schmit
POLICE CAR see:
John Cale
POPE MARTIN V APRON see:
George Maciunas and Robert Watts
PORNOGRAPHY see:
Robert Watts
PORTRAIT OF JOHN LENNON AS A YOUNG CLOUD see:
Collective
POSTAGE STAMPS see:
STAMPS

POSTCARD MACHINE see:
Robert Watts

POSTCARDS see:
Ben Vautier
Robert Watts

POSTER see:
WALLPAPER

PREPARED CIGARETTES see:
CIGARETTE DISPENSER

PREPARED HAMMER THROW HAMMER
see: George Maciunas

PREPARED NEWSPAPERS

PROPOSED PROPAGANDA ACTION FOR NOV. FLUXUS IN N.Y.C. (during May - Nov. period) ... Propaganda through sabotage & disruption of: ... communications system: ... Printing & selling on street corners "revised" & "prepared" editions of N.Y. Times, Daily News, etc. bearing Fluxus announcements (such as "107 days to Fluxus," next day "106 days till Fluxus" etc. etc.) bearing nonexistent news about closing of museums etc.
Fluxus Newsletter No. 6, April 6, 1963.

COMMENTS: *In 1960, Yves Klein prepared an action which involved mimicking the exact format of* Journal du Dimanche, *the Sunday edition of the popular newspaper* France-Soir. *Klein's newspaper,* Dimanche 27 Novembre, *was mass-produced and distributed widely throughout Paris on that day. Klein's work was surely the catalyst for the Fluxus Prepared Newspapers. Maciunas first started publishing the Fluxus newspaper in January, 1964. Later, Alison Knowles stenciled "Fluxus Comes to New York" on various public surfaces and newspapers, announcing the first series of Fluxus concerts in New York in 1964. See also: Tomas Schmit,* Tomorrow Will Be Fluxus Day!

PROGRAMS see:
ADHESIVE PROGRAMS
CARDBOARD BOX PROGRAMS
CARDBOARD PROGRAMS
PAPER HAT PROGRAMS

PSYCHOLOGY see:
Robert Watts

RAINBOW MOVIE see:
Ay-O

RED EARTH FROM AUSCHWITZ see:
Nam June Paik

RELOCATION see:
George Brecht

REQUIEM FOR WAGNER THE CRIMINAL MAYOR see:
Dick Higgins

RIBBON TICKETS

FLUX-ORCHESTRA CONCERT ... TICKETS: giant ... long ribbons.
Flux Fest Kit 2. [ca. December 1969].

COMMENTS: *Although* Ribbon Tickets *were never made by Fluxus, the idea derived from the prop for Robert Watts'* 2" *(Silverman No. 484), a very long ribbon 477.5 x 5.7 cm (ca. 1964), which was used many times for Fluxus performances of Watts'* 2".

ROCKS MARKED BY WEIGHT IN GRAMS
see: Robert Watts

ROMAN EMPEROR APRON see:
George Maciunas and Robert Watts

ROUND DICE

"... These objects I think could be produced cheaper in Italy: ... rubber dip moulded objects: ... round dice ..."
Letter: George Maciunas to Daniela Palazzoli, n.d. Reproduced in Fluxnewsletter, April 1973.

COMMENTS: Round Dice *were never produced by George Maciunas as a Fluxus Edition. He designed* Modular Cabinets *which were die cube display cases, and it seems probable that the idea for this work was his as well.*

RUBBER BRIDGE see:
George Maciunas

RUBBER UDDER see:
Claes Oldenburg

RUGS see:
George Brecht

SAME CARD FLUX DECK see:
George Maciunas

SAND TIMER PIECES see:
TIME CHESS, SAND TIMER PIECES

SANDPAPER TOILET SEAT

PROPOSED FLUXSHOW ... TOILET OBJECTS ... toilet seat variations: ... sandpaper ...
Fluxnewsletter, December 2, 1968 (revised March 15, 1969).

TOILET OBJECTS & ENVIRONMENT ... Toilet seat variations: ... sandpaper ...
Flux Fest Kit 2. [ca. December 1969].

COMMENTS: *Fluxus was bent on undoing two centuries of cultural development. The perpetrator of this particularly insidious act,* Sandpaper Toilet Seat, *remains anonymous.*

SCAR STICK-ONS see:
George Maciunas and Ben Vautier

SCREW-HEADS STICK-ONS

"... By separate mail I am sending some of the new stick-on tattoos we produced. There are 4 other new sheets we are doing now: ... screw heads ... to be stuck on skin or clothing ..."
Letter: George Maciunas to Paul Sharits, June 21, 1967.

COMMENTS: *Images of screw-heads were incorporated into George Maciunas'* Fluxwear 303.

SCREWS see:
George Brecht

SEARS CATALOGUE see:
Paul Sharits

SEE SAW see:
George Maciunas

SEPARATE DOOR IN DOOR see:
George Maciunas

SEX, FEMALE see:
Robert Watts

SEX, MALE see:
Robert Watts

SHAVING CREAM EGGS see:
George Maciunas

SHAVING CREAM FILLED SHOES see:
Robert Watts

SHIRTS see:
CLOTHING

SHOE STEPS see:
George Maciunas

SIGNS see:
George Brecht

SILENCE see:
George Brecht

SINK see:
George Maciunas

SLIPPERY FLOOR see:
George Maciunas

SLIPPERY SHOES see:
Robert Watts

SLIPPERY TOILET SEAT

PROPOSED FLUXSHOW ... TOILET OBJECTS toilet seat variations: ... highly waxed & polished slippery surface, etc.
Fluxnewsletter, December 2, 1968 (revised March 15, 1969).

TOILET OBJECTS & ENVIRONMENT Toilet seat variations: ... highly waxed slippery surface ...
Flux Fest Kit 2. [ca. December 1969].

COMMENTS: *The idea of slipperiness was used both by Ay-O*

and George Maciunas in their work. Slippery Toilet Seat *might have come from either.* See Ay-O's Sudsey Foam Floor *and* Maciunas' Slippery Floor.

SMALL DOOR IN DOOR see:
George Maciunas

SMEARS see:
Robert Watts

SMELL BOX see:
Robert Watts

SMELL CHESS see:
Takako Saito

SMELL ROOM see:
Robert Watts

SMOKE see:
SMOKING

SMOKE FLUXKIT see:
Yoshimasa Wada

SMOKING see:
Joe Jones

SOAP see:
Robert Watts

SOAP BUBBLE MACHINE see:
George Maciunas

SOCKS see:
Robert Watts

SOUND CHESS see:
Takako Saito

SPATIAL POEM NO. 1 see:
Mieko (Chieko) Shiomi

SPATIAL POEM NO. 3 see:
Mieko (Chieko) Shiomi

SPATIAL POEM NO. 4 see:
Mieko (Chieko) Shiomi

SPICE CHESS see:
Takako Saito

SPIDER WEB ROOM see:
Robert Watts

SPORTS see:
FLUX SPORT EQUIPMENT

SPRING STEPS

Any proposals from participants should fit the maze format...Ideas should relate to passage through doors, steps, floor, obstacles, booths...spring steps...
George Maciunas, Further Proposal for Flux-Maze at Rene Block Gallery. [ca. Fall 1974].

COMMMENTS: The *Flux-Maze at Rene Block Gallery was not built, but ideas were transferred to the* Fluxlabyrinth *in Berlin, 1976, where George Maciunas'* See Saw *was built.*

That work used the idea of springiness which is inherent in Spring Steps.

SQUEAKING TOILET SEAT see:
George Maciunas

STAMP DISPENSER see:
Robert Watts

STAMP MACHINE see:
Robert Watts

STAMPS see:
FLUXPOST (AGING MEN)
FLUX POST KIT 7
FLUXPOST 17-17
FLUXPOST (SMILES)
STAMPS: 15¢
STAMPS STICK-ONS
STAMPS: U.S. 10¢

STAMPS: 15¢ see:
Robert Watts

STAMPS STICK-ONS

"...These objects I think could be produced cheaper in Italy:...some new stick-ons that we did not have a chance to produce such as...stamps..."
Letter: George Maciunas to Daniela Palazzoli, n.d. Reproduced in Fluxnewsletter, April 1973.

COMMENTS: *Fluxus produced editions of stamps by both George Maciunas and Robert Watts, but never Stamp Stick-ons.*

STAMPS: U.S. 10¢ see:
Robert Watts

STATIONERY see:
FLUX STATIONERY

STATIONERY see:
George Maciunas

STAY UNTIL THE ROOM IS BLUE see:
Yoko Ono

STEEP STAIR DOOR

"Enclosed is the final plan of labyrinth...the last door would be a sort of step like fire escapes used in New York. At first it would look like a steep stair leading into the ceiling but would slowly lower itself when person starts stepping on it. The stair would need counter weight to permit it to come down not too suddenly."
Letter: George Maciunas to Rene Block, [ca. Summer 1976].

this door is actually a steep stair which must be climbed upon for it to lower down permitting passage.

Counterweight would slow down the movement.
Plan of completed Fluxlabyrinth, Berlin. [ca. September 1976].

COMMENTS: Steep Stair Door *was not built for the Fluxlabyrinth in Berlin. I am inclined to think it was an idea of George Maciunas' based on commercially made attic stairs that lift up into a trap door.*

STEP DOOR see:
FLOOR HINGED DOOR

STEPS see:
FOAM STEPS
SHOE STEPS
SPRING STEPS
STEEP STAIR DOOR

STICK-ONS see:
ARCHAEOLOGY 900
BUTTONS
CIGARETTE BURNS STICK-ONS
DISEASES STICK-ONS
FLUXUS 301
FLUXWEAR 303
FLUXWEAR 304
HERO 603
HERO 604
INK BLOTS STICK-ONS
INSECT STICK-ONS
MOUSTACHE STICK-ONS
SCAR STICK-ONS
SCREW-HEADS STICK-ONS
STAMPS STICK-ONS
TATTOO 101

STRING see:
Robert Watts

STRING DISPENSER see:
CONTINUOUS STRING DISPENSER

SUN IN YOUR HEAD see:
Wolf Vostell

SUN-GLASS HAT see:
8 LENS SUN GLASSES

SUNGLASSES see:
8 LENS SUN GLASSES

SWEAT SHIRTS see:
CLOTHING

TABLECLOTHS see:
Daniel Spoerri

TACTILE ENTRANCE see:
Ay-O

TARGETS see:
George Maciunas

TATTOO FACSIMILES see:
TATTOO 101

Anonymous. TATTOO 101

SCOTT HYDE

TATTOO 101
Silverman No. < 130.I

"...jewelry design. — printed on self adhesive clear or opaque plastic, die-stamp-out. You stick-on your body or clothing these...die cut items. Got already: ...Photos of tattoos..."
Letter: George Maciunas to Ken Friedman, [ca. February 1967].

COMMENTS: This sheet of stick-ons has color reproductions of antique tattoos, and was published by Implosions in 1967. Implosions was a commercial venture started by George Maciunas, Robert Watts and Herman Fine, to market Fluxus and Fluxus-like ideas. Sheets of Tattoo 101 were certainly distributed by Fluxus; however, they were never advertised as Fluxus works.

10 FEET see:
George Maciunas
10 FOOT LONG CIGARETTE see:
Robert Watts

THIN PAPER INVITATIONS
Silverman No. 664

BASIC PROPOSAL/ TITLE: FLUXFEST/ INVITATIONS: printed on 22" x 34" very thin paper and folded 8 times to 2 -1/8" x 1 -1/8" size.
[Fluxus Newsletter] Proposal for Fluxus Paper Concert. [ca. Fall 1967].

COMMENTS: Invitations to "A Paper Event by the Fluxmasters of the Rear-Garde" were designed by George Maciunas. The idea of ungainly pieces of paper containing information, set in tiny type, put the prospective participant at the "Paper Event" immediately in the spirit of things, and were a harbinger of better things to come.

35MM SLIDE see:
Robert Watts

3 COLORED PARAKEETS

28/w BY SPECIAL ORDER a-47 3 colored parakeets $50.
European Mail-Orderhouse: europeanfluxshop, Pricelist. [ca. June 1964].

COMMENTS: Probably ready-mades by Willem de Ridder.

TICKET
Silverman No. < 262.VI

COMMENTS: Ticket is uncredited and was printed with other Flux Tour tickets on the same sheet. It was distributed by Fluxus for the "Fluxfest Presentation of John Lennon and Yoko Ono," April 18-24, 1970. It is certainly a work of George Maciunas.

Anonymous. TICKET

TICKETS see:
ALL INCLUSIVE 4 DAY STAY IN GREEN-LAND TICKET
FACSIMILE TICKET TO NEW YORK ZOOLOGICAL SOCIETY, 1947
GIANT TICKETS
ONE WAY TO SIBERIA
OUTDATED LONDON TO DUBLIN TICKETS
OUTDATED LONDON UNDERGROUND TICKETS
RIBBON TICKETS
TICKET
TIME CHESS, SAND TIMER PIECES see:
George Maciunas

TIME CHESS WITH CLOCKWORK PIECES

... items are in stock, delivery within 2 weeks ... FLUXUSa FLUXCHESS: pieces identified by sound or smell or time etc....FLUXUS a10 time chess, clockwork pieces $100
Vaseline sTREet (Fluxus Newspaper No. 8) May 1966.

COMMENTS: George Maciunas used the innards of clocks and watches in assembling the Fluxus Edition of Robert Watts' Flux Timekit, and later in two works: George Brecht's Universal Machine II and George Brecht and Robert Filliou's Eastern Daylight Flux Time. The idea for a Time Chess with Clockwork Pieces is an extension of George Maciunas' Time Chess, Sand Timer Pieces, although there is no evidence that it was ever made.

TIRE see:
Robert Watts
TOILET see:
FLUX TOILET
TOILET FLOATS see:
George Brecht
TOILET OBJECTS see:
FLUX TOILET
TOILET PAPER PERFORATED WITH LARGE HOLES see:
George Maciunas
TOOLS see:
George Brecht
TRACE see:
Robert Watts
TRANSITION FROM SMALL TO LARGE SCREEN see:
Paul Sharits
TRANSITION THROUGH COLOR SCALE see:
RAINBOW MOVIE
TRANSPARENT BEEF see:
George Maciunas
TRANSPARENT BUTTER see:
George Maciunas
TRANSPARENT ICE CREAM see:
George Maciunas
TRANSPARENT ONION see:
George Maciunas

TRANSPARENT PANCAKES & SYRUP

PROPOSED FLUX DRINKS & FOODS TRANSPARENTMEAL...clear pancakes with clear syrup...
Fluxfest at Stony Brook, Newsletter No. 1, August 18, 1969. versions A and B

COMMENTS: George Maciunas made a number of transparent foods. The idea for this work is probably his also. It was never made.

TREE MOVIE see:
Jackson Mac Low

TRIANGULAR DOOR

Door — (to spider web room) [and] ...Door (to smell room) we need idea for this and next door, perhaps: ...Triangular doors... - easy to make (no curves)...
Notes: Larry Miller to George Maciunas concerning the Flux-labyrinth, Berlin. [ca. August 1976].

COMMENTS: This door was not made for the Fluxlabyrinth. The idea for a Triangular Door was apparently Larry Miller's.

TWELVE JELLO EGGS MOLDED IN AN EGG BOX see:
Robert Watts

12 MOVEMENT FLUX CLOCK see:
George Maciunas

270 DEGREE DOOR see:
George Maciunas and Larry Miller

UNDULATING SURFACE MIRROR see:
Robert Watts

UPSIDE DOWN FOREST see:
Geoffrey Hendricks

UPWARD TURNED FAUCET see:
Joe Jones

URETHANE FOAM EGGS see:
George Maciunas

U.S.A. SURPASSES ALL THE GENOCIDE RECORDS see:
George Maciunas

VENUS DE MILO APRON see:
George Maciunas

VERTICAL LINES MOVING see:
LINEAR TURN

VERY SOFT RACKET see:
George Maciunas

VIRGIN MARY APRON see:
George Maciunas and Robert Watts

WALLPAPER see:
ASSHOLES WALLPAPER
MASS OF SWIMMERS WALLPAPER
NO SMOKING
PEEKER WALLPAPER

WASHINGTON'S FRONT APRON see:
George Maciunas

WATER DISPENSER

PROPOSED FLUXSHOW FOR GALLERY 669 ... AUTOMATIC VENDING MACHINES - DISPENSERS (coin operated)...drink dispenser dispensing water.
Fluxnewsletter, December 2, 1968.

COMMENTS: One of many proposed Fluxus dispensers. Most were never produced.

WATER EGGS see:
George Maciunas

WATER SOLUBLE CUP DISPENSER see:
George Maciunas

WEB OBSTACLE see:
Ay-O

WEIGHT CHESS see:
Takako Saito

WHITE GELATIN EGGS see:
George Maciunas

WOOD BLOCKS OBSTACLE see:
Ay-O

YAMS see:
Robert Watts

YOKO ONO MASK see:
George Maciunas

ZEN FOR FILM see:
Nam June Paik

ZOOLOGY see:
Robert Watts

UNDETERMINED AUTHORS

In planning the Fluxus Yearboxes, George Maciunas, the "Editor in Chief," had wanted to include articles and essays on various subjects for which he did not have an author in mind. These authors were not intended to be anonymous, and yet, as they were not determined, they would not fall in the remainder of the book. Although the material is included in the Collective section, we felt that it was important that the subjects not be overlooked and decided to make this a separate section, appendaged to Anonymous. For the full context of these subjects, refer to Collective.

"Atlas — Index of New Art, Music, Literature, Cinema, Dance in U.S."

It was announced in the first 4 plans for FLUXUS NO. 1 U.S. ISSUE that all editors would contribute "Atlas — index of new art, music, literature, cinema, dance in U.S." In Brochure Prospectus, version B, it was announced that George Maciunas was to be the author of that contribution.
see Collective: FLUXUS 1

"Atlas — Index of New Art, Music, Literature, Cinema, Theatre in Western Europe 1"
"Chronicle — Calendar of Events"
"Critique Contre Critique/Critique Pour Critique"
"Fluxus Festival program insert"
"The Militant Art Politic — a Brutalist Manifesto"
"Reviews — books, magazines, etc"
"Swedish Art Machines"

It was announced in the first plan for FLUXUS NO. 2 WEST EUROPEAN ISSUE that "Critique contre critique/critique pour critique" and "The militant art politic — a brutalist manifesto" would be contributed anonymously, and that the editors would contribute "Atlas — index of new art, music, literature, cinema[,] theatre in Western Europe I."

In the next two preliminary plans for FLUXUS NO. 2 and in Brochure Prospectus, version A, there was to be a Fluxus Festival program insert and a newspaper fold-out containing "Chronicle — calendar of events;" "Index — directory of new art, music, literature & cinema;" and "Reviews — books, magazines, etc." In Brochure Prospectus, version B, all these planned contributions were dropped.

It was announced in the Brochure Prospectus, version A, that a person "to be determined" would contribute an article on "Swedish art machines" to FLUXUS NO. 2 GERMAN & SCANDINAVIAN YEARBOX.
see Collective: FLUXUS NO. 2 WEST EUROPEAN YEAR-BOX 1.

"Brutalist Architecture"
"The Gutai Theatre"
"Japanese Electronic Music (essay & record)"
"Zen Priest Training"

It was announced in the first tentative plan for issues of FLUXUS that a person "to be determined" would contribute "Brutalist architecture," "Japanese electronic music (essay & record)," and "The Gutai theatre" to FLUXUS NO. 3 JAPANESE ISSUE. In the next two plans, the "Brutalist" article was dropped. "Zen Priest training (translation)" was initially to be written by Nam June Paik, then, "to be determined." Finally, it was announced in Brochure Prospectus, version A, that Toshi Ichiyanagi would contribute the "electronic music" and "Gutai" works, and the translator of the "Zen" article was still "to be determined." In Brochure Prospectus, version B, the entire contents for the Japanese issue, by now called FLUXUS NO. 4 JAPANESE YEARBOX, were "to be determined."
see Collective: FLUXUS NO. 3 JAPANESE YEARBOX

"Machine Music of Athanasius Kircher"
"3 Newly Discovered Japanese Medieval Zen Painters"
"Ying Yuch Chieh, the Ink Splasher of Chan Painters"

It was announced in the tentative plans for the first issues of FLUXUS that an author "to be determined" would contribute "Ying Yuch Chieh, the ink splasher of Chan painters" to FLUXUS NO. 4 HOMAGE TO THE DISTANT PAST. In the initial plans for FLUXUS NO. 4, "Machine Music of Athanasius Kircher" was going to be written by a person "to be determined." (This person was later determined to be H.K. Metzger). Another essay by an author "to be determined," "3 newly discovered Japanese medieval Zen painters" was announced in the second, third, and fourth plans for that FLUXUS.
see Collective: FLUXUS NO. 4 HOMAGE TO THE PAST

"Abstract Chirography in France (essay & folio)"
"Italian Experiments in Cinema"
"Junk and Garbage Art"
"New Realist Art"

The earliest plan for FLUXUS NO. 5 WEST EUROPEAN ISSUE II was to include a section, "Junk and garbage art" by a person "to be determined." As plans evolved for that FLUXUS, first Pierre Restany and then Daniel Spoerri was to be the editor of the "Junk art" or "New Realist art" section. Another undetermined author was for a section called "Abstract chirography in France (essay & folio)." By the time the publication evolved into the planned FLUXUS NO. 3 FRENCH YEARBOX, Daniel Spoerri was identified as the editor of the "Abstract chirography" section. "Other essays, inserts, anthologies and records" were "to be determined." Brochure Prospectus, version A, announced "Italian experi-

ments in Cinema" to be contributed by a person "to be determined," for FLUXUS NO. 6 ITALIAN, ENGLISH, AUSTRIAN YEARBOX.
see Collective: FLUXUS NO. 5 WEST EUROPEAN YEARBOX II

"Atlas — Index of New Art, Music, Cinema in E. Europe"
"Anthology of Soviet Realism: Bertolt Brecht, El Lissitzsky, V. Mayakovsky, Yury Pinmenov, A. Korneichuk, Y. Evtushenko"
"Ballet Without Gravity"
"Experimental Music in USSR"
"Junk Architecture"
"New Polish Concrete and Electronic Music"
"Principles of Dialectic Materialism in Concrete Art"
"Potentialities of Concrete Prefabrication in USSR"
"Soviet Machine Music"
"Soviet Glass Electronic Music of Muzzin"
"'Zamek' Group of Concretists in Lublin"

The first plan for FLUXUS NO. 6 EAST EUROPEAN ISSUE calls for three contributions by persons "to be determined," "New Polish concrete and electronic music;" "Principles of Dialectic Materialism in concrete art;" "Potentialities of concrete prefabrication in USSR," and that the editors would contribute: "Atlas — index of new art, music, cinema in E. Europe." The second and third plans identify George Maciunas as the author of the "Dialectic Materialism" article, and still list the other two articles. The "Atlas — index..." was changed to "Other essays, anthologies, inserts and records to be determined" and then was dropped altogether.

Brochure Prospectus, version A, lists George Maciunas as the author of "Dialectic Materialism" and "concrete prefabrication" and adds the following contributions by authors "to be determined:" "New Polish concrete and electronic music;" "ballet without gravity;" "junk architecture;" "Soviet machine music;" "Soviet glass electronic music of Muzzin;" and "'Zamek' group of concretists in Lublin."

Plans for FLUXUS NO. 7 EAST EUROPEAN YEARBOX, appearing in Brochure Prospectus, version B, identify K. Penderecky as the author of "Polish concrete music," and states that A. Volkonski or someone "to be determined" was being consulted on "Experimental music in USSR," adds to the title of the article on "ballet without gravity" "(in orbital space stations)," still lists "junk architecture," states that "glass electronic music" will be a "record," and the "Zamek" contribution would be "works (photographs)." It was also announced in Brochure Prospectus, version B, that FLUXUS NO. 7 EAST EUROPEAN YEARBOX would have an "Anthology of Soviet Realism: Bertolt Brecht, El Lissitzsky, V. Mayakovsky, Yury Pimenov, A. Korneichuk, Y. Evtushenko."
see Collective: FLUXUS NO. 6 EAST EUROPEAN YEARBOX

"Abstract Sound Poetry: Anthology of Tzara, Ball, Arp, Housmann, Schwitters,..."
"Anthology of Dada Sound Poetry"
"Dada Happenings — (corpus)"
"Dada Noise Music"
"Noise Music of Futurists & Dada: Russolo, Ball, Tzara..."
"Origins of Garbage - Junk Art"
"Poems Simultanes (essay & anthology)"
"Significance of Dada Political Orientation"

The first plan for FLUXUS NO. X HOMAGE TO DaDa lists a number of contributions by persons "to be determined":
"Origins of garbage — junk art"
"Noise music of Futurists & Dada: Russolo, Ball, Tzara"
"Poemes simultanes (essay & anthology)"
"Dada happenings — (corpus)"
"Abstract sound poetry: anthology of Tzara, Ball, Arp, Housmann, Schwitters,..."
"Significance of Dada political orientation."

The next two tentative plans for FLUXUS NO. 7 HOMAGE TO DaDa add, alter, and drop contributions by persons "to be determined." The works were to be:
"Corpus of Dada happenings — festivals."
"Dada noise music"
"Significance of Dada political orientation."
"Anthology of Dada sound poetry."

The DaDa FLUXUS was dropped altogether in later plans.
see Collective: FLUXUS NO. 7 HOMAGE TO DADA

COLOR PORTFOLIO

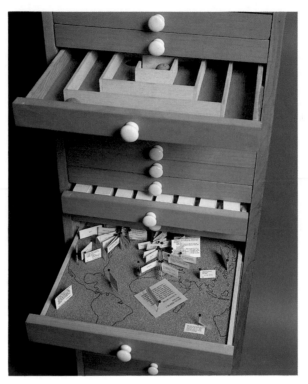

Collective. FLUX CABINET. Detail above
Collective. FLUX CABINET. Left

Collective. FLUX FOOD

Collective. FLUXFILMS and FLUXFILMS LOOPS

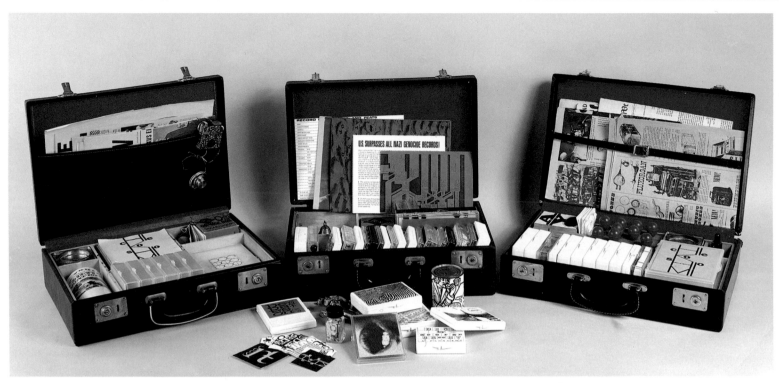

Collective. FLUXKIT. Three examples assembled by George Maciunas between 1965 and 1969

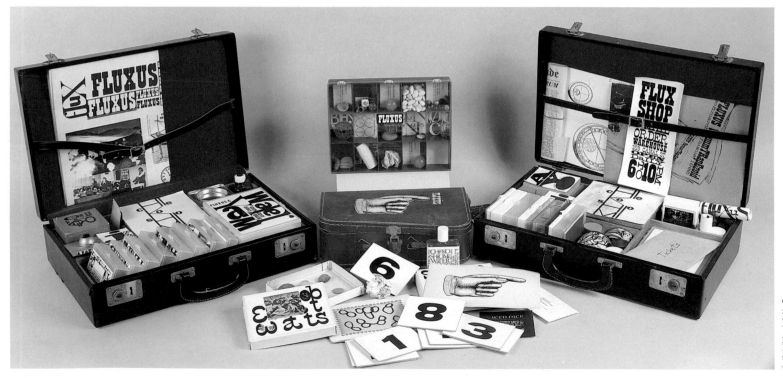

Collective. FLUXKIT. Four different assemblings. The two in the center were assembled by Willem de Ridder for the European Mail-Order Warehouse/Fluxshop, ca. 1965. On either side are Maciunas assemblings of the work.

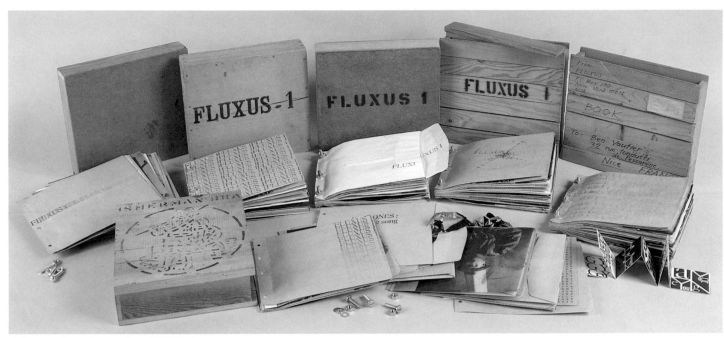

Collective. Several examples of FLUXUS 1

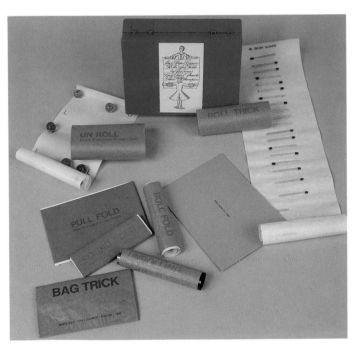

Collective. FLUX PAPER GAMES: ROLLS AND FOLDS

Collective FLUX YEAR BOX 2

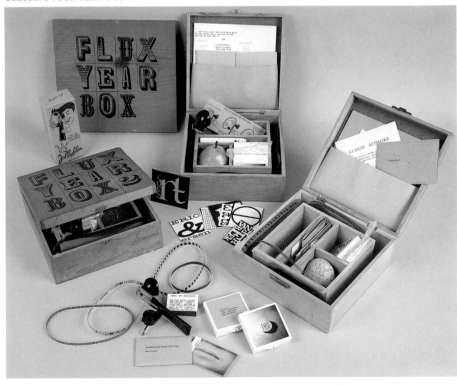

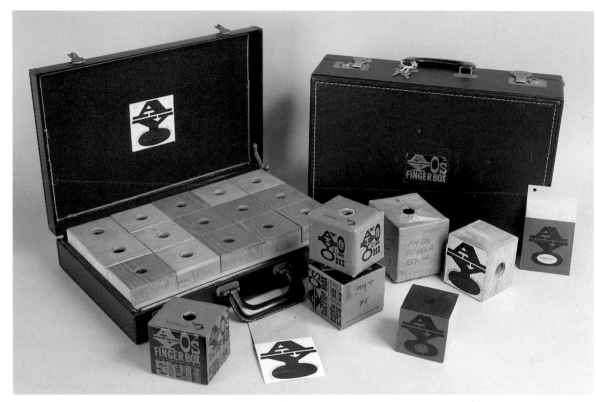

Ay-O. FINGER BOX. A selection of Fluxus Editions, and a prototype made by the artist

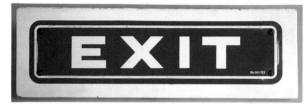

George Brecht. EXIT. A ready-made mounted by the artist

George Brecht. START

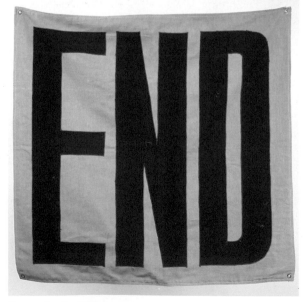

George Brecht. END

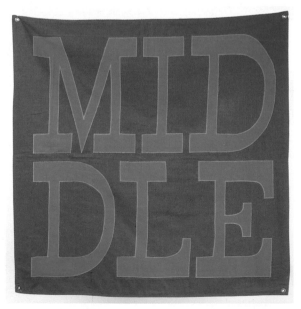

George Brecht. MIDDLE

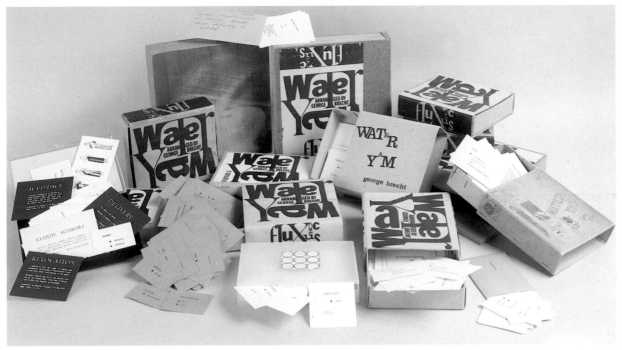

George Brecht. WATÉR YAM

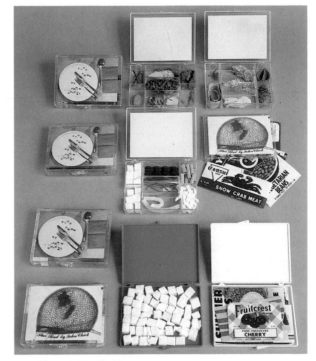

John Chick. FLUX FOOD

George Brecht.
VALOCHE /A FLUX
TRAVEL AID

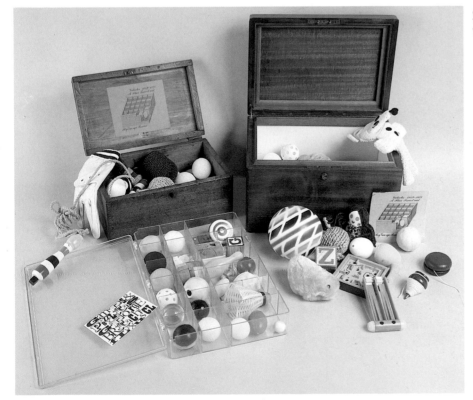

Christo. PACKAGE

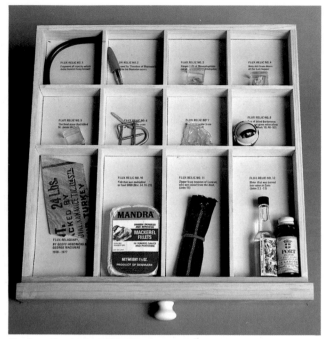

Geoffrey Hendricks. FLUX RELIQUARY.
Example shown is in the FLUX CABINET

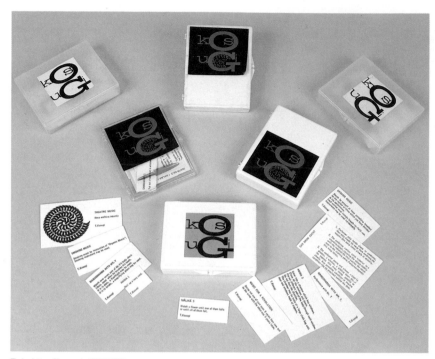

Takehisa Kosugi. EVENTS

Hi Red Center. !

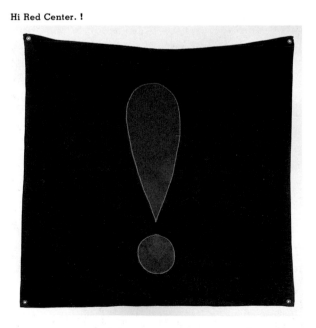

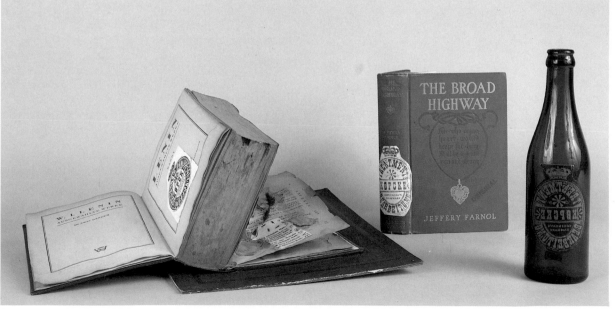

Arthur Koepcke. TREATMENTS

Shigeko Kubota. FLUX MEDICINE

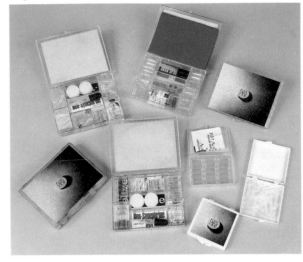

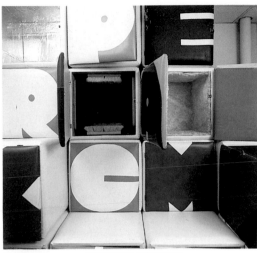

George Maciunas. MODULAR CABINETS

Alison Knowles. BEAN ROLLS

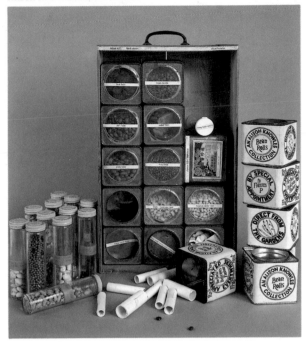

George Maciunas. BIOGRAPHY BOX

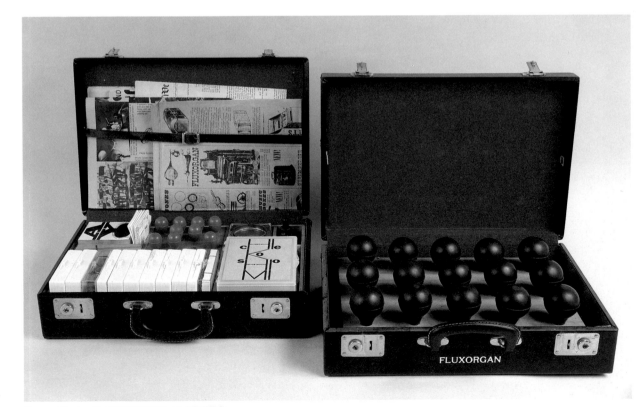

George Maciunas. FLUXORGAN, 12 SOUNDS

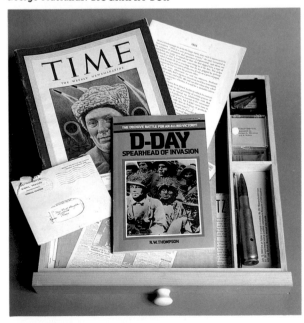

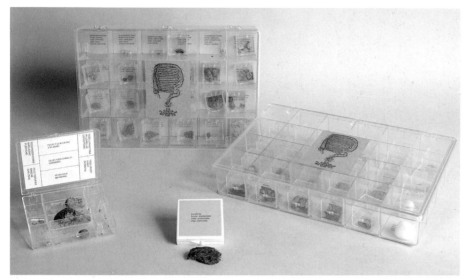

George Maciunas. EXCRETA FLUXORUM

George Maciunas. EXCRETA FLUXORUM

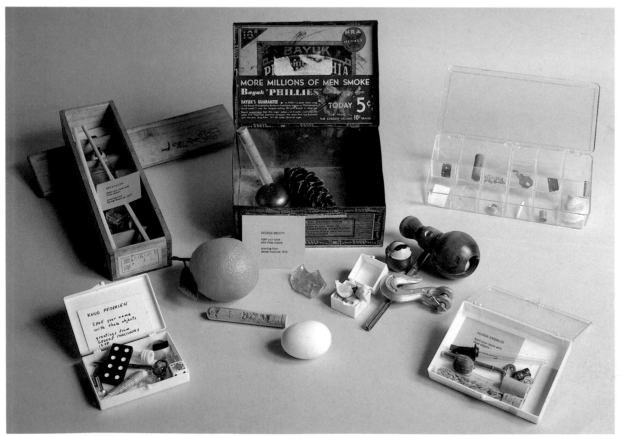

George Maciunas. TRANSPARENT MEAL

George Maciunas.
YOUR NAME SPELLED WITH OBJECTS

George Maciunas. MYSTERY FLUX ANIMAL

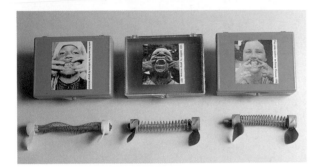

George Maciunas. FLUX SMILE MACHINE

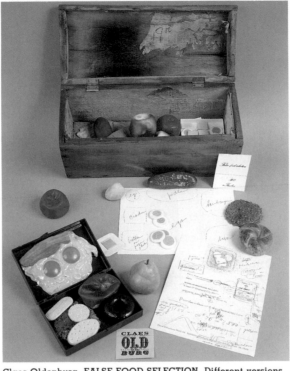

Claes Oldenburg. FALSE FOOD SELECTION. Different versions
and instruction drawings

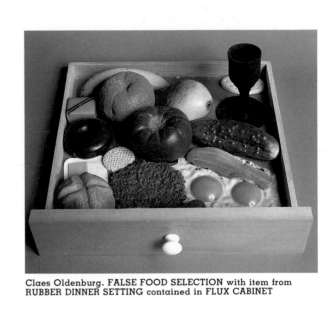

Claes Oldenburg. FALSE FOOD SELECTION with item from
RUBBER DINNER SETTING contained in FLUX CABINET

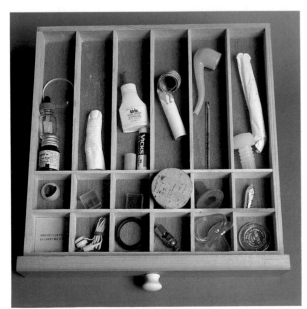

Larry Miller. ORIFICE FLUX PLUGS

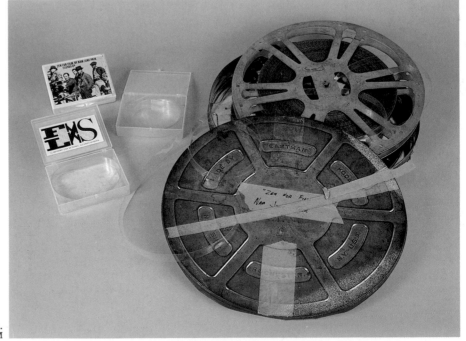

Nam June Paik.
ZEN FOR FILM

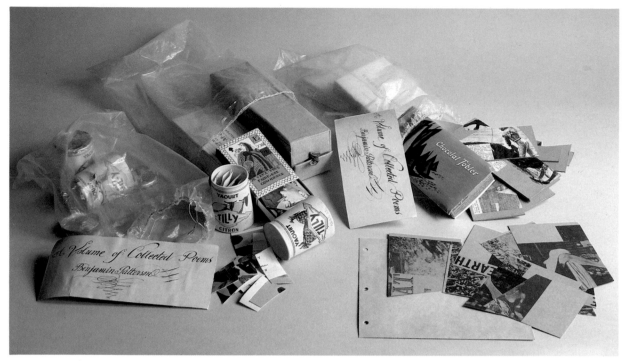

Ben Patterson. POEMS IN BOXES

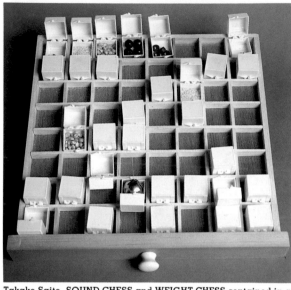

Takako Saito. SOUND CHESS and WEIGHT CHESS contained in a drawer of FLUX CABINET

Takako Saito. GRINDER CHESS

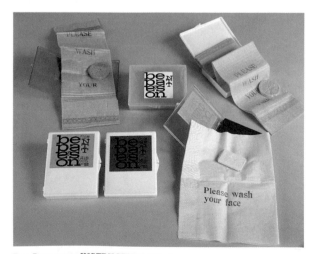

Ben Patterson. INSTRUCTION NO. 2

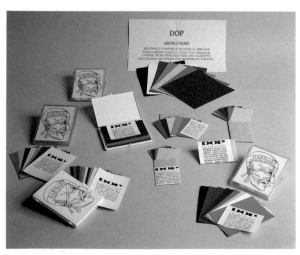

James Riddle. E.S.P. FLUXIT

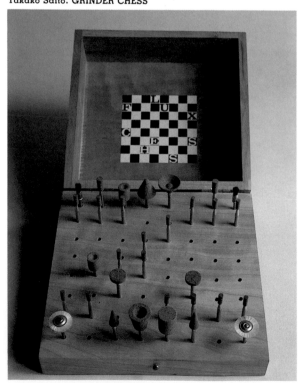

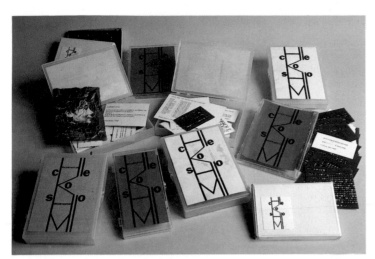

Mieko (Chieko) Shiomi. EVENTS AND GAMES

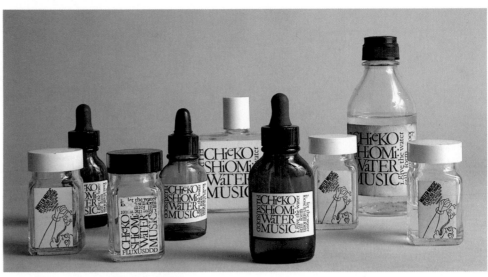

Mieko (Chieko) Shiomi. WATER MUSIC

Ben Vautier. FLUX HOLES. Various Fluxus assemblings with Vautier's original 1964 TROU PORTATIF in the background

Daniel Spoerri and François Dufrêne. L'OPTIQUE MODERNE with
one spectacle from the collection by Daniel Spoerri

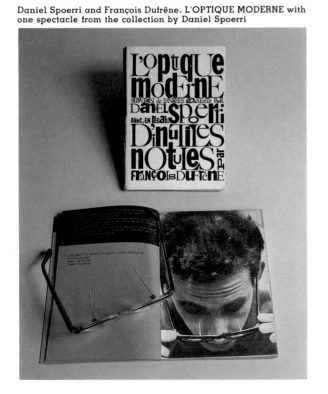

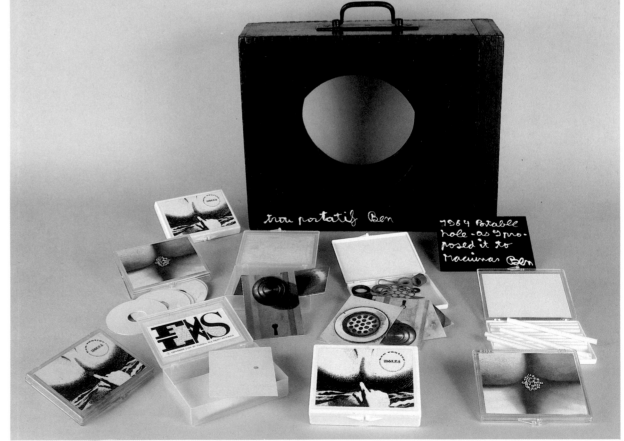

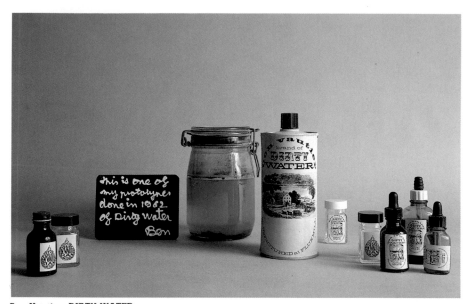

Ben Vautier. DIRTY WATER

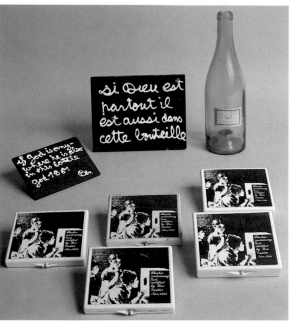

Ben Vautier. FLUXBOX
CONTAINING GOD

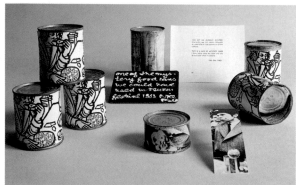

Ben Vautier. FLUX
MYSTERY FOOD

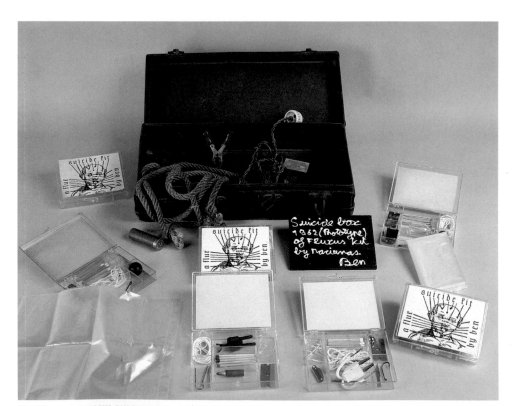

Ben Vautier. A FLUX SUICIDE KIT with Vautier's prototype in the backgound

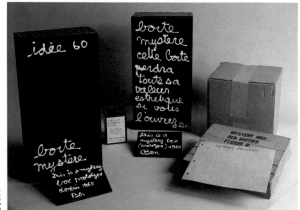

Ben Vautier.
MYSTERY BOX and
MYSTERY ENVELOPE

Robert Watts. COLORED ROCKS

Robert Watts. EGG KIT

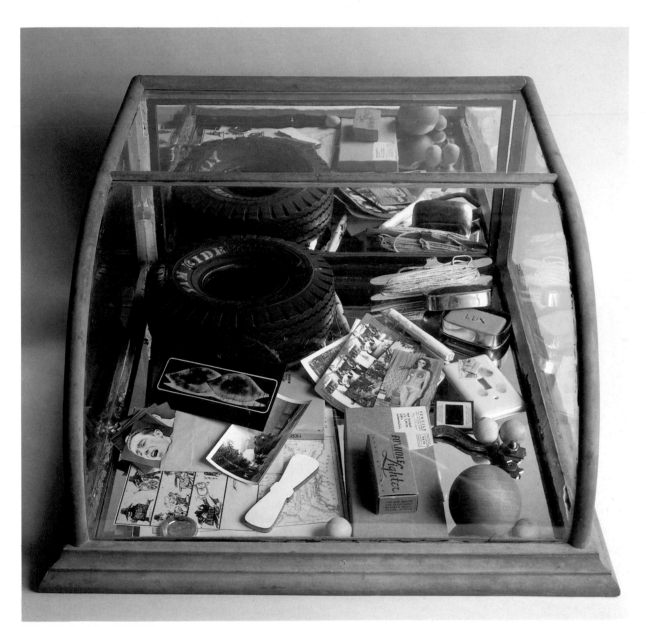

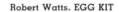

Robert Watts. A TO Z SERIES

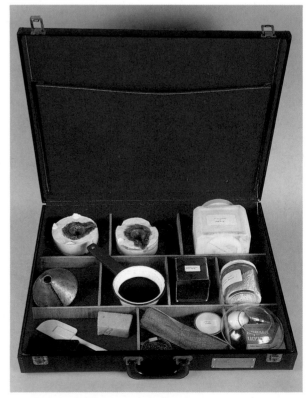

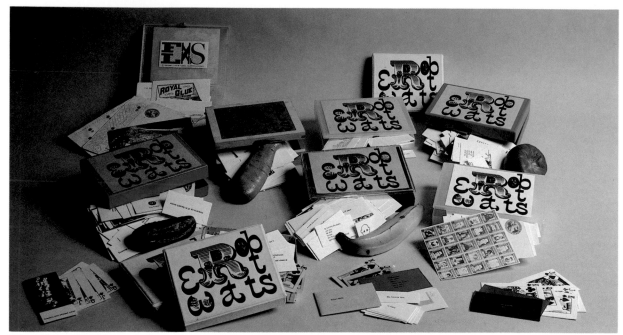

Robert Watts. EVENTS

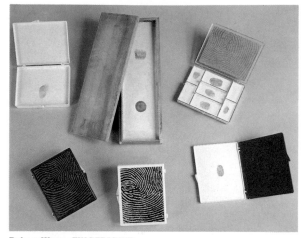

Robert Watts. FINGERPRINT

Robert Watts. FLUX TIMEKIT

Robert Watts. EGG BOX

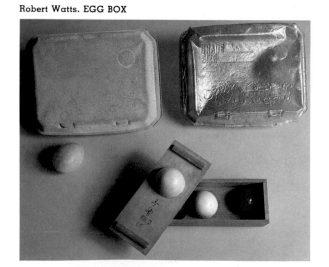

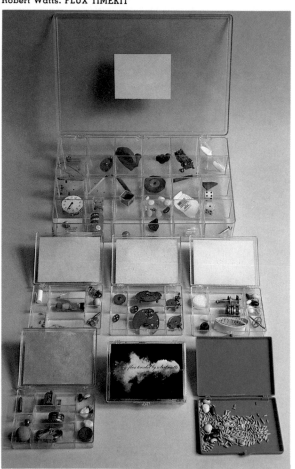

Robert Watts. FLUXSAND HIDE & SEEK

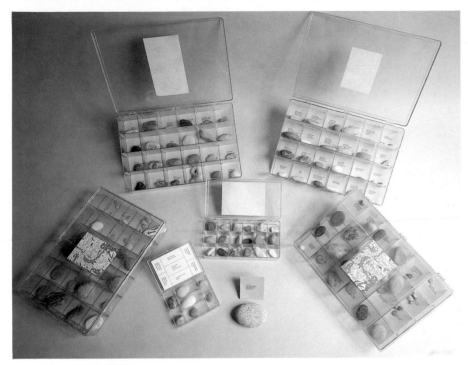

Robert Watts. FLUXATLAS

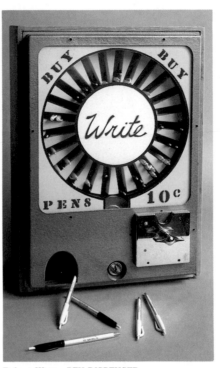

Robert Watts. PEN DISPENSER

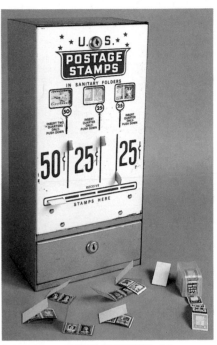

Robert Watts. STAMP DISPENSER. A large version with dispensed Fluxus stamps and a small desktop version

Robert Watts. LIGHT FLUX KIT

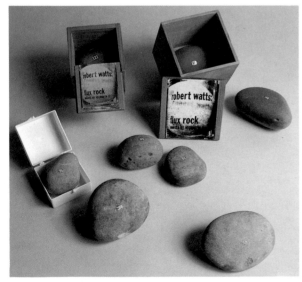

Robert Watts. FLUX ROCKS MARKED BY VOLUME IN CC

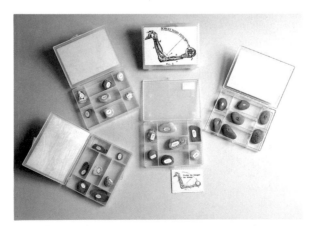

Robert Watts. ROCKS MARKED BY WEIGHT IN GRAMS

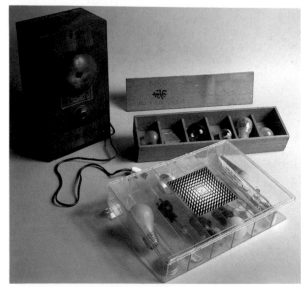

La Monte Young. REMAINS FROM COMPOSITION 1960 NO. 2

Robert Watts. $ BILLS IN WOOD CHEST

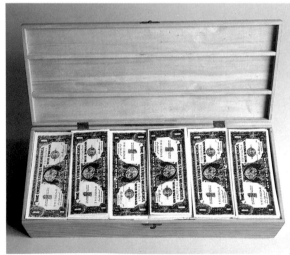

Willem de Ridder. EUROPEAN MAIL-ORDER
WAREHOUSE/FLUXSHOP. Reassembled 1984.
Installation for the exhibition of the Gilbert and Lila
Silverman Fluxus Collection at the Contemporary
Arts Museum, Houston, Texas

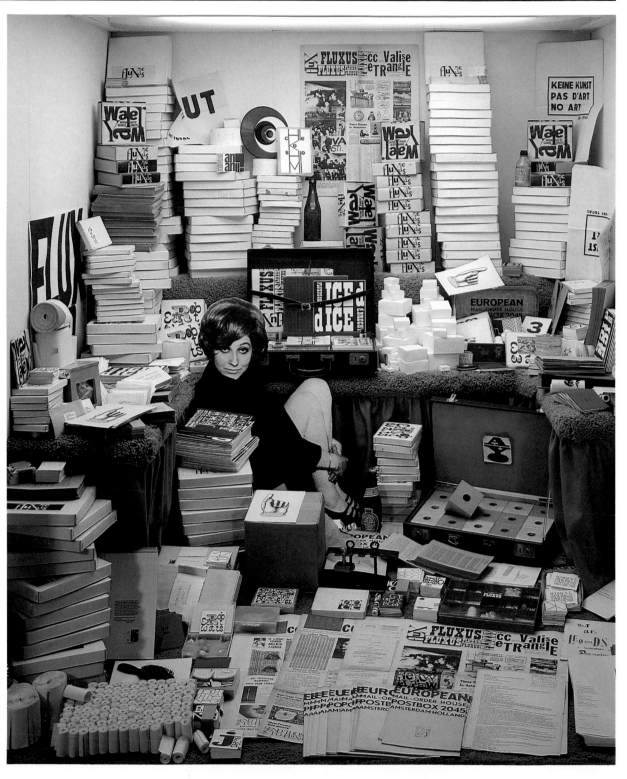

FLUXUS ARTISTS A to Z

A

THEODOR W. ADORNO

It was announced in the tentative plans for the first issues of FLUXUS that T.W.Adorno was being consulted for FLUXUS NO. 2, WEST EUROPEAN YEARBOOK 1, later called GER-MAN & SCANDINAVIAN YEARBOX.
see: COLLECTIVE

MARCEL ALOCCO

EVENTS

FLUX-PROJECTS PLANNED FOR 1967...Marcel Alocco: events in box
Fluxnewsletter, March 8, 1967.

COMMENTS: *This work is not known to have been published by George Maciunas as a Fluxus Edition.*

FLUX ART COLLECTIONS

"Now I can reply to your letter with suggestions for various Flux items. THEY ARE ALL GREAT!!! I will print labels for them all...Flux art collections, by Allocco [sic] ..."
Letter: George Maciunas to Ben Vautier, August 7, 1966.

COMMENTS: *Marcel Alocco was active with the Groupe de Nice. In 1966, Ben Vautier sent a number of ideas by several of the artists active in Nice to George Maciunas for Fluxus Editions. However, this work is not known to have been produced.*

JULIEN ALVARD

It was announced in the tentative plans for the first issues of FLUXUS that Julien Alvard was being consulted for new French art and literature for FLUXUS NO. 5 WEST EUROPEAN YEARBOOK II.
see: COLLECTIVE

ERIC ANDERSEN

[]

ERIC ANDERSEN...
Fluxus v4 ERIC ANDERSEN: $100
Vacuum TRapEzoid (Fluxus Newspaper No. 5) March 1965.

COMMENTS: *It could be presumed that this offering was of Eric Andersen himself, as opposed to an inanimate object. However, it is curious that Ay-O offers Human Body in the same Fluxus newspaper for $500. It isn't known whether anyone ever ordered either of these works.*

Eric Andersen performing, others are not identified. ca. 1964

Eric Andersen. []. ca. 1964

COMPLETE WORKS

4E-1 Complete works of ERIC ANDERSEN (printed in DENMARK) (prices on request)
European Mail-Orderhouse: europeanfluxshop, Pricelist. [ca. June 1964].

4E-1 complete works of ERIC ANDERSEN printed in Denmark $5 & up
Second Pricelist - European Mail-Orderhouse. [Fall 1964].

COMMENTS: *At various times, Eric Andersen mailed out large collections of his works. The contents would vary. Willem de Ridder offered his* Complete Works *through the European Fluxshop in Amsterdam but they were never produced by George Maciunas as a separate Fluxus Edition. An untitled score dated April 1963 by Eric Andersen appears in* FLUXUS PREVIEW REVIEW. *see: COLLECTIVE*

50 OPERA

Silverman No. 1, ff.

FLUXKIT containing following fluxus-publications: (also available separately)...FLUXUSv ERIC ANDERSEN 50 opera, $4
Vacuum TRapEzoid (Fluxus Newspaper No. 5) March 1965.

171

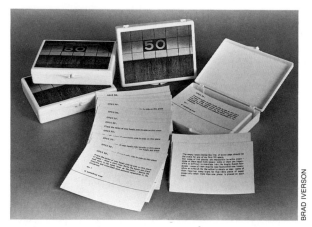

Eric Andersen. 50 OPERA

1965 PUBLICATIONS, AVAILABLE BY OCTOBER ...FLUXUS AA ERIC ANDERSEN 50 opera, boxed $2
ibid.

FLUXKIT containing following fluxus-publications: (also available separately)...FLUXUSv ERIC ANDERSEN: 50 opera, $4
Vaseline sTREet (Fluxus Newspaper No. 8) May 1966.

50 opera $3 by eric andersen
Fluxshopnews. [Spring 1967].

FLUX-PRODUCTS 1961 TO 1969...ERIC ANDERSEN 50 Opera, [$] 4
Fluxnewsletter, December 2, 1968 (revised March 15, 1969).

ERIC ANDERSEN 50 opera, [$] 5
Flux Fest Kit 2. [ca. December 1969].

FLUXUS-EDITIONEN...[Catalogue No.] 723 ERIC ANDERSEN 50 opera
Happening & Fluxus. Koelnischer Kunsverein, 1970.

FLUX-OBJECTS:...05.1966...ERIC ANDERSEN: 50 opera
George Maciunas, Diagram of Historical Developments of Fluxus... [1973].

COMMENTS: *Published by Fluxus in 2 printings, the first, misspelling the word "pultorum" and corrected to "multorum" in the second. Although the plastic box might change the contents and labels of the Fluxus Edition are always identical except as noted.*

FILMS see:
OPUS 49
OPUS 50
OPUS 74 VERSION 2

OPUS 43

4E-5 Opus 43 of Eric Andersen: $100.
Second Pricelist - European Mail-Orderhouse. [Fall 1964].

COMMENTS: *Listed as "6 self-adhesive labels (E.1000 cop.)/ $11" in Eric Andersen's Catalogue No. 11, January 1971. A different work is referred to here. The artist frequently gives the same opus number to different works. It was never published by George Maciunas as a Fluxus Edition.*

OPUS 48

Silverman No. < 1.1, ff.

4E-2 Opus 48 of ERIC ANDERSEN: which gets anonymous when you follow the instruction $5.
Second Pricelist - European Mail-Orderhouse. [Fall 1964].

FLUXUS v1 ERIC ANDERSEN: opus 48 $5
Vacuum TRapEzoid (Fluxus Newspaper No. 5) March 1965.

COMMENTS: *The work consists of a stiff card board with the word "PRESENT" on the lower right front, and a label on the back with the instruction: "Place the chosen tautology" together with a sheet of paper saying "Opus 48...follow the instructions." In the original photograph of the European Mail-Order Warehouse Fluxshop, Willem de Ridder placed a hairbrush on it.*

OPUS 49

4E-3 Opus 49 of ERIC ANDERSEN: film $30.
Second Pricelist - European Mail-Orderhouse. [Fall 1964].

FLUXUS v2 ERIC ANDERSEN: opus 49, film $30
Vacuum TRapEzoid (Fluxus Newspaper No. 5) March 1965.

COMMENTS: *Eric Andersen describes this film as 20 minutes long, dating from 1964. The images are of Andersen performing; trains; and money changing. It was not included in the FLUXFILMS package.*

OPUS 50

4E-4 Opus 50 of ERIC ANDERSEN: film $40.
Second Pricelist - European Mail-Orderhouse. [Fall 1964].

Eric Andersen. OPUS 48

"...Fluxus will publish Andersens 50 opus also..."
Letter: George Maciunas to Willem de Ridder, March 2, 1965.

FLUXUS v3 ERIC ANDERSEN: opus 50, film $40
Vacuum TRapEzoid (Fluxus Newspaper No. 5) March 1965.

COMMENTS: *Eric Andersen describes this film as text and lasting 7 minutes. It was not included in the FLUXFILMS package.*

OPUS 74, VERSION 2

Silverman No. > 2.II

FLUXFILMS SHORT VERSION, 40 MIN AT 24 FRAMES/ SEC. 1400FT....fluxnumber 19 ERIC ANDERSEN OPUS 74, VERSION 2 1'20" single frame exposures, color
Fluxfilms catalogue. [ca. 1966].

FLUXFILM 19 ERIC ANDERSEN: opus 74, 4 sec $5
Vaseline sTREet (Fluxus Newspaper No. 8) May 1966.

opus 74 by Eric Andersen, [component of] Fluxfilms: total package: 1 hr. 40 min.
Fluxnewsletter, March 8, 1967.

FLUX-PRODUCTS 1961 TO 1969...FLUXFILMS, short version Summer 1966 40 min. 1400 ft.:...Opus 74, version 2 -by Eric Andersen;...
Fluxnewsletter, December 2, 1968 (revised March 15, 1969).

Opus 74 by Eric Andersen [component of] FLUXFILMS, short version, Summer 1966. 40 min. 1400 ft.
Flux Fest Kit 2. [ca. December 1969].

SLIDE & FILM FLUXSHOW...ERIC ANDERSEN: OPUS 74, VERSION 2, Single frame exposures, color, 1' 20".
ibid.

FLUXYEARBOX 2, May 1968...19 Film loops by: Eric Andersen,...
ibid.

03.1965...FLUXFILMS: ERIC ANDERSEN: opus 74...
George Maciunas, Diagram of Historical Developments of Fluxus... [1973].

COMMENTS: *Eric Andersen states that the film was originally only 53 frames but later enlarged to 155 frames. The work is a component of both the short and long versions of FLUXFILMS. A loop version is included in Flux Year Box 2 and appears in a Fluxus packaging of film loops.*

PRESENT see:
OPUS 48

UNTITLED

COMMENTS: Eric Andersen describes the work as having been made in July 1965. It consists of 3 plastic boxes, each with a Maciunas designed Eric Andersen monogram card glued to the lid. The first box contains a card with the word "object" on it; the second box, a card with the word "realization" on it; the third contains an object (any object). Copies that Andersen saw always contained a key. Although approximately 5 copies were made, there is apparently no reference to the work in Fluxus publications.

KUNIHARU ARYAMA

It was announced in the tentative plans for the first issues of FLUXUS that Kuniharu Aryama was being consulted for FLUXUS NOS. 3 and 4, JAPANESE YEARBOOK, later called JAPANESE YEARBOX.
see: COLLECTIVE

AY-O

It was announced in the tentative plans for the first issues of FLUXUS that Ay-O or someone to be determined would contribute "sculpture from inside" for FLUXUS NO. 3 JAPANESE ISSUE, later called JAPANESE YEARBOOK and then FLUXUS NO. 4.
see: COLLECTIVE
The concept of "sculpture from inside" is clearly related to Finger Boxes and Tactile Boxes. In FLUXUS 1 Ay-O contributes a work, Put Finger in Hole, which is illustrated with other Finger Boxes. Scores by Ay-O appear in FLUXFEST SALE.

AIR SCULPTURE

FLUXUS qb AYO: air sculpture $100
Vacuum TRapEzoid (Fluxus Newspaper No. 5) March 1965.

FLUXUS qb AYO: air sculpture $100
Vaseline sTREet (Fluxus Newspaper No. 8) May 1966.

flux air sculpture $5...by Ayo
Fluxshopnews. [Spring 1967].

FLUX-PRODUCTS 1961 to 1969...AYO Air sculpture, plastic clear box [$] 5
Fluxnewsletter, December 2, 1968 (revised March 15, 1969).

Ayo...Air sculpture, plastic clear box [$] 5
Flux Fest Kit 2. [ca. December 1969].

FLUX-OBJECTS:...03.1965...AYO: air sculpture
George Maciunas, Diagram of Historical Developments of Fluxus... [1973].

COMMENTS: Because of the price, the earlier listings for Air Sculpture indicate that it either was unique or difficult to make. Once the price changes, it clearly becomes a mass-producible object. Possibly this is the unidentified work repro-

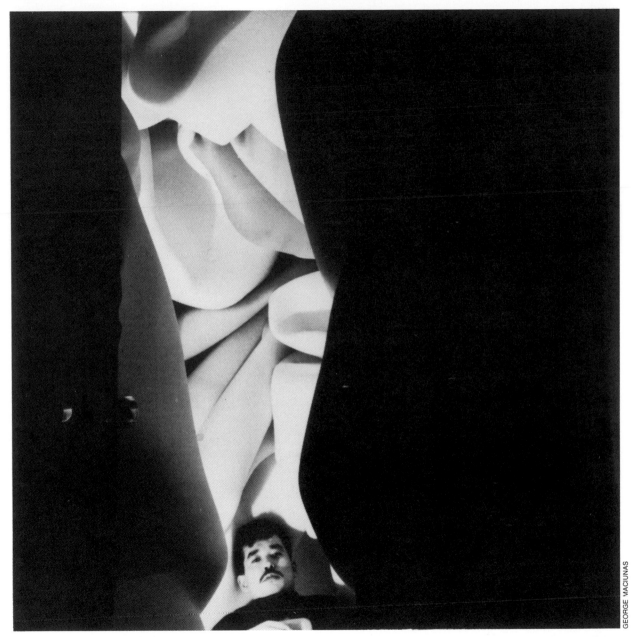

Ay-O, inside his FOAM ROOM. 1963

GEORGE MACIUNAS

duced in Fluxus etc. Addenda II, pp. 10-11 and listed in this book under Anonymous Box With No Label.

ATTACHE CASE see:
FINGER BOX
Ay-O KIT see:
FINGER BOX

BALLOON OBSTACLE

Ay-O...EXIT NO. 8 Vestibule floor covered with inflatable balloons bursting on contact.
Fluxfest Sale. [Winter 1966].

PROPOSED FLUXSHOW...VESTIBULE VARIATIONS, by Ayo Portions of vestibule, stair or main

George Maciunas carrying a balloon to be installed in Ay-O's BALLOON OBSTACLE. FLUXLABYRINTH. Berlin, 1976

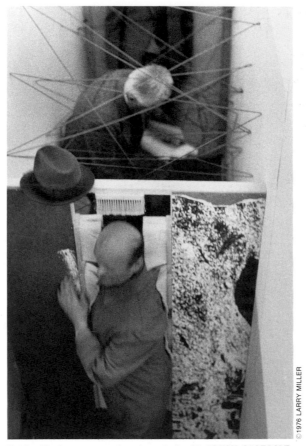

Unidentified man squeezing through Ay-O's BRUSH OBSTACLE. FLUXLABYRINTH. Berlin, 1976

Ay-O. BRUSH TOILET SEAT. Installed in the FLUX TOILET during the Fluxfest at and/or, Seattle, 1977

gallery space prepared as follows:...floor covered with balloons that burst upon contact...
Fluxnewsletter, December 2, 1968 (revised March 15, 1969)

"Balloon Room - needed: Balloons by quantity and inflation method. Today an assistant should locate this and price. We must figure volume. Balloons should be various colors & sizes. Plastic doors (2 polyurethane sheets) I have & wire for above."
Notes: Larry Miller to George Maciunas concerning the Fluxlabyrinth, Berlin. [ca. August 1976].

slit rubber gates containing a room full of balloons.
Plan of completed Fluxlabyrinth, Berlin. [ca. September 1976].

COMMENTS: Balloon Obstacle, *an element of an environment, was realized in the Berlin* Flux Labyrinth. *It was first done in Ay-O's* Rainbow Staircase *environment, November 20, 1965 in New York City.*

BLOCKS see:
WOOD BLOCK OBSTACLE

BRUSH OBSTACLE

Ayo..."2 brooms facing each other"
Instruction drawing for Fluxlabyrinth, Berlin. [ca. August 1976]. version A

"I have brush example available - it is very good - soft again I only located until we alot budget. This would cost about 80-90 MARKS."
Notes: Larry Miller to George Maciunas concerning the Fluxlabyrinth, Berlin. [ca. August 1976].

COMMENTS: As well as making the work for the Fluxlabyrinth in Berlin, George Maciunas used Ay-O's idea of brushes in a cabinet built for Sean Ono Lennon's room in 1977, now in the Silverman collection. See also Brush Toilet Seat which is a variation of the idea.

BRUSH TOILET SEAT

PROPOSED FLUXSHOW...TOILET OBJECTS...

toilet seat variations:...brush mat...
Fluxnewsletter, December 2, 1968 (revised March 15, 1969).

TOILET OBJECTS & ENVIRONMENT...Toilet seat variations:...brush mat...
Flux Fest Kit 2. [ca. December 1969].

Toilet No. 5 Ayo...Toilet seat...stiff brush bristles facing upward.
Fluxnewsletter, April 1973.

1970-1971...FLUX-TOILET...AYO: brush seat...
George Maciunas, Diagram of Historical Developments of Fluxus... [1973].

COMMENTS: This work was realized in the Flux Toilet during the Fluxfest at and/or, Seattle, 1977.

CUBE RUBBER BALL

"...Other going projects:...Ayo...Cube rubber 'ball'..."

Letter: George Maciunas to Ken Friedman, [ca. February 1967].

FLUXPROJECTS FOR 1969...Ayo: rubber cube (for...cube ball)
Fluxnewsletter, December 2, 1968.

COMMENTS: *The work is not known to have been made. In 1977 George Maciunas planned to make large foam cubes and balls for Sean Ono Lennon's play room.*

FILM see:
RAINBOW MOVIE

FINGER BOX
Silverman Nos. 11; 12; 13; 14; 15 ff.; 16 ff.

FLUXUS qq Ayo: FINGER BOX $1.98
cc Valise e TRanglE (Fluxus Newspaper No. 3) March 1964.

AYO'S FINGER BOX. This box, 50 special copies: $1.98 each
Advertisement on Ay-O's Finger Box. [ca. March 1964].

FLUXKIT containing following fluxus-publications: (also available separately)...FLUXUS qq AYO: FINGER BOX, each different, in wood box, $6
cc fiVe ThReE (Fluxus Newspaper No. 4) June 1964.

FLUXUS qqq AYO: finger box SUITCASE with 16 different wood finger boxes $100
ibid.

F-qq AYO: Finger box $1.98
European Mail-Orderhouse: europeanfluxshop, Pricelist. [ca. June 1964].

F-q AYO...finger box $2.
Second Pricelist - European Mail-Orderhouse. [Fall 1964].

Ay-O. FINGER BOX. A selection of Fluxus Editions showing the range of interpretations of the work. In the left foreground, an advertisement for FINGER BOX, and center right, a prototype made by the artist. see color portfolio

BRAD IVERSON

Ay-O's FINGER BOX from the collective work, FLUX CABINET

F-q AYO...fingerbox suitcase (16 boxes) $100
ibid.

FLUXKIT containing following flux-publications:...
Finger Box of Ay-O (in wood box)...
ibid.

"Replies to your questions...Ayo-kit costs me $100 so I can send another only if I get $100. You could sell in future Ayo kits for $120 so you keep $20 for commission...I will mail you a sample...with...one Ayo kit...Please send me money...$100 for Ayo kit OK?..."
Letter: George Maciunas to Willem de Ridder, March 2, 1965.

FLUXKIT containing...FLUXUS qq AYO: finger box, $6
Vacuum TRapEzoid (Fluxus Newspaper No. 5) March 1965.

FLUXUS qqq AYO: finger box SUITCASE with 16 different wood finger boxes $120
ibid.

Fluxus 1 items of the type that may be included [in Fluxus 2] are:...Ay-O finger envelope....
[Fluxus Newsletter], unnumbered, [ca. March 1965].

FLUXKIT containing...FLUXUS qq AYO: finger box $6
Vaseline sTREet (Fluxus Newspaper No. 8) May 1966.

FLUXUS qqq AYO: suitcase with 16 fingerboxes $120
ibid.

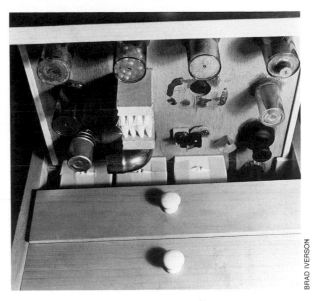

BRAD IVERSON

The work as seen from underneath

"Other going projects:...AyO- finger-boxes-(mass produced version)..."
Letter: George Maciunas to Ken Friedman, [ca. February 1967].

FLUX-PROJECTS PLANNED FOR 1967...Ayo: mass produced finger boxes (hollow rubber cubes in various rainbow colors.)...
Fluxnewsletter, March 8, 1967.

finger hole $7 by ayo
Fluxshopnews. [Spring 1967].

FLUXPROJECTS FOR 1969...Ayo: rubber cube (for finger boxes...)
Fluxnewsletter, December 2, 1968.

FLUX-PRODUCTS 1961 TO 1969...AYO...Finger tactile box, wood 3x3x3'' [$] 8 [also included as part of FLUXKIT]...Finger box set of 16, in attache case, [$] 200
Fluxnewsletter, December 2, 1968 (revised March 15, 1969).

AYO...Finger tactile box, wood, 3'' cube [$] 8... Finger box set of 16, in attache case, [$] 200
Flux Fest Kit 2. [ca. December 1969].

FLUX SHOW: DICE GAME ENVIRONMENT... Ayo's finger box kit...
ibid.

FLUXUS-EDITIONEN... [Catalogue No.] 720 AYO: finger tactile box (karton)
Happening & Fluxus. Koelnischer Kunstverein, 1970.

FLUXUS-EDITIONEN...[Catalogue No.] 721 AYO:
...finger box set of 16 (koffer)
ibid.

FLUX-TOILET:...Toilet No. 5, Ayo...Doors - display on interior side of door...Finger holes*
Fluxnewsletter, April 1973.

[part of Maciunas' Fluxtoilet] Toilet no. 5 Ayo...
Doors - display on interior side of door...Finger holes*
ibid.

FLUX-OBJECTS:...02.1964 AYO:...tactile...finger boxes
George Maciunas, Diagram of Historical Developments of Fluxus... [1973].

AYO 16 tactile finger holes, 12" x 12" $300
Flux Objects, Price List. May 1976.

COMMENTS: *There are numerous variations of this Fluxus Edition - each with the element of mystery, danger, and seduction. The work appears in* FLUXUS 1 *as an envelope with a slit in it, sometimes containing a nylon stocking; in Fluxkits as a numbered edition containing foam rubber; in groups of 15 in attache cases - each box with different contents; in display models and in the Flux Cabinet with some electrically activated elements.*

FINGER ENVELOPE see:
FINGER BOX
FINGER HOLE see:
FINGER BOX
FINGER TACTILE BOX see:
FINGER BOX

FLIP BOOK

...FLUXPACK 3, with the following preliminary contents:...flipbooks by Ayo...
Fluxnewsletter, April 1973.

COMMENTS: *This work is not contained in* FLUXPACK 3. *If the flipbook was to have been made from a film, it would be of* Rainbow Movie, *however there is no evidence that the project got started.*

FLUXLABYRINTH see:
BALLOON OBSTACLE
BRUSH OBSTACLE
TACTILE ENTRANCE
WEB OBSTACLE

FLUX RAIN MACHINE
Silverman No. 18

FLUXUS qp AYO: rain machine, 4 variants, $50,

$100, $150 & $200
Vacuum TRapEzoid (Fluxus Newspaper No. 5) March 1965.

[as above]
Vaseline sTREet (Fluxus Newspaper No. 8) May 1966.

FLUX-PROJECTS PLANNED FOR 1967...Ayo...rain making machine...
Fluxnewsletter, March 8, 1967.

FLUX-PRODUCTS 1961 TO 1969...AYO...Rain machine, 4 variations [$] 50 to 200
Fluxnewsletter, December 2, 1968 (revised March 15, 1969).

FLUX SHOW: DICE GAME ENVIRONMENT...Ayo's rain machines.
Flux Fest Kit 2. [ca. December 1969].

Rain machine, 4 variations [$] 50 to 200
ibid.

FLUXFEST PRESENTATION OF JOHN LENNON & YOKO ONO...MAY 30 - JUNE 5: THE STORE BY JOHN & YOKO + FLUXFACTORY Coin operated vending machines:...rain machine (Ayo)
Schedule of events for Fluxfest presentation of John Lennon and Yoko Ono. [ca. April 1970]. version B

FLUXFEST PRESENTS YOKO ONO...MAY 30 - JUNE 5: THE STORE BY YOKO + FLUXFACTORY ...rain machine (Ayo).
Schedule of events for Fluxfest presentation of John Lennon and Yoko Ono. April 1, 1970. version C

FLUXUS-EDITIONEN...[Catalogue No.] 722 AYO:

Ay-O. **FLUX RAIN MACHINE.** Mechanical by George Maciunas for the label

Ay-O. FLUX RAIN MACHINE. In this Fluxus Edition, water sealed inside the plastic box condenses to form droplets

rain machine
Happening & Fluxus. Koelnischer Kunstverein, 1970.

03.1965...AYO: rain machine...
George Maciunas, Diagram of Historical Developments of Fluxus... [1973].

COMMENTS: *The Fluxus Edition as it was eventually produced by Maciunas (Silverman No. 18) is clearly different from those advertised at $50 to $200. These would have been special order works.*

FLUX TOILET see:
 BRUSH TOILET SEAT
 FINGER BOX
 MEDICINE CABINET
 RAINBOW TOILET PAPER
 SUDS IN TOILET BOWL
FOOD see:
 RAINBOW NOODLES
FOOTSTEPS IN WATER see:
 PROTRUDING NAILS FLOOR
HAND TACTILE BOX see:
 TACTILE BOX

HUMAN BODY

FLUXUS qdp AYO: human body $500
Vacuum TRapEzoid (Fluxus Newspaper No. 5) March 1965.

FLUXUS qdp AYO: tactile human body $500
Vaseline sTREet (Fluxus Newspaper No. 8) May 1966.

COMMENTS: *This is the type of work which would be produced as a "special order." There is no evidence that one was ever made.*

MATTRESS OBSTACLE see:
 TACTILE ENTRANCE

MEDICINE CABINET

Toilet No. 5 Ayo...Medicine cabinet...Vending machine-dispensing Relics - holy shit, by Geoff Hendricks
Fluxnewsletter, April 1973.

COMMENTS: *This work seems only to serve as a display case for Geoffrey Hendricks'* Flux Relics Dispenser.

MIRROR FLOOR

...Individuals in Europe, the U.S. and Japan have discovered each other's work and...events which are original, and often uncategorizable in a strange new way: ... Ayo's EXIT EVENTS: the audience leaves the performance room through a narrow hall, over a large mirror on the floor...
George Brecht, "Something About Fluxus," cc fiVe ThReE (Fluxus Newspaper No. 4) June 1964.

Ay-O...EXIT NO. 4 Vestibule floor covered with mirrors.
Fluxfest Sale. [Winter 1966].

PROPOSED FLUXSHOW...VESTIBULE VARIATIONS, by Ayo Portions of vestibule, stair or main gallery space prepared as follows:...mirror floor, photo-mural floor, etc. etc.
Fluxnewsletter, December 2, 1968 (revised March 15, 1969).

FLUX SHOW: DICE GAME ENVIRONMENT ... SOME FLOOR COMPARTMENTS WITH:...variations by Ayo:...mirror floor...
Flux Fest Kit 2. [ca. December 1969].

...This Fall, we shall publish V TRE no. 10, which shall consist of a plan for Flux-Amusement-Center, to contain...Ayo's floor obstacles...mirror...
Fluxnewsletter, April 1973.

COMMENTS: *This is really two works with similar consequences. See also Peter Moore's photo mural pieces.*

MYSTERY BOX see:
 TACTILE BOX

OBSTACLES see:
 BALLOON OBSTACLE
 MIRROR FLOOR
 PROTRUDING NAILS FLOOR
 TRAPDOOR OBSTACLE
 TUNNEL OBSTACLE
 WATER OBSTACLE
 WEB OBSTACLE
 WOOD BLOCK OBSTACLE
PHOTO-MURAL FLOOR see:
 MIRROR FLOOR
PIVOT IN CENTER DOOR see:
 Anonymous

PROTRUDING NAILS FLOOR

... Individuals in Europe, the U.S. and Japan have discovered each other's work and...events which are original and often uncategorizable in a strange new way:...Ayo's EXIT EVENTS: the audience leaves the performance room through a narrow hall,...over a bed of upward-pointed nails, with foot-sized gaps in the bed, ...
George Brecht, "Something About Fluxus," cc fiVe ThReE (Fluxus Newspaper No. 4) June 1964.

Ay-O...EXIT NO. 1 Audience passes vestibule that has been covered with upwardly protruding nails, except for a few areas in the shape of footprints.
Fluxfest Sale. [Winter 1966].

PROPOSED FLUXSHOW FOR GALLERY 669 ... VESTIBULE VARIATIONS, by Ayo Portions of vestibule filled with...floor portion covered with upwardly protruding nails, except for a few areas in the shape of footprints...These floor variations can also be set up in the main gallery space if no vestibule is available.
Fluxnewsletter, December 2, 1968.

PROPOSED FLUXSHOW...VESTIBULE VARIATIONS, by Ayo Portions of vestibule, stair or main gallery space prepared as follows:...floor covered with upwardly protruding nails, except for a few foot-shape areas....
Fluxnewsletter, December 2, 1968 (revised March 15, 1969).

FLUX SHOW: DICE GAME ENVIRONMENT ... SOME FLOOR COMPARTMENTS WITH...variations by Ayo:...floor with upwardly protruding nails...
Flux Fest Kit 2. [ca. December 1969].

...This Fall, we shall publish V TRE no. 10, which shall consist of a plan for Flux-Amusement-Center, to contain...Ayo's floor obstacles...upright nails...
Fluxnewsletter, April 1973.

COMMENTS: *In some ways this is an extension of the danger element of Ay-O's* Finger Boxes *some of which contain protruding nails.*

RAIN MACHINE *see:*
FLUX RAIN MACHINE

RAINBOW MOVIE

SLIDE & FILM FLUXSHOW...AYO: RAINBOW MOVIE, 1969-1970 Smooth transition through chromatic color scale: yellow to orange to red to violet to blue to turquoise to green to yellow.
Flux Fest Kit 2. [ca. December 1969].

DETAILS OF FLUXFEST PRESENTATION OF JOHN LENNON & YOKO ONO...MAY 16-22: CAPSULE BY JOHN & YOKO + FLUX SPACE CENTER A 3ft cube enclosure (capsule) having various film loops projected on its walls, ceiling and floor to a single viewer inside, total time: 6 min....transition through color scale
Schedule of events for Fluxfest presentation of John Lennon and Yoko Ono. [ca. April 1970]. version A

MAY 16-22: CAPSULE BY JOHN & YOKO + FLUX SPACE CENTER ($1 ADMISSION CHARGE)...about 8 minutes. [including] transition through color scale (Ayo, 1969);
Schedule of events for Fluxfest presentation of John Lennon and Yoko Ono. [ca. April 1970]. version B

MAY 16-22 CAPSULE BY YOKO + FLUX SPACE CENTER...[including] transition through chromatic color scale (Ayo)
Schedule of events for Fluxfest presentation of John Lennon and Yoko Ono. April 1, 1970. version C

FLUXFEST PRESENTATION OF JOHN LENNON & YOKO ONO +* AT 80 WOOSTER ST. NEW YORK --1970...MAY 16-22: CAPSULE BY JOHN & YOKO + FLUX SPACE CENTER A 6 x 6 ft. enclosure having various films projected on its walls to a single viewer inside...transition through color scale (Ayo '69)...
all photographs copyright nineteen seVenty by peTer mooRE (Fluxus Newspaper No.9) 1970.

11.04-29.05.1970 FLUXFEST OF JOHN LENNON & YOKO ONO...16-22.05: FILM ENVIRONMENT 4 wall projection of...rainbow colors, etc. by...ayo, etc.
George Maciunas, Diagram of Historical Developments of Fluxus... [1973].

COMMENTS: *I believe this work exists, although I have never seen it.* Flip Book *could have been made using a similar technique with color papers.*

RAINBOW NOODLES

31.12.1968 NEW YEAR EVE'S FLUX-FEAST (FOOD EVENT)...Ayo: rainbow noodles...
George Maciunas, Diagram of Historical Developments of Fluxus... [1973].

COMMENTS: *Ay-O is a great cook. I remember his preparation of oyster mushrooms in New Marlborough during a Fluxfeast of potatoes and apples.*

RAINBOW TOILET PAPER

Toilet No. 5 Ayo...Toilet paper...Rainbow colors...
Fluxnewsletter, April 1973.

COMMENTS: *The idea might be an adaptation by George Maciunas of Ay-O's preoccupation with rainbows. The work is not known to have been realized.*

ROPE WEB *see:*
WEB OBSTACLE
RUBBER CUBE *see:*
FINGER BOX
RUBBER FOREST *see:*
WEB OBSTACLE

SUDS IN TOILET BOWL

Toilet No. 5 Ayo...Toilet flushing...detergent suds in tank, when flushed foam comes out the bowl.
Fluxnewsletter, April 1973.

Toilet No. 5 Ayo...Toilet bowl display...foam - *ibid.*

1970-1971...FLUX-TOILET...AYO...suds in tank...
George Maciunas, Diagram of Historical Developments of Fluxus... [1973].

COMMENTS: *Detergent dispensed in the tank would make messy suds in the toilet bowl when flushed. This is a variation of the idea of* Sudsey Foam Floor.

SUDSEY FOAM FLOOR

Ay-O...EXIT NO. 3 Vestibule floor covered with foam rubber inpregnated with soap suds.
Fluxfest Sale. [Winter 1966].

PROPOSED FLUXSHOW FOR GALLERY 669 ... VESTIBULE VARIATIONS, by Ayo Portions of vestibule filled with...floor covered with foam rubber impregnated with soap suds...These floor variations can also be set up in the main gallery space if no vestibule is available.
Fluxnewsletter, December 2, 1968.

PROPOSED FLUXSHOW...VESTIBULE VARIA-

TIONS, by Ayo Portions of vestibule, stair or main gallery space prepared as follows:...floor covered with foam rubber impregnated with detergent suds...
Fluxnewsletter, December 2, 1968 (revised March 15, 1969).

FLUX SHOW: DICE GAME ENVIRONMENT ... SOME FLOOR COMPARTMENTS WITH:...Floor variations by Ayo:...foam rubber carpet impregnated with suds....
Flux Fest Kit 2. [ca. December 1969].

...This Fall, we shall publish V TRE no. 10, which shall consist of a plan for Flux-Amusement-Center, to contain...Ayo's floor obstacles...foam...
Fluxnewsletter, April 1973.

COMMENTS: *This work is not known to have been realized.*

SUITCASE *see:*
FINGER BOX

Ay-O. TACTILE BOX

TACTILE BOX
Silverman Nos. 6 ff.

FLUXUS 1963 EDITIONS, AVAILABLE NOW FROM FLUXUS P.O. Box 180, New York 10013, N.Y. or FLUXUS 359 Canal St. New York. CO7-9198 ...FLUXUSq AYO: ''Tactile box'' (100 variants) ea: $20...
Film Culture No. 30, Fall 1963.

''The new publications will be...Tactile Mystery box by Ayo - $20.''
Letter: George Maciunas to Philip Kaplan, November 19, 1963.

BRAD IVERSON

"In reply to your card & inquiry of Nov. 22nd. the Fluxus boxes can be seen at 359 Canal St. 2nd floor...Boxes to be seen:...Ayo - 'tactile box' each different - 100 variations each $20"
Letter: George Maciunas to Philip Kaplan, November 27, 1963.

FLUXUS 1963 EDITIONS, AVAILABLE NOW ... FLUXUS q AYO: "Tactile box" (100 variants) ea. $20...Most materials originally intended for Fluxus yearboxes will be included in the FLUXUSccV TRE newspaper or in individual boxes.
cc V TRE (Fluxus Newspaper No. 1) January 1964.

FLUXUS q AYO: "Tactile box" (100 variants) ea. $20
cc V TRE (Fluxus Newspaper No. 2) February 1964.

FLUXUS q AYO: Tactile box (100 variants) $20
cc Valise e TRanglE (Fluxus Newspaper No. 3) March 1964.

AYO'S TACTILE BOX size 1 x 1 x 1 feet, 100 variants $20 each
Advertisement on Ay-O's Finger Box. [ca. March 1964].

F-q AYO: Tactile box (100 variants) $20
European Mail-Orderhouse: europeanfluxshop, Pricelist. [ca. June 1964].

[as above]
Second Pricelist - European Mail-Orderhouse. [Fall 1964].

FLUXUS q AYO hand tactile box $20
Vacuum TRapEzoid (Fluxus Newspaper No. 5) March 1965.

[as above]
Vaseline sTREet (Fluxus Newspaper No. 8) May 1966.

FLUX-PRODUCTS 1961 TO 1969...AYO Hand tactile box, cardboard 12"x12"x12", [$] 20
Fluxnewsletter, December 2, 1968 (revised March 15, 1969).

AYO Hand tactile box, cardboard 12" cube $20
Flux Fest Kit 2. [ca. December 1969].

"...Ayo hand tactile box, I still have, but it is too large for mailing by post..."
Letter: George Maciunas to Dr. Hanns Sohm, [ca. late 1972].

02.1964 Ayo: tactile hand...boxes
George Maciunas, Diagram of Historical Developments of Fluxus... [1973].

Ayo: tactile objects and environment
Proposal for Flux Fest at New Marlborough. April 8, 1977.

COMMENTS: *The code published in* Notations, *edited by John Cage, seems to correspond to the code on early examples of the Fluxus Editions of* Tactile Box *and indicates contents.* Tactile Boxes, Finger Boxes *and* Tactile Entrance *are all variations of a single concept.*

Unidentified man entering Ay-O's WEB OBSTACLE through TACTILE ENTRANCE. FLUXLABYRINTH. Berlin, 1976
©1976 LARRY MILLER

TACTILE ENTRANCE

Any proposals from participants should fit the maze format...Ideas should relate to passage through doors, steps, floor, obstacles, booths...wet paint on walls...
George Maciunas, Further Proposal for Flux-Maze at Rene Block Gallery. [ca. Fall 1974].

"Enclosed is the final plan of labyrinth...The next obstacle would be two mattresses or foam rubber sheets bent as shown touching each other, but soft enough to permit one to squeeze between them. But since foam is a very non-slippery material, they should be covered with slippery fabric or vinyl or other plastic film. These covers could be painted with white wash (liquid chalk) which would smear all people passing between the mattresses."
Letter: George Maciunas to Rene Block, [ca. Summer 1976].

Ayo section starts with...followed by mattress like

foam bent into U shape, soft enough to permit passage. To facilitate it the foam should be covered with slippery vinyl film or cloth...whitewashed. covered with film
Instruction drawing for Fluxlabyrinth, Berlin. [ca. August 1976]. version A

...This I have bought: 2 soft foam pieces of pink color. I thought Ayo would like pink as a vagina-like birth experience. Also I have ordered 2 kilos of foam scraps at 20 marks only to stuff inside. It may be sufficient as is without poly-urethane and white wash. We can introduce white wash else where.
Notes: Larry Miller to George Maciunas concerning the Fluxlabyrinth, Berlin. [ca. August 1976].

COMMENTS: *This is an extension of the idea of* Tactile Boxes, *except here the whole body is thrust through the opening.*

TACTILE FINGER BOX see:
 FINGER BOX
TACTILE HUMAN BODY see:
 HUMAN BODY

30 DEGREE SLOPE

Ay-O... EXIT NO. 7 Vestibule floor sloped upward and downward about 30°.
Fluxfest Sale. [Winter 1966].

PROPOSED FLUXSHOW FOR GALLERY 669 ... VESTIBULE VARIATIONS, by Ayo...Portions of vestibule filled with...floor portion sloped upward and downward 30°...These floor variations can also be set up in the main gallery space if no vestibule is available.
Fluxnewsletter, December 2, 1968.

PROPOSED FLUXSHOW ... VESTIBULE VARIATIONS, by Ayo Portions of vestibule, stair or main gallery space prepared as follows:...floor sloping upward or downward 30°..
Fluxnewsletter, December 2, 1968 (revised March 15, 1969).

...This Fall, we shall publish V TRE no. 10, which shall consist of a plan for Flux-Amusement-Center, to contain ... Ayo's floor obstacles ... steep slopes...
Fluxnewsletter, April 1973.

COMMENTS: *Ay-O built* Rainbow Staircase *Environment at 363 Canal St. in November 1965. Situated in the staircase of a loft building, there were precursors to* Balloon Obstacle, Web Obstacle *and* Tactile Doors *in addition to 30°Slope. This installation and Yoko Ono's* Maze *of 1970 lead to the ideas for the* Flux-Maze *and* Flux Labyrinth *in 1975/76. See the* Collective *section.*

TRAPDOOR OBSTACLE

...This Fall, we shall publish V TRE no. 10, which shall consist of a plan for Flux-Amusement-Center, to contain...Ayo's floor obstacles...trapdoors...
Fluxnewsletter, April 1973.

COMMENTS: *In the mid 1970s George Maciunas built* Trick Ceiling Hatch, *a trap door, as part of his* Flux Combat with New York State Attorney General (& Police).

TUNNEL OBSTACLE

Ay-O...EXIT NO. 6 Vestibule ceiling lowered to a height of 2 feet from the floor.
Fluxfest Sale. [Winter 1966].

...This Fall, we shall publish V TRE no. 10, which shall consist of a plan for Flux-Amusement-Center, to contain...Ayo's floor obstacles...tunnel...
Fluxnewsletter, April 1973.

COMMENTS: *Larry Miller built a* Tunnel Obstacle *for the* Flux Labyrinth *in Berlin. A* Tunnel Obstacle *was also included in Ay-O's* Rainbow Staircase *Environment in New York City, November 20, 1965.*

UPWARDLY PROTRUDING NAILS see:
PROTRUDING NAILS FLOOR
VENDING MACHINE see:
FLUX RAIN MACHINE
VESTIBULE VARIATIONS see:
BALLOON OBSTACLE
MIRROR FLOOR
PROTRUDING NAILS FLOOR
SUDSEY FOAM FLOOR
30 DEGREE SLOPE
WOOD BLOCKS OBSTACLE

WATER OBSTACLE

...This Fall, we shall publish V TRE no. 10, which shall consist of a plan for Flux-Amusement-Center, to contain...Ayo's floor obstacles...water...
Fluxnewsletter, April 1973.

COMMENTS: *Water is an important element in Fluxus performance and several Fluxus objects. For example: Ben Vautier's* Dirty Water, *Chieko Shiomi's* Water Music, *Ay-O's* Flux Rain Machine, *Carla Liss'* Sacrament Fluxkit *etc.*

WEB OBSTACLE

...Individuals in Europe, the U.S. and Japan have discovered each other's work and...events which are original, and often uncategorizable in a strange new way...Ayo's EXIT EVENTS: the audience leaves the performance room through a narrow hall,...through rows of taut, knee-high strings.
George Brecht, "Something About Fluxus," cc fiVe ThReE [Fluxus Newspaper No. 4] June 1964.

Ay-O...EXIT NO. 2 Vestibule filled with stretched rope at knee height.
Fluxfest Sale. [Winter 1966].

PROPOSED FLUXSHOW FOR GALLERY 669 ... VESTIBULE VARIATIONS, by Ayo Portions of vestibule filled with stretched rope at knee height ... These floor variations can also be set up in the main gallery space if no vestibule is available.
Fluxnewsletter, December 2, 1968.

PROPOSED FLUXSHOW...VESTIBULE VARIATIONS, by Ayo Portions of vestibule, stair or main gallery space prepared as follows:...stretched rope at knee height...
Fluxnewsletter, December 2, 1968 (revised March 15, 1969).

Participants entangled in Ay-O's WEB OBSTACLE. FLUXLABYRINTH. Berlin. 1976

©1976 LARRY MILLER

FLUX SHOW: DICE GAME ENVIRONMENT ... SOME FLOOR COMPARTMENTS WITH...variations by Ayo:...floor with raised rope web, etc.
Flux Fest Kit 2. [ca. December 1969].

Any proposals from participants should fit the maze format...Ideas should relate to passage through doors, steps, floor, obstacles, booths...knee high strings... vertical rubber string, footsteps in water...
George Maciunas, Further Proposal for Flux-Maze at Rene Block Gallery. [ca. Fall 1974].

"Enclosed is the final plan of labyrinth...Ayo's section which would start with a vertical forest of thick rubber bands (rods) You will have to experiment to find best thickness. My guess would be about 5mm round, bought in a drum as a continuous rubber rod. It could be 'woven' between a perforated floor and ceiling panel without ever cutting it...Next would come a 'horizontal' rubber band forest, which would be constructed same way as vertical, except the perforated panels would be at both facing walls."
Letter: George Maciunas to Rene Block, [ca. Summer 1976].

Ayo section starts with a forest of vertical rubber bands, rods...mixed, pencil thick, clothes line rope?
Instruction drawing for Fluxlabyrinth, Berlin. [ca. August 1976]. version A

AYO needed: rubber tubing. Again here, I located at the rubber firm many possibilities. The best was silicone rubber, but it is not so cheap. They also have other tubing that is pretty elastic. I delayed these selections until your arrival. We can discuss money, etc. I suggest we go here together since I have scouted the place somewhat.
Notes: Larry Miller to George Maciunas concerning the Fluxlabyrinth, Berlin. [ca. August 1976].

...a forest of horizontal rubber bands, rods.
Plan of completed Fluxlabyrinth, Berlin. [ca. September 1976].

COMMENTS: *Ay-O's* Web Obstacles *appear in various forms in his environments. The work was realized in the* Fluxlabyrinth *in Berlin.*

WOOD BLOCKS OBSTACLE

Ay-O...EXIT NO. 5 Vestibule floor covered with wood blocks of various shapes.
Fluxfest Sale. [Winter 1966].

PROPOSED FLUXSHOW FOR GALLERY 669 ... VESTIBULE VARIATIONS, by Ayo Portions of vestibule filled with...wood blocks of various shapes ... These floor variations can also be set up in the main gallery space if no vestibule is available.
Fluxnewsletter, December 2, 1968.

PROPOSED FLUXSHOW...VESTIBULE VARIA-
TIONS, by Ayo Portions of vestibule, stair or main
gallery space prepared as follows:...floor covered
with blocks of various shapes...
Fluxnewsletter, December 2, 1968 (revised March 15, 1969).

FLUX SHOW: DICE GAME ENVIRONMENT ...
SOME FLOOR COMPARTMENTS WITH...variations
by Ayo: Sloping floor, area covered with blocks of
various shapes...
Flux Fest Kit 2. [ca. December 1969].

...This Fall, we shall publish V TRE no. 10, which
shall consist of a plan for Flux-Amusement-Center, to
contain...Ayo's floor obstacles...wood blocks etc....
Fluxnewsletter, April 1973.

Any proposals from participants should fit the maze
format...Ideas should relate to passage through doors,
steps, floor, obstacles, booths...blocks...
*George Maciunas, Further Proposal for Flux-Maze at Rene
Block Gallery. [ca. Fall 1974].*

COMMENTS: *This work is not known to have been realized.
The Fluxshow for Gallery 669, and the* Flux-Maze *at the
Rene Block Gallery never happened. Although some of
Ay-O's ideas went into the Berlin* Flux Labyrinth, Wood
Block Obstacles *did not.*

B

MARY BAUERMEISTER

*It was announced in the tentative plans for the first issues of
FLUXUS that M.Bauermeister would contribute "Toward
the new Onthology of Painting" and a "molded plastic re-
lief composition (insert)" for FLUXUS NO. 2 WEST EURO-
PEAN ISSUE 1, later called WEST EUROPEAN YEARBOOK
1, then GERMAN & SCANDINAVIAN YEARBOX.
see: COLLECTIVE*

FRANÇOIS BAYLE

*It was announced in the tentative plans for the first issues of
FLUXUS that Francois Bayle would edit the following con-
tributions: "New magnetic tape music (record); New instru-
mental music (record); happenings; computer music; tradi-
tion of lettrism since Isou; and experiments in Cinema (flip
books)" for FLUXUS 3 FRENCH YEARBOOK.
see: COLLECTIVE*

MAX BENSE

*It was announced in the tentative plans for the first issues of
FLUXUS that Prof. Bense was being consulted for "poetry
machine" for FLUXUS NO. 2 GERMAN & SCANDINA-
VIAN YEARBOX.
see: COLLECTIVE*

CAROL BERGE

*Four poems by Carol Berge appear in Fluxus Newspaper No.
2, February 1964.
see: COLLECTIVE*

LUCIANO BERIO

*It was announced in the tentative plans for the first issues of
FLUXUS that L. Berio was possibly going to edit an antholo-
gy of Italian electronic music by Berio, Ligeti, Maderna,
Nono, Castiglioni, etc. The anthology was to consist of an es-
say and record for FLUXUS NO. 5 WEST EUROPEAN IS-
SUE II.
see: COLLECTIVE*

Jeff Berner. FLUXBOOK

JEFF BERNER

COSMOPOLY

"...We have now 5 card sets which we will have man-
ufactured by real card manufacturer."
Letter: George Maciunas to Ben Vautier, January 10, 1966.

FLUXGAMES...FLUXUS b JEFF BERNER: cos-
mopoly board game with playing cards, dice, chips,
objects and board, boxed $30
Vaseline sTREet (Fluxus Newspaper No. 8) May 1966.

Jeff Berner. COSMOPOLY. A design for the label by George
Maciunas

"...Furthermore Fluxus still publishes...series of
playing cards — Berner..."
Letter: George Maciunas to Ben Vautier, [ca. October 1966].

FLUX-PROJECTS PLANNED FOR 1967...Jeff
Berner: Cosmopoly (card & deck game),...
Fluxnewsletter, March 8, 1967.

COMMENTS: *I don't believe that this work was ever pro-
duced. However, Maciunas designed the label and a proto-
type might well exist for a Fluxus Edition.*

FLUXBOOK
Silverman No. 22

PAST FLUX-PROJECTS (realized in 1966)...Flux-
book by Jeff Berner
Fluxnewsletter, March 8, 1967.

Jeff Berner. FLUXBOOK. A variant label designed by George Maciunas

boxed fluxbook $4.50 by jeff berner
Fluxshopnews. [Spring 1967].

FLUX-PRODUCTS 1961 TO 1969...JEFF BERNER
Boxed fluxbook, varnished bible in clear plastic box
[$] 5
Fluxnewsletter, December 2, 1968 (revised March 15, 1969).

FLUX-PRODUCTS 1961 TO 1970...JEFF BERNER
Fluxbook, varnished bible in clear box [$] 5
Flux Fest Kit 2. [ca. December 1969].

03.1967 JEFF BERNER: glued book...
George Maciunas, Diagram of Historical Developments of Fluxus... [1973].

COMMENTS: *Maciunas designed two labels for this Fluxus Edition. Although I have only seen pages from a small bible used for the contents of the box, pages from other books exist in a file for the work in George Maciunas' estate.*

ELAINE BLOEDOW

A poem by Elaine Bloedow appears in Fluxus Newspaper No. 2, February 1964.
see: COLLECTIVE

JERRY BLOEDOW

It was announced in the tentative plans for the first issues of FLUXUS that Jerry Bloedow would contribute "Lopsiglyphs," "Sestina," "Sword Poem," and with Diane Wakoski, "Conversation between Diane & Jerry stimulated by one hundred ones" for FLUXUS NO. 1 U.S. YEARBOX.
see: COLLECTIVE

GUENTER BOCK

It was announced in the tentative plans for the first issues of FLUXUS that Guenter Bock would contribute an article on architecture for FLUXUS NO. 2, WEST EUROPEAN ISSUE I.
see: COLLECTIVE

WADISLAW BOROWSKI

It was announced in the tentative plans for the first issues of FLUXUS that W. Boroski [sic] would contribute "Cybernetics in Concrete Art" for FLUXUS NO. 7 EAST EUROPEAN YEARBOX.
see: COLLECTIVE

GEORGE MACIUNAS

George Brecht performing "Solo for Violin." 1964

ROBERT BOZZI

EVENTS

FLUX-PROJECTS PLANNED FOR 1967...Robert Bozzi: events in box...
Fluxnewsletter, March 8, 1967.

FLUXPROJECTS FOR 1969...New boxes:...Bozzi events
Fluxnewsletter, December 2, 1968.

COMMENTS: *Robert Bozzi was active with the Groupe de Nice performing Fluxus Events there in the 1960s. Ben Vautier, who organized the group, mailed George Maciunas ideas to be made into Fluxus Editions. This work was never made. A number of scores by Robert Bozzi appear in FLUX-FEST SALE [Winter 1966].*

POSTCARDS

FLUXPROJECTS FOR 1969...Cards:...Bozzi, postcards, etc.
Fluxnewsletter, December 2, 1968.

COMMENTS: *Robert Bozzi's* Postcards *were never made by George Maciunas as a Fluxus Edition.*

GEORGE BRECHT

It was announced in the tentative plans for the first issues of FLUXUS that George Brecht would contribute "Events;" "Experiences, Fixations, Focus," "6 Exhibits," and "3 Telephone Events" for FLUXUS NO. 1 U.S. ISSUE; and "Hakuin, Haiku-Assemblages, Events" for FLUXUS NO. 3 (later called FLUXUS NO. 4 JAPANESE ISSUE). "Events" are rapidly referred to as "Events: scores and other occurrences" in plans for FLUXUS NO. 1 and is published in the Fluxus Newspaper No. 1. Added to other listings in Brochure Prospectus, version B is an essay, "Ten Rules: no rules." This work is published in Fluxus Newspaper No. 2. "6 Exhibits" is listed as "Five Places" in FLUXUS 1.

Other Brecht contributions to Fluxus publications not listed as Fluxus works are: "Word Event" in FLUXUS PREVIEW REVIEW; "Recipe" and various found images and texts in Fluxus Newspaper No. 1; "Direction," "Piano Piece," "Drip Music" and various found images and texts in Fluxus Newspaper Nos. 2 and 3; "Something About Fluxus" in Fluxus Newspaper No. 4 and many scores in FLUXFEST SALE and FLUXFEST KIT 2 (see: COLLECTIVE).

The works of George Brecht offered for sale in the early issues of the Fluxus Newspapers (for instance: pennants, flags, signs, hardware, door events) were either already made by Brecht or could be made to order. Within the nature of these works is the idea that they could be produced either as single samples or editions. During 1964, George Maciunas advertised these and other artists' works to pad the Fluxus lists, as a way of giving the appearance of a 'going operation' while still in the process of defining what Fluxus was to be.

Some of the works were in fact later produced by Maciunas as Fluxus Editions. For example, Arrow exists both as a canvas painted by Brecht, and as a multiple Fluxflag. I consider works that have been listed in Fluxus publications as Fluxus works. However, a work made by Brecht at the same time and in the same spirit but not listed in the publications is considered to be a 'work by a Fluxus artist' but not a 'Fluxus work.'

Pennants, flags and signs are always listed together. The form that these ideas took was apparently of less importance than the idea itself. In this instance, the conceptual grouping has been retained even though a flag, a pennant and a sign of a work may have been made.

A QUESTION OR MORE
Silverman Nos. 27; > 73.I

"...Other going projects:...Brecht - alphabet box..."
Letter: George Maciunas to Ken Friedman, [ca. February 1967].

FLUX-PROJECTS PLANNED FOR 1967...GEORGE BRECHT...A Question or more, (3 wall hangings)...
Fluxnewsletter, March 8, 1967.

FLUXPROJECTS FOR 1968 (In order of priority)... Boxed events & objects (all ready for production):... George Brecht-A Question or more (3 wall hangings)...
Fluxnewsletter, January 31, 1968.

PROPOSED FLUXSHOW FOR GALLERY 669 ... OBJECTS, FURNITURE... boxed events & objects- one of a kind:...A Question or more (3 wall hangings)
Fluxnewsletter, December 2, 1968.

FLUX-PRODUCTS 1961 TO 1969 ... GEORGE BRECHT...A question or more (series of 3 wall hangings) [$] 8
Fluxnewsletter, December 2, 1968 (revised March 15, 1969).

FLUX-PRODUCTS 1961 TO 1970 ... GEORGE BRECHT:...A question or more (3 wall hangings) [$] 8
Flux Fest Kit 2. [ca. December 1969].

"...his [Brecht's] a question or more (I have only one copy)..."
Letter: George Maciunas to Dr. Hanns Sohm, [ca. late 1972].

COMMENTS: *The boxed edition of* A Question or More *is based on George Brecht's* Koan, *a unique work exhibited in his* Toward Events *show at the Reuben Gallery in New York in 1959. Only two prototypes of the Fluxus Edition are known to exist. Neither is complete, the version in the Jean Brown Archive has a title card but is missing a box, the version in the Silverman Collection is missing the title card but not the third box. They were probably both made in early 1967.* A Question or More *evolves into* 3 Wall Hangings *and these banners are not known to have been made by Maciunas as a Fluxus Edition.*

BRAD IVERSON

George Brecht. A QUESTION OR MORE

AIR

FLUXUS 1964 EDITIONS, AVAILABLE NOW... FLUXUS caz series, OBJECTS from GEORGE BRECHT ... FLUXUS ca PENNANTS $30 &up FLAGS $50 &up. Bunting. Sewn legends. With staff. SIGNS, oil on canvas, mounted $25 &up sets of two $40. Available with the following legends: air...
cc Valise e TRanglE (Fluxus Newspaper No. 3) March 1964.

3F-ca PENNANTS from George Brecht...AIR...
European Mail-Orderhouse: europeanfluxshop, Pricelist. [ca. June 1964].

3F/ca PENNANTS from GEORGE BRECHT...air...
Second Pricelist - European Mail-Orderhouse. [Fall 1964].

ITEMS NOT IN STOCK, DELIVERY 1 TO 4 MONTHS...FLUXUS ca GEORGE BRECHT: pennants...air...
Vacuum TRapEzoid (Fluxus Newspaper No. 5) March 1965.

COMMENTS: *This work is not known to have been made by Maciunas as a Fluxus Edition. There is an interesting relationship between Brecht's concept of* Air *and the work of several other artists, notably Marcel Duchamp's* Paris Air, *a ready-made from 1919; Yves Klein's* Le Vide, *1958; Piero Manzoni's* Air Bodies (Balloon Works), *1958; and the Fluxus works: Yoshi Wada's* Cough, *Ay-O's* Air Sculpture *and Ben Vautier's* Flux Nothing.

AIR CONDITIONING

(move through the place)

George Brecht. "Air Conditioning" from WATER YAM

AIR CONDITIONED

SIGNS from the Yamfest Sign Shop/ Air Conditioned ... Paper, metal, enameled, hand-painted, etc. Write for prices.
Yam Festival Newspaper, [ca. 1963].

COMMENTS: *A number of works made for the Yam Festival ended up on early lists of Fluxus works, although this did not. It is not known if Brecht made a version. It is included here because the concept was used in a score from* Water Yam *(Silverman No. 35 ff.)*

ALPHABET BOX see:
A QUESTION OR MORE

ARROW

FOUR FLAGS are available from G.Brecht:...WHITE WITH BLACK ARROW...all in cotton bunting. Write for prices.
Yam Festival Newspaper, [ca. 1963].

FLUXUS 1964 EDITIONS, AVAILABLE NOW ... FLUXUS caz series, OBJECTS from GEORGE BRECHT FLUXUS ca PENNANTS $30 &up FLAGS $ 50 &up. Bunting. Sewn legends. With staff. SIGNS, oil on canvas, mounted $25 &up sets of two $40. Available with the following legends:...(arrow)...
cc Valise e TRanglE (Fluxus Newspaper No. 3) March 1964.

3F-ca PENNANTS from GEORGE BRECHT...arrow...
European Mail-Orderhouse: europeanfluxshop, Pricelist. [ca. June 1964].

3F/ca PENNANTS from GEORGE BRECHT...(arrow)...
Second Pricelist - European Mail-Orderhouse. [Fall 1964].

ITEMS NOT IN STOCK, DELIVERY 1 TO 4 MONTHS...FLUXUS ca GEORGE BRECHT:...pennants...(arrow)...
Vacuum TRapEzoid (Fluxus Newspaper No. 5) March 1965.

"...Take any object you wish from La Cedille qui Sourit, such as very nice Geo. Brecht Flags, which can be used very nicely in any concert. (one says→(arrow)). They can be used as flags or as banners on trumpets etc. ..."
Letter: George Maciunas to Ben Vautier, March 5, 1966.

FLUXFLAGS AND BANNERS ea. $25 28" square, sewnlegends, double bunting, readable both sides, grommets at corners FLUXUSca GEORGE BRECHT: wi following legends:...black on orange: arrow...
Vaseline sTREet (Fluxus Newspaper No. 8) May 1966.

"...Banner with arrow--I am out presently, but could send you a [Hi Red Center] banner with !, looks good too..."
Letter: George Maciunas to Ken Friedman, November 14, 1966.

FLUXFURNITURE...RUGS George Brecht: arrow... woven... 4 ft.x 4 ft. $150, 8 ft.x 8 ft. $300....Available in N.Y.C. at Multiples and late in 1967 at FLUX-SHOP, 18 GREENE ST.
Fluxfurniture, pricelist. [1967].

FLUX-PRODUCTS 1961 TO 1969 ... GEORGE BRECHT...Flags: 28" square, sewn legends... arrow, each [$] 60
Fluxnewsletter, December 2, 1968 (revised March 15, 1969).

FLUX-PRODUCTS 1961 TO 1970 ... GEORGE BRECHT...Flags: 28" sq. sewn legends:...(arrow) ea. [$] 60
Flux Fest Kit 2. [ca. December 1969].

FLUXUS - EDITIONEN ... [Catalogue No.] 735 GEORGE BRECHT:...flag with arrow, 70x70 cm
Happening & Fluxus. Koelnischer Kunstverein, 1970.

COMMENTS: *Arrow, referred to at times as a banner, a flag or a sign, evolved from a painting by Brecht of an arrow entitled* For Any Direction. White With Black Arrow *appears with* White With Word "Flag", White *and* White With Spectral Colors *in his listing of flags in the Yam Festival Newspaper. Although a number of works made for the Yam Festival ended up on the early lists of Fluxus works, the latter two did not. The concept of black/white, white/black with the interplay on obverse/reverse comes out later in the Fluxus Edition of* Flag *by Robert Morris. The idea of direction is later used by Brecht in the Fluxus Edition of* Direction. *George Maciunas produced a Fluxus Edition of* Arrow *as a Fluxflag in the mid 1960s.*

BALL GAME see:
VALOCHE/ A FLUX TRAVEL AID

BALL PUZZLE see:
GAMES & PUZZLES/ BALL PUZZLE

BANNERS see:
FLUXFLAGS AND BANNERS

BEAD PUZZLE see:
GAMES & PUZZLES/ BEAD PUZZLE

BLACK BALL PUZZLE see:
GAMES & PUZZLES/ BLACK BALL PUZZLE

BOARD GAMES see:
GAMES AND PUZZLES/ BOARD GAMES

BOLTS
Silverman No. 33

FLUXUS 1964 EDITIONS, AVAILABLE NOW ... FLUXUS caz series, OBJECTS from GEORGE BRECHT... FLUXUS cf HARDWARE, supplied as-is, ready for use ($1 &up), bolts ...mounted, where practical ($ 5 & up)
cc Valise e TRanglE (Fluxus Newspaper No. 3) March 1964.

3F-cf HARDWARE... bolts...
European Mail-Orderhouse: europeanfluxshop, Pricelist. [ca. June 1964].

3F-cf HARDWARE...bolts...
Second Pricelist - European Mail-Orderhouse. [Fall 1964].

ITEMS NOT IN STOCK, DELIVERY 1 TO 4 MONTHS...FLUXUS cf GEORGE BRECHT: hardware...bolts...
Vacuum TRapEzoid (Fluxus Newspaper No. 5) March 1965.

COMMENTS: *Brecht, 1983: "[originally made in] '62 or '61 ...Unique...I did another one on a larger piece of wood with*

ERNEST MOGOR

George Brecht. BOLT. Photographed in the early 1960s

a chain lock...I had to restore it at one time --the paint had chipped."
Bolt *was bought by the pioneering collector, Sam Wagstaff at George Brecht's "Going to Rome Event" auction, in 1965. The Silvermans purchased* Bolt *from Wagstaff in 1981.*

BOTH/NEITHER

FLUXUS 1964 EDITIONS, AVAILABLE NOW ... FLUXUS caz series, OBJECTS from GEORGE BRECHT FLUXUS ca PENNANTS $30 &up FLAGS $ 50 &up. Bunting. Sewn legends. With staff. SIGNS, oil on canvas, mounted $25 &up sets of two $40. Available with the following legends:...set of 2: both neither...
cc Valise e TRanglE (Fluxus Newspaper No. 3) March 1964.

3F-ca PENNANTS from GEORGE BRECHT...set of two: BOTH/NEITHER...
European Mail-Orderhouse: europeanfluxshop, Pricelist. [ca. June 1964].

3F/ca PENNANTS from GEORGE BRECHT... set of two: both/neither...
Second Pricelist - European Mail-Orderhouse. [Fall 1964].

ITEMS NOT IN STOCK, DELIVERY 1 TO 4 MONTHS...FLUXUS ca GEORGE BRECHT: pennants... set of 2: both neither...
Vacuum TRapEzoid (Fluxus Newspaper No. 5) March 1965.

COMMENTS: *The work is not known to have been produced by Maciunas as a Fluxus Edition.*

BOTTLE BOTTLE-OPENER see:
George Brecht & Robert Filliou

BOXES

FLUXUS 1964 EDITIONS, AVAILABLE NOW ... FLUXUS cas series, OBJECTS from GEORGE BRECHT...FLUXUS cm BOXES. Some are containers and some aren't. Small, simple, cardboard to elaborate ones of fine woods, engraved metal, leather, etc., None are empty, though not all are filled. Made to order. $10 and up.
cc Valise e TRanglE (Fluxus Newspaper No. 3) March 1964.

3F-cm BOXES $10 & up... made to order.
European Mail-Orderhouse: europeanfluxshop, Pricelist. [ca. June 1964].

3F-cm BOXES...made to order. $10 & up
Second Pricelist - European Mail-Orderhouse. [Fall 1964].

ITEMS NOT IN STOCK, DELIVERY 1 TO 4 MONTHS...FLUXUS cm GEORGE BRECHT: boxes ...though not all are filled. $10 & up
Vacuum TRapEzoid (Fluxus Newspaper No. 5) March 1965.

COMMENTS: *Brecht, 1983: "...some are containers and some aren't ...That was just another empty category." The Fluxus Editions of* Valoche *(Silverman Nos. 76, ff.) seem to relate to this idea. Brecht has done a number of unique works in boxes.*

BREAD PUZZLE see:
GAMES & PUZZLES/ BREAD PUZZLE
BRECHT CARDS see:
WATER YAM
BRECHT'S COMPLETE WORKS see:
WATER YAM

BROOMS

FLUXUS 1964 EDITIONS, AVAILABLE NOW ... FLUXUS caz series, OBJECTS from GEORGE BRECHT...FLUXUS cf HARDWARE, supplied as-is, ready for use ($1 &up)...brooms...mounted where practical ($5 & up)
cc Valise e TRanglE (Fluxus Newspaper No. 3) March 1964.

3F-cf HARDWARE...brooms...
European Mail-Orderhouse: europeanfluxshop, Pricelist. [ca. June 1964].

3F-cf HARDWARE...brooms...(mounted).
Second Pricelist - European Mail-Orderhouse. [Fall 1964].

THREE BROOM EVENTS

● broom

● sweeping

● broom sweepings

George Brecht. "Three Broom Events" from WATER YAM

ITEMS NOT IN STOCK, DELIVERY 1 TO 4 MONTHS...FLUXUS cf GEORGE BRECHT: hard-ware...brooms...
Vacuum TRapEzoid (Fluxus Newspaper No. 5) March 1965.

COMMENTS: *The work is not known to have been made by Maciunas as a Fluxus Edition. See the score "Three Broom Events," from* Water Yam *(Silverman No. 35).*

BRUSHES

FLUXUS 1964 EDITIONS, AVAILABLE NOW ... FLUXUS caz series, OBJECTS from GEORGE BRECHT...FLUXUS cf HARDWARE, supplied as-is, ready for use ($1 &up)...brushes... mounted where practical ($5 & up)
cc Valise e TRanglE (Fluxus Newspaper No. 3) March 1964.

3F-cf HARDWARE...brushes...
European Mail-Orderhouse: europeanfluxshop, Pricelist. [ca. June 1964].

3F-cf HARDWARE... brushes...(mounted).
Second Pricelist - European Mail-Orderhouse. [Fall 1964].

ITEMS NOT IN STOCK, DELIVERY 1 TO 4 MONTHS...FLUXUS cf GEORGE BRECHT: hard-ware... brushes...
Vacuum TRapEzoid (Fluxus Newspaper No. 5) March 1965.

COMMENTS: *The work is not known to have been made by Maciunas as a Fluxus Edition. Brecht uses brushes as elements in some of his works. See* Brush Obstacle *and* Brush Toilet Seat *in the Ay-O section for a different use of brushes.*

BUTTER GUIDE

FLUXUS 1964 EDITIONS, AVAILABLE NOW ... FLUXUS caz series, OBJECTS from GEORGE BRECHT...FLUXUS ca PENNANTS $30 &up FLAGS $ 50 &up. Bunting. Sewn legends. With staff. SIGNS, oil on canvas, mounted $25 &up sets of two $40. Available with following legends:... butter guide...
cc Valise e TRanglE (Fluxus Newspaper No. 3) March 1964.

3F-ca PENNANTS from GEORGE BRECHT...BUT-TERGUIDE...
European Mail-Orderhouse: europeanfluxshop, Pricelist. [ca. June 1964].

3F/ca PENNANTS from GEORGE BRECHT...butter-guide...
Second Pricelist - European Mail-Orderhouse. [Fall 1964].

ITEMS NOT IN STOCK, DELIVERY 1 TO 4 MONTHS...FLUXUS ca GEORGE BRECHT: pen-nants...butter guide...
Vacuum TRapEzoid (Fluxus Newspaper No. 5) March 1965.
COMMENTS: *The work is not known to have been produced by Maciunas as a Fluxus Edition.*

CARD GAMES see:
 GAMES AND PUZZLES/ CARD GAMES
CARDS see:
 DECK
 EXIT
 GAMES AND PUZZLES/CARD GAMES
 KEYHOLE
 POSITION
 TABLE
 THREE LAMP EVENTS
 WATER YAM
CARPETS see:
 RUGS

CERTIFICATE OF RELOCATION see:
 RELOCATION

CLOSED ON MONDAYS
Silverman Nos. 72 ff.

FLUX-PRODUCTS 1961 TO 1969 ... GEORGE BRECHT...closed on Mondays, boxed [$] 5
Fluxnewsletter, December 2, 1968 (revised March 15, 1969).

FLUX-PRODUCTS 1961 TO 1970 ... GEORGE BRECHT...Closed on Mondays, boxed [$] 5
Flux Fest Kit 2. [ca. December 1969].

1969-70 Flux-productions, which consist of the fol-lowing: 1969 - GEORGE BRECHT: Closed on Mon-days
Fluxnewsletter, January 8, 1970.

FLUXUS - EDITIONEN ... [Catalogue No.] 732 GEORGE BRECHT:...closed on mondays
Happening & Fluxus. Koelnischer Kunstverein, 1970.

SPRING 1969 BRECHT: closed on mondays...
George Maciunas, Diagram of Historical Developments of Fluxus... [1973].

GEORGE BRECHT...Closed on Mondays, $6
Flux Objects, Price List. May 1976.

COMMENTS: *Brecht, 1983: "It comes from the sign you often see on restaurants 'Closed On Mondays - Ferme le lundi.' So I made a box in Villefranche - it had a rubber band inside. And then George [Maciunas] came with this other thing [the Fluxus Edition] using rubber cement and he had this photo made. That's more or less his recreation of the original model ... [the original] has a little plastic sign on [it] with engraved white letters..."*

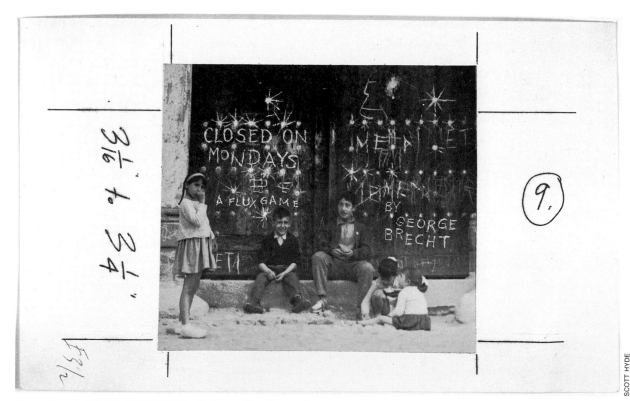

George Brecht. CLOSED ON MONDAYS. Mechanical by George Maciunas

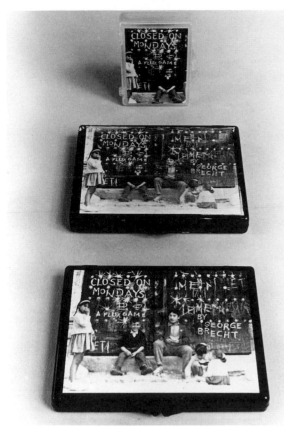

George Brecht. CLOSED ON MONDAYS

The original version made by Brecht is a wooden box kept shut by a rubberband attached inside, and the title handwritten on a label. Another version made by Brecht is reproduced in Henry Martin, An Introduction to George Brecht's, *p. 82. The Fluxus Edition is kept closed with adhesive and the box can only be opened very slightly.*

CLOTHING

FLUXUS 1964 EDITIONS, AVAILABLE NOW ... FLUXUS caz series, OBJECTS from GEORGE BRECHT...FLUXUS ck CLOTHING (locator clothing, ready made clothing, clothing hand-made from hand-woven fabrics, etc.) Hand written catalog, illustrated, $10
cc Valise e TRanglE (Fluxus Newspaper No. 3) March 1964.

3F-ck CLOTHING...Handwritten catalog, illustrated, $10.
European Mail-Orderhouse: europeanfluxshop, Pricelist. [ca. June 1964].

3F-ck CLOTHING...$10.
Second Pricelist - European Mail-Orderhouse. [Fall 1964].

George Brecht. Collage from WATER YAM, related to CLOTHING

...The top and bottomless bathingsuits are going to be shown on the special fluxus fashion-shows next winter together with: 3F-ck Clothing of George Brecht...
European Mail-Orderhouse: advertisement for clothes, [ca. 1964].

ITEMS NOT IN STOCK, DELIVERY 1 TO 4 MONTHS...FLUXUS ck GEORGE BRECHT: clothing handwritten catalogue, illustrated $10
Vacuum TRapEzoid (Fluxus Newspaper No. 5) March 1965.

FLUX-OBJECTS...03.1965...G.BRECHT...clothing.
George Maciunas, Diagram of Historical Developments of Fluxus... [1973].

COMMENTS: *Brecht, 1983:"Locator clothing catalogue and Clothing - never made...."*
Clothing was made for the BLINK show, a quasi Fluxus collaborative event of Brecht, Knowles and Watts in 1963. Photographs taken in New York by Peter Moore prior to the event are reproduced in Fluxus, Etc., *p. 170.*

CLOTHING HAND-MADE FROM HAND-WOVEN FABRICS see:
CLOTHING

CLOUD SCISSORS
Silverman No. 45, ff.

FLUXUS 1964 EDITIONS, AVAILABLE NOW ... FLUXUS ccc CLOUD SCISSORS, $1
cc Valise e TRanglE (Fluxus Newspaper No. 3) March 1964.

2F/ccc CLOUD SCISSORS, $1.
European Mail-Orderhouse: europeanfluxshop, Pricelist. [ca. June 1964].

2F/ccc CLOUD SCISSORS $1.
Second Pricelist - European Mail-Orderhouse. [Fall 1964].

"Put cloud scissors (7 cards with single words) into Brecht Box."
Letter: George Maciunas to Willem de Ridder, February 4, 1965.

"...Cloud Scissors may go into Brecht Water Yam box..."
Letter: George Maciunas to Willem de Ridder, March 2, 1965.

FLUXUSccc GEORGE BRECHT: cloud scissors $1
Vaseline sTREet (Fluxus Newspaper No. 8) May 1966.

FLUX-PRODUCTS 1961 TO 1969 ... GEORGE BRECHT...Cloud scissors, score in envelope (also incl. in Fluxyearbox 2) [$] 1
Fluxnewsletter, December 2, 1968 (revised March 15, 1969).

FLUX-PRODUCTS 1961 TO 1970 ... GEORGE BRECHT...Cloud scissors, score in envelope [$] 1
Flux Fest Kit 2. [ca. December 1969].

COMMENTS: *Brecht, 1983: "...Done at the same time as Cafe Au GoGo..."*
Cafe Au GoGo was a series of events called Monday Night Letters, organized by George Brecht and Robert Watts, November 1964 - November 1965, at the cafe on Bleeker Street in New York City. This work is included in some editions of Water Yam *(Silverman No. 35 ff.) and* Flux Year Box 2 *(Silverman No. 127).*

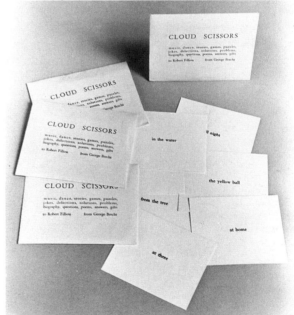

George Brecht. CLOUD SCISSORS

COMPLETE DOORS

FLUXUS 1964 EDITIONS, AVAILABLE NOW ... FLUXUS caz series, OBJECTS from GEORGE BRECHT...FLUXUS ci DOOR EVENTS (...complete doors, etc.) made to order.
cc Valise e TRanglE (Fluxus Newspaper No. 3) March 1964.

3F-ci DOOR EVENTS (...complete doors, etc.)
Handwritten catalog, illustrated, $10
European Mail-Orderhouse: europeanfluxshop, Pricelist.
[ca. June 1964].

3F-ci DOOR EVENTS, (...complete doors, etc.)
Handwritten catalog, illustrated, $10.
Second Pricelist - European Mail-Orderhouse. [Fall 1964].

ITEMS NOT IN STOCK, DELIVERY 1 TO 4
MONTHS...FLUXUS ci GEORGE BRECHT: door e-
vents: complete doors ...prices on request
Vacuum TRapEzoid (Fluxus Newspaper No. 5) March 1965.

FLUX-OBJECTS...03.1965...G.BRECHT...doors...
George Maciunas, Diagram of Historical Developments of
Fluxus... [1973].

COMMENTS: *Brecht, 1983: "...It was mentioned in the*
V TRE *papers that you could order things...you could order*
a door...I would make a special door, but nobody ever or-
dered one..."
 There is also a relationship between this work and the
score "Six Doors" from Water Yam *(Silverman No. 35 ff.)*
Brecht's Complete Doors *were never produced as a Fluxus*
Edition. Doors were made by others. See Anonymous,
George Maciunas, George Maciunas & Larry Miller, and Yoko
Ono.

COMPLETE WORKS see:
 WATER YAM
CRYSTALS see:
 SILICATE MICRO CRYSTALS

CURTAINS

FLUXUS 1964 EDITIONS, AVAILABLE NOW ...
FLUXUS caz series, OBJECTS from GEORGE
BRECHT...FLUXUS ci DOOR EVENTS (...curtains
...) made to order.
cc Valise e TRanglE (Fluxus Newspaper No. 3) March 1964.

3F-ci DOOR EVENTS (...curtains...) Handwritten
catalog, illustrated, $10
European Mail-Orderhouse: europeanfluxshop, Pricelist.
[ca. June 1964].

3F-ci DOOR EVENTS (...curtains...) Handwritten
catalog, illustrated, $10.
Second Pricelist - European Mail-Orderhouse. [Fall 1964].

ITEMS NOT IN STOCK, DELIVERY 1 TO 4
MONTHS...FLUXUS ci GEORGE BRECHT, door e-
vents:...curtains... prices on request
Vacuum TRapEzoid (Fluxus Newspaper No. 5) March 1965.

COMMENTS: *Curtains is not known to have been made by*
Maciunas as a Fluxus Edition.

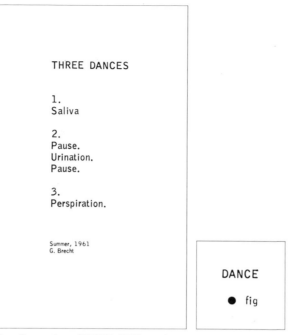

THREE DANCES

1.
Saliva

2.
Pause.
Urination.
Pause.

3.
Perspiration.

Summer, 1961
G. Brecht

DANCE

● fig

Two Scores from **WATER YAM** involving concepts of George
Brecht's **DANCE**

DANCE

FLUXUS 1964 EDITIONS, AVAILABLE NOW ...
FLUXUS caz series, OBJECTS from GEORGE
BRECHT... FLUXUS ca PENNANTS $30 &up
FLAGS $ 50 &up. Bunting. Sewn legends. With staff.
SIGNS, oil on canvas, mounted $25 &up sets of two
$40. Available with following legends:...dance...
cc Valise e TRanglE (Fluxus Newspaper No. 3) March 1964.

3F-ca PENNANTS from GEORGE BRECHT ...
DANCE...
European Mail-Orderhouse: europeanfluxshop, Pricelist.
[ca. June 1964].

3F/ca PENNANTS from GEORGE BRECHT...dance...
Second Pricelist - European Mail-Orderhouse. [Fall 1964].

ITEMS NOT IN STOCK, DELIVERY 1 TO 4
MONTHS...FLUXUS ca GEORGE BRECHT: pen-
nants...dance...
Vacuum TRapEzoid (Fluxus Newspaper No. 5) March 1965.

COMMENTS: *The work is not known to have been made by*
Maciunas as a Fluxus Edition. There are two scores having to
do with dance in Water Yam *(Silverman No. 35 ff.): "Three*
Dances" and "Dance". Brecht also worked with experimental
dancers in New York during the early 1960s.

DAY see:
 DAY/NIGHT

DAY/NIGHT

FLUXUS 1964 EDITIONS, AVAILABLE NOW ...
FLUXUS caz series, OBJECTS from GEORGE
BRECHT/ FLUXUS ca PENNANTS $30 &up FLAGS
$ 50 &up. Bunting. Sewn legends. With staff. SIGNS,
oil on canvas, mounted $25 &up sets of two $40. A-
vailable with following legends:...set of 2: day night...
cc Valise e TRanglE (Fluxus Newspaper No. 3) March 1964.

3F-ca PENNANTS from GEORGE BRECHT...set of
two: DAY/NIGHT...
European Mail-Orderhouse: europeanfluxshop, Pricelist. [ca.
June 1964].

3F/ca PENNANTS from GEORGE BRECHT...set of
two: day/night...
Second Pricelist - European Mail-Orderhouse. [Fall 1964].

ITEMS NOT IN STOCK, DELIVERY 1 TO 4
MONTHS...FLUXUS ca GEORGE BRECHT: pen-
nants...set of 2: day night...
Vacuum TRapEzoid (Fluxus Newspaper No. 5) March 1965.

May 2-8: BLUE ROOM BY JOHN & YOKO + FLUX-
LIARS...Other interior signs: day/night (at night/day)
...all by George Brecht 1961
Schedule of events for Fluxfest presentation of John Lennon
and Yoko Ono. [ca. April 1970]. versions A and B

FLUXFEST PRESENTATION OF JOHN LENNON
& YOKO ONO +* AT 80 WOOSTER ST. NEW YORK
— 1970...MAY 2-8: BLUE ROOM BY JOHN &
YOKO + FLUXLIARS Entire room (floor, walls, ceil-
ing), and furnishings were white...sign during day:
Night, during night: Day (George Brecht 1961)...
all photographs copyright nineteen seVenty by peTer MooRE
(Fluxus Newspaper No. 9) 1970.

COMMENTS: *Neither pennant nor flag versions of the work*
are known to have been made by Maciunas as Fluxus Edi-
tions. However, signs were evidently made for the John &
Yoko Fluxfest in New York City. In the Flux Objects, Price
List, May 1976, Maciunas evolved Day/Night *into two sepa-*
rate works, Night *and* Day.

DECK
Silverman Nos. 69 ff.

"...Those cards (playing cards) are VERY NICE - you
should do the whole pack - then we reproduce. Like
Brecht is making a set which I will have specially re-
produced..."
Letter: George Maciunas to Robert Watts, [before March 11,
1963].

"...We have now 5 card sets which we will have man-
ufactured by real card manufacturer. [Brecht,...] "
Letter: George Maciunas to Ben Vautier, January 10, 1966.

FLUXGAMES...FLUXUScn GEORGE BRECHT:

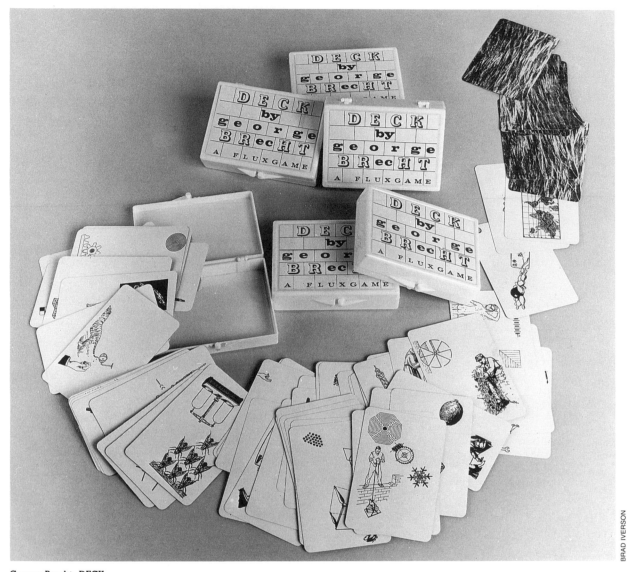

George Brecht. DECK

FLUX-PRODUCTS 1961 TO 1969 ... GEORGE BRECHT...Deck, playing cards, (invent-yourself-game) [$] 8
Fluxnewsletter, December 2, 1968 (revised March 15, 1969).

FLUX-PRODUCTS 1969 TO 1970 ... GEORGE BRECHT...Deck, playing cards [$] 8
Flux Fest Kit 2. [ca. December 1969].

[Catalogue No.] 733 GEORGE BRECHT:...deck, playing cards
Happening & Fluxus. Koelnischer Kunstverein, 1970.

05.1966 G. BRECHT: playing cards...
George Maciunas, Diagram of Historical Developments of Fluxus... [1973].

GEORGE BRECHT...Deck, playing cards $10
Flux Objects, Price List. May 1976.

COMMENTS: *Brecht, 1983: "I either cut the cards up to make the background of the* Universal Machine *or vice versa."*
 The contents of Deck *were produced by a commercial card company for Fluxus. "Card Piece for Voice" from* Water Yam *Silverman No. 35 ff., is an early score using the idea of playing cards and decks of cards. See also* Universal Machine, *Silverman No. 78;* Universal Machine II, *Silverman No. 79; and* Games and Puzzles/Card Games.

DELIVERY
Silverman No. > 35.I

DELIVERY An area is set aside. Delivery of objects to the area is arranged. Inquiries: G.Brecht, Fluxus, P.O. Box 180 New York 13, N.Y.
George Brecht, Water Yam. Adveriesment card: "Delivery."

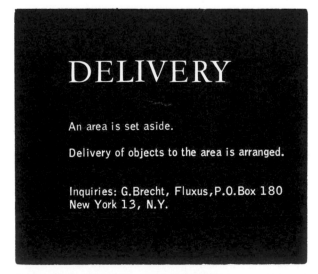

DELIVERY

An area is set aside.

Delivery of objects to the area is arranged.

Inquiries: G.Brecht, Fluxus, P.O.Box 180 New York 13, N.Y.

George Brecht. Advertising card for DELIVERY

deck plastic coated playing cards $8
Vaseline sTREet (Fluxus Newspaper No. 8) May 1966.

FLUXKIT containing following fluxus-publications: (also available separatelly [sic])...FLUXUS cn GEORGE BRECHT: deck plastic coated playing cards, boxed $8
ibid.

"...I am sending you packages with...Brecht playing cards..."
Letter: George Maciunas to Ben Vautier, May 19, 1966.

"...furthermore fluxus...publishes....series of play-ing cards Brecht,..."
Letter: George Maciunas to Ben Vautier, [ca. October, 1966].

"I got hold of a few $ & shipped out by REA a pack-age to you with:...5—Brecht cards [decks]..."
Letter: George Maciunas to Ken Friedman, [ca. February 1967].

PAST FLUX-PROJECTS (realized in 1966)...Objects produced: Deck by George Brecht...
Fluxnewsletter, March 8, 1967.

deck $6.00...by george brecht
Fluxshopnews. [Spring 1967].

"...Put...delivery card into Brecht box..."
Letter: George Maciunas to Willem de Ridder, February 4, 1965.

COMMENTS: *This is a Fluxus adaptation of the George Brecht and Robert Watts' concept from 1962: Yam Festival Part 5 Delivery Event (Silverman No. 471) see Illustration in Fluxus etc. p. 209. This is not actually an object, although objects are inherent in the realization of the work. Earlier Delivery Events were Fluxus-like objects.*

DIRECTION

Silverman Nos.: single sheet version — Silverman No. 64; boxed version — No. 65; book version — No. 66

"...Could you write letters to: F.Becker & Co. Weisbaden Biebrich, Wiesbaden Str. 43. Asking them in my name (sign for me) to print all matters that I have requested for July 16th. plus...2000 sheets of pointing hands, black line on white paper. cheapest paper..."
Letter: George Maciunas to Tomas Schmit, [end of June/beginning of July, 1963].

"...go to the Becker printer & pick up...pointing hands - take all books & pointing fingers..."
Letter: George Maciunas to Tomas Schmit, [2nd week July 1963].

"...put up pointing hands all over Nice all pointing towards posters also put up all over town - in funny & strange places like public toilets, inside tunnels very high up, bottom of fountains - always hands coming towards these places OK? Must be better than Amsterdam..."
Letter: George Maciunas to Tomas Schmit, [mid July 1963].

FLUX-PRODUCTS 1961 TO 1969 ... GEORGE BRECHT...direction, each [$] 3
Fluxnewsletter, December 2, 1968 (revised March 15, 1969).

FLUXUS-EDITIONEN ... [Catalogue No.] 736 GEORGE BRECHT...direction
Happening & Fluxus. Koelnischer Kunstverein, 1970.

COMMENTS: *According to Brecht, the image of the hand was found by Maciunas. Direction was originally a score published in* Water Yam *(Silverman No. 35 ff.), and the idea was developed by Maciunas to include three different Fluxus realizations of the work: single sheets, a book and a boxed version. It also relates to* Arrow. *Note that Brecht titled his painting of an arrow -* For Any Direction.

DOOR EVENTS see:
COMPLETE DOORS
CURTAINS
DOORKNOBS
GLASS
LOCKS
SIGNS

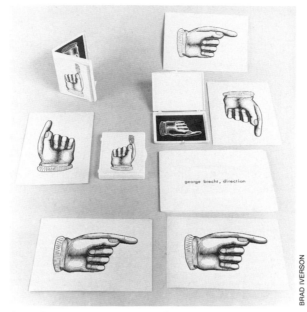

Three Fluxus interpretations of George Brecht's DIRECTION: single sheets, book version, and boxed edition

BRAD IVERSON

DIRECTION

Arrange to observe a sign
indicating direction of travel.

● travel in the indicated direction

● travel in another direction

George Brecht. "Direction" from WATER YAM

DOORKNOBS

FLUXUS 1964 EDITIONS, AVAILABLE NOW ... FLUXUS caz series, OBJECTS from GEORGE BRECHT...FLUXUS ci DOOR EVENTS (...doorknobs...) made to order.
cc Valise e TRanglE (Fluxus Newspaper No. 3) March 1964.

3F-ci DOOR EVENTS (...doorknobs...) Handwritten catalog, illustrated, $10
European Mail-Orderhouse: europeanfluxshop, Pricelist. [ca. June 1964].

3F-ci DOOR EVENTS (...doorknobs...) Handwritten catalog, illustrated, $10.
Second Pricelist - European Mail-Orderhouse. [Fall 1964].

ITEMS NOT IN STOCK, DELIVERY 1 TO 4 MONTHS...FLUXUS ci GEORGE BRECHT door events...doorknobs... prices on request
Vacuum TRapEzoid (Fluxus Newspaper No. 5) March 1965.

COMMENTS: *This work is not known to have been made by Maciunas as a Fluxus Edition.*

DUST

FLUXUS 1964 EDITIONS, AVAILABLE NOW ... FLUXUS caz series, OBJECTS from GEORGE BRECHT/ FLUXUS ca PENNANTS $30 &up FLAGS $ 50 &up. Bunting. Sewn legends. With staff. SIGNS, oil on canvas, mounted $25 &up sets of two $40. Available with following legends:...dust...
cc Valise e TRanglE (Fluxus Newspaper No. 3) March 1964.

3F-ca PENNANTS from GEORGE BRECHT...DUST...
European Mail-Orderhouse: europeanfluxshop, Pricelist. [ca. June 1964].

3F/ca PENNANTS from GEORGE BRECHT...dust...
Second Pricelist - European Mail-Orderhouse. [Fall 1964].

ITEMS NOT IN STOCK, DELIVERY 1 TO 4 MONTHS...FLUXUS ca GEORGE BRECHT: pennants...dust...
Vacuum TRapEzoid (Fluxus Newspaper No. 5) March 1965.

COMMENTS: *Dust is not known to have been made by Maciunas as a Fluxus Edition. There is a Fluxus Edition of Robert Filliou's* Fluxdust. *(Silverman No. < 106.I ff.).*

EARTH MEETING

FLUXUS 1964 EDITIONS, AVAILABLE NOW ... FLUXUS caz series, OBJECTS from GEORGE BRECHT/ FLUXUS ca PENNANTS $30 &up FLAGS $ 50 &up. Bunting. Sewn legends. With staff. SIGNS, oil on canvas, mounted $25 &up sets of two $40. Available with following legends:...earth meeting...
cc Valise e TRanglE (Fluxus Newspaper No. 3) March 1964.

3F-ca PENNANTS from GEORGE BRECHT ... EARTH MEETING...
European Mail-Orderhouse: europeanfluxshop, Pricelist. [ca. June 1964].

3F/ca PENNANTS from GEORGE BRECHT...earth meeting...
Second Pricelist - European Mail-Orderhouse. [Fall 1964].

ITEMS NOT IN STOCK, DELIVERY 1 TO 4 MONTHS...FLUXUS ca GEORGE BRECHT: pen-

nants...earth meeting...
Vacuum TRapEzoid (Fluxus Newspaper No. 5) March 1965.

COMMENTS: *This work is not known to have been made by Maciunas as a Fluxus Edition.*

EASTERN DAYLIGHT FLUX TIME see:
George Brecht and Robert Filliou

EDGE MEMORY

FLUXUS 1964 EDITIONS, AVAILABLE NOW ... FLUXUS caz series, OBJECTS from GEORGE BRECHT FLUXUS ca PENNANTS $30 &up FLAGS $ 50 &up. Bunting. Sewn legends. With staff. SIGNS, oil on canvas, mounted $25 &up sets of two $40. A-vailable with following legends:...edge memory...
cc Valise e TRanglE (Fluxus Newspaper No. 3) March 1964.

3F-ca PENNANTS from GEORGE BRECHT...EDGE MEMORY...
European Mail-Orderhouse: europeanfluxshop, Pricelist. [ca. June 1964].

3F/ca PENNANTS from GEORGE BRECHT...edge memory...
Second Pricelist - European Mail-Orderhouse. [Fall 1964].

ITEMS NOT IN STOCK, DELIVERY 1 TO 4 MONTHS...FLUXUS ca GEORGE BRECHT: pen-nants...edge memory...
Vacuum TRapEzoid (Fluxus Newspaper No. 5) March 1965.

COMMENTS: *This work is not known to have been made by Maciunas as a Fluxus Edition.*

END
Silverman No. > 45.II

FLUXUS 1964 EDITIONS, AVAILABLE NOW ... FLUXUS caz series, OBJECTS from GEORGE BRECHT/ FLUXUS ca PENNANTS $30 &up FLAGS $ 50 &up. Bunting. Sewn legend. With staff. SIGNS, oil on canvas, mounted $25 &up sets of two $40. A-vailable with following legends:...end...
cc Valise e TRanglE (Fluxus Newspaper No. 3) March 1964.

3F-ca PENNANTS from GEORGE BRECHT...END...
European Mail-Orderhouse: europeanfluxshop, Pricelist. [ca. June 1964].

3F/ca PENNANTS from GEORGE BRECHT...end...
Second Pricelist - European Mail-Orderhouse. [Fall 1964].

ITEMS NOT IN STOCK, DELIVERY 1 TO 4 MONTHS...FLUXUS ca GEORGE BRECHT: pen-nants...end...
Vacuum TRapEzoid (Fluxus Newspaper No. 5) March 1965.

"...Take any object you wish from La Cedille qui Sourit, such as very nice Geo. Brecht Flags,...(one says...End...). They can be used as flags or banners. (like boat flags or as banners on trumpets) etc...."
Letter: George Maciunas to Ben Vautier, March 5, 1966.

FLUXFLAGS AND BANNERS ea. $25 28" square, sewnlegends, double bunting, readable both sides, grommets at corners FLUXUS ca GEORGE BRECHT: wi following legends:... red on grey: "end"...
Vaseline sTREet (Fluxus Newspaper No. 8) May 1966.

"...Hi-Red-Center...Hotel event...first time we used Brecht flags: start—middle—end. (on a flag pole, like a ship)..."
Letter: George Maciunas to Ben Vautier, [Fall 1966].

FLUX-PRODUCTS 1961 TO 1969 ... GEORGE BRECHT...Flags: 28" square, sewn legends...end... each: [$] 60
Fluxnewsletter, December 2, 1968 (revised March 15, 1969).

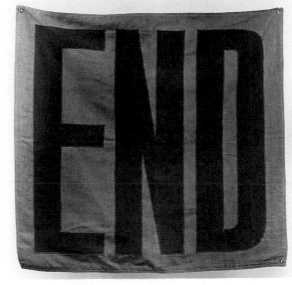

BRAD IVERSON

George Brecht. END. see color portfolio

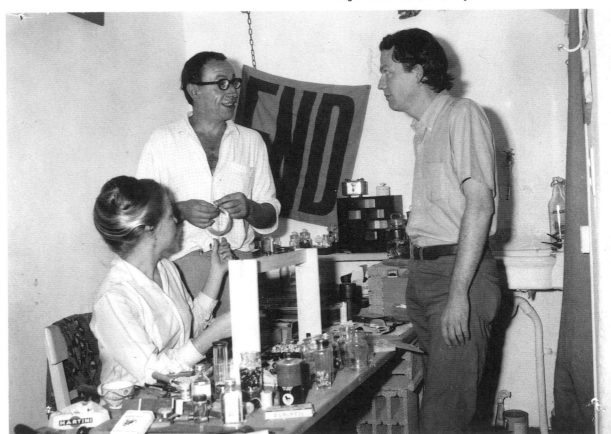

1965 C.J. NOCENTI

Marianne and Robert Filliou with George Brecht in the quasi Flux Shop, La Cedille Qui Sourit, Villefranche, 1965.

FLUX-PRODUCTS 1961 TO 1970 ... GEORGE BRECHT...Flags: 28'' sq. sewn legends:...end...ea: [$] 60
Flux Fest Kit 2. [ca. December 1969].

GEORGE BRECHT...Flags: sewn legends:...end... each $100
Flux Objects, Price List. May 1976.

COMMENTS: *The Fluxus Editions of the three Brecht flags,* Start, Middle, End, *could be viewed as a sequence or as individual concepts. This work has a relationship to Brecht's* Exit.

ENTRANCE-EXIT see:
ENTRY-EXIT

ENTRANCE AND EXIT MUSIC
Silverman No. < 72.I

FLUXUS 1964 EDITIONS, AVAILABLE NOW ... FLUXUS cc ccc EXIT & ENTRANCE music, on tape, $2
cc Valise e TRanglE (Fluxus Newspaper No. 3) March 1964.

2F/cc ccc EXIT & ENTRANCE, music on tape, $2
European Mail-Orderhouse: europeanfluxshop, Pricelist. [ca. June 1964].

2F/cc ccc EXIT & ENTRANCE, music on tape, $2.
Second Pricelist - European Mail-Orderhouse. [Fall 1964].

GAMES...FLUXUS ca GEORGE BRECHT exit and entrance music, on tape $2
Vacuum TRapEzoid (Fluxus Newspaper No. 5) March 1965.

FLUX-PRODUCTS 1961 TO 1969 ... GEORGE BRECHT Entrance—Exit, 6min. tape [$] 8
Fluxnewsletter, December 2, 1968 (revised March 15, 1969).

FLUX-PRODUCTS 1961 TO 1970 ... GEORGE BRECHT...Entrance—Exit, 6min. tape [$] 8
Flux Fest Kit 2. [ca. December 1969].

FLUXUS-EDITIONEN ... [Catalogue No.] 734 GEORGE BRECHT:...entrance-exit, 6 min tape
Happening & Fluxus. Koelnischer Kunstverein, 1970.

COMMENTS: *Maciunas seems to fluctuate in the title, sometimes putting* EXIT *before* ENTRANCE, *which would appear to alter the sense of the piece but could also be seen as an illustration of Maciunas' sense of humor. See Brecht's* Exit *and also "Six Doors", published in Brecht's* Water Yam *(Silverman No. 35 ff.).*

ENTRY

Signs from the Yamfest Sign Shop...ENTRANCE... Paper, metal, enameled, hand-painted, etc. Write for prices.
Yam Festival Newspaper, [ca. 1963].

George Brecht. **ENTRANCE AND EXIT MUSIC**

BRAD IVERSON

FLUX-PRODUCTS 1961 TO 1969 ... GEORGE BRECHT...Flags: 28'' square, sewn legends...entry... each [$] 60
Fluxnewsletter, December 2, 1968 (revised March 15, 1969).

FLUX-PRODUCTS 1961 TO 1970 ... GEORGE BRECHT...Flags: 28'' sq. sewn legends:...entry...ea: [$] 60
Flux Fest Kit 2. [ca. December 1969].

...set of 1969-70 Flux-productions...1970-...George Brecht: Flags...entry
Fluxnewsletter, January 8, 1970.

May 2-8 BLUE ROOM BY JOHN & YOKO + FLUX-LIARS...Other interior signs:...Entry (on the exit)... all by George Brecht 1961
Schedule of events for Fluxfest presentation of John Lennon and Yoko Ono. [ca. April 1970]. versions A and B

FLUXFEST PRESENTATION OF JOHN LENNON & YOKO ONO + * AT 80 WOOSTER ST. NEW YORK-1970...MAY 2 - 8: BLUE ROOM BY JOHN & YOKO + FLUXLIARS Entire room (floor, walls, ceiling), and furnishings were white...Sign on exit

door: Entry (George Brecht '61)...
all photographs copyright nineteen seVenty by peTer mooRe (Fluxus Newspaper No. 9) 1970.

GEORGE BRECHT...Flags: sewn legends:...entry... each: $100
Flux Objects, Price List. May 1976.

COMMENTS: *A flag was not known to have been made by Maciur* ~ *a Fluxus Edition although a sign was evidently made* ... *1970 for the John & Yoko Fluxfest in New York City.* Entry *relates to the Fluxus Editions:* Entrance and Exit Music *and* Entry—Exit *(the film).*

ENTRY-EXIT
Silverman No. < 69.I

"Regarding film festival. - I will send you the following:...Entrance-Exit by George Brecht 6½ min.... You will get these end of April. They and another 6 films make up the whole 2 hour Fluxfilm program.... Incidently, loops from these films will go into Fluxus II Yearboxes. Everything is ready, but I got short on $ & can't produce these boxes in quantity since making film copies is rather expensive....Fluxfilm program was shown at Ann Arbor film fest & won a critics award..."
Letter: George Maciunas to Ben Vautier, March 29, 1966.

FLUXFILMS...FLUXFILM 10 GEORGE BRECHT: entrance-exit, 6.5min, with sound $50
Vaseline sTREet (Fluxus Newspaper No. 8) May 1966.

FLUXFILMS...LONG VERSION, ADDITIONAL FILMS TO SHORT VERSION...[fluxnumber] 10 George Brecht ENTRY-EXIT 6'30'' A smooth linear transition from white, through greys to black, produced in developing tank.
Fluxfilms catalogue. [ca. 1966].

PAST FLUX-PROJECTS (realized in 1966...Flux-films: total package: 1 hr. 40 min....entrance-exit by George Brecht...
Fluxnewsletter, March 8, 1967.

FLUX-PRODUCTS 1961 TO 1969...FLUXFILMS, long version Winter 1966 Short version plus addition of:...Entry-exit by George Brecht...
Fluxnewsletter, December 2, 1968 (revised March 15, 1969).

SLIDE & FILM FLUXSHOW...GEORGE BRECHT: ENTRY-EXIT A smooth linear transition from white, through greys to black, accompanied by sound transition from white noise to sinus wave tone. 6'30''
Flux Fest Kit 2. [ca. December 1969].

FILM AND SOUND ENVIRONMENT A booth must be set up in a fairly dark area, the walls of which are of white vinyl or cotton sheets (about 12' wide x 8'

high) hanging as curtains, creating thus a 12' x 12' or smaller room. Four 8mm wide angle lense loop projectors must be set up in front of each wall on the outside, projecting an image the frame of which is to cover entire wall. Spectators may enter the booth through corners....Black to white film by George Brecht with his Sinus tone to white noise tape.
ibid.

FLUX-PRODUCTS 1961 TO 1969...FLUXFILMS, long version, Winter 1966. Short version plus addition of:...Entry-Exit by George Brecht...total: 1 hr. 40 min. 16mm $400
ibid.

FLUXYEARBOX 2, May 1968...19 film loops by:... [including] ...G.Brecht
ibid.

...MAY 16-22: CAPSULE BY JOHN & YOKO + FLUX SPACE CENTER A 3ft cube enclosure (capsule) having various film loops projected on its walls, ceiling and floor to a single viewer inside, total time: 6 min. [including] ...transition from white to black (George Brecht, 1965) combined with: transition from smile to no smile, 20,000 frames sec. (Shiomi '66)
Schedule of events for Fluxfest presentation of John Lennon and Yoko Ono. [ca. April 1970]. version A

...($1 ADMISSION CHARGE)...about 8 minutes.... [including] transition from white to black (George Brecht, 1965)
Schedule of events for Fluxfest presentation of John Lennon and Yoko Ono. [ca. April 1970]. version B

...CAPSULE BY YOKO + FLUX SPACE CENTER [including] ...transition from white to black (George Brecht)
Schedule of events for Fluxfest presentation of John Lennon and Yoko Ono. April 1, 1970. version C

03.1965 FLUXFILMS:...G.BRECHT: entrance/exit...
George Maciunas, Diagram of Historical Developments of Fluxus... [1973].

"...fluxfilms long version is too expensive and not that good, I would suggest that you purchase only Brechts Entrance-Exit film, 16mm with sound, 6 minutes, $60..."
Letter: George Maciunas to Dr. Hanns Sohm, [ca. late 1972].

"In January I will mail Brecht - Entry-Exit film..."
Letter: George Maciunas to Dr. Hanns Sohm, November 30, 1975.

COMMENTS: *The film exists both as a component of Flux-films/ long version and as an individual Fluxus Edition. See also Brecht's score "Six Doors" published in* Water Yam *(Silverman No. 35 ff.).*

EVENT PROSPECTUS see:
 ICED DICE
EVENTS see:
 WATER YAM
EXHIBIT see:
 FIVE PLACES
EXHIBITS see:
 EXIT
 KEYHOLE
 POSITION
 TABLE
 THREE LAMP EVENTS

EXIT
Silverman No. < 33.I

"Paik has exhibit for next 2 weeks at Wuppertal where I was yesterday - I got one room for fluxus. In that room I also set various cards of G.Brecht...exit etc...We thought in future to integrate our festivals with these 'exhibits'...."
Letter: George Maciunas to Robert Watts, [March 11 or 12, 1963].

SIGNS from the Yamfest Sign Shop, EXIT...Paper, metal, enameled, hand-painted, etc. Write for prices.
Yam Festival Newspaper, [ca. 1963].

"...Fluxus is not an abstraction to do on leisure hours it is the very non-fine-art work you do. (or eventually will do). The best Fluxus 'composition' is a most non personal, 'ready-made' one like Brechts 'Exit' - it does not require any of us to perform it since it happens daily without any 'special' performance of it. Thus our festivals will eliminate themselves (and our need to participate) when they become total ready-mades (like Brechts exit)."
Letter: George Maciunas to Tomas Schmit, [January 1964].

FLUXUS 1964 EDITIONS, AVAILABLE NOW ... FLUXUS caz series, OBJECTS from GEORGE BRECHT/FLUXUS ca PENNANTS $30 & up FLAGS $ 50 &up. Bunting. Sewn legends. With staff. SIGNS, oil on canvas, mounted $25 &up sets of two $40. Available with following legends: ...exit...
cc Valise e TRanglE (Fluxus Newspaper No. 3) March 1964.

3F-ca PENNANTS from GEORGE BRECHT...EXIT...
European Mail-Orderhouse: europeanfluxshop, Pricelist. [ca. June 1964].

3F/ca PENNANTS from GEORGE BRECHT...exit...
Second Pricelist - European Mail-Orderhouse. [Fall 1964].

ITEMS NOT IN STOCK, DELIVERY 1 TO 4 MONTHS...FLUXUS ca GEORGE BRECHT: pennants...exit...
Vacuum TRapEzoid (Fluxus Newspaper No. 5) March 1965.

FLUXFURNITURE...RUGS George Brecht:..."exit" ...woven...4 ft. x 4 ft. $150, 8 ft. x 8 ft. $300. ... Available in N.Y.C. at Multiples and late in 1967 at FLUXSHOP, 18 GREENE ST.
Fluxfurniture, pricelist. [1967].

FLUX-PRODUCTS 1961 TO 1969 ... GEORGE BRECHT...Flags: 28" square, sewn legends,...exit... each: [$] 60
Fluxnewsletter, December 2, 1968 (revised March 15, 1969).

FLUX-PRODUCTS 1961 TO 1970 ... GEORGE BRECHT...Flags: 28" sq. sewn legends:...exit...ea: [$] 60
Flux Fest Kit 2. [ca. December 1969].

...1969-70 Flux-productions, which consist of... 1970-...George Brecht: Flags exit...
Fluxnewsletter, January 8, 1970.

George Brecht. EXIT. A ready-made mounted by the artist. see color portfolio

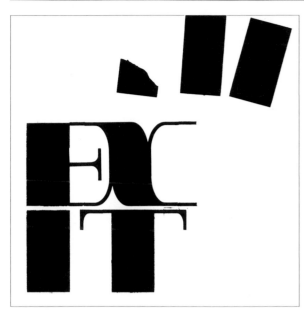

A working study by George Maciunas for a version of George Brecht's EXIT

May 2-8: BLUE ROOM BY JOHN & YOKO + FLUX-LIARS...Other interior signs:...Exit (at wrong door or on blank wall)... all by George Brecht 1961
Schedule of events for Fluxfest presentation of John Lennon and Yoko Ono. [ca. April 1970]. version A

MAY 2-8: BLUE ROOM BY JOHN & YOKO + FLUXLIARS...Signs by George Brecht (1961)... Exit (on blank wall)...
Schedule of events for Fluxfest presentation of John Lennon and Yoko Ono. [ca. April 1970]. version B

FLUXFEST PRESENTATION OF JOHN LENNON & YOKO ONO + * AT 80 WOOSTER ST. NEW YORK — 1970...MAY 2-8: BLUE ROOM BY JOHN & YOKO + FLUXLIARS Entire room (floor, walls, ceiling), and furnishings were white... Sign on blank wall: Exit (George Brecht '61)...
all photographs copyright nineteen seVenty by peTer mooRE (Fluxus Newspaper No. 9) 1970.

GEORGE BRECHT...Flags: Sewn legends:...exit... each: $100
Flux Objects, Price List. May 1976.

COMMENTS: Exit *was used as a performance prop in many of the concerts; the audience leaves and thus performs the piece. There are also two related scores published in* Water Yam *(Silverman No. 35 ff.): "Word Event" and "Six Doors." I don't know if a Fluxus Edition flag or banner was ever made. The sign, a readymade, was mounted by Brecht. A preliminary work for a Fluxflag exists, but I have not seen a finished example.*

SIX DOORS

● EXIT

● ENTRANCE

● EXIT
 ENTRANCE

●

WORD EVENT

● EXIT

G.Brecht
Spring, 1961

George Brecht. Two scores from WATER YAM using the concept of EXIT

EXIT & ENTRANCE MUSIC see:
ENTRANCE & EXIT MUSIC
EXPLODING PISTONS see:
FLOOR WITH EXPLODING PISTONS

FACT/FICTION

FLUXUS 1964 EDITIONS, AVAILABLE NOW ... FLUXUS caz series, OBJECTS from GEORGE BRECHT/ FLUXUS ca PENNANTS $30 &up FLAGS $ 50 &up. Bunting. Sewn legends. With staff. SIGNS, oil on canvas, mounted $25 &up sets of two $40. Available with the following legends:...set of 2: fact fiction...
cc Valise e TRanglE (Fluxus Newspaper No. 3) March 1964.

3F-ca PENNANTS from GEORGE BRECHT...set of two: FACT/FICTION...
European Mail-Orderhouse: europeanfluxshop, Pricelist. [ca. June 1964].

3F-ca PENNANTS from George Brecht...set of two: fact/fiction...
Second Pricelist - European Mail-Orderhouse. [Fall 1964].

ITEMS NOT IN STOCK, DELIVERY 1 TO 4 MONTHS...FLUXUS ca pennants...set of two: fact fiction...
Vacuum TRapEzoid (Fluxus Newspaper No. 5) March 1965.

COMMENTS: *This work is not known to have been made by Maciunas as a Fluxus Edition.*

FAIL MATCHES BY ERIC

FLUX-PROJECTS PLANNED FOR 1967...GEORGE BRECHT:...Fail matches by Eric...
Fluxnewsletter, March 8, 1967.

COMMENTS: Fail Matches by Eric, *was never produced as a Fluxus Edition. Brecht attempted, with the help of Knud Pedersen, to have another match work of his,* Left-Handed Matches, *produced by a commercial match company. They succeeded in having only one prototype made.* Left-Handed Matches *would have had sulfur on both ends, so* Fail Matches by Eric *would probably have had no sulfur at all.*

FICTION see:
FACT/FICTION
FILM see:
ENTRY-EXIT

FIVE PLACES
Component of Silverman No. 117 ff.

"...Fluxus I items of the type that may be included [in Fluxus 2] are:...George Brecht - five places..."
[Fluxus Newsletter], unnumbered, [ca. March 1965].

COMMENTS: *Although* Five Places *is not known to exist as a separate Fluxus Edition, it appears in a number of assemblings of FLUXUS I, and is an object-like work. An envelope rubber stamped with the title and score on the outside and containing five or more cards with the text 'exhibit' on each one,*

SIX EXHIBITS

- ● ceiling
- ● first wall
- ● second wall
- ● third wall
- ● fourth wall
- ● floor

Summer, 1961

George Brecht. "Six Exhibits" from WATER YAM, a score related to FIVE PLACES

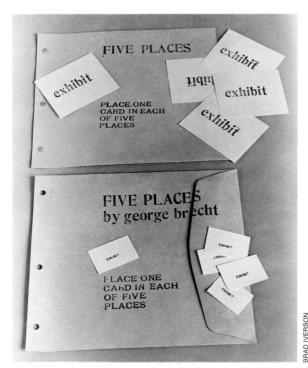

George Brecht. FIVE PLACES. Two versions included in FLUXUS 1

BRAD IVERSON

it is a precursor to individual Fluxus Editions. See also 'Six Exhibits' from Water Yam, Silverman No. 35 ff.

FLAGS

"...Will mail in 2 days a package with various Flux-goodies. But since it won't arrive in time for your Milan event take whatever you need from Villefranche, such as flags etc...."
Letter: George Maciunas to Ben Vautier, March 29, 1966.

"...You still must have a quantity of original Fluxkit flag, music box, etc. consignment, since you paid a-bout $10 for them, I assumed the rest was unsold. That's why I was in no hurry to ship to you next con-signment. You still must have $100 worth of stuff. No?..."
Letter: George Maciunas to Ken Friedman, [ca. February 1967].

PAST FLUX-PROJECTS (realized in 1966)...Flags by George Brecht...
Fluxnewsletter, March 8, 1967.

FLUX SHOW: DICE GAME ENVIRONMENT... SOME FLOOR COMPARTMENTS WITH: Flags & signs by George Brecht
Flux Fest Kit 2. [ca. December 1969].

"...Brecht flags not available anymore, sometimes I will produce a new version..."
Letter: George Maciunas to Dr. Hanns Sohm, [ca. late 1972].

Flash Art Editor, Giancarlo Politi, proposed to pub-lish the 3rd Fluxyearbook, maybe to be called FLUX-PACK 3 with the following preliminary contents:... posters, signs or wallpaper...flag by George Brecht...
Fluxnewsletter, April 1973.

03.1964 GEORGE BRECHT: flags
George Maciunas, Diagram of Historical Developments of Fluxus... [1973].

JULY 4 & 5 FLUXDAY...Flags by...George Brecht...
Proposal for Flux Fest at New Marlborough. April 8, 1977.

COMMENTS: Brecht, 1983: "The ones that were made were the ones that weren't sold...(Hermann Braun) got one...with an arrow and a razor blade."

FLOOR WITH EXPLODING PISTONS

this area for George Brecht. He has submitted very nice idea: walking on exploding pistons.
Instruction drawing for Fluxlabyrinth, Berlin. [ca. August 1976]. version B

COMMENTS: George Maciunas and Larry Miller tried to make this work for Fluxlabyrinth at the Akademie der Künste in Berlin, but were unable to.

END
ENTRY
EXIT
LOCATION
MIDDLE
NO SMOKING
START

FLUXFLAGS AND BANNERS see:
FLAGS

FLUXFURNITURE see:
RUGS

FLUX SCIENCE SHOW see:
George Brecht and George Maciunas

FLUX-WATCH see:
George Brecht and George Maciunas

FOOD

FLUXUS 1964 EDITIONS, AVAILABLE NOW ... FLUXUS caz series, OBJECTS from GEORGE BRECHT/ FLUXUS ca PENNANTS $30 &up FLAGS $ 50 &up. Bunting. Sewn legends. With staff. SIGNS, oil on canvas, mounted $25 &up sets of two $40. Available with following legends: ...food...
cc Valise e TRanglE (Fluxus Newspaper No. 3) March 1964.

3F-ca PENNANTS from GEORGE BRECHT...
FOOD...
European Mail-Orderhouse: europeanfluxshop, Pricelist. [ca. June 1964].

3F/ca PENNANTS from GEORGE BRECHT...food...
Second Pricelist - European Mail-Orderhouse. [Fall 1964].

ITEMS NOT IN STOCK, DELIVERY 1 TO 4 MONTHS...FLUXUS ca GEORGE BRECHT: pennants...food...
Vacuum TRapEzoid (Fluxus Newspaper No. 5) March 1965.

COMMENTS: This work is not known to have been made by Maciunas as a Fluxus Edition.

FORGET THIS

FLUXUS 1964 EDITIONS, AVAILABLE NOW ... FLUXUS caz series, OBJECTS from GEORGE BRECHT/ FLUXUS ca PENNANTS $30 &up FLAGS $ 50 &up. Bunting. Sewn legends. With staff. SIGNS, oil on canvas, mounted $25 &up sets of two $40. Available with following legends: ...forget this...
cc Valise e TRanglE (Fluxus Newspaper No. 3) March 1964.

3F-ca PENNANTS from GEORGE BRECHT...FORGET THIS...
European Mail-Orderhouse: europeanfluxshop, Pricelist. [ca. June 1964].

3F/ca PENNANTS from GEORGE BRECHT...forget this...
Second Pricelist - European Mail-Orderhouse. [Fall 1964].

ITEMS NOT IN STOCK, DELIVERY 1 TO 4 MONTHS ...FLUXUS ca GEORGE BRECHT: pennants...forget this...
Vacuum TRapEzoid (Fluxus Newspaper No. 5) March 1965.

May 2-8: BLUE ROOM BY JOHN & YOKO + FLUXLIARS...Other interior signs...forget this...all by George Brecht 1961
Schedule of events for Fluxfest presentation of John Lennon and Yoko Ono. [ca. April 1970]. versions A and B

FLUXFEST PRESENTATION OF JOHN LENNON & YOKO ONO + * AT 80 WOOSTER ST. NEW YORK – 1970...MAY 2-8: BLUE ROOM BY JOHN & YOKO + FLUXLIARS Entire room (floor, walls, ceiling), and furnishings were white...interior signs: Forget this...(G.Brecht '61)...
all photographs copyright nineteen seVenty by peTer MooRE (Fluxus Newspaper No.9). 1970.

COMMENTS: This work is not known to have been made by Maciunas as a Fluxus Edition pennant or flag. A sign was evidently made in 1970 for the John & Yoko Fluxfest in New York City.

FOUR FLAGS see:
ARROW
WHITE WITH WORD "FLAG"

FRONT

FLUXUS 1964 EDITIONS, AVAILABLE NOW ... FLUXUS caz series, OBJECTS from GEORGE BRECHT/ FLUXUS ca PENNANTS $30 &up FLAGS $ 50 &up. Bunting. Sewn legends. With staff. SIGNS, oil on canvas, mounted $25 &up sets of two $40. Available with following legends: ...front...
cc Valise e TRanglE (Fluxus Newspaper No. 3) March 1964.

3F-ca PENNANTS from GEORGE BRECHT...
FRONT...
European Mail-Orderhouse: europeanfluxshop, Pricelist. [ca. June 1964].

3F/ca PENNANTS from GEORGE BRECHT...front...
Second Pricelist - European Mail-Orderhouse. [Fall 1964].

ITEMS NOT IN STOCK, DELIVERY 1 TO 4 MONTHS ... FLUXUS ca GEORGE BRECHT: pennants...front...
Vacuum TRapEzoid (Fluxus Newspaper No. 5) March 1965.

COMMENTS: This work is not known to have been made by Maciunas as a Fluxus Edition.

FURNITURE

FLUXUS 1964 EDITIONS, AVAILABLE NOW ... FLUXUS caz series, OBJECTS from GEORGE BRECHT...FLUXUS ce FURNITURE (with or without additional objects) prices on request.
cc Valise e TRanglE (Fluxus Newspaper No. 3) March 1964.

3F-ce FURNITURE...prices on request
European Mail-Orderhouse: europeanfluxshop, Pricelist. [ca. June 1964].

3F-ce FURNITURE...prices on request.
Second Pricelist - European Mail-Orderhouse. [Fall 1964].

ITEMS NOT IN STOCK, DELIVERY 1 TO 4 MONTHS...FLUXUS ce GEORGE BRECHT: furniture with or without objects, prices on request.
Vacuum TRapEzoid (Fluxus Newspaper No. 5) March 1965.

03.1965 G.BRECHT: furniture...
George Maciunas, Diagram of Historical Developments of Fluxus... [1973].

COMMENTS: George Brecht made many works involving furniture, such as chairs, stools, tables, coat racks and cupboards. Although Maciunas announced many Fluxus projects for furniture, I don't believe that a Fluxus Edition of Brecht's furniture ideas was ever made. There are at least fifteen scores having to do with furniture in Water Yam *Silverman No. 35 ff. An example of a completed realization is* Chair Event *(Fluxus Etc., Addenda I, pp 31, 32.) Silverman No. < 28.III.*

CHAIR EVENT

on a white chair

a grater

tape measure

alphabet

flag

black

and spectral colors

George Brecht. "Chair Event" from WATER YAM, a score related to FURNITURE that was realized later as sculpture

FURNITURE see:
RUGS
FUTILE BOX see:
Robert Filliou
G.B[recht] EVENTS see:
WATER YAM
G. B[recht] BOX see:
WATER YAM

GAME BOX

PROPOSED FLUXSHOW FOR GALLERY 669 ...
OBJECTS, FURNITURE...Boxed events & objects -
one of a kind:...game box by George Brecht...
Fluxnewsletter, December 2, 1968.

COMMENTS: *The Fluxshow for Gallery 669 in Los Angeles
was not realized. The work would have been a large partici-
pation-type box, possibly based on the concepts of* Games &
Puzzles. *Several different large-sized boxes of various artists'
works were made by Maciunas for exhibitions during the
1970s.*

GAMES see:
DECK
GAMES & PUZZLES
LITTLE REBUS - WISH
NUT BONE
UNIVERSAL MACHINE II
VALOCHE/ A TRAVEL AID

GAMES & PUZZLES

Silverman Nos. 49; 51; > 51.I; 53; 54; 55; > 55.I;
56; 57

"...P.S. You should print labels for...Brecht Game
& Puzzle box...reproduce my labels. I am sending a
few of them. But I do not have enough..."
*Letter: George Maciunas to Willem de Ridder. [March 2,
1965].*

"...I mailed by parcel post - one carton with fol-
lowing:... 6 Brecht ball games...Wholesale cost to
you each [$] 1 suggested selling price sub total——
wholesale cost to you [$] 6—..."
Letter: George Maciunas to Ken Friedman, August 19, 1966.

games & puzzles $3...by george brecht
Fluxshopnews. [Spring 1967].

FLUXYEARBOX 2, May 1968 Games by George
Brecht...
Flux Fest Kit 2. [ca. December 1969].

02.1964...GEORGE BRECHT:...games prototypes
*George Maciunas, Diagram of Historical Developments of
Fluxus... [1973].*

"...I will also include labels and some completed
boxes of...Brecht puzzles...Do you think you can
sell them?"
Letter: George Maciunas to Ben Vautier, October 18, 1977.

COMMENTS: *This is a general listing for* Games & Puzzles.
See also George Brecht's Valoche *which was originally listed
as part of the* Games & Puzzles *series. At least one prototype
(Silverman No. 75) exists using the* Games & Puzzles *label.
The group of works in the Silverman Collection listed above,
are all combinations of the* Games & Puzzles *concepts within
one box. For example, Silverman No. 51 is* Games & Puzzles/
Swim Puzzle/ Ball Puzzle/ Inclined Plane Puzzle, *and contains
the scores for each. Where only one score is included in a
boxed edition, it is then listed in this book under* Games &
Puzzles/ [title of score].

GAMES & PUZZLES/BALL BOX and
GAMES & PUZZLES/BALL GAME see:
VALOCHE/A FLUX TRAVEL AID

GAMES & PUZZLES/ BALL PUZZLE

Silverman Nos. 46; < 49.II

FLUXKIT containing following fluxus-publications:
(also available separately)...FLUXUS cl1 BALL PUZ-
ZLE, by George Brecht, $3
cc fiVe ThReE (Fluxus Newspaper No. 4) June 1964.

FLUXKIT containing following fluxus-publications:
...ball puzzle by George Brecht...
Second Pricelist - European Mail-Orderhouse. [Fall 1964].

FLUXKIT...(also available separately)...FLUXUS
c1 GEORGE BRECHT: ball puzzle ea $3
Vacuum TRapEzoid (Fluxus Newspaper No. 5) March 1965.

GAMES FLUXUS cl1 GEORGE BRECHT: ball puz-
zle, $3
ibid.

FLUXKIT...(also available separately)...FLUXUS c1
GEORGE BRECHT: ball puzzles, each $4
Vaseline sTREet (Fluxus Newspaper No. 8) May 1966.

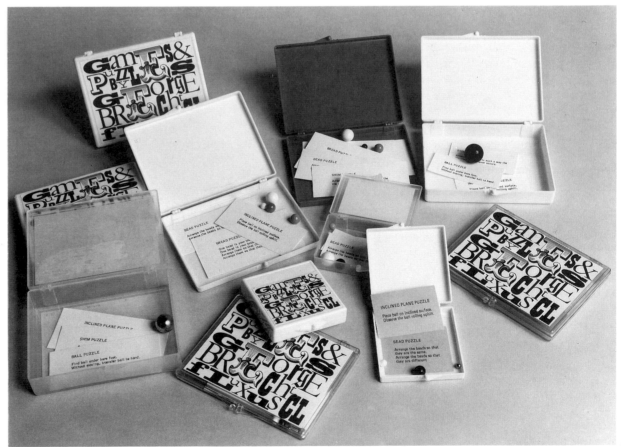

George Brecht. GAMES & PUZZLES

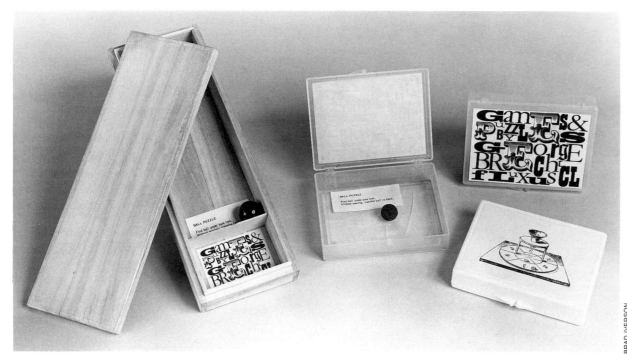

George Brecht. GAMES & PUZZLES/BALL PUZZLE

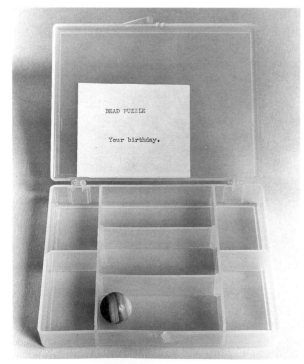

George Brecht. GAMES & PUZZLES/BEAD PUZZLE

FLUXGAMES/FLUXUS c1 GEORGE BRECHT: ball puzzle $4
ibid.

FLUX-PRODUCTS 1961 TO 1969 ... GEORGE BRECHT...Ball puzzle... each [$] 3 [also included in FLUXKIT]
Fluxnewsletter, December 2, 1968 (revised March 15, 1969).

FLUX-PRODUCTS 1961 TO 1970 ... GEORGE BRECHT...Puzzles: Ball ea: [$] 3
Flux Fest Kit 2. [ca. December 1969].

FLUXUS - EDITIONEN ... [Catalogue No.] 728 GEORGE BRECHT:...ball puzzle
Happening & Fluxus. Koelnischer Kunstverein, 1970.

Toilet No. 3 Joe Jones...toilet bowl display...George Brecht ball puzzle: Balls secured by string. Instructions on bottom.
Fluxnewsletter, April 1973.

03.1965 ... 1ST GAMES & PUZZLES:...GEORGE BRECHT: ball puzzles...
George Maciunas, Diagram of Historical Developments of Fluxus... [1973].

GEORGE BRECHT Puzzles: ball...$4
Flux Objects, Price List. May 1976.

COMMENTS: *Although Maciunas advertised Ball Puzzle in Fluxus publications, into the 1970s, the two examples in the Silverman Collection seem to be very early assemblings of the work. They differ significantly: one is a box containing a steel ball bearing; the other is a balsa wood box containing a plastic ball. Both works date from ca. 1965. I have not seen any later assemblings.*

GAMES & PUZZLES/ BEAD PUZZLE
Silverman Nos. 48; 60

...Individuals in Europe, the U.S. and Japan have discovered each other's work...and have grown objects and events which are original, and often uncategorizable, in a strange new way:...George Brecht's BEAD PUZZLE: "Your birthday."
George Brecht, "Something About Fluxus," cc fiVe ThReE (Fluxus Newspaper No. 4) June 1964.

GAMES...FLUXUS cl4 GEORGE BRECHT bead puzzle, $3
Vacuum TRapEzoid (Fluxus Newspaper No. 5) March 1965.

FLUXGAMES FLUXUS c4...GEORGE BRECHT: bead puzzle $4
Vaseline sTREet (Fluxus Newspaper No. 8) May 1966.

FLUX-PRODUCTS 1961 TO 1969 ... GEORGE BRECHT...bead puzzle...each: * [$] 3 [indicated as part of FLUXKIT]
Fluxnewsletter, December 2, 1968 (revised March 15, 1969).

FLUX-PRODUCTS 1961 TO 1970 ... GEORGE BRECHT...Puzzles:...bead... ea: [$] 3
Flux Fest Kit 2. [ca. December 1969].

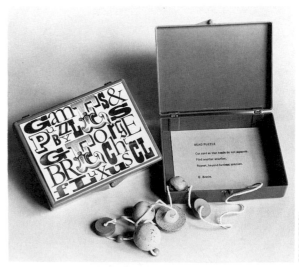

George Brecht. GAMES & PUZZLES/BEAD PUZZLE

FLUXUS - EDITIONEN ... [Catalogue No.] 729 GEORGE BRECHT:...bead puzzle

Happening & Fluxus. Koelnischer Kunstverein, 1970.

03.1965 1ST GAMES & PUZZLES: GEORGE BRECHT:...bead puzzle...

George Maciunas, Diagram of Historical Developments of Fluxus... [1973].

GEORGE BRECHT...Bead Puzzle $8

Flux Objects, Price List. May 1976.

COMMENTS: *Bead Puzzle is included in several of the grouped* Games & Puzzles. *There are at least three different scores for this work. The score for Silverman No. 48, a unique example, reads: "Bead Puzzle/ Your birthday." Silverman No. 53 (an edition containing three different games & puzzles) reads: "Bead Puzzle/Arrange the beads so that they are the same./Arrange the beads so that they are different." And the score in Silverman No. 60 reads: "Bead Puzzle/ Cut cards so that beads do not separate./ Find another solution./ Repeat, beyond farthest solution./ G.Brecht." The objects in this version are radically different from the previous two.*

GAMES & PUZZLES/BLACK BALL PUZZLE

Silverman No. 52

"Replies to your questions...black ball puzzle——go into game & puzzle boxes..."

Letter: George Maciunas to Willem de Ridder, March 2, 1965.

GAMES...FLUXUS cl6 GEORGE BRECHT: black ball puzzle $3

Vacuum TRapEzoid (Fluxus Newspaper No. 5) March 1965.

FLUXGAMES...FLUXUS c6 GEORGE BRECHT: black ball puzzle $4

Vaseline sTREet (Fluxus Newspaper No. 8) May 1966.

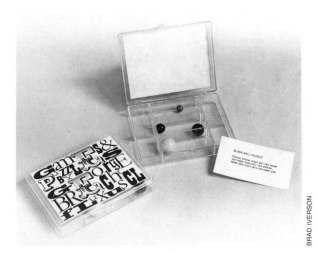

George Brecht. **GAMES & PUZZLES/BLACK BALL PUZZLE**

"...I mailed by parcel post-one carton with following: ...2 Brecht-black balls Wholesale cost to you $1 suggested selling price $2 sub total——wholesale cost to you 2—..."

Letter: George Maciunas to Ken Friedman, August 19, 1966.

FLUX-PRODUCTS 1961 TO 1969 ... GEORGE BRECHT...Black ball puzzle,...boxed * [$] 5 [indicated as part of FLUXKIT]

Fluxnewsletter, December 2, 1968 (revised March 15, 1969).

FLUX-PRODUCTS 1961 TO 1970 ... GEORGE BRECHT...Black ball puzzle...each: [$] 5

Flux Fest Kit 2. [ca. December 1969].

FLUXUS - EDITIONEN ... [Catalogue No.] 726 GEORGE BRECHT:...black ball puzzle

Happening & Fluxus. Koelnischer Kunstverein, 1970.

COMMENTS: *The scores are also included in a grouped* Games & Puzzles *edition, however,* Black Ball Puzzle *appears less frequently.*

GAMES & PUZZLES/BOARD GAMES

FLUXUS 1964 EDITIONS, AVAILABLE NOW ... FLUXUS caz series, OBJECTS from GEORGE BRECHT...FLUXUS cl GAMES AND PUZZLES... BOARD GAMES, with rules $150...All games and puzzles invented and made to order, no two alike.

cc Valise e TRanglE (Fluxus Newspaper No. 3) March 1964.

3F-cl GAMES AND PUZZLES...board games (with rules) $150...(all games and puzzles invented and made to order, no two alike)

European Mail-Orderhouse: europeanfluxshop, Pricelist. [ca. June 1964].

3F-cl GAMES AND PUZZLES...board games (with rules) $150...(all games and puzzles invented and made to order)

Second Pricelist - European Mail-Orderhouse. [Fall 1964].

ITEMS NOT IN STOCK, DELIVERY 1 TO 4 MONTHS...FLUXUS cl GEORGE BRECHT...board games $100

Vacuum TRapEzoid (Fluxus Newspaper No. 5) March 1965.

COMMENTS: *Brecht, 1983: "...Nobody ever subscribed to those..."*
 This work is not known to have been made by Maciunas as a Fluxus Edition.

GAMES & PUZZLES/BREAD PUZZLE

Silverman No. 50

"Replies to your questions...Bread puzzle——go into game & puzzle boxes..."

Letter: George Maciunas to Willem de Ridder, March 2, 1965.

GAMES...FLUXUS c15 GEORGE BRECHT: bread puzzle, $3

Vacuum TRapEzoid (Fluxus Newspaper No. 5) March 1965.

FLUXGAMES...FLUXUS c5 GEORGE BRECHT: bread puzzle $4

Vaseline sTREet (Fluxus Newspaper No. 8) May 1966.

FLUX-PRODUCTS 1961 TO 1969 ... GEORGE BRECHT...bread puzzle...each: [$] 3 [also indicated as part of FLUXKIT]

Fluxnewsletter, December 2, 1968 (revised March 15, 1969).

FLUX-PRODUCTS 1961 TO 1970 ... GEORGE BRECHT...Puzzles:...bread...ea: [$] 3

Flux Fest Kit 2. [ca. December 1969].

COMMENTS: *The score is also included in some of the grouped* Games & Puzzles *editions.*

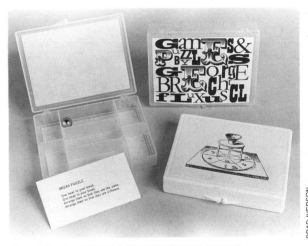

George Brecht. **GAMES & PUZZLES/BREAD PUZZLE**

GAMES & PUZZLES/CARD GAMES

FLUXUS 1964 EDITIONS, AVAILABLE NOW ... FLUXUS caz series, OBJECTS from GEORGE BRECHT...FLUXUS cl GAMES AND PUZZLES CARD GAMES, with rules $100...All games and puzzles invented and made to order, no two alike.

cc Valise e TRanglE (Fluxus Newspaper No. 3) March 1964.

3F-cl GAMES AND PUZZLES/ card games (with rules) $100....no two alike

European Mail-Orderhouse: europeanfluxshop, Pricelist. [ca. June 1964].

3F-cl GAMES AND PUZZLES/ card games (with rules) $100....made to order

Second Pricelist - European Mail-Orderhouse. [Fall 1964].

ITEMS NOT IN STOCK, DELIVERY 1 TO 4 MONTHS...FLUXUS cl GEORGE BRECHT: card games $100
Vacuum TRapEzoid (Fluxus Newspaper No. 5) March 1965.

COMMENTS: Brecht, 1983: "One was shown in [the] Towards Events show [Reuben Gallery, N.Y.C. 1959]...it's illustrated in [Henry] Martin's book [An Introduction to George Brecht's]...I adapted Solitaire rules and made a new game. The title of the work is Solitaire."

It would seem that Deck (Silverman No. 69 ff.) is a conceptual evolution of Brecht's original Card Games idea, although Maciunas did not use the Games & Puzzles label for the Fluxus Edition.

GAMES & PUZZLES/INCLINED PLANE PUZZLE
Silverman Nos. 47; < 49.1

GAMES...FLUXUS c17 GEORGE BRECHT: inclined plane puzzle in plastic box, $3
Vacuum TRapEzoid (Fluxus Newspaper No. 5) March 1965.

FLUXGAMES...FLUXUS c7 GEORGE BRECHT: inclined plane puzzle, all boxed $4
Vaseline sTREet (Fluxus Newspaper No. 8) May 1966.

FLUX-PRODUCTS 1961 TO 1969 ... GEORGE BRECHT...inclined plane puzzle...each: [$] 3 [Also indicated as part of FLUXKIT]
Fluxnewsletter, December 2, 1968 (revised March 15, 1969).

FLUX-PRODUCTS 1961 TO 1970 ... GEORGE BRECHT...Puzzles: incline, ea: [$] 3
Flux Fest Kit 2. [ca. December 1969].

FLUXUS - EDITIONEN ... [Catalogue No.] 731 GEORGE BRECHT:...inclined plane puzzle
Happening & Fluxus. Koelnischer Kunstverein, 1970.

GEORGE BRECHT Puzzles:...incline...$4
Flux Objects, Price List. May 1976.

COMMENTS: The score is also included in several of the Games & Puzzles editions that contain several different scores.

GAMES & PUZZLES/NAME KIT
Silverman No. 61, ff.

"Replies to your questions...Name Kit...–– go into game & puzzle boxes..."
Letter: George Maciunas to Willem de Ridder, March 2, 1965.

GAMES...FLUXUS cl2 GEORGE BRECHT: name kit, $4
Vacuum TRapEzoid (Fluxus Newspaper No. 5) March 1965.

FLUXKIT containing following fluxus-productions:

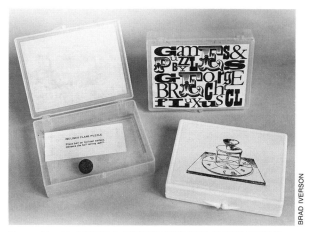

George Brecht. GAMES & PUZZLES/INCLINED PLANE PUZZLE

(also available separately)...FLUXUS c2 GEORGE BRECHT: name kit $4
ibid.

FLUXGAMES...FLUXUS c2 GEORGE BRECHT: name kit $5
Vaseline sTREet (Fluxus Newspaper No. 8) May 1966.

FLUXKIT containing following fluxus-productions: (also available separately)...FLUXUS c2 GEORGE BRECHT: name kit $5
ibid.

"...I mailed by parcel post-one carton with following: ...2 Brecht name kits...wholesale cost to you. each $2 suggested selling price $4 sub total––wholesale cost to you. 4.–..."
Letter: George Maciunas to Ken Friedman, August 19, 1966.

namekit $4.50...by george brecht
Fluxshopnews. [Spring 1967].

FLUX-PRODUCTS 1961 TO 1969 ... GEORGE BRECHT...name kit [$] 5 [Also indicated as part of FLUXKIT]
Fluxnewsletter, December 2, 1968 (revised March 15, 1969).

FLUX-PRODUCTS 1961 TO 1970 ... GEORGE BRECHT...name kit, each: [$] 5
Flux Fest Kit 2. [ca. December 1969].

FLUXUS - EDITIONEN ... [Catalogue No.] 727 GEORGE BRECHT:...name kit
Happening & Fluxus. Koelnischer Kunstverein, 1970.

03.1965 ... 1ST GAMES & PUZZLES: GEORGE BRECHT:...name kit...
George Maciunas, Diagram of Historical Developments of Fluxus... [1973].

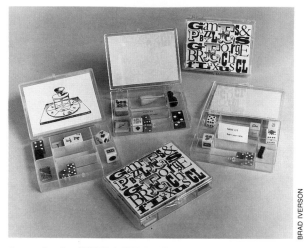

George Brecht. GAMES & PUZZLES/NAME KIT

GEORGE BRECHT...Name Kit $8
Flux Objects, Price List. May 1976.

COMMENTS: George Maciunas adopted a variation of this idea for his own work, Name Kit Box "Your name spelled with objects" (Silverman No. 271, ff.). However, in Maciunas' work, the objects have a specific identity and the first letter of this identity is assigned to the letter in the individual's name for whom the kit was made. In the Fluxus Edition of Brecht's work, the objects have elements of mystery and chance, and are not usually specific letter-connected objects.

GAMES & PUZZLES/PUZZLES

FLUXUS 1964 EDITIONS, AVAILABLE NOW ... FLUXUS caz series, OBJECTS from GEORGE BRECHT...FLUXUS cl GAMES AND PUZZLES... PUZZLES, easy and difficult $150 All games and puzzles invented and made to order, no two alike.
cc Valise e TRanglE (Fluxus Newspaper No. 3) March 1964.

3F-cl GAMES AND PUZZLES...puzzles...(no two alike)
European Mail-Orderhouse: europeanfluxshop, Pricelist. [ca. June 1964].

3F-cl...puzzles, easy and difficult $3 & up (all games and puzzles invented and made to order)
European Mail-Orderhouse: europeanfluxshop, Pricelist. With holograph notes from George Maciunas to Willem de Ridder. [ca. Summer 1964].

3F-cl GAMES AND PUZZLES...puzzles...$3 & up (...made to order)
Second Pricelist - European Mail-Orderhouse. [Fall 1964].

COMMENTS: Puzzles is not known to have been made by Maciunas as a Fluxus Edition. However, Valoche (Silverman Nos. 75 ff.) would seem to grow out of this idea and is a more expensive "no two alike" work.

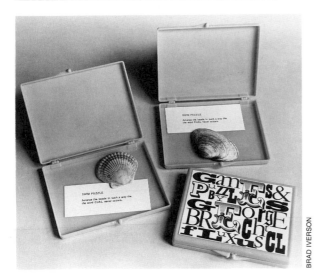

BRAD IVERSON

George Brecht. GAMES & PUZZLES/SWIM PUZZLE

GAMES & PUZZLES/SWIM PUZZLE

Silverman Nos. 58; 58a.; 59

"Replies to your questions...swim puzzles...—— go into games & puzzle boxes..."
Letter: George Maciunas to Willem de Ridder, March 2, 1965.

GAMES...FLUXUS cl3 GEORGE BRECHT: swim puzzle, $3
Vacuum TRapEzoid (Fluxus Newspaper No. 5) March 1965.

FLUXGAMES...FLUXUS c3 GEORGE BRECHT: swim puzzle $4
Vaseline sTREet (Fluxus Newspaper No. 8) May 1966.

FLUX-PRODUCTS 1961 TO 1969 ... GEORGE BRECHT...swim puzzle...each: [$] 3 [Also indicated as part of FLUXKIT]
Fluxnewsletter, December 2, 1968 (revised March 15, 1969).

FLUX-PRODUCTS 1961 TO 1970 ... GEORGE BRECHT...Puzzles:...swim...ea: [$] 3
Flux Fest Kit 2. [ca. December 1969].

FLUXUS - EDITIONEN ... [Catalogue No.] 730 GEORGE BRECHT:...swim puzzle
Happening & Fluxus. Koelnischer Kunstverein, 1970.

GEORGE BRECHT Puzzles:...swim...$4
Flux Objects, Price List. May 1976.

COMMENTS: *The examples in the Silverman Collection contain seashells (a clamshell or a scallop shell). An example in the Archive Hanns Sohm, Staatsgalerie Stuttgart, contains a snail shell. When the score is included in a* Games & Puzzles *edition containing more than one score, only balls are included and not shells.*

George Maciunas speaks of the work in an interview with

Larry Miller 1978: "G.M.: Ball and quiz puzzles...a box that contained a shell, seashell, and the text says, 'Arrange the beads in such a way that the word "C-U-A-L" never occurs.'
L.M.: The word which?
G.M.: C-U-A-L
L.M.: C-U-A-L
G.M.: Never occurs. It would not occur anyway. They are shells, not beads. Very mysterious puzzles. (both laugh)..."
(Published in Fluxus etc./Addenda I, *pp. 11 - 28).*

GLASS

FLUXUS 1964 EDITIONS, AVAILABLE NOW ... FLUXUS caz series, OBJECTS from GEORGE BRECHT...FLUXUS ci DOOR EVENTS (...glass...) made to order.
cc Valise e TRanglE (Fluxus Newspaper No. 3) March 1964.

3F-ci DOOR EVENTS (...glass...) Handwritten catalog, illustrated $10
European Mail-Orderhouse: europeanfluxshop, Pricelist. [ca. June 1964].

3F-ci DOOR EVENTS (...glass...). Handwritten catalog, illustrated, $10
Second Pricelist - European Mail-Orderhouse. [Fall 1964].

ITEMS NOT IN STOCK, DELIVERY 1 TO 4 MONTHS...FLUXUS ci GEORGE BRECHT, door events:...glass, etc. prices on request
Vacuum TRapEzoid (Fluxus Newspaper No. 5) March 1965.

COMMENTS: Glass *is not known to have been made by Maciunas as a Fluxus Edition.*

HAND WOVEN RUGS see:
 RUGS
HAND WRITTEN CATALOGUE, ILLUSTRATED see:
 CLOTHING
 DOOR EVENTS
 RUGS

HARDWARE

FLUX-OBJECTS...03.1965 G.BRECHT:...hardware...
George Maciunas, Diagram of Historical Developments of Fluxus... [1973].

COMMENTS: *Hardware, as listed under* FLUXUS caz series, FLUXUS cf, *is really a descriptive title. See the cross references for Hardware.*

HARDWARE see:
 BOLTS
 BROOMS

BRUSHES
HOUSE NUMBERS
LATCHES
LOCKS
NAILS
SCREWS
TOILET FLOATS
TOOLS

HOUSE NUMBERS

FLUXUS 1964 EDITIONS, AVAILABLE NOW ... FLUXUS caz series, OBJECTS from GEORGE BRECHT...FLUXUS cf HARDWARE, supplied as-is, ready for use ($1 &up)...house numbers...mounted, where practical ($5 & up)
cc Valise e TRanglE (Fluxus Newspaper No. 3) March 1964.

3F-cf HARDWARE...housenumbers...(mounted where practical $5 and up)
European Mail-Orderhouse: europeanfluxshop, Pricelist. [ca. June 1964].

3F-cf HARDWARE...housenumbers...$1 and up (mounted).
Second Pricelist - European Mail-Orderhouse. [Fall 1964].

ITEMS NOT IN STOCK, DELIVERY 1 TO 4 MONTHS...FLUXUS cf GEORGE BRECHT: hardware...house numbers...
Vacuum TRapEzoid (Fluxus Newspaper No. 5) March 1965.

COMMENTS: *This work is not known to have been made by Maciunas as a Fluxus Edition. There is a score in* Water Yam *(Silverman No. 35 ff.) titled "Exhibit Seven (clock)."*

EXHIBIT SEVEN (CLOCK)

● house number

Summer, 1961

Score from WATER YAM incorporating one concept of George Brecht's HOUSE NUMBERS

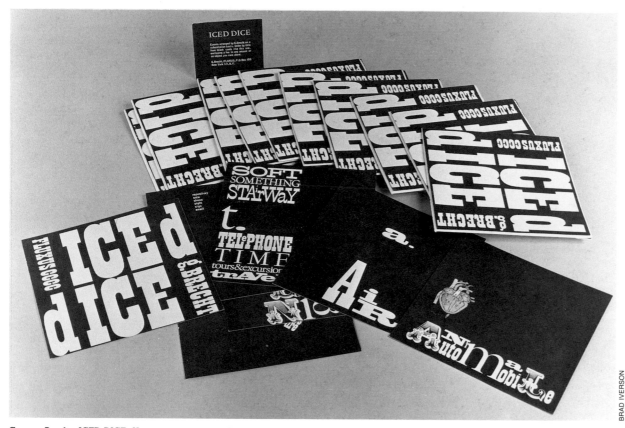

George Brecht. ICED DICE. Numerous copies, with the advertising card from WATER YAM in the background

BRAD IVERSON

Delivery Event...*you could write to me and things would be delivered...Nobody subscribed."*

I have never seen this work packaged by George Maciunas and it's not clear whether he intended to make a boxed edition of it or somehow insert the cards either into Water Yam or some other anthological publication. Willem de Ridder packaged the cards in an envelope with the title card glued on the front (Silverman No. 43a, ff.).

INCLINED PLANE PUZZLE see:
GAMES AND PUZZLES/INCLINED PLANE PUZZLE

KEYHOLE

"Paik has exhibit for next 2 weeks at Wuppertal where I was yesterday - I got one room for Fluxus... In that room I also set various cards of George Brecht ...keyhole over keyhole...We thought in future to integrate our festivals with these 'exhibits'..."
Letter: George Maciunas to Robert Watts, [March 11 or 12, 1963].

COMMENTS: *The work referred to above is a score from* Water Yam *installed by Maciunas a part of the Fluxus exhibition during Paik's Exposition of Music/Electronic Television, at Galerie Parnass, Wuppertal, West Germany in 1963.*
Brecht, 1983: "I once made a little white piece of wood. Again, with two kinds of keyholes—a brass keyhole on one side, a blank metal keyhole on the other, with naturally a hole through the center."

ICED DICE
Silverman No. 43, ff.

FLUXUS 1964 EDITIONS, AVAILABLE NOW ... FLUXUS cc cc ICED DICE, event prospectus $3
cc Valise e TRanglE (Fluxus Newspaper No. 3) March 1964.

2F/cc cc ICED DICE...
European Mail-Orderhouse: europeanfluxshop, Pricelist. [ca. June 1964].

2F/cc cc ICED DICE...
Second Pricelist - European Mail-Orderhouse. [Fall 1964].

"ICED DICE/Events arranged by G.Brecht on a subscription basis. Order by title from black cards like this one, enclosing a fee in any amount or an object you care about. G.Brecht, FLUXUS, P.O. Box 180 New York 13, N.Y."
George Brecht, Water Yam. Advertisement card: "Iced Dice." 1964.

"...Put...iced dice...into Brecht box: ..."
Letter: George Maciunas to Willem de Ridder, February 4, 1965.

FLUXKIT containing following fluxus-publications: (also available separately)...FLUXUS cc cc GEORGE BRECHT: Iced dice, event prospectus (menu cards) $3
Vacuum TRapEzoid (Fluxus Newspaper No. 5) March 1965.

FLUXKIT containing following fluxus-publications: (also available separately)...FLUXUS cccc GEORGE BRECHT: iced dice, event prospectus (menu cards) $3
Vaseline sTREet (Fluxus Newspaper No. 8) May 1966.

FLUX-PRODUCTS 1961 TO 1969 ... GEORGE BRECHT...Iced Dice, (menu cards) [indicated as part of FLUXKIT]
Fluxnewsletter, December 2, 1968 (revised March 15, 1969).

FLUX-PRODUCTS 1961 TO 1970 ... GEORGE BRECHT...Iced Dice, menu cards [$] 3
Flux Fest Kit 2. [ca. December 1969].

COMMENTS: Brecht, 1983: "...Around '63...The original idea was that all the words on there the people could subscribe to. So if it said "Dry Cleaning" you would get in touch with me and tell me what you wanted dry cleaned and I would have it dry cleaned for you as an artwork...related to

KEYHOLE

through **either** side

George Brecht. KEYHOLE

KOAN see:
A QUESTION OR MORE
LABYRINTH see:
FLOOR WITH EXPLODING PISTONS

LADDERS

FLUXUS 1964 EDITIONS, AVAILABLE NOW ... FLUXUS caz series, OBJECTS from GEORGE BRECHT/ FLUXUS cg LADDERS, wood ($40),

LADDER

● Paint a single straight ladder white

Paint the bottom rung black.

Distribute spectral colors on the rungs between

George Brecht. "Ladder" from WATER YAM

specially painted or otherwise prepared ($150)
cc Valise e TRanglE (Fluxus Newspaper No. 3) March 1964.

3F-cg LADDERS, wood, $40. specially painted or otherwise prepared $150
European Mail-Orderhouse: europeanfluxshop, Pricelist. [ca. June 1964].

3F-cg LADDERS, wood, $40. specially painted or otherwise prepared $150
Second Pricelist - European Mail-Orderhouse. [Fall 1964].

ITEMS NOT IN STOCK, DELIVERY 1 TO 4 MONTHS...FLUXUS cg GEORGE BRECHT: ladders, wood $40 specially painted or otherwise prepared,... $150
Vacuum TRapEzoid (Fluxus Newspaper No. 5) March 1965.

FLUX-OBJECTS:...03.1965...G.BRECHT:...ladder...
George Maciunas, Diagram of Historical Developments of Fluxus... [1973].

COMMENTS: *This work is not known to have been made by Maciunas as a Fluxus Edition, but the score for ladder is included in* Water Yam *(Silverman No. 35,ff.). Two ladders are illustrated in Henry Martin,* An Introduction to George Brecht's, *pp. 102 and 158.*

LATCHES

FLUXUS 1964 EDITIONS, AVAILABLE NOW ... FLUXUS caz series, OBJECTS from GEORGE BRECHT...FLUXUS cf HARDWARE, supplied as-is, ready for use ($1 &up)...latches...mounted, where practical ($5 & up)
cc Valise e TRanglE (Fluxus Newspaper No. 3) March 1964.

3F-cf HARDWARE...latches...
European Mail-Orderhouse: europeanfluxshop, Pricelist. [ca. June 1964].

3F-cf HARDWARE...latches...$1 and up (mounted).
Second Pricelist - European Mail-Orderhouse. [Fall 1964].

ITEMS NOT IN STOCK, DELIVERY 1 TO 4 MONTHS...FLUXUS cf GEORGE BRECHT: hardware...latches...
Vacuum TRapEzoid (Fluxus Newspaper No. 5) March 1965.

COMMENTS: *This work is not known to have been made by Maciunas as a Fluxus Edition.*

LIGHT EVENT see:
 THREE LAMP EVENTS

LIMIT

FLUXUS 1964 EDITIONS, AVAILABLE NOW ... FLUXUS caz series, OBJECTS from GEORGE BRECHT/FLUXUS ca PENNANTS $30 &up FLAGS $ 50 &up. Bunting. Sewn legends. With staff. SIGNS, oil on canvas, mounted $25 &up sets of two $40. Available with following legends:...limit...
cc Valise e TRanglE (Fluxus Newspaper No. 3) March 1964.

3F-ca PENNANTS from GEORGE BRECHT...LIMIT...
European Mail-Orderhouse: europeanfluxshop, Pricelist. [ca. June 1964].

3F/ca PENNANTS from GEORGE BRECHT...limit...
Second Pricelist - European Mail-Orderhouse. [Fall 1964].

ITEMS NOT IN STOCK, DELIVERY 1 TO 4 MONTHS...FLUXUS ca GEORGE BRECHT: pennants...limit...
Vacuum TRapEzoid (Fluxus Newspaper No. 5) March 1965.

COMMENTS: *This work is not known to have been made by Maciunas as a Fluxus Edition.*

LISTEN

FLUXUS 1964 EDITIONS, AVAILABLE NOW ... FLUXUS caz series, OBJECTS from GEORGE BRECHT/ FLUXUS ca PENNANTS $30 &up FLAGS $ 50 &up. Bunting. Sewn legends. With staff. SIGNS, oil on canvas, mounted $25 &up sets of two $40. Available with following legends:...listen...
cc Valise e TRanglE (Fluxus Newspaper No. 3) March 1964.

3F-ca PENNANTS from GEORGE BRECHT...LISTEN...
European Mail-Orderhouse: europeanfluxshop, Pricelist. [ca. June 1964].

3F/ca PENNANTS from GEORGE BRECHT...listen...
Second Pricelist - European Mail-Orderhouse. [Fall 1964].

ITEMS NOT IN STOCK, DELIVERY 1 TO 4 MONTHS...FLUXUS ca GEORGE BRECHT: pennants...listen...
Vacuum TRapEzoid (Fluxus Newspaper No. 5) March 1965.

MAY 2-8: BLUE ROOM BY JOHN & YOKO + FLUXLIARS...Other interior signs...listen (no sound),... all by George Brecht 1961
Schedule of events for Fluxfest presentation of John Lennon and Yoko Ono. [ca. April 1970]. versions A and B

FLUXFEST PRESENTATION OF JOHN LENNON & YOKO ONO + * AT 80 WOOSTER ST. NEW YORK — 1970...MAY 2-8: BLUE ROOM BY JOHN & YOKO + FLUXLIARS Entire room (floor, walls, ceiling), and furnishings were white...interior signs:... Listen... (G.Brecht '61)...
all photographs copyright nineteen seVenty by peTer mooRE (Fluxus Newspaper No.9) 1970.

COMMENTS: *This work is not known to have been made by Maciunas as a Fluxus Edition pennant or flag. A sign may have been made in 1970 for the John & Yoko Fluxfest in New York City.*

THE LITTLE REBUS-WISH

FLUX-PROJECTS PLANNED FOR 1967...George Brecht:...The little rebus-wish (game puzzle)...
Fluxnewsletter, March 8, 1967.

COMMENTS: *This work is not known to have been made by Maciunas as a Fluxus Edition. Addi Koepcke worked with rebuses and they are listed as Fluxus Editions in the early Fluxus publications.*

LOCATION

FLUXUS 1964 EDITIONS, AVAILABLE NOW ... FLUXUS caz series, OBJECTS from GEORGE BRECHT/ FLUXUS ca PENNANTS $30 &up FLAGS $ 50 &up. Bunting. Sewn legends. With staff. SIGNS, oil on canvas, mounted $25 &up sets of two $40. Available with following legends:...location...
cc Valise e TRanglE (Fluxus Newspaper No. 3) March 1964.

3F-ca PENNANTS from GEORGE BRECHT...LOCATION...
European Mail-Orderhouse: europeanfluxshop, Pricelist. [ca. June 1964].

3F/ca PENNANTS from GEORGE BRECHT...location...
Second Pricelist - European Mail-Orderhouse. [Fall 1964].

ITEMS NOT IN STOCK, DELIVERY 1 TO 4 MONTHS ...FLUXUS ca GEORGE BRECHT: pennants...location...
Vacuum TRapEzoid (Fluxus Newspaper No. 5) March 1965.

FLUXFLAGS AND BANNERS ea. $25/ 28" square, sewnlegends, double bunting, readable both sides, grommets at corners FLUXUS ca GEORGE BRECHT: wi following legends:...blue on yellow: "location"
Vaseline sTREet (Fluxus Newspaper No. 8) May 1966.

George Brecht. LOCATION. Mechanical by George Maciunas for an unrealized Fluxus Edition

FLUXFURNITURE...RUGS George Brecht:..."location"...woven...4ft.x4ft. $150, 8ft.x8ft. $300.... Available in N.Y.C. at Multiples and late in 1967 at FLUXSHOP, 18 GREENE ST.
Fluxfurniture, pricelist. [1967].

MAY 2-8: BLUE ROOM BY JOHN & YOKO + FLUXLIARS ...Other interior signs:...location...all by George Brecht 1961
Schedule of events for Fluxfest presentation of John Lennon and Yoko Ono. [ca. April 1970]. versions A and B

FLUXFEST PRESENTATION OF JOHN LENNON & YOKO ONO + * AT 80 WOOSTER ST. NEW YORK — 1970 ...MAY 2-8: BLUE ROOM BY JOHN & YOKO + FLUXLIARS Entire room (floor, walls, ceiling), and furnishings were white...interior signs:... Location...(G.Brecht'61)...
all photographs copyright nineteen seVenty by peTer mooRE (Fluxus Newspaper No. 9) 1970.

COMMENTS: *This work is not known to have been made by Maciunas as a Fluxus Edition pennant, flag, banner, or rug. A study for a flag does exist, and a sign was evidently made in 1970 for the John & Yoko Fluxfest in New York City. See also* Relocation.

LOCATOR CLOTHING see:
 CLOTHING
LOCATOR RUGS see:
 RUGS

LOCATOR SIGNS

FLUXUS 1964 EDITIONS, AVAILABLE NOW ... FLUXUS caz series, OBJECTS from GEORGE BRECHT... FLUXUS ch LOCATOR SIGNS. Oil on canvas, with directions for use. 6"x6", 12"x12" & 18"x18" ($35). Larger sizes on request
cc Valise e TRanglE (Fluxus Newspaper No. 3) March 1964.

3F-ch LOCATOR SIGNS...(larger sizes on request)
European Mail-Orderhouse: europeanfluxshop, Pricelist. [ca. June 1964].

3F-ch LOCATOR SIGNS...(larger sizes on request)
Second Pricelist - European Mail-Orderhouse. [Fall 1964].

ITEMS NOT IN STOCK, DELIVERY 1 TO 4 MONTHS ...FLUXUS ch GEORGE BRECHT: locator signs...$35
Vacuum TRapEzoid (Fluxus Newspaper No. 5) March 1965.

COMMENTS: *This work is not known to have been made by Maciunas as a Fluxus Edition, however it relates to Brecht's* Direction. *In the mid-1970s, George Maciunas and Larry Miller worked on different ideas for road signs; one example by Larry Miller,* Either/Either, *is reproduced in* Fluxus Etc., Addenda II, *p. 277.*

LOCKS

FLUXUS 1964 EDITIONS, AVAILABLE NOW ... FLUXUS caz series, OBJECTS from GEORGE BRECHT...FLUXUS ci DOOR EVENTS (...locks...) made to order.
cc Valise e TRanglE (Fluxus Newspaper No. 3) March 1964.

FLUXUS cf HARDWARE, supplied as-is, ready for use ($1 & up)...locks...mounted where practical ($5 & up)
ibid.

3F-ci DOOR EVENTS (...locks...) Handwritten catalog, illustrated, $10
European Mail-Orderhouse: europeanfluxshop, Pricelist. [ca. June 1964].

3F-cf HARDWARE...locks...
ibid.

3F-ci DOOR EVENTS, (...locks...) Handwritten catalog, illustrated, $10.
Second Pricelist - European Mail-Orderhouse. [Fall 1964].

3F-cf HARDWARE...locks...$1 and up (mounted).
ibid.

ITEMS NOT IN STOCK, DELIVERY 1 TO 4 MONTHS...FLUXUS cf GEORGE BRECHT: hardware...locks...
Vacuum TRapEzoid (Fluxus Newspaper No. 5) March 1965.

FLUXUS ci GEORGE BRECHT, door events:...locks ...prices on request
ibid.

COMMENTS: *Brecht, 1983: "I did one on a larger piece of wood with a chain lock on a bigger white board...I don't know what happened to it. I had to restore it at one time, the paint had chipped...[originally made] in '62 or '61..."*
 Although Locks *is not known to have been made by Maciunas as a Fluxus Edition, a similar Fluxus work,* Bolt *was assigned by Brecht.*

MAP

Flash Art editor, Giancarlo Politi, proposed to publish the 3rd Fluxyearbook, maybe to be called FLUXPACK 3, with the following preliminary contents:... map...by George Brecht...
Fluxnewsletter, April 1973.

COMMENTS: *This work is not known to have been made by Maciunas as a Fluxus Edition. In 1967, George Maciunas and Robert Watts worked on a subway map that was to have been commercially produced (Silverman No. >251.I; illustrated in Fluxus Etc. Addenda II p. 183).*

MATCHES see:
 FAIL MATCHES BY ERIC

MEETING

FLUXUS 1964 EDITIONS, AVAILABLE NOW ... FLUXUS caz series, OBJECTS from GEORGE BRECH/ FLUXUS ca PENNANTS $30 &up FLAGS $ 50 &up. Bunting. Sewn legends. With staff. SIGNS, oil on canvas, mounted $25 &up sets of two $40. Available with following legends:...meeting...
cc Valise e TRanglE (Fluxus Newspaper No. 3) March 1964.

3F-ca PENNANTS from GEORGE BRECHT...MEETING...
European Mail-Orderhouse: europeanfluxshop, Pricelist. [ca. June 1964].

3F/ca PENNANTS from GEORGE BRECHT...meeting...
Second Pricelist - European Mail-Orderhouse. [Fall 1964].

ITEMS NOT IN STOCK, DELIVERY 1 TO 4 MONTHS...FLUXUS ca GEORGE BRECHT: pennants...meeting...
Vacuum TRapEzoid (Fluxus Newspaper No. 5) March 1965.

COMMENTS: *This work is not known to have been made by Maciunas as a Fluxus Edition.*

MENU CARDS see:
 ICED DICE

MIDDLE

Silverman No. > 45.III

FLUXUS 1964 EDITIONS, AVAILABLE NOW ...
FLUXUS caz series, OBJECTS from GEORGE
BRECHT/ FLUXUS ca PENNANTS $30 &up FLAGS
$ 50 &up. Bunting. Sewn legends. With staff. SIGNS,
oil on canvas, mounted $25 &up sets of two $40. A-
vailable with following legends: ...middle...
cc Valise e TRanglE (Fluxus Newspaper No. 3) March 1964.

3F-ca PENNANTS from GEORGE BRECHT...MID-
DLE...
*European Mail-Orderhouse: europeanfluxshop, Pricelist.
[ca. June 1964].*

3F/ca PENNANTS from GEORGE BRECHT...mid-
dle...
Second Pricelist - European Mail-Orderhouse. [Fall 1964].

ITEMS NOT IN STOCK, DELIVERY 1 TO 4
MONTHS...FLUXUS ca GEORGE BRECHT: pen-
nants...middle...
Vacuum TRapEzoid (Fluxus Newspaper No. 5) March 1965.

"...Take any object you wish from La Cedille qui
Sourit, Such as very nice Geo. Brecht Flags, ... (one
says..."Middle" ...). They can be used as Flags or
banners. (like boat flags or as banners on trumpets)
etc...."
Letter: George Maciunas to Ben Vautier, March 5, 1966.

FLUXFLAGS AND BANNERS ea. $25/ 28" square,
sewnlegends, double bunting, readable both sides,
grommets at corners FLUXUS ca GEORGE BRECHT:
wi following legends: ...green on blue: "middle"...
Vaseline sTREet (Fluxus Newspaper No. 8) May 1966.

"...I mailed you a batch of May newspaper with
some events which we performed...Hi-Red-Center...
street events: cleaning a section with bizarre tools like
tooth brushes, cotton balls & alcohol, etc. - It went
very well, for some 30 - 40 minutes. First time we
used Brecht flags: start-middle & end (on a flag pole,
like a ship)..."
Letter: George Maciunas to Ben Vautier, [ca. Fall 1966].

FLUXFURNITURE...RUGS George Brecht: ..."mid-
dle"...woven...4ft.x 4ft. $150, 8ft.x 8ft. $300....A-
vailable in N.Y.C. at Multiples and late in 1967 at
FLUXSHOP, 18 GREENE ST.
Fluxfurniture, pricelist. [1967].

FLUX-PRODUCTS 1961 TO 1969 ... GEORGE
BRECHT...Flags: 28" square, sewn legends...middle
... each [$] 60
Fluxnewsletter, December 2, 1968 (revised March 15, 1969).

George Brecht. MIDDLE. see color portfolio

BRAD IVERSON

FLUX-PRODUCTS 1961 TO 1970 ... GEORGE
BRECHT...Flags: 28" sq. sewn legends:...middle...
ea: 60
Flux Fest Kit 2. [ca. December 1969].

MAY 2-8: BLUE ROOM BY JOHN & YOKO + FLUX-
LIARS...Other interior signs:...middle (at edge of
room)...all by George Brecht 1961
*Schedule of events for Fluxfest presentation of John Lennon
and Yoko Ono. [ca. April 1970]. versions A and B*

FLUXFEST PRESENTATION OF JOHN LENNON
& YOKO ONO + * AT 80 WOOSTER ST. NEW
YORK — 1970...MAY 2-8: BLUE ROOM BY JOHN
& YOKO + FLUXLIARS Entire room (floor, walls,
ceiling), and furnishings were white...sign at edge of
room: Middle (George Brecht '61)...
*all photographs copyright nineteen seVenty by peTer mooRE
(Fluxus Newspaper No.9) 1970.*

GEORGE BRECHT Flags: sewn legends:...middle...
each:$100
Flux Objects, Price List. May 1976.

*COMMENTS: Unlike some other Brecht works that were
made by Maciunas as Fluxus Editions, Middle is not known
to have been made by Brecht as a unique work. With two
other Brecht flags, Start and End, it can be viewed as either
forming a three-part unit or as a separate entity. A sign was
evidently made in 1970 for the John & Yoko Fluxfest in
New York City.*

MIND SHADE

FLUXUS 1964 EDITIONS, AVAILABLE NOW ...
FLUXUS caz series, OBJECTS from GEORGE
BRECHT/ FLUXUS ca PENNANTS $30 &up FLAGS
$ 50 &up. Bunting. Sewn legends. With staff. SIGNS,
oil on canvas, mounted $25 &up sets of two $40. A-
vailable with following legends: ...mind shade...
cc Valise e TRanglE (Fluxus Newspaper No. 3) March 1964.

3F-ca PENNANTS from GEORGE BRECHT...MIND
SHADE...
*European Mail-Orderhouse: europeanfluxshop, Pricelist.
[ca. June 1964].*

3F/ca PENNANTS from GEORGE BRECHT...mind
shade...
Second Pricelist - European Mail-Orderhouse. [Fall 1964].

ITEMS NOT IN STOCK, DELIVERY 1 TO 4
MONTHS...FLUXUS ca GEORGE BRECHT: pen-
nants...mind shade...
Vacuum TRapEzoid (Fluxus Newspaper No. 5) March 1965.

*COMMENTS: This work is not known to have been made by
Maciunas as a Fluxus Edition.*

MINE YOURS

FLUXUS 1964 EDITIONS, AVAILABLE NOW ...
FLUXUS caz series, OBJECTS from GEORGE
BRECHT/ FLUXUS ca PENNANTS $30 &up FLAGS
$ 50 &up. Bunting. Sewn legends. With staff. SIGNS,
oil on canvas, mounted $25 &up sets of two $40. A-
vailable with following legends: ...mine yours...
cc Valise e TRanglE (Fluxus Newspaper No. 3) March 1964.

3F-ca PENNANTS from GEORGE BRECHT...MINE
YOURS...
*European Mail-Orderhouse: europeanfluxshop, Pricelist.
[ca. June 1964].*

3F/ca PENNANTS from GEORGE BRECHT...mine
yours...
Second Pricelist - European Mail-Orderhouse. [Fall 1964].

ITEMS NOT IN STOCK, DELIVERY 1 TO 4
MONTHS ... FLUXUS ca GEORGE BRECHT: pen-
nants...mine yours...
Vacuum TRapEzoid (Fluxus Newspaper No. 5) March 1965.

*COMMENTS: This work is not known to have been made by
Maciunas as a Fluxus Edition.*

MONDAY

FLUXUS 1964 EDITIONS, AVAILABLE NOW ...
FLUXUS caz series, OBJECTS from GEORGE
BRECHT/ FLUXUS ca PENNANTS $30 &up FLAGS
$ 50 &up. Bunting. Sewn legends. With staff. SIGNS,

oil on canvas, mounted $25 &up sets of two $40. A-vailable with following legends:...monday...
cc Valise e TRanglE (Fluxus Newspaper No. 3) March 1964.

3F-ca PENNANTS from GEORGE BRECHT...MON-DAY...
European Mail-Orderhouse: europeanfluxshop, Pricelist. [ca. June 1964].

3F/ca PENNANTS from GEORGE BRECHT...mon-day...
Second Pricelist - European Mail-Orderhouse. [Fall 1964].

ITEMS NOT IN STOCK, DELIVERY 1 TO 4 MONTHS ... FLUXUS ca GEORGE BRECHT: pen-nants...monday...
Vacuum TRapEzoid (Fluxus Newspaper No. 5) March 1965.

COMMENTS: *This work is not known to have been made by Maciunas as a Fluxus Edition. Brecht's* Closed on Monday, *was produced later by Maciunas as a Fluxus Edition but is an unrelated work. In 1964 and 1965 George Brecht and Robert Watts arranged a series of events at the Cafe Au GoGo in New York City called "Monday Night Letters." Monday is the traditional day for theaters in New York to be closed, and sometimes theaters were made available for experimental per-formances. Such a series took place in the early 60's at the Living Theater.*

NAILS

FLUXUS 1964 EDITIONS, AVAILABLE NOW ... FLUXUS caz series, OBJECTS from GEORGE BRECHT...FLUXUS cf HARDWARE, supplied as-is, ready for use ($1 &up)...nails... mounted, where practical ($5 & up)
cc Valise e TRanglE (Fluxus Newspaper No. 3) March 1964.

3F-cf HARDWARE...nails...
European Mail-Orderhouse: europeanfluxshop, Pricelist. [ca. June 1964].

3F-cf HARDWARE...nails...$1 and up (mounted).
Second Pricelist - European Mail-Orderhouse. [Fall 1964].

ITEMS NOT IN STOCK, DELIVERY 1 TO 4 MONTHS...FLUXUS cf GEORGE BRECHT: hard-ware...nails...
Vacuum TRapEzoid (Fluxus Newspaper No. 5) March 1965.

COMMENTS: *This work is not known to have been made by Maciunas as a Fluxus Edition.*

NAME KIT see:
GAMES & PUZZLES/NAME KIT
NEITHER see:
BOTH/NEITHER
NEWSPAPER see:
V TRE

NIGHT see:
DAY/ NIGHT
1959 - 1963 [events] see:
WATER YAM
1959 to 1966 [events] see:
WATER YAM
1959 - 1969 [events] see:
WATER YAM
1966 & 1967 events... see:
WATER YAM

NO SMOKING

George Brecht. NO SMOKING. A ready-made assigned by the artist, ca. 1963

NO SMOKING
Silverman Nos. < 31.III; 81

SIGNS from the Yamfest Sign Shop...NO SMOKING ...Paper metal, enameled, hand-painted, etc. Write for prices.
Yam Festival Newspaper, [ca. 1963].

FLUXUS 1964 EDITIONS, AVAILABLE NOW ... FLUXUS caz series, OBJECTS from GEORGE BRECHT/ FLUXUS ca PENNANTS $30 &up FLAGS $ 50 &up. Bunting. Sewn legends. With staff. SIGNS, oil on canvas, mounted $25 &up sets of two $40. A-vailable with following legends:...no smoking...
cc Valise e TRanglE (Fluxus Newspaper No. 3) March 1964.

3F-ca PENNANTS from GEORGE BRECHT...NO SMOKING...
European Mail-Orderhouse: europeanfluxshop, Pricelist. [ca. June 1964].

3F/ca PENNANTS from GEORGE BRECHT...no smoking...
Second Pricelist - European Mail-Orderhouse. [Fall 1964].

ITEMS NOT IN STOCK, DELIVERY 1 TO 4 MONTHS ... FLUXUS ca GEORGE BRECHT: pen-nants...no smoking...
Vacuum TRapEzoid (Fluxus Newspaper No. 5) March 1965.

FLUXFLAGS AND BANNERS ea. $25/ 28" square, sewnlegends, double bunting, readable both sides, grommets at corners FLUXUS ca GEORGE BRECHT: wi following legends:...blue on black: "no smoking"...
Vaseline sTREet (Fluxus Newspaper No. 8) May 1966.

FLUX-PRODUCTS 1961 TO 1969 ... GEORGE BRECHT ... Flags: 28" square, sewn legends...no smoking...each: [$] 60
Fluxnewsletter, December 2, 1968 (revised March 15, 1969).

FLUX-PRODUCTS 1961 TO 1970 ... GEORGE BRECHT...Flags: 28" sq. sewn legends:...no smoking ...ea: [$] 60
Flux Fest Kit 2. [ca. December 1969].

1969 - 70 Flux-productions, which consist of the fol-lowing:... 1970 ... GEORGE BRECHT: Flags... no smoking
Fluxnewsletter, January 8, 1970.

MAY 2-8: BLUE ROOM BY JOHN & YOKO + FLUX-LIARS...Other interior signs...No Smoking...all by George Brecht 1961
Schedule of events for Fluxfest presentation of John Lennon and Yoko Ono. [ca. April 1970]. versions A and B

FLUXFEST PRESENTATION OF JOHN LENNON & YOKO ONO + * AT 80 WOOSTER ST. NEW YORK — 1970...MAY 2-8: BLUE ROOM BY JOHN & YOKO + FLUXLIARS Entire room (floor, walls, ceiling), and furnishings were white...sign at ashtray: No Smoking (George Brecht '61)...
all photographs copyright nineteen seVenty by peTer mooRE (Fluxus Newspaper No. 9) 1970.

"...to produce the Flash Art FLUXPACK 3...con-tents at present will be as follows:...Posters, wallpa-per:...No Smoking by George Brecht..."
Letter: George Maciunas to Giancarlo Politi, reproduced in Fluxnewsletter, April 1973.

Flash Art editor, Giancarlo Politi, proposed to pub-

NO SMOKING EVENT

Arrange to observe a NO SMOKING sign.

● smoking

● no smoking

George Brecht. "No Smoking Event" from WATER YAM

lish the 3rd Fluxyearbook, maybe to be called FLUX-PACK 3, with the following preliminary contents:... poster, signs or wallpaper...No Smoking sign or flag by George Brecht...
Fluxnewsletter, April 1973.

GEORGE BRECHT Flags: sewn legends:...no smoking...each: $100
Flux Objects Price List. May 1976.

COMMENTS: *In the Silverman Collection, No Smoking is a ready-made sign which has been rubber-stamped on the back: "YAM FESTIVAL (Exhibit)." A different version was later used in the John & Yoko Fluxfest in New York City. In the Fluxus Edition of the work, Maciunas incorporated his own typographic design. Because of his allergy to smoke, Maciunas had posted various no smoking signs wherever he lived or worked. See also: George Brecht's, Smoking, and Joe Jones' film, Smoking.*

George Brecht. NO SMOKING. A graphic designed by George Maciunas and used both as wallpaper and a poster or sign

NO VACANCY

SIGNS from the Yamfest Sign Shop...NO VACANCY ...Paper metal, enameled, hand-painted, etc. Write for prices.
Yam Festival Newspaper, [ca. 1963].

FLUXUS 1964 EDITIONS, AVAILABLE NOW ... FLUXUS caz series, OBJECTS from GEORGE BRECHT/ FLUXUS ca PENNANTS $30 &up FLAGS $ 50 &up. Bunting. Sewn legends. With staff. SIGNS, oil on canvas, mounted $25 &up sets of two $40. Available with following legends...no vacancy...
cc Valise e TRanglE (Fluxus Newspaper No. 3) March 1964.

TWO SIGNS

● SILENCE

● NO VACANCY

George Brecht. "Two Signs," including NO VACANCY from WATER YAM

3F-ca PENNANTS from GEORGE BRECHT...NO VACANCY...
European Mail-Orderhouse: europeanfluxshop, Pricelist. [ca. June 1964].

3F/ca PENNANTS from GEORGE BRECHT...no vacancy...
Second Pricelist - European Mail-Orderhouse. [Fall 1964].

ITEMS NOT IN STOCK, DELIVERY 1 TO 4 MONTHS... FLUXUS ca GEORGE BRECHT: pennants...no vacancy...
Vacuum TRapEzoid (Fluxus Newspaper No. 5) March 1965.

COMMENTS: *This work is not known to have been made by Maciunas as a Fluxus Edition. The score "Two Signs" is included in* Water Yam *(Silverman No. 35,ff.).*

NUT BONE
Silverman Nos. 44, ff.

Flash Art editor, Giancarlo Politi, proposed to pub-

George Brecht. NUT BONE

BRAD IVERSON

lish the 3rd Fluxyearbook, maybe to be called FLUX-PACK 3 with the following preliminary contents:... Games:...flipbooks by...Brecht...
Fluxnewsletter, April 1973.

COMMENTS: *Brecht, 1983 "...you could always buy Mickey Mouse flipbooks and you know how kids make stick figures on a page of a book and it moves a little when you flip the pages...?"*
Hendricks: *"Had you done that as a child?"*
Brecht: *"Yes."*

 Maciunas included Nut Bone *in later assemblings of Brecht's* Water Yam *and Flux Yearbox 2.*

OBJECTS

FLUXUS 1964 EDITIONS, AVAILABLE NOW ... FLUXUS caz series, OBJECTS from GEORGE BRECHT
cc Valise e TRanglE (Fluxus Newspaper No. 3) March 1964.

COMMENTS: *These objects would have been ordered directly from Brecht through Fluxus. The "Objects" as referred to here seem to relate to George Brecht and Robert Watts' Delivery Event in the Yam Festival of 1962 and 1963. Participants could send an arbitrary amount of money and receive an object or service not necessarily related to the amount of money sent. It was an exercise in chance and mystery. Following the ad for OBJECTS in the Fluxus Newspaper No. 3, March 1964, there is a list relating to an incomplete alphabetical code. We cannot determine if these were the intended "objects" in the caz series. See Robert Watts: a - z series.*

O'CLOCK

FLUXUS 1964 EDITIONS, AVAILABLE NOW ... FLUXUS caz series, OBJECTS from GEORGE BRECHT/ FLUXUS ca PENNANTS $30 &up FLAGS $ 50 &up. Bunting. Sewn legends. With staff. SIGNS, oil on canvas, mounted $25 &up sets of two $40. Available with following legends:...o'clock...
cc Valise e TRanglE (Fluxus Newspaper No. 3) March 1964.

3F-ca PENNANTS from GEORGE BRECHT...O'CLOCK...
European Mail-Orderhouse: europeanfluxshop, Pricelist. [ca. June 1964].

3F/ca PENNANTS from GEORGE BRECHT... o'clock...
Second Pricelist - European Mail-Orderhouse. [Fall 1964].

ITEMS NOT IN STOCK, DELIVERY 1 TO 4 MONTHS ... FLUXUS ca GEORGE BRECHT: pennants...o'clock...
Vacuum TRapEzoid (Fluxus Newspaper No. 5) March 1965.

COMMENTS: *This work is not known to have been made by Maciunas as a Fluxus Edition.*

PAINTINGS see:
SIGNS
PENNANTS see:
AIR
ARROW
BOTH/NEITHER
BUTTER GUIDE
DANCE
DAY/NIGHT
DUST
EARTH MEETING
EDGE MEMORY
END
EXIT
FACT/FICTION
FOOD
FORGET THIS
FRONT
LIMIT
LISTEN
LOCATION
MEETING
MIDDLE
MIND SHADE
MINE YOURS
MONDAY
NO SMOKING
NO VACANCY
O'CLOCK
QUESTION
RAIN TRICK
RAY
REMBER
REMEMBER THIS
RIVER WAX
ROOM
SILENCE
SMOKE
SOUP
START
SURPRISE SIGNS
THING/THOUGHT
TOP
UNIT
PLAYING CARDS see:
DECK
GAMES AND PUZZLES/ CARD GAMES
POINTING HAND see:
DIRECTION

POSITION

"Paik has exhibit for next 2 weeks at Wuppertal where I was yesterday - I got one room for Fluxus...In that room I also set various cards of G.Brecht...Position...

POSITION

● an insect nearby

George Brecht. POSITION

We thought in future to integrate our festivals with these 'exhibits'..."
Letter: George Maciunas to Robert Watts, [March 11 or 12, 1963].

COMMENTS: *Position was installed by Maciunas as part of the Fluxus exhibition during Paik's Exposition of Music/Electronic Television, March 11 - 20, 1963 at Galerie Parnass, Wuppertal, West Germany. The work illustrated is a card from* Water Yam, *which is what would have been used for the exhibit.*

POSTCARD

Flash Art editor, Giancarlo Politi, proposed to publish the 3rd Fluxyearbook, maybe to be called FLUXPACK 3 with the following preliminary contents:... Postcards: by...George Brecht...
Fluxnewsletter, April 1973.

COMMENTS: *This work is not known to have been made by Maciunas as a Fluxus Edition.*

POSTER SIGNS see:
NO SMOKING
PROSPECTUS see:
RELOCATION
PUZZLES see:
GAMES & PUZZLES/PUZZLES
THE LITTLE REBUS-WISH

QUESTION

FLUXUS 1964 EDITIONS, AVAILABLE NOW ... FLUXUS caz series, OBJECTS from GEORGE BRECHT/ FLUXUS ca PENNANTS $30 &up FLAGS $ 50 &up. Bunting. Sewn legends. With staff. SIGNS, oil on canvas, mounted $25 &up sets of two $40. Available with following legends:...question...
cc Valise e TRanglE (Fluxus Newspaper No. 3) March 1964.

3F-ca PENNANTS from GEORGE BRECHT...QUESTION...
European Mail-Orderhouse: europeanfluxshop, Pricelist. [ca. June 1964].

3F/ca PENNANTS from GEORGE BRECHT...question...
Second Pricelist - European Mail-Orderhouse. [Fall 1964].

ITEMS NOT IN STOCK, DELIVERY 1 TO 4 MONTHS ... FLUXUS ca GEORGE BRECHT: pennants...question...
Vacuum TRapEzoid (Fluxus Newspaper No. 5) March 1965.

COMMENTS: *This work is not known to have been made by Maciunas as a Fluxus Edition. See also:* A Question or More.

RAIN TRICK

FLUXUS 1964 EDITIONS, AVAILABLE NOW ... FLUXUS caz series, OBJECTS from GEORGE BRECHT/ FLUXUS ca PENNANTS $30 &up FLAGS $ 50 &up. Bunting. Sewn legends. With staff. SIGNS, oil on canvas, mounted $25 &up sets of two $40. Available with following legends:...rain trick...
cc Valise e TRanglE (Fluxus Newspaper No. 3) March 1964.

3F-ca PENNANTS from GEORGE BRECHT...RAIN TRICK...
European Mail-Orderhouse: europeanfluxshop, Pricelist. [ca. June 1964].

3F/ca PENNANTS from GEORGE BRECHT...rain trick...
Second Pricelist - European Mail-Orderhouse. [Fall 1964].

ITEMS NOT IN STOCK, DELIVERY 1 TO 4 MONTHS ... FLUXUS ca GEORGE BRECHT: pennants...rain trick...
Vacuum TRapEzoid (Fluxus Newspaper No. 5) March 1965.

COMMENTS: *This work is not known to have been made by Maciunas as a Fluxus Edition.*

RAY

FLUXUS 1964 EDITIONS, AVAILABLE NOW ... FLUXUS caz series, OBJECTS from GEORGE BRECHT/ FLUXUS ca PENNANTS $30 &up FLAGS $ 50 &up. Bunting. Sewn legends. With staff. SIGNS, oil on canvas, mounted $25 &up sets of two $40. Available with following legends:...ray...
cc Valise e TRanglE (Fluxus Newspaper No. 3) March 1964.

3F-ca PENNANTS from GEORGE BRECHT...RAY...
European Mail-Orderhouse: europeanfluxshop, Pricelist. [ca. June 1964].

3F/ca PENNANTS from GEORGE BRECHT...ray...
Second Pricelist - European Mail-Orderhouse. [Fall 1964].

ITEMS NOT IN STOCK, DELIVERY 1 TO 4 MONTHS ... FLUXUS ca GEORGE BRECHT: pennants...ray...
Vacuum TRapEzoid (Fluxus Newspaper No. 5) March 1965.

COMMENTS: This work is not known to have been made by Maciunas as a Fluxus Edition.

READY MADE CLOTHING see:
CLOTHING

READYMADE RUGS see:
RUGS

REBUS-WISH... see:
THE LITTLE REBUS - WISH

George Brecht. RELOCATION. Advertising card from WATER YAM.

RELOCATION

RELOCATION (limited to 5 per year. A signed and numbered CERTIFICATE OF RELOCATION is provided with each realization of the work) Bounds (which may be of any extent) are set by the subscriber. Once set, a relocation within the bounds is arranged. (Send subscriptions or inquiries to George Brecht c/o Fluxus)
cc V TRE (Fluxus Newspaper No. 2) February 1964.

FLUXUS 1964 EDITIONS, AVAILABLE NOW ... FLUXUS caz series, OBJECTS from GEORGE BRECHT...FLUXUS cd RELOCATION. Score/Prospectus, 50 ¢.
cc Valise e TRanglE (Fluxus Newspaper No. 3) March 1964.

3F-cd RELOCATION. score/prospectus, 50¢
European Mail-Orderhouse: europeanfluxshop, Pricelist. [ca. June 1964].

3F-cd RELOCATION, score/prospectus, 50¢
Second Pricelist - European Mail-Orderhouse. [Fall 1964].

RELOCATION (limited to five per year. A signed and numbered Certificate of Relocation is provided with each realization of the work.) Bounds (which may be of any extent) are set by the subscriber. Once set, a relocation within the bounds is arranged. Inquiries: G.Brecht, P.O.Box 180 New York 13, N.Y.
George Brecht, Water Yam. Advertisement card: "Relocation." 1964.

"...Put relocation...into Brecht box...."
Letter: George Maciunas to Willem de Ridder, February 4, 1965.

GAMES...FLUXUS co GEORGE BRECHT, relocation, score-prospectus 50¢
Vacuum TRapEzoid (Fluxus Newspaper No. 5) March 1965.

COMMENTS: Relocation is a continuation of ideas done for the Yam Festival that were concerned with the performance of activities and services as works of art. The idea of "certificate" was used by Piero Manzoni, Yves Klein and Ben Vautier.

REMBER

3F-ca PENNANTS from GEORGE BRECHT, $30 and up, FLAGS, $50 and up. (bunting. sewn legends, with staff) SIGNS (oil on canvas, mounted) $25 and up. Sets of two $40. available with following legends: ...REMBER (not available)...
European Mail-Orderhouse: europeanfluxshop, Pricelist. [ca. June 1964].

COMMENTS: I don't know where Willem de Ridder got this listing. It could have been an error in reading the Fluxus Newspaper No. 3 (March 1964) which lists Remember This. However, Remember This follows the listing for Rember in the same pricelist. One has to assume that it's either an error or an invention, and not a Fluxus work.

REMEMBER THIS

FLUXUS 1964 EDITIONS, AVAILABLE NOW ... FLUXUS caz series, OBJECTS from GEORGE BRECHT/ FLUXUS ca PENNANTS $30 &up FLAGS $ 50 &up. Bunting. Sewn legends. With staff. SIGNS, oil on canvas, mounted $25 &up sets of two $40. A—vailable with following legends:...remember this...
cc Valise e TRanglE (Fluxus Newspaper No. 3) March 1964.

3F-ca PENNANTS from GEORGE BRECHT...REMEMBER THIS...
European Mail-Orderhouse: europeanfluxshop, Pricelist. [ca. June 1964].

3F/ca PENNANTS from GEORGE BRECHT...remember this...
Second Pricelist - European Mail-Orderhouse. [Fall 1964].

ITEMS NOT IN STOCK, DELIVERY 1 TO 4 MONTHS ... FLUXUS ca GEORGE BRECHT: pennants...remember this...
Vacuum TRapEzoid (Fluxus Newspaper No. 5) March 1965.

COMMENTS: This work is not known to have been made by Maciunas as a Fluxus Edition.

RIVER WAX

FLUXUS 1964 EDITIONS, AVAILABLE NOW ... FLUXUS caz series, OBJECTS from GEORGE BRECHT/ FLUXUS ca PENNANTS $30 &up FLAGS $ 50 &up. Bunting. Sewn legends. With staff. SIGNS, oil on canvas, mounted $25 &up sets of two $40. Available with following legends: ...river wax...
cc Valise e TRanglE (Fluxus Newspaper No. 3) March 1964.

3F-ca PENNANTS from GEORGE BRECHT...RIVER WAX...
European Mail-Orderhouse: europeanfluxshop, Pricelist. [ca. June 1964].

3F/ca PENNANTS from GEORGE BRECHT...river wax...
Second Pricelist - European Mail-Orderhouse. [Fall 1964].

ITEMS NOT IN STOCK, DELIVERY 1 TO 4 MONTHS ... FLUXUS ca GEORGE BRECHT: pennants...river wax...
Vacuum TRapEzoid (Fluxus Newspaper No. 5) March 1965.

COMMENTS: River Wax is used as the title for a section by Brecht of Fluxus Newspapers Nos. 3 and 5. However, there are no known objects made by Maciunas as Fluxus Editions of this piece.

ROOM
Silverman No. < 28.1

FLUXUS 1964 EDITIONS, AVAILABLE NOW ... FLUXUS caz series, OBJECTS from GEORGE BRECHT/ FLUXUS ca PENNANTS $30 &up FLAGS $ 50 &up. Bunting. Sewn legends. With staff. SIGNS, oil on canvas, mounted $25 &up sets of two $40. Available with following legends:...room...
cc Valise e TRanglE (Fluxus Newspaper No. 3) March 1964.

3F-ca PENNANTS from GEORGE BRECHT...ROOM
European Mail-Orderhouse: europeanfluxshop, Pricelist. [ca. June 1964].

3F/ca PENNANTS from GEORGE BRECHT...room...
Second Pricelist - European Mail-Orderhouse. [Fall 1964].

ITEMS NOT IN STOCK, DELIVERY 1 TO 4

MONTHS ... FLUXUS ca GEORGE BRECHT: pennants...room...
Vacuum TRapEzoid (Fluxus Newspaper No. 5) March 1965.

FLUXFURNITURE ... RUGS George Brecht: ... "room"... woven... 4ft.x 4ft. $150, 8ft.x 8ft. $300. ...Available in N.Y.C. at Multiples and late in 1967 at FLUXSHOP, 18 GREENE ST.
Fluxfurniture, pricelist. [1967].

COMMENTS: Hendricks, 1983: "Was this a joint work with Alison [Knowles]?"
Brecht: "I think...I'm sure Alison did the silk-screening. It's one of the illustrations from Webster's Dictionary...and then I had "Room" put on by a sign-painter...semi-ironic. This is a room, right? You kind of vaguely know it's already there."
　　The work illustrated was made by Brecht in the early 1960s and is what would have been offered as "SIGNS, oil on canvas, mounted $25 & up" in Fluxus Newspaper No. 3, March 1964. Maciunas is not known to have made a Fluxus Edition of the work.

George Brecht. ROOM

BRAD IVERSON

RUGS

FLUXUS 1964 EDITIONS, AVAILABLE NOW ... FLUXUS caz series, OBJECTS from GEORGE BRECHT... FLUXUS cj RUGS (locator rugs, readymade rugs, hand woven rugs, etc.) Hand written catalog, illustrated $10
cc Valise e TRanglE (Fluxus Newspaper No. 3) March 1964.

3F-cj RUGS...Handwritten catalog, illustrated $10.
European Mail-Orderhouse: europeanfluxshop, Pricelist. [ca. June 1964].

3F-cj RUGS...Handwritten catalog, illustrated $10.
Second Pricelist - European Mail-Orderhouse. [Fall 1964].

ITEMS NOT IN STOCK, DELIVERY 1 TO 4 MONTHS ... FLUXUS cj GEORGE BRECHT: rugs handwritten catalogue, illustrated $10
Vacuum TRapEzoid (Fluxus Newspaper No. 5) March 1965.

"...Other going projects:...Brecht - carpets..."
Letter: George Maciunas to Ken Friedman, [ca. February 1967].

FLUX-PROJECTS PLANNED FOR 1967...George Brecht:...in collaboration with Robert Filliou...rugs...
Fluxnewsletter, March 8, 1967.

FLUX-OBJECTS...03.1965...G.BRECHT...rugs...
George Maciunas, Diagram of Historical Developments of Fluxus... [1973].

COMMENTS: Brecht, 1983: " Rug handwritten catalogue never made..."
　　Maciunas is not known to have made any of Brecht's works into rugs as Fluxus Editions. See individual listings for rugs which were to have been made.

RUGS see:
　　ARROW
　　EXIT
　　LOCATION
　　MIDDLE
　　ROOM
　　TOP
　　12 HUMAN FOOTSTEPS AND 1 DOGS FOOT-
　　　STEP see:
　　　George Brecht and Robert Filliou

SCORES see:
　　CLOUD SCISSORS
　　ICED DICE
　　RELOCATION
　　WATER YAM

SCREWS

FLUXUS 1964 EDITIONS, AVAILABLE NOW ... FLUXUS caz series, OBJECTS from GEORGE BRECHT...FLUXUS cf HARDWARE, supplied as-is, ready for use ($1 &up)...screws...mounted, where practical ($5 & up)
cc Valise e TRanglE (Fluxus Newspaper No. 3) March 1964.

3F-cf HARDWARE...screws...
European Mail-Orderhouse: europeanfluxshop, Pricelist. [ca. June 1964].

3F-cf HARDWARE...screws...$1 and up (mounted).
Second Pricelist - European Mail-Orderhouse. [Fall 1964].

ITEMS NOT IN STOCK, DELIVERY 1 TO 4 MONTHS ...FLUXUS cf GEORGE BRECHT: hardware...screws...
Vacuum TRapEzoid (Fluxus Newspaper No. 5) March 1965.

COMMENTS: This work is not known to have been made by Maciunas as a Fluxus Edition.

SIGNS

FLUXUS 1964 EDITIONS, AVAILABLE NOW ... FLUXUS caz series, OBJECTS from GEORGE BRECHT...FLUXUS ci DOOR EVENTS (signs...) made to order
cc Valise e TRanglE (Fluxus Newspaper No. 3) March 1964.

3F-ci DOOR EVENTS (signs...) Handwritten catalog, illustrated, $10
European Mail-Orderhouse: europeanfluxshop, Pricelist. [ca. June 1964].

[as above]
Second Pricelist - European Mail-Orderhouse. [Fall 1964].

ITEMS NOT IN STOCK, DELIVERY 1 TO 4 MONTHS...FLUXUS ci GEORGE BRECHT: door events:...signs...prices on request
Vacuum TRapEzoid (Fluxus Newspaper No. 5) March 1965.

FLUX-OBJECTS...03.1965...G.BRECHT...signs...
George Maciunas, Diagram of Historical Developments of Fluxus... [1973].

COMMENTS: Signs as listed here pertain to doors, and the activity and function of doors. Although specific signs are not listed, both Exit and Entry exist as Fluxus works. Other Fluxus door-related signs by Brecht are: Front, No Vacancy, Room, and Silence.

SIGNS see:
　　AIR
　　AIR CONDITIONED
　　ARROW
　　BOTH/NEITHER
　　BUTTER GUIDE
　　DANCE
　　DAY/NIGHT
　　DUST
　　EARTH MEETING
　　EDGE MEMORY
　　END
　　ENTRY
　　EXIT
　　FACT/FICTION
　　FOOD
　　FORGET THIS
　　FRONT
　　LIMIT

LISTEN
LOCATION
LOCATOR SIGNS
MEETING
MIDDLE
MIND SHADE
MINE YOURS
MONDAY
NO SMOKING
NO VACANCY
O'CLOCK
QUESTION
RAIN TRICK
RAY
REMBER
REMEMBER THIS
RIVER WAX
ROOM
SILENCE
SMOKE
SOUP
START
SURPRISE SIGNS
THING/THOUGHT
TOP
UNIT

SILENCE

SIGNS from the Yamfest Sign Shop...Silence...Paper, metal, enameled, hand-painted, etc. Write for prices.
Yam Festival Newspaper, [ca. 1963].

FLUXUS 1964 EDITIONS, AVAILABLE NOW ... FLUXUS caz series, OBJECTS from GEORGE BRECHT/FLUXUS ca PENNANTS $30 &up FLAGS $ 50 &up. Bunting. Sewn legends. With staff. SIGNS, oil on canvas, mounted $25 &up sets of two $40. Available with following legends:...silence...
cc Valise e TRanglE (Fluxus Newspaper No. 3) March 1964.

3F-ca PENNANTS from GEORGE BRECHT...SILENCE...
European Mail-Orderhouse: europeanfluxshop, Pricelist. [ca. June 1964].

3F/ca PENNANTS from GEORGE BRECHT...silence...
Second Pricelist - European Mail-Orderhouse. [Fall 1964].

ITEMS NOT IN STOCK, DELIVERY 1 TO 4 MONTHS ... FLUXUS ca GEORGE BRECHT: pennants...silence...
Vacuum TRapEzoid (Fluxus Newspaper No. 5) March 1965.

MAY 2-8: BLUE ROOM BY JOHN & YOKO + FLUXLIARS...Other interior signs:...silence (at exit door),

...by George Brecht 1961
Schedule of events for Fluxfest presentation of John Lennon and Yoko Ono. [ca. April 1970]. version A

MAY 2-8 BLUE ROOM BY JOHN & YOKO + FLUXLIARS...signs by George Brecht (1961):...silence (at exit)...
Schedule of events for Fluxfest presentation of John Lennon and Yoko Ono. [ca. April 1970]. version B

FLUXFEST PRESENTATION OF JOHN LENNON & YOKO ONO + * AT 80 WOOSTER ST. NEW YORK — 1970...MAY 2-8: BLUE ROOM BY JOHN & YOKO + FLUXLIARS Entire room (floor, walls, ceiling), and furnishings were white...interior signs: ...Silence (G.Brecht'61)...
all photographs copyright nineteen seVenty by peTer MooRE (Fluxus Newspaper No. 9) 1970.

COMMENTS: This work is not known to have been made by Maciunas as a Fluxus Edition pennant or flag. A sign was evidently made for the John & Yoko Fluxfest in New York City in 1970.

SILICATE MICRO CRYSTALS see:
George Brecht and George Maciunas

SMOKE

FLUXUS 1964 EDITIONS, AVAILABLE NOW ... FLUXUS caz series, OBJECTS from GEORGE BRECHT/ FLUXUS ca PENNANTS $30 &up FLAGS $ 50 &up. Bunting. Sewn legends. With staff. SIGNS, oil on canvas, mounted $25 &up sets of two $40. Available with following legends:...smoke...
cc Valise e TRanglE (Fluxus Newspaper No. 3) March 1964.

3F-ca PENNANTS from GEORGE BRECHT ... SMOKE...
European Mail-Orderhouse: europeanfluxshop, Pricelist. [ca. June 1964].

3F/ca PENNANTS from GEORGE BRECHT... smoke...
Second Pricelist - European Mail-Orderhouse. [Fall 1964].

ITEMS NOT IN STOCK, DELIVERY 1 TO 4 MONTHS ... FLUXUS ca GEORGE BRECHT: pennants...smoke...
Vacuum TRapEzoid (Fluxus Newspaper No. 5) March 1965.

COMMENTS: Smoke could be a later companion to Brecht's No Smoking, which first appeared as part of the Yam Festival. Although it was not known to have been made as a Fluxus Edition, Maciunas produced a film by Joe Jones called Smoke which is included in the FLUXFILM package (see Collective).

SOUP

FLUXUS 1964 EDITIONS, AVAILABLE NOW ...

FLUXUS caz series, OBJECTS from GEORGE BRECHT/ FLUXUS ca PENNANTS $30 &up FLAGS $ 50 &up. Bunting. Sewn legends. With staff. SIGNS, oil on canvas, mounted $25 &up sets of two $40. Available with following legends:...soup...
cc Valise e TRanglE (Fluxus Newspaper No. 3) March 1964.

3F-ca PENNANTS from GEORGE BRECHT ... SOUP...
European Mail-Orderhouse: europeanfluxshop, Pricelist. [ca. June 1964].

3F/ca PENNANTS from GEORGE BRECHT...soup...
Second Pricelist - European Mail-Orderhouse. [Fall 1964].

ITEMS NOT IN STOCK, DELIVERY 1 TO 4 MONTHS ...FLUXUS ca GEORGE BRECHT: pennants...soup...
Vacuum TRapEzoid (Fluxus Newspaper No. 5) March 1965.

COMMENTS: This work is not known to have been made by Maciunas as a Fluxus Edition.

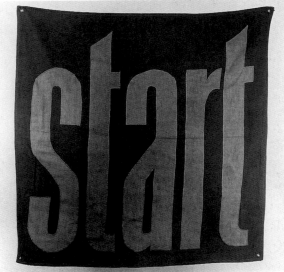

BRAD IVERSON

George Brecht. START. see color portfolio

START
Silverman No. > 45.1

FLUXUS 1964 EDITIONS, AVAILABLE NOW ... FLUXUS caz series, OBJECTS from GEORGE BRECHT/ FLUXUS ca PENNANTS $30 &up FLAGS $ 50 &up. Bunting. Sewn legends. With staff. SIGNS, oil on·canvas, mounted $25 &up sets of two $40. Available with following legends:...start...
cc Valise e TRanglE (Fluxus Newspaper No. 3) March 1964.

3F-ca PENNANTS from GEORGE BRECHT ... START...
European Mail-Orderhouse: europeanfluxshop, Pricelist. [ca. June 1964].

3F/ca PENNANTS from GEORGE BRECHT...start...
Second Pricelist - European Mail-Orderhouse. [Fall 1964].

ITEMS NOT IN STOCK, DELIVERY 1 TO 4 MONTHS ... FLUXUS ca GEORGE BRECHT: pennants...start...
Vacuum TRapEzoid (Fluxus Newspaper No. 5) March 1965.

"...Take any object you wish from La Cedille qui Sourit, such as very nice Geo. Brecht Flags,...(one says "start"...) They can be used as Flags or banners. (like boat flags or as banners on trumpets) etc..."
Letter: George Maciunas to Ben Vautier, March 5, 1966.

FLUXFLAGS AND BANNERS ea. $25/ 28" square, sewnlegends, double bunting, readable both sides, grommets at corners FLUXUS ca GEORGE BRECHT: wi following legends: grey on red "start"...
Vaseline sTREet (Fluxus Newspaper No. 8) May 1966.

"...Hi-Red-Center...Hotel event...first time we used Brecht Flags: start-middle & End (on a flagpole, like a ship)..."
Letter: George Maciunas to Ben Vautier, [ca. Fall 1966].

FLUX-PRODUCTS 1961 TO 1969 ... GEORGE BRECHT...Flags: 28" square sewn legends, start... each: [$] 60
Fluxnewsletter, December 2, 1968 (revised March 15, 1969).

FLUX-PRODUCTS 1961 TO 1970 ... GEORGE BRECHT...Flags: 28" sq. sewn legends: start...ea: [$] 60
Flux Fest Kit 2. [ca. December 1969].

GEORGE BRECHT...Flags: sewn legends: start... each: $100
Flux Objects, Price List. May 1976.

COMMENTS: *Start was first produced by Maciunas as a Fluxus Edition around 1966 and it is basically as it is described in Fluxus Newspaper No. 8. With two other Brecht flags:* Middle *and* End*, it can be viewed as either forming a three-part unit or a separate entity. Brecht used starter flags in his assemblage* Chair Event, *a work from* Water Yam.

A STRATEGY FOR VIETNAM

FLUX-PROJECTS PLANNED FOR 1967...George Brecht:...A strategy for Vietnam (flux-atlas)...
Fluxnewsletter, March 8, 1967.

COMMENTS: *This work is not known to have been made by Maciunas as a Fluxus Edition. George Maciunas worked on two projects related to the war in Vietnam during the same period: a flag poster,* U.S.A. Surpasses All The Genocide Re-

cords!, *(Silverman No. 247); and a sheet of calculations and references,* U.S. Surpasses All Nazi Genocide Records!, *(Silverman No. 245).*

SUITCASE see:
VALOCHE/ A FLUX TRAVEL AID
SUPPLEMENT TO WATER YAM see:
WATER YAM
SUPPLEMENTS TO WORKS OF BRECHT
see: WATER YAM

SURPRISE SIGNS

FLUXUS 1964 EDITIONS, AVAILABLE NOW ... FLUXUS caz series, OBJECTS from GEORGE BRECHT/ FLUXUS ca PENNANTS $30 &up FLAGS $ 50 &up. Bunting. Sewn legends. With staff. SIGNS, oil on canvas, mounted $25 &up sets of two $40. A—vailable with following legends:...surprise signs...
cc Valise e TRanglE (Fluxus Newspaper No. 3) March 1964.

3F-ca PENNANTS from GEORGE BRECHT...surprise signs...
European Mail-Orderhouse: europeanfluxshop, Pricelist. [ca. June 1964].

3F/ca PENNANTS from GEORGE BRECHT...(surprise signs)...
Second Pricelist - European Mail-Orderhouse. [Fall 1964].

ITEMS NOT IN STOCK, DELIVERY 1 TO 4 MONTHS ... FLUXUS ca GEORGE BRECHT: pennants $30 and up...surprise signs...
Vacuum TRapEzoid (Fluxus Newspaper No. 5) March 1965.

COMMENTS: *This was probably not intended to be a work, but rather a descriptive title of unlisted works.*

SWIM PUZZLE see:
GAMES & PUZZLES/ SWIM PUZZLE

TABLE

"Paik has exhibit for next 2 weeks at Wuppertal where I was yesterday - I got one room for Fluxus...In that room I also set various cards of G.Brecht—...TABLE table on top of a table...We thought in future to integrate our festivals with these 'exhibits'..."
Letter: George Maciunas to Robert Watts, [March 11 or 12, 1963].

COMMENTS: *This work was installed by Maciunas as part of the Fluxus exhibition during Paik's Exposition of Music Electronic Television March 11-20, 1963 at Galerie Parnass, Wuppertal, West Germany. The illustration is a card from* Water Yam *and is what Maciunas would have used for the exhibition.*

TABLE
● table

TABLE
● on a white table

George Brecht. TABLE

TAPE see:
ENTRANCE AND EXIT MUSIC

THING/THOUGHT

FLUXUS 1964 EDITIONS, AVAILABLE NOW ... FLUXUS caz series, OBJECTS from GEORGE BRECHT/ FLUXUS ca PENNANTS $30 &up FLAGS $ 50 &up. Bunting. Sewn legends. With staff. SIGNS, oil on canvas, mounted $25 &up sets of two $40. A-vailable with following legends:...set of 2: thing thought...
cc Valise e TRanglE (Fluxus Newspaper No. 3) March 1964.

3F-ca PENNANTS from GEORGE BRECHT...set of two: THING/THOUGHT...
European Mail-Orderhouse: europeanfluxshop, Pricelist. [ca. June 1964].

3F/ca PENNANTS from GEORGE BRECHT...set of two: thing/thought...
Second Pricelist - European Mail-Orderhouse. [Fall 1964].

ITEMS NOT IN STOCK, DELIVERY 1 TO 4 MONTHS ...FLUXUS ca GEORGE BRECHT: pennants...set of 2: thing thought...
Vacuum TRapEzoid (Fluxus Newspaper No. 5) March 1965.

COMMENTS: *This work is not known to have been made by Maciunas as a Fluxus Edition.*

THOUGHT see:
THING/THOUGHT

THREE AQUEOUS EVENTS

FLUXFEST PRESENTATION OF JOHN LENNON & YOKO ONO...MAY 9-15: WEIGHT & WATER BY JOHN & YOKO + FLUXFAUCET...Three Aqueous Events (George Brecht '60) a still...
all photographs copyright nineteen seVenty by peTer mooRE (Fluxus Newspaper No. 9) 1970.

COMMENTS: *Although a performance prop,* Three Aqueous Events: *ice, water and steam take on the qualities of a work as realized for the John and Yoko Fluxfest. See Peter Moore's photograph of the work in Fluxus Newspaper No. 9, illustration No. 63.*

THREE LAMP EVENTS

● on.
off.

● lamp

● off. on.

"It is sure to be dark
if you shut your eyes."(J. Ray)

Summer, 1961

George Brecht. THREE LAMP EVENTS

THREE LAMP EVENTS

"Paik has exhibit for next 2 weeks at Wuppertal where I was yesterday - I got one room for Fluxus...In that room I also set various cards of G.Brecht — light-event in front of switch...We thought in future to integrate our festivals with these 'exhibits'..."
Letter: George Maciunas to Robert Watts, [March 11 or 12, 1963].

COMMENTS: *This work, a Fluxus printing of the score on a single card contained in* Water Yam *(Silverman No. 35, ff.), was installed by Maciunas as part of the Fluxus exhibition during Paik's Exposition of Music Electronic Television, March 11 - 20, 1963 at Galerie Parnass, Wuppertal, West Germany.*

3 WALL HANGINGS see:
A QUESTION OR MORE

TOILET FLOATS

FLUXUS 1964 EDITIONS, AVAILABLE NOW ... FLUXUS caz series, OBJECTS from GEORGE BRECHT...FLUXUS cf HARDWARE, supplied as-is, ready for use ($1 &up)...toilet floats...mounted, where practical ($5 & up)
cc Valise e TRanglE (Fluxus Newspaper No. 3) March 1964.

3F-cf HARDWARE...toilet floats...
European Mail-Orderhouse: europeanfluxshop, Pricelist. [ca. June 1964].

3F-cf HARDWARE...toiletfloats...$1 and up (mounted).
Second Pricelist - European Mail-Orderhouse. [Fall 1964].

ITEMS NOT IN STOCK, DELIVERY 1 TO 4 MONTHS ... FLUXUS cf GEORGE BRECHT: hardware...toilet floats...
Vacuum TRapEzoid (Fluxus Newspaper No. 5) March 1965.

COMMENTS: *This work is not known to have been made by Maciunas as a Fluxus Edition. See* Fluxtoilet *in the collective section for related works. A sign by Brecht "TOILET" was offered for sale in the Yam Festival Newspaper in 1963.*

TOOLS

FLUXUS 1964 EDITIONS, AVAILABLE NOW ... FLUXUS caz series, OBJECTS from GEORGE BRECHT... FLUXUS cf HARDWARE, supplied as-is, ready for use ($1 &up)...tools...mounted, where practical ($5 & up)
cc Valise e TRanglE (Fluxus Newspaper No. 3) March 1964.

3F-cf HARDWARE...tools...
European Mail-Orderhouse: europeanfluxshop, Pricelist. [ca. June 1964].

3F-cf HARDWARE...tools...$1 and up (mounted).
Second Pricelist - European Mail-Orderhouse. [Fall 1964].

ITEMS NOT IN STOCK, DELIVERY 1 TO 4 MONTHS...FLUXUS cf GEORGE BRECHT: hardware...tools...
Vacuum TRapEzoid (Fluxus Newspaper No. 5) March 1965.

COMMENTS: *Tools is not known to have been made by Maciunas as a Fluxus Edition. In the first listing above, it is referred to as part of the Fluxus caz series. It is not known whether Brecht's intention was to make a series similar to those that appear in the Robert Watts section as part of his a - z series.*

TOP

FLUXUS 1964 EDITIONS, AVAILABLE NOW ... FLUXUS caz series, OBJECTS from GEORGE BRECHT/ FLUXUS ca PENNANTS $30 &up FLAGS $ 50 &up. Bunting. Sewn legends. With staff. SIGNS, oil on canvas, mounted $25 &up sets of two $40. Available with following legends:...top...
cc Valise e TRanglE (Fluxus Newspaper No. 3) March 1964.

3F-ca PENNANTS from GEORGE BRECHT...TOP...
European Mail-Orderhouse: europeanfluxshop, Pricelist. [ca. June 1964].

3F/ca PENNANTS from GEORGE BRECHT...top...
Second Pricelist - European Mail-Orderhouse. [Fall 1964].

ITEMS NOT IN STOCK, DELIVERY 1 TO 4 MONTHS ...FLUXUS ca GEORGE BRECHT...pennants...top...
Vacuum TRapEzoid (Fluxus Newspaper No. 5) March 1965.

FLUXFURNITURE...RUGS George Brecht:..."top" ...woven...4ft.x 4ft. $150, 8ft.x 8ft. $300...Available in N.Y.C. at Multiples and late in 1967 at FLUXSHOP, 18 GREENE ST.
Fluxfurniture, pricelist. [1967].

COMMENTS: *This work is not known to have been made by Maciunas as a Fluxus Edition.*

TRUNK see:
VALOCHE/ A FLUX TRAVEL AID

12 HUMAN FOOTSTEPS AND 1 DOGS FOOTSTEP see:
George Brecht and Robert Filliou

UNIT

FLUXUS 1964 EDITIONS, AVAILABLE NOW ... FLUXUS caz series, OBJECTS from GEORGE BRĘCHT/ FLUXUS ca PENNANTS $30 &up FLAGS $ 50 &up. Bunting. Sewn legends. With staff. SIGNS,

oil on canvas, mounted $25 &up sets of two $40. A-vailable with following legends:...unit...
cc Valise e TRanglE (Fluxus Newspaper No. 3) March 1964.

3F-ca PENNANTS from GEORGE BRECHT...UNIT...
European Mail-Orderhouse: europeanfluxshop, Pricelist.
[ca. June 1964].

3F/ca PENNANTS from GEORGE BRECHT...unit...
Second Pricelist - European Mail-Orderhouse. [Fall 1964].

ITEMS NOT IN STOCK, DELIVERY 1 TO 4 MONTHS...FLUXUS ca GEORGE BRECHT: pen-nants...unit...
Vacuum TRapEzoid (Fluxus Newspaper No. 5) March 1965.

COMMENTS: *This work is not known to have been made by Maciunas as a Fluxus Edition.*

UNIVERSAL MACHINE II
Silverman No. 79, ff.

"Universal machine no. 2 by George Brecht $200"
Letter: George Maciunas to Dr. Hanns Sohm, May 1, 1976.

GEORGE BRECHT...Universal Machine III, 1976, 10'' x 10'' box $200
Flux Objects, Price List. May 1976.

"...I will also include labels and some completed boxes... And if I have time Brecht Universal machine ...Do you think you can sell them? Univ. machine should sell for $200..."
Letter: George Maciunas to Ben Vautier, October 18, 1977.

COMMENTS: *The first listing on a Fluxus price list (May, 1976) gives the title* Universal Machine III, *which is correct in the sense that it existed first as a unique work, second as an Edition Mat Mot in 1965, with the Fluxus Edition appearing third. George Maciunas had planned to produce an edition of 100, however probably less than 50 were actually made. See also Larry Miller's instruction drawings for assembling the Fluxus Edition of* Universal Machine, *reproduced in* Fluxus Etc./Addenda II, *pp. 278 - 79.*

VALOCHE/A FLUX TRAVEL AID
Silverman Nos. 75; 76, ff.

SUITCASES and trunks-all sizes. We pack and deliver to you. YAMPAC P.O. Box 412 Metuchen, N.J.
Yam Festival Newspaper, [ca. 1963].

FLUXUS 1964 EDITIONS, AVAILABLE NOW ... FLUXUS caz series, OBJECTS from GEORGE BRECHT ...FLUXUS cb SUITCASE or TRUNK (packed, ready for traveling) $50 and up.
cc Valise e TRanglE (Fluxus Newspaper No. 3) March 1964.

3F-cb SUITCASE or TRUNK...$50 and up.
European Mail-Orderhouse: europeanfluxshop, Pricelist.
[ca. June 1964].

3F-cb SUITCASE or TRUNK (packed, ready for traveling) $50 & up.
Second Pricelist - European Mail-Orderhouse. [Fall 1964].

ITEMS NOT IN STOCK, DELIVERY 1 TO 4 MONTHS...FLUXUS cb GEORGE BRECHT: suitcase or trunk, packed, ready for traveling, $50 and up
Vacuum TRapEzoid (Fluxus Newspaper No. 5) March 1965.

by George Brecht:...Flux-ball-game & puzzle, large box with 26 balls and objects of various kinds (gam-ing, toys, sport, fake eggs, etc.) $100
Fluxnewsletter, April 1975.

by George Brecht...Flux-ball-game & puzzle, large box with 26 balls and objects of various kinds (gam-ing, toys, sport, fake eggs, etc.) $100
[Fluxus price list for a customer]. September 1975.

"George Brecht - ball game, large box - $100"
Letter: George Maciunas to Dr. Hanns Sohm, November 30, 1975.

Brecht ball box, large $100
[Fluxus price list for a customer]. January 7, 1976.

"Valoche by George Brecht, 1st version $100"
Letter: George Maciunas to Dr. Hanns Sohm, May 1, 1976.

GEORGE BRECHT...Valoche, 1975, 12'' x 12'' box $100
Flux Objects, Price List. May 1976.

"I heard from Jean that you may be interested to take Flux boxes for the $800 I owe you...I could suggest...Brecht Valoche - $100"
Letter: George Maciunas to Peter Frank, [ca. March 1977].

"...I will also include labels and some completed boxes...And if I have time Brecht...Valoche—...Do you think you can sell them? ... Should sell for ... $100..."
Letter: George Maciunas to Ben Vautier, October 18, 1977.

COMMENTS: *Brecht, 1983: "It's a multiple version by*

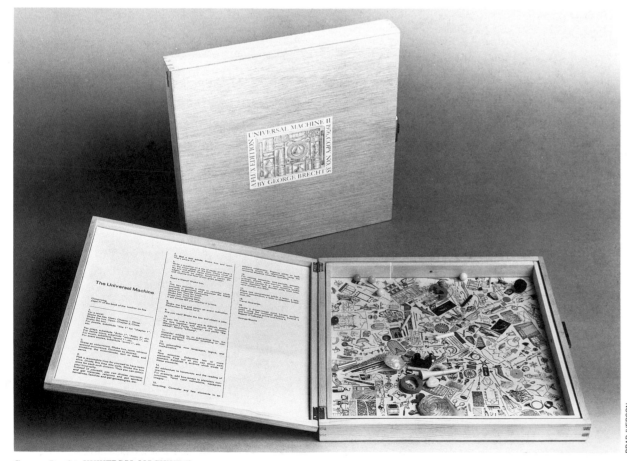

George Brecht. UNIVERSAL MACHINE II

> **SUITCASE**
>
> ● black suitcase
>
> ● white objects

> **SUITCASE**
>
> ● suitcase

> **SUITCASE**
>
> ● from a suitcase

George Brecht. Three scores for "Suitcase" from WATER YAM related to VALOCHE /A FLUX TRAVEL AID

George [Maciunas] of the suitcase I had in the show Toward Events...There was much more variety in the original suit-case."

Valoche began as a unique work called Suitcase, which was made in 1959. It is probable that the early listings in Fluxus publications of Suitcase or Trunk would have been this same work or one made to order. The idea evolves as a Maciunas made Fluxus Edition first as a Games & Puzzles box, Silverman No. 75, in the early '70s, eventually becoming Valoche/A Flux Travel Aid. Silverman No. 76, by 1975. The work evokes both childhood (a box of toys) and death (a case of objects to begin the after-life with). In the last month of his life, George Maciunas was preoccupied with assembling these works and was in the process of making a special one for himself when he died.

V TRE
Silverman No. 540, ff.

"George Brecht's issue [V TRE] is out"
Letter: Dick Higgins to Willem de Ridder, April 28, 1963.

COMMENTS: V TRE, a pre-Fluxus publication edited by George Brecht, was a single sheet printed on both sides with contributions by several artists. The title is said to come from a neon sign, whose letters had all burnt out but four, a chance occurrence. Maciunas incorporated the title of Brecht's pub-lication when he started publishing the fluxus newspapers in 1964, and George Brecht appears on the masthead as "editor" for the first four issues.

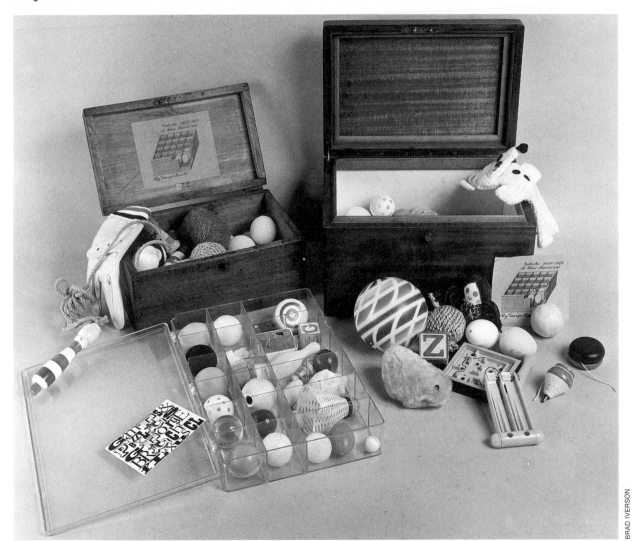

BRAD IVERSON

George Brecht. VALOCHE /A FLUX TRAVEL AID, with a prototype made by George Maciunas using a GAMES & PUZZLES label in the foreground. see color portfolio

> **THREE GAP EVENTS**
>
> ● missing-letter sign
>
> ● between two sounds
>
> ● meeting again
>
>
> To Ray J.
> Spring, 1961
> G. Brecht

George Brecht. "Three Gap Events" from WATER YAM. The "missing-letter sign" relates to V TRE

V TRE

Edited by G. Brecht for V TRE (Box 30, Metuchen, N.J.)

Available after 400 years!

R. Morris

ich liebe mich
du liebst mich
er liebt mich
sie liebt mich
es liebt mich
wir lieben mich
ihr liebt mich
sie lieben mich

KERVRDOMPFCH

Diter Rot

While the United States pavilion at the Brussels World Fair looked like a hamburger, the proposed United States pavilion for the 1963 New York World Fair looks like a sandwich.

The barber's shop.
I wish to be shaved.
Cut my hair, please.

Wat dwy don theink uv MRCA

Wat dwy don theink uv Mroa. Whats dwey dun thonk off Mrurky Ossa qwidgeun lie nosup watta tjen sohtink if Mrymyka. Witta oake denn quink porf Amyamyamyamka. Owy dunno. Kint fink kint fink fust foist oaffe ausoh must bahrf yink bloof blaff whaiio oye dann sink of Yankyinkydoo. Wal wussy dead wuz grow opp in midluklaes Myuka wantang noshtung moor abraz da oaffe schmall!

Claes Oldenburg 1962

LINCOLN, England (UPI) — Harry Jessup told the court that he giggled once when police stopped his car and again at the station because he was in a "nervous situation" not drunk. "It's like people laughing at funerals."

* * * * * * * * * * *

poem play

A BEAUTIFUL DAY

GIRL: What a beautiful day!
THE SUN falls down onto the stage

end

Ruth Krauss

A smooth "magic-carpet" ride on any type road

who returned for the dinner. He, too, received a Chair.

George Brecht. Front page of V TRE

WALL HANGINGS see:
A QUESTION OR MORE
WALLPAPER see:
NO SMOKING
WATCH see:
George Maciunas and Robert Filliou:
EASTERN DAYLIGHT FLUXTIME

WATER YAM
Silverman Nos. 355, ff.

In addition to Fluxus Year Boxes the following special editions are planned. These are editions of works by single composers, poets, artists or what you like. — George Brecht complete works, boxes cards (issue planned in 1962)...
Fluxus Newsletter No. 4, fragment, [ca. October 1962].

"...past & future works published under one cover or in box - a kind of special fluxus edition...sold separately or as part of fluxus yearbox. I am going to publish such special Fluxus editions containing complete works of: George Brecht...This could result in a nice & extensive library - or 'encyclopedia' of works being done these days. A kind of Shosoin warehouse of today..."
Letter: George Maciunas to Robert Watts, December 1962.

"We are publishing such...'solo' boxes of George Brecht...so that we can build up a good library of good things being done nowadays...."
Letter: George Maciunas to Ben Vautier, March 5, 1963.

"...Right now Tomas Schmit stays in my place & puts full time on putting together G.Brecht box..."
Letter: George Maciunas to Robert Watts, [March 11 or 12, 1963].

"...Also will have George Brecht 'complete works'... By fall I should have some 6 issues:...Brecht Flux..."
Letter: George Maciunas to Robert Watts, [ca. early April 1963].

"...The names marked with * will have their complete works published by us. We already have published...George Brecht's complete works..."
Letter: George Maciunas to Ben Vautier, [April 1963].

"...We shall bring to Nice lots of Fluxus publications Brecht cards..."
Letter: George Maciunas to Ben Vautier, May 26, 1963.

"...I will take some 500 of each book...100 books each: London, Amsterdam, Paris, Nice, Florence... This will be quite a load to dispose. (also 100 books in your place)..."
Letter: George Maciunas to Tomas Schmit, June 1, 1963.

"...I will stay in Wiesbaden till Printer completes...

Brecht cards...(2 printers are working now). They should have it completed by June 15..."
Letter: George Maciunas to Tomas Schmit, [before June 8, 1963].

"...It would have been better to have Amsterdam on 29th & Hague on 30th so that I would have fluxus with me for sure, but it's OK to have Amsterdam on June 23 & Haag on 30th. I will have...Brecht's complete works..."
Letter: George Maciunas to Tomas Schmit, [early June, 1963].

"...Go to the Becker printer & pick up: a. All Brecht cards, the ones I brought with me were not complete. Ask him to pack them well as follows: only cards which he has not given to me
1. One package for you (was it 160?)
2. One pack for mailing to De Ridder (I think 120)
3. 100 for you to take to Nice
4. 50 " " " " " " for me which I will take to Florence.
5. - 100 for you to take to Paris
6. - A complete set of 50 cards ones that he printed before & new cards. Incidentally ones he did not print were primarily music compositions such as quartet, solo for saxophone etc. —you will be able to identify them...Go to Buchna - the idiot printer...He will ask for money, etc., etc. tell him that I am now in Holland (better that he doesn't even know which country) and have asked you to pick up [the Spoerri books] for quick delivery & that I will come in a week to pick up...The Brecht cards (which he printed all wrong) (and which I will not pick up)..."
Letter: George Maciunas to Tomas Schmit, [ca. 2nd week of July, 1963].

"...Those Brecht cards, I found are not entirely complete, there are 8 missing - (printer never gave them to me). So don't sell any until you receive 120 of the 8 missing ones plus cover for box. We shall mail them from Nice...P.S. Those Brecht cards in box — the minimum price (one should get) is $2, You can sell for as much as you can...."
Letter: George Maciunas to Willem de Ridder, July 15, 1963.

"...I have mailed to you a package, which contains: a) labels for george brecht box. Glue them by applying wet sponge to the back. Apply them quickly & quickly press the edges & surface, otherwise they don't stick well. Experiment for best way. I enclosed one box that I did. It came out OK...Send brecht box...to J.P. Wilhelm OK?...b) 60 of each card for brecht. The set is complete. It was not complete before, it did not have music compositions, but I am sending the new cards to De Ridder. Each 60 cards are wrapped. Don't loose those cards. They are very expensive! Maybe you could send 10 completed

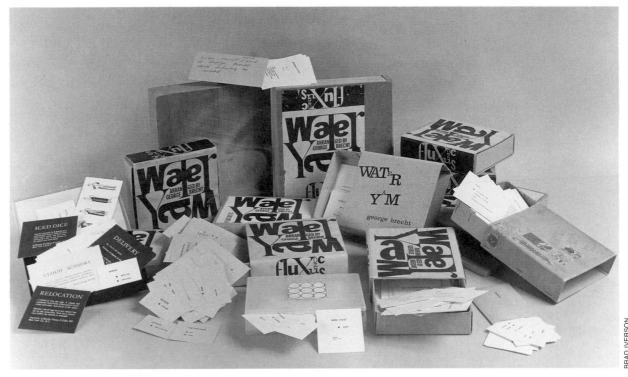

George Brecht. **WATER YAM. The two examples, center right, have collaged covers made by Brecht, ca. 1965. see color portfolio**

BRAD IVERSON

boxes to Denmark & 10 to Sweden. OK?...sell for 10 DM each..."
Letter: George Maciunas to Tomas Schmit, [end of August/ early September, 1963].

FLUXUS c.WATER YAM, arranged by George Brecht in expandable box $4/ works from 1963 - by subsription.
Fluxus Preview Review, [ca. July] 1963.

[as above]
Daniel Spoerri, L'Optique Moderne. List on editorial page. 1963.

FLUXUS SPECIAL EDITIONS 1963-4...FLUXUS c. WATER YAM, arranged by George Brecht, in expandable box $4 works from 1963- by subscription
La Monte Young, LY 1961. Advertisement page. [1963].

"...I have mailed a box to you containing: a) labels for brecht boxes. Glue them by applying wet sponge to back of label. Put them on box quickly & press edges to make it stick well. Then press the whole surface...missing cards - each group separately wrapped. Now you have complete set and can put one of each in box & sell, sell, sell!!! Let me have about $2 for each box. Take name & address of each buyer if he wishes to receive all future brecht compositions...

Don't loose those brecht cards-!! they were very expensive to print..."
Letter: George Maciunas to Willem de Ridder [day before returning to U.S. Fall, 1963].

"...so far of course we can sell only 3 items: Brecht box..."
Letter: George Maciunas to Tomas Schmit, [late October/ early November, 1963].

"...Did anyone buy any Brecht Boxes yet? ..."
Letter: George Maciunas to Tomas Schmit, November 8, 1963.

"In reply to your card & inquiry of Nov. 22nd. the Fluxus boxes can be seen at: 359 Canal St. 2nd floor ...Boxes to be seen...George Brecht - complete works or 'Water Yam' in wood box"
Letter: George Maciunas to Philip Kaplan, November 27, 1963.

FLUXUS 1963 EDITIONS, AVAILABLE NOW FROM FLUXUS P.O. Box 180, New York 10013, N.Y. or FLUXUS 359 Canal St. New York. CO 7-9198 ...FLUXUSc WATER YAM, arranged by George Brecht in wood box, $5 in "special box" $10 works from 1963 - $1 per year...
Film Culture No. 30, Fall 1963.

"...Try to sell !!! Brecht boxes. Tell Emmett & Tomas to Sell, sell, sell the things I left with them!!!! !!!!!!...Did you try to sell things I sent you? Brecht boxes,... ????? I will send you many new things we printed IF you can sell or sold or are selling the things you have...You have complete works of Brecht...so you have big choice for theatre performances..."
Letter: George Maciunas to Willem de Ridder, December 26, 1963.

FLUXUS 1963 EDITIONS, AVAILABLE NOW ... FLUXUS c WATER YAM, arranged by George Brecht in wood box, $5 in "special box" $10 works from 1963 -$1 per year...Most materials originally intended for Fluxus yearboxes will be included in the FLUX-USccV TRE newspaper or in individual boxes.
cc V TRE (Fluxus Newspaper No. 1) January 1964.

"Instructions. (VERY IMPORTANT) - Would you please collate & label as per sample I have sent you Brecht boxes (I believe you have about 120 of them) and mail the following quantities: 30 Brecht boxes... to Galerie Parnass 50 Brecht boxes...to: Gallery One ...One box to each: [11 names] ...charge each 10DM (that makes 110DM which should take care of mailing expences etc.). You can send them a bill or send package collect — so that they must pay post office 10DM & then you get the money.). Also mail: 10 Brecht boxes...to Karl-Erik-Welin-...2 Brecht boxes ...to each:Galerie Niepel...Galerie Schmela...that will relieve you of...100 Brecht boxes. The balance you should keep to sell yourself... Pack those Brecht boxes well, so they won't get squashed."
Letter: George Maciunas to Tomas Schmit, [January 1964].

FLUXUS 1963 EDITIONS, AVAILABLE NOW ... FLUXUS c WATER YAM, arranged by George Brecht in wood box, $5 in "special box" $10 works from 1963 - $1 per year
cc V TRE (Fluxus Newspaper No. 2) February 1964.

FLUXUS 1964 EDITIONS, AVAILABLE NOW ... FLUXUS c WATER YAM, arranged by George Brecht in wood or translucent box, $5 in one of the kind wood box, $10 & up
cc Valise e TRanglE (Fluxus Newspaper No. 3) March 1964.

FLUXKIT containing following fluxus-publications: (also available separately)...FLUXUS c WATER YAM, arranged by George Brecht (complete set of GB e-vents, including the 1964 events) in plastic box, $5
cc fiVe ThReE (Fluxus Newspaper No. 4) June 1964.

2B-Fc WATER YAM, arranged by GEORGE BRECHT in wood or translucent plastic box, $5, in one of the kind wood box, $10 and up.
European Mail-Orderhouse: europeanfluxshop, Pricelist. [ca. June 1964].

2B-Fc WATER YAM, scores, events, works, arranged by GEORGE BRECHT in cardboard, wood or translucent plastic box $5. in one of the kind wood box $10 & up
Second Pricelist - European Mail-Orderhouse. [Fall 1964].

FLUXKIT containing the following flux-publications: WATER YAM arranged by George Brecht (complete set of george brecht events, including the 1964 events) in plastic box...
ibid.

"...Do you have any Brecht boxes left? I remember I left at your place several..."
Letter: George Maciunas to Ben Vautier, January 23, 1965.

"...There are not too many new pieces that you do not know, You have complete set of: George Brecht ...you have the boxes?..."
Letter: George Maciunas to Ben Vautier, February 1, 1965.

"...Put relocation, iced dice, and cloud scissors, (7 cards with single words.) and delivery card into Brecht box..."
Letter: George Maciunas to Willem de Ridder, February 4, 1965.

"Replies to your questions...Cloud Scissors may go into Brecht Water Yam box...."
Letter: George Maciunas to Willem de Ridder, March 2, 1965.

George Brecht. ca. 1963

GEORGE MACIUNAS

FLUXKIT containing the following fluxus-publications: (also available separately) FLUXUS c WATER YAM, arranged by George Brecht (complete set of GB events through 1964) in plastic box, $5

Vacuum TRapEzoid (Fluxus Newspaper No. 5) March 1965.

FLUXKIT... WATER YAM ...(complete set of GB events through 1966) in plastic box: $6

Vaseline sTREet (Fluxus Newspaper No. 8) May 1966.

"...I mailed by parcel post - one carton with following:...1 Geo. Brecht events wholesale cost to you each $3 suggested selling price $6...the Brecht...event boxes also have lots of performance pieces, so you could give several Flux concerts up in Ithaca..."
Letter: George Maciunas to Ken Friedman, August 19, 1966.

"...Furthermore Fluxus still publishes newspaper, supplements to works of Brecht, ..."
Letter: George Maciunas to Ben Vautier, [ca. October, 1966].

FLUX-PROJECTS PLANNED FOR 1967...George Brecht: 1966 & 1967 events (supplement to Water Yam)...
Fluxnewsletter, March 8, 1967.

wateryam (events) $7 by george brecht
Fluxshopnews. [Spring 1967].

FLUX-PRODUCTS 1961 TO 1969 ... GEORGE BRECHT Water Yam, complete set of Brecht events, boxed cards, 1959 to 1966 [$] 20 [indicated as part of FLUXKIT]
Fluxnewsletter, December 2, 1968 (revised March 15, 1969).

FLUX-PRODUCTS 1961 TO 1970 ... GEORGE BRECHT Water Yam, complete events, 1959-66, [$] 20
Flux Fest Kit 2. [ca. December 1969].

FLUXUS - EDITIONEN ... [Catalogue No.] 724 GEORGE BRECHT: water yam, complete events 1959-66 in plastic box
Happening & Fluxus. Koelnischer Kunstverein, 1970.

FLUXUS - EDITIONEN ... [Catalogue No.] 725 GEORGE BRECHT:...water yam, complete events, 1959-63 in cardboard box
ibid.

FLUX-OBJECTS 1963 GEORGE BRECHT: water yam (events)
George Maciunas, Diagram of Historical Developments of Fluxus... [1973].

COMMENTS: Brecht, 1983: "La Monte [Young] got the first pieces [for Water Yam]...I suppose when Maciunas called for pieces, then some of those cards got in...It was his idea to make an edition of the cards."
Hendricks: "How did people regard [card events] when you mailed them out?"
Brecht: "Mostly we didn't get any response."

Hendricks: "They could be realized as objects?"
Brecht: "Yes, 'the egg' for example and 'the six exhibits' you could find around."
Hendricks: "They could also be performances?"
Brecht: "I never went out of my way to perform them. 'The Three Dances' were in the context of James Waring."

There are many different packagings of Water Yam, as well as various printings of the contents. The earliest Fluxus printings of the cards were on orange card stock paper, although some were also printed black on white card stock and done simultaneously with the orange ones. The number of cards increases in later packagings of Water Yam as more works were printed. Other works that appear in assemblings of Water Yam are Cloud Sissors and Nut Bone.

WHITE WITH WORD "FLAG"

FOUR FLAGS are available from G.Brecht:...WHITE WITH WORD "FLAG" all in cotton bunting. Write for prices.
Yam Festival Newspaper, [ca. 1963].

COMMENTS: White With Word "Flag", like the three others of its grouping for flags in the Yam Festival newspaper: White, White with Black Arrow and White with Spectral Colors, depend conceptually on the white background with the addition or exclusion of elements. A number of works made for the Yam Festival ended up on early lists of Fluxus works, although as a Brecht work, this did not. In the Fluxus Newspaper No. 8 (May 1966) there is an advertisement for "FLUX-FLAGS AND BANNERS, Fluxus t Robert Morris: black on white: flag." Perhaps when Maciunas was making the ad, he remembered the attribution for the work incorrectly. Robert Morris had a very slight early association with Fluxus which had ceased by 1966.

Design by George Maciunas for a fluxflag based on WHITE WITH WORD "FLAG" by George Brecht

GEORGE BRECHT and ROBERT FILLIOU

BOTTLE BOTTLE - OPENER

"...Other going projects:...Brecht - bottle opener..."
Letter: George Maciunas to Ken Friedman, [ca. February 1967].

George Brecht and Robert Filliou. BOTTLE BOTTLE-OPENER. Originally planned as a Fluxus Edition, the work was eventually produced by Vice Versand

FLUX-PROJECTS PLANNED FOR 1967...George Brecht:...in collaboration with Robert Filliou: Bottle bottle - opener
Fluxnewsletter, March 8, 1967.

COMMENTS: *Not made by Maciunas as a Fluxus Edition,* Bottle-Bottle Opener *was eventually produced by Wolfgang Feelish in a Vice Versand signed edition of 42. An instruction drawing of the work is reproduced in* Games at the Cedilla, *Something Else Press, New York, 1967.*

EASTERN DAYLIGHT FLUX TIME
Silverman No. 80

"...Other going projects:...Brecht-watch..."
Letter: George Maciunas to Ken Friedman, [ca. February 1967].

FLUX-PROJECTS PLANNED FOR 1967...George Brecht...in collaboration with Robert Filliou...Eastern Daylight flux-watch...
Fluxnewsletter, March 8, 1967.

by George Brecht (with Robert Filliou) Eastern daylight Flux-time, gold plated watch with objects inside: $50
Fluxnewsletter, April 1975.

by George Brecht: (with Robert Filliou)/ Eastern daylight Flux-time, gold plated watch with objects

George Brecht and Robert Filliou. EASTERN DAYLIGHT FLUX TIME

BRAD IVERSON

inside: $50
[Fluxus price list for a customer]. September 1975.

"George Brecht & Filliou - watch - $50"
Letter: George Maciunas to Dr. Hanns Sohm, November 30, 1975.

Brecht/Filliou watch $50
[Fluxus price list for a customer]. January 7, 1976.

"George Brecht & Robert Filliou watch $50"
Letter: George Maciunas to Dr. Hanns Sohm, May 1, 1976.

"...I heard...that you may be interested to take Fluxboxes for the $800 I owe you...I could suggest... Brecht-Filliou watch - $50..."
Letter: George Maciunas to Peter Frank, [ca. March 1977].

COMMENTS: *Brecht has stated that the original concept for the work was his, and that Maciunas had added Robert Filliou's name to it.* Eastern Daylight Flux Time *exists as a Maciunas produced Fluxus Edition.*

FUTILE BOX see:
Robert Filliou

12 HUMAN FOOTSTEPS AND 1 DOGS FOOTSTEP

FLUXFURNITURE...RUGS...George Brecht & Robert Filliou: 12 human footsteps and 1 dogs footstep, woven rug...4ft. x 4ft. $150, 8ft. x 8ft. $300...Available in N.Y.C. at Multiples and late in 1967 at FLUX-SHOP, 18 GREENE ST.
Fluxfurniture, pricelist. [1967].

"...These objects I think could be produced cheaper in Italy:...carpet with foot prints or animal foot prints (elephant prints?)"
Letter: George Maciunas to Daniela Palazzoli, n.d. Reproduced in Fluxnewsletter, April 1973.

COMMENTS: *This work is not known to have been made by Maciunas as a Fluxus Edition. Ay-O's* Upwardly Protruding Nails Floor, *Kosugi's score, "Keep Walking Intently" and George Maciunas'* Shoe Steps *are other Fluxus ideas concerned with footsteps. George Maciunas produced an edition of a box of rubber stamps of animal footprints by Yoko Ono for sale during her one woman exhibition at the Eversen Museum in the early 1970s. There is evidence that Maciunas offered this edition as a Fluxus work, however I find no references to it in Fluxus publications.*

GEORGE BRECHT and ALLAN KAPROW

Excerpts from a radio broadcast discussion between George Brecht and Allan Kaprow entitled: "Happenings and events" appear in Fluxus Newspaper No. 4, June 1964.
see: COLLECTIVE

GEORGE BRECHT and GEORGE MACIUNAS

SILICATE MICRO CRYSTALS
Silverman No. > 60.I

Science Show crystals
Notes: George Maciunas for the Fluxfest 77 at and/or, Seattle [ca. September 1977].

SILICATE MICRO CRYSTALS collected by George Brecht & George Maciunas each specimen $.50
Title card of the work.

COMMENTS: *Silicate Micro Crystals and two other parts of the Fluxscience Show: George Maciunas'* Excreta Fluxorum, *a collection of animal excrement; and Robert Watts'* Flux Atlas, *a collection of stones from all over the world, were made for the Fluxfest at and/or in Seattle, Washington, in the Fall of 1977.*

SILICATE MICRO CRYSTALS

collected by George Brecht & George Maciunas

each specimen: $.50

George Brecht and George Maciunas. Title card for SILICATE MICRO CRYSTALS

CLAUS BREMER and EMMETT WILLIAMS

It was announced in the tentative plans for the first issues of FLUXUS that C. Bremer and E. Williams would contribute an "Anthology of serial poetry" for FLUXUS NO. 2 WEST EUROPEAN ISSUE I.
see: COLLECTIVE

STANLEY BROUWN

Stanley Brouwn's name, misspelled as Brown, appears on the monogram cards which serve as the index for Fluxus I. There is an untitled work, interspersed throughout the edition in an apparently random fashion, which by process of elimination would be attributed to Brouwn. George Maciunas wrote to Willem de Ridder, ca. June 1964, "I think you should certainly include in European Fluxus Stanley Brown. Try to pull him out of the bearhug of Vostell." The European Fluxus edition was never made, although some material for it appears in FLUXUS I and the Fluxus newspapers, see FLUXUS I in the Collective (although Brouwn's name does not appear in any of the texts).

Sylvano Bussotti, 1964

SYLVANO BUSSOTTI

It was announced in the tentative plans for the first issues of FLUXUS that S. Bussoti [sic] would contribute "Graphic Music (a false anthology)" and "New Music in Italy" to FLUXUS NO. 5, WEST EUROPEAN ISSUE II. His contribution in the next two listings for FLUXUS NO. 5 were expanded to include "Graphic Music (a false anthology);" "South Avant Garde (open letter to Maderna);" and edit an "anthology of magnetic-tape music from Italy." In the Brochure Prospectus version A, in addition to the above, the "Anthology of magnetic-tape music" is listed as a record and Bussoti was to also edit a contribution on "Italian happenings." FLUXUS NO. 5 was never made.
see: COLLECTIVE

Unidentified Scores

Scores available by special order:...Also available are scores of works by Sylvano Bussotti...
Fluxus Preview Review, [ca. July] 1963.

COMMENTS: Early in the development of Fluxus, Maciunas planned to sell scores by a number of artists, producing them on demand. It's not clear whether any by Bussotti were ever issued this way by Fluxus.

JOSEPH BYRD

It was announced in the tentative plans for the first issues of FLUXUS that Joseph Byrd would contribute "Modern Music and the Emotion Aesthetic" for FLUXUS NO. 1 U.S. ISSUE. In the Brochure Prospectus, version B, Byrd's planned contribution to FLUXUS NO. 1 also included "2 pieces for R. Maxfield." and he was to contribute two more works: "Critical analysis of the theories of Zhdanov" and "Critical analysis of current Marxists estheticians (in regard to lack of dialectic approach)" for FLUXUS NO. 7 EAST EUROPEAN ISSUE.
see: COLLECTIVE

Unidentified Scores

Scores available by special order:...Also available are scores of works by...Joseph Byrd...
Fluxus Preveiw Review, [ca. July] 1963.

Joseph Byrd, 1961

COMMENTS: I am not able to identify which scores of Joseph Byrd George Maciunas planned to produce. A number of scores from this period exist in the Silverman Collection, although none with a Fluxus copyright. Two scores by Byrd are included in An Anthology, edited by La Monte Young, 1963.

C

JOHN CALE

POLICE CAR
Silverman No. > 82.101

[part of] FLUXFILMS SHORT VERSION...[flux - number] 31 POLICE CAR duration 1' Underexposed sequence of blinking lights on a police car.
Fluxfilms catalogue. [ca. 1966].

PAST FLUX-PROJECTS (realized in 1966)...[part of] Fluxfilms: total package: 1 hr. 40 min...police car by John Cale...
Fluxnewsletter, March 8, 1967,

FLUX-PRODUCTS 1961 TO 1969...FLUXFILMS, short version Summer 1966 40 min. 1400 ft.:...[including] Police car - by John Cale...16 mm [$] 180 8 mm version [$] 50
Fluxnewsletter, December 2, 1968 (revised March 15, 1969).

FLUXFILMS, short version, Summer 1966...Police Car by John Cale...
Flux Fest Kit 2. [ca. December 1969].

FLUXYEARBOX 2, May 1968...19 film loops by:... [including] John Cale
SLIDE & FILM FLUXSHOW...JOHN CALE: POLICE CAR Underexposed sequence of blinking lights on police car. Color. 1'
ibid.

03.1965...FLUXFILMS:...JOHN CALE: police car blinking
George Maciunas, Diagram of Historical Developments of Fluxus... [1973].

COMMENTS: John Cale was the organizer of the Fluxus Concert in London, "A Little Festival of New Music" at Goldsmith's College, July 6, 1963. Before the concert, George Maciunas wrote to Tomas Schmit: "In London you can stay in John Cale's place - but can you borrow somewhere an air mattress?" and then later, "Living will be cheap, since you can sleep free & food you can obtain by searching Cale's kitchen." After the concert Maciunas writes, "But how is this John Cale?? I have never met him, Seems to have funny attitudes about changing programs - very stuffy." Two scores by John Cale appear in Fluxus Preview Review [ca. July] 1963.
see: COLLECTIVE.

JOE CAMMARATA

NOVOCAINE SANDWICH

FLUX DRINKS & FOODS...SANDWICHES...Novocain [sic] sandwich (Joe Cammerata [sic])...
Invitation to Participate in New Year Eve's Flux-Feast. [ca. December 1969].

COMMENTS: *I don't know if Cammarata's sandwich was made. Two scores of his were published in* Flux Fest Kit 2. *[ca. December 1969].*

CORNELIUS CARDEW

It was announced in the tentative plans for the first issues of FLUXUS that C. Cardew and possibly another author would contribute "Neo-Dada in England." for FLUXUS NO. 5 WEST EUROPEAN ISSUE II.
see: COLLECTIVE

ARTHUS C. CASPARI

It was announced in the tentative plans for the first issues of FLUXUS that C. Caspari would contribute "LABY....no more Bauhaus." to FLUXUS NO. 2 WEST EUROPEAN ISSUE. The title of the work changes to "Labyr....absolute architecture" in subsequent plans. It was announced in the Brochure Prospectus, version B, that Caspari would contribute a different work "Theatralisches BYL" to FLUXUS NO. 3 GERMAN & SCANDINAVIAN YEARBOX.
see: COLLECTIVE

PAULO CASTALDI

It was announced in the tentative plans for the first issues of FLUXUS that Paulo Castaldi would contribute "Italian Futurist noise music" for FLUXUS NO. 4 HOMAGE TO THE DISTANT PAST, later called FLUXUS NO. 5.
see: COLLECTIVE

JOHN CAVANAUGH

BLINK
Silverman No. > 82.201, ff.

FLUXFILM 5 JOHN CAVANAUGH: blink, 10 min $40
Vaseline sTREet (Fluxus Newspaper No. 8) May 1966.

FLUXFILMS...LONG VERSION...[flux-number] 5 John Cavanaugh BLINK, [duration] 1' Flicker: white and black alternating frames.
Fluxfilms catalogue, [ca. 1966].

PAST FLUX-PROJECTS (realized in 1966)...Fluxfilms: total package: 1 hr. 40 min....blink by John

Cavanaugh...
Fluxnewsletter, March 8, 1967.

FLUX-PRODUCTS 1961 TO 1969...Fluxfilms, long version Winter 1966 Short version plus addition of: Flicker by John Cavanaugh...
Fluxnewsletter, December 2, 1968 (revised March 15, 1969).

FLUX-PRODUCTS 1961 TO 1970...FLUXFILMS, long version, Winter 1966. Short version plus addition of: Flicker by J.Cavanaugh...
Flux Fest Kit 2. [ca. December 1969].

FLUXYEARBOX 2, 1968...19 film loops by: [including] John Cavanaugh...
ibid.

FILM AND SOUND ENVIRONMENT A booth must be set up in a fairly dark area, the walls of which are of white vinyl or cotton sheets (about 12' wide x 8' high) hanging as curtains, creating thus a 12' x 12' or smaller room. Four 8mm wide angle lense loop projectors must be set up in front of each wall on the outside, projecting an image the frame of which is to cover entire wall. Spectators may enter the booth through corners...Sound and film flicker by J. Cavanaugh.
ibid.

DETAILS...MAY 16-22: CAPSULE BY JOHN & YOKO + FLUX SPACE CENTER A 3ft cube enclosure (capsule) having various film loops projected on its walls, ceiling and floor to a single viewer inside, total time: 6 min.... [including] Flicker (J. Cavanaugh, 1965)...
Schedule of events for Fluxfest presentation of John Lennon and Yoko Ono. [ca. April 1970]. version A

...($1 ADMISSION CHARGE)...about 8 minutes.... [including] Flicker (J. Cavanaugh, 1965)...
Schedule of events for Fluxfest presentation of John Lennon and Yoko Ono. [ca. April 1970]. version B

FLUXFEST PRESENTS YOKO ONO MAY 16-22 CAPSULE BY YOKO + FLUX SPACE CENTER ... [including] flicker (J. Cavanaugh)...
Schedule of events for Fluxfest presentation of John Lennon and Yoko Ono. April 1, 1970. version C

COMMENTS: *Blink, alternating clear (white) and black frames, is included in the long version of Fluxfilms, Silverman No. >123.IV ff. A loop of the film is usually included in* Flux Year Box 2, Silverman No. 125 ff. Blink *is a good example of the multiple uses of a work in Fluxus. There is some confusion about the title of the piece, which is also called "Flicker." Another film in the* Fluxfilms *package, Eyeblink by Yoko Ono, is sometimes referred to as "Blink." Ono's Eyeblink was literal, but projected in surreal time. George Brecht contributed the word "blink" to the collaborative Brecht, Knowles, Watts event: "Sissors Bros. Warehouse" in 1963.*

FLICKER see:
BLINK

GIUSEPPE CHIARI

LA STRADA
Silverman No. 83, ff.

"...As soon as I return from Arizona, I will ship you a Fluxkit, which will have all new compositions, including Gius Chiarri - La Strada. (thats in Fluxus 1 incidentally)..."
Letter: George Maciunas to Ben Vautier, February 1, 1965.

"...Small cards- (confused noises, etc.) are LA STRADA by G.Chiari - one card says that - and it can be used as label. Use small envelope for these cards. One envelope like that is in Fluxus I that I sent to you..."
Letter: George Maciunas to Willem de Ridder, February 4, 1965.

"Replies to your questions...La Strada is better separate. I don't have enough for Yearbook..."
Letter: George Maciunas to Willem de Ridder, March 2, 1965.

FLUXKIT containing following fluxus-publications: (also available separately)...FLUXUS u GIUSEPPE CHIARI: La Strada, score $1
Vacuum TRapEzoid (Fluxus Newspaper No. 5) March 1965.

COMMENTS: *La Strada was distributed as an individual edition and as a component of* FLUXUS 1 *and* FLUXKIT.

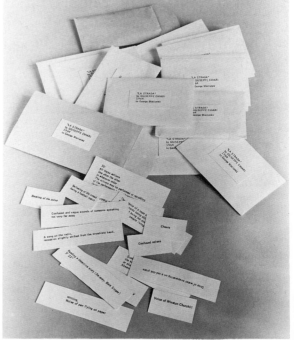

Giuseppe Chiari. **LA STRADA**

Giuseppe Chiari performing "Gesto E Segno." November 1964

GALLERIA BLU

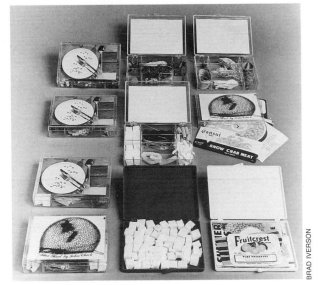

BRAD IVERSON

John Chick. FLUX FOOD. A number of Fluxus interpretations of the work. see color portfolio

Spring 1969...JOHN CHICK: forest foods
George Maciunas, Diagram of Historical Developments of Fluxus... [1973].

JOHN CHICK Fluxfoods, (from the forest) $8
Flux Objects, Price List. May 1976.

COMMENTS: *The work is a marvelously varied Fluxus Edition. Two different Maciunas designed labels were used. The contents change from box to box - sometimes "Synthetic Foods" which are styrofoam bits, sometimes "Forest Foods" which are lichens, acorns, pine needles etc.; sometimes Maciunas would combine the two elements of natural and synthetic.*

Unidentified Scores

Scores available by special order:...Also available are scores of works by...Guiseppe Chiari [unidentified scores]...
Fluxus Preview Review, [ca. July] 1963.

COMMENTS: *There is no evidence that Fluxus produced any scores of Chiari's other than* La Strada, *probably in 1964, a year after this listing.*

JOHN CHICK

FLUX-FOOD
Silverman Nos. 85, ff.

"...Other going projects:...Greg Sharits [sic] - synthetic Fluxfood..."
Letter: George Maciunas to Ken Friedman, [ca. February 1967].

FLUX-PRODUCTS PLANNED FOR 1967 ... Greg Sharits [sic] synthetic flux-food...
Fluxnewsletter, March 8, 1967.

FLUXPROJECTS PLANNED FOR 1968 (In order of priority)...3. Boxed events & objects (all ready for production)...Greg Sharits [sic] - synthetic flux-food...
Fluxnewsletter, January 31, 1968.

JOHN CHICK Flux-food (forest found objects or synthetic food-like objects) in partitioned box [$] 5
Fluxnewsletter, December 2, 1968 (revised March 15, 1969).

JOHN CHICK Fluxfood, forest or synthetic, boxed ea. [$] 5
Flux Fest Kit 2. [ca. December 1969].

FLUXUS-EDITIONEN...[Catalogue No.] 737 JOHN CHICK: fluxfood, synthetic
Happening & Fluxus. Koelnischer Kunstverein, 1970.

Flux Food by John Chick

John Chick. FLUX FOOD. Label for the Fluxus Edition designed by George Maciunas

John Chick. FLUX FOOD. Unused mechanical designed by George Maciunas

John Chick. FLUX FOOD. Unused mechanical designed by George Maciunas

John Chick. FLUX FOOD. Mechanical for one of the two labels used for the Fluxus Edition, designed by George Maciunas

John Chick. FLUX FOOD. Unused mechanical designed by George Maciunas

CHRISTO

PACKAGE
Silverman No. 93

"...Fluxkit now has also object by Christo...has a bundle of wrapped artificial flowers..."
Letter: George Maciunas to Ben Vautier, January 10, 1966.

"...The new Fluxkit besides is better than the old one...it has...also Christo object..."
Letter: George Maciunas to Ben Vautier, March 5, 1966.

FLUXKIT containing following fluxus-publications:

Christo. PACKAGE. see color portfolio

BRAD IVERSON

FERDINAND BOESCH, COURTESY OF CHRISTO

Christo, with Jeanne-Claude and Cyril Christo in front of STORE FRONT, 1965

(also available separately)...FLUXUS e CHRISTO: package $15
Vaseline sTREet (Fluxus Newspaper No. 8) May 1966.

COMMENTS: *Although I have never seen a* Fluxkit *which contains* Package, *Christo states that his copy of* Fluxkit *does have the work in it. Very few examples of this work were made, all were wrapped and tied by Christo. A different work, "L'empaquetage d'edifice public Octobre 1961," is illustrated in Fluxus Newspaper No. 1, January 1964.*

GRIGORI CHUKHRA

It was announced in the tentative plans for the first issues of FLUXUS that G. Chukhra or someone to be determined, would contribute "Film making procedures in Soviet studios" or a work "to be determined" for FLUXUS NO. 6 EAST EUROPEAN ISSUE.
see: COLLECTIVE

JACK COKE'S FARMER'S CO-OP

"your letter-newsletter really freaked me out (i thought 'wow, did i send all that stuff to george? i can't even remember making any of it!')...then i realized that you must have received a package of jack coke's students' work (jack, being very impressed with fluxboxes, had his sculpture students do a bunch of box events)...so, credit for that should go to 'st. cloud state college farmers' cooperative' (most the kids up here are from farms & thought it would be nice to label themselves as such...weird kids, eh?!"
Letter: Paul Sharits to George Maciunas, [Spring 1967].

ARTISTS' INSPIRATION

FLUX-PROJECTS PLANNED FOR 1967...Paul Sharits:...artists' inspiration.
Fluxnewsletter, March 8, 1967.

"...I got a box full of good ideas,...so we up here decided to go ahead with several right away, and I am designing labels for the following...Artists inspiration - very sentimental [label] - romantic poet thinking with turned-up eyes - Byron or someone like this...."
Letter: George Maciunas to Paul Sharits, [after March 8, 1967].

COMMENTS: Artists' Inspiration *was not made by George Maciunas as a Fluxus Edition. Although referred to as a work by Paul Sharits, this was a misunderstanding by Maciunas. It is actually an idea of the students of Jack Coke.*

BLACK PIN BOX

"...I got a box full of good ideas...Later in the year could do:...Black-pin box..."
Letter: George Maciunas to Paul Sharits, [after March 8, 1967].

COMMENTS: *This work was not made by George Maciunas as a Fluxus Edition. It probably was received by Maciunas at the same time as* Artists Inspiration *and was misunderstood to be a work of Paul Sharits.*

BOXBOX see:
KEEP BOX CLOSED

EXPLODING BALLOON BOX

FLUX-PROJECTS PLANNED FOR 1967...Paul Sharits...exploding balloon box...
Fluxnewsletter, March 8, 1967.

"...I got a box full of good ideas,...so we up here decided to go ahead with several right away, and I am designing labels for the following:...Exploding balloon - baroque balloon rising into sky...."
Letter: George Maciunas to Paul Sharits, [after March 8, 1967].

Jack Coke's Farmer's Co-op. EXPLODING BALLOON BOX. Study by George Maciunas for the label

fluxballoon $3...by farmers' co-op.
Fluxshopnews. [Spring 1967].

FLUXPROJECTS FOR 1968 (in order of priority) 3. Boxed events & objects (all ready for production): ...Jack Coke Farmers' Coop...exploding balloon box
Fluxnewsletter, January 31, 1968.

COMMENTS: *Originally listed as Paul Sharits',* Exploding Balloon Box *was an idea of Jack Coke's students. It was never made by George Maciunas as a Fluxus Edition. This work also has a relationship to Greg Sharits'* Bag Trick.

FIND THE END
Silverman Nos. 96; 97, ff.

FLUX-PROJECTS PLANNED FOR 1967...Paul Sharits...thread puzzle-game
Fluxnewsletter, March 8, 1967.

"...I got a box full of good ideas, boxes...with tangled-up thread,...so we up here decided to go ahead with several right away, and I am designing labels for the following:...Tangled up thread/label design incorporating following pictorial mtl.- photo of seaman making knots..."
Letter: George Maciunas to Paul Sharits, [after March 8, 1967].

find the end $3...by farmers' co-op.
Fluxshopnews. [Spring 1967].

FLUXPROJECTS FOR 1968 (in order of priority)...
3. Boxed events & objects (all ready for production):
...Jack Coke Farmers' Co-op...thread puzzle game
Fluxnewsletter, January 31, 1968.

FLUX-PRODUCTS 1961 TO 1969...FARMERS' COOPERATIVE, Find the end, a rope trick, boxed *
[$] 4 [indicated as part of FLUXKIT]
Fluxnewsletter, December 2, 1968 (revised March 15, 1969).

FLUX-PRODUCTS 1961 TO 1970 ... FARMERS' COOPERATIVE Find the end, rope trick, boxed [$] 4
Flux Fest Kit 2. [ca. December 1969].

FLUXUS-EDITIONEN...[Catalogue no.] 738 FAR-

Jack Coke's Farmer's Co-op. FIND THE END. Mechanical for the label designed by George Maciunas

BRAD IVERSON

Jack Coke's Farmer's Co-op. FIND THE END. Three different Fluxus interpretations with the artists' prototype on the right

MERS COOPERATIVE: find the end, rope trick
Happening & Fluxus. Koelnischer Kunstverein, 1970.

COMMENTS: *In early 1967, George Maciunas received a package containing a number of ideas for works which he thought were by Paul Sharits.* Find the End *is actually an anonymous work by Jack Coke's students at St. Cloud State College (also where Paul Sharits was teaching at the time). There are several Maciunas interpretations of this work, most quite different from the original prototype.*

FIRE ALARM

fire alarm $3...by farmers' co-op.
Fluxshopnews. [Spring 1967].

COMMENTS: *Although a Maciunas designed label exists for the work, it is not known to have been produced as a Fluxus Edition.*

FLUX BALLOON see:
 EXPLODING BALLOON BOX

FURRY ANIMAL IN FURRY BOX

"...I got a box full of good ideas,...hairy boxes with

Jack Coke's Farmer's Co-op. FIRE ALARM. Design by George Maciunas for the label

furry animals,...Later in the year could do:...furry animal in furry box..."
Letter: George Maciunas to Paul Sharits, [after March 8, 1967].

COMMENTS: This work was not produced by George Maciunas as a Fluxus Edition. Note the relationship to Per Kirkeby's Solid Wood in Wood Box, *and Meret Oppenheim's* Fur-covered Cup, Saucer and Spoon.

HUMAN FLUX TRAP
Silverman Nos. 94; 95

FLUX-PROJECTS PLANNED FOR 1967...Paul Sharits...human-mouse trap...
Fluxnewsletter, March 8, 1967.

"...I got a box full of good ideas,...so we up here decided to go ahead with several right away, and I am designing labels for the following:...Human-mouse trap/label design incorporating following pictorial mtl. — photo of actual human trap (cage) put up somewhere as amusement piece in a park..."
Letter: George Maciunas to Paul Sharits, [after March 8, 1967].

human flux trap $3...by farmers' co-op.
Fluxshopnews. [Spring 1967].

FLUXPROJECTS FOR 1968 (in order of priority)... 3. Boxed events & objects (all ready for production)... Jack Coke Farmers' Co-op...human mouse trap...
Fluxnewsletter, January 31, 1968.

FLUX-PRODUCTS 1961 TO 1969...FARMERS' COOPERATIVE...Human trap, boxed [$] 6
Fluxnewsletter, December 2, 1968 (revised March 15, 1969).

Jack Coke's Farmer's Co-op. HUMAN FLUX TRAP. Unused mechanical for the label designed by George Maciunas

227

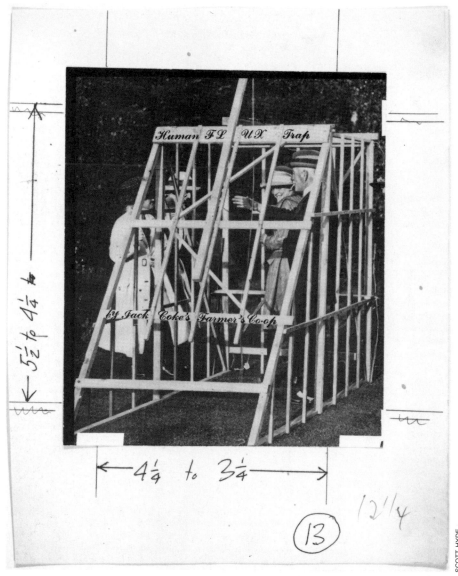

SCOTT HYDE

Jack Coke's Farmer's Co-op. HUMAN FLUX TRAP. Mechanical for the label designed by George Maciunas

BRAD IVERSON

Jack Coke's Farmer's Co-op. HUMAN FLUX TRAP. Clockwise from top, the artists' prototype, a label, and the Fluxus Edition

FLUX-PRODUCTS 1961 TO 1970...FARMERS' COOPERATIVE...Human trap, boxed [$] 6
Flux Fest Kit 2. [ca. December 1969].

FLUXUS-EDITIONEN...[Catalogue No.] 739 FARMERS COOPERATIVE:...human trap
Happening & Fluxus. Koelnischer Kunstverein, 1970.

SPRING 1969...FARMERS COOP: human trap, etc.
George Maciunas, Diagram of Historical Developments of Fluxus... [1973].

COMMENTS: The first listing of this work erroneously credits Paul Sharits. It was actually an anonymous work by students at Saint Cloud State College, who called themselves "Jack Coke's Farmers Coop." This work was produced by George Maciunas as a Fluxus Edition and is basically the same as the artists' made prototype.

KEEP BOX CLOSED

FLUX-PROJECTS PLANNED FOR 1967...Paul

Sharits:...zippered & buttoned ''keep box closed'' box...
Fluxnewsletter, March 8, 1967.

''...I got a box full of good ideas, boxes with zippers, ...so we up here decided to go ahead with several right away, and I am designing labels for the following: ... Zippered 'keep box closed' box - label design incorporating following pictorial mtl. chest front of Emperor Joseph with Passementerie front like hussar uniform.''

Jack Coke's Farmer's Co-op. KEEP BOX CLOSED. Study by George Maciunas for the label

Letter: George Maciunas to Paul Sharits, [after March 8, 1967].

boxbox $7 by farmers' co-op.
Fluxshopnews. [Spring 1967].

FLUXPROJECTS FOR 1968 (in order of priority)...
3. Boxed events & objects (all ready for production)...
Jack Coke Farmers' Co-op...zippered and buttoned box, "keep box closed" box...
Fluxnewsletter, January 31, 1968.

COMMENTS: *Although originally credited to Paul Sharits, Keep Box Closed is actually an anonymous work by students of Jack Coke at Saint Cloud State College (where Sharits was teaching as well). The work was never made by George Maciunas as a Fluxus Edition. It bears a relationship to George Brecht's Closed On Mondays (Silverman No. 72) and Ben Vautier's Mystery Box (Silverman No. 435).*

SELF LIGHTING FIREWORKS

FLUX-PROJECTS PLANNED FOR 1967...Paul Sharits:...self lighting match box
Fluxnewsletter, March 8, 1967.

"...I got a box full of good ideas,...so we up here decided to go ahead with several right away, and I am designing labels for the following:...Match-self lighting box - fireworks picture [for label] ..."
Letter: George Maciunas to Paul Sharits, [after March 8, 1967].

FLUXPROJECTS FOR 1968 (in order of priority) ...
3. Boxed events & objects (all ready for production)...
Jack Coke Farmers' Co-op - self lighting fireworks
Fluxnewsletter, January 31, 1968.

COMMENTS: *Self Lighting Fireworks is an anonymous work by students at St. Cloud State College. Initially listed as a work by Paul Sharits, it bears a strong relationship to Greg Sharits' Fluxus work Roll Trick (Silverman No. 388).*

THREAD PUZZLE GAME see:
FIND THE END
ZIPPERED AND BUTTONED BOX see:
KEEP BOX CLOSED

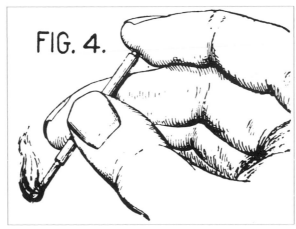

Jack Coke's Farmer's Co-op. SELF LIGHTING FIREWORKS. Study by George Maciunas for the label

CONGO

Congo, a talented chimpanzee in the London Zoo, is shown making a painting in Fluxus Newspaper No. 1. Two works by Congo are reproduced in FLUXUS 1.
see: COLLECTIVE

Congo. The magazine clipping used by George Maciunas for one of Congo's contributions to FLUXUS 1

PHILIP CORNER

It was announced in the tentative plans for the first issues of FLUXUS, that Philip Corner would contribute "Projections of Indeterminacy" and "Chirographic...(score)" (later called "Chirographic...(score fold out)") for FLUXUS NO. 1 U.S. ISSUE. For FLUXUS NO. 3 (later called FLUXUS NO. 4, the JAPANESE ISSUE) Corner was to contribute "Of modern times and ancient sounds." FLUXUS NO. 4 HOMAGE TO THE PAST was to include Corner's essay "The radicals of the 14th. Cent. secular music." This work changes (as does the FLUXUS NO. to 5) to "Medieval musical extremities of Avignon." In the first version of Brochure Prospectus, it was announced that Corner was to contribute "Chirographic piano piece", "Tower Music etc.," and "Lecture for Sunday Performance" for FLUXUS NO. 1, the other contributions remaining the same for FLUXUS NOS. 4 and 5. The second Brochure Prospectus announced contributions of "Chirographic" and "Piano Activities" for the U.S. FLUXUS. None of these works appear in FLUXUS 1.
see: COLLECTIVE

PIANO ACTIVITIES

COMMENTS: *Philip Corner states that a 3 page typescript of*

GEORGE MACIUNAS

Philip Corner, ca. 1961

the score, rubberstamped with the FLUXUS copyright exists, but to his knowledge was not distributed.

Unidentified Scores

Scores available by special order:...Also available are scores of work by...Philip Corner
Fluxus Preview Review, [ca. July] 1963.

"...First to reply to your questions...Cards with short scores - Philip Corner, but to make sure, please describe a few more cards."
Letter: George Maciunas to Willem de Ridder, January 21, 1965.

COMMENTS: It is unclear what the above "unidentified scores" are. A Fluxus printing of "Piano Activities" exists, and other scores typed by Maciunas but without a Fluxus copyright apparently exist, although I haven't seen them. In the early plans for the contents of FLUXUS and the tentative Program for the Festival of New Music, Philip Corner is listed as Music Editor. Scores of his which were planned to be performed in various concerts were: "Passionate Expanse of the Law," "Tower Music for Voices," "Enough! or Too Much!," "Piano Activities," "Flux & Form No. 7," "Flux & Form No. 14," "Chirographic Music for Violin," and "Chirographic Music for Piano." And indeed, some of these works were performed in Fluxus concerts. Although a photographic portrait of Corner was printed to be included in FLUXUS 1, neither it nor scores appear.

ENRICO CRISPOLTI

It was announced in the tentative plans for the first issues of FLUXUS that Enrico Crispolti was being consulted on "new Italian art and literature" for FLUXUS NO. 5 WEST EURO-PEAN ISSUE, (later called FLUXUS NO. 6 ITALIAN, ENGLISH, AUSTRIAN YEARBOX).
see: COLLECTIVE

ROBIN CROZIER

HOT COCKLES

FLUX GAME ROOM...Hot cockles (Robin Crozier)
Preliminary Proposal for a Flux Exhibit at Rene Block Gallery. [ca. 1974].

COMMENTS: The Fluxus exhibition at Rene Block Gallery did not take place. There is no evidence that Hot Cockles ever was made as a Fluxus work.

AKOSH CSERNUS

It was announced in the tentative plans for the first issues of FLUXUS that Akosh Csernus would contribute an essay and anthology on "Sound poetry at present" for FLUXUS NO. 6, later becoming FLUXUS NO. 7 EAST EUROPEAN ISSUE.
see: COLLECTIVE

Walter de Maria, early 1960s

PHOTOGRAPHER NOT IDENTIFIED

D

MANFRED DE LA MOTTE

It was announced in the tentative plans for the first issues of FLUXUS that M. de la Motte would contribute an essay on "Bruening and Twombly" for FLUXUS NO. 2 WEST EUROPEAN ISSUE.
see: COLLECTIVE

WALTER DE MARIA

Walter De Maria was listed as the Art and Sculpture editor of FLUXUS in The Tentative Plans for the Contents of the First

6 Issues of FLUXUS, and was to make two "undetermined" contributions to FLUXUS NO. 1 U.S. ISSUE. In Brochure Prospectus, version A, De Maria is no longer listed as an editor of FLUXUS, however he was to contribute two pieces: "Portrait of John Cage" and "Portrait of the school of Cage, Caged." These two drawings appear in Fluxus Newspaper No. 2, February 1964. There are several contributions by De Maria in An Anthology, *the proto-Fluxus publication edited by La Monte Young and designed by George Maciunas.*

EVENT FOR AUDIENCE

"NOW THE FESTIVAL: (Amsterdam one)...Exhibits ...Walter de Maria - event for audience..."
Letter: George Maciunas to Tomas Schmit, [early June 1963].

COMMENTS: It's not clear whether Maciunas actually exhi-

Willem de Ridder. Several P.K.s from de Ridder-assembled FLUXUS 1s, and a boxed P.K. from the EUROPEAN MAIL-ORDER WAREHOUSE/FLUXSHOP

BRAD IVERSON

bited Event For Audience *during the Amsterdam Fluxus Festival at the Hyperkriterion Theater in 1963.*

WILLEM DE RIDDER

Willem de Ridder made several works which were installed in the European Mail-Order Warehouse/Fluxshop, *but which were never listed in Fluxus publications. They are:*

P.K. Shirt - *a permanently wrinkled men's white shirt.*

P.K., *a crumpled piece of paper, included in most copies of* FLUXUS 1 *that were assembled by de Ridder and is also an individual boxed work.*

Record Landscape - *a miniature landscape with a dwelling mounted on a record.*

an untitled assemblage in a woman's "compact."
as well as other readymades.

P.K. *stands for Papieren Konstellatie, paper constellation in Dutch, a discovery de Ridder had made in 1959 after giving up painting and crumbling his drawing paper, "resulting in* PK *clothing, theatre, parties,... This experience became a universal idea. I didn't iron my shirts, anymore, of course," said de Ridder. "When the city museum of the Hague decided to hang about fifteen huge* PKs *in a big hall it reduced the* PK *to an art object again."* De Ridder Retro/Spective, *Holland Festival, Groninger Museum, 1983, p. 67.*

BOEKJE
Silverman No. < 101.XII

"...Please send me some of your compositions (Preferably 'Book events' - events that are enacted by reader looking through a Fluxus book —..."
Letter: George Maciunas to Willem de Ridder, January 21, 1965.

COMMENTS: Boekje *dates from ca. 1964 and consists of 9 folded blank leaves and a text. It is probable that it was this type of work of de Ridder that Maciunas had in mind. De Ridder had been working with paper pieces called P.K. (Papieren Konstellatie) from 1959.*

©[ca. 1965] PAUL VAN DEN BOS

Willem de Ridder. ca. 1965

CARD PIECE NO. 1

"...We are now preparing Fluxus no. 2 yearbox and would like to include your pieces. (We will include your 'pass-on-to-the-neighbor-card'..."
Letter: George Maciunas to Willem de Ridder, January 21, 1965.

COMMENTS: Card Piece No. 1: *"Please hand this card to your neighbour" is published in Fluxus Newspaper No. 1, January 1964, and is included because it was to be a component of* FLUX YEAR BOX 2 *as well as "Card Piece No. 2."*

EUROPEAN MAIL-ORDER WAREHOUSE/ FLUXSHOP
Silverman No. < 101.IV

"Those Brecht cards, I found are not entirely complete,

there are 8 missing - (printer never gave them to me). So don't sell any until you receive 120 of the 8 missing ones plus cover for box. We shall mail them from Nice ...P.S. Those Brecht cards in box - the minimum price (one I should get) is $2. You can sell for as much as you can."
Letter: George Maciunas to Willem de Ridder, July 15, 1963.

"...have mailed a box to you containing: a) labels for brecht boxes. Glue them by applying wet sponge to back of label. Put them on box quickly & press edges to make it stick well. then press the whole surface. b) missing cards - each group separately wrapped. Now you have complete set and can put one of each in box & sell, sell, sell !!! Let me have about $2 for each box. Take name & address of each buyer if he wishes to receive all future brecht compositions. c) a set of calling cards of various people. d) few La Monte Young books. 50 cents (U.S.) or less for us will be OK. Don't

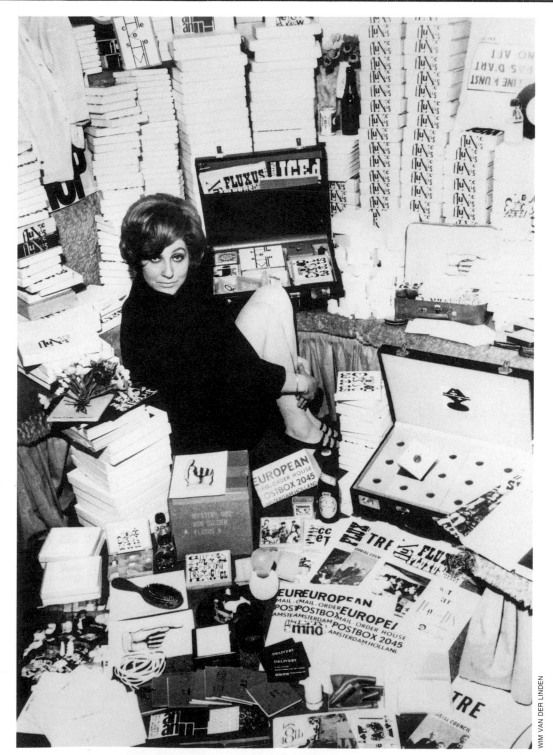

Willem de Ridder. EUROPEAN MAIL-ORDER WAREHOUSE/FLUXSHOP. ca. Winter 1964/65

WIM VAN DER LINDEN

lose those brecht cards -!! they were very expensive to print.''
Letter: George Maciunas to Willem de Ridder, [ca. September 1963].

''Did you try to sell things I sent you? Brecht boxes, Fluxus rolls, La Monte Young 1961 compositions???? I will send you many new things we printed IF you can sell or sold or are selling the things you have. Do propaganda for Fluxus publications.''
Letter: George Maciunas to Willem de Ridder, December 26, 1963.

''I have made a few corrections on this list, items not for sale anymore or withdrawn or not to be published. Also I included the latest list of items which also lists contents of FLUX-KIT (suitcase) Also I have circled items being shipped to you. You will also get two FLUX-KITS (suitcases) You can sell these for $100 or more. They are worth it. Suitcases are being shipped in 2 days. It will be a rather large crate - so be prepared to receive it.... If you sell suitcases send me $60 for each and I will replace them (send you 2 more). It costs me $60 to make up each suitcase, so I must get at least $ for each.
Letter: George Maciunas to Willem de Ridder, [ca. June 1964].

''I will send one attache case to De Ridder, which will contain miniature FLUXSHOP (with 2 things of yours: dirty water - small bottle & holes in box). If you think you may sell this attache case also, I will send you one also. It should sell for $100.''
Letter: George Maciunas to Ben Vautier, June 12, 1964.

''De Ridder will receive also attache case plus 100 of each publication - (that's the dose for all Europe) - so you can take from him anything you think you can sell. But most important keep your accounts organized !!! Don't lose things!''
Letter: George Maciunas to Ben Vautier, July 21, 1964.

''On other side I marked following symbols:... △ people to sell fluxus to but not include them in [European Fluxus]... ⊛ - I am sending their complete works already printed 100 copies being sent to you. [indicated: George Brecht, Takehisa Kosugi, Chieko Shiomi, Robert Watts, Congo (a monkey in London Zoo.)] Do you have Anthology I designed? I am sending some 30 of these books. Sell each for $4. I am shipping crate full of Fluxus on August 3 You should get it by Sept 1st.''
Letter: George Maciunas to Willem de Ridder, [end of July 1964].

''The wood crate has been shipped out. Soon I will send additional box with Fluxus I, unbound pages. You could bind them in Holland. There will be 250 copies.''

Letter: George Maciunas to Willem de Ridder, August 12, 1964.

"You must have the big crate by now, write me any questions about its contents."

Letter: George Maciunas to Willem de Ridder, October 7, 1965.

"Complete works of Hi Red Center (many photos of their events) will be published this spring by us New York Fluxus. Their works will be on cards, wrapped in a 100 Yen bill (printed on hankerchief) and then tied many times with thick ropes. I will send you some 100 copies to sell. OK?...Very good that you have sent anthologies to the East. I will send more. Please send me the material they sent you. I will microfilm it & return it. Also Please send me all their names & addresses, I have many other things I could send them. (I will send you more anthologies as soon as I receive that material you got from them.) I have mailed to you 4 copies of Fluxus anthology. - which a limited edition (total 100 copies) is mostly hand made and therefore expensive. - sort of between Fluxus and Luxus Fluxus. We sell it for $12, you could sell for $10. I also mailed one Fluxus anthology in wood box and with Contents - harmonica on back. This is the way we sell it (in a wood box). I suggest that you have similar boxes made up (like little crates). If you think harmonica on back is nicer than cards in front envelope, let me know, I will make next ones with harmonicas. Make about 30 boxes. I can send you a total of 30 Fluxus anthologies. My·essay and portrait is there & you can reprint it. I will send separate sheets, so you don't have to take the book apart. Sell the books to people who order both regular and luxus edition, because we combined them....Please give 10 copies of Watts & Shiomi cards in boxes to Ben Vautier. He can sell them also. I have mailed him Flux-anthologies directly, so you don't have to give him any Anthologies. We are very pleased to hear of your activities & energetic efforts - Please push - on - ... Why is not European Mail order house not called a FLUXSHOP? when about 95% of items sold are FLUXUS. Besides even in New York FLUXSHOP sold many non-fluxus items. I hope you change name to FLUXSHOP for next revised list. Will write again in a week regarding my views of what Fluxus 'group' is - ...Bob Watts will send pornography directly to you."

Letter: George Maciunas to Willem de Ridder, January 21, 1965.

"Reply to your questions: Fluxyearbox in complete form has been mailed to you. The gray pages were sent to be incorporated into European Fluxbox. So hold them for your own edition. Put relocation, iced dice and cloud scissors, 7 cards with single words, and delivery card into Brecht box All Shiomi cards + bot-

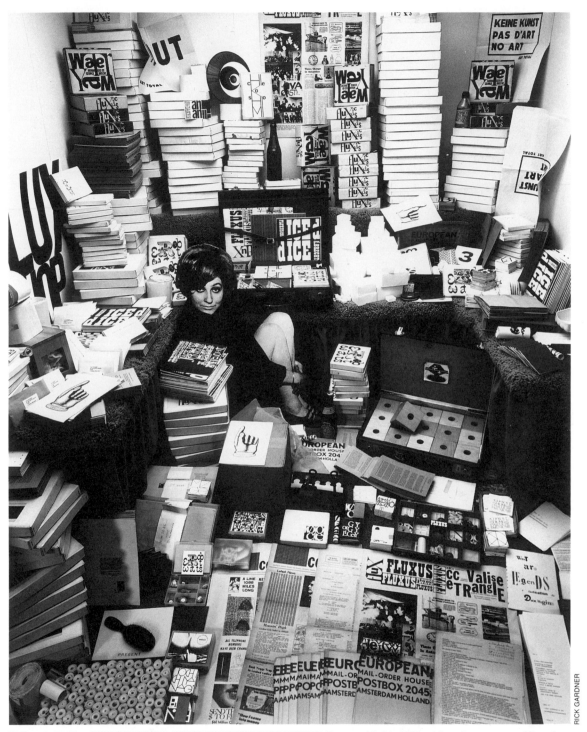

RICK GARDNER

Willem de Ridder. **EUROPEAN MAIL-ORDER WAREHOUSE/FLUXSHOP.** Reassembled in 1984, with a photo cut-out of Dorothea Meijer from a photograph of the original Fluxshop, for the exhibition of the Gilbert and Lila Silverman Collection at The Contemporary Arts Museum, Houston, Texas. see color portfolio

Willem de Ridder. Fluxus fashion handbill for the **EUROPEAN MAIL-ORDER WAREHOUSE/FLUXSHOP**

**EUROPEAN
MAIL-ORDER
WAREHOUSE**
postbox 2045
AMSTERDAM/HOLLAND
ph. 020-243087

This is a photograph of no: a-244,
now available at the
EUROPEAN MAIL-ORDERHOUSE & FLUXSHOP
postbox 2045 - amsterdam - holland

The top- and bottomless bathingsuit
are going to be shown on the special
fluxus fashion-shows next winter
together with:

3F-ck	Clothing	of George Brecht
kk/h	Neckties	
kk/o	Socks	of Robert Watts
	Hats	of Joe Jones
F-ppa	Transparent Suits	
F-ppb	Sweat Shirts	
		of Alison Knowles

etc. etc.

The bathingsuits are fashioned by
LYDIA MERCEDES/model ANNAJANGA
Special photographed at the
"Vinkeveense Plassen" in Holland
for the
EUROPEAN MAIL-ORDERHOUSE & FLUXSHOP
by PAUL VAN DEN BOSCH
DODGERS PRESS ASSOCIATION)

**PHOTO and COPYRIGHT:
PAUL VAN DEN BOS**
Post-Adres: Amstelveenseweg 818
AMSTERDAM-HOLLAND
Tel. (020) b.g.g. (boodsch.d.) - 12 31 23
GEMEENTE GIRO: B 20232

Willem de Ridder. EUROPEAN MAIL-ORDER WAREHOUSE/FLUX-SHOP handbill

tle into Shiomi box. Small cards - (confused noises etc.) are LA STRADA by G. Chiari - one card says that - and it can be used as label. Use small envelope for these cards. One envelope like that is in Fluxus I that I sent to you. I will send soon more material for your own Fluxus box editions. - some photos, and Jackson Mac Low cards for 'Letters for Iris'...Flux shop stamp looks good.''
Letter: George Maciunas to Willem de Ridder, February 4, 1965.

''Once you receive Fluxus I yearbook, you will know the contents. Anima I, Malika 5, Ear drum event - go into Kosugi box. you have more of Kosugi cards. Name kit, swim puzzle, black ball puzzle, Bread puzzle — go into game & puzzle boxes (like one in Flux-kit). Cloud Scissors may go into Brecht Water Yam box. La Strada is better separate. I don't have enough for Yearbook. I will mail to you soon white and transluscent pages for Flux yearbook, plus cards - yellow piece/ questionare/ rich man piece, but not 250, I don't have that many. I will send all that I have OK? Envelopes you can obtain yourself. Very nice of you sell Flux-kit to Stedelijk! I am sending to you 2 more Fluxkits. If you sell kit for $100, you can keep $40 and send me $60, because I must pay others (for endless box, bean box, etc.). Ayo - kit costs me $100 so I can send another only if I get $100. You could sell in future Ayo kits for $120, so you keep $20 for commission. I am making now 5th. Fluxus newspaper with big price list (with photos). Some new items are

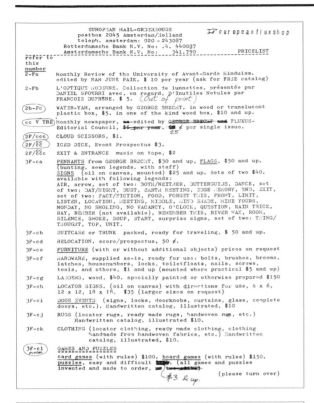

EUROPEAN MAIL-ORDERHOUSE
postbox 2045 Amsterdam/Holland
teleph. amsterdam: 020 - 243087 europeanfluxshop
Rotterdamsche Bank N.V. No: .4, 440037
Amsterdamsche Bank N.V. No: 341.790 PRICELIST

refer to
this
number

2-Fa Monthly Review of the University of Avant-Garde Hinduism.
edited by NAM JUNE PAIK. $ 10 per year (ask for FREE catalog)

2-Fb L'OPTIQUE MODERNE. Collection de lunnettes, présentée par
DANIEL SPOERRI avec, en regard, D'Inutiles Notules par
FRANCOIS DUPRENE. $ 5. (Out of print)

2b-Fc WATER-YAM, arranged by GEORGE BRECHT. in wood or translucent
plastic box, $5. in one of the kind wood box, $10 and up.

cc V TRE Monthly newspaper, edited by GEORGE BRECHT and FLUXUS-
Editorial Council. $6 per year. 25 ¢ per single issue.

2F/ccc CLOUD SCISSORS, $1.

2F/88 ICED DICE, Event Prospectus $3.

2F/88c EXIT & ENTRANCE music in box, $2

3F-ca PENNANTS from GEORGE BRECHT, $30 and up, FLAGS, $50 and up.
(bunting, sewn legends. with staff)
SIGNS (oil on canvas, mounted) $25 and up. Sets of two $40.
available with following legends:
AIR, arrow, set of two: BOTH/NEITHER, BUTTERWIDE, DANCE, set
of two: DAY/NIGHT, DUST, EARTH MEETING, EDGE MEMORY, END, EXIT,
set of two: FACT/FICTION, FOOD, FORGET THIS, FRONT, LIMIT,
LISTEN, LOCATION, MEETING, MIDDLE, MIND SHADE, MINE YOURS,
MONDAY, NO SMOKING, NO VACANCY, O'CLOCK, QUESTION, RAIN TRICK,
RAY, REMBER (not available), REMEMBER THIS, RIVER WAX, ROOM,
SILENCE, SMOKE, SOUP, START, surprise signs, set of two: THING/
THOUGHT, TOP, UNIT.

3F-cb SUITCASE or TRUNK packed, ready for traveling, $ 50 and up.

3F-cd RELOCATION. score/prospectus, 50 ¢

3F-ce FURNITURE (with or without additional objects) prices on request

3F-cf HARDWARE, supplied as-is, ready for use: bolts, brushes, brooms,
latches, housenumbers, locks, toiletfloats, nails, screws,
tools, and others, $1 and up (mounted where practical $5 and up)

3F-cg LADDERS, wood, $40. specially painted or otherwise prepared $150

3F-ch LOCATOR SIGNS, (oil on canvas) with directions for use, 6 x 6,
12 x 12, 18 x 18, $35 (larger sizes on request)

3F-ci DOOR EVENTS (signs, locks, doorknobs, curtains, glass, complete
doors, etc.). Handwritten catalog, illustrated, $10

3F-cj RUGS (locator rugs, ready made rugs, handwoven rug, etc.)
Handwritten catalog, illustrated $10.

3F-ck CLOTHING (locator clothing, ready made clothing, clothing
handmade from handwoven fabrics, etc.) Handwritten
catalog, illustrated, $10.

3F-cl GAMES AND PUZZLES
card games (with rules) $100. board games (with rules) $150.
puzzles, easy and difficult sets. (all games and puzzles
invented and made to order, $3 & up.

 (please turn over)

-2- pricelist: european mail-orderhouse/postbox 2045-amsterdam/holland

3F-cm BOXES $10 and up
some are containers and some aren't. small, simple, cardboard,
to elaborate ones of fine woods, engraved metal, leather etc.
none are empty, though not all are filled. made to order.

4F-1 Complete works of ERIC ANDERSEN (printed in DENMARK)
(prices on request)

F3-e EMMETT WILLIAMS: complete works (inc. 1962) in expandable box

F-d CHIEKO SHIOMI: "Endless Box" $20.

F-dd CHIEKO SHIOMI: Events in wood box $2. #1, will send bottles later.
 Chieko Shiomi: Water music in bottle

5F-h LA MONTE YOUNG: Compositions 1961 bound in linnen: $3
 in paper cover : $1

5F-hh LA MONTE YOUNG: Trio for Strings bound in linnen: $3
 in paper cover : $1

5-1 AN ANTHOLOGY of chance operations, concept art, anti art,
indeterminacy, plans of action, diagrams, music, dance con-
structions, improvisation, meaningless work, natural disasters,
compositions, mathematics, essays, poetry by George Brecht,
Claus Bremer, Earle Brown, Joseph Byrd, John Cage, David Degener,
Walter de Maria, Henry Flynt, Hans Helms, Dick Higgins, Toshi
Ichiyanagi, Terry Jennings, Dennis Johnson, Ray Johnson, Jackson
Mac Low, Richard Maxfield, Robert Morris, Simone Morris, Nam
June Paik, Terry Riley, Diter Rot, James Waring, Emmett Williams,
Christian Wolff, La Monte Young. (editor:La Monte Young) $ 3,98.

6135 all information about SEO (Society for Exhibition Organizing)

LAZ-serie ROBERT WATTS : objects
 rocks in compartmented wood or plastic boxes $3 to $20.
F-kz colored rocks
F-ky gray rocks
F-kx even numbered rocks
F-kx rocks marked by their weight in kilograms #3
F-kv rocks marked by their weight in pounds
F-ku odd numbered rocks
F-kt rocks marked by their volume in cubic cm.
 etc.
F-ka SAND BOXES, with hidden objects $10
F-kb EGG BOXES $10
F-kc WORM BOXES $10

kk/a	PENS	$25	kk/o	SOCKS	$2
kk/b	PENCILS	10 ¢	kk/p	GEOGRAPHY	50 ¢ and up
kk/c	PHOTOGRAPHS	$1, $2.	kk/q	PSYCHOLOGY	$1
kk/d	POSTCARDS	15 ¢	kk/r	ZOOLOGY	15 ¢
kk/e	SOAP	$1 and up	kk/s	PORNOGRAPHY	25 ¢ and up
kk/f	LIGHTER	$8	kk/t	FINGER PRINTS	10 ¢ and up
kk/g	YAMS	25 ¢	kk/u	SMEARS	25 ¢
kk/h	NECKTIE	$2 and up	kk/v	SEX male	$15
kk/i	TIES	$8 and up		female	$25
kk/j	BRIEFCASE	$1 and up	kk/w	TOOLS assorted	75 ¢ and up
kk/k	HOOK	$1 and up	kk/x	STAMPS:U.S.	$10
kk/l	MAGAZINE	$1 and up		other	25 ¢
kk/m	BALL	75 ¢	kk/y	BLIND DATE	$15
kk/n	STRING	10 ¢	kk/z	35 mm SLIDE	50 ¢
				special subject	$2

-3- pricelist: european mail-orderhouse/postbox 2045-amsterdam/holland

F-kl ROBERT WATTS: events in plastic box, $5

F-kkk ROBERT WATTS: chromed goods (hand written catalog, illustrated
 $10.)

P-1 YORIAKI MATSUDEIRA: "Instruction of co-action for cello and
piano: score: 10 sheets, $2.00

 TOSHI ICHIYANAGI "Music for Piano no: 7 (10 large sheets) $8
 "Pianopiece no: 5 50 ¢
must "Pianopiece no: 4 50 ¢
eliminate his scores IBM for Merce Cunningham, one sheet 70 ¢
because he is handled Music for Electric Metronome 1 sheet 70 ¢
now by peters edition. Stanzas for Kenji Kobuyashi 6 sheets $ 2

P-5 GEORGE MACIUNAS
 "Music for Everyman" a music score for dead and living, human,
 animal & inanimate composers (nov. 1961) $3.

P-6 YASUNAO TONE: Anagram for Strings 30 ¢

P-7 YOSHI YUASA: Projection Esemplastic for Piano I (1 sheet) 30 ¢

Fn-i BEN VAUTIER mystery boxes $1 (postage not included)

Fn-o DIRTY WATER in 1 or 2 oz. bottles 50 ¢, in winebottles $1
 in gallon bottles $ 2, in 5 gallon containers

Fn-o COLLECTION OF HOLES, photographs and actual holes in plastic
 box $5.

F-p ALISON KNOWLES: canned bean roll $ 3
F-ppa Transparent Suit $ 20
F-ppb Sweet Shirt $ 10

F-q AYO: Tactile box (100 variants) $ 20
qq Finger box $ 2 finger box $ suitcase, $100 16 finger boxes

F-r TAKEHISA KOSUGI: events in box $ 2

F-g NAM JUNE PAIK: list of publications by special request,
 printed instructions

F-i BEN PATTERSON poems in boxes, : $ 1 and up

F-j DICK HIGGINS: Jefferson's Birthday (works from 1-4-62 to

F-t SOUVENIR BOXES by Lette Eisenhauer (no two alike) $2. 1-4-63)

F-x FLUXUS ACTIONS $ 5

12 ask for all information about APSRINZOR-International
 (Association For Scientific Research In New Methods Of Recreation)

xx MYSTERY MEDICINE $1

xxx ARTIC DISCOGRAPHY, 8 volumes $ 8. Sold

xxy INDEX $ 2 each

xxa MUSIC CHAIR $ 15.

FLUXUS I: anthology of yet unpublished works by: Ayo, George Brecht, Con-
go, Philip Corner, Dick Higgins, Joe Jones, Allan Kaprow,
Alison Knowles, Takehisa Kosugi, Gyorgi Ligeti, Job Morris,
Robert Filliou, George Maciunas, Jackson Mac Low, Chieko
Shiomi, Ben Patterson, Nam June Paik, Ben Vautier, Robert
Watts, Emmett Williams, La Monte Young and others.
in wood box (loose leaf binding) with objects $ 5.
LUXUS- edition, with film, tape, objects, accesories $ 12.

 (please turn over)

-4- pricelist: european mail-orderhouse/postbox 2045-amsterdam/holland

22-fg NAM JUNE PAIK: exhibits and compositions $8
 sound diary, tapes, $2, $4, $6, $8, $10 etc.
 (by special order)

22-fe RICHARD MAXFIELD: tapes (by special order) prices on request.

23 BRIGMO- MAGAZINE
 HEIGH RED CENTER MAGAZINE } edited by TATU IZUMI, AKASEGAVA,
 (in japanese & english) ask for NAFANISHI, and others.
 information.

26 WIM T SCHIPPERS salt $3 per pound

F-m No 2 - Primary Study by HENRY FLYNT 25 ¢

F-j ADOLFAS MEKAS: "guitarre humana" $1
 "boredom" $1

ask for FREE information about FLUXUS, and other FILMS. (for sale, for
hire) american, japanese and european films.

Fd-p DICK HIGGINS: "Legend of Dark City" color film, 5555 ft.
 by special order $1500
Nam June Paik - Zen for Film Requiem for Wagner the Criminal Mayor
20 minutes, $ 50. tape, 5 7inch reels. by special order $50.

28fw BY SPECIAL ORDER a-47 3 colored parakeets $50.
a-4/5 chicken(earthenware) $10 a-4/6 chicken $50.
a-4/6 guinea pig $15 a-4/9 begonia $10.

F-i ALLAN KAPROW: paintings, environments & happenings 140p $4.

Ed-h BEN PATTERSON: complete works (incl. 1963) in expandable box

SEND YOUR ADDRESS TO POSTBOX 2045 FOR REGULAR FREE INFORMATION
phone or write for FREE information/announcements/advertisements about:
concerts, streetevents, pieces, co-operators, magazines, catalogues,
films, objects, boxes, apes, scores, anthologies, books, newspapers,
exhibitions, performances, tours, activities, judgment, confidential
information/gossip, essays, newest works, stories, plans of action,
music, danceconstructions, diagrams, Nam June Paik's smallest book of
the world, largest book of the world, largest book of the world,
heaviest book of the world, narrowest, but not longest book of the
world (width 7 mm., length 50 m.), longest book of the world, most
difficult book of the world, exhibitions of music, postmusic, FLUXUS,
SEO, HEIGH RED CENTER, APSRINGOR-International, LEISMO, works and
activities of George Maciunas (chairman of FLUXUS), Henry Flynt, Stan
Vanderbeek, Sylvano Bussotti, Joseph Byrd, Guiseppe Chiari, Philip
Corner, Kenjiro Ezaki, Terry Jennings, Gyorgi Ligeti, Yasunao Tone,
Grifith Rose, Yuji Takahashi, Dieter Schnebel, George Yuasa, Toshi
Ichiyanagi, Yoriaki Matsudeira, Toshi Ichiyanagi, Ben Vautier,
Dick Higgins, Willem de Ridder, Richard Maxfield, La Monte Young,
Robert Watts, Allan Kaprow, Adolfas Mekas, Wim T. Schippers, Eric
Andersen, Arthur Köpcke, Benjamin Patterson, Bengt af Klintberg, Emmett
Williams, Daniel Spoerri, Robert Filliou, George Brecht, Jackson Mac
Low, Joap Spek, Jean Clarence Lambert, Nam June Paik, Josef Patkowski,
Jean Pierre Wilhelm, Karl Erik Welin, Heinz Klaus Metzger, Michael
Morowitz, Robert Page, Kurt Schwertsik, Pierre Mercure, Bill Wilson,
Eugen Gomringer, Tatu Izumi, Alison Knowles, Chieko Shiomi, Takehisa
Kosugi, John D. Cale, Jonas Mekas, Hashimoto Sohei, Akiyama Kubota,
Frank Trowbridge and Frank Trowbridge, Caspari, John Cage, Earle Brown
Terry Riley, Diter Rot, Simone Morris, Congo, Oyvind Fahlström, K.
Penderecki, Joji Yuri, anonymous person, Henning Christiansen, Tori
Takemitsu, Michael Morowitz, and others.

sending one suitcase
NEWNEWNEWNEWNEWNEWNEWNEWNEWNEW !
FLUXKIT containing following fluxus - publications:
(also available separately)

FLUXUS c	WATER YAM, arranged by George Brecht	
	(complete set of GB events, including the	
	1964 events) in plastic box	$5
FLUXUS cc	V TRE newspaper, edited by the Fluxus	
	Editorial Council, each issue	$1
FLUXUS cl1	BALL PUZZLE, by George Brecht	$3
FLUXUS dd	CHIEKO SHIOMI: "endless box"	$20
FLUXUS dd	CHIEKO SHIOMI: events in box	$2
FLUXUS gz	NAM JUNE YOUNG: ZEN FOR FILM	
	16mm loop, in special plastic box	$3
FLUXUS h	LA MONTE YOUNG: compositions1961	$1
FLUXUS hhh	LA MONTE YOUNG: remains from	
	Composition 1960 no.2, in jar,	$3
FLUXUS ii	BEN PATTERSON: poem-puzzle	25 ¢
FLUXUS ii	BEN VAUTIER: INSTRUCTION 1	50 ¢
FLUXUS iii	BEN VAUTIER: INSTRUCTION 2	50 ¢
FLUXUS iiii	BEN PATTERSON: questionaire	10 ¢
FLUXUS jam	DICK HIGGINS: "Invocation of Canyons &	
	Boulders",16mm color film loop,	
	each loop different, boxed	$6
FLUXUS jak	DICK HIGGINS: Instructions &events	25 ¢
FLUXUS kl	ROBERT WATTS: complete set of events,	
	dollar bill and stamps, in box,	$5
FLUXUS kw	ROBERT WATTS: rocks in compartmented	
	plastic box, marked by their weight	$3
FLUXUS L1	EMMETT WILLIAMS: long poem,	25 ¢
FLUXUS L2	EMMETT WILLIAMS: opera,	25 ¢
FLUXUS L3	EMMETT WILLIAMS: "Four directional	
	song of doubt for 5 voices,"no 2 alike	$3
FLUXUS mx	JOE JONES: mechanical music box titled:	
	"my favorite song" (not sold separately).	
FLUXUS naa	BEN VAUTIER: mystery envelopes	25 ¢
FLUXUS ns	BEN VAUTIER: dirty water, 2oz.bottle	$1
FLUXUS no	BEN VAUTIER: "holes",photos & obj.	$5
FLUXUS p	ALISON KNOWLES: canned bean rolls	$3
FLUXUS qq	AYO: FINGER BOX, each different,	
	in wood box,	$6
FLUXUS r	TAKEHISA KOSUGI: events in wd.box	$2
	TAKEHISA KOSUGI: Theatre music, per-	
	formed on handmade Japanese paper,	$1
FLUXUS s	JAMES RIDDLE: mind event in bottle	$2
FLUXUS zaz	BOX FROM THE EAST,each different	$2

FLUXKIT all listed items in specially partitioned
suitcase,with silkscreen imprint, $100

SEND YOUR ADDRESS TO POSTBOX 2045 FOR REGULAR FREE INFORMATION
phone or write for FREE information/nnouncements/advertisements about:
concerts, streetevents, pieces, co-operators, magazines, catalogues,
films, objects, boxes, tapes, scores, anthologies, books, newspapers,
exhibitions, performances, tours, activities, judgment, confidential
information/gossip, essays, newest works, stories, plans of action,
music, danceconstructions, diagrams, Nam June Paik's smallest book of
the world, largest book of the world, largest book of the world,
heaviest book of the world, narrowest, but not longest book of the
world (width 7 mm., length 50 m.), longest book of the world, most
difficult book of the world, exhibitions of music, postmusic, FLUXUS,
SEO, HEIGH RED CENTER, APSRINGOR-International, LEISMO, works and
activities of George Maciunas (chairman of FLUXUS), Henry Flynt, Stan
Vanderbeek, Sylvano Bussotti, Joseph Byrd, Guiseppe Chiari, Philip
Corner, Kenjiro Ezaki, Terry Jennings, Gyorgi Ligeti, Yoko Ono,
Grifith Rose, Yuji Takahashi, Dieter Schnebel, George Yuasa,
Yasunao Tone, Yoriaki Matsudeira, Toshi Ichiyanagi, Ben Vautier,
Dick Higgins, Willem de Ridder, Richard Maxfield, La Monte Young,
Robert Watts, Allan Kaprow, Adolfas Mekas, Wim T. Schippers, Eric
Andersen, Arthur Köpcke, Benjamin Patterson, Bengt af Klintberg, Emmett
Williams, Daniel Spoerri, Robert Filliou, George Brecht, Jackson Mac
Low, Joap Spek, Jean Clarence Lambert, Nam June Paik, Josef Patkowski,
Jean Pierre Wilhelm, Karl Erik Welin, Heinz Klaus Metzger, Michael
Morowitz, Robert Page, Kurt Schwertsik, Pierre Mercure, Bill Wilson,
Eugen Gomringer, Tatu Izumi, Alison Knowles, Chieko Shiomi, Takehisa
Kosugi, John D. Cale, Jonas Mekas, Hashimoto Sohei, Akiyama Kubota,
Frank Trowbridge and Frank Trowbridge, Caspari, John Cage, Earle Brown
Terry Riley, Diter Rot, Simone Morris, Congo, Oyvind Fahlström, K.
Penderecki, anonymous person, Henning Christiansen, Tori
Takemitsu, Michael Morowitz, and others.
 - X. KAZAKURA. - LUDWIG GOSEWITZ

The first pricelist of the EUROPEAN MAIL-ORDER WARE-
HOUSE/FLUXSHOP, and the pricelist from Fluxus Newspaper No.
4 with corrections and additions by George Maciunas in prepara-
tion for the second pricelist

Chess pieces and musical chairs by Takako Saito. Chess pieces are recognizable by their sound, or weight, or smell, etc. I will mail you a sample together with 2 Fluxkits and one Ayo kit. Please send me money for sold kit $60 & $100 for Ayo kit OK? I am sending by ship mail photos of Hi Red Center events. Their complete works & descriptions of events is being published by FLUXUS, Some will appear in Fluxus newspapers. I am also sending you photos of our events. I am designing cards for you, Schippers, Andersen & Filliou. I am sending Watts stamps. I took care of the London man, since he wrote to me. I sent him almost all our publications. Fluxus will publish Andersens 50 opus also. Let me know if you wish more Fluxus I yearbooks from me. P.S. You should print labels for Brecht Game & Puzzle box, Watts box, Shiomi box, Kosugi box. — reproduce my labels. I am sending a few of them. But I do not have enough of them."
Letter: George Maciunas to Willem de Ridder, March 2, 1965.

COMMENTS: *By late summer 1963 the first great burst of Fluxus performance festivals in Europe was over. George Maciunas had finished producing a number of Fluxus Editions and publications, and plans were made for many subsequent works. Maciunas was preparing to return to New York. In order to assure distribution of Fluxus work, he devised a network of alternative distribution centers - asking Fluxus artists in several cities to have Fluxus Headquarters and Fluxshops. These were to be in Nice, Berlin, Amsterdam, Copenhagen and Tokyo, with Maciunas running the New York headquarters.*

The first Amsterdam Fluxshop was Willem de Ridder's Amstel 47 gallery in the window and cellar of a bookstore. The bookstore, specializing in war memorabilia and esoterica, was seldom open and de Ridder convinced its owner to let him clean up the cellar and make it into a gallery in exchange for watching his store. It was here that Nam June Paik's exhibition of prepared pianos took place, as well as other shows and impromptu performances including one by Stanley Brouwn in the store window. The window also served as a display space for a few Fluxus Editions and current experimental publications. However, in 1964, when de Ridder returned from an extended trip to Scandinavia, he found that the bookstore owner had locked him out. It was then that the second Amsterdam Fluxshop was conceived.

Lydia M. Luyten (Willem de Ridder's "secretary") wrote to artists in July 1964: "Our intention is not only to have a centre where to phone or write to get any information about anybody/anything, we did also print provisional pricelists for the EUROPEAN MAIL-ORDERHOUSE and the EUROPEAN FLUXSHOP (you'll find one in this envelope), we have also the opportunity to sell all interesting or uninteresting works, books, magazines, anthologies, boxes, objects, tapes, films, clothing, pieces, scores, catalogues, newspapers, etc. etc. (not only FLUXUS) out of all parts of the world here in europe. That is why we hope you will inform and send us anything you want to get published, performed or either exhibited or sold, so that our second pricelist will be much more complete. From here we hope to organize concerts, fashionshows, exhibitions, streetevents, publications, lectures, performances, etc. in all european countries."

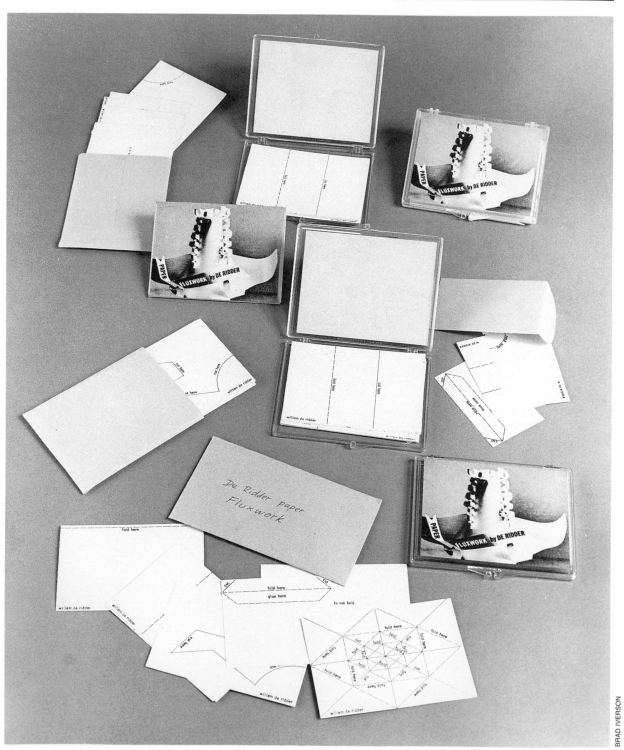

Willem de Ridder. **PAPER FLUXWORK. A variety of Fluxus assemblings**

De Ridder prepared an extensive list of Fluxus works, using the lists from the first few Fluxus newspapers edited by Maciunas in New York, adding Fluxus-like works by Europeans including Eric Andersen, Arthur Koepcke, William Schippers and himself. A magazine was published and promotional mailings prepared. Then, once Maciunas had shipped a crate of additional material during the winter of 1964 - 65, and the parts were assembled, de Ridder set up a mass of Fluxus works in his livingroom. Dorothea Meijer posed provocatively in its midst and a photograph was taken. That evening a movie, Its Harem Time, *was filmed in the same location where the Fluxshop had been. This then was the* European Mail-Order Warehouse/Fluxshop *- a conceptual shop - a photograph, and a mass of objects that could be ordered through the mail. All of the remaining original work from the Fluxshop has been assembled to preserve the concept of the photograph and missing works have been replaced.*

FLIP BOOK

"*...Please send me some of your compositions (Preferably...events that are enacted by reader looking through a fluxus book - such as film flip-books etc....*"
Letter: George Maciunas to Willem de Ridder, January 21, 1965.

COMMENTS: *"Flipbook" was, in Maciunas' mind, a vehicle for viewer involvement and apparently he had wanted to make flipbooks of all the fluxfilms. De Ridder had organized a program,* Signalement '63 *for broadcast on Dutch television and was involved with Wim van der Linden in the Dodgers Syndicate, producing a series of short films called* Sad Movie. *De Ridder had a long involvement in making paper works, "P.K." and small publications like* Boekje, *that required viewer participation. However, he never made a flipbook.*

INVITATION FOR DINNER

Gr-r WILLEM DE RIDDER invitation for dinner (prices on request)...
Second Pricelist - European Mail-Orderhouse. [Fall 1964].

FLUXUS z WILLEM DE RIDDER invitation for dinner, prices on request...
Vacuum TRapEzoid (Fluxus Newspaper No. 5) March 1965.

COMMENTS: *De Ridder, 1984: "A flyer was prepared and mailed out saying that 'as a work of art I could be invited for dinner' - then I'd do weird things when I got there - the same with* A Visit *only the dinner cost more - they had to make a dinner. The price was 150 or 200 Guilders. I did a few, then later we did the Society for Exhibition Organization [S.E.O.] and Society for Party Organization [S.P.O.] and they got quite elaborate."*

PAPER FLUXWORK

Silverman No. 101, ff.

Toilet No. 6, Collective, Toilet paper:...De Ridder paper games printed.
Fluxnewsletter, April 1973.

COMMENTS: *Although* Paper Fluxwork *is included in some copies of* FLUXUS 1 *and* FLUX YEAR BOX 2, *it was issued in a plastic box with a Maciunas designed label, and sold as a separate Fluxus Edition. Maciunas sent it to England for inclusion in the special Fluxus issue of* Art and Artists. *It was not advertised as a Fluxus Edition in any Fluxus publication.*

PAPER EVENTS - FLUX GAME see:
PAPER FLUXWORK
PAPER GAMES see:
PAPER FLUXWORK
PASS-ON-TO-THE-NEIGHBOR-CARD see:
CARD PIECE NO. 1

A VISIT

Gr-rr WILLEM DE RIDDER...a visit (prices on request)
Second Pricelist - European Mail-Orderhouse. [Fall 1964].

FLUXUS z WILLEM DE RIDDER...a visit, prices on request
Vacuum TRapEzoid (Fluxus Newspaper No. 5) March 1965.

COMMENTS: *De Ridder, 1984: "A flyer was prepared and mailed out saying that 'as a work of art, I could be invited to dinner' - then I'd do weird things when I got there - the same with* A Visit, *only the dinner cost more - they had to make a dinner. The price was 150 or 200 Guilders. I did a few."*

NIKI DE SAINT-PHALLE

It was announced in the tentative plans for the first issues of FLUXUS *that "N. de St. Phalle" would contribute "Shot-gun painting" for* FLUXUS NO. 5 WEST EUROPEAN ISSUE.
see: COLLECTIVE

LUCIA DLUGOSZEWSKI

It was announced in the tentative plans for the first issues of FLUXUS *that L. Dlugoszewski would contribute "Glass Identity (score)" for* FLUXUS NO. 1 U.S. ISSUE. *An essay "Is Music Sound" was added to the plans for* FLUXUS NO. 1 *and "Glass Identity (score)" was dropped.*
see: COLLECTIVE

FRANÇOIS DUFRENE

It was announced in the Brochure Prospectus for Fluxus Year Boxes (version B) that F. Dufrêne would contribute "Tango, Comptines and other poems" for FLUXUS NO. 2 FRENCH YEARBOOK-BOX.
see: COLLECTIVE

L'OPTIQUE MODERNE see:
Daniel Spoerri and Francois Dufrene

JEAN DUPUY

MAGNIFICATION PIECE
Silverman No. > 104.101

COMMENTS: *Drawer No. 1 of the Fluxus Cabinet, assembled in 1977 by George Maciunas, contains an untitled work referred to in his notes as "Binoculars by Jean Dupuy and John Lennon, each independently."*

Both artists had been working with magnification, Dupuy with refraction and Lennon with kinetiscopes. Magnification Piece *is clearly a Maciunas interpretation of the two artists' work.*

Jean Dupuy. MAGNIFICATION PIECE contained in FLUX CABINET

E

LARRY EIGNER

It was announced in the Brochure Prospectus for Fluxus Year Boxes (versions A & B) that Larry Eigner would contribute poems for FLUXUS NO. 1 U.S. YEARBOX.
see: COLLECTIVE

HERBERT EIMERT

It was announced in the tentative plans for the first issues of FLUXUS *that Dr. Eimert was being consulted for* FLUXUS NO. 2 WEST EUROPEAN YEARBOOK I.
see: COLLECTIVE

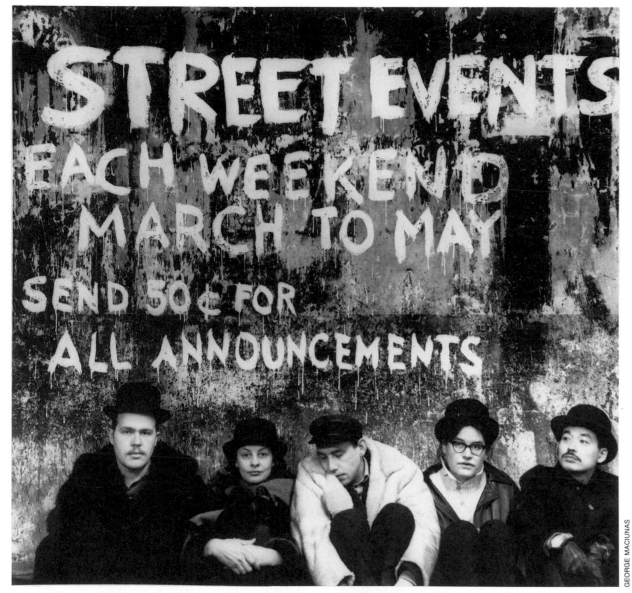

Lette Eisenhauer, second from left. With, left to right: Dick Higgins, Robert Filliou, Alison Knowles and Ay-O. 1964

GEORGE MACIUNAS

LETTE LOU EISENHAUER

SOUVENIR BOXES

FLUXUS 1964 EDITIONS, AVAILABLE NOW ...
FLUXUS t SOUVENIR BOXES by Lette Eisenhauer
No two alike, $2 each.
cc Valise e TRanglE (Fluxus Newspaper No. 3) March 1964.

F-t SOUVENIR BOXES by Lette Eisenhauer (no two alike) $2.
European Mail-Orderhouse: europeanfluxshop, Pricelist. [ca. June 1964].

COMMENTS: Lette Eisenhauer had told me that she never made Souvenir Boxes and is not certain what Maciunas had in mind when he listed the work.
An artist and performer in many early happenings and events, Eisenhauer achieved super-star status in her performance of Ben Patterson's "Whipped Cream Piece (lick piece)"

during Fully Guaranteed 12 Fluxus Concerts at Fluxhall in 1964 in New York City.

KENJIRO EZAKI

Unidentified Scores

Scores available by special order:...Also available are scores of work by...Kenjiro Ezaki
Fluxus Preview Review, [ca. July] 1963.

COMMENTS: No scores of Kenjiro Ezaki have yet been identified as having been published by Fluxus.

F

ÖYVIND FAHLSTRÖM

It was announced in the tentative plans for the first issues of FLUXUS that Öyvind Fahlström would contribute "Possibilities of Electronic Television (plans for electronic TV studio in Stockholm.)" for FLUXUS NO. 2 WEST EUROPEAN ISSUE I, later called FLUXUS NO. 3 GERMAN & SCANDINAVIAN YEARBOX.
see: COLLECTIVE

FARMER'S COOPERATIVE see: JACK COKE'S FARMER'S CO-OP

FEHN

It was announced in the tentative plans for the first issues of FLUXUS that Fehn would contribute "Sonorealization of City" for FLUXUS NO. 2 WEST EUROPEAN ISSUE I, later called FLUXUS NO. 3 GERMAN & SCANDINAVIAN YEARBOX.
see: COLLECTIVE

MORTON FELDMAN

An untitled ready-made cartoon from PUNCH assigned "by M. Feldman" appears in Fluxus Newspaper No. 2.
see: COLLECTIVE

ROBERT FILLIOU

It was announced in the Brochure Prospectus for Fluxus Year Boxes (version B) that Robert Filliou would contribute "Poems," "compositions," and "Biography in cards" for FLUXUS NO. 2 FRENCH YEAROOK. Photographs of Filliou's "13 Facons d'Employer le crane de Emmett Williams, 1963"

are published in the Fluxus Preview Review. *"poeme invalide"
appears in* Fluxus Newspaper No. 3, March 1964.
see: COLLECTIVE

BALL BOX see:
FUTILE BOX

BUTTONS

FLUX-PROJECTS PLANNED FOR 1967...Robert
Filliou:...Buttons
Fluxnewsletter, March 8, 1967.

COMMENTS: *Robert Filliou, 1984: "...Fall of '66 and Spring
of '67, I was in New York...we had several projects that just
came at that time...Many people were making buttons [like
campaign buttons]...It seems to me that what I had in mind
were buttons that people could do themselves...I really can't
remember...whether this idea for buttons was a project of
both George - George Brecht - and mine, you see. I remember
one example, Marianne [Filliou] had a very lovely mini-skirt,
at the time of mini-skirts. A new one, it was very seldom to
have a new (dress). She had made a hole with a cigarette and
we made a button for her that said, 'there is a hole under
this button.' It was lovely, I can still see this pale yellow skirt
and pale yellow button. So probably it was an extension of
this type of thing."*
Hendricks: *"Did it go beyond that?"*
Filliou: *"I have no idea. I saw George (Maciunas) quite fre-
quently. So many of our projects just came out of exuber-
ance and conversations."*

CARDS see:
THE OBVIOUS DECK
CLOCK see:
THE KEY TO ART

COMPLETE WORKS

"...past & future works published under one cover or
in box - a kind of special fluxus edition...sold separ-
ately or as part of fluxus yearbox. I am going to pub-
lish such special Fluxus editions containing complete
works of:...Robert Filliou...This...could result in a
nice & extensive library - or 'encyclopedia' of works
being done these days. A kind of Shosoin warehouse
of today..."
Letter: George Maciunas to Robert Watts, [December 1962].

"...By Fall I should have some 6 Fluxus issues:...
Filliou Flux..."
*Letter: George Maciunas to Robert Watts, [ca. early April
1963].*

"...Dec. to March - we should print lots of materials
in Dick's [Higgins] shop. (...Filliou...)"
*Letter: George Maciunas to Tomas Schmit, [before June 8,
1963].*

Robert Filliou and Arthur Koepcke. London, 1962

© 1962 BRUCE FLEMING

FLUXUS SPECIAL EDITIONS 1963-4...FLUXUS f.
ROBERT FILLIOU: COMPLETE WORKS (incl.
1962), in expandable box $3 works from 1963- by
subscription
Fluxus Preview Review, [ca. July] 1963.

[as above]
*Daniel Spoerri, L'Optique Moderne. List on editorial
page. 1963.*

[as above]
*La Monte Young, LY 1961. Advertisement page.
[1963].*

FLUXUS 1963 EDITIONS, AVAILABLE NOW
FROM FLUXUS P.O. Box 180, New York 10013,
N.Y. or FLUXUS 359 Canal St. New York. CO7-9198
...FLUXUS 1964 EDITIONS:...FLUXUS f ROBERT
FILLIOU: complete works, $6...
Film Culture No. 30, Fall 1963.

FLUXUS 1964 EDITIONS: ...FLUXUS f ROBERT
FILLIOU: complete works, $6...Most materials ori-
ginally intended for Fluxus yearboxes will be includ-
ed in the FLUXUSccV TRE newspaper or in individ-
ual boxes.
cc V TRE (Fluxus Newspaper No. 1) January 1964.

FLUXUS 1964 EDITIONS:...FLUXUS f ROBERT
FILLIOU: complete works, $6
cc V TRE (Fluxus Newspaper No. 2) February 1964.

COMMENTS: *Robert Filiou, 1984: "It goes back to my first
meeting with George Maciunas in 1962."*
Hendricks: *"Where was that?"*
Filliou: *"In Paris. It was Benjamin Patterson who introduced
me to George."*
Hendricks: *"During the Sneak Preview?"*
Filliou: *"Yes, when the [Galerie] Legitime exhibited the
works of Benjamin Patterson that [also] ended up as the
Fluxus Sneak Preview - as you know George Maciunas de-
signed the announcement. So I met George then, and he
came to my place. We lived in Rue des Rose. We saw him sev-
eral times, I remember and I think I put down somewhere, he
lived in a hotel near the Opera and he wore a bowler hat. He
came to Rue des Rose. I showed him some of the things I had
done, like 'L'Immortelle mort du Monde' which is a play where
all the text of the play is on the poster, and other things."*
Hendricks: *"Dick [Higgins] published that?"*
Filliou: *"That's right, that Dick published. I was surrounded
by all kinds of things I was working on. Ideas for postcards,
other things. He said, 'I'm going to publish the complete
works of you, that's going to be one of our first projects,'
and actually it didn't come through....And all this is part of
the legend of Fluxus. And George went back to the United
States, I think around 1963."*
Hendricks: *"The end of '63."*
Filliou: *"That's right. And I didn't see him again until 1966."*
Hendricks: *"Did George take the scores with him, the pieces
that would have made up the Complete Works?"*
Filliou: *"No, I don't think so, because at that time we were
supposed to do it in Paris, you see. So, it has always been a*

*problem kept in mind for a long time because he always, I
know that for years afterwards, he always added in his list
Complete Works."*
Hendricks: *"What would the Complete Works have been?"*
Filliou: *"He would have published things like 'L'Immortelle
Mort du Monde', some scores of action poetry that I had been
making like 33 Kilo Poem, Kabuinima, things like that I was
doing in performances, which by then, some of them had
been published, some not."*
Hendricks: *"Like the No-Play? When was that?"*
Filliou: *"The No-Play comes perhaps a little bit later. No,
that was 1962. Maybe I had already begun to work on what
became Ample Food for Stupid Thought. That might be the
type of thing. Because when Dick finally published it in 1965,
it was my very first publication. Probably that was part of
the thing. We thought maybe it would be in a box or some-
thing like this. We would have figured out how to do it."*
Hendricks: *"But did you ever make a collection or gather
what you would consider Complete Works?"*
Filliou: *"No, because we never came: when we met in '66,
'67, we started to work on other projects, we had lots of
them - up to the end."*
*Filliou's Complete Works was not made by Maciunas as a
Fluxus Edition.*

DUST see:
FLUXDUST

EASTERN DAYLIGHT FLUX TIME see:
George Brecht and Robert Filliou

FILLIOU FLUX see:
COMPLETE WORKS

FILLIOU'S HISTORY OF GOOD TASTE
Silverman No. > 109.I

FLUX-PROJECTS PLANNED FOR 1967...Robert
Filliou: Filliou's History of Good Taste (postcards)...
Fluxnewsletter, March 8, 1967.

COMMENTS: *Filliou, 1984: "In 1958...I read a review of a
book of Dylan Thomas - they were attacking him...for having
'bad taste.'...As a sort of homage to [him], I was going to
write a history of 'good taste' - a book with as many repro-
ductions from museums as possible. Then you would turn the
book over. On the other [side], it would say 'History of Bad
Taste' and [have] exactly the same reproductions....These
photos (for prototype) may have been photos of furniture
taken by Scott Hyde in his commercial work....So just as an
illustration, we may have said we don't have to limit our-
selves just to painting."*

FLUXDUST
Silverman No. < 106.I, ff.

PAST FLUX-PROJECTS (realized in 1966)...Flux-
dust by Robert Filliou
Fluxnewsletter, March 8, 1967.

fluxdust $3.00 by robert filliou
Fluxshopnews. [Spring 1967].

FLUX-PRODUCTS 1961 TO 1969...ROBERT
FILLIOU Fluxdust or fluxhair, boxed, each *[$] 3
[indicated as part of FLUXKIT]
Fluxnewsletter, December 2, 1968 (revised March 15, 1969).

FLUX-PRODUCTS 1961 TO 1970 ... ROBERT
FILLIOU Fluxdust or fluxhair, boxed ea: [$] 3
Flux Fest Kit 2. [ca. December 1969].

FLUXUS-EDITIONEN...[Catalogue no.] 740 RO-
BERT FILLIOU: fluxdust
Happening & Fluxus. Koelnischer Kunstverein, 1970.

03.1967...ROBERT FILLIOU: dust
*George Maciunas, Diagram of Historical Developments of
Fluxus... [1973].*

COMMENTS: *Filliou, 1984: "Two other projects were real-
ized by him [George Maciunas] they came like this, in a con-*

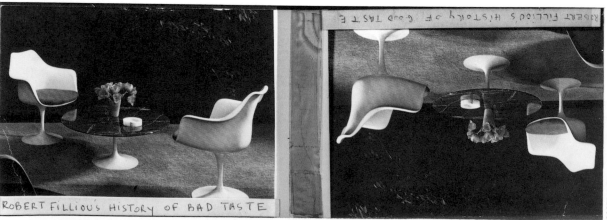

Robert Filliou. FILLIOU'S HISTORY OF GOOD TASTE. Mock-up

Robert Filliou. FLUXDUST

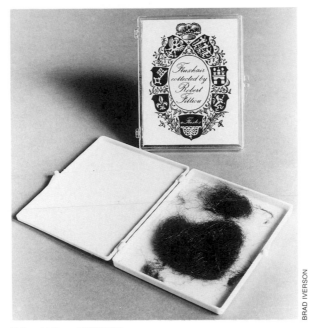

Robert Filliou. FLUXHAIR

FUTILE BOX
Silverman No. > 107.I, ff.

"...Other going projects:...Filliou - ball box..."
Letter: George Maciunas to Ken Friedman, [ca. February 1967].

FLUXPROJECTS PLANNED FOR 1967...George Brecht...in collaboration with Robert Filliou:...Futile box
Fluxnewsletter, March 8, 1967.

FLUXPROJECTS FOR 1968 (In order of priority) 3. Boxed events & objects (all ready for production): futile box
Fluxnewsletter, January 31, 1968.

FLUX-PRODUCTS 1961 TO 1969 ... ROBERT FILLIOU Futile box, ball in non-closing box, May 1969 [$] 6...
Fluxnewsletter, December 2, 1968 (revised March 15, 1969).

FLUX-PRODUCTS 1961 TO 1970 ... ROBERT FILLIOU Futile box, [$] 6...
Flux Fest Kit 2. [ca. December 1969].

versation, probably over a beer in London when we met at the Misfits Fair and I mentioned having a collection of hair and dust...I forgot [about it] - until I received an issue of V TRE [Yam Festival Newspaper, Silverman No. 545] in 1963, where George Brecht wrote, 'Robert Filliou's Galerie Legitime is planning an exhibition of dust.'"

FLUXHAIR
Silverman No. 106, ff.

FLUX-PRODUCTS 1961 TO 1969 ... ROBERT FILLIOU Fluxdust or fluxhair, boxed, each* [$] 3 [indicated as part of FLUXKIT]
Fluxnewsletter, December 2, 1968 (revised March 15, 1969).

FLUX-PRODUCTS 1961 TO 1970 ... ROBERT FILLIOU Fluxdust or fluxhair, boxed, ea: [$] 3 ...
Flux Fest Kit 2. [ca. December 1969].

FLUXUS-EDITIONEN...[Catalogue no.] 741 ROBERT FILLIOU: fluxhair
Happening & Fluxus. Koelnischer Kunstverein, 1970.

COMMENTS: Filliou, 1984: "By the time it was published, I had totally forgotten the idea."
Hendricks: "But Maciunas had dug it up somewhere."
See comments for Fluxdust.

FLUX TOILET see:
LOUIS THE 14th MIRROR

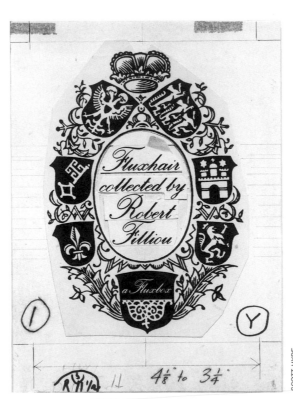

Robert Filliou. FLUXHAIR. Mechanical for the label by George Maciunas

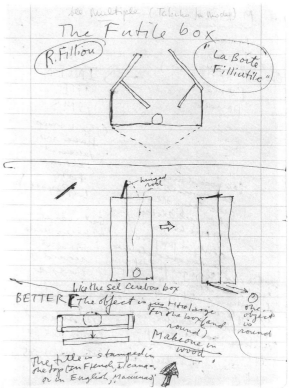

Robert Filliou. Instruction drawing for FUTILE BOX

"...his [Filliou's] futile box, $20, I could send it..."
Letter: George Maciunas to Dr. Hanns Sohm, [ca. late 1972].

COMMENTS: *Filliou, 1984: "Takako [Saito] made a model for me - around 1966. There is a photo of it in the Cedille [qui Sourit] book...it was lost....So it's a new model that Bengt Adler edited in 1977."*
The prototype made by Saito was for the Fluxus Edition which was never made.

HAIR see:
FLUXHAIR

HAIR CIGARETTES

FLUX-PROJECTS PLANNED FOR 1967...Robert Filliou:...Hair cigarettes...
Fluxnewsletter, March 8, 1967.

COMMENTS: *Filliou, 1984: "We spoke in London at the time of the Misfits, to have hair and dust and cigarette butts, like what would form a collection taken from a barbershop." Hendricks: "Maciunas was interested in altering normal things. Like Per Kirkeby's 4 Flux Drinks, where instead of tea, inside there's citric acid." Filliou: "It's possible [that] we thought of rolling cigarettes with hair in it....but it's only a possibility."*
Hair Cigarettes *was never produced as a Fluxus Edition.*

HAND SHOW see:
THE KEY TO ART
HISTORY OF GOOD TASTE see:
FILLIOU'S HISTORY OF GOOD TASTE
THE KEY TO ART see:
Robert Filliou and Scott Hyde

LOUIS THE 14TH MIRROR

PROPOSED FLUXSHOW FOR GALLERY 669 ... TOILET OBJECTS...photo-collage mirror (photo of Luis [sic], 14th head with face cut off to reflect face of onlooker).
Fluxnewsletter, December 2, 1968.

PROPOSED FLUXSHOW...TOILET OBJECTS... Mirrors:...photo - collage mirror (photos of a head with baroque hairdo and face cut off revealing mirror reflecting face of onlooker) by Robert Filliou...
Fluxnewsletter, December 2, 1968 (revised March 15, 1969).

TOILET OBJECTS & ENVIRONMENT...Mirrors:... photo collage (funny head photo with mirror face) by Robert Filliou.
Flux Fest Kit 2. [ca. December 1969].

Toilet No. 3 Joe Jones...Mirror...Filliou - collage mirror
Fluxnewsletter, April 1973.

COMMENTS: Louis the 14th Mirror *is a pun on Louis Quatorze furniture, it also takes the idea of* Monsters are Inoffensive *a step further by transposing the photo-collage to include the 'realism' of the onlooker. Although Maciunas made many preliminary studies for the work, it was never produced as a Fluxus Edition. There is also an element of irony in Maciunas' graphics for Filliou - many use heraldry and royalist images.*

MIRRORS see:
LOUIS THE 14th MIRROR
MONSTERS ARE INOFFENSIVE
MONSTERS ARE INOFFENSIVE see:
Robert Filliou, Daniel Spoerri and Roland Topor (for postcard version)
Robert Filliou, George Maciunas, Peter Moore, Daniel Spoerri and Robert Watts (for mirror, tablecloth and tabletop versions).

THE OBVIOUS DECK
Silverman No. > 109.I

"...other going projects...Filliou - playing cards..."
Letter: George Maciunas to Ken Friedman, [ca. February 1967].

FLUX-PROJECTS PLANNED FOR 1967...Robert Filliou:...Very obvious deck (same face on both sides of playing card deck)...
Fluxnewsletter, March 8, 1967.

IMPLOSIONS INC. PROJECTS...Triple partnership was formed between Bob Watts, Herman Fine and myself [George Maciunas] to introduce into mass market...money producing products...This business will be operated in commercial manner, with intent to make profits...connection between Fluxus collective and Implosions Inc. has not been clarified yet... we could consider at present Fluxus to be a kind of division or subsidary of Implosions. Projects to be realized through Implosions:...Playing cards and other games (Flux-playing cards of...Robert Filliou etc...)
ibid.

obvious deck $6...by Robert Filliou
Fluxshopnews. [Spring 1967].

NEWS FROM IMPLOSIONS, INC.... Planned in 1968:...Playing cards and games (as described in past news-letter)
Fluxnewsletter, January 31, 1968.

FLUXPROJECTS FOR 1969 PRODUCTS - PUBLICATIONS...Playing cards: blank front and back, same front & back (Filliou)
Fluxnewsletter, December 2, 1968.

FLUX-PRODUCTS 1961 TO 1969 ... ROBERT FILLIOU...Obvious Deck, double faced playing cards,

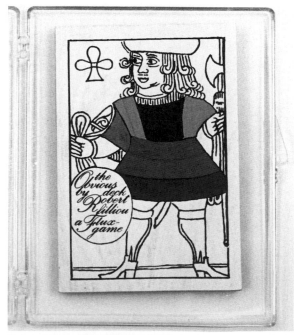

Robert Filliou. THE OBVIOUS DECK, back. Prototype made by George Maciunas

Robert Filliou. THE OBVIOUS DECK, back. Prototype made by George Maciunas

May 1969 [$] 6...
Fluxnewsletter, December 2, 1968 (revised March 15, 1969).

FLUX-PRODUCTS 1961 TO 1970 ... ROBERT FILLIOU...Obvious Deck, double faced play-cards [$] 6...
Flux Fest Kit 2. [ca. December 1969].

COMMENTS: *A Maciunas-made prototype exists, although a Fluxus Edition was never produced. The cards were the same, front and back, so your opponent would 'know your hand.' In a similar concept, Yoko Ono made a chess set where both sides were white, eventually defeating the adversary element in chess (i.e. war).*

POI-POI BEER see:
Robert Filliou and Arthur Koepcke

POI-POI SYMPHONY NO. 1
Silverman No. < 105.VI

COMMENTS: *The score was published by Fluxus, a blueprint positive (2 pages) with ©FLUXUS 1963 stamped on it, however no references to the publication exist.*

Robert Filliou. POI-POI SYMPHONY NO. 1

PART OF FILLIOU'S WHISPERED ART
HISTORY see:
WHISPERED ART HISTORY
POSTCARDS see:
FILLIOU'S HISTORY OF GOOD TASTE
MONSTERS ARE INOFFENSIVE
TABLECLOTHS see:
MONSTERS ARE INOFFENSIVE
TABLETOPS see:
MONSTERS ARE INOFFENSIVE
WORKS FROM 1963 see:
COMPLETE WORKS

WHISPERED ART HISTORY
part of Silverman No. > 118.1

COMMENTS: Whispered Art History *was produced by Knud Pedersen as 12 records for his Children's Art Library in Copenhagen in 1963. An incomplete text from the work is included in FLUXUS 1.*

Robert Filliou. WHISPERED ART HISTORY. The incomplete text included in FLUXUS 1

Robert Filliou and Scott Hyde. THE KEY TO ART. Mechanical for the label by George Maciunas

ROBERT FILLIOU and SCOTT HYDE

THE KEY TO ART
Silverman No. 111

FLUX-PROJECTS PLANNED FOR 1967...Robert Filliou: The Key to Art (collection of artist's hands, boxed translucent cards, clock)...
Fluxnewsletter, March 8, 1967.

ANNOUNCING PHOTOGRAPHS OF 5 ARTIST'S HANDS TO BE EXHIBITED IN THE DISPLAY WINDOWS OF TIFFANY'S, MARCH 27 THROUGH APRIL 12. THE KEY TO ART(?) It has occured to me that the key to art may well consist in learning the significance or meaning of each part, line, marking and shape of the artists' hands. As a group, artists have many things in common distinguishing them from other groups (the military, for example). However, if you observe individual artists' hands you will soon see vast differences. You will notice that some are large, some small, also that some are stiff, others supple. Proceeding carefully with interpretations, finding an indication here, another there, you may form your own judgement about their art without intermediary interpretation by critics. With this in mind, Scott Hyde, the photographer, and I have asked and obtained the collaboration of 22 American and foreign artists. We photographed the hands of: Arman, Ayo, Mark Brusse, Pol Bury, John Cage, Christo, Al Hansen, Dick Higgins, Red Grooms, Alain Jacquet, Robert Breer, Ray Johnson, Alison Knowles, Roy Lichtenstein, Jackson Mc Low, Marisol, Claes Oldenburg, Benjamin Patterson, Takis, Andy Warhol, Robert Watts, Emmett Williams. Our own hands are included, for a total series of 24. The entire series will be produced by Fluxus (div. of Implosions, Inc.) in 2 editions:

1. Clock, 4' diam. with 24 life size hand hour indicators and palmgraphic hour hand. Ed. of 100.
2. Translucent vellum life size prints in box with palmgraphic cover.
Both editions will be available at Multiples, 929 Madison Avenue and at Fluxshops after April 12. ROBERT FILLIOU

Flyer for Robert Filliou and Scott Hyde's The Key to Art(?) [March 1967].

"...Other going projects:...Filliou - clock, and calendar of 24 artist's hands..."
Letter: George Maciunas to Ken Friedman, [ca. 1967].

FLUX-PRODUCTS 1961 TO 1969 ... ROBERT FILLIOU...Hand clock, 24 artists' hands for hours, palmgraphic hour hand, 4ft. x 4ft. by special order [$] 200
Fluxnewsletter, December 2, 1968 (revised March 15, 1969).

FLUX-PRODUCTS 1961 TO 1970 ... ROBERT FILLIOU...Hand clock, 24 artists' hands, 4'sq. [$] 200
Flux Fest Kit 2. [ca. December 1969].

"...his [Filliou's] hand clock, again have negative, but too expensive to produce..."
Letter: George Maciunas to Dr. Hanns Sohm, [ca. late 1972].

COMMENTS: Robert Filliou, 1984: "What is unmistakenly

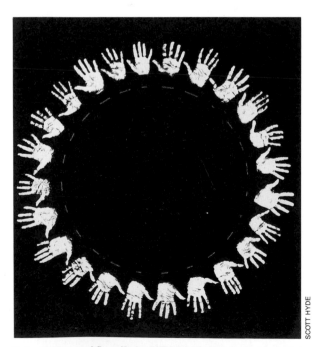

Robert Filliou and Scott Hyde. **THE KEY TO ART.** Kwik-proof print of George Maciunas' layout for the 24 hour clockface of artists' hands

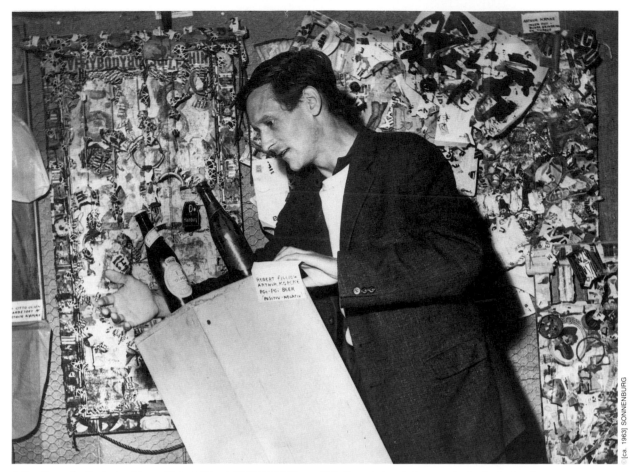

Arthur Koepcke displaying his and Robert Filliou's POI-POI BEER, ca. 1963. Koepcke's paintings are in the background.

George [Maciunas] is the layout of the 24 hands....I had the idea [at that time] that artworks should be shown in shop windows instead of museums....I mentioned to Arman that I would like to make an exhibition of artists' hands so we wouldn't have to have critics to talk about our work - anybody by reading the lines of our hands could see what we are doing. He was very encouraging about it. Then George Brecht told me to see Scott Hyde in New York. He liked the project ...second step was to find windows. When we were taking Andy Warhol's hand he said, 'Why don't you try Tiffany's - I know the window design man.'...Around February '67 [it] opened at Tiffany's....George Maciunas printed The Key to Art announcement...Maciunas might have asked, what about doing a clock?"

Plans for a Fluxus Edition of The Key to Art went well beyond the discussion stage. There were to have been two separate editions of the work:
1. A clock with 24 artists' hands in a limited edition of 100. George Maciunas did the layout of the clockface but did not produce it as a Fluxus Edition. A prototype clock was made by Unlimited in England.
2. A boxed edition of photographs of artists' hands. This version was never produced as a Fluxus Edition, although a multiple version was later done by SABA-Studio, Villingen Edition.

ROBERT FILLIOU and ARTHUR KOEPCKE

POI-POI BEER
Silverman No. < 105.I

Ak-ds ARTHUR KOEPCKE and ROBERT FILLIOU poi-poi beer $10
Second Pricelist - European Mail-Orderhouse. [Fall 1964].

FLUXUS wf [as above]
Vacuum TRapEzoid (Fluxus Newspaper No. 5) March 1965.

COMMENTS: This Fluxus work was produced as an unlimited multiple by Arthur Koepcke during Filliou's exhibition in Denmark in the early 1960s.

ROBERT FILLIOU, GEORGE MACIUNAS, PETER MOORE, DANIEL SPOERRI and ROBERT WATTS

MONSTERS ARE INOFFENSIVE

"...Other going projects...Filliou table top..."
Letter: George Maciunas to Ken Friedman, [ca. February 1967].

FLUX-PROJECTS PLANNED FOR 1967...Robert Filliou: Monsters are Inoffensive (...table tops, table cloths, mirrors)
Fluxnewsletter, March 8, 1967.

IMPLOSIONS INC. PROJECTS...Triple partnership was formed between Bob Watts, Herman Fine and myself [George Maciunas] to introduce into mass market...money producing products...This business will be operated in commercial manner, with intent to make profits....connection between Fluxus collective and Implosions Inc. has not been clarified yet ...we could consider at present Fluxus to be a kind of division or subsidary of Implosions. Projects to be realized through Implosions:...Disposable paper table cloths,...
ibid.

table 36 x 36 $160 by Robert Filliou
Fluxshopnews. [Spring 1967].

FLUXFURNITURE...TABLETOPS, photo-laminates, vinyl surface, ¾" board, formica edging, metal pedestal...Robert Filliou: "Monsters are Inoffensive" montage, dinner setting for 4, 4 variations, 36" x 36", 4 weeks $160.00
Fluxfurniture, pricelist. [1967].

NEWS FROM IMPLOSIONS, INC. ... Planned in 1968:...Disposable paper table cloths,...(Filliou,...ready for production.
Fluxnewsletter, January 31, 1968.

FLUX-PRODUCTS 1961 TO 1969 ... ROBERT FILLIOU...Table top, collage double photo laminated on wood, 36"x 36" [$] 180...
Fluxnewsletter, December 2, 1968 (revised March 15, 1969).

FLUX-PRODUCTS 1961 TO 1970 ... ROBERT FILLIOU ... Table top, photo laminate, 36" sq. [$] 180...
Flux Fest Kit 2. [ca. December 1969].

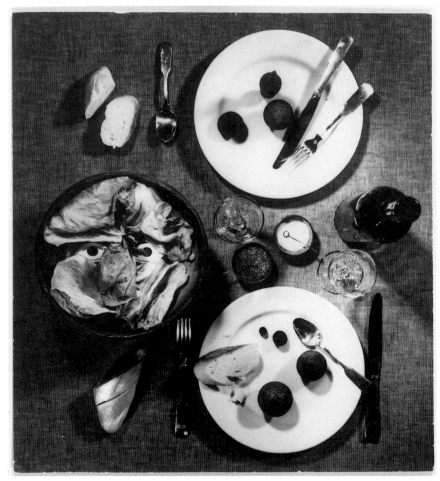

Robert Filliou, George Maciunas, Peter Moore, Daniel Spoerri, and Robert Watts. MONSTERS ARE INOFFENSIVE

Robert Filliou, George Maciunas, Peter Moore, Daniel Spoerri, and Robert Watts. MONSTERS ARE INOFFENSIVE

PHOTOGRAPHER NOT IDENTIFIED

PHOTOGRAPHER NOT IDENTIFIED

"...Filliou's table top, have negatives, but still have to produce it, may cost too much..."
Letter: George Maciunas to Dr. Hanns Sohm, [ca. late 1972].

COMMENTS: *Maciunas also had the idea of carrying* Monsters Are Inoffensive *to mirrors, tablecloths and tabletops. Implosions was just beginning and would publish the work. At a dinner at Bob Watts', Peter Moore took photographs that were later altered by Watts, Maciunas and Filliou. The table settings have a clear relationship to Spoerri's* Meal Variations. *Although many different photographs exist, some table sized, I have not seen a finished photo laminated table, printed table cloth, or mirror.*

ROBERT FILLIOU, DANIEL SPOERRI and ROLAND TOPOR

MONSTERS ARE INOFFENSIVE
Silverman No. 108

"...Other going projects: Filliou-topor-spoerri-postcards 50 in set..."
Letter: George Maciunas to Ken Friedman, [ca. February 1967].

FLUX-PROJECTS PLANNED FOR 1967 ...Robert Filliou: Monsters are Inoffensive (50 postcards...)...
Fluxnewsletter, March 8, 1967.

FLUXPROJECTS FOR 1968 (In order of priority) 7. Robert Filliou - Monsters are Inoffensive (2nd. part)
Fluxnewsletter, January 31, 1968.

NEWS FROM IMPLOSIONS, INC. Various items were produced as planned &...listed in the past newsletter:...Monsters are Inoffensive (postcards by Filliou) (samples included)...
ibid.

FLUX-PRODUCTS 1961 TO 1969 ... ROBERT FILLIOU...Monsters are Inoffensive, collage (photo & drawing) postcards, 22 in clear box [$] 6
Fluxnewsletter, December 2, 1968 (revised March 15, 1969).

FLUX-PRODUCTS 1961 TO 1970 ... ROBERT FILLIOU... Monsters are Inoffensive, 22 postcards [$] 6...
Flux Fest Kit 2. [ca. December 1969].

...set of 1969-70 Flux-productions, which consist of the following: 1969-...Robert Filliou: Monsters are Inoffensive
Fluxnewsletter, January 8, 1970.

FLUXUS — EDITIONEN ... [Catalogue no.] 742 ROBERT FILLIOU: monsters are inoffensive (22 postcards)
Happening & Fluxus. Koelnischer Kunsterverein, 1970.

Robert Filliou, Daniel Spoerri, and Roland Topor. MONSTERS ARE INOFFENSIVE

COMMENTS: *The drawings of Roland Topor, a much admired cartoonist, were manipulated by Filliou, Spoerri and others into a work titled by Robert Filliou,* Monsters Are Inoffensive. *The initial idea was to make a book out of the drawings when George Maciunas proposed publishing the work as postcards. The Fluxus Edition of* Monsters Are Inoffensive *postcards were issued both as loose bundles of cards, and in a plastic box without a label. Enlarging on Filliou's concept, and throwing in ideas of Daniel Spoerri, George Maciunas worked with Filliou, Peter Moore and Robert Watts to design mirrors, tablecloths and tabletops. See: Robert Filliou, George Maciunas, Peter Moore, Daniel Spoerri and Robert Watts:* Monsters Are Inoffensive.

ALBERT M. FINE

BANANA STANDARD

FLUXFLAGS AND BANNERS ea. $25 28" square, sewnlegends, double bunting, readable both sides, grommets at corners...FLUXUS wa ALBERT FINE: yellow on blue: "banana standard"...
Vaseline sTREet (Fluxus Newspaper No. 8) May 1966.

COMMENTS: *There was a banana craze in the mid-sixties, simultaneous with banana jokes. Songs like Donovan's "Mellow Yellow" prompted a mysterious rumor that you could get "high" from smoking dried banana peels. It was also a popular subject in art: Claes Oldenburg had made a drawing in 1965,* Proposed Colossal Monument for Times Square: Banana *and Andy Warhol made a silk-screened banana in 1966 that was used two years later for the record cover,* The Velvet

Underground. *Another metaphor for Fine's Banana Standard, is Banana Republic and the pun on the word "standard" and "status quo." The flag as described would evidently have used words instead of a pictorial banana. It is not known to have been made by Maciunas as a Fluxus Edition. See additional commentary under* Strumpet Trumpet.

BANNERS see:
FLUXFLAG

CARDS

FLUXPROJECTS FOR 1969...Cards: Albert Fine...
Fluxnewsletter, December 2, 1968.

COMMENTS: *It's not clear what this work is. It could refer to an edition of playing cards or some other planned work.*

COMPLETE WORKS see:
EVENTS

EVENTS

...will appear late in 1966...FLUXUS wm ALBERT FINE: events, boxed $5
Vaseline sTREet (Fluxus Newspaper No. 8) May 1966.

"...Furthermore, Fluxus still publishes newspaper, supplements to works...started compl. works of A. Fine,..."
Letter: George Maciunas to Ben Vautier, [ca. October, 1966].

FLUX-PROJECTS PLANNED FOR 1967...Albert M. Fine: events (boxed)
Fluxnewsletter, March 8, 1967.

events $3 by albert fine
Fluxshopnews. [Spring 1967].

FLUXPROJECTS FOR 1968 (in order of priority)... 3. Boxed events & objects (all ready for production): Albert Fine - events
Fluxnewsletter, January 31, 1968.

FLUX-PRODUCTS 1961 TO 1969...ALBERT M. FINE...Events, boxed cards, May 1969 [$] 3
Fluxnewsletter, December 2, 1968 (revised March 15, 1969).

"...a.m. fine events...have only prototypes..."
Letter: George Maciunas to Dr. Hanns Sohm, [ca. late 1972].

COMMENTS: *George Maciunas had planned to produce Fluxus Editions of the complete works of a number of artists. Brecht, Kosugi, Shiomi and Watts were produced; Events, the complete works of Albert Fine, was never made. Several scores by Albert Fine appear in* Fluxfest Sale, *[Winter 1966]. see: COLLECTIVE*

FILM see:
READYMADE
FLUXFILM NO. 20 see:
READYMADE
FLUXFILM NO. 24 see:
READYMADE
FLUXFLAG see:
BANANA STANDARD
STRUMPET TRUMPET
PIECE FOR AUDIENCE see:
PIECE FOR FLUXORCHESTRA

PIECE FOR FLUXORCHESTRA
Silverman No. 114, ff.

FLUXKIT containing following fluxus-publications: (also available separately)...FLUXUS w ALBERT FINE: piece for fluxorchestra $4
Vaseline sTREet (Fluxus Newspaper No. 8) May 1966.

CONCERT NO. 3 - AUDIENCE PIECES...Albert M. Fine Piece for Fluxorchestra Instructions on cards included or to follow by separate mail.
Proposed Program for a Fluxfest in Prague. 1966.

FLUXFEST INFORMATION...Flux-concerts,...or entire fluxfests may be also arranged by the fluxus collective for a fee of $10 per performer per day... Additional costs:...Scores - 25 cents each except: ... Piece for Fluxorchestra...
Fluxfest Sale. [Winter 1966].

PAST FLUX-PROJECTS (realized in 1966)...Piece for Fluxorchestra by Albert M. Fine
Fluxnewsletter, March 8, 1967.

$3 piece for fluxorchestra by albert fine
Fluxshopnews. [Spring 1967].

FLUX-PRODUCTS 1961 TO 1969...ALBERT M. FINE Piece for fluxorchestra, instructions on 24 cards for performers among audience, boxed * [$] 3 [indicated as part of FLUXKIT]...
Fluxnewsletter, December 2, 1968 (revised March 15, 1969).

FLUX-PRODUCTS 1961 TO 1970...ALBERT M. FINE Piece for Fluxorchestra, boxed cards [$] 3
Flux Fest Kit 2. [ca. December 1969].

FLUXUS-EDITIONEN...[Catalogue no.] 743 ALBERT FINE: piece for fluxorchestra, 1966
Happening & Fluxus. Koelnischer Kunstverein, 1970.

03.1967 A. FINE: piece for audience
George Maciunas, Diagram of Historical Developments of Fluxus... [1973].

Albert M. Fine. **PIECE FOR FLUXORCHESTRA**

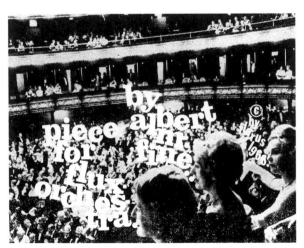

Albert M. Fine. **PIECE FOR FLUXORCHESTRA. Variant label designed by George Maciunas**

COMMENTS: *Although Maciunas made two different labels for the Fluxus Edition of* Piece for Fluxorchestra, *the score always remains the same.*

RAY JOHNSON A MUSICS
Silverman No. 116

COMMENTS: *The title of the work is frequently misread as "Ray Johnson 3 Musics." In the Fluxus version, the artist has signed it as a "poem scroll." An earlier blueprint version exists, but without the graphic embellishment.*

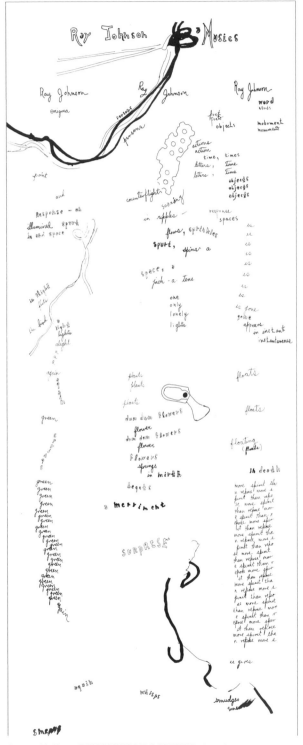

Albert M. Fine. **RAY JOHNSON A MUSICS.** detail

247

READYMADE

Silverman No. < 114.1

FLUXFILMS SHORT VERSION, 40 MIN AT 24 FRAMES/ SEC. 1400FT. ... flux-number 24 Albert Fine READYMADE 0'45'' Produced in developing tank, color.
Fluxfilms catalogue. [ca. 1966].

FLUXFILMS...FLUXFILM 20 ALBERT FINE: 1 min $5
Vaseline sTREet (Fluxus Newspaper No. 8) May 1966.

PAST FLUX-PROJECTS (realized in 1966)...Flux-films: total package: 1 hr. 40 min....loop by Albert Fine...
Fluxnewsletter, March 8, 1967.

PROPOSED R & R EVENINGS: Flux film - walls (loops by...Albert Fine,...)
Fluxnewsletter, January 31, 1968.

[as above]
Fluxnewsletter, December 2, 1968.

FLUX-PRODUCTS 1961 TO 1969 ... FLUXFILMS, short version Summer 1966 40 min. 1400ft:...[including] Readymade - by Albert Fine...16 mm [$] 180 8mm version [$] 50
Fluxnewsletter, December 2, 1968 (revised March 15, 1969).

FLUX-PRODUCTS 1961 TO 1970 [as above]
Flux Fest Kit 2. [ca. December 1969].

SLIDE & FILM FLUXSHOW ... ALBERT FINE: READYMADE Color test strip from developing tank.
ibid.

03.1965 FLUXFILMS: A. FINE: color readymade
George Maciunas, Diagram of Historical Developments of Fluxus... [1973].

COMMENTS: *Color film test strips used in film labs, retrieved and spliced into the* Fluxfilms *package. Each* Readymade *is different.*

SCALE PIECE FOR JOHN CAGE

FLUX-PRODUCTS 1961 TO 1969 ... ALBERT M. FINE...Scale piece for John Cage, scale & instructions [$] 5...
Fluxnewsletter, December 2, 1968 (revised March 15, 1969).

FLUX-PRODUCTS 1961 TO 1970 ... ALBERT M. FINE...Scale piece for John Cage [$] 5
Flux Fest Kit 2. [ca. December 1969].

"...a.m. fine...scale, have only prototypes..."
Letter: George Maciunas to Dr. Hanns Sohm, [ca. late 1972].

COMMENTS: *I have not seen this work. Evidently there was a prototype for a Fluxus Edition.*

SCORES see:
EVENTS
PIECE FOR FLUXORCHESTRA
RAY JOHNSON A MUSICS
SCALE PIECE FOR JOHN CAGE

STRUMPET TRUMPET

FLUXFLAGS AND BANNERS ea. $25 28'' square, sewnlegends, double bunting, readable both sides, grommets at corners...FLUXUS wa ALBERT FINE: ...orange on black: "strumpet trumpet"
Vaseline sTREet (Fluxus Newspaper No. 8) May 1966.

COMMENTS: *If one looks at Fine's* Banana Standard *from a-nother perspective, that of "phallic flag" raising the standard for "maleness," the* Strumpet Trumpet *characterizes women to be whores blowing their horns. Not known to be made by Maciunas as a Fluxus Edition.*

HENRY FLYNT

It was announced in the tentative plans for the first issues of FLUXUS that Henry A. Flynt, Jr. would contribute "The Exploitation of Cultural Revolutionaries in Present Societies" for FLUXUS NO. 1 U.S. YEARBOX. Later, in the Brochure Prospectus for Fluxus Yearboxes (version A), Flynt's contri-bution to FLUXUS NO. 1 was expanded to include: "Linact: Incongruities, Audact Composition," "A way of Enjoying a non-controlled Acoustical Environment," and "My New Con-cept of General Acognitive Culture." In October, 1962, in the second version of the Brochure Prospectus, Flynt's con-tributions to FLUXUS NO. 1 remain the same, but in the list-ing for the contents of FLUXUS NO. 7 EAST EUROPEAN YEARBOX, Flynt was to contribute: "Analysis of Commu-nist Culture," "The Fraud of 'Western Artistic Freedom': Culture for a Decadent Alienated Elite" and "New Culture for Fully Industrialized Communist Society." Flynt's "My New Concept of General Acognitive Culture," was published by Wolf Vostell in de-coll/age 3, *Cologne, December 1962. Its publication there provoked the following outburst from George Maciunas in a letter to Tomas Schmit: "...I lost a few hundred marks already, by printing...Flynt and then eliminating the works because of Vostell's fast deal-ings..."*

In Fluxus Newspaper No. 4, June 1964, George Brecht wrote of Flynt in his essay "Something About Fluxus" that "...In-dividuals in Europe, the U.S., and Japan have discovered each other's work...and have grown objects and events which are original, and often uncategorizable in a strange new way: ... Henry Flynt's professional anti-culture and down-withs (pay-ing culture a sort of inverse compliment), making Alison Knowles' bean-sprouts seem even lovelier."

ACTION AGAINST CULTURAL IMPERIAL-ISM see:
FIGHT MUSICAL DECORATION OF FASCISM!

COLLECTIVE ESSAYS see:
COMPLETE WORKS

THE COMING REVOLUTIONS IN CUL-TURE

XL-F3 the coming revolutions in culture (book) (ask for free information) (price on request)
Second Pricelist - European Mail-Orderhouse. [Fall 1964].

COMMENTS: *Henry Flynt was a prolific polemicist. Although a book may have been planned with the title "The Coming Revolutions in Culture" in 1964, it was never published by Fluxus. Another book,* Blueprint for a Higher Civilization *by Flynt was published by Multipla Edizioni, Milan, in 1975.*

COMMUNISTS MUST GIVE REVOLUTION-ARY LEADERSHIP IN CULTURE see:
Henry Flynt and George Maciunas

COMPLETE WORKS

"...past & future works published under one cover or in box - a kind of special fluxus edition...sold separ-ately or as part of fluxus yearbox. I am going to pub-lish such special Fluxus editions containing complete works of...Henry Flynt...This...could result in a nice & extensive library - or 'encyclopedia' of works being done these days. A kind of Shosoin warehouse of today...."
Letter: George Maciunas to Robert Watts, [December 1962].

In addition to Fluxus Year Boxes the following spe-cial editions [are] being planned. These are editions of works by single composers, poets, artists or what you like...Henry Flynt collective essays (1963 issue)...
Fluxus Newsletter No. 4, fragment, [ca. October 1962].

FLUXUS SPECIAL EDITIONS 1963-4...
FLUXUS m. HENRY FLYNT: EXPANDABLE BOX (Essays) the fluxus FlyntCanon plan
No. 1 Announcement of the Publication of the Suc-cessive Writings of Henry Flynt
Notices will be sent out of each writing by Henry Flynt published. A person may buy whichever writ-ings he wants from those for sale at the time. A re-cord of his purchases will be kept. When he has bought three writings, he will receive a box to keep the writings in. The writings will be numbered in the order of their appearance. Some of the writings will supercede preceding ones, render them worthless. Thus, the notice for each writing will have on it the numbers of any writings it supercedes (for ex., the

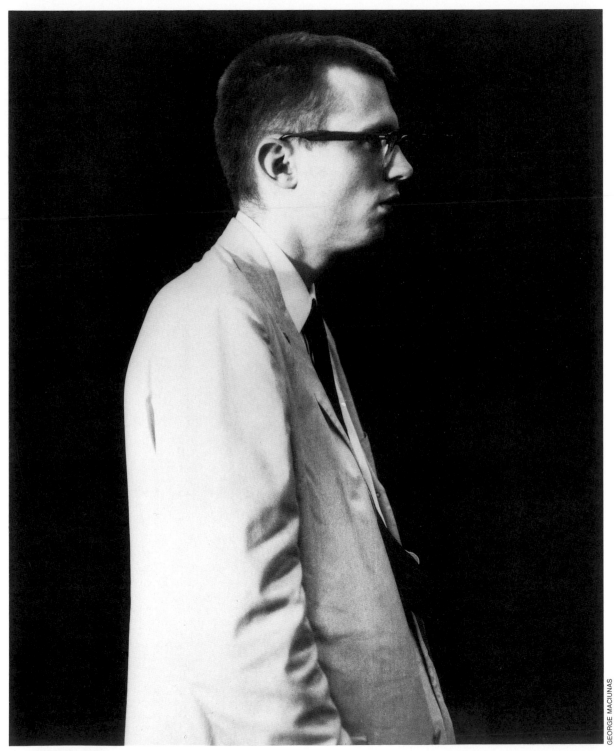

Henry Flynt, ca. 1963

GEORGE MACIUNAS

notice for No.17 might have "No.1, No.9"). A person, to receive a writing, must return any writings he has which it supercedes (for the example, No.1 and No.9), and preferably the notice for them also, to the address given on the notice, so they can be destroyed under supervision. Writings will no longer be offered for sale when they are superceded. This plan has been devised to take into account Henry Flynt's continual improving of the canon of his writings. The superceding writings really will render the superceded worthless; usually they will be versions of preceding writings, much improved on the face. Henry Flynt's intention is thus that the superceded drafts be extinct and the superceding versions alone be extant: only the resulting canon will communicate what he intends. If the writings were not issued until they were perfect, they might await issuance indefinitely. It makes sense to buy later to-be-returned writings; because it is the only way to study Henry Flynt's ideas now: they serve their purpose, and then are superceded. And they do become so obviously worthless that the subscriber might as well return them even if he were not obliged to. Finally, a writing is really worth the sum of the prices of the writings it supercedes and its cost proper. That a person who has not bought the superceded writings pays less for the quantity of printed paper he ultimately possesses may be regarded as a special introductory offer. It really would be detrimental to preserve everything; the extinction of the superceded drafts produces a positive effect in the canon, a superior canon - and the canon Henry Flynt intends.

This announcement is numbered to take into account the possibility that the plan may be changed.
Fluxus Preview Review, [ca. July] 1963.

FLUXUS SPECIAL EDITIONS 1963-4...FLUXUS m. HENRY FLYNT: EXPANDABLE BOX (Essays) perpetual (by subscription) $?
Daniel Spoerri, L'Optique Moderne. List on editorial page. 1963.

[as above]
La Monte Young, LY 1961. Advertisement page. [1963].

FLUXUS 1963 EDITIONS, AVAILABLE NOW FROM FLUXUS P.O. Box 180, New York 10013, N.Y. or FLUXUS 359 Canal St. New York. CO7-9198 ...FLUXUS 1964 EDITIONS:...FLUXUS m HENRY FLYNT: essays
Film Culture No. 30, Fall 1963.

FLUXUS 1964 EDITIONS:...FLUXUS m HENRY FLYNT: essays Most materials originally intended for Fluxus yearboxes will be included in the FLUXUSccV TRE newspaper or in individual boxes.
cc V TRE (Fluxus Newspaper No. 1) January 1964.

FLUXUS 1964 EDITIONS:...FLUXUS m HENRY FLYNT: essays
cc V TRE (Fluxus Newspaper No. 2) February 1964.

COMMENTS: *A Fluxus Edition of* Complete Works *was never published as such. Some of Flynt's essays were published in Fluxus Newspaper No. 3, March 1964;* Communists Must Give Revolutionary Leadership in Culture *was published by World View Publishers, New York, in 1966 and was distributed by Fluxus; and his pamphlet manifesto,* Down With Art *was published by Fluxpress in 1968. "Primary Study" was part of the subscription plan for* Complete Works.

DOWN WITH ART
Silverman No. 582, ff.

FLUX-PRODUCTS 1961 TO 1969...HENRY FLYNT ...Down with Art! pamphlet .50
Fluxnewsletter, December 2, 1968 (revised March 15, 1969).

FLUX-PRODUCTS 1961 TO 1970...HENRY FLYNT ...Down with Art! pamphlet [$] ½
Flux Fest Kit 2. [ca. December 1969].

...a set of 1969-70 Flux-productions, which consist of the following:...Henry Flynt: 1969 - Down with Art!
Fluxnewsletter, January 8, 1970.

COMMENTS: *A 1968 Fluxpress pamphlet manifesto compiled by Flynt,* Down with Art *contains statements and essays, with letters of response from various artists. One of the statements, "From 'Culture' to Veramusement," accompanied by two photographs, was first published in Fluxus Newspaper No. 3, March 1964.*

Henry Flynt. DOWN WITH ART

ESSAYS see:
THE COMING REVOLUTIONS IN CULTURE
COMMUNISTS MUST GIVE REVOLUTIONARY
 LEADERSHIP IN CULTURE
COMPLETE WORKS
DOWN WITH ART
FIGHT MUSICAL DECORATION OF FASCISM!
PRIMARY STUDY

EXPANDABLE BOX see:
COMPLETE WORKS

ACTION AGAINST CULTURAL IMPERIALISM CALLS ON YOU TO

FIGHT MUSICAL DECORATION OF FASCISM!

JOIN THE DEMONSTRATION AT THE WEST GERMAN COMPOSERS CONCERT, TOWN HALL (43RD. STREET WEST OF SIXTH AVENUE), WEDNESDAY, APRIL 29, 8:00PM

In a lecture at Harvard in the fall of 1958, Stockhausen contemptuously dismissed "jazz" as "primitive... barbaric... beat and a few single chords...", and in effect said it was garbage.

By the time he made that fascist-like attack on Afro-American music, Stockhausen was a well-known symbol of contempt and disdain for every kind of workers', farmers', or non-European music, whether the music of Black Americans, East European peasants, Indians, or even most of the music that West German workers themselves like. All of the West German composers on tonight's program share this contempt; Stockhausen is their most significant representative.

"ONLY MY MUSIC EXISTS"
Stockhausen's magazine, as well as his lectures, have decreed over and over that the one True Music is European Serious Music. They have decreed over and over that today music must obey the "scientific" Laws of Music, discovered by Stockhausen - or else it does not exist. (That is, you must compose passage work (Zeitmasse), a concerto grosso (Gruppen), "Dance of the Sugarplum Fairy" (Gesang), a Mahler symphony (Carre), or some such.) In other words, the music of Japan, India, Africa, or in the U.S., R & B or hillbilly music, does not exist ! And Stockhausen's reason: because it is not composed, or is not made up of pitches, etc. etc. (Die Reihe 4, the first essay, sums up the doctrine of Stockhausen's claque.)

STOCKHAUSEN'S DECREES SERVE NEO-NAZISM
Why does Stockhausen NEED to vilify every kind of toilers' music, to limit True Music to the European owning classes, to invent "scientific" Laws which require all music to start from the premises of 19th.- century European Serious Music ? And mainly to carry on vicious fascist vilification of the Black peoples' music as "low and primitive"? Because Stockhausen's Music is composed to serve the West German bosses. Stockhausen is a lackey of the West German bosses and their government, just as Haydn was of the Esterhazys. His patronage comes mainly from the government - owned Cologne Radio. Like all court music, Stockhausen's Music is of course a decoration for the West German bosses. But more than that, it is ideology, capitalist, fascist ideology. Stockhausen's repeated decrees about the lowness of plebian music and the racial inferiority of non - European music, are an integral, essential part of his Art and its "appreciation". Stockhausen's Music is West German fascist ideology.

THE BOSSES HAIL STOCKHAUSEN
Of course, some conservative, philistine elements among the bosses have opposed Stockhausen as "too modern". But this kind of opposition to Stockhausen is rapidly melting away as the bosses of West Europe and America realize that Stockhausen is one of the best salesmen they're going to get. The West German government, which is in the hands of the bosses there, patronizes Stockhausen and brings him here tonight. Already more than a few U.S. millionaires have begun to support Stockhausen. And because of the power of the West German and U.S. bosses, this Musical style is imposed on all weaker nations of the "Free World".

FIGHT FASCIST MUSICAL THOUGHT !

STOCKHAUSEN GET OUT ! TOO MANY LIKE YOU HERE ALREADY !

Action against Cultural Imperialism
359 Canal Street, New York, New York 10013

Henry Flynt. FIGHT MUSICAL DECORATION OF FASCISM!

FIGHT MUSICAL DECORATION OF FASCISM!
Silverman No. 553

XL-F1 HENRY FLYNT leaflets: Action against Cultural Imperialism (prices on request)...
Second Pricelist - European Mail-Orderhouse. [Fall 1964].

COMMENTS: *In the first catalogue of the European Mail-Order Warehouse, Willem de Ridder had offered Flynt's essay,* Primary Study, *for sale without permission. In correspondence about that with de Ridder, Flynt suggested that he sell the leaflet of the Action Against Cultural Imperialism, protesting the West German Composers Concert (Karlheinz Stockhausen) at Town Hall, New York City, April 29, 1964. This leaflet is titled* Fight Musical Decoration of Fascism! *Later in September, a broadside,* Picket Stockhausen Concert *was issued by the same group.*

PRIMARY STUDY

FLUXUS SPECIAL EDITIONS 1963-4...FLUXUS m. HENRY FLYNT: EXPANDABLE BOX (Essays) the fluxus FlyntCanon plan...No. 2 Primary Study by Henry Flynt $0.25
Fluxus Preview Review, [ca. July] 1963.

Primary Study (1956-1964)
Version 7 (Winter 1963-4)
PRIMARY STUDY (1956-1964) Version 7 (Winter 1963-4) BY HENRY FLYNT

Copyright (C) 1964 by Henry A. Flynt, Jr.

Henry Flynt. PRIMARY STUDY (1956-1964) VERSION 7 (WINTER 1963-4). As published in Fluxus Newspaper No. 3

F-m No. 2 - Primary Study by Henry Flynt 25¢
European Mail-Orderhouse: europeanfluxshop, Pricelist. [ca. June 1964].

XL-F2 HENRY FLYNT...new version of primary study. ASK FOR FREE INFORMATION
Second Pricelist - European Mail-Orderhouse. [Fall 1964].

COMMENTS: *Primary Study was intended to be a part of the subscription plan of* Complete Works. *Although* Complete Works *was not published as intended,* Primary Study *might have been available but I haven't seen it. "Primary Study (1956-1964) Version 7 (Winter 1963-64)" appeared in Fluxus Newspaper No. 3, March 1964.*

HENRY FLYNT and GEORGE MACIUNAS

COMMUNISTS MUST GIVE REVOLUTIONARY LEADERSHIP IN CULTURE
Silverman No. 137, ff.

"...Also enclosed a new "book" of H. Flynt (appendix not printed yet),..."
Letter: George Maciunas to Ben Vautier, [Summer 1965].

"...I am preparing several packages for you with... Flynt - Maciunas book which was completed last week..."
Letter: George Maciunas to Ben Vautier, January 10, 1966.

"...I mailed by parcel post - one carton with following:...1 - Flynt on boards - Wholesale cost to you. each - 70 ¢ - suggested selling price - $1 -"
Letter: George Maciunas to Ken Friedman, August 19, 1966.

"...You asked about Fluxus non-participation in DIAS. I just didn't know of enough pieces that were destructive. I think most important Fluxus people are CONSTRUCTIVE. Even Henry Flynt is constructive if you read that essay on tan paper. (with my appendix) you have enough copies?...Few comments on your 'position paper'...Fluxus still publishes...did... also Flynt-Maciunas essay..."
Letter: George Maciunas to Ben Vautier, [ca. October, 1966].

FLUX-PRODUCTS 1961 TO 1969...HENRY FLYNT Communists must give revolutionary leadership in Culture, essay on 2 large sheets [$] 1...
Fluxnewsletter, December 2, 1968 (revised March 15, 1969).

FLUX-PRODUCTS 1961 TO 1970...HENRY FLYNT

Henry Flynt and George Maciunas. COMMUNISTS MUST GIVE REVOLUTIONARY LEADERSHIP IN CULTURE

NOTE ON THE GRAPHICS

A colored stock, which is more rugged and durable than newsprint, but costs as little because it is not bleached, is used.

One type is used throughout. Larger sizes are obtained by photostatic enlargement. Costs and arbitrary stylistic choices involved in using a variety of types are eliminated.

The text fills one conveniently sized sheet. It is thus uniform with the appendices, which must be on large sheets. Costs of cutting, binding, and blank paper for page margins and decoration are eliminated. Text and appendices can also be displayed as posters. (Actually, the text was printed on a larger, standard-size stock. The unfilled part of the stock was used for another job, which was put on the same plate, and the two jobs were cut apart after printing.)

The expanded polystyrene and translucent plastic samples which have to be included to illustrate Appendix 2 are utilized to form permanent back and front covers and a mailing container.

The folding system and size when folded are such that the title section can be shown through the translucent front cover.

George Maciunas' "Note on the Graphics" from COMMUNISTS MUST GIVE REVOLUTIONARY LEADERSHIP IN CULTURE

Communists must give revolutionary leadership in Culture, essay [$] 1...
Flux Fest Kit 2. [ca. December 1969].

COMMENTS: *Flynt's essay is a manifesto on the arts, Maciunas' appendices include Soviet construction methods, Fuller's Geodesic Dome and other cultural "solutions." Designed by George Maciunas, the "book" was published by World View Publishers, New York, 1965.*

BICI FORBES see: BICI HENDRICKS

SIMONE FORTI see: SIMONE MORRIS

JERRY FOYSTER

ONE WAY

FLUXUS o JERRY FOYSTER: "one way" signs $5
cc fiVe ThReE (Fluxus Newspaper No. 4) June 1964.

F-o JERRY FOYSTER: "one way" signs $5
Second Pricelist - European Mail-Orderhouse. [Fall 1964].

COMMENTS: *Presumably ready-mades, it isn't known whether Maciunas ever produced Foyster's* One Way *or had them on hand to sell. The work may be related to George Brecht's* Exit *and* No Smoking *signs.*

CAROLYN FOZZNICK

A mention of Earthquake Event *by Carolyn Fozznick appears in* Fluxus Newspaper No. 1, January 1964.

KEN FRIEDMAN

BOXED EVENTS see:
 EVENTS
BUTTON see:
 GARNISHT KIGELE
CANCELLATION STAMP see:
 INCONSEQUENTIAL IS COMING

CARDS

"...For Summer 1967...cards + Mandatory happening - contents..."
Letter: George Maciunas to Ken Friedman, [ca. February 1967].

FLUXPROJECTS FOR 1969...Cards:...Ken Friedman
Fluxnewsletter, December 2, 1968.

COMMENTS: *Ken Friedman, 1985: "I would imagine that he referred to the* Event Cards *since he never finished producing them. It's possible, knowing George, that he had interpreted some work of mine into playing cards."*

Probably these cards would have been part of a series of cards, made by several artists, that Maciunas was producing. The work is not known to have been realized.

CLEANLINESS FLUX KIT
Silverman No. 141, ff.

"...Cleanliness kit - how does that go? You never described it...Friedman Fluxkit. I would suggest that it include: small plastic boxes:... Cleanliness kit *... *still have to make labels... By end of January I will do another ganged up label job, so I will try to do at least all labels. I will start with: ...in that order: cleanliness kit..."
Letter: George Maciunas to Ken Friedman, November 23, 1966.

"...in a few days, when I will have left my job, I will start among other things your cancellation stamp. Other things to follow: labels for cleanliness kit...for 'clippings' label I got nice engravings of guillotine, & for 'cleanliness' a steam box with head sticking out...

your projects, I think I could schedule as follows:... labels & boxes —— April 15 + cleanliness kit..."
Letter: George Maciunas to Ken Friedman, [ca. February 1967].

FLUX-PROJECTS PLANNED FOR 1967...Ken Friedman:...Cleanliness flux-kit...
Fluxnewsletter, March 8, 1967.

cleanliness kit $3 by ken friedman
Fluxshopnews. [Spring 1967].

FLUXPROJECTS FOR 1968 (In order of priority) 3. Boxed events & objects (all ready for production) ...Ken Friedman...cleanliness flux-kit...
Fluxnewsletter, January 31, 1968.

FLUX-PRODUCTS 1961 TO 1969...KEN FRIEDMAN...Cleanliness kit (miniature cleaning devices) in partitioned box*[$] 5...[also indicated as part of FLUXKIT]
Fluxnewsletter, December 2, 1968 (revised March 15, 1969).

FLUX-PRODUCTS 1961 TO 1970...KEN FRIEDMAN...Cleanliness kit, miniature devises, [sic] boxed [$] 5...
Flux Fest Kit 2. [ca. December 1969].

Ken Friedman. SELF PORTRAIT, ca. 1966

COURTESY OF KEN FRIEDMAN

252

Ken Friedman. CLEANLINESS FLUX KIT

BRAD IVERSON

FLUXUS-EDITIONEN...[Catalogue no.] 748 KEN FRIEDMAN: cleanliness kit
Happening & Fluxus. Koelnischer Kunstverein, 1970.

Toilet no. 2 Paul Sharits/Medicine cabinet: cleanliness kit...behind glass
Fluxnewsletter, April 1973.

SPRING 1969...FRIEDMAN:...cleanliness kit...
George Maciunas, Diagram of Historical Developments of Fluxus... [1973].

...KEN FRIEDMAN...Cleanliness kit, miniature devises, [sic] boxed $8
Flux Objects, Price List. May 1976.

COMMENTS: This Fluxus Edition contains soap papers, sanders etc. - objects related to cleaning, although not restricted
to cleaning the body. Had the Flux-Toilet *been built, Paul Sharits'* Toilet No. 2 *was to have contained Ken Friedman's* Cleanliness Kit.

CLIPPINGS see:
 FLUX CLIPPINGS
CORSAGE KIT see:
 A FLUX CORSAGE

CUT OUT DOLL

"...Friedman Fluxkit. I would suggest that it include: small plastic boxes:...Cut-out doll.*...* still have to make labels..."
Letter: George Maciunas to Ken Friedman, November 23, 1966.

"...your projects, I think I could schedule as follows: for Fall 1967 or 1968...cut-out-doll..."
Letter: George Maciunas to Ken Friedman, [ca. February 1967].

COMMENTS: *Probably a ready-made,* Cut Out Doll *is not known to have been made by Maciunas as a Fluxus Edition.*

DOLL see:
CUT OUT DOLL

EVENTS

"...Friedman Fluxkit. I would suggest that it include: small plastic boxes:...boxed events* (all printed events)...* still have to make labels...By end of January I will do another ganged up label job, so I will try to do at least all labels. I will start with:...in that order: events..."
Letter: George Maciunas to Ken Friedman, November 23, 1966.

FLUX-PROJECTS PLANNED FOR 1967 ... Ken Friedman:...events in box.
Fluxnewsletter, March 8, 1967.

events $3 by ken friedman
Fluxshopnews. [Spring 1967].

FLUXPROJECTS FOR 1968 (In order of priority) 3.Boxed events & objects (all ready for production) ...Ken Friedman...events
Fluxnewsletter, January 31, 1968.

COMMENTS: *Although Maciunas states in the 1968 Fluxus Newsletter that* Events *was ready for production, it was never made as a Fluxus Edition. Ken Friedman is a prolific artist and has self-published collections of his events.*

EXECUTION KIT

"...your projects, I think I could schedule as follows: For Fall 1967 or 1968...execution kit? (Maybe too similar to Ben's suicide kit.)..."
Letter: George Maciunas to Ken Friedman, [ca. February 1967].

COMMENTS: *Maciunas, in deciding on ideas to produce as Fluxus Editions, would frequently reject works that he saw as too similar to another artist's ideas.*

FLUX CLIPPINGS
Silverman Nos. > 146.I; > 146.Ia, ff.

"...Clippings - I like that very much, the best of all you have done. Try to fit into the small plastic box with 7 compartments, like the suicide kit. newspaper clipping can be as large as cover & be right under cover. ...Friedman Fluxkit. I would suggest it include: small plastic boxes:...4. Clippings *...* still have to

Ken Friedman. FLUX CLIPPINGS. Mechanical by George Maciunas for the label

SCOTT HYDE

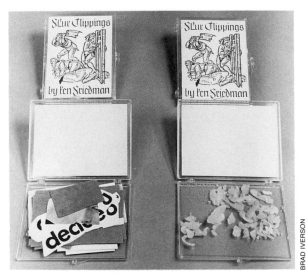

Ken Friedman. FLUX CLIPPINGS

BRAD IVERSON

make labels...By end of January I will do another ganged up label job, so I will try to do at least all labels. I will start with: in that order: Clippings..."
Letter: George Maciunas to Ken Friedman, November 23, 1966.

FLUX-PROJECTS PLANNED FOR 1967...Ken Friedman:...flux-clippings...
Fluxnewsletter, March 8, 1967.

flux clippings $3 by ken friedman
Fluxshopnews. [Spring 1967].

"...your projects, I think I could schedule as follows: Clippings...labels & boxes — April 15...for 'clippings' label I got nice engraving of guillotine...In a few days [when I will have left my job] I will start among other things your cancellation stamp. Other things to follow: labels for...clippings..."
Letter: George Maciunas to Ken Friedman, [ca. February 1967].

"Clippings boxes are empty - you must fill them. You can change other contents if you wish."
Letter: George Maciunas to Ken Friedman, [ca. Winter 1967/68].

FLUXPROJECTS FOR 1968 (In order of priority) 3. Boxed events & objects (all ready for production)... Ken Friedman - flux-clippings...
Fluxnewsletter, January 31, 1968.

FLUX-PRODUCTS 1961 TO 1969 ... KEN FRIEDMAN...Flux-clippings, (nail, hair & other clippings) in partitioned box. [$] 5...
Fluxnewsletter, December 2, 1968 (revised March 15, 1969).

FLUX-PRODUCTS 1961 TO 1970 ... KEN FRIEDMAN...Flux-clippings, boxed [$] 5...
Flux Fest Kit 2. [ca. December 1969].

FLUXUS-EDITIONEN...[Catalogue no.] 747 KEN FRIEDMAN: flux-clippings
Happening & Fluxus. Koelnischer Kunstverein, 1970.

SPRING 1969...FRIEDMAN...clippings
George Maciunas, Diagram of Historical Developments of Fluxus... [1973].

1st shipment:...Including...Friedman:...human clippings...
[Fluxus price list for a customer]. January 7, 1976.

...KEN FRIEDMAN...Flux clippings, boxed $4...
Flux Objects, Price List. May 1976.

COMMENTS: *According to Friedman, when Maciunas assembled this work he used body parts such as fingernails, callouses, bunions, etc. Friedman was so superstitious that when he assembled copies he used clippings from magazines, newspapers, etc.*

A FLUX CORSAGE
Silverman No. 142, ff.

"Friedman Fluxkit. I would suggest that it include: small plastic boxes:...Corsage kit * (I like that very much too.)...* still have to make labels....By end of January I will do another ganged up label job, so I will try to do at least all labels. I will start with:...in

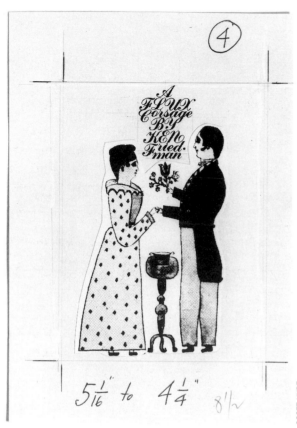

Ken Friedman. A FLUX CORSAGE. Mechanical by George Maciunas for the label

that order: corsage kit...''
Letter: George Maciunas to Ken Friedman, November 23, 1966.

''...In a few days [when I will have left my job] I will start among other things your cancellation stamp. Other things to follow: lables for...corsage kit...your projects, I think I could schedule as follows...corsage kit - labels & boxes, —— April 15...''
Letter: George Maciunas to Ken Friedman, [ca. February 1967].

FLUX-PROJECTS PLANNED FOR 1967 ... Ken Friedman:...Corsage kit...
Fluxnewsletter, March 8, 1967.

flux corsage $3 by ken friedman
Fluxshopnews. [Spring 1967].

FLUXPROJECTS FOR 1968 (In order of priority) 3. Boxed events & objects (all ready for production)... Ken Friedman:...corsage kit...
Fluxnewsletter, January 31, 1968.

FLUX-PRODUCTS 1961 TO 1969...KEN FRIEDMAN Flux-corsage, (boxed packet of sunflower seeds) * [$] 3 [indicated as part of FLUXKIT]...
Fluxnewsletter, December 2, 1968 (revised March 15, 1969).

FLUX-PRODUCTS 1961 TO 1970...KEN FRIEDMAN Flux-corsage, boxed [$] 3...
Flux Fest Kit 2. [ca. December 1969].

FLUXUS-EDITIONEN...[Catalogue no.] 744 KEN FRIEDMAN: flux-corsage
Happening & Fluxus. Koelnischer Kunstverein, 1970.

SPRING 1969...FRIEDMAN: corsage
George Maciunas, Diagram of Historical Developments of Fluxus... [1973].

...KEN FRIEDMAN Flux corsage, boxed $3...
Flux Objects, Price List. May 1976.

COMMENTS: *The Maciunas produced Fluxus Edition of A Flux Corsage always contains loose seeds or packages of seeds. Friedman's prototype for the work (Silverman No. < 142.I),*

contains only the word "Carnation." Other Fluxus works incorporating seeds are Robert Watts' Flux Timekit (Silverman No. 515, ff.) and Alison Knowles' Bean Rolls (Silverman No. 208, ff.).

FLUXCOURT BOX see:
OPEN AND SHUT CASE

FLUXFEAST OF NOTHING PUDDING see:
GARNISHT KIGELE

FLUXMYSTERY

''...your projects, I think I could schedule as follows: For Fall 1967 or 1968 Fluxmystery...''
Letter: George Maciunas to Ken Friedman, [ca. February 1967].

COMMENTS: *Flux Mystery was never produced as a Fluxus Edition by George Maciunas.*

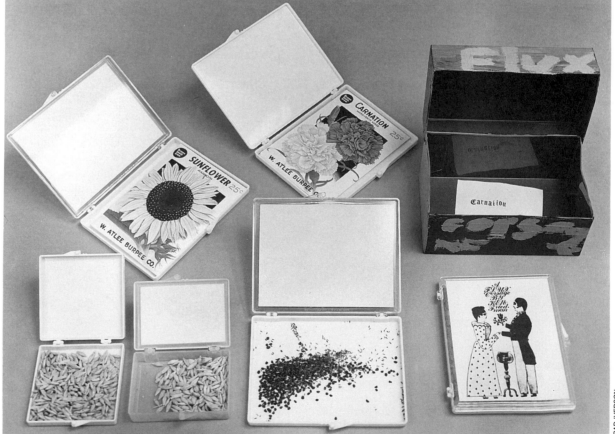

Ken Friedman. A FLUX CORSAGE. The artist's prototype appears upper right

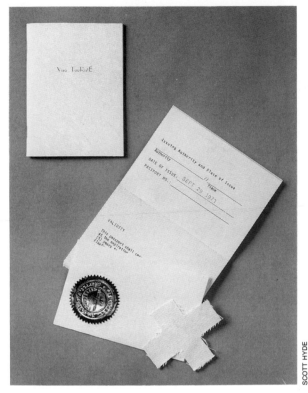

SCOTT HYDE

Ken Friedman. FLUX-PASSPORT

FLUX-PASSPORT

Silverman No. < 138.IV

"...your projects, I think I could schedule as follows: For Summer 1967 passport..."
Letter: George Maciunas to Ken Friedman, [ca. February 1967].

FLUX-PROJECTS PLANNED FOR 1967 ... Ken Friedman:...Flux-passport...
Fluxnewsletter, March 8, 1967.

FLUXPROJECTS FOR 1968 (In order of priority) 3. Boxed events & objects...Ken Friedman...flux-passport...
Fluxnewsletter, January 31, 1968.

Make a passport with a Visa TouRistE to Flux Events. Make the entry stamps out of vegetables. Make a salad from the stamps.
Fluxfest 77 at and/or, Seattle. September 1977.

Visa TouRistE the FLUXPASSPORT with the special VisaTouRistE is the special entry card to Fluxus events during this FluxFest. A photo is needed to affix to the passport and then it will be validated. Each

event will have a special entry stamp. $2.00
ibid.

COMMENTS: George Maciunas first explored the idea of passports in 1966 when he used it as a descriptive title for the Hi Red Center *Fluxclinic Record of Features and Feats. The first mention of a passport attributed to Friedman by Maciunas evidently refers to a piece, since destroyed, that Friedman had titled,* Passport to the State of Flux. *Flux Passport, although planned as early as 1967, was not realized until 10 years later, when it was produced as* Visa TouRistE *at Fluxfest '77 at and/or in Seattle, Washington.*

FLUXPIECE see:
JUST FOR YOU

FLUXPOEMS

"...your projects, I think I could schedule as follows: For Fall 1967 or 1968...fluxpoems..."
Letter: George Maciunas to Ken Friedman, [ca. February 1967].

COMMENTS: Fluxpoems *was not produced by Maciunas as a Fluxus Edition.*

FLUX POST KIT 7 see:
INCONSEQUENTIAL IS COMING

FLUXPOST SEAL see:
INCONSEQUENTIAL IS COMING

FLUXUS WANTS YOU FOR A MANDATORY HAPPENING see:
MANDATORY HAPPENING

FRIEDMAN FLUXKIT

"...I got...items for your kit...Friedman Fluxkit. I would suggest that it include: small plastic boxes:
1. Open & shut case
2. Garnisht Kigele
3. Cleanliness kit *
4. Clippings *
5. Mandatory happening
6. boxed events * (all printed events)
7. portrait mirror. *
8. Corsage kit * (I like that very much too.)
9. Cut-out doll. *
———————————————
special compartments for:
1. procession kit
2. Mobius Strip
3. Tablemap
4. Cancellation stamp.

5. Just for you
6. Sound tapes.
7. roll of tape
———————————————
* still have to make labels. As you see there will be delay in production of the entire kit, since we must

have all components ready. Lets just concentrate doing one thing at a time. By end of January I will do another ganged up label job, so I will try to do at least all labels. I will start with: in that order: Clippings, events, corsage kit, cleanliness kit. When we have all plastic boxes or at least 6 of them ready, we can make a box [leather camera case] where only 6 plastic boxes will fit. & have a Friedman Fluxkit no. 1. Then when we have other items ready can fit a larger case & call that no. 2 etc, etc. . OK?..."
Letter: George Maciunas to Ken Friedman, November 23, 1966.

"...For Fall 1967 or 1968 By this time we could assemble a Friedman solo Fluxkit in attache case."
Letter: George Maciunas to Ken Friedman, [ca. February 1967].

COMMENTS: Although at least eight individual works that would have gone into the Friedman Fluxkit *exist as separate Fluxus Editions, unfortunately Maciunas never assembled the whole work as planned.*

FRIEDMAN FLUXKIT NO. 1 see:
FRIEDMAN FLUXKIT
FRIEDMAN FLUXKIT NO. 2 see:
FRIEDMAN FLUXKIT

GARNISHT KIGELE
Silverman No. < 138.II

"...I don't have yet buttons for Garnisht Kigele... Friedman Fluxkit. I would suggest that it include: small plastic boxes:... Garnisht Kigele..."
Letter: George Maciunas to Ken Friedman, November 23, 1966.

"...You already have...Garnisht Kigele..."
Letter: George Maciunas to Ken Friedman, [ca. February 1967].

PAST FLUX-PROJECTS (realized in 1966)...Garnisht Kigele by Ken Friedman
Fluxnewsletter March 8, 1967.

garnisht kigele $3 by ken friedman
Fluxshopnews. [Spring 1967].

FLUX-PRODUCTS 1961 TO 1969...KEN FRIEDMAN...Garnisht kigele, boxed button [$] 3...
Fluxnewsletter, December 2, 1968 (revised March 15, 1969).

FLUX-PRODUCTS 1961 TO 1970 ... KEN FRIEDMAN...Garnisht kigele, boxed button [$] 3...
Flux Fest Kit 2. [ca. December 1969].

FLUXUS-EDITIONEN...[Catalogue no.] 746 KEN FRIEDMAN: garnisht kigele
Happening & Fluxus. Koelnischer Kunstverein, 1970.

COMMENTS: Meaning "not at all cake," and printed on a campaign-type button, the edition has a relationship to other Friedman works: Open and Shut Case/Fluxcourt Box (Silverman No. 140, ff.).

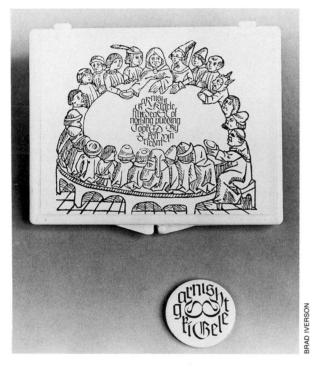

Ken Friedman. GARNISHT KIGELE. Shown above, with its contents displayed in front. Below, part of George Maciunas' mechanical for the label

HUMAN CLIPPINGS see:
FLUX CLIPPINGS

ICE KIT

"...your projects, I think I could schedule as follows: For Fall 1967 or 1968...ice kit..."
Letter: George Maciunas to Ken Friedman, [ca. February 1967].

COMMENTS: This work was not produced by George Maciunas as a Fluxus Edition.

INCONSEQUENTIAL IS COMING
Silverman No. < 138.V

"...Cancellation stamp. This is the very next thing I will have done....Friedman Fluxkit. I would suggest that it include:...special compartments for:...Cancellation stamp..."
Letter: George Maciunas to Ken Friedman, November 23, 1966.

"...In a few days [when I will have left my job] I will start among other things your cancellation stamp... your projects, I think I could schedule as follows: Cancellation stamp. — Mar. 3..."
Letter: George Maciunas to Ken Friedman, [ca. February 1967].

FLUX-PROJECTS PLANNED FOR 1967... Ken Friedman: rubber cancellation stamp...
Fluxnewsletter, March 8, 1967.

FLUX-PROJECTS PLANNED FOR 1967... Collective projects: (All are invited to submit ideas and participate, ideas can be either ready pictorial material or just specified material which we have to find, produce or obtain otherwise)...Flux-postal kit: containing... cancellation stamps...
ibid.

IMPLOSIONS INC. PROJECTS...Triple partnership was formed between Bob Watts, Herman Fine and myself [George Maciunas] to introduce into mass market...money producing products...This business will be operated in commercial manner, with intent to make profits...connection between Fluxus collective and Implosions Inc. has not been clarified yet...we could consider at present Fluxus to be a kind of division or subsidiary of Implosions. Projects to be realized through Implosions:...Postcards, stamps (same as Flux-postal kit)
ibid.

"I am mailing today 2 rubber seals (like post office circular cancellation stamps) one saying: Inconsequential in coming, Fluxpost..."
Letter: George Maciunas to Ben Vautier, March 25, 1967.

"...I have shipped 4 packs to you by now, including your Fluxpost cancellation stamp..."
Letter: George Maciunas to Ken Friedman, March 27, 1967.

fluxpost seal $5 by ken friedman
Fluxshopnews. [Spring 1967].

flux post kit $7
ibid.

[impression of the rubberstamp on front of the postcard]
Letter: George Maciunas to Paul Sharits, June 21, 1967.

FLUXPROJECTS REALIZED IN 1967:...Rubber postal stamps by Ken Friedman
Fluxnewsletter, January 31, 1968.

FLUX-PRODUCTS 1961 TO 1969 ... FLUXPOST KIT 1968...rubber stamp by Ken Friedman...[$] 8 Version without rubber stamps [$] 2
Fluxnewsletter, December 2, 1968 (revised March 15, 1969).

FLUX-PRODUCTS 1961 TO 1970 ... FLUXPOST KIT 1968,...rùbber stamp by Ken Friedman...Boxed: $8
Flux Fest Kit 2. [ca. December 1969].

FLUXUS-EDITIONEN...FLUXPOST KIT, 1968 (... k.friedman...)
Happening & Fluxus. Koelnischer Kusntverein, 1970.

Ken Friedman. INCONSEQUENTIAL IS COMING

Ken Friedman. JUST FOR YOU. Unused stamp

COMMENTS: *Ken Friedman and his* Fluxus West *group used many rubber stamps in their activities; some were readymades and others such as* Fluxus West *were custom made. The only rubber stamps of Friedman that were produced as Fluxus Editions were* Inconsequential Is Coming *(a component of the Collective Fluxus Edition,* Flux Post Kit 7*), and* Just For You *(which was not used).*

LORI TUCCI

Ken Friedman. JUST FOR YOU

JUST FOR YOU
Silverman No. 138, ff.

"...I got all "just for you" items...Friedman Fluxkit. I would suggest that it include:...special compartments for:...Just for you..."
Letter: George Maciunas to Ken Friedman, November 23, 1966.

"...Received package from you, full of crumpled newspapers & 'Just for you's' objects. VERY NICE IDEAS. Your packing list correct, Earlier 'just for yous': 1. broken record/ 2. Slides with objects...Am thinking about label for 'just for you's' Maybe a fancy numbered certificate? or postman making delivery, or Victorian suitor proposing to lady? or letter writing.? Let me know your preferences...
In a few days [when I will have left my job] I will start among other things your cancellation stamp. Other things to follow: labels for...Just for you's.... your projects, I think I could schedule as follows:... Just for yous...labels & boxes — April 15..."
Letter: George Maciunas to Ken Friedman, [ca. February 1967].

FLUX-PROJECTS PLANNED FOR 1967... Ken Friedman:...Just for you packages...
Fluxnewsletter, March 8, 1967.

Just for you $8 by ken friedman
Fluxshopnews. [Spring 1967].

FLUX-PRODUCTS 1961 TO 1969 ... KEN FRIED-MAN...Just for You, each different with certificate [$] 8
Fluxnewsletter, December 2, 1968 (revised March 15, 1969).

FLUX-PRODUCTS 1961 TO 1970 ... KEN FRIED-MAN... Just for You, with flux-certificate [$] 8
Flux Fest Kit 2. [ca. December 1969].

"...Friedman's just for you, are each different..."
Letter: George Maciunas to Dr. Hanns Sohm, [ca. late 1972].

COMMENTS: *Each* Just for You *is an individually assembled work by Ken Friedman that he mailed to Maciunas to distribute through Fluxus, making each example of the edition a personal gesture on the part of the artist. Although many exist, Maciunas evidently never finished designing a label for it or distributed the work. A finished design for a rubber stamp does exist, but it isn't clear how the stamp would have been used. Perhaps the intention was to stamp the objects assembled by Friedman.*

MANDATORY HAPPENING
Silverman No. < 138.I

"...Friedman Fluxkit. I would suggest that it include: small plastic boxes:...Mandatory happening..."
Letter: George Maciunas to Ken Friedman, November 23, 1966.

"...your projects, I think I could schedule as follows: For Summer 1967 ...cards & Mandatory happening-contents...You already have...Mandatory happening [label only]...."
Letter: George Maciunas to Ken Friedman, [ca. February 1967].

FLUX-PROJECTS PLANNED FOR 1967 ... Ken Friedman:...Mandatory happenings (boxed)
Fluxnewsletter, March 8, 1967.

FLUXPROJECTS FOR 1968 (In order of priority) 3. Boxed events & objects (all ready for production): ...Ken Friedman...mandatory happenings...
Fluxnewsletter, January 31, 1968.

FLUX-PRODUCTS 1961 TO 1969 ... KEN FRIED-MAN...Mandatory happenings, cards in box, May 1969 [$] 3...
Fluxnewsletter, December 2, 1968 (revised March 15, 1969).

"...Friedman's...mandatory happenings not produced yet..."
Letter: George Maciunas to Dr. Hanns Sohm, [ca. late 1972].

COMMENTS: *Evidently George Maciunas never completed all the elements for* Mandatory Happening. *A label was printed, probably around the beginning of 1967, and at least one box was sent to Friedman with the label attached. This copy is now in the Silverman Collection (Silverman No. > 138.I); however, I have never seen a Fluxus printing of the contents of the work.*

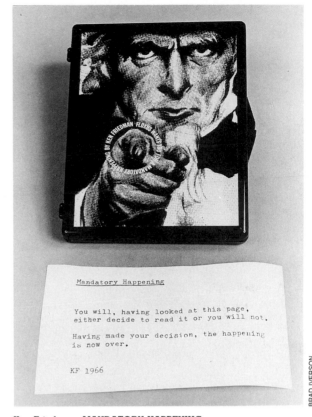

BRAD IVERSON

Ken Friedman. MANDATORY HAPPENING

MAP see:
 TABLE MAP
MIRROR see:
 PORTRAIT

MOEBIUS STRIP

"...Friedman Fluxkit. I would suggest that it include: ...special compartments for:... Moebius Strip..."
Letter: George Maciunas to Ken Friedman, November 23, 1966.

"...your projects, I think I could schedule as follows: For Fall 1967 or 1968...Moebius Strip..."
Letter: George Maciunas to Ken Friedman, [ca. February 1967].

COMMENTS: Moebius Strip *was never produced by George Maciunas as a Fluxus Edition.*

OPEN AND SHUT CASE
Silverman No. 140, ff.

"...Friedman Fluxkit. I would suggest that it include:

Ken Friedman. OPEN AND SHUT CASE

BRAD IVERSON

small plastic boxes:... Open & shut case..."
Letter: George Maciunas to Ken Friedman, November 23, 1966.

"...You already have Open-Shut case...I could not send 30 or more "Open & Shut" cases, because I don't have any left. (only few samples). That's too costly a gift to send. ..."
Letter: George Maciunas to Ken Friedman, [ca. February 1967].

PAST FLUX-PROJECTS (realized in 1966)...Open & Shut case by Ken Friedman
Fluxnewsletter, March 8, 1967.

open & shut case $3 by ken friedman
Fluxshopnews. [Spring 1967].

FLUX-PRODUCTS 1961 TO 1969 ... KEN FRIEDMAN...Open & shut case [$] 3...
Fluxnewsletter, December 2, 1968 (revised March 15, 1969).

FLUX-PRODUCTS 1961 TO 1970 ... KEN FRIEDMAN...Open & shut case [$] 3...
Flux Fest Kit 2. [ca. December 1969].

FLUXUS-EDITIONEN...[Catalogue no.] 745 KEN FRIEDMAN: open & shut case
Happening & Fluxus. Koelnischer Kunstverein, 1970.

03.1967...KEN FRIEDMAN: box event.
George Maciunas, Diagram of Historical Developments of Fluxus... [1973].

...KEN FRIEDMAN...Open & shut case $3...
Flux Objects, Price List. May 1976.

COMMENTS: *Important elements of Fluxus are the simple gag, the obvious and brevity.* Open & Shut Case *incorporates all these: the label is a summons to appear at court for "Open and Shut Case" and inside the case is a card, "Shut Quick."*

PASSPORT see:
FLUX-PASSPORT
POEMS see:
FLUXPOEMS

PORTRAIT

"...Friedman Fluxkit. I would suggest that it include: small plastic boxes: ... portrait - mirror.* ...* still have to make labels..."
Letter: George Maciunas to Ken Friedman, November 23, 1966.

COMMENTS: Portrait *was probably never made as a Fluxus Edition because of its close similarity to Yoko Ono's* Self Portrait *which dates from two years earlier.*

POSTAGE STAMPS

"...You could do the following yet:...Postage Stamps. (will have 100 stamp sheet, each row of 10 by different Flux-man. So you could send material as follows: photos - any size, (will reduce) screened clippings or veloxes - about 100 screen - ½ x ¾" (like Fluxstamp window) Drawings any size (will reduce) ..."
Letter: George Maciunas to Ken Friedman, [ca. February 1967].

COMMENTS: *Maciunas had wanted several artists to make postage stamp projects. It suited his anarchist leanings, as with* Flux Passport. *There is no evidence that Friedman had responded with a stamp concept, although a sheet of his stamps was made for a project in Canada in 1974.*

PROCESSION KIT

"...Friedman Fluxkit. I would suggest that it include: ...special compartments for:...procession kit..."
Letter: George Maciunas to Ken Friedman, November 23, 1966.

"...your projects, I think I could schedule as follows: For Fall 1967 or 1968...procession kit..."
Letter: George Maciunas to Ken Friedman, [ca. February 1967].

COMMENTS: Procession Kit *was never produced by Maciunas as a Fluxus Edition.*

ROLL OF TAPE

"...Friedman Fluxkit. I would suggest that it include: ...special compartments for...roll of tape..."
Letter: George Maciunas to Ken Friedman, November 23, 1966.

COMMENTS: *Ken Friedman, 1985: "The tape was to have had texts printed on it."*
Roll of Tape *was not made as a Fluxus Edition by George Maciunas.*

RUBBER STAMPS see:
INCONSEQUENTIAL IS COMING
JUST FOR YOU

SOUND TAPES

"...Friedman Fluxkit. I would suggest that it include: ...special compartments for:...sound tapes. ..."
Letter: George Maciunas to Ken Friedman, November 23, 1966.

COMMENTS: Sound Tapes *were not produced by Fluxus. A Fluxus Edition of Paik's tapes was offered earlier, and George Brecht's* Entrance and Exit Music *(Silverman No. < 72.I) is another Fluxus Edition tape.*

STAMPS see:
POSTAGE STAMPS

SYMPATHETIC EAR

"...your projects, I think I could schedule as follows: For Summer 1967...Sympathetic Ear..."
Letter: George Maciunas to Ken Friedman, [ca. February 1967].

FLUX-PROJECTS PLANNED FOR 1967 ... Ken Friedman: Sympathetic ear
Fluxnewsletter, March 8, 1967.

FLUXPROJECTS FOR 1968 (In order of priority) 3. Boxed events & objects (all ready for production):... Ken Friedman...sympathetic ear...
Fluxnewsletter, January 31, 1968.

COMMENTS: *George Maciunas never produced* Sympathetic Ear *as a Fluxus Edition. Had it been made, it would have been a plastic case containing a plastic ear.*

TABLE MAP

"...Friedman Fluxkit. I would suggest that it include: ...special compartments for:...Table map..."
Letter: George Maciunas to Ken Friedman, November 23, 1966.

"...You could do the following yet: 1. Table - map - chart...your projects, I think I could schedule as follows: For Fall 1967 or 1968...Table map..."
Letter: George Maciunas to Ken Friedman, [ca. February 1967].

COMMENTS: Table Map *was not produced by George Maciunas as a Fluxus Edition.*

Visa TouRistE see:
FLUX-PASSPORT

G

HEINZ GAPPMAYR

Two poems from Zeichen by Heinz Gappmayr appear in Fluxus Newspaper No. 3, March 1964.

WINFRED GAUL

It was announced in the tentative plans for the first issues of FLUXUS that W. Gaul would contribute "color in new art" for Fluxus No. 2, WEST EUROPEAN ISSUE (YEARBOOK I) later called FLUXUS NO. 3 GERMAN & SCANDINAVIAN YEARBOX.
see: COLLECTIVE

KARL OTTO GOETZ

It was announced in the tentative plans for the first issues of FLUXUS that K.O. Goetz would contribute "Electronic painting and its programming" for FLUXUS NO. 2, later called FLUXUS NO. 3 WEST EUROPEAN YEARBOOK I, then: GERMAN & SCANDINAVIAN YEARBOX.
see: COLLECTIVE

EUGEN GOMRINGER

A poem dated 1953, by Eugen Gomringer appears in Fluxus Newspaper No. 1, January 1964.
see: COLLECTIVE

LUDWIG GOSEWITZ

APPELLATIVISCHE SPRACHE

"...something for a new pricelist of fluxshop: appellativische sprache (27 texts) $20..."
Letter: Ludwig Gosewitz to Willem de Ridder, August 18, 1964.

FR-1 LUDWIG GOSEWITZ...appellativische sprache (27 texts) $20...
Second Pricelist - European Mail-Orderhouse. [Fall 1964].

COMMENTS: Appellativische Sprache [assigned language], offered for sale at $20 would have been a printed facsimile of manuscript texts. I am not able to locate the work under this title in Ludwig Gosewitz' Gesammelte Texte, Rainer Verlag, Berlin, 1976.

ENVELOPES

"...something for a new pricelist of fluxshop: envel-

opes 25¢..."
Letter: Ludwig Gosewitz to Willem de Ridder, August 18, 1964.

FR-1 LUDWIG GOSEWITZ...envelopes 25¢...
Second Pricelist - European Mail-Orderhouse. [Fall 1964].

COMMENTS: Although Envelopes and other works by Ludwig Gosewitz were offered for sale through the European Fluxshop, no works by him appear in other Fluxus references, or were produced by George Maciunas for Fluxus. Gosewitz performed Wurftexte (described by Emmett Williams in Anthology of Concrete Poetry, Something Else Press, New York, 1967, as a "linguistic crap game,") during the Moving Theatre 1 in Amsterdam, October 5, 1962, and he participated in Actions/ Agit-Pop in Aachen, July 20, 1964.

POST - BONS

"...something for a new pricelist of fluxshop: post - bons free..."
Letter: Ludwig Gosewitz to Willem de Ridder, August 18, 1964.

FR-1 LUDWIG GOSEWITZ...post bons free
Second Pricelist - European Mail-Orderhouse. [Fall 1964].

COMMENTS: Perhaps Post-Bons were early Mail Art works.

POSTCARDS

"...something for a new pricelist of fluxshop: post - cards 25¢..."
Letter: Ludwig Gosewitz to Willem de Ridder, August 18, 1964.

FR-1 LUDWIG GOSEWITZ...post cards 25¢...
Second Pricelist - European Mail-Orderhouse. [Fall 1964].

COMMENTS: I have never seen the postcards that Gosewitz sent to de Ridder.

TYPOGRAMME 1
Silverman No. < 147.101

"...something for a new pricelist of fluxshop: typogramme 1 (15 texts) $3..."
Letter: Ludwig Gosewitz to Willem de Ridder, August 18, 1964.

FR-1 LUDWIG GOSEWITZ typogramme 1 (15 texts) $3...
Second Pricelist - European Mail-Orderhouse. [Fall 1964].

COMMENTS: Typogramme I was published by Eugen Gomringer Press, Frauenfeld, Switzerland, 1962, and is an example of Willem de Ridder adding works to his list of already published available material. Maciunas did this in New York as well. An example would be Paul Sharits' Fluxcomic (Autopsy).

TYPOGRAMME 2

"...something for a new pricelist of fluxshop: typogramme 2 (25 texts) $20..."
Letter: Ludwig Gosewtiz to Willem de Ridder, August 18, 1964.

FR-1 LUDWIG GOSEWITZ... typogramme 2 (25 texts) $20...
Second Pricelist - European Mail-Orderhouse. [Fall 1964].

COMMENTS: Typogramme 2 is a collection of 25 original concrete poems, which were printed directly from the manuscript in facsimile by the artist. They were never offered for sale by New York Fluxus, and George Maciunas did not produce a Fluxus Edition of the work.

BOB GRIMES

FLUX PAPER GAMES: ROLLS AND FOLDS see:
COLLECTIVE

PULL FOLD
Silverman No. 147

FLUX SHOW: DICE GAME ENVIRONMENT ENTIRE FLOOR AS DICE HAZARD TABLE DIE CUBES, 15" CUBES ON FLOOR, Marked on sides, top open or closed with clear plastic. Consisting or containing...Paper games by...Grimes...
Flux Fest Kit 2. [ca. December 1969].

COMMENTS: Pull Fold is a separate Fluxus Edition which was included in the Collective work, Flux Paper Games: Rolls and Folds. In 1966, Paul Sharits and David Thompson (Davi Det Hompson) designed and printed Grimes' piece, and sent it, along with the other paper games, to George Maciunas, who designed the label and packaging, and distributed them through Fluxus.

Bob Grimes. PULL FOLD

BRION GYSIN

It was announced in the Brochure Prospectus for Fluxus Year-boxes (version B) that Brion Gysin would contribute "Basic statement on cut-up method & permutated poems (cut card)" for FLUXUS NO. 1 U.S. YEARBOX. This work is included in FLUXUS 1 (Silverman No. 117, ff.).
see: COLLECTIVE

H

RAYMOND HAINS and JACQUES DE LA VILLEGLE

A decollage dated 1950 by Raymond Hains and Jacque de la Villege [sic] appears in Fluxus Newspaper No. 2, February 1964. Neither artist had further involvement with Fluxus.

Ann Halprin. LANDSCAPE EVENT, from FLUXUS 1

ANN HALPRIN

It was announced in the Brochure Prospectus for Fluxus Year-boxes (version B) that Ann Halprin would contribute "Five legged stool (dance score & photographs)" and with her work-shop she would contribute "Landscape score for a 45 Minute Environment" to FLUXUS NO. 1 U.S. YEARBOX. The score for the Landscape Event, although printed in 1963 or 64, does not appear in early assemblings of FLUXUS 1. It was included in a later copy, collated by George Maciunas in 1977 (Silverman No. > 118.II).
see: COLLECTIVE

AL HANSEN

It was announced in the Brochure Prospectus for Fluxus Year-boxes (version A) that Al Hansen would contribute a work

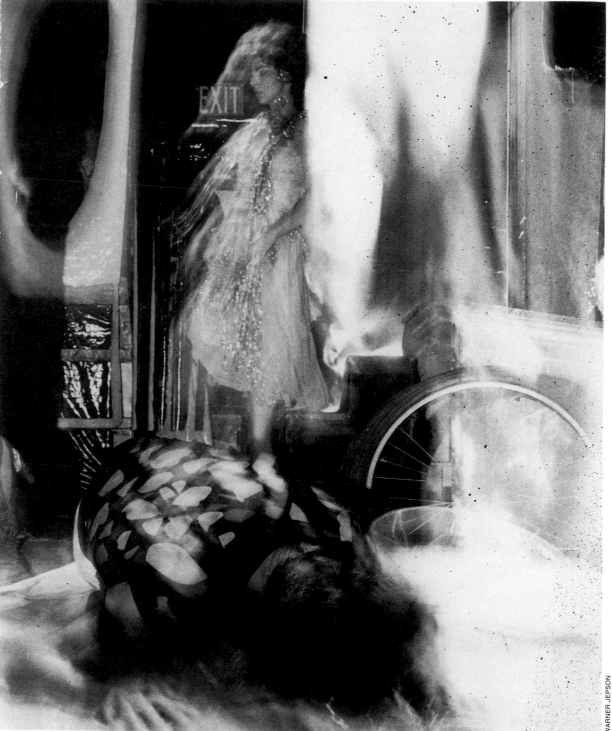

Ann Halprin with John Graham performing, ca. 1962. This photograph was intended for FLUXUS NO. 1 U.S. YEARBOX

"to be determined" for FLUXUS NO. 1 U.S. YEARBOX.
see: COLLECTIVE

SOHEI HASHIMOTO

"Happening No. 1" by Sohei Hashimoto appears in Fluxus Preview Review. *The same work by Hashimoto appears later in* FLUXUS 1 *(Silverman No. 117, ff.) entitled, "Composition for Rich Man."*
see: COLLECTIVE

LEE HEFLIN

EVENTS

FLUX-PROJECTS PLANNED FOR 1967...LEE HEFLIN: events (boxed)
Fluxnewsletter, March 8, 1967.

COMMENTS: *Three scores by Lee Heflin appear in* Fluxfest Sale *[Winter 1966]. George Maciunas never produced a separate Fluxus Edition of Heflin's* Events.

GEORG HEIKE

It was announced in the Brochure Prospectus for Fluxus Yearboxes (versions A & B) that Dr. P.G. Heike would contribute "Overtone structure of ancient wind musical instruments" to FLUXUS NO. 5 HOMAGE TO THE PAST.
see: COLLECTIVE

GEOFFREY HENDRICKS, COURTESY OF BICI FORBES

Bici Hendricks, ca. 1968

BICI HENDRICKS

COLORED BREAD

NEW YEAR EVE'S FLUX-FEAST, DEC. 31, 1969

AT CINEMATHEQUE, 80 WOOSTER ST.... Bici Hendricks:...colored bread (purple etc.)...
Fluxnewsletter, January 8, 1970.

31.12.1969 NEW YEAR EVE'S FLUX-FEAST (FOOD EVENT)...Bici Hendricks:colored bread...
George Maciunas, Diagram of Historical Developments of Fluxus... [1973].

COMMENTS: Colored Bread *was edible homemade bread with food coloring in it. Man Ray did a Surrealist pun with a loaf of French bread: he painted it blue and titled it* Pain Peint. *Bici Hendricks' score "Exit 1," printed in* Flux Fest Kit 2, *is food related, involving eggs. There are also references to her "Black Mono-Meal" and a "White Mono-Meal" in the same publication.*

CRUSHED ICE HAMBURGER SANDWICH

FLUX DRINKS & FOODS ... SANDWICHES: crunched ice hamburger (frozen beef bouillon) (Bici Hendricks)...
Invitation to Participate in New Year Eve's Flux-Feast. [ca. December 1969].

COMMENTS: Crushed Ice Hamburger Sandwich *was evidently not made. In the mid-1960s, Bici Hendricks made* Defrost the American Flag. *An American flag frozen in a block of ice, it made a strong political statement against the U.S. war in Vietnam.*

FLUX STILTS see:
Bici Hendricks and George Maciunas
FOOD see:
COLORED BREAD
CRUSHED ICE HAMBURGER SANDWICH
GRAVEL SOUP
NAIL SOUP

GRAVEL SOUP

FLUX DRINKS & FOODS...SOUPS: gravel soup... (Bici Hendricks)
Invitation to Participate in New Year Eve's Flux-Feast. [ca. December 1969].

COMMENTS: Gravel Soup *was not made as a Fluxus work.*

HARDWARE SOUP

FLUX DRINKS & FOODS...SOUPS:...hardware soup...(Bici Hendricks)
Invitation to Participate in New Year Eve's Flux-Feast. [ca. December 1969].

COMMENTS: Hardware Soup, *although proposed for a Flux-Feast, was not prepared. For her exhibition at the Judson Gallery in 1966, Bici Hendricks made table settings of tools with car hubcaps as plates.*

BRAD IVERSON

Bici Hendricks and George Maciunas. **FLUX STILTS**

NAIL SOUP

FLUX DRINKS & FOODS...SOUPS:...nail soup...
(Bici Hendricks)
Invitation to Participate in New Year Eve's Flux-Feast. [ca. December 1969].

COMMENTS: Nail Soup *was perhaps a pun on the children's story about nail soup, a parable about how gullible people can be.*

STILTS see:
 FLUX STILTS

BICI HENDRICKS and GEORGE MACIUNAS

FLUX STILTS
Silverman No. 299, ff.

FLUX-OLYMPIAD ... TEAM/ soccer ... with stilts
(Bici Hendricks)
Fluxfest at Stony Brook, Newsletter No. 1, August 18, 1969. version B

FLUX OLYMPIAD ... TEAM CONTEST - BALL ... STILT SOCCER (Bici Hendricks)
Flux Fest Kit 2. [ca. December 1969].

DOUGLASS COL. FLUX-SPORTS...STILT SOCCER
(Bici Hendricks)
Poster/Program for Flux-Mass, Flux-Sports and Flux-Show. February 1970.

FEB. 17, 1:30 PM FLUX-SPORTS DOUGLASS COL ...OBSTACLE SHOES:...shoes on stilts...
ibid.

FEB. 17, 1970: FLUX-SPORTS AT DOUGLASS COLLEGE...soccer with players on stilts (Bici Hendricks)
all photographs copyright nineteen seVenty by peTer mooRE (Fluxus Newspaper No. 9) 1970.

1970...FLUXSPORTS:...by bici hendricks: stilt soccer game ...douglass college n.j.
George Maciunas, Diagram of Historical Developments of Fluxus... [1973].

19.05.1973 FLUXGAMES...bici hendricks: stilt soccer game
ibid.

COMMENTS: *In 1970, using Bici Hendricks' idea, George Maciunas constructed several pairs of stilts with baby shoes on the bottoms, to be used for the Flux-Sports event at Douglass College in New Brunswick, New Jersey, and at the Flux Game Fest in New York City in 1973. Fluxus delights in taking the mundane and altering it in such a way to make it nearly impossible to use. See Robert Watts'* Stilt Shoes.

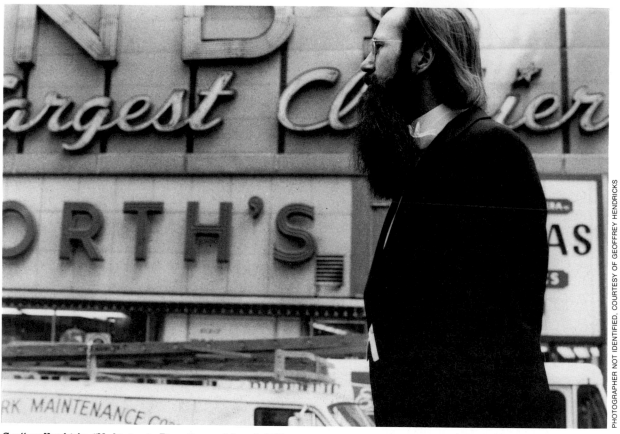

PHOTOGRAPHER NOT IDENTIFIED, COURTESY OF GEOFFREY HENDRICKS

Geoffrey Hendricks. "Meditation in Times Square." June 2, 1972

GEOFFREY HENDRICKS

CLOUD HAT

''...to produce the Flash Art FLUXPACK 3...contents at present will be as follows:...Hats: with clouds by Geoff Hendricks...''
Letter: George Maciunas to Giancarlo Politi, n.d. Reproduced in Fluxnewsletter, April 1973.

COMMENTS: *Geoffrey Hendricks has been incorporating clouds and sky in his work since the mid-1960s.* Cloud Hat *seems to be a Maciunas application of an idea, more than a specific work by Hendricks.* Cloud Hat *was not produced for* FLUXPACK 3.

CLOUDS

MAY 16-22: CAPSULE BY JOHN & YOKO + FLUX SPACE CENTER ($1 ADMISSION CHARGE) A 3ft cube enclosure (capsule) having various film loops projected on its 3 walls, ceiling and floor to a single viewer inside, about 8 minutes...clouds (Geoff Hendricks, 1970;...
Schedule of events for Fluxfest presentation of John Lennon and Yoko Ono. [ca. April 1970]. version B

COMMENTS: *At the time of the John & Yoko Fluxfest, Hendricks was making cloud paintings, postcards, etc. Although he made some films, and possibly a cloud film, there is no evidence that George Maciunas produced* Clouds *as a Fluxfilm. John Lennon used a painting of sky by Geoff Hendricks for the cover of his album* Imagine.

CLOUDS see:
 CLOUD HAT
 MASHED POTATO CLOUDS
 SKY DESERT
DISPENSING MACHINE see:
 FLUX RELIQUARY
FILM see:
 CLOUDS
 MOON LANDING

FLUX DIVORCE ALBUM
Silverman No. 155

1973...HENDRICKS: divorce album
George Maciunas, Diagram of Historical Developments of Fluxus... [1973].

...by Geoff Hendricks: flux-divorce album, boxed (album cut in half): $300, with flux-divorce relics: $450
Fluxnewsletter, April 1975.

by Geoff Hendricks: flux-divorce album, boxed (album cut in half): $300, with flux divorce relics: $450
[Fluxus price list for a customer]. September 1975.

GEOFF HENDRICKS...Divorce album, boxed $400
Flux Objects, Price List. May 1976.

COMMENTS: Flux Divorce Album *consists of altered photographs by Peter Moore, with text and relics from Geoff and Bici Hendricks' "Flux Divorce." The work was assembled in a very small edition by the artist, and offered for sale through Fluxus.*

FLUX RELIQUARY
Silverman No. 153, ff.

"...for the Rome exhibit...you could also install a few vending machines, which you could obtain local-ly...One machine could dispense cat shit, with the label saying: Fluxrelics: holy shit from the diners of the Last Supper, by Geoff Hendricks."
Letter: George Maciunas to Giancarlo Politi, n.d. Reproduced in Fluxnewsletter, April 1973.

Vending machine-dispensing Relics - Holy shit, by Geoff Hendricks [component of] Toilet no. 5 Ayo Medicine cabinet
Fluxnewsletter, April 1973.

1970 GEOFF HENDRICKS: relics
George Maciunas, Diagram of Historical Developments of Fluxus... [1973].

FLUX AMUSEMENT ARCADE...Vending machines, dispensers of holy relics (Hendricks)
Preliminary Proposal for a Flux Exhibit at Rene Block Gallery. [ca. 1974].

Geoffrey Hendricks. FLUX DIVORCE ALBUM

BUZZ SILVERMAN

Geoffrey Hendricks. FLUX RELIQUARY. Unused design for the label by George Maciunas

GEOFF HENDRICKS Flux Reliquary, 7 holy relics, boxed $14...
Flux Objects, Price List. May 1976.

COMMENTS: *This Fluxus Edition exists in at least three versions: a seven compartment plastic box with relics, a vending machine dispensing cat shit, and a drawer in the* Flux Cabinet *where Maciunas attributes the work to both himself and 'Hendricks. There are twelve relics in this version.*

FOOD see:
 MASHED POTATO CLOUDS
 SKY DESERT

MASHED POTATO CLOUDS

NEW YEAR EVE'S FLUX-FEAST, DEC. 31, 1969 AT CINEMATHEQUE, 80 WOOSTER ST....Geoff Hendricks: clouds - mashed potatoes in 10 flavors (vanilla, almond, orange, mint, etc.)...
Fluxnewsletter, January 8, 1970.

31.12.1968 NEW YEAR EVE'S FLUX - FEAST

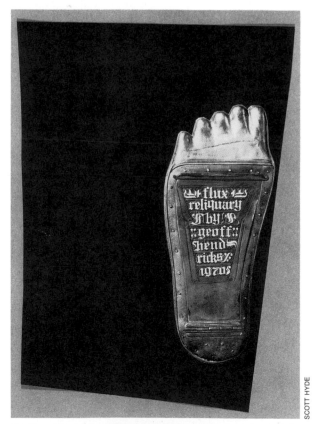

Geoffrey Hendricks. **FLUX RELIQUARY.** Unused mechanical for the label by George Maciunas

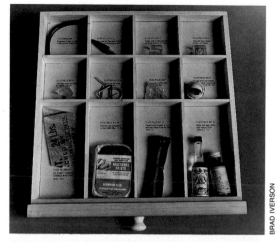

Geoffrey Hendricks. **FLUX RELIQUARY** in **FLUX CABINET.** The work shown is credited to both Hendricks and Maciunas. see color portfolio

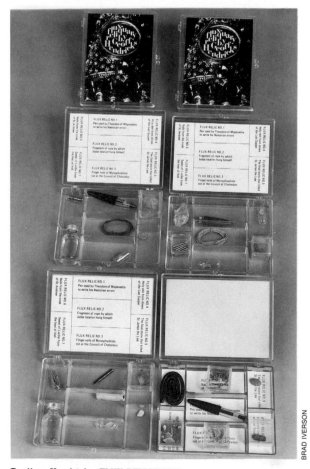

Geoffrey Hendricks. **FLUX RELIQUARY**

(FOOD EVENT)...G. Hendricks:...clouds...
George Maciunas, Diagram of Historical Developments of Fluxus... [1973].

31.12.1969 NEW YEAR EVE'S FLUX - FEAST (FOOD EVENT) G. Hendricks: potatoes in 10 flavors...
ibid.

COMMENTS: Mashed Potato Clouds *could well have been made.*

MOON LANDING

FLUXFEST PRESENTATION OF JOHN LENNON & YOKO ONO + * AT 80 WOOSTER ST. NEW YORK — 1970...MAY 16-22: CAPSULE BY JOHN & YOKO + FLUX SPACE CENTER...A 6x6 ft enclosure having various films projected on its walls to a single viewer inside...Moon landing (Geoff Hendricks '70)...
all photographs copyright nineteen seVenty by peTer mooRE (Fluxus Newspaper No. 9) 1970.

COMMENTS: Moon Landing *is included in an abridged version of* Fluxfilms, *dating from around 1970 and now in the Tate Gallery, London. I have not seen this film and don't know of another print that exists. It could have been a readymade movie of the actual moon landing.*

PHOTO MURAL FLOOR see:
 UPSIDE DOWN FOREST

PICNIC GARBAGE PLACEMAT

"I have...proceeded to produce the Flash Art FLUX-PACK 3...The contents at present will be as follows: Tablecloths:...picnic ground by Geoff Hendricks..."
Letter: George Maciunas to Giancarlo Politi, n.d. Reproduced in Fluxnewsletter, April 1973.

COMMENTS: *Fluxus distributed this work as an individual item, and it is included in the assembled* FLUXPACK 3.

PLACEMAT see:
 PICNIC GARBAGE PLACEMAT

POSTCARDS

Postcards by...Hendricks,...
[George Maciunas], Proposed Contents for Fluxpack 3 to be published in 1973 by Flash Art. [ca. 1972].

COMMENTS: *Although Geoffrey Hendricks had published a number of postcards on his own prior to 1973, he never did a postcard for Fluxus.*

POTATOES see:
 MASHED POTATO CLOUDS

Geoffrey Hendricks. **PICNIC GARBAGE PLACEMAT.** Mechanical by George Maciunas

SCOTT HYDE

RELICS see:
FLUX DIVORCE ALBUM
FLUX RELIQUARY

SCORES
COMMENTS: Scores by Geoffrey Hendricks appear in Flux Fest Kit 2 *[ca. December 1969]. see: COLLECTIVE*

SKY see:
CLOUDS

SKY DESERT
FLUXPROJECTS REALIZED IN 1967: ... Flux-Christmas-meal-event...Geoffrey Hendric[k]s sky desert (sky blue cake with blue layers, blue cream, blue dishes, blue napkins)...
Fluxnewsletter, January 31, 1968.

31.12.1968 NEW YEAR EVE'S FLUX-FEAST (FOOD EVENT) G. Hendricks:...blue cake...
George Maciunas, Diagram of Historical Developments of Fluxus... [1973].

COMMENTS: This ephemeral work, related to Mashed Potato Clouds, Sky Desert *could have been made by the artist for a Fluxfest.*

TABLECLOTH see:
PICNIC GARBAGE PLACEMAT

UPSIDE DOWN FOREST
"Enclosed is the final plan of labyrinth...The fol-lowing room is by Geoff Hendricks which is a kind of upside down forest. The floor should be a photomural of clouds, could be black and white, and you should order one locally right away. (one meter wide by whatever length you can get, like 3 or 4 meters). A number of dry branches should be attached to the ceiling. This room should also have a ceiling. You will notice, that I bunched up all rooms that require a ceiling. The ceiling should have plastic grass. They make a kind of grass rug. I hope you can get it in Berlin, otherwise we will have to bring it with our-selves. To protect the photomural on the floor from wear, it should be covered with clear plastic or glass. The sides could have thicker evergreen branches at-tached to the wall (but always upside down)."
Letter: George Maciunas to Rene Block, [ca. Summer 1976].

...Geoff Hendricks: upside down forest
Instruction drawing for Fluxlabyrinth, Berlin. [ca. August 19, 1976]. version A

"(8) Cloudroom needed: photo + twigs...Re: photo. I was unable so far to locate or get someone to locate suitable clouds in Hendricks style. They should be eas-ily distinguished in figure/ground relationship. Rene offered Gerhard Richter painting reproduction of clouds but I declined - I felt Geoff would not like us-ing another artist's clouds - so I requested by telegram Hendricks postcards. If you did not bring them, I have a slide by Rene that is suitable - so in either case we deliver to the photo lab as a priority 1st thing Monday. This would be good thing for Bob or myself to do. I am told it takes a week - so timing is O.K. I am also told the Academie has plexiglass available for covering the photo. I suggest we authenticate that Monday. In case of cutting we have table saw. Re: twigs Today I have arranged to look for some. Also there are Acade-mie grounds I am told. And weeds out side of doors in Academie Patio. P.S. twigs seem abundant - low priority"
Notes: Larry Miller to George Maciunas concerning the Flux-labyrinth, Berlin, [ca. August 1976].

COMMENTS: This work was not made for the Berlin Flux-labyrinth. *Hendricks has used combinations of forest ele-ments and sky for a number of his environments and instal-lations.*

VENDING MACHINES see:
FLUX RELIQUARY

HEUSSNER
It was announced in the tentative plans for the first issues of FLUXUS that Heussner would contribute "Indeterminate theatre" to FLUXUS NO. 2 WEST EUROPEAN YEARBOOK I, subsequently called FLUXUS NO. 3 GERMAN & SCANDI-NAVIAN YEARBOOK.
see: COLLECTIVE

HI RED CENTER

BOXED PORTRAIT
...will appear in late 1966...FLUXUSsos HI RED CENTER: box portrait $200 custom made box of same weight, height & volume as the subject, and with same size photos of subject on all sides, top & bottom quarter scale box portrait $70
Vaseline sTREet (Fluxus Newspaper No. 8) May 1966.

PHOTOGRAPHER NOT IDENTIFIED

Hi Red Center. **BOXED PORTRAIT**

Genpei Akasegawa, a member of Hi Red Center, ca. 1962

PHOTOGRAPHER NOT IDENTIFIED

e) volume measured of each visitor by immersion into a bathtub filled with water,
f) boxes with photos on all sides, top and bottom and matching each visitor in height, weight and volume could be ordered, or boxes at ½ or ¼ scale could be ordered at less cost,
g) pretty girl brushed off the coats of visitors upon their exit.

The name of the group is derived from the Japanese meaning of the names of the three artists who formed it: Takamatsu = Hi; Akasegawa = Red; Nakawishi = Center.

BUNDLE OF EVENTS
Silverman No. < 168.II, ff.

"...The complete works of Hi Red Center (many photos of their events) will be published this spring by us New York Fluxus. Their works will be on cards, wrapped in a 1000 yen bill (printed on hankerchief) and then tied many times with thick ropes. I will send you some 100 copies to sell. OK?"
Letter: George Maciunas to Willem de Ridder, January 21, 1965.

"...we will soon publish the complete works of Hi Red Center so there will be lots of new pieces..."
Letter: George Maciunas to Ben Vautier, February 1, 1965.

"...I am sending by ship mail photos of Hi Re Center events. Their complete works & descriptions of events is being published by Fluxus, some will appear in Fluxus newspapers..."
Letter: George Maciunas to Willem de Ridder, March 2, 1965.

1965 PUBLICATIONS AVAILABLE BY OCTOBER FLUXUSaa HI RED CENTER, a bundle of events and exhibits on newspaper, wrapped in handkerchief and rope, ed. Shigeko Kubota $4
Vacuum TRapEzoid (Fluxus Newspaper No. 5) March 1965.

FLUXKIT containing following fluxus-publications: (also available separately)...FLUXUS s HI RED CENTER: a bundle of events and exhibits, wrapped in rope, edited by Shigeko Kubota $5
Vaseline sTREet (Fluxus Newspaper No. 8) May 1966.

"...I mailed by parcel post - one carton with following: ...Hi Red Center events/wholesale cost to you. each 30c/ suggested selling price 50c/ sub total. —— wholesale cost to you. 1.50..."
Letter: George Maciunas to Ken Friedman, August 19, 1966.

"...furthermore Fluxus still publishes newspaper, supplements to works...started compl. works...did Hi Red Center..."
Letter: George Maciunas to Ben Vautier, [ca. October 1966].

FLUX-PRODUCTS 1961 TO 1969...HI RED CEN-

FLUX-PRODUCTS 1961 TO 1969...HI RED CENTER ... Box portrait, custom made box of same weight, height & volume as subject and full size photos on 5 sides [$] 300...
Fluxnewsletter, December 2, 1968 (revised March 15, 1969).

[as above]
Flux Fest Kit 2. [ca. December 1969].

"...hi red center portrait, very expensive..."
Letter: George Maciunas to Dr. Hanns Sohm, [ca. late 1972].

COMMENTS: Boxed Portrait was never produced by Maciunas as a Fluxus Edition. The following is a description of the Hi Red Center "Human Box Event" from 1964, which was published in Bundle of Events by Fluxus:

Human box event at imperial Hotel, room no. 340
1. Invitation required visitors to come with necktie, gloves and bag or package.
2. Visitors were given instructions in hotel lobby.
a) not to leave fingerprints on door knobs.
b) gesture in immitation of a woman putting on a red dress.
c) while waiting in lobby to observe neighbours breathing and exhale as he inhales, inhale as he exhales
d) to bring 1000 ¥ bill as passport for entry into room.
In room 340 visitors:
a) had their 1000 ¥ stamped with Hi Red Center symbol,
b) name, address, sex, bag size, capacity, contents and fingerprint was registered on a card,
c) photos of front, back, sides, top, and bottom were taken of each visitor,
d) body of each visitor was measured, weighed and outline drawn,

TER a bundle of events and exhibits, wrapped in rope net, edited by Shigeko Kubota [$] 5...
Fluxnewsletter, December 2, 1968 (revised March 15, 1969).

FLUX-PRODUCTS 1961 TO 1970...HI RED CENTER A bundle of events, in rope net [$] 5...
Flux Fest Kit 2. [ca. December 1969].

FLUXUS - EDITIONEN ... [Catalogue no.] 751 HI RED CENTER[:] a bundle of events, in rope net
Happening & Fluxus. Koelnischer Kunstverein, 1970.

05.1966...HI RED CENTER: bundle of events
George Maciunas, Diagram of Historical Developments of Fluxus... [1973].

COMMENTS: *In 1953, Marcel Duchamp designed a poster - catalogue for the exhibition "DADA 1916 - 1923" at the Sidney Janis Gallery in New York City; the posters were crumpled into balls and placed in trash baskets for people to retrieve. Hi Red Center's* Bundle of Events *is a sheet printed on both sides, of events and photo-documentation, published by Fluxus and edited by Shigeko Kubota. George Maciunas distributed* Bundle of Events *crumpled into a ball and sometimes tied in a rope net, similar to Akasegawa's tied counterfeit 1000 Yen note pieces in the early 1960s, Duchamp's trashed posters, and Christo's* Package.

Hi Red Center. BUNDLE OF EVENTS. Prototype by Genpei Akasegawa

Hi Red Center. BUNDLE OF EVENTS. Tied, crumpled, and folded versions

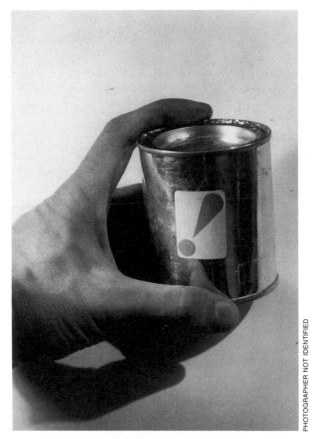

Hi Red Center. CANNED MYSTERY. Photograph taken in 1964 for the artists' group

CANNED MYSTERY
Silverman No. 158, ff.

FLUX-PRODUCTS 1961 TO 1969... HI RED CENTER...canned mystery [$] 4...
Fluxnewsletter, December 2, 1968 (revised March 15, 1969).

COMMENTS: *Produced by Hi Red Center in 1964, these works were offered for sale by Fluxus. The codes on the cans refer to their contents, so you could break the code by opening the can, but that would change the work. There is a relationship of this work to canned works by Piero Manzoni, Arman, Ben Vautier, and Andy Warhol. Arman and Vautier worked with elements of mystery, Manzoni and Warhol with visual perception of the obvious. Alison Knowles'* Bean Rolls *is a canned work meant to be opened.*

CLINICAL RECORD see:
FLUXCLINIC RECORD OF FEATURES AND FEATS
COMPLETE WORKS see:
BUNDLE OF EVENTS

!
Silverman No. > 168.I

FLUXFLAGS AND BANNERS ea. $25 28" square, sewnlegends, double bunting, readable both sides, grommets at corners...FLUXUS s HI RED CENTER: red on black: "!"
Vaseline sTREet (Fluxus Newspaper No. 8) May 1966.

"...Banner with arrow — I am out presently, but I could send you a banner with !, looks good too..."
Letter: George Maciunas to Ken Friedman, November 14, 1966.

COMMENTS: *The exclamation point became a signature for Hi Red Center. Denoting emphasis and statement of fact, they sometimes referred to it as their "trademark." The Fluxus produced ! flag fits right in with Brecht's → and Maciunas' ?.*

FLAG see:
!

FLUXCLINIC RECORD OF FEATURES AND FEATS
Silverman No. 168, ff.

"...we will measure each visitors height, weight, volume (in bathtub) also volume of mouth, head etc, measure strength of head, fingers, measure persons a-

Hi Red Center. !. see color portfolio

bility to stand still, etc, etc. Then a Fluxpassport will be issued with all this data noted down…''
Letter: George Maciunas to Milan Knizak, May 19, 1966.

PAST FLUX-PROJECTS (realized in 1966)…Hi Red Center Hotel Event at Waldorf Astoria Hotel, July. (clinical card printed)
Fluxnewsletter, March 8, 1967.

50c flux clinical record
Fluxshopnews. [Spring 1967].

FLUX-PRODUCTS 1961 TO 1969…HI RED CENTER…Clinical record, folder * .50 [indicated as part of FLUXKIT]…
Fluxnewsletter, December 2, 1968 (revised March 15, 1969).

FLUX-PRODUCTS 1961 TO 1970 …HI RED CENTER…Clinical record, folder ½ [$]…
Flux Fest Kit 2. [ca. December 1969].

RECORD OF FEATURES AND FEATS

NAME						kg.	cm.	mm.	cc.
PREFERRED NAME			STRENGTH	HAIR					
ADDRESS				FOREFINGER PUNCH					
BIRTH DATE & HOUR				FIST SLAM					
BIRTH PLACE				KICK					
PROFESSION OR TRADE			TARGET	MOUTH					
PREFERRED OCCUPATION				FINGER					
OTHER SKILLS				FOOT					
MEASUREMENTS	lbs.	gal.	cm.	cc.	EYESIGHT	BEYOND FOREHEAD			
WEIGHTS	BODY					BEYOND EAR			
	ONE FOOT OFF SCALE					SPOT			
	HEAD				CAPACITIES	SUCK: MAX.			
VOLUMES	BODY					SALIVA PRODUCTION IN 1 MIN.			
	HEAD					BETWEEN FINGERS IN RICE COUNT			
CAPACITIES MOUTH					DIMENSIONS	EXTENDED TONGUE			
	PALM					INFLATED CHEEKS: WIDTH			
DIMENSIONS HEIGHT						GRASP: MAX. DIAMETER			
	HEAD: MIN. DIAMETER					FOOT TO MOUTH: MIN.			
	MAX.DIAMETER					KICK HEIGHT: MAX.			
	NIPPLE TO NIPPLE					STEP: MAX.			
	FINGER TIP TO FINGER TIP: MAX.					MIN.			
	HAIR LENGTH: MAX					LEAN BACK TO FLOOR: MIN.			
	SHOE & FOOT DIFFERENCE					SWAY: MIN. IN 30 SEC.			
OUTLINE: $ 1					SIGN FOREWARD				
SAME SCALE BOX MODEL: $ 200									
QUARTER SCALE BOX MODEL: $ 70		TOE PRINT	KNUCKLE PRINT		SIGN BACKWARD				

POCKET OR HANDBAG CONTENTS		cm.

Hi Red Center. FLUXCLINIC RECORD OF FEATURES AND FEATS

Flash Art Editor, Giancarlo Politi, proposed to publish the 3rd Fluxyearbook, maybe to be called FLUX-PACK 3, with the following preliminary contents:… clinic chart by Hi Red Center, Watts & Maciunas
Fluxnewsletter, April 1973.

COMMENTS: Playing doctor is a favorite children's game. It permits the exploration of each other's body, and acts as a kind of surrogate catharsis against real doctors who hurt. In performance, Fluxus frequently took simple everyday activities, especially children's games, and manipulated them as metaphors for larger social and political views. The folder for Fluxclinic Record of Features and Feats was produced by Fluxus for use in Fluxclinic events starting in 1966, and was offered for sale as a separate item.

HI RED CENTER see:
BUNDLE OF EVENTS
HIGH RED CENTER MAGAZINE see:
KEISHO MAGAZINE

KEISHO MAGAZINE

23 KEISHO MAGAZINE HEIGH [sic] RED CENTER MAGAZINE edited by TATU IZUMI, AKASEGAWA, NAKANISHI, and others. (in japanese & english) ask for/information
European Mail-Orderhouse: europeanfluxshop, Pricelist. [ca. June 1964].

23 KEISHO - MAGAZINE HIGH RED CENTER MAGAZINE edited by TATU IZUMI, G. AKASEGAWA, N. NAKANISHI, J. TAKAHASHI and KAZAKURA in japanese and english ASK FOR FREE INFORMATION
Second Pricelist - European Mail-Orderhouse. [Fall 1964].

COMMENTS: Keisho Magazine was not published by Fluxus and was offered for sale only through the European Mail-Order Warehouse/Fluxshop.

PASSPORT see:
FLUXCLINIC RECORD OF FEATURES AND FEATS
also see:
Ken Friedman: FLUX-PASSPORT

SCORES see:
BUNDLE OF EVENTS

COMMENTS: Scores for "Hotel Event," "Street Cleaning Event" and "Street Car Event" by Hi Red Center appear in Fluxfest Sale [Winter 1966]. The score for a "clinic" by Hi Red Center, adapted by Fluxus, appears in Flux Fest Kit 2 [ca. December 1969].
see: COLLECTIVE

Dick Higgins, ca. 1962

DICK HIGGINS

It was announced in the tentative plans for the first issues of FLUXUS that Dick Higgins would contribute "Some Thoughts on Politics in Art" and an undetermined work to FLUXUS NO. 1 U.S. ISSUE. The contribution plans were later expanded to included "At Least Two Events for One or More Performers," and then "Inroads Rebuff'd" was added. As the plans progressed, "More danger music" was included, and Higgins was to edit "Visuals (collection of inserts)." Finally in the second version of the Brochure Prospectus for Fluxus Yearboxes, Higgins' contributions to FLUXUS NO. 1, U.S. YEARBOX were to be: "Some Thoughts on Politics in Art;" "Complete Danger musics;" "Constellations & Contributions;" "Stacked Deck (photographs);" "Some Aspects of Content & Ideation [sic] in Inroads Rebuff'd or the Disdainfull evacuation;" "Inroads Rebuff'd (text and photographs);" "The Tart or Miss America;" "Legend of the Antidancers;" "Collection of ready mades."

Higgins' contribution to FLUXUS NO. 4 HOMAGE TO THE DISTANT PAST was to be "Nonsence poetry of E. Lear" and for FLUXUS NO. 5 EAST EUROPEAN ISSUE, he or another author was to contribute "Lettrism since Isidore Isou (essay & anthology)." The Lettrism article was later dropped, and in the place of the Edward Lear article Higgins was to contribute "Tradition of experimental literature in English" to FLUXUS NO. 4 (later given the number 5).

Three scores by Higgins appear in Fluxus Preview Review: *"Danger Music No.28," "Yellow Piece"* and *"Bubble Music." "Inroads Rebuff'd"* and *"Yellow Piece"* along with a photograph appear in FLUXUS 1 (Silverman No. 117). Several scores and other pieces are published in Fluxus Newspaper No. 1, January 1964, and two scores appear in Flux Fest Kit 2. see: COLLECTIVE

FILM see:
INVOCATION OF CANYONS AND BOULDERS
LEGEND OF DARK CITY
FLIPBOOK see:
INVOCATION OF CANYONS AND BOULDERS
GENTLE JELLO see:
TASTELESS JELLO

INSTRUCTIONS & EVENTS

FLUXKIT containing following fluxus-publications: (also available separately)...FLUXUS jak DICK HIGGINS: Instructions & events 25¢
cc fiVe ThReE (Fluxus Newspaper No. 4) June 1964.

FLUXKIT containing...events & instructions of Dick Higgins
Second Pricelist - European Mail-Orderhouse. [Fall 1964].

COMMENTS: Instructions & Events *is a very vague title. A prolific artist, Higgins had composed hundreds of scores by June of 1964. George Maciunas planned to include a number of Higgins' pieces in* FLUXUS NO. 1 the U.S. ISSUE, *and was to publish* Jefferson's Birthday, *Higgins' complete scores from April 13th, 1962 to April 13th, 1963. Perhaps* Instructions & Events *were scores at hand, duplicated and sent out. Clearly at 25¢, it wasn't his "Collected" or "Complete Works."*

INVOCATION OF CANYONS AND BOULDERS
Silverman No. 170, ff.

FLUXKIT containing following fluxus-publications: (also available separately) FLUXUS jam DICK HIGGINS: "Invocation of Canyons & Boulders" 16mm color film loop, each loop different, boxed $6
cc fiVe ThReE (Fluxus Newspaper No. 4) June 1964.

"P.S. You could now easily make a FLUXUS film festival with 4 films:...Dick Higgins - mouth film- (we are sending you a loop of this) - it's eating motion of mouth in continuous loop - could play 30 minutes..."
Letter: George Maciunas to Ben Vautier, July 21, 1964.

FLUXKIT containing following fluxus-publications... Invocation of Canyons & Boulders 16mm color film loop, each loop different, boxed, of Dick Higgins...
Second Pricelist - European Mail-Orderhouse. [Fall 1964].

"...I asked Barbara Moore to send you...Dick Higgins film immediately (by Air Mail.) because I forgot to mail..."
Letter: George Maciunas to Ben Vautier, January 23, 1965.

"...I have asked Barbara Moore to send you 2 films... Dick Higgins film. Make loops from them and then you can show them for indefinite length. OK?..."
Letter: George Maciunas to Ben Vautier, February 1, 1965.

FLUXKIT containing following fluxus-publications: (also available separately)...FLUXUS JA DICK HIGGINS: "Invocation of Canyons & Boulders" 16mm color film loop, $6
Vacuum TRapEzoid (Fluxus Newspaper No. 5) March 1965.

PROPOSED FLUXSHOW FOR GALLERY 669 ... SOUND ENVIRONMENT (may be within film environment)...d. Requiem for Wagner by Dick Higgins played with eating mouth film loop.
Fluxnewsletter, December 2, 1968.

PROPOSED FLUXSHOW ALL OBJECTS LISTED

Dick Higgins. **INVOCATIONS OF CANYONS AND BOULDERS.** Three different Fluxus packagings

UNDER FLUX-PRODUCTS 1961 - 1969' PLUS:... SOUND ENVIRONMENT (may be simultaneously and within film environment) c. Requiem for Wagner by Dick Higgins (can be played with his eating mouth film loop).
Fluxnewsletter, December 2, 1968 (revised March 15, 1969).

FLUX-PRODUCTS 1961 TO 1969...DICK HIGGINS Invocation of Canyons and Boulders, 16mm color loop [$] 8
ibid.

FILM AND SOUND ENVIRONMENT...Requiem for Wagner (tape) by R.Higgins with his eating mouth film loop.
Flux Fest Kit 2. [ca. December 1969].

"...higgins, invocation I have, could send it to you..."
Letter: George Maciunas to Dr. Hanns Sohm, [ca. late 1972].

Flash Art Editor, Giancarlo Politi, proposed to publish the 3rd Fluxyearbook, maybe to be called FLUX-PACK 3, with the following preliminary contents:... flip books by...Dick Higgins, anyone else?
Fluxnewsletter, April 1973.

COMMENTS: *There are several different Fluxus packagings of Dick Higgins' film loop,* Invocation of Canyons and Boulders, *although none have a label specifically designed by Maciunas for the work. At some point, probably in the late 1960s, possibly as late as 1973, George Maciunas printed a sequence of stills to produce a flipbook which was to have been included in* Fluxpack 3 *although it is not in the completed copy in the Silverman Collection.*

JEFFERSON'S BIRTHDAY
Silverman No. 554

"...please type it (...before Higgins)..."
Letter: George Maciunas to Tomas Schmit, [between May 15 - 26, 1963].

FLUXUS 1964 EDITIONS:...FLUXUS j DICK HIGGINS: Jefferson's Birthday, $6 (works from April 1962 to April 1963)
Film Culture No. 30, Fall 1963.

Dick Higgins. **JEFFERSON'S BIRTHDAY.** Planned as a Fluxus project. the book was published by Something Else Press

FLUXUS 1964 EDITIONS:...FLUXUS j DICK HIG-GINS: Jefferson's Birthday, $6 (works from April 1962 to April 1963) Most materials originally intend-ed for Fluxus yearboxes will be included in the FLUXUSccV TRE newspaper or in individual boxes.
cc V TRE (Fluxus Newspaper No. 1) January 1964.

FLUXUS 1964 EDITIONS:...FLUXUS j DICK HIG-GINS: Jefferson's Birthday, $6 (works from April 1962 to April 1963)
cc V TRE (Fluxus Newspaper No. 2) February 1964.

FLUXUS 1964 EDITIONS, AVAILABLE NOW... FLUXUS j...[as above]
cc Valise e TRanglE (Fluxus Newspaper No. 3) March 1964.

F-j...[as above]
European Mail-Orderhouse: europeanfluxshop, Pricelist. [ca. June 1964].

[as above]
Second Pricelist - European Mail-Orderhouse. [Fall 1964].

COMMENTS: *George Maciunas planned to publish Higgins' Jefferson's Birthday as part of an ambitious program to pub-lish "complete" and "collected works" of several members of Fluxus, including Tomas Schmit, George Brecht, Nam June Paik, Robert Watts, Emmett Williams and Robert Filliou. Maciunas' production program, coupled with concerts, ill health and monetary problems delayed and defeated many projects. Finally, perhaps as a result of these delays, perhaps because of ideological or personality conflicts, Higgins took the project back. He designed and published it himself as the first title of his newly established Something Else Press, in 1964.*

LEGEND OF DARK CITY

FLUXUS SPECIAL EDITIONS 1963-4 FLUXUS p. DICK HIGGINS: Legend of Dark City (color film, 5555ft.) by special order $1500
Fluxus Preview Review, [ca. July] 1963.

[as above]
Daniel Spoerri, L'Optique Moderne. List on editorial page. 1963.

[as above]
La Monte Young, LY 1961. Advertisement page. [1963].

Fd-p DICK HIGGINS: "Legend of Dark City"... $1500
European Mail-Orderhouse: europeanfluxshop, Pricelist. [ca. June 1964].

COMMENTS: *Produced by the artist, Maciunas never sold any copies of* Legend of Dark City *through Fluxus, nor was it included in the* Fluxfilms *package.*

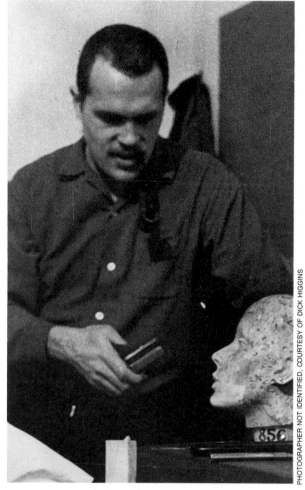

Dick Higgins, ca. 1962

REQUIEM FOR WAGNER THE CRIMINAL MAYOR

FLUXUS SPECIAL EDITIONS 1963-4 FLUXUS p. Requiem for Wagner the Criminal Mayor (tape, 5 7 inch reels) by special order $50
Fluxus Preview Review, [ca. July] 1963.

[as above]
Daniel Spoerri, L'Optique Moderne. List on editorial page. 1963.

[as above]
La Monte Young, LY 1961. Advertisement page. [1963].

Fd-p...[as above]
European Mail-Orderhouse: europeanfluxshop, Pricelist. [ca. June 1964].

Fd-P DICK HIGGINS Requiem for Wagner the crimi-nal mayor tape, 5 7 inch reels $50
Second Pricelist - European Mail-Orderhouse. [Fall 1964].

PROPOSED FLUXSHOW FOR GALLERY 669 ... SOUND ENVIRONMENT (may be within film envi-ronment)...d. Requiem for Wagner by Dick Higgins played with eating mouth film loop.
Fluxnewsletter, December 2, 1968,

PROPOSED FLUXSHOW ALL OBJECTS LISTED UNDER 'FLUX-PRODUCTS 1961-1969' PLUS: ... SOUND ENVIRONMENT (may be simultaneously and within film environment) c. Requiem for Wagner by Dick Higgins (can be played with his eating mouth film loop).
Fluxnewsletter, December 2, 1968 (revised March 15, 1969).

FILM AND SOUND ENVIRONMENT...Requiem for Wagner (tape) by R.Higgins with his eating mouth film loop.
Flux Fest Kit 2. [ca. December 1969].

COMMENTS: *The work was never produced by George Maciunas as a separate Fluxus Edition.*

SCORES see:
 INSTRUCTIONS & EVENTS
 JEFFERSON'S BIRTHDAY
 TO EVERYTHING ITS SEASON
TAPE RECORDING see:
 REQUIEM FOR WAGNER THE CRIMINAL
 MAYOR

TASTELESS JELLO

NEW YEAR EVE'S FLUX-FEAST, DEC. 31 1969 AT CINEMATHEQUE, 80 WOOSTER ST....Dick Higgins: gentle jello-tasteless jello (gelatin & water)...
Fluxnewsletter, January 8, 1970.

31.12.1969 NEW YEAR EVE'S FLUX - FEAST (FOOD EVENT)...Dick Higgins: tasteless jello
George Maciunas, Diagram of Historical Developments of Fluxus... [1973].

COMMENTS: *Evidently* Tasteless Jello *was made for the 1969 New Year Eve's Flux-Feast.*

TO EVERYTHING ITS SEASON
Silverman No. < 169.II

COMMENTS: *A blueprint negative, stamped with the Fluxus copyright, of page four of the work is in the Silverman Col-lection. It is not clear whether the first three pages contained other, unrelated works and formed a collection of Higgins, or they were the first parts of the score.*

SPENCER HOLST

It was announced in the Brochure Prospectus for Fluxus Year-boxes (versions A & B) that Spencer Holst would contribute "sections from 'The Hunger of the Magicians'" to FLUXUS NO. 1 U.S. YEARBOOK.
see: COLLECTIVE

DAVI DET HOMPSON see:
DAVID E. THOMPSON

MICHAEL HOROWITZ

It was announced in the Brochure Prospectus for Fluxus Year-boxes (version A) that Michael Horowitz would contribute a "compressed anthology of abstract & concrete sounds (Burroughs, Themerson, Hollo, Pete Brown, Horowitz, Tom Raworth, David Sladen, C. Cardew)" to FLUXUS NO. 6, ITALIAN, ENGLISH, AUSTRIAN YEARBOX.
see: COLLECTIVE

DIETER HÜLSMANNS

It was announced in the Brochure Prospectus for Fluxus Year-boxes (versions A & B) that Dieter Hülsmanns would contribute "La Sacrification S'Alanguit dans le centre" to FLUX-US NO. 2 (later called FLUXUS NO. 3) GERMAN & SCANDINAVIAN YEARBOX.
see: COLLECTIVE

Alice Hutchins. SELF PORTRAIT. 1966

Alice Hutchins. JEWELRY FLUXKIT. Mechanical for the label by George Maciunas

ALICE HUTCHINS

JEWELRY FLUXKIT
Silverman No. 175, ff.

FLUXPROJECTS FOR 1968 (In order of priority) 3. Boxed events & objects (all ready for production):... flux-jewelry kit by Alice Hutchins, ...
Fluxnewsletter, January 31, 1968.

FLUXPROJECTS FOR 1969 New boxes: Alice Hutchins - jewelry kit
Fluxnewsletter, December 2, 1968.

FLUX-PRODUCTS 1961 TO 1969...ALICE HUTCHINS Jewelry fluxkit, do-it-yourself kit containing springs, bolts, magnets, jingles etc. Apr. 1969 * [indicated as part of FLUXKIT] [$] 6
Fluxnewsletter, December 2, 1968 (revised March 15, 1969).

FLUX-PRODUCTS 1961 TO 1970 ... ALICE HUTCHINS Jewelry fluxkit, hardware parts [$] 6
Flux Fest Kit 2. [ca. December 1969].

...set of 1969-70 Flux-productions which consist of the following: 1969 -...Alice Hutchins: Jewelry Fluxkit
Fluxnewsletter, January 8, 1970.

FLUXUS-EDITIONEN...[Catalogue no.] 752 ALICE HUTCHINS: jewelry fluxkit, hardware parts
Happening & Fluxus. Koelnischer Kunstverein, 1970.

SPRING 1969...ALICE HUTCHINS: jewelry kit
George Maciunas, Diagram of Historical Developments of Fluxus... [1973].

ALICE HUTCHINS, Jewelry flux kit, $10
Flux Objects, Price List. May 1976.

COMMENTS: *Jewelry Fluxkit was usually distributed by Fluxus as an individual edition. In trying to establish it's date, Alice Hutchins pointed out its mention in Grace Glueck's June 16, 1968 review of Fluxus, reproduced in* Fluxus etc., Addenda I, p. 196, *where the work is discussed as a component of* Flux Year Box II *("B" copy Silverman No. > 126.I).*

SCOTT HYDE

THE KEY TO ART see:
Robert Filliou and Scott Hyde

TOSHI ICHIYANAGI

It was announced in the tentative plans for the first issues of FLUXUS that Toshi Ichiyanagi would contribute a work "to be determined" for FLUXUS NO. 3 JAPANESE YEARBOOK. In the Brochure Prospectus for Fluxus Yearboxes (version A), his contribution to FLUXUS NO. 4 JAPANESE YEARBOX was to be "new instrumental music (record);" "Musical happenings (record);" "Japanese Electronic music (essay & record);" and "The Gutai happenings."
see: COLLECTIVE

COMPLETE WORKS

In addition to Fluxus Year Boxes the following special editions [are] planned. These are editions of works by single composers, poets, artists or what you like...Tohi [sic] Ichiyanagi complete works (early 1963)
Fluxus Newsletter No. 4, fragment, [ca. October 1962].

FLUXUS SPECIAL EDITIONS 1963-4...FLUXUS t. TOSHI ICHIYANAGI: COMPLETE WORKS $?
Fluxus Preview Review, [ca. July] 1963.

COMMENTS: *Complete Works of Toshi Ichiyanagi was never published by Fluxus. There were copyright problems, Ichiyanagi was already committed to C.F. Peters, Publishers in New York and objected to Maciunas' publishing his works with the Fluxus copyright.*

IBM FOR MERCE CUNNINGHAM
Silverman No. > 176.101, ff.

Scores available by special order: Toshi Ichiyanagi: IBM for Merce Cunningham, one sheet, $0.30 ...
Fluxus,Preview Review, [ca. July] 1963.

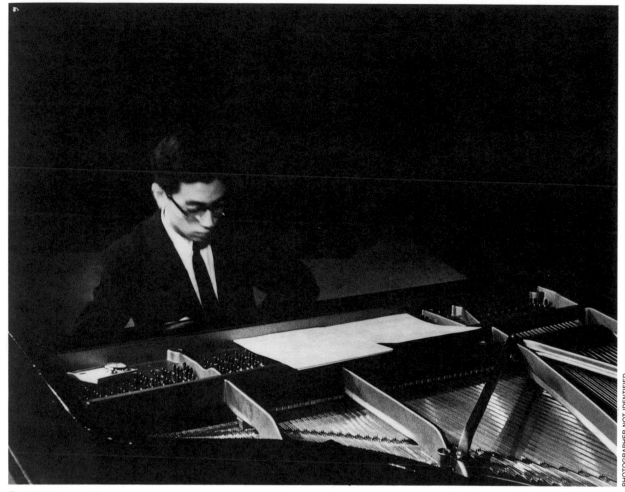

Toshi Ichiyanagi, 1961

PHOTOGRAPHER NOT IDENTIFIED

Toshi Ichiyanagi. IBM FOR MERCE CUNNINGHAM. Only the score is illustrated

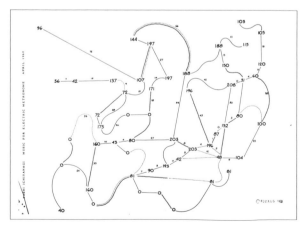

Toshi Ichiyanagi. MUSIC FOR ELECTRONIC METRONOME

P-2 TOSHI ICHIYANAGI...IBM for Merce Cunningham, one sheet 30¢
European Mail-Orderhouse: europeanfluxshop, Pricelist.
[ca. June 1964].

"...must eliminate his scores because he is handled now by Peters edition"
European Mail-Orderhouse: europeanfluxshop, Pricelist.
With holograph notes from George Maciunas to Willem de Ridder. [ca. Summer 1964].

COMMENTS: *The work is printed on two sheets: one, an instruction sheet shared with his instructions for* Music For Electronic Metronome, *and a score. Printed both blueprint positive and blueprint negative. The words ''© FLUXUS 1963'' appear only on the instruction sheet.*

MUSIC FOR ELECTRONIC METRONOME
Silverman No. > 176.102, ff.

Scores available by special order: Toshi Ichiyanagi:...
Music for Electronic Metronome, one sheet, $0.30...
Fluxus Preview Review, [ca. July] 1963.

P-2 TOSHI ICHIYANAGI...Music for Electronic Metronome 1 sheet 30¢...
European Mail-Orderhouse: europeanfluxshop, Pricelist.
[ca. June 1964].

"...must eliminate his scores because he is handled now by Peters edition"
European Mail-Orderhouse: europeanfluxshop, Pricelist.
With holograph notes from George Maciunas to Willem de Ridder. [ca. Summer 1964].

COMMENTS: *A large sheet of score, and an instruction sheet (printed on the same page as* IBM For Merce Cunningham). *Printed both ''blueprint negative'' and ''blueprint positive.''*

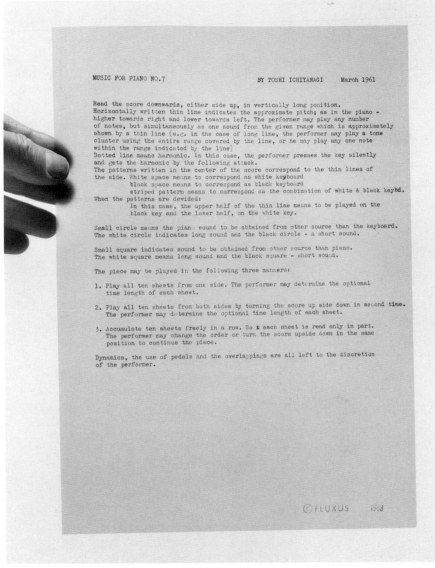

Toshi Ichiyanagi. MUSIC FOR PIANO NO. 7. Instructions

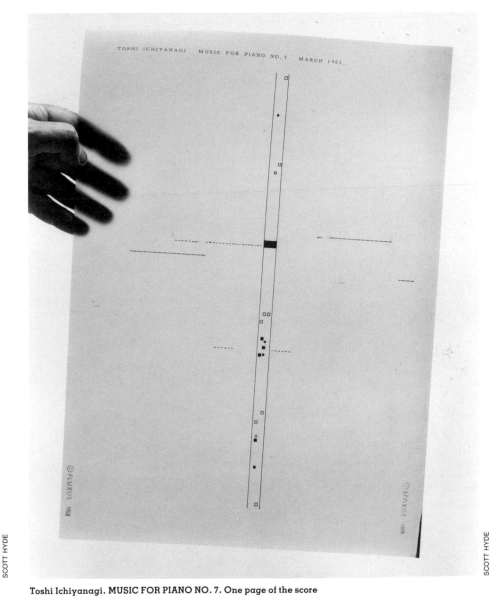

Toshi Ichiyanagi. MUSIC FOR PIANO NO. 7. One page of the score

The words "©FLUXUS 1963" on each sheet identify it as a Fluxus publication.

MUSIC FOR PIANO NO. 7
Silverman No. > 176.105, ff.

Scores available by special order: Toshi Ichiyanagi:... Music for piano no.7, 10 large sheets, $3.00
Fluxus Preview Review, [ca. July] 1963.

P-2 TOSHI ICHIYANAGI "Music for Piano no: 7 (10 large sheets) $3...

European Mail-Orderhouse: europeanfluxshop, Pricelist. [ca. June 1964].

"...must eliminate his scores because he is handled now by Peters edition"
European Mail-Orderhouse: europeanfluxshop, Pricelist. With holograph notes from George Maciunas to Willem de Ridder. [ca. Summer 1964].

COMMENTS: Ten large sheets of score and smaller instruction sheet. Each sheet is stamped with the words "©FLUXUS 1963." Both a "blueprint negative," and a "blueprint positive" exist.

PIANO PIECE NO. 4
Silverman No. > 176.103, ff.

P-2 TOSHI ICHIYANAGI...''Pianopiece no: 4 50¢...
European Mail-Orderhouse: europeanfluxshop, Pricelist. [ca. June 1964].

"...must eliminate his scores because he is handled now by Peters edition"
European Mail-Orderhouse: europeanfluxshop, Pricelist. With holograph notes from George Maciunas to Willem de Ridder. [ca. Summer 1964].

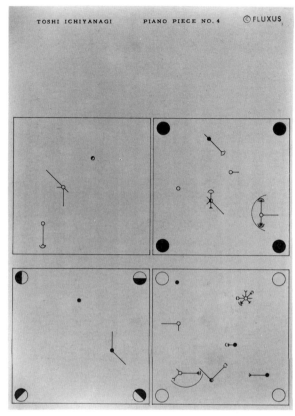

Toshi Ichiyanagi. PIANO PIECE NO. 4

COMMENTS: Printed on one sheet "blueprint negative" with the notice: "© FLUXUS." It is not known if a blueprint positive was made.

PIANO PIECE NO. 5

Silverman No. > 176.104, ff.

P-2 TOSHI ICHIYANAGI..."Pianopiece no: 5 50¢...
European Mail-Orderhouse: europeanfluxshop, Pricelist.
[ca. June 1964].

"...must eliminate his scores because he is handled now by Peters edition"
European Mail-Orderhouse: europeanfluxshop, Pricelist. With holograph notes from George Maciunas to Willem de Ridder. [ca. Summer 1964].

"...Enclosed: Ichiyanagi piano no 5 score, which you can give to Jeff since he may need it. The way we performed (with darts to back of upright piano). — we took a few lines (not all) — line indicates part of piano to be hit, (top or bottom or — number indicates middle), seconds or very slow count. from beginning, or 1 minute total. Ignore dynamic markings (ppp to fff)

since one can't throw darts in such dynamic range..."
Letter: George Maciunas to Ben Vautier, [ca. October 1966].

COMMENTS: Printed on one sheet, "blueprint negative." The words "© FLUXUS" identify it as a Fluxus publication. It's not known if a blueprint positive of the work exits.
 Ichiyanagi's score, "Piano Piece No. 5 (Fluxus variation for 'no performer') was published in Fluxus Preview Review. "Piano Piece No. 5 (Fluxversion II)" was published in Flux Fest Kit 2.

STANZAS FOR KENJI KOBAYASHI

Silverman No. > 176.106, ff.

Scores available by special order: Toshi Ichiyanagi:... Stanzas for Kenji Kobayashi, 6 large sheets, $2.00...
Fluxus Preview Review, [ca. July] 1963.

P-2 TOSHI ICHIYANAGI...Stanzas for Kenji Kobayashi 6 sheets $2
European Mail-Orderhouse: europeanfluxshop, Pricelist. [ca. June 1964].

"...must eliminate his scores because he is handled now by Peters edition"
European Mail-Orderhouse: europeanfluxshop, Pricelist. With holograph notes from George Maciunas to Willem de Ridder. [ca. Summer 1964].

COMMENTS: Six large sheets of scores and a smaller sheet of instructions, each sheet is marked "© FLUXUS 1963." Both a "blueprint negative" and a "blueprint positive" exist.

ISIDORE ISOU

It was announced in some of the tentative plans for the first issues of FLUXUS that Isidore Isou was being consulted for "Lettrism since Isou" for FLUXUS NO. 5 WEST EUROPEAN YEARBOOK II.
see: COLLECTIVE

TATU IZUMI

An "EVENTS" form by Tatu Izumi appears in Fluxus Newspaper No. 1, January 1964.
see: COLLECTIVE

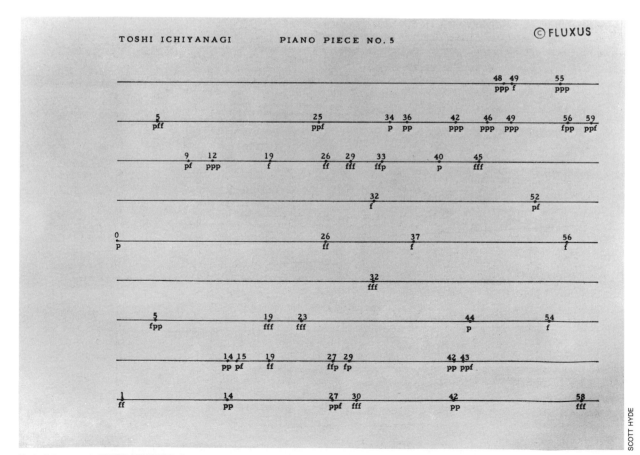

Toshi Ichiyanagi. PIANO PIECE NO. 5

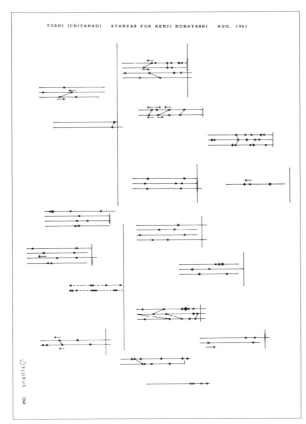

TOSHI ICHIYANAGI STANZAS FOR KENJI KOBAYASHI AUG. 1961

Toshi Ichiyanagi. STANZAS FOR KENJI KOBAYASHI. A part of the score

J

JOERN JANSSEN

It was announced in the tentative plans for the first issues of FLUXUS that Joern Janssen would contribute a work "to be determined" and later identified as an "Anthology of possible architectural critique" for FLUXUS NO. 2 WEST EURO- PEAN YEARBOOK I (later called FLUXUS NO. 3 GERMAN & SCANDINAVIAN YEARBOX).

TERRY JENNINGS

STRING QUARTET

Silverman No. > 176.201, ff.

Scores available by special order:...Also available are scores of works by...Terry Jennings
Fluxus Preview Review, [ca. July] 1963.

COMMENTS: String Quartet *was never advertised by Fluxus as*

an individual work. It is the only score by Jennings I have seen with a Fluxus copyright. One must assume that String Quartet *is the work referred to in* Fluxus Preview Review.

It was announced in the Brochure Prospectus for Fluxus Yearboxes (versions A & B) that Terry Jennings would con- tribute "poems" to FLUXUS NO. 1 U.S. YEARBOX.

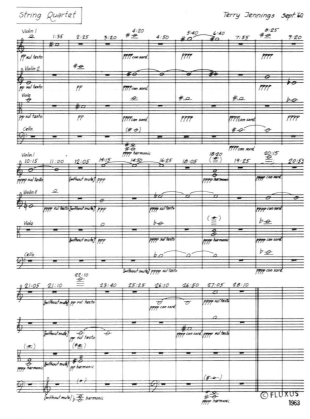

Terry Jennings. STRING QUARTET

DENNIS JOHNSON

It was announced in the Brochure Prospectus for Fluxus Year- boxes (version A & B) that Dennis Johnson would contribute "Items, [a] score, and scraps" to FLUXUS NO. 1 U.S. YEARBOX.

RAY JOHNSON

"Poem for George Brecht's Dog" by Ray Johnson appears in Fluxus Newspaper No. 2, February 1964.

JOE JONES

AEROPHONE see:
George Maciunas

AUTOMATIC DUET

"...I have asked Greg Sharits at Boulder Colo. to send you Joe Jones duet (bells & violin) to you after he is through with it. It is good to use them as sound back- ground with Fluxfilms. You should get them early December..."
Letter: George Maciunas to Ken Friedman, November 14, 1966.

"...Here is diagram of instruments. Tune 2 strings to same note as 2 bells. ring through hole in bar. adjust violin and motor position and length of propeller so it will hit 2 strings very lightly. Always use half voltage for these instruments use special plug. Later I will ship 2 aerophones (same 2 notes) so you can play 2 together. If you sell these instruments, they should go for $40 each. Try to fix violin if possible, it not, let me know and I will send another..."
Letter: George Maciunas to Ken Friedman, February 28, 1967.

COMMENTS: *The duets referred to above use the violin and bells, however, there were many possible combinations of Joe Jones' automatic instruments. In a conversation with Gilbert Silverman, Jones stated that his electrically powered instru- ments were constructed by George Maciunas. Afraid that people would trip over the wires, Jones constructed his using batteries. I think it is probable that Jones did use electricity for some of his early instruments.*

AUTOMATIC FLUXORCHESTRA see:
MECHANICAL FLUXORCHESTRA
AUTOMATIC INSTRUMENTS see:
AUTOMATIC DUET
AUTOMATIC QUARTET
AUTOMATIC TRIO
ELECTRIC MUSIC MACHINE
FLUXHARPSICHORD
MECHANICAL BELL
MECHANICAL CONTRABASS
MECHANICAL DRUM
MECHANICAL FLUXORCHESTRA
MECHANICAL GUITAR
MECHANICAL INSTRUMENTS
MECHANICAL VIOLIN
MUSICAL TRICYCLE
VIOLIN IN BIRD CAGE

AUTOMATIC QUARTET

"...I will ship in 2 days (March 9) [sic] directly to Appolinaire Joe Jones orchestra section of 4 instru- ments (2 violins, aerophone, bells)..."
Letter:, George Maciunas to Ben Vautier, March 5, 1966.

"...I will ship a crate to you with most large Fluxus items such as Joe Jones 4 automatic instruments

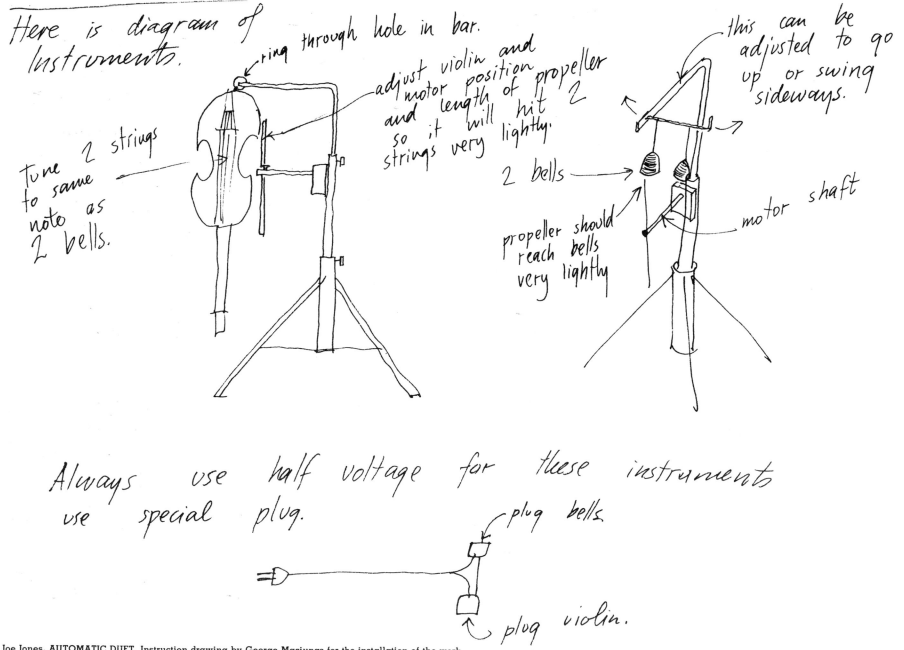

Here is diagram of instruments.

ring through hole in bar.

Tune 2 strings to same note as 2 bells.

adjust violin and motor position and length of propeller so it will hit 2 strings very lightly.

this can be adjusted to go up or swing sideways.

2 bells →

propeller should reach bells very lightly

motor shaft

Always use half voltage for these instruments use special plug.

plug bells

plug violin.

Joe Jones. AUTOMATIC DUET. Instruction drawing by George Maciunas for the installation of the work

(from flux orchestra)...etc. etc. — about 200 lbs. of goodies, so you can have a kind of fluxshop..."
Letter: *George Maciunas to Ben Vautier, May 19, 1966.*

"...Next month we will be able to ship to you more items: Joe Jones automatic quartet..."

Letter: *George Maciunas to Milan Knizak, January 31, 1967.*
"...Here is diagram of instruments. Tune 2 strings to same note as 2 bells. ring through hole in bar. adjust violin and motor position and length of propeller so it will hit 2 strings very lightly. Always use half voltage for these instruments use special plug. Later I will

ship 2 aerophones (same 2 notes) so you can play 4 together. If you sell these instruments, they should go for $40 each. Try to fix violin if possible, if not, let me know and I will send another..."

Letter: *George Maciunas to Ken Friedman, February 28, 1967.*

PROPOSED FLUXSHOW FOR GALLERY 669 ... SOUND MACHINES...Flux-quartet by Joe Jones: 4 automatically playing instruments (violins, duck call, bells, 2 reeds)
Fluxnewsletter, December 2, 1968.

"...Now I will list some new items produced: all in 1972...Some new instruments for Joe Jones Quartet, my contribution (aerophones) one rather funny $100..."
Letter: George Maciunas to Dr. Hanns Sohm, [ca. late 1972].

COMMENTS: *The aerophones in this Fluxus work are by George Maciunas. He constructed other instruments as well for Joe Jones.*

AUTOMATIC TRIO

FLUX SHOW: DICE GAME ENVIRONMENT EN-TIRE FLOOR AS DICE HAZARD TABLE DIE CUBES, 15" CUBES ON FLOOR, Marked on sides, top open or closed with clear plastic. Consisting or containing...Flux trio by Joe Jones
Flux Fest Kit 2. [ca December 1969].

Toilet No. 3, Joe Jones...Doors - display on interior side of door...Wind-up movements. * Electric String trio on side wall of stall. switched on when flushed*
Fluxnewsletter, April 1973.

Toilet No. 3, Joe Jones...Toilet flushing...activates electric string trio.
ibid.

FLUX AMUSEMENT ARCADE...Joe Jones auto-matic trio with Maciunas aerophone (coin activated)
Preliminary Proposal for a Flux Exhibit at Rene Block Gallery. [ca. 1974].

COMMENTS: Automatic Trio *is a permutation of mechanical instruments which could be enlarged to a full* Fluxorchestra *or diminished to solo or duet instruments, depending on the occasion or a purchaser's pocketbook. A trio was not a set group of instruments, for instance, it might consist of an electric string trio, or a violin, bells and an aerophone.*

ATTACHE CASE see:
 ELECTRIC MUSIC MACHINE
 FLUXMUSIC

BELL see:
 AUTOMATIC DUET
 AUTOMATIC QUARTET
 MECHANICAL BELL
 MECHANICAL FLUXORCHESTRA
 MUSICAL DRUM
 TWO WORMS CHASING EACH OTHER

BIRD CAGE see:
 VIOLIN IN BIRD CAGE

Joe Jones. ca. 1976

ROBERT WATTS

CASH REGISTER

"...I got an antique cash register, which we could connect to various events. i.e. each key (there are 100 keys) would be electrically connected to some event, like snow falling, lights off, sounds, visual events, etc. etc. smells, think of something and let me know, we are making this cash register a collective piece (like medieval cathedrals) Up to now we got...Joe Jones... with ideas for cash register. Another 50 keys left - unused...."
Letter: George Maciunas to Ben Vautier, March 29, 1966.

COMMENTS: *One has images of the "Phantom of the Opera," a crazed man pushing the keys and pulling the stops while all*

Joe Jones. "Fluxmusicmachines." A design by George Maciunas for an unused label

sorts of fantastic things happen. Unfortunately, Cash Register *was never completed, so Joe Jones' contribution to it was never made.*

CHAIR

...Individuals in Europe, the U.S., and Japan have discovered each other's work...and have grown objects and events which are original, and often uncategorizable in a strange new way:...Brooklyn Joe Jones' chair, switchboards on the arms. Lower the white translucent hat over your head, and flip the switches. Lights here and there, and sounds from peripheral radios on, off, news, static, twist music, commercials...
George Brecht, "Something About Fluxus," ccfiVe ThReE, (Fluxus Newspaper No. 4) June 1964.

COMMENTS: Joe Jones' Chair was made by the artist for an event, and was never offered for sale as a Fluxus work.

CONTRABASS see:
MECHANICAL CONTRABASS

CONTROL BOXES

...items are in stock, delivery within 2 weeks...JOE JONES: FLUXUS m4
control boxes
for 3 instruments $20
for 6 instruments $30
for 12 instruments $40

for 24 instruments $70
Vaseline sTREet (Fluxus Newspaper No. 8) May 1966.

COMMENTS: Control Boxes were offered for sale by Fluxus to be used with Joe Jones' automatic instruments. Many works by Jones have individual switches and set patterns for the motors, so they wouldn't require control boxes.

$ BILL TOILET PAPER

Toilet No. 3, JOE JONES...Toilet paper...$ bills*
Fluxnewsletter, April 1973.

COMMENTS: George Maciunas' plans for the Flux Toilet, *which can be seen in its entirety in the Collective section of this book, seem to assign certain necessary works to an artist that don't appear to have much relationship to other works they have done. Perhaps Maciunas asked Joe Jones, "What kind of toilet paper do you want?" and he replied "Dollar Bills." I think it is more likely that Maciunas took the idea from his own packaging of Jane Knizak's Fluxus Edition,* Flux Papers, *which has dollar bill toilet paper, along with sheets of other types of toilet paper. Robert Watts has also used fake dollar bills in his* Chest of $.

DOOR see:
HINGE ON TOP DOOR
DOVE see:
MECHANICAL DOVE
DRUM see:
MUSICAL DRUM
MECHANICAL DRUM
DUCK CALL see:
AUTOMATIC QUARTET
MECHANICAL FLUXORCHESTRA
DUET see:
AUTOMATIC DUET
ELECTRIC MOTORS see:
ELECTRIC MUSIC MACHINE

ELECTRIC MUSIC MACHINE

"...I will soon mail you a mechanical Flux-music box, Let me know if we can send you one with electrical motors 115 volts. What voltage is in France, I forget now. 220 v or 110??..."
Letter: George Maciunas to Ben Vautier, [ca. June 1965].

MUSIC MACHINES...FLUXUS me JOE JONES: MUSIC MACHINES...FLUXUS mu with 12 electric motors $160
Vacuum TRapEzoid (Fluxus Newspaper No. 5) March 1965.

FLUX-PRODUCTS 1961 TO 1969...JOE JONES... 12 music movements in attache case, 110v electric motors [$] 150
Fluxnewsletter, December 2, 1968 (revised March 15, 1969).

FLUX-PRODUCTS 1961 TO 1970...JOE JONES... 12 music movements, elec. in at. case [$] 150
Flux Fest Kit 2. [ca. December 1969].

03.1965...JOE JONES: music machines.
George Maciunas, Diagram of Historical Developments of Fluxus... [1973].

COMMENTS: Electric Music Machine is conceptually similar to Fluxmusic, *12 music movements contained in a display box or attache case, but the elements would be automatic, and the sounds more constant and regulated.*

ELECTRIC STRING TRIO see:
AUTOMATIC TRIO
ENVIRONMENT see:
MUSICAL ENVIRONMENT
FAUCET see:
UPWARD TURNED FAUCET

A FAVORITE SONG

Components of Silverman No. 117, ff. and No. 180

FLUXKIT containing following fluxus-publications: (also available separately)...FLUXUS mx JOE JONES: mechanical music box titled: "my favorite song" (not sold separately).
cc fiVe ThReE (Fluxus Newspaper No. 4) June 1964.

FLUXKIT containing following flux-publications... mechanical music box titled: "my favorite song" of Joe Jones...
Second Pricelist - European Mail-Orderhouse. [Fall 1964].

Joe Jones. A FAVORITE SONG. One example from FLUXKIT, left. Two from FLUXUS 1s, incorporating used ribbon from a scoring typewriter, on right

"The Joe Jones motors: for Fluxkit. If you give kits to Barbara, I can have them fixed, since she comes about once a week to my place, she can bring them over. I would replace motors with new ones. Are they mechanical or electric? I can't recall which version you have because present kits are slightly different."
Letter: George Maciunas to Dick Higgins, [ca. 1966].

COMMENTS: *A Favorite Song is really two distinctly different works, related only by their use of randomness. The first* A Favorite Song *is a scramble of used music typewriter ribbon, shoved into a manila envelope, titled and collated into* Fluxus 1. *The second work is a transitor radio built into some examples of* Fluxkit: *when a push button is pressed whatever song happens to be playing on the radio at the time is played. Neither work was offered for sale separately.*

FILM see:
 SMOKING
FLUTE see:
 MECHANICAL FLUXORCHESTRA

FLUXHARPSICHORD
Silverman No. 194

FLUX HARPSICHORD RECITAL...Fluxharpsichord 1975 by Joe Jones (constructed by G. Maciunas)
Fluxnewsletter, May 3, 1975.

COMMENTS: *Fluxharpsichord is a full sized harpsichord, constructed from a kit by Takako Saito, painted white and used by several artists for the Flux Harpsichord concert in New York in 1975. For Joe Jones' "Piece" in the concert, George Maciunas suspended a number of motors with beaters attached to play the harpsichord automatically, similar to the method of activating other Jones instruments. This prepared work has been preserved as Joe Jones* Fluxharpsichord.

FLUXMUSIC
Silverman No. > 184.I

MUSIC MACHINES...FLUXUS me JOE JONES: MUSIC MACHINES FLUXUS me with 12 spring motors $100
Vacuum TRapEzoid (Fluxus Newspaper No. 5) March 1965.

"...I will ship in 2 days (March 9) [sic] directly to Appolinaire...Joe Jones music box...."
Letter: George Maciunas to Ben Vautier, March 5, 1966.

"...I will ship a crate to you with most large Fluxus items such as Joe Jones...kit...etc. - about 200 lbs. of goodies, so you can have a kind of fluxshop..."
Letter: George Maciunas to Ben Vautier, May 19, 1966.

... items are in stock, delivery within 2 weeks ...
FLUXUS me: JOE JONES: music box in suitcase $80
Vaseline sTREet (Fluxus Newspaper No. 8) May 1966.

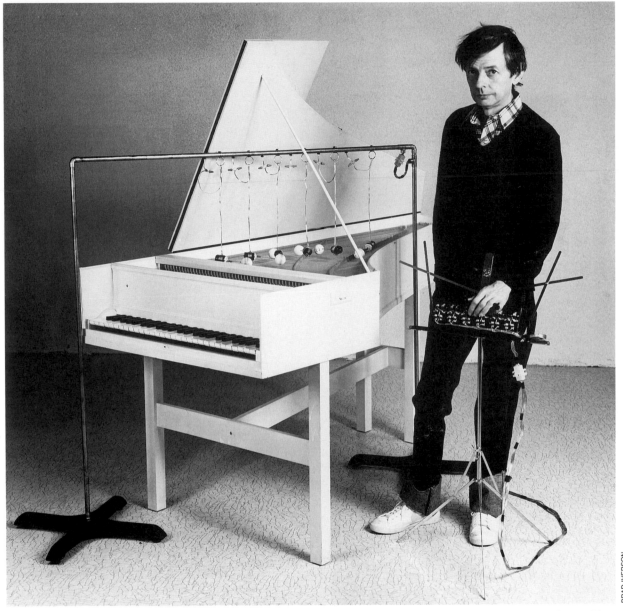

BRAD IVERSON

Joe Jones with the original **FLUXHARPSICHORD** he restored in 1981, switching the power from electricity to a battery operated control box, and changing the beaters to ping-pong balls

PROPOSED FLUXSHOW FOR GALLERY 669 ... SOUND MACHINES...Flux-music-box by Joe Jones: 10 simultaneously playing music movements...
Fluxnewsletter, December 2, 1968.

FLUX-PRODUCTS 1961 TO 1969...JOE JONES... 12 spring noise makers, in attache case [$] 100...
Fluxnewsletter, December 2, 1968 (revised March 15, 1969).

PROPOSED FLUXSHOW ... SOUND ENVIRONMENT (may be played simultaneously and within film environment)...music box with 10 simultaneously playing music movements - by Joe Jones
ibid.

FLUX SHOW: DICE GAME ENVIRONMENT ENTIRE FLOOR AS DICE HAZARD TABLE DIE

Joe Jones. Unused design by George Maciunas for the label of FLUX MUSIC BOX

CUBES, 15″ CUBES ON FLOOR, Marked on sides, top open or closed with clear plastic. Consisting or containing...mechanical sound box by Joe Jones. *Flux Fest Kit 2. [ca. December 1969].*

FLUX-PRODUCTS 1961 TO 1970...JOE JONES... 12 spring noise makers, in attache case [$] 100... *ibid.*

FLUXUS-EDITIONEN...[Catalogue no.] 750 JOE JONES: 12 spring noise makers (koffer) fluxmusic *Happening & Fluxus. Koelnischer Kunstverein, 1970.*

03.1965...JOE JONES: music machines *George Maciunas, Diagram of Historical Developments of Fluxus... [1973].*

COMMENTS: Fluxmusic *is related to both* Electric Music Machine *and* Flux Music Box *in the use of hidden musical elements activated either by electricity or manually, with wind-up keys. The title,* Fluxmusic *appears on the attache case in one version of the work, and uses manually activated elements with clicking and clacking sounds.*

FLUX MUSIC BOX
Silverman No. 182, ff.

FLUXKIT containing following fluxus-publications: (also available separately)...FLUXUS mx JOE JONES: mechanical music box $6
Vacuum TRapEzoid (Fluxus Newspaper No. 5) March 1965.

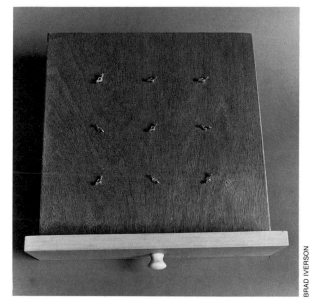

Joe Jones. FLUXMUSIC contained in FLUX CABINET

FLUXKIT containing following fluxus-publications: (also available separately)...FLUXUS mx JOE JONES: mechanical music box $8
Vaseline sTREet (Fluxus Newspaper No. 8) May 1966.

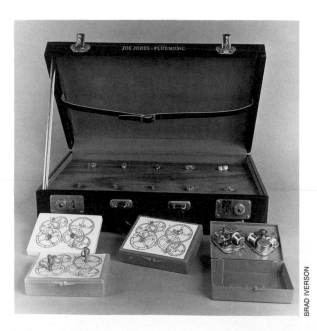

Joe Jones. FLUXMUSIC and four examples of FLUX MUSIC BOXES

"...By post you will be getting Joe Jones flux music kit..."
Letter: George Maciunas to Ken Friedman, February 28, 1967.

"...You still must have a quantity of original Fluxkit, Flag, music box, etc. consignment. Since you paid about $10 for them, I assumed the rest was unsold. That's why I was in no hurry to ship to you next consignment, You still must have $100 worth of stuff. No?..."
Letter: George Maciunas to Ken Friedman, [ca. February 1967].

PAST FLUX-PROJECTS (realized in 1966)...Flux-music box by Joe Jones
Fluxnewsletter, March 8, 1967.

flux musicbox $7 by joe jones
Fluxshopnews. [Spring 1967].

PROPOSED FLUXSHOW FOR GALLERY 669 ... SOUND MACHINES...Flux-music-box by Joe Jones: wind-up noise making machine...
Fluxnewsletter, December 2, 1968.

FLUX-PRODUCTS 1961 TO 1969 ... JOE JONES Music box & mechanical event * [indicated as part of FLUXKIT] ...
Fluxnewsletter, December 2, 1968 (revised March 15, 1969).

FLUX-PRODUCTS 1961 TO 1970 ... JOE JONES Music box, 2 fragmented tunes [$] 8...
Flux Fest Kit 2. [ca. December 1969].

FLUXUS-EDITIONEN...[Catalogue No.] 749 JOE JONES: music box, 2 fragmented tunes
Happening & Fluxus. Koelnischer Kunstverein, 1970.

JOE JONES Music box, 2 fragmented tunes $14...
Flux Objects, Price List. May 1976.

COMMENTS: Flux Music Box *is a manually activated work containing two altered music box mechanisms which produce the dissonant sounds of "two fragmented tunes." The versions offered for sale by Fluxus were constructed by George Maciunas. Another Jones music box,* Tonal Studies *is an early variant of this idea of fragmentation. Two larger works,* Fluxmusic *and* Electric Music Machine, *incorporate some of these elements also.*

FLUXORCHESTRA see:
MECHANICAL FLUXORCHESTRA
FLUX-QUARTET see:
AUTOMATIC QUARTET
FLUX-TOILET see:
AUTOMATIC TRIO

$ BILL TOILET PAPER
FRAGILE PAPER TOWELS
HINGE ON TOP DOOR
HOT SEAT TOILET SEAT
MEDICINE CABINET
UPWARD TURNED FAUCET

FLUX-TRIO see:
AUTOMATIC TRIO

FOUR AUTOMATIC INSTRUMENTS see:
AUTOMATIC QUARTET

FRAGILE PAPER TOWELS

Toilet No. 3, Joe Jones...Paper towels...fragile
Fluxnewsletter, April 1973.

COMMENTS: *This work seems to be a Maciunas idea applied to Jones. It was never made, but has to do with a Fluxus idea of rendering the useful into the functionless.*

GONG see:
MECHANICAL FLUXORCHESTRA

GRINDER MUSIC BOX see:
MUSIC BOX GRINDER

GUITAR see:
MECHANICAL GUITAR

HARPSICHORD see:
FLUXHARPSICHORD

HAT see:
CHAIR
RADIO HAT

HINGE ON TOP DOOR

Toilet No. 3, Joe Jones...Doors - method of opening ...hinge on top.
Fluxnewsletter, April 1973.

COMMENTS: *Hinge on Top Door is a variant of door hinging systems in the Flux-Toilet and Flux Labyrinth. I think it is probable that George Maciunas thought of putting the hinges on top of the door, and just assigned it to Joe Jones as one of his works.*

HORN see:
MECHANICAL FLUXORCHESTRA

HOT SEAT TOILET SEAT

Toilet No. 3, Joe Jones...Toilet seat...Hot- with electric coil inside seat.
Fluxnewsletter, April 1973.

COMMENTS: *Hot Seat Toilet Seat, although never made, was to have been heated with an electric coil inside. It is a variation of the anonymous* Hot Toilet Seat *heated with hot water.*

INSTRUMENT MACHINE see:
MECHANICAL INSTRUMENT
INSTRUMENT ON STAND see:
MECHANICAL INSTRUMENT
LABYRINTH see:
MUSICAL DRUM
LENNON see:
MUSICAL PORTRAIT OF JOHN LENNON

MECHANICAL AEROPHONE

COMMENTS: *In at least three entries for* Mechanical Aerophone: *in Fluxus Newspaper No. 8; Fluxnewsletter, December 2, 1968 (revised March 15, 1969); and Flux Fest Kit 2, Joe Jones is credited with the work. However, in a letter to Rene Block in 1976, George Maciunas states, "Generally Joe designed string and percussion instruments and I designed aerophones...."*
see: GEORGE MACIUNAS

MECHANICAL BELL

...items are in stock, delivery within 2 weeks. ...
FLUXUSm3 JOE JONES: mechanical bells $60
Vaseline sTREet (Fluxus Newspaper No. 8) May 1966.

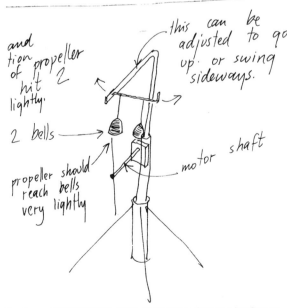

Joe Jones. MECHANICAL BELL. Instruction drawing by George Maciunas for the installation of the work

FLUX-PRODUCTS 1961 TO 1969...JOE JONES... Mechanical...bell...on musical stand, electric 110V motors, each [$] 80
Fluxnewsletter, December 2, 1968 (revised March 15, 1969).

FLUX-PRODUCTS 1961 TO 1970...JOE JONES... Mech....bell, on stand [$] 80
Flux Fest Kit 2. [ca. December 1969].

FLUX-PRODUCTS 1961 TO 1970...SOLO OBJECTS ...AND PUBLICATIONS...JOE JONES...Mech.... bell, on stand [$] 120
[Fluxus price list for a customer]. September 1975.

JOE JONES...Mechanical...bell, each: $100...
Flux Objects, Price List. May 1976.

COMMENTS: *Although offered for sale separately by Fluxus,* Mechanical Bell *was frequently used in combination with other Fluxus mechanical instruments of Joe Jones and George Maciunas,* Two Worms Chasing Each Other *activate a bell in* Flux-Kit *"C" (Silverman No. 122).*

MECHANICAL CONTRABASS

OTHER NEW FLUXUS ITEMS AVAILABLE IN FLUXSHOP OR BY MAIL ... FLUXUS mu JOE JONES: mechanical contrabass $95
cc fiVe ThReE (Fluxus Newspaper No. 4) June 1964.

F-mu... [as above]
Second Pricelist - European Mail-Orderhouse. [Fall 1964].

COMMENTS: *Mechanical Contrabass is not known to have been made by George Maciunas as a Fluxus Edition.*

MECHANICAL CONTROL BOXES see:
CONTROL BOXES

MECHANICAL DOVE

CANON...Major elevation - consecration of the Host ...giant bread positioned under suspended dove, dove move wing, sounds & releases mud.
Outline of Flux-Mass. [February 17, 1970].

FEB.17, 1970: FLUX-MASS BY GEORGE MACIUNAS...Consecration of the host: mechanical dove by Joe Jones flies over bread and releases mud over bread while This is my body is recited 4 times normal speed (recorded)...
all photographs copyright nineteen seVenty by peTer mooRE (Fluxus Newspaper No.9) 1970.

17.02.1970 FLUXMASS...CANON: giant plaster bread positioned under flying mechanical bird which releases mud over bread consecrating it.
George Maciunas, Diagram of Historical Developments of Fluxus... [1973].

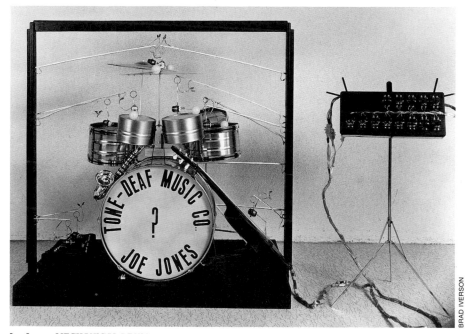

BRAD IVERSON

Joe Jones. MECHANICAL DRUM set and other instruments, with control box. Built by the artist in 1981

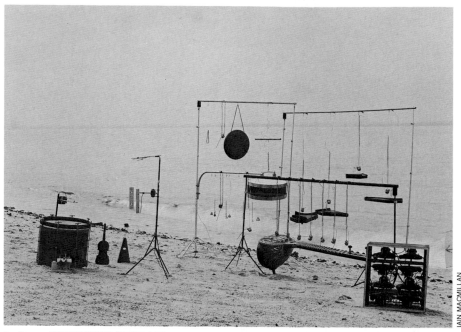

IAIN MACMILLAN

Joe Jones. MECHANICAL FLUXORCHESTRA. A photograph used on the record cover of FLY by Yoko Ono

COMMENTS: Mechanical Dove *was constructed by Joe Jones for use in the Flux Mass at Douglass College in 1970. There is a photograph by Peter Moore of Jones and his* Mechanical Dove *in Fluxus Newspaper No. 9.*

MECHANICAL DRUM

JOE JONES...Mechanical...drum,...each: $100...
Flux Objects, Price List. May 1976.

COMMENTS: Mechanical Drum *is apparently a later development of Joe Jones' automatic instruments. It first appeared in his orchestra constructed for Yoko Ono around 1970 and used on her album* Fly.

MECHANICAL EVENT see:
FLUX MUSIC BOX
MECHANICAL FLUX MUSIC BOX see:
ELECTRIC MUSIC MACHINE

MECHANICAL FLUXORCHESTRA

"...Joe Jones is building a whole mechanical orchestra for the 2nd part [of the concert] ..."
Letter: George Maciunas to Ben Vautier, [Summer 1965].

FROM FLUXORCHESTRA CONCERT AT CAR-NEGIE RECITAL HALL, 1965...Joe Jones: MECH-

ANICAL ORCHESTRA
3 newspaper eVenTs for the pRicE of $1 (Fluxus Newspaper No. 7) February 1, 1966.

"...This Fall, we...intend to visit Prague...We could bring with us many Fluxus objects including the whole automatic orchestra..."
Letter: George Maciunas to Milan Knizak, [January 1966].

"...Joe Jones automatic orchestra would never arrive in time, so we will use them on our Autumn Flux-fests..."
Letter: George Maciunas to Ben Vautier, March 29, 1966.

...items are in stock, delivery within 2 weeks ... FLUXUS m JOE JONES: mechanical fluxorchestra
Vaseline sTREet (Fluxus Newspaper No. 8) May 1966.

CONCERT NO. 5-MECHANICAL...Joe Jones: Automatic Fluxorchestra To be brought over.
Proposed Program for a Fluxfest in Prague. 1966.

FLUXFEST INFORMATION...Flux-concerts,...or entire fluxfests may be also arranged by the fluxus collective for a fee of $10 per performer per day ... Additional costs:...Joe Jones auto-orchestra rental charges are - $5 per instrument or $100 for entire orchestra of 25 instruments per evening....JOE JONES ...MECHANICAL ORCHESTRA Self playing, motor operated reeds, whistles, horns, violins, bells and gongs, all playing predeterminate, dynamically varia-

ble and continuous tone or tones for any length of time. Up to 24 instruments. See special rate schedule.
Fluxfest Sale. [Winter 1966].

OTHER NEWS:...FLUX-WEST center...San Francisco...FLUX-EAST CENTER [in Prague] ...Ben Vautier of course is the West European coordinator...will have stock of Flux-items...and parts of the automatic flux-orchestra.
Fluxnewsletter, March 8, 1967.

PROPOSED FLUXSHOW...SOUND ENVIRONMENT...automatically playing instruments: violin, bells, reeds flutes, duck call, gong, etc. - by Joe Jones.
Fluxnewsletter, December 2, 1968 (revised March 15, 1969).

FLUXFEST INFORMATION...Many fluxpieces are described and listed in the Expanded Arts issue of FILM CULTURE magazine. A reprint can be obtained for $1. Any of the fluxpieces can be performed anytime, anyplace and by anyone, without any payment to Fluxus provided the following conditions are met: 1. if fluxpieces outnumber numerically or exceed in duration other compositions in any concert, the whole concert must be called and advertised as FLUX-CONCERT or FLUXEVENT. A series of such events must be called a FLUXFEST. 2. if fluxpieces do not exceed non-fluxpieces, each such fluxpiece must be identified as a FLUXPIECE. Such credits to Fluxus

may be omitted at a cost of $50 for each piece announced or performed...flux-mechanical concerts & events...
ibid.

MECHANICAL FLUX-CONCERT...JOE JONES: AUTOMATIC FLUXORCHESTRA (may be played until everyone leaves)
Fluxfest at Stony Brook, Newsletter No. 1, August 18, 1969. version B

MUSICAL FLUX-CONCERT...JOE JONES: AUTOMATIC FLUXORCHESTRA May be played until audience leaves
Flux Fest Kit 2. [ca. December 1969].

COMMENTS: *The first* Mechanical Fluxorchestra *constructed in 1965, consisted of mechanized violins, bells and aerophones. By 1966, George Maciunas was announcing a mechanical* Fluxorchestra *with 25 instruments - conceivably such a large orchestra was assembled. However, usually a much smaller* Fluxorchestra *was either sold or used in a Fluxus concert or as background music for* Fluxfilms *screenings.*

MECHANICAL GUITAR

JOE JONES...Mechanical...guitar,...each: $100...
Flux Objects, Price List. May 1976.

COMMENTS: *In the mid 1970s George Maciunas was storing a number of works by Joe Jones from the Tone Deaf Music Co. including works from the "Erector Set" series: violins, guitars, etc. dating from 1968/69. Probably this* Mechanical Guitar *dates from that period.*

MECHANICAL INSTRUMENTS

"Inst. [instruments] on stand $20"
Letter: George Maciunas to Ken Friedman, [Spring 1967].

...This Fall, we shall publish V TRE no. 10, which shall consist of a plan for Flux-Amusement-Center, to contain...Joe Jones instrument machines
Fluxnewsletter, April 1973.

COMMENTS: *This is a general entry, unfortunately there is no way to tell which instruments are being referred to.*

MECHANICAL MUSIC BOX see:
MECHANICAL ORCHESTRA see:
MECHANICAL SOUND BOX see:

MECHANICAL VIOLIN

OTHER NEW FLUXUS ITEMS AVAILABLE IN FLUXSHOP OR BY MAIL ... FLUXUS mo JOE JONES mechanical violins $30 & up
cc fiVe ThReE (Fluxus Newspaper No. 4) June 1964.

F-mo...[as above]
Second Pricelist - European Mail-Orderhouse. [Fall 1964].

...items are in stock, delivery within 2 weeks...FLUX-

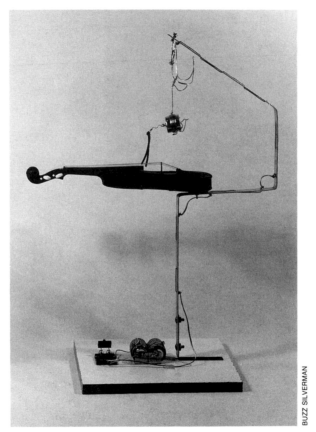

BUZZ SILVERMAN

Joe Jones. MECHANICAL VIOLIN. This example (Silverman No. 185) was constructed by the artist in 1968 and restored ten years later

mechanical violin by joe jones: $ 25

Joe Jones. MECHANICAL VIOLIN, for sale sign

USm1 JOE JONES: mechanical violin $60
Vaseline sTREet (Fluxus Newspaper No. 8) May 1966.

"I got hold of a few $ & shipped out by REA a package to you: with:...1 - Violin, without stand [to replace violin you had] ..."
Letter: George Maciunas to Ken Friedman, [ca. February 1967].

FLUX-PRODUCTS 1961 TO 1969...JOE JONES... Mechanical violin...on music stand, electric 110V motors, each [$] 80
Fluxnewsletter, December 2, 1968 (revised March 15, 1969).

FLUX-PRODUCTS 1961 TO 1970...JOE JONES... Mechanical violin, motorized, on stand [$] 80...
Flux Fest Kit 2. [ca. December 1969].

FLUX-PRODUCTS 1961 TO 1970...SOLO OBJECTS AND PUBLICATIONS...JOE JONES...Mechanical violin, motorized, on stand [$] 120
[Fluxus price list for a customer]. September 1975.

...JOE JONES...Mechanical violin,...each: $100...
Flux Objects, Price List. May 1976.

COMMENTS: *As well as being available for sale separately,* Mechanical Violin *was a standard element of the different combinations of Jones' automatic instruments. They were usually toy violins, sometimes painted black. Those activated by electricity were constructed by George Maciunas. Joe Jones used battery powered motors, and more recently he has been using solar power. There are several different stands used for these Fluxus instruments, including tripods, music stands, modular metal tubing, and later, bent metal yardsticks.*

MEDICINE CABINET

Toilet No. 3, Joe Jones...Medicine cabinet...* Foods Drinks napkins behind glass.
Fluxnewsletter, April 1973.

COMMENTS: *The sparse description of this unrealized piece, which was to have been part of the* Flux-Toilet, *makes it difficult to "read." It is possible that George Maciunas intended the cabinet in Joe Jones' toilet to contain John Chick's* Flux Food, *Per Kirkeby's* 4 Flux Drinks, *Shigeko Kubota's* Flux Napkins *or Ben Patterson's* Instruction No. 2. *On the other hand, the intent of the work might have been an unopenable medicine cabinet with normal provisions unobtainable behind glass.*

MUSIC BOX see:

MUSIC BOX GRINDER

MUSIC BOXES...FLUXUS mx JOE JONES: music box grinder with crank $100

Vacuum TRapEzoid (Fluxus Newspaper No. 5) March 1965.

COMMENTS: *Music Box Grinder was never produced by George Maciunas as a Fluxus Edition.*

MUSIC BOX IN SUITCASE see:
FLUXMUSIC
MUSIC BOX - TONAL STUDIES see:
TONAL STUDIES
MUSIC BOX, TWO FRAGMENTED TUNES
see: FLUX MUSIC BOX
MUSIC MACHINE see:
ELECTRIC MUSIC MACHINE
FLUXMUSIC
MUSIC MACHINE WITH 12 ELECTRIC
MOTORS see:
ELECTRIC MUSIC MACHINE
MUSIC MACHINE WITH 12 SPRING MO-
TORS see:
FLUXMUSIC

MUSICAL DRUM

Any proposals from participants should fit the maze format...Ideas should relate to passage through doors, steps, floor, obstacles, booths...walk inside 6ft drum with bells...

[George Maciunas] , Further Proposal for Flux-Maze at Rene Block Gallery, [ca. Fall 1974].

"Enclosed is the final plan of labyrinth...Next one enters the steel drum, about 2m diameter and 1m wide, welded from steel plate about 3mm thick. little bells and other noise makers should be attached on the inside near the perimeter not to be in the way of the person walking. The person would step inside and walk, making the drum roll forward. There should be rails on both walls to make this walk easier. The floor should be just enough inclined upward to allow the drum return to starting position by itself, but not too steep to make walk impossible."
Letter: George Maciunas to Rene Block, [ca. Summer 1976].

Joe Jones steel drum with bells attached walk inside drum up slight incline...drum passage need hand rails for incline use plywood rails cut at angle.
Instruction drawing for Fluxlabyrinth, Berlin. [ca. August 1976]. version A

"Rolling Drum: this was ordered at the time of my arrival. It will be about $850 and is 2 meters diameter: Also we get rails provided. We should only have to shim the rails. Delivery date is to be this Thursday, I

Visitors entering Joe Jones' MUSICAL DRUM, constructed for FLUX-LABYRINTH. Berlin, 1976

am told. I suggest a foam or spring buffer at the track's downhill end."
Notes: Larry Miller to George Maciunas concerning the Flux-labyrinth, Berlin, [ca. August 1976].

Instruction drawing by George Maciunas for the construction of Joe Jones' MUSICAL DRUM in FLUXLABYRINTH. Berlin, 1976

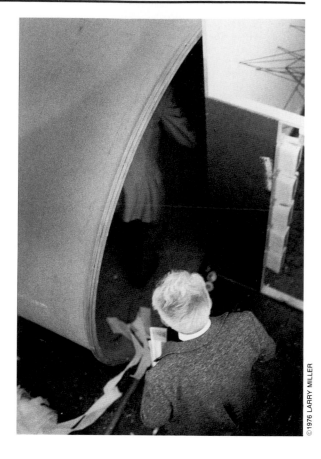

COMMENTS: *Musical Drum was constructed by George Maciunas, Larry Miller and others for the Fluxlabyrinth in Berlin in 1976. Miller described the work to me as consisting of a very large open wooden drum with "moo's" attached inside ("moo's" he explained, "are children's noise makers that are self activated and when turned upside down, make the sound of a cow or some other farm animal"). A participant would step inside and by walking forward, roll the drum up an incline, like a hamster's exercise wheel, and proceed through the labyrinth. The drum would then gently roll back to its original position. Conceptually, Musical Drum is similar to George Maciunas' Giant Wheel constructed in 1973 for the "Fluxgames" in New York City.*

MUSICAL ENVIRONMENT

EXHIBITS...AUGUST 6 & 7 AUDIENCE PARTICIPATION...Musical environment by Joe Jones played by audience
Proposal for Flux Fest at New Marlborough. April 8, 1977.

COMMENTS: *In the mid 1970s, George Maciunas moved from New York City to a rambling, once elegant horse farm*

he had bought in the Berkshires, 100 miles to the north. He had hopes of making a Fluxus center, where Fluxus artists would come to live and work for periods of time. Of course, the plans for the farm included festivals and exhibits. Musical Environment would have been constructed by Maciunas with numerous automatic instruments, or if Joe Jones could have managed to come from Europe where he was living, they both would have worked on the project.

MUSICAL PORTRAIT OF JOHN LENNON

FLUXFEST PRESENTATION OF JOHN LENNON & YOKO ONO+ MAY 23-29: PORTRAIT OF JOHN LENNON AS A YOUNG CLOUD BY YOKO ONO + EVERYPARTICIPANT A 6ft x 10ft wall of 100 drawers (containing more boxes), and doors, all empty except one with a microscope entitled: John's smile. Musical Portrait of John Lennon (by Joe Jones) when one of the doors is opened.
Fluxnewsletter, April 1973.

COMMENTS: Musical Portrait of John Lennon *was to be activated when one of one hundred drawers or doors of a wall size construction was opened. This cabinet was not built for the "Fluxfest presentation of John Lennon & Yoko Ono" in 1970. A similar cabinet was built by George Maciunas for Yoko Ono's one woman show, "This Is Not Here" at the Everson Museum in Syracuse, New York in 1971, but I don't recall Joe Jones' musical portrait being included in it.*

MUSICAL TRICYCLE

FLUX PARADE...By Joe Jones: Musical tricycle
Fluxfest at Stony Brook, Newsletter No. 1, August 18, 1969.
version B

[as above]
Flux Fest Kit 2. [ca. December 1969].

JOE JONES: musical tricycle
Flyer for Flux Game Fest. May 1973.

COMMENTS: Joe Jones constructed a "music bike" for Charlotte Moorman's "4th Annual New York Avant Garde Festival," in 1966, in Central Park, and performed with it throughout the festival. Over the years, he constructed several music bikes or tricycles.

MY FAVORITE SONG see:
A FAVORITE SONG
ORCHESTRA see:
MECHANICAL FLUXORCHESTRA
ORCHESTRA SECTION see:
AUTOMATIC QUARTET
PAPER TOWELS see:
FRAGILE PAPER TOWELS
PORTRAIT OF JOHN LENNON see:
MUSICAL PORTRAIT OF JOHN LENNON

QUARTET see:
AUTOMATIC QUARTET
RADIO see:
CHAIR
RADIO FOR THE DEAF
RADIO HAT
WIND RADIO

RADIO FOR THE DEAF
Silverman No. 178

OTHER NEW FLUXUS ITEMS AVAILABLE IN FLUXSHOP OR BY MAIL...FLUXUS me JOE JONES: radios for the deaf $2
cc fiVe ThReE (Fluxus Newspaper No. 4) June 1964.

F-me...[as above]
Second Pricelist - European Mail-Orderhouse. [Fall 1964].

COMMENTS: Radio for the Deaf *is the casing of a transistor radio. The innards of these same radios were used for the Fluxus Edition of* Wind Radio.

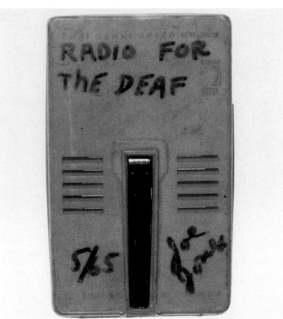

Joe Jones. RADIO FOR THE DEAF

BUZZ SILVERMAN

RADIO HAT

OTHER NEW FLUXUS ITEMS AVAILABLE IN FLUXSHOP OR BY MAIL ... FLUXUS mi JOE JONES: radio hats $40 to $90
cc fiVe ThReE (Fluxus Newspaper No. 4) June 1964.

F-mi... [as above]
Second Pricelist - European Mail-Orderhouse. [Fall 1964].

...bathingsuits are going to be shown on the special fluxus fashion-shows next winter together with: ... Hats of Joe Jones...
European Mail-Orderhouse, advertisement for clothes, [ca. 1964].

NEW!...FLUXUS mi JOE JONES: radio hats $30 to $80
Vacuum TRapEzoid (Fluxus Newspaper No. 5) March 1965.

COMMENTS: A photograph of Joe Jones wearing a mechanical hat, along with editorial comment, appears in Fluxus Newspaper No. 2, February 1964. Radio Hats offered for sale through Fluxus would have been made by the artist.

REED INSTRUMENTS see:
AUTOMATIC QUARTET
MECHANICAL FLUXORCHESTRA

SCORES

COMMENTS: Two scores by Joe Jones, "Duet for Brass Instruments" and "Dog Symphony" were published in Fluxfest Sale, 1966, and a variation of one of these appears in Flux Fest Kit 2, 1969.

SMOKE see:
SMOKING

SMOKING
Silverman No. < 185.1

"...Regarding film festival. — I will send you the following: You will get these end of April...Smoking by Joe Jones. - 20 min...They and another 6 films make up the whole 2 hour Fluxfilm program....Incidentally, loops from these films will go into Fluxus II Yearboxes, Everything is ready, but I got short on $ & can't produce these boxes in quantity, since making film copies is rather expensive....Fluxfilm program was shown at Ann Arbor film fest & won a critics award"
Letter: George Maciunas to Ben Vautier, March 29, 1966.

FLUXFILMS...FLUXFILM 18 JOE JONES: smoking, 15 min $60
Vaseline sTREet (Fluxus Newspaper No. 8) May 1966.

FLUXFILMS SHORT VERSION, 40 MIN AT 24 FRAMES/SEC. 1400 FT....[flux-number] 18 SMOKE 6' High-speed camera, 2000 fr/sec. sequence of cigarette smoke.
Fluxfilms catalogue. [ca. 1966].

PAST FLUX-PROJECTS (realized in 1966...Fluxfilms: total package: 1 hr.40min....smoke by Joe Jones
Fluxnewsletter, March 8, 1967.

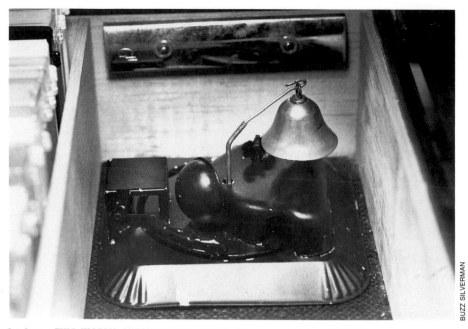

BUZZ SILVERMAN

Joe Jones. **TWO WORMS CHASING EACH OTHER.** This example is in α FLUXKIT

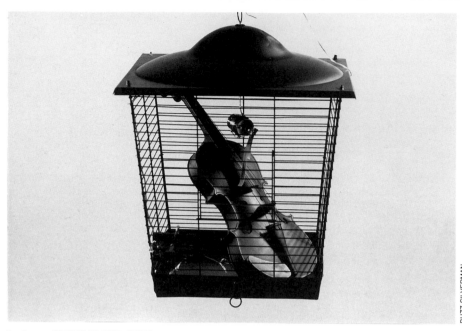

BUZZ SILVERMAN

Joe Jones. VIOLIN IN BIRD CAGE

FLUX-PRODUCTS 1961 TO 1969...FLUXFILMS, short version Summer 1966 40 min. 1400ft.:...[including] Smoke - by Joe Jones...16 mm. [$] 180 8mm version [$] 50
Fluxnewsletter, December 2, 1968 (revised March 15, 1969).

SLIDE & FILM FLUXSHOW...JOE JONES SMOKE Sequence of cigarette smoke shot with high speed camera, 2000fr/ sec. Camera: P. Moore.
Flux Fest Kit 2. [ca. December 1969].

1965 FLUXFILMS:...JOE JONES: Smoking
George Maciunas, Diagram of Historical Developments of Fluxus... [1973].

COMMENTS: *The Fluxfilm* Smoking *is sometimes called "Smoke" which is a less relevant title in its Fluxus context. The film, shot at high speed, shows smoke coming from a person's mouth after taking a drag on a cigarette. Joe Jones smoked a lot. George Maciunas hated smoke, which aggravated his asthma.* Smoking *is a counterpoint to George Brecht's* No Smoking.

SPRING MOTORS see:
FLUXMUSIC
STEEL DRUM see:
MUSICAL DRUM
STRING INSTRUMENTS see:
AUTOMATIC TRIO
VIOLIN

STRING TRIO see:
AUTOMATIC TRIO
10 SIMULTANEOUSLY PLAYING MUSIC MOVEMENTS see:
FLUXMUSIC
TOILET see:
FLUX-TOILET
TOILET SEAT see:
HOT SEAT TOILET SEAT

TONAL STUDIES

NEW! FLUXUS mo JOE JONES: music box-tonal studies $20
Vacuum TRapEzoid (Fluxus Newspaper No. 5) March 1965.

COMMENTS: Tonal Studies *was never made as such by Fluxus, but there is a clear relationship to the more modest* Flux Music Box, *referred to at times as "2 fragmented tunes."*

TRICYCLE see:
MUSICAL TRICYCLE
TRIO see:
AUTOMATIC TRIO
12 MUSIC MOVEMENTS IN ATTACHE CASE see:
ELECTRIC MUSIC MACHINE

12 SPRING NOISE MAKERS IN ATTACHE CASE see:
FLUXMUSIC
2 BELLS see:
MECHANICAL BELLS
2 FRAGMENTED TUNES see:
FLUX MUSIC BOX

TWO WORMS CHASING EACH OTHER
Silverman No. 181

JOE JONES...2 worms chasing each other, boxed $20
Flux Objects, Price List. May 1976.

COMMENTS: Two Worms Chasing Each Other *first appears as an untitled work, built into* Flux-Kit *(Silverman No. 122), in 1969 and is a toy painted black, which also activates a bell. In 1976, George Maciunas located his old supply of these toys and built a few Fluxus boxes with them inside.*

UPWARD TURNED FAUCET

PROPOSED FLUXSHOW FOR GALLERY 669 ... TOILET OBJECTS...sink faucet turned upward with sprayer or fountain head attached.
Fluxnewsletter, December 2, 1968.

PROPOSED FLUXSHOW...TOILET OBJECTS...sink faucet turned upward with sprayer or fountain head

attached.
Fluxnewsletter, December 2, 1968 (revised March 15, 1969).

TOILET OBJECTS & ENVIRONMENT...Sink faucet turned upward or with sprayer attached.
Flux Fest Kit 2. [ca. December 1969].

Toilet No. 3, Joe Jones...Sink faucet...upwards spray
Fluxnewsletter, April 1973.

COMMENTS: Upward Turned Faucet *is a typical Fluxus gag-turn on the water and you get your face washed.*

VIOLIN see:
AUTOMATIC DUET
AUTOMATIC QUARTET
MECHANICAL FLUXORCHESTRA
MECHANICAL VIOLIN
VIOLIN IN BIRD CAGE

VIOLIN IN BIRD CAGE
Silverman No. 177

NEW!...FLUXUS ma JOE JONES: violin in bird cage $50
Vacuum TRapEzoid (Fluxus Newspaper No. 5) March 1965.

... Items are in stock, delivery within 2 weeks ... FLUXUS ma JOE JONES: violin in bird cage $200
Vaseline sTREet (Fluxus Newspaper No. 8) May 1966.

COMMENTS: *Probably most examples of* Violin in Bird Cage *were constructed by Joe Jones for sale through Fluxus, although Maciunas might well have put some together also.*

WHISTLE see:
MECHANICAL FLUXORCHESTRA

WIND RADIO
Silverman No. 179, ff.

OTHER NEW FLUXUS ITEMS AVAILABLE IN FLUXSHOP OR BY MAIL...FLUXUS ma JOE JONES: radios $10
cc fiVe ThReE (Fluxus Newspaper No. 4) June 1964.

F-ma... [as above]
Second Pricelist - European Mail-Orderhouse. [Fall 1964].

COMMENTS: *Joe Jones told me in 1981, that the title of this work was* Wind Radio. *There is no title on the work itself, and no use of the title in Fluxus references, only "Radios $10" in the same ads for* Radios for the Deaf. *A* Wind Radio, *the guts of a transistor radio with a nylon string attached, is contained in a 1965 example of* Flux-Kit *(Silverman No. 120). The idea of the work is a 20th century material-world wind chime. Wind produced sound. Technology routed.*

WIND-UP NOISE MAKING MACHINE see:
FLUX MUSIC BOX

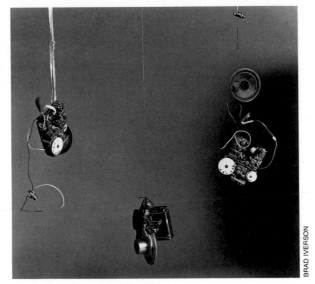

Joe Jones. Three WIND RADIOS

WORMS CHASING EACH OTHER see:
TWO WORMS CHASING EACH OTHER

HIDEKAZU JOSHIDA

It was announced in the tentative plans for the first issues of FLUXUS that Hidekazu Joshida would contribute "I hate Japanese modern art" to FLUXUS NO. 3 (later called FLUXUS NO. 4) JAPANESE YEARBOOK.
see: COLLECTIVE

MARIE JOUDINA and ANDREI VOLKONSKI

It was announced in the early tentative plans for the first issues of FLUXUS that M. Joudina and A. Volkonski were being consulted on "experimental music in USSR" for FLUXUS NO. 6 (later called FLUXUS NO. 7) EAST EUROPEAN YEARBOOK.
see: COLLECTIVE

K

MAURICIO KAGEL

It was announced in the tentative plans for the first issues of FLUXUS that M. Kagel was being consulted for FLUXUS NO. 2 WEST EUROPEAN YEARBOOK I, later called GERMAN & SCANDINAVIAN YEARBOX.
see: COLLECTIVE

ALLAN KAPROW

It was announced in the tentative plans for the first issues of FLUXUS that A. Kaprow would contribute "Historical precedents of 'Environment-happenings'" or a work "to be determined" for FLUXUS NO. 1 U.S. ISSUE. In Brochure Prospectus for Fluxus Yearboxes, version A, Kaprow's contribution to FLUXUS NO. 1 U.S. YEARBOX was to be: "Happenings: Chapel. Stockroom. Happening for Ann Arbor" and in version B, "Stockroom." "Stockroom" was included in FLUXUS 1 (Silverman No. > 118.II) a copy collated in 1977. I have not seen an early assembling of FLUXUS 1 with Kaprow's contribution in it.
see: COLLECTIVE

HAPPENINGS AND EVENTS see:
George Brecht and Allan Kaprow

PAINTINGS, ENVIRONMENTS & HAPPENINGS

In addition to Fluxus Year Boxes the following special editions [are] being planned. These are editions

Allan Kaprow, putting to good use his coffee table book. ASSEMBLAGE, ENVIRONMENTS & HAPPENINGS. Harry N. Abrams Inc., New York. 1966

of works by single composers, poets, artists or what you like...Allan Kaprow Happenings (historical essay)...
Fluxus Newsletter No. 4, fragment, [ca. October 1962].

"...Right now Tomas Schmit stays in my place & puts full time on putting together...Kaprow's book (maybe during summer)..."
Letter: George Maciunas to Robert Watts, [March 11 or 12, 1963].

FLUXUS SPECIAL EDITIONS 1963-4...FLUXUS i. ALLAN KAPROW: Paintings, Environments & Happenings (140 p.) $4
Fluxus Preview Review, [ca. July] 1963.

[as above]
Daniel Spoerri, L'Optique Moderne. List on editorial page. 1963.

[as above]
La Monte Young, LY 1961. Advertisement page. [1963].

F-i ALLAN KAPROW: paintings, environments & happenings 140p $4.
European Mail-Orderhouse: europeanfluxshop, Pricelist. [ca. June 1964].

COMMENTS: *This work was never published by Fluxus. It evolved into* Assemblage, Environments & Happenings *published by Harry N. Abrams Inc., New York in 1966.*

VACLAV KASLIK

It was announced in the Brochure Prospectus for Fluxus Year-boxes (version B) that Vaclav Kaslik would contribute a record, "czech musique concrete" to FLUXUS NO. 7 EAST EUROPEAN YEARBOX.
see: COLLECTIVE

PETER KENNEDY and MIKE PARR

COMMENTS: *In 1974, George Maciunas evidently added two untitled films by Peter Kennedy and Mike Parr to the FLUX-FILMS package. In an invoice to a French museum for FLUX-FILMS, 1974 version, George Maciunas describes them like this: "Flux number 36, Peter Kennedy & Mike Parr [untitled], year [of production] 1970, method of production-tips of feet walking at the very edge of frame, with sound." and "Flux number 37 Peter Kennedy & Mike Parr [untitled], year [of production] 1970, method of production-face going out of focus by layering sheets of plastic between camera and subject, with sound." The only other reference that I've found to these films is an oblique mention of the artists' names with the corresponding fluxfilm numbers on a reference card for Fluxfilms in the Maciunas Estate.*

HELMUT KIRCHGAESSER

It was announced in the tentative plans for the first issues of FLUXUS that Kirchgaesser would contribute "Experimental Film with Ossirograph (painting with printing press) (fold out)" to FLUXUS NO. 2 WEST EUROPEAN ISSUE (YEARBOOK 1), later called FLUXUS NO. 3 GERMAN & SCANDINAVIAN YEARBOX.
see: COLLECTIVE

PER KIRKEBY

BAR BALANCE & SCALE

FLUX-PROJECTS PLANNED FOR 1967...Per Kirkeby:...Bar balance and scale...
Fluxnewsletter, March 8, 1967.

COMMENTS: *Although planned,* Bar Balance & Scale *was never produced by George Maciunas as a Fluxus Edition.*

BAROMETER FACE CLOCK

FLUX-PROJECTS PLANNED FOR 1967...Per Kirkeby:...Clock series (...barometer...faces)...
Fluxnewsletter, March 8, 1967.

COMMENTS: Barometer Face Clock *is not known to exist, even in prototype. It is one of a series of scientific clock faces that Maciunas devised for Per Kirkeby in part because of his training as a scientist. It is probable that Kirkeby had the idea to alter one's sense of time, and Maciunas came up with ideas for specific clock faces. When I discussed the clocks with Kir-*

Per Kirkeby, 1985

JON HENDRICKS

keby, he had no recollection of the pieces, and said that when he was in New York in the mid-sixties, he and Maciunas spent a great deal of time together discussing art etc., and the clock idea probably came from these talks.

BOX BOX see:
 BOXED SOLIDS
BOXED SOLIDS see:
 SOLID CLAY IN CERAMIC BOX
 SOLID GLASS IN GLASS JAR
 SOLID LEATHER IN LEATHER BOX
 SOLID METAL IN METAL BOX
 SOLID PLASTIC IN PLASTIC BOX
 SOLID WOOD IN WOOD BOX
CHESS see:
 MECHANICAL CHESS
CLOCKS see:
 FLUX CLOCKS

COMPASS FACE CLOCK
Silverman No. > 200.I

FLUX-PROJECTS PLANNED FOR 1967...Per Kirkeby:...Clock series (compass...faces)...
Fluxnewsletter, March 8, 1967.

flux clock $8 by per kirkeby
Fluxshopnews. [Spring 1967].

FLUXPROJECTS FOR 1969...Per Kirkeby: clock faces showing - compass directions...
Fluxnewsletter, December 2, 1968.

Per Kirkeby. COMPASS FACE CLOCK. Mechanical by George Maciunas for an unused clock face

Per Kirkeby. COMPASS FACE CLOCK. Mechanical by George Maciunas for the clock face

PROPOSED FLUXSHOW FOR GALLERY 669 ... OBJECTS, FURNITURE...clocks:...clock with face showing direction...by Per Kirkeby
ibid.

FLUX-PRODUCTS 1961 TO 1969...PER KIRKEBY ...Flux clocks with dial faces of: compass...electric or wind-up, each [$] 8...
Fluxnewsletter, December 2, 1968 (revised March 15, 1969).

FLUX-PRODUCTS 1961 TO 1970...PER KIRKEBY ...Fluxclocks with compass...face [$] 8...
Flux Fest Kit 2. [ca. December 1969].

SPRING 1969...PER KIRKEBY: clocks with compass...face.
George Maciunas, Diagram of Historical Developments of Fluxus... [1973].

OBJECTS...Various flux-clocks (time by...compass directions...)
Proposal for 1975/76 Flux-New Year's Eve Event. [ca. November 1975].

Per Kirkeby. COMPASS FACE CLOCK

Per Kirkeby. DEGREE FACE CLOCK

...PER KIRKEBY...Fluxclocks with compass...face, ea: $18
Flux Objects, Price List. May 1976.

COMMENTS: George Maciunas designed two faces for Compass Face Clock. One (Silverman No. > 200.I), could also be read as Protractor Face Clock. The question of authorship of Compass Face Clock is discussed in the comments for Degree Face Clock.

DEGREE FACE CLOCK
Silverman No. > 200.II

FLUXPROJECTS FOR 1969...Per Kirkeby: clock faces showing...degrees of circle...
Fluxnewsletter, December 2, 1968..

PROPOSED FLUXSHOW FOR GALLERY 669 ... OBJECTS, FURNITURE...clocks:...clock with face showing...degrees by Per Kirkeby.
ibid.

Per Kirkeby. DEGREE FACE CLOCK. Mechanical by George Maciunas for the clock face

FLUX-PRODUCTS 1961 TO 1969...PER KIRKEBY
...Flux clocks with dial faces of:...degrees...electric
or wind-up, each [$] 8...
Fluxnewsletter' December 2, 1968 (revised March 15, 1969).

FLUX-PRODUCTS 1961 TO 1970...PER KIRKEBY
...Fluxclocks with...degree face [$] 8
Flux Fest Kit 2. [ca. December 1969].

SPRING 1969...PER KIRKEBY: clocks with... de-
gree face.
*George Maciunas, Diagram of Historical Developments of
Fluxus... [1973].*

OBJECTS...Various flux-clocks (time by degrees...)...
*Proposal for 1975/76 Flux-New Year's Eve Event. [ca. No-
vember 1975].*

...PER KIRKEBY...Fluxclocks with...degree face,
ea: $18
Flux Objects, Price List. May 1976.

OBJECTS AND EXHIBITS...1969: clock faces: ...
degrees...
George Maciunas Biographical Data. 1976.

COMMENTS: *A 360° face, the time is measured by the move-
ment within an arc. Some years ago, when I spoke with
Robert Watts about this and Compass Face Clock, he had re-
called thinking up the idea himself and was surprised when I
told him that George Maciunas advertised them as Per Kirke-
by's. Watts shrugged and said that that was the way George
worked. There would be ideas in the air and Maciunas would
assign the piece to one artist or another. References to Kir-
keby's clocks start in early 1967, around the time that he was
in New York. Maciunas dated clocks in his diagram as Spring,
1969. And Robert Watts signed a Kirkeby Compass Face
Clock in 1972.*

DISTANCE TRAVELED IN MM FACE CLOCK

FLUXPROJECTS FOR 1969...Per Kirkeby: clock
faces showing...distance traveled in mm.
Fluxnewsletter, December 2, 1968.

PROPOSED FLUXSHOW FOR GALLERY 669 ...
OBJECTS, FURNITURE...clocks:...clock with face
showing...distance...by Per Kirkeby
ibid.

COMMENTS: *This clock has to do with the distance the arm
has to travel around the circumference of the face of the
clock. George Maciunas made a clock face of his own which
is deceptively similar, titled* Distance in mm of Perimeter
Face Clock.

FINGER JACKET see:
FLUX FINGER SWEATER

Per Kirkeby. DISTANCE TRAVELED IN MM FACE CLOCK.
Mechanical by George Maciunas for the clock face

FINGER SWEATER see:
FLUX FINGER SWEATER
FLUX BOX see:
SOLID PLASTIC IN PLASTIC BOX

FLUX CLOCKS

"...Other going projects:...Kirkeby -...clocks..."
*Letter: George Maciunas to Ken Friedman, [ca. February
1967].*

FLUX SHOW: DICE GAME ENVIRONMENT EN-
TIRE FLOOR AS DICE HAZARD TABLE DIE
CUBES, 15" CUBES ON FLOOR, Marked on sides,
top open or closed with clear plastic. Consisting or
containing...Flux clocks by P.Kirkeby...
Flux Fest Kit 2. [ca. December 1969].

COMMENTS: *With Kirkeby's various clocks, their use in die
cubes is simultaneous with a different approach to time. Jim
Riddle did* One Hour *where there are a number of printed
faces and one real clock in a die cube.*

FLUX CLOCKS see:
BAROMETER FACE CLOCK
COMPASS FACE CLOCK
DEGREE FACE CLOCK
DISTANCE TRAVELED IN MM FACE CLOCK
PROTRACTOR FACE CLOCK
WEIGHTS FACE CLOCK
FLUX DRINKS see:
4 FLUX DRINKS

FLUX FINGER SWEATER
Silverman No. 199, ff.

FLUX-PROJECTS PLANNED FOR 1967...Per Kirk-
eby:...Finger jacket.
Fluxnewsletter, March 8, 1967.

finger sweater $2 by per kirkeby
Fluxshopnews, [Spring 1967].

FLUX-PRODUCTS 1961 TO 1969...PER KIRKEBY
Finger sweater, boxed [$] 3...
Fluxnewsletter, December 2, 1968 (revised March 15, 1969).

FLUX-PRODUCTS 1961 TO 1970...PER KIRKEBY
Finger Sweater, boxed [$] 3
Flux Fest Kit 2. [ca. December 1969].

FLUXUS-EDITIONEN...[Catalogue No.] 753 PER
KIRKEBY: finger sweater
Happening & Fluxus. Koelnischer Kunstverein, 1970.

COMMENTS: *A pretty useless item, probably Maciunas was
making a reference to Kirkeby's Arctic explorations, where
warmth was essential. Each* Finger Sweater *was hand-knitted
or crocheted, and usually packaged one to a box.*

FLUX TEA see:
4 FLUX DRINKS
FLUX-WOOD see:
SOLID WOOD IN A WOOD BOX

Per Kirkeby. FLUX FINGER SWEATER. Mechanical by George
Maciunas for the label

Per Kirkeby. 4 FLUX DRINKS. Mechanical by George Maciunas for one of two labels used

4 FLUX DRINKS

Silverman No. 196, ff.

''...other going projects:...Per Kirkeby - fluxtea...''
Letter: George Maciunas to Ken Friedman, [ca. February 1967].

FLUX-PROJECTS PLANNED FOR 1967...Per Kirkeby:...Flux-drink (4 teabags filled with - salt, sugar, aspirin, citric acid)...
Fluxnewsletter, March 8, 1967.

Per Kirkeby. 4 FLUX DRINKS. Mechanical by George Maciunas for an unused label

Per Kirkeby. 4 FLUX DRINKS. Mechanical by George Maciunas for an unused label

4 flux-drinks $3 by per kirkeby
Fluxshopnews. [Spring 1967].

FLUXPROJECTS FOR 1968 (In order of priority)
3. Boxed events & objects (all ready for production):
...Per Kirkeby - 4 flux drinks...
Fluxnewsletter, January 31, 1968.

FLUXPROJECTS REALIZED IN 1967: Flux-Christmas-meal-event...Per Kirkeby - 4 fluxdrinks (tea bag with ground aspirin, another with salt, another with citric acid, & sugar)...
ibid.

PROPOSED FLUXSHOW FOR GALLERY 669 ... FOOD CENTER:... 4 flux-teas by Per Kirkeby: tea bags filled with ground aspirin, another with salt, an-

other with citric acid, and another with sugar...
Fluxnewsletter, December 2, 1968.

PROPOSED FLUXSHOW...[as above]
Fluxnewsletter, December 2, 1968 (revised March 15, 1969).

FLUX-PRODUCTS 1961 TO 1969...PER KIRKEBY
...4 flux-drinks, 1st. tea bag with sugar, 2nd. with salt, 3rd with ground aspirin, 4th with citric acid * [$] 5 [also indicated as part of FLUXKIT and as part of PROPOSED FLUXSHOW/FOOD CENTER b.]
ibid.

PROPOSED FLUX DRINKS & FOODS ... TEA VARIATIONS tea bags with: salt, sugar or aspirin, or citric acid.
Fluxfest at Stony Brook, Newsletter No. 1, August 18, 1969. versions A & B

FLUX DRINKS & FOODS...TEA VARIATIONS tea bags with: salt, or sugar,... or aspirin, or citric acid. (Per Kirkeby)...
Invitation to Participate in New Year Eve's Flux-Feast. [ca. December 1969].

FLUX-PRODUCTS 1961 TO 1970...PER KIRKEBY ...4 Flux-drinks, altered tea bags, boxed [$] 5...
Flux Fest Kit 2, [ca. December 1969].

FLUX FOODS AND DRINKS...TEA VARIATIONS: Tea bag with: salt, or sugar, or aspirin, or citric acid. (Per Kirkeby)
ibid.

FLUXUS -EDITIONEN...[Catalogue no.]´ 754 PER KIRKEBY: 4 flux-drinks, tea bags
Happening & Fluxus. Koelnischer Kunstverein, 1970.

"...kirkeby 4 drinks, I have..."
Letter: George Maciunas to Dr. Hanns Sohm, [ca. late 1972].

SPRING 1969...PER KIRKEBY: 4 Teas...
George Maciunas, Diagram of Historical Developments of Fluxus... [1973].

"...P. Kirkeby- 4 fluxdrinks -..."
Letter: George Maciunas to Dr. Hanns Sohm, November 30, 1975.

...PER KIRKEBY 4 flux drinks, altered tea bags, boxed $12...
Flux Objects, Price List. May 1976.

COMMENTS: *Per Kirkeby, 1985: "We started out with salt - that was the basic idea. Salt was something that disappeared in hot water. You can taste it but you can't see it. But you are affected by it. Citric Acid. Aspirins."*
Hendricks: "You never knew that he had done them though?"
Kirkeby: "I knew from the newsletters."
Hendricks: "But he never sent them?"

Per Kirkeby. 4 FLUX DRINKS. Mechanical by George Maciunas for one of two labels used

Per Kirkeby. 4 FLUX DRINKS. Mechanical by George Maciunas

Kirkeby: "No. That was also part of it. When I got those letters about the Flux Food Fest, I somehow couldn't react to it. Had I been in New York, I probably would have done something. In that sense I'm a painter too, and I am simply very attached to concrete things."

FURNITURE see:
FLUX CLOCKS
TABLE TOP WITH DRAWERS

MATCH BOOK

FLUX-PROJECTS PLANNED FOR 1967...Per Kirkeby: Match book...
Fluxnewsletter, March 8, 1967.

COMMENTS: *Per Kirkeby doesn't recall what his match ideas were. It might have had something to do with the lack of wood in Denmark and the country being dependent on Sweden for supplies. George Brecht worked with Knud Pedersen, the Danish artist, on a match project called* Left Handed Matches *in the late sixties.*

MECHANICAL CHESS

"...Other going projects: Kirkeby - chess set..."
Letter: George Maciunas to Ken Friedman, [ca. February 1967].

FLUX-PROJECTS PLANNED FOR 1967...Per Kirkeby:...Mechanical chess (in collaboration with G.M.)...
Fluxnewsletter, March 8, 1967.

COMMENTS: *Mechanical Chess was never produced as a Fluxus Edition, and I don't know how the set would have worked. George Maciunas and Takako Saito made a number of chess sets for Fluxus during the mid-sixties and probably*

Kirkeby suggested the idea to Maciunas as another chess variation.

PROTRACTOR FACE CLOCK

FLUX-PROJECTS PLANNED FOR 1967...Per Kirkeby:...Clock series (...protractor...faces)...
Fluxnewsletter, March 8, 1967.

COMMENTS: *It's possible that* Protractor Face Clock *is* Compass Face Clock, *in that a protractor is used in making a compass. In any case, I have not located any clock face that solely used a protractor.*

SCALE see:
BAR BALANCE & SCALE

SOLID CLAY IN CERAMIC BOX

"...other going projects: ... (Per Kirkeby) - box-box (box containing solid mtl. from which it is made of)...
Letter: George Maciunas to Ken Friedman, [ca. February 1967].

FLUX-PROJECTS PLANNED FOR 1967...Per Kirkeby:...box of solids (solid material in box from same material, 12 variations)...
Fluxnewsletter, March 8, 1967.

boxed solid $7 by per kirkeby
Fluxshopnews. [Spring 1967].

FLUXPROJECTS FOR 1968 (In order of priority) 3....Boxed events & objects (all ready for production):...Per Kirkeby -...box of solids...
Fluxnewsletter, January 31, 1968.

FLUX-PRODUCTS 1961 TO 1969...PER KIRKEBY ...Boxed solid...clay in ceramic box, special order only [$] 20...
Fluxnewsletter, December 2, 1968 (revised March 15, 1969).

SPRING 1969...PER KIRKEBY:...boxed solid...
George Maciunas, Diagram of Historical Developments of Fluxus... [1973].

COMMENTS: *Solid Clay in Ceramic Box, a part of Kirkeby's "Boxed Solids" series, was never produced by Maciunas as a Fluxus Edition.*

SOLID GLASS IN GLASS JAR

"...other going projects: ... (Per Kirkeby) - box-box (box containing solid mtl. from which it is made of)...
Letter: George Maciunas to Ken Friedman, [ca. February 1967].

FLUX-PROJECTS PLANNED FOR 1967...Per Kirkeby:...box of solids (solid material in box from same material, 12 variations)...
Fluxnewsletter, March 8, 1967.

boxed solid $7 by per kirkeby
Fluxshopnews. [Spring 1967].

FLUXPROJECTS FOR 1968 (In order of priority)
3....Boxed events & objects (all ready for production):...Per Kirkeby -...box of solids...
Fluxnewsletter, January 31, 1968.

PROPOSED FLUXSHOW FOR GALLERY 669 ...
OBJECTS, FURNITURE...Boxed events & objects -
one of a kind:...boxed solid (...glass in glass box...
by Per Kirkeby)...
Fluxnewsletter, December 2, 1968.

FLUX-PRODUCTS 1961 TO 1969...PER KIRKEBY
...Boxed solid...solid glass cylinder in glass jar [$] 8...
Fluxnewsletter, December 2, 1968 (revised March 15, 1969).

FLUX-PRODUCTS 1961 TO 1970...PER KIRKEBY
...Boxed solid glass cylinder in glass jar [$] 12...
Flux Fest Kit 2. [ca. December 1969].

SPRING 1969...PER KIRKEBY:...boxed solid...
George Maciunas, Diagram of Historical Developments of Fluxus... [1973].

COMMENTS: *Solid Glass in Glass Jar is a part of Kirkeby's "Boxed Solids" series. Independently, Serge Oldenbourg also made a series of works involving solids. He poured liquid plaster of Paris into various glass containers. Once the contents had solidified, the container was broken, leaving a solid cast of the inside. In 1969, George Maciunas produced Oldenbourg's work, calling it* Flux Contents *and leaving the plaster inside its container.*

SOLID LEATHER IN LEATHER BOX

"...other going projects: ... (Per Kirkeby) - box-box
(box containing solid mtl. from which it is made of)...
Letter: George Maciunas to Ken Friedman, [ca. February 1967].

FLUX-PROJECTS PLANNED FOR 1967...Per Kirkeby:...box of solids (solid material in box from same material, 12 variations)...
Fluxnewsletter, March 8, 1967.

boxed solid $7 by per kirkeby
Fluxshopnews. [Spring 1967].

FLUXPROJECTS FOR 1968 (In order of priority)
3....Boxed events & objects (all ready for production):...Per Kirkeby -...box of solids...
Fluxnewsletter, January 31, 1968.

PROPOSED FLUXSHOW FOR GALLERY 669 ...
OBJECTS, FURNITURE...Boxed events & objects -
one of a kind:...boxed solid (leather in leather box...
by Per Kirkeby)...
Fluxnewsletter, December 2, 1968.

FLUX-PRODUCTS 1961 TO 1969...PER KIRKEBY

...Boxed solid...solid leather in leather box...special
order only [$] 20...
Fluxnewsletter, December 2, 1968 (revised March 15, 1969).

FLUX-PRODUCTS 1961 TO 1970...PER KIRKEBY
...Solid leather in leather box & others, ea [$] 25...
Flux Fest Kit 2. [ca. December 1969].

SPRING 1969...PER KIRKEBY:...boxed solid...
George Maciunas, Diagram of Historical Developments of Fluxus... [1973].

COMMENTS: *Solid Leather in Leather Box was not made by Maciunas as a Fluxus Edition.*

SOLID METAL IN METAL BOX

"...other going projects: ... (Per Kirkeby) - box-box
(box containing solid mtl. from which it is made of)...
Letter: George Maciunas to Ken Friedman, [ca. February 1967].

FLUX-PROJECTS PLANNED FOR 1967...Per Kirkeby:...box of solids (solid material in box from same material, 12 variations)...
Fluxnewsletter, March 8, 1967.

boxed solid $7 by per kirkeby
Fluxshopnews. [Spring 1967].

FLUXPROJECTS FOR 1968 (In order of priority)
3....Boxed events & objects (all ready for production):...Per Kirkeby -...box of solids...
Fluxnewsletter, January 31, 1968.

PROPOSED FLUXSHOW FOR GALLERY 669 ...
OBJECTS, FURNITURE...Boxed events & objects -
one of a kind:...boxed solid (...metal in metal box,
by Per Kirkeby)...
Fluxnewsletter, December 2, 1968.

FLUX-PRODUCTS 1961 TO 1969...PER KIRKEBY
...Boxed solid...metal in metal box...special order
only [$] 20...
Fluxnewsletter, December 2, 1968 (revised March 15, 1969).

SPRING 1969...PER KIRKEBY:...boxed solid...
George Maciunas, Diagram of Historical Developments of Fluxus... [1973].

COMMENTS: *Solid Metal in Metal Box was not made by Maciunas as a Fluxus Edition.*

SOLID PLASTIC IN PLASTIC BOX
Silverman No. 198, ff.

"...other going projects: ... (Per Kirkeby) - box-box
(box containing solid mtl. from which it is made of)...
Letter: George Maciunas to Ken Friedman, [ca. February 1967].

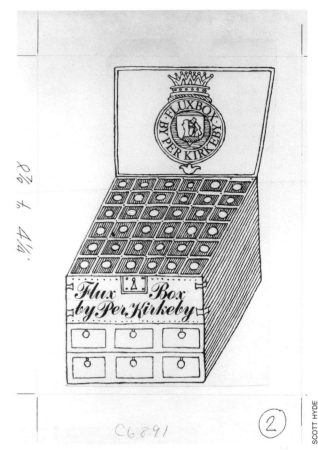

Per Kirkeby. SOLID PLASTIC IN PLASTIC BOX. Mechanical by George Maciunas for the label

FLUX-PROJECTS PLANNED FOR 1967...Per Kirkeby:...box of solids (solid material in box from same material, 12 variations)...
Fluxnewsletter, March 8, 1967.

boxed solid $7 by per kirkeby
Fluxshopnews. [Spring 1967].

FLUXPROJECTS FOR 1968 (In order of priority)
3....Boxed events & objects (all ready for production):...Per Kirkeby -...box of solids...
Fluxnewsletter, January 31, 1968.

FLUX-PRODUCTS 1961 TO 1969...PER KIRKEBY
...Boxed solid, solid plastic in plastic box * [indicated as part of FLUXKIT] [$] 3...
Fluxnewsletter, December 2, 1968 (revised March 15, 1969).

FLUX-PRODUCTS 1961 TO 1970...PER KIRKEBY
...Boxed solid plastic in plastic box [$] 3...
Flux Fest Kit 2. [ca. December 1969].

FLUXUS-EDITIONEN...[Catalogue no.] 755 PER KIRKEBY: boxed solid plastic in plastic box
Happening & Fluxus. Koelnischer Kunstverein, 1970.

SPRING 1969...PER KIRKEBY:...boxed solid...
George Maciunas, Diagram of Historical Developments of Fluxus... [1973].

''...P.Kirkeby - boxed solid [$] 5''
Letter: George Maciunas to Dr. Hanns Sohm, November 30, 1975.

...PER KIRKEBY...Boxed solid plastic in plastic box $6...
Flux Objects, Price List. May 1976.

COMMENTS: *Solid Plastic in Plastic Box is the only "Boxed Solid" known to have been produced by Maciunas as a Flux-us Edition. There are at least three variables, solid white plastic in a white plastic box, red in a red box and black in a black box. Further discussion can be found in the comments for* Solid Glass in Glass Jar *and* Solid Wood in Wood Box.

SOLID WOOD IN WOOD BOX

"...other going projects: ... (Per Kirkeby) - box-box (box containing solid mtl. from which it is made of)...
Letter: George Maciunas to Ken Friedman, [ca. February 1967].

FLUX-PROJECTS PLANNED FOR 1967...Per Kirkeby:...box of solids (solid material in box from same material, 12 variations)...
Fluxnewsletter, March 8, 1967.

boxed solid $7 by per kirkeby
Fluxshopnews. [Spring 1967].

FLUXPROJECTS FOR 1968 (In order of priority) 3....Boxed events & objects (all ready for production):...Per Kirkeby -...box of solids...
Fluxnewsletter, January 31, 1968.

PROPOSED FLUXSHOW FOR GALLERY 669 ... OBJECTS, FURNITURE...Boxed events & objects - one of a kind:...boxed solid (...wood in wood box... by Per Kirkeby)...
Fluxnewsletter, December 2, 1968.

FLUX-PRODUCTS 1961 TO 1969...PER KIRKEBY ...Boxed solid...solid wood in wood box [$] 8...
Fluxnewsletter, December 2, 1968 (revised March 15, 1969).

FLUX-PRODUCTS 1961 TO 1970...PER KIRKEBY ...Boxed solid wood in wood box [$] 8...
Flux Fest Kit 2. [ca. December 1969].

"...boxed solids have to be made on order, I thought you have wood in wood?..."
Letter: George Maciunas to Dr. Hanns Sohm, [ca. late 1972].

SPRING 1969...PER KIRKEBY:...boxed solid...

this box contains wood

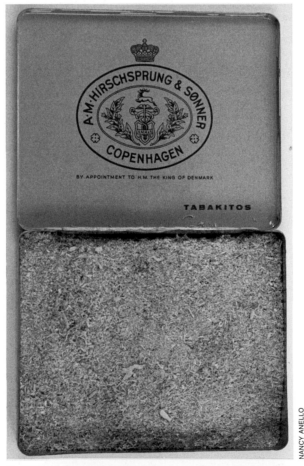

Per Kirkeby. Prototype by the artist for the Fluxus Edition which became SOLID WOOD IN WOOD BOX and the other BOXED SOLIDS

George Maciunas, Diagram of Historical Developments of Fluxus... [1973].

FLUX-PRODUCTS 1961 TO 1970 ... SOLO OBJECTS & PUBLICATIONS...PER KIRKEBY...Boxed solid wood in wood box [$] 10
[Fluxus price list for a customer]. September 1975.

COMMENTS: *This and the other works using the idea of a box containing solid material identical to its container, was conceptually evolved by George Maciunas into a "Boxed Solids" series out of a single idea that was something of a reversal of Kirkeby's original prototype. His was a metal box containing sawdust, labeled "this box contains wood" and titled,* Flux-wood, *which to a scientific mind is true and to a lay-person could be ponderable. Perhaps Kirkeby was responding scientifically to Ben Vautier's* Fluxbox Containing God. *Maciunas uses the lay-person's idea of concrete, the obvious. Serge Oldenbourg did a similar work, independently, at about the same time. It was later produced by Fluxus, titled* Flux Contents *and was a glass bottle containing solidified plaster of Paris.*

TABLE TOP WITH DRAWERS

FLUX-PROJECTS PLANNED FOR 1967...Per Kirkeby:...Table top with drawers...
Fluxnewsletter, March 8, 1967.

COMMENTS: *Not known to have been realized,* Tabletop With Drawers *is possibly a photo-mural tabletop, along the lines of other Fluxfurniture projects done at the time by Watts, Moore, Spoerri and others.*

TEA VARIATIONS see:
4 FLUX DRINKS

WEIGHTS FACE CLOCK

FLUX-PRODUCTS 1961 TO 1969...PER KIRKEBY ...Flux clocks with dial faces of:...weights...electric or wind-up, each [$] 8
Fluxnewsletter, December 2, 1968 (revised March 15, 1969).

COMMENTS: *Perhaps having something to do with a round scale face, 24 pounds - weighing time,* Weights Face Clock *was never made as a Fluxus Edition.*

JANE KNIZAK

FLUX PAPERS
Silverman No. < 208.I, ff.

FLUX-PRODUCTS 1961 TO 1969...JANE KNIZAK Flux-papers, in partitioned box [$] 5
Fluxnewsletter, December 2, 1968 (revised March 15, 1969).

FLUX-PRODUCTS 1961 TO 1970...JANE KNIZAK Flux-papers, boxed [$] 5
Flux Fest Kit 2. [ca. December 1969].

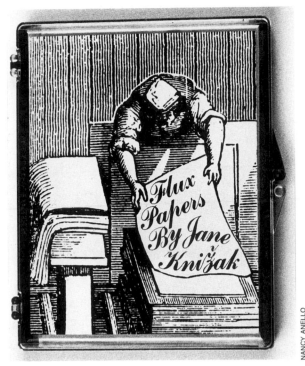

Jane Knizak. **FLUX PAPERS**

...set of 1969-70 Flux-productions which consist of the following: 1969 -...Jane Knizak: Flux papers
Fluxnewsletter, January 8, 1970.

FLUXUS-EDITIONEN...[Catalogue no.] 758 JANE KNIZAK: flux-papers, boxed
Happening & Fluxus. Koelnischer Kunstverein, 1970.

SPRING 1969...JANE KNIZAK: toilet papers
George Maciunas, Diagram of Historical Developments of Fluxus... [1973].

COMMENTS: *This Fluxus Edition consists of various types of toilet paper folded neatly in a plastic box with a Maciunas designed label. Perhaps the work can be considered an extension of* Flux Toilet *ideas and Maciunas' kaka interests. There is also a relationship to Geoffrey Hendricks'* Flux Reliquary *and Maciunas'* Excreta Fluxorum.

MILAN KNIZAK

BOOK see:
COMPLETE WORKS

COMPLETE WORKS
Silverman No. < 201.VII

"...I have enclosed 3 letters one of which may help you to obtain visa and ticket to visit us for a few

Jane Knizak. **FLUX PAPERS**

months. Please choose one of the letters which you think would be most appropriate. I have also asked the N.Y. Cinematheque & Film Co-operative to write you another invitation...Your visit here would also give us the opportunity to formulate and design the publication of your complete works..."
Letter: George Maciunas to Milan Knizak, [ca. January 1966].

"I got your letter regarding your need for a ticket to come to New York. I think I may help out to a degree...Is it necessary for you to have a round trip ticket?...During your stay in N.Y. we could publish your entire works...& organize various summer events in which you could participate...."
Letter: George Maciunas to Milan Knizak, [March 10, 1966].

"...Just received your '8 days' - wonderful piece! we ...should print it together with your other events in a special edition of your works. (on which you could work in New York) Question: do you need air ticket

now? or after you obtain visa? Please let me know."
Letter: George Maciunas to Milan Knizak, May 19, 1966.

"...will appear late in 1966...FLUXUS z MILAN KNIZAK: complete works, cards, objects, fold-outs, in a box $15
Vaseline sTREet (Fluxus Newspaper No. 8) May 1966.

"We were very sorry to hear of your failure to obtain visa to come to New York...In regards to your pieces for your Fluxus 'complete works' edition, I propose that we go ahead anyway and publish them even though you are not in New York to supervise its production. We can always keep you well informed of each stage so that you can make suggestions for changes or improvements. The main problem is getting many of your pieces translated from Czech to English. We do not know any Czechs in New York, since most Czechs in New York are reactionary emigrees and our group is considered leftist, so that I don't have any contact with Lithuanians even. (for same reason).

Do you have copies of all the texts you have sent me? If you do, could you find someone to translate them? (maybe Mrs. Masarykowa?) or a student to whom we could pay for this translation. I would suggest that you translate yourself, and this will help you to learn english better. Your english at present seems to be quite good and we should be able to understand it completely, then correct it and send corrected text for your approval.

If you do not have copies of the texts that you sent us, please let us know soon, so that we can mail them to you for translations (only Czech texts of course) After we have all texts in English, we can figure out the desired format, what is to be printed on cards, rolls, sheets, etc., Of course the gliders you sent will be printed on gliders, the WEEK (which incidentally we like very much) could be printed on a calender, etc, etc. Your street events maybe on street maps. So that it would help, if you could send also a street map of Prague, indicating all locations & time where each event took place..."
Letter: George Maciunas to Milan Knizak, August 15, 1966.

"...Furthermore Fluxus still published newspaper, supplements to works...Started compl. works of... Knizak..."
Letter: George Maciunas to Ben Vautier, [ca. October 1966].

"...Regarding Fluxus-edition of your complete works -we are still working on it. I have difficulty in finding a translator (from Czech to English) I have microfilmed the text and will send originals back to you. Could you translate them? Your english is rapidly improving and is good enough for us to understand. I can correct or re-edit your english where necessary. French & German text I have translated already. I

Left to right: Jan Mach, Vit Mach and Milan Knizak. Prague, ca. 1962

ZDENEK PODLESNY

Manifesto '66
paper event April 22, 65.
The Actual Walk,
Demonstration for Oneself.
Letters.
The Rite.
The active part of the demonstration.
The necessary Activity, 1965
Principles of action art, 1965 Summer
To make certain we got all your translations I have mailed in a package to you copies of all your Czech texts, including text on paper gliders (swallows). If you see anything that was not translated please translate and send english text to me. I still have your original Czech texts..."
Letter: George Maciunas to Milan Knizak, [ca. March 8, 1967].

events & games $20 by milan knizak
Fluxshopnews. [Spring 1967].

FLUXPROJECTS FOR 1968 (In order of priority)...
5. Milan Knizak - complete works - in a -box
Fluxnewsletter, January 31, 1968.

FLUXPROJECTS FOR 1969... Milan Knizak: book (Mar.)
Fluxnewsletter, December 2, 1968.

FLUX-PRODUCTS 1961 TO 1969...MILAN KNIZAK ...Events and games, in pocketed bag, late 1969* [indicated as part of FLUXKIT] [$] 40
Fluxnewsletter, December 2, 1968 (revised March 15, 1969).

"...knizak bag never got produced..."
Letter: George Maciunas to Dr. Hanns Sohm. [ca. late 1972].

SCOTT HYDE

Milan Knizak. COMPLETE WORKS. Mechanical by George Maciunas for the label with the title changed

have also converted your photos to screened negatives and engravings so that I can return your photographs also..."
Letter: George Maciunas to Milan Knizak, January 30, 1967.

"...Other going projects:...Knizak - events in box..."
Letter: George Maciunas to Ken Friedman, [ca. February 1967].

FLUX-PROJECTS PLANNED FOR 1967...Milan Knizak: complete works (events, objects, games etc. boxed)
Fluxnewsletter, March 8, 1967.

"...I received many translations from you, some with recent mail, including: 'Actual' envelope,
'Keeping together manifestation'
events of Sonia Svecova,
4 page 'Active text of action lecture'
[and in a] large envelope, last mail about 4 days ago [:]
Demonstration of the one
Happening for J.Mach,
Text from fold-outs in box, Summer, Fall 65
A walk through Prague Fall 65
How to Actualize the Clothes
Event for House no. 26, Jan. 66
Manifestation 2 of AU

Milan Knizak. COMPLETE WORKS. Study by George Maciunas
for the label, titled here as "Events"

COMMENTS: *In 1968, Milan Knizak and George Maciunas made a mock-up of a book titled* Why Just So. *A collection of texts and photographs of earlier actions etc., it is probably what* Complete Works *would have been had it been published. It contains:*

"AM 22.4.1965
Untitled Lecture
Demonstration of the One
The Actual Walk
Principles of Action Art According to Milan Knizak
Happening for J. Mach
Manifestation 2 of AU
About Destruction
Paper-Swallows
Soldiers Game
Event for the House No.26, Vaclavkova Street, Prague 6
 for Mail Office and for Police
How to Actualize the Clothes
A Walk through Prague"

plus notations for additional texts. Although Complete Works *was never published by Fluxus, several of Knizak's scores were published in* Flux Fest Sale *in 1966 and in* Flux Fest Kit 2 *late in 1969. Starting in 1966, George Maciunas wanted to publish an issue of the Fluxus Newspaper on Milan Knizak and the Actual Group's activities in CSSR. Initially it was to have been titled* VerTical pRaguE, *and later* Viscous TRumpEt. *See:* COLLECTIVE. *Knizak has assembled a number of hand-made books on his work - some deal with single aspects such as fashion, others are collections of many aspects of his vast energies.*

EVENTS & GAMES see:
 COMPLETE WORKS
FILM see:
 INDETERMINATE MOVIE
 INTERMISSION

Milan Knizak. Drawing for the cover of COMPLETE WORKS, with
instructions to George Maciunas

FLUX DREAMS
Silverman No. 201

FLUX-PRODUCTS 1961 TO 1969...MILAN KNIZAK
...Flux dreams, 12 colored small boxes in larger partitioned box * [indicated as part of FLUXKIT] [$] 6...
Fluxnewsletter, December 2, 1968 (revised March 15, 1969).

FLUX-PRODUCTS 1961 TO 1970...MILAN KNIZAK
...Flux dreams, boxed colored boxes [$] 6...
Flux Fest Kit 2. [ca. December 1969].

...set of 1969 - 70 Flux-productions which consist of the following: 1969-...Milan Knizak:...Flux dreams...
Fluxnewsletter, January 8, 1970.

FLUXUS-EDITIONEN...[Catalogue no.] 757 MILAN KNIZAK:...flux dreams, boxed colored boxes
Happening & Fluxus. Koelnischer Kunstverein, 1970.

SPRING 1969...MILAN KNIZAK:... dreams
George Maciunas, Diagram of Historical Developments of Fluxus... [1973].

...MILAN KNIZAK...Flux dreams, boxed colored boxes $8...
Flux Objects, Price List. May 1976.

COMMENTS: *Flux Dreams is a Maciunas interpretation of a Psychedelic dream-like aspect of Knizak's work, however the contents bear little resemblance to Knizak's pieces, which are crude and direct - not decorative.*

Milan Knizak. FLUX DREAMS

297

FLUX SNAKES
Silverman No. > 201.I

FLUX-PRODUCTS 1961 TO 1969...MILAN KNIZAK
...Flux snakes, in clear box * [indicated as part of
FLUXKIT] [$] 3...
Fluxnewsletter, December 2, 1968 (revised March 15, 1969).

FLUX-PRODUCTS 1961 TO 1970...MILAN KNIZAK
...Flux snakes, boxed [$] 3
Flux Fest Kit 2. [ca. December 1969].

...set of 1969-70 Flux-productions which consist of
the following: 1969 -...Milan Knizak:...Flux snakes
Fluxnewsletter, January 8, 1970.

SPRING 1969...MILAN KNIZAK: snakes...
*George Maciunas, Diagram of Historical Developments of
Fluxus... [1973].*

...MILAN KNIZAK...Flux snakes, boxed $4
Flux Objects, Price List. May 1976.

COMMENTS: Flux Snakes *must have been a jokey idea that
George Maciunas picked up from Milan Knizak when he was
in the United States. Knizak has a very ambivalent attitude
toward the Fluxus realizations of his pieces and remembers
very little of their genesis.*

Milan Knizak. FLUX SNAKES. Label designed by George
Maciunas

Milan Knizak. FLUX WHITE MEDITATION

FLUX WHITE MEDITATION
Silverman No. 202

FLUX-PRODUCTS 1961 TO 1969...MILAN KNIZAK
Flux white meditation, in clear box * [indicated as
part of FLUXKIT] [$] 3...
Fluxnewsletter, December 2, 1968 (revised March 15, 1969).

FLUX-PRODUCTS 1961 TO 1970...MILAN KNIZAK
Flux white meditation, boxed [$] 3...
Flux Fest Kit 2. [ca. December 1969].

...set of 1969-70 Flux-productions which consist of
the following: 1969-...Milan Knizak: Flux white
meditation...
Fluxnewsletter, January 8, 1970.

FLUXUS-EDITIONEN...[Catalogue no.] 756 MILAN
KNIZAK: flux white meditation, boxed
Happening & Fluxus. Koelnischer Kunstverein, 1970.

...MILAN KNIZAK Flux white meditation, boxed
$4...
Flux Objects, Price List. May 1976.

COMMENTS: Flux White Meditation: *narcotic powder? dust?
ashes? crushed rocks? The work is not explained and could
relate to any number of Knizak's activities.*

Milan Knizak. FLUX WHITE MEDITATION.
Study by George Maciunas for the label

Milan Knizak, ca. 1966

FOOD see:
SAUSAGE LOG CABIN
TURKEY

INDETERMINATE MOVIE

FLUXPROJECTS FOR 1969 PRODUCTS - PUBLI-
CATIONS...Fluxfilms: by Milan Knizak...
Fluxnewsletter, December 2, 1968.

SLIDE & FILM FLUXSHOW...MILAN KNIZAK: IN-
DETERMINATE MOVIE, 1969 Slow transition from
out-of-focus to focus of a projected piece of rope.
Flux Fest Kit 2. [ca. December 1969].

COMMENTS: Indeterminate Movie *could have been made
either as a movie, or in a film & slide show, with a slide pro-
jector. The film was never made by Fluxus. Milan Knizak has
made four films:* Concert in Holubin, *1971;* Stone Ceremony,
1972; Material Events, *1978; and* Kill Yourself & Fly, *1982.*

INTERMISSION

FLUXPROJECTS FOR 1969 PRODUCTS - PUBLI-
CATIONS...Fluxfilms: by Milan Knizak...
Fluxnewsletter, December 2, 1968.

SLIDE & FILM FLUXSHOW...MILAN KNIZAK: IN-
TERMISSION
Flux Fest Kit 2. [ca. Decmeber 1969].

COMMENTS: Intermission *is probably* Pause - *a film idea
sent to George Maciunas after Knizak saw the Fluxus films in
1966. The score for the film reads, "title, artist, Flux Film
No. - then a real pause."*

PAUSE see:
INTERMISSION

SAUSAGE LOG CABIN

NEW YEAR EVE'S FLUX-FEST, DEC. 31, 1969 AT
CINEMATHEQUE, 80 WOOSTER ST. ...Milan Kni-
zak: sausage log cabin...
Fluxnewsletter, January 8, 1970.

31.12.1969 NEW YEAR EVE'S FLUX-FEAST
(FOOD EVENT)...Milan Knizak: sausage log cabin...
*George Maciunas, Diagram of Historical Developments of
Fluxus... [1973].*

COMMENTS: Sausage Log Cabin *is a food work done in the
context of a Fluxus Feast.*

TURKEY

FLUX DRINKS & FOODS...TURKEY: with con-
crete filling (Milan Knizak)...

*Invitation to Participate in New Year Eve's Flux-Feast. [ca.
December 1969].*

COMMENTS: *Milan Knizak uses concrete as an element of
his work - especially as covers for his hand-assembled books.*

WHY JUST SO see:
COMPLETE WORKS

Alison Knowles, ca. 1962

PHOTOGRAPHER NOT IDENTIFIED

ALISON KNOWLES

BEAN KIT/ 1964 EDITION see:
BEAN ROLLS

BEAN ROLLS
Silverman No. 208, ff.

FLUXUS 1963 EDITIONS, AVAILABLE NOW
FROM FLUXUS P.O. Box 180, New York 10013,
N.Y. or FLUXUS 359 Canal St. New York. CO 7-9198
...FLUXUS 1964 EDITIONS:...FLUXUSp ALISON
KNOWLES: canned bean roll $6
Film Culture No. 30, Fall 1963.

FLUXUS 1964 EDITIONS:...FLUXUS p ALISON
KNOWLES: canned bean roll $6...Most materials ori-
ginally intended for Fluxus yearboxes will be includ-
ed in the FLUXUSccV TRE newspaper or in individ-
ual boxes.
cc V TRE (Fluxus Newspaper No. 1) January 1964.

FLUXUS 1964 EDITIONS:...FLUXUS p ALISON
KNOWLES: canned bean roll $6
cc V TRE (Fluxus Newspaper No. 2) February 1964.

...AVAILABLE NOW...[as above]
cc Valise e TRanglE (Fluxus Newspaper No. 3) March 1964.

...Individuals in Europe, the U.S. and Japan have dis-
covered each other's work...and have grown objects
and events which are original, and often uncategoriz-
able in a strange new way:...Alison Knowles' BEAN
CAN: Early Red Valentines, Early Mohawks, Long
Yellow Six Weeks, English Canterburys...Bean's in-
sulated Boot Foot Wader (Suspenders extra)...Ich
bean ein Star -, ein Kino - Star-...The U.S. bean crop
would make enough bean soup to run Niagara Falls
for three hours....
*George Brecht, "Something About Fluxus," cc fiVe ThReE
(Fluxus Newspaper No. 4) June 1964.*

FLUXKIT containing following fluxus - publications:
(also available separately) ... FLUXUS p ALISON
KNOWLES: canned bean rolls $3
cc fiVe ThReE (Fluxus Newspaper No. 4) June 1964.

F-p ALISON KNOWLES: canned bean roll $6...
*European Mail-Orderhouse: europeanfluxshop, Pricelist.
[ca. June 1964].*

F-p ALISON KNOWLES: canned bean roll $3 [also
listed as part of FLUXKIT]
Second Pricelist - European Mail-Orderhouse. [Fall 1964].

FLUXKIT containing following fluxus - publications:
...FLUXUSp ALISON KNOWLES: canned bean rolls
$3
Vacuum TRapEzoid (Fluxus Newspaper No. 5) March 1965.

CANNED BEAN ROLLS $3 ALL ABOUT BEANS,
IN A CAN ALISON KNOWLES
ibid.

"...If you sell kit for $100, you can keep $40 and
send me $60, because I must pay others (...bean box,
etc.)..."
*Letter: George Maciunas to Willem de Ridder, March 2,
1965.*

FLUXKIT containing following fluxus - publications:
(also available separately) ... FLUXUS p ALISON
KNOWLES: canned bean rolls $4
Vaseline sTREet (Fluxus Newspaper No. 8) May 1966.

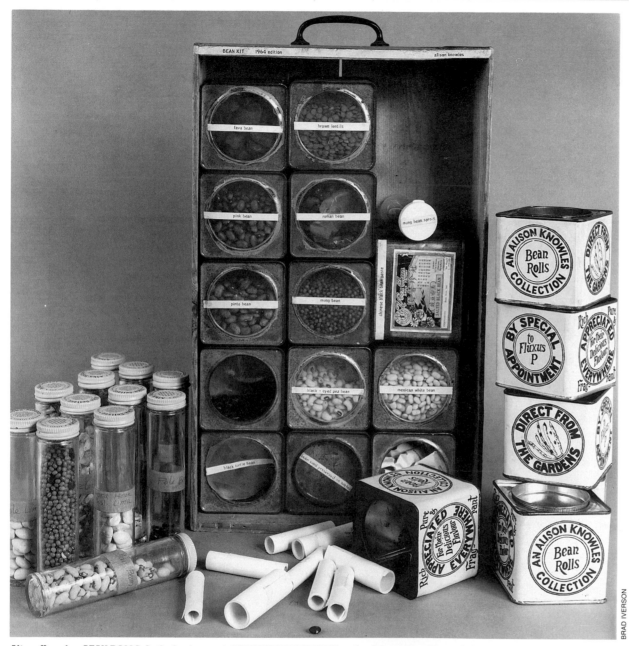

Alison Knowles. BEAN ROLLS. In the background, BEAN KIT/1964 EDITION, and at left are jars of beans labeled by George Maciunas to use for BEAN ROLLS. see color portfolio

works as a book, but in a can. A canned book."

A minute study of the mundane, this classic Fluxus assemblage of the useless is a pinnacle of "anti-art" - a later-day Monet study of haystacks. Excerpts from Alison Knowles' "Canned bean roll" are included in Fluxus Newspaper No. 1, January 1964. Two excerpts are in Fluxus Newspaper No. 2, February 1964. In the 1960s, George Maciunas made a homage to Knowles - assembling beans and other remains from the production of Bean Rolls into Bean Kit/ 1964 Edition (Silverman No. 212 bis b).

BLINDFOLD FOOD see:
SLEEP MASK FOR DINING
CANNED BEAN ROLL see:
BEAN ROLLS
CLOTHES see:
GLOVE TO BE WORN WHILE EXAMINING
SLEEP MASK FOR DINING
SWEAT SHIRT
TRANSPARENT SUIT

GLOVE TO BE WORN WHILE EXAMINING

component of Silverman No. 117, ff.

...Fluxus 1 items of the type that may be included [in Fluxus 2] are:...Alison Knowles - glove...
[Fluxus Newsletter] unnumbered, [ca. March 1965].

COMMENTS: It was announced in the tentative plans for the first issues of FLUXUS that Alison Knowles would contribute "a glove" later "a glove (insert)" and eventually "A glove to be worn while examining (insert)" and another work, "Bats (drawing)." for FLUXUS NO. 1 U.S. ISSUE later called U.S. YEARBOOK and YEARBOX. see: COLLECTIVE.
Glove to be Worn While Examining is included in FLUX-US 1 (Silverman No. 117, ff.).

SCORES

COMMENTS: Alison Knowles' score "Shuffling Piece" is published in Fluxus Preview Review and her "Child Art Piece" appears in Fluxus Newspaper No. 1.

SHIT PORRIDGE

NEW YEAR EVE'S FLUX-FEAST, DEC. 31, 1969 AT CINEMATHEQUE, 80 WOOSTER ST....Alison Knowles: shit porridge...
Fluxnewsletter, January 8, 1970.

31.12.1969 NEW YEAR EVE'S FLUX - FEAST (FOOD EVENT)...Alison Knowles: shit porridge
George Maciunas, Diagram of Historical Developments of Fluxus... [1973].

COMMENTS: Shit Porridge was the hit of the New Year Eve's Flux Feast in 1969. The artist is a very good cook.

BRAD IVERSON

FLUX-PRODUCTS 1961 TO 1969 ... ALISON KNOWLES: Canned bean rolls, can containing rolled paper (all about beans) *[indicated as part of FLUX-KIT]
Fluxnewsletter, December 2, 1968 (revised March 15, 1969).

FLUXUS-EDITIONEN...[Catalogue no.] 759 ALI-

SON KNOWLES: bean rolls, (canned paper rolls) 1964
Happening & Fluxus. Koelnischer Kunstverein, 1970.

02.1964...ALISON KNOWLES: bean rolls
George Maciunas, Diagram of Historical Developments of Fluxus... [1973].

COMMENTS: Alison Knowles, 1986: "A first book - scrolled

SLEEPMASK FOR DINING

"... to produce the Flash Art FLUXPACK 3...Masks: sleepmask for dining by Alison Knowles..."
Letter: George Maciunas to Giancarlo Politi, n.d., reproduced in Fluxnewsletter, April 1973.

FURTHER PROPOSAL FOR FLUX - MAZE AT RENE BLOCK GALLERY, JANUARY 1975...Ideas should relate to passage through doors, steps, floor, obstacles, booths...blindfold food by Alison K.
George Maciunas, Plan for Flux-Maze, New York. [1974].

COMMENTS: Sleepmasks for Dining *were never made by George Maciunas as a Fluxus Edition. The work relates to a performance version of Knowles' "Identical Lunch."*

SWEAT SHIRT

FLUXUS 1964 EDITIONS, AVAILABLE NOW ... FLUXUS ppb [ALISON KNOWLES] SWEAT SHIRT $10
cc Valise e TRanglE (Fluxus Newspaper No. 3) March 1964.

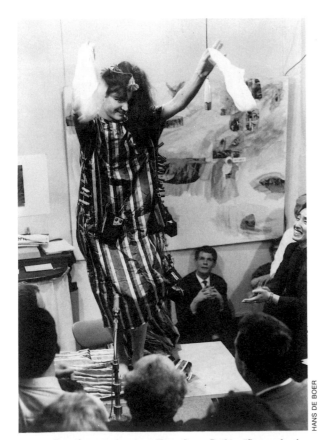

Alison Knowles, performing Nam June Paik's "Serenade for Alison." October 5, 1962 at Galerie Monet, Amsterdam

HANS DE BOER

F-ppb [as above]
European Mail-Orderhouse: europeanfluxshop, Pricelist. [ca. June 1964].

F-p [as above]
Second Pricelist - European Mail-Orderhouse. [Fall 1964].

...bathingsuits are going to be shown on the special fluxus fashion-shows next winter together with:...F-ppb Sweat Shirts of Alison Knowles
European Mail-Orderhouse, advertisement for clothes. [ca. 1964].

03.1964...ALISON KNOWLES: CLOTHING
George Maciunas, Diagram of Historical Developments of Fluxus... [1973].

COMMENTS: *Alison Knowles has made a number of sweatshirts, silk-screening various words or images on them. I don't know of any sweatshirts, made by Knowles, that were specifically distributed through Fluxus, and George Maciunas never produced a Knowles'sweatshirt as a Fluxus Edition. In 1963 a sweatshirt, and other garments such as stockings, a bra and dress were screened with one or more of the three images made by George Brecht, Alison Knowles and Robert Watts for the "Blink" show at the Rolf Nelson Gallery in Los Angeles.*

TRANSPARENT SUIT

FLUXUS 1964 EDITIONS, AVAILABLE NOW ... FLUXUS ppa [ALISON KNOWLES] TRANSPARENT SUIT $20
cc Valise e TRanglE (Fluxus Newspaper No. 3) March 1964.

F-ppa [as above]
European Mail-Orderhouse: europeanfluxshop, Pricelist. [ca. June 1964].

F-p [as above]
Second Pricelist - European Mail-Orderhouse. [Fall 1964].

...bathingsuits are going to be shown on the special fluxus fashion-shows next winter together with:... FLUXUS ppa Transparent Suits...of Alison Knowles
European Mail-Orderhouse, advertisement for clothes, [ca. 1964].

03.1964...A.KNOWLES: CLOTHING
George Maciunas, Diagram of Historical Developments of Fluxus... [1973].

COMMENTS: Transparent Suit *might have been an Emperor's clothes fashion pun, or it could have been actual transparent material made up into clothes. In the mid 1960s, Robert Watts made a transparent feather dress for Lette Eisenhauer and pop designers started rocking the fashion world with see-through clothes. And in the 1970s, topless bathingsuits became popular. The work was never made by George Maciunas as a Fluxus Edition.*

MICHAEL KOENIG

It was announced in the first tentative plans for FLUXUS that M. Koenig would edit an "Anthology of Electronic Music (record & comment) Stockhausen, Eimert, Koenig, Kagel, Boemer, etc." for FLUXUS NO. 2 WEST EUROPEAN ISSUE I. In subsequent plans, the anthology was dropped and he was to contribute "Automation in electronic music production" to FLUXUS NO.2 WEST EUROPEAN YEARBOOK I, later called FLUXUS NO. 3 GERMAN & SCANDINAVIAN YEARBOX.
see: COLLECTIVE

ARTHUR KOEPCKE

It was announced in the Brochure Prospectus, version B, that Arthur Koepcke would edit "collected visuals" and contribute "works [and] compositions" to FLUXUS NO. 3 GERMAN & SCANDINAVIAN YEARBOX. An untitled 1963 composition was published in Fluxus Preview Review, *and a visual work was published in Fluxus Newspaper No. 1.*
see: COLLECTIVE

BOOK see:
TREATMENTS

CHESSMATES

AK-dm ARTHUR KOEPCKE "chessmates" (picture riddle) painted, colored $50 and up.
Second Pricelist - European Mail-Orderhouse. [Fall 1964].

FLUXUS w2 ARTHUR KOEPCKE "chessmates" [as above]
Vacuum TRapEzoid (Fluxus Newspaper No. 5) March 1965.

COMMENTS: *Chessmates are original drawings, collages and paintings involving elements of chess and riddles. Each work*

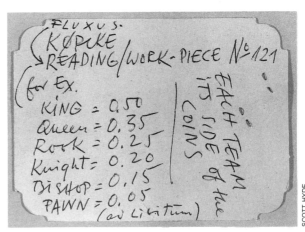

SCOTT HYDE

Arthur Koepcke. CHESSMATES. Proposal to George Maciunas for a Fluxus Edition of the work

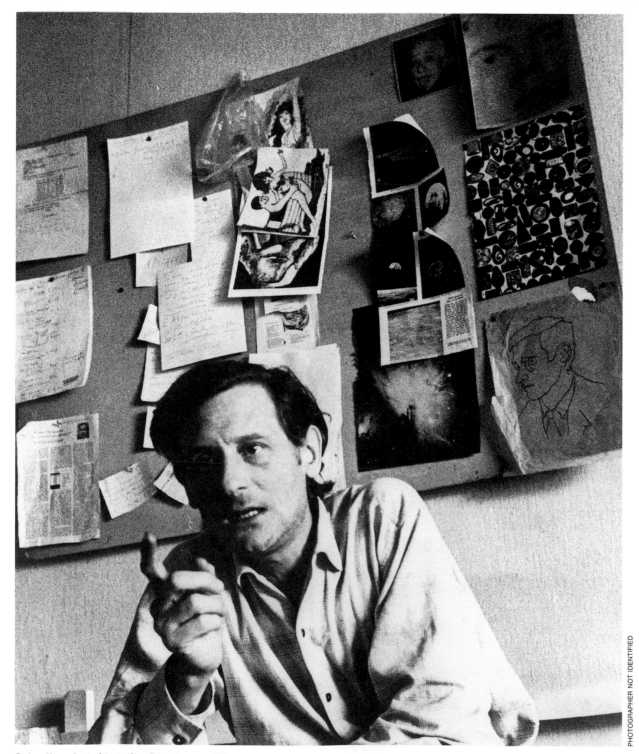

Arthur Koepcke in his studio. Copenhagen. 1965

PHOTOGRAPHER NOT IDENTIFIED

was unique, made by the artist and offered for sale through Fluxus.

COPENHAGEN ELE MELE MINK MANG

AK-dq ARTHUR KOEPCKE: films: --copenhagen ele mele mink mang (60 meters/ 15 minutes) $35...
Second Pricelist - European Mail-Orderhouse. [Fall 1964].

FLUXUS wa ARTHUR KOEPCKE: films copenhagen ele mele mink mang, 15 min. [$] 35...
Vacuum TRapEzoid (Fluxus Newspaper No. 5) March 1965.

COMMENTS: Copenhagen Ele Mele Mink Mang, *titled after a children's song, is a film made by Arthur Koepcke and offered for sale through Fluxus. It was never included in the* Fluxfilms *package.*

THE DOG
Silverman No. < 216.VI

Ak-dq ARTHUR KOEPCKE: films:...--the dog (15 meters/ 3 minutes) $12...
Second Pricelist - European Mail-Orderhouse. [Fall 1964].

FLUXUS wa ARTHUR KOEPCKE: films...the dog, 3 min. $12...
Vacuum TRapEzoid (Fluxus Newspaper No. 5) March 1965.

COMMENTS: The Dog, *a film made by Arthur Koepcke, was offered for sale through Fluxus, but was not included in the* Fluxfilms *package.*

ESSAYS, NOVELS, TALES

AK-dp ARTHUR KOEPCKE: essays, novels, tales. german language, danish $5
Second Pricelist - European Mail-Orderhouse. [Fall 1964].

FLUXUS w5 ARTHUR KOEPCKE: essays, novels, tales. in german and danish, $5
Vacuum TRapEzoid (Fluxus Newspaper No. 5) March 1965.

COMMENTS: Essays, Novels, Tales *are just that. One, titled "The New Reality" was published in* North, *No. 7/8, 1979. However none were ever published by Fluxus.*

FILL: WITH OWN IMAGINATION see:
SURPRISES, CHEERUPS, SUMMONS

FILM

AK-dq ARTHUR KOEPCKE: films:...--film (15 meters/ 3 minutes) $12...
Second Pricelist - European Mail-Orderhouse. [Fall 1964].

FLUXUS wa ARTHUR KOEPCKE: films:... film, 3 min. $12...
Vacuum TRapEzoid (Fluxus Newspaper No. 5) March 1965.

Arthur Koepcke. REBUS

NANCY ANELLO

Arthur Koepcke. SAMPLE WITH NO VALUE

NANCY ANELLO

COMMENTS: Film *is not known to have been distributed by Fluxus, and is not included in the* Fluxfilms *package.*

FILM see:
 COPENHAGEN ELE MELE MINK MANG

THE DOG
PARIS IN CROSS-STITCHES

PARIS IN CROSS-STITCHES

AK-dq ARTHUR KOEPCKE: films:-- paris in cross-

stitchs (15 meters/ 3 minutes) $12.
Second Pricelist - European Mail-Orderhouse. [Fall 1964].

FLUXUS wa ARTHUR KOEPCKE: films:...paris in cross-stitchs, 3 min. $12
Vacuum TRapEzoid (Fluxus Newspaper No. 5) March 1965.

NANCY ANELLO

NANCY ANELLO

Arthur Koepcke. SURPRISES, CHEERUPS, SUMMONS. This example was assembled by Willem de Ridder for the European Fluxshop

COMMENTS: *Perhaps made by Koepcke,* Paris in Cross Stitches *was not known to have been distributed by Fluxus and was not included in the* Fluxfilms *package.*

PICTURE RIDDLES see:
CHESSMATES
REBUS
SAMPLES WITH NO VALUE

POI-POI BEER see:
Robert Filliou and Arthur Koepcke

REBUS
Silverman No. < 216.V

AK-dl ARTHUR KOEPCKE "rebus" (picture - riddle)

painted, colored. $50 and up
Second Pricelist - European Mail-Orderhouse. [Fall 1964].

FLUXUS wl [as above]
Vacuum TRapEzoid (Fluxus Newspaper No. 5) March 1965.

COMMENTS: *Addi Koepcke painted a number of rebuses, each was a unique painting or drawing. A person ordering one through Fluxus would receive a* Rebus *commensurate with the price paid. Unique pieces seemed to be a contradiction to the Fluxus idea of cheap mass-producible art. Koepcke worked quickly and produced a large body of work. He could churn them out, so although they were unique paintings, it was still the idea of an art acessible to everybody.*

SAMPLE WITH NO VALUE
Silverman No. < 216.IV

AK-do ARTHUR KOEPCKE "samples with no value" painted, colored. $50 and up.
Second Pricelist - European Mail-Orderhouse. [Fall 1964].

FLUXUS w4 [as above]
Vacuum TRapEzoid (Fluxus Newspaper No. 5) March 1965.

COMMENTS: *Like* Rebus, Sample With No Value *were unique works. Addi Koepcke also made a rubber stamp with the same title, which he used indiscriminately.*

SURPRISES, CHEERUPS, SUMMONS
Silverman No. < 216.II, ff.

AK-dr [ARTHUR KOEPCKE] surprises, cheerups, summons $2
Second Pricelist - European Mail-Orderhouse. [Fall 1964].

FLUXUS w6 [as above]
Vacuum TRapEzoid (Fluxus Newspaper No. 5) March 1965.

NANCY ANELLO

Arthur Koepcke made this box, collaging part of his label on a Maciunas designed Fluxus label. Empty, the box was perhaps intended for SURPRISES, CHEERUPS, SUMMONS

COMMENTS: *I've determined that Koepcke's rubber stamp, "fill: with own imagination" is part of* Surprises, Cheerups, Summons. *What you could receive is almost anything. The examples that I've seen were realized by Willem de Ridder and were everyday or found objects with the rubber stamp associated with the work in some way.*

TREATMENTS
Silverman No. < 216.I, ff.

AK-dn ARTHUR KOEPCKE "treatments" books $20
Second Pricelist - European Mail-Orderhouse. [Fall 1964].

BRAD IVERSON

Arthur Koepcke. Three versions of TREATMENTS. see color portfolio

FLUXUS w3 ARTHUR KOEPCKE: "treatments"
book $20
Vacuum TRapEzoid (Fluxus Newspaper No. 5) March 1965.

COMMENTS: Koepcke's Treatments were books attacked in a variety of ways, sometimes by glueing the pages together, sometimes by inserting three-dimensional objects between the pages. He also used his Treatments label on other objects, such as an empty beer bottle - in this case the "treatment" was drinking the beer.

FUMIO KOIZUMI

It was announced in the tentative plans for the first issues of FLUXUS that Fumio Koizumi would contribute "Cosmology of Indian Music, ('Musical' Study of Indian Music)" to FLUXUS NO. 4 (later called FLUXUS NO. 5) HOMAGE TO THE PAST.
see: COLLECTIVE

TAKEHISA KOSUGI

EVENTS
Silverman No. 218, ff.

FLUXUS 1963 EDITIONS, AVAILABLE NOW FROM FLUXUS P.O. Box 180, New York 10013, N.Y. or FLUXUS 359 Canal St. New York. CO 7-9198 ...FLUXUSr TAKEHISA KOSUGI: events in wd. box $2
Film Culture No. 30, Fall 1963.

"...We have now...complete works of Kosugi..."
Letter: George Maciunas to Willem de Ridder, December 20, 1963.

FLUXUS 1963 EDITIONS, AVAILABLE NOW... FLUXUS r TAKEHISA KOSUGI: events in wd. box $2
cc V TRE (Fluxus Newspaper No. 1) January 1964.

[as above]
cc V TRE (Fluxus Newspaper No. 2) February 1964.

FLUXUS 1964 EDITIONS, AVAILABLE NOW... FLUXUS r TAKEHISA KOSUGI: events in box $2
cc Valise e TRanglE (Fluxus Newspaper No. 3) March 1964.

FLUXKIT containing following fluxus-publications: (also available separately) FLUXUS r TAKEHISA KOSUGI: events in wd. box $2...
cc fiVe ThReE (Fluxus Newspaper No. 4) June 1964.

F-r TAKEHISA KOSUGI: events in box $2
European Mail-Orderhouse: europeanfluxshop, Pricelist. [ca. June 1964].

F-r TAKEHISA KOSUGI: events in box $2
Second Pricelist - European Mail-Orderhouse. [Fall 1964].

FLUXKIT containing following flux-publications... events in wood box...of takehisa kosugi
ibid.

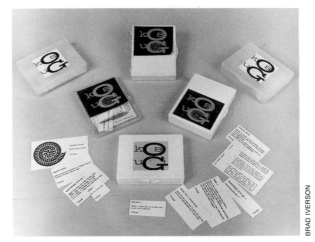

Takehisa Kosugi. EVENTS. see color portfolio

BRAD IVERSON

"...There are not too many new pieces that you do not know, You have complete set of:...Takehisa Kosugi — you have the boxes? let me know what you have."
Letter: George Maciunas to Ben Vautier, February 1, 1965.

"Replies to your questions...Anima 1, Malika 5, Ear drum events — go into Kosugi box, you have more of Kosugi cards....P.S. You should print labels for...Kosugi box - reproduce my labels I am sending a few of them. But I do not have enough of them..."
Letter: George Maciunas to Willem de Ridder, March 2, 1965.

FLUXKIT containing following fluxus-publications: (also available separately)...FLUXUS r TAKEHISA KOSUGI: events in box $2
Vacuum TRapEzoid (Fluxus Newspaper No. 5) March 1965.

FLUXKIT containing following fluxus-publications: (also available separately)...FLUXUS r TAKEHISA KOSUGI events in box $4
Vaseline sTREet (Fluxus Newspaper No. 8) May 1966.

FLUX-PRODUCTS 1961 TO 1969 ... TAKEHISA KOSUGI Events, cards in box, (out of print)
Fluxnewsletter, December 2, 1968 (revised March 15, 1969).

FLUXUS-EDITIONEN...[Catalogue no.] 760 TAKEHISA KOSUGI: pieces, cards in box, 1964
Happening & Fluxus. Koelnischer Kunstverein, 1970.

COMMENTS: Events is a Fluxus Edition of collected scores by Kosugi. Two scores, "Micro I" and "Anima I" first appeared in Fluxus Preview Review, and "Chironomy 1" was published in Fluxus Newspaper No. 1, January 1964. George Maciunas had wanted to make boxed collections of scores or events by a number of the Fluxus artists - with the idea that as new works were published, they could be added to the box.

THEATRE MUSIC
Silverman No. 217, ff.

FLUXKIT containing following fluxus-publications: (also available separately) FLUXUS r...TAKEHISA KOSUGI: Theatre music, performed on handmade Japanese paper, $1
cc fiVe ThReE (Fluxus Newspaper No. 4) June 1964.

FLUXKIT containing the following flux-publications: ...theatre music, performed on handmade japanese paper of Takehisa Kosugi
Second Pricelist - European Mail-Orderhouse. [Fall 1964].

COMMENTS: Offered for sale as an individual Fluxus Edition, the graphic realization of Theatre Music was also included in most copies of FLUXUS 1 and some examples of Fluxkit. The score for Theatre Music was included in FLUXUS 1, reproduced in Fluxus Newspaper No. 2, February 1964, and in Kosugi's Events box.

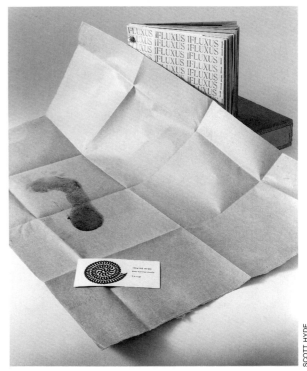

SCOTT HYDE

Takehisa Kosugi. THEATRE MUSIC. This example is contained in FLUXUS 1

HARRY KRAMER

It was announced in the Brochure Prospectus, version B, that Harry Kramer would contribute "Kinetics" to FLUXUS NO. 3 GERMAN & SCANDINAVIAN YEARBOX.
see: COLLECTIVE

RUTH KRAUSS

A poem, "Weather" by Ruth Krauss, with a graphic illustration, was published in Fluxus Newspaper No. 1. Two poems, a different "Weather" and one untitled, were published in Fluxus Newspaper No. 2.

PHILIP KRUMM

"List," a poem by Philip Krumm was published in Fluxus Newspaper No. 1.

SHIGEKO KUBOTA

CALENDAR PLAYING CARDS

"...Would you design a playing card set? We have now 5 card sets which we will have manufactured by real card manufacturer. [...Kubota,...]..."
Letter: George Maciunas to Ben Vautier, January 10, 1966.

...will appear late in 1966...FLUXUS oi SHIGEKO KUBOTA, deck of circular playing cards and calender [sic] $8
Vaseline sTREet (Fluxus Newspaper No. 8) May 1966.

FLUX-PROJECTS PLANNED FOR 1967...Shigeko Kubota: calender - playing [sic] cards (circular)
Fluxnewsletter, March 8, 1967.

COMMENTS: *This work was never produced by George Maciunas as a Fluxus Edition.*

Shigeko Kubota, 1964

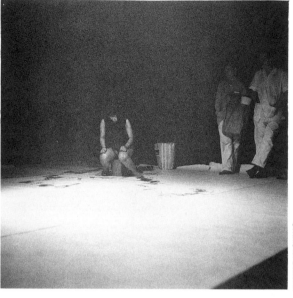

Shigeko Kubota performing her "Vagina Painting," July 4, 1965 at the Perpetual Fluxus Festival in New York City

FLUX MEDICINE
Silverman No. 221, ff.

FLUXKIT containing following fluxus-publications: (also available separately) FLUXUSo SHIGEKO KUBOTA: fluxmedicines $4
Vaseline sTREet (Fluxus Newspaper No. 8) May 1966.

PAST FLUX-PROJECTS (realized in 1966)...Fluxmedicine, anonymous...
Fluxnewsletter, March 8, 1967.

fluxmedicine $4.50
Fluxshopnews. [Spring 1967].

FLUX-PRODUCTS 1961 TO 1969 ... SHIGEKO KUBOTA...Flux medicine, (empty capsules, vials, wrappers etc.) boxed * [indicated as part of FLUX-KIT] [$] 6
Fluxnewsletter, December 2, 1968 (revised March 15, 1969).

FLUX-PRODUCTS 1961 TO 1970 ... SHIGEKO KUBOTA...Flux-medicine, empty capsules, etc. boxed [$] 6
Flux Fest Kit 2. [ca. December 1969].

FLUXUS-EDITIONEN...[Catalogue no.] 762 SHIGEKO KUBOTA: flux-medicine, boxed
Happening & Fluxus. Koelnischer Kunstverein, 1970.

05.1966 SHIGEKO KUBOTA: medicines
George Maciunas, Diagram of Historical Developments of Fluxus... [1973].

SHIGEKO KUBOTA...Flux medicine, empty cap-

sules etc. boxed $14
Flux Objects, Price List. May 1976.

COMMENTS: *The Fluxus Edition of Kubota's* Flux Medicine *is a reflection of Maciunas' own obsession with medicine.* Flux Medicine *is frequently a packaging of remains from the medicines that Maciunas was taking at the time. George Maciunas did a work in 1964 titled* Mystery Medicine. *It is not clear whether* Flux Medicine *just evolved from* Mystery Medicine *with a change of authorship, or if it is a totally different concept.*

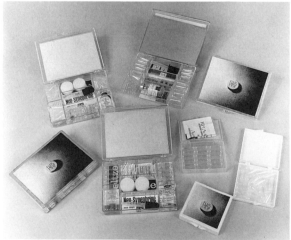

Shigeko Kubota. FLUX MEDICINE. see color portfolio

FLUX NAPKINS

Silverman No. 228, ff.

...Fluxus 1 items of the type that may be included [in Fluxus 2] are:...Shigeko Kubota - dinner napkin...
[Fluxus Newsletter], unnumbered, [ca. March 1965].

FLUXKIT containing following fluxus-publications: (also available separately) FLUXUSoo SHIGEKO KUBOTA: set of napkins $1
Vaseline sTREet (Fluxus Newspaper No. 8) May 1966.

PAST FLUX-PROJECTS (realized in 1966)...Flux-napkins by Shigeko Kubota...
Fluxnewsletter, March 8, 1967.

IMPLOSIONS INC. PROJECTS...Triple partnership was formed between Bob Watts, Herman Fine and myself [George Maciunas] to introduce into mass market ...money producing products...This business will be operated in commercial manner, with intent to make profits...connection between Fluxus collective and Implosions Inc. has not been clarified yet...we could consider at present Fluxus to be a kind of division or subsidiary of Implosions. Projects to be realized through Implosions:...Disposable paper...napkins,...
ibid.

flux napkins $3 by shigeko kubota
Fluxshopnews. [Spring 1967].

NEWS FROM IMPLOSIONS, INC. Various items ... Planned in 1968:...Disposable...napkins,...ready for production.
Fluxnewsletter, January 31, 1968.

FLUX-PRODUCTS 1961 TO 1969 ... SHIGEKO KUBOTA Flux napkins, set of 4 napkins with printed eyes or lips, noses, boxed * [indicated as part of FLUXKIT] [$] 4...
Fluxnewsletter, December 2, 1968 (revised March 15, 1969).

FLUX-PRODUCTS 1961 TO 1970 ... SHIGEKO KUBOTA Flux-napkins, boxed [$] 4...
Flux Fest Kit 2. [ca. December 1969].

FLUXUS-EDITIONEN...[Catalogue no.] 761 SHIGEKO KUBOTA: flux-napkins, boxed
Happening & Fluxus. Koelnischer Kunstverein, 1970.

PROPOSED CONTENTS FOR FLUXPACK 3 TO BE PUBLISHED IN 1973 BY FLASH ART...Napkins face parts by Shigeko Kubota...100 copies signed by: ...Kubota...
[George Maciunas], Proposed Contents for Fluxpack 3. [ca. 1972].

Flash Art editor, Giancarlo Politi, proposed to publish the 3rd Fluxyearbook, maybe to be called FLUX-PACK 3, with the following preliminary contents:

Shigeko Kubota. FLUX NAPKINS as it appears in FLUXUS 1

Household items:...napkins (face parts by Shigeko Kubota)...
Fluxnewsletter, April 1973.

03.1967 KUBOTA: collage napkins
George Maciunas, Diagram of Historical Developments of Fluxus... [1973].

SHIGEKO KUBOTA Flux napkins, boxed $8...
Flux Objects, Price List. May 1976.

COMMENTS: *Titled "Napkin For Next Supper," Flux Napkins first appears anonymously in FLUXUS 1 (Silverman No. 117, ff.) packaged in a manila envelope, and bolted into the anthology. Later, the work is packaged three or four to a plastic box with a Maciunas designed label.*

Shigeko Kubota. FLUX NAPKINS. Label designed by George Maciunas for the Fluxus Edition

HI RED CENTER

hi red center $1...by shigeko kubota
Fluxshopnews. [Spring 1967].

COMMENTS: *Hi Red Center, a newspaper-like Fluxus publication, was edited by Shigeko Kubota. Its proper title is Bundle of Events. See the Hi Red Center section for its complete listing.*

SURGICAL KIT

...will appear late in 1966...FLUXUSoi SHIGEKO KUBOTA: surgical kit, human rubber body consisting of inflatable lungs, heart, stomach, intestines; with surgical instruments and rubber repair supplies. in partitioned case $300
Vaseline sTREet (Fluxus Newspaper No. 8) May 1966.

COMMENTS: *Surgical Kit was never produced by George Maciunas as a Fluxus Edition.*

JEAN CLARENCE LAMBERT

It was announced in the Brochure Prospectus, version B, that J.C. Lambert would contribute "ALEA poesie, Liste Aleatoire" and edit "F" for FLUXUS NO. 2 FRENCH YEAR-BOOK-BOX.
see: COLLECTIVE

GEORGE LANDOW

ARE ERA

OTHER NEW FLUXUS ITEMS AVAILABLE IN FLUXSHOP OR BY MAIL...FLUXUS n films, movies, services by FLUXUS t series - movies by GEORGE LANDOW FLUXUS tak ARE ERA, 3 min. 8mm $50
cc fiVe ThReE (Fluxus Newspaper No. 4) June 1964.

FL-n films, movies, services by GEORGE LANDOW FL-tak ARE ERA, 3 min. 8 mm $50
Second Pricelist - European Mail-Orderhouse. [Fall 1964].

FLUXUS t series - movies by GEORGE LANDOW FLUXUS tak ARE ERA, 3 min. 8mm $50
Vacuum TRapEzoid (Fluxus Newspaper No. 5) March 1965.

COMMENTS: *In 1964 and 65, Fluxus production was being expanded in many different directions. Before 1964, there was an interest in film, but the primary intention was to include articles on film in various issues of the proposed Fluxus Yearboxes, and actual films in the "Luxus Fluxus" deluxe editions. With the expanded product line - individual Fluxus*

Editions by many different artists - it was natural that George Maciunas would figure out methods of packaging inexpensive films for sale. By 1966, Fluxus had produced a short and long version of Fluxfilms. Are Era *is not included in the* Fluxfilms *package.*

THE EVIL FAERIE

Silverman No. < 232.101

FLUXFILMS SHORT VERSION, 40 MIN at 24 FRAMES/SEC. 1400FT. ... flux-number 25 George Landow THE EVIL........ 0'30''
Fluxfilms catalogue. [ca. 1966].

PAST FLUX-PROJECTS (realized in 1966) ... Flux-films: total package: 1 hr.40 min....no.25 by George Landow...
Fluxnewsletter, March 8, 1967.

FLUX-PRODUCTS 1961 TO 1969...FLUXFILMS, short version Summer 1966 40 min. 1400ft.:...[including] The Evil...by George Landow,... 16 mm [$] 180 8mm version [$] 50
Fluxnewsletter, December 2, 1968 (revised March 15, 1969).

FLUX-PRODUCTS 1961 TO 1970...[as above]
Flux Fest Kit 2. [ca. December 1969].

COMMENTS: The Evil Faerie, *Fluxfilm No. 25, is a 30 second film included in both the short and long versions of the* Fluxfilms *package.*

FLEMING FALOON

OTHER NEW FLUXUS ITEMS AVAILABLE IN FLUXSHOP OR BY MAIL...FLUXUS n films, movies, services by FLUXUS t series - movies by GEORGE LANDOW...FLUXUS tok FLEMING FALOON, 10 min. 16mm color, with sound $150
cc fiVe ThReE (Fluxus Newspaper No. 4) June 1964.

FL-n films, movies, services by GEORGE LANDOW ...FL-tok FLAMING FALOON, 10 min. 16 mm. color with/sound $150
Second Pricelist - European Mail-Orderhouse. [Fall 1964].

FLUXUS t series - movies by GEORGE LANDOW... FLUXUS tok FLEMING FALOON,10 min. 16 mm color, with sound $150
Vacuum TRapEzoid (Fluxus Newspaper No. 5) March 1965.

COMMENTS: Fleming Faloon *is not included in the* Fluxfilm *package, and it is very doubtful that any prints were sold because of its high price.*

HOME MOVIES

OTHER NEW FLUXUS ITEMS AVAILABLE IN FLUXSHOP OR BY MAIL...FLUXUS n films, movies, services by FLUXUS t series - movies by GEORGE

LANDOW...FLUXUS tuk home movies made to order.
cc fiVe ThReE (Fluxus Newspaper No. 4) June 1964.

FL-n films, movies, services by GEORGE LANDOW ...FL-tuk home movies made to order
Second Pricelist - European Mail-Orderhouse. [Fall 1964].

FLUXUS t series - movies by GEORGE LANDOW ...FLUXUS tuk home movies made to order
Vacuum TRapEzoid (Fluxus Newspaper No. 5) March 1965.

COMMENTS: Home Movies *were special order items. There is not evidence that anyone ever ordered one.*

INFECTIONS

OTHER NEW FLUXUS ITEMS AVAILABLE IN FLUXSHOP OR BY MAIL...FLUXUS n films, movies, services by FLUXUS t series - movies by GEORGE LANDOW...FLUXUS tik INFECTIONS, loops 8mm, each $10
cc fiVe ThReE (Fluxus Newspaper No. 4) June 1964.

FL-n films, movies, services by GEORGE LANDOW ...FL-tik INFECTIONS, loops 8 mm, each $10
Second Pricelist - European Mail-Orderhouse. [Fall 1964].

FLUXUS t series - movies by GEORGE LANDOW... FLUXUS tik...INFECTIONS, loop 8 mm $10
Vacuum TRapEzoid (Fluxus Newspaper No. 5) March 1965.

COMMENTS: Infections, *a loop film, is not included with the loop films in* Flux Year Box 2, *which was produced a few years after* Infections *was first advertised.*

RICHARD KRAFT AT THE PLAYBOY CLUB

OTHER NEW FLUXUS ITEMS AVAILABLE IN FLUXSHOP OR BY MAIL... FLUXUS n films, movies, services by FLUXUS t series - movies by GEORGE LANDOW...FLUXUS tek Richard Kraft at the Playboy Club, 1.5 minutes, 8mm $45
cc fiVe ThReE (Fluxus Newspaper No. 4) June 1964.

FL-n films, movies, services by GEORGE LANDOW ...FL-tek Richard Kraft at the Playboy Club 1.5 minutes, 8 mm $45
Second Pricelist - European Mail-Orderhouse. [Fall 1964].

FLUXUS t series - movies by GEORGE LANDOW... FLUXUS tek Richard Kraft at the Playboy Club, 1.5 minutes, 8 mm $45
Vacuum TRapEzoid (Fluxus Newspaper No. 5) March 1965.

COMMENTS: Richard Kraft at The Playboy Club *was probably just that. All mention of the film is dropped after March 1965, and it is not included in any of the collective Fluxus film groupings.*

DAN LAUFFER

TURN ON YOUR LOVE LIGHT
Silverman No. < 232.201

lovelight $5 by dan laufer [sic]
Fluxshopnews. [Spring 1967].

FLUX-PROJECTS PLANNED FOR 1967 ... Dan Laufer [sic] : Lovelight (boxed device)
Fluxnewsletter, March 8, 1967.

FLUXPROJECTS FOR 1968 (In order of priority)... 3. Boxed events & objects (all ready for production) ...Dan Laufer [sic] — Lovelight...
Fluxnewsletter, January 31, 1968.

FLUX-PRODUCTS 1961 TO 1969...DAN LAUFER [sic] Lovelight, 110V. boxed [$] 6
Fluxnewsletter, December 2, 1968 (revised March 15, 1969).

FLUX-PRODUCTS 1961 TO 1970...DAN LAUFER [sic] Lovelight, electric, boxed [$] 8
Flux Fest Kit 2. [ca. December 1969].

"...laufer [sic] lovelight is made up on order, $10..."
Letter: George Maciunas to Dr. Hanns Sohm, [ca. late 1972].

COMMENTS: As well as the artist-made prototype, George Maciunas designed and printed labels and made at least one as

Dan Lauffer. TURN ON YOUR LOVE LIGHT. Mechanical by George Maciunas for the label

Dan Lauffer. TURN ON YOUR LOVE LIGHT. Prototype box with instructions

SCOTT HYDE

a Fluxus Edition. A spoof on the psychedelic head-shop, aphrodesiac paraphernalia, the instructions that were to go on the work read as follows:
"WARNING
This box contains one LOVE LIGHT. It is factory tested and in working order. Please DO NOT turn it on to see if it is working (there might be someone else in the room). NEVER turn on yr. LOVE LIGHT unless you REALLY mean it!
While all the alleged aphrodesiac powers of LOVE LIGHT are highly exaggerated, we cannot be responsible if it is turned on with a large group present (unless you like that sort of thing). We repeat, NEVER turn on yr. LOVE LIGHT unless you REALLY mean it.
Dan Lauffer."
Lauffer's only other association with Fluxus products is a

text on three aspects of a performance event, printed in Flux Fest Kit 2.

JOHN LENNON

BINOCULARS see:
MAGNIFICATION PIECE

BOILING WATER IN TANK TOILET

Toilet No. 6, collective...Toilet bowl display - Boiling water (John Lennon)
Fluxnewsletter, April 1973.

1970-1971 FLUX-TOILET:...LENNON: boiling water in tank.
George Maciunas, Diagram of Historical Developments of Fluxus... [1973].

COMMENTS: Boiling Water in Tank Toilet *was never realized as part of a Flux-Toilet.*

CHANGE MACHINE see:
METAL SLUG DISPENSER

DO NOT DISTURB

MAY 2-8: BLUE ROOM BY JOHN & YOKO + FLUX-LIARS...Entire room (floor, walls, ceiling), exterior (door and window), interior furnishings to be white... Other interior signs:...Do not disturb (J. Lennon 1970)...

Schedule of events for Fluxfest presentation of John Lennon and Yoko Ono. [ca. April 1970]. version A

[as above]
Schedule of events for Fluxfest presentation of John Lennon and Yoko Ono. [ca. April 1970]. version B

FLUXFEST PRESENTATION OF JOHN LENNON & YOKO ONO +* AT 80 WOOSTER ST. NEW YORK — 1970...MAY 2-8 BLUE ROOM BY JOHN & YOKO + FLUXLIARS Entire room (floor, walls, ceiling), and furnishings were white...interior sign: Do not disturb (John Lennon '70)...
all photographs copyright nineteen seVenty by peTer mooRE (Fluxus Newspaper No.9) 1970.

COMMENTS: *A very concrete sign in the spirit of George Brecht's* Exit *or* No Smoking *signs,* Do Not Disturb *is a reflection of Lennon's desire for privacy.*

DRY SPONGE see:
John Lennon and Yoko Ono

EDIBLE CLOTHING FASHION

FOOD EVENTS, SUN...AUG. 20 & 21: Edible clothing fashion by John Lennon
Proposal for Flux Fest at New Marlborough. April 8, 1977.

COMMENTS: *Either an idea of Maciunas' assigned to Lennon, or an offhanded idea of Lennon's, the Flux Fest at New Marlborough that* Edible Clothing Fashion *was intended for did not take place. In the 1960s, disposable clothing was popular. Wear it once and throw it away. In that same period, kinky undergarments were available, such as edible panties.*

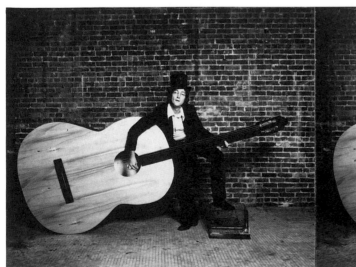
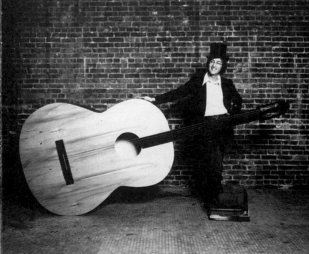
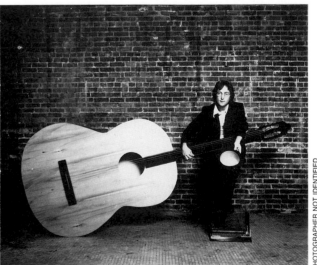

PHOTOGRAPHER NOT IDENTIFIED

John Lennon with his BABY GRAND GUITAR FOR YOKO. 1971

Lennon would have liked the idea of eating the clothes off a woman. There is also an undercurrent in this piece to Yoko Ono's Cut Piece *from the 1960s where she sits on the stage with a pair of scissors and the audience is invited to come and cut her clothes.*

FLUX-TOILET see:
BOILING WATER IN TANK TOILET
WET PAINT SIGN

FLUXTOUR TICKETS see:
ROUNDTRIP TICKET BY AIR TO FORT CHIMO, HUDSON STRAIT
ROUNDTRIP TICKET BY AIR TO GOOSE BAY, LABRADOR
TICKETS FOR SKYTOURS
TICKETS TO ABANDONED BUILDINGS
TICKETS TO A CHINESE THEATRE
TICKETS TO CORTLAND ALLEY
TICKETS TO DESOLATE PLACES
TICKETS TO DISTANT PLACES
TICKETS TO MISERABLE SHOWS
TICKETS TO NARROW STREETS
TICKETS TO STREET CORNERS
TICKETS TO UNKNOWN PLACES

FOOD see:
EDIBLE CLOTHING FASHION

4 SPOONS

MAY 2-8: BLUE ROOM BY JOHN & YOKO + FLUX-LIARS...Entire room (floor, walls, ceiling), exterior (door and window), interior furnishings to be white... WINDOW DISPLAY: 2 sets of 4 spoons in the shop window, one set with sign: 3 spoons, Yoko Ono, 1967, another with sign: 4 spoons, John Lennon 1970. Balance of unused window painted white.
Schedule of events for Fluxfest presentation of John Lennon and Yoko Ono. [ca. April 1970]. version A

MAY 2-8:...Window display: 2 sets of 4 spoons, one set with sign: 3 spoons (Yoko Ono '67), and another with sign: 4 spoons (John Lennon, 1970)
Schedule of events for Fluxfest presentation of John Lennon and Yoko Ono. [ca. April 1970]. version B

FLUXFEST PRESENTATION OF JOHN LENNON & YOKO ONO +* AT 80 WOOSTER ST. NEW YORK — 1970...MAY 2-8 BLUE ROOM BY JOHN & YO-KO +FLUXLIARS Entire room (floor, walls, ceiling), and furnishings were white...window display: set of 4 spoons with sign: 3 spoons (Yoko Ono '67)...another set of 4 spoons with sign: 4 spoons (John Lennon '70)
all photographs copyright nineteen seVenty by peTer mooRE (Fluxus Newspaper No.9) 1970.

COMMENTS: *4 Spoons was a response to Yoko Ono's 3*

John Lennon. 4 SPOONS. Realization made for Yoko Ono's "This Is Not Here" exhibition at the Everson Museum. 1971

Spoons from 1967. In this Fluxus context, the two works were exhibited together. A number of ideas from the "Flux-fest Presentation of John Lennon & Yoko Ono," including this one, were reused in October 1971, in Ono's one-woman show at the Everson Museum.

MAGNIFICATION PIECE
Silverman No. > 232.II

COMMENTS: *In drawer No. 1 of the* Fluxus Cabinet *assembled in 1977 by George Maciunas is an untitled work referred to in his notes as "'binoculars' [by] Jean Dupuy and John Lennon each independently." Both artists had been working with magnification, Dupuy with refraction and Lennon with kinetiscopes. "Binoculars" is clearly a Maciunas interpretation of the artist's work.*

John Lennon. MAGNIFICATION PIECE. Instruction drawing by George Maciunas for a realization of the work

John Lennon. MAGNIFICATION PIECE in FLUX CABINET

The work as seen from underneath

John Lennon. PIECE FOR GEORGE MACIUNAS WHO CAN'T DISTINGUISH BETWEEN THESE COLORS

NANCY ANELLO

(door and window), interior furnishings to be white... A standing needle somewhere in the room with sign: Forget it. Another one with sign: Needle, John Lennon 1970.
Schedule of events for Fluxfest presentation of John Lennon and Yoko Ono. [ca. April 1970]. version A

MAY 2-8:...an upright needle with sign: Forget it. (Yoko Ono) another one with sign: Needle (John Lennon, 1970)...
Schedule of events for Fluxfest presentation of John Lennon and Yoko Ono. [ca. April 1970]. version B

FLUXFEST PRESENTATION OF JOHN LENNON & YOKO ONO+* AT 80 WOOSTER ST. NEW YORK — 1970...MAY 2-8 BLUE ROOM BY JOHN & YO-KO +FLUXLIARS Entire room (floor, walls, ceiling), and furnishings were white...an upright needle with sign: Forget it. (Yoko Ono)...another one with sign: Needle (John Lennon, 1970)...
all photographs copyright nineteen seVenty by peTer mooRE (Fluxus Newspaper No.9) 1970.

COMMENTS: *Needle is another relational response to a piece by Yoko Ono. Both works are needles, but the text on the signs in front of them indicate a different attitude, one metaphoric and one literal. These works were also included in the 'dialogue section' of Ono's Everson Museum exhibition, in 1971.*

PAINT SET see:
PIECE FOR GEORGE MACIUNAS WHO CAN'T DISTINGUISH BETWEEN THESE COLORS

PIECE FOR GEORGE MACIUNAS WHO CAN'T DISTINGUISH BETWEEN THESE COLORS

Silverman No. > 232.I

COMMENTS: *Although never advertised or listed in the publications, at least two Fluxus examples of this work exist. One is in the Silverman Collection and one formerly in the Jean Brown Archive, is now at the Getty Museum. The work consists of a hand-typed title card in a paintbox with a paintbrush and fifteen tubes of chosen water-color paint. George Maciunas was color-blind.*

METAL SLUG DISPENSER

FLUXFEST PRESENTATION OF JOHN LENNON & YOKO ONO ...MAY 30-JUNE 5: THE STORE BY JOHN & YOKO + FLUXFACTORY Coin operated vending machines:...change machine dispensing metal slugs (fake coins for a penny) (John Lennon)...
Schedule of events for Fluxfest presentation of John Lennon and Yoko Ono. [ca. April 1970]. version B

COMMENTS: *This change machine is a reversal of the idea of*

putting a slug into a vending machine, something for nothing, nothing for something. Metal Slug Dispenser was not produced by Fluxus, but a year later, it was built for the vending arcade in Yoko Ono's exhibition at the Everson Museum.

NEEDLE

MAY 2-8: BLUE ROOM BY JOHN & YOKO + FLUX-LIARS...Entire room (floor, walls, ceiling), exterior

ROUNDTRIP TICKET BY AIR TO FORT CHIMO, HUDSON STRAIT

FLUXFEST PRESENTATION OF JOHN LENNON & YOKO ONO+* AT 80 WOOSTER ST. NEW YORK - 1970...APR. 18-24: TICKETS BY JOHN LENNON + FLUXTOURS... roundtrip ticket by air to Fort Chimo, Huson Strait (J. Lennon) $250...
all photographs copyright nineteen seVenty by peTer mooRE (Fluxus Newspaper No.9) 1970.

COMMENTS: Another literal work, the $250 price would have been the actual price of the ticket at the time. A number of tickets were advertised for the Fluxfest and only those which were fakes or jokes were printed up, so this didn't exist except through a ticket office. This work and some of the other tickets were included in the Ono exhibition at the Everson Museum.

ROUNDTRIP TICKET BY AIR TO GOOSE BAY, LABRADOR

FLUXFEST PRESENTATION OF JOHN LENNON & YOKO ONO +* AT 80 WOOSTER ST. NEW YORK — 1970...APR.18-24: TICKETS BY JOHN LENNON + FLUXTOURS...roundtrip ticket by air to Goose Bay, Labrador (John Lennon) $168...
all photographs copyright nineteen seVenty by peTer mooRE (Fluxus Newspaper No.9) 1970.

COMMENTS: Like the previous work, this ticket would have been an actual ticket sold by an airline, so it could not have been produced by Fluxus.

SIGNS see:
DO NOT DISTURB
4 SPOONS
NEEDLE
THIS WINDOW IS 5 FT WIDE
WET PAINT SIGN

THIS WINDOW IS 5 FT WIDE

MAY 2-8: BLUE ROOM BY JOHN & YOKO + FLUXLIARS...Entire room (floor, walls, ceiling), exterior (door and window), interior furnishings to be white... Window sign: This window is 2000 ft. long, Y.O. 1967, also This window is 6ft wide, John Lennon, 1970.
Schedule of events for Fluxfest presentation of John Lennon and Yoko Ono. [ca. April 1970]. version A

MAY 2-8:...window sign: This window is 2000ft wide (Yoko Ono '67), also This window is 5ft wide (John Lennon '70)...
Schedule of events for Fluxfest presentation of John Lennon and Yoko Ono. [ca. April 1970]. version B

FLUXFEST PRESENTATION OF JOHN LENNON & YOKO ONO +* AT 80 WOOSTER ST. NEW YORK — 1970...MAY 2-8 BLUE ROOM BY JOHN & YOKO + FLUXLIARS Entire room (floor, walls, ceiling), and furnishings were white...window sign: This window is 2000ft wide (Yoko Ono '67) another window sign: This window is 5ft wide (John Lennon '70)...
all photographs copyright nineteen seVenty by peTer mooRE (Fluxus Newspaper No.9) 1970.

COMMENTS: There are two versions of this piece. One, six feet, the other five. The important factor is the statement in response to Yoko Ono's poetic sign This Window is 2000ft Long.

TICKETS see:
FLUXTOUR TICKETS

TICKETS FOR SKY TOURS

APR.18-24: TICKETS BY JOHN LENNON + FLUXTOURS Selling to the public various tickets:...sky tours,...(John Lennon);...
Schedule of events for Fluxfest presentation of John Lennon and Yoko Ono. [ca. April 1970]. version B

COMMENTS: Only referred to once, Tickets for Skytours were not produced by Fluxus and the idea was probably to make real tickets available for sale. A year or two earlier, the Lennons made a movie in Denmark of an ascent in a hot air balloon.

TICKETS TO A CHINESE THEATRE

APR.18-24: TICKETS BY JOHN LENNON + FLUXTOURS Selling to the public various tickets:...Chinese theatre,...(John Lennon);...
Schedule of events for Fluxfest presentation of John Lennon and Yoko Ono. [ca. April 1970]. version B

COMMENTS: Tickets to a Chinese Theatre were never made.

TICKETS TO ABANDONED BUILDINGS

APR.18-24: TICKETS BY JOHN LENNON + FLUXTOURS Selling to the public various tickets:...abandoned buildings (10¢)...(John Lennon);...
Schedule of events for Fluxfest presentation of John Lennon and Yoko Ono. [ca. April 1970]. version B

APR.18-24: TICKETS BY JOHN LENNON + FLUXAGENTS Selling to the public various tickets to... buildings,...
Schedule of events for Fluxfest presentation of John Lennon and Yoko Ono. April 1, 1970. version C

...1970 FLUX FEST OF JOHN LENNON & YOKO ONO:...18-20.04 TICKETS by lennon: to abandoned buildings...
George Maciunas, Diagram of Historical Developments of Fluxus... [1973].

COMMENTS: Tickets to Abandoned Buildings would have been fakes and were never printed by Fluxus. They were Lennon's idea of drawing attention to the desolation of parts of New York City.

TICKETS TO CORTLAND ALLEY
Silverman No. > 232.III

FLUXFEST PRESENTATION OF JOHN LENNON & YOKO ONO +* AT 80 WOOSTER ST. NEW YORK — 1970...APR.18-24: TICKETS BY JOHN LENNON + FLUXTOURS...tickets to Cortland Alley, N.Y.C. (John Lennon) desolate, narrow street...
all photographs copyright nineteen seVenty by peTer mooRE (Fluxus Newspaper No.9) 1970.

COMMENTS: George Maciunas printed a Ticket to Cortland Alley as a part of "Fluxtours." Another ticket designed by Maciunas for Lennon Tours called Tour to Cortland Alley New York City was produced for the Ono show at the Everson Museum, in 1971. A few year later, Maciunas organized an event called "Fluxtours," visiting alleys, yards and dead ends.

John Lennon. TICKETS TO CORTLAND ALLEY

TICKETS TO DESOLATE PLACES

APR.18-24: TICKETS BY JOHN LENNON + FLUXTOURS...Selling to the public various tickets: desolate ...places ($1 to $300)...
Schedule of events for Fluxfest presentation of John Lennon and Yoko Ono. [ca. April 1970]. version A

APR.18-24: TICKETS BY JOHN LENNON + FLUXTOURS Selling to the public various tickets: desolate ...places ($1 to $300...)...
Schedule of events for Fluxfest presentation of John Lennon and Yoko Ono. [ca. April 1970]. version B

APR.18-24: TICKETS BY JOHN LENNON + FLUXAGENTS Selling to the public various tickets to desolate places,...
Schedule of events for Fluxfest presentation of John Lennon and Yoko Ono. April 1, 1970. version C

...1970 FLUX FEST OF JOHN LENNON & YOKO ONO:...18-20.04 TICKETS by lennon: to...desolate places, etc.
George Maciunas, Diagram of Historical Developments of Fluxus... [1973].

COMMENTS: These tickets could have been to near or far away places. They were not printed by Fluxus, so the implication is that they would have been actual tickets to real places.

TICKETS TO DISTANT PLACES

APR. 18-24: TICKETS BY JOHN LENNON + FLUX-TOURS...Selling to the public various tickets:...distant places ($1 to $300)...
Schedule of events for Fluxfest presentation of John Lennon and Yoko Ono. [ca. April 1970]. version A

APR. 18-24: TICKETS BY JOHN LENNON + FLUX-TOURS Selling to the public various tickets:...funny 7 distant places ($1 to $300 [for Siberia]),...(John Lennon);...
Schedule of events for Fluxfest presentation of John Lennon and Yoko Ono. [ca. April 1970]. version B

APR. 18-24: TICKETS BY JOHN LENNON + FLUX-AGENTS Selling to the public various tickets to...distant places via difficult passage,...
Schedule of events for Fluxfest presentation of John Lennon and Yoko Ono. April 1, 1970. version C

COMMENTS: *Again, these would have been actual tickets, therefore not printed by Fluxus. They come in the context of "Fluxtour" tickets by a number of different artists, so the distant places are not just an idea in the context of Lennon.*

TICKETS TO MISERABLE SHOWS

APR. 18-24: TICKETS BY JOHN LENNON + FLUX-TOURS...Selling to the public various tickets:...miserable shows ($5)...
Schedule of events for Fluxfest presentation of John Lennon and Yoko Ono. [ca. April 1970]. version A

APR. 18-24: TICKETS BY JOHN LENNON + FLUX-AGENTS Selling to the public various tickets to...miserable shows,...
Schedule of events for Fluxfest presentation of John Lennon and Yoko Ono. April 1, 1970. version C

COMMENTS: *Why take a chance, these shows were guaranteed to be miserable. They were not printed by Fluxus and could have been actual tickets if the idea had gotten that far.*

TICKETS TO NARROW STREETS

APR. 18-24: TICKETS BY JOHN LENNON + FLUX-TOURS Selling to the public various tickets:...narrow streets (10¢) (John Lennon);...
Schedule of events for Fluxfest presentation of John Lennon and Yoko Ono. [ca. April 1970]. version B

COMMENTS: *Another empty category, these tickets were never made by Fluxus.*

TICKETS TO STREET CORNERS

APR. 18-24: TICKETS BY JOHN LENNON + FLUX-TOURS ... Selling to the public various tickets: ... street corners (10¢)...

Schedule of events for Fluxfest presentation of John Lennon and Yoko Ono. [ca. April 1970]. version A

APR. 18-24: TICKETS BY JOHN LENNON + FLUX-AGENTS Selling to the public various tickets to...street corners,...
Schedule of events for Fluxfest presentation of John Lennon and Yoko Ono. April 1, 1970. version C

COMMENTS: *These would have been actual tickets, like bus tickets to obscure places, therefore not printed by Fluxus.*

TICKETS TO UNKNOWN PLACES

APR. 18-24: TICKETS BY JOHN LENNON + FLUX-TOURS...Selling to the public various tickets:...unknown...places ($1 to $300)...
Schedule of events for Fluxfest presentation of John Lennon and Yoko Ono. [ca. April 1970]. version A

APR. 18-24: TICKETS BY JOHN LENNON + FLUX-TOURS Selling to the public various tickets:...unknown...places ($1 to $300...John Lennon);...
Schedule of events for Fluxfest presentation of John Lennon and Yoko Ono. [ca. April 1970]. version B

COMMENTS: *These tickets were never published by Fluxus.*

TOILET see:
FLUX-TOILET

2 EGGS

APR. 11-17 DO IT YOURSELF, BY JOHN & YOKO + EVERYBODY...2 Eggs (by John Lennon) combined with Add colour painting, (eggs filled with ink or paint, to be thrown against a wall)...
Schedule of events for Fluxfest presentation of John Lennon and Yoko Ono. [ca. April 1970]. version A

...APR. 11-17: DO IT YOURSELF. BY JOHN & YOKO+EVERYBODY...2 Eggs (John Lennon'70)...
Fluxnewsletter, April 1973.

FLUXFEST PRESENTATION OF JOHN LENNON & YOKO ONO +* AT 80 WOOSTER ST. NEW YORK — 1970...APR. 11-17: DO IT YOURSELF + EVERYBODY...2 Eggs (John Lennon)...
all photographs copyright nineteen seVenty by peTer mooRE (Fluxus Newspaper No.9) 1970.

COMMENTS: *2 Eggs would have been two actual raw eggs, a literal response to Maciunas' eggs filled with ink or paint which were to be used in the making of Yoko Ono's Add Colour Painting. A photograph of 2 Eggs was published in Fluxus Newspaper No. 9.*

VENDING MACHINE see:
METAL SLUG DISPENSER

WET PAINT SIGN

Toilet no. 6 collective...Toilet seat: Wet Paint sign. (John Lennon)
Fluxnewsletter, April 1973.

COMMENTS: *Wet Paint Sign is not necessarily a literal piece. The paint on the toilet seat could have been dry, but to the trusting soul it would have had the same effect.*

WET SPONGE see:
John Lennon and Yoko Ono

JOHN LENNON and YOKO ONO

DRY SPONGE

MAY 9-15: WEIGHT AND WATER BY JOHN & YOKO + FLUXFAUCET...floor flooded with water to about 1'' height...a dry sponge (by Yoko & John, 1970) this can be made to float by waterproofing the bottom of the sponge.
Schedule of events for Fluxfest presentation of John Lennon and Yoko Ono. [ca. April 1970]. version A

MAY 9-15 [as above] : A dry sponge (Yoko + John, 1970);...
Schedule of events for Fluxfest presentation of John Lennon and Yoko Ono. [ca. April 1970]. version B

FLUXFEST PRESENTATION OF JOHN LENNON & YOKO ONO +* AT 80 WOOSTER ST. NEW YORK — 1970...MAY 9-15: WEIGHT & WATER BY JOHN & YOKO + FLUXFAUCET...suspended...A dry sponge (Yoko + John, 1970)...
all photographs copyright nineteen seVenty by peTer mooRE (Fluxus Newspaper No.9) 1970.

...1970 FLUX FEST OF JOHN LENNON & YOKO ONO:...09 - 15.05 WEIGHT & WATER...sponges by ono & lennon.
George Maciunas, Diagram of Historical Developments of Fluxus... [1973].

COMMENTS: *Dry Sponge was a ready-made constructed by George Maciunas for the John & Yoko Fluxfest. He made a very literal interpretation of the idea, a dry sponge was suspended over a container of water with a wet sponge in it. A photograph of the two works that Maciunas made was reproduced in Fluxus Newspaper No. 9. The original idea was more to illustrate the axiomatic qualities of weight and water by waterproofing the bottom of a dry sponge so it could float on water. In contrast, Wet Sponge would acquire weight, but still float.*

WET SPONGE

MAY 9-15: WEIGHT & WATER BY JOHN & YOKO

+ FLUXFAUCET...A wet sponge (by Yoko & John, 1970)...
Schedule of events for Fluxfest presentation of John Lennon and Yoko Ono. [ca. April 1970]. version A

FLUXFEST PRESENTATION OF JOHN LENNON & YOKO ONO+* AT 80 WOOSTER ST. NEW YORK — 1970...MAY 9-15: WEIGHT & WATER BY JOHN & YOKO + FLUXFAUCET...on the floor: A wet sponge (Yoko + John, 1970)...
all photographs copyright nineteen seVenty by peTer mooRE (Fluxus Newspaper No.9) 1970.

COMMENTS: Wet Sponge *is the counterpoint to* Dry Sponge.

JOAN LESIKEN

Joan Lesiken's score, "Window Music," appears in Flux Fest Kit 2, *1969.*

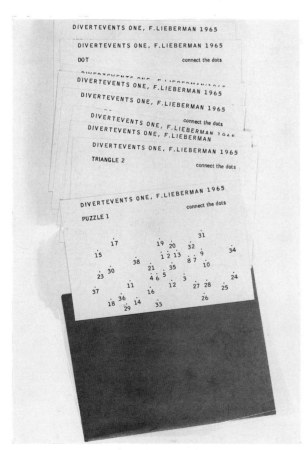

Fredric Lieberman. DIVERTEVENTS ONE

FREDRIC LIEBERMAN

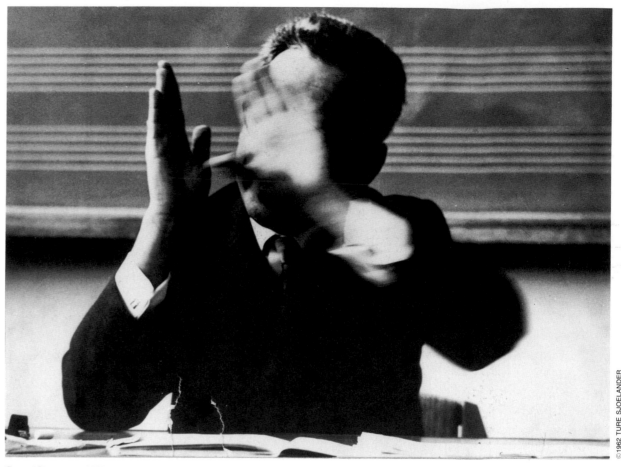

Györgi Ligeti, ca. 1962

DIVERTEVENTS ONE
Silverman No. 233, ff.

Never advertised as an individual Fluxus Edition, Divertevents One *is a group of nine scores or games printed on cards and packaged in a manila envelope almost always included in* Flux Year Box 2. *The work bears a certain relationship to Willem de Ridder's* Paper Fluxwork. *Produced about the same time, they both require direct participation on the scores themselves in order to complete the work.*

GYÖRGI LIGETI

It was announced in the Brochure Prospectus, version B, that Györgi Ligeti would contribute "Die Zukunft der Musik: Eine Kollektive Komposition" to FLUXUS NO. 3 GERMAN & SCANDINAVIAN YEARBOX. His score, "Trois Bagatelles" was included in FLUXUS 1, and "Poeme Symphonique" was published in Fluxus Newspaper No. 1.

"Trois Bagatelles" is printed on a glossy paper and inserted into FLUXUS 1. *Its presentation has the feeling that it could have been offered for sale as an individual work. However, there is no way of knowing whether it was the "unidentified score" offered for sale by special order in the* Fluxus Preview Review.

Unidentified Scores

Scores available by special order:...Also available are scores of work by...Gyorgi Ligeti
Fluxus Preview Review, [ca. July] 1963.

"...once you agree or decide to offer your works for publication and they are accepted, they cannot be offered to and published by any other publisher...I lost a few hundred marks already, by printing Ligeti...and then eliminating the works because of Vostells fast dealings..."
Letter: George Maciunas to Tomas Schmit, [late December 1962/early January 1963].

COMMENTS: Although Maciunas blames Vostell, who was publishing a number of works by artists associated with Fluxus, for the reason that he dropped plans to publish the works of a number of composers, I think it is more likely that Maciunas' idea of Fluxus was becoming more defined. He was paring away many of the "avant-garde" artists from the ranks and focusing more on artists involved with gesture and direct "anti-art" type work. Unless the "unidentified score" is "Trois Bagatelles" I am unable to determine what the work or works could be.

CARLA LISS

ISLAND FLUX SOUVENIR
Silverman No. 236

"...Now I will list some new items produced: all in 1972...Island souvenir kit by Carla Liss, $6..."
Letter: George Maciunas to Dr. Hanns Sohm, [ca. late 1972].

FLUXPRODUCTS PRODUCED IN 1972 & 1973...
Carla Liss: Island flux souvenir, contains sand, plant, moss, shell, coffee bean, coin, postage stamp from islands visited $10...
Fluxnewsletter, April 1973.

1973 CARLA LISS: island souvenir...
George Maciunas, Diagram of Historical Developments of Fluxus... [1973].

by Carla Liss:...Island flux souvenir...$10
Fluxnewsletter, April 1975.

by Carla Liss:...Island flux souvenir, contains sand, plant, moss, shell, coffee bean, coin, postage stamp from island visited $10
[Fluxus price list for a customer]. September 1975.

"...Carla Liss - Island souvenir 10..."
Letter: George Maciunas to Dr. Hanns Sohm, November 30, 1975.

CARLA LISS...Island flux souvenirs, 7 in box $14...
Flux Objects, Price List. May 1976.

COMMENTS: On one level, the contents of this work are the souvenirs of a trip to the Greek Islands that Carla Liss took with George Maciunas. Maciunas was fascinated with islands, and once made plans to purchase Ginger Island in the Caribbean, with the idea to make it a self-sufficient collectively owned Flux-Island where artists would live and work. These plans were stymied when a group of artists were flown there with Maciunas and left instructions with the pilot to return for them in a week. There was no water on the island and everyone slept naked under a tree that exuded a poisonous sap causing rashes and fever. Really a life-threatening situation. In the 1970s, Maciunas also organized various plans to circumvent the world in a converted mine sweeper, stopping at as many obscure islands as possible. These and other plans for journeys are reproduced in Fluxus Etc./ Addenda I.

KAT-FLUX-KIT

1973 CARLA LISS:...cat kit.
George Maciunas, Diagram of Historical Developments of Fluxus... [1973].

COMMENTS: Kat-Flux-Kit was never produced, although Maciunas printed labels for the work. Carla Liss loved cats, but George Maciunas wanted to twist the contents to the macabre.

SACRAMENT FLUXKIT
Silverman No. < 235.1

FLUX-PRODUCTS 1961 TO 1969...CARLA LISS Sacrament flux kit, water in test tubes, from: pond, lake, stream, ocean, river, sea, rain, etc. boxed [$] 6

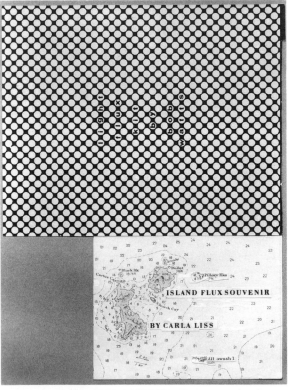

Carla Liss while on a trip to a Greek Island with George Maciunas in 1972

PHOTOGRAPHER NOT IDENTIFIED

Carla Liss. ISLAND FLUX SOUVENIR. Mechanicals by George Maciunas for two unrelated works

SCOTT HYDE

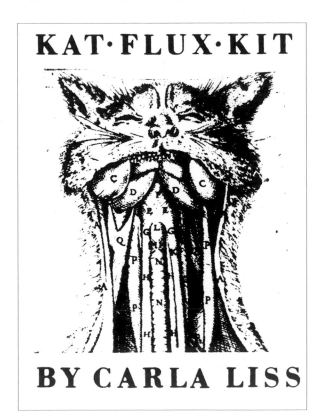

Carla Liss. KAT-FLUX-KIT. Label designed by George Maciunas

Carla Liss. SACRAMENT FLUXKIT

...larger version, in wood case [$] 30
Fluxnewsletter, December 2, 1968 (revised March 15, 1969).

FLUX-PRODUCTS 1961 TO 1969 ... CARLA LISS
Sacrament fluxkit, various waters, boxed [$] 8...larger version, wd. box [$] 30
Flux Fest Kit 2. [ca. December 1969].

FLUX SHOW: DICE GAME ENVIRONMENT EN-
TIRE FLOOR AS DICE HAZARD TABLE DIE
CUBES, 15'' CUBES ON FLOOR, Marked on sides,
top open or closed with clear plastic. Consisting or
containing...Flux water pieces. (Liss...)
ibid.

...set of 1969-70 Flux-productions which consist of
the following: 1969-...Carla Liss: Sacrament flux kit...
Fluxnewsletter, January 8, 1970.

SPRING 1969 CARLA LISS: water from many sources
*George Maciunas, Diagram of Historical Developments of
Fluxus... [1973].*

CARLA LISS Sacrament flux kit, 9 waters, boxed
$20...
Flux Objects, Price List. May 1976.

COMMENTS: *Sacrament Flux Kit is a very beautiful and po-
etic flux work. Collections of waters from different sources,
usually the waters are packaged in Maciunas' used medicine*

Carla Liss. SACRAMENT FLUXKIT. Mechanical by George
Maciunas for a variant label

*bottles. Althought it was intended that they be contained in
test tubes, I have never seen a Maciunas-produced example
packaged this way.*

TRAVEL FLUXKIT
Silverman No. 235

''...Now I will list some new items produced: all in
1972...Travel kit by her [Carla Liss] : $4...''
Letter: George Maciunas to Dr. Hanns Sohm, [ca. late 1972].

FLUXPRODUCTS PRODUCED IN 1972 & 1973 ...
Carla Liss:...Flux travel kit, obsolete tickets, stubs,
schedules etc. $4
Fluxnewsletter, April 1973.

1973 CARLA LISS:...travel kit...
*George Maciunas, Diagram of Historical Developments of
Fluxus... [1973].*

by Carla Liss: flux-travel kit obsolete tickets, stubs,

schedules etc. $4...
Fluxnewsletter, April 1975.

by Carla Liss: Flux-travel kit, obsolete tickets, stubs,
schedules etc. $4...
[Fluxus price list for a customer]. September 1975.

''...Carla Liss - travel kit 4...''
*Letter: George Maciunas to Dr. Hanns Sohm, November 30,
1975.*

CARLA LISS...Flux travel kit $6
Flux Objects, Price List. May 1976.

COMMENTS: *Related to* Flux Island Souvenir, Flux Travel
Kit *is a collection of insignificant memorabilia from travel.*

Carla Liss. TRAVEL FLUXKIT. Label designed by George
Maciunas

ZOFIA LISSA

*It was announced in the tentative plans for the first issues of
FLUXUS that Dr. Zofia Lissa would contribute an article
"Polish experimental cinema-music" to FLUXUS NO. 6 (la-
ter NO. 7) EAST EUROPEAN YEARBOX.*
see: COLLECTIVE

GHERASIM LUCA

*It was announced in the Brochure Prospectus, version B, that
Gherasim Luca would contribute "Le secret du vide et du
plein," "Proportion," and "Coupable ou non" to FLUXUS
NO. 2 FRENCH YEARBOOK-BOX.*
see: COLLECTIVE

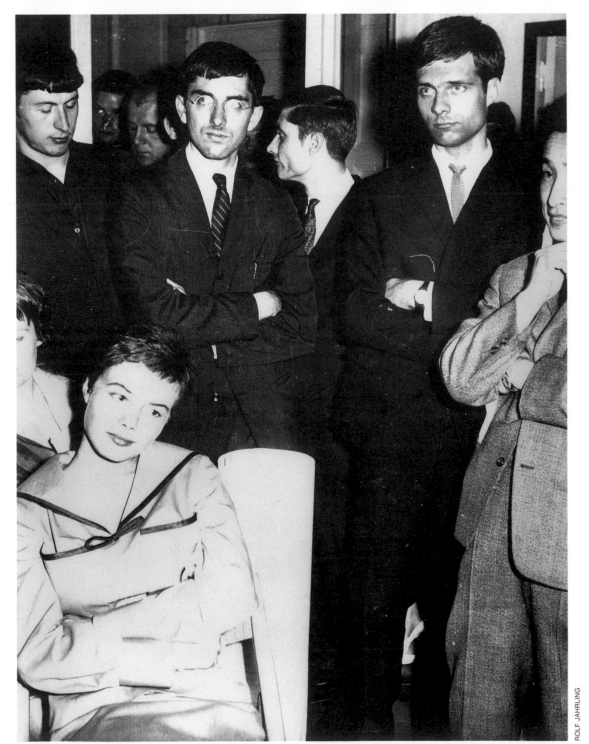

George Maciunas, with glasses. To his left: Terry Riley, Jed Curtis and Nam June Paik, others not identified. At the first Fluxus performance, Kleinen Sommerfest, Galerie Parnass, Wuppertal, West Germany, June 9, 1962

ROLF JAHRLING

M

CHARLES MAC DERMED

It was announced in the Brochure Prospectus, version B, that Ch. Mac Dermed would contribute "Letters (luxus fluxus only)" to FLUXUS NO. 1 U.S. YEARBOX.
see: COLLECTIVE

GEORGE MACIUNAS

It was announced in the initial tentative plans for the first issues of FLUXUS that George Maciunas would contribute "Development of abstraction in Animal Style 7 - 9 cent." and "Moussorgsky - first concretism in Nursery Cycle" to FLUXUS NO. 4 HOMAGE TO THE DISTANT PAST. The "Animal Style" contribution was changed in subsequent plans for FLUXUS NO. 4 (later called FLUXUS NO. 5) to "China's & Europe's cultural debt to Siberia," and with a slight change in the title of the "concretism" essay.

The first tentative plan for FLUXUS NO. 5 WEST EUROPEAN ISSUE II announced an essay, "Abstract chirography (essay and folio) in France." In the next three plans, the title is shortened to "Motivations of abstract chirographist" and then the essay is dropped altogether.

For FLUXUS NO. 6 EAST EUROPEAN ISSUE, Maciunas was to contribute "Dostoyevski - the unsuspected champion of the Party" and "a letter" which becomes "Principles of Dialectic Materialism & concrete art." Listed in the Brochure Prospectus, version A, Maciunas' contribution to the EAST EUROPEAN YEARBOX, now called FLUXUS NO. 7, is the "Early concretism" essay and "Potentialities of concrete prefabrication in USSR." Then, in the final plan for the East European Fluxus, only the "prefabrication" article by Maciunas is listed. This is later published as "Appendix 1. Soviet Prefabriced Building System" in the Henry Flynt and George Maciunas work, Communists Must Give Revolutionary Leadership in Culture.

Announced in Brochure Prospectus, version B, Maciunas was to contribute the following to FLUXUS NO. 1 U.S. YEARBOX:

"Tactile composition for skin (molded paper)"
"Music for Everyman (luxus fluxus only)" [This score was also distributed separately by Fluxus.]
"Infinite poem"
"In Memoriam to Adriano Olivetti (score)" [Four photographs of a performance of this work appear in Fluxus Preview Review. A photograph of another performance is illustrated in Fluxus Newspaper No. 3, and a photograph with a description of the work appears in the "Fluxus (fold out)" section of the Tulane Drama Review Vol. 10 No. 2 Winter 1965. The score was distributed separately by Fluxus.]
"Atlas of new art, music, literature, dance etc." [This was probably Fluxus Diagram which evolves into Fluxus

(Its Historical Development and Relationship to Avant-Garde Movements), and then, Diagram of Historical Development of Fluxus and Other 4 Dimensional, Aural, Optic, Olfactory, Epithelial and Tactile Art Forms.]
"The grand frauds of architecture: M.v.d. Rohe, Saarinen, Bunshaft, F.L. Wright" [published in FLUXUS 1]
"The zoological precursor of Abstract Expressionism" [Probably an evolution of the earlier "Development of abstraction in Animal style 7-9 cent." article. See also Congo's contribution to FLUXUS 1.]

Various scores by Maciunas are published in Fluxfest Sale and Flux Fest Kit 2.
see: COLLECTIVE

ADHESIVE FLOOR

FEB. 17, 1:30 PM FLUX-SPORTS DOUGLASS COL. ...ADHESIVE SURFACE RUN (G. Maciunas)
Poster/program for Flux-Mass, Flux-Sports and Flux-Show. February 1970.

Any proposals from participants should fit the maze format...Ideas should relate to passage through doors, steps, floor, obstacles, booths...adhesive...
[George Maciunas], Further Proposal for Flux-Maze at Rene Block Gallery. [ca. Fall 1974].

"Enclosed is the final plan of labyrinth...the last panel should be an adhesive floor that could be either covered with liquid adhesive that dries to be an adhesive or with double adhesive faced tape. I don't know if the liquid type is available in Berlin. This ends my section."
Letter: George Maciunas to Rene Block, [ca. Summer 1976].

...adhesive - liquid contact adhesive
Instruction drawing for Fluxlabyrinth, Berlin. [ca. August 1976]. version A

...adhesive: must be located. on Monday, an assistant can inquire by phone
Notes: Larry Miller to George Maciunas concerning the Fluxlabyrinth, Berlin. [ca. August 1976].

COMMENTS: George Maciunas liked to mess things up. The idea of adhesive getting spectators stuck up, goes back initially to Adhesive Net in 1966. In 1977, when Maciunas was invited to participate in an exhibition at a Williamstown museum in Massachusetts, he sent in a proposal that the floor of the museum be covered with adhesive. The idea was rejected.

ADHESIVE KNOB DOOR

FLUXFEST PRESENTATION OF JOHN LENNON & YOKO ONO +* AT 80 WOOSTER ST. NEW YORK - 1970...MAY 23-29: PORTRAIT OF JOHN LENNON AS A YOUNG CLOUD BY YOKO ONO & EVERYPARTICIPANT/ A maze with 8 doors each

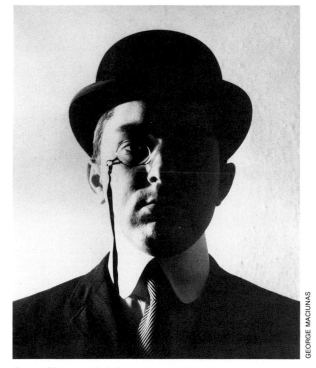

GEORGE MACIUNAS

George Maciunas. Self Portrait, ca. 1963

opening in a different manner:...door with adhesive knob
all photographs copyright nineteen seVenty by peTer mooRE (Fluxus Newspaper No. 9) 1970.

COMMENTS: Although this work is not credited, it is certainly a Maciunas adhesive variation. He would frequently take an idea like prepared ping-pong rackets or prepared eggs and make numerous variations on the concept. Other adhesive works by Maciunas are Adhesive Floor, Adhesive Net, Adhesive Postcard, Adhesive Programs, Adhesive Soled Shoes and Glue Dispenser. Adhesive Toilet Seat by Paul Sharits in the Flux Toilet could be a Maciunas work as well — Maciunas would sometimes assign an idea of his to another artist. However, two other Sharits adhesive works in the Flux Toilet, Stuck Together Toilet Paper and Stuck Together Paper Towels relate to Sharits' Pull Apart.

ADHESIVE NET

31.03.1966...maciunas: adhesive net falls over dancing guests.
George Maciunas, Diagram of Historical Developments of Fluxus... [1973].

PERFORMANCE COMPOSITIONS...1966: Event at Village Gate (benefit for EVO) (adhesive net droping [sic] over dancing guests)...
George Maciunas Biographical Data. 1976.

COMMENTS: This was perhaps the first of Maciunas' adhesive ideas. It was designed to involve an audience directly in the event — somewhat hostile yet at the same time fun.

ADHESIVE POSTCARD

PROPOSED CONTENTS FOR FLUXPACK 3 TO BE PUBLISHED IN 1973 BY FLASH ART...Postcards by...Maciunas...Cost Estimates: for 1000 copies ... postcards [including designs by other artists] $100 ... 100 copies signed by:...Maciunas...
[George Maciunas], Proposed Contents for Fluxpack 3. [ca. 1972].

"...to produce the Flash Art FLUXPACK 3 ... contents will at present be as follows:...Postcards: one side with adhesive by Maciunas..."
Letter: George Maciunas to Giancarlo Politi, n.d. Reproduced in Fluxnewsletter, April 1973.

COMMENTS: Adhesive Postcard was not produced by George Maciunas as a Fluxus Edition for Fluxpack 3. Around this time, possibly later, Joseph Beuys made postcards (not with Fluxus), in wood, metal, and so on. Maciunas' postcard would stick to other letters in the mail and mess up the system.

ADHESIVE PROGRAMS

PROGRAMS (given out at the entry to auditorium)... sheets with pressure sensitive adhesive on the back (uncovered)
[Fluxus Newsletter] Supplement I for Fluxus Paper Concert. [ca. Fall 1967].

COMMENTS: The idea is George Maciunas' and was intended to involve the audience immediately in the performance. It's related to various other paper events and adhesive works, a recurring interest of Maciunas. Adhesive Programs were not made.

ADHESIVE SOLED SHOES

PROPOSED FLUXSHOW...SPORTS-GAMES CENTER...Track & field games:...race on adhesive floor or with adhesive soled shoes, etc.
Fluxnewsletter, December 2, 1968 (revised March 15, 1969).

COMMENTS: This is another of Maciunas' anonymous adhesive ideas. Indications are that this work was never made.

AEROPHONE

...items are in stock, delivery within 2 weeks ... FLUXUSm2 JOE JONES: mechanical aerophone $60
Vaseline sTREet (Fluxus Newspaper No. 8) May 1966.

"Later I will ship 2 aerophones (same 2 notes) so you can play 4 together. If you sell these instruments, they should go for $40 each...By post you will be getting...aerophones..." [to be used in conjunction

with Joe Jones' instruments]
Letter: George Maciunas to Ken Friedman, February 28, 1967.

"I got hold of a few $ & shipped out by REA a package to you: with:...aerophone with stand..."
Letter: George Maciunas to Ken Friedman, [ca. March 1967].

FLUX-PRODUCTS 1961 TO 1969 ... JOE JONES Mechanical...aerophone...on musical stand, electric 110V motors, each [$] 80.
Fluxnewsletter, December 2, 1968 (revised March 15, 1969).

FLUX-PRODUCTS 1961 TO 1970 ... JOE JONES... Mech. aerophone or bell, on stand [$] 80...
Flux Fest Kit 2. [ca. December 1969].

FLUX AMUSEMENT ARCADE...Joe Jones automatic trio with Maciunas aerophone (coin activated)
Preliminary Proposal for a Flux Exhibit at Rene Block Gallery. [ca. 1974].

FLUX-PRODUCTS 1961 TO 1970...SOLO OBJECTS AND PUBLICATIONS...JOE JONES...Mech. aerophone...on stand [$] 120
[Fluxus price list for a customer]. September 1975.

"Dear Rene...Joe Jones and my orchestra. Generally Joe designed string and percussion instruments and I designed aerophones..."
Letter: George Maciunas to Rene Block, [ca. Summer 1976].

COMMENTS: "aerophone [air + voice, sound] 1/ An apparatus invented by Edison for increasing the intensity (amplitude) of sound-waves, as those from spoken words 2/ An instrument having the functions of both an ear-trumpet and a speaking-trumpet." The Century Dictionary, New York, 1911.

Joe Jones was initially credited with Aerophones, perhaps because they were usually used in connection with his mechanical instruments. By 1974 Maciunas identifies Aerophones as his own. These mechanical devices would make banal sounds such as mooing or duck calls, etc.

ALL OTHER THINGS

FLUXUS 1964 EDITIONS, AVAILABLE NOW... FLUXUS zaz ALL OTHER THINGS
cc Valise e TRanglE (Fluxus Newspaper No. 3) March 1964.

COMMENTS: In the context of its appearance in Fluxus Newspaper No. 3, the work is anonymous and perhaps just meant as an indication that everything else is Fluxus as well. I have determined that, at the time, the code "Fluxus z" was George Maciunas'. Maybe he would provide whatever you asked for.

ALPHABET FACE CLOCK

FLUX-PRODUCTS 1961 TO 1969...GEORGE MACIUNAS...Clocks with dial faces:...alphabet...elec-

George Maciunas. ALPHABET FACE CLOCK. Mechanical for the clock face

tric or wind up, each: [$] 8...
Fluxnewsletter, December 2, 1968 (revised March 15, 1969).

FLUX-PRODUCTS 1961 TO 1970...GEORGE MACIUNAS...Clocks with:...alphabet...face, ea: [$] 8...
Flux Fest Kit 2. [ca. December 1969].

COMMENTS: George Maciunas designed and printed up faces for clocks using letters a - z instead of numbers 1 - 12 or 1 - 24. However, I have never seen a clock with this face attached to it. See also the clocks of Per Kirkeby and Robert Watts.

&

FLUX-PRODUCTS 1961 TO 1970 ... GEORGE MA-

George Maciunas. & . An ampersand of the sort Maciunas would have used for a flag. applied on a 15" die cube

CIUNAS...Flags: 28" square, sewn legends:...&... ea: [$] 60...
Flux Fest Kit 2. [ca. December 1969].

COMMENTS: & was never made by George Maciunas as a Fluxus Edition flag. He used the ampersand on 15" die cube display cases made for Fluxus objects in 1970. An ampersand flag would have used this identical image.

ANATOMY see:
FACE ANATOMY MASK
STOMACH ANATOMY APRON
APRONS see:
MEDIEVAL ARMOR APRON
NAPOLEON'S FRONT APRON
NUDE BACK APRON
PAPER APRONS
POPE MARTIN V APRON
ROMAN EMPEROR APRON
STOMACH ANATOMY APRON
VENUS DE MILO APRON
VIRGIN MARY APRON
WASHINGTON'S FRONT APRON
WINGED VICTORY APRON

ARCHITECTURAL MONUMENTS OF THE WORLD, ATLAS OF MAPS

CHARTS, DIAGRAMS AND ATLASES...1972-present: Architectural monuments of the world, Atlas of maps. (still in progress)...
George Maciunas, Biographical Data. 1976.

COMMENTS: George Maciunas had an obsession with charts and diagrams and produced a number of them, some having to do with the history of art, some with architecture, travel and of course his very important chart, Diagram of Historical Development of Fluxus and Other Four Dimensional, Oral, Optic, Olfactory, Epithelial and Tactile Artforms.

ARCTIC BIBLIOGRAPHY

FLUXUS 1964 EDITIONS, AVAILABLE NOW... FLUXUS xxx ARCTIC BIBLIOGRAPHY 8 volumes $8
cc Valise e TRanglE (Fluxus Newspaper No. 3) March 1964.

xxx...[as above]
European Mail-Orderhouse: europeanfluxshop, Pricelist. [ca. June 1964].

xxx ARCTIC BIBLIOGRAPHY, 2 volumes $8. Sold
European Mail-Orderhouse: europeanfluxshop, Pricelist. With holograph notes from George Maciunas to Willem de Ridder. [ca. Summer 1964].

COMMENTS: Arctic Bibliography would have been a ready-made, perhaps with a slight alteration such as putting the word "Fluxus" on the binding. I have never seen this work.

ARTYPE

Silverman No. < 243.III

FLUXFILMS SHORT VERSION, 40 MIN at 24 FRAMES/ SEC. 1400FT. ...flux-number 20 George Maciunas ARTYPE 4'20" Artype patterns on clear film, intended for loops....Editing and titles by George Maciunas
Fluxfilms catalogue, [ca. 1966].

"The film loops are also close to our own work. In fact we were experimenting with Artype screens (dots, parallel lines, single dots) applied directly to clear film (no camera used). Then a pos. or neg. print projected. (Artype will not stand the heat etc. of projector.) So we got very similar optical effects like your dots. We found that parallel line for instance of certain density have a nice way of moving up & up when projected. (this artype, we apply irrespective of frames, just as a continuous ribbon, so various optical things happen, when lines or dots of different densities are projected as movies."
Letter: George Maciunas to Paul Sharits, June 29, 1966.

"...We have some 20 loops, which he could buy each 4 feet on 16mm say for 20 dollars or 8mm for half that price. With these loops he can have a flux wall paper show since many are patterns like dots or lines, from the artype film..."
Letter: George Maciunas to Ken Friedman, [ca. February 1967].

PAST FLUX-PRODUCTS (realized in 1966)...Fluxfilms: total package: 1 hr. 40 min....artype by G. Maciunas...
Fluxnewsletter, March 8, 1967.

FLUX-PROJECTS PLANNED FOR 1967...George Maciunas: Artype film (suppl.)...
ibid.

"...I am finally doing the 8mm print of that 1200 ft. Fluxfilm version. It will be good for straight viewing or loop viewing, some 40 loops that could do a nice Flux-wall paper event, [for instance...moving vertical lines..."
Letter: George Maciunas to Paul Sharits, June 21, 1967.

"...With these loops he can have a flux wall paper show since many are patterns like dots or lines, from the Artype film. Incidentally, i should be able to ship to you the 8mm fluxfilm package in a few weeks, this pack contains all the loop material for flux wallpaper shows, you need some 10 to 20 8mm projectors, and of course white walls and ceilings if you project it on them. You could show say 20 loops of yoko onos walking behinds of 20 different people, or numbers so arranged you have them shift in numerical order,

etc. etc, improvise your own arrangement..."
Letter: George Maciunas to Ken Friedman, [ca. August 1967].

PROPOSED FLUXSHOW FOR GALLERY 669... SOUND ENVIRONMENT (may be within film environment)...Night Music...played with Artype film loop environment...
Fluxnewsletter, December 2, 1968.

PROPOSED FLUXSHOW...SOUND ENVIRONMENT ...Artype film loops.
Fluxnewsletter, December 2, 1968 (revised March 15, 1969).

FLUX-PRODUCTS 1961 TO 1969...FLUXFILMS, short version Summer 1966 40 min. 1400 ft:...Artype - by G. Maciunas,...
ibid.

FLUX-PRODUCTS 1961 TO 1970...FLUXFILMS, short version, Summer 1966. 40 min. 1400 ft.:...Artype by George Maciunas...16mm version $180 8mm version $50...
Flux Fest Kit 2. [ca. December 1969].

SLIDE & FILM FLUXSHOW ... GEORGE MACIUNAS: ARTYPE Various artype patterns (screens, wavy lines, parallel lines etc.) on clear film. No camera.
ibid.

FILM AND SOUND ENVIRONMENT A booth must be set up in a fairly dark area, the walls of which are of white vinyl or cotton sheets (about 12' wide x 8' high) hanging as curtains, creating thus a 12' x 12' or smaller room. Four 8mm wide angle lense loop projectors must be set up in front of each wall on the outside, projecting an image the frame of which is to cover entire wall. Spectators may enter the booth through corners...Night Music by Richard Maxfield together with Artype loops by George Maciunas...
ibid.

1965 FLUXFILMS...MACIUNAS:...artype (dots, lines)...
George Maciunas, Diagram of Historical Developments of Fluxus... [1973].

OBJECTS AND EXHIBITS...1965:...of some 20 films into Flux-film anthology, contributed: films made without camera (using various adhesive patterns on clear film stock): Artype...
George Maciunas Biographical Data. 1976.

COMMENTS: *Maciunas was fascinated with the possibility of working directly on film.* Artype *is a film using commercially made "prestype" or "artype" applied directly on film leader for projection. Very direct.* Artype *is contained both in the* Fluxfilms *package, and as a loop included in* Flux Year Box 2.

ASSHOLES WALLPAPER see:
Ben Vautier

ATTORNEY GENERAL EVENT see:
FLUX-COMBAT BETWEEN G. MACIUNAS & ATTORNEY GENERAL OF NEW YORK 1975 -76

BACKWARD CLOCK

PROPOSED FLUXSHOW FOR GALLERY 669... OBJECTS, FURNITURE...clocks:...backward turning arms; etc.
Fluxnewsletter, December 2, 1968.

FLUX-PRODUCTS 1961 TO 1969... GEORGE MACIUNAS...Clocks with dial faces:...backwards...electric or wind up, each [$] 8...
Fluxnewsletter, December 2, 1968 (revised March 15, 1969).

FLUX-PRODUCTS 1961 TO 1970... GEORGE MACIUNAS Clocks with:... backward...face, ea: [$] 8...
Flux Fest Kit 2. [ca. December 1969].

OBJECTS AND EXHIBITS...1969: clock faces:... backward etc...
George Maciunas Biographical Data. 1976.

COMMENTS: *George Maciunas made a mechanical for the face of* Backward Clock. *I have not seen printed versions of this clock face, and have never seen a finished Fluxus produced clock with a backward face attached. It's not clear whether the arms of the clock turn backwards as well. This and the other altered clock faces are designed to disturb the viewer's sense of time.*

George Maciunas. BACKWARD CLOCK. Mechanical for the clock face

BAD SMELL EGGS

PROPOSED FLUX DRINKS & FOODS...FLUX EGGS emptied egg shells filled with...bad smell (rotten)...
Fluxfest at Stony Brook, Newsletter No. 1, August 18, 1969. versions A and B

FLUX DRINKS & FOODS FLUX EGGS emptied egg shells with...bad smell (rotten)...(G. Maciunas)
Invitation to Participate in New Year Eve's Flux-Feast. [ca. December 1969].

FLUX FOOD AND DRINKS FLUX EGGS:...Empty egg shells filled with...bad smell (rotten food)...
Flux Fest Kit 2. [ca. December 1969].

COMMENTS: Bad Smell Eggs *would have been blown eggshells filled with a foul smelling substance. There is no evidence that these eggs were ever made.*

BADMINGTON RACKETS see:
PING-PONG RACKETS

BALL CHECKERS

FLUXUS a FLUXCHESS: pieces identified by sound or weight or smell etc....FLUXUS a8 bearing ball checkers $30
Vacuum TRapEzoid (Fluxus Newspaper No. 5) March 1965.

...items are in stock, delivery within 2 weeks ... FLUXUS a...FLUXUS a11 ball checkers on grid board $10
Vaseline sTREet (Fluxus Newspaper No. 8) May 1966.

flux checkers $7...by george maciunas
Fluxshopnews. [Spring 1967].

"I got hold of a few $ & shipped out by REA a package to you: with:...checker sets..."
Letter: George Maciunas to Ken Friedman, [ca. February 1967].

FLUX-PRODUCTS 1961 TO 1969...GEORGE MACIUNAS...Ball checkers on plastic egg-crate board [$] 6...
Fluxnewsletter, December 2, 1968 (revised March 15, 1969).

FLUX-PRODUCTS 1961 TO 1970...GEORGE MACIUNAS...Ball checkers on plastic egg-crate board [$] 6...
Flux Fest Kit 2. [ca. December 1969].

COMMENTS: Ball Checkers *was originally conceived using ball bearings as checkers. This evolves into a less expensive game using plastic balls of two different colors, and an industrial light diffusion grid for the board. Maciunas never made a label for Ball Checkers and very few examples of this Fluxus*

George Maciunas. BALL CHECKERS as it was illustrated in Fluxus Newspaper No. 8, 1966

FLUXCHECKERS $6

George Maciunas. Sign advertising BALL CHECKERS as FLUXCHECKERS

Edition exist. The work is a good demonstration of Maciunas' use of ready-made industrial material for art work.

BALLOON JAVELIN

"...By the way I don't think I ever described to you the FLUXUS OLYMPIC Games...What we did was prepare various implements as follows:...'throwing rubber balloon javelin' - who could throw further..."
Letter: George Maciunas to Ben Vautier, February 1, 1965.

FLUXSPORTS (or Fluxolympiad) All items will be brought over...Javelin Long balloon...
Proposed Program for a Fluxfest in Prague. 1966.

PROPOSED FLUXSHOW FOR GALLERY 669 ... SPORTS-GAME CENTER...balloon javelin...
Fluxnewsletter, December 2, 1968.

PROPOSED FLUXSHOW ... SPORTS-GAME CENTER...Track & field games: balloon javelin...
Fluxnewsletter, December 2, 1968 (revised March 15, 1969).

FLUX-OLYMPIAD...[by G. Maciunas]...FIELD ... javelin baloon [sic] javelin...
Fluxfest at Stony Brook, Newsletter No. 1. August 18, 1969. versions A and B

FLUX-OLYMPIAD...FIELD - THROWS BALLOON JAVELIN (George Maciunas)...
Flux Fest Kit 2. [ca. December 1969].

FEB. 17, 1:30PM FLUX-SPORTS DOUGLASS COL. ... WRESTLING, BOXING & JOUSTING ... BALLOON JAVELIN (George Maciunas)
Poster/program for Flux-Mass, Flux-Sports and Flux-Show. February 1970.

COMMENTS: Balloon Javelin *is another variation on sports equipment, designed to deflate the idea of athletics. Some Flux sport games are reminiscent of children's games made with available things at hand. For example, "see who can spit a watermelon seed the farthest," rubber band snapping, catapulting apples at the end of a stick, etc.*

BALLOON RACKET

"...the FLUXUS OLYMPIC Games...What we did was prepare various implements as follows. Badminton rackets: rubber balloon instead of netting - & we sometimes used balloon instead of shuttle (badminton ball)..."
Letter: George Maciunas to Ben Vautier, February 1, 1965.

Fluxsports, Sept. 18, 1964, during perpetual Fluxfest at Washington Sq. Gallery. (badminton game with balloons for racket nets and for shuttles) [photo caption]
Fluxus Vaudeville TouRnamEnt (Fluxus Newspaper No. 6) July 1965.

FLUXSPORTS (or Fluxolympiad) All items will be brought over. Badminton Rackets prepared with balloons in place of racket netting and balloons are used for shuttles...
Proposed Program for a Fluxfest in Prague, 1966.

PROPOSED FLUXOLYMPIAD RACKET GAMES: prepared badminton: rackets with balloons instead of netting...
Fluxnewsletter, January 31, 1968.

[as above]
Fluxnewsletter, December 2, 1968.

FLUX-OLYMPIAD... DUAL CONTEST...Racket... badmington rackets...with balloons instead of netting playing balls,...
Fluxfest at Stony Brook, Newsletter No. 1, August 18, 1969. version A

FEB 17, 1:30PM FLUX-SPORTS DOUGLASS COL. ...BADMINGTON & TABLE TENNIS (George Maciunas) rackets with...inflated surfaces...
Poster/program for Flux-Mass, Flux-Sports and Flux-Show. February 1970.

COMMENTS: Balloon Racket *is an early racket variation, constructed with an armature containing an inflated balloon instead of netting. Obviously a shuttle hitting the racket would bounce off in an unpredictable way. This work is conceptually identical to* Inflated Racket, *which was an altered ping-pong racket.*

BALLOON TICKET
Silverman No. 655

"...The tickets [for Fluxorchestra at Carnegie Recital Hall, September 25, 1965] will be printed on balloons, which must be inflated to permit entry, then the ticket taker will pierce each balloon with a pin..."
Letter: George Maciunas to Ben Vautier, [Summer 1965].

PERFORMANCE COMPOSITIONS...1965: 2nd fluxorchestra concert at Carnegie Recital Hall, designed balloon tickets...
George Maciunas Biographical Data. 1976.

COMMENTS: Balloon Tickets, *made for a Fluxus concert in New York, are another example of Maciunas' desire to make Fluxus a totally participatory art form.*

BEAN KIT/1964 EDITION see:
Alison Knowles
BEARING BALL CHECKERS see:
BALL CHECKERS

BELLS RACKET

by George Maciunas:...ping-pong rackets,...with bells ...etc. ea: $20
Fluxnewsletter, April 1975.

COMMENTS: Bells Racket *would have been a commercially made ping-pong racket with bells attached, making a very noisy game. They are a later development of the various altered ping-pong rackets ideas.*

BICYCLE see:
MULTICYCLE

George Maciunas. BIOGRAPHY BOX. Susan Reinhold July 26, 1944. in the collective FLUX CABINET. see color portfolio

BIOGRAPHY BOX
Silverman No. < 227.1

"...Now I am making...special boxes for various friends - on their birth years - containing all parts of things that happened during that year. So I need to know your birth date - year - month - day - and I will make such a box. You could see some of the boxes at backworks and decide if you want them...."
Letter: George Maciunas to Peter Frank, [ca. March 1977].

COMMENTS: Biography Box *rose out of several ideas that Maciunas was working with: his charts,* Your Name Spelled with Objects, *and* Historical Boxes. *A* Biography Box *contains objects relating to the year of one's birth, perhaps a newspaper from the day one was born, things that were invented that year, etc.* Historical Boxes, *in contrast, contained objects pertaining to a year or epoch, but not necessarily an individual. Maciunas also made combinations of the two; for instance, a box on an historical figure such as Murillo would contain material related to the era of Murillo. This idea of history also carried over to events that were planned for the Fluxus farm in Massachusetts, such as meals using recipes from the Renaissance, everyone coming dressed in period costumes.*

BIRD ORGAN & OTHER BULB ACTIVATED TRICKS DOOR

Toilet no. 4 G. Maciunas...Doors - display on interior side of door - Bird organ * & other bulb activated tricks
Fluxnewsletter, April 1973.

COMMENTS: Bird Organ & Other Bulb Activated Tricks Door *is a combination of Maciunas' organ ideas and the Collective,* Cash Register, *where pressing particular keys would activate different events. In the context of the* Flux Toilet, *this door is similar in concept to the bulb "organ" that Maciunas built on the outside of his loft on Canal Street where some of the early New York Fluxus events took place. Squeeze a bulb and something would happen. This* Flux Toilet *door was never made.*

BOOKS see:
ARCTIC BIBLIOGRAPHY
ENCYCLOPEDIA OF WORLD ART
FLUX PAPER EVENTS
INDEX
BOX FROM THE EAST see:
FRESH GOODS FROM THE EAST
BOX STEPS see:
OBSTACLE STEPS
BOXING GLOVE DOOR see:
George Maciunas and Larry Miller
BREAKABLE BASEBALL FILLED WITH FLUID see:
Anonymous

BREATH FLUX TEST
Silverman No. 269, ff.

"...breath fluxtester is by gm (that's me)..."
Letter: George Maciunas to Dr. Hanns Sohm, [ca. late 1972].

1971 MACIUNAS:...breath test.
George Maciunas, Diagram of Historical Developments of Fluxus... [1973].

by George Maciunas: breath flux-tester, boxed: $10...
Fluxnewsletter, April 1975.

"The story on the other side is self explanatory. As a result of which I have to have eye surgery, since I hardly see anything with the left eye. In one sense, these hospital expenses to me are a windfall to any collectors of flux-objects. Now with high cost of surgery, I must make more objects and begin to respond to various orders and requests for them. Thus I am sending by mail to you the following...Geo. Maciunas ...breath test [$] 10..."
Letter: George Maciunas to Dr. Hanns Sohm. November 30, 1975.

GEORGE MACIUNAS...Breath flux test, boxed, 1971 $10...
Flux Objects, Price List. May 1976.

COMMENTS: George Maciunas *discovered a cache of useless objects on Canal Street and incorporated them into this gag. A friend of mine who is paid restitution from the German government must go to the Consulate every six months to*

George Maciunas. BREATH FLUX TEST. Mechanical for the label

George Maciunas. BULLS EYE FACE CLOCK. Mechanical for the clock face

COMMENTS: The obvious, with a twist. They don't work.

BUTTONS see:
FLUXWEAR 304

CAMOUFLAGED DOORS

...FLUX COMBAT WITH NEW YORK STATE AT-TORNEY GENERAL (& POLICE) BY GEORGE MA-CIUNAS...Flux-fortress (for keeping away the marshals & police:...camouflaged doors...funny messages behind each door...
Fluxnewsletter, May 3, 1975.

COMMENTS: Camouflaged Doors might well have been made. Maciunas was involved with making an elaborate escape route in his ongoing battle with the Attorney General's office over a dispute surrounding his development of co-operative housing for artists in what is now called Soho in New York City.

CAN OF WATER RACKET
Silverman No. < 258.I

''...By the way I don't think I ever described to you the FLUXUS OLYMPIC Games...What we did was prepare various implements as follows. Ping Pong. 1. Racket with can of water attached to it....''
Letter: George Maciunas to Ben Vautier, February 1, 1965.

Fluxsports: ping pong rackets with attached water cans...[photo caption]
fluxus Vaudeville TouRnamEnt (Fluxus Newspaper No. 6) July 1965.

sign an affidavit that she is still alive. Perhaps the intention of *Breath Flux Test is to show you that you are still alive.*

BUGS see:
INSECT STICK-ONS

BULLS EYE FACE CLOCK

FLUX-PRODUCTS 1961 TO 1970... GEORGE MA-CIUNAS Clocks with:... bulls eye face, ea: [$] 8...
Flux Fest Kit 2. [ca. December 1969].

COMMENTS: Although George Maciunas made a mechanical of this work, I have never seen a clock with this face attached to it. The concept bears a strong resemblance to Marcel Du-

champ's Rotoreliefs, *but in this instance the arms of the clock would move, interfering with the bull's eye, whereas in Duchamp's work, the design moves. Or perhaps the work is a pun on Jasper Johns'* Target with Plaster Casts, *1955, Kenneth Noland's free form targets, Frank Stella's squared targets, or Ben Vautier's* To Look At, *included in* Flux Year Box 2.

BURGLARY FLUXKIT
Silverman No. 268, ff.

1970 MACIUNAS: burglary kit...
George Maciunas, Diagram of Historical Developments of Fluxus... [1973].

GEORGE MACIUNAS...Burglary kit, 1971 $10...
Flux Objects, Price List. May 1976.

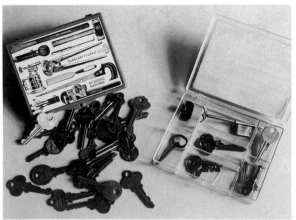

George Maciunas. BURGLARY FLUXKIT

George Maciunas. CAN OF WATER RACKETS

NANCY ANELLO

FLUXSPORTS (or Fluxolympiad) All items will be brought over...PING PONG...rackets with attached cans of water, play over table, winner is one who spills least water...
Proposed Program for a Fluxfest in Prague. 1966.

PROPOSED FLUXOLYMPIAD RACKET GAMES: ...prepared ping pong: rackets with attached cans filled with water,...
Fluxnewsletter, January 31, 1968.

[as above]
Fluxnewsletter, December 2, 1968.

PROPOSED FLUXSHOW ... SPORTS-GAME CENTER...Prepared table tennis: rackets...with attached cans filled with water,...
Fluxnewsletter, December 2, 1968 (revised March 15, 1969).

PROPOSED FLUXSHOW FOR GALLERY 669 ... SPORTS-GAME CENTER: prepared ping-pong: rackets with attached cans filled with water...
ibid.

FLUX-OLYMPIAD...(by G. Maciunas) ... DUAL ... Racket ping-pong...rackets with attached water containers, etc.
Fluxfest at Stony Brook, Newsletter No. 1, August 18, 1969.
versions A and B

FLUX-OLYMPIAD ... DUAL CONTEST - RACKET PREPARED PING-PONG:...rackets with attached water containers,...(George Maciunas)
Flux Fest Kit 2. [ca. December 1969].

FEB 17, 1:30PM FLUX-SPORTS DOUGLASS COL.

...BADMINGTON & TABLE TENNIS (George Maciunas) rackets with...spilling water containers.
Poster/program for Flux-Mass, Flux-Sports and Flux-Show. February 1970.

"For the exhibit, I would suggest a flux-ping pong tournament...you can make simple variations on rackets like:...attached can of water..."
Letter: George Maciunas to David Mayor, n.d. Reproduced in Fluxshoe, 1972.

"...for the Rome exhibit...you could set up a ping pong table with various prepared rackets, such as... racket with can of water attached to it..."
Letter: George Maciunas to Giancarlo Politi, n.d. Reproduced in Fluxnewsletter, April 1973.

PING PONG is played with "prepared" rackets:... rackets with water containers...G.M.
Fluxfest 77 at and/or, Seattle. September 1977.

COMMENTS: *Can of Water Racket is a commercially made ping-pong racket with an empty tin can attached to one surface. These rackets would have been filled with water and used for a very messy game of ping-pong.*

CARDS see:
PLAYING CARD DECK
SAME CARD FLUX DECK

CASH REGISTER

"...I got an antique cash register which we could connect to various events. i.e. each key (there are 100 keys) would be electrically connected to some event, like snow falling, lights off, sounds, visual events, etc. etc. smells, think of something and let me know, we are making this cash register a collective piece (like medieval cathedrals) Up to now we got...myself with ideas for cash register. Another 50 keys left-unused..."
Letter: George Maciunas to Ben Vautier, March 29, 1966.

"...We plan to make the Fluxshop as a continuous event mechanism. Cash register keys would be connected Electrically to all kinds of events; sounds of all kinds or movements, such as falling artificial snow, or shutting off lights, etc, etc. Every time a sale is made and appropriate keys pushed, some different combination of events would occur..."
Letter: George Maciunas to Milan Knizak, May 19, 1966.

COMMENTS: *Cash Register was never made as a Fluxus work. In correspondence, Maciunas stated that he had the Cash Register and designed activities for the various keys when pressed. This work has a relationship to* Bird Organ & Other Bulb Activated Tricks Door.

CEILING HATCHES see:
DUMMY CEILING HATCHES

TRICK CEILING HATCHES
CEILING HINGED DOOR see:
Anonymous
CENTRAL VERTICAL AXIS DOOR see:
Anonymous

CHALK DUMPLINGS

FLUX FOODS AND DRINKS ... DUMPLING VARIATIONS: One of the fillings:...chalk,...(G.M.)
Flux Fest Kit 2. [ca. December 1969].

COMMENTS: *Maciunas' Flux restaurant was short-lived.*

CHANGE MACHINE DISPENSING PENNY FOR DIME

PROPOSED FLUXSHOW FOR GALLERY 669... AUTOMATIC VENDING MACHINES-DISPENSERS (coin operated)...dispenser dispensing pennies (one for a dime)...
Fluxnewsletter, December 2, 1968.

PROPOSED FLUXSHOW...AUTOMATIC VENDING MACHINES-DISPENSERS (coin operated)...change dispenser dispensing pennies (one for dime)...
Fluxnewsletter, December 2, 1968 (revised March 15, 1969).

AUTOMATIC VENDING MACHINES...Change machine dispensing penny for dime...
Flux Fest Kit 2. [ca. December 1969].

MAY 30 - JUNE 5: THE STORE BY JOHN & YOKO + FLUXFACTORY Coin operated vending machines ...change machine dispensing penny for a dime (G.M. 1961)...
Schedule of events for Fluxfest presentation of John Lennon and Yoko Ono. [ca. April 1970]. version B

MAY 30 - JUNE 5: THE STORE BY YOKO + FLUXFACTORY Vending machines (coin operated): ... change machine dispensing penny for a dime...(by G. Maciunas)...
Schedule of events for Fluxfest presentation of John Lennon and Yoko Ono. April 1, 1970. version C

COMMENTS: *Designed in the context of other automatic vending machines by a number of Fluxus artists, there is no evidence that this particular dispenser was ever made.*

CHARTS see:
ARCHITECTURAL MONUMENTS OF THE WORLD, ATLAS OF MAPS
DIAGRAM OF HISTORICAL DEVELOPMENT OF FLUXUS AND OTHER 4 DIMENSIONAL, AURAL, OPTIC, OLFACTORY, EPITHELIAL AND TACTILE ART FORMS

FLUXUS DIAGRAM
FLUXUS (ITS HISTORICAL DEVELOPMENT
AND RELATIONSHIP TO AVANT-GARDE
MOVEMENTS)
HISTORY OF ART
LEARNING MACHINE
CHECKERS see:
BALL CHECKERS
FLUX TIMER CHECKERS

CHEESE EGGS

NEW YEAR EVE'S FLUX-FEAST, DEC 31, 1969
AT CINEMATHEQUE, 80 WOOSTER ST. ...George
Maciunas (with Barbara Moore): eggs containing ...
cheese...
Fluxnewsletter, January 8, 1970.

NEW YEARS EVE'S FLUX-FEST, DEC. 31, 1969...
egg shells stuffed with...cheese...
*all photographs copyright nineteen seVenty by peTer mooRE
(Fluxus Newspaper No. 9) 1970.*

31.12.1969 NEW YEAR EVE'S FLUX - FEAST
(FOOD EVENT)...G. Maciunas: inside eggs:...cheese
etc...
*George Maciunas, Diagram of Historical Developments of
Fluxus... [1973].*

COMMENTS: *Cheese Eggs were blown eggshells filled with
cheese, and were prepared for a Fluxus food event.*

CHESS see:
FLUXCHESS

CHESS TABLE WITH LAMP AND GLASS BOTTLE TOP

FLUXFURNITURE...CUBE TABLES, 15" cubes,
walnut sides, locked corners, George Maciunas: chess
table, lamp, glass bottle top, 4 weeks, $100.00 ...
Available in N.Y.C. at Multiples and late in 1967 at
FLUXSHOP, 18 GREENE ST.
Fluxfurniture, pricelist. [1967].

FLUX SHOW: DICE GAME ENVIRONMENT EN-
TIRE FLOOR AS DICE HAZARD TABLE DIE
CUBES, 15" CUBES ON FLOOR, Marked on sides,
top open or closed with clear plastic. Consisting or
containing...Glass bottle chess & light table.
Flux Fest Kit 2. [ca. December 1969].

COMMENTS: *Chess Table with Lamp and Glass Bottle Top
would be the 15" cube with light behind version of Color
Balls in Bottle-Board Chess. I'm not certain when this chess
table game was first made, however an example was exhibit-
ed in the Happening & Fluxus exhibition in Cologne in 1970.*

CHESS TABLE WITH LAMP AND SPICE CHESS

FLUXFURNITURE ... CUBE TABLES, 15" cubes,
walnut sides, locked corners...George Maciunas: chess
table, lamp, spice chest [sic] (bottled spices as chess
pieces) $100.00...Available in N.Y.C. at Multiples
and late in 1967 at FLUXSHOP, 18 GREENE ST.
Fluxfurniture, pricelist. [1967].

COMMENTS: *Chess Table with Lamp and Spice Chess would
be the table version of* Spice Chess *with illumination under-
neath.*

CHESS TABLES AND LAMPS

"...I would like to send you all new Flux items such
as furniture...I could include...chess table..."
Letter: George Maciunas to Ben Vautier, August 22, 1966.

PAST FLUX-PROJECTS (realized in 1966)...Flux -
furniture:...chess tables and lamps by George Maciu-
nas...
Fluxnewsletter, March 8, 1967.

FLUX-PROJECTS PLANNED FOR 1967...George
Maciunas:...chess tables, lamps.
ibid.

COMMENTS: *Chess Tables and Lamps is a general category,
planned in the context of other Flux furniture and chess vari-
ations.*

CHURCH SYNOD STAMPS

"...to produce Flash Art FLUXPACK 3...contents at
present will be as follows:...Postage stamps:...church
synod by Maciunas..."
*Letter: George Maciunas to Giancarlo Politi, n.d. Reproduced
in Fluxnewsletter, April 1973.*

Flash Art editor, Giancarlo Politi, proposed to pub-
lish the 3rd Fluxyearbook, maybe to be called FLUX-
PACK 3, with the following preliminary contents: ...
Postage stamps: members of a church synod by Ma-
ciunas...
Fluxnewsletter, April 1973.

COMMENTS: *Church Synod Stamps were never produced as
a Fluxus Edition. However, there are preparatory materials
pertaining to these stamps in the Maciunas Estate, now in the
Silverman Collection.*

CITROEN see:
George Maciunas and Robert Watts

CLOCK

FLUX SHOW: DICE GAME ENVIRONMENT EN-
TIRE FLOOR AS DICE HAZARD TABLE DIE
CUBES, 15" CUBES ON FLOOR, Marked on sides,
top open or closed with clear plastic. Consisting or
containing...Flux clocks by...& George Maciunas
Flux Fest Kit 2. [ca. December 1969].

COMMENTS: *A general entry. In this context, Maciunas was
designing ideas that would fit into 15" cubes for display on
the floor. Presumably, a cube would have contained any one
of Maciunas' Flux clocks. James Riddle's Fluxus work, 25
Clockfaces, 1 Clock Cabinet, was a 15" square modular cabi-
net with photographs of clock faces attached to it, one of
which was functional.*

CLOCKS see:
ALPHABET FACE CLOCK
BACKWARD CLOCK
BULLS EYE FACE CLOCK
COLOR WHEEL FACE CLOCK
DECIMAL FACE CLOCK
DISTANCE IN MM OF PERIMETER FACE
CLOCK
FAN CLOCK
FAST TURNING FACE (WITHOUT ARMS)
CLOCK
MIXED NUMBERS FACE CLOCK
MOTOR ONLY CLOCK
12 MOVEMENT FLUX CLOCK

COFFEE DUMPLINGS

FLUX FOODS AND DRINKS ... DUMPLING VARI-
ATIONS: One of the fillings:...coffee,...(G.M.)
Flux Fest Kit 2. [ca. December 1969].

COMMENTS: *It was really tricky to keep the coffee from
dripping out.*

COFFEE EGGS

PROPOSED FLUX DRINKS & FOODS ...FLUX
EGGS emptied egg shells filled with...coffee...
*Fluxfest at Stony Brook, Newsletter No. 1, August 18, 1969.
versions A and B*

FLUX DRINKS & FOODS FLUX EGGS emptied
egg shells filled with...coffee...(G. Maciunas)...
*Invitation to Participate in New Year Eve's Flux-Feast.
[ca. December 1969].*

FLUX FOODS AND DRINKS FLUX EGGS: Emp-
ty egg shells filled with...coffee...
Flux Fest Kit 2. [ca. December 1969].

NEW YEAR EVE'S FLUX - FEAST, DEC. 31, 1969
AT CINEMATHEQUE, 80 WOOSTER ST. ...George
Maciunas (with Barbara Moore): eggs containing...
coffee jello.
Fluxnewsletter, January 8, 1970.

NEW YEARS EVE'S FLUX-FEST, DEC. 31, 1969... egg shells stuffed with...coffee jello...
all photographs copyright nineteen seVenty by peTer mooRE (Fluxus Newspaper No. 9) 1970.

COMMENTS: *Blown eggs filled with coffee jello.*

COLOR BALLS IN BOTTLE-BOARD CHESS
Silverman No. > 242.IV

''...Take any object you wish from La Cedille qui Sourit...Also you could take a glass bottle chess set...''
Letter: George Maciunas to Ben Vautier, March 5, 1966.

...items are in stock, delivery within 2 weeks ... FLUXUSa FLUXCHESS: pieces identified by sound or weight or smell or time etc....FLUXUSa8 color chess, colored ball pieces, board made up of 64 glass bottles, $40
Vaseline sTREet (Fluxus Newspaper No. 8) May 1966.

''I got hold of a few $ & shipped out by REA a package to you: with:...1 - glass bottle & ball chess set...''
Letter: George Maciunas to Ken Friedman, [ca. February 1967].

FLUX-PRODUCTS 1961 TO 1969 ... GEORGE MACIUNAS...Chess sets:...color balls in 64-bottle board [$] 60...
Fluxnewsletter, December 2, 1968 (revised March 15, 1969).

FLUX-PRODUCTS 1961 TO 1970 ...GEORGE MA-

CIUNAS...Chess set color balls in bottle-board [$] 60...
Flux Fest Kit 2. [ca. December 1969].

FLUX SHOW: DICE GAME ENVIRONMENT ENTIRE FLOOR AS DICE HAZARD TABLE DIE CUBES, 15'' CUBES ON FLOOR, Marked on sides, top open or closed with clear plastic. Consisting or containing...Glass bottle chess & light table...
ibid.

FLUXUS-EDITIONEN ... [Catalogue no.] 764 GEORGE MACIUNAS: chess set color balls in bottle-board (koffer)
Happening & Fluxus. Koelnischer Kunstverein, 1970.

OBJECTS AND EXHIBITS...1965:...various chess sets...colored balls...
George Maciunas Biographical Data. 1976.

COMMENTS: *Color Balls in Bottle-Board Chess was first made as a Fluxus Edition with 64 glass jars glued together on their sides to form a square board, containing various colored plastic balls as chessmen. In the late 1960s, this same chess board was placed in a 15'' cube and illuminated from behind. See Chess Table with Lamp and Glass Bottle Top.*

COLOR WHEEL FACE CLOCK

FLUX-PRODUCTS 1961 TO 1969 ... GEORGE MACIUNAS...Clocks with dial faces:...color wheel...electric or wind-up, each [$] 8...
Fluxnewsletter, December 2, 1968 (revised March 15, 1969).

FLUX PRODUCTS 1961 TO 1970 ... GEORGE MACIUNAS Clocks with:... color wheel...face, ea: [$] 8...
Flux Fest Kit 2. [ca. December 1969].

OBJECTS:...Various flux-clocks (time by...colors...)
Proposal for 1975/76 Flux-New Year's Eve Event. [ca. November 1975].

COMMENTS: *There is no evidence that Maciunas ever produced a Fluxus Edition of this work. He was color blind. Later, Maciunas produced a related Fluxus work, John Lennon's Piece for George Maciunas Who Can't Distinguish Between These Colors.*

COMMUNISTS MUST GIVE REVOLUTIONARY LEADERSHIP IN CULTURE see:
Henry Flynt and George Maciunas
COMPARTMENT STEPS see:
OBSTACLE STEPS

COMPOSITION 1971
Silverman No. 269/bis.

COMMENTS: *Composition 1971 is not listed in any of the*

LORI TUCCI

George Maciunas. COMPOSITION 1971

references used for this book. However, the score takes on an object-like quality in the example that George Maciunas had given to Joe Jones at the time that the work was made in 1971 (Silverman No. 269/bis). It stems from an ongoing rivalry with Charlotte Moorman who organized the New York Avant-Garde Festival starting in the early 1960s that many Fluxus artists participated in.

CONCAVE RACKET
Silverman No. < 258.VII

''For the exhibit, I would suggest a flux-ping pong tournament...you can make simple variations on rackets like:...concave surface...''
Letter: George Maciunas to David Mayor, n.d. Reproduced in Fluxshoe, 1972.

''...for the Rome exhibit...you could set up a ping pong table with various prepared rackets, such as... [one] with...concave...surface...''
Letter: George Maciunas to Giancarlo Politi, n.d. Reproduced in Fluxnewsletter, April 1973.

COMMENTS: *Altered ready-mades that would deflect a ping-pong ball in marvelous distortions.*

PHOTOGRAPHER NOT IDENTIFIED

George Maciunas. COLOR BALLS IN BOTTLE-BOARD CHESS as it was illustrated in Fluxus Newspaper No. 8, 1966

NANCY ANELLO

George Maciunas. CONCAVE RACKET

NANCY ANELLO

George Maciunas. CONVEX RACKET with smashed in surface, probably from playing a ping-pong game

NANCY ANELLO

George Maciunas. CONVEX RACKET. A styrofoam version

CONFETTI INVITATIONS

INVITATIONS...printed of 1" sq. and several put in a spring loaded box, which when opened either shoots the little squares up or lets them fall down through a false bottom...
[Fluxus Newsletter] Proposal for Fluxus Paper Concert. [ca. Fall 1967].

COMMENTS: This work is by Maciunas and is an identical concept to his New Flux Year *(Silverman No. 243, ff.).*

CONTINUOUS STRING DISPENSER

PROPOSED FLUXSHOW FOR GALLERY 669... AUTOMATIC VENDING MACHINES-DISPENSERS (coin operated)...dispenser dispensing an endless string (one end only).
Fluxnewsletter, December 2, 1968.

PROPOSED FLUXSHOW ... AUTOMATIC VENDING MACHINES-DISPENSERS (coin operated)... dispenser dispensing an endless string.
Fluxnewsletter, December 2, 1968 (revised March 15, 1969).

AUTOMATIC VENDING MACHINES...Dispenser of an endless string.
Flux Fest Kit 2. [ca. December 1969].

MAY 30 - JUNE 5: THE STORE BY JOHN & YOKO + FLUXFACTORY Coin operated vending machines: ...nut dispenser dispensing into palm...an endless string (G. Maciunas)...
Schedule of events for Fluxfest presentation of John Lennon and Yoko Ono. [ca. April 1970]. version B

MAY 30 - JUNE 5: THE STORE BY YOKO + FLUX-FACTORY Vending machines (coin operated):...dispenser of an endless string (by G.Maciunas)...
Schedule of events for Fluxfest presentation of John Lennon and Yoko Ono. April 1, 1970. version C

"...for the Rome exhibit...Another dispenser could dispense a continuous string..."
Letter: George Maciunas to Giancarlo Politi, n.d. Reproduced in Fluxnewsletter, April 1973.

...This Fall, we shall publish V TRE no. 10, which shall consist of a plan for Flux-Amusement-Center, to contain...Vending machines...nut type dispensers

(dispensing...endless string ...)
Fluxnewsletter, April 1973.

FLUX AMUSEMENT ARCADE...Vending machines, dispensers of...endless string (Maciunas)
Preliminary Proposal for a Flux Exhibit at Rene Block Gallery. [ca. 1974].

COMMENTS: Continuous String Dispenser was never made as a Fluxus Edition. The idea seems to have a certain relationship to Jack Coke's Farmer's Co-op, Find the End. *But in the Maciunas version, after money was deposited string would continue to emerge from the dispenser in a great tangle.*

CONVEX RACKET
Silverman Nos. < 258.II; < 258.IV

FLUX-OLYMPIAD... DUAL...[by G. Maciunas]... Racket ping-pong convex ...etc.
Fluxfest at Stony Brook, Newsletter No. 1, August 18, 1969. versions A and B

FLUX-OLYMPIAD ... DUAL CONTEST - RACKET PREPARED PING-PONG: convex...rackets...(George Maciunas)...
Flux Fest Kit 2. [ca. December 1969].

FEB 17, 1:30PM FLUX-SPORTS DOUGLASS COL. ...BADMINGTON & TABLE TENNIS (George Maciunas) rackets with convex...surfaces...
Poster/program for Flux-Mass, Flux-Sports and Flux-Show. February 1970.

"For the exhibit, I would suggest a flux-ping pong tournament...you can make simple variations on rackets like:...convex...surface..."
Letter: George Maciunas to David Mayor, n.d. Reproduced in Fluxshoe, 1972.

"...for the Rome exhibit...you could set up a ping pong table with various prepared rackets, such as... [one] with...convex surface..."
Letter: George Maciunas to Giancarlo Politi, n.d. Reproduced in Fluxnewsletter, April 1973.

by George Maciunas:...ping-pong rackets, convex... etc. ea: $ 20
Fluxnewsletter, April 1975.

OBJECTS AND EXHIBITS...1966:...designed first prepared ping pong and badmington rackets (...convex...surfaces)
George Maciunas Biographical Data. 1976.

PING PONG is played with "prepared" rackets: convex...G.M.
Fluxfest 77 at and/or, Seattle. September 1977.

COMMENTS: Convex Racket *was constructed by Maciunas in at least two versions: one, a plastic globe glued to the surface of a commercially made ping-pong racket, the other, a styrofoam ball sliced in half and attached to the surfaces of the racket.*

CORRUGATED/UNDULATING RACKET
Silverman No. < 258.V

Fluxsports: ping-pong rackets...with foam rubber corrugated padding etc...[photo caption]
fluxus Vaudeville TouRnamEnt (Fluxus Newspaper No. 6) July 1965.

FLUX-OLYMPIAD...[by G. Maciunas:]...DUAL... Racket ping-pong...corrugated rackets...
Fluxfest at Stony Brook, Newsletter No. 1, August 18, 1969. versions A and B

FLUX-OLYMPIAD...DUAL CONTEST - RACKET PREPARED PING-PONG: ... corrugated rackets ... (George Maciunas)...
Flux Fest Kit 2. [ca. December 1969].

FEB 17, 1:30PM FLUX-SPORTS DOUGLASS COL. ...BADMINGTON & TABLE TENNIS (George Maciunas) rackets with...corrugated...surfaces...
Poster/program for Flux-Mass, Flux-Sports and Flux-Show. February 1970.

NANCY ANELLO

George Maciunas. CORRUGATED/UNDULATING RACKET

"...for the Rome exhibit...you could set up a ping pong table with various prepared rackets, such as... [one] with...corrugated...surface..."
Letter: George Maciunas to Giancarlo Politi, n.d. Reproduced in Fluxnewsletter, April 1973.

by George Maciunas:...ping-pong rackets...corrugated ...ea: $ 20
Fluxnewsletter, April 1975.

OBJECTS AND EXHIBITS...1966:...designed first prepared ping pong and badmington rackets (undulating...surfaces)
George Maciunas Biographical Data. 1976.

PING PONG is played with "prepared" rackets:...corrugated rackets...G.M.
Fluxfest 77 at and/or, Seattle. September 1977.

COMMENTS: *There are many possible variations for this surface. The example in the Silverman Collection uses plastic tubing that is glued sideways to the surface of the racket. The idea of this and other prepared ping-pong rackets is to make the game as difficult and as absurd as possible.*

COTTON DUMPLINGS

FLUX FOODS AND DRINKS ... DUMPLING VARIATIONS: One of the fillings:...cotton,...(G.M.)
Flux Fest Kit 2. [ca. December 1969].

COMMENTS: *Filling, without all those horrid calories.*

CUBE TABLES see:
FLUXFURNITURE

CUBE TENNIS BALL

"...We would like to produce...cube tennis ball or some such thing. ... These objects I think could be produced cheaper in Italy:...rubber dip moulded objects: cube tennis ball..."
Letter: George Maciunas to Daniela Palazzoli, n.d. Reproduced in Fluxnewsletter, April 1973.

COMMENTS: Cube Tennis Ball *was never made as a Fluxus Edition.*

DANCING AEROPHONE

"...Now I will list some new items produced: all in 1972...Some new instruments for Joe Jones Quartet, my contribution (aerophones) one rather funny $100 ..."
Letter: George Maciunas to Dr. Hanns Sohm, [ca. late 1972].

FLUXPRODUCTS PRODUCED IN 1972 & 1973... by George Maciunas:...aerophone, a duck call & dance to be included with Joe Jones tripod instruments, each $100
Fluxnewsletter, April 1973.

1972...MACIUNAS: dancing aerophone...
George Maciunas, Diagram of Historical Developments of Fluxus... [1973].

by George Maciunas:...aerophone, a duck call & dance (rubber bellows) to be included with Joe Jones tripod instruments, 110V, each: $100
Fluxnewsletter, April 1975.

GEORGE MACIUNAS...Dancing aerophone, duck call, 1972 $140...
Flux Objects, Price List. May 1976.

OBJECTS AND EXHIBITS...1970:...dancing duck call machine.
George Maciunas Biographical Data. 1976.

COMMENTS: Dancing Aerophones *are electrified rubber bellows that bob around while in use.*

DANCING COCKROACHES see:
KINESTHESIS SLIDES

DEAD BUG EGGS

PROPOSED FLUX DRINKS & FOODS ... FLUX EGGS emptied egg shells filled with...dead bug, etc.
Fluxfest at Stony Brook, Newsletter No. 1, August 18, 1969. versions A and B

FLUX DRINKS & FOODS FLUX EGGS emptied egg shells filled with...dead bug, etc. (G. Maciunas)...
Invitation to Participate in New Year Eve's Flux-Feast. [ca. December 1969].

COMMENTS: *Another of Maciunas' disgusting egg works,* Dead Bug Eggs *would be actual eggs filled with dead bugs. There is no evidence that this work was ever completed. The work has a relationship to Ben Vautier's* Living Fluxsculpture, *which uses bugs - live ones.*

DECIMAL FACE CLOCK

FLUX-PRODUCTS 1961 TO 1969 ... GEORGE MACIUNAS...Clock with dial faces: decimal system... electric or wind-up, each: [$] 8...
Fluxnewsletter, December 2. 1968 (revised March 15, 1969).

FLUX-PRODUCTS 1961 TO 1970 ... GEORGE MACIUNAS...Clocks with: decimal...face, ea: [$] 8...
Flux Fest Kit 2. [ca. December 1969].

SPRING 1969 ... MACIUNAS: clock with decimal face...
George Maciunas, Diagram of Historical Developments of Fluxus... [1973].

GEORGE MACIUNAS: Clocks with:...decimal faces, ea: $18...
Flux Objects, Price List. May 1976.

OBJECTS AND EXHIBITS...1969: clock faces: decimal...
George Maciunas Biographical Data. 1976.

COMMENTS: *I haven't been able to find evidence of what this clock face would have looked like. It's possible that Decimal Face Clock has something to do with breaking time into a system of a ten hour day with units of 100 minute hours. Another example of Maciunas' desire to reorder society, it was never made as a Fluxus Edition. Robert Watts designed* 10-Hour Flux Clock.

DIAGRAM OF HISTORICAL DEVELOPMENT OF FLUXUS AND OTHER 4 DIMENSIONAL, AURAL, OPTIC, OLFACTORY, EPITHELIAL AND TACTILE ART FORMS
Silverman No. 282, ff.

''I am working on the chart, but very slowly. Could finish probably in a year, because I have more time now. That could conceivably be included in such an anthology as a wall-paper...you could arrange a worthwhile flux-fest ... [including a] flux-history room with exhibit of all original prototypes of objects produced, interesting documents, etc. like my chart like calendar...''
Letter: George Maciunas to Daniela Palazzoli, n.d. Reproduced in Fluxnewsletter, April 1973.

...I have been working on an extensive chart-diagram showing growth and development of fluxus, also preceding, bordering, allied, following and imitative trends. I would like to request all recipients of this letter to send me as many facts as possible on any performances (and what was performed), exhibits, events,

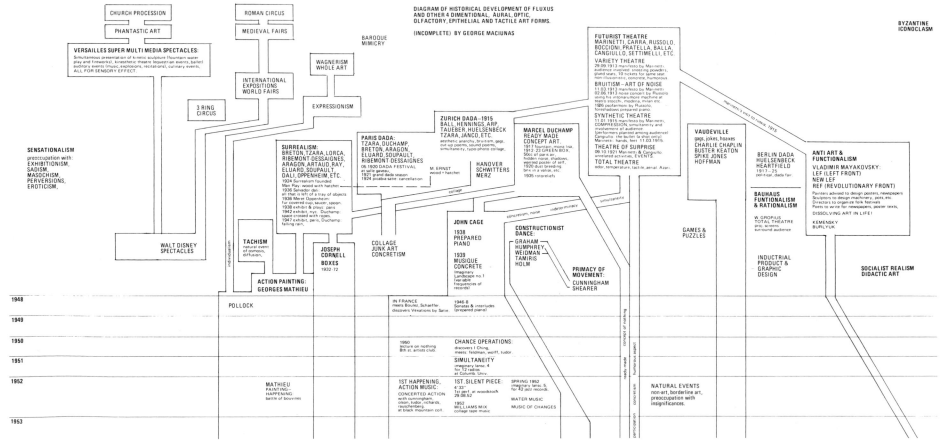

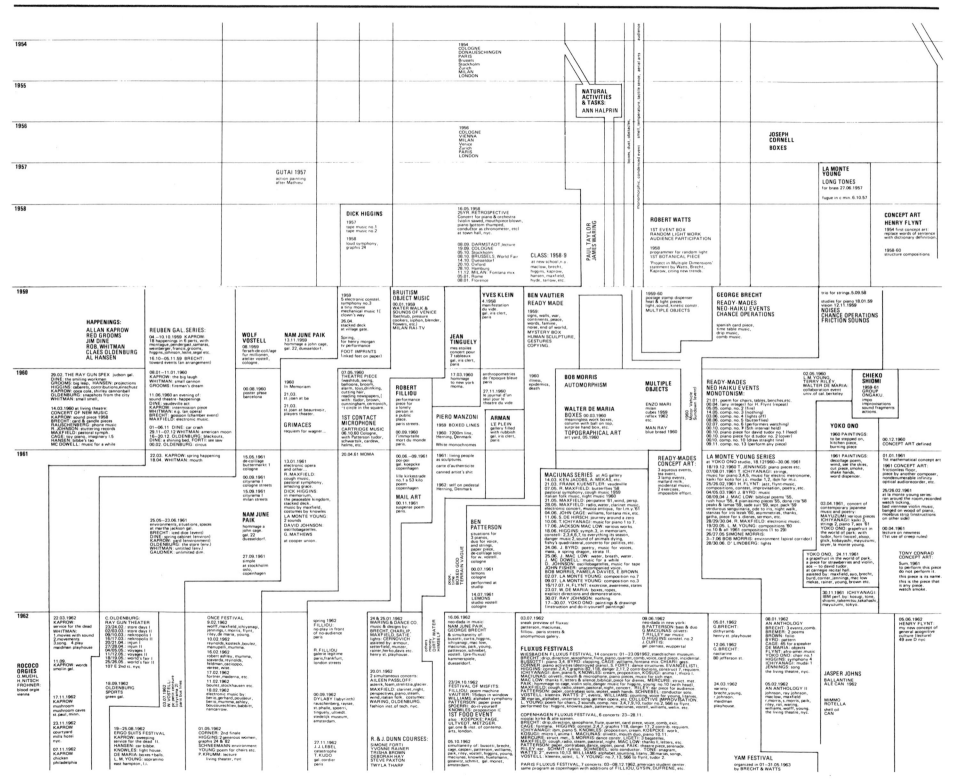

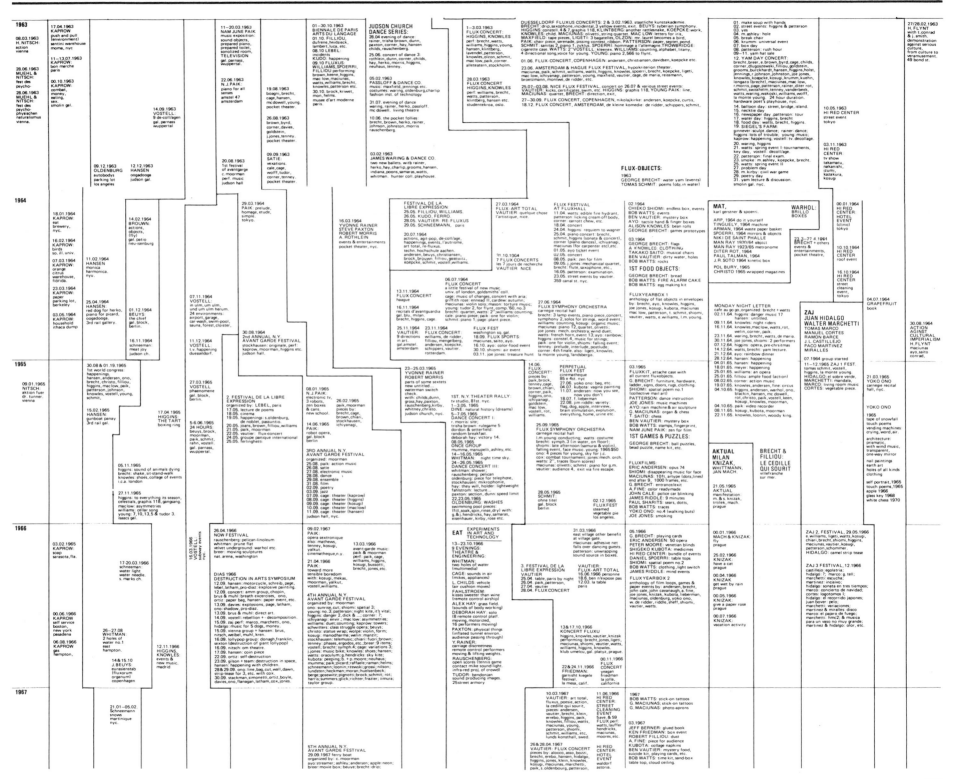

GEORGE MACIUNAS

10 & 12.10.1967
KAPROW:
fluids
(ice structure)
envir. los angeles

29.11–02.12.1967
KAPROW:
moving
chicago streets

23.10.1967
HIGGINS &
KNOWLES:
what did you bring·
higgins: danger 17,
graphis 132
knowles: string,
bean roll, blue ram,
proposition,
newspaper music,
news of the day.
mus. of contemp.
art, chicago.

05.10.1967
12 evenings of manipulations:
ortiz, b. hendricks, toche, kaprow,
hansen, g. hendricks, goldstein,
rose, schneeman, picard, millet,
corner, liebermann, moorman,
ono, paik, schmit, warner.
judson gal. nyc.

bussotti; cage: variations; chiari; christiansen;
corner; dewey; goldstein·marcy; hardy;
hansen; harris; hogle; b. & g. hendricks; higgins;
jacobs, jones, r. johnson, hi-red-center; kosugi;
kaprow: noise; klintberg; koepcke; lebel; ligeti;
leparc; mcwilliams; moran; mortenson; ono;
neuhaus: harbor piece; paik: tv, check, etc.;
picard; patterson; schneemann; shiomi; tone;
toche: mattress; tanabe: noise; usco; viner;
vostell; watts; welin; werner; young.
electronic music by: goldstein, gnazzo, grossi,
ichiyanagi, lucier, lundsten, mathews, nilson,
maginnis, rzewski, stockhausen, tenney,
films by: brakhage, emshwiller, kuchars, lee,
paik·yalkut, sharits, snow, wise, etc.
jazz by: unio·trio, randy kaye qt., favreau tr.,
heckman, giuffre, jordan, sun·ra, kenyatta.

schmit, shiomi, vautier, watts.
young. gal. punto, turin.

FLUX
perf: watts
moores,

01.05. VAUTIER—flux concert:
pieces by: vautier, maciunas, hidalgo,
marchetti, dioniso teatro, rome.

maciunas,
hendricks,
lauffer, etc.

06.06.1967
SIMONETTI:
FLUX CONCERT:
ayo, alocco, vautier, brecht,
hansen, hidalgo, marchetti,
higgins, maciunas, knowles,
williams, schmit, kosugi,
watts, s.oldenbourg, violola
de maria, ono, shiomi, paik,
patterson, jones. perf. by:
albergoni, nespolo, sassi,
simonetti.
gal. bertesca, genoa

15.11.1967
FLUX PAPER CONCERT
time & life building
MACIUNAS: in memoriam to
Olivetti for paper orchestra.
MACIUNAS, LAUFFER,
HENDRICKS, WATTS & WADA:
kill paper not people
(arrow attack on paper curtain)

1968

1968
BOB WATTS
AT STA. CRUZ, CAL.
street event, parades,
aerial, ballon flights,

POTATOE BANQUET:
several potatoe dishes,
drinks, deserts etc.

FLUX HOUSES
(maciunas)

EARTH ART
WALTER DE MARIA 1960
BEN VAUTIER 1961

1968:
CARL ANDRE
HEISER
OPPENHEIM
SMITHSON
DIBBETS
BOB MORRIS

31.12.1968
NEW YEAR EVE'S FLUX-FEAST
(FOOD EVENT)
Takako Saito: rice paper food
Ayo: rainbow noodles
G'Hendricks: blue cake & clouds
G. Maciunas: distilled coffee, tea, etc.

1969

SPRING 1969
BRECHT: closed on mondays
JOHN CHICK: forest foods
FARMERS COOP: human trap, etc.
FRIEDMAN: corsage, clippings,
cleanliness kit, etc.
ALICE HUTCHINS: jewelry kit
PER KIRKEBY: 4 teas, boxed solid,
clocks with compass or degree face.
MILAN KNIZAK: snakes, dreams.
JANE KNIZAK: toilet papers
CARLA LISS: water from many sources
MACIUNAS: clock with decimal face,
multi-faceted mirror, adder, etc.
MOSSET: dots
SERGE OLDENBOURG: solid bottle
SHARITS, GRIMES, THOMPSON:
paper games, events, music etc.
Y. WADA: smoke kit, cough
BOB WATTS: sleeping, sitting kits.

29.03.1969
SIMONETTI:
FLUX CONCERT
pieces by: ayo, alocco,
vautier, brecht, hansen,
hidalgo, marchetti, ono,
higgins, maciunas, riley,
knowles, schmit, paik,
williams, kosugi, young,
friedman, shiomi, jones,
patterson. perf. by:
simonetti, bento, corrado
la cappella, trieste.

31.12.1969
NEW YEAR EVE'S FLUX-FEAST
(FOOD EVENT)
G. Hendricks: potatoes in 10 flavors
Bici Hendricks: colored bread
Dick Higgins: tasteless jello
Milan Knizak: sausage log cabin
Alison Knowles: shit porridge
G. Maciunas: inside eggs: vodka, noodles,
cheese etc. wood, jute, pine cone tea.
Joan Mathews: black foods
H. & V. Pietkiewicz: shit cookies
F. Rycyk: unopenable nuts
Paul Sharits: jello mixed with own wrap.
Y. Wada: vitamin platter & salad soup.
Bob Watts: candy bullets.

ECLECTICISM
(PSEUDO·CONCEPTUAL ART)

ACCONCI:
hand into throat (kosugi '63)
OPPENHEIM:
220 yd condensed dash (fluxsports '64)
run in mud+plaster casts (yves klein)
TERRY FOX:
dust exchange (duchamp, filliou)
footprints (higgins '59, kosugi)
RICHARD LONG:
walking on line (la monte young '61)
BRUCE NAUMAN:
making faces (ben vautier '62, higgins)
clapping hands (joseph byrd '61)
corridor (bob morris '61)
BRUCE MC LEAN:
walk, run, jump (brecht, richard lester, etc)
smiles (higgins, shiomi, yoko ono, etc.)
DAN GRAHAM:
footprints (see above)
BARRY LE VA:
run into wall (la monte young, ben vautier)
JOHN VAN SAUN:
break through wall (see above)
KLAUS RINKE:
rhine water (vautier, carla liss, duchamp)
LES LEVINE:
notion of copying everyone (vautier '64)
JOHN BALDESSARI:
burn own paintings (vautier, ono)

JOHN PERREAULT:
alphabet event (emmett williams '61)
MEL BOCHNER:
measures (hi red center, filliou, ono, etc.)

BILL BECKLEY:
prepared ping-pong (maciunas '64)

EAT ART GALLERY:

1970

17.02.1970
FLUXMASS, by g.maciunas, assisted by:
y.wada, geoff hendricks, joe jones,
alison knowles, hala pietkiewicz, etc.
1. OFFERTORY: priest pours wine inside
own trousers and eats altar furnishings.
2. CANON: giant plaster bread positioned
under flying mechanical bird which
releases mud over bread consecrating it.
Oblation of Gifts: plastic statue melted.
Bread broken with sledge hammers by
gorilla dressed assistants.
3. COMMUNION: laxative cookies.
Communion Antiphon: choir sounds 12
different birds, each answered by revolver
shot from priest. etc.
at voorhees chapel, douglass college, n.j.

FLUXSPORTS:
by larry miller: 100yd. dash with candle,
100yd. run—3 forward, 2 backward.
by g.maciunas: race under hurdles,
100yd. run blowing ping-pong ball on floor.
handicap cup run with drinking, eating, etc.
boxing with giant gloves, bicycle joust,
prepared ping-pong rackets,
6ft. handle floor ping-pong game,
badminton racket, balloon basketball.
by bici hendricks: stilt soccer game,
by bob watts: obstacle shoes.
at gymnasium, douglass college, n.j.

1970
GEOFF HENDRICKS: relics
JOCK REYNOLDS: thermal event,
race, test, dangerous appliance.
MACIUNAS: multi-syringe,
ping-pong rackets, smimile machine,
12 bird aerophone, etc.

11.04—29.05.1970 FLUX FEST OF
JOHN LENNON & YOKO ONO:
11.04. GRAPEFRUIT FLUX-BANQUET
several grapefruit dishes such as wine,
pancakes, stuffings, etc. (collaborative)
11—17.04 DO IT YOURSELF—ONO
painting to be stepped, hammered, etc.
18—24.04 TICKETS by lennon: to
abandoned bldgs, desolate places, etc.
by wada: to visit famous people,
vautier: 100 tickets to same seat, etc.
outdated tickets by maciunas.
25.04—01.05 MEASURE by lennon,
ono, hi red center and flux clinic:
various measurements taken of visitors:
temperature inside shoe (watts) stomach
elasticity, minimum sway, capacity to
shrink etc. (maciunas); head volume,
palm, pocket capacity etc. (hi red center)
02—08.05 BLUE ROOM, concept
pieces by brecht, ono & lennon.
09—15.05. WEIGHT & WATER, traps,
wet holes, concealed wells by maciunas
& watts. water events by brecht,
sponges by ono & lennon.
16—22.05: FILM ENVIRONMENT,
4 wall projection of dots, ascending
lines, rainbow colors, etc. by sharits,
maciunas, ono, ayo, etc.
23—29.05. PORTRAIT OF LENNON
by ono & flux carpenters: 8 doors
in a maze, each opening different way
(pivoted, hinged at top, door in door, etc.

6.11.1970—6.01.1971
HAPPENING & FLUXUS
koelnischen kunstverein.

FLUX-TOILET:
WATTS: toilet seat when sat upon
opens door, colored water in tank,
metalic toilet paper, mirror, soap.
SHARITS: adhesive toilet seat,
stuck - glued toilet paper, etc.
MACIUNAS: squeaking toilet seat,
flushing starts rain, toilet bowl
persicope, ½ door, prepared sink.
AYO: brush seat, suds in tank
LENNON: boiling water in tank.

03.02.1971
FLUX CONCERT
presented by
Albrecht D:
pieces by: brecht,
filliou, higgins,
knowles, shiomi,
maciunas, vautier,
vostell, paik,
albrecht, ono.
stuttgart.

1971
MACIUNAS: burglary kit,
breath test.

VOSTELL: pregnant cow
KAPROW: tire environment
WATTS: parking lot event
VAUTIER: flux concert
SCHNEEMANN: media environment
KOEPCKE: environment
HANSEN: environment
HIGGINS: strip event
MUEHL & NITSCH: orgies

1971

8TH ANNUAL N.Y.
AVANT GARDE FESTIVAL
19.11.1971 armory, lexington & 25 st.
organized by c. moorman
paik: tv; apple: work; battock: mayonaise; bayrak: feast;
black, behrman, breer: rug; brennan: burying; brody,
cal. inst. of arts—open telephone; chiari, christiansen;
clarke: ferris wheel; cooper; copobianco; corner; davis;
davison; de knegt; devyatkin: video tunnel; dewey;
eat: tv info.; feelisch:white roses; ferrari; ferro; fischer;
forbes; fulop; gillette; giordano; gosewitz; hansen; harris;
jon hendricks; geoff hendricks: earth; higgins: mice;
hocking: tv, isobe; james sand; johnson; kaprow: tape;
kitchel; kubota; larrain; lennon: map, wind, giant guitar;
levine: voice print; lezak; lockwood; lurker; maclow: tree
movie; martin; mc neur; mc williams: colossal cake, moore,
netta; nese; nunemaker; oliveros; ono; human maze,
shadows, coin music; ortiz; phillips; picard; preston,
pulsa; raman; railly; rieveschl; ringgold; rockaway, russo;
rzewski; savage: photo event; schneemann: rainbow; seale;
sheffield &co.: balloon; siegel; sigma; silbey; skaggs;
spengenberg; stern; tambellini; thomas; vasulka; freex;
viner; vostell; williams; werner; yalkut etc.

YOKO ONO & JOHN LENNON:
THIS IS NOT HERE.
09.10.1971
EVERSON MUSEUM, SYRACUSE
(realized & designed by maciunas)
disappearing announcement card.
WEIGHT EVENT (collaborative event)
light: radiator, steel beam, cement block,
anvil, refrigerator, heavy: telephone,
shoes, cigarette, apple, guitar, etc.
WATER EVENT (collaborative event)
bendry: steam engine, brecht: still
cage: himself, filliou: eyes, dew gargle,
knowles: ice cube, maciunas: H2 & O.
lennon: napoleon's bladder,
moore: nose dropper, vautier: museum,
pennovich: museum boiler, seagull: toilet,
watts: vw, j.jones: water beater, etc.
BLUE ROOM (yoko ono objects)
growing piece, danger box, water piece,
apple, ad colour ptg. rearrangement pc.
mind objects, cleaning pc. shadows,
sizes, mend pc., white chess, glass keys.
GALLERY OF PART PAINTINGS
LENNON TOURS TICKETS:
one way tickets to goose bay, labrador,
hudson strait, baffin island, etc.
tickets to visit famous people, etc.
VENDING ARCADE:
lennon: kinetoscope, pinball machine,
metal slug dispenser, acorn dispenser.
DO IT YOURSELF PAINTINGS:
draw circle, hammer a nail, to be slept,
to be stepped on, smoked.
SOUND PROOF ROOM:
shadow box, screaming alarm clock, etc.
PLEXIGLAS MAZE
6TH DIMENSION:
masked visitors to sense: hot, cold, taste.

George Maciunas. DIAGRAM OF HISTORICAL
DEVELOPMENT OF FLUXUS AND OTHER
4 DIMENSIONAL, AURAL, OPTIC, OLFACTORY,
EPITHELIAL AND TACTILE ART FORMS

19.05.1973
FLUXGAMES
takako saito: kicking boxes billiard,
rubber band race, flipping box race,
bob watts: canvas loop team race,
ayo: team race on one pair of skis,
g.maciunas: travel inside giant wheel,
multi-bicycle square vehicle,
jousting with tubes on 2 swings,
uncoordinated 6 player chess, etc.
nam june paik: tv hide and seek,
y.wada: drum volley ball,
y.wada: walking on rolling pipes,
shiomi: balance poem,
bici hendricks: stilt soccer game
at 80 wooster st. nyc.

1972
SHIOMI: spatial poem no.3
MACIUNAS: dancing aerophone,
your name spelled with objects,
mouse history.

1973
WATTS: light kit, pebble atlas.
MACIUNAS: shit anthology
HENDRICKS: divorce album
CARLA LISS: island souvenir,
travel kit, cat kit.
SHIOMI: spatial poem no.4

environments, productions - with exact dates!, flux pieces or flux-like pieces by yourselves or others. All this I need by July 4th. Collaborators will receive the completed chart, which will be about 1 x 2 meters.
Fluxnewsletter, April 1973.

"...enclosed is the list or chart for which I need precise information from you on your events, concerts etc. I need dates, places and what was performed and by whom...I have all your correspondence and posters, xeroxes in a neat file and went through it a few times but could not find the list of performances you referred to. All I could find is many copies of 8½ x 11" posters like one saying Fluxfest, July 30, but no year, another Flux Garnisht Kigele, July 30, at Point Loma, 1967 (no contents), another Tony Tusler, July 9 (no year) at La Jolla Cove, another Ben Vautier, July 8/16, (no year) Theatre Red Shed, another Happening Neo Haiku Event, July 23 (no year) at the Red Shed, another Something else readings, July 25 (no year) at Tiny Ork Bookstore, that's all. So please, send me a typed list on single sheet, giving dates, etc. of all events, exhibits you organized...In your letters you always refer to all these lists, and information you sent me, but you never send me, only confuse me, since I begin to think somehow these documents walk away from my file...This week I will send you the new objects, but they are also listed in the chart, and dated too..."
Letter: George Maciunas to Ken Friedman, [ca. April 1973].

ENCLOSURES: Flux history chart...
Fluxnewsletter, May 3, 1975.

CHARTS, DIAGRAMS AND ATLASES...1966-present: History of Avant-garde, particularly its development from Futurism, DaDa, Duchamp, Surrealism, John Cage, Happenings, Events and Fluxus, with particular emphasis on documentation of Fluxus. 23" x 80". (still in progress)...
George Maciunas Biographical Data. May 1976.

COMMENTS: *This great chart by George Maciunas, which he always considered to be incomplete and "still in progress," is a development of his tracing the history of Fluxus in relation to other experimental art movements. The first chart that Maciunas made,* Fluxus Diagram, *was printed early in 1962. The second,* Fluxus (Its Historical Relationship to Other Avant-Garde Movements), *was published around 1966. That same year, he published* Expanded Arts Diagram *in Fluxfest Sale.* Diagram of Historical Development of Fluxus... *traces the influences and precursors of Fluxus from Futurist theatre; Anti-art & Functionalism; Bauhaus; Berlin Dada; Vaudeville; Gags; Jokes; Hoaxes; Marcel Duchamp Ready-Made/Concept Art; and to a lesser degree, Zurich Dada; Paris Dada; Surrealism; Roman Circus; Church Procession, etc.*

DIAGRAMS see:
CHARTS

DISEASES see:
George Maciunas and Ben Vautier

DISGUISES

Silverman No. > 295.II

FLUX COMBAT WITH NEW YORK STATE ATTORNEY GENERAL (& POLICE) BY GEORGE MACIUNAS (EVENT IN PROGRESS)...Maciunas' arsenal of weapons:...various disguises (gorilla mask, bandaged head, gas mask, etc.)
Fluxnewsletter, May 3, 1975.

IN ADDITION TO YOUR OWN PROPOSALS I WOULD ALSO PROPOSE THE FOLLOWING: ... George Maciunas:...disguises...
[George Maciunas] Invitation to Participate in Flux Summer Fest in South Berkshires. March 4, 1977.

COMMENTS: *Gorilla mask disguises were first used by Maciunas on the assistants to the Flux-Mass at Douglass College, February 17, 1970. Gorilla masks turn up later in photographs of Maciunas and various Fluxus activities. In the context of Flux-Combat Between G. Maciunas & Attorney General of*

© 1976 LARRY MILLER

George Maciunas. Gorilla Mask DISGUISE

New York 1975-76, *Maciunas' idea of disguises was absurdities intended to make a mockery of the official process against him.*

DISPENSERS see:
CHANGE MACHINE DISPENSING PENNY FOR DIME
CONTINUOUS STRING DISPENSER
DRINK BEFORE CUP DISPENSER
DRINK WITH CUP MISSING DISPENSER
GLUE DISPENSER
LEAKING CUP DISPENSER
LOOSE SAND DISPENSER
PREPARED EGGS DISPENSER
WATER SOLUBLE CUP DISPENSER

DISPLAY CASE MEDICINE CABINET

Toilet no. 4, G. Maciunas...Medicine cabinet...various * flux-boxes behind glass.
Fluxnewsletter, April 1973.

COMMENTS: *In Maciunas'* Flux Toilet, Display Case Medicine Cabinet *was to have been a glass-fronted display case with various Fluxus boxes in it. These boxes might have been made by Maciunas or other artists, and were intended to undermine one's normal notion of a medicine cabinet.*

DISTANCE IN MM OF PERIMETER FACE CLOCK

FLUX-PRODUCTS 1961 TO 1969 ... GEORGE MACIUNAS ...Clocks with dial faces: ...distance in mm of perimeter...electric or wind-up, each: [$] 8...
Fluxnewsletter, December 2, 1968 (revised March 15, 1969).

George Maciunas. DISTANCE IN MM OF PERIMETER FACE CLOCK. Mechanical for the clock face

FLUX-PRODUCTS 1961 TO 1970 ... GEORGE MACIUNAS Clocks with:... perimeter distance...face, ea: [$] 8...
Flux Fest Kit 2. [ca. December 1969].

GEORGE MACIUNAS Clocks with: perimeter...faces, ea: $18
Flux Objects, Price List. May 1976.

COMMENTS: Distance in MM of Perimeter Face Clock *is deceptively similar to Per Kirkeby's* Distance Traveled in MM Face Clock. *However, Maciunas is concerned with the distance the arm travels in an arc. Although he made a mechanical for this clock face, I have never seen an actual clock with this face attached.*

DISTILLED COFFEE

FLUXPROJECTS REALIZED IN 1967: ... Flux - Christmas-meal-event...George Maciunas - distilled

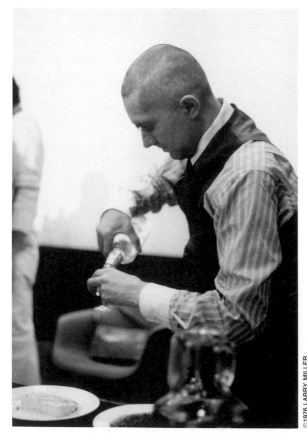

George Maciunas serving a distilled beverage at the New Year Eve's Flux-Feast, 1969

334

coffee...(all like clear water but retaining the taste)
Fluxnewsletter, January 31, 1968.

PROPOSED FLUXSHOW FOR GALLERY 669 ... FOOD CENTER...Distilled (clear) coffee...dispensed in test tubes. (a still may be set up to dispense fresh distilled drinks). by George Maciunas
Fluxnewsletter, December 2, 1968.

PROPOSED FLUXSHOW FOR GALLERY 669 ... FOOD CENTER...[as above]
Fluxnewsletter, December 2, 1968 (revised March 15, 1969).

PROPOSED FLUX DRINKS & FOODS...TRANSPARENTMEAL clear coffee (distilled)...
Fluxfest at Stony Brook, Newsletter No. 1, August 18, 1969. versions A and B

PROPOSED FLUX DRINKS & FOODS...DISTILLED DRINKS: coffee...
ibid.

FLUX DRINKS & FOODS...TRANSPARENT clear coffee...(distilled)...(G. Maciunas)...
Invitation to Participate in New Year Eve's Flux-Feast. [ca. December 1969].

FLUX FOODS AND DRINKS...MONO-MEALS: TRANSPARENT MEAL Clear coffee...(all distilled) ...(George Maciunas)
Flux Fest Kit 2. [ca. December 1969].

31.12.1968 NEW YEAR EVE'S FLUX - FEAST (FOOD EVENT)...G. Maciunas: distilled coffee...
George Maciunas, Diagram of Historical Developments of Fluxus... [1973].

OBJECTS AND EXHIBITS...1969...distilled coffee...
George Maciunas Biographical Data. 1976.

PERFORMANCE COMPOSITIONS...1969: 2nd flux-food event (funny foods) contributed...transparent coffee...
ibid.

COMMENTS: Distilled Coffee *is part of a distilled foods idea that Maciunas made, which related to an earlier work by Yoko Ono. In her distillation event of the mid-60s, water was distilled into nothing. In Maciunas' work, the flavor of food is retained but color is done away with. In this case the coffee looks like clear water, but still has a coffee taste. A relief from the usual greasy spoon fare - coffee that looks like mud and tastes like something else.*

DISTILLED MILK

PROPOSED FLUX DRINKS & FOODS...DISTILLED DRINKS...milk...
Fluxfest at Stony Brook, Newsletter No. 1, August 18, 1969. versions A and B

COMMENTS: Essence du lait.

DISTILLED PRUNE JUICE

FLUXPROJECTS REALIZED IN 1967:...Flux - Christmas-meal-event...George Maciunas -...distilled ...prune juice...(all like clear water but retaining the taste)
Fluxnewsletter, January 31, 1968.

PROPOSED FLUXSHOW FOR GALLERY 669 ... FOOD CENTER:...Distilled (clear)...prune juice... dispensed in test tubes. (a still may be set up to dispense fresh distilled drinks). by George Maciunas
Fluxnewsletter, December 2, 1968.

PROPOSED FLUXSHOW...[as above]
Fluxnewsletter, December 2, 1968 (revised March 15, 1969).

PROPOSED FLUX DRINKS & FOODS...DISTILLED DRINKS...prune juice...
Fluxfest at Stony Brook, Newsletter No. 1, August 18, 1969. versions A and B

FLUX DRINKS & FOODS...TRANSPARENT... prune juice...(distilled)...(G. Maciunas)...
Invitation to Participate in New Year Eve's Flux-Feast. [ca. December 1969].

FLUX FOODS AND DRINKS ... MONO-MEALS: TRANSPARENT MEAL Clear...prune juice...(all distilled)...(George Maciunas)
Flux Fest Kit 2. [ca. December 1969].

COMMENTS: A sure-cure for constipation.

DISTILLED TEA

FLUXPROJECTS REALIZED IN 1967:... Flux - Christmas-meal-event...George Maciunas -...distilled ...tea...(all like clear water but retaining the taste)
Fluxnewsletter, January 31, 1968.

PROPOSED FLUXSHOW FOR GALLERY 669 ... FOOD CENTER...Distilled (clear)...tea...dispensed in test tubes. (a still may be set up to dispense fresh distilled drinks). by George Maciunas
Fluxnewsletter, December 2, 1968.

PROPOSED FLUXSHOW...[as above]
Fluxnewsletter, December 2, 1968 (revised March 15, 1969).

PROPOSED FLUX DRINKS & FOODS... TRANSPARENTMEAL...clear tea (distilled)...
Fluxfest at Stony Brook, Newsletter No. 1, August 18, 1969. versions A and B

PROPOSED FLUX DRINKS & FOODS...DISTILLED DRINKS...tea...
ibid.

FLUX DRINKS & FOODS...TRANSPARENT...tea... (distilled)...(G. Maciunas)...

Invitation to Participate in New Year Eve's Flux-Feast. [ca. December 1969].

FLUX FOODS AND DRINKS ... MONO-MEALS: TRANSPARENT MEAL Clear...tea...(all distilled)... (George Maciunas)
Flux Fest Kit 2. [ca. December 1969].

31.12.1968 NEW YEAR EVE'S FLUX - FEAST (FOOD EVENT)...G. Maciunas: distilled...tea, etc.
George Maciunas, Diagram of Historical Developments of Fluxus... [1973].

OBJECTS AND EXHIBITS...1969:...distilled...tea...
George Maciunas Biographical Data. 1976.

COMMENTS: *Distilled Tea and the other distilled works are a commentary on the increased availability in our society, and dependence on prepared foods, instant foods, sani-pack foods, foods that are packaged and retain little of their original characteristics.*

DISTILLED TOMATO JUICE

FLUXPROJECTS REALIZED IN 1967:... Flux - Christmas-meal-event...George Maciunas...distilled ...tomato juice (all like clear water but retaining the taste)
Fluxnewsletter, January 31, 1968.

PROPOSED FLUXSHOW FOR GALLERY 669 ... FOOD CENTER: Distilled (clear)...tomato juice dispensed in test tubes. (a still may be set up to dispense fresh distilled drinks). by George Maciunas
Fluxnewsletter, December 2, 1968.

PROPOSED FLUXSHOW...[as above]
Fluxnewsletter, December 2, 1968 (revised March 15, 1969).

PROPOSED FLUX DRINKS & FOODS...DISTILLED DRINKS...tomato juice...
Fluxfest at Stony Brook, Newsletter No. 1, August 18, 1969. versions A and B

FLUX DRINKS & FOODS...TRANSPARENT...tomato juice (distilled)...(G. Maciunas)...
Invitation to Participate in New Year Eve's Flux-Feast. [ca. December 1969].

FLUX FOODS AND DRINKS ... MONO - MEALS: TRANSPARENT MEAL Clear...tomato juice, (all distilled)...(George Maciunas)
Flux Fest Kit 2. [ca. December 1969].

COMMENTS: *Like the other distilled liquids that Maciunas made, this one takes away all color from the juice, leaving a clear water which supposedly retains the taste of the original.*

$

FLUX-PRODUCTS 1961 TO 1970 ... GEORGE MA-CIUNAS... Flags: 28'' square, sewn legends:...$...ea: [$] 60...
Flux Fest Kit 2. [ca. December 1969].

COMMENTS: *The banner of capitalism, this flag was never made by George Maciunas as a Fluxus Edition.*

DOORS see:
ADHESIVE KNOB DOOR
BIRD ORGAN & OTHER BULB ACTI-
 VATED TRICKS DOOR
BOXING GLOVE DOOR
CAMOUFLAGED DOOR
CEILING HINGED DOOR
CENTRAL VERTICAL AXIS DOOR
DUMMY DOOR
FLOOR HINGED DOOR
GIANT CUTTING BLADES DOOR
HORIZONTAL AXIS DOOR
KNOB AT HINGES DOOR
MISSING KNOB DOOR
SAFE DOOR
SEPARATE DOORS DOOR
SMALL DOOR IN DOOR
TRICK DOORS
270 DEGREE DOOR

DOTS IN SQUARES

FLUXFEST PRESENTATION OF JOHN LENNON & YOKO ONO +* AT 80 WOOSTER ST. NEW YORK --1970...MAY 16-22: CAPSULE BY JOHN & YOKO + FLUX SPACE CENTER A 6 x 6 ft enclosure having various films projected on its walls to a single viewer inside [including] ...Dots in squares (G. Maciunas '66)
all photographs copyright nineteen seVenty by peTer mooRE (Fluxus Newspaper No.9) 1970.

COMMENTS: *This film would have been made directly on film leader using "prestype" placing dots of different values in squares. It was not included in the* Fluxfilms *package.*

DRINK BEFORE CUP DISPENSER

AUTOMATIC VENDING MACHINES...Drink dispenser dispensing drink with...cup coming after drink...
Flux Fest Kit 2. [ca. December 1969].

MAY 30 - JUNE 5: THE STORE BY YOKO + FLUX-FACTORY Vending machines (coin operated):...drink dispenser dispensing frink [sic]...with cup coming after drink...
Schedule of events for Fluxfest presentation of John Lennon and Yoko Ono. April 1, 1970. version C

...This Fall, we shall publish V TRE no. 10, which shall consist of a plan for Flux-Amusement-Center, to contain...vending machines...dispensers (dispensing...drink before cup...)...
Fluxnewsletter, April 1973.

FLUX AMUSEMENT ARCADE...Vending machines, dispensers of...drinks before cups etc. (Maciunas)
Preliminary Proposal for a Flux Exhibit at Rene Block Gallery. [ca. 1974].

COMMENTS: *Drink Before Cup Dispenser, a real-life drama. How often have you been really thirsty, had just enough money for a coke, put the money in the slot and the coke comes first, then the cup slides down and all you're left with is a mess.*

DRINK WITH CUP MISSING DISPENSER

PROPOSED FLUXSHOW...AUTOMATIC VENDING MACHINES-DISPENSERS (coin operated)...drink dispenser dispensing water with cup missing...
Fluxnewsletter, December 2, 1968 (revised March 15, 1969).

AUTOMATIC VENDING MACHINES...Drink dispenser dispensing drink with cup missing...
Flux Fest Kit 2. [ca. December 1969].

MAY 30 - JUNE 5: THE STORE BY YOKO + FLUX-FACTORY Vending machines (coin operated):...drink dispenser dispensing frink [sic] with cup missing...
Schedule of events for Fluxfest presentation of John Lennon and Yoko Ono. April 1, 1970. version C

COMMENTS: *Similar to the previous work,* Drink with Cup Missing Dispenser *omits the cup altogether.*

DRUMSKIN RACKET

by George Maciunas:...ping-pong rackets...drumskin, etc. ea: $20
Fluxnewsletter, April 1975.

COMMENTS: *Drumskin Racket was never made by Maciunas. I'm not sure whether the intention was to have a drumskin covering a cylinder to make a drumming sound when hit by the ping-pong ball or to just use a drumskin across a racket frame, making a different sound.*

DUET FOR C ON BASS SORDUNE, VOICE AND AN OLD SCORE

PERFORMANCE COMPOSITIONS...1962:...First musical compositions...music for lips...
George Maciunas Biographical Data. 1976.

COMMENTS: *This score was revised on January 2, 1962 and entitled* Trio for Bass Sordune (c Note), Voice, Old Score and Etuis. *It is printed by blueprint, and although it does not have the Fluxus copyright on it, it was a part of the Fluxus*

George Maciunas. DUET FOR C ON BASS SORDUNE, VOICE AND OLD SCORE

DUET FOR FULL BOTTLE AND WINE GLASS

seconds												
shaking												
slow dripping												
fast dripping												
small stream												
pouring												
splashing												
opening corked bottle												
roll bottle												
dropp bottle												
strike bottle with glass												
brake glass												
gargle												
drink												
sipping												
rinsing mouth												
spiting												

George Maciunas. DUET FOR FULL BOTTLE AND WINE GLASS

scores publishing activity that Maciunas was involved with in the early part of 1962.

DUET FOR FULL BOTTLE AND WINE GLASS

Silverman No. 240.2

FLUXFEST INFORMATION...Some pieces not fully described list the availability of a score...Any of the pieces can be performed anytime, anyplace and by anyone, without any payment to fluxus provided ... conditions are met ... Scores - 25 cents each ... George Maciunas DUET FOR FULL BOTTLE AND WINE GLASS, 1962 Various specified sounds (dripping, gargling, sipping, rinsing etc.) are performed. Score.
Fluxfest Sale. [Winter 1966].

PERFORMANCE COMPOSITIONS ... 1962: ... First musical compositions...music for...bottles...
George Maciunas Biographical Data. 1976.

COMMENTS: *The score is printed in the blueprint process and was distributed by Maciunas as part of Fluxus scores publishing activities in the early part of 1962. I have found only one score of Maciunas with a Fluxus copyright on it, unlike the scores by other artists he distributed that almost always had the Fluxus copyright. Either Maciunas just didn't care about the copyright, or felt that he didn't want to put forward his own identity as the dominant part of Fluxus publications and products in the early stages of its development.*

DUMMY CEILING HATCHES

FLUX COMBAT WITH NEW YORK STATE ATTOR-

NEY GENERAL (& POLICE) BY GEORGE MACIUNAS...Flux fortress (for keeping away the marshals & police:...dummy...ceiling hatches, filled or backed with white powder, liquids, smelly extracts etc....
Fluxnewsletter, May 3, 1975.

COMMENTS: *As part of* Flux Combat with New York State Attorney General (& Police), *Maciunas designed a number of disguises, exits and other improbable combat weapons, including* Dummy Ceiling Hatches.

DUMMY DOOR

FLUX COMBAT WITH NEW YORK STATE ATTOR-NEY GENERAL (& POLICE) BY GEORGE MACIU-NAS...Flux fortress (for keeping away the marshals & police:...dummy...doors ...filled or backed with white powder, liquids, smelly extracts, etc. funny messages behind each door...
Fluxnewsletter, May 3, 1975.

COMMENTS: *Dummy Door, similar in concept to* Dummy Ceiling Hatches, *is a part of Maciunas' absurd arsenal of weapons against what he considered to be the even more absurd harassment by the Attorney General's office against him for his irregular way in organizing the Fluxhouse Co-operatives. These co-operatives were designed as a way for artists to own their own studio/living spaces, and not fall victim to escalating rents and the whims of landlords that have so often confronted artists.*

DUMPLINGS see:
FOOD

EGG WHITE EGGS

OBJECTS AND EXHIBITS...1969:...egg-white...
George Maciunas Biographical Data. 1976.

COMMENTS: *Blown eggs filled with just egg whites, then sealed and boiled, so that when opened they would be yokeless.*

EGGS see:
FOOD

8 LENS SUN GLASSES

PROPOSAL The principal business of this Company (to be known as The Greene Street Precinct, Inc.) will be twofold: 1. The operation of a unique entertainment and game environment...spaces fitted with specialty shops, concessions, and featuring a specially designed automated food, drink and game lounge... 2. The development, distribution, and sale of a new product line utilizing the talents of new and well known artists and designers. Products will be of low cost, mass produced and distributed to mass markets here and abroad. Certain more expensive items may be of limited production considered unique and for conspicuous consumption. The product line will embrace certain existing lines of Flux-group and Implosions, Inc. which have proven sales value and/or potential for immediate production...BUDGET - PRODUCT LINE Initiating production of the following new products: 8 sunglass band $10,000...
[George Maciunas and Robert Watts], Proposal for The Greene Street Precinct, Inc. [ca. December 1967].

NEWS FROM IMPLOSIONS, INC. Various items were produced as planned &...listed in the past news-letter:...8-lens sun glasses (worn and turned like slipping -crown)...
Fluxnewsletter, January 31, 1968

PROPOSED CONTENTS FOR FLUXPACK 3 TO BE PUBLISHED IN 1973 BY FLASH ART...Multi sun - glasses by Maciunas [work crossed off by Maciunas]... Cost Estimates: for 1000 copies...sun glasses $600... 100 copies signed by:...Maciunas...
[George Maciunas], Proposed Contents for Fluxpack 3. [ca. 1972].

"...a sun-glass 'hat' or like a crown, which has actually 4 pairs of sun glasses each different like some through fresnel lense, or half sphere lense, box like lense, you can turn it around the head to view through different lenses, could be easily produced by stamping single plastic sheet and dieing [sic] and shaping afterwards."
Fluxnewsletter, April 1973.

COMMENTS: *8 Lens Sun Glasses* are not included in Fluxpack 3, and I doubt they got beyond a drawing or prototype stage.

George Maciunas. ENCYCLOPEDIA OF WORLD ART

NANCY ANELLO

ELASTIC RACKET

"...the FLUXUS OLYMPIC Games...What we did was prepare various implements as follows; Badminton rackets:...rubber band netting on rackets, so when you hit the shuttle hard, it always got stuck into the racket netting..."
Letter: George Maciunas to Ben Vautier, February 1, 1965.

Fluxsports: ping - pong rackets ... with rubber band netting...[photo caption]
fluxus Vaudeville TouRnamEnt (Fluxus Newspaper No. 6) July 1965.

FLUX-OLYMPIAD ... DUAL ... Racket ... badminton rackets with elastic netting, etc.
Fluxfest at Stony Brook, Newsletter No. 1, August 18, 1969. version A

OBJECTS AND EXHIBITS...1966:...designed first prepared ping pong and badmington rackets (...elastic etc. surfaces)...
George Maciunas Biographical Data. 1976.

COMMENTS: *In a way, there is a relationship between* Elastic Racket *and Ay-O's* Web Obstacle. *The ping-pong ball would become entangled with the rubberband netting of the elastic racket.*

ENCYCLOPEDIA OF WORLD ART
Silverman No. < 241.I

COMMENTS: *A Manhattan Yellow Pages from 1964 with a library binding stamped* Encyclopedia of World Art *was given by George Maciunas to Ben Vautier that same year. Although there are no references to it in Fluxus publications or elsewhere, it is a work similar in concept to* Arctic Bibliography *and* Index, *two other altered ready-mades that Maciunas had advertised.*

END AFTER 9
Silverman No. < 243.I

...items are in stock, delivery within 2 weeks...FLUX-FILMS...FLUXFILM 3 END AFTER 9, 1 min $6
Vaseline sTREet (Fluxus Newspaper No. 8) May 1966.

FLUXFILMS SHORT VERSION, 40 MIN AT 24 FRAMES/SEC. 1400FT. ...flux-number 3 Anonymous END AFTER 9 2' word & numeral film (a gag)....Editing and titles by George Maciunas
Fluxfilms catalogue. [ca. 1966].

PAST FLUX-PROJECTS (realized in 1966)...Flux-films: total package: 1 hr. 40 min. ...end after 9 by G. Maciunas.
Fluxnewsletter, March 8, 1967.

FLUX-PRODUCTS 1961 TO 1969...FLUXFILMS, short version Summer 1966 40 min. 1400 ft.:...End

After 9. 16mm [$] 180 8mm version [$] 50
Fluxnewsletter, December 2, 1968 (revised March 15, 1969).

FLUX-PRODUCTS 1961 TO 1970...FLUXFILMS, short version, Summer 1966...End After 9. 16mm version $180 8mm version $50
Flux Fest Kit 2. [ca. December 1969].

03.1965...FLUXFILMS MACIUNAS:...end after 9...
George Maciunas, Diagram of Historical Developments of Fluxus... [1973].

OBJECTS AND EXHIBITS...1965:...of some 20 films into Flux-film anthology, contributed: films made without camera (using various adhesive patterns on clear film stock):...end after 9...
George Maciunas Biographical Data. 1976.

COMMENTS: *This film is just as the title indicates: the sequence of numbers 1 to 9, with the word "end" at the end.*

ENTRY DOOR see:
SMALL DOOR IN DOOR
ESSAYS see:
THE GRAND FRAUDS OF ARCHITECTURE
SEVEN APPENDICES
U.S. SURPASSES ALL NAZI GENOCIDE RECORDS

EXCRETA FLUXORUM
Silverman No. 272, ff.

"...Now I will list some new items produced: all in 1972...Excreta fluxorum by myself (manures from various animals, insects,) small version: $10, large version: $30 (very smelly)..."
Letter: George Maciunas to Dr. Hanns Sohm, [ca. late 1972].

FLUXPRODUCTS PRODUCED IN 1972 & 1973... by George Maciunas:...Excreta fluxorum, excrement from: caterpillar, bird, turtle, hamster, horse, cat, sheep, cockroach, lion, antelope, $10...
Fluxnewsletter, April 1973.

"...Meanwhile I have several new boxes, one a collection of all kinds of shit: caterpillar, bird, horse, sheep, hamster, etc. all in correct latin, so no one will know what the shit is all about..."
Letter: George Maciunas to Ben Vautier, [ca. April 1973].

1973...MACIUNAS: shit anthology
George Maciunas, Diagram of Historical Developments of Fluxus... [1973].

by George Maciunas:...excreta fluxorum, excrement from animals, insects, birds, etc. small version (7 samples): $10, large version (18 samples): $40
Fluxnewsletter, April 1975.

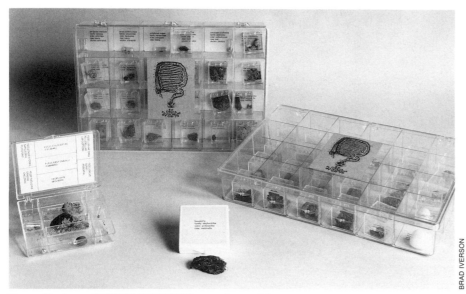

George Maciunas. EXCRETA FLUXORUM. see color portfolio

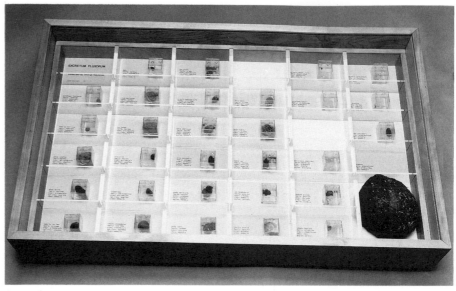

George Maciunas. EXCRETA FLUXORUM. Presented as an aspect of the Flux Science Show with each sample offered for sale separately. see color portfolio

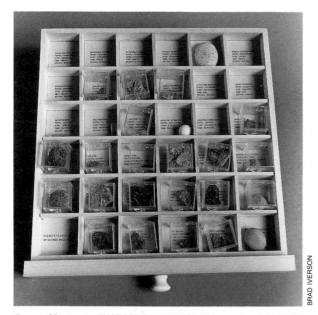

George Maciunas. EXCRETA FLUXORUM. This version is in FLUX CABINET

"The story on the other side is self explanatory. As a result of which I have to have eye surgery, since I hardly see anything with the left eye. In one sense, these hospital expenses to me are a windfall to any collectors of flux-objects. Now with high cost of surgery, I must make more objects and begin to respond to various orders and requests for them. Thus I am sending by mail to you the following...Geo. Maciunas — large excreta box [$] 40..."
Letter: George Maciunas to Dr. Hanns Sohm, November 30, 1975.

...Large shit box by Maciunas $50 (speciments [sic] from some 24 animals)...
[Fluxus price list for a customer]. January 7, 1976.

"Excreta fluxorum, large version, by G. Maciunas $40"
Letter: George Maciunas to Dr. Hanns Sohm, May 1, 1976.

GEORGE MACIUNAS...Excreta fluxorum, animal excrement antholofy [sic], small $12
Flux Objects, Price List. May 1976.

Excreta fluxorum, large, 18 speciments [sic], 1973 $100
ibid.

OBJECTS AND EXHIBITS...1972:...anthology of animal excreta, etc...
George Maciunas Biographical Data. 1976.

Science Show...animal droppings....Show of...shit. "Flux-science"
Notes: George Maciunas for the Fluxfest at and/or, Seattle. [ca. September 1977].

an ANTHOLOGY of ANIMAL SHIT is displayed, from over 40 creatures. Include a wide range and type, from insects, mammals to extinct creatures. Label them in Latin and display as in a science museum.

G.M. ... Sun. 25 ... Science exhibit ... Animal Shit Anthology....
Fluxfest 77 at and/or, Seattle. September 1977.

COMMENTS: *Excreta Fluxorum must have been one of Maciunas' favorite works. It is a collection of many types of animal shit, all properly labeled in Latin. The work exists in various versions: a single specimen included in* Flux Year Box 2, *a small version with seven specimens; a large version with twenty-four specimens; in the* Flux Cabinet *with thirty-six; and a display model subtitled "A Flux Science Show," made for the Flux Fest at and/or in Seattle, contains thirty-four specimens. The only human shit sample is a rock labeled "Cro-Magnon," and frequently, there will be a mythical shit specimen, a white plastic ball labeled "unicorn."*

EXIT see:
 SMALL DOOR IN DOOR
EYEBLINK see:
 Yoko Ono

FACE ANATOMY MASK
Silverman No. 265

"... to produce the Flash Art FLUXPACK 3 ... contents at present will be as follows:...Masks:...face anatomy by Maciunas..."
Letter: George Maciunas to Giancarlo Politi, n.d. Reproduced in Fluxnewsletter, April 1973.

COMMENTS: *Face Anatomy Mask was made by Maciunas to be included in* Fluxpack 3. *The masks were also occasionally distributed by Fluxus as individual works.*

George Maciunas. FACE ANATOMY MASK

FACELESS CLOCK see:
MOTOR ONLY CLOCK
FACETED MIRROR see:
MULTI-FACETED MIRROR

FACETED SURFACE RACKET

Silverman No. < 258.VII

PROPOSED FLUXOLYMPIAD RACKET GAMES:...
prepared ping pong:...rackets with faceted surface,...
Fluxnewsletter, January 31, 1968.

[as above]
Fluxnewsletter, December 2, 1968.

PROPOSED FLUXSHOW FOR GALLERY 669 ...
SPORTS-GAME CENTER:...prepared ping-pong:...
rackets with faceted surface...
ibid.

PROPOSED FLUXSHOW ... SPORTS - GAME CEN-
TER...Prepared table tennis:...rackets [with] ...fac-
eted surface...
Fluxnewsletter, December 2, 1968 (revised March 15, 1969).

COMMENTS: *As far as I can determine,* Faceted Surface
Racket *is identical to* Concave Racket. *A combination of
these two ideas is illustrated.*

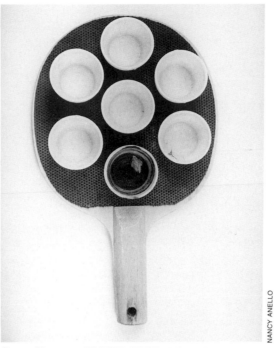

George Maciunas. FACETED SURFACE RACKET

NANCY ANELLO

FACSIMILE TICKET TO GROLIER CLUB EXHIBITION, 1893

Silverman No. < 262.I

FLUXFEST PRESENTATION OF JOHN LENNON
& YOKO ONO +* AT 80 WOOSTER ST. NEW YORK
--1970...APR. 18-24: TICKETS BY JOHN LENNON
+ FLUXTOURS...facsimile ticket to Grolier Club Ex-
hibition, 1893 (George Maciunas)...

*all photographs copyright nineteen seVenty by peTer mooRE
Fluxus Newspaper No. 9) 1970.*

George Maciunas. FACSIMILE TICKET TO GROLIER CLUB
EXHIBITIONS, 1893

COMMENTS: *This is one of Maciunas' fake tickets, or in this
instance, an out of date facsimile ticket. Worthless, but
worth a try.*

FACSIMILE TICKET TO VISIT HOUSE OF COMMONS, 1885

Silverman No. < 262.II

FLUXFEST PRESENTATION OF JOHN LENNON
& YOKO ONO +* AT 80 WOOSTER ST. NEW YORK
--1970...APR. 18-24: TICKETS BY JOHN LENNON
+ FLUXTOURS...facsimile ticket to visit House of
Commons, 1885 (George Maciunas)...

*all photographs copyright nineteen seVenty by peTer mooRE
(Fluxus Newspaper No. 9) 1970.*

COMMENTS: *Another worthless ticket, it is possible that as
a Fluxus gesture, tickets such as this one might have been
presented for entry.*

George Maciunas. FACSIMILE TICKET TO VISIT HOUSE OF
COMMONS, 1885

FAN CLOCK

"1975-6 Objects GM — clock as fast as fan
Notes: George Maciunas on objects, [ca. 1976].

COMMENTS: *Fan Clock is one work in two separate parts. It
was conceived by Larry Miller and built by George Maciunas
in the mid 1970s for Jean Brown. The clock has hands that
spin as fast as a fan, and the fan has blades which move ever
so slowly.*

FAST TURNING FACE (WITHOUT ARMS) CLOCK

PROPOSED FLUXSHOW FOR GALLERY 669 ...

OBJECTS, FURNITURE...clocks: ...fast turning face (without arms)...
Fluxnewsletter, December 2, 1968.

COMMENTS: *In this clock just the face would turn, quite fast, similar to Marcel Duchamp's* Rotoreliefs. *It's possible that the design for* Bulls Eye Face Clock *could have been used for this Fluxus work as well.*

FASTENERS see:
FLUXWEAR 304

FILMS

"...Regarding film festival. - I will send you the following: You will get these - end of April ...Fluxfilm - my own - 20 min....If this is too much, let me know, I will send fewer. They and another 6 films make up the whole 2 hour Fluxfilm program. I will send later (when I can afford) the other 6, so you will have a complete program to show around. Incidentally, loops from these films will go into Fluxus II Yearboxes, Everything is ready, but I got short on $ & can't produce these boxes in quantity, since making film copies is rather expensive. Maybe in a month or two I will issue that yearbox...."
Letter: George Maciunas to Ben Vautier, March 29, 1966.

FLUXPROJECTS FOR 1968 (In order of priority) 12. Film projects, film-wall-paper events in "the garage", fluxshop opening.
Fluxnewsletter, January 31, 1968.

PROPOSED R & R EVENINGS: ... Flux-film-walls (loops by ...George Maciunas,...)
ibid.

[as above]
Fluxnewsletter, December 2, 1968.

FLUXPROJECTS FOR 1969...Fluxfilms: by George Maciunas.
ibid.

FLUX PRODUCTS 1961 TO 1970 ... FLUXYEARBOX 2 May 1968... film loops by: [including] ...G. Maciunas...
Flux Fest Kit 2. [ca. December 1969].

COMMENTS: *This is just a general entry of references to various film ideas, but without specifying the individual works. Most of these are in the context of larger film projects which appear in the Collective section of this book.*

FILMS see:
FLUXFILMS

FISH BREAD

PROPOSED FLUXSHOW FOR GALLERY 669 ... FOOD CENTER:...Fish-meal:...fish bread (from fish bone flour)...
Fluxnewsletter, December 2, 1968.

PROPOSED FLUXSHOW...[as above]
Fluxnewsletter, December 2, 1968 (revised March 15, 1969).

PROPOSED FLUX DRINKS & FOODS...FISHMEAL ...fish bread (from fish bone flour)...
Fluxfest at Stony Brook, Newsletter No. 1, August 18, 1969. versions A and B

FLUX DRINKS & FOODS...MONO-MEALS: FISHMEAL...fish bread (from fish bone flour) ... (G. Maciunas)...
Invitation to Participate in New Year Eve's Flux-Feast. [ca. December 1969].

FLUX FOODS AND DRINKS...MONO-MEALS: FISHMEAL...bread (from fish bone flour) ... (G. Maciunas)
Flux Fest Kit 2. [ca. December 1969].

COMMENTS: *Bread made from fish-meal or fish bone flour. There is no evidence that this bread was actually made. Could be a biblical pun: the loaves and fishes...*

FISH CANDY

PROPOSED FLUX DRINKS & FOODS...FISHMEAL ...fish candy etc.
Fluxfest at Stony Brook, Newsletter No. 1, August 18, 1969. versions A and B

FLUX DRINKS & FOODS...MONO-MEALS: FISHMEAL...fish candy etc. (G. Maciunas)...
Invitation to Participate in New Year Eve's Flux-Feast. [ca. December 1969].

FLUX FOODS AND DRINKS ... MONO - MEAL: FISHMEAL...fish...candy...(G. Maciunas)
Flux Fest Kit 2. [ca. December 1969].

COMMENTS: *Part of a "Mono-Meal" idea, all the various foods would be made from one type of food, in this case, fish. There were other mono-meals, for example, just potatoes, not included in this book because they were not altered.*

FISH DRINK

PROPOSED FLUXSHOW FOR GALLERY 669 ... FOOD CENTER:...Fish-meal: clear fish drink (distilled)...
Fluxnewsletter, December 2, 1968.

PROPOSED FLUXSHOW...[as above]
Fluxnewsletter, December 2, 1968 (revised March 15, 1969).

PROPOSED FLUX DRINKS & FOODS...FISHMEAL clear fish carbonated drink...
Fluxfest at Stony Brook, Newsletter No. 1, August 18, 1969. versions A and B

FLUX DRINKS & FOODS...MONO-MEALS: FISHMEAL clear fish carbonated drink...(G. Maciunas)...
Invitation to Participate in New Year Eve's Flux-Feast. [ca. December 1969].

FLUX FOODS AND DRINKS ... MONO-MEALS: FISHMEAL...clear fish carbonated drink...(G. Maciunas)
Flux Fest Kit 2. [ca. December 1969].

COMMENTS: *Fish Drink might have been made. Conceptually similar to the distillation ideas, it was a clarified carbonated drink, made from fish-meal.*

FISH ICE CREAM

PROPOSED FLUXSHOW...FOOD CENTER:...Fish-meal:...fish ice cream...
Fluxnewsletter, December 2, 1968 (revised March 15, 1969).

PROPOSED FLUX DRINKS & FOODS...FISHMEAL ...fish ice cream...
Fluxfest at Stony Brook, Newsletter No. 1, August 18, 1969. versions A and B

FLUX DRINKS & FOODS...MONO-MEALS: FISHMEAL...fish ice cream...(G. Maciunas)...
Invitation to Participate in New Year Eve's Flux-Feast. [ca. December 1969].

FLUX FOODS AND DRINKS ... MONO-MEALS: FISHMEAL...fish...ice cream...(G. Maciunas)
Flux Fest Kit 2. [ca. December 1969].

COMMENTS: *Another of the "Mono-Meal" ideas.*

FISH JELLO

PROPOSED FLUXSHOW FOR GALLERY 669 ... FOOD CENTER:...Fish-meal:...clear fish jello...
Fluxnewsletter, December 2, 1968.

PROPOSED FLUXSHOW...[as above]
Fluxnewsletter, December 2, 1968 (revised March 15, 1969).

PROPOSED FLUX DRINKS & FOODS...FISHMEAL ...fish jello...
Fluxfest at Stony Brook, Newsletter No. 1, August 18, 1969. versions A and B

PROPOSED FLUX DRINKS & FOODS...TRANSPARENTMEAL...clear fishes (fish flavor jello)...
ibid.

FLUX DRINKS & FOODS...MONO-MEALS: FISHMEAL...fish jello...TRANSPARENT...fish...(clear

jellatin [sic] with appropriate flavours)...(G. Maciunas)...
Invitation to Participate in New Year Eve's Flux-Feast. [ca. December 1969].

FLUX FOODS AND DRINKS ... MONO-MEALS: TRANSPARENT MEAL...clear fish...(clear jellatin with appropriate flavours)...(George Maciunas)
Flux Fest Kit 2. [ca. December 1969].

FLUX FOODS AND DRINKS ... MONO-MEALS: FISHMEAL...fish jello...(G. Maciunas)
ibid.

COMMENTS: *The "Mono-Meal" concept of making an entire meal with one particular food and preparing it in different ways, not just cooking it in different ways, and making other types of dishes that one would normally think of as not pertaining to the original. Fish Jello certainly would be that.*

FISH PASTRY

PROPOSED FLUXSHOW...FOOD CENTER...Fish-meal:...fish pastry...
Fluxnewsletter, December 2, 1968 (revised March 15, 1969).

PROPOSED FLUX DRINKS & FOODS...FISHMEAL ...fish pastry...
Fluxfest at Stony Brook, Newsletter No. 1, August 18, 1969. versions A and B

FLUX DRINKS & FOODS...MONO-MEALS: FISH-MEAL...fish pastry...(G. Maciunas)...
Invitation to Participate in New Year Eve's Flux-Feast. [ca. December 1969].

FLUX FOODS AND DRINKS ... MONO-MEALS: FISHMEAL...fish...pastry...(G. Maciunas)
Flux Fest Kit 2. [ca. December 1969].

COMMENTS: *Fish Pastry, what more could one say?*

FISH PUDDING

PROPOSED FLUXSHOW FOR GALLERY 669 ... FOOD CENTER:...Fish-meal:...fish pudding...
Fluxnewsletter, December 2, 1968.

PROPOSED FLUXSHOW...[as above]
Fluxnewsletter, December 2, 1968 (revised March 15, 1969).

PROPOSED FLUX DRINKS & FOODS...FISHMEAL ...fish pudding...
Fluxfest at Stony Brook, Newsletter No. 1, August 18, 1969. versions A and B

FLUX DRINKS & FOODS...MONO-MEALS: FISH-MEAL...fish pudding...(G. Maciunas)...
Invitation to Participate in New Year Eve's Flux-Feast. [ca. December 1969].

FLUX FOODS AND DRINKS ... MONO-MEALS: FISHMEAL...fish...pudding...(G. Maciunas)
Flux Fest Kit 2. [ca. December 1969].

COMMENTS: *Again, a "Mono-Meal" idea.*

FISH SALAD

FLUX DRINKS & FOODS...MONO-MEALS: FISH-MEAL...fish salad...(G. Maciunas)...
Invitation to Participate in New Year Eve's Flux-Feast. [ca. December 1969].

COMMENTS: *Fish Salad might have been quite delicious in contrast to some of Maciunas' other food ideas. Included here because of its appearance in a sequence for a "Mono-Meal," it is not necessarily an alteration of food.*

FISH TEA

FLUX FOODS AND DRINKS ... MONO-MEALS: FISHMEAL...fish...tea etc. (G. Maciunas)
Flux Fest Kit 2. [ca. December 1969].

COMMENTS: *Fish Tea, presented as a component of Maciunas' fish "Mono-Meal," can also be viewed as one of his "tea variations," which grow out of Per Kirkeby's 4 Flux Drinks.*

FLAGS

...set of 1969-70 Flux-productions, which consist of the following: 1969 ...George Maciunas:...flux flag...
Fluxnewsletter, January 8, 1970.

EXHIBITS...JULY 4 & 5 FLUX DAY...Flags by ... & George Maciunas
Proposal for Flux Fest at New Marlborough. April 8, 1977.

COMMENTS: *This is a general entry for Maciunas' flags that were not identified specifically. See individual flag entries.*

FLAGS see:
&
$
FLUX
FLUXFEST
FLUXSHOP
LOOSE
MATCH FLAG
NO
?
U.S.A SURPASSES ALL THE GENOCIDE
 RECORDS
WIN
YES
FLIES see:
INSECT STICK-ONS
FLOOR HINGED DOOR see:
Anonymous

FLUSHING STARTS RAIN TOILET

Toilet no. 4 G. Maciunas...Toilet flushing...starts fine drizzle of rain over head.
Fluxnewsletter, April 1973.

1970-71...FLUX-TOILET...MACIUNAS:...flushing starts rain...
George Maciunas, Diagram of Historical Developments of Fluxus... [1973].

COMMENTS: *Flushing Starts Rain Toilet, a component of George Maciunas' Flux Toilet environment, which was first built for the Happening & Fluxus exhibition at the Koelnischer Kunstverein late in 1970. However, there were the usual problems with officialdom, and the toilet was never opened to the public. A plan for Flux Toilet, perhaps containing many of the elements that were in the original, appears in the April 1973, Fluxnewsletter. Maciunas again constructed a Flux Toilet at the Flux Fest at and/or in Seattle in the fall of 1977.*

FLUX

...items are in stock, delivery within 2 weeks...FLUX-FLAGS AND BANNERS ea. $25 28" square, sewn-legends, double bunting, readable both sides, grommets at corners...FLUXUSyx FLUXFLAG: white on black: "flux"
Vaseline sTREet (Fluxus Newspaper No. 8) May 1966.

FLUX-PRODUCTS 1961 TO 1970 ... GEORGE MACIUNAS...Flags: 28" square, sewn legends: Flux... ea: [$] 60...
Flux Fest Kit 2. [ca. December 1969].

COMMENTS: *Flux, a flag, was part of an ongoing idea of flags and banners that started in 1964. Flux was not produced in great numbers as a Fluxus work, if it exists at all.*

FLUX see:
FLUXUS

FLUXADDER

"...I will ship a crate to you with most large Fluxus items such as...adder...etc., etc. - about 200 lbs. of goodies, so you can have a kind of Fluxshop..."
Letter: George Maciunas to Ben Vautier, May 19, 1966.

...items are in stock, delivery within 2 weeks ... FLUXUSz FLUXADDER, electric, boxed $40
Vaseline sTREet (Fluxus Newspaper No. 8) May 1966.

FLUX-PROJECTS PLANNED FOR 1967...George Maciunas:...Flux - adding machine...
Fluxnewsletter, March 8, 1967.

PROPOSED FLUXSHOW FOR GALLERY 669 ...

OBJECTS, FURNITURE...Boxed events & objects - one of a kind:...Flux-adder by George Maciunas.
Fluxnewsletter, December 2, 1968.

FLUX-PRODUCTS 1961 TO 1969 ... GEORGE MACIUNAS...Flux-adder, 110V electric [$] 10
Fluxnewsletter, December 2, 1968 (revised March 15, 1969).

FLUX-PRODUCTS 1961 TO 1970 ... GEORGE MACIUNAS...Flux-adder, electric [$] 10...
Flux Fest Kit 2. [ca. December 1969].

"...fluxadder is now in two versions, one measures the number of times you enter and exit own place, another measures number of times you switch light on, in toilet or bathroom for instance, each $40..."
Letter: George Maciunas to Dr. Hanns Sohm, [ca. late 1972].

FLUXPRODUCTS PRODUCED IN 1972 & 1973... by George Maciunas:...fluxadder, measuring number of times one enters and exits own place or toilet, or switches light on and off, each [$] 40...
Fluxnewsletter, April 1973.

SPRING 1969...MACIUNAS:...adder, etc.
George Maciunas, Diagram of Historical Developments of Fluxus... [1973].

by George Maciunas:...flux-adder, measuring number of times one enters and exits own place or toilet, or switches light on and off, each: [$] 40
Fluxnewsletter, April 1975.

FLUX-PRODUCTS 1961 TO 1970 ... GEORGE MACIUNAS...Flux-adder, electric [$] 20...
[Fluxus price list for a customer]. September 1975.

...Electric counter by Maciunas $80...
[Fluxus price list for a customer]. January 7, 1976.

GEORGE MACIUNAS...Fluxadder, measuring exits or light switching, etc. ea: $50...
Flux Objects, Price List. May 1976.

OBJECTS AND EXHIBITS...1969:...adding machine
George Maciunas Biographical Data. 1976.

COMMENTS: *I have never seen this work, although indications are that it did exist. The idea behind it was to keep count of everyday activities.*

FLUX ANIMAL see:
 MYSTERY FLUX ANIMAL
FLUX CHECKERS see:
 BALL CHECKERS
 FLUX TIMER CHECKERS

FLUXCHESS

FLUXKIT containing following fluxus-publications:

(also available separately)...FLUXUSax FLUXCHESS ...$20
Vacuum TRapEzoid (Fluxus Newspaper No. 5) March 1965.

03.1965...G. MACIUNAS:...chess
George Maciunas, Diagram of Historical Developments of Fluxus... [1973].

COMMENTS: *This is just a general entry for Maciunas' chess ideas. One should look at the cross references for specific works.*

FLUXCHESS see:
 BALL CHECKERS
 CHESS TABLE WITH LAMP AND GLASS BOTTLE TOP
 CHESS TABLE WITH LAMP AND SPICE CHESS
 CHESS TABLES AND LAMPS
 COLOR BALLS IN BOTTLE-BOARD CHESS
 GRINDER CHESS
 SPICE CHESS
 TIME CHESS, SAND TIMER PIECES
FLUX CLOCKS see:
 CLOCKS

FLUX-COMBAT BETWEEN G. MACIUNAS & ATTORNEY GENERAL OF NEW YORK 1975-76

FLUX COMBAT WITH NEW YORK STATE ATTORNEY (& POLICE) BY GEORGE MACIUNAS (EVENT IN PROGRESS) a) Attorney General's arsenal of weapons: some 30 subpoenas to Maciunas and all his friends, interrogation of his friends, warrant for arrest of Maciunas, search warrants, 4 angry and frustrated marshals and policemen armed with clubs.
b) Maciunas' arsenal of weapons: humorous, insulting and sneering letters to Attorney General, various disguises (gorilla mask, bandaged head, gas mask, etc.) photos of these disguises sent to Att. General. Flux-fortress (for keeping away the marshals & police: various unbreakable doors with giant cutting blades facing out, reinforced with steel pipe braces, camouflaged doors, dummy and trick doors and ceiling hatches, filled or backed with white powder, liquids, smelly extracts etc. funny messages behind each door, real escape hatches and tunnels leading to other doors, vaults etc. various warning alarm systems. various precautions in entering and departing flux-fortress. After termination of this combat (possibly flight from New York State) documentation of this event will be published by Maciunas (copies of letters, disguise photos, photos of various doors and hatches and photos of escape etc.)
Fluxnewsletter, May 3, 1975.

... Attorney General event by GM $40 (should be

George Maciunas. FLUX-COMBAT BETWEEN G. MACIUNAS & ATTORNEY GENERAL OF NEW YORK 1975-76. Label

complete by end of February) if not will substitute with some other small boxes...
[Fluxus price list for a customer]. January 7, 1976.

GEORGE MACIUNAS...Attorney General event, 12" x 12" box $80
Flux Objects Price List. May 1976.

"1975-6 Objects - GM - Attorney General events"
Notes: George Maciunas on objects, [ca. 1976].

COMMENTS: *In 1966, George Maciunas and Robert Watts, and others associated with Fluxus, saw a need for artists to be able to control their own living and working space. Up until that time many artists in New York had been subjected to the whims of the city building department and other agencies, and were continually faced with harassment for living in substandard buildings. As an extension of Fluxus, Maciunas and the others decided to form artists' co-operatives to purchase warehouse buildings, bring them up to code and make them affordable, frequently reserving space in the building for performance activities that would be of benefit to the members. These were non-profit co-op undertakings; neither Fluxus, Maciunas, nor the others had any intention of getting rich*

from the activities. Later, the area came to be known as Soho and there was a great deal of real estate speculation in the area. The Attorney General's office began to crack down on "illegal co-ops." Maciunas had taken short cuts, which in the strict sense of the law were not proper. The Attorney General issued subpoenas and used strong-arm tactics to intimidate him and bring Maciunas to court. In response, he made a Fluxus event out of the process, sending humorous or insulting letters, preparing disguises, inventing escape routes, mailing cards to friends in Europe and Asia to send back to the Attorney General as though Maciunas were travelling in those countries. He intended to produce a Fluxus Edition of documentation of the event. The box was never produced, although much of the documentation still remains. Some elements of the event are catalogued individually in this book. Other material exists as files and documentation in the Silverman Collection.

FLUX COMBAT WITH NEW YORK STATE ATTORNEY GENERAL (& POLICE) BY GEORGE MACIUNAS (EVENT IN PROGRESS) see:
CAMOUFLAGED DOORS
DISGUISES
DUMMY CEILING HATCHES
DUMMY DOOR
FLUX-COMBAT BETWEEN G. MACIUNAS & ATTORNEY GENERAL OF NEW YORK 1975-76
GIANT CUTTING BLADES DOOR
LETTERS TO ATTORNEY GENERAL
SAFE DOOR
TRICK CEILING HATCHES
TRICK DOORS

FLUX-EGGS see:
FOOD

George Maciunas. FLUXFEST. Finished graphic for the flag

FLUXFEST

FLUX-PRODUCTS 1961 TO 1969 ... GEORGE MACIUNAS...Flags, 28'' square, sewn legends, with grommets: Fluxfest...each: [$] 60
Fluxnewsletter, December 2, 1968 (revised March 15, 1969).

COMMENTS: *Maciunas made preparatory work for the Fluxfest flag. Perhaps a flag does exist, although I have never seen one. It could have been used both for a Flux fest or as an individual work in a way similar to George Brecht's Exhibit: hang it up somewhere and then the activity or occurrence that takes place around the flag is a Flux fest.*

FLUXFILMS see:
ARTYPE
DOTS IN SQUARES
END AFTER 9
EYEBLINK
LINEAR TURN
LINES FALLING OR RISING
1000 FRAMES
PAPER SOUND LOOP
ROPE MOVIE
10 FEET

FLUXFURNITURE see:
CHESS TABLE WITH LAMP AND GLASS BOTTLE TOP
CHESS TABLE WITH LAMP AND SPICE CHESS
CHESS TABLES AND LAMPS
MODULAR CABINETS

FLUXLABYRINTH see:
ADHESIVE FLOOR
BOXING GLOVE DOOR
FOAM STEPS
KNOB AT HINGES DOOR
OBSTACLE STEPS
RUBBER BRIDGE
SEE SAW
SHOE STEPS
SLIPPERY FLOOR
SMALL DOOR IN DOOR
270 DEGREE DOOR

FLUXMOUSE

"...Maciunas mystery animal has now been changed to mouse with the history of its death (in alcohol bottle, can't be mailed....''
Letter: George Maciunas to Dr. Hanns Sohm, [ca. late 1972].

FLUXPRODUCTS PRODUCED IN 1972 & 1973... by George Maciunas: fluxmouse, with history of its death, in alchohol, [sic] each different, not mailable [$] 20...
Fluxnewsletter, April 1973.

1972...MACIUNAS:...mouse history.
George Maciunas, Diagram of Historical Developments of Fluxus... [1973].

by George Maciunas:...Fluxmouse, with history of its death, it alcohol $20...
Fluxnewsletter, April 1975.

COMMENTS: *Very few examples of the Fluxus Edition of Maciunas' Fluxmouse were made. The one that I have seen is an actual mouse with a typewritten history of its death attached to the outside of the bottle. Maciunas states in a letter to Dr. Hanns Sohm (see above) that the mouse takes the place of "Mystery Animal." Mystery Flux Animal was cat gut or some other kind of leathery glob in a labeled glass bottle.*

FLUXORGAN

"...Take any object you wish from La Cedille qui Sourit...Also you could take a...Fluxorgan...''
Letter: George Maciunas to Ben Vautier, March 5, 1966.

"...I will ship a crate to you with most large Fluxus items such as...organ...etc., etc.- about 200 lbs. of goodies, so you can have a kind of Fluxshop...''
Letter: George Maciunas to Ben Vautier, May 19, 1966.

FLUX SHOW: DICE GAME ENVIRONMENT ENTIRE FLOOR AS DICE HAZARD TABLE DIE CUBES, 15'' CUBES ON FLOOR, Marked on sides, top open or closed with clear plastic. Consisting or containing...Flux organ by George Maciunas...
Flux Fest Kit 2. [ca. December 1969].

03.1965...G. MACIUNAS: organ...
George Maciunas, Diagram of Historical Developments of Fluxus... [1973].

COMMENTS: *This is a general category for organs. Fluxorgans that were produced consist of rubber bulbs of the sort that one would use for a syringe or an old-fashioned horn. Attached to these "air compressors" are various sound-making devices. These are then boxed or mounted in one way or another so that only the rubber bulbs are exposed.*

FLUXORGAN see:
FLUXORGAN, 12 SOUNDS

FLUXORGAN, CONSOLE

FLUXORGAN FLUXUSx6 console, keyboard $800
Vacuum TRapEzoid (Fluxus Newspaper No. 5) March 1965.

... items are in stock, delivery within 2 weeks ...
FLUXUSx3 FLUXORGAN, console $800
Vaseline sTREet (Fluxus Newspaper No. 8) May 1966.

FLUX-PRODUCTS 1961 TO 1969 ... GEORGE MA-

CIUNAS...Fluxorgan, keyboard console...any number of calls, by special order only.
Fluxnewsletter, December 2, 1968 (revised March 15, 1969).

COMMENTS: Fluxorgan, Console *was never made by George Maciunas as a Fluxus Edition. In Fluxus Newspaper No. 5, it is described as having a keyboard. There is no evidence of how this organ would have worked, although presumably when keys were pressed, it would activate funny-sounding noisemakers.*

FLUXORGAN, DOOR FRONT VERSION

FLUX-PRODUCTS 1961 TO 1969 ... GEORGE MACIUNAS...Fluxorgan,...door front version, any number of calls, by special order only.
Fluxnewsletter, December 2, 1968 (revised March 15, 1969).

COMMENTS: *A version of this organ was made by the artist at the door to the Flux Shop on Canal Street, around 1964. Another* Fluxorgan, Door Front Version *was made for Joe Jones' Tone Deaf Music Store in the late 1960s in New York City. There is a relationship between this work and Maciunas'* Bird Organ & Other Bulb Activated Tricks Door. *The latter was an interior door display, whereas the door front version is an exterior organ relating more to entry.*

FLUXORGAN, PORTABLE CONSOLE

FLUXORGAN FLUXUSx5 portable console, keyboard $250
Vacuum TRapEzoid (Fluxus Newspaper No. 5) March 1965.

... items are in stock, delivery within 2 weeks ...
FLUXUSx2 FLUXORGAN, portable console $280
Vaseline sTREet (Fluxus Newspaper No. 8) May 1966.

COMMENTS: *A smaller version of* Fluxorgan, Console, *this work is not known to have been made.*

FLUXORGAN, 12 SOUNDS

Silverman No. < 242.II

FLUXKIT containing following fluxus-publications: (also available separately)...FLUXUS ax...OR FLUXORGAN $20
Vacuum TRapEzoid (Fluxus Newspaper No. 5) March 1965.

FLUXKIT containing following fluxus-publications: (also available separately)...FLUXUSx FLUXORGAN: 12 sounds, not sold separately.
Vaseline sTREet (Fluxus Newspaper No. 8) May 1966.

... items are in stock, delivery within 2 weeks ...
FLUXUSx1 FLUXORGAN, 12 sounds, in suitcase $80
ibid.

FLUX-PRODUCTS 1961 TO 1969 ... GEORGE MACIUNAS...Fluxorgan, 12 bulb activating whistles &

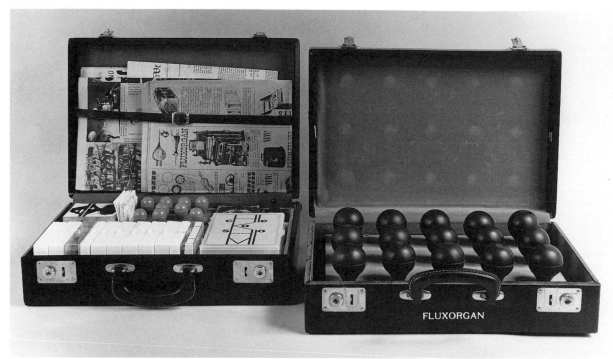

George Maciunas. FLUXORGAN, 12 SOUNDS, built into a FLUXKIT, with another version containing 15 sounds. see color portfolio

BRAD IVERSON

bird calls, in attache case [$] 100...
Fluxnewsletter, December 2, 1968 (revised March 15, 1969).

FLUX-PRODUCTS 1961 TO 1970 ... GEORGE MACIUNAS...Fluxorgan, 12 sound, in attache case [$] 100...
Flux Fest Kit 2. [ca. December 1969].

FLUXUS-EDITIONEN ... [Catalogue No.] 766 GEORGE MACIUNAS: fluxorgan, 12 sound, (koffer)
Happening & Fluxus. Koelnischer Kunstverein, 1970.

OBJECTS AND EXHIBITS...1965:...flux-organ (12 bird calls activated by bellows)...
George Maciunas Biographical Data. 1976.

COMMENTS: *A certain amount of confusion exists about this* Fluxorgan. *There is a twelve sound version in a* Fluxkit. *A fifteen sound organ is contained in an attache case labeled,* Fluxorgan. *There are at times discrepancies in the descriptions of contents in Fluxus Editions. For instance, Ay-O's* Finger Box *in an attache case is consistently listed incorrectly. No fifteen sound* Fluxorgan *is listed in any Fluxus publication, although whenever the work appears in an attache case, it always contains fifteen elements, fifteen rubber bulbs.*

FLUXORGAN, 15 SOUNDS see:
 FLUXORGAN, 12 SOUNDS

FLUXORGAN, 20 SOUNDS, ELECTRICAL

FLUXORGAN FLUXUSx3 electrical, 20 sounds, in suitcase $150
Vacuum TRapEzoid (Fluxus Newspaper No. 5) March 1965.

COMMENTS: *This version was never made.*

FLUXORGAN, 20 SOUNDS, MANUAL

FLUXORGAN FLUXUSx1 manual, 20 sounds, in suitcase, $50
Vacuum TRapEzoid (Fluxus Newspaper No. 5) March 1965.

COMMENTS: *This work was never made as described above. However, a fifteen sound organ in an attache case was produced. See comments under* Fluxorgan, 12 Sounds.

FLUXORGAN, 40 SOUNDS, ELECTRICAL

FLUXORGAN FLUXUSx4 electrical, 40 sounds, in suitcase $250
Vacuum TRapEzoid (Fluxus Newspaper No. 5) March 1965.

COMMENTS: *This version was never made.*

FLUXORGAN, 50 SOUNDS, MANUAL

FLUXORGAN FLUXUSx2 manual, 50 sounds, in

suitcase $90
Vacuum TRapEzoid (Fluxus Newspaper No. 5) March 1965.

COMMENTS: *This version was never produced by George Maciunas as a Fluxus Edition.*

FLUX PAPER EVENTS
Silverman No. > 297, ff.

"...Regarding Flux-magazine. As I said before, I am not too enthusiastic about it, since we would be just repeating ourselves. However I could edit one if you insist. I would still like to put together a paper event-game box with maybe a newspaper for text material. Could you find out about the allowable format, allowable budget, whether it could be printed and manufactured in Italy..."
Letter: George Maciunas to Daniela Palazzoli, n.d. Reproduced in Fluxnewsletter, April 1973.

"Proposal for paper event 16 or 22 pages. 1. Pages glued "pull" printed. 2.———— 3. Entire 16 page

FLUX PAPER EVENTS
BY GEORGE MACIUNAS

Edition Hundertmark

George Maciunas. **FLUX PAPER EVENTS**

SCOTT HYDE

sheet immersed in beer or chemical and then dried. 4. hole through entire book. 5. Stapled edge of 16 pages. 6. cutting + folding instructions. 7. Crumpled & flattened. 8. - [to] 16. etc."
Notes: George Maciunas to Armin Hundertmark, [ca. September, 1976].

"...Here are my proposed section for your magazine: It could be called FLUX PAPER EVENTS BY GEORGE MACIUNAS
page 1: dipped in ammonia or other smelly substance like gasoline, (but one that would not transfer to other pages)
page 2: crumpled and then flattened out
page 3: some raw egg or other food like egg which is without fat so as not to affect other pages, however it will rot and increase in smell, while one smeared with ammonia will eventually stop smelling.
...[pages 4, 5, 6 and 7]: torn in a series, closer and closer to the binding, like drawing shown:
...[pages 8, 9 and 10] : stapled together at edges
...[pages 11 and 12] glued together, either with permanent glue or double faced tape, so that the pages can be re-glued after separation.
page 13: perforated like postage stamp sheet
...[pages 14 and 15]: some powder between these pages, like a spice (cinnamon, pepper,) or best would be sneezing powder, or even ashes.
page 16: folded corners like this:
16 pages should make up one 'signature' or as printers call it, single sheet folded 3 times. I would also suggest some things for the entire book like: a small corner cut off, and also at another corner a hole drilled through in whole book. Like this:..."
Letter: George Maciunas to Armin Hundertmark, [late 1976].

COMMENTS: *One of the few exceptions to Fluxus where the work was produced by another editor, in this case, Armin Hundertmark.* Flux Paper Events *was never advertised as a Fluxus Edition, and perhaps Maciunas didn't even consider it as such. However, it has been included because of its title, Maciunas' involvement in it, and its direct relationship to other Fluxus projects such as* Flux Paper Games; Rolls and Folds, *a Collective work, "A Paper Event by the Fluxmasters of the Rear-Garde" at the Time-Life Building in New York City, sponsored by the Museum of Contemporary Crafts in 1967, and the special Fluxus issue of* Art & Artists *in 1972, which contained a number of paper events ideas for the page not dissimilar to Maciunas'* Flux Paper Events.

FLUX PIECES

COMMENTS: *Only a label exists for* Flux Pieces. *Designed by George Maciunas with a Fluxus copyright, it's not clear what Maciunas had in mind to package with this label - whether it was scores, writings, or object-like works.*

George Maciunas. **FLUX PIECES.** Label

FLUXPOST (AGING MEN)
Silverman No. 276, ff.

OBJECTS AND EXHIBITS...1975:...contributed... postage stamps, published by Multipla, Milan...
George Maciunas Biographical Data. 1976.

COMMENTS: *There is no direct reference to this sheet of postage stamps. By process of elimination, the postage stamps that Maciunas lists in his Biographical Data of 1976 as having been contributed to the* Fluxpack 3, *"published by Multipla," must be* Fluxpost (Aging Men). *The stamps were produced by Maciunas in New York and were distributed by Fluxus, and are also included in* Fluxpack 3.

FLUXPOST (SMILES)
Silverman No. 277, ff.

COMMENTS: *This work was finished by Maciunas in 1978, the year of his death, and had limited distribution in early spring of that year. The images are from the same source as his* Flux Smile Machine *label and* Grotesque Face Mask.

FLUX SCIENCE SHOW see:
EXCRETA FLUXORUM
SILICATE MICRO CRYSTALS

FLUXSHOP

FLUX-PRODUCTS 1961 TO 1969 ... GEORGE MACIUNAS Flags, 28" square, sewn legends, with grommets:...Fluxshop each: [$] 60...
Fluxnewsletter, December 2, 1968 (revised March 15, 1969).

COMMENTS: Fluxshop *is a very practical flag if you happen to have a Flux Shop. Otherwise it would produce curious response from one's neighbors and outrage from the zoning board. The flag could be another* All Other Things *concept.*

345

George Maciunas. FLUXPOST (AGING MEN)

George Maciunas. FLUXPOST (SMILES)

FLUX SMILE MACHINE
Silverman No. 257, ff.

"...Now I will list some new items produced: all in 1972...smile machine..."
Letter: George Maciunas to Dr. Hanns Sohm, [ca. late 1972].

FLUXPRODUCTS PRODUCED IN 1972 & 1973... by George Maciunas:...flux smile machine, device for insertion into mouth, in order to obtain a permanent

smile $10...
Fluxnewsletter, April 1973.

1970...MACIUNAS:...smile machine...
George Maciunas, Diagram of Historical Developments of Fluxus... [1973].

by George Maciunas:...flux-smile machine, device for insertion into mouth, in order to obtain a permanent smile: $10 ...
Fluxnewsletter, April 1975.

GEORGE MACIUNAS...Smile machine, device for mouth, boxed, 1970 $14...
Flux Objects, Price List. May 1976.

OBJECTS AND EXHIBITS...1970: smile machine...
George Maciunas Biographical Data. 1976.

COMMENTS: The labels for this work are always different. The title and other information is typed directly onto the edge of an image cut-out from a magazine or other publica-

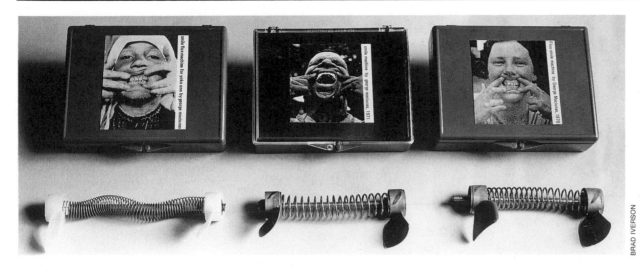

George Maciunas. FLUX SMILE MACHINE. see color portfolio

tion. *The title varies from* Smile Machine by George Maciunas 1971 *to* Flux Smile Machine by George Maciunas 1970 *to* Smile Machine for Yoko Ono by George Maciunas. *There is certainly a parallel relationship between the Maciunas work and a much earlier work of Yoko Ono's,* Self Portrait, *1965, offered for sale by Fluxus. That work evolved into* Box of Smiles *which Ono did in the early 1970s. The Maciunas work contains a gag spring device you put in your mouth that spreads your cheeks apart. The Ono work is a packaged mirror which you "perform" by looking into and smiling.*

FLUX SNOW GAME

Silverman No. 256, ff.

PAST FLUX-PROJECTS (realized in 1966) ... Flux-snow-game...
Fluxnewsletter, March 8, 1967.

snow game $3.00
Fluxshopnews. [Spring 1967].

FLUX-PRODUCTS 1961 TO 1969 ... GEORGE MACIUNAS Snow game, boxed * [indicated as part of FLUXKIT] [$] 3...
Fluxnewsletter, December 2, 1968 (revised March 15, 1969).

FLUX-PRODUCTS 1961 TO 1970 ... GEORGE MACIUNAS...Snow game, boxed [$] 3...
Flux Fest Kit 2. [ca. December 1969].

FLUXUS-EDITIONEN ... [Catalogue no.] 767 GEORGE MACIUNAS: snow game, boxed
Happening & Fluxus. Koelnischer Kunstverein, 1970.

COMMENTS: Flux Snow Game *is another very concrete, gag-like work of Maciunas. The box is overstuffed with white styrofoam pellets that invariably fall on the ground when the*

George Maciunas. FLUX SNOW GAME

ERIC SILVERMAN

box is opened. Involuntary, but gentle, forced participation in the work.

FLUX SNOW TOWER

PROPOSED STRUCTURE FOR FLUX - SNOW - HOUSE (OR SNOW - IN) Needed participant-workers and supervisers: each category supervised by a supervisor and all supervisors coordinated by a chief of construct...surveyors and measurers: 8 with long tape measures, plumb lines, long stick measures, fitters (to fit snow balls together): 10 packers (to pack all concavities and joints with snow): 20 trimmers (to trim all surfaces smooth, vaults, arches, walls, columns): 10 with long shovels, hand trowels, scrapers, etc. ball

rollers (to roll snow into about 2 to 3 ft. diam. balls): 50
Fluxnewsletter, January 31, 1968.

FLUXPROJECTS FOR 1968 (In order of priority)... 2. Snow-event (building a 6 story structure, 100 participants)...Frank Rycyk
ibid.

SUMMARY OF LAST NEWSLETTER (Jan. 31, 1968) ...snowhouse project (never snowed and was therefore not realized in 1968)
Fluxnewsletter, December 2, 1968).

FLUXFEST INFORMATION...Many fluxpieces are described and listed in the Expanded Arts issue of FILM CULTURE magazine. A reprint can be obtained for $1. Any of the fluxpieces can be performed anytime, anyplace and by anyone, without any payment to Fluxus provided the following conditions are met: 1. if fluxpieces outnumber numerically or exceed in duration other compositions in any concert, the whole concert must be called and advertised as FLUX-CONCERT or FLUXEVENT. A series of such events must be called FLUXFEST. 2. if fluxpieces do not

BRAD IVERSON

George Maciunas. FLUX SNOW TOWER. Instruction drawing reproduced in Fluxnewsletter, January 31, 1968

exceed non-fluxpieces, each such fluxpiece must be identified as a FLUXPIECE. Such credits to Fluxus may be omitted at a cost of $50 for each piece announced or performed...flux-snowhouses...
Fluxnewsletter, December 2, 1968 (revised March 15, 1969).

SNOWHOUSE George Maciunas
Fluxfest at Stony Brook, Newsletter No. 1, August 18, 1969. versions A and B

EXTERIOR FLUX-EVENTS ... GEORGE MACIUNAS: SNOW TOWER A 5 story, 40ft high and 32ft diameter snow tower is to be constructed from snow in a form of a vaulted spiral (Pisa tower model). The participant-workers (about 80 needed) are to be divided into teams, each responsible for accomplishing one of the following tasks:
1) rolling snowballs to about 2 to 3ft. diam.
2) rolling balls up the spiral ramp
3) surveying and measuring with plumb line, levels, measuring sticks etc.
4) fitting snow balls on top of each other forming walls of about 3ft. thickness, and sideways for vaults and arches,
5) packing concavities and joints with snow,
6) trimming and scraping smooth all surfaces of walls, arches & vaults. (Plan available)
Flux Fest Kit 2. [ca. December 1969].

COMMENTS: *Unfortunately this work was never realized. It would have been a very ephemeral work, lasting only until a good thaw.*

FLUX SPORT EQUIPMENT see:
 ADHESIVE SOLED SHOES
 BALLOON JAVELIN
 BALLOON RACKET
 BELLS RACKET
 CAN OF WATER RACKET
 CONCAVE RACKET
 CORRUGATED/UNDULATING RACKET
 CUBE TENNIS BALL
 DRUMSKIN RACKET
 ELASTIC RACKET
 FACETED SURFACE RACKET
 GIANT INFLATED BOXING GLOVES
 HINGED RACKET
 HOLE IN CENTER RACKET
 INFLATED RACKET
 LONG HANDLE RACKET
 MUSICAL BARS
 MUSICAL GLOVES
 PING-PONG TABLE
 PREPARED HAMMER THROW HAMMER
 VERY HEAVY LEAD RACKET
 VERY SOFT RACKET
 WOOD GLUED TO SURFACE RACKET

SCOTT HYDE

George Maciunas. FLUX STATIONERY: TORSO IN FUR COAT; FOOT IN SHOE; HAND IN GLOVE

FLUX STATIONERY: FOOT IN SHOE
Silverman No. 283, ff.

PROPOSED CONTENTS FOR FLUXPACK 3 TO BE PUBLISHED IN 1973 BY FLASH ART...Stationery ...envelope with shoe imprint, letter paper with naked foot inprint [sic], by Maciunas...Cost Estimates: for 1000 copies...stationery [3 designs] $150...100 copies signed by:...Maciunas...
[George Maciunas], Proposed Contents for Fluxpack 3. [ca. 1972].

Flash Art editor, Giancarlo Politi, proposed to pub-

lish the 3rd Fluxyearbook, maybe to be called FLUX-PACK 3, with the following preliminary contents:... Stationery:...envelope with shoe imprint, letter paper with naked foot imprint, by Maciunas...
Fluxnewsletter, April 1973.

OBJECTS AND EXHIBITS...1975:...contributed 3 stationery designs...published by Multipla, Milan...
George Maciunas Biographical Data. 1976.

COMMENTS: *This Fluxus Stationery was printed by Maciunas for inclusion in* Fluxpack 3, *which was distributed by Multipla in Milan. The stationery was also distributed by Wooster Enterprises, New York City.*

FLUX STATIONERY: HAND IN GLOVE
Silverman No. 284, ff.

"...to produce the Flash Art FLUXPACK 3...contents at present will be as follows:...Stationery: hand in glove by Maciunas..."
Letter: George Maciunas to Giancarlo Politi, n.d. Reproduced in Fluxnewsletter, April 1973.

"...could be produced cheaper in Italy:...stationery (...envelope printed to look like glove, paper like hand..."
Letter: George Maciunas to Daniela Palazzoli, n.d. Reproduced in Fluxnewsletter, April 1973.

OBJECTS AND EXHIBITS...1975:...contributed 3 stationery designs...published by Multipla, Milan...
George Maciunas Biographical Data. 1976.

COMMENTS: *Maciunas used the* Hand in Glove *stationery as an example of what he calls "functionalism." He says in an interview with Larry Miller in 1978, published in* Fluxus etc./ Addenda I, *"The envelopes were like gloves and the letters were like hands. Now, again, the function is now -- an envelope and a glove -- same function: the glove encloses the hand ...an envelope encloses the hand." He goes on to say, "a non-functional envelope would be an envelope showing, let's say, lots of flowers...and the letterhead may be wheat or something. So one has no connection with the other, and the fact that why flowers have to be on an envelope, they could be on a carpet too...Now that's the difference. That's not concretism, that's functionalism." On some packagings of this stationery and other types that Maciunas produced, credit is given to "Wooster Enterprises Edition, New York City." I'm not sure who was involved with Wooster Enterprises, however, certainly Maciunas was. It's another example of a commercially possible extension of Fluxus that he attempted.* Flux Stationery: Hand in Glove *is included in* Fluxpack 3.

FLUX STATIONERY: TORSO IN FUR COAT
Silverman No. 286, ff.

PROPOSED CONTENTS FOR FLUXPACK 3 TO BE PUBLISHED IN 1973 BY FLASH ART...Stationery ...envelope with fur coat or dress imprint, letter paper with nude body imprint, by Maciunas...Cost Estimates: for 1000 copies...stationery [3 designs] $150 ...100 copies signed by:...Maciunas...
[George Maciunas], Proposed Contents for Fluxpack 3. [ca. 1972].

"...to produce the Flash Art FLUXPACK 3... The contents at present will be as follows:...Stationery:... torso in fur coat by Maciunas..."
Letter: George Maciunas to Giancarlo Politi, n.d. Reproduced in Fluxnewsletter, April 1973.

"...could be produced cheaper in Italy:...stationery (...envelope printed like fur coat, paper as nude body,

all simple screened photos)..."
Letter: George Maciunas to Daniela Palazzoli, n.d. Reproduced in Fluxnewsletter, April 1973.

Flash Art editor, Giancarlo Politi, proposed to publish the 3rd Fluxyearbook, maybe to be called FLUXPACK 3, with the following preliminary contents: ... Stationery: envelope with furcoat imprint, letter paper with nude body imprint...
Fluxnewsletter, April 1973.

OBJECTS AND EXHIBITS...1975:...contributed 3 stationery designs...published by Multipla, Milan...
George Maciunas Biographical Data. 1976.

COMMENTS: *Again, this stationery was originally intended for* Fluxpack 3, *distributed by Multipla in Milan, and is included in the Collective work. It was produced by George Maciunas, distributed by Fluxus, and also by Wooster Enterprises in New York.*

FLUX STILTS see:
Bici Hendricks and George Maciunas

FLUXSYRINGE
Silverman No. < 272.I

"...Now I will list some new items produced: all in 1972...Fluxsyringe by myself, a giant syringe with 64 needles, another version with 12 inch long needle, each $100..."
Letter: George Maciunas to Dr. Hanns Sohm, [ca. late 1972].

FLUXPRODUCTS PRODUCED IN 1972 & 1973... by George Maciunas:...fluxsyringe (part of fluxmedical kit), a giant 1 liter syringe with 64 needles, in wood box $100...
Fluxnewsletter, April 1973.

1970...MACIUNAS: Multi-syringe...
George Maciunas, Diagram of Historical Developments of Fluxus... [1973].

by George Maciunas:...flux-syringe (part of flux -medical kit), a giant syringe with 64 needles, in wood box: $100
Fluxnewsletter, April 1975.

"The story on the other side is self explanatory. As a result of which I have to have eye surgery, since I

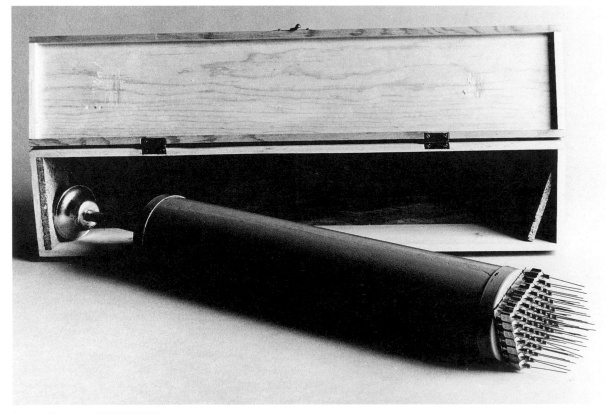

George Maciunas. FLUXSYRINGE

BRAD IVERSON

hardly see anything with the left eye. In one sense, these hospital expenses to me are a windfall to any collectors of flux-objects. Now with high cost of surgery, I must make more objects and begin to respond to various orders and requests for them. Thus I am sending by mail to you the following:...Geo. Maciunas ... large flux syringe [$] 100..."
Letter: George Maciunas to Dr. Hanns Sohm. November 30, 1975.

...Flux-syringe by Maciunas $100...
[Fluxus price list for a customer]. January 7, 1976.

"Large flux syringe by GM $100"
Letter: George Maciunas to Dr. Hanns Sohm, May 1, 1976.

GEORGE MACIUNAS Fluxsyringe, 1 liter syringe with 64 needles, boxed '70, $140...
Flux Objects, Price List. May 1976.

OBJECTS AND EXHIBITS...1970:...64 needle syringe...
George Maciunas Biographical Data. 1976.

COMMENTS: This late Fluxus work has to do in part with Maciunas' preoccupation with medicine and his illnesses that required medication. At one point, mentioned in Fluxnewsletter, April 1973, the piece was to be a component of Flux Medical Kit, which was never produced. I know of only two examples of a Fluxsyringe. The example in the Silverman Collection was a gift from Francesco Conz, who had purchased it from George Maciunas. The other example is one that Maciunas made for the Jean Brown Archive, now a part of the Getty Museum in California.

FLUX TATTOOS see:
STICK-ONS

FLUX TIMER CHECKERS

$30 flux checkers (timers)...by george maciunas
Fluxshopnews. [Spring 1967].

COMMENTS: It's unclear what this checker game is. It seems to have some relationship to Time Chess, Sand Timer Pieces. *However, the only mention of* Flux Timer Checkers *is in* Fluxshopnews, *and there is no reference to* Time Chess, Sand Timer Pieces *in* Fluxshopnews. *There are earlier and later entries for that work, so perhaps Maciunas made an error, although in the first mention of the chess set the price is $60 and the checkers are $30. So I'm just not certain. Perhaps it was a checkerboard using timers, sand timers for the checkers themselves.*

FLUX TOILET see:
BIRD ORGAN & OTHER BULB ACTIVATED
TRICKS DOOR
DISPLAY CASE MEDICINE CABINET
FLUSHING STARTS RAIN TOILET

INFLATED RUBBER TOILET SEAT
MULTI-FACETED MIRROR
PERISCOPE TOILET BOWL
PREPARED FAUCET
SEPARATE DOORS DOOR
SQUEAKING TOILET SEAT
TOILET PAPER PERFORATED WITH LARGE
HOLES
TREATED PAPER TOWELS

FLUX TOUR TICKETS see:
TICKETS

FLUXUS DIAGRAM

"...Fluxus Diagram.
a) I was thinking of Jackson's pieces for audience which tends to depend considerably on theatrical or on eye rather then [sic] ear. Then he has of course straight theatre pieces too.
b) I thought of Dennis Johnson. Is David Johnson really any good? I just heard one electronic piece (at Cooper concert) which I thought was quite mediocre, but then I would rely on your judgement for the diagram, since you are more familiar with his + others' work.
c) Isidore Isou will be in European diagram.
d) By Varese I only meant as transmitter of Futurist + Dada bruitisme from Paris to U.S. like John Cage. No direct influence meant. (This only concerns noises, nothing else) Theatre, theatrical music, I would have attributed to some Dada theatre - happenings' influence. I did not attribute indeterminism to anyone in particular, but your ideas of placing Charles Ives is good.
Your suggestions were most constructive. Maybe now the diagram begins to look a little better..."
Letter: George Maciunas to Dick Higgins, [January 18, 1962].

COMMENTS: Fluxus Diagram is the very first attempt that Maciunas made early in 1962, to place Fluxus and the intention of Fluxus in an historical context, giving examples of what Fluxus works were, and where they derived from. This chart then leads to the other charts or diagrams, such as Fluxus (Its Historical Development and Relationship to Avant - Garde Movements), published around 1966, and Maciunas' great diagram, Diagram of Historical Development of Fluxus and Other 4 Dimensional, Aural, Optic, Olfactory, Epithelial and Tactile Art Forms, published in 1973.

FLUXUS (ITS HISTORICAL DEVELOPMENT AND RELATIONSHIP TO AVANT-GARDE MOVEMENTS)
Silverman No. 279, ff.

"...For your work in Fourre tout, you can use my diagram or comments in any way you like, these are my last or latest thoughts on Fluxus...I am revising it

George Maciunas. FLUXUS (ITS HISTORICAL...)

now after I received various comments including yours, and others. I definitely unintentionally overlooked your anti-art activities, please forgive me, I will include you in category of Anti-Art but I suppose not "Action against Cultural Imperialism" (?) or Political Art.(?) let me know. There will be a lot of other small changes, additions etc., though categories will remain the same. It was impossible to do a complete diagram in 2 weeks. I can improve it now..."
Letter: George Maciunas to Ben Vautier, March 25, 1967.

COMMENTS: *Diagram of Historical Development and Other 4 Dimensional, Aural, Optic, Olfactory, Epithelial and Tactile Art Forms, is an expansion of this diagram. Maciunas' mention of leaving a reference to Vautier's "Political Art" off the chart is a result of Annie Vautier having been detained for many hours of questioning by the police in Nice after Ben and Annie distributed copies of Maciunas' U.S. Surpasses All Nazi Genocide Records broadside outside an American military installation.*

FLUXUS MACHINE

FLUXUS 1964 EDITIONS, AVAILABLE NOW... FLUXUS x FLUXUS MACHINE $5
cc Valise e T RanglE (Fluxus Newspaper No. 3) March 1964.

F-x FLUXUS-MACHINE $5
European Mail-Orderhouse: europeanfluxshop, Pricelist. [ca. June 1964].

[as above]
Second Pricelist - European Mail-Orderhouse. [Fall 1964].

COMMENTS: *I have never seen this work. It could well have been a labeled ready-made, perhaps similar in concept to Ben Vautier's Flux Useless Objects and Robert Watts' Assorted Tools in his "a - z series" — tools whose function he could not figure out.*

FLUXUS 301

Silverman No. 249

"...jewelry design. - printed on self adhesive clear or opaque plastic, die-stamp-out. You stick - on your body or clothing these...die cut items. Got already: ...Engravings of old jewelry..."
Letter: George Maciunas to Ken Friedman, [ca. February 1967].

FLUX-PROJECTS PLANNED FOR 1967...George Maciunas:...plastic stick-ons (disposable jewelry): engravings of 19cent jewelry)...
Fluxnewsletter, March 8, 1967.

stick-on jewelry $1...by george maciunas
Fluxshopnews. [Spring 1967].

FLUX-PRODUCTS 1961 TO 1969 ... GEORGE MACIUNAS...stick-on tattoos: jewelry...each [$] 1
Fluxnewsletter, December 2, 1968 (revised March 15, 1969).

George Maciunas. FLUXUS 301

FLUX-PRODUCTS 1961 TO 1970 ... GEORGE MACIUNAS...Stick-on tattoos: jewelry...ea: [$] 1...
Flux Fest Kit 2. [ca. December 1969].

PROPOSED CONTENTS FOR FLUXPACK 3 TO BE PUBLISHED IN 1973 BY FLASH ART...Stick-ons... jewelry by Maciunas...Cost Estimates: for 1000 copies...stick-ons [5 designs] $500...100 copies signed by:...Maciunas...
[George Maciunas], Proposed Contents for Fluxpack 3. [ca. 1972].

Flash Art editor, Giancarlo Politi, proposed to publish the 3rd Fluxyearbook, maybe to be called FLUXPACK 3, with the following preliminary contents:... Wear items:...body stick-ons (...jewelry by Maciunas)...
Fluxnewsletter, April 1973.

COMMENTS: *These are stick-ons of jewelry. Although the references are to Fluxus products, when the stick-ons were printed, they were copyrighted by Implosions, Inc. and "made exclusively for Paraphernalia." Implosions was a partnership between Robert Watts, Herman Fine, and George Maciunas to "...Introduce into mass-market some potentially money - producing products (of practical nature) (mostly)." Implosions is variously described as an extension of Fluxus and vice versa. In the March 8, 1967 Fluxnewsletter there is some discussion of Implosions projects, including the stick-ons. Paraphernalia was a very fashionable clothing and accessory store at the time, selling "hip" type products.*

FLUXUS WALLPAPER see:
WALLPAPER

FLUXWATER

FLUXFEST PRESENTATION OF JOHN LENNON

& YOKO ONO+* AT 80 WOOSTER ST. NEW YORK - 1970...MAY 9-15: WEIGHT & WATER BY JOHN & YOKO + FLUXFAUCET...Fluxwater (G. Maciunas '70) 50 spring water bottles filled with tap water
all photographs copyright nineteen seVenty by peTer mooRE (Fluxus Newspaper No. 9) 1970.

COMMENTS: *Fluxwater is a reversal - fifty spring water bottles filled with tap water.*

FLUXWEAR 303

Silverman No. > 249.1

"...By separate mail I am sending some of the new stick-on tattoos we produced. There are 4 other new sheets we are doing now:...hinges...to be stuck on skin or clothing..."
Letter: George Maciunas to Paul Sharits, June 21, 1967.

OBJECTS AND EXHIBITS...1967:...stick-on tattoos of hardware etc...
George Maciunas Biographical Data. 1976.

COMMENTS: *These stick-ons have a copyright by Implosions, and were undoubtedly distributed by them as well as Fluxus. They are also included in the Collective Flux Tattoos box.*

George Maciunas. FLUXWEAR 303

FLUXWEAR 304
Silverman No. > 249.II

"...jewelry design. - printed on self adhesive clear or opaque plastic, die-stamp-out. You stick-on your body or clothing these die cut items. Got already:... buttons, zippers, etc...."
Letter: George Maciunas to Ken Friedman, [ca. February 1967].

FLUX-PROJECTS PLANNED FOR 1967...stick-ons (disposable jewelry)...Buttons
Fluxnewsletter, March 8, 1967.

stick-on fasteners $1...by george maciunas
Fluxshopnews. [Spring 1967].

"...By separate mail I am sending some of the new stick-on tattoos we produced. There are 4 other new sheets we are doing now: with zippers,...to be stuck on skin or clothing...."
Letter: George Maciunas to Paul Sharits, June 21, 1967.

SUMMARY OF LAST NEWSLETTER (Jan. 31, 1968) ...stick-ons produced...Maciunas: fasteners...
Fluxnewsletter, December 2, 1968.

FLUX-PRODUCTS 1961 TO 1969...FLUXTAT-

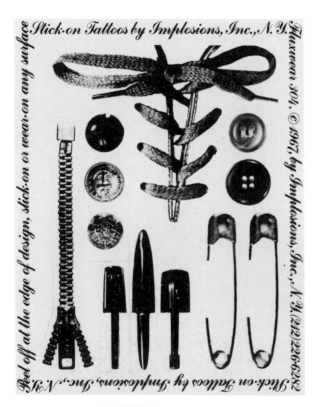

George Maciunas. FLUXWEAR 304

TOOS Winter 1967...fasteners, buttons, zippers by Maciunas...6 - 5x6" stick-on sheets, boxed * [indicated as part of FLUXKIT] [$] 5
Fluxnewsletter, December 2, 1968 (revised March 15, 1969).

FLUX-PRODUCTS 1961 TO 1969 ... GEORGE MACIUNAS...stick-on tattoos:...fasteners...each [$] 1
ibid.

FLUX-PRODUCTS 1961 TO 1970 ... FLUXTATTOOS 1967:...fasteners, buttons, zippers...by George Maciunas...6 [different] 5x6" stick-on sheets, boxed $5
Flux Fest Kit 2. [ca. December 1969].

FLUX-PRODUCTS 1961 TO 1970 ... GEORGE MACIUNAS ...Stick-on tattoos:...fasteners, ea: [$] 1...
ibid.

COMMENTS: *Again, copyrighted and distributed by Implosions, they were produced by George Maciunas and distributed through Fluxus both as individual sheets and as part of the* Collective Flux Tattoos.

FOAM STEPS

Any proposals from participants should fit the maze format...Ideas should relate to passage through doors, steps, floor, obstacles, booths...foam rubber steps
George Maciunas, Further Proposal for Flux-Maze at Rene Block Gallery. [ca. Fall 1974].

"Enclosed is the final plan of labyrinth...one enters my own passage way. 1) one climbs a foam stair, the foam should be covered with thin plywood or masonite to protect the foam from wear but be thin enough to allow some bending. It will be a kind of springy step.
Letter: George Maciunas to Rene Block, [ca. Summer 1976].

"Foam Steps (these are completed) needed: thin covering (possibly) These are completed except gluing. There were many kinds of foam available. I picked a substantial kind. They may not need a covering-if so I suggest thin rubber found at the same store as rubber bridge material. We should use a pliable covering instead of masonite etc."
Notes: Larry Miller to George Maciunas concerning the Fluxlabyrinth, Berlin. [ca. August 1976].

steps made from foam rubber covered at top with thin plywood to prevent damage to foam
Plan of completed Fluxlabyrinth, Berlin. [ca. September 1976].

COMMENTS: *Foam Steps were an element of the Collective environment,* Fluxlabyrinth, *first proposed for a maze at the Rene Block Gallery in New York, and realized in Berlin in the fall of 1976. In 1965, Ay-O used soft steps in his "Rainbow Staircase Environment" in New York City.*

© 1976 LARRY MILLER

George Maciunas. FOAM STEPS being prepared for installation in FLUXLABYRINTH. Berlin, 1976

FOOD see:
BAD SMELL EGGS
CHALK DUMPLINGS
CHEESE EGGS
COFFEE EGGS
COTTON DUMPLINGS
DEAD BUG EGGS
DISTILLED COFFEE
DISTILLED MILK
DISTILLED PRUNE JUICE
DISTILLED TEA
DISTILLED TOMATO JUICE
EGG WHITE EGGS
FISH BREAD
FISH CANDY
FISH DRINK
FISH ICE CREAM
FISH JELLO
FISH PASTRY
FISH PUDDING

FISH SALAD
FISH TEA
FRUIT BRANDY EGGS
GARLIC DUMPLINGS
GOOD SMELL EGGS
GRAPEFRUIT DUMPLINGS
GRAPEFRUIT PANCAKES
GRASS TEA
HOT PEPPER DUMPLINGS
INK EGGS
JUICES
LAXATIVE SANDWICH
LEATHER TEA
LIQUID WHITE GLUE EGGS
MOSS TEA
NOODLE EGGS
PAINT EGGS
PAPER TEA
PINE CONE TEA
PLASTER EGGS
ROPE TEA
RUM DUMPLINGS
SALT DUMPLINGS
SHAVING CREAM EGGS
SLEEPING PILL SANDWICHES
SPAGHETTI EGGS
SQUEAKING TURKEY
STRING EGGS
SUGAR DUMPLINGS
TRANSPARENT BEEF
TRANSPARENT BUTTER
TRANSPARENT ICE CREAM
TRANSPARENT ONION
URETHANE FOAM EGGS
VODKA EGGS
WATER DUMPLINGS
WATER EGGS
WHITE GELATIN EGGS
WINE EGGS
WOOD TEA
WOOL TEA

FOOTSTEPS see:
SHOE STEPS

40 DAY TRIP BY LOCAL BUSES FROM TEXAS TO RIO DE JANEIRO TICKET

FLUXFEST PRESENTATION OF JOHN LENNON & YOKO ONO +* AT 80 WOOSTER ST. NEW YORK --1970...APR. 18-24: TICKETS BY JOHN LENNON + FLUXTOURS...40 day trip by local buses from Texas to Rio De Janeiro (G.M.) $160...
all photographs copyright nineteen seVenty by peTer mooRE (Fluxus Newspaper No. 9) 1970.

COMMENTS: *The ticket offered for sale would have been an actual bus ticket or series of tickets, the idea being an intolerably long and uncomfortable trip from one place to another. A ready-made.*

49 FACET MIRROR see:
MULTI-FACETED MIRROR

FRESH GOODS FROM THE EAST
Silverman No. 241, ff.

FLUXKIT containing following fluxus-publications: (also available separately)...FLUXUS zaz BOX FROM THE EAST, each different, $2
cc fiVe ThReE (Fluxus Newspaper No. 4) June 1964.

FLUXKIT...containing following flux-publications... box from the east.
Second Pricelist - European Mail-Orderhouse. [Fall 1964].

FLUXKIT...FLUXUS zaz BOX FROM THE EAST, ea. different $2
Vacuum TRapEzoid (Fluxus Newspaper No. 5) March 1965.

"...gewgaws for girls is a fluxitem, but I can't recall by whom..."
Letter: George Maciunas to Dr. Hanns Sohm, [ca. late 1972].

COMMENTS: *An early work by Maciunas, Fresh Goods from the East were usually packaged ready-mades or mysterious assemblings. Probably no two are identical.*

FRUIT BRANDY EGGS

NEW YEAR EVE'S FLUX-FEAST, DEC. 31, 1969 AT CINEMATHEQUE, 80 WOOSTER ST. ... George Maciunas (with Barbara Moore): eggs containing... fruit brandy...
Fluxnewsletter, January 8, 1970.

COMMENTS: *Fruit Brandy Eggs are not known to have been made. They would have been blown eggs filled with brandied fruit and served at a Flux Feast.*

FURNITURE see:
FLUXFURNITURE

GARLIC DUMPLINGS

FLUX FOODS AND DRINKS...DUMPLING VARIATIONS: One of the fillings:...garlic,...(G.M.)
Flux Fest Kit 2. [ca. December 1969].

COMMENTS: *I can think of more pleasant food art.*

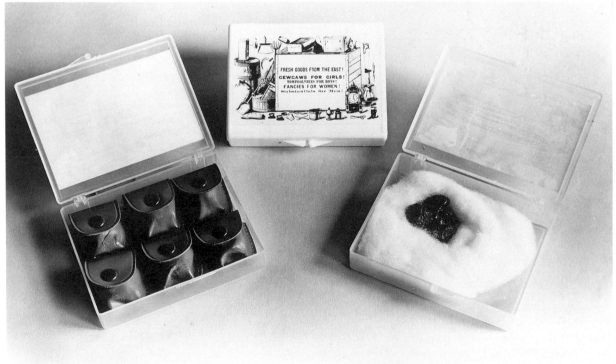

George Maciunas. FRESH GOODS FROM THE EAST. Two Fluxus interpretations and a closed example

BRAD IVERSON

GIANT CUTTING BLADES DOOR

FLUX COMBAT WITH NEW YORK STATE ATTOR-
NEY GENERAL (& POLICE) BY GEORGE MACIU-
NAS...Flux fortress (for keeping away the marshals
& police: various unbreakable doors with giant cutting
blades facing out, reinforced with steel pipe braces ...
funny messages behind each door...
Fluxnewsletter, May 3, 1975.

COMMENTS: *Giant Cutting Blades Door was one of the ele-
ments of Maciunas' combat with the New York State Attor-
ney General. Installed in Maciunas' apartment at the Flux
House in New York City, it consisted of a heavy door with
giant, printing house, paper cutter blades, placed face out on
the surface of the door.*

GIANT INFLATED BOXING GLOVES

FLUX-OLYMPIAD ... DUAL CONTEST Combat
boxing giant gloves...
*Fluxfest at Stony Brook, Newsletter No. 1, August 18, 1969.
version A*

FLUX-OLYMPIAD...by G. Maciunas...DUAL Com-
bat boxing giant inflated gloves...
*Fluxfest at Stony Brook, Newsletter No. 1, August 18, 1969.
version B*

FLUX-OLYMPIAD ... COMBAT - BOXING - GIANT
INFLATED GLOVES (G. Maciunas)
Flux Fest Kit 2. [ca. December 1969].

FEB. 17, 1:30PM FLUX-SPORTS DOUGLASS COL.
...WRESTLING, BOXING & JOUSTING (George
Maciunas) Giant inflated boxing gloves...
*Poster/program for Flux-Mass, Flux-Sports and Flux-Show.
February 1970.*

FEB. 17, 1970: FLUX-SPORTS AT DOUGLASS
COLLEGE...boxing with giant inflated boxing gloves
(G. Maciunas)
*all photographs copyright nineteen seVenty by peTer mooRE
(Fluxus Newspaper No. 9) 1970.*

PROPOSED FLUXANNIVERSARYFEST PRO-
GRAM 1962-1972 SEPT & OCT. ...FLUXOLYMPI-
AD (counterpoint to the Munich one)...Giant boxing
glove match...
Fluxnewsletter, April 1973.

17.02.1970 ... FLUXSPORTS: ... by g. maciunas:...
boxing with giant gloves...
*George Maciunas, Diagram of Historical Developments of
Fluxus... [1973].*

PERFORMANCE COMPOSITIONS...1970:...doug-
lass college...organized flux sport olympiad...giant
glove boxing...
George Maciunas Biographical Data. 1976.

COMMENTS: *A vaudevillian combat, reducing an aggressive
game to gentle sparring.*

GIANT WHEEL

19.05.1973 FLUXGAMES...g. maciunas: travel in-
side giant wheel...
*George Maciunas, Diagram of Historical Developments of
Fluxus... [1973].*

PERFORMANCE COMPOSITIONS...1973:...Organ-
ized & contributed to flux game festival on Wooster
st...human treadwheel...
George Maciunas Biographical Data. 1976.

COMMENTS: *A medieval contraption made of wood, like a
giant 19th century snow roller, an inverted ferris wheel. It
was placed outdoors and people could roll down the street in-
side it. Giant Wheel is related to Joe Jones'* Musical Drum
both in concept and scale.

GLASS BALL FLOOR see:
SLIPPERY FLOOR

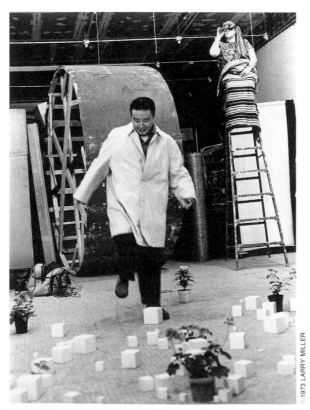

George Maciunas. GIANT WHEEL, visible behind Nam June Paik
playing Takako Saito's game "Kicking Boxes Billiard" at the Flux
Game Fest in New York, May, 1973. Hala Pietkiewicz is watching
the action from a safe distance

GLASS BOTTLE CHESS see:
COLOR BALLS IN BOTTLE-BOARD CHESS

GLIDER PROGRAMS

Herewith is the description of...the entire revised pro-
gram...Performers failing to appear for the rehearsal
will not perform during the concert...Chieko shiomi:
falling event. Programs are distributed to audience as
gliders thrown from the balcony or/and as paper balls
shot out from catapults in the balcony and stage.
Fluxorchestra Circular Letter No. 2. [September 1965].

FLUX-ORCHESTRA CONCERT PROGRAMS: paper
gliders or balls thrown over the audience.
Flux Fest Kit 2. [ca. December 1969].

PERFORMANCE COMPOSITIONS...1965: 2nd flux-
orchestra concert at Carnegie Recital Hall, designed...
glider programs...
George Maciunas Biographical Data. 1976.

COMMENTS: *The programs for the Flux concert were folded
into paper gliders and projected by the performers on stage
into the audience. In 1965, credit for the idea was given to
Chieko Shiomi. However, Maciunas claims credit on his Bio-
graphical Data sheet in 1976. Milan Knizak made a "Paper
Glider Event" in Prague in 1965, as well as a multiple edition
of approximately 100 paper gliders that same year.*

GLUE DISPENSER

PROPOSED FLUXSHOW FOR GALLERY 669 ...
AUTOMATIC VENDING MACHINES-DISPENSERS
(coin operated)...dispenser dispensing...glue...
Fluxnewsletter, December 2, 1968.

PROPOSED FLUXSHOW...AUTOMATIC VENDING
MACHINES-DISPENSERS (coin operated)...nut dis-
penser dispensing into the palm...glue...
Fluxnewsletter, December 2, 1968 (revised March 15, 1969).

AUTOMATIC VENDING MACHINES:...Nut dispens-
er dispensing into the palm...glue.
Flux Fest Kit 2. [ca. December 1969].

FLUX SHOW: DICE GAME ENVIRONMENT EN-
TIRE FLOOR AS DICE HAZARD TABLE DIE
CUBES, 15" CUBES ON FLOOR, Marked on sides,
top open or closed with clear plastic. Consisting or
containing...automatic dispenser of loose...glue.
ibid.

MAY 30-JUNE 5: THE STORE BY JOHN & YOKO
+ FLUXFACTORY Coin operated vending machines:
...nut dispenser dispensing into palm...glue...(G.
Maciunas).
*Schedule of events for Fluxfest presentation of John Lennon
and Yoko Ono. [ca. April 1970]. version B*

MAY 30-JUNE 5: THE STORE BY YOKO + FLUX-FACTORY Vending machines (coin operated):...nut dispenser dispensing into the palm...glue...(by G. Maciunas).
Schedule of events for Fluxfest presentation of John Lennon and Yoko Ono. April 1, 1970. version C

"...for the Rome exhibit...You could also install a few vending machines...[one] could dispense...glue (into the palm of the hand) etc."
Letter: George Maciunas to Giancarlo Politi, n.d. Reproduced in Fluxnewsletter, April 1973.

...This Fall we shall publish V TRE no.10, which shall consist of a plan for Flux-Amusement-Center, to contain...Vending machines...nut type dispensers (dispensing glue...)
Fluxnewsletter, April 1973.

COMMENTS: Glue Dispenser: *deposit money and glue would be dispensed into your hand. Although there is no evidence that this machine was ever constructed, the idea is not dissimilar to* Adhesive Floor *and Maciunas' other adhesive works.*

GOOD SMELL EGGS

PROPOSED FLUX DRINKS & FOODS ... FLUX EGGS emptied egg shells filled with...good smell (spices)...
Fluxfest at Stony Brook, Newsletter No. 1, August 18, 1969. versions A and B

FLUX DRINKS & FOODS FLUX EGGS emptied egg shells filled with...good smell (spices, perfumes)...(G. Maciunas)...
Invitation to Participate in New Year Eve's Flux-Feast. [ca. December 1969].

FLUX FOOD AND DRINKS FLUX EGGS: Emptied egg shells filled with...good smell (spices, perfumes) ...(George Maciunas)
Flux Fest Kit 2. [ca. December 1969].

COMMENTS: Good Smell Eggs *were blown eggs filled with spices or perfumes. The work is related to Takako Saito's* Spice Chess, *where the pieces are determined by their smell.*

GORILLA MASK see:
DISGUISES

THE GRAND FRAUDS OF ARCHITECTURE
component of Silverman No. 117, ff.

"... My essay. - is there & you can reprint it. I will send separate sheets, so you don't have to take the book apart..."
Letter: George Maciunas to Willem de Ridder, January 21, 1965.

COMMENTS: George Maciunas studied architecture at Cooper Union in New York City, and received a Bachelor's degree in architecture from the Carnegie Institute of Technology in Pittsburg, in 1954. The Grand Frauds of Architecture: Mies van der Rohe, Saarinen, Bunshaft, Frank Lloyd Wright *is an indictment by Maciunas of establishment thinking. He favored a mass-producible form of design which would provide inexpensive and beautiful living and working space for the masses. The essay was first announced for inclusion in Fluxus No. 1 U.S. Issue, and is published in* FLUXUS 1. *A further expansion of his design ideas can be found in the Flynt and Maciunas publication,* Communists Must Give Revolutionary Leadership in Culture.

GRAPEFRUIT DUMPLINGS

OPENING: APR. 11, 4PM....GRAPEFRUIT FLUX-BANQUET: ... grapefruit dumplings, ...(by... G. Maciunas,...)
Schedule of events for Fluxfest presentation of John Lennon and Yoko Ono. [ca. April 1970]. version A

OPENING: APR. 11, 4PM....GRAPEFRUIT FLUX-BANQUET:...grapefruit dumplings,...(by Flux-chefs)
Schedule of events for Fluxfest presentation of John Lennon and Yoko Ono. [ca. April 1970]. version B

OPENING: APR. 11, 4PM....GRAPEFRUIT BANQUET Banquet will feature:...grapefruit dumplings, ...(by G. Maciunas,...)
Schedule of events for Fluxfest presentation of John Lennon and Yoko Ono. April 1, 1970. version C

FLUXFEST PRESENTATION OF JOHN LENNON & YOKO ONO AT 80 WOOSTER ST. NEW YORK - 1970 OPENING: APR. 11, 4PM....GRAPEFRUIT FLUX-BANQUET...grapefruit dumplings by G. Maciunas,...
all photographs copyright nineteen seVenty by peTer mooRE (Fluxus Newspaper No.9) 1970.

COMMENTS: Grapefruit Dumplings *were planned in the context of a Flux feast honoring Yoko Ono and John Lennon. Maciunas came up with a number of altered dumpling ideas for a dumpling feast a year earlier.*

GRAPEFRUIT PANCAKES

OPENING: APR. 11, 4PM....GRAPEFRUIT FLUX-BANQUET:...grapefruit pancakes...(by G. Maciunas, ...)
Schedule of events for Fluxfest presentation of John Lennon and Yoko Ono. [ca. April 1970]. version A

OPENING: APR. 11, 4PM....GRAPEFRUIT FLUX-BANQUET:...grapefruit pancakes,...(by Flux-chefs)
Schedule of events for Fluxfest presentation of John Lennon and Yoko Ono. [ca. April 1970]. version B

OPENING: APR. 11, 4PM....GRAPEFRUIT BAN-

QUET Banquet will feature:...grapefruit pancakes,... (by G. Maciunas,...)
Schedule of events for Fluxfest presentation of John Lennon and Yoko Ono. April 1, 1970. version C

...1970 FLUX FEST OF JOHN LENNON & YOKO ONO: 11.04 GRAPEFRUIT FLUX-BANQUET several grapefruit dishes such as...pancakes,...(collaborative)
George Maciunas, Diagram of Historical Developments of Fluxus... [1973].

COMMENTS: *Planned in the context of a grapefruit feast in homage to Yoko Ono's* Grapefruit.

GRASS TEA

FLUX FOODS AND DRINKS...TEA VARIATIONS: ...Tea made from boiling:...grass etc. (George Maciunas)
Flux Fest Kit 2. [ca. December 1969].

COMMENTS: *Although this is a "tea variation,"* Grass Tea *is also a 1960s pun: both "grass" and "tea" were slang for marijuana.*

GRINDER CHESS see:
Takako Saito

GROTESQUE FACE MASK
Silverman No. 264

COMMENTS: *The image for* Grotesque Face Mask *is from a book on "dentistry of nutritional deformities and physical degeneration" which Maciunas also used for his* Fluxpost (Smiles) *stamps, and for some labels of his* Flux Smile Machine. *The masks were distributed individually by Fluxus and are also included in the Collective work,* Fluxpack 3, *which was distributed by Multipla in Milan.*

HARDWARE see:
FLUXWEAR 303

HERO 603
Silverman No. > 249.III

"...jewelry design. - printed on self adhesive clear or opaque plastic, die-stamp-out. You stick - on your body or clothing these...die cut items. Got already: ...Medals...etc..."
Letter: George Maciunas to Ken Friedman, [ca. February 1967].

FLUX-PROJECTS PLANNED FOR 1967...George Maciunas:...plastic stick-ons (disposable jewelry):... medals...
Fluxnewsletter, March 8, 1967.

stick-on medals $1...by george maciunas
Fluxshopnews. [Spring 1967].

"...By separate mail I am sending some of the new stick-on tattoos we produced. There are 4 other new sheets we are going now:...medals, etc. - to be stuck on skin or clothing...."
Letter: George Maciunas to Paul Sharits, June 21, 1967.

SUMMARY OF LAST NEWSLETTER (Jan. 31, 1968) ...stick-ons produced...Maciunas:...medals...
Fluxnewsletter, December 2, 1968.

FLUX-PRODUCTS 1961 TO 1969 ... FLUXTATTOOS Winter 1967:...medals...by Bob Watts [sic] 6 - 5x6'' stick-on sheets, boxed * [indicated as part of FLUXKIT] [$] 5
Fluxnewsletter, December 2, 1968 (revised March 15, 1969).

FLUX-PRODUCTS 1961 TO 1970 ... FLUXTATTOOS 1967:...medals...by Bob Watts [sic] 6 [different] 5x6'' stick-on sheets, boxed $5
Flux Fest Kit 2. [ca. December 1969].

COMMENTS: *Hero 603 is a sheet of stick-ons with images of medals. It was distributed by Fluxus both as an individual sheet, and as part of the Collective work,* Flux Tattoos. *The sheet is copyrighted by Implosions, Inc., a commercial ex-*

George Maciunas. GROTESQUE FACE MASK

George Maciunas. HERO 603

tension of Fluxus products started by Herman Fine, George Maciunas and Robert Watts. However, the idea for these stick-ons began before Implosions was organized, and the work must be considered a Fluxus Edition.

HERO 604
Silverman No. > 249.IV

SUMMARY OF LAST NEWSLETTER (Jan. 31, 1968) ...stick-ons produced...Maciunas:...symbols.
Fluxnewsletter, December 2, 1968

FLUX-PRODUCTS 1961 TO 1969 ... FLUXTATTOOS Winter 1967...symbols by Maciunas, 6 [different] - 5x6'' stick-on sheets, boxed * [indicated as part of FLUXKIT] [$] 5
Fluxnewsletter, December 2, 1968 (revised March 15, 1969).

FLUX-PRODUCTS 1961 TO 1969...GEORGE MACIUNAS...stick-on tattoos: ...symbols, each [$] 1
ibid.

FLUX-PRODUCTS 1961 TO 1970 ... FLUXTATTOOS 1967:...symbols by George Maciunas; 6 [different] - 5x6'' stick-on sheets, boxed $5
Flux Fest Kit 2. [ca. December 1969].

George Maciunas. HERO 604

COMMENTS: *Another sheet of stick-ons, this one using symbols: religious, nationalistic, and other iconographic subjects. Again, the work was distributed by Fluxus, both as an individual sheet and as a part of the Collective,* Flux Tattoos. *The sheet itself is copyrighted by Implosions.*

HINGED RACKET

by George Maciunas:... ping-pong rackets,...hinged ...ea: $20
Fluxnewsletter, April 1975.

OBJECTS AND EXHIBITS...1966:...designed first prepared ping pong and badmington rackets (...hinged ...surfaces)...
George Maciunas Biographical Data. 1976.

COMMENTS: *Hinged Racket is a commercially produced ping-pong racket, cut above the handle and hinged. A drawing by Maciunas for this racket appears in a publication from and/or, Seattle, about the Flux Fest that took place there in 1977. I'm not certain whether the racket was actually made or not.*

HINGES see:
FLUXWEAR 303

HISTORICAL BOXES

EXHIBITS...AUG. 13 & 14 HISTORIC WEEKEND
...Historical boxes by George Maciunas
Proposal for Flux Fest at New Marlborough. April 8, 1977.

"...Now I am making historical boxes the first one,
...was Murillo box or rather everything that happened
during his lifetime. I think it was my best box. So I
decided to do other boxes, one on 1250..."
Letter: George Maciunas to Peter Frank, [ca. March 1977].

COMMENTS: *Historical Boxes* are related to *Biography Box.*
Historical Boxes take either a particular year, such as "1250,"
or an historical figure such as Murillo, the Spanish painter,
and contain information, images, and so on, pertaining to the
period, but with a particular Fluxus slant.

HISTORY OF ART

CHARTS, DIAGRAMS AND ATLASES...1958 - 66:
History of Art 3 dimensional Chart (1st category on
drawer faces, 2nd category on horizontal surface of
drawer interior and 3rd category on vertical multiple
surfaces of drawer interior-faces of filing cards)...
George Maciunas Biographical Data. 1976.

COMMENTS: *Apparently lying somewhere between* Learning
Machine *and Maciunas' great chart,* Diagram of Historical De-
velopment of Fluxus and Other 4 Dimensional, Aural, Optic,
Olfactory, Epithelial and Tactile Art Forms, *this three-dimen-
sional chart would have been much broader in its scope, and
it reflects Maciunas' training and interest in art history. I have
never seen the work, and don't know if it was ever made or
even if it was to have been a Fluxus work. The date of its ap-
parent completion, 1966, is a period of intense Fluxus pro-
duction, and a time Maciunas was expanding the dimension
and shape of Fluxus works into many areas.*

HOLE IN CENTER RACKET

Silverman No. < 258.VIII

"...The FLUXUS OLYMPIC Games...What we did
was prepare various implements as follows. Badming-
ton rackets:...Racket with a large hole, etc...."
Letter: George Maciunas to Ben Vautier, February 1, 1965.

Fluxsports: ping-pong rackets...with holes... [photo
caption]
*fluxus Vaudeville TouRnamEnt (Fluxus Newspaper No. 6)
July 1965.*

FLUXSPORTS (or Fluxolympiad) All items will be
brought over. Badmington...rackets...prepared with
large holes...
Proposed Program for a Fluxfest in Prague, 1966.

FLUXSPORTS (or Fluxolympiad) All items will be
brought over...Ping Pong...rackets with holes, play
over table...
ibid.

PROPOSED FLUXOLYMPIAD RACKET GAMES:
...prepared ping pong:...rackets with holes in center,...
Fluxnewsletter, January 31, 1968.

[as above]
Fluxnewsletter, December 2, 1968.

PROPOSED FLUXSHOW FOR GALLERY 669 ...
SPORTS - GAME CENTER:...prepared ping-pong:...
rackets with holes in center...
ibid.

PROPOSED FLUXSHOW ... SPORTS - GAME CEN-
TER...Prepared table tennis: rackets...with holes in
center...
Fluxnewsletter, December 2, 1968 (revised March 15, 1969).

FLUX-OLYMPIAD...DUAL CONTEST - RACKET
PREPARED PING-PONG:...racket with hole in cen-
ter... (George Maciunas)
Flux Fest Kit 2. [ca. December 1969].

FEB 17, 1:30PM FLUX-SPORTS DOUGLASS COL.
...BADMINGTON & TABLE TENNIS (George Ma-

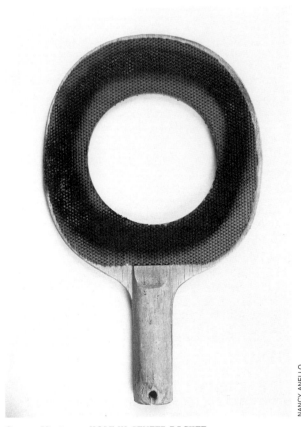

George Maciunas. HOLE IN CENTER RACKET

NANCY ANELLO

ciunas) rackets with...holes in center...
*Poster/program for Flux-Mass, Flux-Sports and Flux-Show.
February 1970.*

"For the exhibit, I would suggest a flux-ping pong
tournament...you can make simple variations on
rackets like:...large hole..."
*Letter: George Maciunas to David Mayor, n.d. Reproduced
in Fluxshoe, 1972.*

"...for the Rome exhibit...you could set up...rackets
with hole..."
*Letter: George Maciunas to Giancarlo Politi, n.d. Reproduced
in Fluxnewsletter, April 1973.*

by George Maciunas:...ping-pong rackets,...hole...
ea: $20
Fluxnewsletter, April 1975.

OBJECTS AND EXHIBITS...1966:...designed first
prepared ping pong and badmington rackets (...with
hole...surfaces)...
George Maciunas Biographical Data. 1976.

PING PONG is played with "prepared" rackets:...rack-
ets with hole in center...G.M.
Fluxfest 77 at and/or, Seattle. September 1977.

COMMENTS: Hole in Center Racket *was made from a com-
mercially made ping-pong racket with a hole cut in the cen-
ter. It is reminiscent of Ben Vautier's Fluxholes. This racket
was made to be used in a Fluxus sports event.*

HOMAGE TO DICK HIGGINS

Silverman No. 240.12

PERFORMANCE COMPOSITIONS ... 1962: ...First
musical compositions...8 homages...
George Maciunas Biographical Data. 1976.

COMMENTS: Homage to Dick Higgins *was distributed by
Maciunas, and is a part of his early Fluxus publishing activi-
ties. The score is printed by the blueprint method, and like
the others by Maciunas, with one exception,* In Memoriam to
Adriano Olivetti, Revised, *it does not have the Fluxus copy-
right on it.*

HOMAGE TO DICK HIGGINS, by George Maciunas, Jan.12,1962
(performance by Dick Higgins to last one year)

During the year of performance, do not create, compose anything but
waltzes and marches for the policemens band.

George Maciunas. HOMAGE TO DICK HIGGINS

HOMAGE TO JACKSON MAC LOW

Silverman No. 240.15

PERFORMANCE COMPOSITIONS ... 1962: ...First
musical compositions...8 homages...
George Maciunas Biographical Data. 1976.

COMMENTS: The score is printed with the blueprint process and does not have the Fluxus copyright on it. It was distributed by Maciunas for Fluxus in early 1962 as part of the publishing program of Fluxus at that time.

HOMAGE TO JACKSON MAC LOW, by George Maciunas, Jan.14,1962

Jackson Mac Low's composition: "Letters for Iris Numbers for silence" must be performed following his established instructions, except instead of pronouncing the letters the following sounds must be executed:

letter shown	sounds to be executed
A	draw air slowly
B	draw air while upper teeth are over lower lip
C	draw air while lips are in whistling position
D	sip any fluid
E	snore
F	cough
G	lunger
H	clear throat
I	tick in throat
J	gargle any fluid
K	rinse mouth and drink
L	spit
M	lip-fart
N	lip smack
O	move mouth in eating motion
P	blow air through saliva at lips
Q	sniff wet nose deeply and swallow
R	sniff wet nose
S	blow wet nose
T	draw air with wet hands clapped together
U	rubb hands
V	clapp hands
W	slap exposed skin
X	strike with fist any part of body
Y	scratch head
Z	scratch other part of body

George Maciunas. HOMAGE TO JACKSON MAC LOW

HOMAGE TO LA MONTE YOUNG

Silverman No. 240.11

FLUXFEST INFORMATION...Some pieces not fully described list the availability of a score...Any of the pieces can be performed anytime, anyplace and by anyone, without any payment to fluxus provided... conditions are met...Scores - 25 cents each...George Maciunas HOMAGE TO LA MONTE YOUNG Lines previously drawn as performance of Compositions 1961 by La Monte Young are erased, scraped and washed. 1962.
Fluxfest Sale. [Winter 1966].

PERFORMANCE COMPOSITIONS ... 1962: ... First musical compositions...8 homages...
George Maciunas Biographical Data. 1976.

COMMENTS: Homage to La Monte Young, *the inventor of the "short form" and the catalyst for the formation of Fluxus, is a score printed by blueprint, first distributed by Fluxus in 1962. The work does not have a Fluxus copyright on it.*

HOMAGE TO LA MONTE YOUNG, by George Maciunas, Jan.12,1962
(preferably to follow performance of any composition of 1961 by LMY.)

Erase, scrape or wash away as well as possible the previously drawn line or lines of La Monte Young or any other lines encountered, like street dividing lines, rulled paper or score lines, lines on sports fields, lines on gaming tables, lines drawn by children on sidewalks etc.

George Maciunas. HOMAGE TO LA MONTE YOUNG

HOMAGE TO PHILIP CORNER

Silverman No. 240.16

PERFORMANCE COMPOSITIONS ... 1962: ... First musical compositions...8 homages...
George Maciunas Biographical Data. 1976.

COMMENTS: Homage to Philip Corner *is a score, printed with the blueprint process. Although it does not have a Fluxus copyright on it, the score was distributed by Fluxus during the early part of 1962.*

HOMAGE TO PHILIP CORNER, by George Maciunas, Jan.14,1962
"Monochrome quartet for base trombone, base sordune, voice & muscles"

seconds								
lowest note on b.tromb.								
lowest note on b.sord.								
lip fart								
mouth-hand fart *								
hand fart (wet or dry)								
real fart								

* hold hands against cheecks, fingers towards ears, leaving only small opening for lips, blow very hard, controling vibration of one cheeck with the hand by pressing or releasing.

Superimpose the grid over any portion of any composition of any Avignon medieval composer and mark down notes into grid squares. Timing for each grid is free and depends on frequency of marks & virtuosity of all the performers.

This should really be on transluent sheet like the large sheet.

George Maciunas. HOMAGE TO PHILIP CORNER

HOMAGE TO RICHARD MAXFIELD

Silverman No. 240.13

FLUXFEST INFORMATION...Some pieces not fully described list the availability of a score...Any of the pieces can be performed anytime, anyplace and by anyone, without any payment to fluxus provided... conditions are met...Scores - 25 cents each...George Maciunas HOMAGE TO RICHARD MAXFIELD Master tape of any composition by Richard Maxfield is erased as it is being rewound after its performance.
Fluxfest Sale. [Winter 1966].

PERFORMANCE COMPOSITIONS ... 1962: ... First musical compositions...8 homages...
George Maciunas Biographical Data. 1976.

COMMENTS: This score, Homage to Richard Maxfield, *printed in the blueprint process, was first distributed by Fluxus in the early part of 1962. It does not have the Fluxus copyright on it.*

HOMAGE TO RICHARD MAXFIELD, by George Maciunas, Jan.12,1962
(performance to follow performance of any tape composition of R.M.)

1. While rewinding the previously played master tape of R.Maxfield, switch on the tape recorder the "erase" switch.
2. A chicken variation on the same theme:
just rewind the previously played tape of R.Maxfield without erasing.

George Maciunas. HOMAGE TO RICHARD MAXFIELD

HOMAGE TO WALTER DE MARIA

Silverman No. 240.14

FLUXFEST INFORMATION...Some pieces not fully described list the availability of a score...Any of the pieces can be performed anytime, anyplace and by anyone, without any payment to fluxus provided ... conditions are met...Scores - 25 cents each... George Maciunas...HOMAGE TO WALTER DE MARIA All of the large constructions of Walter de Maria are brought to performance area by most difficult route: through windows, fire escapes, via crowded subway, bus etc. and then returned to him by same route. 1962
Fluxfest Sale. [Winter 1966].

PERFORMANCE COMPOSITIONS ... 1962: ... First musical compositions...8 homages...
George Maciunas Biographical Data. 1976.

COMMENTS: Another of Maciunas' scores which pay homage to various Fluxus artists, Homage to Walter de Maria *was printed in the blueprint process and distributed by Fluxus. It does not have the Fluxus copyright on it.*

HOMAGE TO WALTER DE MARIA, by George Maciunas, Jan.13,1962

Bring all boxes of Walter de Maria, including the 4ft.x4ft. x 8ft. box to performance area by the most difficult route, like via crowded subway or bus, through skylight, window or fire eskape; and then take them back same way as soon as they are brought in.

George Maciunas. HOMAGE TO WALTER DE MARIA

HORIZONTAL AXIS DOOR see:
Anonymous

HOSPITAL EVENT

"In January I will mail...My own new - Hospital event box which there will be only 6 since I don't have enough bloody clothing. $150"
Letter: George Maciunas to Dr. Hanns Sohm, November 30, 1975.

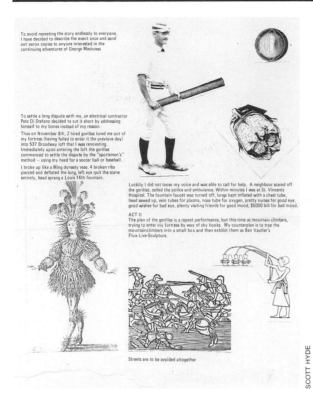

To avoid repeating the story endlessly to everyone, I have decided to describe the event once and send out xerox copies to anyone interested in the continuing adventures of George Maciunas

To settle a long dispute with me, an electrical contractor Pete Di Stefano decided to cut it short by addressing himself to my bones instead of my reason.

Thus on November 8th, 2 hired gorillas lured me out of my fortress (having failed to enter it the previous day) into 537 Broadway loft that I was renovating. Immediately upon entering the loft the gorillas commenced to settle the dispute by the "sportsmen's" method — using my head for a soccer ball or baseball.

I broke up like a Ming dynasty vase. 4 broken ribs pierced and deflated the lung, left eye quit the scene entirely, head sprang a Louis 14th fountain.

Luckily I did not loose my voice and was able to call for help. A neighbour scared off the gorillas, called the police and ambulance. Within minutes I was at St. Vincents Hospital. The fountain faucet was turned off, lungs kept inflated with a chest tube, head sewed up, vein tubes for plasma, nose tube for oxygen, pretty nurses for good eye, good wishes for bad eye, plenty visiting friends for good mood, $5000 bill for bad mood.

ACT II
The plan of the gorillas is a repeat performance, but this time as mountain climbers, trying to enter my fortress by way of sky hooks. My counterplan is to trap the mountainclimbers into a small box and then exhibit them as Ben Vautier's Flux-Live-Sculpture.

Streets are to be avoided altogether

SCOTT HYDE

George Maciunas. Mechanical for flyer describing the circumstances leading to HOSPITAL EVENT

Hospital event original only.

X-ray photos.-
bills.-
sutures - + scissors, tweezers. *
one of all medication + jars, containers.
Police report,
List of visitors.
Cards,
Books- *
Bloody shirt in plastic bag. *

| X-Rays + hist. | Books. | Bloody shirt! |
| | Drugs. | |

George Maciunas. HOSPITAL EVENT. Plan for the contents of the edition

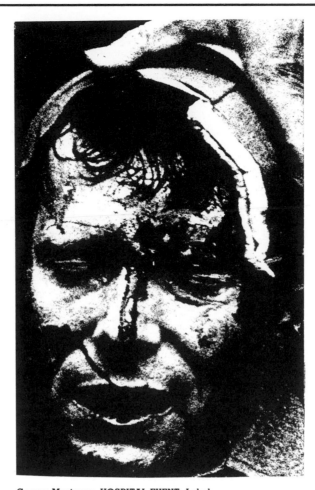

George Maciunas. HOSPITAL EVENT. Label

...Hospital event by Maciunas $200 (Jan. 1976 product, there will be only 10 copies, in 12" x 12" wood box, objects, x-rays etc)...
[Fluxus price list for a customer]. January 7, 1976.

"Hospital event by G. Maciunas $150"
Letter: George Maciunas to Dr. Hanns Sohm, May 1, 1976.

GEORGE MACIUNAS...Hospital event, 12" x 12" box, 1976 (only 8 copies) $200...
Flux Objects, Price List. May 1976.

OBJECTS AND EXHIBITS...1975: edition of Hospital event...
George Maciunas Biographical Data. 1976.

"1975-6 Objects GM - Hospital event - 6 copies"
Notes: George Maciunas on objects, [ca. 1976].

COMMENTS: In 1975, George Maciunas was brutally beaten by two hired thugs over a dispute about a bill. He was in the

hospital for a long time, lost an eye, suffered a deflated lung, and many broken bones. In response to the terrible beating, Maciunas, in his typical way, made an event of it. Besides distributing handbills (see illustration), he planned to make six boxes of relics and documents about the experience, to be called Hospital Event. I have never seen a completed Hospital Event, although there is a good amount of material which could have been included in this box in the George Maciunas Estate now in the Silverman Collection. In 1963, while Maciunas was hospitalized in Wiesbaden, Robert Watts mailed him the prototype of Watts' Hospital Events, an unrelated work to Hospital Event.

HOT PEPPER DUMPLINGS

FLUX FOODS AND DRINKS...DUMPLING VARIATIONS: One of the fillings: hot pepper,...(G. M.)
Flux Fest Kit 2. [ca. December 1969].

COMMENTS: Dumplings with a kick.

HYDROKINETIC - OSMOTIC PAINTING
Silverman No. 237, ff.

COMMENTS: It was announced in the earliest tentative plan

BRAD IVERSON

George Maciunas. HYDROKINETIC – OSMOTIC PAINTING

359

for Fluxus No. 2 West European Issue that George Maciunas would contribute "Hydrokinetic-osmotic painting," clarified in subsequent plans for Fluxus No. 2 as "...(original insert)." These would have been small versions of the work illustrated done in india ink on wet rice paper (Silverman No. 239). In 1969, the idea reappears as Kinetics Nos. 1 to 3, "projection of hollow slide of: 1. Osmosis: drop of india ink in water..."

IN MEMORIAM TO ADRIANO OLIVETTI
Silverman No. 240.17

COMMENTS: In Memoriam to Adriano Olivetti was an often performed score. The first version, printed in blueprint positive without a Fluxus copyright, is on a strip of paper attached to a used Olivetti adding machine tape, which is the "score."

IN MEMORIAM TO ADRIANO OLIVETTI, REVISED
Silverman No. 240.19

FLUXFEST INFORMATION...Some pieces not fully described list the availability of a score...Any of the pieces can be performed anytime, anyplace and by anyone, without any payment to fluxus provided ... conditions are met...Scores - 25 cents each...George Maciunas IN MEMORIAM TO ADRIANO OLIVETTI Each performer chooses any number from a used adding machine paper roll. Performer performs whenever his number appears in a row. Each row indicates beat of metronome. Possible actions to perform on each appearance of the number:
1. bowler hats lifted or lowered,
2. mouth, lip, tongue sounds,
3. opening, closing umbrellas, etc.
Fluxfest Sale. [Winter 1966].

PERFORMANCE COMPOSITIONS ... 1962: ...First musical compositions...music for lips...
George Maciunas Biographical Data. 1976.

PERFORMANCE COMPOSITIONS ... 1962: ... First musical compositions...In memoriam to Adriano Olivetti for bowler hats...
ibid.

COMMENTS: The revised version of In Memoriam to Adriano Olivetti, dated November 8, 1962, has a Fluxus copyright and the date "1963" on the second page of the work. It was printed in the blueprint process and distributed with other Fluxus scores during that period.

George Maciunas. IN MEMORIAM TO ADRIANO OLIVETTI. A detail of the score, which is a continuous strip of adding machine tape. It was used in many Fluxus performances

IN MEMORIAM to ADRIANO OLIVETTI

by George Maciunas
March 20, 1962

Any used tape from an Olivetti adding machine may be used as a score for this piece.

Tempo
Preferably fast (1 to 3 beats per second) and regular. A conductor may direct the group if necessary.

Zero
Stands for silence or lack of action of one beat.

Blank Space
Instead of row stands for silence of one beat.

Each horizontal row must be performed simultaneously.

Performance Variations
Variation no. 1:
Each performer pronounces one vertical row of numbers in any language he wishes. All prounounce horizontal rows simultaneously in even tempo and voice.
Variation no. 2:
Each number represents a pitch sounded on chordophones, aerophones, membranophones or voices.
Variation no. 3:
Each number represents a sound or soundless action as for example:
No. 1 scratching any material
2 sniffing wet nose
3 smacking lips
4 clearing throat or lungering
5 creaking chair, door etc.
6 ripping (fast or slow) paper
7 drop of water into pail
8 shake foot
9 shake coins in pocket
Other sounds or actions may be substituted to obtain louder, softer more or less dense sounds

		47 23 -
		1 09 41
		6 16 26 T
		4 31 06
		6 16 26 -
		1 85 20 T C
		.43
		.43 T
		1 85 20
		1 18 05 -
		67 15 T
		43 10
		43 10 T
		1 85 20
	.00 T	1 18 05 -
X	8 74	67 15 T
X	.02	.00 T
X	.00	
X	17 48 T	4 31 06
	8 74	1 18 05
	17 48	67 05
	26 22 T	.10
		6 16 26 T
	.00 T	
		1 46 00
	8 74	67 15 -
	8 74 T	78 85 T
	8 74 00	
	17 48	2 80 00
	8 91 48 T	1 18 05 -
		1 61 95 T
X	8 74	
X	1 02	41 41
X	.00	3 75 -
X	8 91 48 T	37 66 T
X	.00 T	.06
		.06 T
X	5 56 60	
X	2 52 -	2 66 58
X	.00	3 75
X	1 40,2 63 20 T C	4 45 7
		3 14 90 T
	.00 T C	
		3 14 90
	5 56 60	2 66 58 -
	2 50 -	48 32 T
	.02 -	

```
IN MEMORIAM TO ADRIANO OLIVETTI        By George Maciunas  March 20,1962
                                                  revised:   Nov.  8,1962
                                       ✗

ny used tape from an Olivetti adding machine may be used as a score for this piece.

PERFORMANCE INSTRUCTIONS
Numbers (including zero) represent specific sounds or actions, each of which is
assigned to separate performer. When performed by fewer than 10 performers, the
unassigned excessive numbers represent silences. Same number can also be assigned
to more than one performer if the tape contains more than one of same number per row.
In such cases the second or third performer performs only when 2nd. or 3rd. of same
number appear on the row.
Each horizontal row is performed simultaneously at preferably fast tempo such as
2 regular beats per second. A conductor or metronome may direct the group if necessary.
Blank row represents silence of one beat.

VERSION 1. ( poem )
Each performer pronounces his assigned number in any language.

VERSION 2. ( ballet ) performers to be formally dressed (except no.9,in military unifor
Performers perform the following actions assigned to indicated numbers:
0 - lift bowler hat from head when first 0 is indicated,place on head when next 0 is
    indicated, repeat action for succeeding indications of 0's.
1 - point with finger at someone in the audience (arm outstreched) whenever 1 is
    indicated. Point at different member of audience for each separate indication of 1.
2 - point with finger at ceiling or floor
3 - sit down on a chair when first 3 is indicated, stand up on next indication, etc.
4 - squat down when first 4 is indicated, stand up when next is indicated, etc.
5 - strike floor with cane or umbrella on each indication of 5
6 - open umbrella over head on first indication of 6, close on next, etc.
7 - bow down (towards or away from audience) on first indication of of 7, raise on next
8 - stamp floor with foot on each indication of 8
9 - give military salute with hand on first indication of 9, lower hand on next, etc.

VERSION 3. ( ballet )
Each performer to use different kind of hat. Perform as in Version 2 (zero)

VERSION 4. ( chorale )
0 - smack with lips smartly (sound like drop falling into water) on each indication of
1 - smack with tongue (click like opening corcked bottle),
2 - lip-fart (through tight lips)
3 - lip-fart (with tongue between lips)
4 - draw air (upper teeth over lower lips)
5 - draw air, open mouth, vibrate deep throat (pig like sound)
```

```
6 - blow air between lips vibrating them
7 - dry spitting
8 - lunger
9 - sniff wet nose ( wet nose with water if necessary )

VERSION 5 ( string quartet or ensemble )
0 - strike body with mallet or stick
1 - knock against floor (cello) or table (violin)
2 - shake body (have pellet or pellets placed inside beforehand)
3 - with stick scrape edge of sound hole (obtain squeek or screech)
4 - place instrument in playing position and in non-playing position on next called bea
5 - place bow over strings in playing position        ,,         ,,
6 - (replace beforehand a string with electric heating coil) scrape coil
7 - pluck heating coil
8 - (replace beforehand a string with rubber band) pluck rubber band smartly
9 - open etuis, close it on next called beat.

VERSION 6 (for string quartet only)
1 - pizzicato C
2 -     ,,    C+¼ (tone)
3 -     ,,    C-¼
4 -     ,,    C #

Any sounds or actions of any versions may be combined in any way to form new
versions or new sounds and actions substituted.

EXAMPLE  (combined version 2 and 4)    9 performers (1,3,5,6,7,8,9,0)

16387 - point finger,open umbrella,sit on chair,lip-fart(8),bow down
0086  - lift bowler hat,list boater-hat,lip-fart,close umbrella
1057  - point finger elsewhere,place bowler hat on head,draw air(pig-like),raise-up
608   - open umbrella,lift bowler hat,lip-fart
300   - get up from chair,place bowler hat on head,place boater-hat on head.
3798  - sit down on chair,bow down, give military salute,lip fart

etc.

                                        © FLUXUS 1963
```

George Maciunas. IN MEMORIAM TO ADRIANO OLIVETTI, REVISED

INDEX

COMMENTS: *An early work,* Index *would have been a ready-made, for example an index to a number of volumes, altered by Maciunas by printing ''Fluxus'' on the spine, or in some other way. I have never seen* Index.

INFLATED RACKET

COMMENTS: Inflated Racket *is based on the same idea as* Balloon Racket - *placing balloons where the netting or paddle would be.* Inflated Racket *was for ping-pong, and is not known to have been made until the Flux Fest at and/or, Seattle, 1977.*

INFLATED RUBBER TOILET SEAT

COMMENTS: *Maciunas' interest in toilets and bodily func-*

tions led to a number of works concerned with shit. Inflated Rubber Toilet Seat *would have been a gaggy, squashy toilet seat, a precursor to the soft foam toilet seat sold today.*

INK EGGS

COMMENTS: Ink Eggs *would have been eggs filled with ink. In the context of a Flux food and drink event, the ink might have been sepia, or squid ink which would have been edible. There is no indication that* Ink Eggs *were actually made. See*

also, George Maciunas' Paint Eggs, *which were blown eggs filled with paint, and in that context, used for throwing against a wall to make Yoko Ono's* Add Colour Painting.

INSECT STICK-ONS

PROPOSED CONTENTS FOR FLUXPACK 3 TO BE PUBLISHED IN 1973 BY FLASH ART...Stick-ons ...bugs, spiders,...by Maciunas...Cost Estimates: for 1000 copies...stick-ons [5 designs] $500...100 copies signed by:...Maciunas...
[George Maciunas], Proposed Contents for Fluxpack 3. [ca. 1972].

''...to produce the Flash Art FLUXPACK 3...the contents at present will be as follows:...Stick-ons bugs, flies, spiders by Maciunas...''
Letter: George Maciunas to Giancarlo Politi, n.d. Reproduced in Fluxnewsletter, April 1973.

Flash Art editor, Giancarlo Politi, proposed to publish the 3rd Fluxyearbook, maybe to be called FLUX-PACK 3, with the following preliminary contents: ... Wear items: ...body stick-ons (bugs, spiders, by Maciunas...)
Fluxnewsletter, April 1973.

''...could be produced cheaper in Italy:...some new stick-ons that we did not have a chance to produce such as various insects (full size)...''
Letter: George Maciunas to Daniela Palazzoli, n.d. Reproduced in Fluxnewsletter, April 1973.

COMMENTS: Insect Stick-Ons *were not produced, however a great deal of preparatory material for the work exists in the Maciunas Estate, now in the Silverman Collection.*

INTESTINAL DESIGN APRON see:
STOMACH ANATOMY APRON
JAVELIN see:
BALLOON JAVELIN
JELLO see:
FOOD
JEWELRY see:
FLUXUS 301

JOHN LENNON MASK
Silverman No. 263

OPENING: APR. 11 ... COME IMPERSONATING JOHN & YOKO (photo - masks will be provided to anyone not impersonating.)
Schedule of events for Fluxfest presentation of John Lennon and Yoko Ono. [ca. April 1970]. version A

FLUXFEST PRESENTATION OF JOHN LENNON & YOKO ONO +*AT 80 WOOSTER ST. NEW YORK — 1970...COME IMPERSONATING JOHN & YOKO

George Maciunas. JOHN LENNON MASK

(Photo-masks were provided)...
all photographs copyright nineteen seVenty by peTer mooRE (Fluxus Newspaper No.9) 1970.

APR. 11-17: DO IT YOURSELF - BY JOHN & YOKO + EVERYBODY...John Lennon mask...
ibid.

COMMENTS: John Lennon Mask *is a printed photograph of John Lennon's face, with cut-outs for the eyes. These masks were used for the Flux Fest Presentation of John Lennon and Yoko Ono, initially on North Moore Street in New York City where they were given out to participants. The work had limited distribution beyond that point.*

JUICES

OBJECTS AND EXHIBITS...1969:...juices...
George Maciunas Biographical Data. 1976.

PERFORMANCE COMPOSITIONS...1969: 2nd flux-food event (funny foods) contributed ... distilled juices...
ibid.

COMMENTS: Juices *is a general entry and one should refer to the various distilled juices which Maciunas made.*

JUICES see:
FOOD

KINESTHESIS SLIDES

SLIDE-FILM FLUX-SHOW...George Maciunas: KINESTHESIS BLATTIDAE, 1969 Slide projection of live cockroach Variations with: worms, flies, catterpilars [sic] etc.
Fluxfest at Stony Brook, Newsletter No. 1, August 18, 1969. version B

SLIDE & FILM FLUXSHOW GEORGE MACIUNAS: KINESTHESIS NOS. 1 TO 5, 1969 Projection of hollow slide with live: tadpole, cockroach, fly, caterpillar, worm, plankton.
Flux Fest Kit 2. [ca. December 1969].

MAY 16-22: CAPSULE BY JOHN & YOKO + FLUX SPACE CENTER A 3ft cube enclosure (capsule) having various film loops projected on its walls, ceiling and floor to a single viewer inside, total time: 6 min. [including]...slide projection of...dancing cockroaches (G. Maciunas)...
Schedule of events for Fluxfest presentation of John Lennon and Yoko Ono. [ca. April 1970]. version A

MAY 16-22: CAPSULE BY YOKO + FLUX SPACE CENTER A 3' x 3' x 3' enclosure (capsule) having various film loops projected on its walls and ceiling to a single viewer inside [including] ...(Maciunas)... projection of moving cockroaches
Schedule of events for Fluxfest presentation of John Lennon and Yoko Ono. April 1970. version C

''...for the Rome exhibit, ...You could also do my Kinesthesis slide pieces. You need a magnifying (microscopic) slide projector and few hollowslides (I could send the hollow slides) then you can fill slides with water containing plankton, or place bugs or cockroaches inside these hollow slides and you will have a continuous live show...''
Letter: George Maciunas to Giancarlo Politi, n.d. Reproduced in Fluxnewsletter, April 1973.

COMMENTS: Kinesthesis Slides *were a way of making very direct and immediate slide projections for a Fluxus film capsule and other film events. The slides were hollow glass slides, and one could put any sort of living organism in them to project and watch its movements.*

KINETICS NOS. 1 TO 3

SLIDE-FILM FLUX-SHOW...Yoshimasa Wada & G. Maciunas OSMOSIS Slide projection of: drop of ink in water, alka seltzer tablet in water, shaving cream or urethane foam
Fluxfest at Stony Brook, Newsletter No. 1, August 18, 1969. version B

SLIDE & FILM FLUXSHOW ... GEORGE MACIU-
NAS: KINETICS NOS. 1 TO 3, 1969 Projection of
hollow slide of:
1. Osmosis: drop of india ink in water, drop of oil
paint in turpentine etc.
2. Diffusion: alka seltzer in water, salts, sugar, soap
flakes in water, paint in paints etc. iodine in po-
tassium iodide solution.
3. Crystallization (by precipitation hardening) bari-
um chloride in sulfuric acid, or forming lead chlor-
ide, ferric hydroxide, silver chloride, etc.
Flux Fest Kit 2. [December 1969].

APR. 11-17: DO IT YOURSELF, BY JOHN & YOKO
+ EVERYBODY...Osmosis (drop of india ink into
water contained in hollow slide projected by slide
projector, or on pudle [sic] of water, by G.M.) ...
MAY 16-22: CAPSULE BY JOHN & YOKO + FLUX
SPACE CENTER A 3ft cube enclosure (capsule) hav-
ing various film loops projected on its walls, ceiling,
and floor to a single viewer inside, total time: 6 min.
[including] ...slide projection of diffusion, osmosis of
liquids...(G. Maciunas)...
*Schedule of events for Fluxfest presentation of John Lennon
and Yoko Ono. [ca. April 1970]. version A*

MAY 16-22: CAPSULE BY JOHN & YOKO + FLUX
SPACE CENTER ($1 ADMISSION CHARGE) A 3ft
cube enclosure (capsule) having various film loops pro-
jected on its 3 walls, ceiling and floor to a single view-
er inside, about 8 minutes...slide projection of: diffu-
sion and osmosis of solvents (G. Maciunas, 1969)
*Schedule of events for Fluxfest presentation of John Lennon
and Yoko Ono. [ca. April 1970]. version B*

MAY 16-22: CAPSULE BY YOKO + FLUX SPACE
CENTER A +. x 3' x 3' enclosure (capsule) having
various film loops projected on its walls and ceiling to
a single viewer inside [including] ...slide projection of
diffusion in liquid (Maciunas)...
*Schedule of events for Fluxfest presentation of John Lennon
and Yoko Ono. April 1, 1970. version C*

"... for the Rome exhibit, ... With the microscopic
slide projector you can also show crystallization of
barium chloride in sulfuric acid, or alka seltzer in wa-
ter, etc. etc. All you need is hollow slides..."
*Letter: George Maciunas to Giancarlo Politi, n.d. Reproduced
in Fluxnewsletter, April 1973.*

COMMENTS: *A similar concept to* Kinesthesis Slides, Kinetics
Nos. 1 to 3 *were of three sorts: "osmosis," drops of ink or oil
in water, etc.; "diffusion," alka seltzer, salts in water, etc.;
"crystallization," barium chloride in sulfuric acid, etc. The
idea was to be able to watch the process of these different
kinetic materials evolve. They were planned for Fluxus film
and slide shows. The interest in crystallization has a relation-
ship to a joint work of George Maciunas and George Brecht,*
Silicate Micro Crystals, *and the osmosis relates back to early*

paintings that Maciunas did, wetting rice paper, putting ink
on it, and letting the ink seep. See Hydrokinetic-Osmotic
Painting.

KNOB AT HINGES DOOR see:
George Maciunas and Larry Miller

LABYRINTH see:
FLUXLABYRINTH

LAXATIVE SANDWICH

FLUX FOODS AND DRINKS...AFTER EFFECT
MEALS:...LAXATIVE SANDWICH (G. Maciunas)
Flux Fest Kit 2. [ca. December 1969].

COMMENTS: *Hurrying the process.*

LEAKING CUP DISPENSER

MAY 30 - JUNE 5: THE STORE BY JOHN & YOKO
+ FLUXFACTORY Coin operated vending machines:
...drink dispenser dispensing drink with...leaking cup
(G.M.)
*Schedule of events for Fluxfest presentation of John Lennon
and Yoko Ono. [ca. April 1970]. version B*

...This Fall, we shall publish V TRE no.10 which shall
consist of a plan for Flux-Amusement-Center, to con-
tain...Vending machines...nut type dispensers (dis-
pensing...perforated cup...)
Fluxnewsletter, April 1973.

COMMENTS: *Another of Maciunas' messy drinks dispensing
ideas,* Leaking Cup Dispenser *is not known to have been
made.*

LEARNING MACHINE
Silverman No. 254

CHARTS, DIAGRAMS AND ATLASES...1969: Re-
categorization of fields of knowledge, completed 2 di-
mensional diagram & tabulation, intended as the first
surface of 3 dimensional storage and retrieval system,
called a "learning machine".
George Maciunas Biographical Data. 1976.

...Library, archives, and exhibit space...would con-
tain ... the "learning machine" being developed by
George Maciunas...
*Prospectus for the New Marlborough Centre for the Arts.
[ca. 1976].*

COMMENTS: *A preliminary version of* Learning Machine *is
illustrated. Maciunas had a much more elaborate idea for*
Learning Machine, *which was a three-dimensional work re-
ferred to in his biographical data in 1976. Beyond the printed
sheets, however, the work is not known to have been com-
pleted.*

SCOTT HYDE

George Maciunas. LEARNING MACHINE. Preliminary version

LEATHER TEA

FLUX DRINKS & FOODS...TEA VARIATIONS:...
tea made from boiling:...leather...(G. Maciunas)...
*Invitation to Participate in New Year Eve's Flux-Feast.
[ca. December 1969].*

FLUX FOODS AND DRINKS...TEA VARIATIONS:
...Tea made from boiling:...leather...(George Maciu-
nas)
Flux Fest Kit 2. [ca. December 1969].

COMMENTS: Leather Tea *is a variation of Maciunas' tea
pieces. These tea ideas are derived from Per Kirkeby's work,*
4 Flux Drinks, *where Kirkeby puts citric acid or aspirin or
other such things into tea-bags.*

LENNON MASK see:
JOHN LENNON MASK

LETTERS TO ATTORNEY GENERAL
Silverman No. > 295.I, ff.

FLUX COMBAT WITH NEW YORK STATE ATTORNEY GENERAL (& POLICE) BY GEORGE MACIUNAS (EVENT IN PROGRESS)...Maciunas' arsen-

George Maciunas. LETTERS TO ATTORNEY GENERAL

al of weapons: humorous, insulting and sneering letters to Attorney General...
Fluxnewsletter, May 3, 1975.

"Could you mail me in an envelope a blank postcard. I need it for item 4 (on other side) I will write a message and then send it to you to mail it to Attorney General in N.Y. It will look like I am in Japan. I will do this from all over the world. Absolutely confuse him..."
Letter: George Maciunas to Chieko Shiomi, [ca. May 1975].

COMMENTS: *It's not known how many letters Maciunas wrote to the Attorney General as part of his* Flux-Combat with New York State Attorney General (& Police). *He considered* Letters to Attorney General *a part of his "arsenal of weapons." The examples in the Silverman Collection were either not sent or copies he kept. One, dated April 1, 1975, suggests that the Attorney General investigate a group of people with similar sounding names to Maciunas, such as Machuca, Macinnis, Mak Cheuk Ping, Makarushka, Matuns, etc. Another process which Maciunas started was to send picture postcards to friends in various countries to mail back to the Attorney General, stating, for example, that he is in Nice on May 15th, 3:00PM, or in Japan on another date.*

LIGHT BOX see:
WATER LIGHT BOX
LINEAR FALL see:
LINES FALLING OR RISING

LINEAR TURN

"...I am finally doing the 8mm print of that 1200 ft. Fluxfilm version. It will be good for straight viewing or loop viewing, some 40 loops that could do a nice Flux-wall paper event, [for instance...moving vertical lines...]"
Letter: George Maciunas to Paul Sharits, June 21, 1967.

PROPOSED FLUXSHOW FOR GALLERY 669 ... FILM WALLPAPER ENVIRONMENT A booth must be set up in a fairly dark area, the walls of which are of white vinyl or cotton sheets (about 12ft. wide) hanging as curtains and creating a 12ft x 12ft or smaller room. Four 8mm loop projectors (with wide angle lenses) must be set up, one on front of each wall (on the outside) and projecting an image the frame of which is to cover entire wall. 20 sets of loops are available, such as vertical lines moving left (like a carousel) ...Visitors, a few at a time, must enter this booth to observe the film environment around them.
Fluxnewsletter, December 2, 1968.

PROPOSED FLUXSHOW...FILM WALLPAPER ENVIRONMENT ... [as above] ... 20 sets of loops are available, such as: vertical lines moving carousel fash-

ion clockwise...
Fluxnewsletter, December 2, 1968 (revised March 15, 1969).

MAY 16 - 22 CAPSULE BY JOHN & YOKO + FLUX SPACE CENTER A 3ft cube enclosure (capsule) having various film loops projected on its walls, ceiling and floor to a single viewer inside, total time: 6 min. [including] ... linear...turn (carrousel fashion)...(G. Maciunas)...
Schedule of events for Fluxfest presentation of John Lennon and Yoko Ono. [ca. April 1970]. version A

MAY 16-22: CAPSULE BY JOHN & YOKO + FLUX SPACE CENTER ($1 ADMISSION CHARGE) A 3ft cube enclosure (capsule) having various film loops projected on its 3 walls, ceiling and floor to a single viewer inside, about 8 minutes [including] ...linear turn (carrousel fashion...by G.Maciunas, 1966)
Schedule of events for Fluxfest presentation of John Lennon and Yoko Ono. [ca. April 1970]. version B

COMMENTS: *Linear Turn is a film using presstype or another sort of direct marking on film leader. This film is a good example of how Maciunas would use one idea in a couple of different ways: as an ephemeral wallpaper which is part of a film environment in the capsule, as well as a movie. See also Artype for a similar concept.*

LINES FALLING OR RISING

MAY 16-22: CAPSULE BY JOHN & YOKO + FLUX SPACE CENTER A 3ft cube enclosure (capsule) having various film loops projected on its walls, ceiling and floor to a single viewer inside, total time: 6 min. [including] ... linear fall, (carrousel fashion)...(G. Maciunas)
Schedule of events for Fluxfest presentation of John Lennon and Yoko Ono. [ca. April 1970]. version A

MAY 16-22 CAPSULE BY JOHN & YOKO + FLUX SPACE CENTER ($1 ADMISSION CHARGE) ... about 8 minutes [including] ...linear fall...(carrousel fashion...by G. Maciunas, 1966)
Schedule of events for Fluxfest presentation of John Lennon and Yoko Ono. [ca. April 1970]. version B

MAY 16-22...various film loops projected on its walls and ceiling to a single viewer inside: fall, carrousel (G. Maciunas)...
Schedule of events for Fluxfest presentation of John Lennon and Yoko Ono. April 1, 1970. version C

FLUXFEST PRESENTATION OF JOHN LENNON & YOKO ONO +* AT 80 WOOSTER ST. NEW YORK --1970...MAY 16-22: CAPSULE BY JOHN & YOKO + FLUX SPACE CENTER...A 6 x 6ft enclosure having various films projected on its walls to a single viewer inside...lines falling or rising (G. Maciunas '66)...
all photographs copyright nineteen seVenty by peTer mooRE (Fluxus Newspaper No.9) 1970.

11.04.-29.05.1970 FLUX FEST OF JOHN LENNON
& YOKO ONO...16-22.05: FILM ENVIRONMENT
4 wall projection of dots, ascending lines, rainbow
colors, etc. by sharits, maciunas, ono, ayo, etc.
George Maciunas, Diagram of Historical Developments of
Fluxus... [1973].

COMMENTS: *Like* Linear Turn *and* Artype, *this film incor-*
porates presstype or other direct printing on film leader. Lines
Falling or Rising *is a variant on the film idea of* Linear Turn.

LIQUID WHITE GLUE EGGS

PROPOSED FLUX DRINKS & FOODS FLUX EGGS
emptied egg shells filled with...liquid white glue...
Fluxfest at Stony Brook, Newsletter No. 1, August 18, 1969.
versions A and B

FLUX DRINKS & FOODS FLUX EGGS emptied
egg shells filled with...liquid white glue...(G. Maciu-
nas)...
Invitation to Participate in New Year Eve's Flux-Feast. [ca.
December 1969].

FLUX FOODS AND DRINKS FLUX EGGS: Emptied
shells filled with...liquid white glue...(George Maciu-
nas)
Flux Fest Kit 2. [ca. December 1969].

COMMENTS: *Part of the Flux eggs series that Maciunas*
wanted to make, Liquid White Glue Eggs *would have been*
blown eggs filled with glue and sealed.

LONG HANDLE RACKET

"...By the way I don't think I ever described to you
the FLUXUS OLYMPIC Games...What we did was
prepare various implements as follows. Badminton
rackets:,,,badmington rackets having one meter long
handles, playing with ping-pong ball (on floor)..."
Letter: George Maciunas to Ben Vautier, February 1, 1966.

FLUXSPORTS, (or Fluxolypiad) All items will be
brought over...Ping Pong...long 2m handles, play
on floor, regular net...
Proposed Program for a Fluxfest in Prague, 1966.

PROPOSED FLUXOLYMPIAD RACKETS GAMES:
...prepared ping pong:...rackets with 3ft. long han-
dles (to be played on floor), etc.
Fluxnewsletter, January 31, 1968.

PROPOSED FLUXSHOW FOR GALLERY 669 ...
SPORTS - GAME CENTER...prepared ping-pong:...
rackets with 3ft. long handles (to be played on floor).
Fluxnewsletter, December 2, 1968.

PROPOSED FLUXSHOW...SPORTS - GAME CEN—
TER...Prepared table tennis:...with 3ft. long handles
(to be played on the floor. etc.)...
Fluxnewsletter, December 2, 1968 (revised March 15, 1969).

FLUX-OLYMPIAD...DUAL CONTEST ... Racket...
badmington rackets with 6ft. handles playing ping -
pong balls on floor...
Fluxfest at Stony Brook, Newsletter No. 1, August 18, 1969.
version A

FLUX-OLYMPIAD ... by G. Maciunas...DUAL ...
Rackets with 6 ft. handles playing ping-pong balls
on floor, with balloons instead of shuttles...
Fluxfest at Stony Brook, Newsletter, No. 1, August 18, 1969.
version B

FLUX-OLYMPIAD...DUAL CONTESTS - RACKET
...PREPARED BADMINGTON: with balloons instead
of shuttles, rackets with 6 ft. handles playing ping-
pong on floor, etc. (G.M.)
Flux Fest Kit 2. [ca. December 1969].

FEB 17, 1:30PM FLUX-SPORTS DOUGLASS COL.
...BADMINGTON & TABLE TENNIS (George Ma-
ciunas) rackets with...6ft handles...
Poster/program for Flux-Mass, Flux-Sports and Flux-Show.
February 1970.

FLUXFEST PRESENTATION OF JOHN LENNON
& YOKO ONO+*AT 80 WOOSTER ST. NEW YORK
—1970...Feb 17, 1970: FLUX-SPORTS AT DOUG-
LASS COLLEGE/ tennis with 6ft handle - badming-
ton rackets & ping pong balls
all photographs copyright nineteen seVenty by peTer mooRE
(Fluxus Newspaper No. 9) 1970.

"For the exhibit, I would suggest a flux-ping pong
tournament...you can make simple variations on rack-
ets like: long handle..."
Letter: George Maciunas to David Mayor, n.d. Reproduced
in Fluxshoe, 1972.

"...for the Rome exhibit,...you could set up a ping
pong table with various prepared rackets, such as ...
oversized racket..."
Letter: George Maciunas to Giancarlo Politi, n.d. Reproduced
in Fluxnewsletter, April 1973.

1970...FLUXSPORTS:...by g. maciunas:...6 ft. han-
dle floor ping-pong game, badmington racket...
George Maciunas, Diagram of Historical Developments of
Fluxus... [1973].

COMMENTS: Long Handle Racket: *a ping-pong or badming-*
ton racket with a 3 foot or 6 foot handle attached, very hard
to play with.

LOOSE

FLUX-PRODUCTS 1961 TO 1970 ... GEORGE MA-
CIUNAS...Flags: 28" square, sewn legends:... loose,
ea: [$] 60...
Flux Fest Kit 2. [ca. December 1969].

COMMENTS: *This flag is not known to have been made by*
Maciunas as a Fluxus Edition.

LOOSE SAND DISPENSER

PROPOSED FLUXSHOW FOR GALLERY 669 ...
AUTOMATIC VENDING MACHINES-DISPENSERS
(coin operated)...dispenser dispensing loose sand...
Fluxnewsletter, December 2, 1968.

PROPOSED FLUXSHOW...AUTOMATIC VENDING
MACHINES-DISPENSERS (coin operated)...nut dis-
penser dispensing into the palm loose sand...
Fluxnewsletter, December 2, 1968 (revised March 15, 1969).

AUTOMATIC VENDING MACHINES...Nut dispenser
dispensing into the palm loose sand...
Flux Fest Kit 2. [ca. December 1969].

FLUX SHOW: DICE GAME ENVIRONMENT EN-
TIRE FLOOR AS DICE HAZARD TABLE DIE
CUBES, 15" CUBES ON FLOOR, Marked on sides,
top open or closed with clear plastic. Consisting or
containing...Automatic dispenser of loose sand...
ibid.

MAY 30 - JUNE 5: THE STORE BY JOHN & YOKO
+ FLUXFACTORY Coin operated vending machines:
...nut dispenser dispensing into palm loose sand...(G.
Maciunas)
Schedule of events for Fluxfest presentation of John Lennon
and Yoko Ono. [ca. April 1970]. version B

MAY 30 - JUNE 5: THE STORE BY YOKO + FLUX-
FACTORY Vending machines (coin operated): ...nut
dispenser dispensing into the palm loose sand...
Schedule of events for Fluxfest presentation of John Lennon
and Yoko Ono. April 1, 1970. version C

COMMENTS: *Another dispenser idea, this one you put a coin*
in and loose sand comes out. I don't believe the work was
ever prepared.

MACHINE see:
 FLUXUS MACHINE
MASK see:
 FACE ANATOMY MASK
 GROTESQUE FACE MASK
 JOHN LENNON MASK
 YOKO ONO MASK

MATCH FLAG

NEW YEARS EVE'S FLUX FEST, DEC, 31, 1969...
match flag (In Memoriam to Richard Maxfield) by G.
Maciunas...match flag burning at 12:05
all photographs copyright nineteen seVenty by peTer mooRE
(Fluxus Newspaper No. 9) 1970. [captions for photographs]

COMMENTS: Match Flag, *an arrangement of hundreds of wooden matches in the pattern of an American flag, was ignited just after midnight, 1970, during the New Year's Eve Flux Fest in New York City. Intended as a memorial to Richard Maxfield, the work was a strong statement on the United States war against the Vietnamese, and has a direct relationship to Maciunas'* U.S.A. Surpasses All the Genocide Records *flag poster done two years earlier.*

MAZE
Silverman No. < 277.II

COMMENTS: Maze *derives originally from Takako Saito's* Ball Games *(Silverman No. 383), which uses ball bearings in a glazed box, a game reminiscent of children's handheld "get the ball in the hole" games. In 1970, George Maciunas constructed a Collective work by Yoko Ono and others. This was an eight door maze entitled,* Portrait of John Lennon as a Young Cloud, *for the Fluxfest Presentation of John Lennon & Yoko Ono in New York City. In 1971, Yoko Ono's* Amaze *was constructed with translucent glass panels for her exhibition at the Everson Museum in Syracuse, New York. Around 1973, George Maciunas' plan for Robert Watts' toilet in the Collective* Flux Toilet *included* Game. *Intended as a display on the interior side of the toilet door,* Game *was to have a ball rolling down a maze. The* Maze *idea evolves further into Maciunas' plan for the Collective* Flux-Maze *at the Rene Block Gallery in New York, 1975. This was not built, but ideas for it were transferred to the Collective* Fluxlabyrinth, *realized in Berlin in 1976. Maciunas'* Maze, *included in a drawer of* Flux Cabinet, *dates from 1977, and uses cork and other kinds of balls that roll through holes in the drawer and get lost in the drawers below.*

George Maciunas. MAZE. A drawer in FLUX CABINET, designed so that the balls fall into the drawers below

BRAD IVERSON

MAZE see:
 FLUXLABYRINTH
MECHANICAL AEROPHONE see:
 AEROPHONE
MEDALS see:
 HERO 603
MEDICINE see:
 MYSTERY MEDICINE
MEDICINE CABINET see:
 DISPLAY CASE MEDICINE CABINET
 MULTI-FACETED MIRROR
MEDIEVAL ARMOR APRON see:
 George Maciunas and Robert Watts
MILK see:
 FOOD
MIRROR see:
 MULTI-FACETED MIRROR
MISSING KNOB DOOR see:
 Anonymous

MIXED NUMBERS FACE CLOCK

FLUX-PRODUCTS 1961 TO 1969 ... GEORGE MACIUNAS...Clocks with dial faces:...mixed up numbers...electric or wind up, each: [$] 8...
Fluxnewsletter, December 2, 1968 (revised March 15, 1969).

FLUX-PRODUCTS 1961 TO 1970 ... GEORGE MACIUNAS Clocks with:... mixed numbers...face, ea: [$] 8
Flux Fest Kit 2. [ca. December 1969].

COMMENTS: *I have not been able to identify this clock face and don't believe any Fluxus clocks were made of it.*

MODULAR CABINETS
Silverman No. 258, ff.

PAST FLUX-PROJECTS (realized in 1966)...Fluxfurniture: modular cabinets by:...George Maciunas...
Fluxnewsletter, March 8, 1967.

FLUX-PROJECTS PLANNED FOR 1967...George Maciunas:...modular cabinets...
ibid.

FLUXFURNITURE...MODULAR CABINETS, 15'' cubes, walnut sides and back, locked corners, variations on doors...George Maciunas: photo-laminate, medieval door-hardware (hinges, locks etc.) $60.00... Available in N.Y.C. at Multiples and late in 1967 at FLUXSHOP, 18 GREENE ST.
Fluxfurniture, pricelist. [1967].

COMMENTS: *This is an idea that went through many different permutations. A number of modular cabinets were built to display Fluxus works for the Fluxus exhibits at Douglass*

College in New Jersey and the Koelnischer Kunstverein, in 1970. These modular cabinets were 15'' cubes to contain groups of works, or to contain larger individual works designed to fit the cabinets. In 1977, Maciunas designed Modular Cabinets for Sean Ono Lennon's room in New York City. One group of cabinets that did not get built are described above in the Fluxfurniture pricelist of 1967, although a great deal of preliminary material exists for them in the Maciunas Estate, now in the Silverman Collection.

JON HENDRICKS

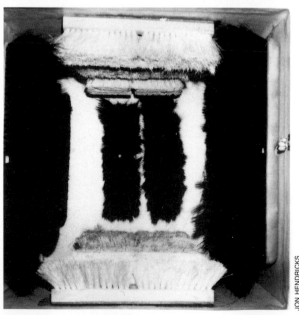

JON HENDRICKS

George Maciunas. MODULAR CABINETS. Two interior views

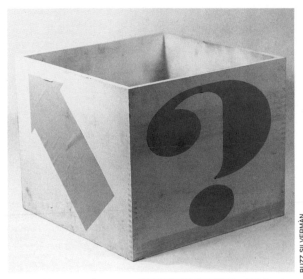

George Maciunas. One type of MODULAR CABINET, a 15" display cube

BUZZ SILVERMAN

MONSTERS ARE INOFFENSIVE see:

Robert Filliou, George Maciunas, Peter Moore
Daniel Spoerri and Robert Watts

MOSS TEA

FLUX FOODS AND DRINKS...TEA VARIATIONS: ...Tea made from boiling:...moss,...(George Maciunas)
Flux Fest Kit 2. [ca. December 1969].

COMMENTS: *Moss Tea is reminiscent of John Chick's Flux Food forest version (Silverman No. 89) which includes gentle forest floor gatherings.*

MOTOR ONLY CLOCK

PROPOSED FLUXSHOW FOR GALLERY 669 ... OBJECTS, FURNITURE...clocks:...faceless clock by George Maciunas...
Fluxnewsletter, December 2, 1968.

FLUX-PRODUCTS 1961 TO 1969 ... GEORGE MACIUNAS...Clocks with dial faces:...motor only...electric or wind-up, each: [$] 8...
Fluxnewsletter, December 2, 1968 (revised March 15, 1969).

FLUX-PRODUCTS 1961 TO 1970 ... GEORGE MACIUNAS Clocks with:... motor only...ea: [$] 8
Flux Fest Kit 2. [ca. December 1969].

COMMENTS: *A faceless clock, with just the motor showing. I have never seen a Fluxus produced clock like this, although commercially produced clocks are now frequently made with the innards exposed.*

MOUSE see:
FLUXMOUSE

MULTICYCLE

"...This spring we will construct a bicycle for 100 people and ride up 5th Avenue. something like this with a space frame construction. & saddles, but no steering..."
Letter: George Maciunas to Ben Vautier, January 10, 1966.

"...The Flux-fest in New York will include...possibly a 20-man bicycle event (one bicycle for 20 riders)..."
Letter: George Maciunas to Milan Knizak, [ca. January 1966].

FLUX-PARADE...GEORGE MACIUNAS: MULTICYCLE A 16 to 100 passenger cycle is to be constructed with a space frame consisting of 4 rows with 4 seats each (or 10 rows with 10 seats each in case of 100 passenger cycle) without steering, but with pedals and wheel for each passenger.
Flux Fest Kit 2. [ca. December 1969].

...In connection to these games, I need as many bicycles as possible together with riders for May 19th or 20th. A giant bicycle vehicle (3 rows with 4 bikes per row, all interconnected with pipe frame) will be built, however without causing any damage to the bicycles, since the pipes will be clamped, and bike frames protected with rubber sleeves.
Fluxnewsletter, April 1973.

PROPOSED FLUXANNIVERSARY FEST PROGRAM 1962-1972...STREET EVENTS...Multicycle by George Maciunas (16 bicycles connected into one unsteerable vehicle)
ibid.

19.05.1973 FLUXGAMES ... g. maciunas: ... multibicycle square vehicle...
George Maciunas, Diagram of Historical Developments of Fluxus... [1973].

PERFORMANCE COMPOSITIONS...1973:...Organized & contributed to flux game festival on Wooster st....multi-bike square vehicle...
George Maciunas Biographical Data. 1976.

COMMENTS: *An improbable construction made for the Flux*

George Maciunas. Fifteen MODULAR CABINETS (Silverman No. >261.Iff.) Built in 1977 for Sean Ono Lennon's room in New York. the cabinets resemble giant alphabet blocks. The interiors have qualities of Ay-O's TACTILE BOXES. see color portfolio

JON HENDRICKS

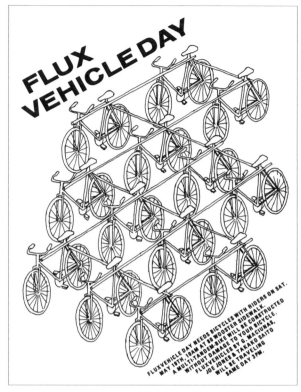

George Maciunas. MULTICYCLE. Flyer for the event

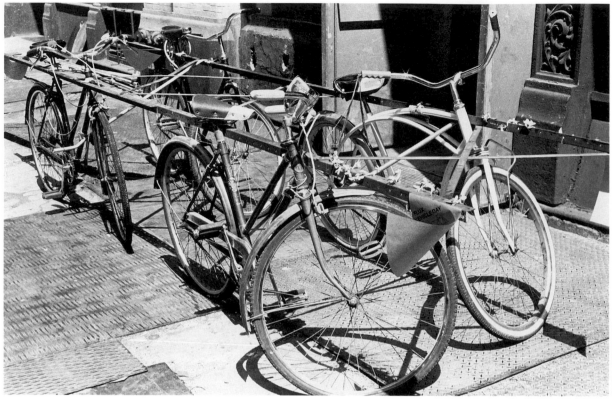

George Maciunas. MULTICYCLE

Vehicle day or Flux Parade. Multicycle was a number of bicycles attached to one another to make a strange and wondrous vehicle to ride in tandem on the streets of New York.

MULTI-FACETED MIRROR
Silverman No. > 242.VI

"... We are working on FLUXFURNITURE ...many chairs and cabinets with various kinds of doors, 15" x 15"...another is like medicine cabinet, 1st door - you see back of head (not your face) - when you open, inside of 1st door has photo of squeezed front face. 2nd door - 50 mirrors set in parabollic dish (like radar screen) so you see 50 faces of yourself..."
Letter: George Maciunas to Ben Vautier, August 7, 1966.

FLUXFURNITURE...MODULAR CABINETS, 15" cubes, walnut sides and back, locked corners, variations on doors. George Maciunas: 49 mirrors set in concave door, multiplying any image 49 times, $100.00... Available in N.Y.C. at Multiples and late in 1967 at FLUXSHOP, 18 GREENE ST.
Fluxfurniture, pricelist. [1967].

PROPOSED FLUXSHOW FOR GALLERY 669 ... TOILET OBJECTS...convex - 49 facet mirror (reflects face 49 times) by George Maciunas...
Fluxnewsletter, December 2, 1968.

PROPOSED FLUXSHOW ... TOILET OBJECTS ... mirrors:...convex - 49 facet mirror reflecting face 49 times - by George Maciunas.
Fluxnewsletter, December 2, 1968 (revised March 15, 1969).

FLUX-PRODUCTS 1961 TO 1969 ... GEORGE MACIUNAS...Mirrored medicine cabinet with convex - 49 facet mirror reflecting face 49 times, [$] 100...
ibid.

FLUX-PRODUCTS 1961 TO 1970 ... GEORGE MACIUNAS...49 facet mirror in wood cabinet, [$] 100...
Flux Fest Kit 2. [ca. December 1969].

TOILET OBJECTS & ENVIRONMENT...Mirrors: ... convex multi faceted by George Maciunas...
ibid.

FLUX SHOW: DICE GAME ENVIRONMENT ENTIRE FLOOR AS DICE HAZARD TABLE DIE CUBES, 15" CUBES ON FLOOR, Marked on sides,

top open or closed with clear plastic. Consisting or containing...Multi faceted mirror by George Maciunas.
ibid.

FLUXUS - EDITIONEN ... [Catalogue no.] 765 GEORGE MACIUNAS: 49 facet mirror in wood cabinet (holzkasten)
Happening & Fluxus. Koelnischer Kunstverein, 1970.

Toilet no. 4 G. Maciunas...Mirror: faceted *
Fluxnewsletter, April 1973.

SPRING 1969...MACIUNAS:...multi-faceted mirror
...
George Maciunas, Diagram of Historical Developments of Fluxus... [1973].

OBJECTS AND EXHIBITS...1969:...multi-faceted mirror...
George Maciunas Biographical Data. 1976.

COMMENTS: *Multi-Faceted Mirror is a Modular Cabinet containing a parabolic dish set with numerous mirrors. The image is a three-dimensional reflection of an image, 49 times. This work was used for exhibitions and was also intended for use in a toilet.*

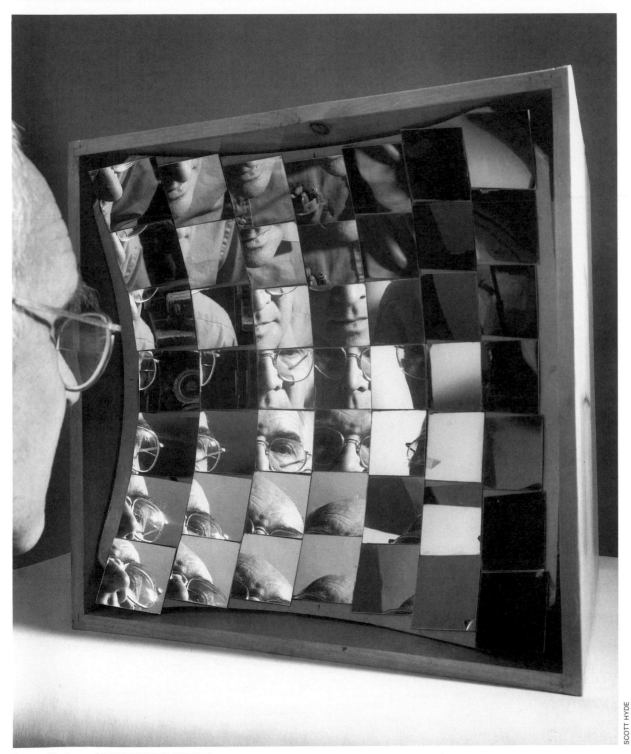

George Maciunas. MULTI-FACETED MIRROR

MULTI-SUNGLASSES see:
 8 LENS SUN GLASSES
MULTI-SYRINGE see:
 FLUXSYRINGE

MUSIC FOR EVERYMAN
Silverman No. 240

P-5 GEORGE MACIUNAS "Music for Everyman" a music score for dead and living, human, animal & inanimate composers (nov. 1961) $3.
European Mail-Orderhouse: europeanfluxshop, Pricelist.
[ca. June 1964].

[as above]
Second Pricelist - European Mail-Orderhouse. [Fall 1964].

FLUXFEST INFORMATION...Some pieces not fully described list the availability of a score...Any of the pieces can be performed anytime, anyplace and by anyone, without any payment to fluxus provided... conditions are met...Scores - 25 cents each except: Music for everyman - $5...George Maciunas MUSIC FOR EVERYMAN, 1961 (Methodology rather than a score) Various marking techniques such as animal footprints, scores of other composers, rain drops etc. may be used on a grid of two coordinates: time scale and sound categories systematized into inanimate sounds (gaseous, liquid, semiliquid, solid) and animate sounds. (about 160 categories). Schematic score.
Fluxfest Sale. [Winter 1966].

"...Enclosed is the score "music for everyman" which you could publish if you wish as a scroll, although it was intended to be on a transparency in order to be able to superimpose on other people's scores..."
Letter: George Maciunas to Ken Friedman, [ca. April 1973].

PERFORMANCE COMPOSITIONS...1962:... First musical compositions...music scored by animals...
George Maciunas Biographical Data. 1976.

COMMENTS: Music for Everyman, *one of the few Maciunas scores specifically advertised for sale by Fluxus, does not have the Fluxus copyright on the work. It is invariably printed on a blueprint negative (translucent sheet), necessary to superimpose it on another score.*

MUSICAL BARS

FLUX-OLYMPIAD...[by G. Maciunas]...DUAL ... fencing with musical bars...
Fluxfest at Stonybrook, Newsletter No. 1, August 18, 1969. versions A and B

FLUX-OLYMPIAD COMBAT-FENCING & JOUSTING MUSICAL BARS (George Maciunas)...
Flux Fest Kit 2. [ca. December 1969].

SCOTT HYDE

MUSIC FOR EVERYMAN
A music score for dead and living, human, animal & inanimate composers by George Maciunas, Nov.1961

COMPOSITIONAL METHODS (marking the grid)
A. Rational and determinate: (1) for the purpose of structure or (2) for the purpose of effect
B. Automatic and indeterminate
 1. direct automatic human marking: with hand, foot or other part of body
 2. animal marking: footmarks of quadrupeds, insects, birds etc.
 3. throwing, spraying, dripping: sand, pebbles, scraps, ink, paint & other solids or liquids
 4. superimposing: over any past or present score, printed matter, drawing etc.
 5. number-letter sequences determined by dice, cards, rulette, telephone books, math.tables etc.

PERFORMANCE:
1. any categories can be used in any desired combinations.
2. duration of each vertical grid may be predetermined in uniform, progressive or irregular pattern
3. number of performers depends on number of categories used and number of categories each performer can perform
4. to produce required actions such as striking, scratching, sawing, braking etc. any implements can be employed such as hammers, axes, saws, sledge hammers, pick axes, sticks, knives, etc.
5. dynamics are determined by size of mark, duration by the length of mark.
6. where pitched sound is called, the pitch is up to the choice of the performer, unless marked in the grid otherwise.
7. microphones can be employed and sound amplified of any category or sequence.
8. composition can be extended to any desired length by extending the grid to be so marked.

George Maciunas. MUSIC FOR EVERYMAN

FEB. 17, 1:30PM FLUX-SPORTS DOUGLASS COL.
...WRESTLING, BOXING & JOUSTING (George Maciunas)...musical gloves...
Poster/program for Flux-Mass, Flux-Sports and Flux-Show. February 1970.

COMMENTS: Musical Gloves *were conceived to produce squeaking sounds on contact. There is no evidence that these gloves were made.*

COMMENTS: *I don't know exactly how this piece would work. Perhaps, on contact, sounds would emit from the bars. I don't believe that it was ever made.*

MUSICAL GLOVES

FLUX-OLYMPIAD COMBAT-BOXING MUSICAL GLOVES; squeaking gloves (G.M.)
Flux Fest Kit 2. [ca. December 1969].

MUSICAL INSTRUMENTS see:
AEROPHONE
DANCING AEROPHONE
FLUXORGAN
FLUXORGAN, CONSOLE
FLUXORGAN, DOOR FRONT VERSION
FLUXORGAN, PORTABLE CONSOLE
FLUXORGAN, 12 SOUNDS
FLUXORGAN, 15 SOUNDS
FLUXORGAN, 20 SOUNDS, ELECTRICAL
FLUXORGAN, 20 SOUNDS, MANUAL
FLUXORGAN, 40 SOUNDS, ELECTRICAL
FLUXORGAN, 50 SOUNDS, MANUAL
MUSICAL BARS
MUSICAL GLOVES
12 BIRD AEROPHONE

MYSTERIOUS ANIMAL see:
MYSTERY FLUX ANIMAL

MYSTERY FLUX ANIMAL
Silverman No. 255

FLUXKIT containing following fluxus-publications: (also available separately)...FLUXUS ziz MYSTERIOUS ANIMAL, in bottle $1
Vacuum TRapEzoid (Fluxus Newspaper No. 5) March 1965.

... items are in stock, delivery within 2 weeks ... FLUXUS ziz MYSTERY ANIMAL, in bottle $1
Vaseline sTREet (Fluxus Newspaper No. 8) May 1966.

FLUX-PRODUCTS 1961 TO 1969 ... GEORGE MACIUNAS...Mystery animal, bottled in alcohol [$] 1...
Fluxnewsletter, December 2, 1968 (revised March 15, 1969).

FLUX-PRODUCTS 1961 TO 1970...[as above]
Flux Fest Kit 2. [ca. December 1969].

COMMENTS: Mystery Flux Animal *is a piece of sinew or twisted leather, bottled in liquid with a label. This work evolves into* Fluxmouse.

MYSTERY MEDICINE

FLUXUS 1964 EDITIONS, AVAILABLE NOW... FLUXUS xx MYSTERY MEDICINE $1
cc Valise e TRanglE (Fluxus Newspaper No. 3) March 1964.

xx MYSTERY MEDICINE $1
European Mail-Orderhouse: europeanfluxshop, Pricelist. [ca. June 1964].

[as above]
Second Pricelist - European Mail-Orderhouse. [Fall 1964].

COMMENTS: *I have never seen the work itself, however, a photograph by Maciunas of medicines in small bottles exists, and a group photograph in Fluxus Newspaper No. 3 seems to indicate that it was made. Shigeko Kubota's* Flux Medicine *grows out of this work.*

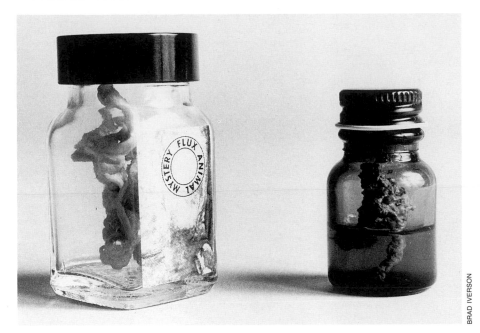

George Maciunas. MYSTERY FLUX ANIMAL. see color portfolio

George Maciunas. MYSTERY MEDICINE. Photographed ca. 1964

NAME KIT BOX see:
YOUR NAME SPELLED WITH OBJECTS

NAPOLEON'S FRONT APRON

''...You could do the following yet:...Collective projects— Apron design. - on paper disposable apron. That's a project we may make some money, by selling it to large beer company, to be used as premium. Got already some designs: all these are full size to match wearer of apron. — Engraving of Napoleon's front, full size, so when apron is on, person seems to have Napoleon front....''
Letter: George Maciunas to Ken Friedman, [ca. February 1967].

FLUX-PROJECTS PLANNED FOR 1967:...George Maciunas:...paper aprons: fronts of...emperors...
Fluxnewsletter, March 8, 1967.

FLUXPROJECTS FOR 1969...Vinyl aprons:...MACIUNAS —...Napoleon III[sic]...
Fluxnewsletter, December 2, 1968.

OFFERTORY...1st turn: Napoleon's front.
Outline of Flux-Mass. [February 17, 1970].

...could be produced cheaper in Italy:...vinyl fabric aprons with various fronts (...Napoleon...)
Letter: George Maciunas to Daniela Palazzoli, n.d. Reproduced in Fluxnewsletter, April 1973.

OBJECTS AND EXHIBITS...1967:...photo aprons (...Napoleon, etc.)...
George Maciunas Biographical Data. 1976.

COMMENTS: Part of the series of aprons planned by Maciunas and Robert Watts, only preliminary material exists for the production of this apron. Many of the ideas were for a commercial venture called Implosions, which was never terribly successful.

NEW FLUX YEAR
Silverman No. 243, ff.

COMMENTS: A trick box, joke box, early examples contained pop out snakes and numerous confetti with the words, "New Flux Year" printed on them. Related to Flux Snow Game, once the box was opened, you would have a mess on the floor.

NEW FLUX YEAR see:
CONFETTI INVITATIONS

NO
Silverman No. < 258.X

FLUX-PRODUCTS 1961 TO 1970 ... GEORGE MACIUNAS...Flags: 28'' square, sewn legends: ... no... ea: [$] 60...
Flux Fest Kit 2. [ca. December 1969].

COMMENTS: A flag made by Maciunas in the late sixties or

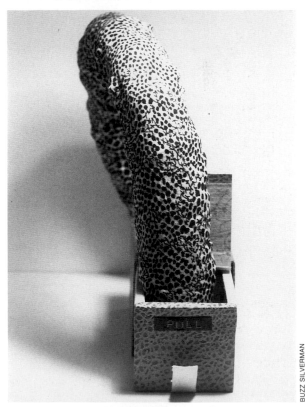

George Maciunas. NEW FLUX YEAR

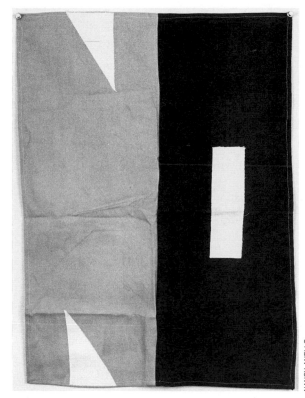

George Maciunas. NO

NANCY ANELLO

early seventies, two examples are known to exist and perhaps others were made. Maciunas made another flag, Yes, which might or might not have been a companion flag to No.

NOODLE EGGS

NEW YEAR EVE'S FLUX-FEAST. DEC. 31. 1969 AT CINEMATHEQUE, 80 WOOSTER ST. ... George Maciunas (with Barbara Moore): eggs containing ... noodles...
Fluxnewsletter, January 8, 1970.

NEW YEARS EVE'S FLUX-FEST, DEC. 31, 1969... egg shells stuffed with...noodles...
all photographs copyright nineteen seVenty by peTer mooRE (Fluxus Newspaper No. 9) 1970.

31.12.1969 NEW YEAR EVE'S FLUX - FEAST (FOOD EVENT)...G. Maciunas: inside eggs:...noodles...
George Maciunas, Diagram of Historical Developments of Fluxus... [1973].

OBJECTS AND EXHIBITS...1969:...noodles...
George Maciunas Biographical Data. 1976.

COMMENTS: Noodle Eggs, *blown eggs filled with noodles,*

were prepared with Barbara Moore for a New Year's Eve Flux Fest Food Event. An earlier Maciunas work, Spaghetti Eggs, *is obviously related to* Noodle Eggs.

NUDE BACK APRON

''...You could do the following yet:...
Collective projects...
 Apron design. - on paper disposable apron. That's a project we may make some money, by selling it to large beer company, to be used as premium. Got already some designs:...

George Maciunas. NUDE BACK APRON prototype. Photographed on Pamela Kraft. ca. 1967

PHOTOGRAPHER NOT IDENTIFIED

Back of person - nude, - photo...
all these are full size to match the wearer of apron.''
Letter: George Maciunas to Ken Friedman, [ca. February 1967].

FLUX-PROJECTS PLANNED FOR 1967...George Maciunas:...paper aprons:...nude back...
Fluxnewsletter, March 8, 1967.

...BREAKING OF THE BREAD... Priest's 5th turn: nude back front
Outline of Flux-Mass. [February 17, 1970].

COMMENTS: Preliminary work was done for the Nude Back Apron *project. Conceived as a paper apron, a cheap disposable work of the sort that later were used for* Implosions *projects. Eventually the idea became a costume for the Flux-Mass in 1970.*

NUDE BODY FUR COAT see:
 FLUX STATIONERY: TORSO IN FUR COAT

OBJECT WRAPPED IN ROPE
Silverman No. < 270, ff.

COMMENTS: Object Wrapped in Rope *was never advertised for sale by Fluxus, and there is apparently no reference to the works in any of the other Fluxus newsletters or newspapers, or in correspondence of Maciunas that we have found. First done in the late 1960s, there is a curious affinity between the sculpture that Eva Hesse was doing around this time, and these pieces. In three of the works - a ball, a bottle, and a glass - the original shape of the wrapped object is retained. One of the works is rope wrapped within itself, an idea not dissimilar to Per Kirkeby's ''boxed solids'' series. Maciunas might be making his own interpretation of ideas explored by Genpei Akasegawa and Christo - that is, of tying objects - but, in this instance, the Maciunas works are completely tied, and the rope becomes the subject.*

OBSTACLE STEPS

''...the final plan of the labyrinth...to step down one would step into three descending boxes, first filled by crumpled newspapers to the total height of 50 cm, next with styrofoam balls or just plain crushed styrofoam to the height of about 17 cm''
Letter: George Maciunas to Rene Block, [ca. Summer 1976].

compartment steps made up of 3 boxes filled with crumpled paper, styrofoam balls, tennis balls
Instruction drawing for Fluxlabyrinth, Berlin. [ca. August 1976]. version A

''...Empty Steps...I held on this until your arrival to determine volumes and expense of filling materials. wood on hand.''
Notes: Larry Miller to George Maciunas concerning the Fluxlabyrinth, Berlin. [ca. August 1976].

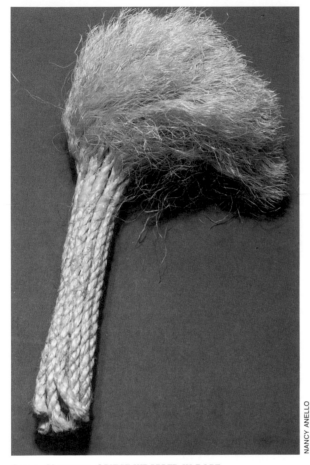

George Maciunas. OBJECT WRAPPED IN ROPE

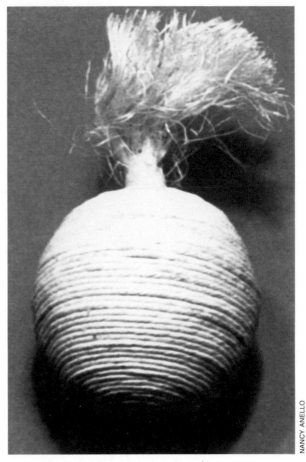

George Maciunas. OBJECT WRAPPED IN ROPE

steps made up of 3 boxes filled with crumpled paper, styrofoam balls, tennis balls
Plan of completed Fluxlabyrinth, Berlin. [ca. September 1976].

COMMENTS: Obstacle Steps *were planned as components of the* Fluxlabyrinth, *the idea being to make descent or ascent extremely difficult.* Obstacle Steps *were not included in the final construction of the* Fluxlabyrinth *in Berlin in 1976, although a related work,* Foam Steps, *was built.*

1000 FRAMES

FLUXFILMS...FLUXFILM 8 1000 FRAMES, 40sec. $6
Vaseline sTREet (Fluxus Newspaper No. 8) May 1966.

03.1965...FLUXFILMS:...MACIUNAS...1000 FRAMES, etc.
George Maciunas, Diagram of Historical Developments of Fluxus... [1973].

COMMENTS: *This film is not included in the* Fluxfilms *package. It was given a Fluxfilm number, and offered for sale as an individual work. It's hard to imagine 1000 frames of film being projected in 40 seconds, so some trick or double meaning must have been intended.*

ONE WAY TICKET TO SIBERIA

APR. 18-24: TICKETS BY JOHN LENNON + FLUX-TOURS Selling to the public various tickets:...funny 7 distant places $1 to $300 [for Siberia])...
Schedule of events for Fluxfest presentation of John Lennon and Yoko Ono. [ca. April 1970]. version B

FLUXFEST PRESENTATION OF JOHN LENNON & YOKO ONO +* AT 80 WOOSTER ST. NEW YORK —1970...APR. 18-24: TICKETS BY JOHN LENNON + FLUXTOURS...one way ticket to Siberia (George Maciunas) $200...
all photographs copyright nineteen seVenty by peTer mooRE (Fluxus Newspaper No.9) 1970.

COMMENTS: *This work would have been a ready-made, not intended for purchase but as a political comment by Maciunas.*

ONE WAY TRIP TO GINGER ISLAND TICKET

FLUXFEST PRESENTATION OF JOHN LENNON & YOKO ONO +* AT 80 WOOSTER ST. NEW YORK —1970...APR. 18-24: TICKETS BY JOHN LENNON + FLUXTOURS...one way trip to Ginger Island (G. M.) $80 become stranded, no way out
all photographs copyright nineteen seVenty by peTer mooRE (Fluxus Newspaper No.9) 1970.

COMMENTS: One Way Trip to Ginger Island Ticket *was a ready-made. The approximate cost of going to Ginger Island was $80. The idea behind the ticket was the experience that Maciunas and a group of Fluxus artists had when they planned to purchase Ginger Island in the Caribbean, and make it into a Fluxus Island. The group was dropped off at the island, became stranded without communications or water, and after sleeping naked under a tree oozing with poisonous sap, everyone became ill. The situation became acute. The island was not purchased. This is just one of many schemes that Maciunas had, some of which became a reality, like the Fluxhouses, and others, such as the "Around the World Trip in a Converted Minesweeper," did not.*

ONE YEAR

"...Now I will list some new items produced: all in 1972...One Year, by myself (all the containers of all the food I ate in a year, glued into a wall panel, about 7 foot high and 10 ft. wide, would be difficult to ship, expensive: $400..."
Letter: George Maciunas to Dr. Hanns Sohm, [ca. late 1972].

"...for the Rome exhibit I could send...my One Year, which is a large panel or wall of empty containers stuck together of all the food I ate within the year."
Letter: George Maciunas to Giancarlo Politi, n.d. Reproduced in Fluxnewsletter, April 1973.

"...you could arrange a worthwhile flux-fest...[in-

George Maciunas. **Instruction drawing for ONE YEAR**

cluding a] 'flux-history' room with exhibit or all original prototypes of objects produced, interesting documents, etc. like my chart like calendar, or I made now a wall of all containers of all food I ate in a year, 2 meters x 2 meters."
Letter: George Maciunas to Daniela Palazzoli, n.d. Reproduced in Fluxnewsletter, April 1973.

FLUXPRODUCTS PRODUCED IN 1972 & 1973 ... by George Maciunas:...One Year, containers of all food eaten by Maciunas, epoxy glued into wall panel, about 7 x 10ft. each year different, year: $400
Fluxnewsletter, April 1973.

by George Maciunas:...One Year, containers of all food eaten by Maciunas, epoxy-glued into a wall panel, about 7 x 10ft. each year different, each: $400...
Fluxnewsletter, April 1975.

GEORGE MACIUNAS...One Year, 7' x 7' panel of empty food containers, '73 $400...
Flux Objects, Price List. May 1976.

COMMENTS: *One Year, is the accumulation of containers of food eaten by the artist in the course of an entire year. The containers were attached to one another and stacked in piles as a direct, concrete work, showing food consumption for that year. An illustration of* One Year *appears in the book,* 1962 Wiesbaden Fluxus 1982.

ONO MASK see:
 YOKO ONO MASK
ORGAN see:
 BIRD ORGAN & OTHER BULB ACTIVATED
 TRICKS DOOR
 FLUXORGAN
 FLUXORGAN, CONSOLE
 FLUXORGAN, DOOR FRONT VERSION
 FLUXORGAN, PORTABLE CONSOLE
 FLUXORGAN, 12 SOUNDS
 FLUXORGAN, 15 SOUNDS
 FLUXORGAN, 20 SOUNDS, ELECTRICAL
 FLUXORGAN, 20 SOUNDS, MANUAL
 FLUXORGAN, 40 SOUNDS, ELECTRICAL
 FLUXORGAN, 50 SOUNDS, MANUAL
OSMOSIS see:
 KINETICS NOS. 1 TO 3
OSMOTIC PAINTING see:
 HYDROKINETIC-OSMOTIC PAINTING

OUTDATED 19TH CENTURY TRAIN TICKETS

APR. 18-24: TICKETS BY JOHN LENNON + FLUX-TOURS...Outdated tickets, 19century train tickets. (10c) by G. Maciunas
Schedule of events for Fluxfest presentation of John Lennon and Yoko Ono. [ca. April 1970]. version A

APR. 18-24: TICKETS BY JOHN LENNON + FLUX-TOURS...outdated tickets (10c) (G.M.)...
Schedule of events for Fluxfest presentation of John Lennon and Yoko Ono. [ca. April 1970]. version B

APR. 18-24: TICKETS BY JOHN LENNON + FLUX AGENTS...Outdated tickets (G. Maciunas)
Schedule of events for Fluxfest presentation of John Lennon and Yoko Ono. April 1, 1970. version C

COMMENTS: *These facsimiles of original 19th century tickets were never printed by Fluxus.*

OVERSIZED RACKET see:
 LONG HANDLE RACKET

PAINT EGGS

PROPOSED FLUX DRINKS & FOODS FLUX EGGS Emptied egg shells filled with...white paint...
Fluxfest at Stony Brook, Newsletter No. 1, August 18, 1969. versions A and B

FLUX DRINKS & FOODS FLUX EGGS emptied egg shells filled with...white paint...(G. Maciunas)...
Invitation to Participate in New Year Eve's Flux-Feast. [ca. December 1969].

FLUX FOODS AND DRINKS FLUX EGGS: Emptied egg shells filled with...white paint...(George Maciunas)
Flux Fest Kit 2. [ca. December 1969].

APR. 11-17: DO IT YOURSELF, BY JOHN & YOKO + EVERYBODY...Add colour painting [Yoko Ono], (eggs filled with ink or paint, to be thrown against a wall)...
Schedule of events for Fluxfest presentation of John Lennon and Yoko Ono. [ca. April 1970]. version A

APR. 11-17: DO IT YOURSELF. BY JOHN & YOKO + EVERYBODY...Flux-eggs (G.M.) eggs filled with paint & to be thrown against the wall.
Schedule of events for Fluxfest presentation of John Lennon and Yoko Ono. [ca. April 1970]. version B

FLUXFEST PRESENTATION OF JOHN LENNON & YOKO ONO+*AT 80 WOOSTER ST. NEW YORK -1970...APR. 11-17: DO IT YOURSELF BY JOHN & YOKO + EVERYBODY...Flux-egg (George Maciunas '70) egg filled with paint & thrown against the wall
all photographs copyright nineteen seVenty by peTer mooRE (Fluxus Newspaper No. 9) 1970.

COMMENTS: *Paint Eggs were first conceived as part of the Flux eggs idea, based on Barbara Moore's* Jello Eggs. *Empty egg shells filled with white paint and sealed, when the eggs were opened, paint would spill out. There were a number of prepared eggs of this sort. The idea was adapted as a response to Yoko Ono's* Add Colour Painting, *an early work that was*

redone for the Flux Fest Presentation of John Lennon and Yoko Ono. In this instance, Maciunas filled eggs with ink or paint to be thrown against the wall, making the Add Colour Painting. See also, Ink Eggs.

PAPER APRONS

IMPLOSIONS INC. PROJECTS...Triple partnership was formed between Bob Watts, Herman Fine and myself [George Maciunas] to introduce into mass market ...money producing products...This business will be operated in commercial manner, with intent to make profits...connection between Fluxus collective and Implosions Inc. has not been clarified yet...we could consider at present Fluxus to be a kind of division or subsidiary of Implosions. Projects to be realized through Implosions:...Paper aprons (made from special woven paper). Used for outdoor cooking, these apron designs will be offered to various beer and food manufacturers as premiums etc. Any photographic or line image can be printed on this paper...
Fluxnewsletter, March 8, 1967.

NEWS FROM IMPLOSIONS, INC....Planned in 1968: ...Paper aprons (described in 1967 flux-newsletter) 12 designs ready for production...
Fluxnewsletter, January 31, 1968.

COMMENTS: *A general entry for an idea that started first as a Flux project and then was shifted to Implosions, Inc., described as "a commercial arm" of Fluxus. See the individual listings for aprons by George Maciunas and Robert Watts.*

PAPER EVENTS see:
 FLUX PAPER EVENTS
PAPER GLIDER PROGRAMS see:
 GLIDER PROGRAMS

PAPER NOISE MACHINE

PROPOSED FLUXSHOW FOR GALLERY 669 ... SOUND MACHINES...Paper noise machine
Fluxnewsletter, December 2, 1968.

PROPOSED FLUXSHOW...SOUND ENVIRONMENT ...paper noise machine - by George Maciunas...
Fluxnewsletter, December 2, 1968 (revised March 15, 1969).

COMMENTS: *This work was never made.*

PAPER SOUND LOOP

FILM AND SOUND ENVIRONMENT A booth must be set up in a fairly dark area, the walls of which are of white vinyl or cotton sheets (about 12' wide x 8' high) hanging as curtains, creating thus a 12' x 12' or smaller room. Four 8mm wide angle lense loop pro-

jectors must be set up in front of each wall on the outside, projecting an image the frame of which is to cover entire wall. Spectators may enter the booth through corners...Paper sound loop with paper punched tape projected loop by G. Maciunas...
Flux Fest Kit 2. [ca. December 1969].

COMMENTS: *The sound of paper going through the projector would create the sound.*

PAPER TEA

FLUX DRINKS & FOODS...TEA VARIATIONS ... tea made from boiling:...paper...(G. Maciunas)...
Invitation to Participate in New Year Eve's Flux-Feast. [ca. December 1969].

FLUX FOODS AND DRINKS...TEA VARIATIONS: ...Tea made from boiling:...paper...(George Maciunas)
Flux Fest Kit 2. [ca. December 1969].

COMMENTS: *A tea variation,* Paper Tea *would have been made by boiling paper (rice paper?). Some food variations contain obvious references to the hardships that Maciunas experienced as a boy in war-torn Europe.*

PAPER TOWELS see:
TREATED PAPER TOWELS

PERHAM'S OPERA HOUSE TICKET
Silverman No. < 262.III

FLUXFEST PRESENTATION OF JOHN LENNON & YOKO ONO+* AT 80 WOOSTER ST. NEW YORK - 1970...APR. 18-24: TICKETS BY JOHN LENNON + FLUXTOURS...ticket to Perham's Opera House (G. Maciunas) building no longer there...
all photographs copyright nineteen seVenty by peTer mooRE (Fluxus Newspaper No. 9) 1970.

COMMENTS: *Facsimile of an antique ticket to* Perham's Opera House, *one of a number of fake tickets prepared for the Flux Fest.*

George Maciunas. PERHAM'S OPERA HOUSE TICKET

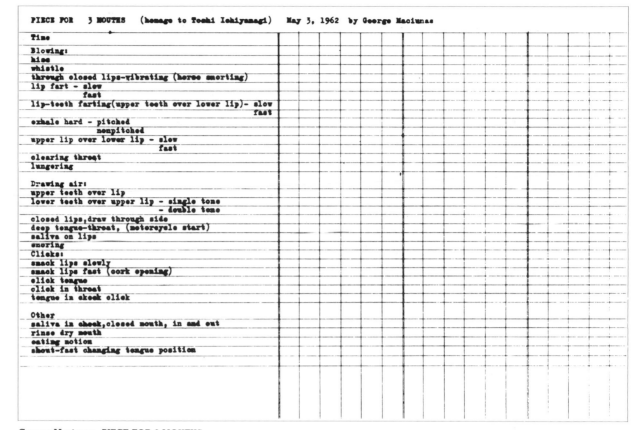

George Maciunas. PIECE FOR 3 MOUTHS

PERISCOPE TOILET BOWL

Toilet no. 4 G. Maciunas...Toilet bowl display - Mirrors in periscope fashion to show action, must have elec. illumination in bowl.
Fluxnewsletter, April 1973.

1970-71 ... FLUX-TOILET ... MACIUNAS: ...toilet bowl periscope...
George Maciunas, Diagram of Historical Developments of Fluxus... [1973].

A toilet is inSTALLed in which the TOILET is a high platform with a hole cut out in a stall, in which the door doesn't open. USERS may view their own activity through a periscope provided on the platform.G.M.
Fluxfest at and/or, Seattle. September 1977.

COMMENTS: Periscope Toilet Bowl *is a convenient way to look at yourself shitting. Interest in bowel movements was explored by at least two other artists early in the 1960s. Guenter Brus was filmed shitting by Kurt Kren, and Robert Whitman made a rear screen projected box of shitting.*

PIECE FOR 3 MOUTHS
Silverman No. 240.18

PERFORMANCE COMPOSITIONS ... 1962:...First musical compositions...music for lips...
George Maciunas Biographical Data. 1976.

COMMENTS: *A score from 1962,* Piece for Three Mouths *is printed in the blueprint method and does not have a Fluxus copyright on it. This and other scores by Maciunas were distributed as a part of the early Fluxus publishing of artists' scores.*

PIN BALL MACHINE

"...you could arrange a worthwhile flux-fest...We would need the following from local sources...money or labor and materials for special constructions such as...pin-ball machine..."
Letter: George Maciunas to Daniela Palazzoli, n.d. Reproduced in Fluxnewsletter, April 1973.

This Fall, we shall publish V TRE no. 10, which shall consist of a plan for Flux-Amusement-Center, to con-

tain:...coin operated machines (pin-ball...)
Fluxnewsletter, April 1973.

FLUX AMUSEMENT ARCADE...pin-ball game (Maciunas)...
Preliminary Proposal for a Flux Exhibit at Rene Block Gallery. [ca. 1974].

COMMENTS: *There are no descriptions of how* Pin Ball Machine *worked, and what alteration was planned to be done to make it particular to Fluxus. It is unlikely that Maciunas would have used a normal pin ball machine without altering it in some way.*

PINE CONE TEA

NEW YEAR EVE'S FLUX-FEAST, DEC. 31, 1969 AT CINEMATHEQUE, 80 WOOSTER ST. ...George Maciunas:...pine cone tea...
Fluxnewsletter, January 8, 1970.

NEW YEARS EVE'S FLUX-FEST, DEC. 31, 1969...
pine cone teas by George Maciunas
all photographs copyright nineteen seVenty by peTer mooRE (Fluxus Newspaper No. 9) 1970.

NEW YEARS EVE'S FLUX-FEST, DEC. 31, 1969...
George Maciunas serving his pine cone tea
ibid.

31.12.1969 NEW YEAR EVE'S FLUX-FEAST (FOOD EVENT)...G. Maciunas:...pine cone tea.
George Maciunas, Diagram of Historical Developments of Fluxus... [1973].

OBJECTS AND EXHIBITS...1969:...tea from...pine cones etc....
George Maciunas Biographical Data. 1976.

PERFORMANCE COMPOSITIONS...1969: 2nd flux-food event (funny foods) contributed...cone...tea...
ibid.

COMMENTS: Pine Cone Tea *is one of Maciunas' tea variations, all of which have a certain relationship to Per Kirkeby's* 4 Flux Drinks. *This one in particular also has conceptual similarities to the forest version of John Chick's* Flux Foods *which contained pine cones, etc. Many of Maciunas' teas were made, but it is not possible to determine which ones people tried.*

PING-PONG RACKETS

This Fall, we shall publish V TRE no. 10, which shall consist of a plan for Flux-Amusement-Center, to contain...Athletics, games, vehicles, rides:(...ping-pong variations...)
Fluxnewsletter, April 1973.

PROPOSED FLUXANNIVERSARY PROGRAM 1962-1972...FLUXOLYMPIAD (counterpoint to

Munich one)...prepared racket ping-pong,... by G.M.
ibid.

1970...MACIUNAS:...ping-pong rackets...
George Maciunas, Diagram of Historical Developments of Fluxus... [1973].

1970 FLUXSPORTS ... by g. maciunas: ... prepared ping-pong rackets
ibid.

FLUX GAME ROOM...prepared ping-pong (Maciunas)
Preliminary Proposal for a Flux Exhibit at Rene Block Gallery, [ca. 1974].

Ping-pong rackets by Maciunas $60 (for 4 rackets, $15 each)...
[Fluxus price list for a customer]. January 7, 1976.

GEORGE MACIUNAS...Ping pong rackets, 10 alterations, each 1970 $20...
Flux Objects, Price List. May 1976.

PERFORMANCE COMPOSITIONS ... 1964:... Initiated 1st sport events at Washington Sq. Gal. own: ping-pong & badmington
George Maciunas Biographical Data. 1976.

OBJECTS AND EXHIBITS...1966:...designed first prepared ping pong and badmington rackets...
ibid.

PERFORMANCE COMPOSITIONS ... 1970:...douglass college...organized flux sport olympiad...various racket games...
ibid.

PERFORMANCE COMPOSITIONS...1973:...rackets set up at Contemporanea. Incontri Internazionali D'Arte. Rome...
ibid.

COMMENTS: *A general entry for ping-pong rackets, the specific alterations are listed under their titles according to their characteristics.*

PING-PONG RACKETS see:
FLUX SPORT EQUIPMENT

PING-PONG TABLE

"For the exhibit, I would suggest a flux-ping pong tournament...The table surface could be also prepared or covered with sound makers like bells, explosive paper charges, etc. etc.-..."
Letter: George Maciunas to David Mayor, n.d. Reproduced in Fluxshoe, 1972.

"...if you could arrange a worthwhile flux-fest...We would need the following from local sources...money

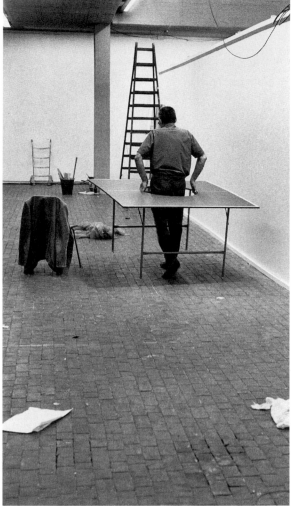

© 1976 LARRY MILLER

George Maciunas installing PING-PONG TABLE at the New York—Downtown Manhattan: Soho exhibition in Akademie der Künste—Berliner Festwochen, Berlin, 1976

or labor or materials for special constructions such as ...ping-pong table..."
Letter: George Maciunas to Daniela Palazzoli, n.d. Reproduced in Fluxnewsletter, April 1973.

PERFORMANCE COMPOSITIONS ... 1973: Ping-pong table...set up at Contemporanea. Incontri Internazionali D'Arte. Rome...
George Maciunas Biographical Data. 1976.

COMMENTS: *Several* Ping-Pong Tables *have been made over the years, the one illustrated was for a Fluxus exhibit in Berlin in 1976. The tables were altered in a variety of ways: cut in two and put on slants with holes in the middle etc. They were to be used with altered ping-pong rackets.*

PLASTER EGGS

PROPOSED FLUXSHOW FOR GALLERY 669 ...
FOOD CENTER: ... Empty egg shells: filled with ...
plaster...
Fluxnewsletter, December 2, 1968.

PROPOSED FLUXSHOW... [as above]
Fluxnewsletter, December 2, 1968 (revised March 15, 1969).

PROPOSED FLUX DRINKS & FOODS FLUX EGGS
emptied egg shells filled with...plaster...
*Fluxfest at Stony Brook, Newsletter No. 1, August 18, 1969.
versions A and B*

FLUX DRINKS & FOODS FLUX EGGS emptied
egg shells filled with...plaster...(G. Maciunas)...
*Invitation to Participate in New Year Eve's Flux-Feast. [ca.
December 1969].*

FLUX FOODS AND DRINKS FLUX EGGS: Emp-
tied egg shells filled with...plaster...(George Maciunas)
Flux Fest Kit 2. [ca. December 1969].

COMMENTS: *Plaster Eggs were blown eggs filled with plaster
so that when the shell was cracked, the egg shape would re-
main. The work has obvious overtones of Serge Oldenbourg's
Flux Contents.*

PLAYING CARD DECK

FLUX-PROJECTS PLANNED FOR 1967 ... George
Maciunas:...Playing card deck...
Fluxnewsletter, March 8, 1967.

COMMENTS: *Playing Card Deck is evidently different from
Same Card Flux Deck. It is not possible to say what Maciunas
had in mind for this particular deck of cards.*

POPE MARTIN V APRON see:
George Maciunas and Robert Watts

POSTAGE STAMPS

FLUX-PROJECTS PLANNED FOR 1967 ... George
Maciunas: ... postage stamps (collective collabora-
tion)...
Fluxnewsletter, March 8, 1967.

IMPLOSIONS INC. PROJECTS...Triple partnership
was formed between Bob Watts, Herman Fine and my-
self [George Maciunas] to introduce into mass market
...money producing products...This business will be
operated in commercial manner, with intent to make
profits....connection between Fluxus collective and
Implosions Inc. has not been clarified yet...we could
consider at present Fluxus to be a kind of division or

subsidiary of Implosions. Projects to be realized
through Implosions:...stamps (same as Flux-postal
kit)...
ibid.

PROPOSED CONTENTS FOR FLUXPACK 3 TO BE
PUBLISHED IN 1973 BY FLASH ART...Postage
stamps...members of some church synod by Maciunas
...Cost Estimates: for 1000 copies...postage stamps [2
designs] $100...100 copies signed by:...Maciunas...
*[George Maciunas], Proposed Contents for Fluxpack 3.
[ca. 1972].*

COMMENTS: *Implosions, an aspiring commercial extension
of Fluxus, repackaged earlier Robert Watts stamps, and evi-
dently hoped to produce new ones by Maciunas and others.
It didn't happen.
Maciunas designed two sheets of postage stamps, both
called* Flux Post. *One was a sequence of* Aging Men, *the other
of* Smiles, *both distributed by Fluxus. The stamps proposed
in the newsletter were to have been a Collective collaboration,
but were never made as a Fluxus product.*

POSTAGE STAMPS see:
STAMPS
POSTCARD see:
ADHESIVE POSTCARD
POSTERS see:
SAFE DOOR
U.S.A. SURPASSES ALL THE GENOCIDE
RECORDS

PREPARED EGGS DISPENSER

FLUX AMUSEMENT ARCADE...Vending machines,
dispensers of...prepared eggs...etc. (Maciunas)
*Preliminary Proposal for a Flux Exhibit at Rene Block Gal-
lery. [ca. 1974].*

COMMENTS: *A variation of vending machine ideas and a
way to distribute prepared eggs. This work was never realized.*

PREPARED FAUCET

Toilet no. 4 G. Maciunas...Sink faucet - thick mud or
thin glue.
Fluxnewsletter, April 1973.

1970-71...FLUX-TOILET...MACIUNAS:...prepared
sink.
*George Maciunas, Diagram of Historical Developments of
Fluxus... [1973].*

COMMENTS: *Part of George Maciunas'* Flux Toilet, *Prepared
Faucet would produce thick mud or thin glue instead of wa-
ter when turned on. There is a similarity between Maciunas'*
Glue Dispenser *and* Prepared Faucet.

PREPARED HAMMER THROW HAMMER

FLUX-OLYMPIAD...[by G. Maciunas] FIELD ...
hammer throw hammer as vessel filled with fluid
(paint etc.)
*Fluxfest at Stony Brook, Newsletter No. 1, August 18, 1969.
versions A and B*

FLUX-OLYMPIAD...FIELD - THROWS...HAMMER
THROW: hammer as vessels filled with fluid (paint
etc.) (George Maciunas)...
Flux Fest Kit 2. [ca. December 1969].

COMMENTS: Prepared Hammer Throw Hammer, *when
thrown, would spew paint or whatever onto the spectators.*

PREPARED PING-PONG RACKETS see:
FLUX SPORT EQUIPMENT

PROGRAMS see:
ADHESIVE PROGRAMS

?

FLUX-PRODUCTS 1961 TO 1970 ... GEORGE MA-
CIUNAS...Flags: 28" square, sewn legends:...?...ea:
[$] 60...
Flux Fest Kit 2. [ca. December 1969].

COMMENTS: *Preparatory work for Maciunas' flag,* ?, *was
done. However, a completed flag is not known to exist. Ques-
tion marks also appear on die cube display cases that Maciu-
nas built for the Fluxus exhibition at Douglass College in
1970, and were planned earlier for the Flux Fest at Stony
Brook in 1969.*

George Maciunas. Sketch for ?

RACKETS see:
FLUX SPORT EQUIPMENT
ROMAN EMPEROR APRON see:
George Maciunas and Robert Watts
ROPE OBJECTS see:
OBJECTS WRAPPED IN ROPE

ROPE MOVIE

SLIDE & FILM FLUXSHOW ... GEORGE MACIU-
NAS: ROPE MOVIE Rope in sprocketless projector,
together with: ROBERT WATTS: ROPE RECORD...
Flux Fest Kit 2. [ca. December 1969].

COMMENTS: *An improbable work,* Rope Movie *would have
been rope projected in a sprocketless projector. There is no
evidence that this work was ever realized. The idea of rope
appears in* Object Wrapped in Rope, *and* Rope Tea.

ROPE TEA

FLUX DRINKS & FOODS...TEA VARIATIONS...
tea made from boiling:...rope (sisal, jute, manila)...
(G. Maciunas)...
*Invitation to Participate in New Year Eve's Flux-Feast. [ca.
December 1969].*

FLUX FOODS AND DRINKS...TEA VARIATIONS:
...Tea made from boiling:...rope (sisal, jute, manila),
...(George Maciunas)
Flux Fest Kit 2. [ca. December 1969].

NEW YEAR EVE'S FLUX-FEAST, DEC. 31, 1969
AT CINEMATHEQUE, 80 WOOSTER ST. George
Maciunas:...jute & manila rope...tea...
Fluxnewsletter, January 8, 1970.

NEW YEAR EVE'S FLUX-FEST, DEC. 31, 1969 ...
jute & manila rope...teas by George Maciunas
*all photographs copyright nineteen seVenty by peTer mooRE
(Fluxus Newspaper No. 9) 1970.*

31.12.1969 NEW YEAR EVE'S FLUX-FEAST
(FOOD EVENT)...G. Maciunas:...jute...tea.
*George Maciunas, Diagram of Historical Developments of
Fluxus... [1973].*

OBJECTS AND EXHIBITS ... 1969: ... tea from
ropes...
George Maciunas Biographical Data. 1976.

PERFORMANCE COMPOSITIONS...1969: 2nd flux-
food event (funny foods) contributed...rope...tea...
ibid.

COMMENTS: Rope Tea *is another of Maciunas' tea varia-
tions, prepared either with sisal or jute rope, and offered as a
drink for the New Years Eve's Flux Fest Food Event. This
tea was made.*

George Maciunas. ROPE TEA

©1970 LARRY MILLER

RUBBER BALLOON JAVELIN see:
BALLOON JAVELIN
RUBBER BALLOON RACKET see:
BALLOON RACKET

RUBBER BRIDGE

Any proposals from participants should fit the maze
format...Ideas should relate to passage through doors,
steps, floor, obstacles, booths...rubber bridge...
*George Maciunas, Further Proposal for Flux-Maze at Rene
Block Gallery. [ca. Fall 1974].*

"Enclosed is the final plan of labyrinth...next, one
enters on a rubber bridge, which could be either from

heavy rubber sheet held like suspended bridge or from
perimeter by being wrapped around wood frame or a
trampoline type canvas held around perimeter by
springs as shown on drawing. this bridge should be at
50cm. height...."
Letter: George Maciunas to Rene Block, [ca. Summer 1976].

Rubber Bridge: needed: Rubber This too, I held to
wait for your consultation. There is a firm we visited
that has a variety of sheet and tube rubbers as well as
a collection of Canal Street type rubber products. I
suggest this method instead of springs. It would be
easy...For a significant experience, I suggest above
dimensions. Rubber firm suggested approx. 1cm thick-
ness, but they have many choices. Above dimensions
equal about 130 MARKS (60-70 $)
*Notes: Larry Miller to George Maciunas concerning the Flux-
labyrinth, Berlin. [ca. August 1976].*

rubber bridge or trampoline type bridge (canvas held
by springs at perimeter)
*Plan of completed Fluxlabyrinth, Berlin. [ca. September
1976].*

COMMENTS: Rubber Bridge *was first proposed as an element
of the Collective* Flux-Maze *at the Rene Block Gallery in
1974. Its idea was trampoline-like. A see-saw with certain
similar principles was made for the* Fluxlabyrinth *in Berlin in
1976.*

RUBBERBAND RACKET see:
ELASTIC RACKET

RUM DUMPLINGS

FLUX FOODS AND DRINKS ...DUMPLING VARI-
ATIONS: One of the fillings:...rum, etc. (G.M.)
Flux Fest Kit 2. [ca. December 1969].

COMMENTS: *This was a favorite New Year's Eve item.*

SAFE DOOR
Silverman No. 267

PROPOSED CONTENTS FOR FLUXPACK 3 TO BE
PUBLISHED IN 1973 BY FLASH ART...Posters
24 x 34...safe door by Maciunas...Cost Estimates:
for 1000 copies...posters [5 designs], games $700...
100 copies signed by:...Maciunas...
*[George Maciunas], Proposed Contents for Fluxpack 3.
[ca. 1972].*

"...to produce the Flash Art FLUXPACK 3...con-
tents at present will be as follows:...Posters, wallpa-
per:...safe (vault) door by Maciunas..."
*Letter: George Maciunas to Giancarlo Politi, n.d. Reproduced
in Fluxnewsletter, April 1973.*

George Maciunas. SAFE DOOR

Flash Art editor, Giancarlo Politi, proposed to publish the 3rd Fluxyearbook, maybe to be called FLUX-PACK 3, with the following preliminary contents:... posters, signs or wallpaper (...safe door by G.Maciunas...)
Fluxnewsletter, April 1973.

COMMENTS: *Safe Door is a photo-reproduction of a Mosler Safe Co. bank vault door, and is included in* Fluxpack 3. *A unique photographic version of the work, closer to actual size (Silverman No. 266), was used by Maciunas as a part of his* Flux-Combat Between G. Maciunas & Attorney General of New York 1975-76 *as a trompe d'oeil door in his apartment. See* Dummy Door.

SALT DUMPLINGS

FLUX FOODS AND DRINKS ... DUMPLING VARI-ATIONS: One of the fillings:...salt,...(G.M.)
Flux Fest Kit 2. [ca. December 1969].

COMMENTS: *This dumpling is most closely related to Per Kirkeby's* 4 Flux Drinks.

SAME CARD FLUX DECK
Silverman No. 252, ff.

"...We have now 5 card sets which we will have manufactured by real card manufacturer. [...myself] ..."
Letter: George Maciunas to Ben Vautier, January 10, 1966.

PAST FLUX-PROJECTS (realized in 1966) ... Same card flux-deck...anonymous...
Fluxnewsletter, March 8, 1967.

FLUX-PROJECTS PLANNED FOR 1967 ... George Maciunas: Same card-flux deck...
ibid.

same card deck $4...by george maciunas
Fluxshopnews. [Spring 1967].

PROPOSED FLUXOLYMPIAD...BOARD GAMES: ...card games with...duplicate cards,...
Fluxnewsletter, January 31, 1968.

[as above]
Fluxnewsletter, December 2, 1968.

FLUX-PRODUCTS 1961 TO 1969 ... GEORGE MA-CIUNAS...Same card deck, deck of 52 same cards, * [indicated as part of FLUX KIT] [$] 4...
Fluxnewsletter, December 2, 1968 (revised March 15, 1969).

...1969-70 Flux-productions, which consist of the following: 1969-...George Maciunas same card deck,...
Fluxnewsletter, January 8, 1970.

FLUX-PRODUCTS 1961 TO 1970 ... GEORGE MA-CIUNAS...Same card deck, [$] 4...
Flux Fest Kit 2. [ca. December 1969].

FLUXUS - EDITIONEN ... [Catalogue No.] 768 GEORGE MACIUNAS: same card deck
Happening & Fluxus. Koelnischer Kunstverein, 1970.

GEORGE MACIUNAS...Same card deck $8...
Flux Objects , Price List. May 1976.

CARD GAME is played with cards that are all the same. G.M.
Fluxfest 77 at and/or, Seattle. September 1977.

COMMENTS: *A simple gag,* Same Card Flux Deck *is a Fluxus packaged deck of commercially produced cards containing 52 identical cards - in a way, a response to Ben Vautier's* Flux Missing Card Deck *where one card in the deck was missing.*

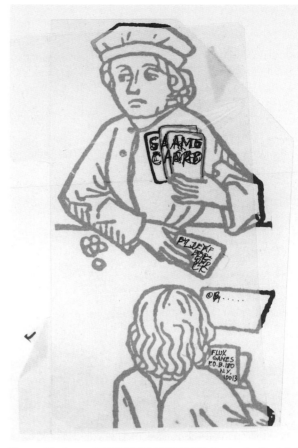

SCOTT HYDE

George Maciunas. SAME CARD FLUX DECK. Design for the label when credited to Jeff Berner

ERIC SILVERMAN

George Maciunas. SAME CARD FLUX DECK

An unused mechanical for a label for Same Card Flux Deck *(see illustration) implies that the work is by Jeff Berner. Very mysterious. On the back of that mechanical, Jeff Berner wrote "Yes" and made a "c" with a circle around it, "1966," and his name: "Jeff Berner," seeming to indicate that he approved the design for the deck of cards.*

SAND CLOCK CHESS see:
TIME CHESS, SAND TIMER PIECES
SANDWICHES see:
FOOD
SCAR STICK-ONS see:
George Maciunas and Ben Vautier
SCORES see:
DUET FOR C ON BASS SORDUNE, VOICE AND
AN OLD SCORE
DUET FOR FULL BOTTLE AND WINE GLASS
HOMAGE TO DICK HIGGINS
HOMAGE TO JACKSON MAC LOW
HOMAGE TO LA MONTE YOUNG
HOMAGE TO PHILIP CORNER
HOMAGE TO RICHARD MAXFIELD
HOMAGE TO WALTER DE MARIA
IN MEMORIAM TO ADRIANO OLIVETTI
IN MEMORIAM TO ADRIANO OLIVETTI, RE-
VISED
MUSIC FOR EVERYMAN
PIECE FOR 3 MOUTHS
SOLO FOR BALLOONS
SOLO FOR IMPORTANT MAN
SOLO FOR RICH MAN
SOLO FOR SICK MAN
SOLO FOR VIOLIN
TRIO FOR BASS SORDUNE (C NOTE), VOICE,
OLD SCORE AND ETUIS, (REVISED)
TRIO FOR LADDER, MUD AND PEBBLES
12 PIANO COMPOSITIONS FOR NAM JUNE
PAIK

SEE SAW

Any proposals from participants should fit the maze format...Ideas should relate to passage through doors, steps, floor, obstacles, booths...see saw...
George Maciunas, Further Proposal for Flux-Maze at Rene Block Gallery. [ca. Fall 1974].

see saw pivot 2' high
Instruction drawing for Fluxlabyrinth, Berlin. [ca. August 1976] version A

"Enclosed is the final plan of labyrinth...at the top of it foam step or about 50cm height one steps at the raised part of a see-saw To prevent a sudden fall, the see-saw should be kept in that position with a counterweight or heavy automobile type spring. as one slow-

© 1976 LARRY MILLER

George Maciunas. SEE SAW. Installed in FLUXLABYRINTH. Berlin. 1976

ly walks forward, the see-saw will tip the other way bringing the walker back to floor level."
Letter: George Maciunas to Rene Block, [ca. Summer 1976].

See Saw needed: spring or cushion system This is nearly completed. Perhaps instead of springs, we can use foam again...
Notes: Larry Miller to George Maciunas concerning the Fluxlabyrinth, Berlin. [ca. August 1976].

see saw
Plan of completed Fluxlabyrinth, Berlin. [ca. September 1976].

COMMENTS: See Saw *is an element of the* Fluxlabyrinth, *designed for one of the passageways.*

SCOTT HYDE

SCOTT HYDE

George Maciunas. Instruction drawings for SEE SAW

SEPARATE DOORS DOOR

FLUXFEST PRESENTATION OF JOHN LENNON & YOKO ONO+*AT 80 WOOSTER ST. NEW YORK - 1970...MAY 23-29: PORTRAIT OF JOHN LENNON AS A YOUNG CLOUD BY YOKO ONO & EVERY PARTICIPANT/ A maze with 8 doors each opening in a different manner...door split in separate top and bottom halfs...
all photographs copyright nineteen seVenty by peTer mooRE (Fluxus Newspaper No. 9) 1970.

Toilet No. 4 G. Maciunas - Doors - method of opening - 2 separate doors on top of each other.
Fluxnewsletter, April 1973.

1970-71...FLUX-TOILET:...MACIUNAS:...½ door...
George Maciunas, Diagram of Historical Developments of Fluxus... [1973].

COMMENTS: Separate Doors Door *was intended for* Flux Toilet, *the idea seems like the old-fashioned Dutch doors.*

SEVEN APPENDICES see:
Henry Flynt and George Maciunas

SHAVING CREAM EGGS

PROPOSED FLUX DRINKS & FOODS FLUX EGGS emptied egg shells filled with...shaving cream...
Fluxfest at Stony Brook, Newsletter No. 1, August 18, 1969. versions A and B

FLUX DRINKS & FOODS FLUX EGGS emptied egg shells filled with...shaving cream...(G. Maciunas)...
Invitation to Participate in New Year Eve's Flux-Feast. [ca. December 1969].

FLUX FOODS AND DRINKS FLUX EGGS: Emptied egg shells filled with...shaving cream...(George Maciunas)
Flux Fest Kit 2. [ca. December 1969].

COMMENTS: Shaving Cream Eggs *would have been blown eggs filled with shaving cream.*

SHIT ANTHOLOGY see:
EXCRETA FLUXORUM

SHOE STEPS

Any proposals from participants should fit the maze format...Ideas should relate to passage through doors, steps, floor, obstacles, booths...shoe steps...
George Maciunas, Further Proposal for Flux-Maze at Rene Block Gallery. [ca. Fall 1974].

"Enclosed is the final plan of labyrinth...next, one proceeds upward again by way of shoe steps. These will need some explanation. Slipper like shoe rests should be made from leather or canvas uppers nailed to wood or plywood soles, big enough to allow another shoe slip in and out easily. these slippers should be mounted on wood posts continuously rising to 50cm height at the end of the run. They should be placed in various contorted positions, toes sloping down or up, sideways, so as to make the "walk" awkward and difficult but not impossible. There should be something like either water. or upward facing nails or some other dangerous material on the ground below to prevent the walker from just walking on the ground..."
Letter: George Maciunas to Rene Block, [ca. Summer 1976].

Shoe Steps waits for you
Notes: Larry Miller to George Maciunas concerning the Fluxlabyrinth, Berlin. [ca. August 1976].

Various shoe steps: slipper type shoe rest made from leather attached to wood sole, oversized to fit largest shoe, held on top of wood post. sloping sideways - sloping upward - sloping downward at heel
Plan of completed Fluxlabyrinth, Berlin. [ca. September 1976].

COMMENTS: Shoe Steps, *sometimes called "Footsteps," were shoe shapes, like clogs, placed on ascending pedestals with other obstacles underneath so that one could not avoid them in Fluxlabyrinth.*

SILICATE MICRO CRYSTALS see:
George Brecht and George Maciunas
SINK see:
PREPARED FAUCET
6 FT. HANDLE RACKET see:
LONG HANDLE RACKET

George Maciunas. SHOE STEPS. Instruction drawing

George Maciunas. SHOE STEPS being installed by the artist in FLUXLABYRINTH. Berlin. 1976

SLEEPING PILL SANDWICHES

FLUX DRINKS & FOODS...SANDWICHES:...sleeping pill sandwich (G. Maciunas)...
*Invitation to Participate in New Year Eve's Flux-Feast.
[ca. December 1969].*

FLUX FOODS AND DRINKS ... AFTER EFFECT MEALS:...SLEEPING PILL SANDWICH (G. Maciunas)
Flux Fest Kit 2. [ca. December 1969].

COMMENTS: *Maciunas had a serious interest in medicine and food. Perhaps the idea behind* Sleeping Pill Sandwiches *was that sometimes you eat and get sleepy anyway —* Sleeping Pill Sandwiches *guarantees it. The idea of spiked food comes from Per Kirkeby's* 4 Flux Drinks, *and an alternative culture notion at the time of "turning people on" by putting drugs in food or drink without the knowledge of the people who were to consume it.*

SLIDES see:
KINESTHESIS SLIDES
KINETICS NOS. 1 TO 3

SLIPPERY FLOOR

Any proposals from participants should fit the maze format...Ideas should relate to passage through doors, steps, floor, obstacles, booths...slippery balls...
George Maciunas, Further Proposal for Flux-Maze at Rene Block Gallery. [ca. Fall 1974].

"Enclosed is the final plan of labyrinth...then one enters open "slippery floor" covered by small glass black balls that I shipped from New York.
Letter: George Maciunas to Rene Block, [ca. Summer 1976].

slippery floor glass balls...black glass balls.
Instruction drawing for Fluxlabyrinth, Berlin. [ca. August 1976]. version A

Glass Balls waits for you I have not had a chance to unpack the container you shipped.
Notes: Larry Miller to George Maciunas concerning the Fluxlabyrinth, Berlin. [ca. August 1976].

COMMENTS: Slippery Floor *is an element of* Fluxlabyrinth. *One had to walk across masses of marbles, or black glass balls on the floor to get to* Adhesive Floor.

SMALL DOOR IN DOOR

FLUXFEST PRESENTATION OF JOHN LENNON AND YOKO+* AT 80 WOOSTER ST. NEW YORK - 1970...MAY 23-29: PORTRAIT OF JOHN LENNON AS A YOUNG CLOUD BY YOKO ONO & EVERY PARTICIPANT/ A maze with 8 doors each opening in a different manner ... door openable

George Maciunas. SLIPPERY FLOOR in FLUXLABYRINTH. Berlin, 1976

through a small trap door, with knob on other side...
all photographs copyright nineteen seVenty by peTer mooRE (Fluxus Newspaper No. 9) 1970.

this door has a small door in it. to open it one has to open small door and find the door knob on other side which opens the large door.
Instruction drawing for Fluxlabyrinth, Berlin. [ca. August 1976]. version A

"Enclosed is the final plan of labyrinth...All doors should be openable from entry side only...First door is one with a small (about 10cm square) door with its own knob. one has to open it and pass the hand through, looking for the knob of the big door on other side that will open door. This way only smart people will be able to enter. Anyone passing that door will be able to pass all obstacles...There should be no written instructions on the door..."
Letter: George Maciunas to Rene Block, [ca. Summer 1976].

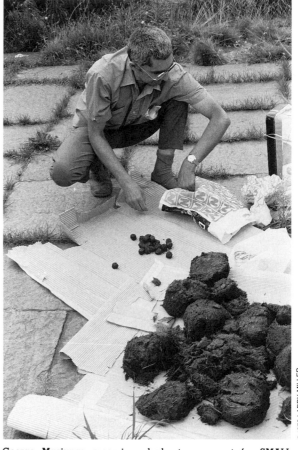

George Maciunas preparing elephant excrement for SMALL DOOR IN DOOR, part of FLUXLABYRINTH. Berlin, 1976

"Door - Small door inset, materials available."
Notes: Larry Miller to George Maciunas concerning the Fluxlabyrinth, Berlin. [ca. August 1976].

this door has a small door in it, to open it one has to open the small door and find the door knob for the large door, which is contained in a box filled with elephant shit.
Plan of completed Fluxlabyrinth, Berlin. [ca. September 1976].

COMMENTS: *As an entry door,* Small Door in Door *was designed to test the intelligence of participants. If you couldn't figure it out, you couldn't get into the* Fluxlabyrinth, *built in Berlin in 1976. As an exit door, one has to reach through the tiny door within the larger door to get to the handle of that larger door. However, in order to reach the handle, your hand had to pass through elephant shit. There was a big stink, and the elephant shit disappeared. Maciunas made a stand and refused to let the labyrinth open until the elephant shit had been replaced. Eventually, more shit was found, and the labyrinth opened.*

SMILE FLUX MACHINE FOR YOKO ONO BY GEORGE MACIUNAS see:
FLUX SMILE MACHINE

SMILE MACHINE see:
FLUX SMILE MACHINE

SMILE STAMPS see:
FLUXPOST (SMILES)

SNOW GAME see:
FLUX SNOW GAME

SNOW HOUSE see:
FLUX SNOW TOWER

SNOW TOWER see:
FLUX SNOW TOWER

SOAP BUBBLE MACHINE

"...Other going projects:...soap bubble machine..."
Letter: George Maciunas to Ken Friedman, [ca. February 1967].

FLUX SHOW: DICE GAME ENVIRONMENT ENTIRE FLOOR AS DICE HAZARD TABLE DIE CUBES, 15" CUBES ON FLOOR, Marked on sides, top open or closed with clear plastic. Consisting or containing...Soap bubble machine...
Flux Fest Kit 2. [ca. December 1969].

COMMENTS: *This work was never made.*

SOLO FOR BALLOONS

Silverman No. 240.8

PERFORMANCE COMPOSITIONS... 1962: ... First musical compositions...music for...balloons...
George Maciunas Biographical Data. 1976.

COMMENTS: *A score from early January 1962, and dedicated to Jean-Pierre Wilhelm, one of the important figures in the early Fluxus activities. This score, printed in blueprint, was distributed by Fluxus, however, it does not have the Fluxus copyright on it.*

SOLO FOR IMPORTANT MAN

Silverman No. 240.9

FLUXFEST INFORMATION...Some pieces not fully described list the availaility of a score...Any of the pieces can be performed anytime, anyplace and by anyone, without any payment to fluxus provided... conditions are met...Scores - 25 cents each...George Maciunas SOLO FOR IMPORTANT MAN telegram is sent to the place performing this event.
Fluxfest Sale. [Winter 1966].

COMMENTS: *Solo for Important Man anticipates a much later performance work of Maciunas, "12 Big Names." The score for the first says "send telegram saying 'Solo for important*

man' to the theatre performing the piece." The idea of "12 Big Names," done in the mid 1970s, was an announcement with the title of the work and the names of 12 very prominent artists, then during the performance the names of the artists were projected, very large, on a screen for the audience.

SOLO FOR RICH MAN

Silverman No. 240.3

COMMENTS: *Solo for Rich Man is a score, printed blueprint, and distributed by Fluxus, but it does not have a Fluxus copyright on it.*

SOLO FOR SICK MAN

Silverman No. 240.10

FLUXFEST INFORMATION...Some pieces not fully described list the availability of a score...Any of the pieces can be performed anytime, anyplace and by anyone, without any payment to fluxus provided ... conditions are met...Scores - 25 cents each... George Maciunas SOLO FOR SICK MAN, 1962 Specified sounds of various medications after a score.
Fluxfest Sale. [Winter 1966].

COMMENTS: *Another early score of Maciunas' printed in blueprint, and distributed by Fluxus, although it does not have a Fluxus copyright on it.*

SOLO FOR VIOLIN

Silverman No. 240.6

FLUXFEST INFORMATION...Some pieces not fully described list the availability of a score...Any of the pieces can be performed anytime, anyplace and by anyone, without any payment to fluxus provided ... conditions are met...Scores - 25 cents each ... George Maciunas...SOLO FOR VIOLIN, 1962 Old classic is performed on a violin. Where pauses are called, violin is mistreated by scratching the floor with it, dropping pebbles through f hole, pulling out pegs etc. Score.
Fluxfest Sale. [Winter 1966].

PERFORMANCE COMPOSITIONS... 1962: ... First musical compositions...music for...violin...
George Maciunas Biographical Data. 1976.

COMMENTS: *Printed in blueprint positive, Solo for Violin is a random pattern score. The copy illustrated was prepared by*

SOLO FOR BALLOONS	for J.P. Wilhelm,	by George Maciunas	Jan. 3, 1962							
seconds										
blow baloon up										
let out air from balloon slowly										
fast										
rub fully blown balloon with hands										
strike balloon with hand										
pierce balloon with pin										

George Maciunas. SOLO FOR BALLOONS

SOLO FOR IMPORTANT MAN	for Manfred de la Motte,	by George Maciunas,	Jan. 3, 1962
Send telegram saying "Solo for Important man" to the theatre performing the piece.			

George Maciunas. SOLO FOR IMPORTANT MAN

SOLO FOR RICH MAN											
seconds											
shaking coins											
dropping coins											
striking coins											
wrinkling paper money											
fast ripping of ,,											
slow ripping of ,,											
striking paper money											
throwing coins											

George Maciunas. SOLO FOR RICH MAN

SOLO FOR SICK MAN	by George Maciunas, Jan.4,1962																						
seconds																							
cough																							
lunger																							
spit																							
gargle																							
draw air (pitched)																							
snore (non pitched)																							
sniff wet nose																							
sniff deeply & swallow																							
blow wet nose																							
swallow pill																							
shake pills in bottle																							
sipp cough syrup																							
use nebulizer-vaporiser																							
put drops into nose																							
drop pills over floor																							
put drops into glass of water																							

George Maciunas. SOLO FOR SICK MAN

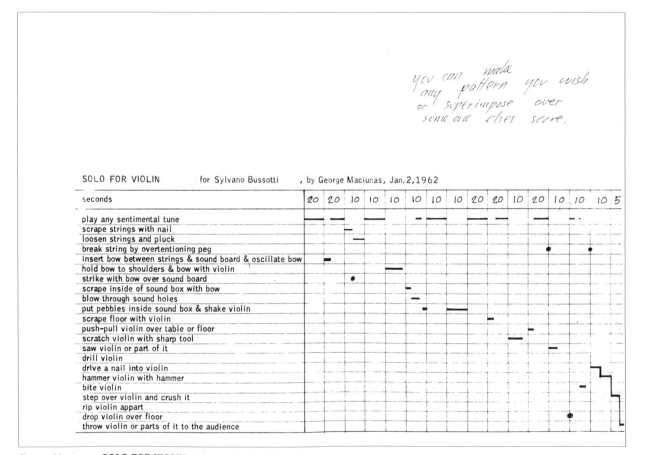

you can make any pattern you wish or superimpose over some one elses score.

| SOLO FOR VIOLIN | for Sylvano Bussotti | , by George Maciunas, Jan.2,1962 |

George Maciunas. SOLO FOR VIOLIN with notations by the artist

Maciunas with timing and a pattern placed on it. This score was distributed by Fluxus in its unprepared form, and does not have a Fluxus copyright on it.

SPAGHETTI EGGS

FLUX FOODS AND DRINKS FLUX EGGS Emptied egg shells filled with...spagetty [sic], etc. (George Maciunas)
Flux Fest Kit 2. [ca. December 1969].

COMMENTS: *Robert Filliou and Emmett Williams invented the* Spaghetti Sandwich *in 1963. In an affidavit, the artists state, "the first sandwich was born from necessity and consumed forthwith." Maciunas'* Spaghetti Eggs *would have been blown eggs filled with spaghetti and sealed, prepared in the context of a Flux foods and drink event.*

SPECIAL 8 HOUR WALKING TOUR OF NEW YORK CITY

FLUXFEST PRESENTATION OF JOHN LENNON & YOKO ONO+* AT 80 WOOSTER ST. NEW YORK - 1970...APR. 18-24: TICKETS BY JOHN LENNON + FLUXTOURS...Special 8 hour walking Fluxtour of New York City (G. Maciunas) $1...
all photographs copyright nineteen seVeny by peTer mooRE (Fluxus Newspaper No. 9) 1970.

COMMENTS: *Tickets for Special 8 Hour Walking Fluxtour of New York City were not printed by Fluxus. The ideas of tours to out-of-the-way places is a recurring one in Fluxus, and that is the idea behind these tickets.*

SPICE CHESS see:
Takako Saito
SPIDERS see:
INSECT STICK-ONS
SPORTS EQUIPMENT see:
FLUX SPORT EQUIPMENT

SQUEAKING TOILET SEAT

TOILET OBJECTS & ENVIRONMENT...Toilet seat variations:...squeaking rubber toy seat, etc.
Flux Fest Kit 2. [ca. December 1969].

Toilet no. 4 G. Maciunas...Toilet seat:...squeaking.
Fluxnewsletter, April 1973.

1970-71...FLUX-TOILET...MACIUNAS: squeaking toilet seat...
George Maciunas, Diagram of Historical Developments of Fluxus... [1973].

COMMENTS: *A whoopie cushion type toilet seat that would squeak or fart when sat upon in the* Flux Toilet.

SQUEAKING TURKEY

FLUX DRINKS & FOODS...TURKEY:...with squeaking rubber toy turkey...(G. Maciunas)...
Invitation to Participate in New Year Eve's Flux-Feast. [ca. December 1969].

FLUX FOODS AND DRINKS ... NON-EDIBLES ... TURKEY STUFFINGS:...squeaking rubber toy turkey inside real turkey (G. Maciunas)
Flux Fest Kit 2. [ca. December 1969].

COMMENTS: *A fake rubber toy turkey, planned for a Flux drinks and food meal. Carve into it and it would squeak. See* Claes Oldenburg's False Foods Selection, *fake foods work packaged as a Fluxus Edition, and Milan Knizak's* Turkey.

STAMPS see:
CHURCH SYNOD STAMPS
FLUXPOST (AGING MEN)
FLUXPOST (SMILES)
POSTAGE STAMPS

STATIONERY see:
FLUX STATIONERY: FOOT IN SHOE
FLUX STATIONERY: HAND IN GLOVE
FLUX STATIONERY: TORSO IN FUR COAT

STEPS see:
BOX STEPS
FOAM STEPS
OBSTACLE STEPS
SHOE STEPS

STICK-ONS

IMPLOSIONS INC. PROJECTS ... Triple partnership was formed between Bob Watts, Herman Fine and myself [George Maciunas] to introduce into mass market...money producing products...This business will be operated in commercial manner, with intent to make profits...connection between Fluxus collective and Implosions Inc. has not been clarified yet ... we could consider at present Fluxus to be a kind of division or subsidiary of Implosions. Projects to be realized through Implosions:...Stick-ons (disposable jewelry): printed on clear or colored acetate or vinyl 9'' x 11¾'' (image size), Images may be photographs (will be screened) or drawings, engravings, words etc. any color. Plastic sheet will have self-adhesive backs that will permit them to be stuck on skin or clothing. Sheets will also be die cut or contain partly die cut (snap-out) shapes in the shape of the image or anything else...
Fluxnewsletter, March 8, 1967.

NEWS FROM IMPLOSIONS, INC. Various items were produced as planned &...listed in the past news-letter:...Stick-ons, samples included
Fluxnewsletter, January 31, 1968.

NEWS FROM IMPLOSIONS, INC....Planned in 1968:
...More stick-ons (some 8 designs)
ibid.

...set of 1969-70 Flux-productions which consist of the following: 1969...George Maciunas:...Flux tattoos,...
Fluxnewsletter, January 8, 1970.

FLUXUS-EDITIONEN...[Catalogue No.] 717 FLUX-TATTOOS, b. watts - g. maciunas 1967
Happening & Fluxus. Koelnischer Kunstverein, 1970.

1967...G. MACIUNAS Stick-on tattoos...
George Maciunas, Diagram of Historical Developments of Fluxus... [1973].

COMMENTS: *Planned first as a Flux project in 1967, the idea to produce and distribute stick-ons was shifted to a short-lived commercial wing of Fluxus called Implosions, Inc. The sheets of stick-ons carry the Implosions imprint, but they were also distributed as Fluxus works, and the Collective packaging of stick-ons carries a Maciunas-designed label:* Flux Tattoos.

STICK-ONS see:
FLUXUS 301
FLUXWEAR 303
FLUXWEAR 304
HERO 603
HERO 604
INSECT STICK-ONS
SCAR STICK-ONS
WORM STICK-ONS

STOMACH ANATOMY APRON
Silverman No. 251

FLUX-PROJECTS PLANNED FOR 1967 ... George Maciunas:...paper aprons:...anatomical section of front (digestive system etc.)...
Fluxnewsletter, March 8, 1967.

FLUXPROJECTS FOR 1969... Vinyl aprons: ...Maciunas -...anatomy.
Fluxnewsletter, December 2, 1968.

PROPOSED CONTENTS FOR FLUXPACK 3 TO BE PUBLISHED IN 1973 BY FLASH ART Vinyl aprons stomach by Maciunas...Cost Estimates: for 1000 copies aprons [2 designs] $500...100 copies signed by:...Maciunas...
[George Maciunas], Proposed Contents for Fluxpack 3. [ca. 1972].

"...to produce the Flash Art FLUXPACK 3 ... contents at present will be as follows:...Aprons: anatomy of stomach by Maciunas..."
Letter: George Maciunas to Giancarlo Politi, n.d. Reproduced in Fluxnewsletter, April 1973.

George Maciunas. STOMACH ANATOMY APRON

ERIC SILVERMAN

"...could be produced cheaper in Italy...vinyl fabric aprons with various fronts (...intestants [sic] etc.)..."
Letter: George Maciunas to Daniela Palazzoli, n.d. Reproduced in Fluxnewsletter, April 1973.

Flash Art editor, Giancarlo Politi, proposed to publish the 3rd Fluxyearbook, maybe to be called FLUX-PACK 3, with the following preliminary contents:... Wear items: vinyl aprons (stomach anatomy by Maciunas...)
Fluxnewsletter, April 1973.

1967...G. MACIUNAS: photo-aprons
George Maciunas, Diagram of Historical Developments of Fluxus... [1973].

OBJECTS AND EXHIBITS...1967:...photo aprons (...stomach anatomy...)...
George Maciunas Biographical Data. 1976.

OBJECTS AND EXHIBITS...1975:...contributed ... 2 aprons...published by Multipla, Milan...
ibid.

COMMENTS: *Stomach Anatomy Apron was first planned, along with a number of other aprons, in 1967. The work was produced sometime between then and 1973, when* Flux Pack 3 *was prepared for distribution by Multipla in Italy and is included in the Silverman's example of* Flux Pack 3. *This apron is a work which Maciunas uses in an interview with Larry Miller in 1977 to explain his idea of functionalism; that is, the apron covers ones stomach and the picture on the apron is a stomach and digestive tract, so its function as an apron also illustrates what takes place underneath the apron.*

STRING EGGS

FLUX FOODS AND DRINKS FLUX EGGS: emptied egg shells filled with...string...(George Maciunas)
Flux Fest Kit 2. [ca. December 1969].

COMMENTS: *Blown eggs filled with string,* String Eggs *remind one of Jack Coke's Farmer's Co-op* Find the End *and also Maciunas'* Continuous String Dispenser. *Another allusion would be to worms.*

SUGAR DUMPLINGS

FLUX FOODS AND DRINKS...DUMPLING VARIATIONS: One of the fillings:...sugar,...(G.M.)
Flux Fest Kit 2. [ca. December 1969].

COMMENTS: *These were never made.*

SUNGLASSES see:
 8 LENS SUN GLASSES

SYMBOLS see:
 HERO 604

SYRINGE see:
 FLUXSYRINGE

TABLETOP FOR DISPLAYING SMALL OBJECTS

PROPOSED FLUXSHOW FOR GALLERY 669 ...
OBJECTS, FURNITURE a.tabletops...(by Maciunas)
b. tabletops for displaying small objects will be like a gaming table with locations for displays marked like in a stamp album. All table tops are photographs laminated between wood tabletop and vinyl surface. They require stands or legs as shown: [sketch] These pedestal type stands can be obtained from New York for $12 each, plus shipping charges. Additional table tops are in the form of photographs (unlaminated) which should be placed over a table of same size and covered with glass.
Fluxnewsletter, December 2, 1968.

COMMENTS: *The Fluxus exhibition did not take place at Gallery 669. At the Fluxfest at and/or in Seattle, 1977, Maciunas constructed a display surface for a giant* Light Fluxkit *by Robert Watts, marked off like a stamp album.*

TABLETOPS see:
 FLUXFURNITURE
 MONSTERS ARE INOFFENSIVE
 TABLETOPS FOR DISPLAYING SMALL OBJECTS

TARGETS

FLUX-OLYMPIAD...[by G.Maciunas] FIELD...arch-

George Maciunas and Slash Slettebak using **TABLETOP FOR DISPLAYING SMALL OBJECTS** to exhibit Robert Watts' **FLUX TIMEKIT** at and/or. Seattle, Washington, 1977

BERT GARNER

ery funny targets (visual and sound)
Fluxfest at Stony Brook, Newsletter No. 1, August 18, 1969.
versions A and B

FLUX-OLYMPIAD...FIELD - ARCHERY FUNNY TARGETS (sound & sight) (G.M.)
Flux Fest Kit 2. [ca. December 1969].

Flash Art editor, Giancarlo Politi, proposed to publish the 3rd Fluxyearbook, maybe to be called FLUX-PACK 3, with the following preliminary contents:...
Games:...targets by...Maciunas
Fluxnewsletter, April 1973.

FLUX AMUSEMENT ARCADE...target.
Preliminary Proposal for a Flux Exhibit at Rene Block Gallery, [ca. 1974].

COMMENTS: *In one entry,* Targets *are referred to as "visual or sound." When an arrow was shot into one, it would make a sound, or if it was a visual target, it might be like one of the "personality targets" of the 60s; for instance, a dart board*

with a picture of De Gaulle's face on it. The work was never made and was not included in Fluxpack 3.

TATTOOS see:
 STICK-ONS

TEA see:
 FOOD

10 FEET
Silverman No. < 243.II

FLUXFILMS...FLUXFILM 7 10 FEET, 16 sec $4
Vaseline sTREet (Fluxus Newspaper No. 8) May 1966.

FLUXFILMS SHORT VERSION, 40 MIN AT 24 FRAMES/SEC. 1400FT. ... flux-number 7 George Maciunas 10 FEET 0'45'' Prestype on clear film measuring tape, 10ft. length...Editing and titles by George Maciunas
Fluxfilms catalogue. [ca. 1966].

PAST FLUX-PROJECTS (realized in 1966)...10 feet by G. Maciunas...
Fluxnewsletter, March 8, 1967.

FLUX-PRODUCTS 1961 TO 1969 ... FLUXFILMS, short version Summer 1966 40 min. 1400 ft:...10 ft. - by Maciunas...16 mm [$] 180 8mm version [$] 50
Fluxnewsletter, December 2, 1968 (revised March 15, 1969).

FLUX-PRODUCTS 1961 TO 1970...[as above]
Flux Fest Kit 2. [ca. December 1969].

SLIDE & FILM FLUXSHOW...GEORGE MACIUNAS: 10 FEET Projection of clear measuring 10ft. tape. 1' 15'' No camera.
ibid.

1965 FLUXFILMS:...MACIUNAS: 10ft...
George Maciunas, Diagram of Historical Developments of Fluxus... [1973].

OBJECTS AND EXHIBITS ... 1965:... of some 20 films into Flux-film anthology, contributed: films made without camera (using various adhesive patterns on clear film stock):...10 feet...
George Maciunas Biographical Data. 1976.

COMMENTS: *10* Feet *is a very literal, concrete film, marking off the number of feet the film projects. The work is included in the* Fluxfilms *package.*

TICKETS see:
 FACSIMILE TICKET TO GROLIER CLUB EXHIBITION, 1893
 FACSIMILE TICKET TO VISIT HOUSE OF COMMONS, 1885

40 DAY TRIP BY LOCAL BUSES FROM TEXAS
 TO RIO DE JANEIRO TICKET
ONE WAY TICKET TO SIBERIA
ONE WAY TRIP TO GINGER ISLAND TICKET
OUTDATED 19TH CENTURY TRAIN TICKETS
PERHAM'S OPERA HOUSE TICKET
SPECIAL 8 HOUR WALKING FLUXTOUR OF
 NEW YORK CITY

TIME CHESS, SAND TIMER PIECES
Silverman No. > 242.V

... items are in stock, delivery within 2 weeks ...
FLUXUSa FLUXCHESS: pieces identified by sound
or weight or smell or time etc. ... FLUXUS a9 time
chess, hourglass pieces $60
Vaseline sTREet (Fluxus Newspaper No. 8) May 1966.

FLUXSPORTS (or Fluxolympiad) All items will be
brought over...Chess Tournament...with time set
(each piece is timed by a wound mechanism) when
the mechanism runs out the piece is lost.
Proposed Program for a Fluxfest in Prague, 1966.

FLUX-PRODUCTS PLANNED FOR 1967...George
Maciunas:...Sand clock chess...
Fluxnewsletter, March 8, 1967.

PROPOSED FLUXOLYMPIAD...BOARD GAMES:
...chess tournament with:...sand timer pieces,...
Fluxnewsletter, January 31, 1968.

[as above]
Fluxnewsletter, December 2, 1968.

PROPOSED FLUXSHOW FOR GALLERY 669 ...

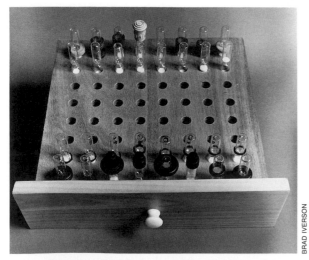

George Maciunas. TIME CHESS, SAND TIMER PIECES. Included in
FLUX CABINET

BRAD IVERSON

SPORTS - GAME CENTER...chess sets with:...sand
timer pieces...
ibid.

FLUX-PRODUCTS 1961 TO 1969 ... GEORGE MA-
CIUNAS ... Chess sets:...sand timer pieces in hard-
wood case [$] 60...
Fluxnewsletter, December 2, 1968 (revised March 15, 1969).

PROPOSED FLUXSHOW...SPORTS - GAME CEN-
TER...Chess tournament with:...sand-timer pieces...
ibid.

FLUX-OLYMPIAD...DUAL CONTEST...Board chess
pieces timed from the time they are used...
Fluxfest at Stony Brook, Newsletter No. 1, August 18, 1969.
version A

FLUX-OLYMPIAD [by G. Maciunas] ... DUAL...
Board chess pieces timed from the time they are used
(sand timers)
Fluxfest at Stony Brook, Newsletter No. 1, August 18, 1969.
version B

FLUX-PRODUCTS 1961 TO 1970 ... GEORGE MA-
CIUNAS...Chess set sand timers in hardwood chest
[$] 60...
Flux Fest Kit 2. [ca. December 1969].

FLUX - OLYMPIAD ... DUAL CONTEST - CHESS
TIME CHESS: pieces timed for 3 min. from the time
they are first used (sand timers) (George Maciunas)
ibid.

FLUX SHOW: DICE GAME ENVIRONMENT...timer
chess sets...
ibid.

FLUX SHOW: DICE GAME ENVIRONMENT EN-
TIRE FLOOR AS DICE HAZARD TABLE DIE
CUBES, 15" CUBES ON FLOOR, Marked on sides,
top open or closed with clear plastic. Consisting or
containing...timer chess sets.
ibid.

FLUX-PRODUCTS 1961 TO 1970 ... GEORGE MA-
CIUNAS...Chess set sand timers in hardwood chest
[$] 100...
[Fluxus price list for a customer]. September 1975.

OBJECTS: ... Timed chess pieces (4 minute sand
clocks)
*Proposal for 1975/76 Flux-New Year's Eve Event. [ca. No-
vember 1975].*

...timer chess by Maciunas $100 (each piece is a sand
timer, new play rules)...
[Fluxus price list for a customer]. January 7, 1976.

GEORGE MACIUNAS...Chess set, sand timers in

wood box, 12" x 12" $140...
Flux Objects, Price List. May 1976.

OBJECTS AND EXHIBITS...1965:...various chess
sets (...sand timers, etc.)...
George Maciunas Biographical Data. 1976.

CHESS is played with pieces which are sand timers.
G.M.
Fluxfest 77 at and/or, Seattle. September 1977.

*COMMENTS: Egg timers with various rubber aprons indicat-
ing the value of the chess pieces in a wooden board with holes
drilled into it. The implication is that when one makes a
move, the timer is turned upside down and the next move has
to take place before the sand runs through. A similar idea is
employed in Flux Timer Checkers, a work that is not known
to exist. Maciunas worked on a number of chess ideas with
Takako Saito, and attribution is at times difficult. However,
Takako Saito has clarified a number of concepts and most are
now correctly credited to her.*

TIMERS see:
 FLUX TIMER CHECKERS
 TIME CHESS, SAND TIMER PIECES
TOILET see:
 FLUX TOILET

TOILET PAPER PERFORATED WITH LARGE HOLES

Toilet No. 4 G. Maciunas...Toilet paper...perforated
with large holes
Fluxnewsletter, April 1973.

*COMMENTS: Holy toilet paper, Toilet Paper Perforated
with Large Holes, a messy prospect, was unfortunately never
produced.*

TRANSPARENT BEEF

PROPOSED FLUX DRINKS & FOODS TRANSPA-
RENTMEAL...clear beef (beef flavor jello)...
Fluxfest at Stony Brook, Newsletter No. 1, August 18, 1969.
versions A and B

FLUX DRINKS & FOODS...TRANSPARENT...beef
etc. ...(clear jellatin [sic] with appropriate flavours)
...(G. Maciunas)...
*Invitation to Participate in New Year Eve's Flux-Feast. [ca.
December 1969].*

FLUX FOODS AND DRINKS ... MONO-MEALS:
TRANSPARENT MEAL...clear...beef...(clear jella-
tin with appropriate flavours)...(George Maciunas)
Flux Fest Kit 2. [ca. December 1969].

COMMENTS: Transparent Beef was made in the context of a

"Transparent Meal," in which all foods were clear liquids or gelatin that retained their original flavor.

TRANSPARENT BUTTER

PROPOSED FLUX DRINKS & FOODS TRANSPA-RENTMEAL...clear butter (with butter flavor)...
Fluxfest at Stony Brook, Newsletter No. 1, August 18, 1969. versions A and B

FLUX DRINKS & FOODS...TRANSPARENT...clear butter...(clear jellatin [sic] with appropriate flavours)...(G. Maciunas)...
Invitation to Participate in New Year Eve's Flux-Feast. [ca. December 1969].

FLUX FOODS AND DRINKS ... MONO-MEALS: TRANSPARENT MEAL...clear butter (jello with butter flavor)...(George Maciunas)
Flux Fest Kit 2. [ca. December 1969].

COMMENTS: Transparent Butter, *retaining flavor, but not the color or consistency of butter.*

TRANSPARENT FISH see:
FISH JELLO

TRANSPARENT FOODS see:
FOOD

TRANSPARENT ICE CREAM

PROPOSED FLUX DRINKS & FOODS TRANSPA-RENTMEAL...clear ice cream etc. ...
Fluxfest at Stony Brook, Newsletter No. 1, August 18, 1969. versions A and B

FLUX DRINKS & FOODS...TRANSPARENT...clear ice cream etc. (G. Maciunas)...
Invitation to Participate in New Year Eve's Flux-Feast. [ca. December 1969].

FLUX FOODS AND DRINKS ... MONO-MEALS: TRANSPARENT MEAL ... clear ice cream, etc. (George Maciunas)
Flux Fest Kit 2. [ca. December 1969].

COMMENTS: *Another work reducing a pleasant food down to its taste, but dispensing with the color and texture that one associates with it.*

TRANSPARENT MEAL

FLUX NEW YEAR EVE, 1974 - COLORED MEAL: ...Transparent, by George Maciunas
Fluxnewsletter, May 3, 1975.

COMMENTS: *This meal was made. The idea was originally proposed for the "Fluxfest" at Stony Brook, New York, in 1969. See individual entries for "transparent" and "distilled" foods.*

George Maciunas. **TRANSPARENT MEAL.** see color portfolio

©1970 LARRY MILLER

TRANSPARENT ONION

PROPOSED FLUX DRINKS & FOODS TRANSPA-RENTMEAL...clear onions (jello with onion flavor)...
Fluxfest at Stony Brook, Newsletter No. 1, August 18, 1969. versions A and B

FLUX DRINKS & FOODS...TRANSPARENT...onion ...(clear jellatin [sic] with appropriate flavours)... (G. Maciunas)...
Invitation to Participate in New Year Eve's Flux-Feast. [ca. December 1969].

FLUX FOODS AND DRINKS ... MONO-MEALS: TRANSPARENT MEAL...clear...onion (clear jellatin with appropriate flavours)...(George Maciunas)
Flux Fest Kit 2. [ca. December 1969].

COMMENTS: *Transparent Onion, described as Jello with onion flavor.*

TRAP DOOR see:
TRICK CEILING HATCHES

TREATED PAPER TOWELS

Toilet no. 4, G. Maciunas...Paper towels...with chemical making hands dirty.
Fluxnewsletter, April 1973.

COMMENTS: *To be included in Maciunas' Flux Toilet, Treated Paper Towels would have contained a chemical to make your hands dirty again.*

TRICK CEILING HATCHES

FLUX COMBAT WITH NEW YORK STATE ATTOR-NEY GENERAL (& POLICE) BY GEORGE MACIU-NAS... Flux fortress (for keeping away the marshals

& police:...trick...ceiling hatches, filled or backed with white powder, liquids, smelly extracts, etc....
Fluxnewsletter, May 3, 1975.

COMMENTS: Trick Ceiling Hatches *are a counter-point to* Dummy Ceiling Hatches, *planned for Maciunas' "Flux Combat with New York State Attorney (& Police)." A* Trick Ceiling Hatch *still exists in Maciunas' old studio in New York City. The ceiling hatch is a tiny trap door which one could hardly imagine Maciunas fitting through.*

TRICK DOORS

FLUX COMBAT WITH NEW YORK STATE ATTOR-NEY GENERAL (& POLICE) BY GEORGE MACIU-NAS... Flux fortress (for keeping away the marshals & police: ...trick doors, filled or backed with white powder, liquids, smelly extracts, etc. funny messages behind each door...
Fluxnewsletter, May 3, 1975.

COMMENTS: *Maciunas prepared a whole arsenal of gags and tricks to combat the seriousness of the Attorney General's action against him in New York City. This arsenal included Giant Cutting Blades Door, Safe Door, and Trick Ceiling Hatches. I have never found a record of all the elements to his Flux fortress that were contructed.* Trick Doors *might well have been prepared.*

TRIO FOR BASS SORDUNE (C NOTE), VOICE, OLD SCORE AND ETUIS (REVISED)
Silverman No. 240.5

FLUXFEST INFORMATION...Some pieces not fully described list the availability of a score...Any of the pieces can be performed anytime, anyplace and by anyone, without any payment to fluxus provided ... conditions are met...Scores - 25 cents each...George Maciunas TRIO FOR BASS SORDUNE, OLD SCORE, MOUTH & ETUIS, 1962 Score.
Fluxfest Sale. [Winter 1966].

PERFORMANCE COMPOSITIONS ... 1962: ... First musical compositions...music for lips...
George Maciunas Biographical Data. 1976.

COMMENTS: *This is the revised version of* Duet for C on Bass Sordune, Voice and an Old Score *(Silverman No. 240.IV). It was printed in the blueprint method, and distributed by Fluxus, but does not have the Fluxus copyright on it.*

TRIO FOR LADDER, MUD AND PEBBLES
Silverman No. 240.1

PERFORMANCE COMPOSITIONS ... 1962: ... First musical compositions...music for...mud...pebbles...

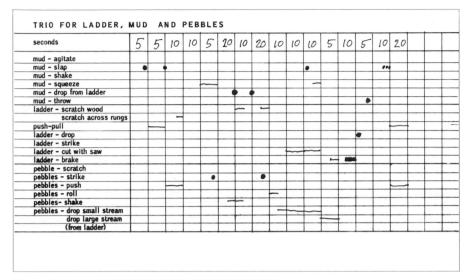

George Maciunas. TRIO FOR LADDER, MUD AND PEBBLES

TRIO FOR BASS SORDUNE (C NOTE), VOICE, OLD SCORE AND ETUIS for Heinz Klaus Metzger
by George Maciunas, Jan.2,1962 (revised)

- seconds
- C on sordune
- scratch score
- shake score
- thumb through score
- shuffle score
- throw-drop score
- strike suspended score
- wrinkle score
- pierce score
- cut score
- rip score fast / slow
- throat-lip pitched voice / not pitched
- laugh
- cough
- draw air
- lunger
- clear throat
- throat tick
- gargle
- drink
- lip-teeth pitched voice / not pitched
- hiss
- lip-fart
- sipp
- rinse mouth
- spit
- blow
- smack lips
- whistle
- eating motion
- scratch etuis
- push-pull etuis
- drop etuis
- slam cover down
- kick etuis

George Maciunas. TRIO FOR BASS SORDUNE (C NOTE), VOICE, OLD SCORE AND ETUIS (REVISED)

12 PIANO COMPOSITIONS FOR NAM JUNE PAIK, by George Maciunas, Jan.2,1962

Composition no.1	let piano movers carry piano into the stage
Composition no.2	tune the piano
Composition no.3	paint with orange paint patterns over piano
Composition no.4	with a straight stick the length of a keyboard sound all keys together
Composition no.5	place a dog or cat (or both) inside the piano and play Chopin
Composition no.6	stretch 3 highest strings with tuning key till they burst
Composition no.7	place one piano on top of another (one can be smaller)
Composition no.8	place piano upside down and put a vase with flowers over the sound box
Composition no.9	draw a picture of the piano so that the audience can see the picture
Composition no.10	write piano composition no.10' and show to audience the sign
Composition no.11	wash the piano, wax and polish it well
Composition no.12	let piano movers carry piano out of the stage

George Maciunas. 12 PIANO COMPOSITIONS FOR NAM JUNE PAIK

ladders...
George Maciunas Biographical Data. 1976.

COMMENTS: An early score of Maciunas, printed in blueprint and distributed by Fluxus, but without the Fluxus copyright. The example illustrated was prepared by Maciunas with a time and action pattern. However, this particular score was originally issued without its notations and the performer would have had to write his or her own.

TURKEY see:
SQUEAKING TURKEY

12 BIRD AEROPHONE

FEB. 17, 1970: FLUX-MASS BY GEORGE MACIUNAS...Communion Antephon: 12 different bird calls from choir are answered with 12 gunshots by the priest...
all photographs copyright nineteen seVenty by peTer mooRE (Fluxus Newspaper No.9) 1970.

1970...MACIUNAS:...12 bird aerophone, etc.
George Maciunas, Diagram of Historical Developments of Fluxus... [1973].

"...Aerophone (black box)...contains 12 bird sounds and a relay..."
Letter: George Maciunas to Rene Block, [ca. Summer 1976].

OBJECTS AND EXHIBITS...1970:...12 bird aerophone machine...
George Maciunas Biographical Data. 1976.

COMMENTS: 12 Bird Aerophone, described as a black box containing twelve bird sounds and a relay, this instrument was evidently first made for Flux Mass at Douglass College, 1970, and then for the Berlin Fluxus event in 1976. I've never seen the finished work.

12 MOVEMENT FLUX CLOCK

... items are in stock, delivery within 2 weeks ... FLUXUSy FLUXCLOCK, 12 movements $100
Vaseline sTREet (Fluxus Newspaper No. 8) May 1966.

FLUX-PROJECTS PLANNED FOR 1967...George Maciunas:...Fluxclock...
Fluxnewsletter, March 8, 1967.

COMMENTS: This work was never made by Maciunas as a Fluxus Edition.

12 PIANO COMPOSITIONS FOR NAM JUNE PAIK
Silverman No. 240.7

FLUXFEST INFORMATION...Some pieces not fully described list the availability of a score...Any of the pieces can be performed anytime, anyplace and by anyone, without any payment to fluxus provided ... conditions are met...Scores - 25 cents each...George Maciunas...
1962 PIANO PIECES
1. piano is moved to performing area
2. piano is tuned
3. with a stick of keyboard length, all keys are sounded together

4. a dog or cat (or both) are placed inside piano and an old classic played
5. three highest strings are stretched with tuning key till they burst
6. one piano is place on top of another
7. piano is placed upside down and a vase of flowers placed over it
8. picture of piano is drawn
9. "piano piece no.9" is written and sign shown to audience
10. piano is whitewashed
11. piano is washed and waxed.
12. piano is removed.

Fluxfest Sale. [Winter 1966].

PERFORMANCE COMPOSITIONS ... 1962: ... First musical compositions ... 12 piano pieces ...
George Maciunas Biographical Data. 1976.

COMMENTS: *This group of now classic Fluxus scores,* 12 Piano Compositions for Nam June Paik *was originally published in early 1962 by blueprint. They were distributed by Fluxus during that period, although Maciunas didn't put a Fluxus copyright on the sheets. A slightly different version was published in* Fluxfest Sale, *Winter 1966.*

20 LB RUBBER BOOTS see:
George Maciunas and Yoko Ono

270 DEGREE DOOR see:
George Maciunas and Larry Miller

URETHANE FOAM EGGS

PROPOSED FLUX DRINKS & FOODS FLUX EGGS emptied egg shells filled with ... urethane foam ...
Fluxfest at Stony Brook, Newsletter No. 1, August 18, 1969. versions A and B

FLUX DRINKS & FOODS FLUX EGGS emptied egg shells filled with ... urethane foam ... (G. Maciunas) ...
Invitation to Participate in New Year Eve's Flux-Feast. [ca. December 1969].

FLUX FOODS AND DRINKS FLUX EGGS: Emptied egg shells filled with ... urethane foam ... (George Maciunas)
Flux Fest Kit 2. [ca. December 1969].

COMMENTS: *Blown eggs filled with urethane foam and sealed, when opened would be a solid foam egg shape. There is no evidence that these eggs were actually made.*

U.S. SURPASSES ALL NAZI GENOCIDE RECORDS
Silverman No. 245, ff.

"... In few weeks I will also mail you political leaflets (1000) with statistics proving U.S. genocide in Vietnam exceeding Nazi genocide in Europe. (Nazi genocide - 5% of Europeans) (U.S. genocide - 6% of Vietnamese). VERY IMPORTANT TO HAVE THIS PAPER SPREAD WIDELY. It took me a whole year to dig up these statistics, which could be considered reliable..."
Letter: George Maciunas to Ben Vautier, [ca. Fall 1966].

"... I mailed 500 leaflets to DIAS on U.S. Genocide in Vietnam. In fact, I am mailing you 500 sheets also. Distribute them widely, and if you need more, let me know...."
Letter: George Maciunas to Ben Vautier, [ca. October 1966].

PUBLICATIONS, ESSAYS, ARTICLES: ... 1966: essay: US surpasses all nazi genocide records! publ. by Edizioni di cultura contemporanea, Milan, no. 2, ED 912 ...
George Maciunas Biographical Data. 1976.

U.S. SURPASSES ALL NAZI GENOCIDE RECORDS!

Nazis conducted their "pacification" of Europe by confiscating the grain, burning down of houses, forcible concentration and by massacring 5% of European population hostile to Nazi occupation.[1] The whole world, including the American public was horrified by these Nazi crimes of genocide. Yet today, the United States is employing exactly the same (if not more destructive) methods in trying to pacify the South Vietnamese by destroying their crops, burning their houses,[2] forcing them into camps and by massacring 6% of the population hostile to U.S. occupation,[3] and continuing to do so at the rate of 2% per year without an end in sight.[4] Surprisingly, today there is no repetition of the public indignation and repugnance, nor any effort to charge U.S. leaders for committing these crimes of genocide and standing them for trial, (something we did with Nazi leaders), nor any effort to overthrow these lunatic leaders (something we criticised the Germans for not doing with Hitler), nor refusal of the military to carry out these crimes (something we criticised the Wehrmacht for not doing), The really appalling and incredible fact is that the majority of American people, the same people who were horrified by the Nazi genocide figure of 5%, support the more extensive genocide when committed by U.S. leaders, even urge these leaders to increase it, and some sick elements of the population even volunteer to commit them. (Nazis had no such luck, they had to conscript convicts into antipartisan SS troops.) Are we becoming a nation of criminals? or have we lost our capacity to reason under the magic spell of Our Leader? or were the Nazis innocent after all, since they, like the U.S. leaders, did it all in the name of "anticommunism"?

1 The countries included are France, Belgium, Holland, Denmark, Norway, Poland, Czechoslovakia, Yugoslavia, Greece and the occupied part of U.S.S.R. (population of about 80 million). Also included is 50% of population from countries allied with Nazis, but which supported considerable anti-Nazi partisan movements such as Italy, Hungary and Rumania. The total population at 1940 of these countries was about 280 million. The total of civilians and partisans killed was 23 million. Of these, about 9 million were Jewish casualties due to the Nazi "Final Solution" rather than their "Pacification" program. Casualties connected to Nazi antipartisan or "pacification" action therefore were about 14 million civilians and partisans or 5% of the population of 280 million. These figures were compiled from: Woytinsky, W.S. and Woytinsky, E.S. "World Population and Production - Trends and Outlook," 1953, p.47.

2 20,000 acres of crops have been destroyed by U.S. forces. (New York Times, March 3, 1966)
1000 huts were destroyed by U.S. forces in an average 3 weeks of fighting (New York Times, Feb.15, 1966), or approximatelly 17,000 huts per year, or at the rate of U.S. escalation a total of 40,000 during the period of U.S. pacification effort. To this must be added the number of buildings destroyed by bombing not directly connected with ground operations.

3 To arrive at greater reliability, this percentage was obtained from 3 unrelated sources:
a. statement of U.S. Congressman Zablocki that early in 1966 there were 2 civilians killed by U.S. and allied forces for every mortal casualty of partisans or N.L.F. forces. (New York Times, Mar.17, 1966, p.9)
b. 100,000 civilians killed by U.S. and allied forces in 1965. (Nation, June 13, 1966, p.704)

c. Statistics provided by Cantho hospital. (New York Times, June 6, 1966). About 6000 wounded civilians are received by the hospital serving an area populated by 500,000. The proportion of mortal to wounded casualties is about 1:1 as indicated by reports of casualties in typical bombed villages, as for example in Beduc where 48 civilians were killed and 55 wounded. (New York Times, Oct.31, 1965). From this fact it is possible to estimate the percentage of civilian mortal casualties as being 5000 out of half a million or 1% of the population per year. The casualties of the N.L.F. forces were as follows: prior to and including 1964 - 75,000 (New York Times, Mar. 6, 1965 p.3); 30,000 (25,000 in 9 months) in 1965 (New York Times, Oct.18, 1965); 24,000 (4,000 per month) during first 6 months of 1966 (New York Times, Apr.22, 1966); total killed in N.L.F. forces - 130,000. To arrive at a civilian casualty percentage that could be compared objectively to Nazi inflicted casualties, it is necessary to relate the deaths only to a population subjected to such pacification action. Just as Germany, Austria and part of Italy were excluded from the total European population considered, so should the Saigon controlled population be. It is a generally accepted fact, that half of the South Vietnamese population (urban) is under the control of the Saigon regime and the other half (rural) under the N.L.F. control. The total South Vietnamese population being 15 million, the two halves would amount to 7.5 million each. The percentage of civilian deaths due to U.S. pacification action would be calculated as follows:
a. According to Rep. Zablocki's statement, 130,000 deaths of N.L.F. forces plus 260,000 civilian deaths, following the 1:2 rate established by him would amount to a total of 390,000 or 5.2% of the population.
b. According to the figure established in the Nation article, 100,000 civilian deaths in 1965 constitutes a rate of 1:3.3, thus 130,000 deaths of N.L.F. forces plus 390,000 civilian deaths would amount to 7% of population.
c. According to the figure of 1% per year casualties derived from Cantho hospital statistics, 75,000 deaths in 1965 constitutes a rate of 1:2.5, thus 130,000 deaths of N.F.L. forces plus 325,000 civilian deaths would amount to 6% of the population.
6% figure was used as being the mean percent. Considering the diversity of sources and diversity in method of calculation it is surprising how close to each other are all 3 estimates.

4 The rate of 2% for 1966 has been established as follows: 4,000 deaths per month of N.L.F. forces establishes a yearly rate of 48,000. At the average ratio of 1:1.5, the civilian deaths will amount to 120,000 or a total of 168,000, thus 2% of 7.5 million.

Statistics of other war casualties are given here for comparison:
Number of civilians killed by N.L.F. forces: 11,000 or 1/4% of the total South Vietnamese population. (New York Times, April 29, 1966 p.2)
Number of civilians killed in Germany during the 2nd World War (mainly as a result of bombing): 700,000, or 1% of the German population. (Woytinsky, "World Population and Production - Trends and Outlook," 1953, p.47)

George Maciunas, P.O.Box 180, New York 10013

George Maciunas. U.S. SURPASSES ALL NAZI GENOCIDE RECORDS

U.S.A. SURPASSES ALL THE GENOCIDE RECORDS!

KUBLAI KHAN MASSACRES 10% IN NEAR EAST

SPAIN MASSACRES 10% OF AMERICAN INDIANS

JOSEPH STALIN MASSACRES 5% OF RUSSIANS

NAZIS MASSACRE 5% OF OCCUPIED EUROPEANS AND 75% OF EUROPEAN JEWS

U.S.A. MASSACRES 6.5% OF SOUTH VIETNAMESE & 75% OF AMERICAN INDIANS

FOR CALCULATIONS & REFERENCES WRITE TO: P.O. BOX 180, NEW YORK, N.Y. 10013

George Maciunas. U.S.A. SURPASSES ALL THE GENOCIDE RECORDS

COMMENTS: U.S. Surpasses All Nazi Genocide Records *is a detailed study of genocide that Maciunas made in reaction to the horror of the United States involvement in Vietnam. The statistics on this leaflet are summarized on the flag poster,* U.S.A. Surpasses All the Genocide Records. *Although never advertised or offered through Fluxus, the work is frequently included in* Fluxkits *and other Collective works from the time. Maciunas mailed a thousand copies of the leaflet to Ben Vautier in Nice, and Ben and his wife Annie stood in front of the United States military installation there, handing the leaflets out. The Americans had the French police arrest Annie. She was separated from her infant child, held and interrogated by the police for many hours, terrifying Annie as well as Ben and their child. DIAS, mentioned in Maciunas' second letter to Ben Vautier above, stands for Destruction in Art Symposium, which took place in London that autumn. Sending 500 broadsides to DIAS was Maciunas' contribution to that event.*

U.S.A SURPASSES ALL THE GENOCIDE RECORDS
Silverman No. 247, ff.

NEWS FROM IMPLOSIONS, INC. ... Flag poster (samples included)...
Fluxnewsletter, January 31, 1968.

COMMENTS: U.S.A. Surpasses All the Genocide Records, *the flag poster, is curiously only listed once in Fluxus publications and then by implication, as a publication of Implosions, a commercial branch of Fluxus started by Maciunas, Robert Watts, and Herman Fine. The work was not signed. It has the image of death in place of stars, and calculations about genocide in place of stripes. The poster was widely distributed, and is illustrated in books on political posters from that era. I think that Maciunas particularly wanted the poster to be anonymous so that its impact would be seen for itself, not because of a name associated with it. On the poster, one is invited to send for calculations and references to "p.o. box 180, New York, NY 10012" (the Fluxus postal box). One would have received an essay with calculations titled* U.S. Surpasses All Nazi Genocide Records, *with Maciunas' name printed on it.*

VENDING MACHINES see:
DISPENSERS

VENUS DE MILO APRON
Silverman No. 250

"...You could do the following yet:...Apron design.-(Collective projects) on paper disposable apron. That's

a project we may make some money, by selling it to large beer company, to be used as premium. Got already some designs: (all these are full size to match wearer of apron.)...Photo of Greek...statue..."
Letter: George Maciunas to Ken Friedman, [ca. February 1967].

FLUX-PROJECTS PLANNED FOR 1967...Bob Watts:...Paper aprons:...fronts of famous statues - matching full size (in collaboration with G.M.) - Venus de Milo...
Fluxnewsletter, March 8, 1967.

FLUXPROJECTS FOR 1969...Vinyl aprons:...Maciunas - Venus de Milo...
Fluxnewsletter, December 2, 1968.

CANON...Priest's 2nd turn: Venus de Milo front
Outline of Flux-Mass. [February 17, 1970].

FEB. 17, 1970: FLUX - MASS BY GEORGE MACIUNAS...COMMUNION: priest with chasuble front as Venus de Milo offers to congregation cookies...
all photographs copyright nineteen seVenty by peTer mooRE (Fluxus Newspaper No. 9) 1970.

PROPOSED CONTENTS FOR FLUXPACK 3 TO BE PUBLISHED IN 1973 BY FLASH ART Vinyl aprons ...Venus de Milo by Maciunas...Cost Estimates: for 1000 copies...aprons $500 [2 designs] ...100 copies signed by:...Maciunas...
[George Maciunas], Proposed Contents for Fluxpack 3. [ca. 1972].

"...to produce the Flash Art FLUXPACK 3...Aprons: ...Venus de Milo by Maciunas..."
Letter: George Maciunas to Giancarlo Politi, n.d. Reproduced in Fluxnewsletter, April 1973.

"...could be produced cheaper in Italy...vinyl fabric aprons with various fronts (...Venus de Milo...)"
Letter: George Maciunas to Daniela Palazzoli, n.d. Reproduced in Fluxnewsletter, April 1973.

Flash Art editor, Giancarlo Politi, proposed to publish the 3rd Fluxyearbook, maybe to be called FLUXPACK 3, with the following preliminary contents:... Wear items: vinyl aprons (...Venus de Milo torso by Maciunas)...
Fluxnewsletter, April 1973.

OBJECTS AND EXHIBITS...1967:...photo aprons (venus de milo...)...
George Maciunas Biographical Data. 1976.

OBJECTS AND EXHIBITS...1975:...contributed... 2 aprons...published by Multipla, Milan...
ibid.

COMMENTS: This vinyl apron is included in Fluxpack 3, *distributed by Multipla in Italy. It was an anthology of disposable and wearable Flux items of the sort that Maciunas was*

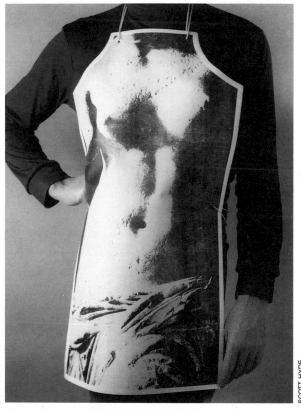

SCOTT HYDE

George Maciunas. VENUS DE MILO APRON

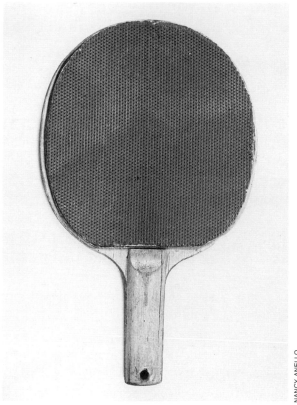

NANCY ANELLO

George Maciunas. VERY HEAVY LEAD RACKET

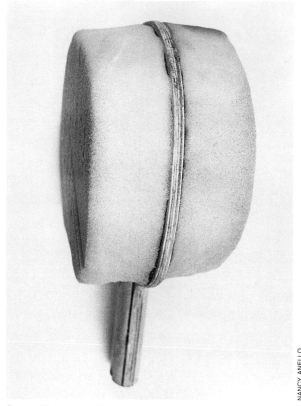

NANCY ANELLO

George Maciunas. VERY SOFT RACKET

planning to produce earlier with *Implosions. Although* Venus de Milo Apron *was first announced as a project of Robert Watts in collaboration with Maciunas, the work was eventually claimed by Maciunas alone.*

VERTICAL LINES MOVING see:
 LINEAR TURN

VERY HEAVY LEAD RACKET
Silverman No. < 258.III

''For the exhibit, I would suggest a flux-ping pong tournament...you can make simple variations on rackets like:...very heavy, lead surface, etc...''
Letter: George Maciunas to David Mayor, n.d. Reproduced in Fluxshoe, 1972.

''...for the Rome exhibit...you could set up a ping pong table with various prepared rackets, such as ... very heavy rackets, etc.''
Letter: George Maciunas to Giancarlo Politi, n.d. Reproduced in Fluxnewsletter, April 1973.

by George Maciunas: ... ping-pong rackets ... lead... etc. ea: [$] 20
Fluxnewsletter, April 1975.

COMMENTS: Very Heavy Lead Rackets *are prepared ping - pong rackets with sheets of lead hidden under their rubberized paddle fronts, apparently normal, but extremely heavy to lift. The idea is taken from earlier weight perception pieces by John Lennon and Yoko Ono, realized at her One Woman Exhibition at the Everson Museum in 1971.*

VERY SOFT RACKET
Silverman No. < 258.VI

FLUXSPORTS (or Fluxolympiad) All items will be brought over....Ping Pong...rackets with foam padding.
Proposed Program for a Fluxfest in Prague. 1966.

PROPOSED FLUXOLYMPIAD RACKET GAMES: ...prepared ping pong:...rackets with extremely soft surfaces,...
Fluxnewsletter, January 31, 1968.

[as above]
Fluxnewsletter, December 2, 1968.

PROPOSED FLUXSHOW FOR GALLERY 669 ... SPORTS - GAME CENTER...prepared ping-pong:... rackets with extremely soft surfaces...
ibid.

PROPOSED FLUXSHOW ... SPORTS-GAME CENTER...Prepared rable tennis: rackets...with extremely soft surfaces...
Fluxnewsletter, December 2, 1968 (revised March 15, 1969).

FLUX-OLYMPIAD ... DUAL CONTEST...Racket... ping-pong...with soft rubber pading [sic] , etc.
Fluxfest at Stony Brook, Newsletter No. 1, August 18, 1969. version A

FLUX-OLYMPIAD...DUAL CONTEST-RACKET... PREPARED PING PONG:...very soft (inflated) rackets, etc.
Flux Fest Kit 2. [ca. December 1969].

''For the exhibit, I would suggest a flux-ping pong tournament...you can make simple variations on rack-

ets like:...very soft foam..."
Letter: George Maciunas to David Mayor, n.d. Reproduced in Fluxshoe, 1972.

"...for the Rome exhibit...you could set up a ping pong table with various prepared rackets, such as... [one] with very soft surface..."
Letter: George Maciunas to Giancarlo Politi, n.d. Reproduced in Fluxnewsletter, April 1973.

PING PONG is played with "prepared" rackets:...soft rackets. G.M.
Fluxfest 77 at and/or, Seattle. September 1977.

COMMENTS: *Commercially produced ping-pong rackets with foam rubber attached on either side, they would absorb the impact of the ping-pong ball so that when hit, the racket would deflect the ball erratically.*

VIRGIN MARY APRON see:
George Maciunas and Robert Watts

VODKA EGGS

NEW YEAR EVE'S FLUX-FEAST, DEC. 31, 1969 AT CINEMATHEQUE, 80 WOOSTER ST....George Maiunas (with Barbara Moore): eggs containing: vodka...
Fluxnewsletter, January 8, 1970.

NEW YEAR EVE'S FLUX-FEST, DEC. 31, 1969... egg shells stuffed with vodka...
all photographs copyright nineteen seVeny by peTer mooRE (Fluxus Newspaper No. 9) 1970.

31.12.1969 NEW YEAR EVE'S FLUX - FEAST (FOOD EVENT)...G. Maciunas: inside eggs: vodka...
George Maciunas, Diagram of Historical Developments of Fluxus... [1973].

OBJECTS AND EXHIBITS...1969:...eggs containing vodka...
George Maciunas Biographical Data. 1976.

COMMENTS: *Vodka Eggs were prepared with Barbara Moore for the New Year's Eve Fluxfest Food Event, 1969.*

WALLPAPER see:
ASSHOLES WALLPAPER
SAFE DOOR

WASHINGTON'S FRONT APRON

FLUX-PROJECTS PLANNED FOR 1967...George Maciunas:...paper aprons: fronts of generals...
Fluxnewsletter, March 8, 1967.

CANON...Priest's 3rd turn: Washington's front.
Outline of Flux-Mass. [February 17, 1970].

FEB. 17, 1970: FLUX-MASS BY GEORGE MACIUNAS...OFFERTORY,...Water to wine: priest with chasuble front as gen. Washington cuts with scissors an inflated superman filled with wine...
all photographs copyright nineteen seVenty by peTer mooRE (Fluxus Newspaper No. 9) 1970.

COMMENTS: *Washington's Front Aprons were planned first as disposable paper aprons but were never produced. Later, the idea was used for a costume during Flux Mass at Douglass College.*

WATER see:
FLUXWATER

WATER DUMPLINGS

FLUX FOODS AND DRINKS ... DUMPLING VARIATIONS: One of the fillings:...water,...(G.M.)
Flux Fest Kit 2. [ca. December 1969].

COMMENTS: *An inverted wonton soup.*

WATER EGGS

PROPOSED FLUXSHOW FOR GALLERY 669 ... FOOD CENTER: ... Empty egg shells: filled with water ...
Fluxnewsletter, December 2, 1968.

PROPOSED FLUXSHOW...[as above]
Fluxnewsletter, December 2, 1968 (revised March 15, 1969).

PROPOSED FLUX DRINKS & FOODS FLUX EGGS emptied egg shells filled with...water...
Fluxfest at Stony Brook, Newsletter No. 1, August 18, 1969. versions A and B

FLUX DRINKS & FOODS FLUX EGGS emptied egg shells filled with...water...(G. Maciunas)..
Invitation to Participate in New Year Eve's Flux-Feast. [ca. December 1969].

FLUX FOODS AND DRINKS FLUX EGGS: Emptied egg shells filled with...water...(George Maciunas)
Flux Fest Kit 2. [ca. December 1969].

COMMENTS: *The visual impact of breaking open an egg and having water spill out must have been quite revolting.*

WATER LIGHT BOX

FLUX SHOW: DICE GAME ENVIRONMENT ENTIRE FLOOR AS DICE HAZARD TABLE DIE CUBES, 15" CUBES ON FLOOR, Marked on sides, top open or closed with clear plastic. Consisting or containing...Water light box by George Maciunas...
Flux Fest Kit 2. [ca. December 1969].

COMMENTS: *Maciunas was experimenting with display installations for Fluxus works, using 15" die cubes — like giant dice scattered hazardously around the exhibition floor. Some of these cubes are illuminated from underneath, and perhaps Water Light Box was a die cube containing water and something else, illuminated from below with a light. I don't know whether this work was ever made.*

WATER SOLUBLE CUP DISPENSER

PROPOSED FLUXSHOW...AUTOMATIC VENDING MACHINES-DISPENSERS (coin operated)...drink dispenser dispensing water...into a water soluble cup.
Fluxnewsletter, December 2, 1968 (revised March 15, 1969).

AUTOMATIC VENDING MACHINES ... Drink dispenser dispensing drink with...water soluble cup...
Flux Fest Kit 2. [ca. December 1969].

MAY 30-JUNE 5: THE STORE BY JOHN & YOKO + FLUXFACTORY Coin operated vending machines: ...drink dispenser dispensing drink with water soluble ...cup (G.M.)...
Schedule of events for Fluxfest presentation of John Lennon and Yoko Ono. [ca. April 1970]. version B

MAY 30-JUNE 5: THE STORE BY YOKO + FLUXFACTORY Vending machines (coin operated): ... drink dispenser dispensing frink [sic] with...water soluble cup...
Schedule of events for Fluxfest presentation of John Lennon and Yoko Ono. April 1, 1970. version C

"...could be produced cheaper in Italy:...paper cup made from paper that dissolves in water..."
Letter: George Maciunas to Daniela Palazzoli, n.d. Reproduced in Fluxnewsletter, April 1973.

COMMENTS: *Water Soluble Cup Dispenser was never made. However, the idea would have been to put money in the slot and as soon as the liquid gets in the cup, disintegration begins.*

WHEEL see:
GIANT WHEEL

WHITE GELATIN EGGS

PROPOSED FLUX DRINKS & FOODS FLUX EGGS emptied egg shells filled with...white jellatin [sic]...
Fluxfest at Stony Brook, Newsletter No. 1, August 18, 1969. versions A and B

FLUX DRINKS & FOODS FLUX EGGS emptied egg shells filled with ... white jellatin [sic] ... (G. Maciunas)...
Invitation to Participate in New Year Eve's Flux-Feast. [ca. December 1969].

FLUX FOODS AND DRINKS FLUX EGGS: Emptied egg shells filled with ... white jellatin [sic] ... (George Maciunas)
Flux Fest Kit 2. [ca. December 1969].

COMMENTS: *Blown eggs filled with white gelatin, giving the appearance of a totally white, gelatinous, yolkless egg when opened.*

WHITE PAINT EGGS see:
PAINT EGGS

WIN

FLUX-PRODUCTS 1961 TO 1970 ... GEORGE MACIUNAS...Flags: 28'' square, sewn legends: ... win... ea: [$] 60...
Flux Fest Kit 2. [ca. December 1969].

COMMENTS: *Win, intended as a flag, is not known to have been made by Maciunas as a Fluxus Edition.*

WINE EGGS

NEW YEAR EVE'S FLUX-FEAST, DEC. 31, 1969 AT CINEMATHEQUE, 80 WOOSTER ST. ...George Maciunas (with Barbara Moore): eggs containing ... wine...
Fluxnewsletter, January 8, 1970.

NEW YEARS EVE'S FLUX-FEST, DEC. 31, 1969... egg shells stuffed with...wine...
all photographs copyright nineteen seVenty by peTer mooRE (Fluxus Newspaper No. 9) 1970.

COMMENTS: *Similar in concept to* Vodka Eggs, Wine Eggs *were blown eggs that were filled with wine and then sealed. A number of other eggs were prepared by George Maciunas and Barbara Moore at the New Year's Eve Flux Fest, and some of the ideas could have come from her.*

WINGED VICTORY APRON see:
George Maciunas and Robert Watts

WOOD GLUED TO SURFACE RACKET

"...By the way I don't think I ever described to you the FLUXUS OLYMPIC Games...What we did was prepare various implements as follows. Ping Pong. ... Racket with various pieces of wood glued to surface like this — so the ball would bounce into wrong directions. etc. etc. ..."
Letter: George Maciunas to Ben Vautier, February 1, 1965.

COMMENTS: *A ping-pong racket with cubes of wood or angled bits of wood glued to the surface of the racket, deflecting the ball in erratic directions.*

WOOD TEA

FLUX DRINKS & FOODS...TEA VARIATIONS ... tea made from boiling: wood...(G. Maciunas)...
Invitation to Participate in New Year Eve's Flux-Feast. [ca. December 1969].

FLUX FOODS AND DRINKS...TEA VARIATIONS: tea made from boiling: wood,...(George Maciunas)
Flux Fest Kit 2. [ca. December 1969].

NEW YEAR EVE'S FLUX-FEAST, DEC. 31, 1969 AT CINEMATHEQUE, 80 WOOSTER ST. ... George Maciunas:...wood...tea
Fluxnewsletter, January 8, 1970.

NEW YEARS EVE'S FLUX-FEST, DEC. 31, 1969... wood...teas by George Maciunas
all photographs copyright nineteen seVenty by peTer mooRE (Fluxus Newspaper No. 9) 1970.

31.12.1969 NEW YEAR EVE'S FLUX-FEAST (FOOD EVENT)...G. Maciunas:...wood...tea.
George Maciunas, Diagram of Historical Developments of Fluxus... [1973].

PERFORMANCE COMPOSITIONS...1969: 2nd flux-food event (funny foods) contributed...wood tea...
George Maciunas Biographical Data. 1976.

COMMENTS: Wood Tea *was made by pouring boiling water over wood for a Fluxus food event in 1969. The improbable becomes plausible if sassafras, cinnamon, or other aromatic wood is used.*

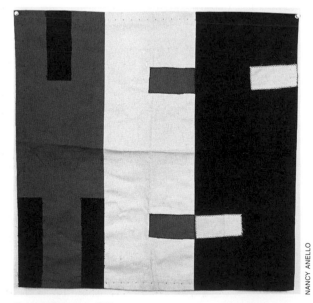

George Maciunas. YES

NANCY ANELLO

WOOL TEA

FLUX DRINKS & FOODS ... TEA VARIATIONS... tea made from boiling:...wool...(G. Maciunas)...
Invitation to Participate in New Year Eve's Flux-Feast. [ca. December 1969].

FLUX FOODS AND DRINKS...TEA VARIATIONS: Tea made from boiling:...wool,...(George Maciunas)
Flux Fest Kit 2. [ca. December 1969].

COMMENTS: *Another tea variation, it is not known to have been made.*

WORMS STICK-ONS

PROPOSED CONTENTS FOR FLUXPACK 3 TO BE PUBLISHED IN 1973 BY FLASH ART...Stick-ons ...worms by Maciunas...Cost Estimates: for 1000 copies ... stick-ons [5 designs] $500 ... 100 copies signed by:...Maciunas...
[George Maciunas], Proposed Contents for Fluxpack 3. [ca. 1972].

COMMENTS: *These stick-ons were not made.*

George Maciunas. YOKO ONO MASK

YES

Silverman No. < 258.IX

FLUX-PRODUCTS 1961 TO 1970 ... GEORGE MA-
CIUNAS...Flags: 28'' square, sewn legends:...yes...
ea: [$] 60...
Flux Fest Kit 2. [ca. December 1969].

COMMENTS: Yes, *made as a Fluxus Edition flag, can be seen
either as a companion to Maciunas'* No, *or as a work alone.*

YOKO ONO MASK

Silverman No. 262

OPENING: APR. 11, 4PM. COME IMPERSONATING
JOHN & YOKO (photo-masks will be provided to
anyone not impersonating.)...
*Schedule of events for Fluxfest presentation of John Lennon
and Yoko Ono. [ca. April 1970]. version A*

FLUXFEST PRESENTATION OF JOHN LENNON
& YOKO ONO+* AT 80 WOOSTER ST. NEW YORK
-1970 OPENING: APR. 11, 4PM COME IMPERSON-
ATING JOHN & YOKO (Photo-masks were provided)
*all photographs copyright nineteen seVenty by peTer mooRE
(Fluxus Newspaper No.9) 1970.*

FLUXFEST PRESENTATION OF JOHN LENNON
& YOKO ONO...APR. 11-17 DO IT YOURSELF —
BY JOHN & YOKO + EVERYBODY...Yoko Ono
mask...
ibid.

*COMMENTS: A photo-offset image of Yoko Ono's face, cut
in the shape of a mask and distributed at the time of the Flux
Fest Presentation of John Lennon and Yoko Ono in 1970.*

YOUR NAME SPELLED WITH OBJECTS

Silverman No. 271, ff.

1972 ... MACIUNAS: ... your name spelled with ob-
jects...
*George Maciunas, Diagram of Historical Developments of
Fluxus... [1973].*

by George Maciunas:...Your name, spelled out with
objects: $20...
Fluxnewsletter, April 1975.

"GM - name box - gift"
*Letter: George Maciunas to Dr. Hanns Sohm, November 30,
1975.*

...Your name by Maciunas $20...
[Fluxus price list for a customer]. January 7, 1976.

GEORGE MACIUNAS...Spell your name, 1972 $40...
Flux Objects, Price List. May 1976.

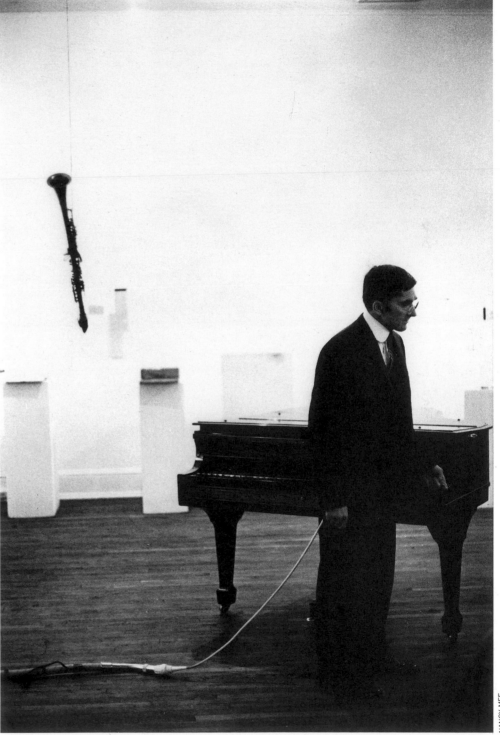

George Maciunas in performance at the Fluxfest at and/or. Seattle, Washington, 1977

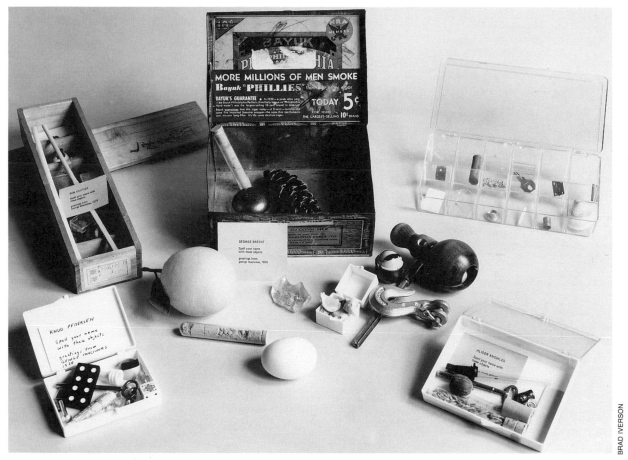

George Maciunas. YOUR NAME SPELLED WITH OBJECTS. Left to right: Kund Pedersen, Ben Vautier, George Brecht, Dick Higgins and Alison Knowles. see color portfolio

BRAD IVERSON

OBJECTS AND EXHIBITS...1972: names spelled with objects...
George Maciunas Biographical Data. 1976.

COMMENTS: Maciunas, in deciding which ideas to produce as Fluxus Editions, would frequently reject proposals that he saw as too similar to another artist's ideas. On the other hand, he himself would sometimes appropriate or expand on other artists' ideas. One example is "Name Kit Box" Your Name Spelled with Objects *(Silverman No. 271, ff.) which is preceded by George Brecht's* Games & Puzzles/Name Kit *"Spell Your Name" (Silverman No. 61, ff.) But whereas Brecht's* Name Kit *is a "mind game," Maciunas' objects are concrete and stand for the letters in a person's name.*

ZIPPERS see:
FLUXWEAR 304

GEORGE MACIUNAS and LARRY MILLER

BOXING GLOVE DOOR

boxing glove
Instruction drawing for Fluxlabyrinth, Berlin. [ca. August 1976]. version A

"Door (Boxing Glove)/ materials yet needed: Boxing Glove Bob or you should design this. If we must buy 2 gloves to get one, then we should design it to use both gloves. Maybe one for head and one for groin. I suggest left handed door - pulling to open bringing gloves into position. Perhaps they should stop at door plane, so no one with glasses or soft groin is hurt."
Notes: Larry Miller to George Maciunas concerning the Fluxlabyrinth, Berlin. [ca. August 1976].

COMMENTS: This combative piece seems in certain respects like a work of Ben Vautier who once during a performance threateningly approached the audience swinging a hatchet. Boxing Glove Door *could also be by Robert Watts, although more probably it was by George Maciunas who wrote two boxing pieces, "Boxing Gloves on Lock Sticks" and "Boxing at Balloons." Larry Miller explained to me that* Boxing Glove Door *was by him and Maciunas. The boxing glove was changed to a swinging ball on a pendulum in the* Fluxlabyrinth.

KNOB AT HINGES DOOR

Any proposals from participants should fit the maze format...Ideas should relate to passage through doors, steps, floor, obstacles, booths ... door with knob at hinges...
George Maciunas, Further Proposal for Flux-Maze at Rene Block Gallery. [ca. Fall 1974].

door with knob at hinges
Plan of completed Fluxlabyrinth, Berlin. [ca. September 1976].

COMMENTS: I don't know whose concept this is. It doesn't relate to any other particular Fluxus work that I can think of, but it does have to do with changing one's perception of the normal function of things, as many Fluxus works do. Larry Miller, in conversation with me about the Fluxlabyrinth, *stated that this was a joint work of his and Maciunas'.*

PENDULUM see:
BOXING GLOVE DOOR
SWINGING BALL DOOR see:
BOXING GLOVE DOOR

270 DEGREE DOOR

this revolving or 270 degree door must be opened 270 degrees to permit anyone to enter
Instruction drawing for Fluxlabyrinth, Berlin. [ca. August 1976]. version A

"Enclosed is the final plan of labyrinth ... the next door I call 270 degree door. To open it, or rather to pass through it, one has to walk back 270 degrees, because otherwise there is no room to pass it, through it one enters my own passageway..."
Letter: George Maciunas to Rene Block, [ca. Summer 1976].

"Door (270°) I have materials + solution for this. Installation on Monday."
Notes: Larry Miller to George Maciunas concerning the Fluxlabyrinth, Berlin, [ca. August 1976].

this door swinging 270 degrees, must be opened 270 degrees to permit anyone to enter. While opening it, the beach ball is lifted and set in a magnetic catch to

be released by the next visitor...this door releases a catch causing a beach ball to swing on a pendulum and hit the face of the visitor.
Plan of completed Fluxlabyrinth, Berlin. [ca. September 1976].

COMMENTS: *Designed to function as a cock for* Boxing Glove Door, *the idea for* 270 Degree Door *was originally George Maciunas'. It became a collaborative project in Berlin while being built, and was altered to a ball and pendulum.*

GEORGE MACIUNAS and YOKO ONO

20 LB RUBBER BOOTS

MAY 9-15: WEIGHT & WATER BY JOHN & YOKO + FLUXFAUCET Store flooded with water to about 1'' height...Visitors would be provided with rubber boots weighed down to up to 20lbs. (By Yoko + G. Maciunas)

Schedule of events for Fluxfest presentation of John Lennon and Yoko Ono. [ca. April 1970]. version A

MAY 9-15: store floor flooded with water to about 1'' height. Visitors either barefooted or provided with rubber boots with weights (Yoko + Maciunas)...
Schedule of events for Fluxfest presentation of John Lennon and Yoko Ono. [ca. April 1970]. version B

COMMENTS: *These two artists collaborated on many projects together, which at times caused bitter friction but produced an amazing body of work. The Fluxus works that grew out of this collaboration have been listed under either George Maciunas or Yoko Ono, whoever the piece is attributed to. Maciunas also designed and realized many Yoko Ono and John Lennon works for her one woman show at the Everson Museum in 1971. That exhibition is a clear extension of Fluxus, and ideas overlap with Fluxus in numerous ways.* 20 lb Rubber Boots *evolves into works at the Everson show, and later into Maciunas'* Very Heavy Lead Racket.

George Maciunas and Larry Miller. BOXING GLOVE DOOR. Instruction drawing by George Maciunas for installation in FLUXLABYRINTH. Berlin, 1976

SCOTT HYDE

GEORGE MACIUNAS and BEN VAUTIER

SCAR STICK-ONS

FLUX-PROJECTS PLANNED FOR 1967 ... George Maciunas:...plastic stick-ons (disposable jewelry): ... scars, (in collaboration with Ben Vautier),...
Fluxnewsletter, March 8, 1967.

FLUXPROJECTS FOR 1969 PRODUCTS - PUBLICATIONS...Stick-ons:...scars...
Fluxnewsletter, December 2, 1968.

COMMENTS: *Ben Vautier does not recall works with scars. Perhaps Maciunas thought that Ben should have. These stick-ons were not made. See:* Anonymous Disease Stick-ons.

GEORGE MACIUNAS and ROBERT WATTS

APRONS see:
 MEDIEVAL ARMOR APRON
 POPE MARTIN V APRON
 ROMAN EMPEROR APRON
 VENUS DE MILO APRON
 VIRGIN MARY APRON
 WINGED VICTORY APRON
CITROEN see:
 PHOTO DOORS AND ROOF FOR CITROEN

MEDIEVAL ARMOR APRON

FLUX-PROJECTS PLANNED FOR 1967 ... Bob Watts:...Paper aprons:...fronts of famous statues - matching full size (in collaboration with G.M.)...Medieval armor...etc.
Fluxnewsletter, March 8, 1967.

COMMENTS: *Preliminary work exists for a* Medieval Armor Apron, *but it was never completed. This idea reflects Maciunas' interest in Medieval history, which turns up in such works as* Historical Boxes *and cabinets with medieval hasps and hinges.*

PAPER APRONS

NEWS FROM IMPLOSIONS, INC....Planned in 1968: ...Paper aprons (described in 1967 flux-newsletter) 12 designs ready for production
Fluxnewsletter, January 31, 1968.

COMMENTS: *This is a general listing for a type of apron planned.*

PHOTO DOORS AND ROOF FOR CITROEN

FLUXPROJECTS FOR 1969...Maciunas & Watts:

GEORGE MACIUNAS

George Maciunas and Robert Watts. PHOTO DOORS AND ROOF FOR CITROEN. The car used for the project

photo doors and roof for citroen.
Fluxnewsletter, December 2, 1968.

COMMENTS: Maciunas and Watts considered the Citroen 2CV to be an ideal car in terms of efficiency and design. Maciunas discussed the car in Appendix 4 of Communists Must Give Revolutionary Leadership in Culture, and during this period, Watts purchased one of these cars. Although a number of photos of the Citroen were in the Maciunas Estate, which is now in the Silverman Collection, a finished work does not exist.

POPE MARTIN V APRON

FLUX-PROJECTS PLANNED FOR 1967 ... Bob Watts:...Paper aprons:...fronts of famous statues - matching full size (in collaboration with G.M.) ... Martin V (pope) etc.
Fluxnewsletter, March 8, 1967.

COMMENTS: Just another iconoclastic design idea for an apron not made.

ROMAN EMPEROR APRON

"...You could do the following yet:...Collective projects - Apron design. - on paper disposable apron. That's a project we may make some money, by selling it to large beer company, to be used as premium. Got already some designs:...all these are full size to match wearer of apron. - Photo of...Roman statue..."
Letter: George Maciunas to Ken Friedman, [ca. February 1967].

FLUX-PROJECTS PLANNED FOR 1967 ... Bob Watts:...Paper aprons:...fronts of famous statues - matching full size (in collaboration with G.M.) -...Roman Emperor...etc.
Fluxnewsletter, March 8, 1967.

COMMENTS: Preliminary work exists, but finished aprons were never made.

VENUS DE MILO APRON see:
George Maciunas

VIRGIN MARY APRON

FLUX-PROJECTS PLANNED FOR 1967 ... Bob Watts:...Paper aprons:...fronts of famous statues - matching full size (in collaboration with G.M.) -...Virgin Mary...etc.
Fluxnewsletter, March 8, 1967.

COMMENTS: This work reflects Fluxus' attitude toward religion.

WINGED VICTORY APRON

FLUX-PROJECTS PLANNED FOR 1967 ... Bob Watts:...Paper aprons:...fronts of famous statues - matching full size (in collaboration with G.M.) ... Winged victory...etc.
Fluxnewsletter, March 8, 1967.

COMMENTS: Winged Victory Apron was never produced as a Fluxus Edition. The idea is an example of Fluxus' position on art and functionalism.

ANGUS MAC LISE

It was announced in the Brochure Prospectus, version B, that Angus Mac Lise would contribute "Calender" [sic], "The Doubletake Walk" to FLUXUS NO. 1 U.S. YEARBOX.
see: COLLECTIVE

YEAR

Year by angus mac lise, a wednesday paper supplement printed by the dead language new york 56 ludlow street...$1
Yam Festival Newspaper, [ca. 1963].

YEAR The new universal solar calendar Handwritten copies $1 from Angus Mac Lise 516 E. 5th St. New York, N.Y.
Sissor Bros. Warehouse Newspaper, [1963].

YEAR The new univeral solar calendar, Handwritten copies: $1 printed copies: 50 cents. Angus MacLise, 516 E. 5th Street
cc V TRE (Fluxus Newspaper No. 1) January 1964.

COMMENTS: Angus Mac Lise was a mystical poet and innovative book artist. He was a close friend of several Fluxus artists. I believe Maciunas arranged the printing of both Year *and* Calendar *which are facsimiles of Mac Lise's holographic designed texts.*

GEORGE MACIUNAS

Jackson Mac Low, posing as Edward Eggleston in his play, Verdurous Sanguinaria, performed at Yoko Ono's loft in April, 1961. The photograph was used on an announcement for Maciunas' AG Gallery that June and again for FLUXUS 1

JACKSON MAC LOW

It was announced in the first three tentative plans for FLUXUS NO. 1 U.S. ISSUE that Jackson Mac Low would contribute "Letters for Iris Numbers for Silence" and a work to be determined, "(card)." Later, his planned contribution to FLUXUS NO. 1 U.S. YEARBOX, as announced in Brochure Prospectus version A, was to be:
 "Letters for Iris numbers for silence"
 "From Nuclei III"
 "Punctuation mark numbers"
 "Tree Movie"
 "Rush Hour"
 "One Hundred"
 "A little Dissertation concerning"
 "Mississippi & Tennessee for Iris"
 "A story for Iris Lezak"
 "3 Drawings-Asymmetries"
This contribution, as announced in Brochure Prospectus version B, was amended to be:
 "Letters for Iris numbers for silence"
 "From Nuclei III"
 "Punctuation mark numbers"
 "One Hundred"
 "Machault"

"the 3rd. biblical poem & foreword"
"Rush Hour & introduction"
"Tree Movie"
"Thanks I & II"
"Piano Suite for David Tudor & John Cage"
"On the concern with the new"

Two "Vocabularies," "Thanks II," and "Letters for Iris Numbers for Silence" are included in FLUXUS 1. "Piano Suite for David Tudor & John Cage" and "Tree Movie" were published in Fluxus Newspaper No. 1. "One Hundred" and "Punctuation Mark Numbers," along with a riddle poem, were published in Fluxus Newspaper No. 2. Three "Social Projects" appear in Fluxus Preview Review.

COLLECTIVE WORKS

In addition to Fluxus Year Boxes the following special editions [are] planned. These are editions of works by single composers, poets, artists or what you like...Jackson Mac Low collective works (late 1963)...
Fluxus Newsletter No. 4, fragment, [ca. October 1962].

COMMENTS: Collective Works *were never published by Fluxus, perhaps because of a clarification of Fluxus' aesthetic and political attitude which occurred in late 1962 and 1963, and differed in subtle, and some not so subtle ways from Mac Low's. In* Fluxus Newsletter No. 6 (April 1963) *Maciunas and others proposed "sabotage" art actions for New York Fluxus. Mac Low responded in* Fluxus Newsletter No. 7, May 1, 1963:

"Integration of Fluxus festival with political activites such as:
Support of a). Strikers & locked-out workers
 b). Walks for peace
Denunciation & agitation against:
 a). War in Vietnam
 b). U.S. agression [sic] towards Cuba
 c). Nuclear testing
 d). Racial segregation & discrimination
 e). Capital punishment etc. etc. etc....
In General: association with positive social actions & activities, never with antisocial, terroristic activities such as sabotage activities proposed in newsletter 6."

As Fluxus grew, its position, and especially Maciunas', became a synthesis of the earlier "sabotage" ideas and Mac Low's "positive" program.

LETTERS FOR IRIS NUMBERS FOR SILENCE
Silverman No. 117, ff.

"...I will send soon more material...Some photos, and Jackson Mac Low cards for 'Letters for Iris'..."
Letter: George Maciunas to Willem de Ridder, February 4, 1965.

COMMENTS: *Contained in most copies of* FLUXUS 1, *the work has the feeling of later Fluxus boxed editions.*

TREE MOVIE

Tree* Movie
Select a tree*. Set up and focus a movie camera so that the tree* fills most of the picture. Turn on the camera and leave it on without moving it for any number of hours. If the camera is about to run out of film, substitute a camera with fresh film. The two cameras may be alternated in this way any number of times. Sound recording equipment may be turned on simultaneously with the movie cameras. Beginning at any point in the film, any length of it may be projected at a showing.
*) for the word "tree", one may substitute "mountain", "sea", "flower", "lake", etc. Jackson Mac Low ...N.Y. January, 1961
cc V TRE (Fluxus Newspaper No. 1) January 1964.

"P.S. You could now easily make a FLUXUS film festival with 4 films:...Jackson Mac Low - Tree movie. - just film from tripod a tree for an hour or so..."
Letter: George Maciunas to Ben Vautier, July 21, 1964.

COMMENTS: Tree Movie *is the conceptual precursor to Andy Warhol's* Empire State *and* Sleep, *and is related to minimalist works of the 1960s and 70s.*

MANTOVANI

It was announced in some of the tentative plans for the first issues of FLUXUS that Mantovani would contribute "long scroll (fold out)" to FLUXUS NO. 2 WEST EUROPEAN YEARBOOK 1.
see: COLLECTIVE

YORIAKI MATSUDAIRA

CO-ACTION FOR CELLO AND PIANO I
Silverman No. > 327.101, ff.

Scores available by special order:...Yoriaki Matsudeira [sic]: Co-Action for Cello and Piano I, 10 sheets, $2.00
Fluxus Preview Review, [ca. July] 1963.

Yoriaki Matsudaira. CO-ACTION FOR CELLO AND PIANO I. Piano part 3 of the score is illustrated. Holograph drawing by George Maciunas for the Fluxus Edition

P-1 YORIAKI MATSUDEIRA [sic]: "Instruction of co-action for cello and piano I score: 10 sheets $2.00
European Mail-Orderhouse: europeanfluxshop, Pricelist. [ca. June 1964].

P-1 YORIAKI MATSUDEIRA [sic]: Instructions of co-action for cello and piano. score/ 10 sheets $2.
Second Pricelist - European Mail-Orderhouse. [Fall 1964].

COMMENTS: *The work consists of an introduction sheet and 10 sheets of scores. The words "© FLUXUS 1963" appear on each sheet, except the introduction. A "blueprint" copy and a "blueprint negative," as well as the original hand-drawn score by George Maciunas for the Fluxus Editions are in the Silverman Collection.*

RICHARD MAXFIELD

It was announced in the tentative plans for the first issues of FLUXUS that Richard Maxfield would contribute "Music without Score" and an untitled record, later called "Night Music (?) (to be determined)" to FLUXUS NO. 1 U.S. ISSUE. The listing in the Brochure Prospectus version A dropped the record. Then in version B of the Prospectus, the record is offered again, but only in the 'luxus fluxus.' He was also to contribute "Oscillographic studies of some ancient musical instr[uments]" to FLUXUS NO. 4 HOMAGE TO THE DISTANT PAST. Plans for this contribution were dropped in the Brochure Prospectus. Performance instructions for Maxfield's "SYMPHONY NO. 1" appear in Flux Fest Kit 2.
see: COLLECTIVE

Unidentified Audio Tapes

FLUXUS SPECIAL EDITIONS 1963-4...FLUXUS o. RICHARD MAXFIELD: tapes by special order
Fluxus Preview Review, [ca. July] 1963.

[as above]
Daniel Spoerri, L'Optique Moderne. List on editorial page. 1963.

[as above]
La Monte Young, LY 1961. Advertisement page. [1963].

22-fo RICHARD MAXFIELD: tapes (by special order) prices on request.
European Mail-Orderhouse: europeanfluxshop, Pricelist. [ca. June 1964].

COMMENTS: *These unidentified tapes are not known to have been produced by George Maciunas as a Fluxus Edition, although Maciunas must have had tapes by Maxfield which he used in Fluxus concerts at that time. An amusing counterpoint to this entry is George Maciunas'* Homage to Richard Maxfield *— a score that perhaps explains why there isn't a Fluxus Edition of Maxfield's audio tapes.*

ADOLFAS MEKAS

BOREDOM I & II

In addition to Fluxus Year Boxes the following special editions [are] planned. These are editions of works by single composers, poets, artists or what you like...Adolfas Mekas "Boredom I & II"...(1962 issue)
Fluxus Newsletter No. 4, fragment, [ca. October 1962].

FLUXUS SPECIAL EDITIONS 1963-4...FLUXUS j. ADOLFAS MEKAS:...BOREDOM $4
Fluxus Preview Review, [ca. July] 1963.

[as above]
Daniel Spoerri, L'Optique Moderne. List on editorial page. 1963.

[as above]
La Monte Young, LY 1961. Advertisement page. [1963].

F-j ADOLFAS MEKAS:..."boredom" $4
European Mail-Orderhouse: europeanfluxshop, Pricelist. [ca. June 1964].

COMMENTS: *Adolfas Mekas is a film maker and the brother of Jonas Mekas.* Boredom I & II *was never made as a Fluxus Edition.*

QUIRITARE HUMANA

In addition to Fluxus Year Boxes the following special editions [are] planned. These are editions of works by single composers, poets, artists or what you like...Adolfas Mekas..."Quiritare Humana" (1962 issue)
Fluxus Newsletter No. 4, fragment, [ca. October 1962].

FLUXUS SPECIAL EDITIONS 1963-4...FLUXUS j. ADOLFAS MEKAS: QUIRITARE HUMANA $3...
Fluxus Preview Review, [ca. July] 1963.

[as above]
Daniel Spoerri, L'Optique Moderne. List on editorial page. 1963.

[as above]
La Monte Young, LY 1961. Advertisement page. [1963].

F-j ADOLFAS MEKAS: "quiritare humana" $3...
European Mail-Orderhouse: europeanfluxshop, Pricelist. [ca. June 1964].

COMMENTS: *There is no evidence that this work was produced by Maciunas as a Fluxus Edition.*

JONAS MEKAS

It was announced in the initial three tentative plans for the first issues of FLUXUS that Jonas Mekas would contribute

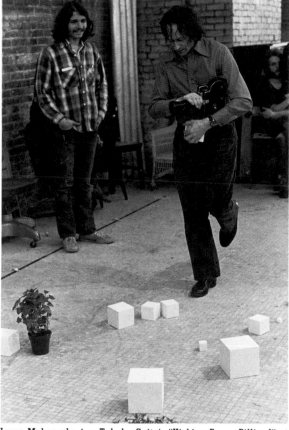

Jonas Mekas playing Takako Saito's "Kicking Boxes Billiard" at the Flux Game Fest. Others not identified. New York City, May, 1973

© 1973 LARRY MILLER

"Experiments in cinema - U.S.A." and edit an "Anthology of statements" for FLUXUS NO. 1 U.S. ISSUE (later called U.S. YEARBOX). These contributions are changed in Brochure Prospectus version B to "A press release," and "American Film poets." Mekas was also going to edit sections on "Experiments in Cinema" for FLUXUS NO. 2 WEST EUROPEAN ISSUE 1, later called FLUXUS NO. 2 GERMAN & SCANDINAVIAN YEARBOX; FLUXUS NO. 3 JAPANESE ISSUE; FLUXUS NO. 5 WEST EUROPEAN ISSUE II; and FLUXUS NO. 6 EAST EUROPEAN ISSUE, later called FLUXUS NO. 7 EAST EUROPEAN YEARBOX.

Unfortunately, none of these essays appear in Fluxus publications. The only work attributed to Mekas to be published by Fluxus appears in Fluxus Preview Review, *and is a sardonic put-down of Hollywood films. Jonas Mekas is the long time editor of* Film Culture *and founder and director of Anthology Film Archives in New York City. George Maciunas had a very close relationship with Mekas. He designed a number of issues of* Film Culture, *as well as the space for Anthology Film Archives in one of the Fluxhouses.*
see: COLLECTIVE

Lydia Mercedes. **TOPLESS BATHING SUIT** modeled by Annajanga

© [ca. 1965] PAUL VAN DEN BOS

LYDIA MERCEDES

TOP AND BOTTOMLESS BATHINGSUITS

The top - and bottomless bathingsuits are going to be shown on the special fluxus fashion-shows next winter...The bathingsuits are fashioned by LYDIA MERCEDES/ model ANNAJANGA Special photographed at the "Vinkeveense Plassen" in Holland for the EUROPEAN MAIL-ORDERHOUSE & FLUX-SHOP by PAUL VAN DEN BOSCH...
European Mail-Orderhouse, advertisement for clothes, [ca. 1964].

COMMENTS: These bathing suits were very popular at the time, and much in demand. Unfortunately, few original Fluxus Top and Bottomless Bathingsuits survived the ravages of time, although I did see one at a distance during one of my curatorial missions to the beaches of the Cote d'Azure. Despite my pleas, the owner was unwilling to part with it at any cost, so I'm still looking.

HEINZ-KLAUS METZGER

It was announced in the tentative plans for the first issue of FLUXUS that H.K. Metzger would contribute "Cage, Marx, Stirner...Is Anarchism anachronized?" to FLUXUS NO. 2 WEST EUROPEAN YEARBOX 1, later called FLUXUS NO. 3 GERMAN & SCANDINAVIAN YEARBOX. Additionally, in the first plan for FLUXUS NO. 2, he was to contribute "German philosophy after and against Heidegger" and edit "digests of Adorno and Suzuki in Culture/Nature." These two contributions were dropped and in the Brochure Prospectus version A, he was to contribute "Horst Egon Kalinowski" to FLUXUS NO. 2, which was by that time called GERMAN & SCANDINAVIAN YEARBOX. Starting in the second plans for FLUXUS NO. 4 HOMAGE TO THE PAST, later called FLUXUS NO. 5, Metzger was to contribute "Machine Music of Athanasius Kircher" and "Moritz Hauptmann and the musical time."
see: COLLECTIVE

MIROSLAV MILETIC

It was announced in the Brochure Prospectus version B, that Miroslav Miletic would contribute "New music in Yugoslavia" to FLUXUS NO. 7 EAST EUROPEAN YEARBOX.
see: COLLECTIVE

LARRY MILLER

BOXING GLOVE DOOR see:
George Maciunas and Larry Miller

DARK MAZE

"...Dark Maze materials needed: Strobe Flash +

Switching design They have some novaply and masonite at Academie that can be used"
Notes: Larry Miller to George Maciunas concerning the Fluxlabyrinth, Berlin. [ca. August 1976].

Larry Miller's section: labyrinth within a labyrinth, vertical and horizontal passages, all in total darkness except on passing one portion a strobe flash is switched on.
Plan of completed Fluxlabyrinth, Berlin. [ca. September 1976].

COMMENTS: Dark Maze was a labyrinth within a labyrinth, entirely dark, but with an escape hatch for people who got stuck.

DOORS see:
BOXING GLOVE DOOR
KNOB AT HINGES DOOR
MANY KNOBS DOOR
270 DEGREE DOOR

FLUX-WIFE

NEW FLUX OBJECTS...Future new objects by Larry Miller: Flux-wife (inflatable in attache case)
Fluxnewsletter, May 3, 1975.

COMMENTS: Flux-wife, probably a ready-made inflatable sex prop packaged in an attache case, was never produced as a Fluxus Edition. The idea is related to two other unrealized Fluxus works: Ay-O's Human Body or "Tactile Human Body" and Robert Watts' Chick in a Box or "Babe in a Box," and also to Yves Klein's Tactile Sculpture, a box with holes so that one could reach inside to feel a crouching, naked woman.

FRUIT & VEGETABLE CHESS

COMMENTS: Only preliminary sketches exist for this chess idea where it's fruits against the veggies. A preliminary instruction drawing by George Maciunas for the work is reproduced in Fluxus Etc./ Addenda II, p. 248 (Silverman No. > 297.VI). See also Robert Watts' Fruit and Vegetable Sections Stick-ons.

KNOB AT HINGES DOOR see:
George Maciunas and Larry Miller

MANY KNOBS DOOR

Larry Miller's section door with many knobs only one opens door
Instruction drawing for Fluxlabyrinth, Berlin. [ca. August 1976]. version A

"Enclosed is the final plan of labyrinth...Larry Miller's door, which would contain many door knobs, maybe as many as 20 or 30, all turning, but only one actually

Larry Miller at the entrance to FLUXLABYRINTH during construction. Berlin, 1976

LARRY MILLER Orifice flux plugs, 9" x 13" box $100
Flux Objects, Price List. May 1976.

"1975-6 Objects - Larry Miller - Orifice Flux Plugs."
[George Maciunas], Invitation to Paricipate in Flux Summer Fest in South Berkshires. March 4, 1977.

COMMENTS: *This Fluxus Edition is a Pandora's box of objects people use to stick in holes in their bodies.*

PERSPECTIVE STAIR

"Enclosed is the final plan of labyrinth...I know that he [Larry Miller] wants to build a perspective stair (one getting smaller and narrower)..."
Letter: George Maciunas to Rene Block, [ca. Summer 1976].

COMMENTS: *The idea of* Perspective Stair *is based on an* Alice in Wonderland *perception of space. Evidently, the stairs were not built.*

Larry Miller. MANY KNOBS DOOR. Installation in FLUXLABYRINTH. Berlin, 1976

opening the door. He is still designing his section..."
Letter: George Maciunas to Rene Block, [ca. Summer 1976].

"Door - Many Knobs we have all materials"
Notes: Larry Miller to George Maciunas concerning the Fluxlabyrinth, Berlin. [ca. August 1976].

This door has 20 knobs, but only one will open door; door is pivoted along a horizontal central axis
Plan of completed Fluxlabyrinth, Berlin. [ca. September 1976].

COMMENTS: Many Knobs Door *was constructed for* Fluxlabyrinth *in Berlin, 1976.*

ORIFICE FLUX PLUGS
Silverman No. 330, ff.

NEW FLUX OBJECTS: ORIFICE FLUX PLUGS, 1974 BY LARRY MILLER containing various plugs to plug human orifices such as: ear plug, ear wax, earphone, rectal medicine, enema syringe, nose drops, snuff, cotton balls, eye drops, pacifyer [sic], cigar, mouth ball, whistle, glass eye, bullet, plaster finger, etc....
Fluxnewsletter, May 3, 1975.

"The story on the other side is self explanatory. As a result of which I have to have eye surgery, since I hardly see anything with the left eye. In one sense, these hospital expenses to me are a windfall to any collectors of flux-objects. Now with high cost of surgery, I must make more objects and begin to respond to various orders and requests for them. Thus I am sending by mail to you the following...Larry Miller - orifice box [$] 100..."
Letter: George Maciunas to Dr. Hanns Sohm, November 30, 1975.

Orifice plugs by Larry Miller $100 (Dec. 1975 product)
[Fluxus price list for a customer]. January 7, 1976.

"Orifice plugs by Larry Miller $100"
Letter: George Maciunas to Dr. Hanns Sohm, May 1, 1976.

Larry Miller. ORIFICE FLUX PLUGS

Larry Miller. ORIFICE FLUX PLUGS contained in a drawer of FLUX CABINET. see color portfolio

RUBBER NAILS FLOOR

"Enclosed is the final plan of labyrinth...Larry Miller ...also was thinking of floor covered with rubber nails, which may be difficult to obtain..."
Letter: George Maciunas to Rene Block, [ca. Summer 1976].

COMMENTS: *Rubber Nails Floor, an unrealized element for* Fluxlabyrinth, *is Miller's gentle adaptation of Ay-O's Pro-truding Nails Floor which used actual nails in a Fluxus adaptation of the fakir's bed of nails.*

SCORES

COMMENTS: *Several performance instructions by Larry Miller appear in* Flux Fest Kit 2.

SLOW FAN

1975-6 Objects...Larry Miller - slow fan (like clock)
Notes: George Maciunas for the Fluxfest 77 at and/or, Seattle [ca. September 1977].

COMMENTS: *Larry Miller has done a significant body of work with fans, altering their function and our notion of their function. For the "Delayed Flux New Year's Eve Event" at the Clock Tower in New York, April 18, 1976, Miller converted an enormous exterior clock face into a giant Fluxus fan titled,* Flux Winding (Silverman No. > 330.IV, ff.). *Slow Fan was constructed by George Maciunas in Jean Brown's Fluxus room as a counterpoint to his own* Fan Clock.

270 DEGREE DOOR see:
George Maciunas and Larry Miller

Larry Miller installing FLUX WINDING in the Clocktower for the Delayed Flux New Year's Eve Time Event, New York City, April 18, 1976. It is related to SLOW FAN and to FAN CLOCK, a work erroneously credited to George Maciunas

KATE MILLETT

CABINET

FLUX-PROJECTS PLANNED FOR 1967 ... Kate Millet [sic] : ...cabinet...
Fluxnewsletter, March 8, 1967.

COMMENTS: *Cabinet was never built as a Fluxus Edition.*

DINNERWARE
Silverman No. 331

"...Other going projects: ...[Kate Millett] - dishes..."
Letter: George Maciunas to Ken Friedman, [ca. February 1967].

FLUX-PROJECTS PLANNED FOR 1967 ... Kate Millet [sic] Dinnerware.
Fluxnewsletter, March 8, 1967.

FLUX-PRODUCTS 1961 TO 1969...KATE MILLET [sic] Dinner ware, by special order
Fluxnewsletter, December 2, 1968 (revised March 15, 1969).

FLUX-PRODUCTS 1961 TO 1970...KATE MILLET [sic] Dinner ware, each: [$] 100
Flux Fest Kit 2. [ca. December 1969].

COMMENTS: *Dinnerware exists only in prototype for a Fluxus Edition. See also* Photo Laminated Dinner Setting Table Top.

Kate Millett. Prototype for DINNERWARE

Kate Millett standing in **THE CITY OF SAIGON**, an element of her larger environment. **TRAP**. New York. 1967

GEORGE MACIUNAS

DISPOSABLE DISHES & CUPS

IMPLOSIONS INC. PROJECTS...Triple partnership was formed between Bob Watts, Herman Fine and myself [George Maciunas] to introduce into mass market ...money producing products....This business will be operated in commercial manner, with intent to make profits...connection between Fluxus collective and Implosions Inc. has not been clarified yet...we could consider at present Fluxus to be a kind of division or subsidiary of Implosions. Projects to be realized through Implosions: ... Disposable paper ... dishes, cups.
Fluxnewsletter, March 8, 1967.

NEWS FROM IMPLOSIONS, INC....Planned in 1968: ...Disposable...dishes & cups,...Kate Millet [sic] ... ready for production.
Fluxnewsletter, January 31, 1968.

COMMENTS: *These throw-away dishes were not produced. Presumably, they were to be mass-produced versions of Millett's "special order"* Dinnerware.

PHOTO LAMINATED DINNER SETTING TABLE TOP

FLUXFURNITURE TABLETOPS, photo-laminates, vinyl surface, ¾" board, formica edging, metal pedestal...Kate Millet [sic]: dinner setting for 2, 24" x 28", 4 weeks, $90.00...Available in N.Y.C. at Multiples and late in 1967 at FLUXSHOP, 18 GREENE ST.
Fluxfurniture, pricelist. [1967].

FLUX-PRODUCTS 1961 TO 1969...KATE MILLET [sic] Table top, photo laminated on wood, 30" x 30" [$] 120...
Fluxnewsletter, December 2, 1968 (revised March 15, 1969).

FLUX-PRODUCTS 1961 TO 1970...KATE MILLET [sic] Table top, photo laminate, 30" sq. [$] 120
Flux Fest Kit 2. [ca. December 1969].

COMMENTS: *This table top was part of a series of Fluxus photo-laminated table tops using photos of some of Millett's improbable* Dinnerware. *The work was never produced.*

STOOL

"...Other going projects:...Kate Millet [sic]-stool..."
Letter: George Maciunas to Ken Friedman, [ca. February 1967].

FLUX-PROJECTS PLANNED FOR 1967... KATE MILLET [sic] stool (with human-like feet & shoes),...
Fluxnewsletter, March 8, 1967.

IMPLOSIONS INC. PROJECTS...Triple partnership was formed between Bob Watts, Herman Fine and myself [George Maciunas] to introduce into mass market

...money producing products...This business will be operated in commercial manner, with intent to make profits....connection between Fluxus collective and Implosions Inc. has not been clarified yet...we could consider at present Fluxus to be a kind of division or subsidiary of Implosions. Projects to be realized through Implosions:...Low cost furniture (like the stool of Kate Millet [sic])...
Fluxnewsletter, March 8, 1967.

FLUXFURNITURE...CHAIRS Kate Millett: 2 legged stool with shoes, $40.00...Available in N.Y.C. at Multiples and late in 1967 at FLUXSHOP, 18 GREENE ST.
Fluxfurniture, pricelist. [1967].

NEWS FROM IMPLOSIONS, INC....Planned in 1968: ...Stool by Kate Millet
Fluxnewsletter, January 31, 1968.

Kate Millett sitting on STOOL

GEORGE MACIUNAS

FLUX-PRODUCTS 1961 TO 1969...KATE MILLET [sic] 2 legged & shoed stool, by special order only [$] 100
Fluxnewsletter, December 2, 1968 (revised March 15, 1969).

FLUX-PRODUCTS 1961 TO 1970...KATE MILLET [sic] 2 legged & shoed stool, [$] 100
Flux Fest Kit 2. [ca. December 1969].

COMMENTS: Stool *was shown at Kate Millett's furniture show at the Judson Gallery in 1966. The work created quite a stir, and Maciunas, who must have seen the exhibition, wanted to produce Fluxus Editions of several pieces. Unfortunately, only the original and perhaps one or two copies were made — all by the artist.*

TABLE

FLUX-PROJECTS PLANNED FOR 1967 ... Kate Millet [sic] :...table,...
Fluxnewsletter, March 8, 1967.

COMMENTS: *Like* Stool, Table *was exhibited at Millett's Judson Gallery Furniture Show, and was one of her works that Maciunas wanted to produce as a Fluxus Edition. Only the Millett original exists.*

Kate Millett. STOOL

GEORGE MACIUNAS

FRANZ MON

It was announced in the tentative plans for the first issues of FLUXUS *that Franz Mon would contribute "Bernard Schultze" to* FLUXUS NO. 2 WEST EUROPEAN YEAR-BOOK 1 *(later called* FLUXUS NO. 3 GERMAN & SCANDINAVIAN YEARBOX).
see: COLLECTIVE

BARBARA MOORE

CHEESE EGGS see:
George Maciunas
COFFEE EGGS see:
George Maciunas

FLUX COOK POT

1965 PUBLICATIONS, AVAILABLE BY OCTOBER FLUXUSaa BARBARA MOORE, flux cook pot, collection of recipes in a pot, $4
Vacuum TRapEzoid (Fluxus Newspaper No. 5) March 1965.

"...he has tried as hard as he could to duplicate my efforts by asking Fluxus people whom Fluxus publishes to publish with him not me...He has...tried unsuccessfully to pirate Barbara Moore, who is collecting a Flux-cook-book..."
Letter: George Maciunas to Ben Vautier, [ca. Summer 1965].

"...I do not agree that Higgins ... is not competing with Fluxus. There are too many incidents where he offered to publish some piece that was intended for fluxus (like Barbaras cookbook,...)"
Letter: George Maciunas to Ben Vautier, [ca. October 1966].

FLUX-PROJECTS PLANNED FOR 1967 ... Barbara Moore: Flux cook-book-pot.
Fluxnewsletter March 8, 1967.

COMMENTS: *A "cookbook" of Fluxus recipes, packaged in a cooking pot. Unfortunately, this work was never realized as a Fluxus Edition.*

JELLO EGGS

FLUXPROJECTS REALIZED IN 1967: ... Flux-Christmas-meal-event ... Barbara Moore - intact egg shells (except for tiny hole) containing jello instead of egg.
Fluxnewsletter, January 31, 1968.

PROPOSED FLUXSHOW FOR GALLERY 669 ... FOOD CENTER:...Empty egg shells: filled with... jello...
Fluxnewsletter, December 2, 1968.

Barbara Moore watching George Maciunas (center) and others prepare Maciunas' MULTICYCLE during Flux Game Fest. New York City, May, 1973

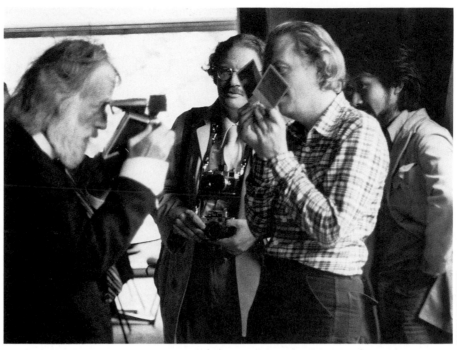

Peter Moore, center, with Robert Watts, George Brecht and Yoshimasa Wada. Berlin, 1976

PROPOSED FLUXSHOW...Empty egg shells filled with...jello...etc.
Fluxnewsletter, December 2, 1968 (revised March 15, 1969).

COMMENTS: Barbara Moore's Jello Eggs *are apparently the catalyst for a whole series of "prepared eggs" credited to Maciunas. The work is conceptually related to Per Kirkeby's "boxed solids" series, and Serge Oldenbourg's* Flux Contents. *I believe the ephemeral aspect of* Jello Eggs *appealed to Maciunas. Impermanence and duration of time are two major elements that Fluxus derived from the Futurists.*

FRUIT BRANDY EGGS see:
 George Maciunas
NOODLE EGGS see:
 George Maciunas
VODKA EGGS see:
 George Maciunas
WINE EGGS see:
 George Maciunas

PETER MOORE

ATTACHE CASE

FLUX-PROJECTS PLANNED FOR 1967 ... Peter Moore: ¼" thick attache case (inside contents-photographic),...
Fluxnewsletter, March 8, 1967.

FLUXPROJECTS FOR 1969...Peter Moore: ¼" photo-briefcase.
Fluxnewsletter, December 2, 1968.

FLUX-PRODUCTS 1961 TO 1969...PETER MOORE ...Attache case ¼" thick, photo laminated on plywood, with regular handle [$] 60
Fluxnewsletter, December 2, 1968 (revised March 15, 1969).

FLUX-PRODUCTS 1961 TO 1970...PETER MOORE ...Attache case, photo laminate, ¼" thick [$] 60
Flux Fest Kit 2. [ca. December 1969].

COMMENTS: Attache cases are synonymous with businessmen and that official "other world" that Fluxus was the antithesis of. Several Fluxus works are packaged in attache cases: Ay-O's Finger Boxes; *Maciunas'* Fluxorgan *and* Ball Checkers; *Joe Jones'* Fluxmusic; *Robert Watts'* Egg Kit, *and of course,* Fluxkits. *Others were planned. There are indications that Moore's* Attache Case *was made; however, I have not seen one.*

CLUTTERED DESK TABLE TOP see:
 Peter Moore and Robert Watts

DISPOSABLE PAPER TABLE CLOTHS see:
 Peter Moore and Robert Watts

DOWNWARD VIEW FROM A TALL BUILDING

...items are in stock, delivery within 2 weeks...FLUX-FURNITURE & ACCESSORIES ... FLUXUS f3 PETER MOORE: photo-floor tiles, in multiples of 4 ft. x 4 ft....downward view from a tall building $80...
Vaseline sTREet (Fluxus Newspaper No. 8) May 1966.

FLUX-PROJECTS PLANNED FOR 1967 ... Peter Moore:...photo-floor tiles,...
Fluxnewsletter, March 8, 1967.

FLUX-PRODUCTS 1961 TO 1969 ... PETER MOORE: ... Photo-floor tiles, in multiples of 4ft. x 4ft. downward view from tall bldg....laminated vinyl, each 4 x 4 square [$] 100
Fluxnewsletter, December 2, 1968 (revised March 15, 1969).

FLUX SHOW: DICE GAME ENVIRONMENT ... SOME FLOOR COMPARTMENTS WITH:...Floor photo murals by Peter Moore.
Flux Fest Kit 2. [ca. December 1969].

COMMENTS: A vertigo special, this and Downward View of Elevator Shaft *were typical Fluxus perversions.*

DOWNWARD VIEW OF ELEVATOR SHAFT

...items are in stock, delivery within 2 weeks...FLUX-
FURNITURE & ACCESSORIES ... FLUXUS f3
PETER MOORE: photo- floor tiles, in multiples of
4 ft. x 4 ft....view down an elevator shaft $80
Vaseline sTREet (Fluxus Newspaper No. 8) May 1966.

FLUX-PROJECTS PLANNED FOR 1967 ... Peter
Moore: ... Photo-rug, photo-floor tiles ... [possibly
of downward view of elevator shaft] .
Fluxnewsletter, March 8, 1967.

FLUXFURNITURE...RUGS...Peter Moore: down-
ward view of elevator shaft, photo-emulsion rug, 4 ft.
x 4 ft. $150, 8 ft. x 8 ft. $300....Available in N.Y.C.
at Multiples and late in 1967 at FLUXSHOP, 18
GREENE ST.
Fluxfurniture, pricelist. [1967].

FLUX-PRODUCTS 1961 TO 1969 ... PETER
MOORE Photo-floor tiles, in multiples of 4ft. x 4ft....
view down an elevator shaft, laminated vinyl, each 4
x 4 square [$] 100
Fluxnewsletter, December 2, 1968 (revised March 15, 1969).

FLUX-PRODUCTS 1961 TO 1970...PETER MOORE
...Photo-floor tiles, 4' sq. vinyl laminate, view down
an elevator shaft, ea: [$] 100
Flux Fest Kit 2. [ca. December 1969].

FLUX SHOW: DICE GAME ENVIRONMENT ...
SOME FLOOR COMPARTMENTS WITH:...Floor
photo murals by Peter Moore.
ibid.

COMMENTS: *A photographic trickster's perverse practical
joke.*

FLUXFURNITURE see:
FURNITURE

FURNITURE see:
DOWNWARD VIEW FROM A TALL BUILDING
DOWNWARD VIEW OF ELEVATOR SHAFT
INVERSE PANORAMIC PORTRAIT OF ANY
 HUMAN SUBJECT
TABLE TOPS
VENETIAN BLINDS
WALL TILES

INVERSE PANORAMIC PORTRAIT OF ANY HUMAN SUBJECT
Silverman No. < 337.I

...items are in stock, delivery within 2 weeks...FLUX-
FURNITURE & ACCESSORIES ... FLUXUS f1
PETER MOORE, photo-rug $300 photoreproduction
on canvas of an inverse panoramic portrait of any hu-
man subject, (photo of all sides flattened out)
Vaseline sTREet (Fluxus Newspaper No. 8) May 1966.

"...another new development: we are working on
FLUXFURNITURE. Peter Moore:...Rug - nude girl
all spread out (photo reproduction) like a bear rug..."
Letter: George Maciunas to Ben Vautier, August 7, 1966.

NANCY ANELLO

Peter Moore. **INVERSE PANORAMIC PORTRAIT OF ANY HUMAN
SUBJECT.** This "human subject" is Lette Eisenhauer

FLUX-PROJECTS PLANNED FOR 1967 ... Peter
Moore:...photo-rug,...
Fluxnewsletter, March 8, 1967.

COMMENTS: *This work, in two dimensions, uses a concept
similar to Hi Red Center's three-dimensional Boxed Portrait.
Inverse Panoramic Portrait of Any Human Subject is some-
times referred to as a bearskin rug, making a pun of the par-
ticular subject's nakedness. The only example of the work
that I have seen (Silverman No. < 337.I) is a fragile wall
hanging piece — the photo emulsion would have quickly
worn off if the work had been used as a rug.*

MONSTERS ARE INOFFENSIVE see:
Robert Filliou, George Maciunas, Peter Moore,
 Daniel Spoerri and Robert Watts
PHOTO-BRIEFCASE see:
ATTACHE CASE
PHOTO-FLOOR TILES see:
DOWNWARD VIEW FROM A TALL BUILDING
DOWNWARD VIEW OF ELEVATOR SHAFT

PHOTO MASK OF GEORGE MACIUNAS
Silverman No. 337

FLUX NEW YEAR EVE, 1973 — DISGUISES: with
Peter & Barbara Moore, Hala Pietkiewicz, Yasunao
Tone - photomasks of G.Maciunas
Fluxnewsletter, May 3, 1975.

COMMENTS: *This Photo Mask of George Maciunas is a work
that refers to Maciunas' earlier masks of John Lennon and
Yoko Ono.*

RUGS see:
DOWNWARD VIEW OF ELEVATOR SHAFT
INVERSE PANORAMIC PORTRAIT OF ANY
 HUMAN SUBJECT
TABLE COVER: CLUTTERED DESK see:
CLUTTERED DESK
TABLE TOPS see:
Peter Moore and Robert Watts
TILES see:
DOWNWARD VIEW FROM A TALL BUILDING
DOWNWARD VIEW OF ELEVATOR SHAFT

VENETIAN BLINDS

...items are in stock, delivery within 2 weeks...FLUX-
FURNITURE & ACCESSORIES ... FLUXUS f2
PETER MOORE: photo-venetian blinds, any human
subject, $300
Vaseline sTREet (Fluxus Newspaper No. 8) May 1966.

"...We are working on FLUXFURNITURE...Peter
Moore: Venetian blinds: you pull one way - girl all

Peter Moore. PHOTO MASK OF GEORGE MACIUNAS

©1973 PETER MOORE

dressed (full size photo) pull another way - "nude"...''
Letter: George Maciunas to Ben Vautier, August 7, 1966.

PAST FLUX-PROJECTS (realized in 1966)... Flux-furniture: venetial [sic] blinds by Peter Moore,...
Fluxnewsletter, March 8, 1967.

FLUX-PROJECTS PLANNED FOR 1967 ... Peter Moore:...photo-venetian blinds
ibid.

FLUXFURNITURE...VENETIAN BLINDS, photo-laminates, any subject, custom made, 8 weeks, Peter Moore $300.00 ... Available in N.Y.C. at Multiples and late in 1967 at FLUXSHOP, 18 GREENE ST.
Fluxfurniture, pricelist. [1967].

FLUX-PRODUCTS 1961 TO 1969...PETER MOORE Photo-venetian blinds, any human subject (front figure & back, etc.) by special order only, [$] 400...
Fluxnewsletter, December 2, 1968 (revised March 15, 1969).

FLUX-PRODUCTS 1961 TO 1970...PETER MOORE Photo venetian blinds, any subject, (front & back, etc.) by special order [$] 400
Flux Fest Kit 2. [ca. December 1969].

''...Peter Moore venetian blinds, very expensive, $400, he [Peter Moore] has one which I made up, and another can be made up...''
Letter: George Maciunas to Dr. Hanns Sohm, [ca. late 1972].

05.1966...PETER MOORE venetial [sic] blinds
George Maciunas, Diagram of Historical Developments of Fluxus... [1973].

COMMENTS: *A peeker's delight, this brilliant work served as a model for Maciunas'* Flux Stationery: Torso in Fur Coat *made a number of years later.*

WALL TILES

FLUX-PROJECTS PLANNED FOR 1967 ... Peter Moore:...wall tiles
Fluxnewsletter, March 8, 1967.

COMMENTS: *This is a vague general entry for projects of Peter Moore that Fluxus planned to produce. No* Wall Tiles *of any subjects are known to have been made.*

PETER MOORE and ROBERT WATTS

CLUTTERED DESK TABLE TOP

''...I don't know whether I mentioned our involvement now in making furniture...using photo laminations on table tops - like...a messy desk top....''
Letter: George Maciunas to Paul Sharits, [April 1966].

''...Another new development: We are working on FLUXFURNITURE...Bob Watts - a disorderly desk (all photographic)...''
Letter: George Maciunas to Ben Vautier, August 7, 1966.

FLUX-PROJECTS PLANNED FOR 1967 ... Bob Watts: Table tops...Desk blotter-mat, etc.
Fluxnewsletter, March 8, 1967.

FLUXFURNITURE...TABLETOPS, photo-laminates, vinyl surface, ¾'' board, formica edging, metal pedestal...Robert Watts & Peter Moore: desk top...21'' x 25'', 4 weeks, $80.00 ... Available in N.Y.C. at Multiples and late in 1967 at FLUXSHOP, 18 GREENE ST.
Fluxfurniture, pricelist. [1967].

PROPOSED FLUXSHOW FOR GALLERY 669 ... OBJECTS, FURNITURE a. tabletops: desk,...(by Watts, Moore,...)...All table tops are photographs laminated between wood table top and vinyl surface. They require stands or legs as shown: [sketch] These pedestal type stands can be obtained from New York for $12 each, plus shipping charges. Additional table tops are in the form of photographs (unlaminated) which should be placed over a table of same size and covered with glass.
Fluxnewsletter, December 2, 1968.

GEORGE MACIUNAS

Peter Moore and Robert Watts. CLUTTERED DESK TABLE TOP

FLUX-PRODUCTS 1961 TO 1969 ... ROBERT WATTS...Tabletops, 30'' square, photo laminated on wood:...cluttered desk...(in collaboration with Peter Moore), [$] 80
Fluxnewsletter, December 2, 1968 (revised March 15, 1969).

FLUX-PRODUCTS 1961 TO 1970 ... ROBERT WATTS...Table tops, photo laminates, 30'' sq.... cluttered desk, ea: [$] 80
Flux Fest Kit 2. [ca. December 1969].

PROPOSED CONTENTS FOR FLUXPACK 3 TO BE PUBLISHED IN 1973 BY FLASH ART...Table covers...cluttered desk by Peter Moore...Cost Estimates: for 1000 copies...table covers [2 designs] $500...100 copies signed by:...Moore...
[George Maciunas], Proposed Contents for Fluxpack 3. [ca. 1972].

...Flash Art editor, Giancarlo Politi, proposed to publish the 3rd Fluxyearbook, maybe to be called FLUX-PACK 3, with the following preliminary contents: Household items: table covers (...cluttered desk by Peter Moore)...
Fluxnewsletter, April 1973.

FLUX-PRODUCTS 1961 TO 1970 ... SOLO OBJECTS AND PUBLICATIONS...ROBERT WATTS... cluttered desk...[$] 100
[Fluxus price list for a customer]. September 1975.

COMMENTS: *Curiously,* Cluttered Desk Table Top *was progressively credited first to Robert Watts, then Watts and Peter Moore, and finally to Peter Moore alone. The work is part of a series of Fluxus photo-laminated table tops by Robert Filliou, Daniel Spoerri, Robert Watts, etc. — some were produced, some only partially finished.*

DISPOSABLE PAPER TABLE CLOTHS

IMPLOSIONS INC. PROJECTS...Triple partnership was formed between Bob Watts, Herman Fine and myself [George Maciunas] to introduce into mass market...money producing products...This business will be operated in commercial manner, with intent to make profits...connection between Fluxus collective and Implosions Inc. has not been clarified yet...we could consider at present Fluxus to be a kind of division or subsidiary of Implosions. Projects to be realized through Implosions: ... Disposable paper table cloths,...
Fluxnewsletter, March 8, 1967.

NEWS FROM IMPLOSIONS, INC....Planned in 1968: ...Disposable paper table cloths,...Bob Watts - Peter Moore...ready for production.
Fluxnewsletter, January 31, 1968.

COMMENTS: Disposable Paper Table Cloths *by Peter Moore and Robert Watts were never made. They would have been of subjects such as their* Cluttered Desk Table Top.

TABLE TOPS

PAST FLUX-PROJECTS (realized in 1966) ... Fluxfurniture: table tops by ... Robert Watts & Peter Moore,...
Fluxnewsletter, March 8, 1967.

FLUX-PROJECTS PLANNED FOR 1967 ... Peter Moore:...table-tops in collaboration with Bob Watts.
ibid.

FLUX SHOW: DICE GAME ENVIRONMENT ... SOME FLOOR COMPARTMENTS WITH: ... Table tops by Moore, Watts,...
Flux Fest Kit 2. [ca. December 1969].

COMMENTS: *Again, this is a general entry for these two artists' joint table top ideas. The only one realized and advertised by Fluxus is* Cluttered Desk Table Top.

SHIRYU MORITA

It was announced in the tentative plans for the first issues of FLUXUS that S. Morita was being consulted for a section on "Abstract chirography (origins, aesthetics) essay & folio" to be included in FLUXUS NO. 3 (later called FLUXUS NO. 4) JAPANESE YEARBOOK. George Maciunas was to contribute an article on "Abstract chirography" to the Distant Past FLUXUS issue.
see: COLLECTIVE

ROBERT MORRIS

It was announced in the first three tentative plans for the first issues of FLUXUS that Robert Morris would contribute "Environments or a work to be determined," later expanded to include "happenings" to FLUXUS NO. 1 U.S. YEARBOOK. Morris' contribution to FLUXUS NO. 1 was excluded in the Brochure Prospectus version A; however in version B an entirely different work, "Words & Actions - a Polemic" together with "Sculpture (photographs)" were listed.
see: COLLECTIVE

FLAG

FLUXFLAGS AND BANNERS ea. $25 28'' square, sewnlegends, double bunting, readable both sides, grommets at corners...FLUXUSt ROBERT MORRIS: black on white: "flag"
Vaseline sTREet (Fluxus Newspaper No. 8) May 1966.

FLUX-PRODUCTS 1961 TO 1969 ... ROBERT MORRIS: Flag, 28'' square, sewn legend, readable both sides, Flag, [$] 100
Fluxnewsletter, December 2, 1968 (revised March 15, 1969).

FLUX-PRODUCTS 1961 TO 1970 ... ROBERT MORRIS Flag, 28'' sq. sewn legends, FLAG [$] 100
Flux Fest Kit 2. [ca. December 1969].

COMMENTS: *At the time of the Yam Festival, around 1963, George Brecht offered a flag, titled* White with Word "Flag," *for sale in the Yam Festival Newspaper. There is no way of telling if Maciunas had Brecht's flag in mind in 1966 when Robert Morris'* Flag *was first advertised for sale in the Fluxus Newspaper No. 8. I tend to think that Maciunas wanted to include a work of Morris' and remembered wrong. Only a Maciunas-designed mechanical for* Flag *exists.*

POSTCARD WITH SPECIFICATIONS ABOUT ITSELF

... to produce the Flash Art FLUXPACK 3 ... Postcards:...specifications about itself (after Bob Morris)
Fluxnewsletter, April 1973.

COMMENTS: *This postcard was never made. It is based on a well-known early work by Robert Morris, discussed in Maciu-*

Robert Morris. FLAG

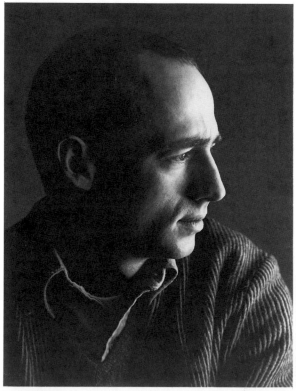

Robert Morris. ca. 1961. Portrait intended for FLUXUS NO. 1 U.S. YEARBOOK

nas' interview with Larry Miller in 1978 (first published in Fluxus Etc./ Addenda I):

LM: *"...how does [functionalism] differ from automor-phism that you have under Bob Morris?*

GM: *Oh, it's entirely different thing now. Automorphism means a thing making itself.*

LM: *Uh huh.*

GM: *Okay. So, now, and he was about the only one that I know that practiced that form of art. And I coined that term, he, nobody, I think, has used that term, automorphism.*

LM: *Uh huh.*

GM: *By that is meant, for instance, I'll give you some classic examples of this. He built a box which contained its own making — sound of its own making, a tape, the making of that box. And that's all it was, it was just a box with tape inside of its own making. He made a filing system, the whole like a library card filing system.*

LM: *I know that piece...a file that refers to itself.*

GM: *...where every card described its own making: where he got the paper, where the card, what size, and you know, like everything was pure automorphism, you know, but, like, that has nothing to do with function-alism.*

LM: *Or concretism?*

GM: *Well, it's very concrete."*

SIMONE MORRIS

It was announced in the tentative plans for the first issues of FLUXUS that Simone Morris would contribute "Dance con-structions" or "a work to be determined" to FLUXUS NO. 1 U.S. YEARBOOK.
see: COLLECTIVE

OLIVIER MOSSET

FLUX DOTS

Silverman No. 338, ff.

"Now I can reply to your letter with suggestions for various Flux items. THEY ARE ALL GREAT!!! I will print labels for them all....flux dots,..."
Letter: George Maciunas to Ben Vautier, August 7, 1966.

"...I am going ahead with labels. Questions. flux-dots by Mosset...this is the way these will be printed un-less you correct me in 4 days..."
Letter: George Maciunas to Ben Vautier, [ca. August 1966].

"By ship mail I am mailing all the new boxes and ex-tra labels I printed up. Yours, others from Nice, New York, etc...Some didn't print well (like Dots) so I will have to reprint with next label job..."
Letter: George Maciunas to Ben Vautier, [ca. October 1966].

FLUX-PROJECTS PLANNED FOR 1967 ... Mosset: Flux-dots.
Fluxnewsletter, March 8, 1967.

Olivier Mosset. FLUX DOTS. Mechanical for the label by George Maciunas

SCOTT HYDE

FLUXPROJECTS FOR 1968 (In order of priority)...
3. Boxed events & objects (all ready for production)
...Mosset - flux-dots;...
Fluxnewsletter January 31, 1968.

FLUX-PRODUCTS 1961 TO 1969...MOSSET Flux-dots, in plastic box* [indicated as part of FLUXKIT] [$] 3
Fluxnewsletter, December 2, 1968 (revised March 15, 1969).

FLUX-PRODUCTS 1961 TO 1970...MOSSET Flux-dots, boxed [$] 3
Flux Fest Kit 2. [ca. December 1969].

FLUXUS-EDITIONEN...[Catalogue No.] 769 MOS-SET: flux-dots, boxed
Happening & Fluxus. Koelnischer Kunstverein, 1970.

SPRING 1969:...MOSSET: dots
George Maciunas, Diagram of Historical Developments of Fluxus... [1973].

COMMENTS: *Olivier Mosset is an artist who was briefly asso-ciated with Ben Vautier's "Groupe de Nice." George Maciunas' Flux Snow Game and New Flux Year are both conceptually very similar to Mosset's Flux Dots, and date from this period.*

YEVGENI MURZIN

It was announced in the Brochure Prospectus version B, that Yevgeni Murzin would contribute "Photoelectric Machine automatically playing pitch-time graphs" to FLUXUS NO. 7 EAST EUROPEAN YEARBOX.
see: COLLECTIVE

N

YUSUKE NAKAHARA

It was announced in the tentative plans for the first issues of

FLUXUS that Y. Nakahara was being consulted for FLUXUS NO. 3 JAPANESE YEARBOOK (later called FLUXUS NO. 4 JAPANESE YEARBOX).
see: COLLECTIVE

YOSHIO NOMURA

It was announced in the tentative plans for the first issues of FLUXUS that Prof. Nomura was being consulted on "Zen Monk Music (essay & record)" for FLUXUS NO. 4 HOMAGE TO THE DISTANT PAST (later referred to as FLUXUS NO.5 HOMAGE TO THE PAST).
see: COLLECTIVE

HANS NORDENSTROEM

An illustration for a "plug out" motor (a motor to pull out a plug) by Hans Nordenstroem appears in Fluxus Newspaper No. 2.
see: COLLECTIVE

GASTONE NOVELLI see: KURT SONDERBORG and GASTONE NOVELLI

SERGE OLDENBOURG

FLUX CONTENTS
Silverman No. 340, ff.

"Now I can reply to your letter with suggestions for various Flux items. THEY ARE ALL GREAT!!! I will print labels for them all....flux contents, maybe call Fluxdrink? or Fluxwine, by Serge Oldenbourg - (solid plaster in bottle.) I like his idea, very nice & easy to produce...."
Letter: George Maciunas to Ben Vautier, August 7, 1966.

"...I am going ahead with labels. Questions...Flux contents/Fluxdrink? by Serge Oldenbourg ... this is the way these will be printed unless you correct me in 4 days..."
Letter: George Maciunas to Ben Vautier, [ca. August 1966].

$1.50 flux content
Fluxshopnews. [Spring 1967].

FLUX-PRODUCTS 1961 TO 1969 ... SERGE OLDENBOURG Flux contents, bottle full of solid plaster * [indicated as part of FLUXKIT] [$] 1
Fluxnewsletter, December 2, 1968 (revised March 15, 1969).

FLUX-PRODUCTS 1961 TO 1970 ... SERGE OL-

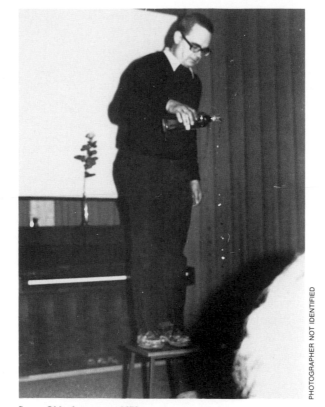

Serge Oldenbourg, ca. 1970

PHOTOGRAPHER NOT IDENTIFIED

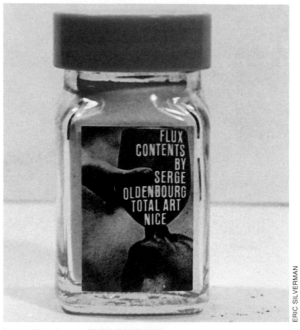

Serge Oldenbourg. FLUX CONTENTS

ERIC SILVERMAN

DENBOURG Flux-contents, full bottle [$] 2
Flux Fest Kit 2. [ca. December 1969].

FLUXUS - EDITIONEN ... [Catalogue No.] 770 SERGE OLDENBOURG: flux-contents, full bottle
Happening & Fluxus. Koelnischer Kunstverein, 1970.

SPRING 1969...SERGE OLDENBOURG: solid bottle
George Maciunas, Diagram of Historical Developments of Fluxus... [1973].

COMMENTS: *Serge Oldenbourg was a participant with Ben Vautier and others in the Fluxus activities in Nice during the mid 1960s. In 1966, Oldenbourg traveled to Prague to perform in the Fluxus concerts there. During this visit, he gave his passport to a young Russian musician on his way to the West. Oldenbourg was arrested and spent several years in jail. The incident created a great fear in Maciunas that Oldenbourg was somehow trying to sabotage Fluxus, and undermine Maciunas' desire to bring Fluxus to Russia and other Eastern European countries.*

CLAES OLDENBURG

It was announced in the Brochure Prospectus version B that Claes Oldenburg would contribute a work "to be determined" to FLUXUS NO. 1 U.S. YEARBOX.
see: COLLECTIVE

At a meeting with George Maciunas in 1965, Oldenburg discussed a number of projects for Fluxus with joint participation of Multiples, a gallery in New York. Fluxus was to handle production and the out of town mail-order business, and Multiples was to have exclusive rights in New York. Specific objects planned were: *die cut plexiglass* Lorgnettes, *to be sold for $20 each, of which 100 were to be included in* Flux Year Box 2; *a 10"* Udder (Rubber Udder) *which Maciunas estimated would cost $3 each to produce;* Thin Clothing; Bulbs *or* "'Stage' Bulbs" [Light Bulbs], *as well as using the bulbs as the "keyboard on [a] small organ" (this idea is apparently a variation on Maciunas'* Fluxorgans *which use rubber syringe bulbs);* Food [False Food Selection] *and* Rubber Flower, *which were to sell for $100 and cost $20 to produce through a special "dip" process; and "Bottle"* [Heinz Catsup Bottle]. *These works were also to be packaged together in an* Anthology *or* Portable Museum *to be sold for $200. Two other, less specific projects discussed were a "little film loop" for* Flux Year Box 2 *and "games" for the "3rd [Fluxus] Yearbook." Only* Food [False Food Selection] *and* Bulb [Light Bulb] *(which appears in some examples of* Flux Year Box 2 *and not as a separate edition) were produced by Fluxus.*

DESTRUCTION KIT

"...Oldenburg is also doing 3 solo Fluxkits...Another with various destruction machines: grinders, squeezers, crushers, and many objects to be destroyed...."
Letter: George Maciunas to Ben Vautier, January 10, 1966.

...will appear late in 1966...FLUXUS gi CLAES OLDENBURG: destruction kit, various destruction de-

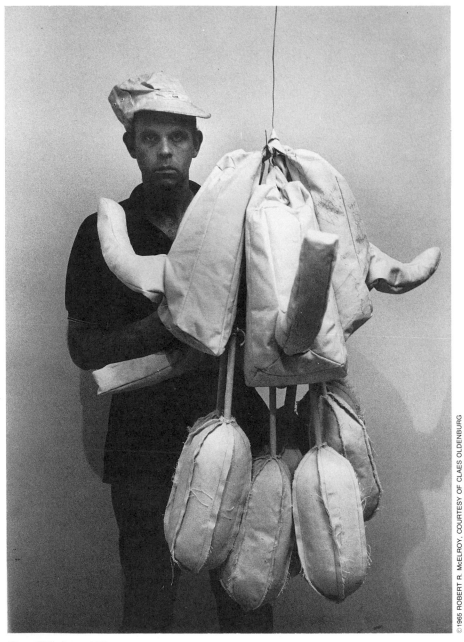

Claes Oldenburg. 1965

©1965 ROBERT R. McELROY. COURTESY OF CLAES OLDENBURG

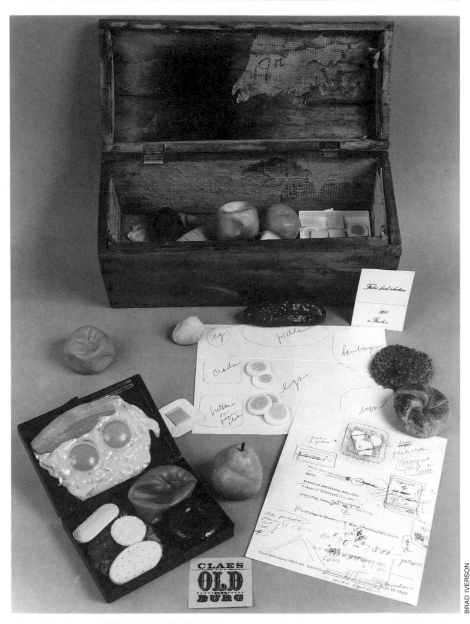

BRAD IVERSON

Claes Oldenburg. FALSE FOOD SELECTION. Prototype box in background, an unused label resting against it. In foreground, notes for the edition and samples of false foods. The fake orange and pear are from FLUX YEAR BOX 2s. Lower left, the Fluxus Edition and a Maciunas designed monogram card used for the label. see color portfolio

vices and objects to be destroyed, in suitcase $150
Vaseline sTREet (Fluxus Newspaper No. 8) May 1966.

COMMENTS: Destruction Kit *was never produced as a Flux-us Edition. 1965 and 1966 were a period of increasing inter-national hostility. The United States was especially involved* with destruction, both at home with the violent suppression of Black rights and subsequent riots in many of our cities, and abroad in Southeast Asia where the war in Vietnam was being escalated uncontrollably by American military and po-litical Redfearnicks. Oldenburg's Destruction Kit *certainly would have reflected his opposition to racism and American genocidal conquest.*

FALSE FOOD SELECTION
Silverman No. 341, ff.

FLUX-PROJECTS PLANNED FOR 1967 ... Claes Oldenburg: False food selection.
Fluxnewsletter, March 8, 1967.

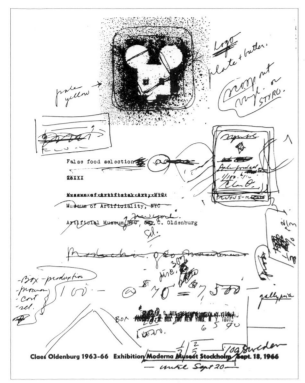

Claes Oldenburg. FALSE FOOD SELECTION. Notes for the Fluxus Edition (left and above)

FLUXPROJECTS FOR 1968 (In order of priority)...
11. Claes Oldenburg - false food selection
Fluxnewsletter, January 31, 1968.

"The story on the other side is self explanatory. As a result of which I have to have eye surgery, since I hardly see anything with the left eye. In one sense, these hospital expenses to me are a windfall to any collectors of flux-objects. Now with high cost of surgery, I must make more objects and begin to respond to various orders and requests for them. Thus I am sending by mail to you the following...Claes Oldenburg - prototype box [$] 20..."
Letter: George Maciunas to Dr. Hanns Sohm. November 30, 1975.

"Prototype box by Claes Oldenburg $20"
Letter: George Maciunas to Dr. Hanns Sohm, May 1, 1976.

COMMENTS: *Planning started in 1965 for* False Food Selection, *which is the only Oldenburg work to be fully realized as a Fluxus Edition, and then only on a small tentative scale. The idea to do a signed and numbered edition of one hundred was not done at all. Versions of the work appear in* Flux Year Box 2 *and* Flux Cabinet.

LIGHT BULB

COMMENTS: *A fake* Light Bulb *is included in some examples of* Flux Year Box 2. *In 1965, Oldenburg discussed a number of projects for Fluxus with joint participation of Multiples, in New York. A separate Fluxus packaging of* Light Bulb *is not known.*

PROTOTYPE BOX see:
FALSE FOOD SELECTION

RUBBER DINNER SETTING KIT

"...Oldenburg is also doing 3 solo Fluxkits. One with a rubber dinner which pops up when you open suitcase..."
Letter: George Maciunas to Ben Vautier, January 10, 1966.

...will appear late in 1966...FLUXUS ga CLAES OLDENBURG: rubber dinner setting, in suitcase $150
Vaseline sTREet (Fluxus Newspaper No. 8) May 1966.

COMMENTS: *A rubber stem "glass" is included in Oldenburg's* False Food Selection *in* Flux Cabinet, *and is designed to pop up when the drawer is opened. However, beyond this, and an instruction drawing by Maciunas for a ketchup bottle, there is no trace of* Rubber Dinner Setting Kit *in Fluxus.*

RUBBER UDDER

"...Fluxkit now has also object by...Oldenburg... a rubber cows udder attached to cover, so when you open cover of kit, udder pops down..."
Letter: George Maciunas to Ben Vautier, January 10, 1966.

"...The new Fluxkit besides is better than the old one. It has Oldenburg rubber cows udders..."
Letter: George Maciunas to Ben Vautier, March 5, 1966.

FLUXKIT containing following fluxus-publications: ...FLUXUSg CLAES OLDENBURG, rubber udder not sold separately
Vaseline sTREet (Fluxus Newspaper No. 8) May 1966.

"...could be produced cheaper in Italy:...rubber dip moulded objects:...cows udder (as cream or coffee

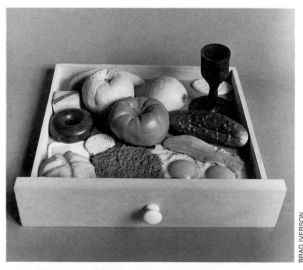

Claes Oldenburg. FALSE FOOD SELECTION contained in a drawer of FLUX CABINET with a pop-up stem glass from RUBBER DINNER SETTING KIT. see color portfolio

BRAD IVERSON

dispenser or a hat)..."
Letter: George Maciunas to Daniela Palazzoli, n.d. Reproduced in Fluxnewsletter, April 1973.

COMMENTS: *Planning for* Rubber Udder *began in 1965 at a meeting between Oldenburg and George Maciunas. Either* Udder *or* Heinz Catsup Bottle *was to be the first "introduction object" for Oldenburg's Fluxus line. Maciunas made instruction drawings for the production of both works, neither were produced.*

THEATRE KIT

...will appear late in 1966 ... FLUXUS go CLAES OLDENBURG: theatre kit, stage with figures moved by remote control $150
Vaseline sTREet (Fluxus Newspaper No. 8) May 1966.

COMMENTS: Theatre Kit *was never made as a Fluxus Edition.*

Unidentified Kit

"...I will ship & crate to you with most large Fluxus items such as...Oldenburg kit...etc., etc. - about 200 lbs. of goodies, so you can have a kind of Fluxshop..."
Letter: George Maciunas to Ben Vautier, May 19, 1966.

COMMENTS: *Whatever kit this was, it remains unknown — never sent to Vautier.*

YOKO ONO

It was announced in the tentative plans for the first issues of FLUXUS that Yoko Ono would contribute "Kinetics (essay and anthology of inserts)" to FLUXUS NO. 3 JAPANESE YEARBOOK. In FLUXUS 1 (Silverman No. > 118.II) she contributed Self Portrait. "Instructions for Poem No. 86" *with an illustration was published in Fluxus Newspaper No. 2. see: COLLECTIVE*

ADD COLOUR PAINTING

APR. 11-17: DO IT YOURSELF, BY JOHN & YOKO + EVERYBODY...2 Eggs (by John Lennon) combined with Add colour painting (eggs filled with ink or paint, to be thrown against a wall)
Schedule of events for Fluxfest presentation of John Lennon and Yoko Ono. [ca. April 1970]. version A

COMMENTS: *At Yoko Ono's exhibition at the Indica Gallery in London, 1966, she exhibited blank canvases with instructions to "add colour." The version of this work installed at the Tone Deaf Music Co. in April 1970, for the Fluxfest, was helped along with George Maciunas'* Paint Eggs.

ADHESIVE KNOB DOOR see:
George Maciunas

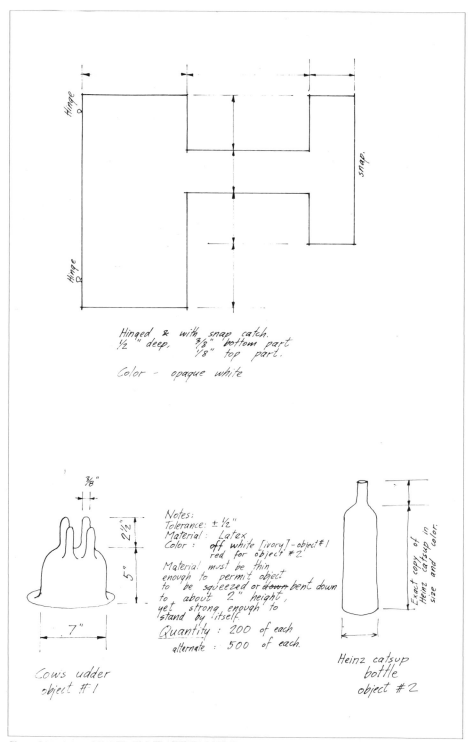

Claes Oldenburg. RUBBER UDDER, HEINZ CATSUP BOTTLE and possibly LORGNETTES. Instruction drawings by George Maciunas for the Fluxus Editions

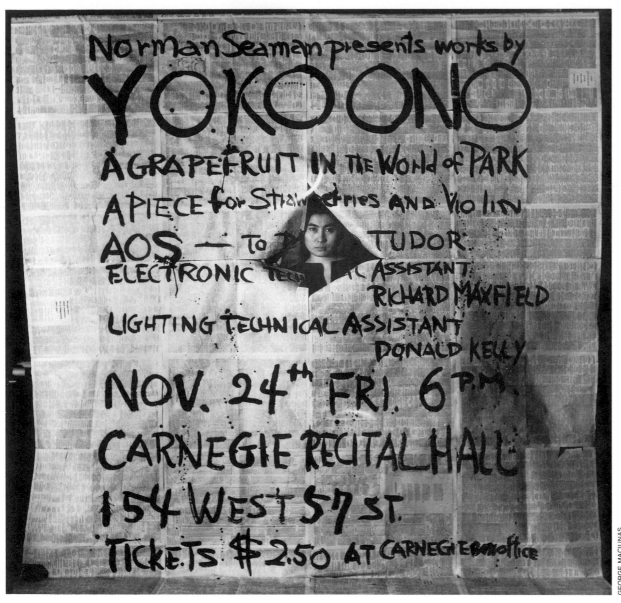

Yoko Ono. 1961

GEORGE MACIUNAS

Yoko Ono. ADD COLOR PAINTING. Made by the artist ca. 1971

PHOTOGRAPHER NOT IDENTIFIED

Yoko Ono. AIR DISPENSER

PHOTOGRAPHER NOT IDENTIFIED

AIR DISPENSER

MAY 30 - JUNE 5: THE STORE BY JOHN & YOKO + FLUXFACTORY Coin operated vending machines: ...machine dispensing sky (air)...by Yoko Ono...
Schedule of events for Fluxfest presentation of John Lennon and Yoko Ono. [ca. April 1970]. version B

MAY 30-JUNE 5: THE STORE BY YOKO + FLUX-FACTORY Vending machines (coin operated): machine dispensing...air (by Yoko Ono);
Schedule of events for Fluxfest presentation of John Lennon and Yoko Ono. April 1, 1970. version C

Toilet no. 6 collective/ medicine cabinet...Vending machine dispensing air capsules by Yoko Ono.
Fluxnewsletter, April 1973.

... This Fall, we shall publish V TRE no. 10, which shall consist of a plan for Flux-Amusement-Center,

to contain...Vending machines...nut type dispensers (dispensing...air...)
ibid.

YOKO ONO 1965...Vending machines:...air
George Maciunas, Diagram of Historical Developments of Fluxus... [1973].

415

COMMENTS: *Yoko Ono's* Air Dispenser *is an idea that developed out of her* Sky Dispenser *from 1966 or 1967, and also her void or reduction works that require one to imagine them. The notion of air as art was explored by other artists, notably Marcel Duchamp's* Paris Air, *1919; Yves Klein's* Le Vide, *1958; and Piero Manzoni's* Air Bodies, *1958. Other Fluxus artists air works were Ay-O's* Air Sculpture; *George Brecht's* Air; *Ben Vautier's* Flux Nothing; *and Yoshimasa Wada's* Cough. *An* Air Dispenser *is in the Archiv Sohm at the Staatsgalerie Stuttgart.*

BLINK see:
EYEBLINK

BODY ACCESSORIES

MAY 30-JUNE 5: THE STORE BY YOKO + FLUX-FACTORY... Sale of body accessories: halos, horns, 3rd eyes, tails, hoofs, skin blemishes, scars, etc. (by Yoko Ono)
Schedule of events for Fluxfest presentation of John Lennon and Yoko Ono. [ca. April 1970]. version B

MAY 30 - JUNE 5: THE STORE BY JOHN & YOKO + FLUXFACTORY...[as above]
Schedule of events for Fluxfest presentation of John Lennon and Yoko Ono. April 1, 1970. version C

COMMENTS: Body Accessories *were not produced by George Maciunas as a Fluxus Edition.*

BOX OF SMILE see:
SELF PORTRAIT
CEILING HINGED DOOR see:
Anonymous
CENTRAL VERTICAL AXIS DOOR see:
Anonymous

CHART

"The story on the other side is self explanatory. As a result of which I have to have eye surgery, since I hardly see anything with the left eye. In one sense, these hospital expenses to me are a windfall to any collectors of flux-objects. Now with high cost of surgery, I must make more objects and begin to respond to various orders and requests for them. Thus I am sending by mail to you the following...Yoko's...chart ...never produced."
Letter: George Maciunas to Dr. Hanns Sohm. November 30, 1975.

COMMENTS: *I don't know what this* Chart *could be. It seems very unlike other Ono works. Perhaps George Maciunas planned to make a chart involving ideas and works of Ono in a typical Maciunas fashion.*

CHESS see:
PIECES HIDDEN IN LOOK-ALIKE
CONTAINERS, CHESS SET
CLOCK see:
WATER CLOCK
COMPLETE WORKS see:
GRAPEFRUIT
GRAPEFRUIT NO. 2

CROWDING IN

MAY 16-22 CAPSULE BY JOHN & YOKO + FLUX SPACE CENTER A 3ft cube enclosure (capsule) having various film loops projected on its walls, ceiling and floor to a single viewer inside, total time: 6 min. ...Elephants crowding in, (?)
Schedule of events for Fluxfest presentation of John Lennon and Yoko Ono. [ca. April 1970]. version A

MAY 16-22: CAPSULE BY YOKO + FLUX SPACE CENTER A 3' x 3' x 3' enclosure (capsule) having various film loops projected on its walls and ceiling to a single viewer inside:...crowding-in, compressing (Yoko Ono);...
Schedule of events for Fluxfest presentation of John Lennon and Yoko Ono. April 1, 1970. version C

COMMENTS: *This film was not made as a Fluxus work. The idea of crowding is used by Robert Watts in his "swimming pool event no. 3" in Fluxus Newspaper No. 1, January 1964, and also as the image on a label by Maciunas for Milan Knizak's unrealized* Flux Events.

CRYING MACHINE DISPENSING TEARS

MAY 30-JUNE 5: THE STORE BY JOHN & YOKO + FLUXFACTORY Coin operated vending machines ...crying machine dispensing tears,...
Schedule of events for Fluxfest presentation of John Lennon and Yoko Ono. [ca. April 1970]. version B

MAY 30 - JUNE 5: THE STORE BY YOKO + FLUX-FACTORY Vending machines (coin operated):...crying machine dispensing tears,...
Schedule of events for Fluxfest presentation of John Lennon and Yoko Ono. April 1, 1970. version C

YOKO ONO 1965 vending machines: crying...
George Maciunas, Diagram of Historical Developments of Fluxus... [1973].

COMMENTS: *Maciunas'* Diagram, *referred to above, indicates that a tear dispenser was made in 1965, and I recall* Crying Machine Dispensing Tears *at Yoko Ono's one woman show at the Everson Museum in 1971.*

DANCE see:
DO IT YOURSELF FLUXFEST

DISPENSERS see:
AIR DISPENSER
CRYING MACHINE DISPENSING TEARS
MACHINE DEVOURING DEPOSITED OBJECTS
SKY DISPENSER

DO IT YOURSELF FLUXFEST
Silverman No. 349, ff.

DO IT YOURSELF FLUXFEST PRESENTS Yoko Ono & Dance Co.
3 newspaper eVenTs for the pRicE of $1 (Fluxus Newspaper No. 7) February 1, 1966.

FLUX-PRODUCTS 1961 TO 1969 ... V TRE FLUX-NEWSPAPERS...3 newspaper eVenTs for the pRicE of $1, no 7. Feb. 1966...Do it yourself dance series by Yoko Ono & Co...
Fluxnewsletter, December 2, 1968 (revised March 15, 1969).

COMMENTS: *Do It Yourself Fluxfest was published in 3 newspaper eVenTs for the pRicE of $1 (Fluxus Newspaper No. 7, February 1966), and simultaneously on card stock that was cut to be packaged as a Fluxus boxed edition. A year later, Yoko Ono composed a revised version, advertising it as "Yoko Ono's 13 Days Do-It-Yourself Dance Festival To Be Held in London." Yoko Ono's original manuscript for the first version, with changes and notes by George Maciunas, is now in the Silverman Collection.*

DO IT YOURSELF PAINTING

FLUXFEST PRESENTATION OF JOHN LENNON & YOKO ONO+* AT 80 WOOSTER ST. NEW YORK —1970...APR. 11-17: DO IT YOURSELF-BY JOHN & YOKO + EVERYBODY...Do It Yourself painting (Yoko Ono)...
all photographs copyright nineteen seVenty by peTer mooRE (Fluxus Newspaper No. 9) 1970.

COMMENTS: *This work is conceptually identical to* Add Colour Painting, *and was realized at the Fluxfest in 1970 and in the "Blue Room" at Ono's Everson exhibition in 1971.*

DOORS see:
ADHESIVE KNOB DOOR
CEILING HINGED DOOR
CENTRAL VERTICAL AXIS DOOR
FLOOR HINGED DOOR
HORIZONTAL AXIS DOOR
MISSING KNOB DOOR
SEPARATE DOORS DOOR
SMALL DOOR IN DOOR

DRAW CIRCLE PAINTING

APR. 11-17 DO IT YOURSELF, BY JOHN & YOKO

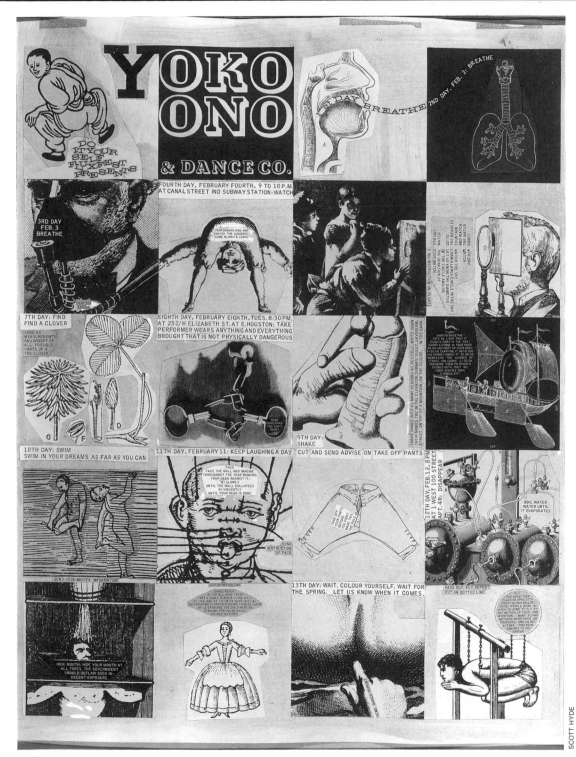

Yoko Ono. DO IT YOURSELF FLUXFEST. Mechanical by George Maciunas

SCOTT HYDE

+ EVERYBODY...Yoko Ono...Draw Circle painting.
Schedule of events for Fluxfest presentation of John Lennon and Yoko Ono. [ca. April 1970]. version A

APR. 11-17. DO IT YOURSELF. BY JOHN & YOKO + EVERYBODY...Draw Circle painting (Yoko Ono '64).
Schedule of events for Fluxfest presentation of John Lennon and Yoko Ono. [ca. April 1970]. version B

FLUXFEST PRESENTATION OF JOHN LENNON & YOKO ONO+* AT 80 WOOSTER ST. NEW YORK —1970...APR. 11-17...Draw Circle painting (Yoko Ono '64)...
all photographs copyright nineteen seVenty by peTer mooRE (Fluxus Newspaper No.9) 1970.

COMMENTS: Another spectator-enhanced work dating from 1964. The work has been realized a number of times.

DRY SPONGE see:
John Lennon and Yoko Ono
EXTERIOR SIGNS see:
SIGNS

EYEBLINK
Silverman No. > 347.I

"...Regarding film festival, - I will send you the following: You will get these end of April...Blink by Yoko Ono...They and another 6 films make up the whole 2 hour Fluxfilm program....Incidentally, loops from these films will go into Fluxus II Yearboxes. Everything is ready, but I got short on $ & can't produce these boxes in quantity, since making film copies is rather expensive....Fluxfilm program was shown at Ann Arbor film fest & won a critics' award...."
Letter: George Maciunas to Ben Vautier, March 29, 1966.

... items are in stock, delivery within 2 weeks ... FLUXFILMS...FLUXFILM 9 ONE, 1 min $6
Vaseline sTREet (Fluxus Newspaper No. 8) May 1966.

... items are in stock, delivery within 2 weeks ... FLUXFILMS...FLUXFILM 15 EYEBLINK, 5 min $20
ibid.

FLUXFILMS SHORT VERSION, 40 MIN AT 24 FRAMES/SEC. 1400FT.... flux-number 9 Anonymous EYEBLINK 1' High-speed camera, 2000fr/sec. view of one eyeblink * [camera: Peter Moore, Editing and titles by George Maciunas]
Fluxfilms catalogue. [ca. 1966].

PAST FLUX-PROJECTS (realized in 1966)...Fluxfilms: total package: 1 hr. 40 min. ...blink-anonymous
Fluxnewsletter, March 8, 1967.

PROPOSED FLUXSHOW...FILM WALLPAPER EN-VIRONMENT. A booth must be set up in a fairly dark area, the walls of which are of white vinyl or cotton sheets (about 12ft. wide) hanging as curtains and creating a 12ft x 12ft or smaller room. Four 8mm loop projectors (with wide angle lenses) must be set up, one on front of each wall (on the outside) and projecting an image the frame of which is to cover entire wall...20 sets of loops are available, such as: ... slow motion blinking eyes, etc.
Fluxnewsletter, December 2, 1968 (revised March 15, 1969).

FLUX-PRODUCTS 1961 TO 1969...FLUXFILMS, short version Summer 1966 40min. 1400ft.: Eyeblink ...by G. Maciunas...16mm [$] 180 8mm version [$] 50
ibid.

FLUX-PRODUCTS 1961 TO 1970 ... [as above]
Flux Fest Kit 2. [ca. December 1969].

SLIDE & FILM FLUXSHOW...ANONYMOUS: EYE-BLINK High-speed camera, 2000fr/sec. view of one eyeblink Camera: Peter Moore. 1 min.
ibid.

FILM AND SOUND ENVIRONMENT A booth must be set up in a fairly dark area, the walls of which are of white vinyl or cotton sheets (about 12' wide x 8' high) hanging as curtains, creating thus a 12' x 12' or smaller room. Four 8mm wide angle lense [sic] loop projectors must be set up in front of each wall on the outside, projecting an image the frame of which is to cover entire wall. Spectators may enter the booth through corners...Slow motion blinking eyes with audience or street sounds picked up by microphone.
ibid.

OBJECTS AND EXHIBITS...1965:...of some 20 films into Flux-film anthology, contributed: films made without camera ... eyeblink (high speed camera) ...
George Maciunas Biographical Data. 1976.

COMMENTS: *Eyeblink was filmed with a high-speed camera. It is the image of a single eye blink, and lasts about three minutes when projected normally. A good deal of confusion exists about the authorship of the work, and its Fluxfilm number. In the Fluxfilms catalogue, Fluxfilm No. 9, Eyeblink, is listed as Anonymous and lasting one minute, and Fluxfilm No. 15 is not included. In Fluxus Newspaper No. 8, Eyeblink is given the Fluxfilm number 15, lasting 5 minutes, and no artist's credit, and Fluxfilm No. 9 is called "ONE," lasts one minute and costs $6. In Maciunas' notes on Flux-films, Fluxfilm No. 9 is called "One Blink," and lasts one minute. Then periodically, Maciunas takes credit for the work, although in his letter to Ben Vautier in 1966, he refers to "Blink by Yoko Ono". My feeling is that Fluxfilms No. 9 and 15 are the same film. Further, Maciunas at the time was*

working *with optical manipulation. Ono was using simple images and commonplace events with sexual overtones. So there is no doubt in my mind that the film Eyeblink is by Ono.*

FILM

PROPOSED R&R EVENINGS: ... Flux-film-walls (loops by...Yoko Ono, etc.)
Fluxnewsletter, January 31, 1968.

[as above]
Fluxnewsletter, December 2, 1968.

11.04 - 29.05.1970 FLUX FEST OF JOHN LENNON & YOKO ONO ... 16-22.05: FILM ENVIRONMENT 4 wall projection [including] ...ono,...etc.
George Maciunas, Diagram of Historical Developments of Fluxus... [1973].

COMMENTS: *This is a general entry for various uses of Ono's films.*

FILMS see:
 CROWDING IN
 EYEBLINK
 FLY
 NUMBER 1
 NUMBER 4
 SNOW FALLING AT DAWN
FLOOR HINGED DOOR see:
 Anonymous

FLY

... MAY 16 - 22: CAPSULE BY JOHN & YOKO + FLUX SPACE CENTER A 3ft cube enclosure (capsule) having various film loops projected on its walls, ceiling and floor to a single viewer inside, total time: 6 min.... [including] ...fly (top, bottom, front and side views shot simultaneously from aeroplane without showing any parts of the plane, projection will give sensation of Bird flight) by Yoko Ono, (realized 1970)...
Schedule of events for Fluxfest presentation of John Lennon and Yoko Ono. [ca. April 1970]. version A

COMMENTS: *This film, titled Fly, was not made. It should not be confused with another Ono film called Fly in which a fly walks on a naked woman's body and then flies out the window.*

FORGET IT

MAY 2-8: BLUE ROOM BY JOHN & YOKO + FLUX-LIARS...Entire room (floor, walls, ceiling), exterior (door and window), interior furnishings to be white... A standing needle somewhere in the room with sign:

Yoko Ono. FORGET IT. Constructed for the artist ca. 1971

Forget it. Another one with sign: Needle, John Lennon 1970.
Schedule of events for Fluxfest presentation of John Lennon and Yoko Ono. [ca. April 1970]. version A

MAY 2-8:...an upright needle with sign: Forget it. (Yoko Ono) another one with sign: Needle (John Lennon, 1970)...
Schedule of events for Fluxfest presentation of John Lennon and Yoko Ono. [ca. April 1970]. version B

FLUXFEST PRESENTATION OF JOHN LENNON & YOKO ONO AT 80 WOOSTER ST. NEW YORK - 1970...MAY 2-8...an upright needle with sign: Forget it (Yoko Ono)...another one with sign: Needle (John Lennon, 1970)
all photographs copyright nineteen seVenty by peTer mooRE (Fluxus Newspaper No. 9) 1970.

COMMENTS: *A simple version of Forget It was constructed by Maciunas in 1970, and a much more elegant version was produced for Ono's Everson Museum show in 1971.*

GRAPEFRUIT

FLUXUS SPECIAL EDITIONS 1963-4...FLUXUS u. YOKO ONO: COMPLETE WORKS $?
Fluxus Preview Review, [ca. July] 1963.

Collection of works by Yoko Ono $3.00 before $6 after publication Subscribe to Grapefruit Apt. 1001 Konno Building, 53 Konnomachi Shibuyaku, Tokyo, Japan
cc V TRE (Fluxus Newspaper No. 2) February 1964.

FOR THOSE WHO WISH TO SPEND MORE WE HAVE GRAPEFRUIT $7 FOR TOILET READING SEND YOUR ORDER AND MONEY TO YOKO ONO C/O FLUXUS P.O. BOX 180 NEW YORK 10013
Fluxus Offset Printing Negative. [1964].

''...we may print complete works of Yoko Ono who is coming to New York. If not, I will send you all type-set prints for you to print...''
Letter: George Maciunas to Willem de Ridder, [ca. end of July 1964].

''...When I return I will mail you complete works of Yoko Ono! many very good pieces! She is now in New York. One of the best composers. I will send you my own copy as soon as I microfilm it. OK?...''
Letter: George Maciunas to Ben Vautier, February 1, 1965.

04.07.1964 GRAPEFRUIT book
George Maciunas, Diagram of Historical Developments of Fluxus... [1973].

COMMENTS: *Grapefruit is a collection of Yoko Ono's early scores and pieces in English and Japanese. Maciunas had planned to produce a Fluxus Edition of Ono's complete works in 1963, but he was in Germany and she had returned to Japan from New York by that time, so the book was first published in Japan in 1964 by the "Wunternaum Press," in reality, self-published. Some years later, the book was enlarged and changed and mass-market editions were brought out by commercial publishers in England, the United States, and Japan.*

GRAPEFRUIT NO. 2

''... will appear late in 1966 ... FLUXUS ha YOKO ONO, grapefruit no. 2 events, exhibits in a grapefruit $10
Vaseline sTREet (Fluxus Newspaper No. 8) May 1966.

COMMENTS: *"Ono's Sales List," (Silverman No. 346) 1965, lists "GRAPEFRUIT II - over 200 compositions not published in GRAPEFRUIT, in Music, Painting, Event, Poetry, and Object (including TOUCH POEMS), to be published in 1966. pre-publication price...$5 - post-publication price...$10-"
Grapefruit No. 2 was never produced, either by Fluxus or a commercial publisher. It seemed to be one of those works that was always in the planning stages. I remember in the early 1970s when we would be working on some project, and the joke would be: "Charge it to Grapefruit No. 2."*

HORIZONTAL AXIS DOOR see:
Anonymous
INTERIOR SIGNS see:
SIGNS

KITCHEN PIECE

APR. 11-17: DO IT YOURSELF, BY JOHN & YOKO

+ EVERYBODY ... by Yoko Ono ... Wash painting (paintings by other artists or rags to be used to wash street)...
Schedule of events for Fluxfest presentation of John Lennon and Yoko Ono. [ca. April 1970]. version A

FLUXFEST PRESENTATION OF JOHN LENNON & YOKO ONO +* AT 80 WOOSTER ST. NEW YORK —1970...APR.11-17: DO IT YOURSELF-BY JOHN & YOKO + EVERYBODY...Kitchen Piece (Yoko Ono '60) painting to wipe floor and street with...
all photographs copyright nineteen seVenty by peTer mooRE (Fluxus Newspaper No. 9) 1970.

COMMENTS: *Kitchen Piece ("painting to wipe floor and street with"), dated 1960, is one of Yoko Ono's works designed to force reconsideration of the value of art. Another related work is Painting to be Stepped On. Ono's early conceptual works frequently unsettled one's notion of painting.*

LOOK-ALIKE BOXES OF DIFFERENT WEIGHTS see:
Yoko Ono and Takako Saito

MACHINE DEVOURING DEPOSITED OBJECTS

MAY 30-JUNE 5: THE STORE BY JOHN & YOKO + FLUXFACTORY Coin operated vending machines ...machine devouring deposited objects...by Yoko Ono...
Schedule of events for Fluxfest presentation of John Lennon and Yoko Ono. [ca. April 1970]. version B

MAY 30-JUNE 5: THE STORE BY YOKO + FLUX-FACTORY Vending machines (coin operated): machine receiving deposited objects and making them disappear,...(by Yoko Ono)...
Schedule of events for Fluxfest presentation of John Lennon and Yoko Ono. April 1, 1970. version C

COMMENTS: *This work was never made.*

MEND

MAY 2-8: BLUE ROOM BY JOHN & YOKO + FLUXLIARS Entire room (floor, walls, ceiling), exterior...and interior furnishings to be white...A cup on a table with sign:...Mend, Y.O. 1966
Schedule of events for Fluxfest presentation of John Lennon and Yoko Ono. [ca. April 1970]. version A

MAY 2-8: [as above] ...A cup on a table with sign: ...Mend (Yoko Ono '66)...
Schedule of events for Fluxfest presentation of John Lennon and Yoko Ono. [ca. April 1970]. version B

FLUXFEST PRESENTATION OF JOHN LENNON & YOKO ONO +* AT 80 WOOSTER ST. NEW YORK

-1970...MAY 2-8: BLUE ROOM BY JOHN & YOKO + FLUXLIARS Entire room (floor, walls, ceiling), and furnishings were white...cup...with sign: Mend (Yoko Ono '66)...
all photographs copyright nineteen seVenty by peTer mooRE (Fluxus Newspaper No. 9) 1970.

COMMENTS: *Mend and Not to be Appreciated Until It's Broken are two related works, forming a potential dialogue as they were exhibited by Fluxus. The ideas were also used separately by Ono. A multiple version of Mend, or "Mend Piece I" is included in the three-dimensional periodical, S.M.S., and a 1966 version is illustrated in This is Not Here, edited by John Lennon in 1971.*

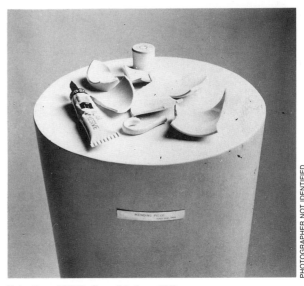

PHOTOGRAPHER NOT IDENTIFIED

Yoko Ono. MEND. Assembled ca. 1971

MISSING KNOB DOOR see:
Anonymous

NOT TO BE APPRECIATED UNTIL IT'S BROKEN

MAY 2-8: BLUE ROOM BY JOHN & YOKO + FLUXLIARS Entire room (floor, walls, ceiling), exterior...and interior furnishings to be white...A cup on a table with sign: Not to be appreciated until it's broken, Yoko Ono 1966....
Schedule of events for Fluxfest presentation of John Lennon and Yoko Ono. [ca. April 1970]. version A

MAY 2-8: [as above] ...A cup on a table with sign: Not to be appreciated until it's broken, (Yoko Ono '66)...
Schedule of events for Fluxfest presentation of John Lennon and Yoko Ono. [ca. April 1970]. version B

FLUXFEST PRESENTATION OF JOHN LENNON & YOKO ONO +* AT 80 WOOSTER ST. NEW YORK -1970...MAY 2-8: BLUE ROOM BY JOHN & YOKO + FLUXLIARS Entire room (floor, walls, ceiling), and furnishings were white...a cup with sign: Not to be appreciated until it's broken (Yoko Ono)...
all photographs copyright nineteen seVenty by peTer mooRE (Fluxus Newspaper No. 9) 1970.

COMMENTS: *This poetic work was exhibited by Fluxus with Mend, forming a literal cause-and-effect piece.*

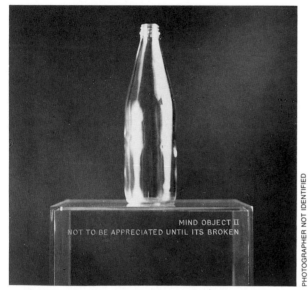

Yoko Ono. NOT TO BE APPRECIATED UNTIL IT'S BROKEN. Constructed ca. 1971

PHOTOGRAPHER NOT IDENTIFIED

NUMBER 1
Silverman No. > 347.II

...items are in stock, delivery within 2 weeks...FLUX-FILMS ... FLUXFILM 14 YOKO ONO: no. 1, 10 min $40
Vaseline sTREet (Fluxus Newspaper No. 8) May 1966.

FLUXFILMS LONG VERSION, ADDITIONAL FILMS TO SHORT VERSION flux-number 14 Yoko Ono NUMBER 1 6' High-speed camera, 2000fr/sec. match striking fire.*...camera: Peter Moore Editing and titles by George Maciunas
Fluxfilms catalogue. [ca. 1966].

Fluxfilms: total package: 1 hr. 40 min. no.1...by Yoko Ono,...
Fluxnewsletter, March 8, 1967.

FLUX-PRODUCTS 1961 TO 1969...FLUXFILMS, long version Winter 1966 Short version plus addition

of: ... No.1 - by Yoko Ono; ... total: 1hr. 40 min. 3600ft. 16mm only [$] 400
Fluxnewsletter, December 2, 1968 (revised March 15, 1969).

FLUX-PRODUCTS 1961 TO 1970 ...FLUXFILMS, long version, Winter 1966. Short version plus addition of:...No. 1 by Yoko Ono,...total: 1hr. 40 min. 16mm $400
Flux Fest Kit 2. [ca. December 1969].

COMMENTS: *Yoko Ono's* Number 1, *Fluxfilm No. 14, a sexually charged, high speed film of "match striking fire," was offered for sale as an individual film and as part of the* Fluxfilms *package long version. The work is apparently based on Yoko Ono's 1955 composition, "Lighting Piece."*

NUMBER 4
Silverman No. > 347.III

"...Regarding film festival. - I will send you the following: You will get these end of April...Blink by Yoko Ono, or her 'walk'...They and another 6 films make up the whole 2 hour Fluxfilm program....Incidentally, loops from these films will go into Fluxus II Yearboxes. Everything is ready, but I got short on $ & can't produce these boxes in quantity, since making film copies is rather expensive....Fluxfilm program was shown at Ann Arbor film fest & won a critics award."
Letter: George Maciunas to Ben Vautier, March 29, 1966.

...items are in stock, delivery within 2 weeks...FLUX-FILMS...FLUXFILM 16 YOKO ONO: no. 4, 4 min $16
Vaseline sTREet (Fluxus Newspaper No. 8) May 1966.

FLUXFILMS SHORT VERSION, 40 MIN AT 24 FRAMES/SEC. 1400FT....flux-number 16 Yoko Ono NUMBER 4 5'30" Sequences of buttock movement as various performers walked. Filmed at constant distance.
Fluxfilms catalogue. [ca. 1966].

Fluxfilms: total package: 1 hr. 40 min....no.4 by Yoko Ono,...
Fluxnewsletter, March 8, 1967.

"...I am finally doing the 8mm print of that 1200 ft. Fluxfilm version. It will be good for straight viewing or loop viewing, some 40 loops that could do a nice Flux-wall paper event, [for instance...walking behinds..."
Letter: George Maciunas to Paul Sharits, June 21, 1967.

"...This pack contains all the loop material for flux wallpaper shows, you need some 10 to 20 8mm projectors, and of course white walls and ceilings if you project it on them. You could show say 20 loops of yoko onos walking behinds of 20 different people..."
Letter: George Maciunas to Ken Friedman, [ca. August 1967].

FLUX-PRODUCTS 1961 TO 1969...FLUXFILMS, short version Summer 1966 40 min. 1400ft. ... [including] Number 4 - by Yoko Ono;...16mm [$] 180 8mm version [$] 50
Fluxnewsletter, December 2, 1968 (revised March 15, 1969).

FLUX-PRODUCTS 1961 TO 1970...FLUXFILMS, short version, Summer 1966. 40 min. 1400 ft.: ... Number 4 by Yoko Ono,...16mm version $180 8mm $50
Flux Fest Kit 2. [ca. December 1969].

SLIDE & FILM FLUXSHOW...NUMBER 4 Sequences of buttock movement of various walking performers. 5'30"
ibid.

FILM AND SOUND ENVIRONMENT A booth must be set up in a fairly dark area, the walls of which are of white vinyl or cotton sheets (about 12' wide x 8' high) hanging as curtains, reating [sic] thus a 12' x 12' or smaller room. Four 8mm wide angle lense [sic] loop projectors must be set up in front of each wall on the outside, projecting an image the frame of which is to cover entire wall. Spectators may enter the booth through corners....Buttock movement (film loop) by Yoko Ono with lip & tube sound by Maciunas.
ibid.

...MAY 16-22: CAPSULE BY JOHN & YOKO + FLUX SPACE CENTER A 3ft cube enclosure (capsule) having various film loops projected on its walls, ceiling and floor to a single viewer inside, total time: 6 min. ...[including] ...No. 4 (close up of walking nude buttock) Yoko Ono, 1966
Schedule of events for Fluxfest presentation of John Lennon and Yoko Ono. [ca. April 1970]. version A

CAPSULE BY JOHN & YOKO + FLUX SPACE CENTER ($1 ADMISSION CHARGE)...about 8 minutes ...[including] ...No. 4 (close up of walking nude buttock) (Yoko Ono, 1966)...
Schedule of events for Fluxfest presentation of John Lennon and Yoko Ono. [ca. April 1970]. version B

FLUXFEST PRESENTATION OF JOHN LENNON & YOKO ONO+* AT 80 WOOSTER ST. NEW YORK - 1970...MAY 16-22: CAPSULE BY JOHN & YOKO + FLUX SPACE CENTER A 6 x 6 ft enclosure having various films projected on its walls to a single viewer inside ... No. 4 (Yoko Ono '66) close up of walking buttock...
all photographs copyright nineteen seVenty by peTer mooRE (Fluxus Newspaper No.9) 1970.

1965 FLUXFILMS:...Yoko Ono: no. 4 (walking buts)
George Maciunas, Diagram of Historical Developments of Fluxus... [1973].

COMMENTS: *Yoko Ono on* Film No. 4, *London, 1967, published in* This Is Not Here, *1971:*

"...This film proves that anybody can be a director....I'm hoping that after seeing this film people will start to make their own home movies like crazy.

"In 50 years or so...they would come to the No. 4 film and see a sudden swarm of exposed bottoms, that these bottoms in fact belonged to people who represented the London scene. And I hope that they would see that the 60's was not only the age of achievements, but of laughter. This film, in fact, is like an aimless petition signed by people with their anuses. Next time we wish to make an appeal, we should send this film as the signature list..."

Maciunas used two images of asses identical to, or from, Number 4 *for Ben Vautier's* Assholes Wallpaper, *and one image for the label of* Flux Holes. *It was an image that delighted Maciunas. The film was begun in New York and expanded greatly by Ono in London. Parts of the earlier New York shooting are used by Fluxus. The work appears in all versions of the* Fluxfilms *package, and was offered for sale as a separate film, appears as an 8mm film loop in* Flux Year Box 2, *and was intended for use in the film capsule.*

ONE see:
EYEBLINK

PAINTING TO BE STEPPED ON

APR. 11-17: DO IT YOURSELF BY JOHN & YOKO + EVERYBODY... Painting to be stepped on, (Yoko Ono '61) ink pad as door mat...
Schedule of events for Fluxfest presentation of John Lennon and Yoko Ono. [ca. April 1970]. version B

FLUXFEST PRESENTATION OF JOHN LENNON & YOKO ONO +* AT 80 WOOSTER ST. NEW YORK —1970...APR.11-17: DO IT YOURSELF-BY JOHN & YOKO + EVERYBODY...Painting to be stepped on (Yoko Ono '61) ink pad as door mat...
all photographs copyright nineteen seVenty by peTer mooRE (Fluxus Newspaper No. 9) 1970.

11.04-29.05.1970 FLUXFEST OF JOHN LENNON & YOKO ONO: ... 11-17.04 DO IT YOURSELF - ONO painting to be stepped,...
George Maciunas, Diagram of Historical Developments of Fluxus... [1973].

COMMENTS: *The score for this work is dated winter, 1960 as it appears in the 1970 edition of* Grapefruit, *published by Simon and Schuster, New York. One is instructed to leave a canvas or painting on the ground for people to step on. A version was exhibited by George Maciunas in his AG Gallery in New York in 1961. Maciunas' Fluxus realization of Takehisa Kosugi's* Theatre Music, *"keep walking intently," footsteps on paper, which is included in* FLUXUS 1, *was produced by placing paint in pans on the floor at an entrance and fine paper beyond. Maciunas' realization of Ono's* Painting to be Stepped On *during the John and Yoko Fluxfest was identical to the Kosugi, which, of course, derives from Ono.*

Yoko Ono. PAINTING TO HAMMER A NAIL. Constructed ca. 1971

PHOTOGRAPHER NOT IDENTIFIED

PAINTING TO HAMMER A NAIL

APR. 11-17: DO IT YOURSELF BY JOHN & YOKO + EVERYBODY...by Yoko Ono...Painting to hammer a nail, (each on 6' x 9' wall)...
Schedule of events for Fluxfest presentation of John Lennon and Yoko Ono. [ca. April 1970]. version A

APR. 11-17: ... [as above] ... Painting to hammer a nail (Yoko Ono '61)...
Schedule of events for Fluxfest presentation of John Lennon and Yoko Ono. [ca. April 1970]. version B

FLUXFEST PRESENTATION OF JOHN LENNON & YOKO ONO+* AT 80 WOOSTER ST. NEW YORK - 1970...APR.11-17: DO IT YOURSELF - BY JOHN & YOKO + EVERYBODY...Painting to hammer a nail
all photographs copyright nineteen seVenty by peTer mooRE (Fluxus Newspaper No. 9) 1970.

YOKO ONO 1965...nail paintings...
George Maciunas, Diagram of Historical Developments of Fluxus... [1973].

11.04-29.05.1970 FLUXFEST OF JOHN LENNON & YOKO ONO: ... 11-17.04 DO IT YOURSELF - ONO painting to be hammered, etc.
ibid.

COMMENTS: *This participatory work dates from 1961, and one version was adopted by Maciunas for the John and Yoko Fluxfest. Ono wrote several variations: "hammer a nail into a piece of glass," "mirror," "canvas," "wood," "metal."*

PAINTINGS see:
ADD COLOUR PAINTING
DO IT YOURSELF PAINTING
DRAW CIRCLE PAINTING
KITCHEN PIECE
PAINTING TO BE STEPPED ON
PAINTING TO HAMMER A NAIL
SMOKE PAINTING

PIECES HIDDEN IN LOOK-ALIKE CONTAINERS, CHESS SET

APR. 11-17: DO IT YOURSELF BY JOHN & YOKO + EVERYBODY...by Yoko Ono...Chess Set, (each with piece hidden in look-alike container)...
Schedule of events for Fluxfest presentation of John Lennon and Yoko Ono. [ca. April 1970]. version A

COMMENTS: *Yoko Ono is a strong pacifist, working for peace in numerous ways throughout her life. Chess is a war-mimicking game, and both the chess sets she designed defeat combat. In Ono's other chess set (not a Fluxus work) both sides are white. By the middle of the game, even master players would get hopelessly mixed up.*

Yoko Ono. WHITE CHESS SET. Constructed ca. 1971, the set is conceptually similar to her Fluxus work. PIECES HIDDEN IN LOOK-ALIKE CONTAINERS, CHESS SET

PHOTOGRAPHER NOT IDENTIFIED

PORTRAIT OF JOHN LENNON AS A YOUNG CLOUD

MAY 23-29: PORTRAIT OF JOHN LENNON AS A YOUNG CLOUD BY YOKO ONO + EVERYPARTICIPANT A 6ft x 10ft wall of 100 drawers (containing more boxes), and doors, all empty inside except one with a microscope entitled: John's smile. Musical

portrait of John Lennon (by Joe Jones) when one of the doors is opened.

Schedule of events for Fluxfest presentation of John Lennon and Yoko Ono. [ca. April 1970]. version B

MAY 23-29: PORTRAIT OF JOHN LENNON AS A YOUNG CLOUD BY YOKO ONO + EVERYBODY A wall of many drawers and doors, all empty inside except one with a microscope titled: "John's smile"

Schedule of events for Fluxfest presentation of John Lennon and Yoko Ono. April 1, 1970. version C

COMMENTS: *There are two versions of this work. This one, described above, wasn't built until 1971, for Yoko Ono's "This is Not Here" at the Everson Museum. A collective work of the same title was "a maze of 8 doors each opening in a different manner," built by Maciunas for the John & Yoko Fluxfest.*

PORTRAIT OF JOHN LENNON AS A YOUNG CLOUD see:
Collective

RAIN

MAY 2-8: BLUE ROOM BY JOHN & YOKO + FLUXLIARS Entire room (floor, walls, ceiling), exterior (door & window) interior furnishings to be white ... Exterior signs: ... rain ... (according to the weather of the day) by Yoko Ono 1967.

Schedule of events for Fluxfest presentation of John Lennon and Yoko Ono. [ca. April 1970]. version A

MAY 2-8: ...[as above] ... Exterior signs:... rain, ... (according to weather) (Yoko Ono '67) .

Schedule of events for Fluxfest presentation of John Lennon and Yoko Ono. [ca. April 1970]. version B

FLUXFEST PRESENTATION OF JOHN LENNON & YOKO ONO +*AT 80 WOOSTER ST. NEW YORK - 1970 ... MAY 2-8: BLUE ROOM BY JOHN & YOKO + FLUXLIARS Entire room (floor, walls, ceiling), and furnishings were white ... exterior signs: ... Rain...(according to the weather (Yoko Ono)...

all photographs copyright nineteen seVenty by peTer mooRE (Fluxus Newspaper No. 9) 1970.

COMMENTS: *A sign.*

SCORES see:
DO IT YOURSELF
GRAPEFRUIT
GRAPEFRUIT NO. 2
Unidentified Scores

SELF PORTRAIT
Silverman No. > 346.I, ff.

BUY NOW! SELFPORTRAIT BY YOKO ONO $1

ONLY $5 WITH FRAME...SEND YOUR ORDER AND MONEY TO YOKO ONO C/O FLUXUS P.O. BOX 180 NEW YORK 10013

Fluxus Offset Printing Negative. [1964].

FLUXKIT containing following fluxus-publications: (also available separately)...FLUXUSh YOKO ONO: self portrait $1

Vaseline sTREet (Fluxus Newspaper No. 8) May 1966.

YOKO ONO 1965...self portrait, 1965...

George Maciunas, Diagram of Historical Developments of Fluxus... [1973].

COMMENTS: *The one shown (Silverman No. > 346.I) was made by Ono. Maciunas included a version he produced in some copies of FLUXUS 1. Some years later, Ono produced many versions of a closely related work, A Box of Smile (Silverman No. 350) — some of these made by Maciunas for Ono. In 1970, Maciunas started assembling his own Flux Smile Machine, which was an homage to Ono. In Ono's work, one is prompted to smile naturally at recognition of the idea. Maciunas' contains a gag mouth-spreading device — forced grin.*

Yoko Ono. SELF PORTRAIT. Top version is included in some copies of FLUXUS 1. Bottom version with mirror reflecting text on envelope was assembled by Ono in 1965 and distributed both through the artist and Fluxus

SEPARATE DOORS DOOR see:
George Maciunas

SIGNS see:
MEND
NOT TO BE APPRECIATED UNTIL IT'S
BROKEN
RAIN
SKY
SPRING
STAY UNTIL THE ROOM IS BLUE
THIS IS NOT HERE
THIS LINE IS A PART OF A LARGE SPHERE,
A STRAIGHT LINE EXISTS ONLY IN YOUR
MIND
THIS SPHERE WILL BE A SHARP POINT WHEN
IT GETS TO THE FAR SIDE OF THE ROOM
IN YOUR MIND
THIS WINDOW IS 2000 FT WIDE
3 SPOONS
USE ASHTRAY FOR ASHES
WIND

SKY

MAY 2-8: BLUE ROOM BY JOHN & YOKO +
FLUXLIARS Entire room (floor, walls, ceiling), exterior (door & window) interior furnishings to be white...Exterior signs:...sky,...(according to the weather of the day) by Yoko Ono 1967.
Schedule of events for Fluxfest presentation of John Lennon and Yoko Ono. [ca. April 1970]. version A

MAY 2-8:...[as above]...Exterior signs...sky...(according to weather) (Yoko Ono '67)
Schedule of events for Fluxfest presentation of John Lennon and Yoko Ono. [ca. April 1970]. version B

COMMENTS: *Yoko Ono used the idea of sky in many conceptual works throughout the 1960s. The most famous work is probably* Painting to See the Skies, *1961, which is a canvas with a hole cut into it. At this time, Ben Vautier was working with literal holes, and Ay-O was involved with tactile holes.*

SKY DISPENSER

Silverman No. > 346.II

MAY 30-JUNE 5: THE STORE BY JOHN & YOKO
+ FLUXFACTORY Coin operated vending machines:
...machine dispensing sky...by Yoko Ono
Schedule of events for Fluxfest presentation of John Lennon and Yoko Ono. [ca. April 1970]. version B

MAY 30-JUNE 5: THE STORE BY YOKO + FLUX-
FACTORY Vending machines (coin operated):...machine dispensing sky...(by Yoko Ono),...
Schedule of events for Fluxfest presentation of John Lennon and Yoko Ono. April 1, 1970. version C

Yoko Ono. SKY DISPENSER. Inscribed "Word Machine Piece #1 'Sky Machine' by Yoko Ono 1961. Realized by Anthony Cox 1966"

Yoko Ono. Sky from SKY DISPENSER

COMMENTS: *"Ono's Sales List," 1965, lists a* Sky Machine *for $1,500 — "machine produces nothing when coin is deposited." In 1966, Yoko Ono had a stainless steel dispenser built that produced a small card with the word "sky" on it when a coin was deposited.*

SMALL DOOR IN DOOR see:
George Maciunas

SMOKE PAINTING

APR. 11-17: DO IT YOURSELF BY JOHN & YOKO
+ EVERYBODY...by Yoko Ono...Smoke painting (paintings by other artists burned by cigarette fire)...
Schedule of events for Fluxfest presentation of John Lennon and Yoko Ono. [ca. April 1970]. version A

COMMENTS: Smoke Painting *is a Fluxus recycling of an earlier Ono concept.*

SNOW FALLING AT DAWN

BUY NOW! SOUNDTAPE AND, OR FILM OF THE
SNOW FALLING AT DAWN 25¢ PER INCH TYPES:
A. SNOW OF INDIA B. SNOW OF KYO C. SNOW
OF AOS...SEND YOUR ORDER AND MONEY TO
YOKO ONO C/O FLUXUS P.O. BOX 180 NEW
YORK 10013
Fluxus Offset Printing Negative. [1964].

COMMENTS: *These tapes were packaged by the artist and are not known to have been widely distributed by Fluxus.*

SOUNDTAPE see:
SNOW FALLING AT DAWN

SPRING

MAY 2-8: BLUE ROOM BY JOHN & YOKO + FLUXLIARS Entire room (floor, walls, ceiling), exterior (door & window) interior furnishings to be white … Exterior signs: Spring … (according to the weather of the day) by Yoko Ono 1967…
Schedule of events for Fluxfest presentation of John Lennon and Yoko Ono. [ca. April 1970]. version A

MAY 2-8:…[as above]…Exterior signs: spring…(according to weather) (Yoko Ono '67)
Schedule of events for Fluxfest presentation of John Lennon and Yoko Ono. [ca. April 1970]. version B

FLUXFEST PRESENTATION OF JOHN LENNON & YOKO ONO+* AT 80 WOOSTER ST. NEW YORK - 1970…MAY 2-8: BLUE ROOM BY JOHN & YOKO + FLUXLIARS Entire room (floor, walls, ceiling), and furnishings were white…exterior signs: Spring… (according to weather (Yoko Ono)…
all photographs copyright nineteen seVenty by peTer mooRE (Fluxus Newspaper No. 9) 1970.

COMMENTS: Spring — *a conceptual signage work.*

STAY UNTIL THE ROOM IS BLUE

MAY 2-8: BLUE ROOM BY JOHN & YOKO + FLUXLIARS…Entire room (floor, walls, ceiling), exterior (door & window) interior furnishings to be white…Other interior signs: Stay until the room is blue Y.O. 1966,…
Schedule of events for Fluxfest presentation of John Lennon and Yoko Ono. [ca. April 1970]. version A

MAY 2-8:…[as above] …Stay until the room is blue (Yoko Ono '66);…
Schedule of events for Fluxfest presentation of John Lennon and Yoko Ono. [ca. April 1970]. version B

FLUXFEST PRESENTATION OF JOHN LENNON & YOKO ONO+* AT 80 WOOSTER ST. NEW YORK - 1970…MAY 2-8: BLUE ROOM BY JOHN & YOKO + FLUXLIARS Entire room (door, walls, ceiling) and furnishings were white…interior sign: Stay until the room is blue (Yoko Ono '66)…
all photographs copyright nineteen seVenty by peTer mooRE (Fluxus Newspaper No. 9) 1970.

COMMENTS: *This sign refers to the title of the environment, "Blue Room," which was painted entirely white.*

TEAR DISPENSER see:
DISPENSERS
13 DAYS DO-IT-YOURSELF DANCE FESTIVAL see:
DO IT YOURSELF FLUXFEST

THIS IS NOT HERE

MAY 2-8: BLUE ROOM BY JOHN & YOKO + FLUXLIARS…Entire room…exterior…interior furnishings to be white…A very large box with sign: This is not here, Y.O. 1967…
Schedule of events for Fluxfest presentation of John Lennon and Yoko Ono. [ca. April 1970]. version A

MAY 2-8:…[as above]…A very large box with sign: This is not here (Yoko Ono '67)…
Schedule of events for Fluxfest presentation of John Lennon and Yoko Ono. [ca. April 1970]. version B

[as above]
all photographs copyright nineteen seVenty by peTer mooRE (Fluxus Newspaper No. 9) 1970.

COMMENTS: *This Is Not Here dates from 1967, and was used as the title of Ono's one woman show at the Everson Museum in 1971.*

THIS LINE IS A PART OF A LARGE SPHERE, A STRAIGHT LINE EXISTS ONLY IN YOUR MIND

MAY 2-8: BLUE ROOM BY JOHN & YOKO + FLUXLIARS…Entire room…exterior…interior furnishings to be white…Long straight line with sign: This line is a part of a large sphere, a straight line exists only in your mind, Y.O. 1966&70…
Schedule of events for Fluxfest presentation of John Lennon and Yoko Ono. [ca. April 1970]. version A

MAY 2-8:…[as above]
Schedule of events for Fluxfest presentation of John Lennon and Yoko Ono. [ca. April 1970]. version B

FLUXFEST PRESENTATION OF JOHN LENNON & YOKO ONO +* AT 80 WOOSTER ST. NEW YORK —1970…MAY 2-8: BLUE ROOM BY JOHN & YOKO + FLUXLIARS Entire room (floor, walls, ceiling), and furnishings were white…Long straight line with sign: this line is a part of a large sphere, a straight line exists only in your mind, (Yoko Ono, 1966 & 70)…
all photographs copyright nineteen seVenty by peTer mooRE (Fluxus Newspaper No.9) 1970.

COMMENTS: *Yoko Ono did a number of works using the idea of lines, which grew out of La Monte Young's Compositions 1961 as a sort of artists' dialogue.*

THIS SPHERE WILL BE A SHARP POINT WHEN IT GETS TO THE FAR SIDE OF THE ROOM IN YOUR MIND

MAY 2-8: BLUE ROOM BY JOHN & YOKO + FLUXLIARS…Entire room…exterior…interior furnishings to be white…soft rubber ball with sign: This sphere will be a sharp point when it gets to the far

side of the room in your mind. Yoko Ono 1964…
Schedule of events for Fluxfest presentation of John Lennon and Yoko Ono. [ca. April 1970]. version A

MAY 2-8:…[as above]
Schedule of events for Fluxfest presentation of John Lennon and Yoko Ono. [ca. April 1970]. version B

FLUXFEST PRESENTATION OF JOHN LENNON & YOKO ONO+*AT 80 WOOSTER ST. NEW YORK - 1970…MAY 2-8: BLUE ROOM BY JOHN & YOKO + FLUXLIARS Entire room (floor, walls ceiling), and furnishings were white…soft rubber ball with sign: This sphere will be a sharp point when it gets to the far side of the room in your mind. (Yoko Ono '64)…
all photographs copyright nineteen seVenty by peTer mooRE (Fluxus Newspaper No. 9) 1970.

COMMENTS: *This work, which dates from 1964, was adopted by Maciunas for the 1970 Fluxus event. A clear plexiglass sphere was used for the piece when it was realized again a year later at Ono's show at the Everson Museum.*

THIS WINDOW IS 2000 FT WIDE

MAY 2-8: BLUE ROOM BY JOHN & YOKO + FLUXLIARS…Entire room (floor, walls, ceiling), exterior (door & window), interior furnishings to be white…Window sign: This window is 2000 ft. long, Y.O. 1967, also This window is 6ft wide, John Lennon, 1970
Schedule of events for Fluxfest presentation of John Lennon and Yoko Ono. [ca. April 1970]. version A

MAY 2-8:…window sign: This window is 2000ft wide (Yoko Ono '67), also This window is 5ft wide (John Lennon '70…
Schedule of events for Fluxfest presentation of John Lennon and Yoko Ono. [ca. April 1970]. version B

FLUXFEST PRESENTATION OF JOHN LENNON & YOKO ONO +* AT 80 WOOSTER ST. NEW YORK -1970…MAY 2-8: BLUE ROOM BY JOHN & YOKO + FLUXLIARS Entire room (floor, walls, ceiling), and furnishings were white…window sign: This window is 2000ft wide (Yoko Ono '67)…another window sign: This window is 5 ft wide (John Lennon '70)…
all photographs copyright nineteen seVenty by peTer mooRE (Fluxus Newspaper No. 9) 1970.

COMMENTS: *This conceptual work, from 1967, was installed by Maciunas for the John & Yoko Fluxfest in 1970 as a dialogue with John Lennon's literal work,* This Window Is 5 Ft Wide.

3 SPOONS

MAY 2-8: BLUE ROOM BY JOHN & YOKO + FLUXLIARS…Entire room (floor, walls, ceiling), ex-

Yoko Ono. 3 SPOONS. Assembled ca. 1971

PHOTOGRAPHER NOT IDENTIFIED

terior (door and window), interior furnishings to be white...WINDOW DISPLAY: 2 sets of 4 spoons in the shop window, one set with sign: 3 spoons, Yoko Ono, 1967, another with sign: 4 spoons, John Lennon 1970...
Schedule of events for Fluxfest presentation of John Lennon and Yoko Ono. [ca. April 1970]. version A

MAY 2-8:...Window display: 2 sets of 4 spoons, one set with sign: 3 spoons (Yoko Ono '67), and another with sign: 4 spoons (John Lennon, 1970)
Schedule of events for Fluxfest presentation of John Lennon and Yoko Ono. [ca. April 1970]. version B

FLUXFEST PRESENTATION OF JOHN LENNON & YOKO ONO+* AT 80 WOOSTER ST. NEW YORK -1970...MAY 2-8: BLUE ROOM BY JOHN & YOKO + FLUXLIARS Entire room (floor, walls, ceiling), and furnishings were white...window display: set of 4 spoons with sign: 3 spoons (Yoko Ono '67)...another set of 4 spoons with sign: 4 spoons (John Lennon '70)...
all photographs copyright nineteen seVenty by peTer mooRE (Fluxus Newspaper No. 9) 1970.

COMMENTS: *Ono's simple distortions of apparent reality, when thought about, become more real than the seemingly obvious.* 3 Spoons *was used for the Fluxus show with John Lennon's literal* 4 Spoons.

20 LB RUBBER BOOTS see:
George Maciunas and Yoko Ono

Unidentified Scores

Scores available by special order...Also available are scores of works by...Yoko Ono...
Fluxus Preview Review, [ca. July] 1963.

COMMENTS: *Unfortunately, I haven't been able to identify which of Yoko Ono's scores George Maciunas was planning to distribute through Fluxus in 1963. Clearly, they were to be separate from her "Complete Works," which became Grapefruit, as both are listed in the same Fluxus prospectus.*

USE ASHTRAY FOR ASHES

MAY 2-8: BLUE ROOM BY JOHN & YOKO + FLUXLIARS...Entire room...exterior...interior furnishings to be white...Other interior signs:...Use ashtray for ashes (Y.O. 1966)...
Schedule of events for Fluxfest presentation of John Lennon and Yoko Ono. [ca. April 1970]. version A

MAY 2-8:...[as above]...Use ashtray for ashes (Yoko Ono '66)...
Schedule of events for Fluxfest presentation of John Lennon and Yoko Ono. [ca. April 1970]. version B

FLUXFEST PRESENTATION OF JOHN LENNON & YOKO ONO+* AT 80 WOOSTER ST. NEW YORK -1970...MAY 2-8: BLUE ROOM BY JOHN & YOKO + FLUXLIARS Entire room (floor, walls, ceiling), and furnishings were white...interior sign: Use ashtray for ashes (Yoko Ono '66)
all photographs copyright nineteen seVenty by peTer mooRE (Fluxus Newspaper No. 9) 1970.

COMMENTS: *This is an atypically literal work of Ono's.*

VENDING MACHINES see:
DISPENSERS
WASH PAINTING see:
KITCHEN PIECE

WATER CLOCK

OBJECTS...Water clock by Yoko Ono
Proposal for 1975/76 Flux-New Year's Eve Event. [ca. November 1975].

"The story on the other side is self explanatory. As a result of which I have to have eye surgery, since I hardly see anything with the left eye. In one sense, these hospital expenses to me are a windfall to any collectors of flux-objects. Now with high cost of surgery, I must make more objects and begin to respond to various orders and requests for them. Thus I am sending by mail to you the following...Yoko's water clock..."
Letter: George Maciunas to Dr. Hanns Sohm. November 30, 1975.

"...Second package was mailed in February...inside was a plastic tube, which I will explain now how to use. It is a water clock by Yoko Ono (collaborated by myself) $200 First remove one of the corks and fill the top half of the tube with water fully, the balls will be far apart and slowly will be coming together, until when the top water runs to the bottom half, when the balls will "kiss" each other, in the middle I provided two eye screws by which the tube can be suspended, best against a wall, since it will tend to tip over when top heavy..."
Letter: George Maciunas to Dr. Hanns Sohm, May 1, 1976.

COMMENTS: *George Maciunas made at least one* Water Clock, *which is now in the Archiv Sohm at the Staatsgalerie Stuttgart.*

© 1976 LARRY MILLER

George Maciunas demonstrating Yoko Ono's WATER CLOCK. Berlin, 1976

WEIGHTS see:
 LOOK-ALIKE BOXES OF DIFFERENT
 WEIGHTS

WET SPONGE see:
 John Lennon and Yoko Ono

WIND

MAY 2-8: BLUE ROOM BY JOHN & YOKO +
FLUXLIARS Entire room...exterior (door and window), interior furnishings to be white...Exterior signs:
...wind, etc. (according to the weather of the day) by
Yoko Ono 1967.
*Schedule of events for Fluxfest presentation of John Lennon
and Yoko Ono. [ca. April 1970]. version A*

MAY 2-8:...[as above]...Exterior signs:...wind, etc.
(according to weather) (Yoko Ono '67)
*Schedule of events for Fluxfest presentation of John Lennon
and Yoko Ono. [ca. April 1970]. version B*

FLUXFEST PRESENTATION OF JOHN LENNON
& YOKO ONO+* AT 80 WOOSTER ST. NEW YORK
-1970...MAY 2-8: BLUE ROOM BY JOHN & YOKO
+ FLUXLIARS Entire room (floor, walls, ceiling),
and furnishings were white ... exterior signs ... Wind
(according to weather (Yoko Ono)...
*all photographs copyright nineteen seVenty by peTer mooRE
(Fluxus Newspaper No. 9) 1970.*

COMMENTS: *A poetic sign work, made for the Fluxfest.*

YOKO ONO & DANCE CO. see:
 DO IT YOURSELF FLUXFEST

YOKO ONO and TAKAKO SAITO

LOOK-ALIKE BOXES OF DIFFERENT WEIGHTS

MAY 9-15: WEIGHT & WATER BY JOHN & YOKO
+ FLUX-FAUCET Store floor flooded with water to
about 1" height...12 look-alike boxes of different
weights, from light, floating on the surface, to heavy
ones glued to the floor, (Yoko & Takako Saito...
*Schedule of events for Fluxfest presentation of John Lennon
and Yoko Ono. [ca. April 1970]. version A*

...[as above]...10 look-alike boxes of different
weights, from light, floating on the surface, to heavy
ones glued to the floor. (Yoko + Takako Saito)...
*Schedule of events for Fluxfest presentation of John Lennon
and Yoko Ono. [ca. April 1970]. version B*

COMMENTS: *This work was not realized for the "weight and
water" part of the Fluxfest Presentation of John Lennon &
Yoko Ono. The idea is based on Takako Saito's* Weight Chess
where chess pieces look identical, but have different weights

inside that correspond to the values of the pieces. Weight deception is also used by Maciunas for his Very Heavy Lead
Racket (Silverman No. < 258.III).*

ROCHELLE OWENS

*It was announced in the Brochure Prospectus version B, that
Rochelle Owens would contribute "Poems" to FLUXUS
NO. 1 U.S. YEARBOX. see: COLLECTIVE*

P

NAM JUNE PAIK

*"Paik looks. (I am going to make a photo of him for Fluxus,
so I will send you a copy.) He is small, short I mean, smaller
than Toshi, with hair not too short but growing straight up,
like a field of wheat. Walks around all winter in sandals and a
scarf wound right to his eyes. Calls nearly everyone Hallo,
Hallo, Hallo when he has something to say. He is very modest
and unpretentious which is in great contrast to many people
here and N.Y. In fact he is not eager to perform or have his
work performed at all, which is even more unusual. He speaks
English + German like Japanese, so very few can understand
him at first. He is extremely friendly." Letter: George
Maciunas to Dick Higgins, January 18, 1962.*

*It was announced in the first plan for FLUXUS NO. 2 WEST
EUROPEAN ISSUE 1 that Nam June Paik would contribute
"Towards a new Onthology of Music," "several studies (compositions)," and "Apology of John Cage." The next two plans
for FLUXUS NO. 2 expanded Paik's contribution to include
"A sound collage (record)." Brochure Prospectus version A
lists the following: "Apology of John Cage," "Towards the
New Onthology of Music," "Several studies," "Ode to Chen-Chu or to Dmitri Karamazov" and "Zen exercises (record)"
for FLUXUS NO. 2, now called GERMAN & SCANDINAVIAN YEARBOX. Brocure Prospectus version B dropped "several studies" and added "New compositions" for GERMAN
& SCANDINAVIAN YEARBOX, now called FLUXUS NO. 3.*

*Initially, Paik was going to contribute "Zen Priest training" to
FLUXUS NO. 3 JAPANESE ISSUE and "Oriental Nihilism in
the Past" to FLUXUS NO. 4 HOMAGE TO THE DISTANT
PAST. Both these contributions were dropped and then plans
called for "Indeterminism in Korean Medieval Art," for
FLUXUS NO. 4 (later called FLUXUS NO. 5 HOMAGE TO
THE PAST). The scores for "Zen for the Street," "Dragging
Suite," "Composition for poor man," were published in
Fluxus Preview Review. The title "Composition for poor
man" was later changed to "Nam June Paik's Theatre for
Poor Man" and was included in FLUXUS 1. "Banking Piece,"
a collaboration by Paik and Frank Trowbridge is also published in Fluxus Preview Review. An article on Nam June Paik
was reproduced in Fluxus Newspaper No. 1. Photographs of
his "Prepared Pianos," included in the "Exposition of Music
Electronic Television" at Galerie Parnass (Wuppertal, West
Germany, March 11-20, 1963), appeared in Fluxus News-*

*paper No. 3. Later, Paik's essay "Afterlude to the Exposition
of Experimental Television 1963, March.Galerie Parnass" was
published in Fluxus Newspaper No. 4. Two performance
instructions, "Zen for Street" and "Dragging Suite" were included in Flux Fest Kit 2.*

ADDING MACHINE TAPE

*"For the 'Review of the Univ. of Avant garde Hinduism' I have the following items which you may want
to use in some way. (I can have 100 of each very soon)
...Adding machine tape..."*
*Letter: George Maciunas to Nam June Paik, [ca. February
1963].*

COMMENTS: *Adding Machine Tape was never distributed by
Fluxus as an aspect of The Monthly Review of the University
for Avant-Garde Hinduism. The idea for tape comes from
George Maciunas, and relates to his In Memoriam to Adriano
Olivetti, a score that incorporates used Olivetti adding machine tape.*

ANIMALS see:
 LITTLE LIVE ANIMALS

ARM-PIT HAIR OF A CHICAGOAN NEGRO PROSTITUTE

wer liefert was?
who supplies what?
qui peut livrer quoi?
As Spiegle. Co. in Chicago or Neckermann
Versand in Frankfurt
FLUXUS macht es moeglich
Wir liefern Musik,
we supply music,
...or arm-pit hair of a chicagoan negro prostitute
etc...
*Nam June Paik, The Monthly Review of the University for
Avant-Garde Hinduism. [ca. March 1963].*

COMMENTS: *Perhaps a Maciunas fantasy — Paik had not yet
come to America.*

AUTOMOBILE DOOR HANDLES

*"For the 'Review of the Univ. of Avant garde Hinduism' I have the following items which you may want
to use in some way. (I can have 100 of each very soon)
...Many automobile parts (from my Chevrolet which
fell apart) like...door handles..."*
*Letter: George Maciunas to Nam June Paik, [ca. February
1963].*

COMMENTS: *Maciunas had a succession of wonderous automobiles during his stay in Germany. Periodically, they would
break down. Maciunas loved to recycle junk into art — ready-made, leave-it-as-you-find-it art, not the voguish assemblage*

art of Cesar, Chamberlain, and others who were just making the scene. Automobile Door Handles *were never distributed by Fluxus as an aspect of* The Monthly Review of the University for Avant-Garde Hinduism.

AUTOMOBILE PARTS see:
 AUTOMOBILE DOOR HANDLES
 MOTOR PARTS
 SPEEDOMETER
 TYRES
 WINDSHIELD WIPER
BAGATELLES AMERICAINES-1 see:
 SMALLEST BOOK OF THE WORLD

BLEEDING DOG'S CADAVER

To the subscriber of the Monthly Review of the University for Avant-Garde Hinduism sometimes comes something by mail. once or twice or thrice,...or you will be attacked by the bleeding dog's cadaver via express package...
Nam June Paik, The Monthly Review of the University for Avant-Garde Hinduism. [ca. March 1963].

[as above]
Fluxus Preview Review, [ca. July] 1963.

COMMENTS: Bleeding Dog's Cadaver *is not known to have been distributed by Fluxus to subscribers of* The Monthly Review of the University for Avant-Garde Hinduism. *Paik used a slaughtered cow's head in his "Exposition of Music Electronic Television" at Galerie Parnass, March 11-20, 1963. The authorities ordered the offending head removed.*

BOOKS see:
 CATALOGUES
 COMPLETE WORKS
 ENCYCLOPEDIAS
 HEAVIEST BOOK OF THE WORLD
 LARGEST BOOK OF THE WORLD
 LAW BOOKS
 LONGEST BOOK OF THE WORLD
 MOST DIFFICULT BOOK OF THE WORLD
 NARROWEST, BUT NOT LONGEST BOOK OF
 THE WORLD
 SMALLEST BOOK OF THE WORLD
 STORY BOOKS
BOTTLES see:
 CORTISONE BOTTLE OF G.MACIUNAS
 JARS
 MEDICINE (PILL) JAR
 NOSEDROP BOTTLES W/ DROPPER

CALENDAR PAGES

"For the 'Review of the Univ. of Avant garde Hindu-

GEORGE MACIUNAS

Nicht rauchen no smoking!

Nam June Paik during Festum Fluxorum. Musik Und Antimusik Das Instrumentale Theater, Duesseldorf, February, 1962

ism' I have the following items which you may want to use in some way. (I can have 100 of each very soon) ...Calendar pages (many)..."
Letter: George Maciunas to Nam June Paik, [ca. February 1963].

COMMENTS: *Western* Calendar Pages *were never distributed by Fluxus as an aspect of* The Monthly Review of the University for Avant-Garde Hinduism. *It's probable that Paik used Eastern* Calendar Pages *in his mailings of* The Monthly Review *when he traveled to Japan shortly after his exhibition at the Galerie Parnass in 1963. In 1959, Piero Manzoni made a work of thirty calendar pages attached to a sheet titled,* Settembre, 1959.

CATALOGUES

"For the 'Review of the Univ. of Avant garde Hinduism' I have the following items which you may want to use in some way. (I can have 100 of each very soon) ... Books (all kinds)...catalogues"
Letter: George Maciunas to Nam June Paik, [ca. February 1963].

COMMENTS: *This is a suggestion from Maciunas who did several ready-made books as Fluxus Editions.*

CHILDREN'S TOYS

"For the 'Review of the Univ. of Avant garde Hinduism' I have the following items which you may want to use in some way. (I can have 100 of each very soon) ...I can get many many children's toys. (old ones)..."
Letter: George Maciunas to Nam June Paik, [ca. February 1963].

COMMENTS: *Although never used by Fluxus as an aspect of Paik's* The Monthly Review of the University for Avant-Garde Hinduism, *Paik integrated doll parts and other children's toys into his "Exposition of Music Electronic Television" in March, 1963. Children's toys appear later in the Fluxus Edition of George Brecht's* Valoche, *and elsewhere.*

COAT HANGERS

"For the 'Review of the Univ. of Avant garde Hinduism' I have the following items which you may want to use in some way.... Many coat hangers. (wood or metal) I can get 100 any time. etc. etc...."
Letter: George Maciunas to Nam June Paik, [ca. February 1963].

COMMENTS: *A Maciunas suggestion,* Coat Hangers *were never distributed by Fluxus as an aspect of* The Monthly Review of the University for Avant-Garde Hinduism.

COIN see:
1 CENT COIN IN ENVELOPE

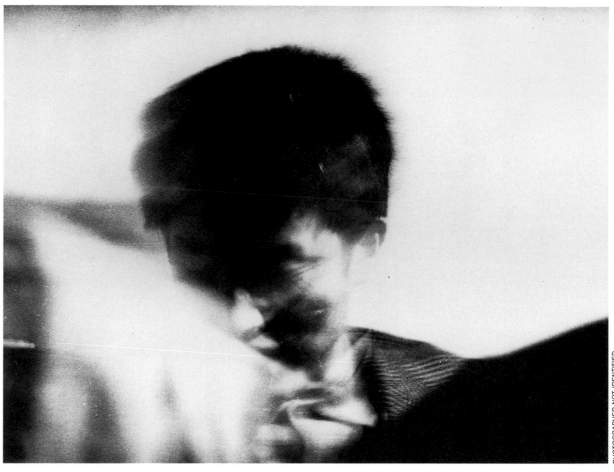

Nam June Paik. 1963

PHOTOGRAPHER NOT IDENTIFIED

COMPLETE WORKS

"...past & future works published under one cover or in a box - a kind of special fluxus edition...sold separately or as part of fluxus yearbox. I am going to publish such special Fluxus editions containing complete works of: ... Nam June Paik (maybe) ... This... could result in a nice & extensive library - or 'encyclopedia' of good works being done these days. A kind of Shosoin warehouse of today...."
Letter: George Maciunas to Robert Watts, [December 1962].

"...By Fall I should have some 6 Fluxus issues:...Nam June Paik Flux...Eventually I will acquire a press myself, for dealing with those stupid printers drains my patience..."
Letter: George Maciunas to Robert Watts, [ca. April 1963].

FLUXUS SPECIAL EDITIONS 1963-4...FLUXUSg.

NAM JUNE PAIK EXHIBITS & COMPOSITIONS $8
Daniel Spoerri, L'Optique Moderne. List on editorial page. 1963.

[as above]
La Monte Young, LY 1961. Advertisement page. [1963].

22-fg NAM JUNE PAIK: exhibits and compositions $8...
European Mail-Orderhouse: europeanfluxshop, Pricelist. [ca. June 1964].

[as above]
Second Pricelist - European Mail-Orderhouse. [Fall 1964].

COMMENTS: *Paik's* Complete Works *were never produced by George Maciunas as a Fluxus Edition. Rolf Jährling prepared a photo book on Paik's "Exposition of Music Electronic Television" in 1963, but it was never completed. See also, Paik's* Largest Book of the World.

CORTISONE BOTTLE OF G. MACIUNAS

wer liefert was?
who supplies what?
qui peut livrer quoi?
As Spiegle. Co. in Chicago or Neckermann
Versand in Frankfurt
FLUXUS macht es moeglich
Wir liefern Musik,
we supply music,...
or Cortisone bottle of G. Maciunas,...
Nam June Paik, The Monthly Review of the University for Avant-Garde Hinduism, [ca. March 1963].

COMMENTS: *Although* Cortisone Bottles of G. Maciunas *were never distributed by Fluxus to subscribers of* The Monthly Review of the University for Avant-Garde Hinduism, *Maciunas' medicine paraphernalia appears in numerous Fluxus Editions.*

DIARY see:
SOUND DIARY

DIRTY NAILS OF JOHN CAGE

wer liefert was?
who supplies what?
qui peut livrer quoi?
As Spiegle. Co. in Chicago or Neckermann
Versand in Frankfurt
FLUXUS macht es moeglich
Wir liefern Musik,
we supply music,...
or dirty nails of John Cage cut in 1963,...
Nam June Paik, The Monthly Review of the University for Avant-Garde Hinduism. [ca. March 1963].

COMMENTS: Dirty Nails of John Cage *is an homage/putdown of his mentor similar in spirit to Paik's gesture of cutting off Cage's necktie.*

DOG'S CADAVER see:
BLEEDING DOG'S CADAVER
DOOR see:
AUTOMOBILE DOOR HANDLES
PIANO ACTIVATED DOOR
EARTH see:
RED EARTH FROM AUSCHWITZ

ENCYCLOPEDIAS

"For the 'Review of the Univ. of Avant garde Hinduism' I have the following items which you may want to use in some way. (I can have 100 of each very soon) ... Books (all kinds)...encyclopedias..."
Letter: George Maciunas to Nam June Paik, [ca. February 1963].

COMMENTS: *Although not used as a Paik work, Maciunas made several Fluxus works of ready-made encyclopedias:* Arctic Bibliography, Index, *and* Encyclopedia of World Art.

EXHIBITS AND COMPOSITIONS see:
COMPLETE WORKS

EXPERIMENTAL TELEVISION

FLUXUS SPECIAL EDITIONS 1963-4...FLUXUS g. N.J. PAIK: Experimental Television, in cooperation with DIN 4 $?
Fluxus Preview Review, [ca. July] 1963.

COMMENTS: *This was to have been a publication by Paik titled,* Experimental Television. *It wasn't published by Fluxus. A long theoretical essay by Paik on experimental television was published in Fluxus Newspaper No. 4, June 1964. Perhaps this essay was to have been the basis for the publication advertised in the* Fluxus Preview Review.

FILMS see:
ZEN FOR FILM

GENUINE WATER FROM DUNKERQUE

wer liefert was?
who supplies what?
qui peut livrer quoi?
As Spiegle. Co. in Chicago or Neckermann
Versand in Frankfurt
FLUXUS macht es moeglich
Wir liefern Musik,
we supply music, that is, the genuine water from Dunkerque in organic glass bottle,...
Nam June Paik, The Monthly Review of the University for Avant-Garde Hinduism. [ca. March 1963].

FLUXUS SPECIAL EDITIONS 1963-4...To the subscriber of the Monthly Review of Avant-Garde Hinduism sometimes comes something by mail. Once or twice or thrice, you will find...genuine water from Dunkerque, in organic glass bottle,...
Fluxus Preview Review, [ca. July] 1963.

COMMENTS: *Vautier's* Dirty Water, *Liss'* Sacrament Fluxkit, *and Maciunas'* Fluxwater *all have a relationship to Paik's* Genuine Water from Dunkerque, *a work never realized.*

GLUE

"For the 'Review of the Univ. of Avant garde Hinduism' I have the following items which you may want to use in some way. (I can have 100 of each very soon) ... Much glue..."
Letter: George Maciunas to Nam June Paik, [ca. February 1963].

COMMENTS: *Maciunas' fascination with glue and adhesives extends to a number of his Fluxus works. Glue was never distributed by Fluxus as an aspect of* The Monthly Review of the University for Avant-Garde Hinduism.

HAIR see:
ARM-PIT HAIR OF A CHICAGOAN NEGRO PROSTITUTE

HEAVIEST BOOK OF THE WORLD

NAM JUNE PAIK-FLUXUS Publications g series; gg, ggggg, ggggggg in cooperation with VERLAG HAGAR (Rheinland), others handmade by the author. On sale between 1963 and 1973. With the preface of Jean-Pierre Wilhelm.... gggg: heaviest book of the world - the heaviest book - printed metal plates (25-75 pages) bound with barbed wire
20kg = 50 DM (postage uninvolved)
30kg = 70 DM (" ")
40 kg = 100 DM (" ")...
Fluxus Preview Review, [ca. July] 1963.

...phone or write for FREE information/ announcements/ advertisements about:...Nam June Paik's ... heaviest book of the world,...
European Mail-Orderhouse: europeanfluxshop, Pricelist. [ca. June 1964].

COMMENTS: *The* Heaviest Book of the World *was never made. In 1932, the Futurists printed a book on metal pages, Marinetti's* Parole in Liberta Futuriste - olfaative, tattili, termiche. *During the Fluxus period, Milan Knizak made several books on his work with cement covers imbedded with broken glass, metal, etc.*

JARS

"For the 'Review of the Univ. of Avant garde Hinduism' I have the following items which you may want to use in some way. (I can have 100 of each very soon) ... Jars. 8cm x 10cm. glass with metal screw-on cover...."
Letter: George Maciunas to Nam June Paik, [ca. February 1963].

COMMENTS: *Ready-made* Jars, *another Maciunas suggestion, were never distributed by Fluxus as an aspect of* The Monthly Review of the Univierisity for Avant-Garde Hinduism.

LARGEST BOOK OF THE WORLD

NAM JUNE PAIK-FLUXUS Publications g series; gg, ggggg, ggggggg, in cooperation with VERLAG HAGAR (Rheinland), others handmade by the author. On sale between 1963 and 1973. With the preface of Jean-Pierre Wilhelm.... ggg: largest book of the world - catalogue to the Exposition of Music in Galerie Parnass -

12 NF total area 700x700cm = 490000qcm ...
Fluxus Preview Review, [ca. July] 1963.

phone or write for FREE information/ announcements/ advertisements about: ... Nam June Paik's ... largest book of the world ...
European Mail-Orderhouse: europeanfluxshop, Pricelist. [ca. June 1964].

COMMENTS: *Rolf Jährling, the director of Galerie Parnass, prepared a book of offset photographs of Paik's "Exposition of Music Electronic Television," which was to have had texts by Tomas Schmit and Paik. However, it was never completed or distributed.*

LAW BOOKS

"For the 'Review of the Univ. of Avant garde Hinduism' I have the following items which you may want to use in some way. (I can have 100 of each very soon) ... Books (all kinds) law books ..."
Letter: George Maciunas to Nam June Paik, [ca. February 1963].

COMMENTS: *Law Books were a suggestion from Maciunas, and would have been ready-mades.*

LIST OF PUBLICATIONS

FLUXUS 1963 EDITIONS, AVAILABLE NOW FROM FLUXUS P.O. Box 180, New York 10013, N.Y. or FLUXUS 359 Canal St. New York. CO 7-9198 ...FLUXUS 1964 EDITIONS:...FLUXUSg NAM JUNE PAIK: list of publications by special request ...
Film Culture No. 30, Fall 1963.

FLUXUS 1964 EDITIONS:...FLUXUS g NAM JUNE PAIK: list of publications by special request ...Most materials originally intended for Fluxus yearboxes will be included in the FLUXUSccV TRE newspaper or in individual boxes.
cc V TRE (Fluxus Newspaper No. 1) January 1964.

FLUXUS 1964 EDITION:...FLUXUS g NAM JUNE PAIK: list of publications by special request
cc V TRE (Fluxus Newspaper No. 2) February 1964.

FLUXUS 1964 EDITIONS, AVAILABLE NOW ... FLUXUS g NAM JUNE PAIK: list of publications by special request. Works printed in Japan.
cc Valise e TRanglE (Fluxus Newspaper No. 3) March 1964.

F-g [as above]
European Mail-Orderhouse: europeanfluxshop, Pricelist. [ca. June 1964].

[as above]
Second Pricelist - European Mail-Orderhouse. [Fall 1964].

COMMENTS: *Paik's List of Publications was never produced*

as a Fluxus work. Such lists were advertised by Fluxus for other artists, such as George Brecht as well.

LITTLE LIVE ANIMALS

"For the 'Review of the Univ. of Avant garde Hinduism' I have the following items which you may want to use in some way. (I can have 100 of each very soon) ...Little animals (live) of all kinds. (like ones I sent you) ..."
Letter: George Maciunas to Nam June Paik, [ca. February 1963].

COMMENTS: *Little Live Animals, a Maciunas suggestion, were never distributed by Fluxus as an aspect of Paik's The Monthly Review of the University for Avant-Garde Hinduism. Maciunas later produced a Fluxus Edition of Ben Vautier's Living Flux Sculpture, which contained live animals.*

LONGEST BOOK OF THE WORLD

NAM JUNE PAIK-FLUXUS Publications g series; gg, ggggg, ggggggg in cooperation with VERLAG HAGAR (Rheinland), others handmade by the author. On sale between 1963 and 1973. With the preface of Jean-Pierre Wilhelm....ggggggg: longest book of the world length more than 50 meters oo gulden ...
Fluxus Preview Review, [ca. July] 1963.

phone or write for FREE information/announcements/advertisements about: ... Nam June Paik's ... longest book of the world,...
European Mail-Orderhouse: europeanfluxshop, Pricelist. [ca. June 1964].

COMMENTS: *Paik's 50 meter, Longest Book of the World, was never published as a Fluxus work. Maciunas published several Fluxus works as long scrolls in 1963: Emmett Williams' An Opera and abcdefghijklmnopqrstuvwxyz, and the Collective work: Fluxus Preview Review.*

MAP

PROPOSED CONTENTS FOR FLUXPACK 3 TO BE PUBLISHED IN 1973 BY FLASH ART...Map...by Nam June Paik...
[George Maciunas], Proposed Contents for Fluxpack 3. [ca. 1972].

COMMENTS: *Map is not included in* Fluxpack 3, *and was never produced as a separate Fluxus Edition. In 1963, Paik drew an imaginary map, "Fluxus Island in Decollage Ocean" (Silverman No. 357), which Wolf Vostell incorporated into a poster ad for De-Coll/age No. 4.*

MEDICINE (PILL) JAR

"For the 'Review of the Univ. of Avant garde Hinduism' I have the following items which you may want to use in some way. (I can have 100 of each very soon)

... Medicine (pill) jar 2 cm x 8 cm. (like one I sent you) ..."
Letter: George Maciunas to Nam June Paik, [ca. February 1963].

COMMENTS: *These jars, suggested by Maciunas, were never distributed by Fluxus as an aspect of The Monthly Review of the University for Avant-Garde Hinduism. Such medicine jars appear frequently in other Fluxus works.*

THE MONTHLY REVIEW OF THE UNIVERSITY FOR AVANT-GARDE HINDUISM
Silverman No. < 352.I, ff.

"For the 'Review of the Univ. of Avant garde Hinduism' I have the following items which you may want to use in some way. (I can have 100 of each very soon)
1. Jars. 8cm x 10cm. glass with metal screw-on cover.
2. Nose drop bottles. with dropper.
3. Medicine (pill) jar. 2cm x 8cm. (like one I sent you)
4. Little animals (live) of all kinds. (like ones I sent you)
5. Books (all kinds) law books, storeys [sic], encyclopedias etc. catalogues.
6. Adding machine tape
8. [sic] Old plans, structural details.
9. Pieces of plastic, construction materials.
10. Many - many rubber bands, paper clips.
11. Many automobile parts (from my Chevrolet which fell apart) like motor parts, speedometer, door handles, tyres of parts of them, windshield wiper - many many items.
12. Pages from bibles, history books etc.
13. Much glue
14. Calendar pages (many)
15 Many coat hangers. (wood or metal) I can get 100 any time. etc. etc.
I will write more after I investigate the Army junk yard. (I will also ask Emmett Williams for his list.)
16. I can get many many childrens toys. (old ones)
Letter: George Maciunas to Nam June Paik, [ca. February 1963].

"...Schmit is now staying in my place helping out with Fluxus work...AND this special Paiks review 'Monthly review of Avant Garde Hinduism' which we are going to mail out sometimes very frequently (you will be getting this 'Review' soon). That's another of Paik's 'Music for mail' Supposedly a secret - so don't tell anyone except Brecht..."
Letter: George Maciunas to Robert Watts, [before March 11, 1963].

"...Right now Tomas Schmit stays in my place & puts full time on putting together...plus Paiks 'review' of course..."
Letter: George Maciunas to Robert Watts, [March 11 or 12th, 1963].

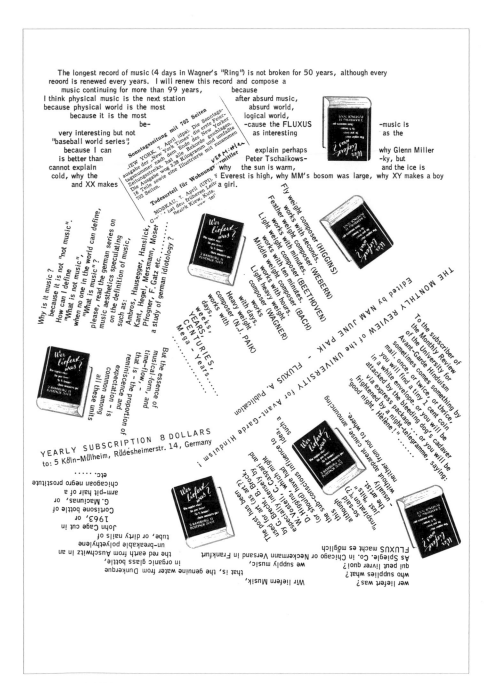

Postmusic
The Monthly Review of the University for Avant-garde Hinduism.
edited by N. J. PAIK
FLUXUS a. publication
- an essay for the new ontology of music -

New ontology of music (PAIK)

I am tired of renewing the form of music.
- serial or aleatoric, graphic or five lines, instrumental or bellcanto, screaming or action, tape or live... -
I ~~hope~~ must renew the ontological form of music.
In the normal concert,
the sounds move, the audience sit down.
In my sosaid action music,
the sounds, etc., move, the audience is attacked by me.
In the "Symphony for 20 rooms",
the sounds, etc., move, the audience moves also.
In my "Omnibus music No.1"(1961),
the sounds sit down, the audience visits them.
In the Music Exposition,
the sounds sit, the audience plays or attacks them.
In the "Moving theatre" in the street,
the sounds move in the street, the audience meets or encounters them "unexpectedly" in the street.
The beauty of moving theatre lies in this "surprise a priori", because almost all of the audience is uninvited,
not knowing what it is, why it is, who is the composer, the player, organizer - or better speaking- organizer,
composer, player.
"Music for the long road" - and without audience,
"Music for the large place" - and without audience
are more platonic.
Alison Knowles notifying no one escaped secretly from the hotel and saying nothing unrolled 1000 meter sound tape
in a street of Copenhagen.
There was not one invited "audience", not one photographer; only the program was due to be printed,
announcing "Time indeterminate, date indeterminate, place somewhere in Copenhagen and Paris."
"The music for high tower and without audience" is more platonic. Alison Knowles "ascended" to the top of the
"Eiffel tower" and cut her beautiful long hair in the winter wind. No one noticed, no programm was printed,
no journalist was there. Sorry, Dick Higgins saw it. It is just the unavoidable evil. He is her husband.
The most platonic music was xxxxx with ooooo , which no one in the world knows about, except us two.
Precisely speaking, only this xxxxx can be called a "happening". "Happening is just one thing in this world,
one thing through which you cannot become "famous". If you make the publicity in advance, invite the critics, sell
tickets to snobs, and buy many copies of newspapers having written about it, - then it is no more a "happening".
It is just a concert. I never use therefore this holy word "happening" for my "concerts", which are equally snobbish
as those of Franz Liszt. I am just more self-conscious or less hypocritical than my anti-artist friends. I am the same
clown as Goethe and Beethoven.
The Post music "The Monthly Review of the University of Avant-garde Hinduism" comes in succession from my search
for the new ontology of music, and simultaneously is
The first "Journalisme pour la Journalisme" in the sense of "l'art pour l'art", or
"La poste pour la poste" in the sense of "l'art pour l'art".

Every revolution of musical form was due to, or had something to do with the new ontological form of music.
for example in the gregorian chant the time when it was to be played was of main importance.
Imagine how matin services in the early mornings sound completely different from vesper services in the evenings,
although melody is almost same for the outsider.
This WHEN (time of day and day of year, a very interesting measure, which shall be intensely developed & exploited
in my post music "The Monthly Review of the University of Avant-garde Hinduism")disappeared in 18th century
when that music escaped from the church.
Pre-classical symphony (mood music a la MANTOVANI) came into life to entertain the half-intellectual nobles
in their dining rooms, grew up to the Ninth Symphony to satisfy the heroism of romantic free-bourgeois and then
fell down to the Schubertlieder to be sung in a Vienna "gasse".
Bach's Goldberg Variations should be so long as to make the "lord" fall asleep.
KARAJAN's show business and
CALLAS' idiotology are
unthinkable without the record industry.
New American style boring music is probably a reaction and resistance against the too thrilling Hollywood movies.
Post music is as calm, as cold, as dry, as non-expressionistic as my television experiments.
You get something in a year.
When you are about to forget the last one you received you get something again.
This has a fixed form, and this is like the large ocean......
calm sunny calm calm
rainy calm windy calm sunny
calm sunny sunny sunny calm
stormy calm stormy stormy
stormy calm stormy rainy calm calm calm etc..................

Nam June Paik. **THE MONTHLY REVIEW OF THE UNIVERSITY FOR AVANT-GARDE HINDUISM**

SCOTT HYDE

Nam June Paik. THE MONTHLY REVIEW OF THE UNIVERSITY FOR AVANT-GARDE HINDUISM. A group of mailings

THE MONTHLY REVIEW of the UNIVERSITY for Avant-Garde Hinduism! Edited by NAM JUNE PAIK - FLUXUS A. Publication
YEARLY SUBSCRIPTION 8 DOLLARS to: 5 Koeln-Muelheim, Ruedesheimerstr. 14, Germany
To the subscriber of the Monthly Review of the University for Avant-Garde Hinduism sometimes comes something by mail. once, or twice, or thrice, you will find a tiny 1 cent coin in a white envelope. or you will be attacked by the bleeding dog's cadaver via express package...or you will be frightened by a night-tele-gramme, saying "good night, Helene!".......
wer liefert was?
who supplies what?
qui peut livrer quoi?
As Spiegle. Co. in Chicago or Neckermann Versand in Frankfurt
FLUXUS macht es moeglich
Wir liefern Musik,
we supply music,
that is, the genuine water from Dunkerque, in organic glass bottle, the red earth from Auschwitz in an un-

breakable polyethylene tube, or dirty nails of John Cage cut in 1963, or Cortisone bottle of G.Maciunas, or arm-pit hair of a chicagoan negro prostitute etc.... The post has been used for art (as art?) by G. Brecht; B. Brock, especially intensely by W. Vostell, C. Caspari and D. Higgins, which might (or should) have had the sub-conscious influence to this idea, although such a so-said "inspiration" (?) just "hits" the artist.- usually without apparent cause, announcing neither from nor to where....
Postmusic...an essay for the new ontology of music - ...I am tired of renewing the form of music....The Post music "The Monthly Review of Avant-garde Hinduism" comes in succession from my search for the new ontology of music, and simultaneously is The first "Journalisme pour la Journalisme" in the sense of "l'art pour l'art", or "La poste pour la poste" in the sense of "l'art pour l'art"....This WHEN (time of day and day of year, a very interesting measure, which shall be intensely developed & exploited in my post music "The Monthly Review of the University of Avant-garde Hinduism") disappeared in 18th century

when that music escaped from the church....Post music is as calm, as cold, as dry, as non-expressionistic as my television experiments. You get something in a year. When you are about to forget the last one you received you get something again. This has a fixed form, and this is like the large ocean......calm sunny calm calm rainy calm windy calm sunny calm sunny sunny sunny calm stormy calm stormy stormy stormy calm stormy rainy calm calm calm etc.................
Nam June Paik, The Monthly Review of the University for Avant-Garde Hinduism. [ca. March 1963].

PROPOSED PROPAGANDA ACTION FOR NOV. FLUXUS IN N.Y.C. (during May - Nov. period) ... Propaganda through sale of fluxus publications (fluxus ...a,...): to be dispatched by end of April to N.Y.C.
Fluxus Newsletter No. 6, April 6, 1963.

"...I mailed a package with...Paik's review sheets. I mailed some 150. The rest you should keep, in case you get some good addresses to mail to. OK?..."
Letter: George Maciunas to Tomas Schmit, May 26, 1963.

FLUXUS SPECIAL EDITIONS 1963-4
FLUXUS a. Monthly Review of the University of Avant-Garde Hinduism. edited by Nam June Paik $8 per year
The time of day and day of year, this very interesting time measure which disappeared with gregorian chant, shall be intensely developed and exploited in the post music of Nam June Paik. To the subscriber of the Monthly Review of the University for Avant-Garde Hinduism sometimes comes something by mail. Once, or twice, or thrice, you will find a tiny 1 cent coin in a white envelope, or genuine water from Dunkerque in organic glass bottle, or the red earth from Auschwitz in an unbreakable polyethylene tube, or you will be attacked by the bleeding dog's cadaver via express package...or you will be frightened by a night-tele-gramme, saying: "good night, Helene!".......When you are about to forget the last one you received you get something again. This has a fixed form, and is like the large ocean...calm sunny calm calm rainy calm windy calm sunny calm sunny sunny sunny calm stormy calm stormy stormy stormy calm stormy rainy calm calm calm calm etc.........
Fluxus Preview Review, [ca. July] 1963.

FLUXUS SPECIAL EDITIONS 1963-4...FLUXUS a. Monthly Review of the University of Avant-Garde Hindusim. edited by NAM JUNE PAIK $8 per year
Daniel Spoerri, L'Optique Moderne. List on editorial page. 1963.

[as above]
La Monte Young, LY 1961. Advertisement page. [1963].

FLUXUS 1963 EDITIONS, AVAILABLE NOW FROM FLUXUS P.O. Box 180, New York 10013, N.Y. or FLUXUS 359 Canal St. New York. CO7-9198 FLUXUSa Monthly Review of the University of Avant-Garde Hinduism. edited by Nam June Paik $10 per year....
Film Culture No. 30, Fall 1963.

FLUXUS 1963 EDITIONS, AVAILABLE NOW ... FLUXUS a Monthly Review of the University of Avant-Garde Hinduism, edited by Nam June Paik $10 per year.
cc V TRE (Fluxus Newspaper No. 1) January 1964.

[as above]
cc V TRE (Fluxus Newspaper No. 2) February 1964.

FLUXUS 1964 EDITIONS, AVAILABLE NOW...
[as above]
cc Valise e TRanglE (Fluxus Newspaper No. 3) March 1964.

2-Fa Monthly Review of the University of Avant-Garde Hinduism. edited by NAM JUNE PAIK, $10 per year (ask for FREE catalog)
European Mail-Orderhouse: europeanfluxshop, Pricelist. [ca. June 1964].

2-Fa Monthly Review of the University of Avant-Garde Hinduism edited by NAM JUNE PAIK. $10 per year. ASK FOR FREE INFORMATION
Second Pricelist - European Mail-Orderhouse. [Fall 1964].

COMMENTS: *The Monthly Review of the University for Avant-Garde Hinduism was intended to be a mailed three-dimensional periodical on Nam June Paik's concept of "Post-music," I believe based on the idea of George Brecht's and Robert Watts' Yam Festival Delivery Event (Silverman No. 471) of a year earlier, and Ray Johnson's mail art ideas. The first manifestation of Paik's Review was a single sheet newspaper-like publication with an essay by Paik on "The New Ontology of Music," and manifestos for the publication. Shortly after, Paik made up a rubber stamp (in the manner of the Yam Festival rubber stamps, Silverman No. 29, ff.) which he stamped on envelopes, cards, and works, and mailed successively — tiny one penny coins, a recycled Yam Festival Exhibit, picture postcards, his "moving theater" manifestos, chopsticks, and more (Silverman No. < 352.I, ff.) over the next few months. The concept for the Review is especially significant in relationship to Fluxus product coming at a point when Maciunas was expanding the idea of Fluxus publications to include individually packaged works by artists.*

MONTHLY REVIEW OF THE UNIVERSITY FOR AVANT-GARDE HINDUISM see:
ADDING MACHINE TAPE
ARM PIT HAIR OF A CHICAGOAN NEGRO
 PROSTITUTE
AUTOMOBILE DOOR HANDLES
BLEEDING DOG'S CADAVER

CALENDAR PAGES
CATALOGUES
CHILDREN'S TOYS
COAT HANGERS
CORTISONE BOTTLE OF G.MACIUNAS
DIRTY NAILS OF JOHN CAGE
ENCYCLOPEDIAS
GENUINE WATER FROM DUNKERQUE
GLUE
JARS
LAW BOOKS
LITTLE LIVE ANIMALS
MEDICINE (PILL) JAR
MOTOR PARTS
NIGHT TELEGRAMME
NOSEDROP BOTTLES W/ DROPPER
1 CENT COIN IN ENVELOPE
PAGES FROM BIBLES
PAGES FROM HISTORY BOOKS
PAPER CLIPS
PLANS OF STRUCTURAL DETAILS
PLASTIC CONSTRUCTION MATERIALS
RED EARTH FROM AUSCHWITZ
SPEEDOMETER
STORY BOOKS
TYRES
WINDSHIELD WIPER

MOST DIFFICULT BOOK OF THE WORLD

NAM JUNE PAIK-FLUXUS Publications g series; gg, ggggg, ggggggg in cooperation with VERLAG HAGAR (Rheinland), others handmade by the author. On sale between 1963 and 1973. With the preface of Jean-Pierre Wilhelm....ggggggg: most difficult book of the world - anthology of world's unreadable letters -
Fluxus Preview Review, [ca. July] 1963.

phone or write for FREE information/ announcements/ advertisements about:...Nam June Paik's ... most difficult book of the world...
European Mail-Orderhouse: europeanfluxshop, Pricelist. [ca. June 1964].

COMMENTS: *This book was never produced as a Fluxus Edition.*

MOTOR PARTS

"For the 'Review of the Univ. of Avant garde Hindusim' I have the following items which you may want to use in some way. (I can have 100 of each very soon) ... Many automobile parts (from my Chevrolet which fell apart) like motor parts..."
Letter: George Maciunas to Nam June Paik, [ca. February 1963].

COMMENTS: *Another Maciunas suggestion for an aspect of*

The Monthly Review of the University for Avant-Garde Hinduism *that was not used.*

MUSIC see:
POST MUSIC
MUSIC FOR MAIL see:
MONTHLY REVIEW OF THE UNIVERSITY OF AVANT-GARDE HINDUISM
NAM JUNE PAIK FLUX see:
COMPLETE WORKS

NARROWEST, BUT NOT LONGEST BOOK OF THE WORLD

NAM JUNE PAIK-FLUXUS Publications g series, gg, ggggg, ggggggg in cooperation with VERLAG HAGAR (Rheinland), others handmade by the author. On sale between 1963 and 1973 with the preface of Jean-Pierre Wilhelm. ... ggggg: narrowest, but not longest book of the world width 7mm, length 50meters xx lire
Fluxus Preview Review, [ca. July] 1963.

phone or write for FREE information/ announcements/ advertisements about:...Nam June Paik's ... narrowest, but not longest book of the world (width 7mm. length 50m.)...
European Mail-Orderhouse: europeanfluxshop, Pricelist. [ca. June 1964].

COMMENTS: *Paik's book suggestions expand one's perception of the book form. Unfortunately, none were made.*

NIGHT TELEGRAMME

To the subscriber of the Monthly Review of the University for Avant-Garde Hinduism sometimes comes something by mail. once, or twice, or thrice,...or you will be frightened by a night-telegramme, saying: "good night, Helene!"...
Nam June Paik, The Monthly Review of the University for Avant-Garde Hinduism. [ca. March 1963].

[as above]
Fluxus Preview Review, [ca. July] 1963.

COMMENTS: *In the era of telegrams, one arriving in the night usually brought with it the news of tragedy.*

NOSEDROP BOTTLES W/ DROPPER

"For the 'Review of the Univ. of Avant garde Hinduism' I have the following items which you may want to use in some way. (I can have 100 of each very soon) ... Nose drop bottles. with dropper..."
Letter: George Maciunas to Nam June Paik, [ca. February 1963].

COMMENTS: Maciunas later used nosedrop bottles to package some of Ben Vautier's Dirty Water, and Chieko Shiomi's Water Music.

1 CENT COIN IN ENVELOPE

To the subscriber of the Monthly Review of the University for Avant-Garde Hinduism sometimes comes something by mail. once, or twice, or thrice, you will find a tiny 1 cent coin in a white envelope...
Nam June Paik, The Monthly Review of the University for Avant-Garde Hinduism. [ca. March 1963].

[as above]
Fluxus Preview Review, [ca. July] 1963.

COMMENTS: 1 Cent Coin in Envelope was actually tiny pfennig coins mailed in otherwise empty envelopes, rubber stamped "Monthly Review of the University of Avant-Garde Hinduism."

Nam June Paik. 1 CENT COIN IN ENVELOPE

PAGES FROM BIBLES

"For the 'Review of the Univ. of Avant garde Hinduism' I have the following items which you may want to use in some way. (I can have 100 of each very soon) ... Pages from bibles..."
Letter: George Maciunas to Nam June Paik, [ca. February 1963].

COMMENTS: Pages from Bibles were never distributed by Fluxus as an aspect of The Monthly Review of the University for Avant-Garde Hindusim. Later, Maciunas packaged pages from a tiny Bible in Jeff Berner's Fluxbook (Silverman No. 22).

PAGES FROM HISTORY BOOKS

"For the 'Review of the Univ. of Avant garde Hinduism' I have the following items which you may want

to use in some way. (I can have 100 of each very soon) ... Pages from...history books etc...."
Letter: George Maciunas to Nam June Paik, [ca. February 1963].

COMMENTS: A Maciunas suggestion, Pages from History Books were not used for Paik's Review. In 1964, Robert Watts used pages from a geography book for his "a-z series," Geography.

PAIK'S REVIEW see:
MONTHLY REVIEW FOR AVANT-GARDE HINDUISM

PAPER CLIPS

"For the 'Review of the Univ. of Avant garde Hinduism' I have the following items which you may want to use in some way. (I can have 100 of each very soon) ... Many - many ...paper clips..."
Letter: George Maciunas to Nam June Paik, [ca. February 1963].

COMMENTS: Paper Clips were a Maciunas suggestion. They were not used.

PIANO ACTIVATED DOOR

Any proposals from participants should fit the maze format ... Ideas should relate to passage through doors, steps, floor, obstacles, booths...N.J. Paik piano activating door...
[George Maciunas]. Further Proposal for Flux-Maze at Rene Block Gallery. [ca. Fall 1974].

"... Enclosed is the final plan of labyrinth ... One enters then a space of Paik which contains a piano. One of the keys (preferably a black, sharp key) should be fixed to switch on electrical momentary switch which would buzz open the door lock (standard magnetic door opener used in apartments), the door is self closing, and the key near enough to allow the same person to press the key and hold or push the door open..."
Letter: George Maciunas to Rene Block, [ca. Summer 1976].

Piano and electric door needed: system to activate buzzer-latch. We have the piano in the building, I am told. We can bring it in place Monday. I have the buzzer-latch, and wire at academie, but did not buy switch I wait for Bob - is a good job for him.
Notes: Larry Miller to George Maciunas concerning the Flux-labyrinth, Berlin. [ca. August 1976].

N.J. Paik piano activates door. One key on piano is electrically switched to activate an electrical door opener.
Plan of completed Fluxlabyrinth, Berlin. [ca. September 1976].

COMMENTS: One had to hit the right key on the prepared piano and simultaneously turn the door handle to open the door, which was situated a good stretch away from the piano.

PIANOS see:
PIANO ACTIVATED DOOR
PREPARED PIANO
PREPARED TOY PIANO
SEX PIANO

PLANS OF STRUCTURAL DETAILS

"For the 'Review of the Univ. of Avant garde Hinduism' I have the following items which you may want to use in some way. (I can have 100 of each very soon) ... Old plans, structural details..."
Letter: George Maciunas to Nam June Paik, [ca. February 1963].

COMMENTS: George Maciunas frequently made trash into art. Plans of Structural Details would have been discarded work from his job on the army base. His suggestion for their use as an aspect of The Monthly Review of the University for Avant-Garde Hinduism was not used.

PLASTIC CONSTRUCTION MATERIALS

"For the 'Review of the Univ. of Avant garde Hinduism' I have the following items which you may want to use in some way. (I can have 100 of each very soon) ... Pieces of plastic, construction materials..."
Letter: George Maciunas to Nam June Paik, [ca. February 1963].

COMMENTS: Although not used by Paik for his Review, Maciunas later used plastic construction material for such works as his Ball Checkers.

POST MUSIC see:
MONTHLY REVIEW OF THE UNIVERSITY FOR AVANT-GARDE HINDUISM

POSTCARDS

PROPOSED CONTENTS FOR FLUXPACK 3 TO BE PUBLISHED IN 1973 BY FLASH ART ... Postcards by...Paik... Cost Estimates: for 1000 copies ... postcards [including designs by other artists] $100...
[George Maciunas], Proposed Contents for Fluxpack 3. [ca. 1972].

COMMENTS: Postcards by Nam June Paik were not produced by Fluxus, and are not included in Fluxpack 3.

PREPARED PIANO

"...Next weekend I will go to Wuppertal where Paik

Nam June Paik. PIANO ACTIVATED DOOR, installed in FLUXLABYRINTH, Berlin, 1976

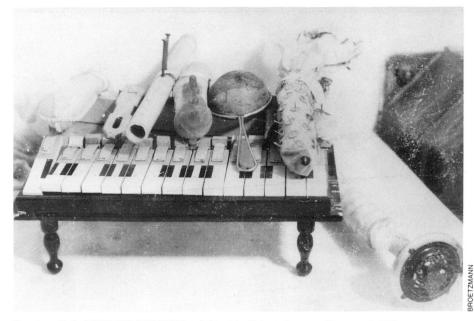

Nam June Paik. PREPARED TOY PIANO exhibited in Galerie Parnass, Wuppertal, 1963

is completing setting up his 'exhibit' and make a very detailed photo-reportage of his...pianos etc, etc. - all very interesting..."
Letter: George Maciunas to Robert Watts, [before March 11, 1963].

"...Paik has exhibit for next 2 weeks at Wuppertal where I was yesterday...Paik's exhibit was VERY GOOD! He had one piano, all keys underpinned so none could be depressed - very good! Then he had 2 "prepared pianos" one key depressed - radio inside piano - on another key connected to vacuum cleaner (also inside) another to house lights, so when you depress - all lights are off. Then many objects pop-out when other keys depressed - very nicely prepared. I photographed all I could (some with long exposures to show movement) but many things can not be pictorially documented. (like house lights)...."
Letter: George Maciunas to Robert Watts, [March 11 or 12, 1963].

NOW THE FESTIVAL (Amsterdam one)...Program I suggest as follows...Exhibits...Nam June Paik - all the things you [Tomas Schmit] will do..."
Letter: George Maciunas to Tomas Schmit, [early June 1963].

FLUXUS AMUSEMENT ARCADE ... Nam June Paik prepared piano
Preliminary Proposal for a Flux Exhibit at Rene Block Gallery. [ca. 1974].

COMMENTS: *Willem de Ridder organized the "Fluxus Festi-*

val" in Amsterdam and the Hague in June 1963. At the same time, he put on an exhibition of Nam June Paik's Prepared Pianos titled, "Piano for All Senses," in his gallery, Amstel 47, June 22 to July 13, 1963. The work was "interpreted and realized" by Tomas Schmit, Manfred Montwe, Peter Broetzmann, and Willem de Ridder, and served as an adjunct to the Fluxus performances. "Art by license" was something explored by Arthur Koepcke two or three years earlier when he realized some of Daniel Spoerri's "snare pictures." George Maciunas must certainly have been influenced by the idea of "art by license," as the bulk of Fluxus product was accomplished this way. I don't find evidence that he worked on Paik's "Piano for All Senses," but he was in Amsterdam at that time, and had instructed Tomas Schmit to prepare the exhibits. The idea of using Paik's Prepared Piano as a Fluxus work reappears years later in a proposal for a "Fluxus Amusement Arcade."*

PREPARED TOY PIANOS

"Paik has exhibit for next 2 weeks at Wuppertal where I was yesterday...Paiks exhibit was VERY GOOD! He had one piano, all keys underpinned so none could be depressed - very good! Then he had 2 'prepared pianos' one key depressed - radio inside - on. another key connected to vacuum cleaner (also inside) another to house lights, so when you depress-all lights are off. Then many objects pop-out when other keys depressed - very nicely prepared. I photographed all I could (some with long exposures to show movement) but many things can not be pictorially documented. (like house lights)...I got one room for Fluxus...We

thought in future to integrate our festivals with these 'exhibits' (we will add...Paik & his 2 'prepared' toy pianos)...."
Letter: George Maciunas to Robert Watts, [March 11 or 12, 1963].

COMMENTS: Prepared Toy Pianos *were altered children's toys that were much more portable than* Prepared Pianos. *Paik must have given Maciunas two of these small artworks for the Fluxus exhibits.*

PREPARED TV SETS

"...Next weekend I will go to Wuppertal where Paik is completing setting up his 'exhibit' and make a very detailed photo-reportage of his TV sets...etc. etc. - all very interesting..."
Letter: George Maciunas to Robert Watts, [before March 11, 1963].

"Paik has exhbiit for next 2 weeks at Wuppertal where I was yesterday. I got one room for Fluxus. ... We thought in future to integrate our festivals with these 'exhibits' (we will add a TV set from Paik...)...then he had 12 TV sets also 'prepared' - rewired, with signals from generators, radios, tape recorders fed-in. So some show distorted images, some just abstractions, like a single line, the thickness of which you can control by TV dials. VERY NICE distortions. Some images more like on a cylinder - so one sees them move up (right side up) and then down-upside down. Paik apparently studied electronics for whole year or 2 to

have those TV sets prepared (and all done secretly without anyone knowing). He is full of 'secrets', very strange person this Paik. He will be in New York end of April and wants to meet you all Yam people. May-be you & George [Brecht] can come to N.Y.C. some day, otherwise Paik will get lost going to N.J."
Letter: George Maciunas to Robert Watts, [March 11 or 12, 1963].

afterlude to the EXPOSITION of EXPERIMENTAL TELEVISION 1963, March. Galerie Parnass. nam june PAIK...
INDETERMINISM and VARIABILITY is the very UNDERDEVELOPED parameter in the optical art, although this has been the central problem in music for the last 10 years, (just as parameter SEX is very underdeveloped in music, as opposed to literature and optical art.

a) I utilized intensely the live-transmission of normal program, which is the most variable optical and semantical event, in Nineteen-sixties. The beauty of distorted Kennedy is different from the beauty of football hero, or not always pretty but always stupid female announcer.

b) Second dimension of variability.
13 sets suffered 13 sorts of variation in their VID-EO-HORIZONTAL-VERTICAL units. I am proud to be able to say that all 13 sets actually changed their inner circuits. No Two sets had the same kind of technical operation. Not one is the simple blur, which occurs, when you turn the vertical and horizontal control-button at home. I enjoyed very much the study of electronics, which I began in 1961, and some life-danger, I met while working with 15 Kilo-Volts. I had the luck to meet nice collaborators: HIDEO UCHIDA (president of UCHIDA Radio Research institute), a genial avantgarde electronican, who discovered the principle of Transistor 2 years earlier than the Americans, and SHUYA ABE, allmightly politechnican, who knows that the science is more a beauty than the logic. UCHIDA is now trying to prove the telepathy and prophesy electromagnetically.

c) As the third dimension of variability, the waves from various generators, tape-recorders and radios are fed to various points to give different rhythms to each other. This rather old-typed beauty, which is not essentially combined with High Frequency Technique, was easier to understand to the normal audience, maybe because it had some humanistic aspects.

d) There are as many sorts of TV circuits, as French cheese-sorts. F.i. some old models of 1952 do certain kind of variation, which new models with automatic frequency control cannot do.

... Zen is anti-avant-garde, anti-frontier spirit, anti-Kennedy,.

Zen is responsible of asian poverty.
How can I justify ZEN, without justifying asian povty ??
It is another problem, to which I will refer again in the next essay.
Anyway, if you see my TV, please, see it more than 30 minutes.
"the perpetual evolution is the perpetual UNsatisfaction. it is the only merit of Hegelian dialectic."
 (R.AKUTAGAWA)
"the perpetual Unsatisfaction is the perpetual evolution. it is the main merit of experimental TV"
 (N.J.P.)
The frustration remains as the frustration.
There is NO catharsis.
Don't expect from my TV: Shock., Expressionism., Romanticism., Climax., Surprise., etc...... for which my previous compositions had the honour to be praised. In Galerie Parnass, one bull's head made more sensation than 13 TV sets. May-be one needs 10 years to be able to perceive delicate difference of 13 different "distortions" (?), as it was so in perceiving the delicate difference of many kinds of "noises" (?) in the field of electronic music.
Excerpts from Nam June Paik, "Afterlude to the Exposition of Experimental Television," cc fiVe ThReE (Fluxus News-paper No. 4) June 1964.

COMMENTS: *Only one* Prepared TV Set, Zen For TV, *became a Fluxus work.*

PUBLICATIONS see:
 LIST OF PUBLICATIONS

RED EARTH FROM AUSCHWITZ

wer liefert was?
who supplies what?
qui peut livrer quoi?
As Spiegle. Co. in Chicago or Neckermann
Versand in Frankfurt
FLUXUS macht es moeglich
Wir liefern Musik,
we supply music,...
the red earth from Auschwitz in an un-breakable polyethylene tube,...
Nam June Paik, The Monthly Review of the University for Avant-Garde Hinduism. [ca. March 1963].

FLUXUS SPECIAL EDITIONS 1963-4...To the subscriber of the Monthly Review of the University for Avant-Garde Hinduism sometimes comes something by mail...or the red earth from Auschwitz in an unbreakable polyethylene tube,...
Fluxus Preview Review, [ca. July] 1963.

COMMENTS: *Maciunas had written to Paik in January of 1963 that he could get earth from Auschwitz from Polish friends but it would take 3 to 4 months because it would have to have government approval and sending it in a crate through East Germany would be very complicated.*

RUBBER BANDS

"For the 'Review of the Univ. of Avant garde Hinduism' I have the following items which you may want to use in some way. (I can have 100 of each very soon) ... Many-many rubber bands...."
Letter: George Maciunas to Nam June Paik, [ca. February 1963].

COMMENTS: *Ready-mades of the* Paper Clips *variety.*

SEX PIANO

"...Next weekend I will go to Wuppertal where Paik is completing setting up his 'exhibit' and make a very detailed photo-reportage of his...pianos etc, etc. - all very interesting..."
Letter: George Maciunas to Robert Watts, [before March 11, 1963].

"... Paik has exhibit for next 2 weeks at Wuppertal where I was yesterday - I got one room for fluxus....We thought in future to integrate our festivals with these 'exhibits' (we will add a TV set from Paik & his 2 'prepared' toy pianos). So could you send me more objects of your own that we could exhibit, pencils, etc, etc. Paiks exhibit was VERY GOOD! He had one piano, all keys underpinned so none could be depressed - very good! Then he had 2 'prepared pianos' one key depressed - radio inside piano - on. another key connected to vacuum cleaner (also inside) another to house lights, so when you depress - all lights are off. Then many objects pop-out when other keys depressed - very nicely prepared. I photographed all I could (some with long exposures to show movement) but many things can not be pictorially documented. (like house lights)...."
Letter: George Maciunas to Robert Watts, [March 11 or 12, 1963].

PROPOSED PRELIMINARY CONTENTS OF NYC FLUXUS IN NOV..."Armory show of new American pornography" (films, pictures, events, objects) - being arranged by J. Mekas & Film Culture (& to include Paik - sex pianos.)
Fluxus Newsletter No. 6, April 6, 1963.

NOW THE FESTIVAL. (Amsterdam one)...Program I suggest as follows...Exhibits...Nam June Paik - all the things you [Tomas Schmit] will do ..."
Letter: George Maciunas to Tomas Schmit, [early June 1963].

"...Take to Amsterdam...Paik - sex piano (more stamps enclosed)..."
Letter: George Maciunas to Tomas Schmit, [early June 1963].

"...When you go to Amsterdam VERY IMPORTANT - see if you can arrange maybe a one concert festival in that gallery or somewhere. I will bring the Festival box & exhibits (you bring...paiks sex piano...)"
Letter: George Maciunas to Tomas Schmit, [mid June 1963].

COMMENTS: Paik used quite a lot of sex paraphernalia and double entendres on his Prepared Pianos and other works during his "Exposition of Music Electronic Television" at the Galerie Parnass, March 11-20, 1963. Some of these ideas and small works were transferred to the Amsterdam Fluxus Festival two months later. See Prepared Piano.

SMALLEST BOOK OF THE WORLD

NAM JUNE PAIK - FLUXUS Publications g series; gg, ggggg, ggggggg in cooperation with VERLAG HAGAR (Rheinland), others handmade by the author. On sale between 1963 and 1973. With the preface of Jean - Pierre Wilhelm. gg: smallest book of the world - bagatelles americaines - 1 $20 (in capsules, bottled, pennies and lens provided.)...
Fluxus Preview Review, [ca. July] 1963.

phone or write for FREE information/ announcements/ advertisements about:...Nam June Paik's smallest book of the world...
European Mail-Orderhouse: europeanfluxshop, Pricelist. [ca. June 1964].

COMMENTS: The Smallest Book of the World was never produced as a Fluxus Edition.

SOUND DIARY

FLUXUS SPECIAL EDITIONS 1963-4...FLUXUS r. NAM JUNE PAIK: SOUND DIARY, tapes $2, $4, $6, $8, $10, $12...etc....(by special order)...
Fluxus Preview Review, [ca. July] 1963.

[as above]
Daniel Spoerri, L'Optique Moderne. List on editorial page. 1963.

[as above]
La Monte Young, LY 1961. Advertisement page. [1963].

22-fg NAM JUNE PAIK:...sound diary, tapes, $2, $4, $6, $8, $10 etc. (by special order)
European Mail-Orderhouse: europeanfluxshop, Pricelist. [ca. June 1964].

[as above]
Second Pricelist - European Mail-Orderhouse. [Fall 1964].

COMMENTS: Sound Diary was a tumble of sound tapes that

Paik made during his early years in Germany. At least one chunk of this tape was boxed by Maciunas with a Paik monogram card, as a Fluxus Edition. That example is now in the Archiv Sohm at the Staatsgalerie Stuttgart.

SPEEDOMETER

"For the 'Review of the Univ. of Avant garde Hinduism' I have the following items which you may want to use in some way. (I can have 100 of each very soon) ... Many automobile parts (from my Chevrolet which fell apart) like...speedometer..."
Letter: George Maciunas to Nam June Paik, [ca. February 1963].

COMMENTS: Speedometer was another ready-made car part from Maciunas' junked automobile. It was never used as an aspect of The Monthly Review of the University for Avant-Garde Hinduism.

STORY BOOKS

"For the 'Review of the Univ. of Avant garde Hinduism' I have the following items which you may want to use in some way. (I can have 100 of each very soon) ... Books (all kinds)...stories..."
Letter: George Maciunas to Nam June Paik, [ca. February 1963].

COMMENTS: A Maciunas suggestion, ready-made Story Books were never distributed by Fluxus as an aspect of The Monthly Review of the University for Avant-Garde Hinduism.

TAPES see:
SOUND DIARY
TELEGRAM see:
NIGHT TELEGRAM
TELEVISION see:
EXPERIMENTAL TELEVISION
PREPARED TV SETS
ZEN FOR TV
TOYS see:
CHILDREN'S TOYS
PREPARED TOY PIANO

TYRES

"For the 'Review of the Univ. of Avant garde Hinduism' I have the following items which you may want to use in some way. (I can have 100 of each very soon) ... Many automobile parts (from my Chevrolet which fell apart) like...tyres..."
Letter: George Maciunas to Nam June Paik, [ca. February 1963].

COMMENTS: Tires from Maciunas' junked Chevy were never

distributed by Fluxus as an aspect of The Monthly Review of the University for Avant-Garde Hinduism. Robert Watts planned to use a tire titled, Yam Ride (Silverman No. 475), for one of his Delivery Events in 1963 through the Yam Festival Warehouse. Later, he used the same tire for his "a to z series," Tire (Silverman No. > 483.XVI).

WATER FROM DUNKERQUE see:
GENUINE WATER FROM DUNKERQUE

WINDSHIELD WIPER

"For the 'Review of the Univ. of Avant garde Hinduism' I have the following items which you may want to use in some way. (I can have 100 of each very soon) ... Many automobile parts (from my Chevrolet which fell apart) like...windshield wiper - many many items."
Letter: George Maciunas to Nam June Paik, [ca. February 1963].

COMMENTS: These ready-mades were not used.

ZEN FOR FILM
Silverman No. < 354.I, ff.

FLUXKIT containing following fluxus-publications: (also available separately)...FLUXUS gz NAM JUNE PAIK: ZEN FOR FILM 16mm loop, in special plastic box $3
cc fiVe ThReE (Fluxus Newspaper No. 4) June 1964.

...Individuals in Europe, the U.S., and Japan have discovered each other's work and...have grown objects and events which are original, and often uncategorizable in a strange new way: ...Nam June Paik's ZEN FOR FILM. (See it, then go to your neighborhood theater and see it again.)
George Brecht, "Something About Fluxus," cc fiVe ThReE (Fluxus Newspaper No. 4) June 1964.

... Nam June Paik - Zen for Film 20 minutes, 16mm $50 loop - 16mm $3
European Mail-Orderhouse: europeanfluxshop, Pricelist. With holograph notes from George Maciunas to Willem de Ridder. [ca. Summer 1964].

"...P.S. You could now easily make a FLUXUS film festival with 4 films: 1. Paiks Zen for film (transparent blank film) about 20 or 30 minutes..."
Letter: George Maciunas to Ben Vautier, July 21, 1964.

FLUXKIT containing following flux-publications: ...Nam June Paik's zen for film (16 mm loop, in special plastic box)...
Second Pricelist - European Mail-Orderhouse. [Fall 1964].

Fd-q NAM JUNE PAIK zen for film 20 minutes, 16 mm $50. loop - 16 mm $3.
ibid.

Nam June Paik. ZEN FOR FILM. see color portfolio

"...I asked Barbara Moore to send you a loop of Paik ...immediately (by Air Mail.) because I forgot to..."
Letter: George Maciunas to Ben Vautier, January 23, 1965.

"...I have asked Barbara Moore to send you 2 films, Paiks-Zen for film...Make loops from them and then you can show them for indefinite length.OK?..."
Letter: George Maciunas to Ben Vautier, February 1, 1965.

FLUXKIT containing following fluxus-publications: (also available separately)...FLUXUS gz NAM JUNE PAIK: zen for film 16mm loop, in plastic box $3
Vacuum TRapEzoid (Fluxus Newspaper No. 5) March 1965.

FLUXFILMS...FLUXUS gzz zen for film 16mm, 20 min. b. & w. no sound, $50
ibid.

NAM JUNE PAIK ZEN FOR FILM, 1962-4 realized by fluxus, 30 min. rental: $10
Film Culture, No. 43 (Winter 1966).

FLUX-PRODUCTS 1961 TO 1969...FLUXFILM 1963 Zen for film - by Nam June Paik, 44 min. 1600 ft. 16mm [$] 80
Fluxnewsletter, December 2, 1968 (revised March 15, 1969).

FLUXUS-EDITIONEN...[Catalogue No.] 776 NAM JUNE PAIK: zen for film, boxed 1964
Happening & Fluxus. Koelnischer Kunstverein, 1970.

03.1965...NAM JUNE PAIK: zen for film
George Maciunas, Diagram of Historical Developments of Fluxus... [1973].

1964 FLUX FESTIVAL AT FLUXHALL ... 08.05 paik: zen for film
ibid.

FILMS, SAT. EVE....JULY 9 & 10 NATURE ... Zen for film by Nam June Paik
Proposal for Flux Fest at New Marlborough. April 8, 1977.

COMMENTS: Zen For Film exists in two distinct Fluxus versions: a small boxed edition, usually with a Maciunas-designed label (Silverman No. 355), and a long 16mm version suitable for theater showings (Silverman No. < 354.I). The latter predates the small boxed version, and is only known to exist in a single example.

ZEN FOR TV
Silverman No. < 352.IX

... Paik has exhibit for next 2 weeks at Wuppertal where I was yesterday...he had 12 TV sets also 'prepared' - rewired, with signals from generators, radios, tape recorders fed-in. So some show distorted images, some just abstractions, like a single line, the thickness of which you can control by TV dials. VERY NICE distortions...Paik apparently studied electronics for whole year or 2 to have those TV sets prepared (and all done secretly without anyone knowing)...I got one room for Fluxus...We thought in future to integrate our festivals with these 'exhibits' (we will add a TV set from Paik...)"
Letter: George Maciunas to Robert Watts, [March 11 or 12, 1963].

"...for inclusion in TV program...Nam June Paik: "Zen for TV". He did this in Wuppertal as one of his "prepared" TV sets - (this can be announced). I don't know how it was prepared but the technicians probably would know what signal to feed the transmitter (no camera needed). Result is this.

 white thin line on a blank screen.

screen

Hold this line for 2 minutes at least or more if time is available.
Letter: George Maciunas to Willem de Ridder, [early August 1963].

...Second dimension of variability.
13 sets suffered 13 sorts of variation in their VIDEO-HORIZONTAL-VERTICAL units. I am proud to be able to say that all 13 sets actually changed their inner circuits. No Two sets had the same kind of technical operation. Not one is the simple blur, which occurs, when you turn the vertical and horizontal control-button at home....
...Zen is anti-avant-garde, anti-frontier spirit, anti-Kennedy,
Zen is responsible of asian poverty.
How can I justify ZEN, without justifying asian poverty??
It is another problem, to which I will refer again in the next essay.

BRAD IVERSON

MELANIE HEDLUND

Nam June Paik. ZEN FOR TV

Anyway, if you see my TV, please, see it more than 30 minutes.

Excerpts from Nam June Paik, "Afterlude to the Exposition of Experimental Television," cc fiVe ThReE (Fluxus Newspaper No. 4) June 1964.

COMMENTS: *Zen For TV is a prepared TV set on its side. The picture tube is dark except for a single vertical line. The original work was exhibited in 1963 at the Galerie Parnass and was lost in Wuppertal in 1967. Since then several replicas have been made. See* Prepared TV Sets.

JOSEF PATKOWSKY

It was announced in the tentative plans for the first issues of FLUXUS that J. Patkowski would contribute a work "to be determined" to FLUXUS NO. 6 EAST EUROPEAN YEARBOOK (later called FLUXUS NO. 7 EAST EUROPEAN YEARBOX).
see: COLLECTIVE

BENJAMIN PATTERSON

It was announced in the Brochure Prospectus version A, that Ben Patterson would contribute "Variations for double bass" to FLUXUS NO. 1 U.S. YEARBOX. Brochure Prospectus version B greatly expanded Patterson's contribution to also include "Second solo dance from 'Lemons'," "Overture," "Septet from 'Lemons'," "Traffic Light - A very Lawful Dance," and "Collage poem." FLUXUS 1 (Silverman No. 117) contains "Overture, version II," and "Overture, version III," "Septet from 'Lemons'," "Solo Dance from 'Lemons' 1961," "Traffic Light," "Variations for Double Bass" (1961, revised 1962), with four photos of Patterson performing this work, Poem Puzzle, and "Questionnaire."

In Fluxus Preview Review, excerpts from his "Methods & Processes" and two illustrations from "Paper piece" appear. Fluxus Newspaper No. 1 published " man who runs: New York Public Library Event" with a diagram. Fluxus Newspaper No. 2 published "Pond," a performance piece with a diagrammatic illustration and a work/visual contribution. Descriptive listings for "Paper Piece," "Overture," "Septet (from 'Lemons')," "Solo Dance (from 'Lemons')," "Traffic Light," "Variations for Double Bass" and "Pond" were published in Fluxus Fest Sale. "Overture" and "Septet (from 'Lemons')" were published in Flux Fest Kit 2.

ANTS
Silverman No. > 358.XI

COMMENTS: *Ants is a 1960 score ("photographs of ants on paper"), revised in 1962 as a work "to be used in conjunction with 1962 'grid' compositions of George Maciunas." The score appears on a single blueprint sheet with two other Patterson scores, Second Solo Dance from "Lemons" and Traffic Light. There is not a "Fluxus copyright" on the sheet, but the typing and manner of printing are consistent with other Fluxus scores of this period, leading me to certainty that the sheet was produced by Maciunas, and distributed with other Fluxus scores.*

COMPLETE WORKS

"...past & future works published under one cover or in box - a kind of special fluxus edition...sold separately or as part of fluxus yearbox. I am going to publish such special Fluxus editions containing complete works of:...Ben Patterson...this could result in a nice & extensive library - or "encyclopedia" of good works being done these days. A kind of Shosoin warehouse of today..."
Letter: George Maciunas to Robert Watts, December 1962.

"...we are publishing such "solo" boxes of...Ben Patterson...so that we can build up a library of good things done these days..."
Postcard: George Maciunas to Ben Vautier, March 5, 1962.

"...Then when I get to N.Y. could do...Ben Patterson..."
Letter: George Maciunas to Robert Watts, [ca. early April 1963].

"...Dec. to March - we should print lots of materials in Dicks shop. (...Patterson,...)..."
Letter: George Maciunas to Tomas Schmit, [before June 8, 1963].

FLUXUS SPECIAL EDITIONS 1963-4...FLUXUS h. BEN PATTERSON: COMPLETE WORKS (incl 1963), in expandable box $4 works from 1964 - by subscription
Fluxus Preview Review, [ca. July] 1963.

[as above]
Daniel Spoerri, L'Optique Moderne. List on editorial page. 1963.

[as above]
La Monte Young, LY 1961. Advertisement page. [1963].

SECOND SOLO DANCE FROM "LEMONS" Benjamin Patterson, Köln,1961

A large pulley is hung from ceiling.
A rope of a length that both ends reach floor is hung through pulley.
Dancer ties loop in one end, lays face down, or face up, or face left or face right (or tries all four positions), places freest through loop and hoist self using free end.
Dance may end after ceiling is achieved, or after failures of a predetermined number of attempts, or upon exhaustion.

TRAFFIC LIGHT - A very Lawful Dance - for Ennis Benjamin Patterson,Wiesbaden,June 1962

A traffic light, with or without special pedestrian signals is found or positioned on street corner or at stage center.
Performer(s) waits at real or imaginary curb on red signal,
alerts self on yellow signal,
crosses street or stage on green signal.
Achieving opposite side, performer(s) Turns, repeats sequence.
A performance may consist of an infinite, an indeterminate or a predetermined number of repetitions.

ANTS (photographs of ants on paper) Benjamin Patterson,Düsseldorf, 1960
 Wiesbaden, 1962
A 1960 Composition of Benjamin Patterson anticipating and to be used in conjunction with 1962 "grid" compositions of George Maciunas

Benjamin Patterson. Fluxus printing of three scores: ANTS; SECOND SOLO DANCE FROM "LEMONS"; TRAFFIC LIGHT

ROLF JÄHRLING

ROLF JÄHRLING

Benjamin Patterson performing "Solo for Double Bass" at Kleinen
Sommerfest, Galerie Parnass, Wuppertal, June 9, 1962

ROLF JÄHRLING

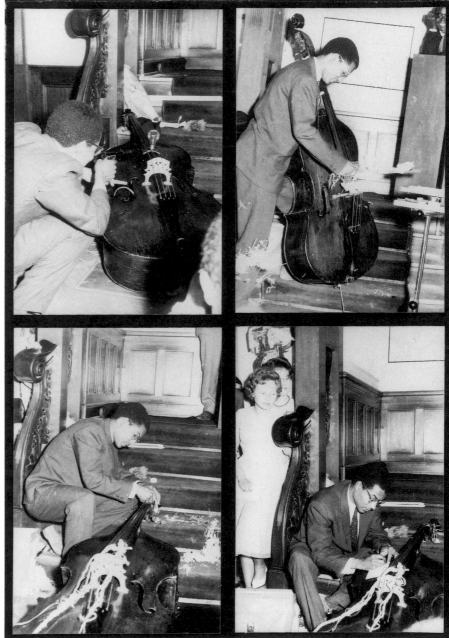

ROLF JÄHRLING

FLUXUS 1964 EDITIONS:...FLUXUS i BEN PATTERSON: complete works, $6 by subscription
Film Culture No. 30, Fall 1963.

FLUXUS 1964 EDITIONS: ... FLUXUS i BEN PATTERSON: complete works, $6 works from 1964 - by subscription...Most materials originally intended for Fluxus yearboxes will be included in the FLUXUS ccV TRE newspaper or in individual boxes.
cc V TRE (Fluxus Newspaper No. 1) January 1964.

FLUXUS 1964 EDITIONS:...FLUXUS i BEN PATTERSON: complete works, $6 works from 1964 - by subscription
cc V TRE (Fluxus Newspaper No. 2) February 1964.

Fd-h BEN PATTERSON: complete works (incl. 1963) in expandable box $4.
European Mail-Orderhouse: europeanfluxshop, Pricelist. [ca. June 1964].

COMMENTS: *Fluxus never produced a boxed edition of Ben Patterson's Complete Works. In 1962 Patterson self-published a collection of his scores, titled Methods & Processes (Silverman No. 358, ff.) and some time in 1962, or possibly 1963, George Maciunas made a blueprint edition of some of Patterson's without a Fluxus copyright.*

DANCE INSTRUCTION see:
INSTRUCTION NO. 1

FLUX ORGAN

FLUX SHOW: DICE GAME ENVIRONMENT ENTIRE FLOOR AS DICE HAZARD TABLE DIE CUBES, 15" CUBES ON FLOOR, Marked on sides, top open or closed with clear plastic. Consisting or containing...Flux organ by Ben Patterson
Flux Fest Kit 2. [ca. December 1969].

COMMENTS: *This work was never made by George Maciunas as a Fluxus Edition.*

INSTRUCTION NO. 1
Silverman No. 359, ff.

FLUXKIT containing following fluxus-publications: (also available separately)...FLUXUS ii BEN PATTERSON: INSTRUCTION 1 50¢
cc fiVe ThReE (Fluxus Newspaper No. 4) June 1964.

F-i BEN PATTERSON:...instructions in boxes $1 & up
Second Pricelist - European Mail-Orderhouse. [Fall 1964].

FLUXKIT containing following flux-publications: ... instruction 1,...of Ben Patterson...
ibid.

FLUXUS iai BEN PATTERSON: dance instructions $2
Vacuum TRapEzoid (Fluxus Newspaper No. 5) March 1965.

PAUL SILVERMAN

Benjamin Patterson. INSTRUCTION NO. 1. Two versions

FLUX-PRODUCTS 1961 TO 1969...BEN PATTERSON Instruction no.1 (dance instruction) large sheet, out of print...
Fluxnewsletter, December 2, 1968 (revised March 15, 1969).

FLUX-PRODUCTS 1961 TO 1970...BEN PATTERSON Instruction no.1, large sheet, out of print...
Flux Fest Kit 2. [ca. December 1969].

PROPOSED CONTENTS FOR FLUXPACK 3 TO BE PUBLISHED IN 1973 BY FLASH ART...Dance steps floor poster by Ben Patterson...Cost Estimates: for 1000 copies...posters [5 designs] , games $700...
[George Maciunas] , Proposed Contents for Fluxpack 3. [ca. 1972].

...Flash Art editor, Giancarlo Politi, proposed to publish the 3rd Fluxyearbook, maybe to be called FLUXPACK 3, with the following preliminary contents:...Games: dance step floor sheet by Benjamin Patterson...
Fluxnewsletter, April 1973.

03.1965...PATTERSON: dance instruction
George Maciunas, Diagram of Historical Devlopments of Fluxus... [1973].

COMMENTS: *Instruction No. 1 are hand-drawn works by Ben Patterson, given over to George Maciunas for Fluxus distribution. There are several versions. In 1972, Maciunas planned to make five printed versions of* Instruction No. 1 *for inclusion in* Fluxpack 3. *These were never produced.*

INSTRUCTION NO. 2
Silverman No. 362, ff.

FLUXKIT containing following fluxus-publications: (also available separately) ... FLUXUS iii BEN PATTERSON: INSTRUCTION 2 $3
cc fiVe ThReE (Fluxus Newspaper No. 4) June 1964.

F-i BEN PATTERSON: ... instructions in boxes $1 & up
Second Pricelist - European Mail-Orderhouse. [Fall 1964].

FLUXKIT containing following flux-publications:... instruction 2,...of Ben Patterson...
ibid.

FLUXKIT containing following fluxus-publications: (also available separately) ... FLUXUS iii BEN PATTERSON: instruction 2 $3
Vacuum TRapEzoid (Fluxus Newspaper No. 5) March 1965.

FLUXKIT...FLUXUS iii BEN PATTERSON: instruction 2 $4

Vaseline sTREet (Fluxus Newspaper No. 8) May 1966.

"...I mailed by parcel post-one carton with following: Quantity-1/ Item-Patterson instruction/ Wholesale cost to you. each-1/ suggested selling price/ sub total-1 — wholesale cost to you..."

Letter: George Maciunas to Ken Friedman, August 19, 1966.

instruction 2 $3 by ben patterson

Fluxshopnews. [Spring 1967].

FLUX-PRODUCTS 1961 TO 1969...BEN PATTERSON...Instruction no.2 (soap & towel with instructions,) boxed [$] 5...

Fluxnewsletter, December 2, 1968 (revised March 15, 1969).

FLUX-PRODUCTS 1961 TO 1970...BEN PATTERSON Instruction no.2 boxed [$] 5

Flux Fest Kit 2. [ca. December 1969].

FLUXUS-EDITIONEN ... [Catalogue No.] 771 BEN PATTERSON: instruction no. 2, boxed

Happening & Fluxus. Koelnischer Kunstverein, 1970.

COMMENTS: *This is a very direct and practical work. Packaged in a plastic box, with a Maciunas-designed label, are a piece of soap and a paper towel rubber stamped "Wash your face." Fluxus didn't beat around the bush.*

LEMONS see:
 SECOND SOLO DANCE FROM "LEMONS"
 SEPTET FROM "LEMONS"

Benjamin Patterson. INSTRUCTION NO. 2. see color portfolio

BRAD IVERSON

OVERTURE (VERSION II)
Silverman No. > 358.V, ff.

COMMENTS: *Overture (Version II) is printed by blueprint on a sheet together with* Overture (Version III) *and the first part of* Septet *from "Lemons," with a Fluxus copyright on the bottom. Although never advertised as an individual Fluxus publication, these scores were distributed by Fluxus as a part of its early publishing activity. A different printing of the identical text appears in* FLUXUS 1.

OVERTURE (VERSION III)
Silverman No. > 358,VI, ff.

COMMENTS: *Overture (Version III) appears on the same Fluxus blueprint printing with* Overture (Version II). *A different printing of this work is included in* FLUXUS 1.

PAPER PIECE
Silverman No. > 358.VIII, ff.

COMMENTS: *Two printing variations of this work exist in the Silverman Collection: one, a blueprint negative with a Fluxus copyright, the other, a blueprint positive without the Fluxus copyright. Otherwise, the works are identical.* Paper Piece *was never advertised as a separate Fluxus publication.*

POEM PUZZLE see:
 POEMS IN BOXES

POEMS IN BOXES
Silverman No. > 358.II, ff.

FLUXUS 1964 EDITIONS, AVAILABLE NOW... FLUXUS i BEN PATTERSON: poems in boxes, no 2 alike, $1 and up.

cc Valise e TRanglE (Fluxus Newspaper No. 3) March 1964.

FLUXKIT containing following fluxus-publications: (also available separately) ... FLUXUS ii BEN PATTERSON: poem-puzzle 25¢

cc fiVe ThReE (Fluxus Newspaper No. 4) June 1964.

F-i BEN PATTERSON poems in boxes, no two alike: $1 and up

European Mail-Orderhouse: europeanfluxshop, Pricelist. [ca. June 1964].

F-i BEN PATTERSON: poems and instructions in boxes $1 & up

Second Pricelist - European Mail-Orderhouse. [Fall 1964].

FLUXKIT containing following flux-publications:... poem puzzle,...of Ben Patterson...

ibid.

COMMENTS: *The earliest versions of* Poems *were collages made by Patterson. A printed version appears in* FLUXUS 1 *and a boxed edition assembled by Maciunas of the printed version is known to exist.*

overture
(version II.)

preparation:
a noise-maker(1) wrapped(2) and sealed(3) is placed in a small container(2). this container is wrapped and sealed and placed in a larger container. The larger container is wrapped and sealed and placed in a still larger container, is wrapped and sealed and placed in a still larger container; etc.. time, space, and expense determine the number of containers, wrappings and sealings.

performance:
a performer unseals, unwraps and opens containers. Two musicians standing on either side of the unwrapper produce alternately the lowest possible tones on (1) a bass brass-wind instrument and (2) a large gong or tam-tam. coincident with the opening of each container, the musicians perform a long tone in ensemble. as the noise-maker is unwrapped, the two musicians perform a very long tone in ensemble.
after a pause the unwrapper performs a single long tone with the noise-maker.
1. a simple device to be blown, such as a tube with an obstruction, producing a "white-noise" is preferred.
2. wrappings are of paper, cellophane, leather, cloth, wood, metal, plastic, etc.
3. sealings are of wax, glue, zippers, buttons, nails, ropes, tape, locks, nuts and bolts, etc. (knives, scissors, wrenches, blow-torches, cork-screws, bottle-openers, surgical instruments, etc. are used to open sealings.)
4. containers are boxes, barrels, baskets, caskets, suitcases, punch bowls, safes, garbage trucks, storerooms, grottos, etc.

benjamin patterson
paris, 1961

(version III)

preparation:
see version II. substitute a "canned" woman's laugh for noise maker(1),(2)

performance:
a performer unseals, unwraps, and opens containers. turn off laugh when "canning" device is unwrapped.
1. laugh is "canned" on small transistor tape-recorder or similar device.
2. device should be wrapped in such a manner that laugh is inaudible at beginning.

septet from "lemons"

preparation:
small quantities of water are placed in each of seven whistling tea kettles. A rubber ballon is fitted over the whistle of each kettle in a manner that does not hinder whistling.
performance:
an assistant places kettles on individual heating devices, arranged in a row, and water is brought to boil.
Three performers seated at a reasonable range from the kettles explode the inflating ballons in any sequence with pellets fired from a gas or air pistol.

© FLUXUS 1963

1. determine quantities of water to avoid simultaneous boiling.
2. whistles are of differing frequencies.
3. performers may smoke, converse, read, play cards, etc. while awaiting boiling of water.
4. aim carefully.

PAPER PIECE

5 performers

instrumentation:
15 sheets of paper per performer approximate size of standard newspaper, quality varied, newspaper, tissue paper, light cardboard, colored, printed or plain.
3 paper bags per performer; quality, size and shape varied

duration:
10 to 12½ minutes

procedure:
A general sign from a chairman will begin the piece. Within the following 30 seconds performers enter at will. The piece ends when the paper supply is exhausted.

By each performer,
7 sheets are performed
SHAKE
BREAK- opposite edges of the sheet are grasped firmly and sharply jerked apart
TEAR- each sheet is reduced to particles less than 1/10 size of the original

5 sheets are performed
CRUMPLE
RUMPLE
BUMPLE- bump between hands

3 sheets are performed
RUB
SCRUB
TWIST- twist tightly to produce a squeaking sound

3 bags are performed
POOF- inflate with mouth
POP!

dynamics are improvised within natural borders of approximate ppp of TWIST and fff of POP!
each performer previously selects, arranges, materials and sequence of events. arrangement of sequence may concern not only general order - sheet no. 1 SHAKE, BREAK, TEAR; no. 2 RUB, SCRUB TWIST; no. 3 POOF, POP! - the inner order may also be considered- TWIST, SCRUB, RUB. method of performance should be marked on each sheet.

benjamin patterson
sept. 1960, köln

© FLUXUS 1963

Benjamin Patterson. PAPER PIECE

Benjamin Patterson. A Fluxus printing of three scores: OVERTURE (VERSION II); OVERTURE (VERSION III); and SEPTET FROM "LEMONS"

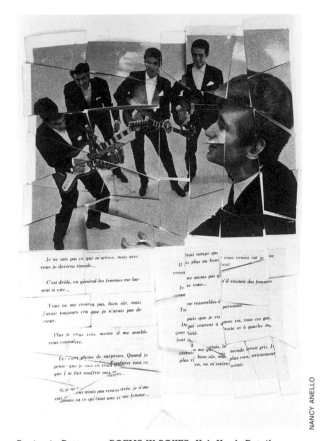

Benjamin Patterson. POEMS IN BOXES, Vol. No. 1. Detail

QUESTIONNAIRE
Silverman No. < 359.I

FLUXKIT containing following fluxus-publications: (also available separately)...FLUXUS iiii BEN PATTERSON: questionaire 10¢
cc fiVe ThReE (Fluxus Newspaper No. 4) June 1964.

FLUXKIT containing following flux-publications:... questionaire of Ben Patterson...
Second Pricelist - European Mail-Orderhouse. [Fall 1964].

"Replies to your questions...I will mail to you soon... cards —...questionaire...envelopes, you can obtain yourself...."
Letter: George Maciunas to Willem de Ridder, March 2, 1965.

please answer this question carefully.

yes ☐

no ☐

Benjamin Patterson. QUESTIONNAIRE

...Fluxus 1 items of the type that may be included [in Fluxus 2] are...Ben Patterson - questionaire...
[Fluxus Newsletter], unnumbered, [ca. March 1965].

FLUX-PRODUCTS 1961 TO 1969...BEN PATTERSON...Questionaire, included in Fluxyearbox 2
Fluxnewsletter, December 2, 1968 (revised March 15, 1969).

COMMENTS: Questionaire, a single small card, is included in some examples of FLUXUS 1, Fluxkit, and Flux Year Box 2. A few copies were distributed as individual works in envelopes, which George Maciunas titled by hand.

SCORES see:
 ANTS
 COMPLETE WORKS
 INSTRUCTION NO. 1
 INSTRUCTION NO. 2
 OVERTURE (VERSION II)
 OVERTURE (VERSION III)
 PAPER PIECE
 SECOND SOLO DANCE FROM "LEMONS"
 SEPTET FROM "LEMONS"
 TRAFFIC LIGHT

SECOND SOLO DANCE FROM "LEMONS"
Silverman No. > 358.IX

COMMENTS: Second Solo Dance from "Lemons" appears on a single blueprint sheet with Traffic Light, and Ants. The sheet does not have a Fluxus copyright, but the typing and printing are consistent with other Fluxus scores of this period, and I am convinced that it was produced and distributed by George Maciunas for Fluxus, probably in 1962. This work was to have been included in FLUXUS NO. 1 U.S. YEARBOOK.

SEPTET FROM "LEMONS"
Silverman No. > 358.VII

COMMENTS: This work was printed by blueprint on two sheets, both with the Fluxus copyright on the bottom. The first sheet also contains Overture (Version II) and Version III. An identical printing exists in the Silverman Collection without the Fluxus copyright and a different printing appears in FLUXUS 1.

TRAFFIC LIGHT
Silverman No. > 358.X

a very lawful dance for Ennis/ a traffic light...benjamin patterson June, 1962
Yam Festival Newspaper, [ca. 1963].

THE NEXT TRAFFIC LIGHT YOU NOTICE will be part of an exhibit of works by Ben Patterson currently on view at the YAM GALLERY.
ibid.

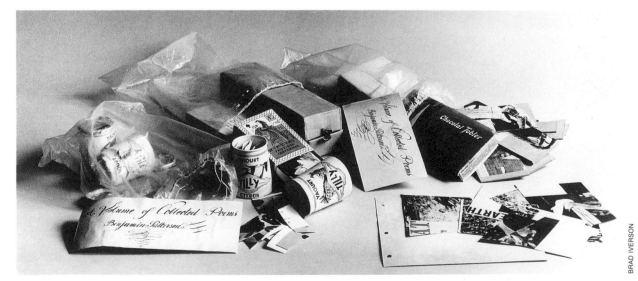

Benjamin Patterson. POEMS IN BOXES. see color portfolio

COMMENTS: Traffic Light *appears on a single blueprint sheet with* Second Solo Dance from "Lemons" *and* Ants. *The sheet does not have a Fluxus copyright, but the typing and printing are consistent with other Fluxus scores of this period (1962-63), and I am certain it was produced and distributed by George Maciunas for Fluxus. A different printing of this work appears in* FLUXUS 1.

WORKS FROM 1964 see:
COMPLETE WORKS

KRZYSZTOF PENDERECKY

It was announced in the Brochure Prospectus version B, that K. Penderecky would contribute "Polish concrete music" to FLUXUS NO. 7 EAST EUROPEAN YEARBOX.
see: COLLECTIVE

HALA and VERONICA PIETKIEWICZ

SHIT COOKIES

NEW YEAR EVE'S FLUX-FEAST, DEC. 31, 1969 AT CINEMATHEQUE, 80 WOOSTER ST ... Hala & Veronica Pietkiewiez: shit cookies...
Fluxnewsletter, January 8, 1970.

NEW YEARS EVE'S FLUX-FEST, DEC. 31, 1969... shit cookies by Hala & Veronica Pietkiewicz
all photographs copyright nineteen seVenty by peTer mooRE (Fluxus Newspaper No. 9) 1970.

©1977 ROBERT WATTS

Hala Pietkiewicz at Flux Food Atlas & Snow Event Weekend, New Marlboro, Massachusetts. January 22, 1977

446

31.12.1969 NEW YEAR EVE'S FLUX-FEAST (FOOD EVENT)...H. & V. Pietkiewicz: shit cookies...
George Maciunas, Diagram of Historical Developments of Fluxus... [1973].

COMMENTS: *The tasters were tentative in their gastronomic testing.*

LARRY POONS

It was announced in the Brochure Prospectus versions A and B, that Larry Poons would contribute "Baltimore Seaside Zephyr (graphic)" or "(drawing)" to FLUXUS NO. 1 U.S. YEARBOX.
see: COLLECTIVE

R

ELY RAMAN

FLUX-PHONE
Silverman No. > 365.101

FLUX-PROJECTS PLANNED FOR 1967 ... Ely Raman: Flux-phone (answering service)
Fluxnewsletter March 8, 1967.

FLUXPROJECTS FOR 1968 (In order of priority) Ely Raman - flux-phone (answering service) we got the automatic machine already at the Cinematheque.
Fluxnewsletter, January 31, 1968.

FLUXPROJECTS FOR 1969 ... Ely Raman: flux-phone (answering service)
Fluxnewsletter, December 2, 1968.

FLUXFEST INFORMATION...Many fluxpieces are described and listed in the Expanded Arts issue of FILM CULTURE magazine. A reprint can be obtained for $1. Any of the fluxpieces can be performed anytime, anyplace and by anyone, without any payment to Fluxus provided the following conditions are met: 1. if fluxpieces outnumber numerically or exceed in duration other compositions in any concert, the whole concert must be called and advertised as FLUX-CONCERT or FLUXEVENT. A series of such events must be called a FLUXFEST. 2. if fluxpieces do not exceed non-fluxpieces, each such fluxpiece must be identified as a FLUXPIECE. Such credits to Fluxus may be omitted at a cost of $50 for each piece announced or performed ... flux-phone answering service...
Fluxnewsletter, December 2, 1968 (revised March 15, 1969).

FLUXPHONE answering machine Ely Raman
Fluxfest at Stony Brook, Newsletter No. 1, August 18, 1969. versions A and B

NANCY ANELLO

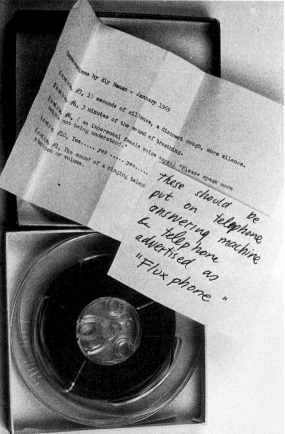

NANCY ANELLO

Ely Raman. FLUX-PHONE tape and instructions for use on an answering machine

COMMENTS: Flux-Phone exists as a tape recording of five compositions for an automatic answering machine. Dial an advertised number for Flux-Phone, and when connected hear composition no. 1, "The sound of a ringing telephone lasting for 3 minutes. no change in pitch or volume," or compositon no. 4, "3 minutes of the sound of breathing," etc. These works are dated January, 1969. Plans for the service were listed as early as 1967, and I don't know if tapes were made then as well. There is no record of the service being fully realized.

MARGARET RANDALL

It was announced in the Brochure Prospectus version B, that Margaret Randall would contribute "poems" to FLUXUS NO. 1 U.S. YEARBOX.
see: COLLECTIVE

ALEXIS RANNIT

It was announced in the tentative plans for the first issues of FLUXUS that Alexis Rannit would contribute "Byzantine abstract - lettrist poetry" to FLUXUS NO. 4 HOMAGE TO THE DISTANT PAST (later called FLUXUS NO. 5 HOMAGE TO THE PAST).
see: COLLECTIVE

PIERRE RESTANY

It was announced in the second and third tentative plans for the first issues of FLUXUS that Restany was being consulted for: "The garbage artists in France (Tinguiley [sic], Arman, Klein, Cezar [sic] etc.)" for FLUXUS NO. 5 WEST EURO-PEAN YEARBOOK II.
see: COLLECTIVE

JOCK REYNOLDS

DANGEROUS APPLIANCE see:
POTENTIALLY DANGEROUS ELECTRICAL HOUSEHOLD APPLIANCE

DETERMINE THE VALUES
Silverman No. 336, ff.

1970 JOCK REYNOLDS:...test,...
George Maciunas, Diagram of Historical Developments of Fluxus... [1973].

JOCK REYNOLDS:...Fluxtest of values, boxed $6
Flux Objects, Price List. May 1976.

COMMENTS: Jock Reynolds, one of the more socially critical Fluxus artists, pits a pearl against a pebble or bean. The implications are obvious.

BUZZ SILVERMAN

BUZZ SILVERMAN

Jock Reynolds. DETERMINE THE VALUES

Jock Reynolds. DETERMINE THE VALUES. An unused mechanical for the label by George Maciunas

FLUX DEVICE see:
POTENTIALLY DANGEROUS ELECTRICAL HOUSEHOLD APPLIANCE

FLUX RACE see:
GREAT RACE

FLUX SPORT see:
GREAT RACE

FLUX TEST see:
DETERMINE THE VALUES REVEALING FACT

GREAT RACE
Silverman No. 367, ff.

1970 JOCK REYNOLDS:...race,...
George Maciunas, Diagram of Historical Developments of Fluxus... [1973].

JOCK REYNOLDS...Flux race, boxed $6...
Flux Objects, Price List. May 1976.

Jock Reynolds. GREAT RACE. Label designed by George Maciunas

Jock Reynolds. GREAT RACE

ERIC SILVERMAN

COMMENTS: The old joke goes:
 "Great day for the race."
 "What race?"
 "The human race."

POTENTIALLY DANGEROUS ELECTRICAL HOUSEHOLD APPLIANCE
Silverman No. > 368.I, ff.

1970 JOCK REYNOLDS:...dangerous appliance.
George Maciunas, Diagram of Historical Developments of Fluxus... [1973].

JOCK REYNOLDS ... Dangerous appliance, boxed $8...
Flux Objects, Price List. May 1976.

COMMENTS: *The element of danger is quite common in Fluxus and is almost always self-imposed.*

Jock Reynolds. POTENTIALLY DANGEROUS ELECTRICAL HOUSEHOLD APPLIANCE. Label designed by George Maciunas

RACE see:
 GREAT RACE

REVEALING FACT
Silverman No. 368, ff.

1970 JOCK REYNOLDS: thermal event,...
George Maciunas, Diagram of Historical Developments of Fluxus... [1973].

JOCK REYNOLDS Thermal event, 1970 $8...
Flux Objects, Price List. May 1976.

COMMENTS: *Although very few copies were made, this work contains the attributes of a classic Fluxus work: good and evil, sex, humor, participation.*

TEST see:
 FLUX TEST

ERIC SILVERMAN

Jock Reynolds. REVEALING FACT

ERIC SILVERMAN

THERMAL EVENT see:
 REVEALING FACT

RON RICE

It was announced in the Brochure Prospectus version B, that Ron Rice would contribute "portrait of an artist with a bad tooth" to FLUXUS NO. 1 U.S. YEARBOX.
see: COLLECTIVE

MARY CAROLINE RICHARDS

It was announced in the Brochure Prospectus version B, that M.C. Richards would contribute "poems & foreword by Jackson Mac Low" to FLUXUS NO. 1 U.S. YEARBOX.
see: COLLECTIVE

HANS RICHTER

It was announced in the second and third tentative plans for the first issues of FLUXUS that Hans Richter would contribute "Anti Dada notes of notes" to FLUXUS NO. 7 HOMAGE TO DaDa.
see: COLLECTIVE

JAMES RIDDLE

CABINET see:
 25 CLOCKFACES, 1 CLOCK, CABINET
CLOCK CABINET see:
 25 CLOCKFACES, 1 CLOCK, CABINET

DECK OF CARDS

"...We have now 5 card sets which we will have manufactured by real card manufacturer....Riddle,..."
Letter: George Maciunas to Ben Vautier, January 10, 1966.

COMMENTS: This work was never produced as a Fluxus Edition. George Maciunas had a commercially produced "ESP" deck, "for testing Extra Sensory Perception," that Riddle had sent him, and perhaps he thought of imitating this deck. See E.S.P. Fluxkit, *which is a set of color "cards" with instructions, and also* One Hour, *which exists in a card version.*

DOP see:
 E.S.P. FLUXKIT

E.S.P. FLUXKIT
Silverman No. 372, ff.

"FLUXUS has no position on Burroughs or psychedelics. Jim Riddle (a fluxman) is very interested in psychedelics, ESP, LSD etc. has done two Flux-events last summer. One was ESP event across the country

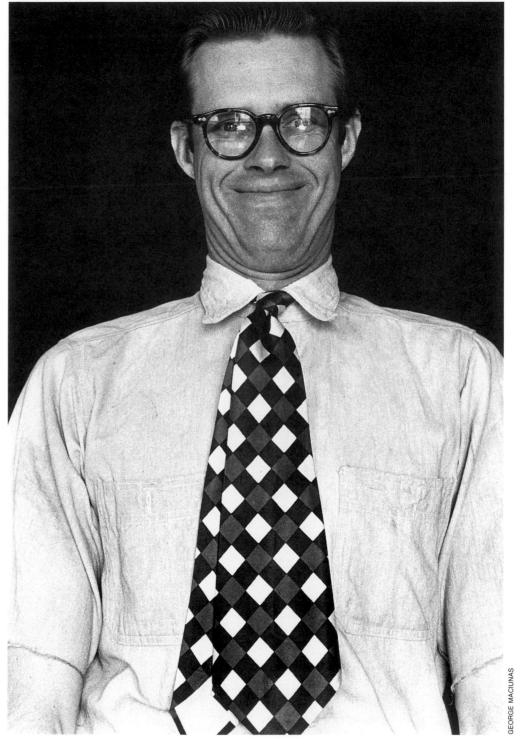

James Riddle. 1966

GEORGE MACIUNAS

(by mail.). Interesting results. Gysin piece included for itself not for his position on junk.''
Letter: George Maciunas to Paul Sharits, July 11, 1966.

PAST FLUX-PROJECTS (realized in 1966)...E.S.P. Fluxkit by James Riddle,...
Fluxnewsletter, March 8, 1967.

e.s.p. fluxkit $3.00...by james riddle
Fluxshopnews. [Spring 1967].

FLUXPROJECTS FOR 1968 (In order of priority)... 4. Flux-year-box 2 (...ESP kit by J. Riddle, card games)
Fluxnewsletter, January 31, 1968.

FLUX-PRODUCTS 1961 TO 1969 ... JAMES RIDDLE E.S.P. Fluxkit, boxed, also included in Fluxyearbox 2 * [indicated as part of FLUXKIT] [$] 3
Fluxnewsletter, December 2, 1968 (revised March 15, 1969).

FLUX-PRODUCTS 1961 TO 1970 ... JAMES RIDDLE E.S.P. Fluxkit, boxed [$] 3...
Flux Fest Kit 2. [ca. December 1969].

FLUXUS - EDITIONEN ... [Catalogue No.] 772 JAMES RIDDLE E.S.P. fluxkit, boxed
Happening & Fluxus. Koelnischer Kunstverein, 1970.

COMMENTS: *There are many Fluxus packagings of E.S.P. Fluxkit.* The work was issued as an individual edition, and is a component of some *Fluxkits and most copies of* Flux Year Box 2.

EVERYTHING
Silverman No. > 377.I, ff.

FLUX-PROJECTS PLANNED FOR 1967...Collective projects: (All are invited to submit ideas and participate, ideas can be either ready pictorial material or just specified material which we have to find, produce or obtain otherwise)...Flux-postal kit: containing ... cancellation stamps,...
Fluxnewsletter, March 8, 1967.

IMPLOSIONS INC. PROJECTS ... Triple partnership was formed between Bob Watts, Herman Fine and myself [George Maciunas] to introduce into mass market

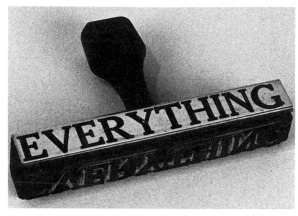
James Riddle. EVERYTHING

...money producing products...This business will be operated in commercial manner, with intent to make profits....connection between Fluxus collective and Implosions Inc. has not been clarified yet...we could consider at present Fluxus to be a kind of division or subsidiary of Implosions. Projects to be realized through Implosions:...Postcards, stamps (same as Flux-postal kit)
ibid.

flux post kit $7 [containing Everything]
Fluxshopnews. [Spring 1967].

[impression of rubberstamp used on letter].
Letter: George Maciunas to Paul Sharits, June 21, 1967.

FLUX-PRODUCTS 1961 TO 1969 ... FLUXPOST KIT 1968 ... rubber stamp by ... Jim Riddle [$] 8 Version without rubber stamps [$] 2
Fluxnewsletter, December 2, 1968 (revised March 15, 1969).

FLUX-PRODUCTS 1961 TO 1970 ... FLUXPOST KIT, 1968: ... rubber stamp by ... Jim Riddle. Boxed $8
Flux Fest Kit 2. [ca. December 1969].

FLUXUS-EDITIONEN...[Catalogue No.] 719... (... j. riddle) FLUXPOST KIT, 1968... j. riddle
Happening & Fluxus. Koelnischer Kunstverein, 1970.

COMMENTS: *Everything, a rubber stamp first made by James Riddle in 1965 or 1966 (Silverman No. > 377.I), was later produced by George Maciunas as a Fluxus Edition (Silverman No. > 377.II), probably in June 1967, in a version smaller than Riddle's. This work is included in* Flux Post Kit 7.
The idea of Everything *was originally explored by Ben Vautier in 1960 with* Tout *and* Partie du Tout a Ben. *In 1961, Daniel Spoerri made a rubber stamp, "Attention Oeuvre d'Art," for his exhibition at Galerie Koepcke in Copenhagen, which he used to stamp mundane items bought at a grocery store and other things. Vautier was impressed with this stamp and gave the idea over to George Maciunas who produced the Fluxus Edition of Vautier's rubber stamp,* Ben Vautier Certi-

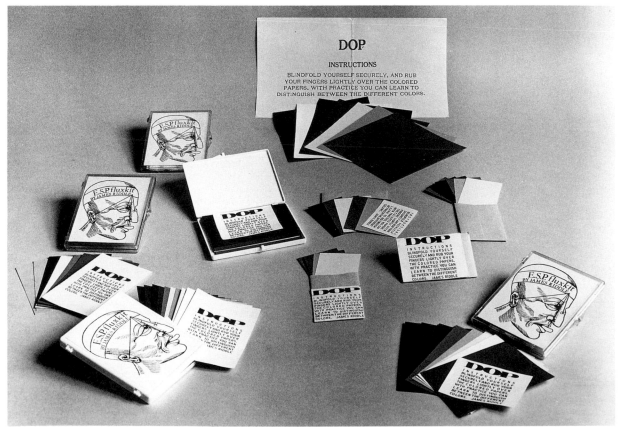
James Riddle. E.S.P. FLUXKIT. A variety of Fluxus packagings. see color portfolio

fies This to Be a Work of Fluxart ("Everything"), which is also packaged in Flux Post Kit 7.

On August 22, 1965, "The Perpetual Fluxfest" presented James Riddle's Everything, "a variety show with audio-visual events and exhibits" at the Cinematheque Theater, 85 East 4th Street, New York City. The exhibits included bottled Urine, LSD stickers, Instant Happenings, and much more.

FILMS see:
9 MINUTES
FLUXFURNITURE see:
25 CLOCKFACES, 1 CLOCK, CABINET
FLUXPOST KIT see:
EVERYTHING

INSTANT HAPPENINGS
Silverman No. 369, ff.

FLUXKIT containing following fluxus-publications: (also available separately) ... FLUXUS s JAMES RIDDLE: mind event in bottle $4
cc fiVe ThReE (Fluxus Newspaper No. 4) June 1964.

OTHER NEW FLUXUS ITEMS AVAILABLE IN FLUXSHOP OR BY MAIL:... FLUXUS s JAMES RIDDLE: mind event in bottle $5
ibid.

F-s JAMES RIDDLE mind events in bottle $5...
Second Pricelist - European Mail-Orderhouse. [Fall 1964].

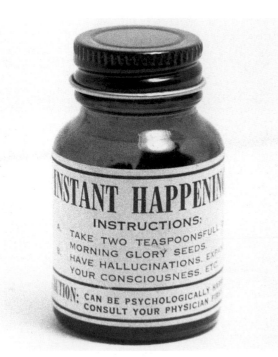

James Riddle. INSTANT HAPPENINGS

ERIC SILVERMAN

FLUXKIT containing following flux-publications:... mind event in bottle of James Riddle...
ibid.

FLUXKIT containing following fluxus-publications: (also available separately)...FLUXUS u JAMES RIDDLE... mind events, boxed $5
Vaseline sTREet (Fluxus Newspaper No. 8) May 1966.

FLUX-PRODUCTS 1961 TO 1969 ... JAME RIDDLE...Instant happenings, bottles [$] 1
Fluxnewsletter, December 2, 1968 (revised March 15, 1969).

05.1966 JAMES RIDDLE: mind events
George Maciunas, Diagram of Historical Developments of Fluxus... [1973].

COMMENTS: Instant Happenings *is usually referred to as "mind event in bottle." The work was produced by the artist and distributed by Fluxus. The bottle contains Morning Glory seeds, a hallucinogen if consumed in sufficient quantities. A variation of this work, Riddle's* A Psychedelic Happening *(Silverman No. 370), is a rubber stamped manila envelope containing Morning Glory seeds.*

MIND EVENT IN BOTTLE see:
INSTANT HAPPENINGS

MIND EVENT POSTER

OTHER NEW FLUXUS ITEMS AVAILABLE IN FLUXSHOP OR BY MAIL:... FLUXUS sos JAMES RIDDLE:...mind event poster $5
cc fiVe ThReE (Fluxus Newspaper No. 4) June 1964.

F-sos JAMES RIDDLE mind event poster $5.
Second Pricelist - European Mail-Orderhouse. [Fall 1964].

FLUXUS sos JAMES RIDDLE: mind event poster $5
Vacuum TRapEzoid (Fluxus Newspaper No. 5) March 1965.

FLUX-PRODUCTS 1961 TO 1969 ... JAMES RIDDLE...Mind Event, 4' x 5' poster, [$] 6
Fluxnewsletter, December 2, 1968 (revised March 15, 1969).

FLUX-PRODUCTS 1961 TO 1970 ... JAMES RIDDLE...Mind Event, 4' x 5' poster [$] 6
Flux Fest Kit 2. [ca. December 1969].

COMMENTS: This work is not known to me.

9 MINUTES
Silverman No. > 371.I, ff.

FLUXFILMS ... LONG VERSION, ADDITIONAL FILMS TO SHORT VERSION...[flux-number] 6 James Riddle 9 MINUTES 9' Time counter, in seconds and minutes.
Fluxfilms catalogue. [ca. 1966].

"...Regarding film festival. — I will send you the following: You will get these end of April...James Riddle - 10 minutes, 10 min....They and another 6 films make up the whole 2 hour Fluxfilm program....Fluxfilm program was shown at Ann Arbor Film Fest & won a critics award..."
Letter: George Maciunas to Ben Vautier, March 29, 1966.

FLUXFILMS...FLUXFILM 6 JAMES RIDDLE: 9 minutes, 9min $36
Vaseline sTREet (Fluxus Newspaper No. 8) May 1966.

PAST FLUX-PROJECTS (realized in 1966)...Fluxfilms: total package: 1 hr. 40 min.... 9 minutes by James Riddle,...
Fluxnewsletter, March 8, 1967.

"...You could show say...numbers so arranged you have them shift in numerical order..."
Letter: George Maciunas to Ken Friedman, [ca. August 1967].

FLUX-PRODUCTS 1961 TO 1969...FLUXFILMS, long version Winter 1966 Short version plus addition of:...9 minutes - by James Riddle,...total: 1 hr. 40 min. 3600ft. 16mm only: [$] 400
Fluxnewsletter, December 2, 1968 (revised March 15, 1969).

FLUX-PRODUCTS 1961 TO 1970 ... FLUXFILMS, long version, Winter 1966. Short version plus addition of:...9 min. by James Riddle,...total: 1hr. 40 min. 16mm $400
Flux Fest Kit 2. [ca. December 1969].

1965 FLUXFILMS:...JAMES RIDDLE: 9 minutes
George Maciunas, Diagram of Historical Developments of Fluxus... [1973].

COMMENTS: Truth in advertising — the film is just what it says it is. 9 Minutes *is a component of the long version of* Fluxfilms. *The ten minute version mentioned in one of Maciunas' letters is not known to exist.*

ONE HOUR
Silverman No. 371, ff.

ONE HOUR...BY JIM RIDDLE
3 newspaper eVenTs for the pRicE of $1 (Fluxus Newspaper No. 7) February 1, 1966.

FLUX-PRODUCTS 1961 TO 1969 ... V TRE FLUX-NEWSPAPERS...3 newspaper eVenTs for the pRicE of $1, no 7. Feb. 1966...One hout [sic] by Jim Riddle ...
Fluxnewsletter, December 2, 1968 (revised March 15, 1969).

COMMENTS: One Hour *is a time sequence event, printed in* Fluxus Newspaper No. 7. *A separate simultaneous printing was done on white card stock with blank verso that could be cut into cards. The same images are used for* 25 Clockfaces, 1 Clock, Cabinet.

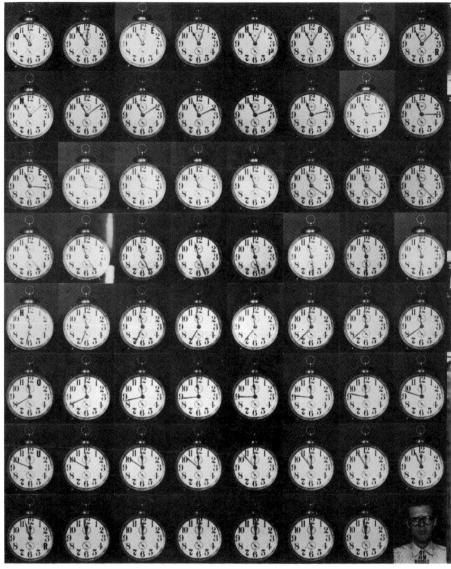

James Riddle. ONE HOUR

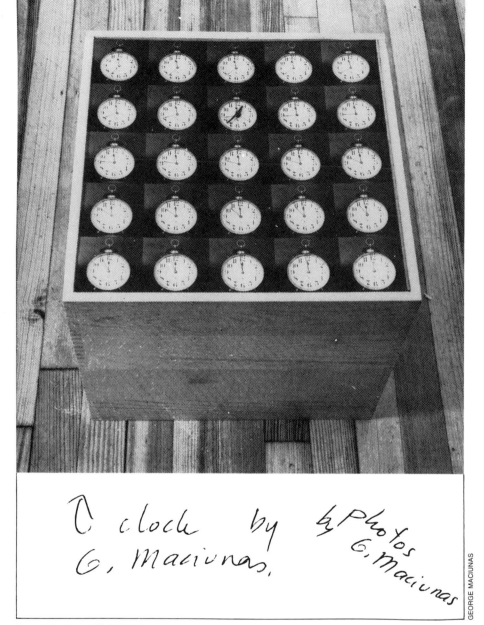

James Riddle. 25 CLOCKFACES, 1 CLOCK, CABINET. On this paste-up, George Maciunas credits the work to himself

POSTER see:
MIND EVENT POSTER

A PSYCHEDELIC HAPPENING
Silverman No. 370

''...A psychedelic happening in envelope is by Riddle ...''

Letter: George Maciunas to Dr. Hanns Sohm, [ca. late 1972].

COMMENTS: *This work is conceptually similar to* Instant Happenings.

RUBBER STAMP see:
EVERYTHING

25 CLOCKFACES, 1 CLOCK, CABINET
Silverman No. > 371.II

''...Another new development: We are working on

FLUXFURNITURE....many chairs and cabinets with various kinds of doors, 15'' x 15''. One has 25 clock faces printed, but one has real clock arms moving, although from distance they all look alike...''
Letter: George Maciunas to Ben Vautier, August 7, 1966.

PAST FLUX-PROJECTS (realized in 1966)...Flux-furniture: modular cabinets by: James Riddle,...
Fluxnewsletter, March 8, 1967.

clock cabinet $100 by james riddle
Fluxshopnews. [Spring 1967].

FLUXFURNITURE...MODULAR CABINETS, 15" cubes, walnut sides and back, locked corners, variations on doors...George Maciunas & James Riddle: 25 clock faces, one operable, photo-laminate, $100.00 ...Available in N.Y.C. at Multiples and late in 1967 at FLUXSHOP, 18 GREENE ST.
Fluxfurniture, pricelist. [1967].

PROPOSED FLUXSHOW FOR GALLERY 669 ... OBJECTS, FURNITURE...clocks: 25 clockface clock by Jim Riddle,...
Fluxnewsletter, December 2, 1968.

FLUX-PRODUCTS 1961 TO 1969 ... JAMES RIDDLE...Cabinet with 25 clockfaces, only one working, [$] 100
Fluxnewsletter December 2, 1968 (revised March 15, 1969).

FLUX-PRODUCTS 1961 TO 1970 ... JAMES RIDDLE...Cabinet with 25 clockfaces, 1 clock [$] 100...
Flux Fest Kit 2. [ca. December 1969].

FLUX SHOW: DICE GAME ENVIRONMENT ENTIRE FLOOR AS DICE HAZARD TABLE DIE CUBES, 15" CUBES ON FLOOR, Marked on sides, top open or closed with clear plastic. Consisting or containing...Flux Clock cabinet by James Riddle.
ibid.

FLUXUS-EDITIONEN...[Catalogue No.] 773 JAMES RIDDLE: cabinet with 25 clockfaces, 1 clock (holzkasten)
Happening & Fluxus. Koelnischer Kunstverein, 1970.

COMMENTS: *Using twenty-five images from* One Hour, *Maciunas built a Flux clock into a fifteen inch cube. One clock image has working hands and movements hidden inside the cabinet.*

TERRY RILEY

PIANO PIECE
Silverman No. > 377.101

COMMENTS: Piano Piece *was printed by blueprint from a master with a 1963 Fluxus copyright. The work was distributed with other Fluxus scores of the period. However, we could find no reference to the work being among Fluxus scores for sale.*

GRIFITH ROSE

It was announced in the Brochure Prospectus versions A and

B, *that Griffith W. Rose [sic] would contribute "Squares, 2nd Ennead, Bass Clarinet piece" later clarified as a "score," to* FLUXUS NO. 1 U.S. YEARBOX.
see: COLLECTIVE

Unidentified Scores

Scores available by special order:...also available are scores of work by...Grifith Rose
Fluxus Preview Review, [ca. July] 1963.

COMMENTS: *It's possible that Grifith Rose's* Unidentified Scores *offered for sale by "special order" was "Squares, 2nd Ennead, Bass Clarinet Piece" which was to have been in* FLUXUS NO. 1 U.S. YEARBOX. *I have never seen this work.*

DITER ROT

It was announced in the initial plans for the first issues of FLUXUS *that Diter Rot would contribute "Poetry machine" to* FLUXUS NO. 2 WEST EUROPEAN ISSUE 1. *The contribution was dropped in further plans for that issue. It was picked up again later, in the Brochure Prospectus versions A and B, and expanded to "poetry machine & essay" for* FLUXUS NO. 2 GERMAN & SCANDINAVIAN YEARBOX, *later called* FLUXUS NO. 3.

PIANO PIECE
by Terry Riley

Three tape recorders are placed so that they can be easily turned on and off by the performers.

Find a flat river rock and hang it on strings so that it will vibrate. Use only middle register, and keep it going with the fingers.

Use several dozen flat oblong erasers for throwing into the piano from any distance desirable.

Some materials that are found in the enviroment can be used, as well as plain wooden drumsticks to make scraping sounds inside the piano.

When using the piano, avoid any virtuoso playing, and string glissandes, except lengthwise on a string.

Some simple tunes may be played on the piano to complement the tape-recorders from time to time.

The piece should end at just the proper moment.

—

© FLUXUS 1963

Terry Riley. PIANO PIECE

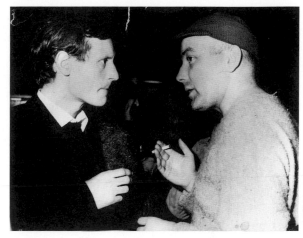

MANFRED TISCHER

Diter Rot, right, talking with Arthur Koepcke, ca. 1961

Instructions on how to "produce" Diter Rot's "Poem Machine," with editorial illustrations were published in Fluxus Newspaper No. 2.
see: COLLECTIVE

GERHARD RUEHM

It was announced in the Brochure Prospectus version B, that Gerhard Ruehm would participate in FLUXUS NO. 3 GERMAN & SCANDINAVIAN YEARBOX.
see: COLLECTIVE

WERNER RUHNAU

It was announced in the Brochure Prospectus versions A and B, that Werner Ruhnau would contribute "indeterminate & immaterial theatre" to FLUXUS NO. 2 (later called FLUXUS NO. 3) GERMAN & SCANDINAVIAN YEARBOX.
see: COLLECTIVE

FRANK RYCYK, JR.

FLUX SNOW TOWER see:
George Maciunas

CHOCOLATE FILLED NUT SHELLS

NEW YEAR EVE'S FLUX-FEAST, DEC. 31, 1969 AT CINEMATHEQUE, 80 WOOSTER ST. ... Frank Rycyk, Jr.:...chocolate inside nut shells...
Fluxnewsletter, January 8, 1970.

COMMENTS: Chocolate Filled Nut Shells *relates to Maciunas' eggs filled with other substances, but is a more obvious realization in that it is something one might find at a candy store.*

UNOPENABLE NUTS

NEW YEAR EVE'S FLUX-FEAST, DEC. 31, 1969
AT CINEMATHEQUE, 80 WOOSTER ST. ... Frank
Rycyk, Jr.: unopenable nuts in openable paper enclo-
sures;...
Fluxnewsletter, January 8, 1970.

31.12.1969 NEW YEAR EVE'S FLUX-FEAST
(FOOD EVENT)...F. Rycyk: unopenable nuts...
*George Maciunas, Diagram of Historical Developments of
Fluxus... [1973].*

COMMENTS: *I missed these nuts.*

TAKAKO SAITO

BALL CHAIR see:
ROLLING BALL CHAIR

BALL GAMES
Silverman No. 383

... items are in stock, delivery within 2 weeks ...
FLUXUS au TAKAKO SAITO: ball games $20
Vaseline sTREet (Fluxus Newspaper No. 8) May 1966.

COMMENTS: *Takako Saito's* Ball Games, *offered for sale by
Fluxus, were always made by the artist. They were based
loosely on children's ball toys. The idea for George Maciunas'*
Maze *(Silverman No. < 277.II) comes from this work.*

BELL CHAIR see:
SOUNDING BELL CHAIR
BELL CHESS see:
SOUND CHESS

BUZZER CHAIR

FLUX-PRODUCTS 1961 To 1969...TAKAKO SAI-
TO...Music chairs:... buzzer,...each: [$] 60
Fluxnewsletter, December 2, 1968 (revised March 15, 1969).

FLUX-PRODUCTS 1961 TO 1970...TAKAKO SAI-
TO...Musical chairs...buzzer...each [$] 80
ibid.

FLUX-PRODUCTS 1961 TO 1970 ... SOLO OB-
JECTS AND PUBLICATIONS...TAKAKO SAITO ...
Musical chairs...buzzer...[$] 100
[Fluxus price list for a customer]. September 1975.

TAKAKO SAITO...Musical chairs,...buzzer,...ea:
$100...
Flux Objects, Price List. May 1976.

PHOTOGRAPHER NOT IDENTIFIED

Takako Saito with her SOUND CHESS or WEIGHT CHESS, probably photographed by George Maciunas, Winter 1964

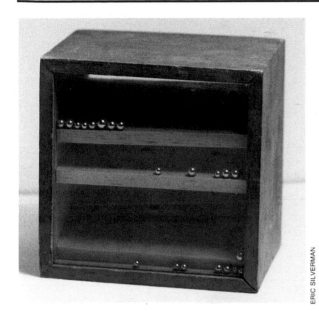

ERIC SILVERMAN

Takako Saito. BALL GAME

COMMENTS: Buzzer Chair *would be an* Event Chair *or* Musical Chair *depending on point of view. Although I have not seen this particular work, the chairs were built as cubes with leather or rubber stretched across the top with open bottoms. Inside were devices to produce sound when activated by sitting.*

CHAIRS see:
FLUXFURNITURE

CHESS see:
FLUXCHESS

CHESS BOARD DOOR

Toilet No. 6 Collective...Doors - display on interior side of door...Chess boards can be played by 2 people swinging door around. One person inside another outside the stall. (Takako Saito)
Fluxnewsletter, April 1973.

COMMENTS: *Any of Saito's chess games could have been used for* Chess Board Door.

ECHIZENGAMI

FLUXPROJECTS REALIZED IN 1967...Flux-Christmas-meal-event...Takako Saito - Echizengami (paper, after being "cooked" over a low flame revealed drawing of various foods)...
Fluxnewsletter, January 31, 1968.

31.12.1968 NEW YEAR EVE'S FLUX-FEAST

(FOOD EVENT)...Takako Saito: rice paper food...
George Maciunas, Diagram of Historical Developments of Fluxus... [1973].

COMMENTS: *Zen food.*

EVENT CHAIRS

FLUXFURNITURE ... CHAIRS ... Takako Saito: ... "event chairs", 15" cubes, leather tops, 12 variations, sitting activates mechanism producing event, $60 to 160...Available in N.Y.C. at Multiples and late in 1967 at FLUXSHOP, 18 GREENE ST.
Fluxfurniture, pricelist. [1967].

COMMENTS: *This is a general entry for twelve variations of chairs that would produce an event or occurrence when they were activated by sitting down on them.* Event Chairs *could produce sounds and would then be* Musical Chairs.

FLUXCHESS

"...By post you will be getting...fluxchess..."
Letter: George Maciunas to Ken Friedman, February 28, 1967.

PAST FLUX-PROJECTS (realized in 1966)...Fluxfurniture: Fluxchess by Takako Saito and George Maciunas.
Fluxnewsletter, March 8, 1967.

03.1965 T. SAITO: chess
George Maciunas, Diagram of Historical Developments of Fluxus... [1973].

COMMENTS: *This is a general entry for unidentified chess sets by Takako Saito. See* Fluxchess *for the specific works.*

FLUXCHESS see:
CHESS BOARD DOOR
FLUXCHESS
GRINDER CHESS
JEWEL CHESS
NUT & BOLT CHESS
SMELL CHESS
SOUND CHESS
SPICE CHESS
WEIGHT CHESS

FLUXFURNITURE see:
BUZZER CHAIR
EVENT CHAIRS
MUSICAL CHAIRS
ROLLING BALL CHAIR
SOUNDING BELL CHAIR
SQUIRTING WATER CHAIR

FLUX-TOILET see:
CHESS BOARD DOOR

FURNITURE see:
FLUXFURNITURE

GAME BOARD

PROPOSED CONTENTS FOR FLUXPACK 3 TO BE PUBLISHED IN 1973 BY FLASH ART...Game board by Takako Saito...Cost Estimates: for 100 copies ... posters [5 designs] games $700...100 copies signed by:...Saito...
[George Maciunas], Proposed Contents for Fluxpack 3. [ca. 1972].

Flash Art Editor, Giancarlo Politi, proposed to publish the 3rd Fluxyearbook, maybe to be called FLUXPACK 3, with the following preliminary contents:...Games:...game board by Takako Saito;...
Fluxnewsletter, April 1973.

COMMENTS: Game Board *was not included in* Fluxpack 3, *nor produced as a Fluxus Edition.*

GRINDER CHESS
Silverman No. 242

FLUXUS a FLUXCHESS: pieces identified by sound or weight or smell etc....FLUXUS a7 grinder chess $20
Vacuum TRapEzoid (Fluxus Newspaper No. 5) March 1965.

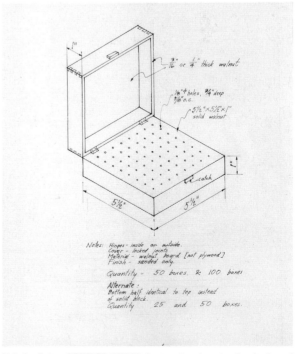

SCOTT HYDE

Takako Saito. GRINDER CHESS. Instruction drawing for the board by George Maciunas

... items are in stock, delivery within 2 weeks ...
FLUXUSa FLUXCHESS: pieces identified by sound
or weight or smell or time etc....FLUXUS a7 grinder
chess $35
Vaseline sTREet (Fluxus Newspaper No. 8) May 1966.

$30 flux chess grinders...by George Maciunas
Fluxshopnews. [Spring 1967].

FLUX-PRODUCTS 1961 TO 1969 ... GEORGE MA-
CIUNAS Chess sets: grinders for pieces in hardwood
case, [$] 40
Fluxnewsletter, December 2, 1968 (revised March 15, 1969).

FLUX-PRODUCTS 1961 TO 1970 ... GEORGE MA-
CIUNAS...Chess set grinders in hardwood chest [$]
40
Flux Fest Kit 2. [ca. December 1969].

FLUX SHOW: DICE GAME ENVIRONMENT EN-
TIRE FLOOR AS DICE HAZARD TABLE DIE
CUBES, 15" CUBES ON FLOOR, Marked on sides,
top open or closed with clear plastic. Consisting or
containing...grinder...chess sets.
ibid.

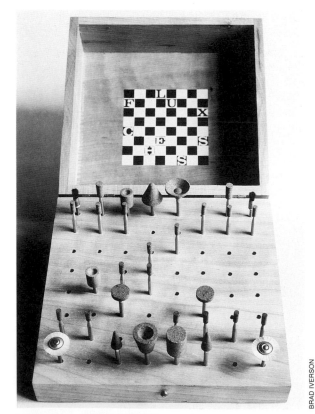

Takako Saito. GRINDER CHESS. see color portfolio

BRAD IVERSON

456

FLUXUS-EDITIONEN ... [Catalogue No.] 763
GEORGE MACIUNAS: chess set, grinders in hard-
wood chest
Happening & Fluxus. Koelnischer Kunstverein, 1970.

FLUX-PRODUCTS 1961 TO 1970 ... GEORGE MA-
CIUNAS...Chess set grinders in hardwood chest
[$] 80...
[Fluxus price list for a customer]. September 1975.

Grinder chess by Saito & GM $100
[Fluxus price list for a customer]. January 7, 1976.

GEORGE MACIUNAS Chess set, grinders in hard-
wood box $80...
Flux Objects, Price List. May 1976.

OBJECTS AND EXHIBITS...1965:...various chess
sets (pieces as grinders...)
George Maciunas Biographical Data. 1976.

COMMENTS: *Takako Saito, stated in a letter to me dated
August 18, 1982: "...Fluxus chess with grinders That is also
the original one was mine. When I gave it to George one of
two pieces were missing (Because the grinders which I wanted
to use specially too expensive for me to buy.) The one in the
photo is all pieces were used stone grinders. The one what I
made was all pawns were stone and metal grinders and other
pieces were [drawings of grinders] and others mixed I think.
When I gave all the chess sets to George, I said 'he can use
them as the Fluxus chess without mentioning my name.'"*

Takako Saito. GRINDER CHESS. Photographed in 1966 for Fluxus
Newspaper No. 8

PHOTOGRAPHER NOT IDENTIFIED

JEWEL CHESS

FLUXUS a FLUXCHESS: pieces identified by sound
or weight or smell etc....FLUXUS a5 jewel chess $40
Vacuum TRapEzoid (Fluxus Newspaper No. 5) March 1965.

... items are in stock, delivery within 2 weeks ...
FLUXUSa FLUXCHESS: pieces identified by sound
or weight or smell or time etc....FLUXUSal2 jewel
chess, in plastic cubes, $60
Vaseline sTREet (Fluxus Newspaper No. 8) May 1966.

FLUX-PRODUCTS 1961 TO 1969...TAKAKO SAI-
TO Chess sets:...jewelry pieces in plastic cubes,
[$] 60...
Fluxnewsletter, December 2, 1968 (revised March 15, 1969).

FLUX-PRODUCTS 1961 TO 1970...TAKAKO SAI-
TO...Chess set jewels in plastic cubes [$] 80...
Flux Fest Kit 2. [ca. December 1969].

COMMENTS: *Various types of fake jewels form the chess
pieces. An example of this work is in the Hermann and
Marietta Braun Collection in Remscheid, West Germany.*

LIQUIDS CHESS see:
 SMELL CHESS

MAGIC BOAT
Component of Silverman No. 117, ff.

... Fluxus 1 items of the type that may be included
[in Fluxus 2] are:...the magic boat...
[Fluxus Newsletter], unnumbered, [ca. March 1965].

COMMENTS: *This work is included in many examples of
FLUXUS 1. Magic Boat is an origami boat constructed by the
artist.*

MUSICAL CHAIRS

FLUXUS 1964 EDITIONS, AVAILABLE NOW ...
FLUXUS xxa MUSIC CHAIR $15
cc Valise e TRanglE (Fluxus Newspaper No. 3) March 1964.

xxa MUSIC CHAIR $15
*European Mail-Orderhouse: europeanfluxshop, Pricelist.
[ca. June 1964].*

"... Some new items are... musical chairs by Takako
Saito ...I will mail you a sample..."
*Letter: George Maciunas to Willem de Ridder, March 2,
1965.*

FLUXUS ai FLUXCHAIRS, 10 variant[s], $20 to $40
Vacuum TRapEzoid (Fluxus Newspaper No. 5) March 1965.

... items are in stock, delivery within 2 weeks ...
FLUXFURNITURE & ACCESSORIES...FLUXUS ai

SCOTT HYDE

Takako Saito. MAGIC BOAT contained in FLUXUS 1

TAKAKO SAITO: musical chairs, ea. $40
Vaseline sTREet (Fluxus Newspaper No. 8) May 1966.

"I would like to send you all new flux items such as furniture...I could include...musical chairs..."
Letter: George Maciunas to Ben Vautier, August 22, 1966.

PAST FLUX-PROJECTS (realized in 1966)...Flux-furniture: chairs by Takako Saito...
Fluxnewsletter, March 8, 1967.

FLUXFURNITURE...CHAIRS...Takako Saito: "musical chairs"...15" cubes, leather tops, 12 variations,

sitting down activates mechanism producing event, $60 to 160...Available in N.Y.C. at Multiples and late in 1967 at FLUXSHOP, 18 GREENE ST.
Fluxfurniture, pricelist. [1967].

03.1964 TAKAKO SAITO: musical chairs
George Maciunas, Diagram of Historical Developments of Fluxus... [1973].

COMMENTS: *I believe any early* Musical Chairs *would have been constructed by the artist, and later ones (from around 1967) were constructed by George Maciunas. I doubt that twelve variations were built. However, I have seen a* Rolling Ball Chair, *and one with an aerophone. Several others are known to exist. See also* Event Chairs.

NUT & BOLT CHESS
Silverman No. 378

FLUXUS a FLUXCHESS: pieces identified by sound or weight or smell etc....FLUXUS a6 nut & bolt chess, $20
Vacuum TRapEzoid (Fluxus Newspaper No. 5) March 1965.

... items are in stock, delivery within 2 weeks ... FLUXUS a FLUXCHESS: pieces identified by sound or weight or smell or time etc....FLUXUS a6 nut and bolt chess $30
Vaseline sTREet (Fluxus Newspaper No. 8) May 1966.

FLUX-PRODUCTS 1961 TO 1969...TAKAKO SAITO Chess sets:...nut & bolt pieces in hardwood case, [$] 40
Fluxnewsletter, December 2, 1968 (revised March 15, 1969).

FLUX-PRODUCTS 1961 TO 1970...TAKAKO SAITO...Chess set, nut & bolt pieces, boxed [$] 40...
Flux Fest Kit 2. [ca. December 1969].

COMMENTS: *Various types of nuts and bolts form the pieces. Unfortunately, the example in the Silverman Collection is lost, and I haven't located a photograph or another example.*

POSTCARDS

PROPOSED CONTENTS FOR FLUXPACK 3 TO BE PUBLISHED IN 1973 BY FLASH ART ... Postcards by... Saito ... Cost Estimates: for 100 copies ...postcards [including designs by other artists] $100 ...100 copies signed by:...Saito...
[George Maciunas], Proposed Contents for Fluxpack 3. [ca. 1972].

COMMENTS: *Postcards by Saito were never made as a Fluxus Edition.*

RICE PAPER FOOD see:
ECHIZENGAMI

ROLLING BALL CHAIR

"...I don't know whether I mentioned our involvement now in making furniture - mostly utilizing 15" wood cubes as...'musical chairs' (sitter activates some event inside the chair, like rolling balls,...)..."
Letter: George Maciunas to Paul Sharits, [ca. April 6, 1966].

PROPOSED FLUXSHOW FOR GALLERY 669 ... OBJECTS, FURNITURE...music - chairs by Takako Saito (...rolling ball)
Fluxnewsletter, December 2, 1968.

FLUX-PRODUCTS 1961 TO 1969...TAKAKO SAITO...Music chairs: ...rolling ball,...each: [$] 60
Fluxnewsletter, December 2, 1968 (revised March 15, 1969).

FLUX-PRODUCTS 1961 TO 1970...TAKAKO SAITO...Musical chairs...rolling ball,...each [$] 80
Flux Fest Kit 2. [ca. December 1969].

FLUX SHOW: DICE GAME ENVIRONMENT ENTIRE FLOOR AS DICE HAZARD TABLE DIE CUBES, 15" CUBES ON FLOOR, Marked on sides, top open or closed with clear plastic. Consisting or containing...Musical chair by Takako Saito (balls)
ibid.

FLUXUS-EDITIONEN ... [Catalogue No.] 775 TAKAKO SAITO: musical chair with rolling ball (holzkasten)
Happening & Fluxus. Koelnischer Kunstverein, 1970.

FLUX-PRODUCTS 1961 TO 1970 ... SOLO OBJECTS AND PUBLICATIONS...TAKAKO SAITO ...Musical chairs...rolling ball... [$] 100
[Fluxus price list for a customer]. September 1975.

TAKAKO SAITO Musical chairs,...rolling ball, etc. ea: $100...
Flux Objects, Price List. May 1976.

COMMENTS: *This work consists of a fifteen inch wood cube, with leather stretched across the top, and an open bottom. Inside is an ingeniously simple contraption that activates a box containing a ball when the chair is sat down on. Could be considered either an* Event Chair *or a* Musical Chair.

SMELL CHESS

Silverman No. 378 bis

"...Some new items are Chess pieces...by Takako Saito. Chess pieces are recognizable by their... smell, etc. I will mail you a sample..."
Letter: George Maciunas to Willem de Ridder, March 2, 1965.

FLUXUS a FLUXCHESS: pieces identified by sound or weight or smell etc. ... FLUXUS a1 smell chess, liquids $30
Vacuum TRapEzoid (Fluxus Newspaper No. 5) March 1965.

Takako Saito. SMELL CHESS

...items are in stock, delivery within 2 weeks...FLUXKIT containing following fluxus-publications: (also available separatelly) ... FLUXUS a2 FLUXCHESS, smell pieces, spices $40
Vaseline sTREet (Fluxus Newspaper No. 8) May 1966.

...items are in stock, delivery within 2 weeks...FLUXUS a FLUXCHESS: pieces identified by sound or weight or smell or time etc. ...FLUXUS a1 smell chess, liquids $40
ibid.

...items are in stock, delivery within 2 weeks...FLUXUSa FLUXCHESS: pieces identified by sound or weight or smell or time etc. ... FLUXUSa2 smell chess, spices $40
ibid.

PROPOSED FLUXOLYMPIAD ... BOARD GAMES: ...chess tournament with: smell chess,...
Fluxnewsletter, January 31, 1968.

[as above]
Fluxnewsletter, December 2, 1968.

PROPOSED FLUXSHOW FOR GALLERY 669 ... SPORTS-GAME CENTER ... chess sets with: smell pieces,...
ibid.

FLUX-PRODUCTS 1961 TO 1969...TAKAKO SAITO Chess sets:...liquid smell pieces, bottled, [$] 60...
Fluxnewsletter, December 2, 1968 (revised March 15, 1969).

PROPOSED FLUXSHOW ... SPORTS-GAME CENTER...Chess tournament with: smell pieces...
ibid.

FLUX-OLYMPIAD ... DUAL ... Board chess smell pieces (Takako Saito)
Fluxfest at Stony Brook, Newsletter No. 1, August 18, 1969.
versions A and B

FLUX-PRODUCTS 1961 TO 1970...TAKAKO SAITO ... Chess set, liquid smells, test tubes, boxed [$] 80 ...
Flux Fest Kit 2. [ca. December 1969].

COMMENTS: *The chess pieces are vials containing liquids with various smells. I believe all liquid* Smell Chess *sets distributed by Fluxus were made by the artist.* Spice Chess *is also a* Smell Chess *set, but through common usage the title of that work became standardized to* Spice Chess.

SMELL CHESS see:
SPICE CHESS

SOUND CHESS

Silverman No. < 378.III

"... Some new items are chess pieces ... by Takako Saito. Chess pieces are recognizable by their sound... I will mail you a sample..."
Letter: George Maciunas to Willem de Ridder, March 2, 1965.

FLUXUS a FLUXCHESS: pieces identified by sound or weight or smell etc....FLUXUS a3 sound chess, $40
Vacuum TRapEzoid (Fluxus Newspaper No. 5) March 1965.

... items are in stock, delivery within 2 weeks ... FLUXUS a FLUXCHESS: pieces identified by sound or weight or smell or time etc.... FLUXUS a3 sound chess, wood blocks $60 FLUXUS a4 sound chess, bells, $40
Vaseline sTREet (Fluxus Newspaper No. 8) May 1966.

FLUXSPORTS (or Fluxolympiad) all items will be brought over...Chess tournament...[with] bell set (different tuned bells for different pieces)...
Proposed Program for a Fluxfest in Prague, 1966.

PROPOSED FLUXOLYMPIAD ... BOARD GAMES: ...chess tournament with:...sound pieces, etc.
Fluxnewsletter, January 31, 1968.

[as above]
Fluxnewsletter, December 2, 1968.

PROPOSED FLUXSHOW FOR GALLERY 669 ...

BRAD IVERSON

Takako Saito. SOUND CHESS and WEIGHT CHESS contained in a drawer of FLUX CABINET. see color portfolio

SPORTS-GAME CENTER...chess sets with:...sound pieces, etc.
ibid.

FLUX-PRODUCTS 1961 TO 1969...TAKAKO SAIto Chess sets:...rattling wood blocks for pieces, conventional board [$] 60
Fluxnewsletter, December 2, 1968 (revised March 15, 1969).

PROPOSED FLUXSHOW... SPORTS-GAME-CENTER...Chess tournament with:...sound pieces...
ibid.

FLUX-OLYMPIAD ... DUAL CONTEST ... Board chess... sound pieces (Takako Saito)
Fluxfest at Stony brook, Newsletter No. 1, August 18, 1969. versions A and B

FLUX-PRODUCTS 1961 TO 1970...TAKAKO SAITO...Chess set sounding wood blocks [$] 100...
Flux Fest Kit 2. [ca. December 1969].

FLUX SHOW: DICE GAME ENVIRONMENT ENTIRE FLOOR AS DICE HAZARD TABLE DIE CUBES, 15" CUBES ON FLOOR, Marked on sides, top open or closed with clear plastic. Consisting or containing...sound,...chess sets.
ibid.

FLUX-OLYMPIAD...DUAL CONTEST - CHESS ... SOUND CHESS: rattling pieces (T. Saito)
ibid.

"...Incidentally, if you have her [Saito] sound chess,

2 copies please send one set back, I never intended to sell my only copy. That is the one that was sent to the unfortunate Cologne show..."
Letter: George Maciunas to Dr. Hanns Sohm, [ca. late 1972].

Sound chess by Takako Saito $100
[Fluxus price list for a customer]. January 7, 1976.

TAKAKO SAITO...Chess set, plastic sounding boxes, in wood box $120...
Flux Objects, Price List. May 1976.

"...I heard from Jean that you may be interested to take the Flux boxes for the $800 I owe you...I would suggest the following...Takako's sound chess - $100 (she is mailing for me a new batch, wood)..."
Letter: George Maciunas to Peter Frank, [ca. March 1977].

"Thanks for your letter. I will be in New York on June 6 & will mail you by air the hinges & hooks. Meanwhile I am rushing to write you that $70 per set is OK with me, but 60 sets is a lot for me to absorb in one year. Maybe 20 sound, and then 5 of each other. that would make 40 sets, but if you already started 60, then OK - do them...Be certain to pack them in a lot of newspapers and good, maybe double carton box. I always get boxes by post all torn up, because they are so weak...If possible I would like to have you make 20 or 25 sound chess and less of weight..."
Letter: George Maciunas to Takako Saito, May 30, 1977.

COMMENTS: *Various versions of* Sound Chess *were made, both by Takako Saito and by George Maciunas. Saito-made sets were crafted in sealed wooden boxes with subtle sounding objects hidden within. Maciunas was less of a crafts person and would use plastic with harsher or funnier sounding contents. The* Sound Chess *in* Flux Cabinet *assembled by Maciunas is combined with* Weight Chess. *See illustration.*

SOUNDING BELL CHAIR

PROPOSED FLUXSHOW FOR GALLERY 669 ... OBJECTS, FURNITURE ... music-chairs by Takako Saito (bell...)
Fluxnewsletter, December 2, 1968.

FLUX-PRODUCTS 1961 TO 1969...TAKAKO SAITO Music chairs: sounding bell,...each: [$] 60
Fluxnewsletter, December 2, 1968 (revised March 15, 1969).

FLUX-PRODUCTS 1961 TO 1970...TAKAKO SAITO...Musical chairs: sounding bell...each [$] 80
Flux Fest Kit 2. [ca. December 1969].

FLUX SHOW: DICE GAME ENVIRONMENT ENTIRE FLOOR AS DICE HAZARD TABLE DIE CUBES, 15" CUBES ON FLOOR, Marked on sides, top open or closed with clear plastic. Consisting or containing...Musical chair by Takako Saito (bells)
ibid.

FLUX-PRODUCTS 1961 TO 1970 ... SOLO OBJECTS AND PUBLICATIONS...TAKAKO SAITO... Musical chairs, sounding bell...[$] 100
[Fluxus price list for a customer]. September 1975.

TAKAKO SAITO...Musical chairs, bell,...ea: $100...
Flux Objects, Price List. May 1976.

COMMENTS: *Indications are that this chair was made by Fluxus, however, I have never seen one. It would function in a similar way to other Musical Chairs or Event Chairs. A bell hidden inside would be activated when the chair was sat upon.*

SPICE CHESS
Silverman No. < 378.IV

FLUXUS a FLUXCHESS: pieces identified by sound or weight or smell etc....FLUXUS a2 smell chess, spices $30
Vacuum TRapEzoid (Fluxus Newspaper No. 5) March 1965.

... items are in stock, delivery within 2 weeks ... FLUXUS a FLUXCHESS pieces identified by sound or weight or smell or time etc. ... FLUXUS a2 smell chess, spices $40
Vaseline sTREet (Fluxus Newspaper No. 8) May 1966.

FLUXSPORTS (or Fluxolympiad) All items will be brought over...Chess tournament with spice set (pieces recognized by smell only)...
Proposed Program for a Fluxfest in Prague, 1966.

$40 flux chess (spices) by George Maciunas
Fluxshopnews. [Spring 1967].

"I got hold of a few $ & shipped out by REA a package to you: with:...1 - chess-spice set..."
Letter: George Maciunas to Ken Friedman, [ca. February 1967].

SPICE FLUXCHESS
WHITE
P - CINNAMON
R - NUTMEG
N - GINGER
B - CLOVE
K - CARDAMON
Q - ANISE
BLACK
P - BLACK PEPPER
R - COREANDER
N - TUMERIC
B - CUMMIN SEED
K - ASAFOETIDA
Q - CAEN PEPPER

Takako Saito. SPICE CHESS. Identification of pieces

FLUX-PRODUCTS 1961 TO 1969...TAKAKO SAI-
TO Chess sets: spices in test tubes for pieces in hard-
wood case [$] 60
Fluxnewsletter, December 2, 1968 (revised March 15, 1969).

FLUX-PRODUCTS 1961 TO 1970...TAKAKO SAI-
TO Chess set spices in test tubes, wood box [$] 60...
Flux Fest Kit 2. [ca. December 1969].

FLUX SHOW: DICE GAME ENVIRONMENT EN-
TIRE FLOOR AS DICE HAZARD TABLE DIE
CUBES, 15'' CUBES ON FLOOR, Marked on sides,
top open or closed with clear plastic. Consisting or
containing...Spice,...chess sets.
ibid.

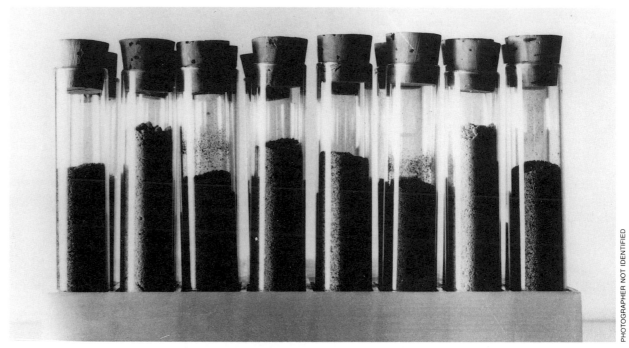

Takako Saito. SPICE CHESS photographed in 1966 for Fluxus Newspaper No. 8

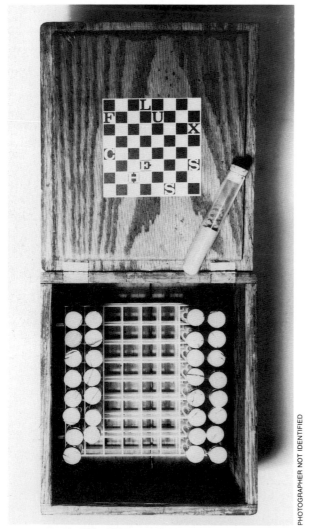

Takako Saito. SPICE CHESS photographed in 1966 for Fluxus
Newspaper No. 8

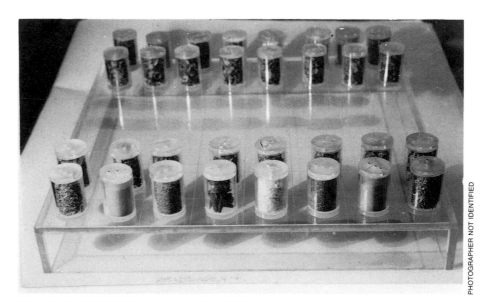

Takako Saito. SPICE CHESS photographed ca. 1966

FLUX-OLYMPIAD...DUAL CONTEST - CHESS ...
SMELL CHESS: spices (Takako Saito)
ibid.

FLUXUS-EDITIONEN ... [Catalogue No.] 774

TAKAKO SAITO: chess set spices in test tubes, wood
box
Happening & Fluxus. Koelnischer Kunstverein, 1970.

FLUX-PRODUCTS 1961 TO 1970 ... SOLO OB-

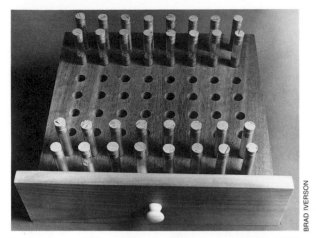

Takako Saito. SPICE CHESS contained in a drawer of FLUX CABINET

BRAD IVERSON

JECTS AND PUBLICATIONS...TAKAKO SAITO Chess set spices in test tubes, wood box [$] 100
[Fluxus price list for a customer]. September 1975.

Spice chess by Takako Saito $100
[Fluxus price list for a customer]. January 7, 1976.

TAKAKO SAITO Chess set, spices in test tubes, wood box $120...
Flux Objects, Price List. May 1976.

a CHESS game is played with a set made of SPICES in test tubes. T.S.
Fluxfest 77 at and/or, Seattle. September 1977.

COMMENTS: Spice Chess *is a type of* Smell Chess. *The title of the work was originally* Smell Chess, Spices. *Through common usage the title became shortened. George Maciunas was very fond of this work, and even took credit for it on occasion. The value of the pieces is determined by the smell (as well as color and textures) of their contents.*

SQUIRTING WATER CHAIR

"I don't know whether I mentioned our involvement now in making furniture - mostly utilizing 15" wood cubes as...'musical chairs' (sitter activates some event inside the chair, like...squirting water...)."
Letter: George Maciunas to Paul Sharits, [ca. April 6, 1966].

FLUX-PRODUCTS 1961 TO 1969...TAKAKO SAITO...Music chairs:... squirting water etc. each [$] 60
Fluxnewsletter, December 2, 1968 (revised March 15, 1969).

FLUX-PRODUCTS 1961 TO 1970...TAKAKO SAITO ... Musical chairs ... squirting water, etc. each [$] 80
Flux Fest Kit 2. [ca. December 1969].

FLUX-PRODUCTS 1961 TO 1970 ... SOLO OBJECTS AND PUBLICATIONS...TAKAKO SAITO...

Musical chairs...squirting water...[$] 100
[Fluxus price list for a customer]. September 1975.

COMMENTS: Squirting Water Chair *seems most like an* Event Chair. *I have never seen a Fluxus produced example.*

WEIGHT CHESS
Silverman No. < 378.V

"...Some new items are Chess pieces...by Takako Saito. Chess pieces are recognizable by their...weight ...I will mail you a sample..."
Letter: George Maciunas to Willem de Ridder, March 2, 1965.

FLUXUS a FLUXCHESS: pieces identified by sound or weight or smell etc....FLUXUS a4 weight chess, board as scale $60
Vacuum TRapEzoid (Fluxus Newspaper No. 5) March 1965.

... items are in stock, delivery within 2 weeks ... FLUXUS a FLUXCHESS: pieces identified by sound or weight or smell or time etc....FLUXUS a5 weight chess, board made up of 64 scales, $100
Vaseline sTREet (Fluxus Newspaper No. 8) May 1966.

FLUX-PRODUCTS 1961 TO 1969...TAKAKO SAITO Chess sets:...pieces of various weights on board made from 64 scales [$] 200
Fluxnewsletter, December 2, 1968 (revised March 15, 1969).

PROPOSED FLUXSHOW ... SPORTS - GAME CENTER...Chess tournament with:...weight pieces...
ibid.

"Thanks for your letter. I will be in New York on June 6 & will mail you by air the hinges & hooks. Meanwhile I am rushing to write you that $70 per set is OK with me, but 60 sets is a lot for me to absorb in one year. Maybe 20 sound, and then 5 of each other. that would make 40 sets, but if you already started 60, then OK - do them...Be certain to pack them in a lot of newspapers and good, maybe double carton box. I always get boxes by post all torn up, because they are so weak...If possible I would like to have you make 20 or 25 sound chess and less of weight..."
Letter: George Maciunas to Takako Saito, May 30, 1977.

COMMENTS: Weight Chess *is similar to* Sound Chess *in that the sealed pieces contain different hidden weights, and the players must judge the value of the pieces by some other means than sight. In the* Flux Cabinet *that George Maciunas assembled in 1977, he combined the two chess concepts into one set.*

ED SANDERS

It was announced in the Brochure Prospectus version B, that Ed Sanders would contribute "Prayer-wheel & vision" to FLUXUS 1 U.S. YEARBOX.
see: COLLECTIVE

PIERRE SCHAEFFER

It was announced in the tentative plans for the first issues of FLUXUS *that P. Schaeffer would initially edit, then was being consulted on "Anthology of Musique Concrete: Scheffer [sic], Henry, Arthuy, Philippot, Ferrari, Mache, Xenakis, Boucourechliev, Vandelle, Chamass, Sauguet, Barraque ... (essay & record)" for* FLUXUS NO. 5 WEST EUROPEAN YEARBOOK II.
see: COLLECTIVE

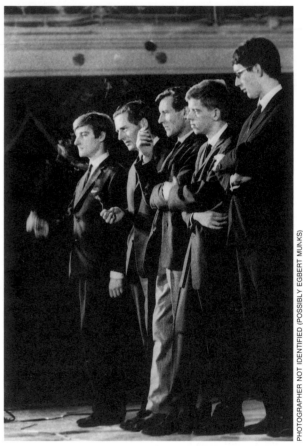

PHOTOGRAPHER NOT IDENTIFIED (POSSIBLY EGBERT MULKS)

Wim T. Schippers, far left, performing his "Niet Roken, Niet Eten, Roken, Eten" (No Smoking, No Eating, Smoking, Eating) during the Flux-Festival in the Kurzaal, Scheveningen, the Netherlands, November 13, 1964. Left to right: Schippers, unidentified, Arthur Koepcke, Eric Andersen, Martin van Duynhoven

WIM T. SCHIPPERS

SALT

26 WIM T SCHIPPERS salt $3 per pound
European Mail-Orderhouse: europeanfluxshop, Pricelist. [ca. June 1964].

26 WIM T SCHIPPERS salt per pound $3 per pound
$5 per pound $9
Second Pricelist - European Mail-Orderhouse. [Fall 1964].

FLUXUSy WIM T SCHIPPERS, salt, per pound $3
Vacuum TRapEzoid (Fluxus Newspaper No. 5) March 1965.

*COMMENTS: Wim T. Schippers was active with Willem
De Ridder in the Holland Fluxus and related events starting in
1963. Schippers used salt as a primary element in an installa-
tion at the Fodor Museum, Amsterdam, December 7, 1962 -
January 7, 1963. George Maciunas designed a monogram card
for Schippers. However, I have found no evidence that he
packaged Salt as a Fluxus Edition.*

TOMAS SCHMIT

*It was announced in the Brochure Prospectus, version B, that
Tomas Schmit would contribute "Action music" and "audi-
ence compositions" to FLUXUS NO. 3 GERMAN & SCAN-
DINAVIAN YEARBOX.*

*"Piano Piece for George Maciunas No. 1," "Sanitas 79," and
"Sanitas 196," together with photographs of* Poem V, Poem
VI, Poem VII *and* Poem VIII *and instructions for their use,
are published in* Fluxus Preview Review.

*"Sanitas 2," "Sanitas 13," "Sanitas 22," "Sanitas 35," "Sani-
tas 107," "Sanitas 165," "Zyklus for Water Pails" and "Floor
and Foot Theatre," a group of performance scores, appear in*
FLUXUS 1 *(Silverman No. 117).*

*There are two fragments of blueprint scores by Tomas
Schmit, dated 1962, in the Silverman Collection. The typing
and printing of these sheets are consistent with other Fluxus
scores from the same period. However, if a Fluxus copyright
ever existed on the sheets, it has since been cut off. These
two sheets contain:*
 "from: Sanitas 2; 35; 165"
 "from 3 piano pieces for GM [no.] 1"
 *"Zyklus for water-pails (or beer bottles or wine bottles
 etc.)"*
 "Piece for Piano and Voice"

*An interpretation of Schmit's "Poeme serielle" was repro-
duced in Fluxus Newspaper No. 1 and several of his perfor-
mance scores were reproduced in both* Fluxfest Sale *and* Flux
Fest Kit 2.

BOMB

FURTHER PROPOSALS FOR N.Y.C. FLUXUS
FROM TOMAS SCHMIT...On the day of the opening
concert call all museums, theaters, concert halls etc.,
by phone, anonymously, saying: "there is a time-bomb
in your facility!" Little packages, well hidden & con-
taining a card inscribed "bomb" should be deposited
in these locations. - in this way all museums, theatres,
halls, etc, would be closed for the evening, the anni-

Tomas Schmit, standing with left to right, Marcel Broodthaers, Arthur Koepcke and Robert Filliou. Antwerp, 1969

MARIA GILISSEN

versary of which would be celebrated as Fluxus day
through the coming years.
Fluxus Newsletter No. 7, May 1, 1963.

*COMMENTS: This Provo-like work, proposed in the spirit of
Dada and the anti-art tradition, was not realized.*

COMPLETE WORKS

"...past & future works published under one cover or
in box - a kind of special fluxus editions...sold separ-
ately or as part of fluxus yearbox. I am going to pub-
lish such special Fluxus editions containing complete
works of:...Tomas Schmit...This could result in a
nice & extensive library - or encyclopedia of good
works being done these days. A kind of Shosoin ware-
house of today..."
Letter: George Maciunas to Robert Watts, [December 1962].

"...1. Could you send me all your works (they do not
have to be in english translations): the complete Sa-
nitas, etc. etc. OK?
2. Would you be interested to offer me exclusive rights
to publish your works (which may mean all your
works, if the rest of Sanitas is as good as other things
you sent me). I have similar arrangement with Ben
Patterson, Filliou, George Brecht, Robert Watts,
La Monte Young. (the kind of arrangement Cage has
with Peters editions). The advantage of such arrange-
ment is that such works can be combined with fluxus
year-boxes (them being boxes), or sold separately, or
parts combined with fluxus. The works will be copy-
righted when published, which means their perfor-
mances will be controlled by yourself through fluxus,
and indiscriminate copy prohibited. Besides Paik and
Filliou, you are the only European (Paik is not Euro-
pean anyway) whom I offered such arrangement,
because I think, next after Paik and possibly Norden-
stroem you are the best European composer of events

& action music. My one condition however (like that of any other serious publisher) is that once you agree or decide to offer your works for publication and they are accepted, they can not be offered to and published by any other publisher. This is necessary to protect my investment in printing and distribution. I lost a few hundred marks already, by printing Ligeti & Flynt and then eliminating the works because of Vostells fast dealings. Since fluxus will be copyrighted as a whole I can not legally include materials that already appeared in print. Such "preview" type appearance of fluxus materials in other publications like Decollage is therefore very harmful to me financially and I must insist thus on "conventional" publishers conditions. OK? If you offer to me exclusive rights to publish your works, I am bound of course to publish all that you submit (once I agree initially) just as you are bound to submit the works to no one else but me (once you agree initially) it is a sort of "Faust" arrangement. Let me know your thoughts on this. I will hold on printing the things you sent me until I hear from you..."
Letter: George Maciunas to Tomas Schmit, [end of December 1962 or early January 1963].

"...Thanks for your compositions & letter. Very good compositions. The matter on the back[*] should clarify the question you had re: having not enough to publish. I can print now whatever you desire and then keep adding sheets or cards (if each composition is on a separate card) as you produce new works. OK? So send me whatever you desire to publish. I am typing all the things you send so far. Please send english translations of all works. I will print original german text on one side of the card and english translation on the other side. Do not worry about having the english text absolutely correct. I will correct it if it needs any correction. OK? The reason I am offering exclusive arrangement to you is that from the things you did so far I can see you will be doing very nice work in future. Having them published & circulated will give fresh impetus for your efforts & still better results - SO KEEP WORKING. I will copyright all works, so that you will be protected against unauthorized use of them. Any performance of them should bring royalties to you. Tell Paik not to send your pieces to anyone else until they are published & distributed...."
[*Fluxus Newsletter No. 5, January 1, 1963].
Letter: George Maciunas to Tomas Schmit, [January 1963].

"...Then when I get to N.Y. could do...Tomas Schmit..."
Letter: George Maciunas to Robert Watts, [ca. April 1963].

"...Dec. to March - we should print lots of materials in Dick's shop. (...your own...)"
Letter: George Maciunas to Tomas Schmit, [before June 8, 1963].

"... Take to Amsterdam ... All your things —...items for your compositions..."
Letter: George Maciunas to Tomas Schmit, [early June 1963].

FLUXUS SPECIAL EDITIONS 1963-4...FLUXUS I. TOMAS SCHMIT: COMPLETE WORKS (incl. 1963)- works from 1964 - by subscription
Fluxus Preview Review, [ca. July] 1963.

[as above]
Daniel Spoerri, L'Optique Moderne. List on editorial page. 1963.

[as above]
La Monte Young, LY 1961. Advertisement page. [1963].

COMMENTS: *Tomas Schmit's* Complete Works *were never published by Fluxus. The work was planned as an expandable box containing Schmit's scores and poems, packaged similarly to the productions of Brecht, Watts and Shiomi. In 1978, the Koelnischer Kunstverein published a volume of Schmit's Collected Works.*

DANGER MUSIC BY DICK HIGGINS LABEL

FURTHER PROPOSALS FOR N.Y.C. FLUXUS FROM TOMAS SCHMIT...Attach or paste cards to buildings, automobiles, trees etc, saying for instance ..."this is a danger music by Dick Higgins"...etc,etc...
Fluxus Newsletter No. 7, May 1, 1963.

"... NOW THE FESTIVAL: (Amsterdam one)... Included in "Festum Fluxorum...Program I suggest as follows: ... Street compositions ... Tomas Schmit — Street ready-mades (cards on autos, buildings)..."
Letter: George Maciunas to Tomas Schmit, [early June 1963].

COMMENTS: *This papillon was never made. A similar application was done by George Maciunas, using event cards from George Brecht's* Water Yam, *at the Fluxus exhibition in the kitchen of Galerie Parnass in Wuppertal, during Nam June Paik's "Exposition of Music Electronic Television," March 11 to 20, 1963.*

EMMETT WILLIAMS

FURTHER PROPOSALS FOR N.Y.C. FLUXUS FROM TOMAS SCHMIT...Change names & titles on concert posters etc., for instance..."today in town hall — Quintet in G major by (Emmett Williams)" ... etc. etc. This change can be affected by pasting preprinted labels....
Fluxus Newsletter No. 7, May 1, 1963.

"... NOW THE FESTIVAL: (Amsterdam one)...Included in "Festum Fluxorum"...Program I suggest as follows: ... Street compositions...Tomas Schmit ...

Street montage (revising existing posters etc.)..."
Letter: George Maciunas to Tomas Schmit, [early June 1963].

COMMENTS: Emmett Williams *alteration was never printed.*

FLUXUS

FURTHER PROPOSALS FOR N.Y.C. FLUXUS FROM TOMAS SCHMIT...Change names & titles on concert posters etc., for instance..."today in Metropolitan Opera — (FLUXUS) by R. Wagner" etc. etc. This change can be affected by pasting preprinted labels....
Fluxus Newsletter No. 7, May 1, 1963.

"... NOW THE FESTIVAL: (Amsterdam one)... Included in "Festum Fluxorum"...Program I suggest as follows: ... Street compositions ... Tomas Schmit ... Street montage (revising existing posters etc.)..."
Letter: George Maciunas to Tomas Schmit, [early June 1963].

COMMENTS: Fluxus *alteration was never printed.*

LABELS see:
DANGER MUSIC BY DICK HIGGINS LABEL
EMMETT WILLIAMS
FLUXUS
POEM BY TOMAS SCHMIT LABEL

ONE WAY TRIP TO WHARTON TRACT, N.J.

FLUXFEST PRESENTATION OF JOHN LENNON & YOKO ONO +* AT 80 WOOSTER ST. NEW YORK --1970...APR. 18-24: TICKETS BY JOHN LENNON + FLUXTOURS...One way trip to Wharton Tract, N.J. (Tomas Schmit) out 8hrs. by foot...
all photographs copyright nineteen seVenty by peTer mooRE (Fluxus Newspaper No. 9) 1970.

COMMENTS: *A ready-made, this ticket was a planned realization of Tomas Schmit's "Sanitas No. 79."*

POEM

"...Paik has exhibit for next 2 weeks at Wuppertal where I was yesterday - I got one room for Fluxus... In that room I also set...various 'poems' of Tomas Schmit...we thought in future to integrate our festivals with these 'exhibits'..."
Letter: George Maciunas to Robert Watts, [March 11 or 12, 1963].

"...I will print foto of a poem of yours, so write titles of them all, so I can choose OK? This prospectus should be good enough to sell for 25¢ or so. Like min-

iature fluxus magazine...."
Letter: George Maciunas to Tomas Schmit, May 26, 1963.

"...Take to Amsterdam...All your things - poems..."
Letter: George Maciunas to Tomas Schmit, [early June 1963].

"...NOW THE FESTIVAL: (Amsterdam one)....Exhibits. Tomas Schmit - poems..."
Letter: George Maciunas to Tomas Schmit, [early June 1963].

"...When you go to Amsterdam VERY IMPORTANT -see if you can arrange maybe a one concert festival in that gallery or somewhere...you bring your poems..."
Letter: George Maciunas to Tomas Schmit, [mid June 1963].

"...Get here as soon as you can. Bring with you:... your poems..."
Letter: George Maciunas to Tomas Schmit, October 21, 1963.

FLUX OBJECTS: 1963...TOMAS SCHMIT: poems (obj. in water)
George Maciunas, Diagram of Historical Developments of Fluxus... [1973].

COMMENTS: *Manfred Leve's photograph of the Fluxus exhibition in the kitchen of Galerie Parnass, Wuppertal, during Paik's "Exposition of Music Electronic Television," March 11-20, 1963, shows four of Tomas Schmit's* Poems. *It is not possible to see whether these are the same four* Poems *which are illustrated in* Fluxus Preview Review.

POEM BY TOMAS SCHMIT LABEL

FURTHER PROPOSAL FOR N.Y.C. FLUXUS FROM TOMAS SCHMIT...Attach or paste cards to buildings, automobiles, trees etc, saying for instance ..."poem by Tomas Schmit" etc. etc....
Fluxus Newsletter No. 7, May 1, 1963.

"... NOW THE FESTIVAL: (Amsterdam one) ... Included in "Festum Fluxorum...Program I suggest as follows: ... Street compositions ... Tomas Schmit ... Street ready-mades (cards on autos, buildings)..."
Letter: George Maciunas to Tomas Schmit, [early June 1963].

COMMENTS: *This application is not known to have been made by Fluxus.*

POEM V

[illustration] Poem V..."shake well before reading!", feb 63
Fluxus Preview Review, [ca. July] 1963.

COMMENTS: *This unique Fluxus work was constructed by the artist in February, 1963, and was reproduced in* Fluxus Preview Review. *During this period, George Maciunas was just beginning the production of Fluxus Editions, and was still either encouraging artists to make the works for Fluxus, or providing raw materials, such as peanutbutter jars, for them.*

POEM VI

"...Photos of all your poems came out VERY WELL! ...So I will have both poems printed VI & VII in newspaper-preview-prospectus. You need more jars? I will send 2 more in same series + a spray for text...."
Letter: George Maciunas to Tomas Schmit, [mid June 1963].

[illustration] Poem VI..."shake well before reading!", feb. 63
Fluxus Preview Review, [ca. July] 1963.

COMMENTS: *This unique Fluxus work was reproduced in* Fluxus Preview Review. *It is now in the Archiv Sohm at the Staatsgalerie Stuttgart.*

POEM VII

"...Photos of all your poems came out VERY WELL! even poem VII which was difficult to photograph. So I will have both poems printed VI & VII in newspaper-preview-prospectus. You need more jars? I will send 2 more in same series + a spray for text..."
Letter: George Maciunas to Tomas Schmit, [mid June 1963].

[illustration] Poem VII..."shake well before reading!", feb. 63
Fluxus Preview Review, [ca. July] 1963.

COMMENTS: *Poem VII was reproduced in* Fluxus Preview Review. *It is now lost.*

POEM VIII

[illustration] Poem VIII..."Shake well before reading!", feb. 63
Fluxus Preview Review, [ca. July] 1963.

COMMENTS: *Poem VIII was reproduced in* Fluxus Preview Review.

POSTERS see:
TODAY IS NO DAY!
TOMORROW WILL BE FLUXUS DAY!

poem V poem VI poem VII poem VIII
"shake well before reading! ", feb 63

GEORGE MACIUNAS

Tomas Schmit. Four POEMS reproduced in FLUXUS PREVIEW REVIEW

SANITAS NO. 79 see:
ONE WAY TRIP TO WHARTON TRACT, N.J.

SHAKE WELL BEFORE READING see:
POEM V
POEM VI
POEM VII
POEM VIII

STICK-ONS see:
LABELS

TICKET see:
ONE WAY TRIP TO WHARTON TRACT, N.J.

TODAY IS NO DAY!

FURTHER PROPOSALS FOR N.Y.C. FLUXUS FROM TOMAS SCHMIT ... On the day before the festival post an immense number of posters inscribed: "today is no day! tomorrow will be the fifth of November! (if concert is to start on 5th)...
Fluxus Newsletter No. 7, May 1, 1963.

COMMENTS: *Today Is No Day was never produced by Fluxus.*

TOMORROW WILL BE FLUXUS DAY!

FURTHER PROPOSALS FOR N.Y.C. FLUXUS. FROM TOMAS SCHMIT ... On the day before the festival post an immense number of posters inscribed: ...or "tomorrow will be FLUXUS day!"
Fluxus Newsletter No. 7, May 1, 1963.

COMMENTS: *Although this poster work was never produced, it clearly led to Alison Knowles' "Fluxus Comes to New York" (Silverman No. < 634.1, reproduced in* Fluxus Etc., *Addenda I, p. 120), which Knowles stenciled on newspapers, sidewalks, Fluxus publications, etc., in preparation for "Fully Guaranteed 12 Fluxus Concerts" in New York, March to May, 1964. See also Anonymous:* Prepared Newspapers.

WORKS 1964 - BY SUBSCRIPTION see:
COMPLETE WORKS

DIETER SCHNEBEL

It was announced in the Brochure Prospectus, version A, that Dieter Schnebel was being consulted for FLUXUS NO. 2 GERMAN & SCANDINAVIAN YEARBOX.
see: COLLECTIVE

GLOSSOLALIE

Scores available by special order:...Dieter Schnebel: Glossolalie (Musik fuer Sprecher und Instrumentalisten), 16 large pages $5...
Fluxus Preview Review, [ca. July] 1963.

COMMENTS: *I have not seen this work and do not know whether it was produced as a Fluxus Edition or not.*

REACTIONS

Silverman No. > 385.301, ff.

Scores available by special order:...Dieter Schnebel: ...Reactions (Konzert fuer einen Instrumentalisten & Publikum), large sheet & instructions $1...
Fluxus Preview Review, [ca. July] 1963.

COMMENTS: *This score with instruction sheet is printed both by blueprint negative and blueprint positive. The examples in the Silverman Collection do not have the Fluxus copyright on them. The work is part of the early Fluxus publishing activity and had only limited distribution.*

VISIBLE MUSIC I

Scores available by special order:...Dieter Schnebel: ...Visible Music I (Fuer 1 Dirigenten und 1 Instrumentalisten), large sheet & instructions $1...
Fluxus Preview Review, [ca. July] 1963.

COMMENTS: *I have not seen this work and do not know whether it was produced as a Fluxus Edition or not.*

VISIBLE MUSIC II

Silverman No. > 385.302

Scores available by special order:...Dieter Schnebel: ...Visible Music II (Solo fuer einen Dirigenten) 2 large sheets & instructions $2
Fluxus Preview Review, [ca. July] 1963.

COMMENTS: *In the example of this work in the Silverman Collection, the instructions are printed blueprint positive and the score blueprint negative. None of the sheets have the Fluxus copyright.*

KURT SCHWERTSIK

It was announced in the Brochure Prospectus, version A, that Schwertzik [sic] would make a contribution "to be determined" to FLUXUS NO. 6 ITALIAN, ENGLISH, AUSTRIAN YEARBOX.
see: COLLECTIVE

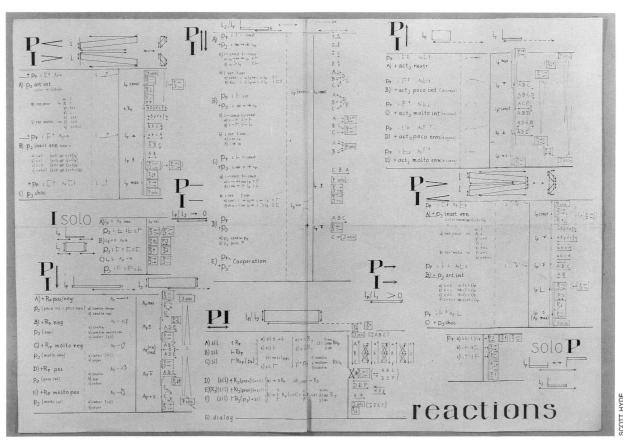

Dieter Schnebel. REACTIONS. Score

Dieter Schnebel. VISIBLE MUSIC II. Instructions

KURT SCHWITTERS

It was announced in the tentative plans for the first issues of FLUXUS that "a Theatre piece" by Kurt Schwitters would be included in FLUXUS NO. 7 HOMAGE TO DADA.
see: COLLECTIVE

SARA SEAGULL

PLATFORM SHOES

...FEB. 17, 1970: FLUX-SPORTS AT DOUGLASS COLLEGE...race with platform shoes of different heights (Sara Seagull)
all photographs copyright nineteen seVenty by peTer mooRE (Fluxus Newspaper No. 9) 1970.

COMMENTS: These shoes were made for the "Flux-Sports" events at Douglass College, New Brunswick, New Jersey, February 17, 1970. George Maciunas' Shoe Steps, made for the Fluxlabyrinth in Berlin in 1976, have a curious conceptual relationship to Seagull's work.

Greg Sharits with Paul Sharits' son, Christopher, ca. 1967

Sara Seagull, 1974

GREG SHARITS

BAG TRICK
Silverman No. 386

COMMENTS: Bag Trick is a component of the Collective Flux Paper Games: Rolls and Folds and was not distributed separately. The work was printed and designed by Paul Sharits and David Thompson [Davi Det Hompson] and assembled either by them or Greg Sharits. Finished Bag Tricks were then given to Maciunas for inclusion in the collective work, and distribution by Fluxus.

Greg Sharits. BAG TRICK

FILM PROJECTS

FLUX-PRODUCTS PLANNED FOR 1967 ... Greg Sharits:...film projects.
Fluxnewsletter, March 8, 1967.

COMMENTS: Film Projects by Greg Sharits were not produced by Fluxus.

FLUX PAPER GAMES: ROLLS AND FOLDS see:
Collective

ROLL FOLD
Silverman No. 387

COMMENTS: Roll Fold is a component of the Collective Flux Paper Games: Rolls and Folds. Like Bag Trick, it was given to Maciunas already assembled for inclusion in the collective work. Roll Fold was not distributed by Fluxus as a separate work.

Greg Sharits. ROLL FOLD

SCOTT HYDE

Greg Sharits. ROLL TRICK

SCOTT HYDE

ROLL TRICK
Silverman No. 388

COMMENTS: Roll Trick *is a component of the Collective* Flux Paper Games: Rolls and Folds. *It was designed and printed by Paul Sharits and David Thompson [Davi Det Hompson] and assembled either by them or Greg Sharits. Completed pieces were then given to George Maciunas for inclusion in the collective work.* Roll Trick *was not distributed by Fluxus as an individual work.*

SYNTHETIC FLUX-FOOD see:
John Chick

PAUL SHARITS

ADHESIVE TOILET SEAT

PROPOSED FLUXSHOW FOR GALLERY 669 ... TOILET OBJECTS...toilet seat covered with pressure sensitive adhesive (or double faced adhesive tape) ...
Fluxnewsletter, December 2, 1968.

PROPOSED FLUXSHOW...TOILET OBJECTS...toilet seat variations: covered with double face adhesive tape...
Fluxnewsletter, December 2, 1968 (revised March 15, 1969).

TOILET OBJECTS & ENVIRONMENT...Toilet seat variations: double faced adhesive tape cover...
Flux Fest Kit 2. [ca. December 1969].

Toilet No. 2, Paul Sharits: ... Toilet seat: Adhesive — covered daily with double-face adhesive tape)
Fluxnewsletter, April 1973.

1970-1971 FLUX-TOILET: ... SHARITS: adhesive toilet seat,...
George Maciunas, Diagram of Historical Developments of Fluxus... [1973].

COMMENTS: *In June 1968, Paul Sharits made two non-Fluxus sculptures which were modified household appliances called* Flux Toilet I *and* Flux Toilet II. *The proposed* Adhesive Toilet Seat, *originally intended for a Flux show in a Los Angeles gallery, was presented as an anonymous work. Sharits had an interest in adhesives, going back to the first work he sent to Maciunas in 1966, a pull apart bookwork later titled* Flux Music. *That work may have influenced George Maciunas'* Adhesive Net, *also made in 1966.*

PHOTOGRAPHER NOT IDENTIFIED

Ira Newman, Paul Sharits and Jane Kemp, Summer, 1969

ARTIST'S INSPIRATION see:
Jack Coke's Farmer's Co-op

AUTOPSY
Silverman No. 390

FLUX-PROJECTS PLANNED FOR 1967 ... Paul
Sharits:...Fluxcomic (autopsy),...
Fluxnewsletter, March 8, 1967.

COMMENTS: *This book was designed and printed by the
artist. There is no evidence that Maciunas actively distributed
the work as a Fluxus Edition.*

BLACK PIN BOX see:
Jack Coke's Farmer's Co-op
BOOKS see:
AUTOPSY
OPEN THE DOOR

DOOR OPENING DOOR

Toilet No. 2, Paul Sharits: Doors - method of opening
...only small door with handle on outside - large door
with handle on inside. Access via small door with arm
to open door from inside.
Fluxnewsletter, April 1973.

COMMENTS: *Door Opening Door originally appears as an
anonymous Small Door in Door in the 1970 maze, "Portrait
of John Lennon as a Young Cloud." This idea develops into a
functional door of George Maciunas' for the exit of Fluxlaby-
rinth in 1976. So, although Door Opening Door appears in
the plan for Paul Sharits' Flux Toilet, I believe it could really
be an idea of Maciunas'.*

DOORS see:
DOOR OPENING DOOR
FLUXCLOCK DOOR DISPLAY
PAPER ACCORDION SOUND DOOR

DOTS 1 & 3
Silverman No. > 390.II, ff. and > 390.III, ff.

"...The film loops are also close to our own work. In
fact we were experimenting with Artype screens (dots,
parallel lines, single dots) applied directly to clear film
(no camera used). Then a pos. or neg. print projected.
(Artype will not stand the heat etc. of projector.) So
we got very similar optical effects like your dots. We
found that parallel lines for instance of certain densi-
ty have a nice way of moving up & up when projected.
(this artype, we apply irrespective of frames, so vari-
ous optical things happen, when lines or dots of dif-
ferent densities are projected as movies....''
Letter: George Maciunas to Paul Sharits, June 29, 1966.

FLUXFILMS SHORT VERSION, 40 MIN AT 24
FRAMES/SEC. 1400 FT. ... flux-number 27 Paul
Sharits DOTS 1 & 3 2' Single frame exposures of
dot-screens
Fluxfilms catalogue. [ca. 1966].

PAST FLUX-PROJECTS (realized in 1966)...Flux -
films: total package: 1 hr. 40 min...[including] dotts
[sic],...(3 loop films) by Paul Sharits,...
Fluxnewsletter, March 8, 1967.

"...Film Coop sent a travelling film library to Europe,
in which was included a re-edited Fluxfilm package -
1200ft version has all the best material including your
4 loop films (Dots...)...I am finally doing the 8 mm
print of that 1200 ft. Fluxfilm version. It will be good
for straight viewing or loop viewing, some 40 loops
that could do a nice Flux-wall paper event, (for in-
stance all dotted wall)....''
Letter: George Maciunas to Paul Sharits, June 21, 1967.

FLUX-PRODUCTS 1961 TO 1969...FLUXFILMS.
short version Summer 1966 40 min. 1400ft....[includ-
ing] Dots by Paul Sharits,...16mm [$] 400 8mm [$] 50
Fluxnewsletter, December 2, 1968 (revised March 15, 1969).

"...Regarding Capsule. It will be a suspended 3 x 3 x 3
booth with translucent panels, so we can project on
all 4 sides, top & bottom. Get all kinds of effects. I
thought projecting your dots...separately of course...''
Letter: George Maciunas to Paul Sharits, [ca. April 1970].

MAY 16-22: CAPSULE BY JOHN & YOKO + FLUX
SPACE CENTER A 3ft cube enclosure (capsule) hav-
ing various film loops projected on its walls, ceiling
and floor to a single viewer inside, total time: 6 min.
[including] transition from small to large screens....
*Schedule of events for Fluxfest presentation of John Lennon
and Yoko Ono. [ca. April 1970]. version A*

MAY 16-22: CAPSULE BY JOHN & YOKO + FLUX
SPACE CENTER ($1 ADMISSION CHARGE) ... [as
above] about 8 minutes...[including] transition from
small to large screens...by Paul Sharits, 1966...
*Schedule of events for Fluxfest presentation of John Lennon
and Yoko Ono. [ca. April 1970]. version B*

MAY 16-22 CAPSULE BY YOKO + FLUX SPACE
CENTER ... [including] ... screen transition, ... (Paul
Sharits);...
*Schedule of events for Fluxfest presentation of John Lennon
and Yoko Ono. April 1, 1970. version C*

FLUXFEST PRESENTATION OF JOHN LENNON
& YOKO ONO +* AT 80 WOOSTER ST. NEW YORK
—1970...MAY 16-22: CAPSULE BY JOHN & YOKO
+ FLUX SPACE CENTER A 6x6 ft enclosure having
various films projected on its walls to a single viewer
inside. ... transition from small to large dot-screens

(Paul Sharits '66)...
*all photographs copyright nineteen seVenty by peTer mooRE
(Fluxus Newspaper No. 9) 1970.*

SLIDE & FILM FLUXSHOW ...PAUL SHARITS: ...
DOTS 1 & 3 Single frame exposures of dot-screens...
Flux Fest Kit 2. [ca. December 1969].

FLUX-PRODUCTS 1961 TO 1970... FLUXFILMS.
short version. Summer 1966. 40min. 1400ft: ... [in-
cluding] Dots ... by Paul Sharits, ... 16mm version
$180 8mm version $50
ibid.

1965...FLUXFILMS:...PAUL SHARITS:...dotts
[sic]
*George Maciunas, Diagram of Historical Developments of
Fluxus... [1973].*

11.04-29.05.1970 FLUX FEST OF JOHN LENNON
& YOKO ONO...16-22.05: FILM ENVIRONMENT
4 wall projection of dots...by sharits,...etc.
ibid.

COMMENTS: *Paul Sharits' Dots 1 & 3 are filmed dots, opti-
cally sequencing into patterns, which differ from George
Maciunas' Artype where commercial "Artype" patterns were
applied directly to film, making a progression of images.*

EXPLODING BALLOON BOX see:
Jack Coke's Farmer's Co-op

FAUCET FLUSHES TOILET NO. 5

Toilet No. 2, Paul Sharits: ... Sink faucet ... faucet
flushes toilet no. 5
Fluxnewsletter, April 1973.

COMMENTS: *Although the idea for a prepared Flux Toilet
appears to have originated with Paul Sharits in 1968, I think
this particular work is one of Maciunas' trickster pranks.*

FILM

"...We distribute however only Fluxus publications.
But we would like to publish any future work of yours
(printed matter or production of objects) and would
like to offer you participation in our yearbox which
contains 8 mm 2ft film loops, with film viewer,...''
Letter: George Maciunas to Paul Sharits, April 6, 1966.

"...I received the...film loops. All are great, terrific
and in time for Fluxus II yearbook....''
Letter: George Maciunas to Paul Sharits, June 29, 1966.

"...We put your 4 loops both in Fluxus II and Flux-
film program. We would like to send you at least [an]
8mm print of the entire 1½ hour film package....''
Letter: George Maciunas to Paul Sharits, [ca. Fall 1966].

FLUX-PROJECTS PLANNED FOR 1967 ... Paul Sharits: several film projects,...
Fluxnewsletter, March 8, 1967.

PROPOSED R&R EVENINGS:...Flux-film-walls (loops by Paul Sharits,...)
Fluxnewsletter, January 31, 1968.

[as above]
Fluxnewsletter, December 2, 1968.

FLUXPROJECTS FOR 1969 PRODUCTS - PUBLICATIONS...Fluxfilms: by...Paul Sharits...
ibid.

FLUXYEARBOX 2, MAY 1968...19 film loops by: [including] ...Paul Sharits,...
Flux Fest Kit 2. [ca. December 1969].

FILM AND SOUND ENVIRONMENT A booth must be set up in a fairly dark area, the walls of which are of white vinyl or cotton sheets (about 12' wide x 8' high) hanging as curtains, creating thus a 12'x12' or smaller room. Four 8mm wide angle lense loop projectors must be set up in front of each wall on the outside, projecting an image the frame of which is to cover entire wall. Spectators may enter the booth through corners....Paul Sharits film & tape loops.
ibid.

COMMENTS: *This is a general entry for Sharits' films, all of which were made by him, and then integrated into Fluxus film projects by Maciunas. Film loops which were included in* Flux Year Box 2 *were* Sears Catalogue, Dots 1&3, *and* Wrist Trick. *Loops were also intended to be used in* Fluxfilms *Environment. see Collective.*

FILMS see:
FLUXFILMS

FLUSHING STARTS LAUGHTER OR FARTS, TOILET

Toilet No. 2, Paul Sharits: ... Toilet flushing ... Starts recorded laugh or toilet sounds like farts.
Fluxnewsletter, April 1973.

COMMENTS: *I don't believe that this prepared toilet was ever made.*

FLUXBOOK see:
OPEN THE DOOR

FLUXCLOCK DOOR DISPLAY

Toilet No. 2, Paul Sharits: ...Doors — display on interior side of door...paper sound (delaminating accor-

dion) when small door opened. Inside display Fluxclocks
Fluxnewsletter, April 1973.

COMMENTS: *The idea is a display of Fluxclocks by other artists. Sharits is not known to have made clocks.*

FLUXCOMIC see:
AUTOPSY
FLUXFILM NO. 26 see:
SEARS CATALOGUE
FLUXFILM NO. 27 see:
DOTS 1 & 3
FLUXFILM NO. 28 see:
WRIST TRICK
FLUXFILM NO. 29 see:
UNROLLING EVENT
WORD MOVIE
FLUXFILM NO. 30 see:
WORD MOVIE
FLUXFILMS see:
DOTS 1 & 3
FILM
N:O:T:H:I:N:G
RAZOR BLADES
SEARS CATALOGUE
UNROLLING EVENT
WORD MOVIE
WRIST TRICK

FLUX MUSIC
Silverman No. 389, ff.

"...I received...the 'pull apart' book event...great, terrific and in time for Fluxus II yearbook. will include them in our Fall price list. Especially the 'pull apart' is in true Fluxus style...It will go very well..."
Letter: George Maciunas to Paul Sharits, June 29, 1966.

"...incidently your paper event box (rolls, folds, etc) we are putting in a 9" x 3" jar, so it will be a 'jar of rolls.' Label showing people folding or doing something with rolls. If you like, I could send for your approval all label designs before they are printed...."
Letter: George Maciunas to Paul Sharits, [ca. March 18, 1967].

PROPOSED CONTENTS FOR FLUXPACK 3 TO BE PUBLISHED IN 1973 BY FLASH ART...Paper Events ...paper music by Paul Sharits...Cost Estimates: for 1000 copies...[2] paper events $500...
[George Maciunas], Proposed Contents for Fluxpack 3. [ca. 1972].

Flash Art Editor, Giancarlo Politi, proposed to publish the 3rd Fluxyearbook, maybe to be called FLUX-

Paul Sharits. FLUX MUSIC in its earliest form produced by Sharits. This example is from a FLUX YEAR BOX 2

PACK 3, with the following preliminary contents:... Games:...paper events:...paper music by P.Sharits)...
Fluxnewsletter, April 1973.

COMMENTS: *Originally titled* Pull/Glue, *the work was designed and printed by the artist and submitted to George Maciunas for distribution by Fluxus. It was included in the collective works* Flux Paper Games: Rolls and Folds *and* Flux Year Box 2. *It evolved into a sound piece variously titled* Flux Music, Flux Sound *and* Pull Apart *designed and printed by George Maciunas and included in* Flux Envelope Paper Events. Flux Music *is conceptually related to* Sound Fold.

FLUX PAPER GAMES: ROLLS AND FOLDS
see: Collective
FLUX SOUND see:
FLUX MUSIC
FLUX TOILET see:
ADHESIVE TOILET SEAT
DOOR OPENING DOOR
FAUCET FLUSHES TOILET NO. 5
FLUSHING STARTS LAUGHTER OR FARTS, TOILET
FLUXCLOCK DOOR DISPLAY
MEDICINE CABINET
MIRROR
PAPER ACCORDION SOUND DOOR
STUCK TOGETHER PAPER TOWELS
STUCK TOGETHER TOILET PAPER
TOILET BOWL DISPLAY

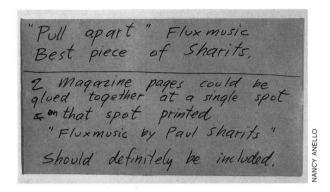

NANCY ANELLO

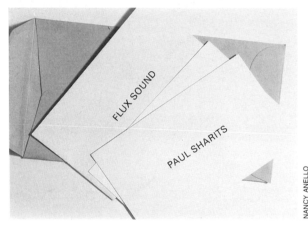

NANCY ANELLO

Paul Sharits. A later form of FLUX MUSIC produced by Fluxus and titled "Flux Sound." Holographed notes from George Maciunas to Carla Liss proposing the concept for two pages of the special Fluxus issue of ART AND ARTISTS magazine

FOOD see:
JELLO MIXED WITH OWN WRAP
FURRY ANIMAL IN FURRY BOX see:
Jack Coke's Farmer's Co-op
HUMAN FLUX TRAP see:
Jack Coke's Farmer's Co-op

JELLO MIXED WITH OWN WRAP

NEW YEAR EVE'S FLUX-FEAST, DEC. 31, 1969 AT CINEMATHEQUE, 80 WOOSTER ST. ... Paul Sharits: jello in their own paper packs and wrappings...
Fluxnewsletter, January 8, 1970.

31.12.1969 NEW YEAR EVE'S FLUX - FEAST (FOOD EVENT)...Paul Sharits: jello mixed with own wrap
George Maciunas, Diagram of Historical Developments of Fluxus... [1973].

COMMENTS: *Direct food prep.*

KEEP BOX CLOSED BOX see:
Jack Coke's Farmer's Co-op

MEDICINE CABINET

Toilet No. 2, Paul Sharits:...Medicine cabinet- ... cleanliness kit, suicide kit etc. behind glass
Fluxnewsletter, April 1973.

COMMENTS: *This work seems to only serve as a display case for Vautier's* A Flux Suicide Kit *and Friedman's* Cleanliness Flux Kit.

MIRROR

Toilet No. 2, Paul Sharits: ... Mirror ... covered with opaque window cleaner. Must be wiped off ea. time.
Fluxnewsletter, April 1973.

COMMENTS: *The cleanest toilet mirror around.*

NAPKINS see:
STUCK TOGETHER NAPKINS

N:O:T:H:I:N:G

''...We will include your long films in our next package, since now we have lost our shirts in various film projects. Very expensive thing those films....''
Letter: George Maciunas to Paul Sharits, July 11, 1966.

''...will await with anticipation...'nothing' for next fluxfilm edition. I think the 1st (actually 2nd) version will be printed into 4 of 16mm and about 20 - 8mm. before we make 3rd program...''
Letter: George Maciunas to Paul Sharits, [ca. Fall 1966].

COMMENTS: *This film is not included in the* Fluxfilms *package, however, there is a solid black film loop in some* Flux Year Box 2s *which could be* N:O:T:H:I:N:G.

OPEN THE DOOR

''...Thank you very much for the books (...& open the door). We like them very much, we distribute however only Fluxus publications...On the second thought, we could distribute your previous work like the open door if you stamped in anywhere - 'Flux-book' or 'distributed by Fluxus' on 50 copies which we could take on consignment with some $ advance.''
Letter: George Maciunas to Paul Sharits, April 6, 1966.

FLUX-PROJECTS PLANNED FOR 1967 ... Paul Sharits:...Open the door - an incision (fluxbook),...
Fluxnewsletter, March 8, 1967.

open the door $6 fluxbook by Paul Sharits
Fluxshopnews. [Spring 1967].

FLUX-PRODUCTS 1961 TO 1969...PAUL SHARITS Open the door, flux-book [$] 6
Fluxnewsletter, December 2, 1968 (revised March 15, 1969).

...set of 1969-70 Flux-productions which consist of the following: 1969 - Paul Sharits Open the Door;...
Fluxnewsletter, January 8, 1970.

FLUX-PRODUCTS 1961 TO 1970...PAUL SHARITS Open the Door, flux-book [$] 6...
Flux Fest Kit 2. [ca. December 1969].

COMMENTS: Open the Door *was produced by Sharits, and had limited distribution by Fluxus.*

PAPER ACCORDION SOUND DOOR

Toilet No. 2, Paul Sharits: ... Doors - display on interior side of door ... paper sound (delaminating accordion) when small door opened. Inside display: Flux-clocks
Fluxnewsletter, April 1973.

COMMENTS: *The work is an extension of* Flux Music.

PAPER EVENT JAR see:
Collective
PAPER MUSIC see:
FLUX MUSIC
PAPER TOWELS see:
STUCK TOGETHER PAPER TOWELS

POSTCARDS

PROPOSED CONTENTS FOR FLUXPACK 3 TO BE PUBLISHED IN 1973 BY FLASH ART...Postcards by...Sharits...Cost Estimates: for 1000 copies...postcards [including designs by other artists] $100...
[George Maciunas], Proposed Contents for Fluxpack 3. [ca. 1972].

COMMENTS: Postcards *by Paul Sharits are not included in* Fluxpack 3.

PULL APART see:
FLUX MUSIC
PULL/GLUE see:
FLUX MUSIC

RAZOR BLADES

''RAZOR BLADES for loops - very good idea - splice them & I will get boxes & labels...''
Letter: George Maciunas to Paul Sharits, [ca. Spring 1968].

COMMENTS: Razor Blades *was apparently a split screen loop film with pairs of texts projected like "razor blades,"*

"birth space/penis falling." It was also called "25 minutes of staggered loop cycles." Sharits was to have shown it at the Cinematheque in N.Y.C. and wanted Maciunas to package loop sets of it in boxes to be sold after the screening. It isn't known whether this was done.

SCORE

Instructions for the performance of "90 Angles, 1966 Street or Field Version" by Paul Sharits appears in both Flux Fest Sale and Flux Fest Kit 2.

SEARS CATALOGUE
Silverman No. > 390.I, ff.

FLUXFILMS SHORT VERSION, 40 MIN AT 24 FRAMES/SEC. 1400FT...flux-number 26 Paul Sharits SEARS CATALOGUE 1-3 2' Single frame exposures, pages from Sears Catalogue
Fluxfilms catalogue. [ca. 1966].

PAST FLUX-PROJECTS (realized in 1966)... Flux - films: total package: 1 hr. 40 min.... [including] sears, ...(3 loop films) by Paul Sharits,...
Fluxnewsletter, March 8, 1967.

"...Film Coop sent a travelling film library to Europe, in which was included a re-edited Flux-film package - 1200 ft. version — has all the best material including your 4 loop films. (...sears)..."
Letter: George Maciunas to Paul Sharits, June 21, 1967.

FLUXPROJECTS FOR 1968 (In order of priority) ... 12. Film projects, film-wall-paper events in "the garage", Fluxshop opening.
Fluxnewsletter, January 31, 1968.

PROPOSED FLUXSHOW FOR GALLERY 669 ... FILM WALLPAPER ENVIRONMENT A booth must be set up in a fairly dark area, the walls of which are of white vinyl or cotton sheets (about 12ft. wide) hanging as curtains and creating a 12ft x 12ft or smaller room. Four 8mm loop projectors (with wide angle lenses) must be set up, one on front of each wall (on the outside) and projecting an image the frame of which is to cover entire wall, 20 sets of loops are available, such as...single frame exposures of Sears catalogue etc.etc....Visitors, a few at a time, must enter this booth.
Fluxnewsletter, December 2, 1968.

FLUX-PRODUCTS 1961 TO 1969...FLUXFILMS, short version Summer 1966 40 min. 1400ft.:... [including] Sears Catalogue...by Paul Sharits,...16mm [$] 180 8mm version [$] 50
Fluxnewsletter, December 2, 1968 (revised March 15, 1969).

FILM WALLPAPER ENVIRONMENT ... 20 sets of loops are available such as:...single frame exposures

of Sears catalogue,...
ibid.

SLIDE & FILM FLUXSHOW ... PAUL SHARITS: SEARS CATALOGUE 1-3 Pages from Sears catalogue, single frame exp.
Flux Fest Kit 2. [ca. December 1969].

FLUX-PRODUCTS 1961 TO 1970 ... FLUXFILM short version, Summer 1966. 40min. 1400ft: ... [including] Sears Catalogue...by Paul Sharits,...16mm version $180 8mm version $50
ibid.

"...Regarding capsule. It will be a suspended 3 x 3 x 3 booth with translucent panels, so we can project on all 4 sides, top & bottom. Get all kinds of effects. I thought projecting your...sears separately of course..."
Letter: George Maciunas to Paul Sharits, [ca. April 1970].

MAY 16-22: CAPSULE BY JOHN & YOKO + FLUX SPACE CENTER A 3ft cube enclosure (capsule) having various film loops projected on its walls, ceiling and floor to a single viewer inside, total time: 6 min. ...[including] single frame exposures of Sears Catalogue pages (Paul Sharits)...
Schedule of events for Fluxfest presentation of John Lennon and Yoko Ono. [ca. April 1970]. version A

MAY 16-22: CAPSULE BY JOHN & YOKO + FLUX SPACE CENTER ($1 ADMISSION CHARGE)...[as above] about 8 minutes [including] single frame exposures of Sears pages...by Paul Sharits, 1966...
Schedule of events for Fluxfest presentation of John Lennon and Yoko Ono. [ca. April 1970]. version B

MAY 16-22 CAPSULE BY YOKO + FLUX SPACE CENTER...including single frame exposures (Paul Sharits);...
Schedule of events for Fluxfest presentation of John Lennon and Yoko Ono. April 1, 1970. version C

FLUXFEST PRESENTATION OF JOHN LENNON & YOKO ONO +* AT 80 WOOSTER ST. NEW YORK --1970...MAY 16-22: CAPSULE BY JOHN LENNON & YOKO + FLUX SPACE CENTER A 6 x 6 ft enclosure having various films projected on its walls to a single viewer inside...single frame exposures of Sears Catalogue pages (Paul Sharits '66)...
all photographs copyright nineteen seVenty by peTer mooRE (Fluxus Newspaper No. 9) 1970.

1965...FLUXFILMS:...PAUL SHARITS: sears,...
George Maciunas, Diagram of Historical Developments of Fluxus... [1973].

COMMENTS: *This film is sometimes called* Sears 1-3 *or* Sears. *The images are from Sears Roebuck Catalogues.*

SELF LIGHTING FIREWORKS see:
Jack Coke's Farmer's Co-op

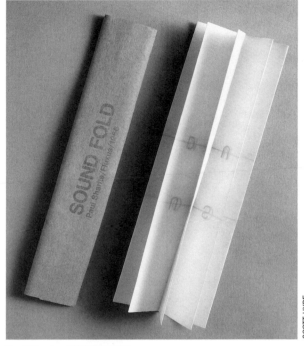

SCOTT HYDE

Paul Sharits. SOUND FOLD

SOUND FOLD
Silverman No. 391, ff.

COMMENTS: *A component of* Flux Paper Games: Rolls and Folds *(Silverman No. 131) designed, printed and assembled by Paul Sharits and David Thompson and packaged by Maciunas with a Fluxus label. Although its presentation is quite different, it is the same concept as* Flux Music.

STUCK TOGETHER NAPKINS

"... to produce the Flash Art FLUXPACK 3 ... The contents at present will be as follows:...Napkins (all stuck together) by Paul Sharits..."
Letter: George Maciunas to Giancarlo Politi, n.d. Reproduced in Fluxnewsletter, April 1973.

COMMENTS: Stuck Together Napkins *are not included in* Fluxpack 3. *There is a clear relationship between Sharits' stuck together pieces and George Maciunas' adhesive works.*

STUCK TOGETHER PAPER TOWELS

Toilet No. 2, Paul Sharits...Paper towels...stuck together
Fluxnewsletter, April 1973.

COMMENTS: *This work, and Sharits' two other stuck together works are related to* Sound Fold *and* Flux Music.

STUCK TOGETHER TOILET PAPER

Toilet No. 2, Paul Sharits...Toilet paper...stuck together
Fluxnewsletter, April 1973.

1970-71 ... FLUX-TOILET: ... SHARITS: ... Stuck-glued toilet paper, etc....
George Maciunas, Diagram of Historical Developments of Fluxus... [1973].

COMMENTS: *Like starting a new roll of toilet paper and finding the glue has stuck the first 20 sheets together - the paper keeps coming off in shreds.*

THREAD PUZZLE GAME see:
Jack Coke's Farmer's Co-op

TOILET BOWL DISPLAY

Toilet No. 2, Paul Sharits:...Toilet bowl display ... Floating rubber shit. secured by string.
Fluxnewsletter, April 1973.

COMMENTS: *Toilet Bowl Display reminds me of Claes Oldenburg's* False Food Selection. *This Sharits work is not known to have been made by Fluxus.*

TOILET PAPER see:
STUCK TOGETHER TOILET PAPER

TOILET PAPER EVENT see:
UNROLLING EVENT

TOILETS see:
FLUX TOILET

TRANSITION FROM SMALL TO LARGE SCREENS see:
DOTS 1 & 3

UNROLLING EVENT
Silverman No. > 390.V, ff.

FLUXFILMS SHORT VERSION, 40 MIN AT 24 FRAMES/ SEC. 1400FT.... flux-number 29 Paul Sharits UNROLLING EVENTS Single frame exposures of toilet paper event
Fluxfilms catalogue. [ca. 1966].

FLUX-PRODUCTS 1961 TO 1969...FLUXFILMS, short version Summer 1966 40min. 1400ft.: [including] Unrolling event...by Paul Sharits,...16mm [$] 180 8mm version [$] 50
Fluxnewsletter, December 2, 1968 (revised March 15, 1969).

FLUX-PRODUCTS 1961 TO 1970...FLUXFILMS, short version, Summer 1966. 40min. 1400ft.:...[including] Unrolling event by Paul Sharits,...16mm [$] 180 8mm version [$] 50
Flux Fest Kit 2. [ca. December 1969].

SLIDE & FILM FLUXSHOW ... PAUL SHARITS: ... UNROLLING EVENT Toilet paper event, single frame exposures.
ibid.

COMMENTS: Unrolling Event *is a scatological film depicting the use and disposal of toilet paper. A snippet of the film is used as a loop in some copies of* Flux Year Box 2, *and as a component of* Unrolling Screen Piece. *The film does not appear in prints of the* Fluxfilms *packages that I have seen. In Maciunas' notes for* Fluxfilms *he gives* Word Movie *the Fluxfilm number 29, the number listed in* Fluxfilms Catalogue, *ca. 1966, for* Unrolling Event.

UNROLLING SCREEN PIECE
Silverman No. 392, ff.

COMMENTS: *This work is a component of* Flux Paper Games: Rolls and Folds *(Silverman No. 131) and contains a film loop from Sharits' film* Unrolling Event. *It was designed and printed by the artist and David Thompson, then packaged by Maciunas with a Fluxus label.*

WALL POEM
Silverman No. < 389.I, ff.

FLUX-PROJECTS PLANNED FOR 1967 ... Paul Sharits:...wall poem,...
Fluxnewsletter, March 8, 1967.

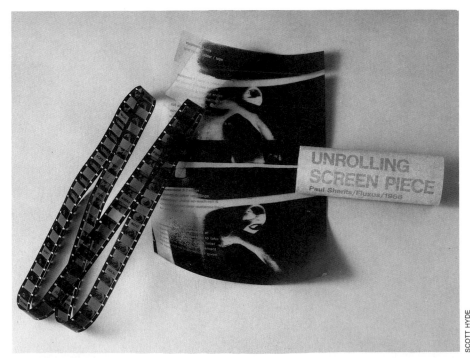

SCOTT HYDE

Paul Sharits. UNROLLING SCREEN PIECE

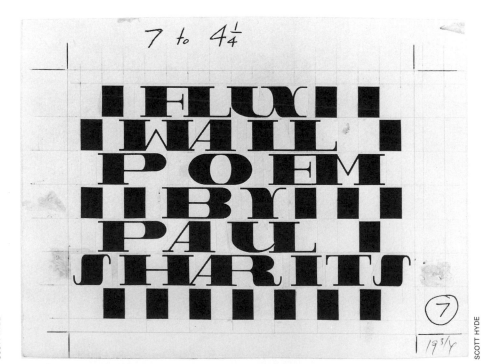

SCOTT HYDE

Paul Sharits. WALL POEM. Mechanical for the label by George Maciunas

"...I got a box full of good ideas...so we up here decided to go ahead with several right away. and I am designing labels for the following...wall poem - label — typographic...."
Letter: George Maciunas to Paul Sharits, [after March 18, 1967].

wall poem $3...by Paul Sharits
Fluxshopnews. [Spring 1967].

"...Your word poem should be out by new year..."
Letter: George Maciunas to Paul Sharits, [after November 8, 1967].

FLUXPROJECTS FOR 1968 (In order of priority)...
3. Boxed events & objects (all ready for production)
...Paul Sharits - wall poem,...
Fluxnewsletter, January 31, 1968.

"... Have labels for many new boxes (enclosed) yet have to print your cards for word - wall poem..."
Letter: George Maciunas to Paul Sharits, [ca. Spring 1968].

FLUXPROJECTS FOR 1969...Cards:...Paul Sharits wall poem,...
Fluxnewsletter, December 2, 1968.

FLUX-PRODUCTS 1961 TO 1969...PAUL SHARITS ...Wall poem, boxed, May 1969* [indicated as part of FLUXKIT] [$] 3
Fluxnewsletter, December 2, 1968 (revised March 15, 1969).

FLUX-PRODUCTS 1961 TO 1970...PAUL SHARITS ...Wall poem, boxed [$] 3...
Flux Fest Kit 2. [ca. December 1969].

"...Sharits wall poem is available, not very good..."
Letter: George Maciunas to Dr. Hanns Sohm, [ca. late 1972].

"The story on the other side is self explanatory. As a result of which I have to have eye surgery, since I hardly see anything with the left eye. In one sense, these hospital expenses to me are a windfall to any collectors of flux-objects. Now with high cost of surgery, I must make more objects and begin to respond to various orders and requests for them. Thus I am sending by mail to you the following:...Paul Sharits - wall poem - [$] 2..."
Letter: George Maciunas to Dr. Hanns Sohm, November 30, 1975.

COMMENTS: Handy words, packaged by Fluxus.

WORD MOVIE

Silverman No. > 390.VI, ff.

"...Yes, we would be interested in your Word Film, All Fluxfilms are numbered, so the credit runs like this;
FLUXFILM No. 29(this would be the next number)/

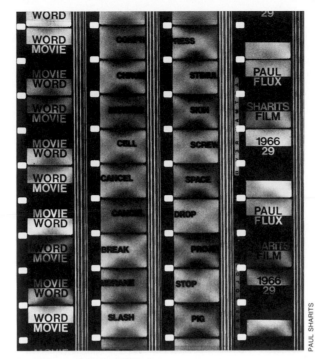

Paul Sharits. WORD MOVIE. Stills from the film

(c) copyright by film maker or FLUXUS 1966 depending on who pays for 2 prints to be deposited in copyright office then title, filmmaker -, if no title then FLUXFILM 29 BY PAUL SHARITS
Copyright is not really necessary. Some film makers insist on it then we get it...."
Letter: George Maciunas to Paul Sharits, July 11, 1966.

"...Will await with anticipation the 'word movie'...for next fluxfilm edition I think the 1st (actually 2nd) version will be printed into 4 of 16mm and 20 - 8mm before we make the 3rd program..."
Letter: George Maciunas to Paul Sharits, [ca. Fall 1966].

FLUXFILMS SHORT VERSION, 40 MIN AT 24 FRAMES/ SEC. 1400FT. ... flux-number 30 Paul Sharits WORD MOVIE 4' Single frame exposures of words, color
Fluxfilms catalogue. [ca. 1966].

"...Films - Word Movie is great. Could use color version too, Fluxpackage has 2 short color films, which we print separately & then splice-in. Though all are silent. At least for a while they will to save on costs. Maybe by summer we can do something about sound & then include your sound version. On second thought, why not include your present color-sound version & specifiy the whole 1200 ft reel to be played through sound system, so there will be lots of white noise and

then suddenly a bit of sound and color. May liven up the entire package this way. Yes, when you have chance and $, please send sound and color version...."
Letter: George Maciunas to Paul Sharits, [after March 18, 1967].

"...Received your Word Movie - GREAT! You are getting expert on single frame sequences, they really work! effect is terriffic! I would like to include this in our flux package of 16 & 8mm versions, Except 8mm would be without sound, & 16 with sound, OK?... You have so many films now, you should have solo evening at Cinematheque - suggest during Flux-Fest in Sept when we will have films, film environments (walls, ceiling floor), sports events, concerts, etc. - so a few days could be devoted to your films or film environments. Can you come to New York in September?..."
Letter: George Maciunas to Paul Sharits, [Spring 1968].

FLUX-PRODUCTS 1961 TO 1969...FLUXFILMS, short version Summer 1966 40 min. 1400 ft.: ... [including] Word Movie - by Paul Sharits,...16mm [$] 180 8mm version [$] 50
Fluxnewsletter, December 2, 1968 (revised March 15, 1969).

FLUX-PRODUCTS 1961 TO 1970...FLUXFILMS, short version, Summer 1966. 40 min. 1400 ft.: ...[including] Word Movie by P. Sharits,...16mm version $180 8mm version $50
Flux Fest Kit 2. [ca. December 1969].

FILM AND SOUND ENVIRONMENT A booth must be set up in a fairly dark area, the walls of which are of white vinyl or cotton sheets (about 12' wide x 8' high) hanging as curtains, creating thus a 12' x 12' or smaller room. Four 8mm wide angle lense loop projectors must be set up in front of each wall on the outside, projecting an image the frame of which is to cover entire wall. Spectators may enter the booth through corners....Word Movie by Paul Sharits with lip and tongue sound tape loop.
ibid.

SLIDE & FILM FLUXSHOW ... PAUL SHARITS: WORD MOVIE Single frame exposures of words & colors. 4'
ibid.

FLUXFEST PRESENTATION OF JOHN LENNON & YOKO ONO +* AT 80 WOOSTER ST. NEW YORK —1970...MAY 16-22: CAPSULE BY JOHN & YOKO + FLUX SPACE CENTER A 6 x 6 ft enclosure having various films projected on its walls to a single viewer inside....Word Movie (Paul Sharits '66)...
all photographs copyright nineteen seVenty by peTer mooRE (Fluxus Newspaper No.9) 1970.

FILM AND SOUND ENVIRONMENT A booth must be set up in a fairly dark area, the walls of which are

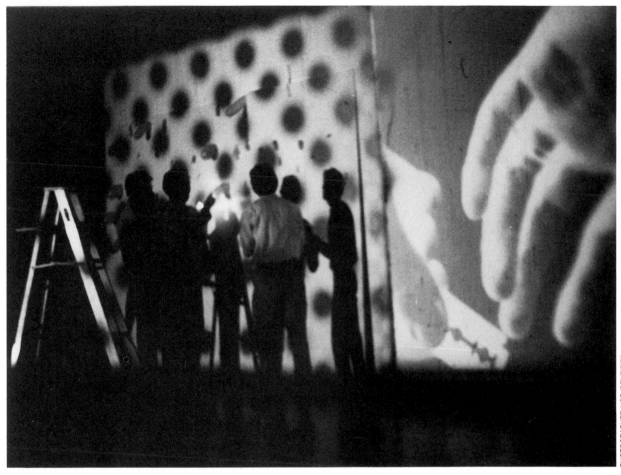

PHOTOGRAPHER NOT IDENTIFIED

Paul Sharits. Images from WRIST TRICK and DOTS 1 & 3 being used in a "Flux-Wallpaper Event," ca. 1967

of white vinyl or cotton sheets (about 12' wide x 8' high) hanging as curtains, creating thus a 12' x 12' or smaller room. Four 8mm wide angle lense loop projectors must be set up in front of each wall on the outside, projecting an image the frame of which is to cover entire wall. Spectators may enter the booth through corners...Word Movie by Paul Sharits with lip and tongue sound tape loop.
ibid.

COMMENTS: *Paul Sharits, wrote about* Word Movie *in a sequence of letters to George Maciunas from July 1966 to April 1967:*
"...each frame has a different work....Soundtrack - a flow of words derived from pastry recipes & suicide notes....words flash so rapidly that they form new words...visual effect? All letters black on white ground produce a whole series of greys optically. Sound track will consist of slowly enunciated words....decided to reshoot title and credit for Word Movie *so color sound version won't be sent for a few more weeks."*

Confusion exists about the Fluxfilm number for Word Movie. Albert Fine's Dance is Fluxfilm number 30 in the long version of Fluxfilms (Silverman No. > 123.IV) and Fluxfilm number 29 is usually Sharits' Unrolling Event.

WRIST TRICK
Silverman No. > 390.IV, ff.

FLUXFILMS SHORT VERSION, 40 MIN AT 24 FRAMES/SEC. 1400 FT. ... flux-number 28 Paul Sharits WRIST TRICK Single frame exposures of hand held rasorblade [sic]
Fluxfilms catalogue. [ca. 1966].

PAST FLUX-PROJECTS (realized in 1966) ... Flux - films: total package: 1 hr. 40 min.... [including] wrist trick (3 loop films)by Paul Sharits,...
Fluxnewsletter, March 8, 1967.

"...Film Coop sent a travelling film library to Europe,

in which was included a re-edited Flux-film package - 1200 ft. version. — has all the best material including your 4 loop films. (...wrist trick...)"
Letter: George Maciunas to Paul Sharits, June 21, 1967.

FLUX-PRODUCTS 1961 TO 1969... FLUXFILMS, short version Summer 1966 40min. 1400ft.: ... [including] Wrist Trick ... by Paul Sharits ... 16 mm [$] 180 8mm version [$] 50
Fluxnewsletter, December 2, 1968 (revised March 15, 1969).

SLIDE & FILM FLUXSHOW...PAUL SHARITS:... WRIST TRICK Various gestures of hand held rasorblade [sic], single frame exposures.
Flux Fest Kit 2. [ca. December 1969].

FLUX-PRODUCTS 1961 TO 1970 ... FLUXFILMS, short version, Summer 1966. 40min. 1400ft.:...[including] Wrist Trick...by Paul Sharits...16 mm version $180 8mm version $50
ibid.

COMMENTS: *Images of hand and arm — another hand appears holding a razor blade, making the gesture of slitting the wrist. The film is included in both the short and long versions of* Fluxfilms.

BOB SHEFF

HUM
Silverman No. 394, ff.

COMMENTS: Hum *is a sheet of instructions with attached paper components for performance. The work is included in most copies of* Flux Year Box 2. *However, we have found no evidence that it was ever offered for sale or distributed as an individual Fluxus work.*

SCOTT HYDE

Bob Sheff. HUM

MIEKO (CHIEKO) SHIOMI

Chieko Shiomi's score, "Mirror," was published in Fluxus Newspaper No. 1 *and "Event for the Midday in the Sunlight" in* Fluxus Newspaper No. 2. *Numerous scores are published in* Flux Fest Sale *and* Flux Fest Kit 2, *some of which also appear in the Fluxus Edition of her* Events and Games.

AIR EVENT
Silverman No. 396

Chieko Shiomi: Air event, during Fluxfest at Washington Sq. Gallery. (breath of various participants being auctioned off) [caption for photograph of the event]
fluxus Vaudeville TouRnamEnt (Fluxus Newspaper No. 6) July 1965.

COMMENTS: *Piero Manzoni made* Air Sculpture *in 1960, which was the artist's breath in a balloon. These works were exhibited at Arthur Koepcke's gallery in Copenhagen, which also showed works by several Fluxus artists. Manzoni's* Air Sculpture *was surely known by the time of the 1964 event the Washington Square Gallery in New York City.*

BALLOON EVENT see:
AIR EVENT
CALENDAR see:
SPATIAL POEM NO. 3

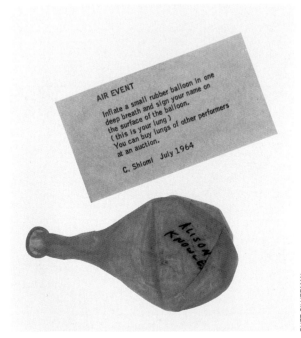

Mieko (Chieko) Shiomi. **AIR EVENT**

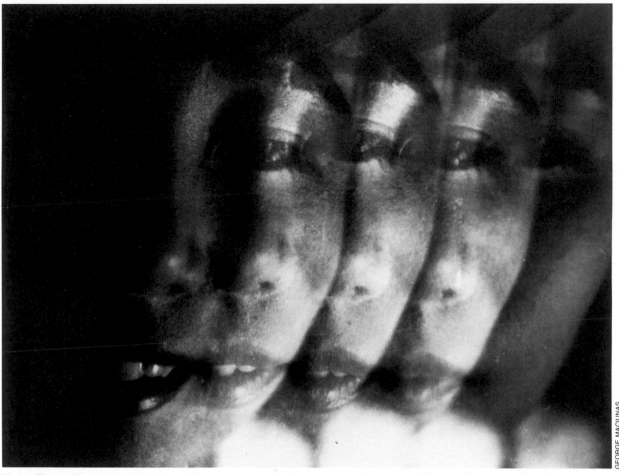

Mieko (Chieko) Shiomi. Portrait by George Maciunas interpreting Shiomi's score "Disappearing Music for Face," 1964. This photograph was also used for the label of a Fluxus Edition of DISAPPEARING MUSIC FOR FACE

CARDS

FLUXPROJECTS FOR 1969 ... Cards:...Chieko Shiomi,...
Fluxnewsletter, December 2, 1968.

COMMENTS: *Because of the context of the reference, it is not clear whether "cards" are playing cards, event cards, or parts of a* Spatial Poem.

COMPLETE WORKS see:
EVENTS AND GAMES
DIRECTION EVENT see:
SPATIAL POEM NO. 2

DISAPPEARING MUSIC FOR ENVELOPES
Silverman No. > 403.I, ff.

"...Fluxus 1 items of the type that may be included [in Fluxus 2] are: ... Chieko Shiomi - endless envelope..."
[Fluxus Newsletter], unnumbered, [ca. March 1965].

COMMENTS: *This work is a variation of the idea of* Endless Box *as well as* Disappearing Music for Face. *It was first used in* FLUXUS 1 *as an untitled sequence of envelopes of diminishing sizes within each other. In the collective* Flux Envelope Paper Events, *the work is used to contain various paper events, works by other artists.*

DISAPPEARING MUSIC FOR FACE
Silverman No. < 407.I, ff (film); 407, ff. (flipbook)

"...Chieko Shiomi & Shigeko Kubota arrived here in New York, very nice girls. Brought many news from Japan activities. New compositions. I will print them

475

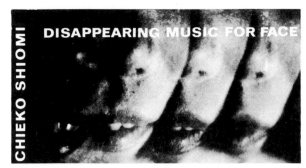

Mieko (Chieko) Shiomi. DISAPPEARING MUSIC FOR FACE.
Label designed by George Maciunas

in next newspaper...Some new pieces:
 Chieko Shiomi - disappearing music for face
smile — stop to smile, very smooth transition that
could take say 5 minutes. You could also make a film
of mouth only. We shall make a film of this and set of
photographs....PS. You could now easily make a
Fluxus film festival with 4 films:...Shiomi - disappear-
ing music for face 5 or 10 minutes...."
Letter: George Maciunas to Ben Vautier, July 21, 1964.

FLUXFILMS FLUXUS dde CHIEKO SHIOMI: dis-
appearing music for face, 16mm film, 1 min $20
Vacuum TRapEzoid (Fluxus Newspaper No. 5) March 1965.

"...Regarding film festival. — I will send you the fol-
lowing: You will get these end of April....Disappear-
ing music for face by Chieko Shiomi - 20 min....They
and another 6 films make up the whole 2 hour Flux-
film program...Incidentally, loops from these films
will go into Fluxus II Yearboxes. Everything is ready,
but I got short of $ & can't produce these boxes in
quantity, since making film copies is rather expensive
...Fluxfilm program was shown at Ann Arbor Film-
fest & won a critics award."
Letter: George Maciunas to Ben Vautier, March 29, 1966.

... items are in stock, delivery within 2 weeks FLUX-
FILMS...FLUXFILM 4 CHIEKO SHIOMI: disappear-
ing music for face, 15 min $60
Vaseline sTREet (Fluxus Newspaper No. 8) May 1966.

FLUXFILMS SHORT VERSION, 40 MIN AT 24
FRAMES/SEC. 1400FT. ... flux-number 4 Chieko
Shiomi DISAPPEARING MUSIC FOR FACE 10'
High-speed camera, 2000fr/sec. transition from smile
to no-smile * [*camera: Peter Moore]
Fluxfilms catalogue, [ca. 1966].

PAST FLUX-PROJECTS (realized in 1966)...Flux -
films: total package: 1 hr. 40 min...[including] disap-
pearing music for face by Chieko Shiomi,...
Fluxnewsletter, March 8, 1967.

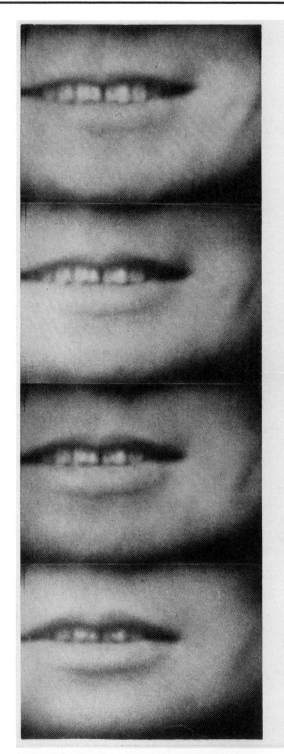

Mieko (Chieko) Shiomi. DISAPPEARING MUSIC FOR FACE. Stills from the film used in the flipbook version

PAUL SILVERMAN

Mieko (Chieko) Shiomi. DISAPPEARING MUSIC FOR FACE. The flipbook version

"...We have a nice condensed one reel program with the best pieces in them, or all short pieces plus the smile to no smile film as the only long film...."
Letter: George Maciunas to Ken Friedman, July 17, 1967.

FLUX-PRODUCTS 1961 TO 1969 ... FLUXFILMS, short version Summer 1966 40 min. 1400ft.:...[including] Disappearing music for face - Chieko Shiomi; ...16mm [$] 180 8mm version [$] 50
Fluxnewsletter, December 2, 1968 (revised March 15, 1969).

SLIDE & FILM FLUXSHOW ... CHIEKO SHIOMI: DISAPPEARING MUSIC FOR FACE Transition from smile to no-smile 10min. Shot at 2000fr/sec. Camera: Peter Moore, Simultaneously with:...
Flux Fest Kit 2. [ca. December 1969].

FLUX-PRODUCTS 1961 TO 1970 ... FLUXFILMS, short version, Summer 1966. 40min. 1400ft.:...[including] Disappearing music for face by Chieko Shiomi...16mm $180 8mm $50
ibid.

MAY 16-22: CAPSULE BY JOHN & YOKO + FLUX SPACE CENTER A 3ft cube enclosure (capsule) having various film loops projected on its walls, ceiling and floor to a single viewer inside, total time: 6 min. ...[including] transition from white to black (George Brecht, 1965) combined with: transition from smile to no smile, 20,000 frames/sec. (Shiomi '66)...
Schedule of events for Fluxfest presentation of John Lennon and Yoko Ono. [ca. April 1970]. version A

Flash Art editor, Giancarlo Politi, proposed to publish the 3rd Flux Yearbook maybe to be called FLUX-PACK 3, with the following preliminary contents:... Games:...flipbooks by... Shiomi,...
Fluxnewsletter, April 1973.

1965 FLUXFILMS...SHIOMI: disappearing music for face
George Maciunas, Diagram of Historical Developments of Fluxus... [1973].

COMMENTS: Disappearing Music for Face *was originally made as a movie by Fluxus. It is of a smile, starring Yoko Ono. Filmed with a high speed camera and projected at normal speed, the effect is a sensual slow-motion. The flipbook version uses images from the movie. George Maciunas had wanted to produce a number of flipbooks from the* Fluxfilms, *however only this one and Dick Higgins'* Invocation of Canyons and Boulders *were made from Fluxus films. George Brecht's* Nut Bone *(Silverman No. 44) is a Fluxus flipbook thought of as a film, but not made from a movie. The work is subtitled "A Yamfest Movie."*

ENDLESS BOX
Silverman No. 402, ff.

"... The new publications will be ... Endless box by Chieko Shiomi - $20...."
Letter: George Maciunas to Philip Kaplan, November 19, 1963.

"In reply to your inquiry of Nov. 22nd the Fluxus boxes can be seen at: 359 Canal St 2nd floor...Boxes to be seen:...Chieko Shiomi - 'endless box' $20..."
Letter: George Maciunas to Philip Kaplan, November 27, 1963.

FLUXUS 1963 EDITIONS, AVAILABLE NOW FROM FLUXUS P.O. Box 180, New York 10013, N.Y. or FLUXUS 359 Canal St. New York, CO7-9198 ...FLUXUSd CHIEKO SHIOMI: "Endless box" $20...
Film Culture No. 30, Fall 1963.

FLUXUS 1963 EDITIONS, AVAILABLE NOW ... FLUXUS d CHIEKO SHIOMI: "Endless box" $20
cc V TRE (Fluxus Newspaper No. 1) January 1964.

[as above]
cc V TRE (Fluxus Newspaper No. 2) February 1964.

FLUXUS 1964 EDITIONS, AVAILABLE NOW ... FLUXUS d CHIEKO SHIOMI: "Endless box" $20
cc Valise TRanglE (Fluxus Newspaper No. 3) March 1964.

FLUXKIT containing following fluxus-publications: (also available separately) ... FLUXUS d CHIEKO SHIOMI: "endless box"
cc fiVe ThReE (Fluxus Newspaper No. 4) June 1964.

5F-d CHIEKO SHIOMI "Endless Box" $20
European Mail-Orderhouse: europeanfluxshop, Pricelist. [ca. June 1964].

d CHIEKO SHIOMI endless box $20
Second Pricelist - European Mail-Orderhouse. [Fall 1964].

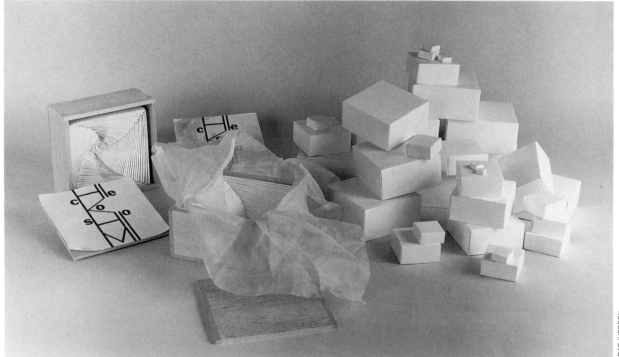

BRAD IVERSON

Mieko (Chieko) Shiomi. ENDLESS BOX

FLUXKIT containing following flux-publications:... endless box by Chieko Shiomi...
ibid.

"I will send attache case as soon as return from Arizona ... I could not send it now, because Chieko Shiomi did not make 'endless boxes.' Everything else was ready...."
Letter: George Maciunas to Ben Vautier, January 23, 1965.

"...If you sell kit for $100, you can keep $40 and send me $60, because I must pay others (for endless box..."
Letter: George Maciunas to Willem de Ridder, March 2, 1965.

FLUXUS d CHIEKO SHIOMI: "endless box" $20
Vacuum TRapEzoid (Fluxus Newspaper No. 5) March 1965.

FLUXKIT containing following fluxus-publications: (also available separately) ... FLUXUS d CHIEKO SHIOMI: endless box $35
Vaseline sTREet (Fluxus Newspaper No. 8) May 1966.

FLUX-PRODUCTS 1961 TO 1969 ... CHIEKO SHI-OMI: Endless box, boxed [$] 20...
Fluxnewsletter, December 2, 1968 (revised March 15, 1969).

FLUX-PRODUCTS 1961 TO 1970 ... MIEKO (CHIEKO) SHIOMI Endless box, boxed [$] 30
Flux Fest Kit 2. [ca. December 1969].

FLUX SHOW: DICE GAME ENVIRONMENT ENTIRE FLOOR AS DICE HAZARD TABLE DIE CUBES, 15" CUBES ON FLOOR, Marked on sides, top open or closed with clear plastic. Consisting or containing...Endless box by Chieko Shiomi
ibid.

FLUXUS-EDITIONEN...[Catalogue No.] 777 MIEKO (CHIEKO) SHIOMI endless box, boxed
Happening & Fluxus. Koelnischer Kusntverein, 1970.

02.1964 CHIEKO SHIOMI: endless box
George Maciunas, Diagram of Historical Developments of Fluxus... [1973].

"...Could you make 20 Endless boxes, the kind that Chieko Shiomi made? Origami style, the largest was 5" x 5" x 2½" and got smaller (30 boxes) till smallest was ¼" only. I will write soon again..."
Letter: George Maciunas to Takako Saito, May 30, 1977.

COMMENTS: Endless Box, *a paper folder tour de force, was a Fluxus work always handmade by the artist. The work appears in many copies of Fluxkit and was distributed packaged in a wood box wrapped in silk, as an individual Fluxus Edition.*

ENDLESS ENVELOPE see:
DISAPPEARING MUSIC FOR ENVELOPES
ENVELOPES see:
DISAPPEARING MUSIC FOR ENVELOPES

EVENTS AND GAMES
Silverman No. 397, ff.

FLUXUS 1963 EDITIONS, AVAILABLE NOW FROM FLUXUS P.O. Box 180, New York 10013, N.Y. or FLUXUS 359 Canal St. New York.CO7-9198 ...FLUXUSdd CHIEKO SHIOMI: events in wood box $2...
Film Culture No. 30, Fall 1963.

"... new publications will be ... Events by Chieko Shiomi in hand made wood box $4...."
Letter: George Maciunas to Philip Kaplan, November 19, 1963.

"...We have now...complete works of...Shiomi..."
Letter: George Maciunas to Willem de Ridder, December 26, 1963.

FLUXUS 1963 EDITIONS, AVAILABLE NOW ... FLUXUS dd CHIEKO SHIOMI: events in wood box $2
cc V TRE (Fluxus Newspaper No. 1) January 1964.

[as above]
cc V TRE (Fluxus Newspaper No. 2) February 1964.

FLUXUS 1964 EDITIONS, AVAILABLE NOW ... FLUXUSdd CHIEKO SHIOMI events in wood box $2
cc Valise e TRangIE (Fluxus Newspaper No. 3) March 1964.

FLUXKIT containing following fluxus-publications: (also available separately) ... FLUXUS dd CHIEKO SHIOMI: events in box $2
cc fiVe ThReE (Fluxus Newspaper No. 4) June 1964.

5F-dd CHIEKO SHIOMI: Events in wood box $2
European Mail-Orderhouse: europeanfluxshop, Pricelist. [ca. June 1964].

dd CHIEKO SHIOMI. events in wood box $2
Second Pricelist - European Mail-Orderhouse. [Fall 1964].

FLUXKIT containing following flux-publications:... events in box by Chieko Shiomi...
ibid.

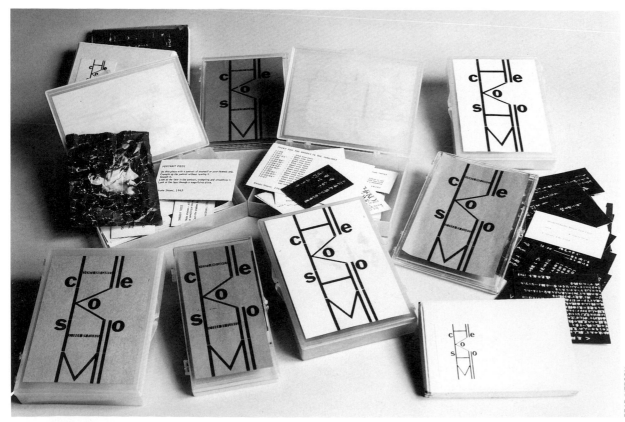

Mieko (Chieko) Shiomi. EVENTS AND GAMES. see color portfolio

BRAD IVERSON

did you receive the 2nd catalog of THE EUROPEAN MAIL-ORDERHOUSE & FLUXSHOP? [which advertises] ...chiekoshiomi - box...
How to be Satisfluxdecolanti?... [ca. Fall 1964].

"...Please give 10 copies of...Shiomi, cards in boxes to Ben Vautier. He can sell them also...."
Letter: George Maciunas to Willem de Ridder, January 21, 1965.

"...I wrote to De Ridder asking him to give you 10 sets of...Shiomi compositions..."
Letter: George Maciunas to Ben Vautier, January 23, 1965.

"...There are not too many new pieces that you do not know, You have complete set of...Chieko Shiomi — you have the boxes?..."
Letter: George Maciunas to Ben Vautier, February 1, 1965.

"...Reply to your questions:...All Shiomi cards + bottle into Shiomi box...."
Letter: George Maciunas to Willem de Ridder, February 4, 1965.

"...P.S. You should print labels for...Shiomi box — reproduce my labels. I am sending a few of them. But I do not have enough of them...."
Letter: George Maciunas to Willem de Ridder, March 2, 1965.

FLUXKIT containing following fluxus-publications (also available separately) ... FLUXUS dd CHIEKO SHIOMI: events in box $3
Vacuum TRapEzoid (Fluxus Newspaper No. 5) March 1965.

"...Few comments on your 'position paper'...Furthermore Fluxus still publishes newspaper, supplements to works of...Shiomi..."
Letter: George Maciunas to Ben Vautier, [ca. October 1966].

FLUXKIT containing following fluxus-publications: (also available separately) ... FLUXUS dd CHIEKO SHIOMI: events in box $5
Vaseline sTREet (Fluxus Newspaper No. 8) May 1966.

"I got hold of a few $ & shipped out by REA a package to you: with:...Shiomi boxes..."
Letter: George Maciunas to Ken Friedman, [ca. February 1967].

FLUX-PROJECTS PLANNED FOR 1967...Chieko Shiomi:...1966 & 67 events (supplement)...
Fluxnewsletter, March 8, 1967.

events & games $4.50 by chieko shiomi
Fluxshopnews. [Spring 1967].

FLUX-PRODUCTS 1961 TO 1969 ... MIEKO SHIOMI...Events & games, boxed cards* [indicated as part of FLUXKIT] [$] 4...
Fluxnewsletter, December 2, 1968 (revised March 15, 1969).

FLUX-PRODUCTS 1961 TO 1970 ... MIEKO (CHIEKO) SHIOMI...Events & games, boxed cards [$] 4...
Flux Fest Kit 2. [ca. December 1969].

FLUXUS-EDITIONEN...[Catalogue No.] 778 MIEKO (CHIEKO) SHIOMI: events & games, boxed cards 1964
Happening & Fluxus. Koelnischer Kunstverein, 1970.

02.1964 CHIEKO SHIOMI:...events
George Maciunas, Diagram of Historical Developments of Fluxus... [1973].

MIEKO SHIOMI Events & games, boxed cards $8
Flux Objects, Price List. May 1976.

COMMENTS: This Fluxus Edition of Shiomi's scores is printed in both English and Japanese. George Maciunas planned to produce editions of a number of Fluxus artists' collected or "complete" works in boxes so that supplements could be added. In some cases, objects by that artist could be added as well. George Maciunas suggested to Willem de Ridder in 1965 that he add Shiomi's Water Music to her Events and Games boxed edition, however I have never seen a Maciunas produced Fluxus Edition of Events and Games with anything but the scores and a crumpled photographic portrait of Shiomi.

FALLING EVENT see:
SPATIAL POEM NO. 3

FILM see:
DISAPPEARING MUSIC FOR FACE

FLIPBOOK see:
DISAPPEARING MUSIC FOR FACE

FLUX ATLAS see:
SPATIAL POEM NO. 2

FLUX-RECORD

FLUX-PROJECTS PLANNED FOR 1967 ... Chieko Shiomi:...Flux-record
Fluxnewsletter, March 8, 1967.

FLUX-PRODUCTS 1961 TO 1969 ... MIEKO SHIOMI...Flux-record (to be played under running water) [$] 4
Fluxnewsletter, December 2, 1968 (revised March 15, 1969).

FLUX-PRODUCTS 1961 TO 1970 ... MIEKO (CHIEKO) SHIOMI...Flux-record [$] 5
Flux Fest Kit 2. [ca. December 1969].

"...shiomi flux record is available..."
Letter: George Maciunas to Dr. Hanns Sohm, [ca. late 1972].

COMMENTS: Although George Maciunas stated that Flux-Record was available, I have never seen one, and other than being a ready-made, don't know what it could be.

FLUX RECORD PLAYER see:
Mieko (Chieko) Shiomi and Robert Watts

MAP

PROPOSED CONTENTS FOR FLUXPACK 3 TO BE PUBLISHED IN 1973 BY FLASH ART...Map by Mieko Shiomi...100 copies signed by:...Shiomi...
[George Maciunas], Proposed Contents for Fluxpack 3. [ca. 1972].

Flash Art Editor, Giancarlo Politi, proposed to publish the 3rd Fluxyearbook, maybe to be called FLUX-PACK 3, with the following preliminary contents... Games:...map by Mieko Shiomi,...
Fluxnewsletter, April 1973.

COMMENTS: Possibly Spatial Poem No. 2 or a new project otherwise unidentified.

MAPS see:
SPATIAL POEM NO. 1
SPATIAL POEM NO. 2
MICROFILM see:
SPATIAL POEM NO. 4
OPEN EVENT see:
SPATIAL POEM NO. 5
PAPER GLIDER PROGRAMS see:
George Maciunas
POEMS see:
SPATIAL POEM NO. 1
SPATIAL POEM NO. 2
SPATIAL POEM NO. 3
SPATIAL POEM NO. 4
SPATIAL POEM NO. 5
SPATIAL POEMS
RECORD see:
FLUX-RECORD
RECORD PLAYER see:
FLUX RECORD PLAYER
SHADOW EVENT see:
SPATIAL POEM NO. 4
SHADOW PIECE II see:
EVENTS AND GAMES
SMILE FILM see:
DISAPPEARING MUSIC FOR FACE

SPATIAL POEM NO. 1
Silverman No. < 410.I, ff.

FLUXUS din CHIEKO SHIOMI: spacial [sic] poem, 70 word locations indicated by flags pinned to map board, not sold, but exchanged for objects.
Vacuum TRapEzoid (Fluxus Newspaper No. 5) March 1965.

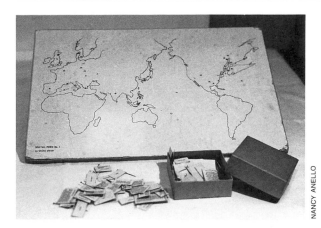

Mieko (Chieko) Shiomi. SPATIAL POEM NO. 1

NANCY ANELLO

... items are in stock, delivery within 2 weeks ...
FLUXUS d1 CHIEKO SHIOMI: spatial poem no. 1
word locations of 70 performers indicated by flags
pinned to a map board $30
Vaseline sTREet (Fluxus Newspaper No. 8) May 1966.

spatial poem 1 $30...by chieko shiomi
Fluxshopnews. [Spring 1967].

FLUX-PRODUCTS 1961 TO 1969 ... MIEKO SHIO-
MI...Spatial poem no. 1, map board with pinned flags
[$] 30...
Fluxnewsletter, December 2, 1968 (revised March 15, 1969).

FLUX-PRODUCTS 1961 TO 1970 ... MIEKO (CHI-
EKO) SHIOMI...Spatial poem no.1, map with pinned
flags [$] 40...
Flux Fest Kit 2. [ca. December 1969].

FLUX SHOW: DICE GAME ENVIRONMENT EN-
TIRE FLOOR AS DICE HAZARD TABLE DIE
CUBES, 15" CUBES ON FLOOR, Marked on sides,
top open or closed with clear plastic. Consisting or
containing...Spatial poem no. 1 by Chieko Shiomi.
ibid.

FLUXPRODUCTS PRODUCED IN 1972 & 1973...
Mieko Shiomi: Spatial poem no. 1, cork map with
flags (permanently laminated, mounted on map in
clear plastic box) $100...
Fluxnewsletter, April 1973.

03.1965 SHIOMI: Spatial poem no. 1 (collective mail
art)
*George Maciunas, Diagram of Historical Developments of
Fluxus... [1973].*

Spatial poem no. 1, cork map with flags (permanently
laminated, mounted on map in clear plastic box) $100
Fluxnewsletter, April 1975.

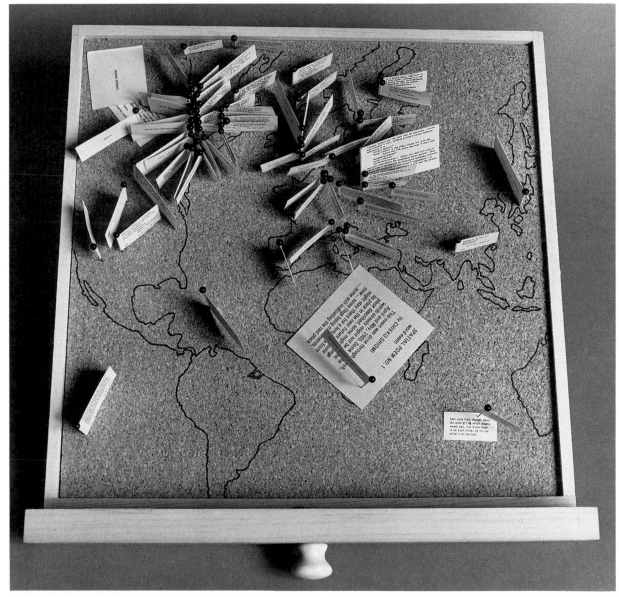

Mieko (Chieko) Shiomi. **SPATIAL POEM NO. 1**, contained in a drawer of **FLUX CABINET**

BRAD IVERSON

Mieko Shiomi: Spatial Poem no. 1, cork map with
flags (permanently laminated, mounted on map, in
clear plastic box) $100...
[Fluxus price list for a customer]. September 1975.

FLUX-PRODUCTS 1961 TO 1970 ... SOLO OB-
JECTS AND PUBLICATIONS...MIEKO (CHIEKO)
SHIOMI...Spatial poem no.1, map with pinned flags
[$] 100
ibid.

Shiomi spatial poem no:1 $100 (cork map with pin -
flags in wood 12" x 12" box)
[Fluxus price list for a customer]. January 7, 1976.

MIEKO SHIOMI...spatial poem no. 1, map & pinned
flags, wood box: $120
Flux Objects, Price List. May 1976.

COMMENTS: Chieko Shiomi sent instructions for Spatial
Poem No. 1, *described as a "Word Event," to people in many*

parts of the world: "Write a word or words on the enclosed card and place it somewhere." The information was gathered in 1965 and used for the Fluxus Edition.

SPATIAL POEM NO. 2
Silverman No. 411, ff.

"...I am sending you packages with...Shiomi spatial poem 2, which was printed as FLUXATLAS series. (I will send 30 copies)..."
Letter: George Maciunas to Ben Vautier, May 19, 1966.

... items are in stock, delivery within 2 weeks ... FLUXUSd2 CHIEKO SHIOMI: spatial poem no.2 record of various directions simultaneously faced by 56 performers, large map $3
Vaseline sTREet (Fluxus Newspaper No. 8) May 1966.

"...I mailed by parcel post - one carton with following: Quantity - 5, Item - Shiomi-spatial poem No. 2... Wholesale cost to you.each. - 30¢, suggested selling price-50¢, sub total.—wholesale cost to you.- 1.50..."
Letter: George Maciunas to Ken Friedman, August 19, 1966.

PAST FLUX-PROJECTS (realized in 1966)...Spatial Poem no. 2 by Cheko [sic] Shiomi...
Fluxnewsletter, March 8, 1967.

spatial poem 2 $1...chieko shiomi
Fluxshopnews. [Spring 1967].

FLUX-PRODUCTS 1961 TO 1969 ... MIEKO SHIOMI...Spatial Poem no. 2, folder [$] 2...
Fluxnewsletter, December 2, 1968 (revised March 15, 1969).

FLUX-PRODUCTS 1961 TO 1970 ... MIEKO (CHIEKO) SHIOMI Spatial poem no.2, folded map [$] 2...
Flux Fest Kit 2. [ca. December 1969].

05.1966...SHIOMI: spatial poem no. 2
George Maciunas, Diagram of Historical Developments of Fluxus... [1973].

MIEKO SHIOMI...Spatial poem no.2 folded map $4...
Flux Objects, Price List. May 1976.

COMMENTS: This Fluxus map is a record of Chieko Shiomi's Spatial Poem No. 2. A "direction event," the instructions for participants were "around the time listed - simultaneous - what kind of direction were you facing or moving towards?"

SPATIAL POEM NO. 3
Silverman No. > 412.I

... items are in stock, delivery within 2 weeks ... FLUXUSd3 CHIEKO SHIOMI: spatial poem no. 3 to be published late in 1966
Vaseline sTREet (Fluxus Newspaper No. 8) May 1966.

"...Other going projects:...Chieko Shiomi - spatial poem no. 3. (very large project)...."
Letter: George Maciunas to Ken Friedman, [ca. February 1967].

"...enclosed are 2 texts for Chieko's Spatial poem no. 3 which I am now preparing & designing for publication. Could you translate them into English & send them to me...."
Letter: George Maciunas to Milan Knizak, [ca. March 8, 1967 (date obscured)].

FLUX-PROJECTS PLANNED FOR 1967... Chieko Shiomi: Spatial Poem no. 3 (as a daily calender [sic] & map puzzle),...
Fluxnewsletter, March 8, 1967.

spatial poem 3 $6...by chieko shiomi
Fluxshopnews. [Spring 1967].

FLUXPROJECTS FOR 1968 (In order of priority) 1. Chieko Shiomi: Spatial Poem no. 3...
Fluxnewsletter, January 31, 1968.

FLUXPROJECTS FOR 1969 PRODUCTS - PUBLICATIONS...Printing Spatial Poem no. 3 (Jan.)
Fluxnewsletter, December 2, 1968.

FLUX-PRODUCTS 1961 TO 1969 ... MIEKO SHIOMI...Spatial poem no. 3, calender [sic], [$] 10...
Fluxnewsletter, December 2, 1968 (revised March 15, 1969).

FLUX-PRODUCTS 1961 TO 1970 ... MIEKO (CHIEKO) SHIOMI...Spatial poem no. 3, calender [sic], in 1970 [$] 11
Flux Fest Kit 2. [ca. December 1969].

...set of 1969-70 Flux-productions, which consist of the following: 1970 - Spatial poem no. 3, calender [sic] (production to be completed by mid-February)
Fluxnewsletter, January 8, 1970.

Mieko (Chieko) Shiomi. SPATIAL POEM NO. 2

Mieko (Chieko) Shiomi. SPATIAL POEM NO. 3

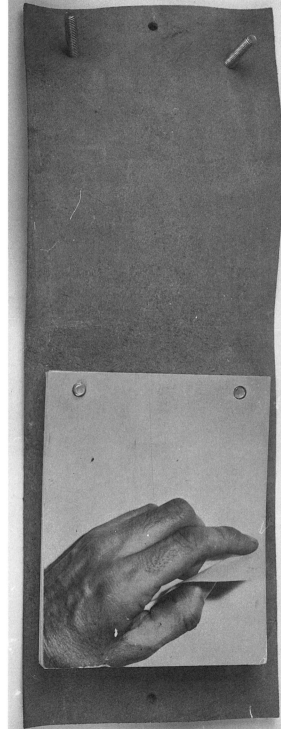

NANCY ANELLO

An open view of Shiomi's SPATIAL POEM NO. 3

"Dear Mieko;...Meanwhile I am sending in a few days Poem no. 3 (few copies) by air...since the west coast ships are still on strike (I think)...."
Letter: George Maciunas to Mieko Shiomi, [early 1972].

"You may have received by now Poem no. 3 and maybe can't figure out the way it is supposed to be hung. These are prototypes and I will change the length of the rivets, now however when hung as shown, the pages will tend to fall down (which was the original intention) about 1/3rd of the way, so you must pick up the fallen pages and hang them on the upper rivets, continuing taking off the pages till the upper rivets hold most of the pages, because they will start falling again when the upper course is full. I could use instead of longer rivets, bolts with threads which would also prevent the pages from falling down. I also will make several models with wood back or thicker leather.... I hope you like the design...."
Postcard: George Maciunas to Mieko Shiomi, March 16, 1972.

"...also her [Shiomi] Spatial poem no. 3 (a calendar which I thought I mailed to you)...would cost $10 each..."
Letter: George Maciunas to Dr. Hanns Sohm, [ca. late 1972].

FLUXPRODUCTS PRODUCED IN 1972 & 1973 ... Mieko Shiomi:...Spatial poem no. 3,(falling events) loose leaf calender [sic], mounted on leather back with pins, to be hung, not boxed $12...
Fluxnewsletter, April 1973.

1972 SHIOMI: spatial poem no. 3
George Maciunas, Diagram of Historical Developments of Fluxus... [1973].

Spatial Poem no. 3, (falling events) loose leaf calender [sic], mounted on leather back (to be hung) or boxed $15...
Fluxnewsletter, April 1975.

Mieko Shiomi:...Spatial Poem no. 3, (falling events) loose leaf calender [sic], mounted on leather back (to be hung) or boxed $15
[Fluxus price list for a customer]. September 1975.

FLUX-PRODUCTS 1961 TO 1970 ... SOLO OBJECTS AND PUBLICATIONS...MIEKO (CHIEKO) SHIOMI...Spatial poem no. 3, calender [sic], in 1970 [$] 20
ibid.

"The story on the other side is self explanatory. As a result of which I have to have eye surgery, since I hardly see anything with the left eye. In one sense, these hospital expenses to me are a windfall to any collectors of flux-objects. Now with high cost of surgery, I must make more objects and begin to respond to various orders and requests for them. Thus I am

sending by mail to you the following...Mieko Shiomi — poem no. 3 [$] 15..."
Letter: George Maciunas to Dr. Hanns Sohm, November 30, 1975.

Shiomi spatial poem no. 3 $20 (a loose leaf calendar falling event)
[Fluxus price list for a customer]. January 7, 1976.

MIEKO SHIOMI...spatial poem no. 3, calender [sic] in wood box $30...
Flux Objects, Price List. May 1976.

COMMENTS: Spatial Poem No. 3 *was produced in both a calendar-like edition and a boxed edition. Described as a "falling event," the instructions to participants for the work were: "the phenomenon of a fall is actually a segment of a movement towards the center of the earth. This very moment countless objects are falling. Let's take part in this centripetal event." Maciunas designed the calendar-like edition (see illustration) so that the sheets would continue to fall off.*

SPATIAL POEM NO. 4
Silverman No. 413

FLUXPROJECTS FOR 1968 (in order of priority) ... 9. Chieko Shiomi - Spatial poem nos. 4 & 5
Fluxnewsletter, January 31, 1968.

FLUXPROJECTS FOR 1969 ... Chieko Shiomi: Spatial poem no. 4, (graphics)...
Fluxnewsletter, December 2, 1968.

"...You can use the money for producing Poem no. 4 ...Don't you think we should produce each poem separately, but in such a form that they could be eventually combined into a single package? For instance if poem no. 4 is microfilmed on 35mm roll (for slide projector), then the same reel could be included into the final box or whatever (maybe a box with partitions for each separate poem)...."
Letter: George Maciunas to Chieko Shiomi, [early 1972].

"...also Spatial poem no. 4, which I just produced in microfilm version (shadow events), I can send both,

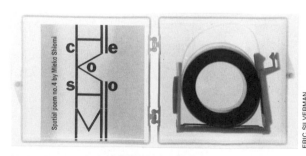

ERIC SILVERMAN

Mieko (Chieko) Shiomi. SPATIAL POEM NO. 4

both would cost $10 each...''
Letter: George Maciunas to Dr. Hanns Sohm, [ca. late 1972].

FLUXPRODUCTS PRODUCED IN 1972 & 1973 ...
Mieko Shiomi:...Spatial Poem no. 4, (shadow events) microfilm record of all events, with small 35mm viewer, boxed $20
Fluxnewsletter, April 1973.

1973 SHIOMI: spatial poem no. 4
George Maciunas, Diagram of Historical Developments of Fluxus... [1973].

Spatial Poem no. 4 (shadow events) microfilm record of all events, with small 35mm viewer, boxed $25
Fluxnewsletter, April 1975.

Mieko Shiomi:...Spatial Poem no. 4, (shadow events) Microfilm record of all events, with small 35mm viewer, boxed, $25
[Fluxus price list for a customer]. September 1975.

''The story on the other side is self explanatory. As a result of which I have to have eye surgery, since I hardly see anything with the left eye. In one sense, these hospital expenses to me are a windfall to any collectors of flux-objects. Now with high cost of surgery, I must make more objects and begin to respond to various orders and requests for them. Thus I am sending by mail to you the following...Mieko Shiomi ...poem no. 4 [$] 25...''
Letter: George Maciunas to Dr. Hanns Sohm, November 30, 1975.

Shiomi spatial poem no. 4 $30 (this is a microfilm version with a small viewer, shadow event)
[Fluxus price list for a customer]. January 7, 1976.

''Spatial poem no. 4, by Mieko Shiomi $25''
Letter: George Maciunas to Dr. Hanns Sohm, May 1, 1976.

MEIKO SHIOMI Spatial poem no. 4, microfilm with viewer, boxed $30
Flux Objects, Price List. May 1976.

COMMENTS: *Spatial Poem No. 4 was produced on microfilm with a viewer in a boxed Fluxus Edition. The work is the documentation of Chieko Shiomi's ''Shadow Event.'' Participants were instructed to ''project the shadow of the letters S H A D O W of the enclosed film.'' The documentation was then assembled for the Fluxus Edition.*

SPATIAL POEM NO. 5

FLUXPROJECTS FOR 1968 (In order of priority) ...
9. Chieko Shiomi - Spatial poem nos. 4 & 5...
Fluxnewsletter, January 31, 1968.

COMMENTS: *Spatial Poem No. 5 was Shiomi's ''Open Event'' with instructions to a participant to ''open something which is closed.'' Not produced by George Maciunas as a Fluxus Edition, this and eight other ''spatial poems'' are documented*

in Shiomi's book, Spatial Poem, *self published, Osaka, 1976.*

SPATIAL POEMS

''...Furthermore Fluxus still...[produces a] going series of Shiomi spatial poems...''
Letter: George Maciunas to Ben Vautier, [ca. October 1966].

''... Don't you think we should produce each poem separately, but in such a form that they could be eventually combined into a single package? For instance if poem no.4 is microfilmed on 35mm roll (for slide projector), then the same reel could be included into the final box or whatever (maybe a box with partitions for each separate poem)...''
Letter: George Maciunas to Mieko Shiomi, [early 1972].

COMMENTS: *Unfortunately Fluxus never produced an edition of all Shiomi's* Spatial Poems *boxed together.*

SUPPLEMENTS TO WORKS see:
 EVENTS AND GAMES

WATER MUSIC
Silverman No. 404, ff.

ddd - Chieko Shiomi: Water music, in bottle $1, will send bottles later.
European Mail-Orderhouse: europeanfluxshop, Pricelist. With holograph notes from George Maciunas to Willem de Ridder. [ca. Summer 1964].

ddd CHIEKO SHIOMI. water music, in bottle $1
Second Pricelist - European Mail-Orderhouse. [Fall 1964].

FLUXKIT containing following fluxus-publications (also available separately)... FLUXUS ddd CHIEKO SHIOMI: water music, bottled $1
Vacuum TRapEzoid (Fluxus Newspaper No. 5) March 1965.

[as above]
Vaseline sTREet (Fluxus Newspaper No. 8) May 1966.

water music $1.50...by chieko shiomi
Fluxshopnews. [Spring 1967].

FLUX-PRODUCTS 1961 TO 1969 ... MIEKO SHIOMI...Water music, bottled * [indicated as part of FLUXKIT] [$] 1...
Fluxnewsletter, December 2, 1968 (revised March 15, 1969).

FLUX-PRODUCTS 1961 TO 1970 ... MIEKO (CHIEKO) SHIOMI...Water music, bottled [$] 2...
Flux Fest Kit 2. [ca. December 1969].

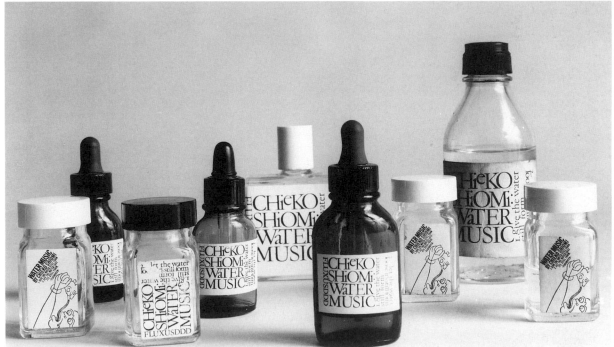

Mieko (Chieko) Shiomi. WATER MUSIC. see color portfolio

BRAD IVERSON

Mieko (Chieko) Shiomi. 1964

GEORGE MACIUNAS

FLUX SHOW: DICE GAME ENVIRONMENT EN-TIRE FLOOR AS DICE HAZARD TABLE DIE CUBES, 15'' CUBES ON FLOOR, Marked on sides, top open or closed with clear plastic. Consisting or containing...Flux water pieces. (...Shiomi,...)
ibid.

FLUXUS-EDITIONEN ... [Catalogue No.] 779 MIEKO (CHIEKO) SHIOMI: water music, bottled
Happening & Fluxus. Koelnischer Kunstverein, 1970.

COMMENTS: *This poetic Fluxus work was realized in a number of different bottles, and George Maciunas designed two separate labels for the work. Other Fluxus works using water are Carla Liss'* Sacrament Fluxkit, *Ay-O's* Flux Rain Machine, *Ben Vautier's* Dirty Water *and Nam June Paik's unrealized* Genuine Water from Dunkerque, *among others.*

WORD EVENT see:
SPATIAL POEM NO. 1

MIEKO (CHIEKO) SHIOMI and ROBERT WATTS

FLUX RECORD PLAYER

FLUX SHOW: DICE GAME ENVIRONMENT EN-TIRE FLOOR AS DICE HAZARD TABLE DIE CUBES, 15'' CUBES ON FLOOR, Marked on sides, top open or closed with clear plastic. Consisting or containing...Flux record player. (Bob Watts & Shiomi)
Flux Fest Kit 2. [ca. December 1969].

COMMENTS: *Flux Record Player was never produced as a Fluxus work. Maybe it was intended for playing Shiomi's* Flux-Record *which was to be played under water, or with Watts'* Rope Record, *a coiled rope played with different "needles," like feathers or wire.*

JACQUES SICLIER

It was announced in the first tentative plans for FLUXUS that J. Siclier or someone to be determined would contribute "Experiments in Cinema" to FLUXUS NO. 5 WEST EURO-PEAN ISSUE II.
see: COLLECTIVE

GIANNI-EMILIO SIMONETTI

Untitled

PROPOSED CONTENTS FOR FLUXPACK 3 TO BE PUBLISHED IN 1973 BY FLASH ART...Something

by Simonetti,,,100 copies signed by:...Simonetti [George Maciunas], *Proposed Contents for Fluxpack 3.* [ca. 1972].

COMMENTS: *Nothing by Gianni-Emilio Simonetti was included in* Fluxpack 3.

DON SMITHERS

It was announced in the tentative plans for the first issues of FLUXUS that Don Smithers would contribute "Renaissance instrumentation (essay & record)" to FLUXUS NO. 4 HOMAGE TO THE DISTANT PAST (later called FLUXUS NO. 5 HOMAGE TO THE PAST). see: COLLECTIVE

KURT SONDERBORG and GASTONE NOVELLI

It was announced in the Brochure Prospectus version B, that Sonderborg & Gastone Novelli would contribute "scribbles" to FLUXUS NO. 2 FRENCH YEARBOOK-BOX. see: COLLECTIVE

DANIEL SPOERRI

It was announced in the Brochure Prospectus version A, that Daniel Spoerri would edit "New Realist art (essays, original inserts)," "Art in motion," "Neo-dada," "Abstract Chirography (inserts, essay)" and "Other subjects to be determined" for FLUXUS NO. 3 FRENCH YEARBOX. In Brochure Prospectus version B, Spoerri's contribution to FLUXUS NO. 2 FRENCH YEARBOOK-BOX was to edit "Works by Arman, Cesar, Christo, Dufrene, Yves Klein, Arthur Koepcke, Rotella, Spoerri, Benjamin Vautier, Jacques de Villegle, Jean Tinguely." A performance piece, "Hommage a l'Allemagne" and an illustration of his "Fakir's spectacles" from L'Optique Moderne *appear in* Fluxus Preview Review. *Fluxus Newspaper No. 1 included a photograph of Spoerri performing a ballet.* see: COLLECTIVE

EGGCYCLOPEDIA

FLUX-PROJECTS PLANNED FOR 1967 ... Daniel Spoerri: Eggcyclopedia (maybe for 1968) *Fluxnewsletter, March 8, 1967.*

COMMENTS: *Eggcyclopedia was never produced as a Fluxus Edition. The work presumably would have had something to do with food, reflecting Daniel Spoerri's longtime involvement with that healthful pursuit.*

L'OPTIQUE MODERNE see:
Daniel Spoerri and Francois Dufrene

Daniel Spoerri, center, ca. 1955. Between 1954 and 1957 Spoerri was "premier danseur a l'opera de Berne," Switzerland

© [ca. 1955] ERISMANN

PHOTOGRAPHER NOT IDENTIFIED

Daniel Spoerri and Emmett Williams. March, 1964

MEAL VARIATION NO. 1 EATEN BY ARMAN
Silverman No. 417

1965 PUBLICATIONS AVAILABLE BY OCTOBER ...FLUXUS bo DANIEL SPOERRI: tablemat 21" x 25" full size reproduction of each variation from the "31 Variations on a meal". in 1965 the following variations will be available: Arman...Limited edition of 100, printed on linen, each tablemat, one variation $4 *Vacuum TRapEzoid (Fluxus Newspaper No. 5) March 1965.*

FLUXFURNITURE...TABLETOPS, photo-laminates, vinyl surface, ¾" board, formica edging, metal pedestal. Daniel Spoerri: from "31 variations on a meal" single variation per top, following variations available: Arman...21" x 25" size, 2 to 4 week delivery, $80.00 ...Available in N.Y.C. at Multiples and late in 1967 at FLUXSHOP, 18 GREENE ST. *Fluxfurniture, pricelist. [1967].*

FLUXUS-EDITIONEN...[Catalogue No.] 780 DANIEL SPOERRI: tabletop, silkscreen from his 31 variations on a meal (arman) *Happening & Fluxus. Koelnischer Kunstverein, 1970.*

ERIC SILVERMAN

Daniel Spoerri. MEAL VARIATION NO. 1 EATEN BY ARMAN. Tablecloth version

COMMENTS: While Daniel Spoerri was in New York in 1964, he prepared a number of meals with the help of some Fluxus friends such as Lette Eisenhauer, for a three day exhibition at the Allan Stone Gallery. Originally titled "29 Variations on a Meal" and then expanded to "31 Variations on a Meal," the work consisted of meals eaten by various artists and art world figures. Spoerri affixed the 'remains' as artworks entitled, "So Easily Made No. ..."

Photographs of the meals were taken and George Maciunas embarked on a scheme to produce both photo-laminated tabletops of the meals and tablecloths with the title Meal Variation No. ...Eaten by... "from 31 Variations on a Meal." Four Fluxus Edition tablecloths are known to have been produced: No. 1 Eaten by Arman; No. 2 Eaten by Marcel Duchamp; No. 3 Eaten by Ben Patterson; and No. 4 Eaten by Jack Youngerman. Additional meals reached production stages. In addition, photo-laminated tabletops of Meal Variations...Eaten by Duchamp, Patterson, Ferro and possibly others, were produced by Fluxus.

MEAL VARIATION NO. 2 EATEN BY MARCEL DUCHAMP
Silverman No. 418

1965 PUBLICATIONS AVAILABLE BY OCTOBER ...FLUXUS bo DANIEL SPOERRI tablemat 21"x 25" full size reproduction of each variation from the "31 Variations on a meal". in 1965 the following variations will be available:...Duchamp...Limited edition of 100, printed on linen, each tablemat, one variation $4
Vacuum TRapEzoid (Fluxus Newspaper No. 5) March 1965.

FLUXFURNITURE...TABLETOPS, photo-laminates, vinyl surface, ¾" board, formica edging, metal pedestal. Daniel Spoerri: from "31 variations on a meal" single variation per top, following variations available: ...Duchamp...21" x 25" size, 2 to 4 weeks delivery, $80.00...Available in N.Y.C. at Multiples and late in 1967 at FLUXSHOP, 18 GREENE ST.
Fluxfurniture, pricelist. [1967].

COMMENTS: Done both as a Fluxus tabletop and tablecloth.

MEAL VARIATION NO. 3 EATEN BY BEN PATTERSON
Silverman No. > 418.I and 420

1965 PUBLICATIONS AVAILABLE BY OCTOBER ...FLUXUS bo DANIEL SPOERRI tablemat 21"x 25" full size reproduction of each variation from the "31 Variations on a meal". in 1965 the following variations will be available:...Patterson...Limited edition of 100, printed on linen, each tablemat, one variation $4
Vacuum TRapEzoid (Fluxus Newspaper No. 5) March 1965.

FLUXFURNITURE...TABLETOPS, photo-laminates, vinyl surface, ¾" board, formica edging, metal pedestal. Daniel Spoerri: from "31 variations on a meal" single variation per top, following variations available:

Daniel Spoerri. MEAL VARIATION NO. 3 EATEN BY BEN PATTERSON. Tablecloth version

SCOTT HYDE

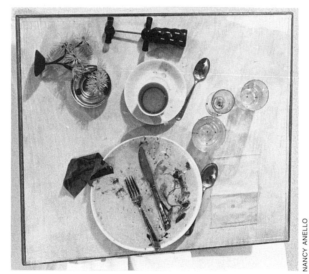

Daniel Spoerri. MEAL VARIATION NO. 3 EATEN BY BEN PATTERSON. Photo-laminated tabletop version

NANCY ANELLO

...Ben Patterson...21" x 25" size. 2 to 4 week delivery, $80.00...Available in N.Y.C. at Multiples and late in 1967 at FLUXSHOP, 18 GREENE ST.
Fluxfurniture, pricelist. [1967].

COMMENTS: Fluxus produced photo-laminated tabletop and tablecloth editions of this work.

MEAL VARIATION NO. 4 EATEN BY JACK YOUNGERMAN
Silverman No. 419, ff.

1965 PUBLICATIONS AVAILABLE BY OCTOBER ... FLUXUS bo DANIEL SPOERRI: tablemat 21" x

Daniel Spoerri. MEAL VARIATION NO. 2 EATEN BY MARCEL DUCHAMP.

ERIC SILVERMAN

Daniel Spoerri. MEAL VARIATION NO. 4 EATEN BY JACK YOUNGERMAN.

ERIC SILVERMAN

25" full size reproduction of each variation from the "31 Variations on a meal". in 1965 the following variations will be available:...Youngerman. Limited edition of 100, printed on linen, each tablemat, one variation $4
Vacuum TRapEzoid (Fluxus Newspaper No. 5) March 1965.

FLUXFURNITURE...TABLETOPS, photo-laminates, vinyl surface, ¾" board, formica edging, metal pedes-

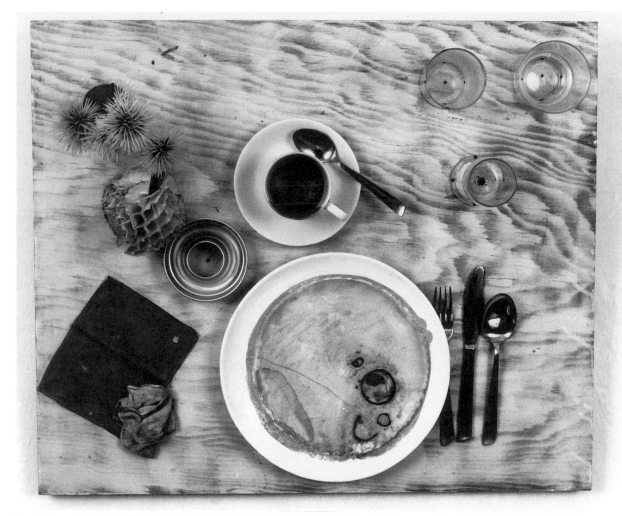

Daniel Spoerri. MEAL VARIATION NO. 4 EATEN BY JACK YOUNGERMAN. The original mounted meal from which the Fluxus Edition was made

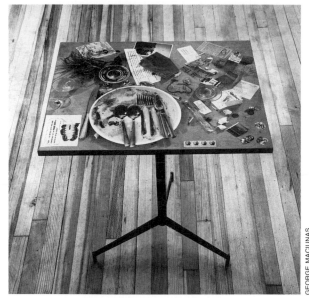

Daniel Spoerri. MEAL VARIATION NO. 7 EATEN BY FERRO. Photo-laminated tabletop with pedestal version. Photographed for promotional purposes ca. 1967

$80.00...Available in N.Y.C. at Multiples and late in 1967 at FLUXSHOP, 18 GREENE ST.
Fluxfurniture, pricelist. [1967].

COMMENTS: *This photo-laminated tabletop was made and photographed by George Maciunas for promotional purposes. Its present whereabouts is not known.*

MEAL VARIATION NO. [] EATEN BY BILLY LENNICK

FLUXFURNITURE...TABLETOPS, photo-laminates, vinyl surface, ¾.. board, formica edging, metal pedestal. Daniel Spoerri: from "31 variations on a meal" single variation per top, following variations available: ...Billy Lennick...21'' x 25'' size, 2 to 4 weeks delivery $80.00...Available in N.Y.C. at Multiples and late in 1967 at FLUXSHOP, 18 GREENE ST.
Fluxfurniture, pricelist. [1967].

COMMENTS: *Although preparatory material exists for this work, it is not known to have been produced as a Fluxus Edition tabletop.*

MEAL VARIATION NO. [] EATEN BY M. KYRBY

FLUXFURNITURE...TABLETOPS, photo-laminates, vinyl surface, ¾'' board, formica edging, metal pedestal. Daniel Spoerri: from "31 variations on a meal" single variation per top, following variations available:

tal. Daniel Spoerri: from "31 variations on a meal" single variation per top, following variations available: ...Youngerman...21'' x 25'' size, 2 to 4 week delivery, $80.00...Available in N.Y.C. at Multiples and late in 1967 at FLUXSHOP, 18 GREENE ST.
Fluxfurniture, pricelist. [1967].

COMMENTS: *This work exists as a Fluxus Edition tablecloth.*

MEAL VARIATION NO. 5 EATEN BY DANIEL SPOERRI

COMMENTS: *Preparatory materials, the photograph and a typeset title, exist for a Fluxus Edition, although I have never seen the finished work.*

MEAL VARIATION NO. 6 EATEN BY A FAMOUS MODEL

COMMENTS: *Preparatory materials, the photograph and a typeset title, exist for a Fluxus Edition, although I have never seen the finished work.*

MEAL VARIATION NO. 7 EATEN BY FERRO

FLUXFURNITURE...TABLETOPS, photo-laminates, vinyl surface, ¾'' board, formica edging, metal pedestal. Daniel Spoerri: from "31 variations on a meal" single variation per top, following variations available: ...Ferro...21'' x 25'' size, 2 to 4 week delivery,

...M. Kyrby...21" x25" size, 2 to 4 week delivery, $80.00...Available in N.Y.C. at Multiples and late in 1967 at FLUXSHOP, 18 GREENE ST.
Fluxfurniture, pricelist. [1967].

COMMENTS: *I think M. Kyrby must be Michael Kirby, the performance artist and author. A Fluxus Edition tabletop of this meal is not known to have been produced.*

MIRROR see:
MONSTERS ARE INOFFENSIVE
MONSTERS ARE INOFFENSIVE see:
Robert Filliou, George Maciunas, Peter Moore, Daniel Spoerri, and Robert Watts (for mirror, tablecloth, and tabletop versions)
Robert Filliou, Daniel Spoerri, and Roland Topor (for postcard version)
SO EASILY MADE NO. ... see:
MEAL VARIATION NO. 1 EATEN BY ARMAN
SPECTACLE COLLECTION see:
L'OPTIQUE MODERNE

TABLECLOTHS

IMPLOSIONS INC. PROJECTS...Triple partnership was formed between Bob Watts, Herman Fine and my-self [George Maciunas] to introduce into mass market ...money producing products...This business will be operated in commercial manner, with intent to make profits....connection between Fluxus collective and Implosions Inc. has not been clarified yet...we could consider at present Fluxus to be a kind of division or subsidiary of Implosions. Projects to be realized through Implosions:...Disposable paper table cloths,...
Fluxnewsletter, March 8, 1967.

NEWS FROM IMPLOSIONS, INC....Planned in 1968: ... Disposable paper table cloths, ... Spoerri, ... ready for production.
Fluxnewsletter, January 31, 1968.

COMMENTS: *Disposable paper tablecloths by Daniel Spoerri were never produced by Fluxus. Four versions of his Meal Variations silkscreened on cloth were made by Fluxus in small unnumbered editions.*

TABLECLOTHS see:
MONSTERS ARE INOFFENSIVE
TABLEMATS
TABLEMATS see:
MEAL VARIATION NO. 1 EATEN BY ARMAN
MEAL VARIATION NO. 2 EATEN BY MARCEL DUCHAMP
MEAL VARIATION NO. 3 EATEN BY BEN PATTERSON
MEAL VARIATION NO. 4 EATEN BY JACK YOUNGERMAN

TABLETOPS
Silverman No. 420

...items are in stock, delivery within 2 weeks... FLUXFURNITURE & ACCESSORIES...FLUXUSbo DANIEL SPOERRI tabletops in multiples of 21" x 25", each multiple with laminated full size photore-production of one variation from his "31 Variations on a meal". any combinations of variations available. table top with single variation $30/ tabletop with two variations $60/ tabletop with four variations $120/ metal table legs, $20
Vaseline sTREet (Fluxus Newspaper No. 8) May 1966.

"...Another new development: We are working on FLUXFURNITURE....Tables: laminated full size photos (Spoerri's 35 variations)..."
Letter: George Maciunas to Ben Vautier, August 7, 1966.

"...I don't know whether I mentioned our involve-ment now in making furniture...using photo lami-nations on table tops — like table after meal,..."
Letter: George Maciunas to Paul Sharits, [early 1966 prob-ably after April 6, 1966].

"...I would like to send you all new flux items such as furniture, but it is rather bulky...would have to ship in a crate as freight...could include Spoerri's table...if you will keep furniture then I will send [what] we already have but can't sell because they are prototypes...."
Letter: George Maciunas to Ben Vautier, August 22, 1966.

PAST FLUX-PROJECTS (realized in 1966) ... Flux-furniture: table tops by Daniel Spoerri,...
Fluxnewsletter, March 8, 1967.

table 21 x 25 $80 by Daniel Spoerri
Fluxshopnews. [Spring 1967].

PROPOSED FLUXSHOW FOR GALLERY 669, LOS ANGELES, OPENING NOV. 26, 1968 ... OBJECTS, FURNITURE a. tabletops:...(by Spoeri [sic] ...)... All table tops are photographs laminated between wood table top and vinyl surface. They require stands or legs as shown: [sketch] These pedestal type stands can be obtained from New York for $12 each, plus shipping charges. Additional table tops are in the form of photographs (unlaminated) which should be place over a table of same size and covered with glass.
Fluxnewsletter, December 2, 1968.

FLUX-PRODUCTS 1961 TO 1969 ... DANIEL SPOERRI...Tabletops in multiples of 21" x 25", each a variation from his "31 variations on a meal" laminated photograph on wood, each: [$] 60
Fluxnewsletter, December 2, 1968 (revised March 15, 1969).

FLUX-PRODUCTS 1961 TO 1970 ... DANIEL SPOERRI...Tabletops, photo-laminates, 21" x 25"

each from his 31 variations on a meal, each [$] 60
Flux Fest Kit 2. [ca. December 1969].

FLUX SHOW: DICE GAME ENVIRONMENT ... SOME FLOOR COMPARTMENTS WITH: ... Table tops by...Spoerri.
ibid.

05.1966...DANIEL SPOERRI: table tops
George Maciunas, Diagram of Historical Developments of Fluxus... [1973].

COMMENTS. *General references to a number of planned tabletops using photo-lamination, the only tabletops fully realized were* Meal Variations No.2 Eaten by Duchamp, No. 3 Eaten by Patterson *and* No. 7 Eaten by Ferro *and the joint* Monsters Are Inoffensive. *Preliminary material exists for at least 32 of Spoerri's "31 Variations on a Meal." To confuse matters further, the original preserved meals are titled* So Easily Made No.... (Silverman No. < 417.I).

TABLETOPS see:
MEAL VARIATION NO. 1 EATEN BY ARMAN
MEAL VARIATION NO. 2 EATEN BY MARCEL DUCHAMP
MEAL VARIATION NO. 3 EATEN BY BEN PATTERSON
MEAL VARIATION NO. 4 EATEN BY JACK YOUNGERMAN
MEAL VARIATION NO. 5 EATEN BY DANIEL SPOERRI
MEAL VARIATION NO. 6 EATEN BY A FAMOUS MODEL
MEAL VARIATION NO. 7 EATEN BY FERRO
MEAL VARIATION NO. [] EATEN BY BILLY LENNICK
MEAL VARIATION NO. [] EATEN BY M. KYRBY
MONSTERS ARE INOFFENSIVE
31 VARIATIONS ON A MEAL see:
TABLEMATS
TABLETOPS

DANIEL SPOERRI and FRANÇOIS DUFRENE

L'OPTIQUE MODERNE
Silverman No. 415

"...Right now Tomas Schmit stays in my place & puts full time on putting together...Spoerri's & Dufrene's book on spectacles..."
Letter: George Maciunas to Robert Watts, [March 11 or 12, 1963].

PROPOSED PROPAGANDA ACTION FOR NOV. FLUXUS IN N.Y.C. (during May - Nov. period) ...

Daniel Spoerri. 1963

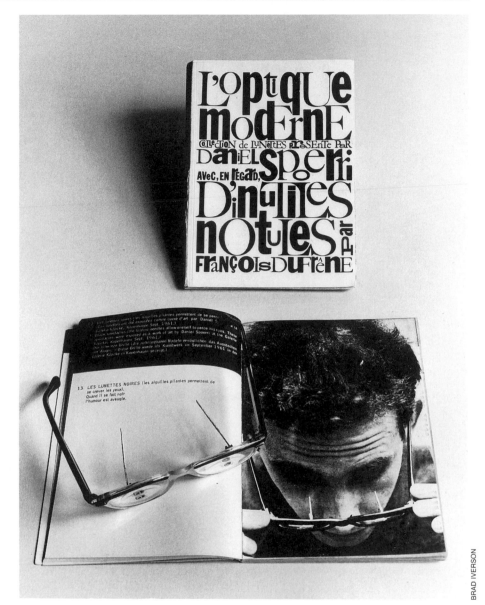

Daniel Spoerri and François Dufrene. L'OPTIQUE MODERNE with one spectacle from the collection by Daniel Spoerri. see color portfolio

Propaganda through sale of fluxus publications (fluxus...b,...): to be dispatched by end of April to N.Y.C. *Fluxus Newsletter No. 6, April 6, 1963.*

"...I have already printed Fluxus B. (Spoerri-Dufrene) & am sending 200 to New York 40 to ea: yourself, George, Dick, JML, Mekas...By fall I should have some 6 Fluxus issues...Spoerri flux (done)...Eventually I will aquire a press myself, for dealing with those stupid printers drains my patience...."

Letter: George Maciunas to Robert Watts, [ca. early April 1963].

"...We already have published Spoerri's spectacle collection..."

Letter: George Maciunas to Ben Vautier, [April 1963].

"...We are publishing...Daniel Spoerri's - spectacle collection...so that we can build up a good library of good things being done these days...."
Letter: George Maciunas to Ben Vautier, March 5, 1963.

"...We shall bring to Nice lots of Fluxus publications ...Spoerri - Dufrene book...I hope you could store them in your shop for distribution in your area..."
Letter: George Maciunas to Ben Vautier, May 26, 1963.

"...I will definitely keep large Ford because the small Citroen could just not carry all the books...I will take some 500 of each book...100 books each: London, Amsterdam, Paris, Nice, Florence...This will be quite a load to dispose. (also 100 books in your place.)..."
Letter: George Maciunas to Tomas Schmit, June 1, 1963.

"...It would have been better to have Amsterdam on 29th. & Hague on 30th. so that I would have fluxus with me for sure, but it's OK. to have Amsterdam on June 23 & Haag on 30th. I will have...Spoerri..."
Letter: George Maciunas to Tomas Schmit, [early June 1963].

"...Go to Buchna - the idiot printer, who has 700 of Spoerri books...He will ask for money etc, etc. tell him that I am now in Holland (better that he doesn't even know which country) and have asked you to pick up 300 of these books for quick delivery & that I will come in a week to pick-up the other 400...Actually he can keep the other 400 books. Dick Higgins told me they were so badly printed we could not sell them in New York. Spoerri may sell them in Paris & Vautier in Nice. So take 200 of them to Paris & 100 to Nice. OK?...In Paris get rid of the Spoerri books, etc. If you can't fit the passengers, try to wrap some suitcases on the roof. Maybe they can keep some books on the knees. You can always take fewer books to Nice. Leave in Paris all...Spoerri books if you can't fit them - though it would be good to have them...."
Letter: George Maciunas to Tomas Schmit, [2nd week of July 1963].

FLUXUS SPECIAL EDITIONS 1963-4...FLUXUSb. L'OPTIQUE MODERNE Collection de lunettes presentee par DANIEL SPOERRI avec, en regard, D'INUTILES NOTULES par Francois DUFRENE $4; luxus fluxus, in a box, 50 copies, each with one spectacle from the collection $40
Fluxus Preview Review, [ca. July] 1963.

[as above]
Daniel Spoerri, L'Optique Moderne. List on editorial page. 1963.

[as above]
La Monte Young, LY 1961. Advertisement page. [1963].

FLUXUS 1963 EDITIONS, AVAILABLE NOW FROM FLUXUS P.O. Box 180, New York 10013, N.Y. or FLUXUS 359 Canal St. New York.CO7-9198 ...FLUXUSb L'OPTIQUE MODERNE Collection de [sic] presente par DANIEL SPOERRI, avec, en regard, D'INUTILES NOTULES par Francois Dufrene, $5 (20 copies left)
Film Culture No. 30, Fall 1963.

FLUXUS 1963 EDITIONS AVAILABLE NOW... FLUXUS b L'OPTIQUE MODERNE Collection de [sic] presente par DANIEL SPOERRI, avec, en regard, D'INUTILES NOTULES par Francois Dufrene, $5 (20 copies left)
cc V TRE (Fluxus Newspaper No. 1) January 1964.

[as above]
cc V TRE (Fluxus Newspaper No. 2) February 1964.

FLUXUS 1964 EDITIONS, AVAILABLE NOW... FLUXUS b L'OPTIQUE MODERNE Collection de [sic] presente par DANIEL SPOERRI, avec, en regard, D'INUTILES NOTULES par Francois Dufrene, $5 (2 copies left)
cc Valise e TRanglE (Fluxus Newspaper No. 3) March 1964.

...Individuals in Europe, the U.S. and Japan have discovered each other's work...and have grown objects and events which are original, and often uncategorizable, in a strange new way:...Daniel Spoerri's OPTIQUE MODERNE: collection of unknown spectacles, with Dufrene's useless notes.
George Brecht, "Something About Fluxus," cc fiVe ThReE (Fluxus Newspaper No. 4) June 1964.

2-Fb L'OPTIQUE MODERNE. Collection de lunettes, presentee par DANIEL SPOERRI avec, en regard, D'Inutiles Notules par FRANCOIS DUFRENE. $5
European Mail-Orderhouse: europeanfluxshop, Pricelist. [ca. June 1964].

2-Fb L'OPTIQUE MODERNE. Collection de lunettes, presentee par DANIEL SPOERRI avec, en regard, D'Inutiles Notules par FRANCOIS DUFRENE. $5. (Out of print)
European Mail-Orderhouse: europeanfluxshop, Pricelist. With holograph notes from George Maciunas to Willem de Ridder. [ca. Summer 1964].

2-FB L'OPTIQUE MODERNE. Collection de lunettes, presentee par DANIEL SPOERRI avec, en regard, d'Inutiles notules par FRANCOIS DUFRENE. $5. OUT OF PRINT!!!
Second Pricelist - European Mail-Orderhouse. [Fall 1964].

FLUX-PRODUCTS 1961 TO 1969 ... DANIEL SPOERRI L'optique Moderne, Collection de [sic] presente par Daniel Spoerri, avec, enregard, D'inutiles notules part Francois Dufrene, (out of print)
Fluxnewsletter, December 2, 1968 (revised March 15, 1969).

FLUX-PRODUCTS 1961 TO 1970 ... DANIEL SPOERRI L'optique Moderne, book, out of print
Flux Fest Kit 2. [ca. December 1969].

COMMENTS: *Despite Dick Higgins' reported reservations about L'Optique Moderne (see Letter: George Maciunas to Tomas Schmit, 2nd week July 1963.), I find this book to be among the most beautiful published in the 1960s. Evidently Maciunas carried out his scheme to dupe the printer out of being paid, and abandoned more than half the edition. By the fall of 1963, Maciunas was advertising "20 copies left" and a few months later "2 copies left." The "luxus fluxus" edition, a copy of a book with "one spectacle from the collection," was planned. It is not known to have been distributed as such by Maciunas.*

KARLHEINZ STOCKHAUSEN

It was announced in the initial plans for the first issues of FLUXUS that K. Stockhausen would contribute " 'Originale' 'paar' etc." to FLUXUS NO. 2 WEST EUROPEAN ISSUE 1. In the next three plans for FLUXUS NO. 2 WEST EUROPEAN YEARBOOK 1, later called GERMAN & SCANDINAVIAN YEARBOX, it was announced that Stockhausen was "being consulted."

In 1964, several members of Fluxus, under the banner of Action Against Cultural Imperialism, picketed the performance of Stockhausen's "Originale" in New York City. They attacked statements attributed to Stockhausen: "jazz (Black Music) is primitive...barbaric...beat and a few simple cords ...garbage...." The group declared: "The first cultural task is publicly to expose and fight the domination of white, European — U.S. Ruling Class Art!"

KUMI SUGAI

It was announced in the Brochure Prospectus version B, that Kumi Sugai would contribute "calligraphy" to FLUXUS NO. 2 FRENCH YEARBOOK-BOX.
see: COLLECTIVE

YUJI TAKAHASHI

Unidentified Scores

Scores available by special order:...Also available are scores of works by...Yuji Takahashi.
Fluxus Preview Review, [ca. July] 1963.

COMMENTS: *I have not been able to determine what scores Fluxus planned to distribute by Yuji Takahashi, and have so far found none of his with a Fluxus copyright on them.*

BILL TARR

GROWING AIR BAG CLOSET

...This Fall, we shall publish V TRE no. 10, which shall consist of a plan for Flux-Amusement-Center, to contain the following...Bill Tarr's closets for people (...being pressed by growing air bag,...)...
Fluxnewsletter, April 1973.

COMMENTS: *This claustrophobic, environmental work was never realized by Fluxus.*

LOWERED CEILING CLOSET

...This Fall, we shall publish V TRE no. 10, which shall consist of a plan for Flux-Amusement-Center, to contain the following...Bill Tarr's closets for people (...being pressed by...lowered ceiling, etc.)...
Fluxnewsletter, April 1973.

COMMENTS: *Fluxus torture closet No. 17, fortunately audiences were spared by a chronic lack of funds.*

PING-PONG BALLS INUNDATION CLOSET

...This Fall, we shall publish V TRE no. 10, which shall consist of a plan for Flux-Amusement-Center, to contain the following...Bill Tarr's closets for people (being inundated in ping-pong balls,...)...
Fluxnewsletter, April 1973.

FLUX-AMUSEMENT-ARCADE...Bill Tarr's closet for people (being inundated in ping-pong balls) 3 x 3ft x 6ft high...
Preliminary Proposal for a Flux Exhibit at Rene Block Gallery. [ca. 1974].

Any proposals from participants should fit the maze format...Ideas should relate to passage through doors, steps, floor, obstacles, booths...Bill Tarr's ball booth...
[George Maciunas], Further Proposal for Flux-Maze at Rene Block Gallery. [ca. Fall 1974].

COMMENTS: *Ping-Pong Balls Inundation Closet was not realized as a Fluxus environmental work. The idea is similar in concept to Ay-O's* Balloon Obstacle, *which was built for the* Fluxlabyrinth *in Berlin, 1976. It is also reminiscent of a college prank.*

HOWARD TEMPLE

"Audience Piece" by Howard Temple was published in Flux Fest Kit 2, *1969.*
see: COLLECTIVE

ANDRE THOMKINS

It was announced in the Brochure Prospectus version B, that

Andre Thomkins would contribute "Osmotic painting" to FLUXUS NO. 3, GERMAN & SCANDINAVIAN YEARBOX.
see: COLLECTIVE

DAVID E. THOMPSON

FLUX PAPER GAMES: ROLLS AND FOLDS see:
Collective
PAPER EVENT JAR see:
Collective

UN ROLL
Silverman No. 422

COMMENTS: Un Roll *is a component of the Collective work,* Flux Paper Games: Rolls and Folds, *and was never offered as a separate Fluxus Edition. Un Roll was designed, printed and assembled by David E. Thompson and Paul Sharits, for inclusion in the Collective Fluxus Edition.*

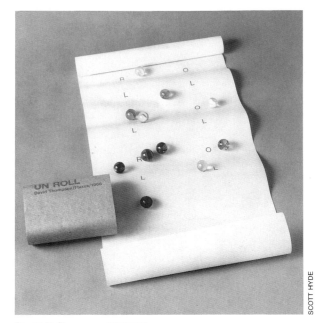

David E. Thompson. UN ROLL

JEAN TINGUELY

It was announced in the initial plan for the first issues of FLUXUS *that possibly Tinguiley [sic] would contribute "Painting Machine" to* FLUXUS NO. 5 WEST EUROPEAN ISSUE II. *"Portrait of Jean Tinguely," a photograph by Christer Christian was reproduced in Fluxus Newspaper No. 1.*
see: COLLECTIVE

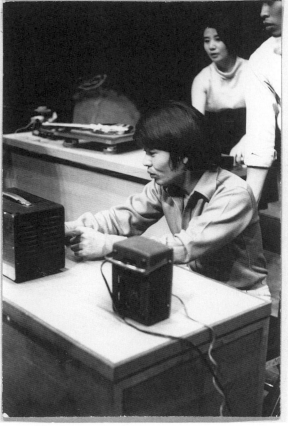

Yasunao Tone, front, with Mieko (Chieko) Shiomi and an unidentified man in performance at Nikkei Hall, Tokyo. June, 1968

YASUNAO TONE

ANAGRAM FOR STRINGS
Silverman No. > 422.101, ff.

Scores available by special order:...Yasunao Tone: Anagram for strings, $0.30
Fluxus Preview Review, [ca. July] 1963.

P-6 YASUNAO TONE: Anagram for Strings 30¢
European Mail-Orderhouse: europeanfluxshop, Pricelist. [ca. June 1964].

P-6 Yasunao TONE: anagram for strings 30¢
Second Pricelist - European Mail-Orderhouse. [Fall 1964].

COMMENTS: Anagram for Strings *was published by Fluxus using both the blueprint negative and positive process, bearing a Fluxus copyright, 1963. This score was distributed by Fluxus along with other scores produced with the same process in 1962 and 1963.*

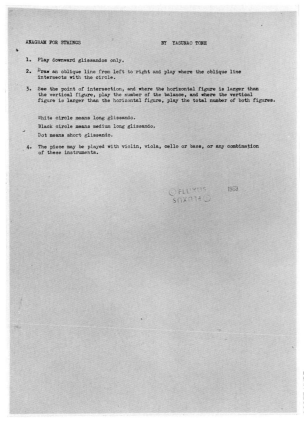

SCOTT HYDE

Yasunao Tono. ANAGRAM FOR STRINGS. Above, instructions, and to the right, the score

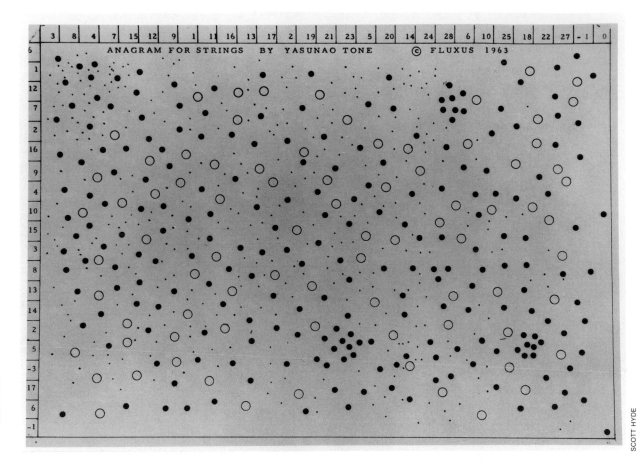

SCOTT HYDE

YOSHIAKI TONO

It was announced in some of the tentative plans for the first issues of FLUXUS that Yoshiaki Tono was being consulted for FLUXUS NO. 3 (later, FLUXUS NO. 4) JAPANESE YEARBOOK.
see: COLLECTIVE

ROLAND TOPOR

MONSTERS ARE INOFFENSIVE see:
Robert Filliou, Daniel Spoerri, and Roland Topor

FRANK TROWBRIDGE

It was announced in the Brochure Prospectus version B, that F. Trowbridge would make a contribution to FLUXUS NO. 3 GERMAN & SCANDINAVIAN YEARBOX.
see: COLLECTIVE

PER OLOF ULTVEDT

It was announced in the Brochure Prospectus version B, that Per Olof Ultvedt would contribute a work "to be determined" to FLUXUS NO. 3 GERMAN & SCANDINAVIAN YEAR-BOX.
see: COLLECTIVE

V

PIETER VANDERBEEK

5 O'CLOCK IN THE MORNING
Silverman No. > 422.201, ff.

FLUXFILMS ... FLUXFILM 17 PIETER VANDER-

BEEK - 5 o'clock in the morning, 5 min $20
Vaseline sTREet (Fluxus Newspaper No. 8) May 1966.

FLUXFILMS ... LONG VERSION, ADDITIONAL FILMS TO THE SHORT VERSION...[including] flux-number 17 Pieter Vanderbeek 5'O'CLOCK IN THE MORNING 6' High speed camera, 2000fr/sec. walnuts and rocks falling. *[camera: Peter Moore]
Fluxfilms catalogue. [ca. 1966].

PAST FLUX-PROJECTS (realized in 1966)...Flux-films: total package 1 hr. 40 min....[including] 5 o'clock in the morning by Pieter Vanderbeek,...
Fluxnewsletter, March 8, 1967.

FLUX-PRODUCTS 1961 TO 1969...FLUXFILMS, long version Winter 1966 Short version plus addition of:...[including] 5 o'clock in the morning - by Pieter Vanderbeek;...total: 1 hr. 40 min. 3600ft. 16mm only: [$] 400
Fluxnewsletter, December 2, 1968 (revised March 15, 1969).

FLUX-PRODUCTS 1961 TO 1970...FLUXFILMS long version, Winter 1966. Short version plus addition

of:...[including] 5 o'clock in the morning by Pieter Vanderbeek, ...total: 1hr. 40min. 16mm $400
Flux Fest Kit 2. [ca. December 1969].

COMMENTS: *Fluxfilm No.17, 5 O'Clock in the Morning, consists of images of rocks and nuts falling. It was shot with a high speed camera by Peter Moore. The work is included in the long version of the* Fluxfilms *package. Although offered for sale as a separate film in 1966, I have found no evidence that an individual print was made by Fluxus.*

STAN VANDERBEEK

It was announced in the Brochure Prospectus version A that "Stanley Vanderbeek" would contribute a "film flipbook (to be determined)" to FLUXUS NO. 1 U.S. YEARBOX. Brochure Prospectus, version B, lists "film flip books" for FLUXUS 1 and "16 mm film sections (luxus fluxus only)." A "classified ad" requesting film footage of any kind was placed by Vanderbeek in Fluxus Newspaper No. 1.

ACHOO MR. KEROOCHEV

FLUXUS SPECIAL EDITIONS 1963-4...FLUXUS q. STAN VANDERBEEK: FILMS:...achoo mr. keroochev (1min 45sec) $40
Fluxus Preview Review, [ca. July] 1963.

[as above]
Daniel Spoerri, L'Optique Moderne. List on editorial page. 1963.

[as above]
La Monte Young, LY 1961. Advertisement page. [1963].

COMMENTS: *The title is a reference to Nikita Krushchev, former Soviet head of state. Although presumably made by the artist, there is no evidence that a Fluxus produced edition of the film exists.*

A LA MODE

FLUXUS SPECIAL EDITIONS 1963-4...FLUXUS q. STAN VANDERBEEK: FILMS: a la mode (b.w. 7min) $50...
Fluxus Preview Review, [ca. July] 1963.

[as above]
Daniel Spoerri, L'Optique Moderne. List on editorial page. 1963.

[as above]
La Monte Young, LY 1961. Advertisement page. [1963].

COMMENTS: A La Mode *is not known to have been produced or distributed by Fluxus.*

MANKINDA

FLUXUS SPECIAL EDITIONS 1963-4...FLUXUS q. STAN VANDERBEEK: FILMS:...mankinda (b.w.

10min) $125...
Fluxus Preview Review, [ca. July] 1963.

[as above]
Daniel Spoerri, L'Optique Moderne. List on editorial page. 1963.

[as above]
La Monte Young, LY 1961. Advertisement page. [1963].

COMMENTS: Mankinda, *a sarcastic title appropriate to Fluxus, is not known to have been produced or distributed as a Fluxus Edition.*

READY MADE

Silverman No. > 422.301, ff.

FLUXYEARBOX 2, May 1968...19 film loops by: [including] ...Stan Vanderbeek...
Flux Fest Kit 2. [ca. December 1969].

COMMENTS: *George Maciunas included various ready-made films in different assemblings of* Flux Year Box 2, *assigning them to Stan Vanderbeek. A key to these films is an ad that Vanderbeek placed in Fluxus Newspaper No. 1, January, 1964: "i am looking all the time for movie film, home movies, newsreels, leftovers from other movies, old time movies, new time movies...in almost any condition, i will come and take it away anywhere, anytime...."*

WHAT WHO HOW

FLUXUS SPECIAL EDITIONS 1963-4...FLUXUS q. STAN VANDERBEEK: FILMS:...what who how (b.w. 9min) $100...
Fluxus Preview Review, [ca. July] 1963.

[as above]
Daniel Spoerri, L'Optique Moderne. List on editorial page. 1963.

[as above]
La Monte Young, LY 1961. Advertisement page. [1963].

COMMENTS: *This film is not known to have been produced or distributed by Fluxus.*

WHEEEEELS NO. 2

FLUXUS SPECIAL EDITIONS 1963-4...FLUXUS q. STAN VANDERBEEK: FILMS:...wheeeeels no. 2 (b.w. 5min) $85...
Fluxus Preview Review, [ca. July] 1963.

[as above]
Daniel Spoerri, L'Optique Moderne. List on editorial page. 1963.

[as above]
La Monte Young, LY 1961. Advertisement page. [1963].

COMMENTS: *This film is not known to have been produced or distributed by Fluxus.*

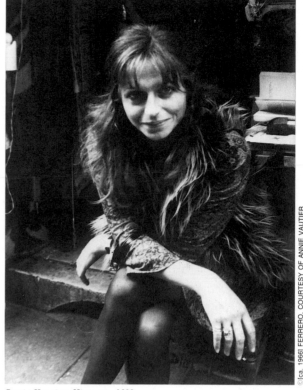

© [ca. 1966] FERRERO, COURTESY OF ANNIE VAUTIER

Annie Vautier. Nice, ca. 1966

ANNIE VAUTIER

FLUX MOBILE

"Now I can reply to your letter with suggestions for various Flux items. THEY ARE ALL GREAT!!! I will print labels for them all...flux mobile - (seeds.) VERY GOOD! by Ben or Annie?..."
Letter: George Maciunas to Ben Vautier, August 7, 1966.

"...I am going ahead with labels. Questions...Fluxmobile by Annie - no last name?...this is the way these will be printed unless you correct me in 4 days..."
Letter: George Maciunas to Ben Vautier, [ca. August 1966].

"... I am just completing labels for your box ideas like flying bullet (1/1000000 sec. exposure) for mobile (which is very slow)..."
Letter: George Maciunas to Ben Vautier, August 22, 1966.

COMMENTS: *The concept of using seeds to represent growth and time were also incorporated by Maciunas into Ken Friedman's* A Flux Corsage *in late 1966. By 1967, both seeds and the bullet label intended for Vautier's* Flux Mobile *were used by Maciunas for Robert Watts'* Flux Time Kit. *Unfortunately,* Flux Mobile *was never produced by George Maciunas as a Fluxus Edition.*

Il n'est pas nécessaire de venir. Pourtant sachez que Annie expose, du 7 au 13 Décembre 1967, quelques pots de fleurs à la Galerie BEN DOUTE DE TOUT. Elle les arrosera tous les soirs.
Les fleurs ne sont pas en vente.
Annie.

It is not necessary to come. Yet please be informed that Annie shall expose some pots of flowers at the Galerie BEN DOUBTS EVERYTHING from the 7 th to the 13 th of December 1967. She shall water them every day.
The flowers are not on sale.
Annie.

BEN VAUTIER

Annie Vautier realized an aspect of her **FLUX MOBILE** at Galerie Ben Doute de Tout. Nice, 1967

BEN VAUTIER

ABSENCE OF ART IS ART see:
FLUXCERTIFICATES

AESTHETICS

''...Few comments on your 'position paper'...your definition of Fluxus is excellent. I agree with your position fully...You also mention that it would not be in my range to publish your MSS on Aesthetics ... How do you know?...Could print your aesthetics in

V TRE like the essays of Brecht, N.J. Paik etc....''
Letter: George Maciunas to Ben Vautier, [ca. October 1966].

COMMENTS: Aesthetics *was first published in 1962 as a small pamphlet titled* Manifest de l'Art. *Ben Vautier republished the work in 1965, giving it its present title. In 1966, George Maciunas suggested publishing it in English in one of the Fluxus newspapers, however this was never done. An expanded version was included in* Textes Theoriques Tracts 1960-1974, *edited by Giancarlo Politi.*

ANYTHING BOX see:
FLUXANYTHING BOX
ARMOIRE see:
COMPLETE WORKS

ASSHOLES WALLPAPER
Silverman No. 278

NEWS FROM IMPLOSIONS, INC...Planned in 1968: ...More posters, including ''Wall-paper poster'' or poster that can be pasted in multiples, like wall-paper: ...close-up view of buttock...
Fluxnewsletter, January 31, 1968.

PROPOSED CONTENTS FOR FLUXPACK 3 TO BE PUBLISHED IN 1973 BY FLASH ART ... posters 24x34...assholes by Ben Vautier...Cost Estimates: for 1000 copies...posters [5 designs], games $700 ... 100 copies signed by:...Vautier...
[George Maciunas], Proposed Contents for Fluxpack 3. [ca. 1972].

Ben Vautier, brushing his teeth after eating **FLUX MYSTERY FOOD**, George Maciunas is looking on, during "Festival D'Art Total et du Comportement," in Nice. July, 1963. This photo was cropped and used for the label of smaller cans of **FLUX MYSTERY FOOD**

BUZZ SILVERMAN

Ben Vautier. ASSHOLES WALLPAPER

...to produce the Flash Art FLUXPACK 3....the contents at present will be as follows: Posters, wallpaper: ...ass holes by Ben Vautier...
Letter: George Maciunas to Giancarlo Politi, n.d. Reproduced in Fluxnewsletter, April 1973.

Flash Art editor, Giancarlo Politi, proposed to publish the 3rd Fluxyearbook, maybe to be called FLUX-PACK 3, with the following preliminary contents:... poster, signs, or wallpaper (...assholes by Ben Vautier ...)...
Fluxnewsletter, April 1973.

COMMENTS: Ben Vautier, with Jon Hendricks, 1984:
B.V.: "Poster Assholes, what is this?"
J.H.: "That's the wallpaper, really."
B.V.: "But that's not my wallpaper, that was Yoko Ono. My asshole photo was a visible asshole, Yoko's was just the ass not the hole. So I would say the posters were not my assholes."
J.H.: "I understand. It's also listed as a Maciunas piece."
B.V.: "As Paik says, Maciunas was an asshole fan. He loved going to toilets."
 The images on Assholes Wallpaper are two stills from Yoko Ono's Film No. 4. It is included in Fluxpack 3. Although in the past I have attributed it to Maciunas, he credited Vautier and once, Watts (in an unpublished letter to Gino Di Maggio, editor of Multhipla which distributed Fluxpack 3).

PHOTOGRAPHER NOT IDENTIFIED

Ben Vautier. 1963

ATLAS see:
FLUX SHOP LOCATIONS (ATLAS)

AUDIENCE PIECE NUMBER 5
Silverman No. < 461.I

APR. 18-24: TICKETS BY JOHN LENNON + FLUX-TOURS Selling to the public...tickets to locked up theatre (Ben Vautier);...
Schedule of events for Fluxfest presentation of John Lennon and Yoko Ono. [ca. April 1970]. version B

FLUXFEST PRESENTATION OF JOHN LENNON & YOKO ONO +* AT 80 WOOSTER ST. NEW YORK --1970...APR. 18-24: TICKETS BY JOHN LENNON + FLUXTOURS...Audience piece no. 5 (Ben Vautier) tickets to locked up theatre...
all photographs copyright nineteen seVenty by peTer mooRE (Fluxus Newspaper No. 9) 1970.

COMMENTS: The score as published in Fluxfest Sale reads:
 AUDIENCE PIECE NO. 5, 1964 Tickets are to be sold
 between 8 & 9 PM. At 9 PM announcement is made that
 the play has already started and will end at 12PM, yet at
 no time will the audience be admitted.
 A unique work titled Fluxus Piece 1965: Nobody Is Ad-

mitted In *(Silverman No. < 433.IV)* is a signed and titled photograph ready-made version of the concept of "Audience Piece No. 5, 1964."
 On June 16, 1966, Ben Vautier realized "Personne" at a theater in Nice. The audience was barred from entering. George Maciunas published the ticket for the John and Yoko Fluxfest in 1970 based on the score.

ADMIT 2 APRIL 30 — AUDIENCE PIECE ★NUMBER 5★ BY BEN VAUTIER AT 80 WOOSTER STREET·8:50PM — a flux·tour TICKET

Ben Vautier. AUDIENCE PIECE NUMBER 5

BALL GAMES
"...Meanwhile think about objects that I could produce...ball games...etc. OK?..."
Letter: George Maciunas to Ben Vautier, May 19, 1966.

COMMENTS: Ben Vautier doesn't remember ever sending suggestions for Ball Games to George Maciunas to be made as a Fluxus Edition.

BEN'S LITANY see:
I BEN SIGN

BEN VAUTIER CERTIFIES THIS TO BE A WORK OF FLUXART
Silverman No. > 441.IV

Ben Vautier. The die for BEN VAUTIER CERTIFIES THIS TO BE A WORK OF FLUXART

FLUX - PROJECTS PLANNED FOR 1967 ... Ben Vautier...Flux-art certificates (rubber stamp and seal) ...Collective projects: (All are invited to submit ideas and participate, ideas can be either ready pictorial ma-

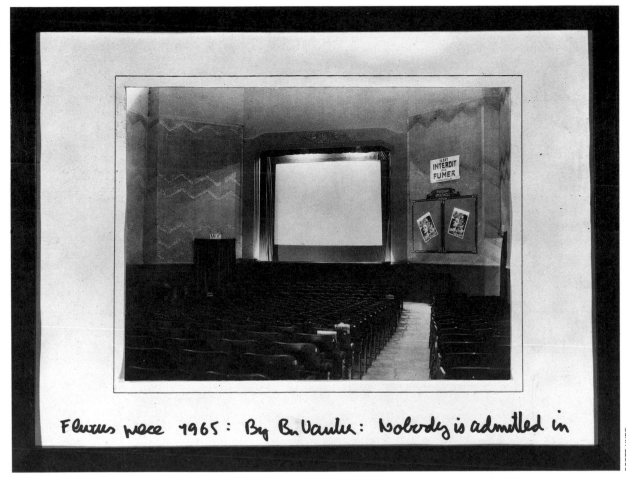

SCOTT HYDE

Fluxus piece 1965: By Ben Vautier: Nobody is admitted in

Ben Vautier. FLUXUS PIECE 1965: NOBODY IS ADMITTED IN. A titled ready-made version of the concept for AUDIENCE PIECE NUMBER 5

terial or just specified material which we have to find, produce or obtain otherwise)...Flux-postal kit: containing ... cancellation stamps,...
Fluxnewsletter, March 8, 1967.

IMPLOSIONS, INC. PROJECTS...Triple partnership was formed between Bob Watts, Herman Fine and myself [George Maciunas] to introduce into mass market ...money producing products...This business will be operated in commercial manner, with intent to make profits....connection between Fluxus collective and Implosions Inc. has not been clarified yet...we could consider at present Fluxus to be a kind of division or subsidiary of Implosions. Projects to be realized through Implosions:...stamps (same as Flux-post kit)...
ibid.

"...I am mailing today 2 rubber seals (like post office circular cancellation stamps)...Ben Vautier — 'BEN

VAUTIER CERTIFIES THIS TO BE A WORK OF FLUXART' just thought to stamp here...."
Letter: George Maciunas to Ben Vautier, March 25, 1967.

[component of] flux post kit $7
Fluxshopnews. [Spring 1967].

FLUXPROJECTS REALIZED IN 1967:...Rubber postal stamps by Ken Friedman & Ben Vautier
Fluxnewsletter, January 31, 1968.

FLUX-PRODUCTS 1961 TO 1969...FLUXPOST KIT 1968 ... [including] rubber stamp by ... Ben Vautier,...[$] 8 Version without rubber stamps [$] 2
Fluxnewsletter, December 2, 1968 (revised March 15, 1969).

FLUX-PRODUCTS 1961 TO 1970 ... FLUXPOST KIT, 1968: ... [including] rubber stamp by ... Ben Vautier...$8
Flux Fest Kit 2. [ca. December 1969].

FLUXUS-EDITIONEN...[Catalogue No.] 718 FLUX-POST KIT, 1968 (... b. vautier,...)
Happening & Fluxus. Koelnischer Kunstverein, 1970.

COMMENTS: *Ben Vautier, 1984: "My seals were numerous. After [Daniel] Spoerri's* Attention oeuvre d'art *[a rubber-stamp Spoerri used to stamp ready-made objects], I said,* Partie du tout a Ben *[Part of Ben's Everything]."*
 The *Ben Vautier Certifies This to Be a Work of Fluxart* rubberstamp was produced by *Fluxus in early 1967 and was included in the Collective* Flux Post Kit 7. *The stamp is a free translation of Vautier's* Partie du tout a Ben *sign dating originally from 1960, and certificate (Silverman No. > 426.II) made for the Fluxus Festival in Nice, 1963. In 1966, James Riddle made the rubberstamp* Everything, *which was produced the following year by Maciunas for* Flux Post Kit 7.

BLACK BOX
Silverman No. < 423,IV, ff.

"...I did not receive yet...Black Boxes, I will get them soon I suppose...."
Letter: George Maciunas to Ben Vautier, [ca. June, before July 1, 1965].

NANCY ANELLO

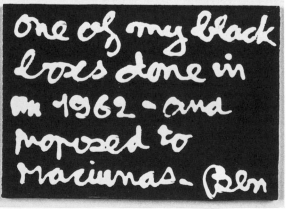

One of my black boxes done in in 1962 - and proposed to maciunas. Ben

NANCY ANELLO

Ben Vautier. BLACK BOX. The 1962 prototype and a plaque about the work from 1984

COMMENTS: *Ben Vautier proposed making* Black Boxes *with nothing on them* Le Boite noir vide [Empty Black Box], *then doing black boxes with inscriptions. Eventually Ben did 12 black boxes as an element of several concepts such as mystery, holes, god, etc. for La Cedille Qui Sourit. The idea comes from the early 1960s. It was never sent to Maciunas and not done as a Fluxus Edition.*

BOITE MYSTERE see:
MYSTERY BOX
CAR see:
FLUX CAR

CARD GAME

"...Meanwhile think about objects that I could produce,...card games...etc. OK?..."
Letter: George Maciunas to Ben Vautier, May 19, 1966.

"...Your card game idea sounds very good! Please work on it & send to me. If you like, we can add funny but related pictorial matter each card. We can do it in Winter..."
Letter: George Maciunas to Ben Vautier, August 7, 1966.

FLUX-PROJECTS PLANNED FOR 1967...Ben Vautier...card game,...
Fluxnewsletter, March 8, 1967.

COMMENTS: *Ben Vautier, 1984: "I never thought of card games."*
In Maciunas' notes there is a description of a Ben Vautier card game with 54 cards and 2 to 10 players. The cards would have instructions such as 'Turn Lights Off,' 'Stand on Table' printed on them.

CARD GAMES see:
MISSING CARD DECK
CATALOGUE see:
FLUX CATALOGUE
CERTIFICATES see:
ABSENCE OF ART IS ART
BEN VAUTIER CERTIFIES THIS TO BE A
 WORK OF FLUXART
FLUX CERTIFICATES
KICK IN THE PANTS CERTIFICATE
LIVING FLUXSCULPTURE
PARTIE DU TOUT A BEN
TIME CERTIFICATE

CHESS SETS

"...Meanwhile think about objects that I could produce, chess sets...etc. OK?..."
Letter: George Maciunas to Ben Vautier, May 19, 1966.

COMMENTS: *Never done by Ben Vautier and not known to have been produced by George Maciunas as a Fluxus Edition.*

CLOCK see:
FLUX CLOCK
COLORS see:
FLUX COLORS

COMPLETE WORKS

"We are now in process of printing the French FLUX-US which includes many of your very nice pieces - the 'holes' terraine vague' - vomit bottles, a box of god, etc. etc. In fact I like your things so much I think we should print a special Fluxus edition of your works only - a kind of expandable - yearly additive 'complete works of Ben Vautier' Fluxus box. We are publishing such 'solo' boxes of George Brecht, Emmett Williams, Daniel Spoerri's - spectacle collection, Ben Patterson & few others. I think you should certainly join these Fluxus 'soloists' - so that we can build up a good library of good things being done nowadays. Fluxus finances all publication, so you do not have to pay anything. You get 50% of profits from sales in exchange for exclusive rights you give to Fluxus, i.e. no other publisher should publish your works without our mutual agreement, since all Fluxus materials are copyrighted...."
Letter: George Maciunas to Ben Vautier, March 5, 1963.

"...I enclose 2 newsletters which I meant to send earlier. The first one (no. 5) concerns proposal to print your works in a separate edition (continually renewable and expandable) I have several of your things you sent for French Fluxus via Spoerri who is editing it. I can reuse this material for your 'solo' edition. So please send your other compositions etc. as soon as possible...."
Letter: George Maciunas to Ben Vautier, [April 1963].

"...I got a weighty letter & works from you, which I was very pleased to receive. First, quick questions:
1. Is it alright with you if we type-set all your text? or do you prefer facsimile reproduction of your handwriting?
2. Can you send English text as well as French? We would like to publish all text in 2 languages and there is no one up here knowing both languages as well as you do. We could type-set all text & send a proof to you which you could proof-read & translate to English, OK?
3. By all means, please send me your recent work also & photographs. To save on postage, you could send text only, and keep photographs for the time when we arrive to Nice. ..."
Letter: George Maciunas to Ben Vautier, [May 1963].

"...We can discuss your solo box in Nice. We would print it in New York, since D. Higgins has all printing equipment & will obtain soon an offset press, which we can use for Fluxus publications. It will be much more economical to print all planned books etc. on our own equipment. We should definitely include actual objects in your solo-box, but maybe in special editions only which can be sold for more..."
Letter: George Maciunas to Ben Vautier, [May 1963].

"...By separate mail I am sending:...some 10 kg. of text from Ben Vautier...i just received...Please type it...without margin but with carbon copy, so we can send him for proofreading, he will then also send english translation...."
Letter: George Maciunas to Tomas Schmit, [between May 15-26, 1963].

"...Vautiers stuff...when you type it, be sure not to type same thing twice, I have taken as many duplicates as I noticed but may have missed a big number..."
Letter: George Maciunas to Tomas Schmit, May 26, 1963.

"...Your works are being typeset & we will mail proofs by June 8. I think I wrote in my last letter, that we could print your solo book in New York...."
Letter: George Maciunas to Ben Vautier, May 26, 1963.

"In regards to Fluxus copyrights etc. on your works. I think no one will object to your special publications of 100 copies of some works. In fact you could note that they are Fluxus SSS or SSSS or SSSSS publication. Assuming we assign letter 'S' to all your works publications etc. For instance Nam June Paik has 'g' for his first publication, then 'gg' for 2nd, ggg for 3rd, gggg, ggggg, ggg--etc-- Under same system you could send out original texts, objects to limited mailing list. You could choose various letter combinations starting with S - ad infinitum. Say - 1st mailing to be Fluxus SMXOV then SXMVO then SVOMX etc, etc. infinite number of combinations. Anything starting with S (or any other letter, maybe you prefer 'V'?) would indicate as your Fluxus number (or rather letter).... Have your English text ready by July 27 — that's a dead line very dead. We shall have it type-set in August & September and then print the whole book Oct-Dec. in New York OK? Also have all photographs ready by July 27 so I can take them with me. We shall use some of your handwriting in the book, especially the large ones..."
Letter: George Maciunas to Ben Vautier, [late May/early June, 1963].

"...Dec. to March - we should print lots of materials in Dicks shop. (...Vautier etc.)..."
Letter: George Maciunas to Tomas Schmit, [before June 8, 1963].

"...quick answer and remarks...Vautier on special paper with carbon copy is OK...."
Letter: George Maciunas to Tomas Schmit, [mid June 1963].

FLUXUS SPECIAL EDITIONS 1963-4...FLUXUS s. BEN VAUTIER: COMPLETE WORKS $?
Fluxus Preview Review, [ca. July] 1963.

FLUXUS 1963 EDITIONS, AVAILABLE NOW FROM FLUXUS P.O. Box 180, New York 10013, N.Y. or FLUXUS 359 Canal St. New York.CO7-9198 ... FLUXUS 1964 EDITIONS: ...FLUXUSnn BEN VAUTIER: complete works $8...
Film Culture No. 30, Fall 1963.

FLUXUS 1964 EDITIONS: ... FLUXUS nn BEN VAUTIER complete works $8...Most materials originally intended for Fluxus yearboxes will be included in the FLUXUSccV TRE newspaper or in individual boxes.
cc V TRE (Fluxus Newspaper No. 1) January 1964.

FLUXUS 1964 EDITIONS: ... FLUXUS nn BEN VAUTIER: complete works $8...
cc V TRE (Fluxus Newspaper No. 2) February 1964.

"...Your book 'Everything' maybe I could print it here cheaper & design it for you. Let me know how many pages etc. & I will tell you the cost. I could share the cost with you 50%...."
Letter: George Maciunas to Ben Vautier, [ca. Summer 1965].

"...I am mailing all the new boxes and extra labels I printed...Also got a label for your box that could contain your complete compositions (on cards like: Brecht, Watts, Shiomi etc) ... a few comments about your position paper...furthermore Fluxus still publishes newspaper, supplements to works of...yourself eventually..."
Letter: George Maciunas to Ben Vautier, [ca. October 1966].

COMMENTS: *Ben Vautier, 1984: "Would have been — complete works/complete Ben — Ben Dieu, chest, [L'armoire d'Arman], Moi Ben je signe:'*

Vautier's collected works, Ben Dieu had already been self-published by the time discussions had begun for a Fluxus edition of Complete Works. The Fluxus edition would presumably have been published in English and expand on Ben Dieu. Vautier developed the idea further by assembling an armoire of objects and texts which he planned to ship to Maciunas — an enormous flux kit of Vautier's Complete Works, but too heavy and expensive to ship to New York. Later, Vautier traded this armoire with Arman for an offset machine. L'armoire d'Arman is now in the Stedelijk Museum, Amsterdam. By the summer of 1965, Vautier was still assembling his collected writings and documentation for a work to be called Everything, *which Maciunas offered to print and design in New York. It was published by Vautier in 1970 as* Ecrit pour la gloire a force de tourner en rond et d'etre jaloux. *see:* Flux Catalogue, Special Issue of V TRE *and* Vautier Kit.

COMPLETE WORKS see:
FLUX CATALOGUE
FLUX SHOP LOCATIONS (ATLAS)

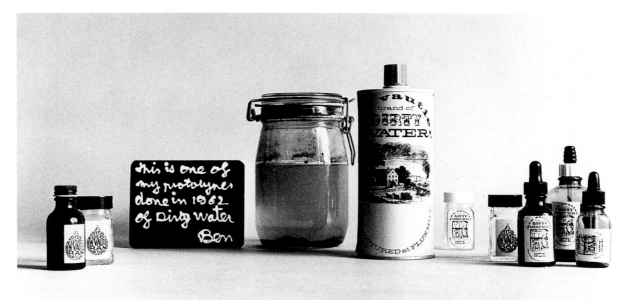

Ben Vautier. DIRTY WATER. see color portfolio

BRAD IVERSON

SPECIAL ISSUE OF V TRE see:
VAUTIER KIT
DECLARATIONS see:
FLUX DECLARATIONS
JE SIGNE TOUT
DICTIONARY see:
FLUX CATALOGUE

DIRTY WATER
Silverman No. 427, ff.

"...We want to...sell your bottled dirty water (in labeled wine bottles)...(by mail & through exhibits). So any money coming from these sales would be yours... Dirty water...in wine bottles,- water from bath water, dish water etc etc. OK?..."
Letter: George Maciunas to Ben Vautier, February 6, 1964.

"...I will send one attache case to De Ridder, which will contain miniature FLUXSHOP (with 2 things of yours: dirty water - small bottle..."
Letter: George Maciunas to Ben Vautier, June 12, 1964.

...Individuals in Europe, the U.S. and Japan have discovered each other's work...and have grown objects and events which are original, and often uncategorizable in a strange new way:...Ben Vautier's bottle of Dirty Water...
George Brecht, "Something About Fluxus," cc fiVe ThReE (Fluxus Newspaper No. 4) June 1964.

FLUXUS 1964 EDITIONS, AVAILABLE NOW ... FLUXUS n series, ITEMS FROM BEN VAUTIER... FLUXUS no DIRTY WATER, in 1 or 2 oz. bottles 50¢ in wine bottles $1, in gallon bottles $2 in 5 gallon containers $6
cc Valise e TRanglE (Fluxus Newspaper No. 3) March 1964.

FLUXKIT containing following fluxus-publications: (also available separately) ... FLUXUS ni BEN VAUTIER: dirty water, 2 oz. bottle $1
cc fiVe ThReE (Fluxus Newspaper No. 4) June 1964.

Fn-o DIRTY WATER in 1 or 2 oz. bottles 50¢, in wine bottles $1 in gallon bottles $2, in 5 gallon containers $6
European Mail-Orderhouse: europeanfluxshop, Pricelist. [ca. June 1964].

Fn-o BEN VAUTIER... [as above]
Second Pricelist - European Mail-Orderhouse. [Fall 1964].

FLUXKIT containing following flux-publications: ... dirty water, 2 oz. bottle,...of Ben Vautier
ibid.

FLUXKIT containing following fluxus-publications: (also available separately) ... FLUXUS ni BEN VAUTIER: dirty water, 2 oz. bottle $1
Vacuum TRapEzoid (Fluxus Newspaper No. 5) March 1965.

BEN VAUTIER FLUXUS ni DIRTY WATER 2oz. bottle, $1, 1 qt. bottle, $5
ibid.

FLUXKIT containing following fluxus-publications: (also available separately) ... FLUXUS ni BEN VAUTIER: dirty water, 2oz. bottle $1
Vaseline sTREet (Fluxus Newspaper No. 8) May 1966.

dirty water $1.50...by ben vautier
Fluxshopnews. [Spring 1967].

FLUX-PRODUCTS 1961 TO 1969...BEN VAUTIER ...Dirty water, bottled * [indicated as part of FLUX-KIT] [$] 2
Fluxnewsletter, December 2, 1968 (revised March 15, 1969).

FLUX-PRODUCTS 1961 TO 1970...BEN VAUTIER ...Dirty water, bottled [$] 3...
Flux Fest Kit 2. [ca. December 1969].

FLUX SHOW: DICE GAME ENVIRONMENT EN-TIRE FLOOR AS DICE HAZARD TABLE DIE CUBES, 15" CUBES ON FLOOR, Marked on sides, top open or closed with clear plastic. Consisting or containing...Flux water pieces. (...Vautier)
ibid.

FLUXUS-EDITIONEN...[Catalogue No.] 787 BEN VAUTIER dirty water, bottled
Happening & Fluxus. Koelnischer Kunstverein, 1970.

"...dirty water is still available but I am afraid to mail liquids by mail..."
Letter: George Maciunas to Dr. Hanns Sohm, [ca. late 1972].

03.1964...BEN VAUTIER:...dirty water,...
George Maciunas, Diagram of Historical Developments of Fluxus... [1973].

BEN VAUTIER...Dirty water, bottled $5
Flux Objects, Price List. May 1976.

COMMENTS: *Ben Vautier made his first* Dirty Water *on December 7, 1961, and the following year made several others. The idea of doing a Fluxus Edition of* Dirty Water *was probably proposed to George Maciunas in 1963, and manufactured by Fluxus in 1964.*

DISEASED FACE MASK

"...to produce the Flash Art FLUXPACK 3...contents at present will be as follows:...Masks:...diseased face by Ben Vautier,..."
Letter: George Maciunas to Giancarlo Politi, n.d. Reproduced in Fluxnewsletter, April 1973.

COMMENTS: *Ben Vautier 1984: "Not mine. I sent photos of* Illness. *I signed* Illness *and* Death, *and I sent photos out of a medical book."*

DISQUE DE MUSIQUE TOTAL
Silverman No. > 426.V

"...The Flux-kit will be sent free to you also. ONLY

PLEASE! send 100 copies of your part in the book. We ran out of...record labels, so we have NOTHING FROM YOU TO PUT IN FLUXUS!!! So please send a quantity of your contribution. Send anything you like...."
Letter: George Maciunas to Ben Vautier, January 23, 1965.

COMMENTS: *Ben did both covers for records and labels (for middle of records). You can put the labels on any record.* Disque de musique total *is included in some copies of* FLUX-US 1 *and Vautier's* Ben Dieu.

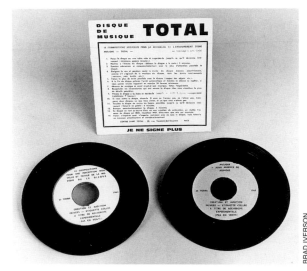

Ben Vautier. DISQUE DE MUSIQUE TOTAL

BRAD IVERSON

EGG see:
 FLUX EGG
EVERYTHING see:
 BEN VAUTIER CERTIFIES THIS TO BE A
 WORK OF FLUXART
 FLUX CATALOGUE
 FLUX SHOP LOCATIONS (ATLAS)

FALSE FLUXBOX

"Now I can reply to your letter with suggestions for various Flux items. THEY ARE ALL GREAT!!! I will print labels for them all. False Fluxbox by Ben....."
Letter: George Maciunas to Ben Vautier, August 7, 1966.

COMMENTS: *Ben Vautier, 1984: "I was interested in the idea of falseness."*
 This work was never produced as a Fluxus Edition by George Maciunas.

50 DIFFERENT WAYS TO READ A PAGE
see:
 FIFTYEIGHT PROPOSITIONS FOR ONE PAGE

FIFTYEIGHT PROPOSITIONS FOR ONE PAGE
Silverman No. 439

"The story about Dick Higgins, is that he is trying to fight me not I - him. Since he started his publishing venture he has tried as hard as he could to duplicate my efforts by asking Fluxus people whom Fluxus publishes to publish with him not me. Now, that is not very ethical. He has so pirated Ben Patterson, Filliou, tried unsuccessfully to pirate Barbara Moore, who is collecting a Flux-cook-book. I don't mind at all when he publishes people like Tomas Schmit, Al Hansen, Ray Johnson, Mac Low, who are not planned for Fluxus publications. There are enough unpublished people around he could use. There is no need for piracy. It is the technique of Wolf Vostell all over again. Now, your sending the 50 different ways to read a page disturbs me just as much as if George Brecht had sent him something. After all, I do not ask on the sly people like Ray Johnson or Al Hansen to send me things, because I know how Dick Higgins would feel and I have no reason to fight him, or aggravate or sabotage him. I got your material from Kubota for Flux page. I will use it. If you have any other newspaper page ideas - send it. Especially newspaper page-events (like 50 diff. ways to read a page). In other words, not events of something else, but events related to paper page, OK?"
Letter: George Maciunas to Ben Vautier, [ca. Summer 1965].

"...I am just ready to print your 50 cards. They are slightly different...Do you prefer the card version to that of book version? Let me know as soon as possible. I will print in 10 days...(You will have your 50 cards in Flux II)..."
Letter: George Maciunas to Ben Vautier, January 10, 1966.

FIFTYEIGHT PROPOSITIONS FOR ONE PAGE BY BEN VAUTIER 1965
3 newspaper eVenTs for the pRicE of $1 (Fluxus Newspaper No. 7) February 1, 1966.

"You are doing superb FLUXWORK! Paris & Nice concerts sound terrific...They are described in the V TRE I mailed, same newspaper that has your 50 propositions on a page..."
Letter: George Maciunas to Ben Vautier, May 19, 1966.

FLUX-PRODUCTS 1961 TO 1969 ... V TRE FLUX-NEWSPAPERS...3 newspaper eVenTs for the pRicE of $1, no. 7 Feb. 1966...58 propositions for one page by Ben Vautier...
Fluxnewsletter, December 2, 1968 (revised March 15, 1969).

COMMENTS: *Fiftyeight Propositions for One Page was first published in Fluxus Newspaper No. 7, and simultaneously printed on heavy stock so that it could be cut up into a card edition of the work. It seems that this was not done. Cutting*

	imagine some unknown color on the left corner of this page	take a photo of this page	send this page to Ray Johnson 176 Suffolk Street New York, U.S.A.	look through this hole at the world	fold this page many times to the smallest possible size
FIFTYEIGHT PROPOSITIONS FOR ONE PAGE BY BEN VAUTIER 1965	paint this page white	write on this page a short definition of art and then write on the opposite side the exact contrary - consider both sides as part of my definition of art	close your eyes while you look at this page	try to stop thinking while looking at this page	where is fluxus on this page ?
return to the preceding page	don't laugh and stare at this page for 1 hour in public	swallow this page	put your finger down your throat and vomit over this page	look everywhere else	listen five minutes before turning this page
don't forget this page	hang this page on a string - don't touch it - wait till it disappears	wait until something happens and write it on the next page		wait till a fly settles on this page and watch it closely till it flies away (if necessary put some sugar on the page)	astonish someone quickly with this page
please consider that everything on the left side of this line is sculpture and on the right side is music — sculpture / music	I don't propose you do anything with this page	read what is written on this page	change something on this page	what is new on this page ?	just any page would have done as well as this page
this page was written in France on the 25th of July 1965	spit on this page	eat something over this page	write as much as you can on this page	turn 14 pages slowly	remember details of your first love affair before turning this page
hide this page somewhere	put your nose on this page and keep it there for 5 minutes	write on this page what you think the U.S. President should do to stop the war in Vietnam	try to put a horse on this page	place your ear on this page and listen until some sound occurs	place this page in the middle of a street on a windy day
multiply 4673 times 17883 on this page	touch with one finger the whole surface of this page	draw a vase of flowers on this page	mount your photo on this page	set fire to this page	hide this page
miss the next page	turn this page	return to the preceding page write your name on this page	erase or scratch out your name from the preceding page	put this page in some obvious place	tear this page into many small pieces then reconstruct it
hold on to this page for 24 hours	this page is not a work of art	this page is a work of art	sign here please _____	send this page to the police	think of five interesting things to do with the next five pages

Ben Vautier. FIFTYEIGHT PROPOSITIONS FOR ONE PAGE

up the sheet defeated Maciunas' idea of "propositions for one page :" although the work clearly was originally planned for 58 separate pages.

FILMS

"…When you have a chance, please send me a print of your film, so we can splice it on our 2 hour program which we want to distribute in 8mm print that will cost only $60 for 2 hours…."
Letter: George Maciunas to Ben Vautier, May 19, 1966.

FLUX-PROJECTS PLANNED FOR 1967 … Ben Vautier: 5 films
Fluxnewsletter, March 8, 1967.

COMMENTS: *It is not known which of Vautier's films were referred to in Fluxnewsletter, March 8, 1967. Notes in George Maciunas' Estate ascribed Fluxfilm Nos. 38, 39, 40, 41 to Ben Vautier. Maciunas sent a reel containing four 8mm films by Vautier to the organizers of Fluxshoe, a Fluxus event in England in 1972. This reel, evidently containing the same films as reel one in the Silverman Collection, is now in the Tate Gallery, in London. The following are notes written by George Maciunas on Vautier's film can (Silverman Nos. > 458.I and II) ca. 1970:*
Reel one —
1. *sitting still with covered eyes — sees nothing, hears nothing, says nothing '66*
2. *1963 swimming across Nice harbor fully clothed*
3. *lifting & holding up a chest of drawers. 1969*
4. *Sitting on promenade in Nice with sign "watch me — that's all" 1962*
Reel two -
1. *watching self on mirror for 10 min. 1966.*
2. *unwinding a spool of string 1966*
3. *Banging own head against a wall, 70*
4. *sleeping on a sidewalk. 63*

Public, *intended as a Fluxus film, was lost. See Ben Vautier's comments for that work.*

FILMS see:
FILM LOOPS
PUBLIC

FILM LOOPS

"…That yearbox [Fluxus 2] will have 8 mm film loops (about 10) and an eye viewer projector to view those films…Film loops should be 2 feet long. You can send one original and I will make 100 copies. Original can be 8 mm or 16 mm…."
Letter: George Maciunas to Ben Vautier, May 11, 1965.

"…Did I mention our 8mm film loops for Fluxus II?? …but maybe you would like to do a loop also? 2 ft long/8mm (or 4ft/16mm) You can just send me 'script' or tell what to do and I can have the film made. OK?…"
Letter: George Maciunas to Ben Vautier, January 10, 1966.

COMMENTS: Ben Vautier, 1984: "I did a film but never loops."

FLAGS

"...Meanwhile think about objects that I could produce...FLAGS - ...etc. OK?"
Letter: George Maciunas to Ben Vautier, May 19, 1966.

COMMENTS: Ben Vautier, 1984: "I produced no flags for Maciunas."

FLIP BOOK MOVIES

"...We are now preparing Fluxus no. 2, which will not be a book like no.1, but a box like drawing, with various small items in it, like flip books (movies) ...a kind of GAME BOX. So please send me anything you think will fit into such miniature Flux-kit. Maybe you can make flip-book movies? They should be at least 60 pages to work well..."
Letter: George Maciunas to Ben Vautier, January 23, 1965.

COMMENTS: Ben Vautier, 1984: "No Flip Book Movie."

FLUX ANIMAL see:
 LIVING FLUXSCULPTURE

FLUXANYTHING BOX
Silverman No. < 439.II

"Now I can reply to your letter with suggestions for various Flux items. THEY ARE ALL GREAT !!! I will print labels for them all. ...Fluxanything box, by Ben..."
Letter: George Maciunas to Ben Vautier, August 7, 1966.

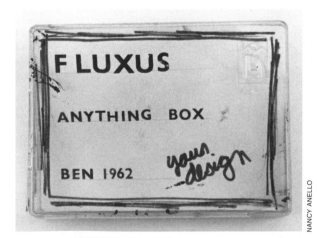

Ben Vautier. FLUXANYTHING BOX. Prototype for an unrealized Fluxus Edition, shown open and closed

COMMENTS: Ben Vautier, 1984: "The first time I did it was in my shop. There was a box you could put anything in it and take anything out of it: Prenez - Mettez."
 Ben Vautier gave George Maciunas a prototype for Fluxanything Box, dated 1962. The work was never produced as a Fluxus Edition.

FLUX ART see:
 FLUX PAINTING
FLUX BOOK see:
 UNTITLED BOOKLET

FLUXBOX CONTAINING GOD
Silverman No. 451, ff.

"...We are now in process of printing the French FLUXUS which includes...a box of god..."
Letter: George Maciunas to Ben Vautier, March 5, 1963.

PAST FLUX-PROJECTS (realized in 1966)...God box;...by Ben Vautier
Fluxnewsletter, March 8, 1967.

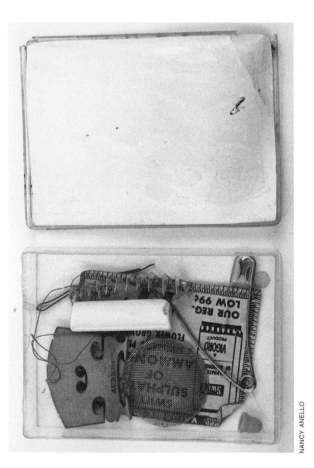

god $3...by ben vautier
Fluxshopnews. [Spring 1967].

FLUX-PRODUCTS 1961 TO 1969...BEN VAUTIER ...god, each box: [$] 3
Fluxnewsletter, December 2, 1968 (revised March 15, 1969).

FLUX-PRODUCTS 1961 TO 1970...BEN VAUTIER ...Boxed God [$] 3
Flux Fest Kit 2. [ca. December 1969].

FLUXUS-EDITIONEN...[Catalogue No.] 784 BEN VAUTIER: boxed god
Happening & Fluxus. Koelnischer Kunstverein, 1970.

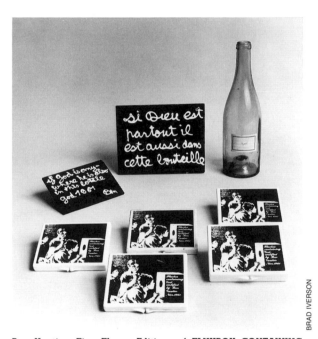

Ben Vautier. Five Fluxus Editions of FLUXBOX CONTAINING GOD. In the background, an early Vautier GOD bottle with plaque, and to the left, a recent translation made by the artist. see color portfolio

Ben Vautier. FLUXBOX CONTAINING GOD. A variant label designed by George Maciunas, never used for the Fluxus Edition

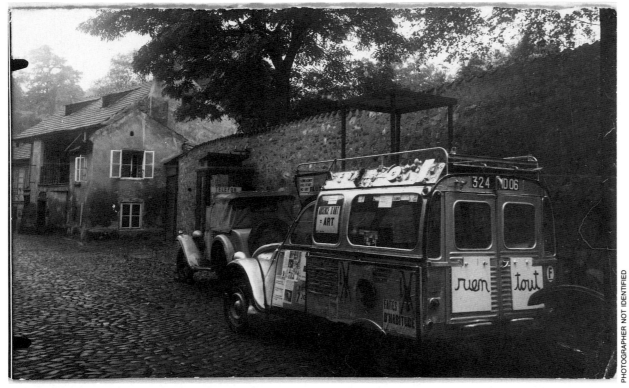

Ben Vautier's FLUX CAR in 1966, parked on a street in Prague behind Milan Knizak's antique 1931 car

Ben Vautier. An early prototype for FLUX CATALOGUE

BEN VAUTIER...Boxed God $3...
Flux Objects, Price List. May 1976.

COMMENTS: Fluxbox Containing God *derives from Ben Vautier's 1961 painting,* Dieu, *ping-pong balls or bottles with ''Dieu'' written on them and* Dieu en boites *[Boxed God]. In the Fluxus Edition, the boxes are sealed, for good reason.*

FLUX CAR

''...The Fluxcar would have been a great idea, maybe

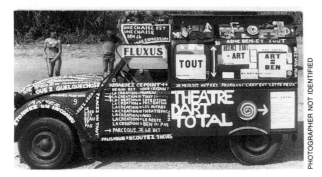

Ben Vautier. FLUX CAR, photographed in Nice around 1964

that can be done next year or during our tour...''
Letter: George Maciunas to Ben Vautier, [ca. Fall 1966].

COMMENTS: Ben Vautier, 1984: ''That was my Citroen 2CV with the Fluxus Museum in it. The idea was to make it open up. We could put up string and all the Fluxus items could go around it. This was when we went to Prague. We could perform on top and behind. It was covered with Fluxus sentences and [my] Theatre d'Art Total. It was repainted. Later, there was a second and third car. Now I would like a caravan, or a train. Not like the train Vostell did and called a Flux Train. That was more a Vostell-Kienholz happening. My idea would have had chests in it for every artist.''

FLUX CATALOGUE
Silverman No. < 423,VI, ff.

''Now I can reply to your letter with suggestions for various Flux items. THEY ARE ALL GREAT !!! I will print labels for them all. ...Flux catalog by Ben (dictionary) OK!!...''
Letter: George Maciunas to Ben Vautier, August 7, 1966.

COMMENTS: Ben Vautier, 1984: ''It could be the notion of 'Everything' more as an idea than a publication. It could also have been my review Tout *but I doubt it because he didn't read French. It could also have been the Dictionary signed*

(tout) (Ben). *I think Maciunas did the catalogue like a Sears Catalogue.''*

Vautier began signing dictionaries, encyclopedias and other reference books as his 'Complete Works' in 1960. Silverman Nos. < 423.VI and < 423.VII are prototypes for the idea of Flux Catalogue *which Maciunas had planned to produce - that is, a titled ready-made - not the actual complete or collected works. It is the idea of signing everything.*

FLUX CERTIFICATES

''...Meanwhile please consider my offer...for thinking up events - that we could perform in our future 'concerts.' Something like 'kick in the pants' but applied to a larger audience, it would be kind of difficult to kick all audience one by one, giving each signed certificates....''
Letter: George Maciunas to Ben Vautier, March 5, 1963.

PROPOSED PRELIMINARY CONTENTS OF NYC FLUXUS IN NOV. ... sale of Ben Vautier ''certifi-

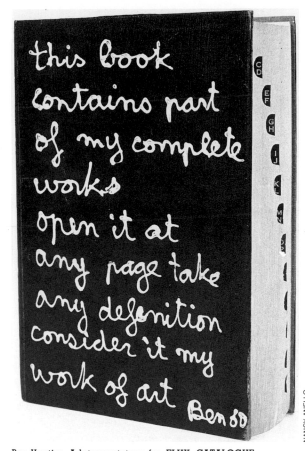

this book
contains part
of my complete
works
open it at
any page take
any definition
consider it my
work of art
Ben 60

NANCY ANELLO

Ben Vautier. A later prototype for FLUX CATALOGUE

cates''...
Fluxus Newsletter No. 6, April 6, 1963.

''Now I can reply to your letter with suggestions for
various Flux items. THEY ARE ALL GREAT !!! I
will print labels for them all...Fluxcertificates,OK!
by Ben. ...''
Letter: George Maciunas to Ben Vautier, August 7, 1966.

COMMENTS: *Ben Vautier made a number of certificates.
Evidently George Maciunas wanted to produce more for
Fluxus than he made use of. In conjunction with the Fluxus
Festival in Nice, 1963, Ben signed* Human Beings *as works of
art and issued certificates to his assignees. That work evolved
into* Living Fluxsculptures. Kick in the Pants Certificate *was
published in* Fluxus Preview Review *and a* Time Certificate
was published in Fluxus Newspaper No. 1. *Later, Fluxus pro-
duced a rubberstamp edition of* Ben Vautier Certifies This to
Be a Work of Fluxart. *Two more certificates were printed in
Ben's* Untitled Booklet *which is included in* FLUXUS 1.
These are: Certifie authentique partie du tout a Ben *and* Ab-
sence of Art is Art.

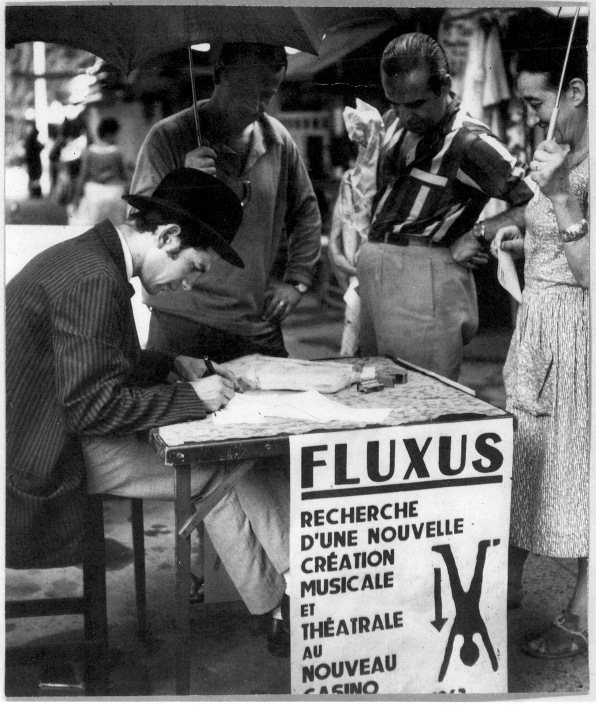

GEORGE MACIUNAS

Ben Vautier signing certificates. Nice, 1963

FLUX CLOCK
Silverman No. < 423.IX, ff.

''Now I can reply to your letter with suggestions for various Flux items. THEY ARE ALL GREAT !!! I will print labels for them all…Flux clock (2 clocks, one right, one defective) by Ben…''
Letter: George Maciunas to Ben Vautier, August 7, 1966.

FLUX-PROJECTS PLANNED FOR 1967…Ben Vautier…Flux-clock,…
Fluxnewsletter, March 8, 1967.

COMMENTS: *Ben Vautier, 1984: "The idea is mine but I never realized it on purpose. I remember proposing a clock with no hands and Maciunas saying everyone did it before. So I did not do it."*

Ben Vautier signed "time" in 1961 and states that he "proposed clocks as art to Maciunas." He made certificates for "Time" (published in Fluxus Newspaper No. 1) and set a clock at 6:31, with the alarm set for 10:00 (Silverman No. < 423.IX). This 1961 work, Le Temps, figures as a prototype of one of his suggestions to Maciunas for Flux Clock.

FLUX COLORS
Silverman No. < 423.X, ff.

''Now I can reply to your letter with suggestions for various Flux items. THEY ARE ALL GREAT !!! I will print labels for them all. …flux colors OK! …''
Letter: George Maciunas to Ben Vautier, August 7, 1966.

COMMENTS: *Ben Vautier, 1984: "Was just going to a color shop and buying the color grades. It's in the Armoire [L'Armoire d'Arman]. It was in reaction to Yves Klein's Monochromes. Jealous, I signed all colors 'Ben'."*

FLUX DECLARATIONS

''Now I can reply to your letter with suggestions for various Flux items. THEY ARE ALL GREAT !!! I will print labels for them all. …flux declarations. …''
Letter: George Maciunas to Ben Vautier, August 7, 1966.

FLUX-PROJECTS PLANNED FOR 1967 … Ben Vautier:…declaration cards,…
Fluxnewsletter, March 8, 1967.

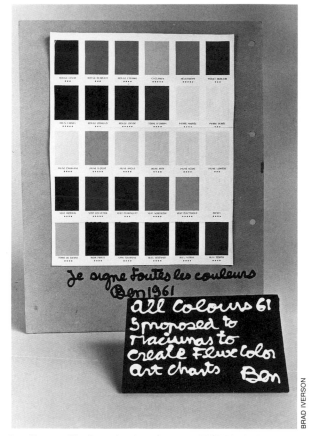

Ben Vautier. The basis for the concept of FLUXCOLORS, with a plaque done by the artist in 1984 to explain its relationship to Fluxus

An early Ben Vautier TIME with a vintage photograph. To the right, a descriptive 1984 plaque by the artist. All relate to the concept of FLUX CLOCK

COMMENTS: Ben Vautier, 1984: "I think he means the cards like 'I did this before you.' The only declaration cards I remember were the cards that I made when I arrived in America in 1964. Maybe I had in mind to publish more cards but only as projects."

An example of a Flux Declaration is Je signe tout, included in FLUXUS 1.

FLUX EGG

"Now I can reply to your letter with suggestions for various Flux items. THEY ARE ALL GREAT !!! I will print labels for them all...Flux egg (maybe too fragile)..."
Letter: George Maciunas to Ben Vautier, August 7, 1966.

COMMENTS: Ben Vautier, 1984: "The Flux egg represented (1) life, egg gives life that gives egg (2) was also beautiful shape. So I thought, why do an Arp? Do an egg! It never was called Flux Egg. It was 'Ben's egg.' But of course anything that went to Maciunas became Fluxus."

This work contains an element of competition or imitation of Piero Manzoni, who put his thumb print on eggs (as art works) in 1960. George Maciunas frequently used blown eggs in assembling George Brecht's Valoche and his own, Your Name Spelled with Objects.

FLUX HOLES
Silverman No. 430, ff.

"...We are now in process of printing the French FLUXUS which includes...the 'holes'..."
Letter: George Maciunas to Ben Vautier, March 5, 1963.

FLUXUS 1964 EDITIONS, AVAILABLE NOW ...
FLUXUS n series, ITEMS FROM BEN VAUTIER...
FLUXUS ni COLLECTION OF HOLES, photographs and actual holes, in plastic box $5
cc Valise e TRanglE (Fluxus Newspaper No. 3) March 1964.

FLUXKIT containing following fluxus-publications: (also available separately) ... FLUXUS no BEN VAUTIER: "holes", photos & obj. $5
cc fiVe ThReE (Fluxus Newspaper No. 4) June 1964.

Ben Vautier. FLUX HOLES. Mechanical by George Maciunas

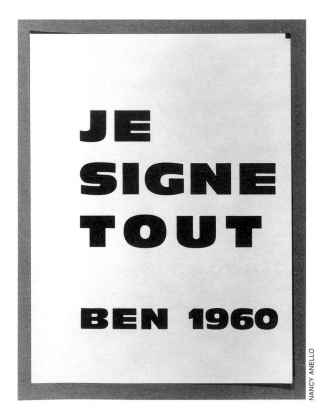
Ben Vautier. A FLUX DECLARATION used for FLUXUS 1

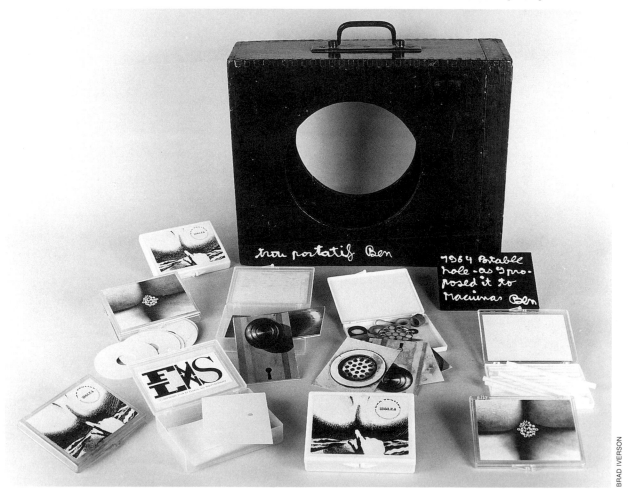
Ben Vautier. FLUX HOLES. Various assemblings of the work. In the background is a related work from 1964, TROU PORTATIF, with a plaque made by the artist in 1984 explaining its relationship to FLUX HOLES. see color portfolio

505

"...I will send one attache case to De Ridder, which contain miniature FLUXSHOP (with 2 things of yours:...holes in box)..."
Letter: George Maciunas to Ben Vautier, June 12, 1964.

Fn-o COLLECTION OF HOLES, photographs and actual holes in plastic box $5
European Mail-Orderhouse: europeanfluxshop, Pricelist. [ca. June 1964].

Fn-o BEN VAUTIER...[as above]
Second Pricelist - European Mail-Orderhouse. [Fall 1964].

FLUXKIT containing following flux-publications:... holes (Photos & objects) of Ben Vautier
ibid.

FLUXKIT containing following fluxus-publications: (also available separately) ... FLUXUS no BEN VAUTIER: collection of holes, $3
Vacuum TRapEzoid (Fluxus Newspaper No. 5) March 1965.

FLUXKIT...[as above] $4
Vaseline sTREet (Fluxus Newspaper No. 8) May 1966.

"...I mailed by parcel post-one carton with following: Quantity: 1/ Item: Vautier holes—, Wholesale cost to you. each: 1/ Suggested selling price—, sub total —— wholesale cost to you: 1 ..."
Letter: George Maciunas to Ken Friedman, August 19, 1966.

holes $3...by ben vautier
Fluxshopnews. [Spring 1967].

FLUX-PRODUCTS 1961 TO 1969...BEN VAUTIER ...collection of holes,...each box [$] 3
Fluxnewsletter, December 2, 1968 (revised March 15, 1969).

FLUX-PRODUCTS 1961 TO 1970...BEN VAUTIER ...Collection of holes, boxed [$] 3...
Flux Fest Kit 2. [ca. December 1969].

FLUXUS-EDITIONEN ... [Catalogue No.] 783 BEN VAUTIER: collection of holes, boxed
Happening & Fluxus. Koelnischer Kunstverein, 1970.

03.1964...BEN VAUTIER:...holes
George Maciunas, Diagram of Historical Developments of Fluxus... [1973].

BEN VAUTIER...Collection of holes, boxed $4
Flux Objects, Price List. May 1976.

"...I will also include labels and some completed boxes of your...holes..."
Letter: George Maciunas to Ben Vautier, October 18, 1977.

COMMENTS: Ben Vautier, 1984: "No comment. I like holes maybe because it has to do with Non Art."

Ben Vautier first worked with holes in 1959 and 1960, signing as ready-mades holes that were cut or broken in boxes or walls. The idea of working with holes must have been given to George Maciunas in 1963, when he was working on putting out a French edition of Fluxus. A Fluxus anthology of French artists never came out, but Flux Holes was made separately. Photographs of holes from the Fluxus Edition were reproduced in Fluxus Newspaper No. 3, March 1964. Yoko Ono had cut a hole in a canvas in 1961. The work was titled Painting to See the Sky, and was shown at her exhibition in Maciunas' AG Gallery in New York the same year. Ay-O is another Fluxus artist intimately involved with holes.

FLUX KIT see:
VAUTIER KIT

FLUX LIGHT
Silverman No. < 423.V, ff.

"Now I can reply to your letter with suggestions for various Flux items. THEY ARE ALL GREAT !!! I will print labels for them all. ...Flux light by Ben (could have many variations, like a 8 volt light with 115 volt cord, so it would burn out as soon as you switched it on.)..."
Letter: George Maciunas to Ben Vautier, August 7, 1966.

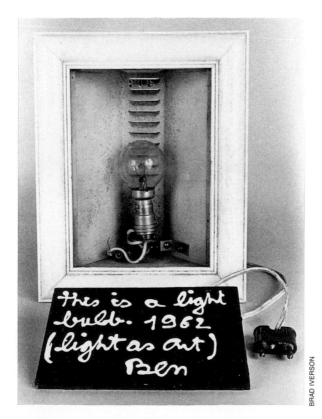

Ben Vautier. A 1962 LIGHT BULB on which the idea for FLUX LIGHT was based. The plaque was made by the artist in 1984

COMMENTS: Ben Vautier, 1984: "All origins of light — sun — candles. Often the light bulb itself. Just a plain bulb, signed with a magic marker or pen."

Ben Vautier signed light and light bulbs in 1962, and from his concept, Maciunas responded with a gaggy Fluxus event light. Flux Light was not produced by Maciunas as a Fluxus Edition, however Maciunas did use ready-made fake soft light bulbs for Claes Oldenburg's Fluxus work, Light Bulb. Oldenburg had suggested the work to Maciunas in 1965, but it was not included in the Fluxus oeuvre until later. See also Robert Watts' prototype for Light Flux Kit (Silverman No. < 519.l) which uses various light bulbs among its contents.

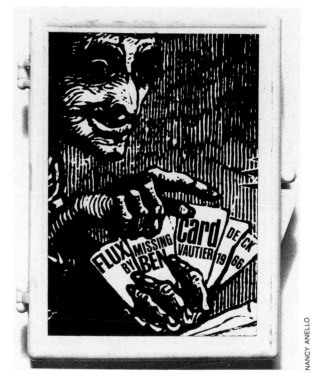

Ben Vautier. FLUX MISSING CARD DECK

FLUX MISSING CARD DECK
Silverman No. 449, ff.

"...Would you design a playing card set? We have now 5 card sets which we will have manufactured by real card manufacturer...& I thought it would be nice to have also one set of yourself since you are the top man & most imaginative man in all Europe (& I would say top among 3 in world)..."
Letter: George Maciunas to Ben Vautier, January 10, 1966.

"Now I can reply to your letter with suggestions for various Flux items. THEY ARE ALL GREAT !!! I will print labels for them all. ...Flux missing card set

VERY GOOD & easy!!...Your card game idea sounds very good! Please work on it & send it to me. If you like, we can add funny but related pictorial matter each card, we can do it in Winter..."
Letter: George Maciunas to Ben Vautier, August 7, 1966.

"...I like your box ideas, because they are so cheap to produce & very funny - like missing card deck - GREAT!"
Letter: George Maciunas to Ben Vautier, [ca. October 1966].

PAST FLUX-PROJECTS (realized in 1966)...Flux-missing card deck,...by Ben Vautier.
Fluxnewsletter, March 8, 1967.

missing card deck $1.50...by ben vautier
Fluxshopnews. [Spring 1967].

PROPOSED FLUXOLYMPIAD...BOARD GAMES: ...card games with...missing cards...
Fluxnewsletter, January 31, 1968.

FLUX-PRODUCTS 1961 TO 1969...BEN VAUTIER ...Missing card deck [$] 2
Fluxnewsletter, December 2, 1968 (revised March 15, 1969).

FLUX-PRODUCTS 1961 TO 1970...BEN VAUTIER ...Missing card deck [$] 3...
Flux Fest Kit 2. [ca. December 1969].

FLUXUS-EDITIONEN ... [Catalogue No.] 785 BEN VAUTIER: missing card deck
Happening & Fluxus. Koelnischer Kunstverein, 1970.

03.1967...BEN VAUTIER:...playing cards, etc.
George Maciunas, Diagram of Historical Developments of Fluxus... [1973].

BEN VAUTIER...Missing card deck $3
Flux Objects, Price List. May 1976.

COMMENTS: Ben Vautier, 1984: "I told Maciunas to do the Missing Card Deck *and with 52 missing card decks he could* make 7 Same Card Deck."
Evidently, George Maciunas took this idea for his own. *See George Maciunas,* Same Card Flux Deck.

FLUX MYSTERY FOOD
Silverman No. 442, ff.

"Now I can reply to your letter with suggestions for various Flux items. THEY ARE ALL GREAT !!! I will print labels for them all. ...Flux mystery food by Ben! VERY GOOD & easy to produce using ready made cans. OK?..."
Letter: George Maciunas to Ben Vautier, August 7, 1966.

PAST FLUX-PROJECTS (realized in 1966)... Flux - mystery food,...by Ben Vautier.
Fluxnewsletter, March 8, 1967.

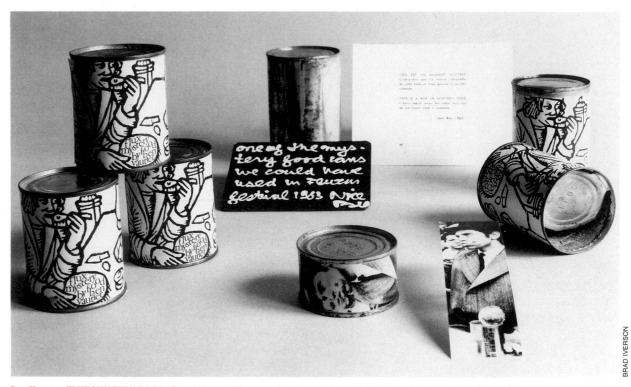

Ben Vautier. FLUX MYSTERY FOOD. Two different Fluxus packagings of the work and an original unlabeled can of the kind used in the 1963 Fluxus Festival in Nice, a Vautier label from 1963 and a plaque made by the artist in 1984. see color portfolio

BRAD IVERSON

mystery food $1...by ben vautier
Fluxshopnews. [Spring 1967].

FLUX-PRODUCTS 1961 TO 1969...BEN VAUTIER Mystery food, canned * [indicated as part of FLUX-KIT] [$] 1
Fluxnewsletter, December 2, 1968 (revised March 15, 1969).

FLUX-PRODUCTS 1961 TO 1970...BEN VAUTIER Mystery food, canned [$] 1...
Flux Fest Kit 2. [ca. December 1969].

FLUXUS-EDITIONEN ... [Catalogue No.] 781 BEN VAUTIER: mystery food, canned
Happening & Fluxus. Koelnischer Kunstverein, 1970.

03.1967 BEN VAUTIER: mystery food,...
George Maciunas, Diagram of Historical Developments of Fluxus... [1973].

BEN VAUTIER Mystery food, canned $4...
Flux Objects, Price List. May 1976.

COMMENTS: Ben Vautier, 1984: "In Nice, the contents of one of the boxes of cans at 'The Provence' were lychees. They looked very curious."

The event that Vautier refers to was part of the Fluxus Festival in Nice, 1963, which George Maciunas participated in. The origins of Flux Mystery Food date to then.

FLUX NOTHING BOX

"Now I can reply to your letter with suggestions for various Flux items. THEY ARE ALL GREAT !!! I will print labels for them all. ...Flux nothing box by Ben..."
Letter: George Maciunas to Ben Vautier, August 7, 1966.

COMMENTS: Ben Vautier, 1984: "There was an edition [not Fluxus] of This Box Contains Something *and you would open it up and there's nothing. That was the idea. When I signed* Nothing - *my mother told me, 'Ben there's no such thing as nothing'."*
Nothing, Mystery, *and* Anything *are all completely separate ideas. See: Anonymous* Box with No Label.

FLUX PAINTING
Silverman No. < 440.II, ff.

"Now I can reply to your letter with suggestions for

various Flux items. THEY ARE ALL GREAT!!! I will print labels for them all. ...Flux painting by Ben..."
Letter: George Maciunas to Ben Vautier, August 7, 1966.

COMMENTS: *Ben Vautier, 1984: "Maciunas didn't like the idea of signing — he was anti-signing. I don't know what Maciunas meant by my Flux-painting, but I thought at the time that we should re-sign any painting and call it Flux Art."*

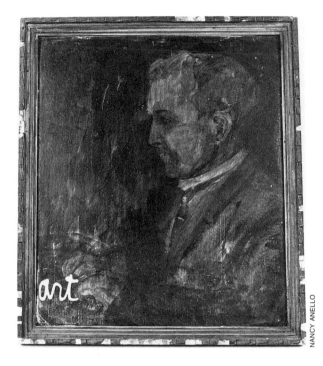

NANCY ANELLO

Ben Vautier. FLUX PAINTING. An early original treatment by Vautier, later used as the idea for FLUX PAINTING. Below, a 1984 plaque made by the artist about its relationship to Fluxus

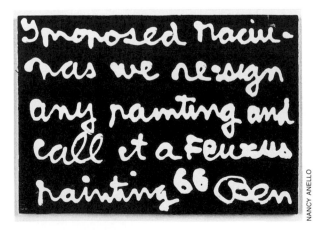

NANCY ANELLO

FLUX POSTERS

FLUX-PROJECTS PLANNED FOR 1967 ... Ben Vautier:... Flux-posters,...
Fluxnewsletter, March 8, 1967.

COMMENTS: *Ben Vautier, 1984: " I had many ideas for Flux-posters as street pieces, like: 'Look at the opposite pavement (Flux theatre is going on).' For instance, 'Flux poetry: say anything,' 'Flux music: listen to anything' were projects I had wanted to do. I sent him around 10 ideas."*
 See also: Stickers *and* Terrain Vague.

FLUX POST KIT see:
 BEN VAUTIER CERTIFIES THIS TO BE A
 WORK OF FLUX ART
 (1) RECEIVE, (2) RETURN
 THE POSTMAN'S CHOICE
 YOUR THUMB PRESENT
FLUX SAMPLER see:
 FLUX USELESS OBJECT

FLUX SHOP LOCATIONS (ATLAS)

"Now I can reply to your letter with suggestions for various Flux items. THEY ARE ALL GREAT !!! I will print labels for them all. ...flux shop locations (atlas) by Ben..."
Letter: George Maciunas to Ben Vautier, August 7, 1966.

COMMENTS: *Ben Vautier, 1984: "I had decided that the pyramids could be a Flux-piece. Make a map giving people instructions where they could see Fluxus works."*
 There is an obvious relationship of this work to Ben's concept for Flux Catalogue.

A FLUX SUICIDE KIT
Silverman No. 446, ff.

"Now I can reply to your letter with suggestions for various Flux items. THEY ARE ALL GREAT!!! I will print labels for them all....flux suicide kit by Ben..."
Letter: George Maciunas to Ben Vautier, August 7, 1966.

"For Fall 1967 or 1968...execution kit? (maybe too similiar to Ben's suicide kit.)..."
Letter: George Maciunas to Ken Friedman, [ca. February 1967].

PAST FLUX-PROJECTS (realized in 1966)...Suicide kit,...by Ben Vautier.
Fluxnewsletter, March 8, 1967.

suicide kit $4.50...by ben vautier
Fluxshopnews. [Spring 1967].

FLUX-PRODUCTS 1961 TO 1969...BEN VAUTIER ...Suicide fluxkit, partitioned box * [indicated as

part of FLUXKIT] [$] 5
Fluxnewsletter, December 2, 1968 (revised March 15, 1969).

FLUX-PRODUCTS 1961 TO 1970...BEN VAUTIER ...Suicide fluxkit, partitioned box [$] 5...
Flux Fest Kit 2. [ca. December 1969].

FLUXUS-EDITIONEN ... [Catalogue No.] 786 BEN VAUTIER: suicide fluxkit, boxed
Happening & Fluxus. Koelnischer Kunstverein, 1970.

Toilet no. 2 Paul Sharits...Medicine cabinet:...suicide kit etc. * behind glass
Fluxnewsletter, April 1973.

03.1967...BEN VAUTIER:... suicide kit,...
George Maciunas, Diagram of Historical Developments of Fluxus... [1973].

BEN VAUTIER ...Suicide flux kit, 7 devices, boxed $8
Flux Objects, Price List. May 1976.

"...I will also include labels and some completed boxes of your suicide..."
Letter: George Maciunas to Ben Vautier, October 18, 1977.

COMMENTS: *Ben Vautier, 1984: "[In the original kit] I used two live electric wires: you tie them to your ears and put your feet in a bucket of water, sleeping pills, rope. They were real systems. I never used nails or fish hooks, those were from Maciunas."*
 See also Suicide Booth *which is an extension of this work.*

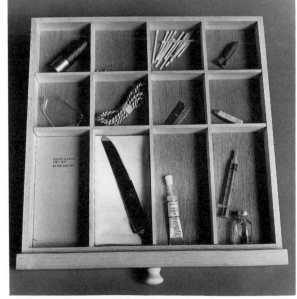

BRAD IVERSON

Ben Vautier. A FLUX SUICIDE KIT contained in FLUX CABINET

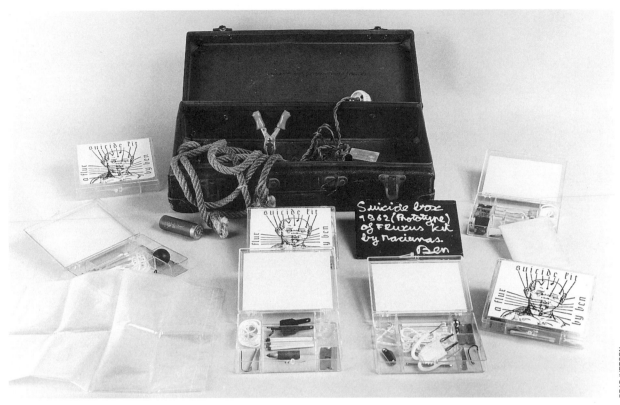

Ben Vautier. A FLUX SUICIDE KIT. In the background, the original Vautier prototype with explanatory plaque made by the artist in 1984. see color portfolio

BRAD IVERSON

FOLD/UNFOLD
Silverman No. 438, ff.

COMMENTS: Ben Vautier, 1984: "I did a piece in Ben Dieu *which I proposed for Fluxus. Folded paper with 'unfold' [written] on the corner edge and then you unfold until you get to 'fold' in the center, and then you refold. He told me it was too much like a George Brecht."*

Fold/Unfold *is a component of* Flux Year Box 2, *and titled "Gesture Piece by Ben Vautier." In 1984 Vautier was not aware that the work had been realized.*

FURNITURE
Silverman No. < 439.IV, ff.

"...Meanwhile think about objects that I could produce...FURNITURE, etc. OK?..."
Letter: George Maciunas to Ben Vautier, May 19, 1966.

"...Please send furniture ideas to me, so we can start producing them..."
Letter: George Maciunas to Ben Vautier, August 22, 1966.

"...I did not receive from you: your furniture projects. ..."
Letter: George Maciunas to Ben Vautier, November 14, 1966.

COMMENTS: Ben Vautier, 1984: "I don't remember, but in the 1960s I had done stools in hommage to George Brecht. It was funny furniture and George Maciunas wanted funny furniture."

Illustrated is a unique work by Ben Vautier, of the type he would have offered Maciunas to produce as a Fluxus Edition. However, the project was never realized.

FLUXTOUR TICKETS see:
TICKETS

FLUX USELESS OBJECT
Silverman No. < 439.I, ff.

"Now I can reply to your letter with suggestions for various Flux items. THEY ARE ALL GREAT !!! I will print labels for them all. ...flux useless objects, maybe should be called Flux sampler ? by Ben..."
Letter: George Maciunas to Ben Vautier, August 7, 1966.

COMMENTS: Ben Vautier, 1984: "I started collecting objects which I couldn't understand the function of. I proposed to Maciunas to call them Flux objects because they had no meaning. Undeterminable objects: You push a button, you don't know why. If I found out what the object was, I'd give it up. In other words, function isn't enough."

Robert Watts used a similar rationale of uselessness for his ready-made, Assorted Tools, *in his "a to z series."*

FLUXUS/THEATRE D'ART TOTAL see:
THEATRE D'ART TOTAL

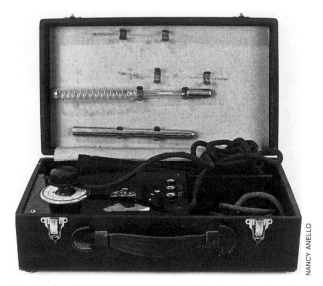

Ben Vautier. FLUX USELESS OBJECT. A Vautier assigned readymade of the sort intended for the Fluxus work. The plaque was made by the artist in 1984

NANCY ANELLO

GAMES see:
BALL GAMES
FLUX MISSING CARD DECK
FOLD/UNFOLD

NANCY ANELLO

UNFOLD

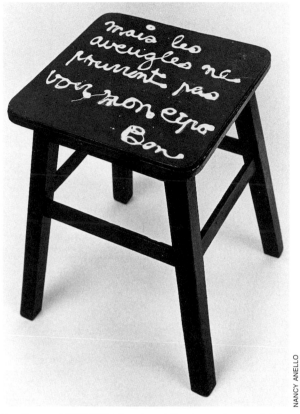

Ben Vautier. FURNITURE. An original Vautier stool, intended for Fluxus, with a 1984 plaque made by the artist

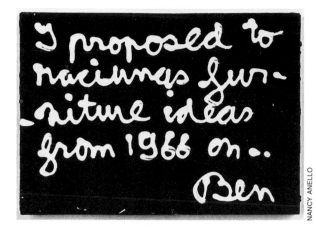

FLUX-PRODUCTS 1961 TO 1969, V TRE FLUX - NEWSPAPERS...Vague TREasure, no. 9 Apr. 1969 Vautier Litany, Filliou autobiography, Ayo's list, Gherasim Luca - litany, Eric Andersen - fluxpage, Fluxclinic record, news of past 3 years, $1
Fluxnewsletter, December 2, 1968 (revised March 15, 1969).

1970 - Vague TREasure (Vautier Litany, Eric Andersen page, news of past year, etc.)...
Fluxnewsletter, January 8, 1970.

FLUX-PRODUCTS 1961 TO 1970...Vague TREasure, no. 9, 1970: Vautier Litany, Filliou autobiography, Ayo's List, Gherasim Luca Litany, Eric Andersen fluxpage, Fluxclinic record, news of past years.
Flux Fest Kit 2. [ca. December 1969].

COMMENTS: *Ben Vautier, 1984: "He was against* I Ben Sign, *and then he finally accepted it."*
Originally, I Ben Sign *was "Litany" or "Vautier Litany" and was to be included in a Fluxus newspaper. Although typeset by Maciunas, the work was never published by Fluxus.*

GESTURE PIECE BY BEN VAUTIER

Ben Vautier. FOLD/UNFOLD

GESTURE PIECE see:
 FOLD/UNFOLD
GOD see:
 FLUXBOX CONTAINING GOD
HOLES see:
 FLUX HOLES

HUMAN BEING see:
 LIVING FLUXSCULPTURE

I BEN SIGN
Silverman No. > 439.II

"...Kubota will issue next Fluxus newspapers, starting March. We will include your 'litany' (list of all inventions) and your theatre pieces. If you have any other material - please send it over...."
Letter: George Maciunas to Ben Vautier, January 23, 1965.

"...Few comments on your 'position paper'...your definition of Fluxus is excellent. I agree with your position fully...You also mention that it would not be in my range to publish ... 'I Ben Sign' — How do you know? In fact it is not true. I have already set with IBM 'I Ben Sign' as a litany to go to next V TRE issue - Nov. Dec. 1966. Incidentally - shall we call it 'Ben's Litany'? I think I have a complete list of 'I Ben Sign'..."
Letter: George Maciunas to Ben Vautier, [ca. October 1966].

JE SIGNE TOUT
component of Silverman No. 117, ff.

COMMENTS: *A Vautier printing of* Je signe tout *with Robert Filliou's* Whispered Art History *printed on the other side was included in most copies of* FLUXUS 1. *Ben's textual work is a* Flux Declaration.

JE SIGNE TOUT LES COULEURS see:
 FLUX COLORS
JUST LOOK AT ME see:
 PHOTO
KEINE KUNST see:
 NO ART

LITANY OF BEN VAUTIER:

I Ben sign as my personal work of art and creation for ever after –

IN 1958
I signed declaration paintings such as "I am Art" or "Turn this around" around "
I signed Vomit Paintings I vomited on a varnished canvas, later into jars.
IN 1959
I signed Human Sculptures I bought and sold men or women as mobile sculptures
I signed Copies I did copies entitled "Ben imitating x is superior to x"
I signed unbalanced objects Objects positioned as if they would fall but did not fall.
I signed Everything My first gesture to take possession of the notion of everything.
I signed Something Missing A tooth missing, a finger missing, missing money etc.
I signed Mystery Boxes Boxes containing mysterious objects (boxes never to be opened).
IN 1960
I signed holes
I signed events Accompanied by certificates (such as slaps, kicks etc).
I signed all television programs
I signed death as work of art incomplete list of my works.
I signed illness and epidemics
IN 1961
I signed the Pope
I signed God and put him in a box 80cm x 80cm x 80cm. He is for sale.
I signed undoing knots I presented a gigantic knot to be untied.
I signed Art in all its meanings and manifestations.
I signed the Truth such as 1 plus 1 equals 2, or "I want to be a great fellow"
I signed the Others Duchamp, Isou, Klein, Cage, Brecht etc.
I signed Time selling certificates, authentifying it as Work of Art.
I signed Encyclopedia Britanica as an uncomplete porttrait xxxxxxxxxxxxxx
I decided to sign "not" signing
I signed Junk Yards
IN 1962
I bought, signed and sold the soul of Serge Oldenbourg living in Nice
I signed empty boxes
I signed love
I signed light
I signed accidents
I signed pain
I signed Dirty Water Exhibited and sold one quart of stagnant & dirty water
I signed my Signature
I signed rain
I signed my testicules
I signed Africa
I signed the Universe on July the 7th.
I signed Murder
I signed Myself
I signed Lies
I signed Beauty
I signed selling ideas to others
IN 1964
I stopped signing

Ben Vautier. I BEN SIGN or "Litany." typeset by George Maciunas. It was planned for publication in a Fluxus Newspaper

KICK IN THE PANTS CERTIFICATE
component of Silverman No. 542, ff.

"...Meanwhile please consider my offer...for thinking up events - that we could perform in our future 'concerts.' Something like 'kick in the pants' but applied to a larger audience, it would be kind of difficult to kick all audience one by one, giving each signed certificates...."
Letter: George Maciunas to Ben Vautier, March 5, 1963.

"...We would propose the following program for Nice: Exhibits: (maybe in lobby of theatre works of yourself, George Brecht, Nam June Paik, Robert Watts, Walter De Maria, Tomas Schmit, myself, also Daniel Spoerri, Robert Filliou, Emmett Williams.) Here you could sell your 'certificates' like kick in the pants...."
Letter: George Maciunas to Ben Vautier, [May 1963].

"...Also enclosed his kick in the pants piece - please type it with margin (standard) & send me back...OK? So I will have complete text for prospectus...Ben's certificate: The present attestation is to certify that I Benjamin Vautier have effectively kicked M........... in the posterior with my special shoe and that this very kick must be considered as a work of art (Art gestures, kicks, bites, slaps, kisses created in 1961).
Date....... Time.......
Place....... No.
Signature.................
Notice & Observations. ——with std. margin. ..."
Letter: George Maciunas to Tomas Schmit, [between May 15 - 26, 1963].

COMMENTS: Kick in the Pants Certificate *was printed in* Fluxus Preview Review, *1963, but not issued by Fluxus as a separate Fluxus Edition.*

The present attestation is to certify that I Benjamin Vautier have effectively kicked M.................in the posterior with my special shoe and that this very kick must be considered as a work of art (Art gestures, kicks, bites, slaps, kisses created in 1961).
Date time place No.
Signature
notice & observations.

Ben Vautier. KICK IN THE PANTS CERTIFICATE

KIT see:
 VAUTIER KIT
LE TEMPS see:
 TIME
LIGHT see:
 FLUX LIGHT

LIGHT BULB see:
 FLUX LIGHT
LITANY see:
 I BEN SIGN

LIVING FLUXSCULPTURE
Silverman No. > 439.I

''...NOW THE FESTIVAL: (Amsterdam one)... Exhibits. Ben Vautier - 'living sculpture'...''
Letter: George Maciunas to Tomas Schmit, [early June 1963].

PAST FLUX-PROJECTS (realized in 1966)...living flux-sculpture;...by Ben Vautier
Fluxnewsletter, March 8, 1967

flux animal $1.50...by ben vautier
Fluxshopnews. [Spring 1967].

FLUX-PRODUCTS 1961 TO 1969...BEN VAUTIER
Flux-animal... each box: [$] 3
Fluxnewsletter, December 2, 1968 (revised March 15, 1969).

FLUX-PRODUCTS 1961 TO 1970...BEN VAUTIER
...Flux-animal (sometimes dead) [$] 4...
Flux Fest Kit 2. [ca. December 1969].

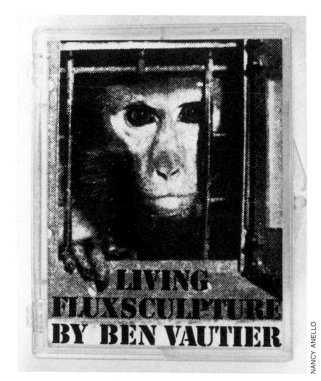

NANCY ANELLO

Ben Vautier. LIVING FLUXSCULPTURE

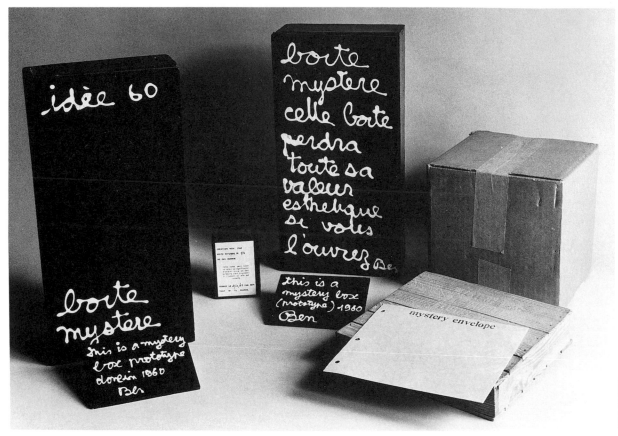

BRAD IVERSON

Ben Vautier. MYSTERY BOX. On the left, two original Vautier MYSTERY BOXES with a Vautier edition between. The explanatory plaques were made by the artist in 1984. On the right, an unmarked Fluxus Edition of MYSTERY BOX; a FLUXUS 1 with MYSTERY BOX stenciled on one side which was sent by Maciunas to Vautier; and a MYSTERY ENVELOPE from FLUXUS 1. see color portfolio

FLUXUS-EDITIONEN ... [Catalogue No.] 788 BEN VAUTIER: living flux-sculpture, boxed
Happening & Fluxus. Koelnischer Kunstverein, 1970.

''...Vautier animal is living sculpture...''
Letter: George Maciunas to Dr. Hanns Sohm, [ca. late 1972].

COMMENTS: Ben Vautier, 1984: "Fleas, microbes, ants, etc. — but alive not dead."
 Living Fluxsculpture *is the evolution of* Sculpture Vivant, *a 1959 work where Ben signs human beings as works of art. One such signing occured during the Festival d'Art Total et du Comportment, the Fluxus festival at Nice in 1963. In the early 1960s, Piero Manzoni had signed people as works of art and issued certificates as well.*

MAGAZINE

Fn-r BEN VAUTIER...magazine...$2
Second Pricelist - European Mail-Orderhouse. [Fall 1964].

COMMENTS: Magazine would have been a signed ready-made — part of Ben's idea of signing everything.

MASKS see:
 DISEASED FACE MASK

MIRRORS

''...I did not receive yet 150 mirrors...!!! I will get them soon I suppose. ...''
Letter: George Maciunas to Ben Vautier, [ca. June, before July 1st, 1965].

COMMENTS: Ben Vautier, 1984: "Just mirrors, signed in the corner and could be interpreted in different ways: (1) as best representation of a two-dimensional surface, which is the definition of painting. (2) Portraits."
 Ben Vautier worked with reflection in 1962. The works were called Les Vitres. *The Vautier idea was not used for a Fluxus Edition, perhaps because a similar idea,* Self Portrait *by Yoko Ono (1964), was offered for sale by Fluxus.*

MISSING CARD DECK see:
 FLUX MISSING CARD DECK

Ben Vautier. MYSTERY BOX installed in a drawer of FLUX CABINET

MYSTERY BOX
Silverman No. 435, ff.

FLUXUS 1963 EDITIONS, AVAILABLE NOW FROM FLUXUS P.O. Box 180, New York 10013, N.Y. or FLUXUS 359 Canal St. New York.CO7-9198 ...FLUXUSn BEN VAUTIER: "Mystery box" $2...
Film Culture No. 30, Fall 1963.

"...In reply to your card and inquiry of Nov. 22nd. the Fluxus boxes can be seen at: 359 Canal St. 2nd floor...Boxes to be seen:...Ben Vautier - Mystery Box $1"

Letter: George Maciunas to Philip Kaplan, November 27, 1963.

FLUXUS 1963 EDITIONS, AVAILABLE NOW ... FLUXUS n BEN VAUTIER: "Mystery box" $2...
cc V TRE (Fluxus Newspaper No. 1) January 1964.

[as above]
cc V TRE (Fluxus Newspaper No. 2) February 1964.

"...We want to...sell your mystery boxes (by mail & through exhibits). So any money coming from these sales would be yours...We are packing your mystery boxes in nice carton boxes - the following items:
1. In flat boxes 30 x 30 x 1cm - dust
2. In wood boxes 20 x 20 x 5cm - egg shells
3. In carton boxes 25 x 25 x 25cm - garbage: chipped plaster, used mimeograph stencils. dried up tea bags (used), orange skins. etc. — each in separate boxes.

Each box sold for $2 nicely sealed, so there is no way to tell what is inside unless you open. Is that OK? We call them 'Ben Vautier Mystery box no.____' Fluxus no. n. — that is your identification letter. nicely silk screened on box. OK? This will be very practical since we can dispose of garbage...and even get money for it"
Letter: George Maciunas to Ben Vautier, February 6, 1964.

FLUXUS 1964 EDITIONS, AVAILABLE NOW ... FLUXUS n series, ITEMS FROM BEN VAUTIER FLUXUS na MYSTERY BOXES: $1 postage not incl.
cc Valise e TRanglE (Fluxus Newspaper No. 3) March 1964.

Fn-i BEN VAUTIER mystery boxes $1 (postage not included)
European Mail-Orderhouse: europeanfluxshop, Pricelist. [ca. June 1964].

Fn-i BEN VAUTIER mystery boxes $1
Second Pricelist - European Mail-Orderhouse. [Fall 1964].

PROPOSED FLUXOLYMPIAD ... STREET GAMES AND EVENTS ... hiding sealed boxes filled with rubbish,
Fluxnewsletter, January 31, 1968.

[as above]
Fluxnewsletter, December 2, 1968.

FLUX-PRODUCTS 1961 TO 1969...BEN VAUTIER mystery box, 10lbs. carton * [indicated as part of FLUXKIT] [$] 1
Fluxnewsletter, December 2, 1968 (revised March 15, 1969).

FLUX-PRODUCTS 1961 TO 1970...BEN VAUTIER ...Mystery carton, 10 to 30lbs. carton [$] 5...
Flux Fest Kit 2. [ca. December 1969].

02.1964...BEN VAUTIER: mystery box
George Maciunas, Diagram of Historical Developments of Fluxus... [1973].

03.1965...BEN VAUTIER: mystery box
ibid.

COMMENTS: Ben Vautier, 1984: "I did many Mystery Boxes in different forms. They were in my room of objects when [George Maciunas] visited me in '63."
George Maciunas produced Fluxus interpretations of both Mystery Box *and the related work,* Mystery Envelope *(the envelope is included in* FLUXUS 1). *If the contents of a Mystery Box were to be revealed, the work would cease to exist.*

MYSTERY ENVELOPE
Component of Silverman No. > 118.II

FLUXKIT containing following fluxus-publications: (also available separately) ... FLUXUS naa BEN VAUTIER: mystery envelopes 25c
cc fiVe ThReE (Fluxus Newspaper No. 4) June 1964.

FLUXKIT containing following flux-publications:... mystery envelopes...of Ben Vautier
Second Pricelist - European Mail-Orderhouse. [Fall 1964].

COMMENTS: *Vautier made a number of* Mystery Envelopes *prior to Fluxus. The Maciunas produced work appears in some examples of* FLUXUS 1.

MYSTERY FOOD see:
FLUX MYSTERY FOOD
NINE DIRECTIONS FOR ART see:
UNTITLED BOOKLET

NO ART
Silverman No. > 441.I, ff.

"...I NEED MORE MATERIALS FROM YOU TO PUT IN FLUXUS 1, (like the printed bag or booklets)..."
Letter: George Maciunas to Ben Vautier, January 5, 1965.

"...ONLY PLEASE! send 100 copies of your part in the book. We ran out of 'bag over the head' then ran out of small booklets you sent, then..."
Letter: George Maciunas to Ben Vautier, January 23, 1965.

Ben Vautier. NO ART

FLUX-PRODUCTS 1961 TO 1969...BEN VAUTIER
No Art paper bag. [$] 1
Fluxnewsletter, December 2, 1968 (revised March 15, 1969).

FLUX-PRODUCTS 1961 TO 1970...BEN VAUTIER
NO ART paper bag [$] 2
Flux Fest Kit 2. [ca. December 1969].

COMMENTS: *Ben Vautier, 1984: "The idea of no art stronger than art took form [in] different directions...I used the bag as a blindfold and written on the bag was 'no art.' "*
 No Art *was published by the artist in France, and offered for sale by Fluxus. It might have been included in some assemblings of* FLUXUS 1. *Printed in bold block letters on a white paper bag, the complete text is in three languages. In the late 50s and early 60s, Ben owned a record store which he turned into a Total Art Merzbau and printed several paper bags decorated with his own distinctive typography. The idea of* No Art *comes from these earlier bags and is related to* Nothing. *It is also in the original* European Mail Order Warehouse/Fluxshop *of Willem de Ridder.*

NOTHING see:
 FLUX NOTHING BOX

100 TICKETS TO SAME SEAT, SAME DAY SHOW
Silverman No. < 461.II

APR. 18-24: TICKETS BY JOHN LENNON + FLUX-TOURS:...100 tickets to same seat, same day show (10¢) by Ben Vautier,...
Schedule of events for Fluxfest presentation of John Lennon and Yoko Ono. [ca. April 1970] version A

APR. 18-24: TICKETS BY JOHN LENNON + FLUX-TOURS...100 tickets to same seat, same day show (10¢) (Ben Vautier)
Schedule of events for Fluxfest presentation of John Lennon and Yoko Ono. [ca. April 1970]. version B

APR.18-24: TICKETS BY JOHN LENNON + FLUX-AGENTS Selling to the public...many tickets to same seat, same day show (Ben Vautier),...
Schedule of events for Fluxfest presentation of John Lennon and Yoko Ono. April 1, 1970. version C

FLUXFEST PRESENTATION OF JOHN LENNON & YOKO ONO +* AT 80 WOOSTER ST. NEW YORK --1970...APR. 18-24: TICKETS BY JOHN LENNON + FLUXTOURS 100 tickets to same numbered seat, same day show (Ben Vautier)...
all photographs copyright nineteen seVenty by peTer mooRE (Fluxus Newspaper No. 9) 1970.

11.04-29.05 1970 FLUX FEST OF JOHN LENNON & YOKO ONO: 18-24.04 TICKETS:...Vautier: 100 tickets to same day seat, etc.
George Maciunas, Diagram of Historical Developments of Fluxus... [1973].

COMMENTS: *Ben Vautier, 1984: "Maciunas loved tickets. I never did any tickets."*
 Taking Vautier's idea, Maciunas printed multiple facsimile copies of a Ticketron ticket to "Elephant Steps" at Hunter College, April 23, 1970, 8:30pm, Orchestra, Row R, Seat 2. The tickets were given out during the John & Yoko Fluxfest.

Ben Vautier. One of 100 TICKETS TO SAME SEAT, SAME DAY SHOW

(1) RECEIVE (2) RETURN
Silverman No. 436, ff.

"...Your postcards will be printed very soon with many other card jobs. Will mail you 100 or so..."
Letter: George Maciunas to Ben Vautier, March 29, 1966.

"...You know, that I am reprinting all your cards for American postcard size. Already printed...'fold - return'..."
Letter: George Maciunas to Ben Vautier, [ca. October 1966].

FLUX-PROJECTS PLANNED FOR 1967...Collective projects: (All are invited to submit ideas and participate, ideas can be either ready pictorial material or just specified material which we have to find, produce or obtain otherwise)...Flux-postal kit: containing postcards...[by Ben Vautier and others]
Fluxnewsletter, March 8, 1967.

FLUX-PROJECTS PLANNED FOR 1967 ... Ben Vautier:...Flux-postcard events (series),...
ibid.

IMPLOSIONS INC. PROJECTS...Triple partnership was formed between Bob Watts, Herman Fine and myself [George Maciunas] to introduce into mass market ...money producing products...This business will be operated in commercial manner, with intent to make profits....connection between Fluxus collective and Implosions Inc. has not been clarified yet...we could consider at present Fluxus to be a kind of division or subsidiary of Implosions. Projects to be realized through Implosions: ... Postcards, ... (same as Flux postal kit)
ibid.

[component of] flux post kit $7
Fluxshopnews. [Spring 1967].

flux post cards 20¢ ea...by ben vautier
ibid.

FLUXPROJECTS REALIZED IN 1967...Post cards by Ben Vautier (included)
Fluxnewsletter, January 31, 1968.

FLUX-PRODUCTS 1961 TO 1969...BEN VAUTIER ...Postcards, 3 different kinds, each: * [indicated as part of FLUXKIT] [$] .2
Fluxnewsletter, December 2, 1968 (revised March 15, 1969).

FLUX-PRODUCTS 1961 TO 1969 ... FLUXPOST KIT 1968...[including] 3 post cards by Ben Vautier ...[$] 8 Version without rubber stamps [$] 2
ibid.

FLUX-PRODUCTS 1961 TO 1970 ... FLUXPOST KIT, 1968:...[including] 3 post cards by Ben Vautier, boxed: $8...
Flux Fest Kit 2. [ca. December 1969].

POSTCARD

(1) RECEIVE, (2) RETURN, BEN-FLUXUS, 1965. TO RETURN CARD, FOLD THE OTHER WAY

FLUXPOSTCARD BY BEN, 1965

Ben Vautier. (1) RECEIVE (2) RETURN

THE SEAL OF THE POST SHOULD BE CONSIDERED AS THE PROOF OF THE DATE THIS WORK OF ART WAS CREATED. BEN - FLUXUS

POSTCARD

FLUXPOSTCARD BY BEN, 1965

Ben Vautier. PROOF OF DATE. This image was made from a completed negative for the unpublished Fluxus Edition

FLUX-PRODUCTS 1961 TO 1970...BEN VAUTIER ...Postcards, 3 different kinds, all for [$] ½ ...
ibid.

FLUXUS-EDITIONEN...[Catalogue No.] 718 FLUX-POST KIT, 1968 (... b. vautier,...)
Happening & Fluxus. Koelnischer Kunstverein, 1970.

COMMENTS: (1) *Receive,* (2) *Return is dated 1965, but apparently was not printed until 1966. Rarely included in* Flux Year Box 2, *it is usually in* Flux Post Kit 7. *This and Vautier's other Fluxus postcards were distributed individually as well.*

PAINTING see:
 FLUX PAINTING
PAPER BAG see:
 NO ART
PARTIE DU TOUT A BEN see:
 BEN VAUTIER CERTIFIES THIS TO BE A
 WORK OF FLUXART
 FLUX CERTIFICATES
PAS D'ART see:
 NO ART
PORTABLE HOLE see:
 FLUX HOLES

PHOTO

Fn-r BEN VAUTIER...photo $2.
Second Pricelist - European Mail-Orderhouse. [Fall 1964].

COMMENTS: *Ben Vautier, 1984: "I think the photo was* Just Look at Me - Regardez moi cela suffit *that I sent to Willem de Ridder."*
 Photo *could also have been a signed ready-made. During this period Ben Vautier expanded on Ray Johnson's mail art and Marcel Duchamp's ready-made concepts. See also Vautier's comments for* The Postman's Choice.

POSTCARD

PROPOSED CONTENTS FOR FLUXPACK 3 TO BE PUBLISHED IN 1973 BY FLASH ART ... Postcards by Vautier... Cost Estimates: for 100 copies ... postcards [including designs by other artists] $100...100 copies signed by:...Vautier...
[George Maciunas], Proposed Contents for Fluxpack 3. [ca. 1972].

Flash Art editor, Giancarlo Politi, proposed to publish the 3rd Fluxyearbook, maybe to be called FLUX-PACK 3, with the following preliminary contents: ... Postcards: by Ben Vautier...
Fluxnewsletter, April 1973.

COMMENTS: Fluxpack 3 *does not contain* Postcards *by Ben Vautier.*

POSTCARD DISPENSER

FLUX AMUSEMENT ARCADE...Stamp & postcard dispensers (Watts & Vautier)
Preliminary Proposal for a Flux Exhibit at Rene Block Gallery. [ca. 1974].

COMMENTS: *Ben Vautier, 1984: "All Maciunas' idea. I never worked with dispensers until 1970, but he had never seen them."*
 George Maciunas' *idea for a* Postcard Dispenser *would have been of the same character as a Robert Watts — looking real, but dispensing Vautier's Fluxus postcards.*

POSTCARDS see:
 (1) RECEIVE, (2) RETURN
 POSTCARD
 THE POSTMAN'S CHOICE
 PROOF OF DATE
 YOUR THUMB PRESENT
POSTERS see:
 ASSHOLES WALLPAPER
 FLUX POSTERS

THE POSTMAN'S CHOICE
Silverman No. 454, ff.

"... This double faced postcard is WONDERFUL PIECE !!! Can I reprint 1000 of them! & sell for 10¢ each? half profit for you OK?...This postcard is work of genius, absolutely wonderful. I can see the Post Office being all gummed-up in confusion!..."
Letter: George Maciunas to Ben Vautier, January 10, 1966.

"...Your postcards will be printed very soon with many other card jobs. Will mail you 100 or so..."
Letter: George Maciunas to Ben Vautier, March 29, 1966.

"...You know that I am reprinting all your cards for American postcard size. Already printed 'postman's choice'..."
Letter: George Maciunas to Ben Vautier, [ca. October 1966].

FLUX-PROJECTS PLANNED FOR 1967 ... Ben Vautier:...Flux - postcard events (series)
Fluxnewsletter, March 8, 1967.

FLUX-PROJECTS PLANNED FOR 1967...Collective projects: (All are invited to submit ideas and participate, ideas can be either ready pictorial material or just specified material which we have to find, produce or obtain otherwise)...Flux-postal kit: containing postcards...
ibid.

POSTCARD

FLUXPOSTCARD BY BEN, 1965

THE POSTMAN'S CHOICE
LE CHOIX DU FACTEUR

Ben Vautier. THE POSTMAN'S CHOICE. The image is the same on both sides of the postcard

IMPLOSIONS INC. PROJECTS...Triple partnership was formed between Bob Watts, Herman Fine and myself [George Maciunas] to introduce into mass market ...money producing products...This business will be operated in commercial manner, with intent to make profits....connection between Fluxus collective and Implosions Inc. has not been clarified yet...we could consider at present Fluxus to be a kind of division or subsidiary of Implosions. Projects to be realized through Implosions: ... Postcards...(same as Flux - postal kit)
ibid.

[component of] flux post kit $7
Fluxshopnews. [Spring 1967].

flux post cards 20¢ ea....by ben vautier
ibid.

FLUXPROJECTS REALIZED IN 1967...Post cards by Ben Vautier (included) [with newsletter]
Fluxnewsletter, January 31, 1968.

FLUX-PRODUCTS 1961 TO 1969...BEN VAUTIER ...Postcards, 3 different kinds, each * [indicated as part of FLUXKIT] [$] .2
Fluxnewsletter, December 2, 1968 (revised March 15, 1969).

FLUX-PRODUCTS 1961 TO 1969 ... FLUXPOST KIT 1968...[including] 3 post cards by Ben Vautier ...[$] 8 Version without rubber stamps [$] 2
ibid.

FLUX-PRODUCTS 1961 TO 1970 ... FLUXPOST KIT, 1968:...[including] 3 post cards by Ben Vautier ...boxed $8...
Flux Fest Kit 2. [ca. December 1969].

FLUX-PRODUCTS 1961 TO 1970...Postcards, 3 different kinds, all for [$] ½
ibid.

FLUXUS-EDITIONEN...[Catalogue No.] 718 FLUX-POST KIT, 1968 (...b. vautier,...)
Happening & Fluxus. Koelnischer Kunstverein, 1970.

COMMENTS: *Ben Vautier, 1984: "I remember sending 5 postcard projects to George Maciunas. He evidently only printed 3. I think Number 4 was an ego card: 'Just Look At Me.' "*

·Although dated 1965, this Fluxus postcard was not printed until 1966. It is usually included in both Flux Year Box 2 *and* Flux Post Kit 7.

PRINTS

Fn-r BEN VAUTIER prints,...$2.
Second Pricelist - European Mail-Orderhouse. [Fall 1964].

COMMENTS: *During this period Ben Vautier mailed out numerous signed ready-mades, such as pictures of holes,*

scanty-clad comely women, money, other peoples paintings, etc. *Prints* were related to specific works and to his idea of signing everything.

PROOF OF DATE
Silverman No. < 436.I

COMMENTS: *This recently discovered 1965 postcard* Proof of Date *exists only as a photographic negative plate prepared by George Maciunas for a Fluxus Edition. We have found no evidence that it was ever printed or advertised for sale by Fluxus. In a 1984 conversation, Ben Vautier recalled sending five postcard projects to George Maciunas: (1) Receive, (2) Return; The Postman's Choice; Your Thumb Present; an ego card, Just Look at Me which was not produced.* Proof of Date *would have been the fifth postcard project.*

PUBLIC

"...Will try to film here your public film (their entry, waiting & exit) IT IS GREAT IDEA. (But will cost maybe $100 to film...) In fact we will do it during winter when we get our own theatre...."
Letter: George Maciunas to Ben Vautier, [ca. Fall 1966].

COMMENTS: *Ben Vautier, 1984: "Public film was two projects: one was to film the audience coming in to a cinema, waiting for a film, no film. The last image is them leaving. The second is a film of me insulting the public. Example: 'Why did you come? You are fools.' It was lost in Lyon. I tried to reconstruct it from rushes but I didn't like the results."*

PUBLICATIONS see:
AESTHETICS
COMPLETE WORKS
FIFTYEIGHT PROPOSITIONS FOR ONE PAGE
I BEN SIGN
NINE DIRECTIONS FOR ART
SPECIAL ISSUE OF V TRE
THEATRE D'ART TOTAL
TOTAL ART MAGAZINE
UNTITLED BOOKLET

RECEIVE/RETURN see:
(1) RECEIVE, (2) RETURN

RECORDS see:
DISQUE DE MUSIQUE TOTAL

REGARDEZ MOI CELA SUFFIT see:
PHOTO

RUBBER STAMPS see:
BEN VAUTIER CERTIFIES THIS TO BE A
WORK OF FLUXART

SCAR STICK-ONS see:
George Maciunas and Ben Vautier

SCORES

COMMENTS: *Numerous scores by Ben Vautier are published*

in his Theatre d'Art Total, Fluxfest Sale *and* Flux Fest Kit 2.

SEE GOD THROUGH THIS FLUX TUBE OF BEN see:
FLUXBOX CONTAINING GOD
SOLO BOX see:
COMPLETE WORKS

SPECIAL ISSUE OF V TRE

FLUX-PROJECTS PLANNED FOR 1967...Ben Vautier:...special issue of V TRE.
Fluxnewsletter, March 8, 1967.

COMMENTS: *Ben Vautier, 1984: "We agreed to do a special issue and that we'd write each other, but it never happened."*
A permutation of the Fluxus Edition of the artist's collected works. See also: Complete Works *and* Vautier Kit.

STAMP DISPENSER

FLUX AMUSEMENT ARCADE...Stamp & postcard dispensers (Watts & Vautier)
Preliminary Proposal for a Flux Exhibit at Rene Block Gallery. [ca. 1974].

COMMENTS: *Ben Vautier suggested only one stamp to George Maciunas, which he described to me in 1984 as "a very subtle stamp, just 2 of the perforations were missing." This stamp was never produced by Fluxus, so the stamp dispenser would have only been for Robert Watts.*

STICKERS

"...Place cards like you suggested for New York all over objects, public statues, buildings etc. (although Ben may not like it since it sounds a bit like what he does - he signs everything) - Maybe better to let Ben be the author or all - That's it! Ben Vautier cards for all these things. OK?..."
Letter: George Maciunas to Tomas Schmit, [after July 6, 1963].

COMMENTS: *The idea of* Stickers *is like the 'Papillons' that Dadaists and Surrealists made. Not known to have been produced by George Maciunas as a Fluxus Edition.*

STICKERS see:
DISQUE DE MUSIQUE TOTAL

SUICIDE BOOTH

...This Fall, we shall publish V TRE no. 10, which shall consist of a plan for Flux-Amusement-Center, to contain:...Ben Vautier's suicide room...
Fluxnewsletter, April 1973.

FLUX AMUSEMENT ARCADE...Ben Vautier's suicide booth, 3 x 6ft x 6ft high
Preliminary Proposal for a Flux Exhibit at Rene Block Gallery. [ca. 1974].

COMMENTS: *An enlargement of* A Flux Suicide Kit, Suicide Booth *was never made.*

SUICIDE FLUXKIT see:
A FLUX SUICIDE KIT
TARGETS see:
TO LOOK AT

TERRAIN VAGUE

"...We are now in process of printing the French FLUXUS which includes...terrain vague..."
Letter: George Maciunas to Ben Vautier, March 5, 1963.

COMMENTS: *A statement on a placard designating the surroundings as a work of art by Ben. The work is reproduced in* Fluxus Newspaper No. 2. *Curiously or perhaps intentionally, the work has the same title as Eric Losfeld's radical publishing house in Paris, active in the 50s and 60s. Literally meaning "vacant lot," in Vautier's terms it is more a designated arbitrary area.*

THEATRE D'ART TOTAL
Silverman No. 445, ff.

"...I did receive your...cards in plastic envelopes, Envelopes but no pieces of paper (in 3 languages) that goes inside envelopes...."
Letter: George Maciunas to Ben Vautier, [ca. June, before July 1, 1965].

Ben Vautier. THEATRE D'ART TOTAL, above and at right

NANCY ANELLO

PAST FLUX-PROJECTS (realized in 1966)...Theatre d'art total,...by Ben Vautier.
Fluxnewsletter, March 8, 1967.

total theatre $3...by ben vautier
Fluxshopnews. [Spring 1967].

FLUX-PRODUCTS 1961 TO 1969...BEN VAUTIER total theatre... each box: [$] 3
Fluxnewsletter, December 2, 1968 (revised March 15, 1969).

FLUX-PRODUCTS 1961 TO 1970...BEN VAUTIER ...Total theatre, boxed [$] 3
Flux Fest Kit 2. [ca. December 1969].

FLUXUS-EDITIONEN ... [Catalogue No.] 782 BEN VAUTIER: total theatre, boxed
Happening & Fluxus. Koelnischer Kunstverein, 1970.

COMMENTS: *Ben Vautier, 1984: "My complete theatre from 1964 on. I was very influenced by Fluxus; Maciunas and Brecht. Theatre d'Art Total was very much influenced by what I had seen in London in '62 [Festival of Misfits]."*

The scores contained in Theatre d'Art Total *were first sent to Maciunas already printed and packaged by Ben Vautier*

NANCY ANELLO

in a plastic pouch. In this form, they were included in most assemblings of Flux Year Box 2 *and only later placed in a plastic box with a Maciunas designed label.*

TICKETS see:
AUDIENCE PIECE NUMBER 5
100 TICKETS TO SAME SEAT, SAME DAY
SHOW
TIME see:
FLUXCLOCK

TIME CERTIFICATE
component of Silverman No. 549

COMMENTS: *Published in Fluxus Newspaper No. 1, Time Certificate deals with the concept that art can consist of a designated "lapse of time." Vautier's realization of time,* Le Temps, *is a prototype for a Fluxclock that wasn't produced by Fluxus.*

BY THE PRESENT ATTESTATION
I BEN VAUTIER DECLARE ARTISTIC REALITY
AND MY PERSONAL WORK OF ART :
THE LAPSE OF TIME BETWEEN
_____ OCLOCK _____ MINUTES AND _____ SECONDS
OF THE YEARS _____ OF THE _____ CENTURY _____ BY GREENWICH TIME.
AND
_____ OCLOCK _____ MINUTES AND _____ SECONDS
OF THE YEARS _____ OF THE _____ CENTURY _____ BY GREENWICH TIME.
BEN _____

Ben Vautier. TIME CERTIFICATE

TO LOOK AT
Silverman No. 437, ff.

Ben Vautier. TO LOOK AT

ERIC SILVERMAN

COMMENTS: Ben Vautier, 1984: "It was just a nice ready-made piece I found on the street, but there was no concept in aiming and shooting. I still don't understand the concept behind that piece. I only see Pop, which is not interesting in it today."

Included in Flux Year Box 2, To Look At is a ready-made target. It is not known to have been distributed as an individual Fluxus work.

TOTAL ART MAGAZINE

Fn-s BEN VAUTIER total art magazine $3.
Second Pricelist - European Mail-Orderhouse. [Fall 1964].

COMMENTS: Ben Vautier is not certain what this work was. It could have been an issue of his review, Tout.

TOTAL ART MATCH-BOX

Silverman No. 440, ff.

"...Some time ago I received many matchboxes from you, which will be included in Fluxus 2...there will be various games + your matches...."
Letter: George Maciunas to Ben Vautier, May 11, 1965.

"...I did receive your -...Match Boxes..."
Letter: George Maciunas to Ben Vautier, [ca. June, before July 1, 1965].

COMMENTS: Ben Vautier, 1984: "A Non Art Anti Art concept and rejoins [Gustav] Metzger etc. in Destruction Art."

TOTAL ART MATCH-BOX

USE THESE MATCHS TO DESTROY ALL ART — MUSEUMS ART LIBRARY'S — READY MADES POP — ART AND AS I BEN SIGNED EVERYTHING WORK OF ART — BURN ANYTHING — KEEP LAST MATCH FOR THIS MATCH —

ERIC SILVERMAN

Ben Vautier. TOTAL ART MATCH-BOX

TOTAL THEATRE see:
THEATRE D'ART TOTAL

TURN THIS PAGE
component of Silverman No. 117, ff.

"...FLUXUS 2 yearbox is now in planning stage & I am requesting various people to contribute....more things like...Vautier's 'turn page'..."
Letter: George Maciunas to Robert Watts, January 21, 1965.

"...Fluxus 1 items of the type that may be included are...Ben Vautier - 'turn the page'..."
Fluxus Newsletter, unnumbered, [ca. March 1965].

COMMENTS: Ben Vautier, 1984: "see — fold and unfold, same concept, influenced by G. Brecht. Very simple gesture."
Turn this Page is included in FLUXUS 1.

27 CARDS IN A PLASTIC POUCH see:
THEATRE D'ART TOTAL

UNTITLED BOOKLET
component of Silverman No. > 117.II, ff.

"...The Flux-kit will be sent free to you also. ONLY PLEASE! Send 100 copies of your part in the book. We...ran out of small booklets you sent, so...we have NOTHING FROM YOU TO PUT IN FLUXUS!!!"
Letter: George Maciunas to Ben Vautier, January 23, 1965.

"...I did receive your - Flux-book...."
Letter: George Maciunas to Ben Vautier, [ca. June, before July 1, 1965].

COMMENTS: This is a pamphlet produced by Ben Vautier and sent to George Maciunas for inclusion in FLUXUS 1.

USELESS OBJECTS see:
FLUX USELESS OBJECT

VAUTIER KIT
Silverman No. > 441.III

"...Send me by sea mail 100 of each of your pieces for small Flux kit. like posters, objects (small) compositions etc..etc. Send it soon, OK?..."
Letter: George Maciunas to Ben Vautier, July 21, 1964.

"...Meanwhile think about objects that I could produce...kits (in attache cases)...etc. OK?..."
Letter: George Maciunas to Ben Vautier, May 19, 1966.

COMMENTS: This work is either an extension of or a parallel to Vautier's Complete Works. Fluxus never produced a collection of various concepts by Vautier in one kit.

VAUTIER LITANY see:
I BEN SIGN

VOMIT

"...We are now in process of printing the French FLUXUS which includes...vomit bottles...."
Letter: George Maciunas to Ben Vautier, March 5, 1963.

COMMENTS: Maciunas never produced the French Fluxus he refers to. And although Ben Vautier made several Vomits, a Fluxus Edition was never produced.

V TRE see:
SPECIAL ISSUE OF V TRE

WALLPAPER see:
ASSHOLES WALLPAPER
WATER see:
DIRTY WATER

YOUR THUMB PRESENT
Silverman No. 453, ff.

"...Your postcards will be printed very soon with many other card jobs. Will mail you 100 or so..."
Letter: George Maciunas to Ben Vautier, March 29, 1966.

"...Your thumb card - VERY FUNNY!! You know, that I am reprinting all your cards for American postcard size:...Will do others and thumb card by November..."
Letter: George Maciunas to Ben Vautier, [ca. October 1966].

FLUX-PROJECTS PLANNED FOR 1967 ... Ben Vautier:...Flux-postcard events (series)
Fluxnewsletter, March 8, 1967.

FLUX-PROJECTS PLANNED FOR 1967...Collective projects: (All are invited to submit ideas and participate, ideas can be either ready pictorial material or just specified material which we have to find, produce or obtain otherwise)...Flux-postal kit: containing postcards...
ibid.

FLUX POST CARD
© 1967, BY FLUXUS

Your thumb present now on this side of this card is the realization of my intention.

Votre pouce qui se trouve sur cette face de cette carte est la realisation de mon intention.

BY BEN, 1966

Ben Vautier. YOUR THUMB PRESENT

IMPLOSIONS INC. PROJECTS...Triple partnership was formed between Bob Watts, Herman Fine and myself [George Maciunas] to introduce into mass market ...money producing products...This business will be operated in commercial manner, with intent to make profits....connection between Fluxus collective and Implosions Inc. has not been clarified yet...we could consider at present Fluxus to be a kind of division or subsidiary of Implosions. Projects to be realized through Implosions:...Postcards,...
ibid.

[component of] flux post kit $7
Fluxshopnews. [Spring 1967].

flux post cards 20¢ ea....by ben vautier
ibid.

"...Am sending new postcards (thumb) that we printed here - 1000 -..."
Letter: George Maciunas to Ben Vautier, [ca. November 15, 1967].

FLUXPROJECTS REALIZED IN 1967...Post cards by Ben Vautier (included)
Fluxnewsletter, January 31, 1968.

FLUX-PRODUCTS 1961 TO 1969 ... FLUXPOST KIT 1968...[including] 3 post cards by Ben Vautier, ...[$] 8 Version without rubber stamps [$] 2
Fluxnewsletter, December 2, 1968 (revised March 15, 1969).

FLUX-PRODUCTS 1961 TO 1969...Postcards, 3 different kinds, each: *[indicated as part of FLUXKIT] [$] .2
ibid.

FLUX-PRODUCTS 1961 TO 1970 ... FLUXPOST KIT, 1968:...[including] 3 post cards by Ben Vautier, boxed: $ 8
Flux Fest Kit 2. [ca. December 1969].

FLUX-PRODUCTS 1961 TO 1970...Postcards, 3 different kinds, all for [$] ½
ibid.

FLUXUS-EDITIONEN...[Catalogue No.] 718 FLUX-POST KIT, 1968 (... b. vautier,...)
Happening & Fluxus. Koelnischer Kunstverein, 1970.

COMMENTS: Your Thumb Present, *a Fluxus postcard, was not printed until 1967. It is included in many copies of* Flux Year Box 2 *and all copies of* Flux Post Kit 7 *as well as distributed individually.*

EMILIO VILLA

It was announced in the Brochure Prospectus version B that Emilio Villa would contribute "Un eden Precox" to FLUXUS NO. 2 FRENCH YEARBOOK-BOX.
see: COLLECTIVE

ANDREI VOLKONSKI

In Brochure Prospectus version A, it was announced that Marie Joudina was being consulted with Andrei Volkonski on "Experimental music in USSR" for FLUXUS NO. 7 EAST EUROPEAN YEARBOX. Brochure Prospectus version B, lists only Volkonski as the intended author.
see: COLLECTIVE

MICHAEL VON BIEL

It was announced in the Brochure Prospectus, versions A and B, that M. von Biel would contribute "Chance methods in musical compositional methods of past centuries" corrected to "Chance methods in musical compositions of the past" to FLUXUS NO.5 HOMAGE TO THE PAST. It was announced in Brochure Prospectus version A that he would contribute "essay against concretism" and "other subjects to be determined" to FLUXUS NO. 6 ITALIAN, ENGLISH, AUSTRIAN YEARBOX.
see: COLLECTIVE

WOLF VOSTELL

It was announced in the Brochure Prospectus version A that Wolf Vostell would contribute "Decollage (inserts, originals)" and "collected visuals" to FLUXUS NO. 2 GERMAN & SCANDINAVIAN YEARBOX and later, in Brochure Prospectus version B only "Decollage (originals in luxus fluxus only)" appears listed for FLUXUS NO. 3 GERMAN & SCANDINAVIAN YEARBOX.
see: COLLECTIVE

ACTION PAGE see:
 YELLOW PAGES OR AN ACTION PAGE
FILM see:
 SUN IN YOUR HEAD

SUN IN YOUR HEAD
Silverman No. < 466.101, ff.

FLUXFILMS ... LONG VERSION, ADDITIONAL FILMS TO SHORT VERSION...flux-number 23 Wolf Vostell SUN IN YOUR HEAD 6' Various TV screen distortions & interferences
Fluxfilms catalogue. [ca. 1966].

PAST FLUX-PROJECTS (realized in 1966)...Flux-films: total package: 1 hr. 40 min....[including] sun in your head by Wolf Vostell,...
Fluxnewsletter, March 8, 1967.

PROPOSED R&R EVENINGS:...Flux-film-walls (loops by...Wolf Vostell,...)
Fluxnewsletter, January 31, 1968.

[as above]
Fluxnewsletter, December 2, 1968.

FLUX-PRODUCTS 1961 TO 1969...FLUXFILMS, long version Winter 1966 Short version plus addition of:...[including] Sun in your head - by Wolf Vostell, total: 1 hr. 40 min. 3600ft. 16mm only: [$] 400
Fluxnewsletter, December 2, 1968 (revised March 15, 1969).

FLUX-PRODUCTS 1961 TO 1970...FLUXFILMS,

long version, Winter 1966. Short version plus addition of...[including] Sun in your head by Wolf Vostell, total: 1 hr. 40min. 16mm $400
Flux Fest Kit 2. [ca. December 1969].

SLIDE & FILM FLUXSHOW...WOLF VOSTELL: SUN IN YOUR HEAD TV screen distortions and interferences. 6'
ibid.

FILM AND SOUND ENVIRONMENT A booth must be set up in a fairly dark area, the walls of which are of white vinyl or cotton sheets (about 12' wide x 8' high) hanging as curtains, creating thus a 12' x 12' or smaller room. Four 8mm wide angle lense loop projectors must be set up in front of each wall on the outside, projecting an image the frame of which is to cover entire wall. Spectators may enter the booth through corners....TV distortions by Wolf Vostell with sound static and distortions from radio.
ibid.

DICK HIGGINS

Wolf Vostell. ca. 1966

Wolf Vostell. YELLOW PAGES OR AN ACTION PAGE. as it appeared in Fluxus Newspaper No. 8

FLUXYEARBOX 2, May 1968...19 film loops by: [including] ...Wolf Vostell...
ibid.

COMMENTS: Fluxfilm No. 23 was evidently made in 1963 as a "Television de-collage." It consists of single frame sequences taken from TV, of airplanes, women, men, etc., with periodic distortion of the images, probably made with the horizontal and vertical knob of the television set. The image is broken with texts such as "silence" or "ich liebe dich." Edo Johnson is credited as camera person.

YELLOW PAGES OR AN ACTION PAGE
component of Silverman No. 569, ff.

YELLOW PAGES OR AN ACTION PAGE BY WOLF VOSTELL, 1966
Vaseline sTREet (Fluxus Newspaper No. 8) May 1966.

PAST FLUX-PROJECTS (realized in 1966)...Vaseline sTREet (V TRE no. 8) Newspaper event (action page) by Wolf Vostell...
Fluxnewsletter, March 8, 1967.

FLUX-PRODUCTS 1961 TO 1969 ... V TRE FLUX-NEWSPAPERS...Vaseline sTREet, no. 8 May 1966... action page by Wolf Vostell...[indicated as part of FLUXKIT]
Fluxnewsletter, December 2, 1968 (revised March 15, 1969).

COMMENTS: A score for individual participation in a month long event regarding hunger during times of food rationing. The work is published as a page in Fluxus Newspaper No. 8.

W

YOSHIMASA WADA

CIGARETTE DISPENSER

PROPOSED FLUXSHOW FOR GALLERY 669 ... AUTOMATIC VENDING MACHINES-DISPENSERS (coin operated)...cigarette dispenser dispensing pre-pared cigarettes (with flash paper, with smoke pow-der, with tea leaves etc.)
Fluxnewsletter, December 2, 1968.

PROPOSED FLUXSHOW...AUTOMATIC VENDING MACHINES-DISPENSERS (coin operated)...cigarette dispenser dispensing prepared cigarettes: with flash paper, with smoke powder, with tea leaves etc.
Fluxnewsletter, December 2, 1968 (revised March 15, 1969).

AUTOMATIC VENDING MACHINES...Cigarette dispenser dispensing prepared cigarettes: with flash paper, with smoke powder, with rope or rubber in tobacco, etc.
Flux Fest Kit 2. [ca. December 1969].

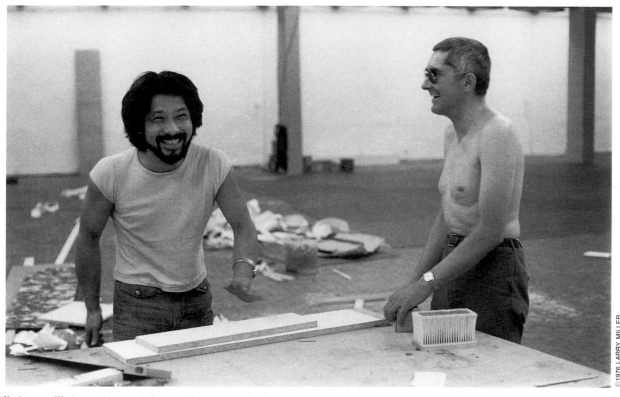

Yoshimasa Wada, working with George Maciunas on the Ay-O section of FLUXLABYRINTH. Berlin, 1976

©1976 LARRY MILLER

MAY 30-JUNE 6: THE STORE BY JOHN & YOKO + FLUXFACTORY Coin operated vending machines: ...Cigarette dispenser dispensing cigarettes with rope, dried fruit, sawdust & other filling,...
Schedule of events for Fluxfest presentation of John Lennon and Yoko Ono. [ca. April 1970]. version B

MAY 30-JUNE 5: THE STORE BY YOKO + FLUX-FACTORY Vending machines (coin operated):...ciga-rette dispenser dispensing prepared cigarettes, with rope, tobacco, dried fruit skins etc. mixed in the to-bacco,...(by Yoshimasa Wada);...
Schedule of events for Fluxfest presentation of John Lennon and Yoko Ono. April 1, 1970. version C

COMMENTS: *The idea of* Cigarette Dispenser *vending pre-pared smokes was initially anonymous. It could have been George Maciunas', relating to his altered food works, throwing in ideas of Per Kirkeby's and Greg Sharits'. In 1969, Fluxus produced Yoshi Wada's* Smoke Fluxkit *and Maciunas then credits the dispenser to Wada in 1970, altering the proposed contents of the cigarettes to reflect his work.*

COUGH

FLUX-PRODUCTS 1961 TO 1969...YOSHIMASA

WADA...Cough, preserved in sealed box [$] 1
Fluxnewsletter, December 2, 1968 (revised March 15, 1969).

FLUX-PRODUCTS 1961 TO 1970...YOSHIMASA WADA...Cough, preserved in sealed box [$] 1
Flux Fest Kit 2. [ca. December 1969].

''...Wada's cough only a prototype...''
Letter: George Maciunas to Dr. Hanns Sohm, [ca. late 1972].

SPRING 1969...Y. WADA:... cough
George Maciunas, Diagram of Historical Developments of Fluxus... [1973].

COMMENTS: *The prototype of this work, now in the Staats-galerie Stuttgart, is an apparently empty, clear plastic box which has been sealed shut. Prestype on the lid gives the title* Flux Miracle, *and then information such as "contents: George's cough sealed by Yoshimasa Wada on Feb. 7, 1969..."*
In 1970, Maciunas mailed two empty, clear plastic sealed boxes, but without labels or other identifying marks, to Armin Hundertmark in West Germany. One of these is now in the Silverman Fluxus Collection and could be Wada's Cough.

DISPENSERS see:
CIGARETTE DISPENSER
PERFUME DISPENSER

FLUX MIRACLE see:
COUGH

FLUXPERFUME

COMMENTS: *Several mechanicals exist for the labels that George Maciunas designed for* Fluxperfume. *The work was never produced as such. The title could have been an earlier version of* Smoke Fluxkit, *smoke being the Fluxus perfume. See* Perfume Dispenser.

FLUX SMOKE SET see:
SMOKE FLUXKIT
FLUXTOUR TICKETS see:
UNAUTHORIZED TICKET TO VISIT JAMES STEWART
UNAUTHORIZED TICKET TO VISIT JONAS MEKAS
UNAUTHORIZED TICKET TO VISIT LA MONTE YOUNG
UNAUTHORIZED TICKET TO VISIT LAUREN BACALL
FOOD see:
SALAD SOUP
VITAMIN PLATTER

GROWTH

SLIDE & FILM FLUXSHOW...YOSHIMASA WADA: GROWTH Projection of hollow slides with urethane foam, shaving cream, dry sugar, salt filling each slide.
Flux Fest Kit 2. [ca. December 1969].

COMMENTS: *An ephemeral work not known to exist, it could relate to George Maciunas'* Kinethesis Slide *pieces.*

SCOTT HYDE

Yoshimasa Wada. Unfinished mechanical by George Maciunas for the label of FLUXPERFUME

Yoshimasa Wada. Three unfinished mechanicals by George Maciunas for the label of FLUXPERFUME

SCOTT HYDE

PERFUME see:
FLUXPERFUME

PERFUME DISPENSER

MAY 30-JUNE 5: THE STORE BY JOHN & YOKO + FLUXFACTORY Coin operated vending machines ...Perfume dispenser dispensing various strange scents and smokes (Yoshimasa Wada),...
Schedule of events for Fluxfest presentation of John Lennon and Yoko Ono. [ca. April 1970]. version B

COMMENTS: *Perfume Dispenser is related to Wada's* Smoke Fluxkit *and* Cigarette Dispenser. *All would produce the unexpected. This dispenser was not made.*

SALAD SOUP

NEW YEAR EVE'S FLUX-FEAST, DEC. 31. 1969 AT CINEMATHEQUE, 80 WOOSTER ST....Yoshimasa Wada:...salad soup...
Fluxnewsletter, January 8, 1970.

31.12.1969 NEW YEAR EVE'S FLUX-FEAST (FOOD EVENT)...Y. Wada salad soup...

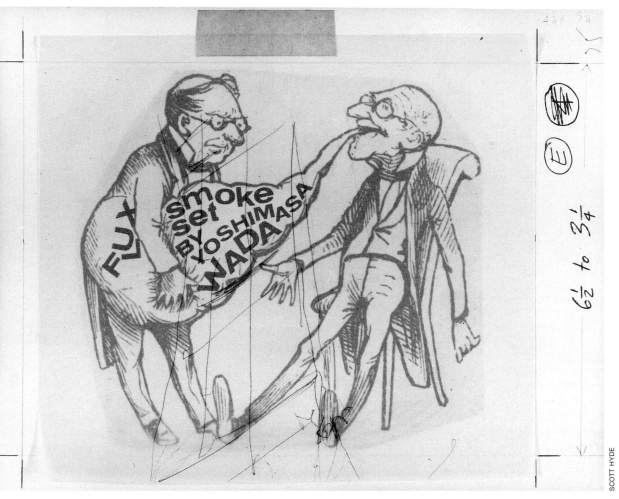

Yoshimasa Wada. SMOKE FLUXKIT. Unused mechanical by George Maciunas for the label, called here, FLUX SMOKE SET

SCOTT HYDE

George Maciunas, Diagram of Historical Developments of Fluxus... [1973].

COMMENTS: *Salad Soup was a Fluxus Gastromonic delight — two birds killed with one stone.*

SCORE see:
UNTITLED SCORE
SMOKE see:
CIGARETTE DISPENSER
PERFUME DISPENSER
SMOKE FLUXKIT
SMOKE MACHINE

SMOKE FLUXKIT
Silverman No. 466, ff.

FLUX-PRODUCTS 1961 TO 1969...YOSHIMASA

WADA Smoke fluxkit, in partitioned box * [indicated as part of FLUXKIT] [$] 5
Fluxnewsletter, December 2, 1968 (revised March 15, 1969).

FLUX-PRODUCTS 1961 TO 1970...YOSHIMASA WADA Smoke fluxkit, partitioned box [$] 5...
Flux Fest Kit 2. [ca. December 1969].

...a set of 1969-70 Flux-productions which consist of the following: 1969 - smoke flux kit
Fluxnewsletter, January 8, 1970.

FLUXUS-EDITIONEN ... [Catalogue No.] 789 YOSHIMASA WADA: smoke fluxkit
Happening & Fluxus. Koelnischer Kunstverein, 1970.

SPRING 1969...Y. WADA: smoke kit,...
George Maciunas, Diagram of Historical Developments of Fluxus... [1973].

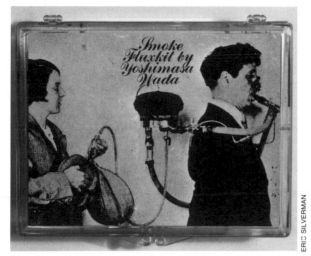

Yoshimasa Wada. SMOKE FLUXKIT

ERIC SILVERMAN

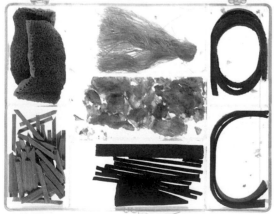

Yoshimasa Wada. SMOKE FLUXKIT

ERIC SILVERMAN

YOSHIMASA WADA Smoke flux kit, 8 materials, boxed $8
Flux Objects, Price List. May 1976.

COMMENTS: *A Fluxus Edition containing various materials that would make pleasant or vile smelling smoke when burned. The first version of the box was titled* Flux Smoke Set, *with instructions inside, "light it, watch, smell."*

SMOKE MACHINE

FLUX SHOW: DICE GAME ENVIRONMENT EN-TIRE FLOOR AS DICE HAZARD TABLE DIE CUBES, 15'' CUBES ON FLOOR, Marked on sides, top open or closed with clear plastic. Consisting or containing...Smoke machine by Yoshimasa Wada.
Flux Fest Kit 2. [ca. December 1969].

COMMENTS: Smoke Machine *would have been an instrument to burn Yoshimasa Wada's collected materials that made nice or foul smelling smoke.*

TICKETS TO VISIT FAMOUS PEOPLE see:
 FLUX TOUR TICKETS

UNAUTHORIZED TICKET TO VISIT
JAMES STEWART
Silverman No. > 466.I

APR. 18-24: TICKETS BY JOHN LENNON + FLUX-TOURS...tickets to visit famous people ($1 to 10¢) by Y. Wada,...
Schedule of events for Fluxfest presentation of John Lennon and Yoko Ono. [ca. April 1970]. version A

APR. 18-24: TICKETS BY JOHN LENNON + FLUX-TOURS Selling to the public various tickets:...to visit famous people (Y. Wada);...
Schedule of events for Fluxfest presentation of John Lennon and Yoko Ono. [ca. April 1970]. version B

APR. 18-24: TICKETS BY JOHN LENNON + FLUX-AGENTS Selling to the public various tickets to ...

visit famous people (by Y. Wada),...
Schedule of events for Fluxfest presentation of John Lennon and Yoko Ono. April 1, 1970. version C

FLUXFEST PRESENTATION OF JOHN LENNON & YOKO ONO +* AT 80 WOOSTER ST. NEW YORK —1970...APR. 18-24: TICKETS BY JOHN LENNON + FLUXTOURS...Unauthorized tickets to visit famous people (Yoshimasa Wada):...tickets to visit James Stewart through stage door of Anta theater...
all photographs copyright nineteen seVenty by peTer mooRE (Fluxus Newspaper No. 9) 1970.

11.04-29.05.1970 FLUX FEST OF JOHN LENNON & YOKO ONO:...18-24.04 TICKETS...by Wada: to visit famous people,...
George Maciunas, Diagram of Historical Developments of Fluxus... [1973].

COMMENTS: *Yoshimasa Wada's unauthorized ticket series takes two famous actors and two famous artists who would be impossible to visit at the time or place indicated.*

UNAUTHORIZED TICKET TO VISIT
JONAS MEKAS
Silverman No. > 466.II

APR. 18-24: TICKETS BY JOHN LENNON + FLUX-TOURS...tickets to visit famous people ($1 to 10¢), by Y. Wada,...
Schedule of events for Fluxfest presentation of John Lennon and Yoko Ono. [ca. April 1970]. version A

APR. 18-24: TICKETS BY JOHN LENNON + FLUX-TOURS Selling to the public various tickets:...to visit famous people (Y. Wada);...
Schedule of events for Fluxfest presentation of John Lennon and Yoko Ono. [ca. April 1970]. version B

APR. 18-24: TICKETS BY JOHN LENNON + FLUX-AGENTS Selling to the public various tickets to ... visit famous people (by Y. Wada),...
Schedule of events for Fluxfest presentation of John Lennon and Yoko Ono. April 1, 1970. version C

FLUXFEST PRESENTATION OF JOHN LENNON

Yoshimasa Wada. UNAUTHORIZED TICKET TO VISIT JAMES STEWART

Yoshimasa Wada. UNAUTHORIZED TICKET TO VISIT JONAS MEKAS

& YOKO ONO +* AT 80 WOOSTER ST. NEW YORK
—1970...APR. 18-24: TICKETS BY JOHN LENNON
+ FLUXTOURS...Unauthorized ticket to visit fa-
mous people (Yoshimasa Wada):...tickets to visit
Jonas Mekas at Hotel Chelsea at 10:58PM, May 8th...
*all photographs copyright nineteen seVenty by peTer mooRE
(Fluxus Newspaper No.9) 1970.*

11.04-29.05.1970 FLUX FEST OF JOHN LENNON
& YOKO ONO:...18-24 TICKETS...by Wada: to
visit famous people,...
*George Maciunas, Diagram of Historical Developments of
Fluxus... [1973].*

COMMENTS: *This ticket is a little obscure. Perhaps on May
8th, 1970 at 10:58pm, Jonas Mekas was in the midst of a
screening at another location.*

UNAUTHORIZED TICKET TO VISIT
LA MONTE YOUNG
Silverman No. > 466.III

APR. 18-24: TICKETS BY JOHN LENNON + FLUX-
TOURS...tickets to visit famous people ($1 to 10¢)
by Y. Wada,...
*Schedule of events for Fluxfest presentation of John Lennon
and Yoko Ono. [ca. April 1970]. version A*

APR. 18-24: TICKETS BY JOHN LENNON + FLUX-
TOURS Selling to the public various tickets:...to visit
famous people (Y. Wada);...
*Schedule of events for Fluxfest presentation of John Lennon
and Yoko Ono. [ca. April 1970]. version B*

APR. 18-24: TICKETS BY JOHN LENNON + FLUX-
AGENTS Selling to the public various tickets to...
visit famous people (by Y. Wada),...
*Schedule of events for Fluxfest presentation of John Lennon
and Yoko Ono. April 1, 1970. version C*

FLUXFEST PRESENTATION OF JOHN LENNON
& YOKO ONO +* AT 80 WOOSTER ST. NEW YORK
—1970...APR. 18-24: TICKETS BY JOHN LENNON
+ FLUXTOURS...Unauthorized tickets to visit fa-
mous people (Yoshimasa Wada):...tickets to visit

La Monte Young (front door always locked)...
*all photographs copyright nineteen seVenty by peTer mooRE
(Fluxus Newspaper No. 9) 1970.*

11.04-29.05.1970 FLUX FEST OF JOHN LENNON
& YOKO ONO:...18-24.04 TICKETS...by Wada: to
visit famous people,...
*George Maciunas, Diagram of Historical Developments of
Fluxus... [1973].*

COMMENTS: *Perhaps this was George Maciunas again poking
fun at La Monte Young's reclusive habits. In FLUXUS 1,
Maciunas used a photo of Young peering through the mail
slot in his front door.*

UNAUTHORIZED TICKET TO VISIT
LAUREN BACALL
Silverman No. > 466.IV

APR. 18-24: TICKETS BY JOHN LENNON + FLUX-
TOURS...tickets to visit famous people ($1 to 10¢),
by Y. Wada,...
*Schedule of events for Fluxfest presentation of John Lennon
and Yoko Ono. [ca. April 1970]. version A*

APR. 18-24: TICKETS BY JOHN LENNON + FLUX-
TOURS Selling to the public various tickets:...to visit
famous people (Y. Wada);...
*Schedule of events for Fluxfest presentation of John Lennon
and Yoko Ono. [ca. April 1970]. version B*

APR. 18-24: TICKETS BY JOHN LENNON + FLUX-
AGENTS Selling to the public various tickets to...
visit famous people (by Y. Wada),...
*Schedule of events for Fluxfest presentation of John Lennon
and Yoko Ono. April 1, 1970. version C*

FLUXFEST PRESENTATION OF JOHN LENNON
& YOKO ONO +* AT 80 WOOSTER ST. NEW YORK
—1970...APR. 18-24: TICKETS BY JOHN LENNON
+ FLUXTOURS...Unauthorized tickets to visit fa-
mous people (Yoshimasa Wada): tickets to visit Lauren
Bacall through stage door of Palace theater...
*all photographs copyright nineteen seVenty by peTer mooRE
(Fluxus Newspaper No. 9) 1970.*

11.04-29.05.1970 FLUX FEST OF JOHN LENNON
& YOKO ONO:...18-24.04 TICKETS...by Wada: to
visit famous people,...
*George Maciunas, Diagram of Historical Developments of
Fluxus... [1973].*

COMMENTS: *One of the hottest tickets in town.*

UNTITLED SCORE

COMMENTS: *An untitled performance instruction, having to
do with arrows and smoke by Yoshimasa Wada appears in
Flux Fest Kit 2. see: COLLECTIVE*

VENDING MACHINES see:
DISPENSERS

VITAMIN PLATTER
NEW YEAR EVE'S FLUX-FEAST, DEC. 31, 1969
AT CINEMATHEQUE, 80 WOOSTER ST....Yoshi-
masa Wada: vitamin platter...
Fluxnewsletter, January 8, 1970.

31.12.1969 NEW YEAR EVE'S FLUX - FEAST
(FOOD EVENT)...Y. Wada: vitamin platter...
*George Maciunas, Diagram of Historical Developments of
Fluxus... [1973].*

COMMENTS: *Minimalist food, very popular in New York at
that time.*

DIANE WAKOSKI

*It was announced in the Brochure Prospectus version A, that
Diane Wakoski would contribute "stimulated by one hundred
ones" and "Poems (2)" to FLUXUS NO. 1 U.S. YEARBOX.
In Brochure Prospectus, version B, she was simply to contri-
bute "poems" to the FLUXUS YEARBOX.
see: COLLECTIVE*

JAMES WARING

*It was announced in the Brochure Prospectus version B, that
James Waring would contribute "formal comic and chance
poems" to FLUXUS NO. 1 U.S. YEARBOX.
see: COLLECTIVE*

ROBERT WATTS

*It was announced in Brochure Prospectus version B that
Robert Watts would contribute "Theatre Events for intermis-
sion," "Playing cards," "postage stamps," "dollar bill," and
"Collection of ready mades" to FLUXUS NO. 1 U.S. YEAR-
BOX. Watts' contributions to FLUXUS 1 vary from copy to
copy. They usually contain sheets or blocks of his stamps,
samples of Hospital Events, a Dollar Bill, a few Playing Cards,*

Yoshimasa Wada. UNAUTHORIZED TICKET TO VISIT LA MONTE
YOUNG

Yoshimasa Wada. UNAUTHORIZED TICKET TO VISIT LAUREN
BACALL

as well as printed ready-mades and photomontage. Dollar Bill is reproduced in Fluxus Newspaper No. 2 and evolves into a separate Fluxus Edition, $ Bills in Wood Chest. A number of Watts' scores appear in various Fluxus publications: Fluxus Preview Review, Fluxus Newspaper No. 2, Fluxfest Sale, Flux Year Box 2 and Flux Fest Kit 2. Many are collected in Watts' Events also. He contributed a ready-made to Fluxus Newspaper No. 2, and collages to Fluxus Newspapers Nos. 3 and 4.
see: COLLECTIVE

A TO Z SERIES see:
[a]	PENS
[b]	PENCILS
[c]	PHOTOGRAPHS
[d]	POSTCARDS
[e]	SOAP
[f]	LIGHTER
[g]	YAMS
[h]	NECKTIE
[i]	TIRE
[j]	BRIEFCASE
[k]	BOOK
[l]	MAGAZINE
[m]	BALL
[n]	STRING
[o]	SOCKS
[p]	GEOGRAPHY
[q]	PSYCHOLOGY
[r]	ZOOLOGY
[s]	PORNOGRAPHY
[t]	FINGERPRINTS
[u]	SMEARS
[v]	SEX, FEMALE
[v]	SEX, MALE
[w]	ASSORTED TOOLS
[x]	STAMPS
[y]	BLIND DATE
[z]	35 MM SLIDE
	OBJECTS

COMMENTS: The FLUXUS kk a-z series of Robert Watts, first advertised in Fluxus Newspaper No. 3, was assembled by the artist in 1982 and 1983 using, where possible, objects that would have been sent out in 1964 or subsequent years and in instances where those objects no longer existed, finding suitable substitutes. A glass display case was chosen by the artist in 1982 to hold the entire series and is now an integral part of the work.

ACCESSORIES

"...Received your 2 letters, NICE BOX OF ACCESSORIES & CUT-OUTS-READYMADES...In luxus fluxus we will include accessories...Luxus Fluxus has no deadline - since it will be assembled only when an order comes for it. Let me know if you need money for postage (mailing all these things)...."
Letter: George Maciunas to Robert Watts, [ca. Summer 1962].

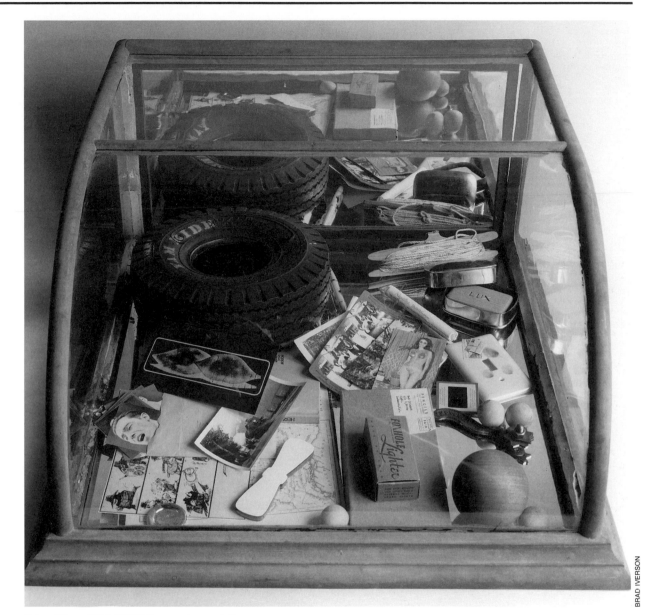

BRAD IVERSON

Robert Watts. A TO Z SERIES. see color portfolio

COMMENTS: Accessories and Cut-Outs were ready-made images, usually of a sexual persuasion, that Robert Watts clipped from magazines and books. Some of these found their way into his a to z series. Some are cropped images printed in FLUXUS 1, and some appear as elements of collages in the Fluxus newspapers.

APRONS see:
HAIRY MAN IN SHORTS APRON

MEDIEVAL ARMOR APRON
NUDE FRONT APRON
NUDE WAITRESS WITH TRAY APRON
PAPER APRONS
POPE MARTIN V APRON
ROMAN EMPEROR APRON
VENUS DE MILO APRON
VIRGIN MARY APRON
WAITER WITH TRAY APRON
WINGED VICTORY APRON

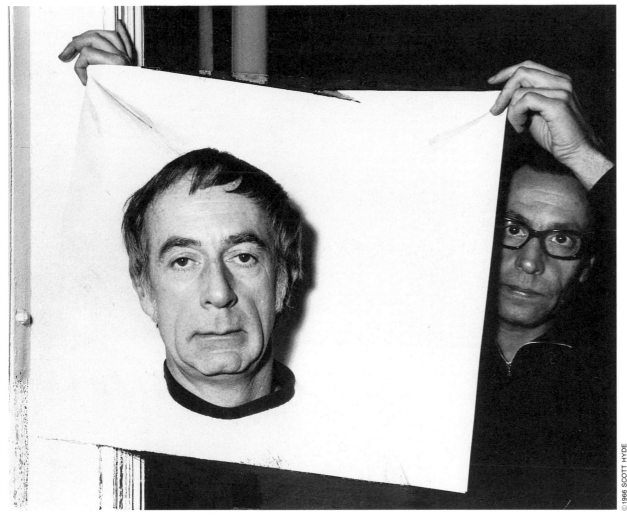

Robert Watts and Robert Filliou. New York, December, 1966

Robert Watts. ASSORTED TOOLS

FLUXUS kk a to z series;...(m) ball 75¢...
cc Valise-e TRanglE (Fluxus Newspaper No. 3) March 1964.

KAZ-serie[s] ROBERT WATTS: objects ... kk/m BALL 75¢
European Mail-Orderhouse: europeanfluxshop, Pricelist. [ca. June 1964].

KAZ series OBJECTS from ROBERT WATTS...kk/m ball $0.75
Second Pricelist - European Mail-Orderhouse. [Fall 1964].

FLUXUS kk ROBERT WATTS: a to z series...(m) ball 75¢...
Vacuum TRapEzoid (Fluxus Newspaper No. 5) March 1965.

COMMENTS: *A nice ball — hardwood, glazed antique clay marble, etc. A ready-made of one sort or another.*

ASSORTED TOOLS
Silverman No. > 483.XXXI

FLUXUS 1964 EDITIONS, AVAILABLE NOW ... FLUXUS kk a to z series;...(w) assorted tools, 75¢ & up...
cc Valise e TRanglE (Fluxus Newspaper No. 3) March 1964.

KAZ - serie[s] ROBERT WATTS: objects ... kk/w TOOLS assorted 75¢ and up
European Mail-Orderhouse: europeanfluxshop, Pricelist. [ca. June 1964].

KAZ series OBJECTS from ROBERT WATTS...kk/w tools assorted 75¢ & up
Second Pricelist - European Mail-Orderhouse. [Fall 1964].

FLUXUS kk ROBERT WATTS: a to z series ... (w) assorted tools 75¢ & up...
Vacuum TRapEzoid (Fluxus Newspaper No. 5) March 1965.

COMMENTS: *Robert Watts, 1982: "Things that you'd find on Canal Street [New York City] — they'd look like tools but aren't."*

BABE IN A BOX see:
 CHICK IN A BOX

BALL
Silverman No. > 483.XX

FLUXUS 1964 EDITIONS, AVAILABLE NOW ...

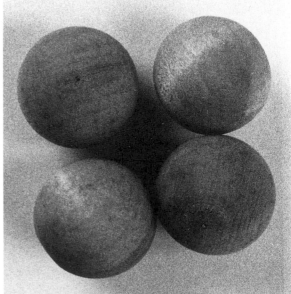

Robert Watts. BALL

BANNERS

FLUX-PROJECTS PLANNED FOR 1967...Bob Watts:...Banners...
Fluxnewsletter, March 8, 1967.

COMMENTS: *It is unspecified what Watts would have put on* Banners, *and none were made for Fluxus. He had a banner made for the Yam Festival in 1963 (Silverman No. > 482.I) that hung outside the Hardware Poet's Playhouse, New York City.*

BATHING KIT

...will appear late in 1966...FLUXUS ko ROBERT WATTS: bathing kit, $100
Vaseline sTREet (Fluxus Newspaper No. 8) May 1966.

FLUX-PRODUCTS 1961 TO 1969 ... ROBERT WATTS: bathing kit...on special order only, each: [$] 100
Fluxnewsletter, December 2, 1968 (revised March 15, 1969).

FLUX-PRODUCTS 1961 TO 1970 ... ROBERT WATTS...bathing kit, by special order only, each: [$] 100
Flux Fest Kit 2. [ca. December 1969].

COMMENTS: Bathing Kit *was a "special order" item — made up by the artist on request. It would have contained ready-made things related to bathing.*

BATHING SUIT

FLUX-PROJECTS PLANNED FOR 1967...Bob Watts:...bathing suit imprinted with similar subjects as aprons...
Fluxnewsletter, March 8, 1967.

05.1966...BOB WATTS: clothing,...
George Maciunas, Diagram of Historical Developments of Fluxus... [1973].

COMMENTS: Bathing Suit *was never produced by George Maciunas as a Fluxus Edition. Robert Watts' idea was to have a photo-image of a naked woman's torso, front and back, or a man's genitalia and buttocks manipulated with a dot matrix screen, so that at a distance the person would appear nude but on closer inspection all one would see was a disappointing abstact pattern of light and dark dots.*

BATHROOM WEIGHT SCALE see:
 SCALE

BIOLOGY 704
Silverman No. < 516.I

"...jewelry design. -printed on self adhesive clear or opaque plastic, die-stamp-out. You stick-on your

Robert Watts. BIOLOGY 704

body or clothing these...die cut items. Got already: ...human parts - photos (nipples, navels ...etc - full size)..."
Letter: George Maciunas to Ken Friedman, [ca. February 1967].

FLUX-PROJECTS PLANNED FOR 1967 ... Bob Watts:...Stick-ons (disposable jewelry): full size imprints of human parts (nipples, navels...etc)
Fluxnewsletter, March 8, 1967.

SUMMARY OF LAST NEWSLETTER (Jan. 31, 1968) ...stick-ons produced. Watts: nipples, navels....
Fluxnewsletter, December 2, 1968.

FLUX-PRODUCTS 1961 TO 1969 ... FLUXTATTOS Winter 1967...nipples, navels by Bob Watts ...6 - 5x6" stick-on sheets, boxed * [indicated as part of FLUXKIT] [$] 5
Fluxnewsletter, December 2, 1968 (revised March 15, 1969).

FLUX-PRODUCTS 1961 TO 1969 ... ROBERT WATTS Stick-ons tattoos...nipples & navels, each [$] 1
ibid.

FLUX-PRODUCTS 1961 TO 1970 ... FLUXTAT-

TOS 1967:...nipples, navels by Bob Watts...6 - 5x6" stick-on sheets, boxed $5
Flux Fest Kit 2. [ca. December 1969].

FLUX-PRODUCTS 1961 TO 1970 ... ROBERT WATTS...Stick-on tattoos ...nipples, navels...[$] 1
ibid.

COMMENTS: *Planned and advertised as a Fluxus project, these stick-ons of body parts were produced by Implosions, a commercial venture of George Maciunas, Robert Watts and Herman Fine.* Biology 704 *was included in the collective Fluxus Edition of* Flux Tattoos.

BLIND DATE
Silverman No. > 483.XXXIII

Robert Watts. BLIND DATE

FLUXUS 1964 EDITIONS, AVAILABLE NOW ...
FLUXUS kk a to z series;...(y) blind date $15...
cc Valise e TRanglE (Fluxus Newspaper No. 3) March 1964.

KAZ-serie[s] ROBERT WATTS: objects kk/y BLIND
DATE $15
*European Mail-Orderhouse: europeanfluxshop, Pricelist.
[ca. June 1964].*

KAZ series OBJECTS from ROBERT WATTS...kk/y
blind date $15
Second Pricelist - European Mail-Orderhouse. [Fall 1964].

FLUXUS kk ROBERT WATTS: a to z series...(x)
blind date $15..
Vacuum TRapEzoid (Fluxus Newspaper No. 5) March 1965.

COMMENTS: *Robert Watts, 1982: "You'd get something
that had to do with a blind date: very small pictures from a
magazine that advertised girls looking for men."*

Robert Watts. BOOK

BOOK
Silverman No. > 483.XVIII

FROM THE YAM FESTIVAL WAREHOUSE ...
BOOK $1 & up
Yam Festival Newspaper, [ca. 1963].

FLUXUS 1964 EDITIONS, AVAILABLE NOW ...
FLUXUS kk a to z series;...(k) book $1 & up...
cc Valise e TRanglE (Fluxus Newspaper No. 3) March 1964.

KAZ-serie[s] ROBERT WATTS: objects ... kk/k
BOOK $1 & up
*European Mail-Orderhouse: europeanfluxshop, Pricelist.
[ca. June 1964].*

KAZ series OBJECTS from ROBERT WATTS...kk/k
book $1 & up
Second Pricelist - European Mail-Orderhouse. [Fall 1964].

FLUXUS kk ROBERT WATTS: a to z series...(j)
book $1 & up...
Vacuum TRapEzoid (Fluxus Newspaper No. 5) March 1965.

COMMENTS: *A ready-made, leaning toward the literary
mundane.*

BOOK OF PHOTOS

"...Few comments on your 'position paper'...There
are too many incidents where he [Dick Higgins] of-
fered to publish some piece that was intended for
Fluxus...Bob Watts book of photos, etc. etc.)..."
Letter: George Maciunas to Ben Vautier, [ca. October 1966].

COMMENTS: *This work was never produced by George
Maciunas as a Fluxus Edition.*

BOUNCING SHOES

FLUX-OLYMPIAD...TRACK-HURDLES, OBSTAC-
LES ... OBSTACLE SHOES ... bouncing shoes ...
(Robert Watts)
Flux Fest Kit 2. [ca. December 1969].

FEB. 17, 1:30PM FLUX-SPORTS DOUGLASS COL.
...OBSTACLE SHOES:...bouncing shoes...
*Poster/program for Flux-Mass, Flux-Sports and Flux-Show.
February, 1970.*

PROPOSED FLUXANNIVERSARY FEST PRO-
GRAM 1962-1972 SEPT & OCT....FLUXOLYMPIAD
(counterpoint to Munich one) obstacle shoes run by
Bob Watts
Fluxnewsletter, April 1973.

1970 FLUXSPORTS:...by bob watts: obstacle shoes
*George Maciunas, Diagram of Historical Developments of
Fluxus... [1973].*

COMMENTS: *The "bounce" was literal; these were shoes
with springs attached to their bottoms.*

BRANDED WOMAN'S THIGH see:
BRANDS

BRANDS
component of Silverman No. 117, ff.

"...We will include in fluxus:...the cattle branding
signs & the 'branded' woman's thigh right behind it..."
Letter: George Maciunas to Robert Watts, [Summer 1962].

"...BIG QUESTION !!! The hospital event pictures,
we exhibited in Wuppertals Gallery Parnass (Paik's ex-
hibit) & visitors hammered so hard the pictures are
damaged. Can we substitute others in exhibits & in
Fluxus? (I can still include it)?? OK with you? (like
the picture from your puzzle & one with the brand)
(both being printed up). Let me know...or send sub-
stitute pictures with red dots...."
*Letter: George Maciunas to Robert Watts, [ca. early April
1963].*

COMMENTS: *This sexist work, produced in the spirit of the
early 60s before the Revolution, is published in FLUXUS 1.*

Robert Watts. BRIEFCASE

BRIEFCASE
Silverman No. > 483.XVII

FROM THE YAM FESTIVAL WAREHOUSE ...
BRIEFCASE $1
Yam Festival Newspaper, [ca. 1963].

FLUXUS 1964 EDITIONS, AVAILABLE NOW ...
FLUXUS kk a to z series;...(j) briefcase $1 & up...
cc Valise e TRanglE (Fluxus Newspaper No. 3) March 1964.

KAZ-serie[s] ROBERT WATTS: objects ... kk/j
BRIEFCASE $1 and up
*European Mail-Orderhouse: europeanfluxshop, Pricelist.
[ca. June 1964].*

KAZ series OBJECTS from ROBERT WATTS...kk/j
briefcase $1 & up
Second Pricelist - European Mail-Orderhouse. [Fall 1964].

FLUXUS kk ROBERT WATTS: a to z series ... (i) briefcase $1 & up...
Vacuum TRapEzoid (Fluxus Newspaper No. 5) March 1965.

COMMENTS: *A cheap cardboard portfolio painted silver and green with Watts' code letter "Fluxus k" added. Another type of* Briefcase *was to have been a plastic ready-made.*

BRONZE PENCIL see:
CHROMED PENCIL

BULLETS see:
CANDY BULLETS

Robert Watts. BUS TICKET TO GINGER BREAD CASTLE, HAMBURG, N.J. Validated April 17, 1970

BUS TICKET TO GINGER BREAD CASTLE, HAMBURG, N.J.
Silverman No. > 518.I

FLUXFEST PRESENTATION OF JOHN LENNON & YOKO ONO +* AT 80 WOOSTER ST. NEW YORK —1970...APR. 18-24: TICKETS BY JOHN LENNON + FLUXTOURS...bus to Ginger Bread Castle, N.J. (Bob Watts) $4.70...
all photographs copyright nineteen seVenty by peTer mooRE (Fluxus Newspaper No. 9) 1970.

COMMENTS: *Gingerbread Castle is a children's amusement and theme park in New Jersey. The tickets were ready-mades.*

CAMPAIGN RIBBONS see:
HERO 601

CANDY BULLETS

NEW YEAR EVE'S FLUX-FEAST, DEC. 31, 1969 AT CINEMATHEQUE, 80 WOOSTER ST.... Bob Watts: shooting with gun candies into guests' mouths.
Fluxnewsletter, January 8, 1970.

31.12.1969 NEW YEAR EVE'S FLUX - FEAST (FOOD EVENT)...Bob Watts candy bullets.
George Maciunas, Diagram of Historical Developments of Fluxus... [1973].

COMMENTS: *A sweet way to go.*

CARDS see:
COMPLETE WORKS
EVENTS
PLAYING CARDS

CASCADE see:
FILMS

CASE OF EVENTS see:
EVENTS

CASH REGISTER

"...I hear you are sick & have nothing to do...you could build a cash register for fluxus shop OK? Very important! Build one where instead of sum in $ funny pictures come out & objects, and maybe sounds - OK?..."
Letter: George Maciunas to Robert Watts, March 13, 1964.

"...I got an antique cash register, which we could connect to various events. i.e. each key (there are 100 keys) would be electrically connected to some event, like snow falling, lights off, sounds, visual events, etc. etc. smells, think of something and let me know, we are making this cash register a collective piece (like medieval cathedrals) Up to now we got Bob Watts, ... with ideas for cash register. Another 50 keys left - unused...."
Letter: George Maciunas to Ben Vautier, March 29, 1966.

COMMENTS: *There is no record of what Robert Watts planned for his contribution to the Fluxus Cash Register.*

CATTLE BRANDING SIGNS see:
BRANDS

CHESS see:
WATER CHESS

CHEST OF $ BILLS see:
$ BILLS IN WOOD CHEST

CHICK IN A BOX

"...By all means send a chick in a box to me..."
Letter: George Maciunas to Robert Watts, [before March 11, 1963].

"...Also VERY IMPORTANT. PLEASE SEND OBJECTS FOR EXHIBITS. Not bulky objects, objects that would fit into automobile. (like that babe in a box you promised) (not bronze covered)...."
Letter: George Maciunas to Robert Watts, [ca. early April 1963].

COMMENTS: *This work would have been a ready-made,*

probably an inflatable sex aid ordered from a girlie magazine, not an Easter "chick."

CHROME see:
CHROMED GOODS
CHROMED LOLLIPOP
CHROMED PENCIL
WORM BOX

CHROMED GOODS
Silverman No. > 483.IV, ff.

FLUXUS 1964 EDITIONS, AVAILABLE NOW ... FLUXUS kkk ROBERT WATTS: chromed goods, Hand written catalog, illustrated $10
cc Valise e TRanglE (Fluxus Newspaper No. 3) March 1964.

F-kkk ROBERT WATTS: chromed goods (hand written catalog, illustrated $10.)
European Mail-Orderhouse: europeanfluxshop, Pricelist. [ca. June 1964].

F-kkk ROBERT WATTS. chromed goods, handwritten catalog, illustrated $10
Second Pricelist - European Mail-Orderhouse. [Fall 1964].

FLUX SHOW: DICE GAME ENVIRONMENT ENTIRE FLOOR AS DICE HAZARD TABLE DIE CUBES, 15" CUBES ON FLOOR, Marked on sides, top open or closed with clear plastic. Consisting or containing...chrome objects by Bob Watts.
Flux Fest Kit 2. [ca. December 1969].

COMMENTS: *In the early 1960s, cars with lots of chrome were greatly admired. With a "Pop" sensitivity, Watts picked up on this, first casting everyday objects in bronze then having the work chromeplated. A "hand written catalog" was never made, but would likely have contained, among* Chromed Lollipop, Chromed Pencil, *"Thinex No. 2" and* Worm Box *offered by Fluxus, his other chromed objects:* Toothbrush, Box of Eggs, Best 46-2 [pencil], Onward - SE 161 - No. 2 [pencil], Roll of Tape, Clams, 10 Franks on Tray, 2 Franks on Dish, Sandwich, Pear, Pears, Book of Matches, Ice Cream Soda, Box of Candy, Stamp Machine No. 7, Puzzle, Fish, 5 Littleneck Clams and 4 Crabs on Dish, Small Bread, 100 Bread Loaves on Rack, W.C. Set with Brush, Butter & Dish, Cup Cake & Dish, Puzzle and Pouch, Fish on Orange Dish, Jar with Nuts and Opaque Jar, Potato, Stone, 2 Fish on Plate, Egg Rack.

Robert Watts. CHROMED TOOTHBRUSH. This is one of the CHROMED GOODS that would have been included in a "handwritten catalogue"

CHROMED LOLLIPOP

"...I mean we could publish a 100 boxes - each containing objects which you would 'mass produce' like in factory - Lollipops chrome plated..."
Letter: Geroge Maciunas to Robert Watts, [before March 11, 1963].

COMMENTS: *Chromed Lollipop was made by the artist, however its present whereabouts is not known. Although various chromed objects were made, none were mass-produced.*

Robert Watts. CHROMED PENCIL

CHROMED PENCIL
Silverman No. > 483.III

"...we could publish a 100 boxes - each containing objects which you would 'mass produce' like in factory - pencils that don't write...so I suggest for box ...a 'travellers kit', sell for maybe $50...Inside all compartmentalized...the objects, bronze pencils etc. etc...."
Letter: George Maciunas to Robert Watts, [before March 11, 1963].

COMMENTS: *This work was among the commercially produced everyday objects that Watts had chrome-plated. Three* Chromed Pencils *are known to have been made:* Thinex No. 2 *(Silverman No. > 483.III), and* Best 46-2, *and* Onward-SE 161-No. 2.

CHROMED TOOTHBRUSH see:
CHROMED GOODS
CIGARETTE see:
10 FOOT LONG CIGARETTE
CITROEN see:
George Maciunas and Robert Watts
CLOCKS see:
MOIRE CLOCK FACE CLOCK
10 - HOUR FLUX CLOCK
CLOTHING see:
APRONS
BATHING SUITS
BOUNCING SHOES
CUSTOM MADE SHIRT

DISINTEGRATING SHOES
FEMALE UNDERPANTS
FEMALE UNDERSHIRT
FISH SHOES
FLUX CLOTHING CHEST
GLOVES
HAIRY MAN IN SHORTS APRON
HERE I COME SWEATSHIRT
ICE FILLED SHOES
INCLINED PLANE SHOES
MALE UNDERPANTS
MALE UNDERSHIRT
MUSICAL SHOES
NAIL SHOES
NECKTIE
NUDE FRONT APRON
NUDE WAITRESS WITH TRAY APRON
POPE MARTIN V APRON
ROMAN EMPEROR APRON
SHAVING CREAM FILLED SHOES
SLIPPERY SHOES
SOCKS
STILT SHOES
STUFFED SHIRT WITH BOW TIE
VENUS DE MILO APRON
VIRGIN MARY APRON
WAITER WITH TRAY APRON
WINGED VICTORY APRON

CLOUD LAMP

FLUXFURNITURE...LAMPS, 15" cubes, walnut sides, locked corners, translucent front and back ... Robert Watts: clouds, $80.00...Available at Multiples in N.Y.C. and late in 1967 at FLUXSHOP, 18 GREENE ST.
Fluxfurniture, pricelist. [1967].

COMMENTS: *One of George Maciunas' adaptations to fit his idea of standardized 15" cube modules for either furniture or display of Fluxus works. I'm not sure that* Cloud Lamp *was ever made, although considerable preliminary material exists in the Maciunas Estate (now part of the Silverman Collection). Robert Watts also constructed a series of* Desk Clouds, *ca. 1967, (Silverman No. < 508.VI) and* Floor Cloud, *ca. 1970 (Silverman No. < 508.IX) which were prototypes for Fluxus Editions, but never produced or listed. Geoffrey Hendricks' cloud pieces have been a continuing artistic concern of his from the early 1960s, and also Yoko Ono's sky works such as* Sky Dispenser *and her series, "Painting to See the Skies."*

CLOUDS see:
CLOUD LAMP
CLOUD ON LUMINOUS CEILING PANEL
DESK CLOUD
FLOOR CLOUD

CLOUDS ON LUMINOUS CEILING PANEL

... items are in stock, delivery within 2 weeks ... FLUXUSkr ROBERT WATTS: clouds on luminous ceiling panel, 2' x 2' $100
Vaseline sTREet (Fluxus Newspaper No. 8) May 1966.

FLUX-PROJECTS PLANNED FOR 1967... Bob Watts:...Luminous ceiling (clouds)...
Fluxnewsletter, March 8, 1967.

FLUX-PRODUCTS 1961 TO 1969 ... ROBERT WATTS...Clouds on luminous ceiling panel, 2' x 4' [$] 100
Fluxnewsletter, December 2, 1968 (revised March 15, 1969).

FLUX-PRODUCTS 1961 TO 1970 ... [as above]
Flux Fest Kit 2. [ca. December 1969].

"Watts...clouds very expensive..."
Letter: George Maciunas to Dr. Hanns Sohm, [ca. late 1972].

03.1967 BOB WATTS:...cloud ceiling
George Maciunas, Diagram of Historical Developments of Fluxus... [1973].

COMMENTS: *Robert Watts, 1982: "A silkscreened image of clouds on a dropped bathroom ceiling. Only one was made."*
see: *Luminous Ceilings.*

CLUTTERED DESK TABLE TOP see:
Peter Moore and Robert Watts

COLORED ROCKS
Silverman No. < 495.I

FLUXUS 1964 EDITIONS, AVAILABLE NOW ... FLUXUSkaz series, OBJECTS from ROBERT WATTS ROCKS in compartmented wood or plastic boxes $4 to $20...FLUXUS kz colored rocks
cc Valise e TRanglE (Fluxus Newspaper No. 3) March 1964.

KAZ-serie[s] ROBERT WATTS: objects rocks in compartmented wood or plastic boxes $4 to $20. F-kz colored rocks
European Mail-Orderhouse: europeanfluxshop, Pricelist. [ca. June 1964].

KAZ series OBJECTS from ROBERT WATTS F ROCKS in compartmented wood or plastic boxes $4 to $20. F-kz colored rocks
Second Pricelist - European Mail-Orderhouse. [Fall 1964].

03.1964...BOB WATTS: rocks
George Maciunas, Diagram of Historical Developments of Fluxus... [1973].

COMMENTS: *Robert Watts' first altered rock (Silverman No. < 495.I) was an angular shaped chunk of rock painted white with a "5" and an "&" stenciled on in yellow. This rock*

BRAD IVERSON

Robert Watts. COLORED ROCKS. see color portfolio

could be considered a Colored Rock, an Odd Numbered Rock or Single Rock Marked by Number. *An early photograph of Fluxus works reproduced in Fluxus Newspaper No. 3, March 1964, shows a wooden box with four painted rocks, each with an odd number. The artist would have made these earlier works, with Maciunas taking over for the production of* Flux Rock Marked by Volume in CC, Rocks Marked by Weight in Grams *and the later* Fluxatlas.

COLORED WATER TOILET BOWL

Toilet No. 1 Bob Watts...Toilet bowl display: colored water from tank Blue, then clear then blue again.
Fluxnewsletter, April 1973.

1970-1971 FLUX-TOILET: WATTS:...colored water in tank...
George Maciunas, Diagram of Historical Developments of Fluxus... [1973].

COMMENTS: *It is quite common now to have blue disinfectant dispensed into a toilet bowl. I suspect few people realize that they have a Fluxus work in their tanks.*

COMPARTMENTALIZED SUITCASE see:
COMPLETE WORKS

COMPLETE WORKS

"...Would you care to have all your past & future works published under one cover or in box-a kind of special fluxus edition. This could be sold separately or as part of fluxus yearbox. I am going to publish such special Fluxus editions containing complete works...This project - if continued could result in a nice & extensive library -or 'encyclopedia' of good works being done these days. A kind of Shosoin warehouse of today. One condition however. I will finance & distribute boxes, supply you with a few 100's. for your own $, BUT — I must have exclusive right to publish them AND ALL YOUR FUTURE WORKS. A kind of Faust - Mephisto, Cage - Peters deal. All works will be copy-righted (internationally) so no copies will be permitted & no performances without some $

to you. Let me know your thoughts on this...."
Letter: George Maciunas to Robert Watts, [December 1962].

"...Your own very private box. I suppose could include your other works like objects etc. (I mean photos of objects) or actual objects...SEND ME ALL YOUR STUFF!..."
Letter: George Maciunas to Robert Watts, [ca. January 1, 1963].

"...Now, about the contents of your letter: boxes etc. I mean we could publish a 100 boxes-each containing objects which you would 'mass produce' like in a factory-pencils that don't write, leaking ink bottles, etc. Lolipops chrome plated - all wonderful stuff - NO PHOTOGRAPHS, - BUT OBJECTS - Like a suitcase of goodies...So I suggest for box to do like this: Like a travelers suitcase a 'travelers kit', sell for maybe $50 or so. Then inside all compartmentalized. In one card events in another playing cards...Then in other compartments - the objects, bronze pencils etc. etc - all mass-produced. Then another compartment with photographs of 2 kinds - one kind of large objects that can't fit in case another of film studies-stills, — ...Then the box can contain flattened animals, or books of all kinds. So the suitcase can be sold as a whole or only parts of - each compartment separately. We can advertise in New Yorker & say for $50 this 'hand crafted attache case' with all that a businessman - traveller needs — & maybe sell 100 of them, then we make another 100 or start a factory!!?...So please let me know your opinions - ideas on:...suggested Watts compartmentalized suitcase - 'attache' case...."
Letter: George Maciunas to Robert Watts, [before March 11, 1963].

"...Paik has exhibit for next 2 weeks at Wuppertal.... I got one room for Fluxus, so I set 3 things of yours: the 3 playing cards, puzzle, and the hospital event which the visitors can perform. In case some pictures disapear during exhibit - can you send others that could be printed? (for your box-edition)...."
Letter: George Maciunas to Robert Watts, [March 11 or 12, 1963].

"...Then when I get to N.Y. could do your box..."
Letter: George Maciunas to Robert Watts, [ca. early April 1963].

SUITCASES and trunks - all sizes. We pack and deliver to you. YAMPAC...
Yam Festival Newspaper, [ca. 1963].

FLUXUS 1963 EDITIONS, AVAILABLE NOW FROM FLUXUS P.O. Box 180, New York 10013, N.Y. or FLUXUS 359 Canal St. New York. CO 7-9198 ... FLUXUS 1964 EDITIONS: ... FLUXUSkkk ROBERT WATTS: "Suitcase" $40...
Film Culture No. 30, Fall 1963.

GEORGE MACIUNAS

Robert Watts. CROSSED NUDE LEGS TABLE TOP, photographed by George Maciunas ca. 1967

spiration for assembling works in this manner. Robert Watts' *Complete Works* isn't known to have been produced by George Maciunas, but many of the objects listed as components of the "travelers kit" in his letter to Watts of March 11, 1963, are known to exist. The correspondence about the work gives a fairly good idea of what Maciunas' aims were and his relationship with the artists he worked with. *Complete Works* could have become the FLUXUS kk a to z series *(see cross reference a to z for the listing of its components)* or Events, which was supplemented over a period of time.

CROSSED NUDE LEGS TABLECLOTH see:
CROSSED NUDE LEGS TABLE TOP

CROSSED NUDE LEGS TABLE TOP
Silverman No. 508

"...I don't know whether I mentioned our involvement now in making furniture...using photo laminations on table tops - like...photo of girls crossed nude legs - same size, so any sitter behind legs looks like the crossed legs were part of the sitter..."
Letter: George Maciunas to Paul Sharits, [after April 6, 1966].

"...We are working on FLUXFURNITURE...one top with full size photo of girls crossed legs, so when you sit on correct side it looks as if these girls legs belong to you. very funny effect..."
Letter: George Maciunas to Ben Vautier, August 7, 1966.

"...I would like to send you all new flux items such as furniture but it is rather bulky...would have to ship in a crate as freight...If you will keep furniture then I will send [what] we already have but can't sell because they are prototypes...I could include...Bob Watts' table..."
Letter: George Maciunas to Ben Vautier, August 22, 1966.

FLUX-PROJECTS PLANNED FOR 1967 ... Bob Watts:...Table tops (...dining table- photolaminates of sitters' crossed legs)...
Fluxnewsletter, March 8, 1967.

FLUXFURNITURE...TABLETOPS, photo-laminates, vinyl surface, ¾" board, formica edging, metal pedestal...Robert Watts & Peter Moore:...crossed legs, 21" x 25", 4 weeks, $80.00...Available in N.Y.C. at Multiples and late in 1967 at FLUXSHOP, 18 GREENE ST.
Fluxfurniture, price list. [1967].

PROPOSED FLUXSHOW FOR GALLERY 669 ... OBJECTS, FURNITURE...tabletops:...crossed legs ...(by Watts,...)...All table tops are photographs laminated between wood table top and vinyl surface. They require stands or legs as shown: [sketch] These pedestal type stands can be obtained from New York for $12 each, plus shipping charges. Additional table tops are in the form of photographs (unlaminated)

"This Saturday...we shall have another Fluxus meeting...Can you come? You could stay late & we could discuss your box...."
Letter: George Maciunas to Robert Watts, October 9, 1963.

FLUXUS 1964 EDITIONS:...FLUXUS kkk ROBERT WATTS: "Suitcase" $40 Most materials originally intended for Fluxus yearboxes will be included in the FLUXUSccV TRE newspaper or in individual boxes.
cc VTRE (Fluxus Newspaper No. 1) January 1964.

FLUXUS 1964 EDITION:...Fluxus kkk ROBERT WATTS: "Suitcase" $40
cc V TRE (Fluxus Newspaper No. 2) February 1964.

COMMENTS: Marcel Duchamp's *Boite en Valise* was the in-

which should be placed over a table of same size and covered with glass.
Fluxnewsletter, December 2, 1968.

FLUX-PRODUCTS 1961 TO 1969 ... ROBERT WATTS...Tabletops, 30" square, photo laminated on wood: full scale crossed nude legs, [$] 80...in collaboration with Peter Moore.
Fluxnewsletter, December 2, 1968 (revised March 15, 1969).

FLUX-PRODUCTS 1961 TO 1970 ... ROBERT WATTS ... Table tops, photo laminates, 30" sq. Crossed nude legs...ea: [$] 80
Flux Fest Kit 2. [ca. December 1969].

PROPOSED CONTENTS FOR FLUXPACK 3 TO BE PUBLISHED IN 1973 BY FLASH ART...Table covers nude crossed legs by Watts...Cost Estimates: for 1000 copies...table covers $500 [2 designs] ...100 copies signed by: Watts...
[George Maciunas], Proposed Contents for Fluxpack 3, [ca. 1972].

"...to produce the Flash Art FLUXPACK 3, ... contents at present will be as follows: ... Tablecloths: crossed legs by Bob Watts,..."
Letter: George Maciunas to Giancarlo Politi, n.d. Reproduced in Fluxnewsletter, April 1973.

Flash Art editor, Giancarlo Politi, proposed to publish the 3rd Fluxyearbook, maybe to be called FLUXPACK 3, with the following preliminary contents:... Household items: table covers (crossed nude legs by Bob Watts...)
Fluxnewsletter, April 1973.

FLUX-PRODUCTS 1961 TO 1970 ... SOLO OBJECTS AND PUBLICATIONS...ROBERT WATTS... Crossed nude legs...[$] 100
[Fluxus price list for a customer]. September 1975.

COMMENTS: *George Maciunas produced a Fluxus Edition photo-laminated tabletop of this work which was offered for sale as Fluxfurniture. He also produced a vinyl table cloth using the same image (Silverman No. > 508.II) for* Fluxpack 3.

CUSTOM MADE SHIRT

... items are in stock, delivery within 2 weeks. FLUXUS kp ROBERT WATTS: shirt, custommade $30
Vaseline sTREet (Fluxus Newspaper No. 8) May 1966.

05.1966...BOB WATTS: clothing,...
George Maciunas, Diagram of Historical Developments of Fluxus... [1973].

COMMENTS: *I have never seen a* Custom Made Shirt *by Robert Watts. He designed several different articles of clothing for Fluxus, and his t-shirts were worn by performers in the Fluxorchestra at Carnegie Recital Hall concert, New York, in*

Robert Watts. Design by George Maciunas for the label of CUSTOM MADE SHIRT

1965. George Brecht also offered "hand-made clothing" for sale through Fluxus. And Willem de Ridder displayed his invention, a permanently wrinkled shirt, in the European Mail Order Warehouse/Fluxshop.

CUT-OUTS see:
 ACCESSORIES
 HOSPITAL EVENTS
DECALS see:
 PARKING METER DECAL
 STICK-ONS
DECK OF PLAYING CARDS see:
 PLAYING CARDS
DECLARATION OF INDEPENDENCE see:
 GIANT STAMP IMPRINT ENVELOPE: SIGNERS
 OF THE DECLARATION OF INDEPEN-
 DENCE LETTER PAPER

DESK BLOTTER
Silverman No. < 508.IV

FLUX-PROJECTS PLANNED FOR 1967 ... Bob Watts: Table tops...Desk blotter-mat, etc.
Fluxnewsletter, March 8, 1967.

COMMENTS: *This photo-laminated Fluxus Edition is an example of Watts' interest in unusual perspective.*

DESK CLOUD see:
 CLOUD LAMP
DINING TABLE MEAL BEING EATEN see:
 DINNER SETTING

DINNER SETTING TABLE TOP
Silverman No. > 508,I, ff.

PROPOSED FLUXSHOW FOR GALLERY 669 ... OBJECTS, FURNITURE...tabletops:...dinner setting (by Watts,...)...All table tops are photographs laminated between wood table top and vinyl surface. They require stands or legs as shown: [sketch] These pedestal type stands can be obtained from New York for $12 each, plus shipping charges. Additional table tops are in the form of photographs (unlaminated) which should be placed over a table of same size and covered with glass.
Fluxnewsletter, December 2, 1968.

COMMENTS: *The idea for this work dates from a 1965 drawing by Robert Watts (Silverman No. < 508.XII). Around 1967, Watts worked with the Fluxus photographer Peter Moore, to make the photographs for a* Dinner Setting Table Top. *The illustration shows the unlaminated version.*

DIRTY PAPER TOWELS

IMPLOSIONS INC. PROJECTS ... Triple partnership was formed between Bob Watts, Herman Fine and myself [George Maciunas] to introduce into mass market ...money producing products...This business will be operated in commercial manner, with intent to make profits...connection between Fluxus collective and Implosions Inc. has not been clarified yet...we could consider at present Fluxus to be a kind of division or subsidiary of Implosions. Projects to be realized through Implosions:...Disposable paper...towels,...
Fluxnewsletter, March 8, 1967.

PROPOSED FLUXSHOW FOR GALLERY 669 ... TOILET OBJECTS...roll of used paper towels (dirty)...
Fluxnewsletter, December 2, 1968.

Robert Watts. DESK BLOTTER

Robert Watts. DINNER SETTING TABLE TOP. The original photography for the work was done by Peter Moore

PROPOSED FLUXSHOW...TOILET OBJECTS...roll of used paper towels, or new ones with dirt and hand marks printed on.
Fluxnewsletter, December 2, 1968 (revised March 15, 1969).

TOILET OBJECTS & ENVIRONMENT...Roll of used paper towels, or new ones but imprinted with dirt & hand marks.
Flux Fest Kit 2. [ca. December 1969].

Toilet No. 1 Bob Watts ... Paper towels - dirty - 2nd. hand with foot prints
Fluxnewsletter, April 1973.

COMMENTS: *This work was never produced as a Fluxus Edition. Conceptually, it is a companion work to George Maciunas' Treated Paper Towels — towels treated with a chemical to make ones hands dirty.*

DISINTEGRATING SHOES

FLUX-OLYMPIAD...TRACK - HURDLES, OBSTA-CLES...OBSTACLE SHOES...disintegrating shoes...
Flux Fest Kit 2. [ca. December 1969].

FEB. 17, 1:30PM FLUX-SPORTS DOUGLASS COL. ...OBSTACLE SHOES:...disintegratein [sic] shoes...
Poster/program for Flux-Mass, Flux-Sports and Flux-Show. February 1970.

PROPOSED FLUXANNIVERSARY FEST PRO-GRAM 1962-1972 SEPT & OCT...FLUXOLYMPIAD (counterpoint to Munich one) obstacle shoes run by Bob Watts...
Fluxnewsletter, April 1973.

1970 FLUXSPORTS:...by bob watts: obstacle shoes
George Maciunas, Diagram of Historical Developments of Fluxus... [1973].

COMMENTS: *These shoes were not made.*

DISPENSERS see:
 PENS
 POSTCARD DISPENSER
 STAMP DISPENSER
DISPOSABLE JEWELRY see:
 STICK-ONS
DISPOSABLE PAPER TABLE CLOTH see:
 Peter Moore and Robert Watts

Robert Watts. DOLLAR BILL

DOLLAR BILL
Silverman No. > 470.I

"...can make nice counterfeit $?, could start good business on offset press here..."
Letter: George Maciunas to Robert Watts, [ca. June 1962].

"...We will include in fluxus:...your $ bill etc....I can print $ bills. HOW MANY?? What kind of paper? Funny paper? like cardboard, glass-transparent paper. What ?????? You have some preferences or should I choose. Or maybe use a little of all kinds of paper. Plate may not be of use to you, since the German off-

set press here uses slightly different grip, unless you can adapt the grip to US offset. Let me know. The only difficulty will be mailing $ bills by APO [army post office] I may loose APO deal. So maybe we figure some way of shipping by or via some traveler. German mail no good either, since then U.S. Customs opens packages. I will look for travellers going back to States...."

Letter: George Maciunas to Robert Watts, [Summer 1962].

PROPOSED PROPAGANDA ACTION FOR NOV. FLUXUS IN N.Y.C. (during May - Nov. period) ... Propaganda through "compositions" performed on streets & other public places. (such as:...Releasing balloons (helium filled) (arranged to explode high in the air) bearing R. Watts dollar bills...

Fluxus Newsletter No. 6, April 6, 1963.

FLUXKIT containing following fluxus-publications: (also available separately)...FLUXUS kl ROBERT WATTS: complete set of events, dollar bill and stamps, in box, $5

cc fiVe ThReE (Fluxus Newspaper No. 4) June 1964.

FLUXKIT containing following flux-publications:... complete set of events, dollar bill and stamps (in box), ...of Robert Watts

Second Pricelist - European Mail-Orderhouse. [Fall 1964].

PROPOSED CONTENTS FOR FLUXPACK 3 TO BE PUBLISHED IN 1973 BY FLASH ART...$ bill by Watts...100 copies signed by: Watts...

[George Maciunas], Proposed Contents for Fluxpack 3. [ca. 1972].

COMMENTS: *Robert Watts, 1982: "George [Maciunas] used a copy of the drypoint etching that had been used by Arturo Schwarz for his portfolio gravure edition of* Dollar Bill.*"*

 Robert Watts' Fluxus Dollar Bill *is a drawing of a US dollar, the same size as the real McCoy, but has the same image printed on both sides. It is pre-dated by Roy Lichtenstein's "pre-pop"* Ten Dollar Bill, *a lithograph from 1956. Compared with Andy Warhol's* Printed Dollar Bill, *also from 1962, Watts' was intended to be distributed in great quantities, more like give-aways to devalue art as well as money.*

DOLLAR BILL TOILET PAPER

PROPOSED FLUXSHOW FOR GALLERY 669 ... TOILET OBJECTS ... toilet paper with dollar bills printed on it.

Fluxnewsletter, December 2, 1968.

COMMENTS: *Perhaps George Maciunas wanted to print Robert Watts'* Dollar Bills *on toilet paper. By 1968, Maciunas already had used gag toilet paper in Jane Knizak's Flux Papers, and could easily have used rolls of this paper for a toilet object in the proposed Fluxshow for Gallery 669 in Los Angeles.*

Robert Watts. $ BILLS IN WOOD CHEST. see color portfolio

BRAD IVERSON

$ BILLS IN WOOD CHEST
Silverman No. 524

by Bob Watts:...$ bills in wood chest $80
Fluxnewsletter, April 1975.

dollar bills in chest by Watts $100
[Fluxus price list of a customer]. January 7, 1976.

"Chest of $ bills by Bob Watts $100"
Letter: George Maciunas to Dr. Hanns Sohm, May 1, 1976.

COMMENTS: *$ Bills in Wood Chest is a late Fluxus work using stacks of the much earlier work,* Dollar Bill, *packed in a wood box. By making a more recognizable object out of a toss-away, the artist and George Maciunas who had produced the work for Fluxus, seem to contradict the original intent of* Dollar Bill.

DOORS see:
MAZE
TARGET DOOR
TOILET SEAT WHEN SAT UPON OPENS DOOR

EAR STICK-ONS

FLUX-PROJECTS PLANNED FOR 1967 ... Bob Watts:...Stick-ons (disposable jewelry): full size imprints of human parts (...ears etc.)
Fluxnewsletter, March 8, 1967.

COMMENTS: *This work was never produced by George Maciunas as a Fluxus Edition.*

EATING see:
TRACE NO. 22

Robert Watts. Version of $ BILLS IN WOOD CHEST, contained in a drawer of FLUX CABINET

EATING KIT

... will appear late in 1966...FLUXUS koi ROBERT WATTS: eating kit, $100
Vaseline sTREet (Fluxus Newspaper No. 8) May 1966.

FLUX-PROJECTS PLANNED FOR 1967 ... Bob Watts: ...Eating kit...
Fluxnewsletter, March 8, 1967.

FLUX-PRODUCTS 1961 TO 1969 ... ROBERT WATTS...eating kit - on special order only, each: [$] 100
Fluxnewsletter, December 2, 1968 (revised March 15, 1969).

"...Watts...eating kit...made to order..."
Letter: George Maciunas to Dr. Hanns Sohm, [ca. late 1972].

COMMENTS: *This is one of several kits based on a single human bodily function that Robert Watts planned to make on order. The others were* Bathing Kit, Sitting Kit *and* Sleeping Kit. *Although Robert Watts has made these works, none were produced by George Maciunas as Fluxus Editions.*

EGG BOX
Silverman No. < 483.II, ff.

FLUXUS 1964 EDITIONS, AVAILABLE NOW ... FLUXUS kaz series, OBJECTS from ROBERT WATTS ...FLUXUS kb EGG BOXES $10
cc Valise e TRanglE (Fluxus Newspaper No. 3) March 1964.

KAZ-serie[s] ROBERT WATTS: objects...F-kb EGG

Robert Watts. EGG BOX. In foreground, an early version which appeared in Fluxus Newspaper No. 3, March, 1964 in a photograph of a selection of Fluxus works. see color portfolio

BOXES $10
European Mail-Orderhouse: europeanfluxshop, Pricelist. [ca. June 1964].

PROPOSAL The principle business of this Company (to be known as The Greene Street Precinct, Inc.) will be twofold: 1. The operation of a unique entertainment and game environment...spaces fitted with specialty shops, concessions, and featuring a specially designed automated food, drink and game lounge ... 2. The development, distribution, and sale of a new product line utilizing the talents of new and well known artists and designers. Products will be of low cost, mass produced and distributed to mass markets here and abroad. Certain more expensive items may be of limited production considered unique and for conspicuous consumption. The product line will embrace certain existing lines of Flux-group and Implo-

sions, Inc. which have proven sales value and/or potential for immediate production...BUDGET — PRODUCT LINE Initiating production of the following new products: ...Egg Boxes $1,000...
[George Maciunas and Robert Watts], Proposal for The Greene Street Precinct, Inc. [ca. December 1967].

NEWS FROM IMPLOSIONS, INC. Various items were produced as planned &...listed in the past newsletter: ...Plastic egg boxes by Robert Watts...
Fluxnewsletter, January 31, 1968.

COMMENTS: *In 1982, Robert Watts recalled producing a number of vacuum-formed egg boxes with different kinds of eggs inside for the Supermarket Show at the Paul Bianchini Gallery in New York City, in 1964. In 1963, Watts had made a chrome-plated* Box of Eggs. *See also* Egg Kit *and* Twelve Jello Eggs Molded in an Egg Box, *which are further extensions of his egg ideas.*

EGG KIT

Silverman No. > 483.VI

FLUXUS kt ROBERT WATTS: EGGKIT, egg making tools & materials in suitcase, $60
Vacuum TRapEzoid (Fluxus Newspaper No. 5) March 1965.

... items are in stock, delivery within 2 weeks ... FLUXUSka ROBERT WATTS: eggkit, $60 egg, making tools & materials in suitcase
Vaseline sTREet (Fluxus Newspaper No. 8) May 1966.

FLUX-PRODUCTS 1961 TO 1969 ... ROBERT WATTS...Eggkit, egg making tools and materials in attache case [$] 100
Fluxnewsletter, December 2, 1968 (revised March 15, 1969).

FLUX-PRODUCTS 1961 TO 1970 ... ROBERT WATTS:...Eggkit, egg making kit, in attache case [$] 100
Flux Fest Kit 2. [ca. December 1969].

FLUXUS-EDITIONEN ... [Catalogue No.] 794 ROBERT WATTS: egg making kit (koffer)
Happening & Fluxus. Koelnischer Kunstverein, 1970.

1964 1ST FOOD OBJECTS:...BOB WATTS: egg making kit
George Maciunas, Diagram of Historical Developments of Fluxus... [1973].

COMMENTS: *This work is a masterpiece of the obvious. A kit with everything one needs to make an egg.*

ELBOW STICK-ONS

FLUX-PROJECTS PLANNED FOR 1967 ... Bob Watts:...Stick-ons (disposable jewelry): full size imprints of human parts (...elbows...etc.)
Fluxnewsletter, March 8, 1967.

COMMENTS: Elbow Stick-ons *was never produced by George Maciunas as a Fluxus Edition.*

EVEN NUMBERED ROCKS

FLUXUS 1964 EDITIONS, AVAILABLE NOW ... FLUXUS kaz series, OBJECTS from ROBERT WATTS ROCKS in compartmented wood or plastic boxes, $4 to $20...FLUXUS kx even numbered rocks
cc Valise e TRanglE (Fluxus Newspaper No. 3) March 1964.

KAZ-serie[s] ROBERT WATTS : objects rocks in compartmented wood or plastic boxes $4 to $20 ... F-kx even numbered rocks
European Mail-Orderhouse: europeanfluxshop, Pricelist. [ca. June 1964].

KAZ series OBJECTS from ROBERT WATTS ... F ROCKS in compartmented wood or plastic boxes $4. to $20...F-kx even numbered rocks
Second Pricelist - European Mail-Orderhouse. [Fall 1964].

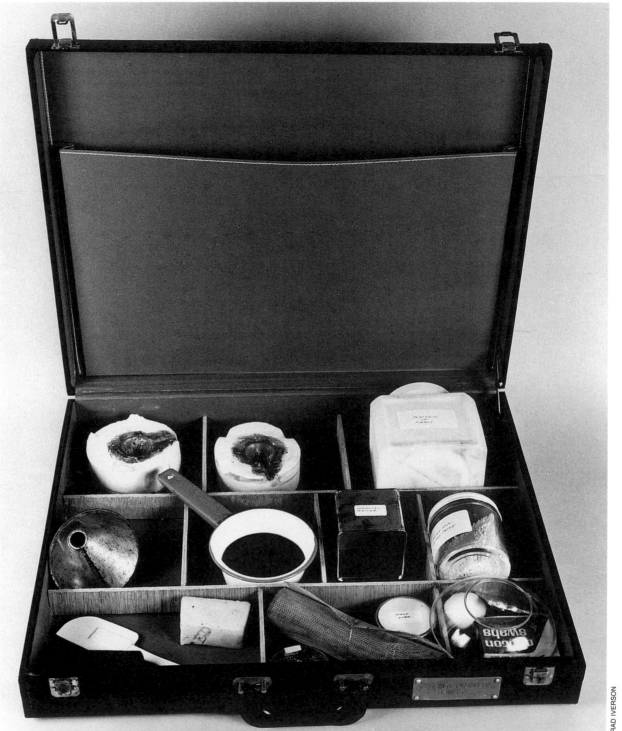

Robert Watts. EGG KIT. This example was assembled by the artist in 1982. see color portfolio

BRAD IVERSON

Robert Watts. Different packagings and contents of EVENTS. see color portfolio

03.1964 BOB WATTS: rocks
George Maciunas, Diagram of Historical Developments of Fluxus... [1973].

COMMENTS: I have not seen an Even Numbered Rock *but suppose it would be similar to an* Odd Numbered Rock *and almost certainly made by the artist for distribution by Fluxus.*

EVENTS
Silverman No. 489, ff.

"...Received...box of accessories & cut-outs - ready mades & very nice events...We will include in Fluxus 1, all events you sent....Ones you send later - we can include in other editions. Besides we can always perform them...."
Letter: George Maciunas to Robert Watts, [Summer 1962].

"...Thanks very much for your very nice events & no event. I liked especially the Casual event. We will do that in our street demonstration in Dusseldorf - Feb... KEEP SENDING..."
Letter: George Maciunas to Robert Watts, [December 1962].

"QUICK! do you prefer your events on page cards? I am printing your first batch (event 10, 13 etc.) on

pages, but last batch (casual event, no event etc.) on cards. OK?"
Letter: George Maciunas to Robert Watts, [ca. January 1, 1963].

"...So I suggest for box to do like this: Like a...'Travelers Kit,' sell for $50 or so. Then inside, all compartmentalized. In one, card events...."
Letter: George Maciunas to Robert Watts, [before March 11, 1963].

FLUXUS SPECIAL EDITIONS 1963-4...FLUXUS k. ROBERT WATTS: CASE OF EVENTS - OBJECTS - CARDS $?...works from 1964 - by subscription,...
Fluxus Preview Review, [ca. July] 1963.

[as above]
Daniel Spoerri, L'Optique Moderne. List on editorial page. 1963.

[as above]
La Monte Young, LY 1961. Advertisement page. [1963].

FLUXUS 1963 EDITIONS, AVAILABLE NOW FROM FLUXUS P.O. Box 180, New York 10013, N.Y. or FLUXUS 359 Canal St. New York. CO7-9198 FLUXUS k ROBERT WATTS: events in wood box $3
Film Culture No. 30, Fall 1963.

"...new publications will be...Events by Robert Watts in hand made wood box, $4"
Letter: George Maciunas to Philip Kaplan, November 27, 1963.

FLUXUS 1963 EDITIONS, AVAILABLE NOW ... FLUXUS k ROBERT WATTS: events in wood box $3
cc V TRE (Fluxus Newspaper No. 1) January 1964.

[as above]
cc V TRE (Fluxus Newspaper No. 2) February 1964.

FLUXUS 1964 EDITIONS, AVAILABLE NOW ... FLUXUS kl ROBERT WATTS: events in wood box $3
cc Valise e TRanglE (Fluxus Newspaper No. 3) March 1964.

FLUXKIT containing following fluxus-publications: (also available separately)...FLUXUS kl ROBERT WATTS: complete set of events, dollar bill and stamps, in box $5
cc fiVe ThReE (Fluxus Newspaper No. 4) June 1964.

...F-k1 ROBERT WATTS: events in wood box, $3
European Mail-Orderhouse: europeanfluxshop, Pricelist. [ca. June 1964].

FLUXKIT containing following flux-publications:... complete set of events, dollar bill, and stamps (in box) ...of Robert Watts
Second Pricelist - European Mail-Orderhouse. [Fall 1964].

F-k1 ROBERT WATTS events in plastic box $5
ibid.

did you receive the 2nd catalog of THE EUROPEAN MAIL-ORDERHOUSE & FLUXSHOP? [which advertises] ...robertwattsbox...
How to be Satisfluxdecolanti?... [ca. Fall 1964].

"...Please give 10 copies of Watts...cards in boxes to Ben Vautier. He can sell them also..."
Letter: George Maciunas to Willem de Ridder, January 21, 1965.

"... I wrote De Ridder asking him to give you 10 sets of Watts..."
Letter: George Maciunas to Ben Vautier, January 23, 1965.

"...There are not too many new pieces that you do not know, you have complete set of:...Robert Watts ...you have the boxes?..."
Letter: George Maciunas to Ben Vautier, February 1, 1965.

"...I will soon print extra cards so could include your new compositions if you have any..."
Letter: George Maciunas to Robert Watts, February 25, 1965.

"...P.S: You should print labels for...Watts box - reproduce my labels. I am sending a few of them. But I do not have enough..."
Letter: George Maciunas to Willem de Ridder, March 2, 1965.

FLUXKIT containing following fluxus-publications: (also available separately)...FLUXUS kl ROBERT WATTS: complete set of events, in plastic box, $5
Vacuum TRapEzoid (Fluxus Newspaper No. 5) March 1965.

FLUXKIT containing following fluxus-publications: (also available separately) FLUXUS kl ROBERT WATTS: events, complete set through 1966 $6
Vaseline sTREet (Fluxus Newspaper No. 8) May 1966.

"... I mailed by parcel post - one carton with following: Quantity-1, Item - Bob Watts events...Wholesale cost to you. each - $2.5, suggested selling price - $5, sub total — wholesale cost to you. 2.5...The...Watts events boxes also have lots of performance pieces, so you could give several 'fluxconcerts' up in Ithaca..."
Letter: George Maciunas to Ken Friedman, August 19, 1966.

"...Furthermore Fluxus still publishes...supplements to works of...Watts..."
Letter: George Maciunas to Ben Vautier, [ca. October 1966].

FLUX-PROJECTS PLANNED FOR 1967 ... Bob Watts: 1966 & 67 events (supplement)...
Fluxnewsletter, March 8, 1967.

events $7...by robert watts
Fluxshopnews. [Spring 1967].

FLUX-PRODUCTS 1961 TO 1969 ... ROBERT WATTS:...Events, boxed cards & rubber vegetable * [indicated as part of FLUXKIT] [$] 8
Fluxnewsletter, December 2, 1968 (revised March 15, 1969).

FLUX-PRODUCTS 1961 TO 1970 ... ROBERT WATTS...Events, boxed cards & rubber vegetable [$] 8
Flux Fest Kit 2. [ca. December 1969].

FLUXUS-EDITIONEN ... [Catalogue No.] 791 ROBERT WATTS: events, boxed cards
Happening & Fluxus. Koelnischer Kunstverein, 1970.

02.1964 BOB WATTS events
George Maciunas, Diagram of Historical Developments of Fluxus... [1973].

ROBERT WATTS Events, boxed cards & rubber vegetable $16
Flux Objects, Price List. May 1976.

COMMENTS: *Robert Watts' Events were part of an attempt by George Maciunas to publish individual editions of the complete event 'scores' or works by a number of Fluxus artists. This particular work evolves out of Watts' Complete Works and his scores are usually packaged with some other objects, such as stamps, Dollar Bill, Hospital Events and later, fake foods such as a rubber cucumber.*

EXPLOSIVES see:
HOSPITAL EVENTS

FAUCET see:
SOAPY WATER FAUCET

FEMALE UNDERPANTS
Silverman No. > 517.I

Herewith is the description of...the entire revised program...Performers failing to appear for the rehearsal will not perform during the concert...Orchestra costume designed by Robert Watts will be distributed during the rehearsal. Performers wishing to keep these costumes after the concert will be able to do so.
Fluxorchestra Circular Letter No. 2. [September 1965].

"...[for concert in Milan] take any object you wish from La Cedille qui Sourit,...Also you could take ... Watts pants, which all performers in concert could wear. (We used these uniforms in N.Y. Fluxorchestra concert)...."
Letter: George Maciunas to Ben Vautier, March 5, 1966.

... items are in stock, delivery within 2 weeks ... FLUXUSkn ROBERT WATTS: pants, silkscreened $5
Vaseline sTREet (Fluxus Newspaper No. 8) May 1966.

FLUX-PRODUCTS 1961 TO 1969 ... ROBERT

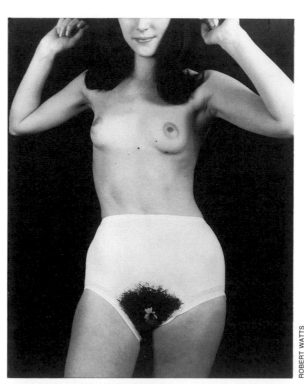

Robert Watts. FEMALE UNDERPANTS, photographed ca. 1966 on a model for promotion

WATTS ... Underpants, silkscreened ... female, each [$] 5
Fluxnewsletter, December 2, 1968 (revised March 15, 1969).

FLUX-PRODUCTS 1961 TO 1970 ... ROBERT WATTS...Underpants, silkscreened...female [$] 5
Flux Fest Kit 2. [ca. December 1969].

"...may still have a few underpants [by Watts]..."
Letter: George Maciunas to Dr. Hanns Sohm, [ca. late 1972].

05.1966...BOB WATTS: clothing
George Maciunas, Diagram of Historical Developments of Fluxus... [1973].

COMMENTS: *In his letter to Ben Vautier in 1966, George Maciunas suggests that performers in the Fluxus Concert that took place in New York, September 25, 1965, wore Watts' pants. I have found no photographic evidence to suggest they wore Female Underpants. The Fluxus Edition of this work had quite wide distribution.*

FEMALE UNDERSHIRT
Silverman No. < 504.II

"...Orchestra members will wear costumes made by Bob Watts, 'T' shirts imprinted with photo of...breasts for women...."
Letter: George Maciunas to Ben Vautier, [Summer 1965].

Herewith is the description of...the entire revised

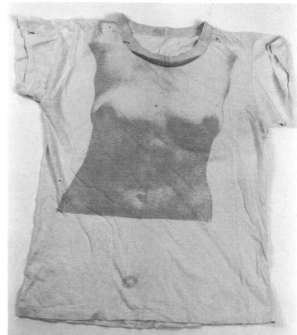

Robert Watts. FEMALE UNDERSHIRT

program...Performers failing to appear for the rehearsal will not perform during the concert...Orchestra costume designed by Robert Watts will be distributed during the rehearsal. Performers wishing to keep these costumes after the concert will be able to do so.
Fluxorchestra Circular Letter No. 2. [September 1965].

... items are in stock, delivery within 2 weeks. ... FLUXUS km ROBERT WATTS...shirt, silkscreened, female $5
Vaseline sTREet (Fluxus Newspaper No. 8) May 1966.

FLUX-PRODUCTS 1961 TO 1969 ... ROBERT WATTS...Undershirts, silkscreened chest:...female, each [$] 5
Fluxnewsletter, December 2, 1968 (revised March 15, 1969).

FLUX-PRODUCTS 1961 TO 1970 ... ROBERT WATTS...Undershirts, silkscreened chest,...f [$] 5
Flux Fest Kit 2. [ca. December 1969].

05.1966...BOB WATTS: clothing,...
George Maciunas, Diagram of Historical Developments of Fluxus... [1973].

COMMENTS: *Female Undershirts were first made as costumes for members of the orchestra performing at the Fluxus Concert at Carnegie Recital Hall, New York City, September 25, 1965, and later offered for sale as Fluxus works.*

FILM LOOPS

"...Or another idea-I can get in England for one $ little hand operated 8mm projectors - for one eye. They work only for loops. - so why don't you specially make a 8mm film loop!!! or several loops - and we include those loops with the $1 eye projector - they work very well, I can get them cheaper if I buy in big quantities. - but you must design films in loops - any diameter loops. Tell that to George [Brecht] too!...So please let me know your opinion - ideas etc. on ... loop-films..."
Letter: George Maciunas to Robert Watts, [before March 11, 1963].

COMMENTS: *The only film by Robert Watts to be made into a loop and distributed by Fluxus was Trace No. 22, Fluxfilm No. 11. It was included in Flux Year Box 2 and in a separate boxed edition of film loops (Silverman No. > 123.II).*

FILM LOOPS see:
COMPLETE WORKS
FILM STILLS see:
PHOTOGRAPHS

FILMS

"... This film of yours ... How much could we sell

prints of it for??? Have you batch of stills from it?? SEND PRICE & STILLS AS SOON AS POSSIBLE..."
Letter: George Maciunas to Robert Watts, [ca. January 1, 1963].

"...Then there can be special offer to sell films at a price, say, if it costs to print $340 - sell film for $500. ...KEEP SENDING ALL THINGS! (I may have in few months the $340 to send you for film copy)..."
Letter: George Maciunas to Robert Watts, [before March 11, 1963].

"...Also get in touch with Jonas Mekas (c/o FILM VULTURE)[sic] ...They have many contacts with distributors & could distribute widely your film PLUS, they will organize a grandiose FLUXUS ARMORY SHOW OF NEW AMERICAN PORNOGRAPHY (during fall together with Fluxus fest)..."
Letter: George Maciunas to Robert Watts, [ca. early April 1963].

FLUXUS SPECIAL EDITIONS 1963-4...FLUXUS k. ROBERT WATTS:...films by special order
Fluxus Preview Review, [ca. July] 1963.

[as above]
Daniel Spoerri, L'Optique Moderne. List on editorial page. 1963.

[as above].
La Monte Young, LY 1961. Advertisement page. [1963].

FLUX-PROJECTS PLANNED FOR 1967 ... Bob Watts:...Film projects
Fluxnewsletter March 8, 1967.

FLUX-PRODUCTS 1961 TO 1970 ... FLUXYEAR-BOX 2, May 1968...19 film loops by:... [including] Watts.
Flux Fest Kit 2. [ca. December 1969].

COMMENTS: *General references to Robert Watts films. In conversation with Robert Watts in 1986, the artist recalled having made his first film, Cascade, in 1962 and corresponding with George Maciunas about it.*

FILMS see:
FLUXFILMS

FINGER BOX
Silverman No. > 502.I

PROPOSED FLUXSHOW FOR GALLERY 669 ... OBJECTS, FURNITURE...fingerhole by Bob Watts;...
Fluxnewsletter, December 2, 1968.

COMMENTS: *This is a unique work, made by the artist around 1965. On it he wrote, "FLUXUS kp" designating it a Fluxus work with his code letter, "k." Although George*

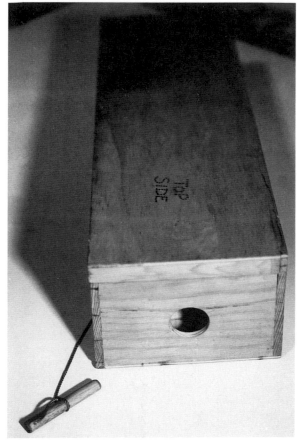

Robert Watts. FINGER BOX

NANCY ANELLO

Maciunas never produced a Fluxus Edition of Finger Box, *in 1968, he planned to use either that specific work or to construct one for the proposed Flux show at Gallery 669 in Los Angeles, calling it "Fingerhole."*

FINGERHOLE see:
FINGER BOX

FINGERPRINT
Silverman No. 483.XXVII and 499, ff.

FLUXUS 1964 EDITIONS, AVAILABLE NOW ... FLUXUS kk a to z series...(t) finger prints 10¢ and up...
cc Valise e TRanglE (Fluxus Newspaper No. 3) March 1964.

KAZ-serie[s] ROBERT WATTS: objects kk/t FINGER PRINTS 10 ¢ and up
European Mail-Orderhouse: europeanfluxshop, Pricelist. [ca. June 1964].

Robert Watts. FINGERPRINT. see color portfolio

BRAD IVERSON

all photographs copyright nineteen seVenty by peTer mooRE

1965 Fingerprint *on plaster, along with a rubber molded nipple is contained in a wood box (Silverman No. 499) and is where the more commonly seen Fluxus Edition evolves from. A separate work,* Light Switch Plate With Fingerprint *directly relates to* Fingerprint.

FINGERPRINT see:
 LIGHT SWITCH PLATE WITH FINGERPRINT
FINGERPRINT BOX see:
 FINGERPRINT

FIRE ALARM CAKE

1964...1ST FOOD OBJECTS: BOB WATTS: FIRE ALARM CAKE
George Maciunas, Diagram of Historical Developments of Fluxus... [1973].

COMMENTS: *This Fluxus work was eaten.*

FISH SHOES

FLUX-OLYMPIAD ... TRACK ... hurdles, obstacles with obstacle shoes:...fish shoes...(Bob Watts)
Fluxfest at Stony Brook, Newsletter No. 1, August 18, 1969. version B

FLUX-OLYMPIAD...TRACK - HURDLES, OBSTACLES...OBSTACLE SHOES:...fish shoes...(Robert Watts)
Flux Fest Kit 2. [ca. December 1969].

PROPOSED FLUXANNIVERSARY FEST PROGRAM 1962-1972 SEPT & OCT...FLUXOLYMPIAD (counterpoint to Munich one)...obstacle shoes run by Bob Watts...
Fluxnewsletter, April 1973.

1970 FLUXSPORTS:...by bob watts: obstacle shoes
George Maciunas, Diagram of Historical Developments of Fluxus... [1973].

COMMENTS: *Robert Watts does not remember these shoes.*

5 MINUTE HELICOPTER FLIGHT OVER NEW YORK CITY TICKET

FLUXFEST PRESENTATION OF JOHN LENNON & YOKO ONO +* AT 80 WOOSTER ST. NEW YORK --1970...APR. 18-24: TICKETS BY JOHN LENNON + FLUXTOURS ...5 minute helicopter flight over New York City (Bob Watts) $5.40...
all photographs copyright nineteen seVenty by peTer mooRE (Fluxus Newspaper No. 9) 1970.

COMMENTS: *Another of Robert Watts' ready-made tickets.*

KAZ series OBJECTS from ROBERT WATTS...kk/t fingerprints 10¢ & up.
Second Pricelist - European Mail-Orderhouse. [Fall 1964].

FLUXKIT containing following fluxus-publications: (also available separately)...FLUXUS kg ROBERT WATTS: fingerprint in box $2
Vacuum TRapEzoid (Fluxus Newspaper No. 5) March 1965.

FLUXKIT containing following fluxus-publications: (also available separately) ... FLUXUS kg ROBERT WATTS: fingerprint in box, $4
Vaseline sTREet (Fluxus Newspaper No. 8) May 1966.

"...I mailed by parcel post-one carton with following: Quantity - 1; Item: Watts fingerprint -; Wholesale cost to you. each - [$] 1; suggested selling price; - sub total — wholesale cost to you [$] 1..."
Letter: George Maciunas to Ken Friedman, August 19, 1966.

finger print $3...by robert watts
Fluxshopnews. [Spring 1967].

FLUX-PRODUCTS 1961 TO 1969 ... ROBERT WATTS...Finger print, boxed * [indicated as part of FLUXKIT] [$] 3
Fluxnewsletter, December 2, 1968 (revised March 15, 1969).

FLUX-PRODUCTS 1961 TO 1970 ... ROBERT WATTS...Finger print, boxed [$] 3
Flux Fest Kit 2. [ca. December 1969].

FLUXUS-EDITIONEN ... [Catalogue No.] 790 ROBERT WATTS: finger print, boxed
Happening & Fluxus. Koelnischer Kunstverein, 1970.

03.1965...BOB WATTS: fingerprint
George Maciunas, Diagram of Historical Developments of Fluxus... [1973].

COMMENTS: *A variety of* Fingerprints *were made. The price in 1964 seems to indicate that they would have been prints on paper for 10 cents, and the more elaborate at higher prices. Ten* Fingerprints *that had been collected by Watts were illustrated in Fluxus Newspaper No. 3, March, 1964. A*

FLAGS

EXHIBITS...JULY 4 & 5 FLUX DAY flags by Bob Watts,...
Proposal for Flux Fest at New Marlborough. April 8, 1977.

COMMENTS: *Fluxus never produced any flags by Robert Watts, but the idea came from a banner that he made for the "Yam Festival" (Silverman No. 483.1) in 1963.*

FLATTENED PEOPLE OR FLATTENED FROGS

"...We could publish 100 boxes, each containing objects which you could 'mass produce' like in a factory ...NO PHOTOGRAPHS-BUT OBJECTS - Like a suitcase of goodies. Then why flatten out people-easier to flatten out animals like frogs, Catch 100 frogs put in press - & we put in book. Or maybe can get people from morgue - flatten (they will increase in size very much, so then they either must be cut to 100 pages or folded like newspaper.)...Then the box can contain flattened animals..."
Letter: George Maciunas to Robert Watts, [before March 11, 1963].

COMMENTS: *These works are not known to have been produced by George Maciunas as Fluxus Editions.*

FLEXING MIRROR see:
UNDULATING SURFACE MIRROR

FLIGHT

MAY 16-22 CAPSULE BY YOKO + FLUX SPACE CENTER A 3' x 3' enclosure (capsule) having various film loops projected on its walls and ceiling to a single viewer inside:...flight...(Bob Watts);...
Schedule of events for Fluxfest presentation of John Lennon and Yoko Ono. April 1, 1970. version C

COMMENTS: *This film was not used by Fluxus.*

FLIPBOOKS see:
FULL MOON
FLOOR CLOUD see:
CLOUD LAMP

FLUSHING ACTIVATES LAUGHTER OR CLAPPING TOILET

a TOILET is ALTERED so that a laughing or clapping noise is heard as it is flushed. R.W.
Fluxfest 77 at and/or, Seattle. September 1977.

COMMENTS: *An "approved" function.*

Robert Watts. FLUXATLAS. The version in foreground is a component of FLUX YEAR BOX 2. see color portfolio

BRAD IVERSON

FLUSHING RELEASES MIST OF SMELLS TOILET

Toilet no. 1 Bob Watts ... Toilet flushing ... Releases mist of smells: lysol, chlorox, moth flakes, coffee, turpentine, cloves, alcohol, vanilla.
Fluxnewsletter, April 1973.

COMMENTS: *I don't believe this work was ever realized.*

FLUXATLAS
Silverman No. 520, ff.

"...Now I will list some new items produced: all in 1972...Fluxatlas by Watts, various stones from locations around the world, small version: $20, large $40 (only 20 issued)..."
Letter: George Maciunas to Dr. Hanns Sohm, [ca. late 1972].

We need about 50 pebbles (smooth, rounded small stones) to fit a compartment not larger than 25mm x 40mm x 15mm from specific and well described locations (country, town vicinity, which beach or shore, which sea, lake or river). This is for a large Geography box by Bob Watts, which will contain pebbles from various parts of the world. (so far we have pebbles from Azores, Menorca, Cycladic islands, Cape Hatterras, end of Long Island, Manhattan, Nova Scotia, Maine). All contributors will receive a box in return. No deadline.
Fluxnewsletter, April 1973.

"... I got the stones, but they are too small, they should be about ½" diameter or the size to fit the plastic partitioned boxes..."
Letter: George Maciunas to Ken Friedman, [ca. April 1973].

1973 WATTS:...pebble atlas.
George Maciunas, Diagram of Historical Developments of Fluxus... [1973].

FLUXPRODUCTS PRODUCED IN 1972 & 1973 ... by Bob Watts:...Fluxatlas, various stones from locations around the world, small version (7 stones): $20, large version (12 stones): $40
ibid.

by Bob Watts:...Fluxatlas, various stones from loca-

Robert Watts. An enormous version of FLUXATLAS, made for the Fluxfest at and/or in Seattle, 1977. The rocks were for sale individually. Larry Miller designed the case for the work in 1985

BRAD IVERSON

tions around the world, small version (7 stones): $20, large version (18 stones) $100
Fluxnewsletter, April 1975.

"The story on the other side is self explanatory. As a result of which I have to have eye surgery, since I hardly see anything with the left eye. In one sense, these hospital expenses to me are a windfall to any collectors of flux-objects. Now with high cost of surgery, I must make more objects and begin to respond to various orders and requests for them. Thus I am sending by mail to you the following...Bob Watts ... large pebble atlas — [$] 100..."
Letter: George Maciunas to Dr. Hanns Sohm, November 30, 1975.

Large pebble atlas by Watts $100
[Fluxus price list for a customer]. January 7, 1976.

"Flux atlas (U.S. version) by Bob Watts $100"
Letter: George Maciunas to Dr. Hanns Sohm, May 1, 1976.

ROBERT WATTS...Fluxatlas, pebbles from 18 locations $100...Fluxatlas, pebbles from 7 locations $16
Flux Objects, Price List. May 1976.

Show of rocks..."Flux-science"
Notes: George Maciunas for the Fluxfest 77 at and/or, Seattle. [ca. September 1977].

Robert Watts. Version of FLUXATLAS contained in a drawer of FLUX CABINET

BRAD IVERSON

Science Show...rocks...
ibid.

"I heard from Jean that you may be interested to take Flux boxes for the $800 I owe you. I would suggest the following...large Watts rock atlas $100..."
Letter: George Maciunas to Peter Frank, [ca. March 1977].

COMMENTS: There are several versions of Fluxatlas including single rocks, classified by geographical location. An enormous version (Silverman No. > 521.I) made for the Fluxus exhibition at and/or in Seattle in 1977 is of particular interest because each sample was for sale separately, making the work simultaneously a "museum piece" and an affordable work for anyone. Fluxatlas is also an illustration of how George Maciunas could use the group (see: Fluxnewsletter, April 1973) to work for the benefit of each other. In a letter from Maciunas to Paul Sharits in early 1966 he writes: "... How did you collect the paper events from such diverse geographical locations? Were they all together at one time? Because in the case of the original Fluxus group, the people were all together & then spread out like the first apostles..."

FLUX CLOTHING CHEST

FLUX SHOW: DICE GAME ENVIRONMENT ENTIRE FLOOR AS DICE HAZARD TABLE DIE CUBES, 15" CUBES ON FLOOR, Marked on sides,

top open or closed with clear plastic. Consisting or containing...Flux clothing chest by Bob Watts.
Flux Fest Kit 2. [ca. December 1969].

COMMENTS: This is an idea by George Maciunas using 15" die cubes to display various Fluxus works. Watts' clothing would have been his Fluxus underwear and sweat shirts.

FLUXFILM 11 see:
TRACE NO. 22
FLUXFILM 12 see:
TRACE NO. 23
FLUXFILM 13 see:
TRACE NO. 24
FLUXFILMS see:
FLIGHT
FULL MOON
TRACE NO. 22
TRACE NO. 23
TRACE NO. 24
FLUXFURNITURE see:
CLOUD LAMP
CLOUDS ON LUMINOUS CEILING PANEL
CLUTTERED DESK TABLE TOP
CROSSED NUDE LEGS TABLE TOP
DINNER SETTING TABLE TOP
FLUX CLOTHING CHEST
FOUNTAIN LAMP
LAMPS
LUMINOUS CEILINGS
MODULAR CABINETS
MONSTERS ARE INOFFENSIVE
SAND BOX TABLE
TABLE TOPS
UNDULATING SURFACE MIRROR
FLUX JEWELRY/PEARLS see:
PEARL NECKLACE
FLUX LIGHT KIT see:
LIGHT FLUX KIT
FLUX LUX SOAP see:
SOAP
FLUX PLACE MAT see:
PLACE MATS

FLUXPOST 17-17
Silverman No. 487, ff.

"I have your FLUXPOST stamps printed (in black & blue) 2000 copies, but not perforated. Perf. costs $40 & I could not afford it. If you can wait till March 1st. (when I return to N.Y.) then OK. If you would like it done sooner, then you could pick-up the printed stamps at Zaccar, 237 Lafayette & take it to Supreme Bookbinder, 704 Broadway. explaining to Supreme

Robert Watts. FLUXPOST 17-17

how you wish to have it perforated...."
Letter: George Maciunas to Robert Watts, January 21, 1965.

"...I will finance completion of your postage stamps..."
Letter: George Maciunas to Robert Watts, February 25, 1965.

"... Replies to your questions ... I am sending Watts stamps...."
Letter: George Maciunas to Willem de Ridder, March 2, 1965.

FLUXKIT containing following fluxus-publications:

(also available separately) ... FLUXUS kf ROBERT WATTS: fluxpost stamps, sheet of 100 different stamps, $1
Vacuum TRapEzoid (Fluxus Newspaper No. 5) March 1965.

[as above]
Vaseline sTREet (Fluxus Newspaper No. 8) May 1966.

"... I mailed by parcel-post - one carton with following: Quantity - 20; Item - Watts stamps...Wholesale cost to you. each - 30¢; suggested selling price -; sub total—wholesale cost to you. - [$] 6.00..."
Letter: George Maciunas to Ken Friedman, August 19, 1966.

FLUX-PROJECTS PLANNED FOR 1967...Collective projects: (All are invited to submit ideas and participate, ideas can be either ready pictorial material or just specified material which we have to find, produce or obtain otherwise)...Flux-postal kit: containing... stamps...
Fluxnewsletter, March 8, 1967.

IMPLOSIONS INC. PROJECTS ... Triple partnership was formed between Bob Watts, Herman Fine and myself [George Maciunas] to introduce into mass market ...money producing products...This business will be operated in commercial manner, with intent to make profits...connection between Fluxus collective and Implosions Inc. has not been clarified yet...we could consider at present Fluxus to be a kind of division or subsidiary of Implosions. Projects to be realized through Implosions:...stamps (same as Flux-postal kit)
ibid.

fluxpost stamps $1...by robert watts
Fluxshopnews. [Spring 1967].

[component of] flux post kit $7
ibid.

FLUX-PRODUCTS 1961 TO 1969 ... FLUXPOST KIT 1968 100 stamp sheet - by Bob Watts * [indicated as part of FLUXKIT] ... [$] 8 Version without rubber stamps [$] 2
Fluxnewsletter December 2, 1968 (revised March 15, 1969).

FLUX-PRODUCTS 1961 TO 1969 ... ROBERT WATTS...Flux-post stamps, 100 per sheet [$] 1
ibid.

FLUX-PRODUCTS 1961 TO 1970 ... ROBERT WATTS...Flux-post stamps, 100 per sheet [$] 1
Flux Fest Kit 2. [ca. December 1969].

FLUX-PRODUCTS 1961 TO 1970 ... FLUXPOST KIT, 1968: [including] 100 stamp sheet by Bob Watts ...boxed: $8
ibid.

FLUXUS-EDITIONEN...[Catalogue No.] 719 FLUX-

POST KIT, 1968 (b. watts,...
Happening & Fluxus. Koelnischer Kunstverein, 1970.

03.1965 BOB WATTS: stamps,...
George Maciunas, Diagram of Historical Developments of Fluxus... [1973].

COMMENTS: *Many of the references to Watts' stamps give no indication whether they refer to* Yamflug/5 Post 5 *or* Fluxpost 17-17, *both of which were distributed by Fluxus and later, Implosions, in a variety of forms. Blocks of these or other Watts stamps are included in his* Events *and the Collective* Fluxpost Kit 7, *as well as in assemblings of* FLUXUS 1. *Although advertised as a component of* Fluxkit, *I have not seen sheets of stamps as a separate item in that work.*

FLUX RECORD PLAYER see:
Chieko Shiomi and Robert Watts

PHOTOGRAPHER NOT IDENTIFIED

Robert Watts. FLUX ROCKS MARKED BY VOLUME IN CC. Preparatory photograph for the label

FLUX ROCKS MARKED BY VOLUME IN CC
Silverman No. > 497.I, ff.

FLUXUS 1964 EDITIONS, AVAILABLE NOW ... FLUXUSkaz series, OBJECTS from ROBERT WATTS ROCKS in compartmented wood or plastic boxes, $4

to $20...FLUXUS kt rocks marked by their volume in cubic cm etc.
cc Valise e TRanglE (Fluxus Newspaper No. 3) March 1964.

KAZ-serie[s] ROBERT WATTS : objects rocks in compartmented wood or plastic boxes $4 to $20.... F-kt rocks marked by their volume in cubic cm. etc.
European Mail-Orderhouse: europeanfluxshop, Pricelist. [ca. June 1964].

KAZ series OBJECTS from ROBERT WATTS F ROCKS in compartmented wood or plastic boxes $4. to $20....F-kt rocks marked by their volume in cubic cm. etc.
Second Pricelist - European Mail-Orderhouse. [Fall 1964].

... items are in stock, delivery within 2 weeks ... FLUXUSku ROBERT WATTS: single rock marked by its...volume, in wood box $20
Vaseline sTREet (Fluxus Newspaper No. 8) May 1966.

... items are in stock, delivery within 2 weeks ... FLUXUSkv ROBERT WATTS: rocks marked by their volume in cubic cm. in small plastic box $6
ibid.

"...By post you will be getting...some large rocks (marked by volume in boxes)..."
Letter: George Maciunas to Ken Friedman, February 28, 1967.

PAST FLUX-PROJECTS (realized in 1966) ... Flux-rock marked by volume in cc...by Robert Watts.
Fluxnewsletter, March 8, 1967.

fluxrock volume $7...by robert watts
Fluxshopnews. [Spring 1967].

FLUX-PRODUCTS 1961 TO 1969 ... ROBERT WATTS...Rocks, marked by...volume, small pebbles in partitioned box [$] 6
Fluxnewsletter, December 2, 1968 (revised March 15, 1969).

FLUX-PRODUCTS 1961 TO 1970 ... ROBERT WATTS...Rocks, marked by...vol. boxed [$] 8
Flux Fest Kit 2. [ca. December 1969].

FLUXUS-EDITIONEN ... [Catalogue No.] 793 ROBERT WATTS: rock, marked by volume, in antique box
Happening & Fluxus. Koelnischer Kunstverein, 1970.

Toilet no. 1 Bob Watts: ... Medicine cabinet: Rocks marked by volume in c.c.
Fluxnewsletter, April 1973.

03.1964...BOB WATTS: rocks
George Maciunas, Diagram of Historical Developments of Fluxus... [1973].

Rock, marked by...volume, boxed $12
Flux Objects, Price List. May 1976.

BRAD IVERSON

Robert Watts. Different versions of **FLUX ROCKS MARKED BY VOLUME IN CC.** see color portfolio

BRAD IVERSON

Robert Watts. **FLUXSAND HIDE & SEEK.** Two examples with a label in foreground. see color portfolio

COMMENTS: This work exists only as single marked rocks, either in labeled wood or plastic boxes or unboxed. They were always assembled by George Maciunas and grow out of Watts' Odd Numbered Rocks and Colored Rocks (Silverman No. < 495.1).

FLUXSAND HIDE & SEEK
Silverman No. 509, ff.

FLUXUS 1964 EDITIONS, AVAILABLE NOW ... FLUXUS kaz series, OBJECTS from ROBERT WATTS ...FLUXUSka SAND BOXES, with hidden objects $10
cc Valise e TRanglE (Fluxus Newspaper No. 3) March 1964.

KAZ-serie[s] ROBERT WATTS : objects ... F-ka SAND BOXES, with hidden objects $10
European Mail-Orderhouse : europeanfluxshop, Pricelist. [ca. June 1964].

KAZ series OBJECTS from ROBERT WATTS...F-ka SAND BOXES, with hidden objects $10.
Second Pricelist - European Mail-Orderhouse. [Fall 1964].

"I would like to see you on your next N.Y. trip (this week)...to show for your approval a few new labels I am printing up for your...'Sand-hide & seek' (Remember?)..."
Postcard: George Maciunas to Robert Watts, September 22, 1966.

PAST FLUX-PROJECTS (realized in 1966) ...Flux-sand hide & seek...by Robert Watts.
Fluxnewsletter, March 8, 1967.

hide & seek $4.50...by robert watts
Fluxshopnews. [Spring 1967].

FLUX-PRODUCTS 1961 TO 1969 ... ROBERT WATTS...Hide & seek, in sand box, [$] 5
Fluxnewsletter, December 2, 1968 (revised March 15, 1969).

FLUX-PRODUCTS 1961 TO 1970 ... ROBERT WATTS...Hide & seek, in sand box [$] 5
Flux Fest Kit 2. [ca. December 1969].

FLUX SHOW: DICE GAME ENVIRONMENT EN-

TIRE FLOOR AS DICE HAZARD TABLE DIE CUBES, 15" CUBES ON FLOOR, Marked on sides, top open or closed with clear plastic. Consisting or containing...Flux sand box game by Bob Watts.
ibid.

"...Watts hide and seek is messy, because sand always leaks out from any box..."
Letter: George Maciunas to Dr. Hanns Sohm, [ca. late 1972].

COMMENTS: Robert Watts, 1982: "Hidden objects were things like nipples, condoms, rubber and chrome worms."

Robert Watts' comments refer to the early version of the work, when it was called Sand Box. When George Maciunas assembled the work under the aegis of Fluxus he didn't use chromed objects, but frequently put in clay marbles or colored plastic balls, as well as condoms.

FLUX-SCIENCE SHOW see:
FLUXATLAS
FLUXSHIRT, FEMALE see:
FEMALE UNDERSHIRT

FLUXSHIRT, MALE see:
 MALE UNDERSHIRT
FLUX STATIONERY see:
 GIANT STAMP IMPRINT ENVELOPE:
 GRAFFITI LETTER PAPER
 GIANT STAMP IMPRINT ENVELOPE: SIGNERS
 OF THE DECLARATION OF INDEPEN-
 DENCE LETTER PAPER
FLUX TATTOOS see:
 STICK-ONS

FLUX TIMEKIT
Silverman No. 511, ff.

"I would like to see you on your next N.Y. trip (this week)...to show for your approval a few new labels I am printing up for your 'time kit'...(remember?)..."
Postcard: George Maciunas to Robert Watts, September 12, 1966.

PAST FLUX-PROJECTS (realized in 1966)...Flux-time kit...by Robert Watts.
Fluxnewsletter, March 8, 1967.

time kit $7...by robert watts
Fluxshopnews. [Spring 1967].

PROPOSED FLUXSHOW FOR GALLERY 669, OPENING NOV. 26, 1968...OBJECTS, FURNITURE ...Boxed events & objects - one of a kind: time kit by Bob Watts,...
Fluxnewsletter, December 2, 1968.

FLUX-PRODUCTS 1961 TO 1969 ... ROBERT WATTS...Time kit (various time measuring or telling devices) in partitioned box * [indicated as part of FLUXKIT] [$] 8
Fluxnewsletter, December 2, 1968 (revised March 15, 1969).

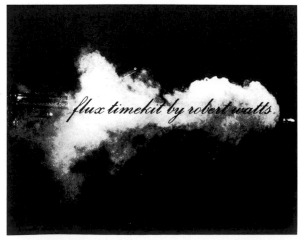

Robert Watts. FLUX TIMEKIT. Label by George Maciunas

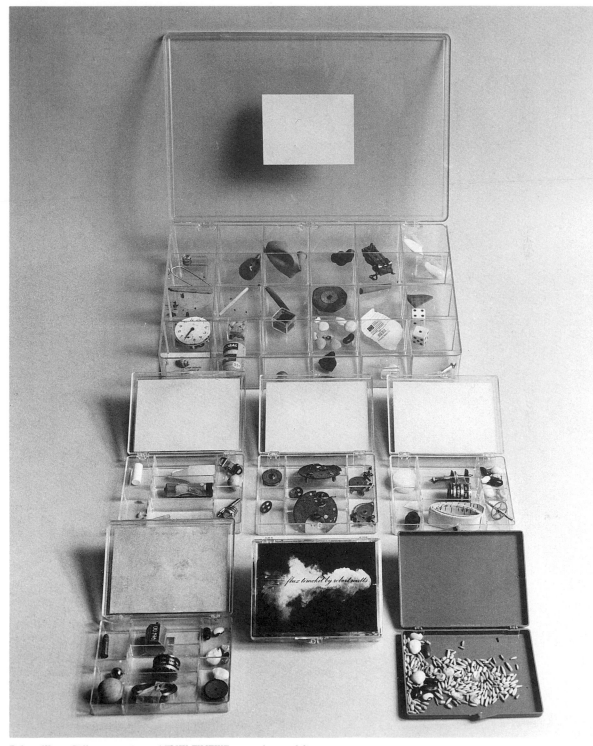

Robert Watts. Different versions of FLUX TIMEKIT. see color portfolio

BRAD IVERSON

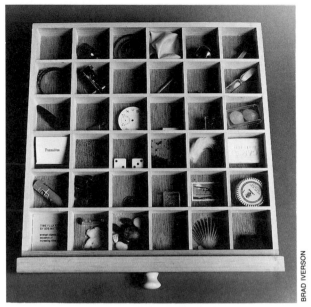

BRAD IVERSON

Robert Watts. Version of FLUX TIMEKIT, titled here, "Time Flux kit," contained in a drawer of FLUX CABINET

FLUX-PRODUCTS 1961 TO 1969 ... ROBERT WATTS...Time kit, special time measuring device, in antique box [$] 20
ibid.

FLUX SHOW: DICE GAME ENVIRONMENT ENTIRE FLOOR AS DICE HAZARD TABLE DIE CUBES, 15'' CUBES ON FLOOR, Marked on sides, top open or closed with clear plastic. Consisting or containing...Flux time kit by Bob Watts.
Flux Fest Kit 2. [ca. December 1969].

FLUX-PRODUCTS 1961 TO 1970 ... ROBERT WATTS...Time kit (time measuring devices) boxed [$] 8
ibid.

FLUXUS-EDITIONEN ... [Catalogue No.] 795 ROBERT WATTS: flux-time kit, boxed
Happening & Fluxus. Koelnischer Kunstverein, 1970.

Toilet no. 1 Bob Watts:...Medicine cabinet:...Time kits.
Fluxnewsletter, April 1973.

03.1967...BOB WATTS: time kit,...
George Maciunas, Diagram of Historical Developments of Fluxus... [1973].

OBJECTS: ...Time-kit (Bob Watts)
Proposal for 1975/76 Flux-New Year's Eve Event. [ca. November 1975].

ROBERT WATTS...Time kit, 7 time measuring de-

vices, boxed $12
Flux Objects, Price List. May 1976.

A TIME PUZZLE in which as many as 100 objects are arranged on a board according to time, is played. R.W.
Fluxfest at and/or, Seattle. September 1977.

COMMENTS: *Robert Watts, 1982: "All kinds of things related to time: like a rifle bullet (pretty quick), seeds that grow at different rates, maybe a match."*

FLUX TOILET see:
 COLORED WATER TOILET BOWL
 DIRTY PAPER TOWELS
 DOLLAR BILL TOILET PAPER
 FLUSHING ACTIVATES LAUGHTER OR
 CLAPPING TOILET
 FLUSHING RELEASES MIST OF SMELLS
 TOILET
 FLUX ROCK MARKED BY VOLUME IN CC
 FLUX TIMEKIT
 MAZE
 MYLAR TOILET PAPER
 SOAP
 TARGET
 TOILET SEAT WHEN SAT UPON OPENS DOOR
 UNDULATING SURFACE MIRROR

FLUXTOURS TICKETS see:
 BUS TICKET TO GINGER BREAD CASTLE,
 HAMBURG, N.J.
 5 MINUTE HELICOPTER FLIGHT OVER NEW
 YORK CITY TICKET
 9 HOUR ROUND TRIP BY BUS TO CAPE MAY,
 N.J. TICKET
 3 HOUR HARLEM TOUR TICKET
 TICKET TO BEAR MOUNTAIN
FLUXUS KK A TO Z SERIES see:
 A TO Z SERIES
FLUXUS LIGHT BOX see:
 LIGHT FLUX KIT
FOG BOX see:
 FOG MACHINE

FOG MACHINE

Fog Machine - I assume we will want a ceiling. There are materials at Academie ready & easy for this.
Notes: Larry Miller to George Maciunas concerning the Flux-labyrinth, Berlin. [ca. August 1976].

fogg [sic] machine
Plan of completed Fluxlabyrinth, Berlin. [ca. September 1976].

COMMENTS: *Worked for a while, then lost steam.*

FOODS see:
 CANDY BULLETS
 CHROMED LOLLIPOP
 FIRE ALARM CAKE
 FRUIT AND VEGETABLE SECTIONS STICK-
 ONS
 TWELVE JELLO EGGS MOLDED IN AN EGG
 BOX

FOUNTAIN LAMP

FLUX-PROJECTS PLANNED FOR 1967 ... Bob Watts:...Water fountain...
Fluxnewsletter, March 8, 1967.

FLUXFURNITURE...LAMPS, 15'' cubes, walnut sides, locked corners, translucent front and back, Robert Watts: fountain, a water fall over luminous photo of water, with pump, $200.00...Available in N.Y.C. at Multiples and late in 1967 at FLUXSHOP, 18 GREENE ST.
Fluxfurniture, pricelist. [1968].

COMMENTS: *Preliminary photographic studies exist for* Fountain Lamp, *but I have never seen a completed one by Fluxus.*

PHOTOGRAPHER NOT IDENTIFIED

Robert Watts. Photographic study for FRUIT AND VEGETABLE SECTIONS STICK-ONS

FRUIT AND VEGETABLE SECTIONS STICK-ONS

FLUX-PROJECTS PLANNED FOR 1967 ... Bob Watts:...Stick-ons (disposable jewelry):...Fruit and Vegetable sections.
Fluxnewsletter, March 8, 1967.

COMMENTS: *Although these stick-ons were not produced by Fluxus, preparatory photographic material does exist for the work. At one point, George Maciunas planned to make a* Fruit and Vegetable Chess *set by Larry Miller.*

FULL MOON

"...Fluxus 2, yearbox is now in planning stage & I am requesting various people to contribute BOOK events Especially flipbook films (I have prepared your full moon, but need more.)..."
Letter: George Maciunas to Robert Watts, January 21, 1965.

COMMENTS: *Related to Robert Watts'* Moonscape Stamps, *a* Full Moon *flipbook would have been the phases of the moon, rising and setting.*

FURNITURE see:
FLUXFURNITURE

Robert Watts. GEOGRAPHY

NANCY ANELLO

GAMES see:
FLUX TIMEKIT
HOSPITAL EVENTS
MAZE
PLAYING CARDS
TARGET

GEOGRAPHY
Silverman No. > 483.XXIII

FLUXUS 1964 EDITIONS, AVAILABLE NOW ... FLUXUS kk a to z series...(p) geography 50¢ & up...
cc Valise e TRanglE (Fluxus Newspaper No. 3) March 1964.

KAZ - serie[s] ROBERT WATTS: objects ... kk/p GEOGRAPHY 50¢ and up
European Mail-Orderhouse: europeanfluxshop, Pricelist. [ca. June 1964].

KAZ series OBJECTS from ROBERT WATTS...kk/p geography 50¢ & up
Second Pricelist - European Mail-Orderhouse. [Fall 1964].

FLUXUS kk ROBERT WATTS: a to z series ... (p) geography 50¢ & up...
Vacuum TRapEzoid (Fluxus Newspaper No. 5) March 1965.

COMMENTS: Geography, *a ready-made map, evolves later into* Fluxatlas, *a collection of rocks from all over the world.*

GEOGRAPHY BOX see:
FLUXATLAS

GIANT STAMP IMPRINT ENVELOPE: GRAFFITI LETTER PAPER

FLUXPROJECTS FOR 1969...Stationery (envelope with giant postage stamp, letter paper with graffiti).
Fluxnewsletter, December 2, 1968.

COMMENTS: *This work was not made. It is closely related to the next entry which was produced by Fluxus, and* Old Writing.

GIANT STAMP IMPRINT ENVELOPE: SIGNERS OF THE DECLARATION OF INDEPENDENCE LETTER PAPER
Silverman No. < 524.V a & b

PROPOSED CONTENTS FOR FLUXPACK 3 TO BE PUBLISHED IN 1973 BY FLASH ART ... Stationery envelope with giant stamp imprint, letter paper with signatures of Decl. of American Independence, by Watts...Cost Estimates: for 1000 copies...stationery [3 designs] $150...100 copies signed by: Watts...
[George Maciunas]. Proposed Contents for Fluxpack 3. [ca. 1972].

Robert Watts. GIANT STAMP IMPRINT ENVELOPE: SIGNERS OF THE DECLARATION OF INDEPENDENCE LETTER PAPER

"... to produce the Flash Art FLUXPACK 3 ... contents at present will be as follows:...Stationery: signers of D. of I. in giant stamp by Watts.
Letter: George Maciunas to Giancarlo Politi, n.d. Reproduced in Fluxnewsletter, April 1973.

Flash Art editor, Giancarlo Politi, proposed to publish the 3rd Fluxyearbook, maybe to be called FLUXPACK 3, with the following preliminary contents: ... Stationery: envelope with giant stamp imprint, letter paper with imprint of signatures of Decl. of American Independence, by Watts,...
Fluxnewsletter, April 1973.

COMMENTS: *This two part work consists of an envelope*

with an enlargement of a postal meter stamp and letter paper with facsimile signatures. Produced by Fluxus, it was included in Fluxpack 3.

GLOVES

PROPOSED CONTENTS FOR FLUXPACK 3 TO BE PUBLISHED IN 1973 BY FLASH ART ... gloves — plastic-hand — Watts

[George Maciunas], Proposed Contents for Fluxpack 3. [ca 1972].

Flash Art editor, Giancarlo Politi, proposed to publish the 3rd Fluxyearbook, maybe to be called FLUX-PACK 3, with the following preliminary contents:... Wear items: paper or vinyl gloves by Watts,...

Fluxnewsletter, April 1973.

COMMENTS: Robert Watts remembers making drawings for this work, but it was never produced by George Maciunas as a Fluxus Edition.

GRAFFITI see:
GIANT STAMP IMPRINT ENVELOPE: GRAF-FITI LETTER PAPER

GRAY ROCKS

FLUXUS 1964 EDITIONS, AVAILABLE NOW ... FLUXUS kaz series, OBJECTS from ROBERT WATTS ROCKS in compartmented wood or plastic boxes $4 to $20...FLUXUS ky gray rocks

cc Valise e TRanglE (Fluxus Newspaper No. 3) March 1964.

KAZ - serie[s] ROBERT WATTS : objects rocks in compartmented wood or plastic boxes $4 to $20.... F-ky gray rocks

European Mail-Orderhouse: europeanfluxshop, Pricelist. [ca. June 1964].

KAZ series OBJECTS from ROBERT WATTS ... F ROCKS in compartmented wood or plastic boxes $4. to $20....F-ky gray rocks

Second Pricelist - European Mail-Orderhouse. [Fall 1964].

03.1964...BOB WATTS: rocks

George Maciunas, Diagram of Historical Developments of Fluxus... [1973].

COMMENTS: These rocks might have been ready-mades, or grey painted rocks offered for sale through Fluxus as Colored Rocks *were.*

HAIRY MAN IN SHORTS APRON

FLUX-PROJECTS PLANNED FOR 1967 ... Bob Watts:...Paper aprons:...hairy man in shorts...

Fluxnewsletter, March 8, 1967.

COMMENTS: One of many apron ideas tossed out for Fluxus, the artist thinks a prototype might have been made, but never the edition.

HAND WITH CIGARETTE, PEA ON PLATE PLACE MAT
Silverman No. < 508.II

''...I got hold of a few $ & shipped out by REA a package to you...2 sets of Watts place mats....''
Letter: George Maciunas to Ken Friedman, [ca. February 1967].

FLUX-PROJECTS PLANNED FOR 1967 ... Bob Watts: table mats...
Fluxnewsletter, March 8, 1967.

COMMENTS: This work is one of three different place mats using trompe l'oiel photographs laminated between plastic that the artist made as prototypes for Fluxus Editions. Another photo-laminated work, Desk Blotter *(Silverman No. < 508.IV) was made in prototype.*

Robert Watts. HAND WITH CIGARETTE, PEA ON PLATE PLACE MAT

HATS WITH HAIR

''...to produce the Flash Art FLUXPACK 3 ... contents at present will be as follows:...Hats:...with hair by Watts.''
Letter: George Maciunas to Giancarlo Politi, n.d. Reproduced in Fluxnewsletter, April 1973.

COMMENTS: This work was not produced by George Maciunas as a Fluxus Edition and was not included in Fluxpack 3. The artist doesn't recall what it might have been and suggests it could have been another invention in Maciunas' imagination.

HERE I COME SWEATSHIRT

FLUX-PROJECTS PLANNED FOR 1967 ... Bob

Watts:...Sweat shirts with statements: here I come (front) there I go (back), etc.
Fluxnewsletter, March 8, 1967.

IMPLOSIONS INC. PROJECTS...Triple partnership was formed between Bob Watts, Herman Fine and myself [George Maciunas] to introduce into mass market ...money producing products...This business will be operated in commercial manner, with intent to make profits....connection between Fluxus collective and Implosions Inc. has not been clarified yet...we could consider at present Fluxus to be a kind of division or subsidiary of Implosions. Projects to be realized through Implosions:...Sweat shirts (printed front and back, or front alone), may have images or statements...
ibid.

05.1966 BOB WATTS: clothing,...
George Maciunas, Diagram of Historical Developments of Fluxus... [1973].

COMMENTS: Although initially a Fluxus project, Robert Watts remembers having made at least one prototype Here I Come Sweatshirt *for Implosions.*

HERO 601
Silverman No. < 516.II

stick-on ribbons $1...by robert watts
Fluxshopnews. [Spring 1967].

SUMMARY OF LAST NEWSLETTER (Jan. 31, 1968) ...Stick-ons produced. Watts:...campaign ribbons
Fluxnewsletter, December 2, 1968.

FLUX-PRODUCTS 1961 TO 1969 ... FLUXTAT-TOOS Winter 1967 Campaign ribbons, medals...by Bob Watts...6 - 5 x 6'' stick-on sheets, boxed * [indicated as part of FLUXKIT] [$] 5
Fluxnewsletter, December 2, 1968 (revised March 15, 1969).

FLUX-PRODUCTS 1961 TO 1969 ... ROBERT WATTS...Stick-on tattoos, campaign ribbons...each: [$] 1
ibid.

FLUX-PRODUCTS 1961 TO 1970 ... ROBERT WATTS Stick-on tattoos, ribbons...[$] 1
Flux Fest Kit 2. [ca. December 1969].

FLUXTATTOOS 1967: Campaign ribbons,...medals ...by Bob Watts...6 [different]- 5x6'' stick-on sheets, boxed $5
ibid.

COMMENTS: Although a Fluxus project, this sheet of stick-ons was produced by Implosions, which was an attempt to commercialize Fluxus and Fluxus-like ideas. Hero 601 was included in the collective edition, Flux Tattoos.

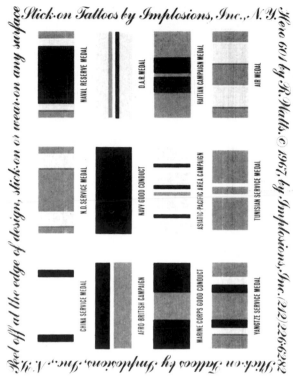

Robert Watts. HERO 601

HOSPITAL EVENTS
Silverman No. 483

"I got your letter on the last day in the hospital (they did not succeed in curing me!) So I was not able to do the Hospital events - first I would be too tired and then had no dice...Your letter, you know, the one to the hospital did not have my name on the envelope HA! HA! So what do they do? they open to see to whom it could be & what do they find? the Hospital Events HA! HA! & the cards, - It almost got to the nurses, but unfortunately nurses do not distribute mail. That could have been dangerous...."
Letter: George Maciunas to Robert Watts, [before March 11, 1963].

"...Your last hospital event is terrific! (all tables dented now). Paik has exhibit for next 2 weeks at Wuppertal...I got one room for fluxus so I set [up] 3 things of yours...the hospital event which the visitors can perform. In case some pictures disappear during exhibit - can you send others that could be printed? (for your box-edition)...We thought in future to integrate our festivals with these 'exhibits'..."
Letter: George Maciunas to Robert Watts, [March 11 or 12, 1963].

"...BIG QUESTION !!! The hospital event pictures, we exhibited in Wuppertals Gallery Parnass (Paik's exhibit) & visitors hammered so hard the pictures are damaged. Can we substitute others in exhibits & in Fluxus? (I can still include it)?? OK with you? (like the picture from your puzzle & one with the brand) (both being printed up). Let me know...or send substitute pictures with red dots...."
Letter: George Maciunas to Robert Watts, ca. early April 1963].

"...This hospital event (with hammer) is OK? (I mean to substitute the pictures, since in last show the public banged away so hard they ruined the pictures)..."
Letter: George Maciunas to Robert Watts, [ca. May 1, 1963].

"...NOW THE FESTIVAL: (Amsterdam one)....Exhibits....Robert Watts - hospital event..."
Letter: George Maciunas to Tomas Schmit, [early June 1963].

HOSPITAL EVENTS
dedicated to gm
also to passerbyes

Instructions:

place on firm surface
strike sharp blow with hammer and nail
on black dots
in sequence indicated by numbers

Robert Watts. HOSPITAL EVENTS. Above, the instructions and below, one of the sheets for an "event"

"...for inclusion in TV program...Robert Watts: Hospital event for GM. take picture of De Gaulle or Kennedy or Adenauer. Best to show Kennedy (president) Show picture so no edges are seen. Picture stretched over frame. Performer from behind with finger, in fast sequence pierces one eye (goes with finger through it) then second eye, mouth, & then middle of forehead. Make little holes beforehand so finger will be able to pierce neatly without ripping-up picture. Practice with another paper. Sequence must be fast, like one, two, three, four. OK?..."
Letter: George Maciunas to Willem de Ridder, [early August 1963].

"...FLUXUS 2 yearbox is now in planning stage & I am requesting various people to contribute...more things like your Hosp. event..."
Letter: George Maciunas to Robert Watts, January 21, 1965.

"...Fluxus 1 items of the type that could be included are:...Bob Watts - hospital events..."
[Fluxus Newsletter], unnumbered, [ca. March 1965].

PROPOSED CONTENTS FOR FLUXPACK 3 TO BE PUBLISHED IN 1973 BY FLASH ART ... Paper Events hitting explosive charges hidden in picture, by Watts...Cost Estimates: for 1000 copies...[2] paper events $500...100 copies signed by: Watts...
[George Maciunas], Proposed Contents for Fluxpack 3. [ca. 1972].

Flash Art editor, Giancarlo Politi, proposed to publish the 3rd Fluxyearbook, maybe to be called FLUXPACK 3, with the following preliminary contents... Games:...paper events: (hitting explosive discs hidden in picture by Watts,...)
Fluxnewsletter, April 1973.

COMMENTS: Some Hospital Events were included in FLUXUS 1 and a few appeared in some assemblings of Robert Watts' Events. I have never seen a complete set of Hospital Events packaged by George Maciunas. The work does not appear in Fluxpack 3.

HOT DOG see:
 TRACE NO. 23

ICE FILLED SHOES

FLUX-OLYMPIAD ... TRACK ... hurdles, obstacles with obstacle shoes: shoes filled with...crushed ice... (Bob Watts)
Fluxfest at Stony Brook, Newsletter No. 1, August 18, 1969. version B

FLUX-OLYMPIAD...TRACK - HURDLES, OBSTACLES/OBSTACLE SHOES: shoes filled with...crushed ice (Robert Watts)
Flux Fest Kit 2. [ca. December 1969].

FEB. 17, 1:30PM FLUX-SPORTS DOUGLASS COL.
...OBSTACLE SHOES: shoes filled with...crushed
ice...
*Poster/program for Flux-Mass, Flux-Sports and Flux-Show.
February, 1970.*

PROPOSED FLUXANNIVERSARY FEST PRO-
GRAM 1962-1972 SEPT & OCT...FLUXOLYMPIAD
(counterpoint to Munich one)...obstacle shoes run by
Bob Watts...
Fluxnewsletter, April 1973.

1970, FLUXSPORTS:...by bob watts: obstacle shoes
*George Maciunas, Diagram of Historical Developments of
Fluxus... [1973].*

COMMENTS: *The artist does not recall these shoes.*

INCLINED PLANE SHOES

FLUX-OLYMPIAD ... TRACK ... hurdles, obstacles
with obstacle shoes:...inclined plane shoes etc. (Bob
Watts)
*Fluxfest at Stony Brook, Newsletter No. 1, August 18, 1969.
version B*

FLUX-OLYMPIAD...TRACK-HURDLES, OBSTA-
CLES/OBSTACLES SHOES:...inclined plane shoes...
(Robert Watts)
Flux Fest Kit 2. [ca. December 1969].

FEB. 17 1:30PM FLUX-SPORTS DOUGLASS COL.
...OBSTACLE SHOES:...inclined plane shoes...
*Poster/program for Flux-Mass, Flux-Sports and Flux-Show.
February, 1970.*

PROPOSED FLUXANNIVERSARY FEST PRO-
GRAM 1962-1972 SEPT & OCT...FLUXOLYMPIAD
(counterpoint to Munich one)...obstacle shoes run
by Bob Watts...
Fluxnewsletter, April 1973.

1970 FLUXSPORTS:...bob watts: obstacle shoes
*George Maciunas, Diagram of Historical Developments of
Fluxus... [1973].*

COMMENTS: *Robert Watts recalls these as being like plat-
form shoes, some with toes up, others with toes down. Parti-
cipants could choose combinations of either type. See also
George Maciunas' Shoe Steps.*

INK BOTTLES see:
LEAKING INK BOTTLES

LADDER WALLPAPER

PROPOSED CONTENTS FOR FLUXPACK 3 TO BE
PUBLISHED IN 1973 BY FLASH ART...Posters 24
x 24 ladder by Watts...Cost Estimates: for 1000

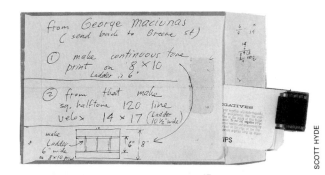

SCOTT HYDE

GEORGE MACIUNAS

**Robert Watts. LADDER WALLPAPER. George Maciunas' notes and
photographic study for the work**

copies...posters [5 designs], games $700...100 copies
signed by: Watts...
*[George Maciunas], Proposed Contents for Fluxpack 3.
[ca. 1972].*

"...to produce the Flash Art FLUXPACK 3...con-
tents at present will be as follows:...Posters, wall-
paper:...ladder by Watts,..."
*Letter: George Maciunas to Giancarlo Politi, n.d. Reproduced
in Fluxnewsletter, April 1973.*

Flash Art editor, Giancarlo Politi, proposed to pub-
lish the 3rd Fluxyearbook, maybe to be called FLUX-
PACK 3, with the following preliminary contents:

Household items:...poster, signs or wallpaper (ladder
by Watts...)
Fluxnewsletter, April 1973.

COMMENTS: Ladder Wallpaper *was never completed as a
Fluxus work.*

LAMPS

PAST FLUX-PROJECTS (realized in 1966)...Flux-
furniture:...lamps...by Robert Watts
Fluxnewsletter, March 8, 1967.

COMMENTS: *Robert Watts planned to make a fireplace lamp,
complete with "burning" fake logs, but it was not made.*

LAMPS see:
CLOUD LAMP
FOUNTAIN LAMP
SAND BOX TABLE

LARGE ROCK IN WOOD OR ANTIQUE BOX

"I got hold of a few $ & shipped out by REA a pack-
age to you: with:...2 - Large rocks in antique boxes -
$8 each - minimum. wholesale...."
*Letter: George Maciunas to Ken Friedman, [ca. February
1967].*

PROPOSED FLUXSHOW FOR GALLERY 669 ...
OBJECTS, FURNITURE...Boxed events & objects -
one of a kind:...large rock by Bob Watts
Fluxnewsletter, December 2, 1968.

FLUX-PRODUCTS 1961 TO 1969 ... ROBERT
WATTS...Rocks...large rocks, single per wood box
[$] 8
Fluxnewsletter, December 2, 1968 (revised March 15, 1969).

FLUX-PRODUCTS 1961 TO 1969 ... ROBERT
WATTS...Rocks,...large rocks in antique boxes [$] 30
ibid.

FLUX-PRODUCTS 1961 TO 1970 ... ROBERT
WATTS...Rocks, marked, in antique box [$] 30
Flux Fest Kit 2. [ca. December 1969].

03.1964...BOB WATTS: rocks
*George Maciunas, Diagram of Historical Developments of
Fluxus... [1973].*

COMMENTS: *We have combined the two versions of this
work, as the Large Rock in Antique Box is a deluxe version
of Large Rock in Wood Box. Robert Watts sometimes pack-
aged his early rock works in wood boxes, and George Maciu-
nas usually packaged Watts' Flux Rock Marked by Volume in
CC in old oriental boxes. I believe Large Rock in Wood or
Antique Box was intended to be an unaltered rock in a special
box. Perhaps "marked" in the Flux Fest Kit 2 entry means
labeled. I have never seen this work and don't believe it was
made.*

LEAKING INK BOTTLES

''...Now about the contents of your letter: boxes etc. ...we could publish a 100 boxes - each containing objects which you would 'mass produce' like in factory - ...leaking ink bottles etc....''
Letter: George Maciunas to Robert Watts, [before March 11, 1963].

COMMENTS: Leaking Ink Bottles *would have been altered ready-mades. They were never produced by Fluxus.*

LIGHT FLUX KIT
Silverman No. 519

''...Now I will list some new items produced: all in 1972...Light fluxkit by Watts either in large box or as light fixture, very nice item but not cheap: $60...''
Letter: George Maciunas to Dr. Hanns Sohm, [ca. late 1972].

FLUXPRODUCTS PRODUCED IN 1972 & 1973 by Bob Watts: Light Fluxkit, in large box or as light fixture, (110V) contains peculiar light bulbs with sockets, chemical light, optics etc. $100...
Fluxnewsletter, April 1973.

1973 WATTS: light kit,...
George Maciunas, Diagram of Historical Developments of Fluxus... [1973].

by Bob Watts:...Light Fluxkit, in large box or as light fixture (110V) contains peculiar light bulbs with sockets, chemical light, optics, etc. $100
Fluxnewsletter, April 1975.

''The story on the other side is self explanatory. As a result of which I have to have eye surgery, since I hardly see anything with the left eye. In one sense, these hospital expenses to me are a windfall to any collectors of flux-objects. Now with high cost of surgery, I must make more objects and begin to respond to various orders and requests for them. Thus I am sending by mail to you the following...Bob Watts, light kit (110 V only) — $100...''
Letter: George Maciunas to Dr. Hanns Sohm. November 30, 1975.

Light kit by Watts (110 Volt) $100
[Fluxus price list for a customer], January 7, 1976.

''Light kit by Bob Watts (110 Volts!) $100''
Letter: George Maciunas to Dr. Hanns Sohm, May 1, 1976.

ROBERT WATTS...Light kit, 12 light devices, 9'' x 13'' box, 110 volts $100
Flux Objects, Price List. May 1976.

COMMENTS: *There were several versions of this work: a unique prototype (Silverman No. 502), a Maciunas produced boxed edition, an unlabeled light fixture, and a participation version which used a Maciunas designed display table that*

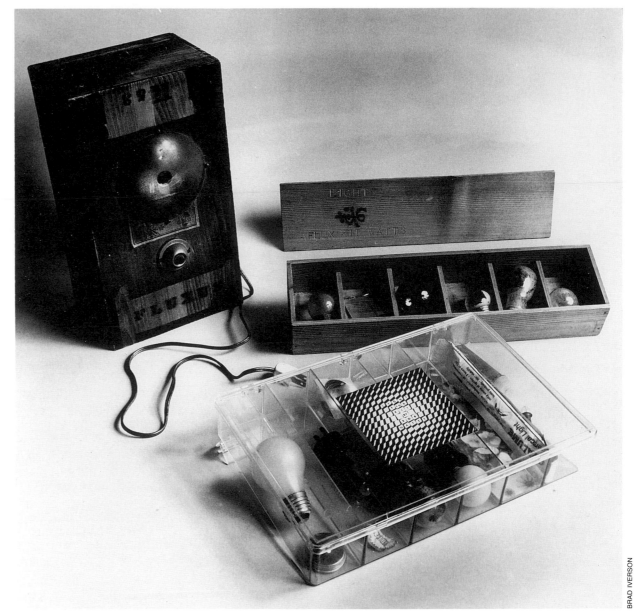

Robert Watts. LIGHT FLUX KIT. Two prototypes made by the artist, with the Maciunas assembled Fluxus Edition in foreground. see color portfolio

had a grid superimposed on it, like a page in a stamp album. The latter was built for the Fluxfest at and/or in Seattle, 1977.

LIGHT SWITCH PLATE WITH FINGER-PRINT
Silverman No. 507, ff.

... items are in stock, delivery within 2 weeks ... FLUXUSkq ROBERT WATTS: light switch plate with fingerprint, $5
Vaseline sTREet (Fluxus Newspaper No. 8) May 1966.

FLUX-PRODUCTS 1961 TO 1969 ... ROBERT WATTS...light switch plate with fingerprint [$] 5
Fluxnewsletter, December 2, 1968 (revised March 15, 1969).

Robert Watts. LIGHT SWITCH PLATE WITH FINGER PRINT

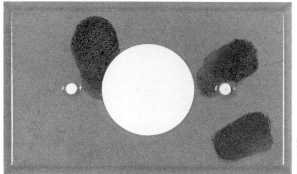

Robert Watts. A version of LIGHT SWITCH PLATE WITH FINGER-PRINT. using an electrical outlet plate

FLUX-PRODUCTS 1961 TO 1970 ... ROBERT WATTS...Light switch plate with fingerprint [$] 5
Flux Fest Kit 2. [ca. December 1969].

"...Watts...light switch are available ..."
Letter: George Maciunas to Dr. Hanns Sohm, [ca. late 1972].

05.1966 ...BOB WATTS:...light switch
George Maciunas, Diagram of Historical Developments of Fluxus... [1973].

COMMENTS: *This work is related to* Fingerprint. *An inconspicuous Fluxus gesture when installed on a wall as a light-switch plate.*

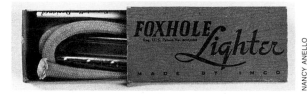

Robert Watts. LIGHTER

LIGHTER
Silverman No. > 483.XIII

FROM THE YAM FESTIVAL WAREHOUSE ... LIGHTER $8
Yam Festival Newspaper, [ca. 1963].

FLUXUS 1964 EDITIONS, AVAILABLE NOW ... FLUXUS kk a to z series;...(f) lighter $8...
cc Valise TRanglE (Fluxus Newspaper No. 3) March 1964.

KAZ-serie[s] ROBERT WATTS: objects ... kk/f LIGHTER $8
European Mail-Orderhouse: europeanfluxshop, Pricelist. [ca. June 1964].

KAZ series OBJECTS from ROBERT WATTS...kk/f lighter $8
Second Pricelist - European Mail-Orderhouse. [Fall 1964].

FLUXUS kk ROBERT WATTS: a to z series...(e) lighter $8...
Vacuum TRapEzoid (Fluxus Newspaper No. 5) March 1965.

COMMENTS: *This ready-made "foxhole lighter" was originally offered for sale from the proto-Fluxus "Yam Festival Warehouse" that was organized by George Brecht and Robert Watts in 1962 and 1963. Lighter was transferred to Watts' Fluxus a to z series.*

LIPS STICK-ONS

FLUX-PROJECTS PLANNED FOR 1967 ... Bob Watts:...Stick-ons (disposable jewelry): full size imprints of human parts (...lips...etc.)
Fluxnewsletter, March 8, 1967.

COMMENTS: *This work was never produced as a Fluxus Edition.*

LUMINOUS CEILINGS

PAST FLUX-PROJECTS (realized in 1966)...Flux-furniture...luminous ceilings by Robert Watts
Fluxnewsletter, March 8, 1967.

COMMENTS: *There may be more variations of* Luminous Ceilings, *but* Clouds on Luminous Ceiling Panel *is the only one known to exist.*

MAGAZINE
Silverman No. > 483.XIX

FROM THE YAM FESTIVAL WAREHOUSE...MAGAZINE $1 & up
Yam Festival Newspaper, [ca. 1963].

FLUXUS 1964 EDITIONS, AVAILABLE NOW ... FLUXUS kk a to z series;...(l) magazine $1 & up...
cc Valise e TRanglE (Fluxus Newspaper No. 3) March 1964.

KAZ-serie[s] ROBERT WATTS: objects...kk/l MAGAZINE $1 and up
European Mail-Orderhouse: europeanfluxshop, Pricelist. [ca. June 1964].

kaz series OBJECTS from ROBERT WATTS...kk/l magazine $1 & up
Second Pricelist - European Mail-Orderhouse. [Fall 1964].

FLUXUS kk ROBERT WATTS: a to z series ... (k) magazine $1 & up...
Vacuum TRapEzoid (Fluxus Newspaper No. 5) March 1965.

COMMENTS: *This work is a ready-made French satirical magazine from the early 1960s.*

MALE UNDERPANTS
Silverman No. 517

"...Orchestra members will wear costumes made by Bob Watts,...Conductor will wear trousers with imprint of penis...."
Letter: George Maciunas to Ben Vautier, [Summer 1965].

Herewith is the description of...the entire revised program...Performers failing to appear for the rehearsal will not perform during the concert...Orchestra costume designed by Robert Watts will be distributed during the rehearsal. Performers wishing to keep these costumes after the concert will be able to do so.
Fluxorchestra Circular Letter No. 2. [September 1965].

"...[for concert in Milan] Take any objects you wish from La Cedille qui Sourit,...Also you could take... Watts pants, which all performers in concert could

wear (We used these uniforms in N.Y. Fluxorchestra concert)...''
Letter: George Maciunas to Ben Vautier, March 5, 1966.

... items are in stock, delivery within 2 weeks ...
FLUXUSkn ROBERT WATTS: pants, silkscreened $5
Vaseline sTREet (Fluxus Newspaper No. 8) May 1966.

FLUX-PRODUCTS 1961 TO 1969 ... ROBERT WATTS...Underpants, silkscreened: male...each [$] 5
Fluxnewsletter, December 2, 1968 (revised March 15, 1969).

FLUX-PRODUCTS 1961 TO 1970 ... ROBERT WATTS...Underpants, silkscreened, male...[$] 5
Flux Fest Kit 2. [ca. December 1969].

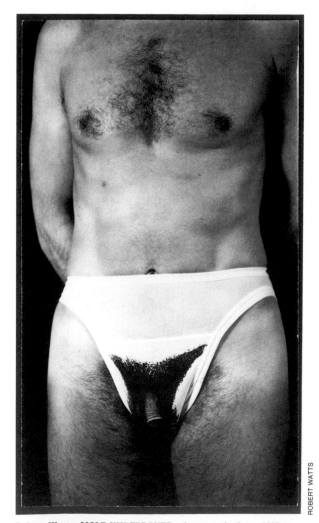

Robert Watts. MALE UNDERPANTS, photographed ca. 1966 on a model for promotion

''...may still have a few underpants [by Watts]...''
Letter: George Maciunas to Dr. Hanns Sohm, [ca. late 1972].

05.1966...BOB WATTS: clothing,...
George Maciunas, Diagram of Historical Developments of Fluxus... [1973].

COMMENTS: *This explicit work reportedly features the genitals of John Chamberlain, famous American sculptor. Evidently* Male Underpants *were not produced in time for the Fluxus Concert on September 25, 1965, as photographs of that event show the orchestra wearing only Watts'* Male *and* Female Undershirts.

MALE UNDERSHIRT
Silverman No. < 504.I

''...Orchestra members will wear costumes made by Bob Watts, ('T' shirts imprinted with photo of full size hairy chest - for men...''
Letter: George Maciunas to Ben Vautier, [Summer 1965].

Herewith is the description of...the entire revised program...Performers failing to appear for the rehearsal will not perform during the concert...Orchestra costume designed by Robert Watts will be distributed during the rehearsal. Performers wishing to keep these costumes after the concert will be able to do so.
Fluxorchestra Circular Letter No. 2 [September 1965].

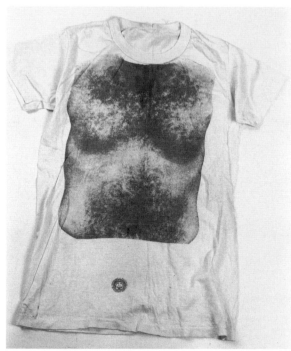

Robert Watts. MALE UNDERSHIRT

... items are in stock, delivery within 2 weeks. ...
FLUXUS km ROBERT WATTS: fluxshirt, male shirt, silkscreened, male $5
Vaseline sTREet (Fluxus Newspaper No. 8) May 1966.

FLUX-PRODUCTS 1961 TO 1969 ... ROBERT WATTS ... Undershirts, silkscreened chest: male ... each [$] 5
Fluxnewsletter, December 2, 1968 (revised March 15, 1969).

FLUX-PRODUCTS 1961 TO 1970 ... ROBERT WATTS...Undershirts, silkscreened chest, m...[$] 5
Flux Fest Kit 2. [ca. December 1969].

05.1966...BOB WATTS: clothing,...
George Maciunas, Diagram of Historical Developments of Fluxus... [1973].

COMMENTS: *Robert Watts designed bare chested T-shirts for the performers to wear during the Fluxorchestra concert at Carnegie Recital Hall in New York City, September 25, 1965. These undershirts were later offered for sale by Fluxus. In revealing what they obscured they anticipate Maciunas' later apron and face mask ideas.*

MASS OF SWIMMERS WALLPAPER see:
Anonymous

MAZE

Toilet no. 1 Bob Watts...Doors - display on interior side of door...Game - ball rolling down a maze.
Fluxnewsletter, April 1973.

COMMENTS: *There is clearly a relationship between this work and Takako Saito's* Ball Game, *(Silverman No. 383) and George Maciunas'* Maze.

McLUHAN SWEATSHIRT see:
SWEAT SHIRTS
MEDALS see:
HERO 601
MEDICINE CABINET see:
FLUX ROCK MARKED BY VOLUME IN CC
FLUX TIMEKIT
MEDIEVAL ARMOR APRON see:
George Maciunas and Robert Watts

MESSAGE CARD THREE
Silverman No. 469

FROM THE YAM FESTIVAL WAREHOUSE...POSTCARDS 15¢
Yam Festival Newspaper, [ca. 1963].

FLUXUS 1964 EDITIONS, AVAILABLE NOW ... FLUXUS kk a to z series...(d) postcards 15¢. ...
cc Valise e TRanglE (Fluxus Newspaper No. 3) March 1964.

Robert Watts. MESSAGE CARD THREE postcard

KAZ-serie[s] ROBERT WATTS: objects ... kk/d
POSTCARDS 15¢
European Mail-Orderhouse: europeanfluxshop, Pricelist.
[ca. June 1964].

KAZ series OBJECTS from ROBERT WATTS...kk/d
postcards $0.15
Second Pricelist - European Mail-Orderhouse. [Fall 1964].

FLUXKIT containing following fluxus-publications:
(also available separately)...FLUXUS ke ROBERT
WATTS: postcards, ea. 10¢
Vacuum TRapEzoid (Fluxus Newspaper No. 5) March 1965.

FLUX-PROJECTS PLANNED FOR 1967...Collective
projects: (All are invited to submit ideas and partici-
pate, ideas can be either ready pictorial material or
just specified material which we have to find, produce
or obtain otherwise)...Flux-postal kit: containing
postcards,...
Fluxnewsletter, March 8, 1967.

IMPLOSIONS INC. PROJECTS...Triple partnership
was formed between Bob Watts, Herman Fine and my-
self [George Maciunas] to introduce into mass market
...money producing products...This business will be
operated in commercial manner, with intent to make
profits...connection between Fluxus collective and
Implosions Inc. has not been clarified yet...we could
consider at present Fluxus to be a kind of division or
subsidiary of Implosions. Projects to be realized
through Implosions:...Postcards, stamps (same as
Flux-postal kit)
ibid.

[component of] flux post kit $7
Fluxshopnews. [Spring 1967].

FLUX-PRODUCTS 1961 TO 1969 ... FLUXPOST
KIT 1968...2 postcards by Bob Watts * [indicated as
part of FLUXKIT] ...[$] 8 Version without rubber
stamps [$] 2
Fluxnewsletter, December 2, 1968 (revised March 15, 1969).

FLUXUS-EDITIONEN...[Catalogue No.] 718 FLUX-
POST KIT, 1968 (b. watts,...)
Happening & Fluxus. Koelnischer Kunstverein, 1970.

COMMENTS: *Published by the artist, circa 1961, it would
have been available in 1963 for Yam Festival subscriptions
and to use in the Fluxus a-z series. There is no evidence it
was used for either of these, but the work is included in some
assemblings of Robert Watts'* Events *and the collective* Flux
Post Kit 7.

METALLIC TOILET PAPER see:
MYLAR TOILET PAPER
MIRROR see:
UNDULATING SURFACE MIRROR

MODULAR CABINETS

PAST FLUX-PROJECTS (realized in 1968)...Flux-
furniture:... modular cabinets by: ... Robert Watts...
Fluxnewsletter, March 8, 1967.

COMMENTS: *This is a general entry for George Maciunas'
cabinets that were designed to hold various works by Robert
Watts. See* Fluxfurniture *for the cross reference to specific
furniture.*

MOIRE CLOCK FACE CLOCK

FLUXPROJECTS FOR 1969...Bob Watts: moire
clock face
Fluxnewsletter, December 2, 1968.

PROPOSED FLUXSHOW FOR GALLERY 669 ...
OBJECTS, FURNITURE ... clocks: ... moire clock
face by Bob Watts;...
ibid.

COMMENTS: *Robert Watts recalls that a prototype was
made for a* Moire Clock Face Clock *using two moving disks
of Ben-Day dots to create the moire patterns. The clock was
never produced as a Fluxus Edition by George Maciunas.*

MONSTERS ARE INOFFENSIVE see:
Robert Filliou, George Maciunas, Peter Moore,
Daniel Spoerri, and Robert Watts

MOONSCAPE STAMPS

PROPOSED CONTENTS FOR FLUXPACK 3 TO BE
PUBLISHED IN 1973 BY FLASH ART ... Postage
stamps moonscape or other, by Watts...Cost Esti-
mates: for 1000 copies...postage stamps [2 designs]
$100...100 copies signed by: Watts:...
[George Maciunas], Proposed Contents for Fluxpack 3.
[ca. 1972].

''...to produce the Flash Art FLUXPACK 3...con-

tents at present will be as follows:...Postage stamps:
moonscape by Watts,...''
*Letter: George Maciunas to Giancarlo Politi, n.d. Reproduced
in Fluxnewsletter, April 1973.*

Flash Art editor, Giancarlo Politi, proposed to pub-
lish the 3rd Fluxyearbook, maybe to be called FLUX-
PACK 3, with the following preliminary contents...
Postage stamps: moonscape by Watts,...
Fluxnewsletter, April 1973.

COMMENTS: *Related to Robert Watts'* Full Moon *flip book
idea,* Moonscape Stamps *were to use images of the moon.
The stamps were not produced by Fluxus, although prepara-
tory material exists. Recently, the artist made a sheet of
stamps using a single image of the moon.*

MUSICAL SHOES

FLUX-OLYMPIAD ... TRACK-HURDLES, OBSTA-
CLES/ OBSTACLES SHOES:...musical shoes, etc.
(Robert Watts)
Flux Fest Kit 2. [ca. December 1969].

FEB. 17, 1:30PM FLUX-SPORTS DOUGLASS COL.
...OBSTACLE SHOES:...musical shoes...
*Poster/program for Flux-Mass, Flux-Sports and Flux-Show.
February, 1970.*

PROPOSED FLUXANNIVERSARY FEST PRO-
GRAM 1962-1972 SEPT & OCT...FLUXOLYMPIAD
(counterpoint to Munich one)...obstacle shoes run by
Bob Watts...
Fluxnewsletter, April 1973.

1970 FLUXSPORTS:...bob watts: obstacle shoes
*George Maciunas, Diagram of Historical Developments of
Fluxus... [1973].*

COMMENTS: *The artist does not recall these shoes.*

MYLAR TOILET PAPER

Toilet no. 1 Bob Watts...Toilet paper - Mylar - * met-
alic [sic] finish
Fluxnewsletter, April 1973.

1970-1971 FLUX-TOILET: WATTS:...metalic [sic]
toilet paper...
*George Maciunas, Diagram of Historical Developments of
Fluxus... [1973].*

COMMENTS: *This work was never made.*

NAIL SHOES

FLUX-OLYMPIAD...TRACK hurdles, obstacles, with
obstacles shoes:...made of nails,...(Bob Watts)
*Fluxfest at Stony Brook, Newsletter No. 1, August 18, 1969.
version B*

FLUX-OLYMPIAD ... TRACK-HURDLES, OBSTA-
CLES OBSTACLE SHOES:...made of nails...(Robert
Watts)
Flux Fest Kit 2. [ca. December 1969].

FEB. 17 1:30PM FLUX-SPORTS DOUGLASS COL.
...OBSTACLE SHOES: shoes...made of nails...
*Poster/program for Flux-Mass, Flux-Sports and Flux-Show.
February, 1970.*

PROPOSED FLUXANNIVERSARY FEST PRO-
GRAM 1962-1972 SEPT & OCT...FLUXOLYMPIAD
(counterpoint to Munich one)...obstacle shoes by
Bob Watts...
Fluxnewsletter, April 1973.

1970 FLUXSPORTS:...bob watts: obstacle shoes
*George Maciunas, Diagram of Historical Developments of
Fluxus... [1973].*

COMMENTS: Nail Shoes *were a parody on commercially
made sports shoes and had spikes and other nails attached to
their soles.*

NAVELS see:
> BIOLOGY 704
NECKLACE see:
> PEARL NECKLACE

Robert Watts. NECKTIE

NECKTIE
Silverman No. > 483.XV

FROM THE YAM FESTIVAL WAREHOUSE ...
NECKTIE $2 & UP
Yam Festival Newspaper, [ca. 1963].

FLUXUS 1964 EDITIONS, AVAILABLE NOW ...
FLUXUS kk a to z series;...(h) necktie $2 & up...
cc Valise e TRanglE (Fluxus Newspaper No. 3) March 1964.

KAZ-serie[s] ROBERT WATTS: objects kk/h NECK-
TIE $2 and up
*European Mail-Orderhouse: europeanfluxshop, Pricelist.
[ca. June 1964].*

KAZ series OBJECTS from ROBERT WATTS...kk/h
necktie $2 & up
Second Pricelist - European Mail-Orderhouse. [Fall 1964].

...to be shown on the special fluxus fashion-shows
next winter together with: ... kk/h Neckties ... of
Robert Watts
*European Mail-Orderhouse, advertisement for clothes
[ca. 1964].*

FLUXUS kk ROBERT WATTS: a to z series ... (g)
necktie $2 & up...
Vacuum TRapEzoid (Fluxus Newspaper No. 5) March 1965.

COMMENTS: *This work, a Formica laminated wood bow tie,
was constructed by the artist and offered for sale through
Fluxus.*

9 HOUR ROUND TRIP BY BUS TO CAPE MAY, N.J. TICKET

FLUXFEST PRESENTATION OF JOHN LENNON
& YOKO ONO +* AT 80 WOOSTER ST. NEW YORK
—1970...APR. 18-24: TICKETS BY JOHN LENNON
+ FLUXTOURS...9 hour round trip by bus to Cape
May, N.J. (Bob Watts) $10...
*all photographs copyright nineteen seVenty by peTer mooRE
(Fluxus Newspaper No. 9) 1970.*

COMMENTS: *Another ready-made "ticket to somewhere."*

1966 & 67 EVENTS see:
> EVENTS
NIPPLES see:
> BIOLOGY 704
NUDE BACK APRON see:
> George Maciunas

NUDE FRONT APRON

FLUXPROJECTS FOR 1969...Vinyl aprons: Watts -
coarse screen nude front,...
Fluxnewsletter, December 2, 1968.

COMMENTS: *The artist did a great deal of work with nudes.
Nude Front Apron exists only as a photographic prototype.
A related work, Nude Back Apron, was made by George
Maciunas.*

NUDE WAITRESS WITH TRAY APRON

"...You could do the following yet:...Collective pro-
jects...Apron design. — on paper disposable apron.
That's a project we may make some money, by selling
it to large beer company, to be used as premium. Got
already some designs:...front of person holding tray
with beer can ... all these are full size to match the
wearer of apron."
*Letter: George Maciunas to Ken Friedman, [ca. February
1967].*

FLUX-PROJECTS PLANNED FOR 1967... Bob
Watts:...Paper aprons:...waitress with tray (nude)...
Fluxnewsletter, March 8, 1967.

COMMENTS: *Photographs and other preparatory material
exists for this work, but the artist's dream of mass-marketing
them to a beer company was never realized.*

OBJECTS

FLUXUS 1963 EDITIONS, AVAILABLE NOW
FROM FLUXUS P.O. Box 180, New York 10013,
N.Y. or FLUXUS 359 Canal St. New York. CO 7-9198
...FLUXUS 1964 EDITIONS:...FLUXUS kk Robert
Watts: OBJECTS (list by request)...
Film Culture No. 30, Fall 1963.

FLUXUS 1964 EDITIONS:...FLUXUS kk Robert
Watts: OBJECTS (list by request)...Most materials
originally intended for Fluxus yearboxes will be in-
cluded in the FLUXUSccV TRE newspaper or in indi-
vidual boxes.
cc V TRE (Fluxus Newspaper No. 1) January 1964.

FLUXUS 1964 EDITIONS:...FLUXUS kk Robert
Watts: OBJECTS (list by request)
cc V TRE (Fluxus Newspaper No. 2) February 1964.

Robert Watts. Photographic study for NUDE WAITRESS WITH
TRAY APRON

Robert Watts. Four photographic studies for NUDE FRONT APRON

ROBERT WATTS

COMMENTS: *This listing is possibly the precursor to Robert Watts' "Fluxus kk a to z series." A list of objects "from the Yam Festival Warehouse" is published in the Yam Festival Newspaper. Some of those objects later become objects in the a - z series. The list of Objects advertised by Fluxus is not known to exist.*

OBSTACLE SHOES see:
 BOUNCING SHOES
 DISINTEGRATING SHOES
 FISH SHOES
 ICE FILLED SHOES
 INCLINED PLANE SHOES
 MUSICAL SHOES
 NAIL SHOES
 SHAVING CREAM FILLED SHOES
 SLIPPERY SHOES
 STILT SHOES

ODD NUMBERED ROCKS
Silverman No. < 495.I

FLUXUS 1964 EDITIONS, AVAILABLE NOW ... FLUXUS kaz series, OBJECTS from ROBERT WATTS ROCKS in compartmented wood or plastic boxes, $4 to $20...FLUXUS ku odd numbered rocks
cc Valise e TRanglE (Fluxus Newspaper No. 3) March 1964.

KAZ-serie[s] ROBERT WATTS: objects rocks in compartmented wood or plastic boxes $4 to $20... F-ku odd numbered rocks
European Mail-Orderhouse: europeanfluxshop, Pricelist. [ca. June 1964].

KAZ series OBJECTS from ROBERT WATTS F ROCKS in compartmented wood or plastic boxes $4. to $20...F-ku odd numbered rocks
Second Pricelist - European Mail-Orderhouse. [Fall 1964].

BRAD IVERSON

Robert Watts. ODD NUMBERED ROCKS

03.1964...BOB WATTS: rocks
George Maciunas, Diagram of Historical Developments of Fluxus... [1973].

COMMENTS: *Robert Watts' first altered rock (Silverman No. < 495.I) is an angular shaped chunk of rock painted white with a "5" and an "&" stenciled on in yellow. This rock could be considered a* Colored Rock, *an* Odd Numbered Rock *or* Single Rock Marked by Number. An early photograph of Fluxus works reproduced in Fluxus Newspaper No. 3, March 1964, shows a wooden box with four painted rocks, each with an odd number. The artist would have made these earlier works, with Maciunas taking over for the production of* Flux Rock Marked by Volume in CC, Rocks Marked by Weight in Grams *and the later* Fluxatlas, *etc.*

OLD WRITING
Silverman No. > 469.I

"...We will include in Fluxus:...Old writing..."
Letter: George Maciunas to Robert Watts, [Summer 1962].

COMMENTS: *Not included in* FLUXUS 1, *this work has a relationship to what George Maciunas once described as Watts' "illegal" works:* Dollar Bill, *stamps, etc.* Old Writing *is a precursor to two of Watts' later works:* Giant Stamp Imprint Envelope: Graffiti Letter Paper *and* Giant Stamp Imprint Envelope: Signers of Declaration of Independence Letter Paper.

PANTS see:
FEMALE UNDERPANTS
MALE UNDERPANTS

PAPER APRONS

IMPLOSIONS, INC. PROJECTS...Triple partnership was formed between Bob Watts, Herman Fine and myself [George Maciunas] to introduce into mass market ...money producing products...This business will be operated in commercial manner, with intent to make profits....connection between Fluxus collective and Implosions Inc. has not been clarified yet...we could consider at present Fluxus to be a kind of division or subsidiary of Implosions. Projects to be realized through Implosions:...Paper aprons (made from special woven paper). Used for outdoor cooking, these apron designs will be offered to various beer and food manufacturers as premiums etc. Any photographic or line image can be printed on this paper...
Fluxnewsletter, March 8, 1967.

NEW FROM IMPLOSIONS, INC....Planned in 1968: ...Paper aprons (described in 1967 flux-newsletter) 12 designs ready for production...
Fluxnewsletter, January 31, 1968.

COMMENTS: *This is a general entry. Specific works are listed under "Aprons."*

Robert Watts. OLD WRITING

PAPER TOWELS see:
DIRTY PAPER TOWELS

PARKING METER DECAL

PROPOSED CONTENTS FOR FLUXPACK 3 TO BE PUBLISHED IN 1973 BY FLASH ART...Stick-ons parking meter decal by Watts...Cost Estimates: for 1000 copies...stick-ons [5 designs] $500...100 copies signed by: Watts...
[George Maciunas], Proposed Contents for Fluxpack 3. [ca. 1972].

"...to produce the Flash Art FLUXPACK 3...contents at present will be as follows:...Stick-ons, decals: parking meter decal by Watts,..."
Letter: George Maciunas to Giancarlo Politi, n.d. Reproduced in Fluxnewsletter, April 1973.

PERMANENT PARKING DECAL
PEEL OFF BACKING—APPLY TO METER

Robert Watts. Photographic study for PARKING METER DECAL

Flash Art editor, Giancarlo Politi, proposed to publish the 3rd Fluxyearbook, maybe to be called FLUXPACK 3, with the following preliminary contents... Household items:...parking meter decal by Watts,..."
Fluxnewsletter, April 1973.

COMMENTS: *This was first done for* S.M.S. *No. 4, August, 1968, published by the Letter Edged in Black Press, New York, and was not included in* Fluxpack 3.

PEARL NECKLACE
Silverman No. > 508.V

PROPOSED CONTENTS FOR FLUXPACK 3 TO BE PUBLISHED IN 1973 BY FLASH ART...Necklace by Watts...100 copies signed by: Watts...
[George Maciunas], Proposed Contents for Fluxpack 3. [ca. 1972].

"...to produce the Flash Art FLUXPACK 3...contents at present will be as follows:...Stick-ons, decals ...pearl necklace by Watts."
Letter: George Maciunas to Giancarlo Politi, n.d. Reproduced in Fluxnewsletter, April 1973.

Flash Art editor, Giancarlo Politi, proposed to publish the 3rd Fluxyearbook, maybe to be called FLUXPACK 3, with the following preliminary contents...

NANCY ANELLO

Robert Watts. PEARL NECKLACE prototype

Wear items: ... paper jewelry (string of pearls by Watts),...
Fluxnewsletter, April 1973.

COMMENTS: A three-dimensional photo-laminated proto-type of this work was made in the mid 1960s (see illustration) but it was not produced as stick-ons for Fluxpack 3.

PEBBLE ATLAS see:
FLUXATLAS

PEE KIT
Silverman No. 506, ff.

FLUX DRINKS & FOODS:...URINE COLORS food with invisible drug giving color to the urine of the person eating it (red, blue, green, orange). (Bob Watts)
Invitation to Participate in New Year Eve's Flux-Feast. [ca. December 1969].

FLUX FOODS AND DRINKS ... AFTER EFFECT MEALS: URINE COLORS: food with drug giving color to the urine of person eating it. (red, blue, green, orange etc.) (Robert Watts)
Flux Fest Kit 2. [ca. December 1969].

BUZZ SILVERMAN

Robert Watts. PEE KIT prototype

SCOTT HYDE

Robert Watts. Instruction drawing for PEE KIT, called here "Flux Pee Kit"

COMMENTS: The idea of the food event referred to above grows out of a prototype for Pee Kit that Robert Watts made in the mid 1960s. He recalls that George Maciunas planned to make a Fluxus Edition of the work.

PENCILS
Silverman No. > 483.IX

"...We thought in future to integrate our festivals with these 'exhibits'...So could you send me more objects of your own that we could exhibit, pencils, etc. etc...."
Letter: George Maciunas to Robert Watts, [March 11 or 12, 1963].

FLUXUS 1964 EDITIONS, AVAILABLE NOW ... FLUXUS kk a to z series;...(b) pencils 10¢...
cc Valise e TRanglE (Fluxus Newspaper No. 3) March 1964.

NANCY ANELLO

Robert Watts. PENCILS

KAZ-serie[s] ROBERT WATTS: objects...kk/b PEN-CILS 10¢
European Mail-Orderhouse: europeanfluxshop, Pricelist. [ca. June 1964].

KAZ series OBJECTS from ROBERT WATTS...kk/b pencils $0.10
Second Pricelist - European Mail-Orderhouse. [Fall 1964].

FLUXUS kk ROBERT WATTS: a to z series...(b) pencils 10¢
Vacuum TRapEzoid (Fluxus Newspaper No. 5) March 1965.

COMMENTS: Produced for the artist by a pencil manufac-turer in New Jersey, the pencils were variously imprinted with: "Yes," "No," "Bed Cricket" and "Yam Festival." Chromed Pencil (Silverman No. > 483.III) was produced by Robert Watts at about the same time as Pencils.

PENCILS see:
 CHROMED PENCIL
PEN DISPENSER see:
 PENS

PENS
Silverman No. > 483.VIII

FLUXUS 1964 EDITIONS, AVAILABLE NOW ...
FLUXUS kk a to z series; (a) pens $.25...
cc Valise e TRanglE (Fluxus Newspaper No. 3) March 1964.

KAZ-serie[s] ROBERT WATTS: objects ... kk/a
PENS $25 [sic]
*European Mail-Orderhouse: europeanfluxshop, Pricelist.
[ca. June 1964].*

KAZ series OBJECTS from ROBERT WATTS...kk/a
pens $25 [sic]
Second Pricelist - European Mail-Orderhouse. [Fall 1964].

FLUXUS kk ROBERT WATTS: a to z series, (a) pens
25¢...
Vacuum TRapEzoid (Fluxus Newspaper No. 5) March 1965.

COMMENTS: Pens *used for the a to z series were of two
sorts: a sexy ready-made "made in Denmark," and others
that Robert Watts ordered from a commercial pen manufac-
turer containing performance instructions. These latter pens
were also used in an altered pen dispenser. Pen Dispenser
(Silverman No. < 483.I), although never offered for sale by
Fluxus, was probably made in 1963 at about the same time
as Watts' earliest* Stamp Dispenser. *These two works are
precursors to a large number of planned Fluxus dispensers
and vending machines by several artists.*

Robert Watts. PENS

PHOTOGRAPHS
Silverman No. > 483.X

FROM THE YAM FESTIVAL WAREHOUSE...PHO-
TOGRAPHS $1, $2
Yam Festival Newspaper, [ca. 1963].

FLUXUS 1964 EDITIONS, AVAILABLE NOW ...
FLUXUS kk a to z series;...(c) photographs $1, $2
cc Valise e TRanglE (Fluxus Newspaper No. 3) March 1964.

KAZ-serie[s] ROBERT WATTS: objects...kk/c PHO-
TOGRAPHS $1, $2.
*European Mail-Orderhouse: europeanfluxshop, Pricelist.
[ca. June 1964].*

KAZ series OBJECTS from ROBERT WATTS...kk/c
photographs $1, $2
Second Pricelist - European Mail-Orderhouse. [Fall 1964].

Robert Watts. PEN DISPENSER. Never offered for sale by Fluxus,
but dispensed PENS, and was the precursor to Fluxus vending
machine ideas. see color portfolio

Two examples of Robert Watts' ready-made PHOTOGRAPHS

FLUXUS kk ROBERT WATTS: a to z series...(c)
photographs $1 to $2...
Vacuum TRapEzoid (Fluxus Newspaper No. 5) March 1965.

COMMENTS: *Old fashioned photographs, ready-mades
found in junk shops and chosen by the artist to convey his
various interests.*

PHOTOGRAPHS OF LARGE OBJECTS

''...So I suggest for box...a 'travellers kit,' sell for
maybe $50 or so...Inside all compartmentalized...
Then another compartment with photographs of 2
kinds - one kind of large objects that can't fit in case
another of film studies - stills''
*Letter: George Maciunas to Robert Watts, [before March 11,
1963].*

COMMENTS: Photographs of Large Objects *in the sense of
Marcel Duchamp putting photographs of works as well as rep-
licas into* Boite en Valise *as opposed to found* Photographs *or
ready-mades such as in the a - z series. The "film study stills"
would have been either stills from Watts' movies or ready-
mades found in memorabilia stores. "Travellers kit" was not
made as such, but was produced as a very pared down version
called* Events.

PHOTOS see:
 BOOK OF PHOTOS

561

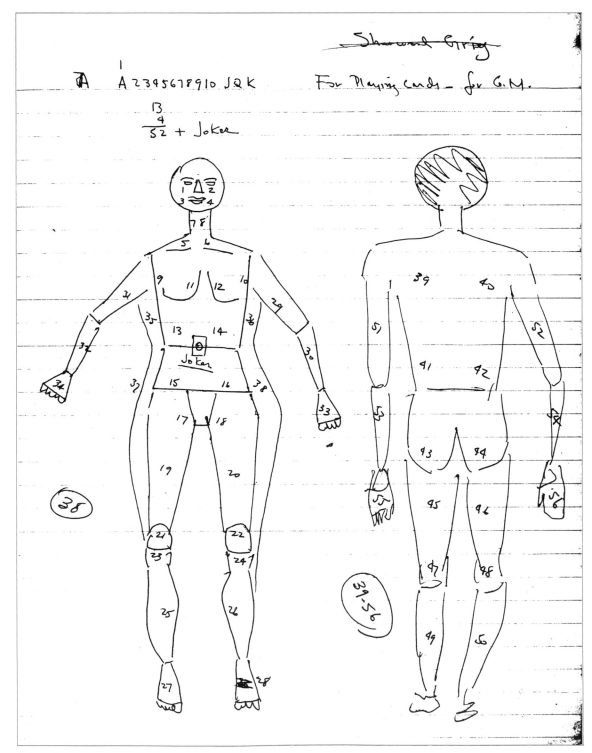

Robert Watts. Instruction drawing for PLAYING CARDS

PICTURE SCALE see:
 SCALE
PLACE MATS see:
 HAND WITH CIGARETTE, PEA ON PLATE
 PLACE MAT
 SLICE OF CUCUMBER ON PLATE PLACE MAT
 SYRINGE ON PLATE PLACE MAT

PLAYING CARDS

Silverman No. 505, ff.

"...We will include in Fluxus:...playing cards (VERY
NICE)..."
Letter: George Maciunas to Robert Watts, [Summer 1962].

"I suggest for box...a travellers suitcase, a 'travellers
kit', sell for $50 or so....[the] inside all compart-
mentalized. In one...playing cards - Those cards (play-
ing cards) are VERY NICE - You should do the whole
pack - Then we reproduce...."
*Letter: George Maciunas to Robert Watts, [before March 11,
1963].*

"...Paik has exhibit for next 2 weeks at Wuppertal

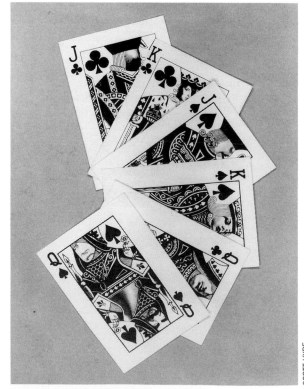

SCOTT HYDE

Robert Watts. 6 PLAYING CARDS printed on backs of the programs
for the "Fluxorchestra at Carnegie Recital Hall" concert in New
York City. June 27, 1964

where I was yesterday. I got one room for Fluxus, so I set 3 things of yours: the 3 playing cards... We thought in future to integrate our festivals with these 'exhibits'....By summer we should be ready to work on next projects — so don't delay too long on your things...— MORE PLAYING CARDS!!!..."
Letter: George Maciunas to Robert Watts, [March 11 or 12, 1963].

"...NOW THE FESTIVAL: (Amsterdam one)....Exhibits. ...Robert Watts -...playing cards..."
Letter: George Maciunas to Tomas Schmit, [early June 1963].

"...Furthermore Fluxus still publishes...series of playing cards - Watts..."
Letter: George Maciunas to Ben Vautier, [ca. October 1966].

FLUXKIT containing following fluxus-publications: (also available separately) ... FLUXUS kd ROBERT WATTS: playing cards, set of 12 (4 suites [sic] of J, Q,K) $1
Vacuum TRapEzoid (Fluxus Newspaper No. 5) March 1965.

... will appear late in 1966 ... FLUXUSka ROBERT WATTS: deck of playing cards, plastic coated $8
Vaseline sTREet (Fluxus Newspaper No. 8) May 1966.

"...Other going projects...Bob Watts - playing cards..."
Letter: George Maciunas to Ken Friedman, [ca. February 1967].

IMPLOSIONS INC. PROJECTS...Triple partnership was formed between Bob Watts, Herman Fine and myself [George Maciunas] to introduce into mass market ...money producing products...This business will be operated in commercial manner, with intent to make profits....connection between Fluxus collective and Implosions Inc. has not been clarified yet...we could consider at present Fluxus to be a kind of division or subsidiary of Implosions. Projects to be realized through Implosions:...Playing cards and other games (Flux-playing cards of Bob Watts,...)
Fluxnewsletter, March 8, 1967.

NEWS FROM IMPLOSIONS, INC....Planned in 1968:

Robert Watts. Prototype for complete deck of PLAYING CARDS

...Playing cards and games (as described in past newsletter)
Fluxnewsletter, January 31, 1968.

COMMENTS: *Robert Watts, 1982: "No decks ever completed because George [Maciunas] couldn't find anyone to print the cards cheaply."*
Six of Robert Watts' playing card designs were used as the backs for the program (Silverman No. 638) of the Fluxorchestra at Carnegie Recital Hall, New York City, June 27, 1964. The program could be held like a hand of cards. Sometimes the cards are components of Flux Year Box 2, *and Watts'* Events. *The cards illustrated are prototypes for a complete deck.*

POPE MARTIN V APRON see:
George Maciunas and Robert Watts

PORNOGRAPHY
Silverman No. > 483.XXVI

FLUXUS 1964 EDITIONS, AVAILABLE NOW ... FLUXUS kk a to z series;...(s) pornography 25¢ and up...
cc Valise e TRanglE (Fluxus Newspaper No. 3) March 1964.

KAZ-serie[s] ROBERT WATTS: objects...kk/s PORNOGRAPHY 25¢ and up
European Mail-Orderhouse: europeanfluxshop, Pricelist. [ca. June 1964].

KAZ series OBJECTS from ROBERT WATTS...kk/s "pornography" 25¢ & up.
Second Pricelist - European Mail-Orderhouse. [Fall 1964].

"...De Ridder - Europe Fluxshop has one order for 'Pornography' from you. Please send him one..."
Letter: George Maciunas to Robert Watts, January 21, 1965.

" ... Bob Watts will send pornography directly to you..."
Letter: George Maciunas to Willem de Ridder, January 21, 1965.

FLUXUS kk ROBERT WATTS: a to z series...(s) pornography 25¢ & up...
Vacuum TRapEzoid (Fluxus Newspaper No. 5) March 1965.

COMMENTS: *Soft core, early 60s stuff — ready-made variety.*

POSTAL METER STAMP ENVELOPE see:
GIANT STAMP IMPRINT ENVELOPE: SIGNERS OF THE DECLARATION OF INDEPENDENCE LETTER PAPER

POSTCARD DISPENSER

This Fall, we shall publish V TRE no. 10, which shall

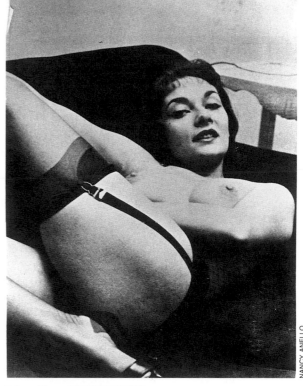
Robert Watts. PORNOGRAPHY

consist of a plan for Flux-Amusement-Center, to contain...postcard machines...
Fluxnewsletter, April 1973.

FLUX AMUSEMENT ARCADE...Stamp & postcard dispensers (Watts & Vautier)
Preliminary Proposal for a Flux Exhibit at Rene Block Gallery. [ca. 1974].

COMMENTS: *There is no evidence that Robert Watts ever planned to make a* Postcard Dispenser. *George Maciunas must have been extrapolating on Watts'* Pen Dispenser *and* Stamp Dispenser.

POSTCARD MACHINE see:
POSTCARD DISPENSER

POSTCARDS
Silverman No. > 483.XI, ff.

FLUXUS 1964 EDITIONS, AVAILABLE NOW ... FLUXUS kk a to z series;...(d) postcards 15¢...
cc Valise e TRanglE (Fluxus Newspaper No. 3) March 1964.

KAZ - serie[s] ROBERT WATTS: objects ... kk/d
POSTCARDS 15¢
European Mail-Orderhouse: europeanfluxshop, Pricelist.
[ca. June 1964].

KAZ series OBJECTS from ROBERT WATTS...kk/d
postcards $0.15
Second Pricelist - European Mail-Orderhouse. [Fall 1964].

COMMENTS: Postcards intended for use in Robert Watts'
a to z series were either commercially produced ready-
mades or Yam Postcards.

Robert Watts. POSTCARDS

POSTCARDS

PROPOSED CONTENTS FOR FLUXPACK 3 TO BE
PUBLISHED IN 1973 BY FLASH ART...Postcards
by...Watts...Cost Estimates: for 1000 copies...post-
cards [including designs by other artists] $100...100
copies signed by: Watts...
[George Maciunas], Proposed Contents for Fluxpack 3.
[ca. 1972].

Flash Art editor, Giancarlo Politi, proposed to pub-
lish the 3rd Fluxyearbook, maybe to be called FLUX-
PACK 3, with the following preliminary contents:...
Postcards...Watts,...
Fluxnewsletter, April 1973.

COMMENTS: Postcards are not included in Fluxpack 3 *and I*
have not found material for a new postcard by Robert Watts
that George Maciunas might have produced. Perhaps he
planned to reprint an earlier Watts postcard.

POSTCARDS see:
 MESSAGE CARD THREE
 YAM POSTCARD
POSTERS see:
 LADDER WALLPAPER
 WINDOW WALLPAPER

POTATO ICE CREAM

FLUX DRINKS & FOODS...POTATOMEAL...pota-
to ice cream...(Bob Watts)
Invitation to Participate in New Year Eve's Flux-Feast.
[ca. December 1969].

COMMENTS: This work was not made.

POTATO JELLO

FLUX DRINKS & FOODS...POTATOMEAL...pota-
to jello...(Bob Watts)
Invitation to Participate in New Year Eve's Flux-Feast.
[ca. December 1969].

COMMENTS: This work was not made.

PSYCHOLOGY
Silverman No. > 483.XXIV

FLUXUS 1964 EDITIONS, AVAILABLE NOW ...

Robert Watts. PSYCHOLOGY

FLUXUS kk a to z series;...(q) psychology $1...
cc Valise e TRanglE (Fluxus Newspaper No. 3) March 1964.

KAZ-serie[s] ROBERT WATTS: objects...kk/q PSY-
CHOLOGY $1
European Mail-Orderhouse: europeanfluxshop, Pricelist.
[ca. June 1964].

KAZ series OBJECTS from ROBERT WATTS...kk/q
psychology $1
Second Pricelist - European Mail-Orderhouse. [Fall 1964].

FLUXUS kk ROBERT WATTS: a to z series ... (q)
psychology $1...
Vacuum TRapEzoid (Fluxus Newspaper No. 5) March 1965.

COMMENTS: Robert Watts used ready-made printed photo-
graphs of a man mimicking psychological stress for this work.

PUZZLE
Silverman No. < 483.VI

"...Can we substitute others in other exhibits & in
Fluxus? (I can still include it)?? OK with you? (like
the picture from your puzzle...) (both being printed
up). Let me know as soon as possible or send substi-
tute pictures with red dots...."
Letter: George Maciunas to Robert Watts, [ca. early April
1963].

"...Paik has exhibit for next 2 weeks at Wuppertal...
I got one room for Fluxus, so I set 3 things of yours:
...[including] puzzles...We thought in future to inte-
grate our festivals with these 'exhibits'...."
Letter: George Maciunas to Robert Watts, [March 11 or 12,
1963].

COMMENTS: The Puzzle *mentioned in correspondence still*
exists. The work was made by mounting the photographs of a
nude woman on cardboard and cutting out shapes for a puz-
zle, much the same way as in Ben Patterson's Poem Puzzles
or Poems in Boxes. *In 1964 Robert Watts made two chromed*
Puzzles *in chamois pouches. One was inscribed either "NO"*
or "ON," the other was a doughnut.

Robert Watts. PUZZLE

READYMADES

"…Received your 2 letters, NICE BOX OF ACCES-
SORIES & CUT-OUTS-READYMADES…"
Letter: George Maciunas to Robert Watts, [Summer 1962].

"…KEEP SENDING NICE THINGS like events, ready
mades, things etc. etc. KEEP SENDING…"
Letter: George Maciunas to Robert Watts, [December 1962].

*COMMENTS: Ready-mades were an important element of
Robert Watts' Fluxus work, as the cross references listed be-
low show. Maciunas' reference to* Readymades *was in response
to unidentified works that Watts had sent to him.*

READYMADES see:
 ACCESSORIES
 ASSORTED TOOLS
 BALL
 BLIND DATE
 BOOK
 BRIEFCASE
 BUS TICKET TO GINGERBREAD CASTLE,
 HAMBURG, N.J.
 CHICK IN A BOX
 5 MINUTE HELICOPTER RIDE OVER NEW
 YORK CITY TICKET
 GEOGRAPHY
 LEAKING INK BOTTLES
 LIGHTER
 MAGAZINE
 9 HOUR ROUND TRIP BY BUS TO CAPE MAY,
 N.J. TICKET
 OLD WRITING
 PENS
 PHOTOGRAPHS
 PORNOGRAPHY
 POSTCARDS
 PSYCHOLOGY
 SEX, FEMALE
 SEX, MALE
 SOCKS
 STAMPS: 15¢
 STAMPS: 10¢
 STRING
 35 MM SLIDE
 3 HOUR HARLEM TOUR TICKET
 TICKET TO BEAR MOUNTAIN
 TRACE NO. 22
 ZOOLOGY

RECORD see:
 ROPE RECORD

RIBBONS see:
 HERO 601

Robert Watts. ROCKS. This Fluxus Edition of non-specific rocks
was assembled by Willem De Ridder for the European Mail-Order
Warehouse/Fluxshop ca. 1965

BRAD IVERSON

ROCKS

FLUX SHOW: DICE GAME ENVIRONMENT EN-
TIRE FLOOR AS DICE HAZARD TABLE DIE
CUBES, 15" CUBES ON FLOOR, Marked on sides,
top open or closed with clear plastic. Consisting or
containing…Flux rocks by Bob Watts.
Flux Fest Kit 2. [ca. December 1969].

03.1964 BOB WATTS: rocks
*George Maciunas, Diagram of Historical Developments of
Fluxus… [1973].*

*COMMENTS: A general listing, the "Flux rocks" displayed in
a 15" cube would have been* Flux Rock Marked by Volume
in CC *or* Rocks Marked by Weight in Grams. *George Maciunas
did not start work on* Fluxatlas *until 1972.*

ROCKS see:
 COLORED ROCKS
 EVEN NUMBERED ROCKS
 FLUXATLAS
 FLUX ROCK MARKED BY VOLUME IN CC
 GRAY ROCKS
 LARGE ROCK IN WOOD OR ANTIQUE BOX
 ODD NUMBERED ROCKS
 ROCKS MARKED BY WEIGHT IN GRAMS

 ROCKS MARKED BY WEIGHT IN POUNDS
 SINGLE ROCK MARKED BY NUMBER
ROCKS MARKED BY WEIGHT see:
 ROCKS MARKED BY WEIGHT IN GRAMS
 ROCKS MARKED BY WEIGHT IN POUNDS

ROCKS MARKED BY WEIGHT IN GRAMS
Silverman No. 496, ff.

FLUXUS 1964 EDITIONS, AVAILABLE NOW …
FLUXUSkaz series, OBJECTS from ROBERT WATTS
ROCKS, in compartmented wood or plastic boxes, $4
to $20…FLUXUS kw rocks marked by their weight
in kilograms
cc Valise e TRanglE (Fluxus Newspaper No. 3) March 1964.

FLUXKIT containing following fluxus-publications:
(also available separately) … FLUXUS kw ROBERT
WATTS: rocks in compartmented plastic box, marked
by their weight $3
cc fiVe ThReE (Fluxus Newspaper No. 4) June 1964.

…Individuals in Europe, the U.S. and Japan have dis-
covered each other's work…and have grown objects
and events which are original, and often uncategoriz-
able in a strange new way:…Bob Watts' BOX OF

SCOTT HYDE

Robert Watts' notes for various editions of Fluxus ROCKS and
other ideas

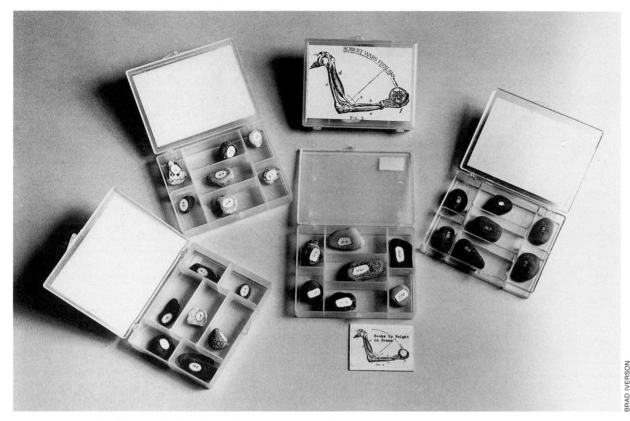

Robert Watts. ROCKS MARKED BY WEIGHT IN GRAMS. see color portfolio

BRAD IVERSON

ROCKS marked with their weight in kilograms.
George Brecht, "Something About Fluxus," cc fiVe ThReE (Fluxus Newspaper No. 4) June 1964.

KAZ-serie[s] ROBERT WATTS: objects rocks in compartmented wood or plastic boxes $4 to $20 F-kw rocks marked by their weight in kilograms
European Mail-Orderhouse: europeanfluxshop, Pricelist. [ca. June 1964].

KAZ-serie[s] ROBERT WATTS: objects ... F-kw rocks marked by their weight in kilograms $3
European Mail-Orderhouse: europeanfluxshop, Pricelist. With holograph notes from George Maciunas to Willem de Ridder. [ca. Summer 1964].

KAZ series OBJECTS from ROBERT WATTS F ROCKS in compartmented wood or plastic boxes $4. to $20....F-kw rocks marked by their weight in kilograms
Second Pricelist - European Mail-Orderhouse. [Fall 1964].

FLUXKIT containing following flux-publications:... rocks in compartmented plastic box, marked by their weight of Robert Watts
ibid.

"...on your next trip to NYC. please bring about 100 pebbles, unnumbered I can weigh them + number to save you time. bring also accurate gram scale...."
Letter: George Maciunas to Robert Watts, February 25, 1965.

FLUXKIT containing following fluxus-publications: (also available separately)...FLUXUS kw ROBERT WATTS: rocks in compartmented box, marked by their weight in grams $3.
Vacuum TRapEzoid (Fluxus Newspaper No. 5) March 1965.

FLUXKIT containing following fluxus-publications: (also available separately)...FLUXUS kw ROBERT WATTS: rocks in compartmented box, marked by their weight in grams $5
Vaseline sTREet (Fluxus Newspaper No. 8) May 1966.

...items are in stock, delivery within 2 weeks ... FLUXUSkw ROBERT WATTS: rocks marked by their weight in grams, in small plastic box $5
ibid.

...items are in stock, delivery within 2 weeks ... FLUXUSku ROBERT WATTS: single rock marked by its weight...in wood box $20
ibid.

"...I mailed by parcel post - one carton with following: Quantity - 1; Item - Watts pebbles...Wholesale cost to you. each - [$] 2; suggested selling price —; subtotal—wholesale cost to you. - [$] 2..."
Letter: George Maciunas to Ken Friedman, August 19, 1966.

fluxrock weights $4.50...by robert watts
Fluxshopnews. [Spring 1967].

FLUX-PRODUCTS 1961 TO 1969 ... ROBERT WATTS...Rocks, marked by weight...small pebbles in partitioned box [$] 6
Fluxnewsletter, December 2, 1968 (revised March 15, 1969).

FLUX-PRODUCTS 1961 TO 1970 ... ROBERT WATTS...Rocks, marked by weight...boxed [$] 8
Flux Fest Kit 2. [ca. December 1969].

FLUX-PRODUCTS 1961 TO 1970 ... ROBERT WATTS...Pebbles, marked by weight, part. box [$] 6
ibid.

FLUXUS-EDITIONEN ... [Catalogue No.] 792 ROBERT WATTS:...rocks, marked by weight, boxed
Happening & Fluxus. Koelnischer Kunstverein, 1970.

03.1964...BOB WATTS: rocks
George Maciunas, Diagram of Historical Developments of Fluxus... [1973].

Rock, marked by weight...boxed $12
Flux Objects, Price List. May 1976.

COMMENTS: It appears that in March of 1964 when the first Rocks Marked by Wgt were advertised, there was the intention to differentiate rocks marked in grams, kilos and pounds. Subsequently, pounds and kilos were dropped and rocks were either identified by 'grams' or 'wgt.'

ROCKS MARKED BY WEIGHT IN KILO-GRAMS see:
ROCKS MARKED BY WEIGHT IN GRAMS

ROCKS MARKED BY WEIGHT IN POUNDS

FLUXUS 1964 EDITIONS, AVAILABLE NOW ... FLUXUSkaz series, OBJECTS from ROBERT WATTS ROCKS in compartmented wood or plastic boxes, $4 to $20...FLUXUS kv rocks marked by their weight in pounds
cc Valise e TRanglE (Fluxus Newspaper No. 3) March 1964.

KAZ-serie[s] ROBERT WATTS: objects rocks in compartmented wood or plastic boxes $4 to $20 F-kv rocks marked by their weight in pounds
European Mail-Orderhouse: europeanfluxshop, Pricelist. [ca. June 1964].

KAZ series OBJECTS from ROBERT WATTS F
ROCKS in compartmented wood or plastic boxes $4.
to $20 f-kv rocks marked by their weight in pounds
Second Pricelist - European Mail-Orderhouse. [Fall 1964].

03.1964...BOB WATTS: rocks
*George Maciunas, Diagram of Historical Developments of
Fluxus... [1973].*

COMMENTS: *This work is not known to have been produced.
It is a variation on the idea of* Rocks Marked by Weight in
Grams.

ROMAN EMPEROR APRON see:
George Maciunas and Robert Watts

ROPE RECORD

SLIDE & FILM FLUXSHOW ... ROBERT WATTS:
ROPE RECORD Coiled rope record played with vari-
ous replacements for needle (feather, wire, spring, etc)
Flux Fest Kit 2. [ca. December 1969].

COMMENTS: *Robert Watts exhibited a* Rope Record, *titled*
Sounds of String *in the "String and Rope" show at the Sidney
Janis Gallery, New York, 1970. George Maciunas never pro-
duced a Fluxus Edition of the work but did make a number
of rope works of his own.*

SAFE POST/K.U.K. FELDPOST/JOCKPOST
Silverman No. 468

COMMENTS: *These stamps, using images of W.C. Fields and
a drawn female torso, were published by the artist in 1961.
Blocks of them are occasionally used in* FLUXUS 1 *and
Robert Watts'* Events *and are included in Watts'* Stamp Ma-
chine *(Silverman No. < 479.VIII).*

SAFE POST/K.U.K. FELDPOST/JOCKPOST
Silverman No. 476, ff.

COMMENTS: *These stamps (photomontage of women's
body parts and hardware) were published by the artist in
1962. Blocks of the stamps are occasionally used in
FLUXUS 1,* Watts' Events *and included in Robert Watts'*
Stamp Machine, *(Silverman No. < 479.VIII),* Stamp Dispen-
ser *(Silverman No. < 479.VII), and* Flux Post Kit 7 *(Silver-
man No. > 130.I).*

SAND BOX TABLE

FLUX-PROJECTS PLANNED FOR 1967 ... Bob
Watts:...Sand box - table...
Fluxnewsletter, March 8, 1967.

FLUXFURNITURE...CUBE TABLES, 15" cubes,
walnut sides, locked corners...Robert Watts: sand ta-
ble, thin layer of sand over photo transparency of

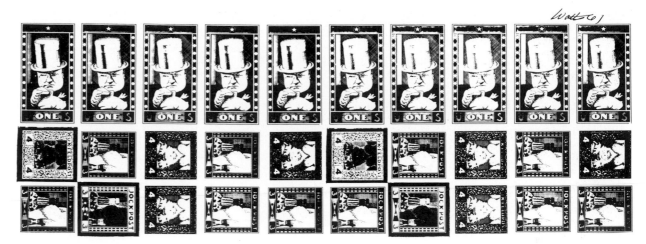

Robert Watts. SAFE POST/K.U.K. FELDPOST/JOCKPOST

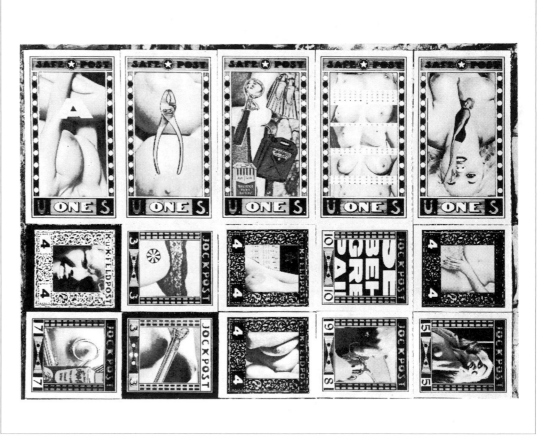

Robert Watts. SAFE POST/K.U.K. FELDPOST/JOCKPOST

sand, lamp, $80.00...Available in N.Y.C. at Multiples and late in 1967 at FLUXSHOP, 18 GREENE ST.
Fluxfurniture, pricelist. [1967].

03.1967...BOB WATTS: sand box table top,...
George Maciunas, Diagram of Historical Developments of Fluxus... [1973].

COMMENTS: *Based on the idea of Watts' Fluxsand Hide & Seek, the table or table lamp was not made by Fluxus. Photographic material that would have been used for the work exists in the Estate of George Maciunas, now part of the Silverman Fluxus Collection.*

SAND BOXES see:
FLUXSAND HIDE & SEEK

SCALE

"...Tomas Schmit is preparing your bathroom weight scale so we can exhibit it. That scale is a very good idea..."
Letter: George Maciunas to Robert Watts, [ca. April 1963].

"...NOW THE FESTIVAL: (Amsterdam one)....Exhibits....Robert Watts —...weighing scale..."
Letter: George Maciunas to Tomas Schmit, [early June 1963].

"...Take to Amsterdam Watts scale..."
Letter: George Maciunas to Tomas Schmit, [early June 1963].

"...When you go to Amsterdam VERY IMPORTANT - see if you can arrange maybe a one concert festival in that gallery or somewhere...(you bring...Watts Scale — you must complete it..."
Letter: George Maciunas to Tomas Schmit, [mid June 1963].

PROPOSED FLUXSHOW FOR GALLERY 669 ... TOILET OBJECTS...picture scale by Bob Watts.
Fluxnewsletter, December 2, 1968.

FLUX AMUSEMENT ARCADE...Weighing scale (Watts),...
Preliminary Proposal for a Flux Exhibit at Rene Block Gallery. [ca. 1974].

COMMENTS: *Evidently this work was constructed by either Tomas Schmit or George Maciunas for the early Fluxus exhibits in Europe. Robert Watts had sent Maciunas instructions for the work which involved taking a normal bathroom scale, removing the cover and glueing cut-out images of women's breasts, thighs, buttocks, etc. over the numbers, then replacing the cover. The work is either lost or destroyed.*

SEX, FEMALE
Silverman No. > 483.XXX

FLUXUS 1964 EDITIONS, AVAILABLE NOW ...

FLUXUS kk a to z series;...(v) sex,...female $25...
cc Valise e TRanglE (Fluxus Newspaper No. 3) March 1964.

KAZ-serie[s] ROBERT WATTS: objects...kk/v SEX female $25
European Mail-Orderhouse: europeanfluxshop, Pricelist. [ca. June 1964].

KAZ series OBJECTS from ROBERT WATTS...kk/v sex - female $25
Second Pricelist - European Mail-Orderhouse. [Fall 1964].

FLUXUS kk ROBERT WATTS: a to z sereis...(v) sex ...female $25...
Vacuum TRapEzoid (Fluxus Newspaper No. 5) March 1965.

COMMENTS: *Robert Watts, 1982: "Inflatables from a sex shop. One I liked was in L.A. Free Press called 'auto suck.'"*
Robert Watts used a ready-made tampon, a distorted idea of female sex, for Sex, Female, when he reassembled the a to z series in 1982 and 1983. Originally, as he states, the work would have been a ready-made sex aid.

Robert Watts. SEX, FEMALE

SEX, MALE
Silverman No. > 483.XXIX

FLUXUS 1964 EDITIONS, AVAILABLE NOW ... FLUXUS kk a to z series;...(v) sex, male $15...
cc Valise e TRanglE (Fluxus Newspaper No. 3) March 1964.

KAZ-serie[s] ROBERT WATTS: objects...kk/v SEX male $15
European Mail-Orderhouse: europeanfluxshop, Pricelist. [ca. June 1964].

KAZ series OBJECTS from ROBERT WATTS...kk/v sex - male $15
Second Pricelist - European Mail-Orderhouse. [Fall 1964].

FLUXUS kk ROBERT WATTS: a to z series...(v) sex, male $15...
Vacuum TRapEzoid (Fluxus Newspaper No. 5) March 1965.

COMMENTS: *When Robert Watts reconstructed his a to z series in 1982 and 1983, he used a ready-made condom for Sex, Male, the orifice creating an opposite for the phallic-shaped tampon used for Sex, Female. As originally listed, the price of $15 indicated that the work would have been more substantial, perhaps a vibrator.*

Robert Watts. SEX, MALE

SHAVING CREAM FILLED SHOES

FLUX-OLYMPIAD TRACK...hurdles, obstacles with obstacle shoes: shoes filled with shaving cream...(Bob Watts)
Fluxfest at Stony Brook, Newsletter No. 1, August 18, 1969. version B

FLUX-OLYMPIAD...TRACK — HURDLES, OBSTACLES...OBSTACLE SHOES: shoes filled with shaving cream...(Robert Watts)
Flux Fest Kit 2. [ca. December 1969].

FEB. 17, 1:30PM FLUX-SPORTS DOUGLASS COL. ...OBSTACLE SHOES: shoes filled with shaving cream...
Poster/program for Flux-Mass, Flux-Sports and Flux-Show. February, 1970.

PROPOSED FLUXANNIVERSARY FEST PROGRAM 1962-1972 SEPT & OCT...FLUXOLYMPIAD (counterpoint to Munich one) obstacle shoes run
Fluxnewsletter, April 1973.

1970 FLUXSPORTS:...by bob watts: obstacle shoes
George Maciunas, Diagram of Historical Developments of Fluxus... [1973].

COMMENTS: *Regular shoes filled with shaving cream to slosh around in.*

SHIRTS see:
CUSTOM MADE SHIRT

HERE I COME SWEATSHIRT
STUFFED SHIRT WITH BOW TIE
FEMALE UNDERSHIRT
MALE UNDERSHIRT
SWEAT SHIRTS
SHOES see:
OBSTACLE SHOES
SHOES MADE OF NAILS see:
NAIL SHOES
**SIGNERS OF THE DECLARATION OF IN-
DEPENDENCE LETTER PAPER** see:
GIANT STAMP IMPRINT ENVELOPE: SIGNERS
OF THE DECLARATION OF INDEPEN-
DENCE LETTER PAPER
SIGNS see:
LADDER WALLPAPER

SINGLE ROCK MARKED BY NUMBER
Silverman No. < 495.l

... items are in stock, delivery within 2 weeks ...
FLUXUSkt ROBERT WATTS: single rock marked
by number, in wood box $20
Vaseline sTREet (Fluxus Newspaper No. 8) May 1966.

03.1964...BOB WATTS: rocks
*George Maciunas, Diagram of Historical Developments of
Fluxus... [1973].*

COMMENTS: *I don't know how these rocks would have
varied from* Odd Numbered Rocks *or* Even Numbered Rocks.

SINGLE ROCK MARKED BY ITS VOLUME
see: FLUX ROCKS MARKED BY VOLUME IN CC
SINGLE ROCK MARKED BY WEIGHT see:
ROCKS MARKED BY WEIGHT IN GRAMS

SITTING KIT

...will appear late in 1966...FLUXUSke ROBERT
WATTS: sitting kit, $100
Vaseline sTREet (Fluxus Newspaper No. 8) May 1966.

FLUX-PROJECTS PLANNED FOR 1967 ... Bob
Watts:...Sitting kit...
Fluxnewsletter, March 8, 1967.

FLUX-PRODUCTS 1961 TO 1969 ... ROBERT
WATTS...sitting kit...on special order only, each:
[$] 100
Fluxnewsletter, December 2, 1968 (revised March 15, 1969).

FLUX-PRODUCTS 1961 TO 1970 ... ROBERT
WATTS...sitting kit...by special order only, each:
[$] 100
Flux Fest Kit 2. [ca. December 1969].

"...Watts...sitting kit...made to order..."
Letter: George Maciunas to Dr. Hanns Sohm, [ca. late 1972].

SPRING 1969...BOB WATTS:...sitting kits
*George Maciunas, Diagram of Historical Developments of
Fluxus... [1973].*

COMMENTS: *Robert Watts, 1982: "Zen influence. Objects
having nothing to do with sitting."*
As a special order item to be assembled by the artist,
George Maciunas never produced Sitting Kit *as a Fluxus Edi-
tion. The work was built by Robert Watts in 1980.*

SLEEPING KIT

... will appear late in 1966 ... FLUXUS ki ROBERT
WATTS: sleeping kit, $100
Vaseline sTREet (Fluxus Newspaper No. 8) May 1966.

FLUX-PROJECTS PLANNED FOR 1967 ... Bob
Watts:...Sleeping kit...
Fluxnewsletter, March 8, 1967.

FLUX-PRODUCTS 1961 TO 1969 ... ROBERT
WATTS...sleeping kit...on special order only, each:
[$] 100
Fluxnewsletter, December 2, 1968 (revised March 15, 1969).

FLUX-PRODUCTS 1961 TO 1970 ... ROBERT
WATTS...Sleeping kit... by special order only, each:
[$] 100
Flux Fest Kit 2. [ca. December 1969].

"...Watts...sleeping kit...made to order..."
Letter: George Maciunas to Dr. Hanns Sohm, [ca. late 1972].

SPRING 1969...BOB WATTS: sleeping...kits
*George Maciunas, Diagram of Historical Developments of
Fluxus... [1973].*

COMMENTS: *Robert Watts, 1982: "Lots of things to sleep
on — air mattresses [and so on]."*
Like Sitting Kit, *this work was a special order item, to be
assembled by the artist and therefore, never produced by
George Maciunas as a Fluxus Edition. The work was built by
Robert Watts in 1980.*

SLICE OF CUCUMBER ON PLATE PLACE MAT
Silverman No. < 508.III

"...I got hold of a few $ & shipped out by REA a
package to you...2 sets of Watts place mats..."
*Letter: George Maciunas to Ken Friedman, [ca. February
1967].*

FLUX-PROJECTS PLANNED FOR 1967 ... Bob
Watts:...table mats...
Fluxnewsletter, March 8, 1967.

Robert Watts. SLICE OF CUCUMBER ON PLATE PLACE MAT

COMMENTS: *A photo-laminated place mat,* Slice of Cucum-
ber on Plate Place Mat *was made as a prototype for a Fluxus
Edition.*

SLIDES see:
35 MM SLIDE

SLIPPERY SHOES

FLUX-OLYMPIAD...TRACK-HURDLES, OBSTA-
CLES ... OBSTACLE SHOES: ... slippery shoes ...
(Robert Watts)
Flux Fest Kit 2. [ca. December 1969].

FEB. 17, 1:30PM FLUX-SPORTS DOUGLASS COL.
...OBSTACLE SHOES:..slippery shoes...
*Poster/program for Flux-Mass, Flux-Sports and Flux-Show.
February, 1970.*

PROPOSED FLUXANNIVERSARY FEST PRO-
GRAM 1962-1972 SEPT & OCT...FLUXOLYMPIAD
(counterpoint to Munich one)...obstacle shoes run
by Bob Watts...
Fluxnewsletter, April 1973.

FLUXSPORTS:...by bob watts: obstacle shoes
*George Maciunas, Diagram of Historical Developments of
Fluxus... [1973].*

COMMENTS: *These "obstacle shoes" had greased soles.*

SMEARS

FLUXUS 1964 EDITIONS, AVAILABLE NOW ...
FLUXUS kk a to z series;...(u)...smears 25 cents...
cc Valise e TRanglE (Fluxus Newspaper No. 3) March 1964.

KAZ-serie[s] ROBERT WATTS: objects ... kk/u
SMEARS 25¢
*European Mail-Orderhouse: europeanfluxshop, Pricelist.
[ca. June 1964].*

KAZ series OBJECTS from ROBERT WATTS...kk/u
smears 25¢
Second Pricelist - European Mail-Orderhouse. [Fall 1964].

FLUXUS kk ROBERT WATTS: a to z series ... (u)
smears 25¢...
Vacuum TRapEzoid (Fluxus Newspaper No. 5) March 1965.

COMMENTS: *Robert Watts, 1982: "Would have been a vaginal smear."*

SMELL BOX see:
SMELL ROOM

SMELL ROOM

Any proposals from participants should fit the maze
format...Ideas should relate to passage through doors,
steps, floor, obstacles, booths...smell box...
*George Maciunas, Further Proposal for Flux-Maze at Rene
Block Gallery. [ca. Fall 1974].*

"Enclosed is the final plan of labyrinth...The third
Watts room will be with some smell, it should also
have a roof. The smell could be either burning tar, or
sulfur or hashish, we will think of something. It could
be a different smell for each day..."
Letter: George Maciunas to Rene Block, [ca. Summer 1976].

smell room
*Instruction drawing for Fluxlabyrinth, Berlin. [ca. August
1976]. version A*

Smell room needed: smells Perhaps the entry door
could be whoopee cushion or whoopee cushions some-
where on floor to make a fart sound. Then we could
have sulfur smell. I will have assistant locate a novelty
and gag store to inquire. also: we could have unmarked
aerosol cans with various smells so people could spray.
*Notes: Larry Miller to George Maciunas concerning the Flux-
labyrinth, Berlin. [ca. August 1976].*

COMMENTS: *Smell Room was not built in the* Fluxlabyrinth.
This work is related to Takako Saito's Spice Chess, *sometimes
referred to as "smell chess."*

SOAP
Silverman No. > 483.XII, ff.

FROM THE YAM FESTIVAL WAREHOUSE...SOAP
$1 & up
Yam Festival Newspaper. [ca. 1963].

FLUXUS 1964 EDITIONS, AVAILABLE NOW ...
FLUXUS kk a to z series;...(e) soap $1 and up
cc Valise e TRanglE (Fluxus Newspaper No. 3) March 1964.

KAZ-serie[s] ROBERT WATTS: objects ... kk/e
SOAP $1 and up

*European Mail-Orderhouse: europeanfluxshop, Pricelist.
[ca. June 1964].*

KAZ series OBJECTS from ROBERT WATTS...kk/e
soap $1 & up
Second Pricelist - European Mail-Orderhouse. [Fall 1964].

FLUXUS kk ROBERT WATTS: a to z series...(d)
soap $1 & up...
Vacuum TRapEzoid (Fluxus Newspaper No. 5) March 1965.

FLUXPROJECTS FOR 1969...Bob Watts: thin coat
of real soap over a plastic soap (washes off in first use)
Fluxnewsletter, December 2, 1968.

PROPOSED FLUXSHOW FOR GALLERY 669 ...
TOILET OBJECTS...thin coat of real soap over a
plastic soap (washes off in first use) by Bob Watts.
ibid.

PROPOSED FLUXSHOW...TOILET OBJECTS ...
plastic soap with thin coat of real soap that washes
off in first use — by Bob Watts.
Fluxnewsletter, December 2, 1968 (revised March 15, 1969).

TOILET OBJECTS & ENVIRONMENT...Plastic soap
with thin coat of quickly washable soap by Bob Watts.
Flux Fest Kit 2. [ca. December 1969].

"We would like to produce...Another object: a soap
covered plastic soap shape, so that real soap would
wash off instantly...These objects...could be pro-
duced cheaper in Italy:...real soap thin cover of face
plastic soap,..."
*Letter: George Maciunas to Daniela Palazzoli, n.d. Repro-
duced in Fluxnewsletter, April 1973.*

Toilet no. 1 Bob Watts:...Soap thin coat on plastic
facsimile
Fluxnewsletter, April 1973.

1970-1971 FLUX-TOILET: WATTS:...soap.
*George Maciunas, Diagram of Historical Developments of
Fluxus... [1973].*

Robert Watts. SOAP

COMMENTS: *Robert Watts carved two bars of soap in wood,*
Lux *(Silverman No. > 483.XII), and* Flux, *which is now in
the Staatsgalerie Stuttgart. These bars, although missing the
thin coating of soap, could be considered prototypes for the
Fluxus Edition which was never made. The artist told me
that the idea for* Soap *came from a Playboy soap that had the
image of a nude woman in the center. In Watts' a to z series,*
Lux *was the "and up" model.*

SOAPY WATER FAUCET

Toilet no. 1 Bob Watts:...Sink faucet soapy water
Fluxnewsletter, April 1973.

COMMENTS: *Soapy Water Faucet reflects what a lot of
Robert Watts' works are all about: paradox.*

SOCKS

FLUXUS 1964 EDITIONS, AVAILABLE NOW ...
FLUXUS kk a to z series;...(o) socks $2...
cc Valise e TRanglE (Fluxus Newspaper No. 3) March 1964.

KAZ-serie[s] ROBERT WATTS: objects ... kk/o
SOCKS $2
*European Mail-Orderhouse: europeanfluxshop, Pricelist.
[ca. June 1964].*

KAZ series OBJECTS from ROBERT WATTS ...kk/o
socks $2
Second Pricelist - European Mail-Orderhouse. [Fall 1964].

...to be shown on the special fluxus fashion-shows
next winter together with:...kk/o Socks of Robert
Watts
*European Mail-Orderhouse, advertisement for clothes,
[ca. 1964].*

FLUXUS kk ROBERT WATTS: a to z series ... (o)
socks $2...
Vacuum TRapEzoid (Fluxus Newspaper No. 5) March 1965.

COMMENTS: *I have not seen this work. Robert Watts de-
scribed them as ready-mades of the sort available in the early
60s from specialty stores.*

SPIDER WEB ROOM

Enclosed is the final plan of labyrinth...one enters the
room with spider webb [sic] machine. This should also
have a ceiling but not as dark...
Letter: George Maciunas to Rene Block, [ca. Summer 1976].

Watts: spiderweb machine
*Plan of completed Fluxlabyrinth, Berlin. [ca. September
1976].*

COMMENTS: *This work was not made for the* Fluxlabyrinth,
probably because of its similarity to Ay-O's Web Obstacle,
which was built.

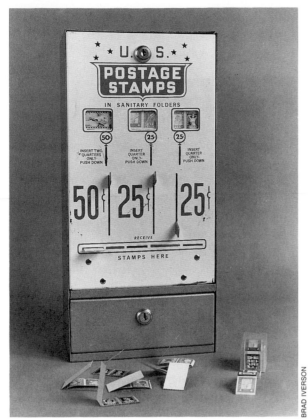

A large STAMP DISPENSER assembled by Robert Watts in 1982 and a smaller, undated desktop version. see color portfolio

BRAD IVERSON

STAMP DISPENSER
Silverman No. < 479.VIII, ff.

This Fall, we shall publish V TRE no. 10, which shall consist of a plan for Flux-Amusement-Center, to contain...Stamp...machines...
Fluxnewsletter, April 1973.

FLUX AMUSEMENT ARCADE...Stamp & postcard dispensers (Watts & Vautier)
Preliminary Proposal for a Flux Exhibit at Rene Block Gallery. [ca. Fall 1974].

COMMENTS: *Robert Watts' earliest* Stamp Dispenser *dates from 1963. It was a commercial, windowless dispenser with its original markings obliterated, and stenciled by the artist. That and several other variations dispensed Watts' stamps when money was deposited. These dispensers were exhibited but never offered for sale by Fluxus. They only appear in the Fluxus publications in connection with a proposed "Flux Amusement Center" in 1973 and 1974. This is especially curious, as I believe Maciunas took the idea for numerous Fluxus dispensers from Watts.*

STAMP MACHINE see:
STAMP DISPENSER

STAMPS

"...Very nice postage stamps - send more of these, will mail fluxus with them..."
Letter: George Maciunas to Robert Watts, [ca. June 1962].

FROM THE YAM FESTIVAL WAREHOUSE ... STAMPS 25¢
Yam Festival Newspaper. [ca 1963].

"I hear you are sick & have nothing to do. I can paste the postage stamp frames - that's not much work. It would not pay shipping all these sheets,..."
Letter: George Maciunas to Robert Watts, March 13, 1964.

FLUXKIT containing following flux-publications:... complete set of events, dollar bill and stamps (in box) ...of Robert Watts
Second Pricelist - European Mail-Orderhouse. [Fall 1964].

"...Also, I will finance completion of your postage stamps...."
Postcard: George Maciunas to Robert Watts, February 25, 1965.

FLUX-PROJECTS PLANNED FOR 1967 ... Bob Watts:...Fluxstamps and postcards...
Fluxnewsletter, March 8, 1967.

IMPLOSIONS INC. PROJECTS...Triple partnership was formed between Bob Watts, Herman Fine and myself [George Maciunas] to introduce into mass market ...money producing products...This business will be operated in commercial manner, with intent to make profits....connection between Fluxus collective and Implosions Inc. has not been clarified yet...we could consider at present Fluxus to be a kind of division or subsidiary of Implosions. Projects to be realized through Implosions:...stamps (same as Flux-postal kit)...
Fluxnewsletter, March 8, 1967.

COMMENTS: *These general listings for stamps actually refer to several different works and should be read in conjunction with Watts' specific stamps produced around the dates of the references.*

STAMPS see:
FLUXPOST 17-17
GIANT STAMP IMPRINT ENVELOPE: GRAFITTI LETTER PAPER
GIANT STAMP IMPRINT ENVELOPE: SIGNERS OF THE DECLARATION OF INDEPENDENCE LETTER PAPER
MOONSCAPE STAMPS
SAFE POST/K.U.K. FELDPOST/JOCKPOST

STAMPS: 15¢
STAMPS U.S.: 10¢
YAMFLUG/ 5 POST 5

STAMPS: 15¢
Silverman No. > 483.XXXII (2)

FLUXUS 1964 EDITIONS, AVAILABLE NOW ... FLUXUS kk a to z series;...(x) stamps...other 15¢...
cc ValisE e TRanglE (Fluxus Newspaper No. 3) March 1964.

KAZ-serie[s] ROBERT WATTS: objects ... kk/x STAMPS:...other 15¢
European Mail-Orderhouse: europeanfluxshop, Pricelist. [ca. June 1964].

KAZ series OBJECTS from ROBERT WATTS...kk/x stamps:...other 15¢
Second Pricelist - European Mail-Orderhouse. [Fall 1964].

COMMENTS: *Antiquarian philatelic foreign stamps with a face value of "15¢."*

Robert Watts **STAMPS: 15¢** **STAMPS: U.S. 10¢**

NANCY ANELLO NANCY ANELLO

STAMPS: U.S. 10¢
Silverman No. > 483.XXXII (1)

FLUXUS 1964 EDITIONS, AVAILABLE NOW ... FLUXUS kk a to z series;...(x) stamps...U.S. 10¢...
cc ValisE e TRanglE (Fluxus Newspaper No. 3) March 1964.

KAZ-serie[s] ROBERT WATTS: objects ... kk/x STAMPS:U.S. 10¢...
European Mail-Orderhouse: europeanfluxshop, Pricelist. [ca. June 1964].

KAZ series OBJECTS from ROBERT WATTS...kk/x stamps: u.s. 10¢...
Second Pricelist - European Mail-Orderhouse. [Fall 1964].

COMMENTS: *This work is a ready-made antiquarian philatelic U.S. stamp with a face value of "10¢."*

STATIONERY see:
GIANT STAMP IMPRINT ENVELOPE: GRAFFITI PAPER
GIANT STAMP IMPRINT ENVELOPE: SIGNERS OF THE DECLARATION OF INDEPENDENCE LETTER PAPER

STEP ON IT

FLUXFEST PRESENTATION OF JOHN LENNON & YOKO ONO +* AT 80 WOOSTER ST. NEW YORK -—1970...MAY 9-15: WEIGHT & WATER BY JOHN & YOKO + FLUXFAUCET...Step on it (Bob Watts) crushed styrofoam over water hole...

all photographs copyright nineteen seVenty by peTer mooRE (Fluxus Newspaper No. 9) 1970.

COMMENTS: *Danger lurks under every footstep. Fluxus is out to get you one way or another.*

STICK-ON TATTOOS see:
STICK-ONS

STICK-ONS

FLUX-PROJECTS PLANNED FOR 1967 ... Bob Watts:...tattooes [sic] (whole series)...
Fluxnewsletter, March 8, 1967.

IMPLOSIONS INC. PROJECTS...Triple partnership was formed between Bob Watts, Herman Fine and myself [George Maciunas] to introduce into mass market ...money producing products...This business will be operated in commercial manner, with intent to make profits....connection between Fluxus collective and Implosions Inc. has not been clarified yet...we could consider at present Fluxus to be a kind of division or subsidiary of Implosions. Projects to be realized through Implosions:...Stick-ons (disposable jewelry): printed on clear or colored acetate or vinyl 9" x 11¾" (image size), images may be photographs (will be screened) or drawings, engravings, words etc. any color. Plastic sheets will have self-adhesive backs that will permit them to be stuck on skin or clothing. Sheets will also be die cut or contain partly die cut (snap-out) shapes in the shape of the image or anything else...
Fluxnewsletter, March 8, 1967.

FLUX-PROJECTS PLANNED FOR 1967 ... Bob Watts:...Stick-ons (disposable jewelry):...Tattooes [sic] (whole series)...
ibid.

stick-on tattoos $1
Fluxshopnews. [Spring 1967].

NEWS FROM IMPLOSIONS, INC. Various items were produced as planned &...listed in the past newsletter:...Stick-ons, samples included
Fluxnewsletter, January 31, 1968.

NEWS FROM IMPLOSIONS, INC....Planned in 1968: ...More stick-ons (some 8 designs)
ibid.

FLUXUS-EDITIONEN...[Catalogue No.] 717 FLUX-TATTOOS...b.watts...1967
Happening & Fluxus. Koelnischer Kunstverein, 1970.

1967 BOB WATTS: stick-on tattoos
George Maciunas, Diagram of Historical Developments of Fluxus... [1973].

COMMENTS: *General references to "stick-ons," see specific works listed under Stick-ons.*

STICK-ONS see:
BIOLOGY 704
EAR STICK-ONS
ELBOW STICK-ONS
FRUIT AND VEGETABLE SECTIONS STICK-ONS
HERO 601
LIP STICK-ONS
PARKING METER DECAL
PEARL NECKLACE

STILT SHOES

FLUX-OLYMPIAD...TRACK...hurdles, obstacles with obstacle shoes:...shoes on stilts,...(Bob Watts)
Fluxfest at Stony Brook, Newsletter No. 1, August 18, 1969. version B

FLUX-OLYMPIAD/ TRACK-HURDLES, OBSTACLES...OBSTACLE SHOES:... shoes on stilts... (Robert Watts)
Flux Fest Kit 2. [ca. December 1969].

PROPOSED FLUXANNIVERSARY FEST PROGRAM 1962-1972 SEPT & OCT...FLUXOLYMPIAD (counterpoint to Munich one)...obstacle shoes run by Bob Watts...
Fluxnewsletter, April 1973.

FLUXSPORTS:...by bob watts: obstacle shoes
George Maciunas, Diagram of Historical Developments of Fluxus... [1973].

COMMENTS: *A very confusing entry that seems to point to Flux Stilts, a work I have previously credited to Bici Hendricks (Forbes) and George Maciunas, as being actually an idea of Robert Watts'. By comparing the entries for the artists, it now appears that the game played with the stilts was by Hendricks and Maciunas.*

STRING
Silverman No. > 483.XXI

FLUXUS 1964 EDITIONS, AVAILABLE NOW ... FLUXUS kk a to z series;...(n) string 10¢...
cc Valise e TRanglE (Fluxus Newspaper No. 3) March 1964.

KAZ-serie[s] ROBERT WATTS: objects ... kk/n STRING 10¢
European Mail-Orderhouse: europeanfluxshop, Pricelist. [ca. June 1964].

KAZ series OBJECTS from ROBERT WATTS...kk/n string $0.10
Second Pricelist - European Mail-Orderhouse. [Fall 1964].

FLUXUS kk ROBERT WATTS: a to z series... (n) string 10¢...
Vacuum TRapEzoid (Fluxus Newspaper No. 5) March 1965.

COMMENTS: *This work is a ready-made, chosen by the artist from string that he saved.*

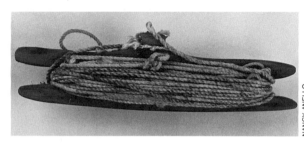

Robert Watts. STRING

NANCY ANELLO

STRING see:
ROPE RECORD

STUFFED SHIRT WITH BOW TIE
Silverman No. 504

FLUX-PROJECTS PLANNED FOR 1967 ... Bob Watts:...Shirt fronts...
Fluxnewsletter, March 8, 1967.

COMMENTS: *This work has a Fluxus copyright on it, but apparently had only limited distribution. In the early 1960s, George Maciunas made several unconventional photographic portraits. One of these was of Robert Watts, showing only a formally attired, white-tied torso, excluding the head. I suspect this portrait was the inspiration for Stuffed Shirt with Bow Tie.*

SUITCASE see:
COMPLETE WORKS

SUN GLASSES

"...Other going projects:...Bob Watts...sun glasses..."
Letter: George Maciunas to Ken Friedman, [ca. February 1967].

COMMENTS: *The artist does not recall what this work would have been. Perhaps this is just another instance of*

LORI TUCCI

Robert Watts. STUFFED SHIRT WITH BOW TIE

Maciunas crediting others with the wrong work. George Maciunas did plan to make 8 Lens Sun Glasses.

SUPPLEMENT TO WORKS see:
COMPLETE WORKS
SWALLOWING see:
TRACE NO. 22

SWEAT SHIRTS
Silverman No. 516

FLUX-PROJECTS PLANNED FOR 1967 ... Bob Watts: ...sweat shirts...
Fluxnewsletter, March 8, 1967.

COMMENTS: Implosions produced Robert Watts' McLuhan Sweatshirt, which is most likely the work referred to.

SWIM

MAY 16-22 CAPSULE BY YOKO + FLUX SPACE CENTER A 3'x3'x3' enclosure (capsule) having vari-

GEORGE MACIUNAS

Portrait of Robert Watts, by George Maciunas

ous film loops projected on its walls and ceiling to a single viewer inside:...swim etc. (Bob Watts);...
Schedule of events for Fluxfest presentation of John Lennon and Yoko Ono. April 1, 1970. version C

COMMENTS: *Robert Watts knows of no film of his that relates to Swim. Another mistaken identity?*

Robert Watts. A McLuhan SWEAT SHIRT

SYRINGE ON PLATE PLACE MAT
Silverman No. < 508.1

"...I got hold of a few $ & shipped out by REA a package to you...2 sets of Watts place mats...."
Letter: George Maciunas to Ken Friedman, [ca. February 1967].

FLUX-PROJECTS PLANNED FOR 1967 ... Bob Watts:...table mats...
Fluxnewsletter, March 8, 1967.

COMMENTS: *This work is another photo-laminated prototype for a Fluxus Edition. As so often happened, ideas outran finances and few place mats were produced.*

Robert Watts. SYRINGE ON PLATE PLACE MAT

TABLE CLOTH see:
CROSSED NUDE LEGS TABLE TOP
TABLE MATS see:
PLACE MATS

TABLETOPS

PAST FLUX-PROJECTS (realized in 1966)...Flux - furniture: table tops by...Robert Watts...
Fluxnewsletter, March 8, 1967.

table 25 x 25 $90 by Robert Watts
Fluxshopnews. [Spring 1967].

"...Watts...table tops were always available..."
Letter: George Maciunas to Dr. Hanns Sohm, [ca. late 1972].

COMMENTS: *General references to Fluxus tabletops made by Robert Watts.*

TABLETOPS see:
FLUXFURNITURE

TARGET

Flash Art editor, Giancarlo Politi, proposed to publish the 3rd Fluxyearbook, maybe to be called FLUX-PACK 3, with the following preliminary contents:... Games:...targets by Watts...
Fluxnewsletter, April 1973.

COMMENTS: *Target is not included in* Fluxpack 3, *and the artist doesn't recall the work. Perhaps Maciunas related the idea of Watts' Hospital Events to this game or Ben Vautier's work,* To Look At, *which is a target.*

TARGET DOOR

Toilet no. 1 Bob Watts: Doors - method of opening: No handle elec. push-switch behind target. To get in: throw super ball to target on door. hitting center will activate switch & open door...
Fluxnewsletter, April 1973.

COMMENTS: *According to Robert Watts,* Target Door *"was completed or nearly so" for the* Flux Toilet *at the Happening & Fluxus exhibition in the Koelnischer Kunstverein, November 6, 1970 to January 6, 1971.*

TATTOOS see:
STICK-ONS

10 FOOT LONG CIGARETTE

EXTERIOR FLUX-EVENTS ROBERT WATTS: ... ANTI-SMOKING EVENT A 10ft long cigarette will be set up, held by threads. Passers-by will be invited

to take a puff, but not to exceed 10'' of the cigarette length.
Flux Fest Kit 2. [ca. December 1969].

COMMENTS: *Robert Watts smoked, George Maciunas was vehemently against smoking. The cigarette was never made.*

Robert Watts. 10-HOUR FLUX CLOCK

10-HOUR FLUX CLOCK
Silverman No. 518

COMMENTS: *Curiously, this Fluxus Edition was never advertised or listed by Fluxus. The finished face appears on printed sheets with other Flux clock faces by various artists, and is acknowledged to be the work of Robert Watts.*

THERE I GO SWEATSHIRT see:
HERE I COME SWEATSHIRT

Robert Watts. 35MM SLIDE

35MM SLIDE
Silverman No. > 483.XXXIV

FLUXUS 1964 EDITIONS, AVAILABLE NOW ...
FLUXUS kk a to z series;...(z) 35mm slide, any subject 50¢, special order $2
cc Valise e TRanglE (Fluxus Newspaper No. 3) March 1964.

KAZ-serie[s] ROBERT WATTS: objects...kk/z 35mm SLIDE 50¢ special subject $2
European Mail-Orderhouse: europeanfluxshop, Pricelist. [ca. June 1964].

KAZ series OBJECTS from ROBERT WATTS...kk/z 35mm slide 50¢ special subject $2
Second Pricelist - European Mail-Orderhouse. [Fall 1964].

FLUXUS kk ROBERT WATTS: a to z series ... (y) 35mm slide, any subject 50¢, special order $2.
Vacuum TRapEzoid (Fluxus Newspaper No. 5) March 1965.

COMMENTS: *"Any subject" slides were leftover ready-mades from Robert Watts' slide file.*

3 HOUR HARLEM TOUR TICKET

FLUXFEST PRESENTATION OF JOHN LENNON & YOKO ONO+*AT 80 WOOSTER ST. NEW YORK —1970...APR. 18-24: TICKETS BY JOHN LENNON + FLUXTOURS ... 3 hour Harlem Tour (Bob Watts) $4.50...
all photographs copyright nineteen seVenty by peTer mooRE (Fluxus Newspaper No. 9) 1970.

COMMENTS: *Never made as a Fluxus Edition, this and some other works were planned by Watts to taunt prejudice.*

TICKET TO BEAR MOUNTAIN

FLUXFEST PRESENTATION OF JOHN LENNON & YOKO ONO +* AT 80 WOOSTER ST. NEW YORK --1970...APR. 18-24: TICKETS BY JOHN LENNON + FLUXTOURS...Bear Mountains (by boat, return by bus) (Bob Watts) $4.00...
all photographs copyright nineteen seVenty by peTer mooRE (Fluxus Newspaper No. 9) 1970.

COMMENTS: *A ready-made ticket to a nice place to visit.*

TICKETS see:
 FLUXTOURS TICKETS
TIME KIT see:
 FLUX TIMEKIT

TIRE
Silverman No. > 483.XVI

FROM THE YAM FESTIVAL WAREHOUSE...TIRE 50$
Yam Festival Newspaper. [ca. 1963].

FLUXUS 1964 EDITIONS, AVAILABLE NOW ...
FLUXUS kk a to z series:...(i) tire $8 & up...
cc Valise e TRanglE (Fluxus Newspaper No. 3) March 1964.

KAZ-serie[s] ROBERT WATTS: objects...kk/i TIRE $8 and up
European Mail-Orderhouse: europeanfluxshop, Pricelist. [ca. June 1964].

KAZ series OBJECTS from ROBERT WATTS...kk/i tire $8 & up
Second Pricelist - European Mail-Orderhouse. [Fall 1964].

FLUXUS kk ROBERT WATTS: a to z series...(h) tire $8 & up...
Vacuum TRapEzoid (Fluxus Newspaper No. 5) March 1965.

COMMENTS: *Tire, also titled* Yam Ride, *was offered for sale by Watts through the Yam Festival Warehouse. Through Fluxus it was included in his a to z series. The work is an altered ready-made.*

TOILET see:
 FLUX TOILET
TOILET PAPER see:
 DOLLAR BILL TOILET PAPER
 MYLAR TOILET PAPER

TOILET SEAT WHEN SAT UPON OPENS DOOR

Toilet no. 1 Bob Watts...Toilet Seat: Seat with elec. switch controlling door. Door with spring, held in

LORI TUCCI

Robert Watts. TIRE

closed position with lock. Lock opens by solenoid switch. When seat sat upon - door opens. When seat empty door closes.
Fluxnewsletter, April 1973.

Toilet no. 1 Bob Watts Doors - method of opening: ...To get out: sit down on seat.
ibid.

1970-1971 FLUX-TOILET: WATTS: toilet seat when sat upon opens door...
George Maciunas, Diagram of Historical Developments of Fluxus... [1973].

a TOILET is ALTERED so that the door to the stall may be opened only when the outer door to the bathroom is opened or when one sits on the toilet seat. R.W.
Fluxfest at and/or, Seattle. September 1977.

COMMENTS: *Robert Watts recalls that this inversion of privacy was done in Germany for the original* Flux Toilet *at the* Happening & Fluxus Exhibition, Koelnischer Kunstverein, November 1970 to January 1971.

TOOLS see:
 ASSORTED TOOLS

TRACE NO. 22
Silverman No. > 506.I

"...FLUXUS 2 yearbox is now in planning stage & I am requesting various people to contribute....more things like your...trace..."
Letter: George Maciunas to Robert Watts, January 21, 1965.

...items are in stock, delivery within 2 weeks...FLUXFILMS...FLUXFILM 11 ROBERT WATTS: swallowing, $20
Vaseline sTREet (Fluxus Newspaper No. 8) May 1966.

FLUXFILMS SHORT VERSION, 40 MIN AT 24 FRAMES/SEC. 1400 FT....flux-number 11 Robert M. Watts TRACE 1'15'' X-ray sequence of mouth and throat: salivating, eating.
Fluxfilms catalogue. [ca. 1966].

PAST FLUX-PROJECTS (realized in 1966)...Fluxfilms: total package: 1 hr. 40 min....[including] 3 films by R. Watts...
Fluxnewsletter, March 8, 1967.

FLUX-PRODUCTS 1961 TO 1969...FLUXFILMS short version Summer 1966 40min. 1400ft.:...[including] Trace - by Bob Watts...16mm [$] 180 8mm version [$] 50
Fluxnewsletter, December 2, 1968 (revised March 15, 1969).

FLUX-PRODUCTS 1961 TO 1969 FLUXFILMS,

long version Winter 1966 Short version plus addition of: ... [including] 2 Traces - by Bob Watts;...total: 1 hr. 40 min. 3600ft. 16mm only: [$] 400
ibid.

FLUX-PRODUCTS 1961 TO 1970 ...FLUXYEAR-BOX 2, May 1968:...19 film loops by:... [including] Watts.
Flux Fest Kit 2. [ca. December 1969].

FLUX-PRODUCTS 1916 TO 1970 ... FLUXFILMS, long version, Winter 1966. Short version plus addition of... [including] 2 Traces by R. Watts,...total: 1hr. 40 min. 16mm $400
ibid.

SLIDE & FILM FLUXSHOW...ROBERT WATTS: TRACE X-ray sequence of mouth and throat: eating, salivating, speaking, 0'45"
ibid.

1965 FLUXFILMS...BOB WATTS: traces
George Maciunas, Diagram of Historical Developments of Fluxus... [1973].

COMMENTS: *Trace No. 22, also called Fluxfilm No. 11, is included in both the short and long versions of the* Fluxfilms *package (Silverman No. < 123.IV), and as a film loop in* Flux Year Box 2. *Watts retrieved the film from his dentist's garbage. The film contains x-ray images of a person in profile, speaking, eating and swallowing.*

TRACE NO. 23
Silverman No. > 506.II

...items are in stock, delivery within 2 weeks...FLUX-FILMS...FLUXFILM 12 ROBERT WATTS: hot dog, 3min $20
Vaseline sTREet (Fluxus Newspaper No. 8) May 1966.

FLUXFILMS LONG VERSION, ADDITIONAL FILMS TO SHORT VERSION...flux-number 12 TRACE
Fluxfilms catalogue. [ca. 1966].

PAST FLUX-PROJECTS (realized in 1966)...Flux-films: total package: 1 hr. 40 min....[including] 3 films by R. Watts...
Fluxnewsletter, March 8, 1967.

FLUX-PRODUCTS 1961 TO 1969...FLUXFILMS, Long version Winter 1966 Short version plus addition of:...[including] 2 Traces - by Bob Watts;...total: 1 hr. 40 min. 3600ft, 16 mm only: [$] 400
Fluxnewsletter, December 2, 1968 (revised March 15, 1969).

FLUX-PRODUCTS 1961 TO 1970 FLUXFILMS. long version, Winter 1966. Short version plus addition of:...[including] 2 Traces by R. Watts,...total: 1hr.

40min. 16mm $400
Flux Fest Kit 2. [ca. December 1969].

1965 FLUXFILMS...BOB WATTS: traces
George Maciunas, Diagram of Historical Developments of Fluxus... [1973].

COMMENTS: *Trace No. 23, also called Fluxfilm No. 12, is included in the long version of the* Fluxfilms *package (Silverman No. < 123.IV). The work begins with a demarcation line on an asphalt tennis court. A hand points into the distance. Then, a female torso with the numbers 408 and 409 appears. The woman caresses herself with different decorated plastic hot dogs (banana shapes). The film ends with the image of an egg floating on water. In conversation with Robert Watts in 1986, the artist described "Hot Dog" as close-up images of a naked female performer's pubic hair and thighs, passing a flocked plastic hot dog through her legs. Robert Watts also made* Hot Dog Rattle *(Silverman No. 473) for a* Yam Festival Delivery Event *and* Five Bunting Hot Dogs, *(Silverman No. > 473.I). Both works are ca. 1962.*

TRACE NO. 24
Silverman No. > 506.III

... items are in stock, delivery within 2 weeks ...
FLUXFILMS ... FLUXFILM 13 ROBERT WATTS; $20
Vaseline sTREet (Fluxus Newspaper No. 8) May 1966.

FLUXFILMS LONG VERSION, ADDITIONAL FILMS TO SHORT VERSION...flux-number 13 TRACE
Fluxfilms catalogue. [ca. 1966].

PAST FLUX-PROJECTS (realized in 1966) ... Flux-films: total package: 1 hr. 40 min....[including] 3 films by R. Watts...
Fluxnewsletter, March 8, 1967.

FLUX-PRODUCTS 1961 TO 1969...FLUXFILMS, long version Winter 1966 Short version plus addition of: ... [including] 2 Traces - by Bob Watts; ... total: 1 hr. 40 min, 3600 ft, 16mm only: [$] 400
Fluxnewsletter, December 2, 1968 (revised March 15, 1969).

FLUX-PRODUCTS 1961 TO 1970 FLUXFILMS, long version, Winter 1966. Short version plus addition of:...[including] 2 Traces by R. Watts,...total: 1hr. 40min. 16mm $400
Flux Fest Kit 2. [ca. December 1969].

1965 FLUXFILMS...BOB WATTS: traces
George Maciunas, Diagram of Historical Developments of Fluxus... [1973].

COMMENTS: *Trace No. 24, also called Fluxfilm No. 13, is included in the long version of the* Fluxfilms *package (Silverman No. < 123.IV). The film begins with a photograph of Marilyn Monroe. Then it shifts to a woman's body, from the belly down, wriggling under piles of cellophane.*

TRAVELLERS KIT see:
 EVENTS
T-SHIRTS see:
 SHIRTS
TUXEDO T-SHIRT see:
 STUFFED SHIRT WITH BOW TIE

TWELVE JELLO EGGS MOLDED IN AN EGG BOX

FLUXPROJECTS REALIZED IN 1967: ... Flux-Christmas-meal-event...Bob Watts - 12 jello eggs molded in an egg box...
Fluxnewsletter, January 31, 1968.

COMMENTS: *This work was an edible version of Robert Watts' Egg Box.*

UNDERPANTS see:
 FEMALE UNDERPANTS
 MALE UNDERPANTS
UNDERSHIRT see:
 FEMALE UNDERSHIRT
 MALE UNDERSHIRT

UNDULATING SURFACE MIRROR

PROPOSED FLUXSHOW...TOILET OBJECTS...mirrors: continuously undulating (motor driven) surface - by Bob Watts
Fluxnewsletter, December 2, 1968 (revised March 15, 1969).

FLUX SHOW: DICE GAME ENVIRONMENT ENTIRE FLOOR AS DICE HAZARD TABLE DIE CUBES, 15" CUBES ON FLOOR, Marked on sides, top open or closed with clear plastic. Consisting or containing...Undulating surface mirror by Bob Watts.
Flux Fest Kit 2. [ca. December 1969].

TOILET OBJECTS & ENVIRONMENT ... Mirrors: motorized undulating surface by Bob Watts,...
ibid.

Toilet no. 1 Bob Watts...Mirror: undulating * motorized
Fluxnewsletter, April 1973.

1970-1971 FLUX-TOILET: WATTS:...mirror,...
George Maciunas, Diagram of Historical Developments of Fluxus... [1973].

COMMENTS: *This Fluxus work was built into one of George Maciunas' 15" cube display cases. One is now in the Archiv Sohm at the Staatsgalerie Stuttgart.*

URINE COLORS see:
 PEE KIT

VENUS DE MILO APRON see:
George Maciunas

VIRGIN MARY APRON see:
George Maciunas and Robert Watts

WAITER WITH TRAY APRON

FLUX-PROJECTS PLANNED FOR 1967 ... Bob Watts:...Paper aprons: front of waiter with tray...
Fluxnewsletter, March 8, 1967.

COMMENTS: *This apron was never made by George Maciunas as a Fluxus Edition.*

WAITRESS WITH TRAY APRON see:
NUDE WAITRESS WITH TRAY APRON

WALLPAPER see:
LADDER WALLPAPER
MASS OF SWIMMERS WALLPAPER
WINDOW WALLPAPER

WATER CHESS

FLUX-PROJECTS PLANNED FOR 1967 ... Bob Watts: Water chess...
Fluxnewsletter, March 8, 1967.

COMMENTS: *Water Chess was never made by George Maciunas as a Fluxus Edition.*

WATER FOUNTAIN see:
FOUNTAIN LAMP

WATTS KIT see:
COMPLETE WORKS

WEAR ITEMS see:
STICK-ONS

WEIGHT see:
SCALE
ROCKS MARKED BY WEIGHT IN GRAMS
ROCKS MARKED BY WEIGHT IN POUNDS

WIGGLY BODY see:
TRACE NO. 24

WINDOW WALLPAPER

Flash Art editor, Giancarlo Politi, proposed to publish the 3rd Fluxyearbook, maybe to be called FLUX-PACK 3, with the following preliminary contents:... Household items:...poster, signs or wallpaper (...window by Watts...)
Fluxnewsletter, April 1973.

COMMENTS: *Robert Watts, 1986: "Like to put on your wall so you would have a window."*
This work was never made, but it is related to a unique

work by the artist which is an actual window with water falling over the glass.

WINGED VICTORY APRON see:
George Maciunas and Robert Watts

WORKS FROM 1964 see:
EVENTS

Robert Watts. WORM BOX

WORM BOX
Silverman No. > 483.V

FLUXUS 1964 EDITIONS, AVAILABLE NOW ... FLUXUS kaz series, OBJECTS from ROBERT WATTS...FLUXUS kc WORM BOXES $10
cc Valise e TRanglE (Fluxus Newspaper No. 3) March 1964.

KAZ-serie[s] ROBERT WATTS: objects ... F-kc WORM BOXES $10
European Mail-Orderhouse: europeanfluxshop, Pricelist. [ca. June 1964].

COMMENTS: *Worm Box is a chromed bait box filled with sand and containing chromed earthworms. It was produced by the artist and offered for sale through Fluxus. There is a clear relationship between this early work and Watts' Sand Boxes which evolved into* Fluxsand Hide & Seek.

YAM POSTCARD
Silverman No. 470

FROM THE YAM FESTIVAL WAREHOUSE...POST-CARDS 15¢
Yam Festival Newspaper. [ca. 1963].

FLUXUS 1964 EDITIONS, AVAILABLE NOW ... FLUXUS kk a to z series;...(d) postcards 15¢...
cc Valise e TRanglE (Fluxus Newspaper No. 3) March 1964.

KAZ-serie[s] ROBERT WATTS: objects ... kk/d POSTCARDS 15¢
European Mail-Orderhouse: europeanfluxshop, Pricelist. [ca. June 1964].

KAZ series OBJECTS from ROBERT WATTS...kk/d postcards $0.15
Second Pricelist - European Mail-Orderhouse. [Fall 1964].

FLUXKIT containing following fluxus-publications: (also available separatelly [sic]) ... FLUXUS ke ROBERT WATTS: postcards, ea. 10¢
Vacuum TRapEzoid (Fluxus Newspaper No. 5) March 1965.

FLUX-PROJECTS PLANNED FOR 1967...Collective projects: (All are invited to submit ideas and participate, ideas can be either ready pictorial material or just specified material which we have to find, produce or obtain otherwise)...Flux-postal kit: containing postcards,...
Fluxnewsletter, March 8, 1967.

IMPLOSIONS INC. PROJECTS...Triple partnership was formed between Bob Watts, Herman Fine and myself [George Maciunas] to introduce into mass market ...money producing products...This business will be operated in commercial manner, with intent to make profits....connection between Fluxus collective and Implosions Inc. has not been clarified yet...we could consider at present Fluxus to be a kind of division or subsidiary of Implosions. Projects to be realized through Implosions:...Postcards, stamps (same as Flux-postal kit)...
ibid.

[component of] flux post kit $7
Fluxshopnews. [Spring 1967].

FLUX-PRODUCTS 1961 TO 1969 ... FLUXPOST KIT 1968...2 postcards by Bob Watts * [indicated as part of FLUXKIT] ... [$] 8 Version without rubber stamps [$] 2
Fluxnewsletter, December 2, 1968 (revised March 15, 1969).

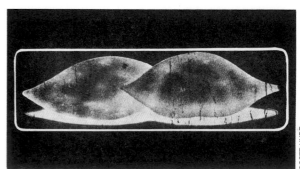

Robert Watts. YAM POSTCARD

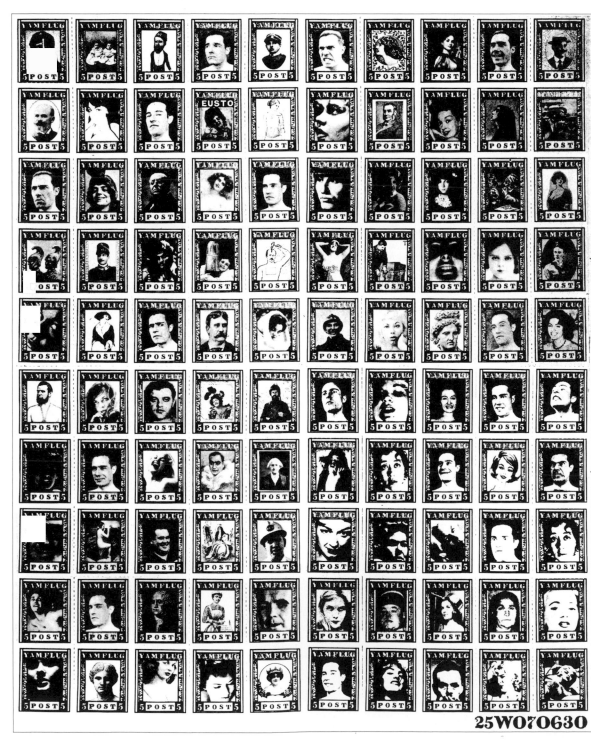

25W070630

Robert Watts. YAMFLUG / 5 POST 5

FLUXUS-EDITIONEN...[Catalogue No.] 718 FLUX-POST KIT, 1968 (b. watts,...)
Happening & Fluxus. Koelnischer Kunstverein, 1970.

COMMENTS: Yam Postcard was published by Robert Watts in 1962. It is included in some assemblings of the Fluxus Edition of FLUXUS 1 and Flux Post Kit 7 and Watts' Events. Watts used this work in his reconstruction of the a-z series, Fluxus kk (g) Yams $1 and up. However, the artist states that this card was made for the Yam Festival and that the work in the a-z series might have had something to do with a real yam as the price indicates that it wouldn't have been just a postcard.

YAM RIDE see:
 TIRE

YAMFLUG/ 5 POST 5
Silverman No. 479, ff.

''Very very nice postage stamps. - send more of these, - will mail fluxus with them or some.''
Letter: George Maciunas to Robert Watts, [possibly 1964].

''...I am sending Watts stamps...''
Letter: George Maciunas to Willem de Ridder, March 5, 1965.

FLUXKIT containing following fluxus-publications: (also available separately) ... FLUXUS kf ROBERT WATTS: fluxpost stamps, sheet of 100 different stamps, $1
Vacuum TRapEzoid (Fluxus Newspaper No. 5) March 1965.

FLUXKIT containing following fluxus-publications: (also available separately) FLUXUS kf ROBERT WATTS: fluxpost stamps, sheet of 100 different stamps, $1
Vaseline sTREet (Fluxus Newspaper No. 8) May 1966.

FLUX-PROJECTS PLANNED FOR 1967...Collective projects: (All are invited to submit ideas and participate, ideas can be either ready pictorial material or just specified material which we have to find, produce or obtain otherwise)... Flux-postal kit: containing ...stamps...
Fluxnewsletter, March 8, 1967.

IMPLOSIONS INC. PROJECTS...Triple partnership was formed between Bob Watts, Herman Fine and myself [George Maciunas] to introduce into mass market ...money producing products...This business will be operated in commercial manner, with intent to make profits....connection between Fluxus collective and Implosions Inc. has not been clarified yet...we could consider at present Fluxus to be a kind of division or subsidiary of Implosions. Projects to be realized through Implosions:...Postcards, stamps (same as Flux-postal kit)
ibid.

fluxpost stamps $1...by robert watts
Fluxshopnews. [Spring 1967].

[component of] flux post kit $7
ibid.

FLUX-PRODUCTS 1961 TO 1969 ... ROBERT WATTS...Flux-post stamps, 100 per sheet [$] 1
Fluxnewsletter, December 2, 1968 (revised March 15, 1969).

FLUX-PRODUCTS 1961 TO 1970 ... ROBERT WATTS...Flux-post stamps, 100 per sheet [$] 1
Flux Fest Kit 2. [ca. December 1969].

FLUXUS-EDITIONEN...[Catalogue No.] 718 FLUX-POST KIT, 1968 (b. watts,...
Happening & Fluxus. Koelnischer Kunstverein, 1970.

COMMENTS: *Many of these entries for Robert Watts' stamps give no indication as to whether they refer to Yamflug/ 5 Post 5, produced in 1963, or to Fluxpost 17-17, produced in 1964. Both were distributed by Fluxus and later, Implosions, in a variety of forms. At times, blocks of these sheets or other Watts stamps were used in assemblings of FLUXUS 1, Flux Post Kit 7 and Watts' Events. Although advertised as appearing in Fluxkit, I have not seen sheets of stamps as a separate item in a kit.*

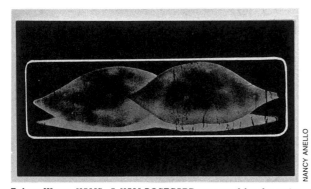

Robert Watts. YAMS. A YAM POSTCARD was used by the artist when he assembled his "a to z series" in 1982

YAMS
Silverman No. > 483.XIV

FROM THE YAM FESTIVAL WAREHOUSE ... YAMS $1
Yam Festival Newspaper. [ca. 1963].

"...Those Yam lectures - things - I am very interested. But I think we should have a COMMON FRONT - CENTRALIZATION of all such activities. Yam there, Fluxus here, not so good, why not combine all into one effort - So we can make World Revolution with Yamflux??? Then there is problem of duplication. We will arrive in Nov - December (I mean myself, Paik & Schmit) & hope with the help of you all to make big

Festum Fluxorum, but then if you are making that now, then maybe we should not do a Fluxorum? I mean there is this problem with audience etc. They won't know whats coming whats going & we will end up losing IDENTITY. So I think all PROLETARIANS SHOULD UNITE!!! COMMON FRONT !!! etc. etc. I wrote this to Brecht but he was evasive - you talk with him on this...."
Letter: George Maciunas to Robert Watts, [Before March 11, 1963].

FLUXUS 1964 EDITIONS, AVAILABLE NOW ... FLUXUS kk a to z series;...(g) yams $1 and up...
cc Valise e TRanglE (Fluxus Newspaper No. 3) March 1964.

KAZ-serie[s] ROBERT WATTS: objects ... kk/g YAMS $1 and up
European Mail-Orderhouse: europeanfluxshop, Pricelist. [ca. June 1964].

KAZ series OBJECTS from ROBERT WATTS...kk/g yams $1 & up
Second Pricelist - European Mail-Orderhouse. [Fall 1964].

FLUXUS kk ROBERT WATTS: a to z series...(f) yams $1 & up...
Vacuum TRapEzoid (Fluxus Newspaper No. 5) March 1965.

COMMENTS: *Robert Watts used a Yam Postcard for this work when he reconstructed his a to z series in 1982 and 1983. Originally it would have been an actual yam, and the more expensive version could have been a cast chromed yam or a Yam Collage (Silverman No. < 468.I).*

ZOOLOGY
Silverman No. > 483.XXV

FLUXUS 1964 EDITIONS, AVAILABLE NOW ...

Robert Watts. ZOOLOGY

FLUXUS kk a to z series;...(r) zoology 15¢...
cc Valise e TRanglE (Fluxus Newspaper No. 3) March 1964.

KAZ-serie[s] ROBERT WATTS: objects ... kk/r ZOOLOGY 15¢
European Mail-Orderhouse: europeanfluxshop, Pricelist. [ca. June 1964].

KAZ-series OBJECTS from ROBERT WATTS...kk/r zoology 15¢
Second Pricelist - European Mail-Orderhouse. [Fall 1964].

FLUXUS kk ROBERT WATTS: a to z series...(r) zoology 15¢...
Vacuum TRapEzoid (Fluxus Newspaper No. 5) March 1965.

COMMENTS: *Zoology consists of ready-made cartoons, animal images cut out of magazines.*

KARL-ERIK WELIN

It was announced in the tentative plans for the first issues of FLUXUS that Karl-Erik Welin would contribute "New possibilities in the interpretation of Cage and his followers" to FLUXUS NO. 2 WEST EUROPEAN YEARBOOK 1 (later called FLUXUS NO. 3 GERMAN & SCANDINAVIAN YEARBOX).
see: COLLECTIVE

KNUT WIGGEN

It was announced in the tentative plans for the first issues of FLUXUS that K. Wiggen would contribute "Music Machine" to FLUXUS NO. 2 WEST EUROPEAN YEARBOOK 1 (later called FLUXUS NO. 3 GERMAN & SCANDINAVIAN YEARBOX).
see: COLLECTIVE

JEAN-PIERRE WILHELM

It was announced in the initial plans for the first issues of FLUXUS that J. P. Wilhelm would contribute "W. Gaul" later clarified in the Brochure Prospectus as "Winfred Gaul — Dialogue avec le neant" to FLUXUS NO. 2 WEST EUROPEAN YEARBOOK 1 (later called FLUXUS NO. 3 GERMAN & SCANDINAVIAN YEARBOX). In the second and third plans for FLUXUS NO. 2 WEST EUROPEAN YEARBOOK 1, he was going to contribute "Thoughts" and edit an "Anthology of new poetry."
see: COLLECTIVE

EMMETT WILLIAMS

It was announced in the second and third tentative plans for the first issues of FLUXUS that Emmett Williams would contribute "Universal and generative poems (?)" to FLUXUS NO. 2 WEST EUROPEAN YEARBOOK 1. This planned con-

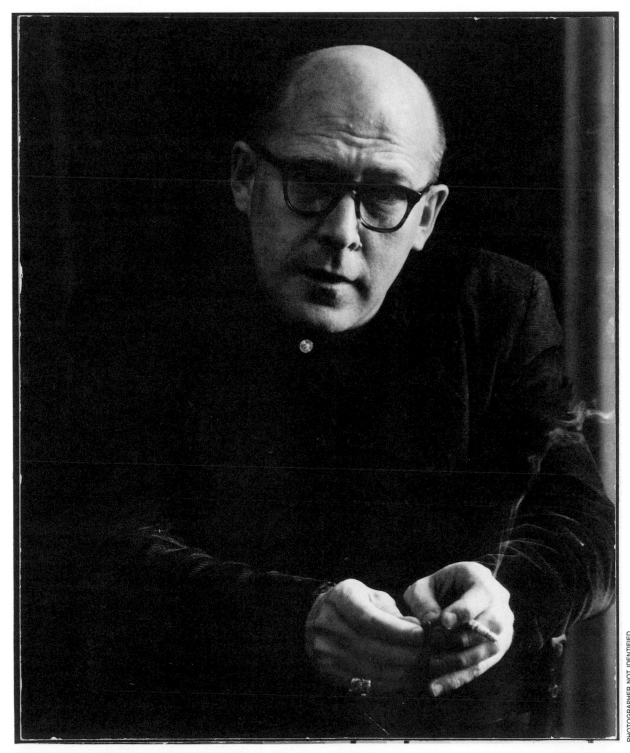

Portrait of Emmett Williams ca. 1963, possibly by George Maciunas

PHOTOGRAPHER NOT IDENTIFIED

tribution, without the "?" was shifted to FLUXUS NO. 1 U.S. YEARBOX as it was announced in Brochure Prospectus version A. Then, in Brochure Prospectus version B, Williams' contribution is changed to "a german chamber opera for 38 marias," "litany and response" and for "luxus" FLUXUS, "4-dimensional song of doubt for 5 voices."

Included in FLUXUS 1 are the following:
 b song for Five Performers
 Counting Song No. 1 - 6
 Duet for Performer(s) and Audience
 Litany & Response No. 2 for Alison Knowles
 Litany & Response for Female & Male Voices
 Song of Uncertain Length
 Tag
 10 Arrangements for 5 Performers
 two untitled works
 Voice Piece for La Monte Young
and two works inserted separately into the edition:
 abcdefghijklmnopqrstuvwxyz, *and* An Opera.

"A german chamber opera for 38 marias" was published in Fluxus Newspaper No. 2, and described in Fluxfest Sale. Four Directional Song of Doubt for 5 Voices became a separate Fluxus Edition. Besides the work included in FLUXUS 1 and Fluxus Newspaper No. 2, Williams' scores appear in Fluxus Preview Review, Fluxus Newspaper No. 1, Fluxfest Sale, and Flux Fest Kit 2. See also : Claus Bremer and Emmett Williams, and COLLECTIVE

abcdefghijklmnopqrstuvwxyz
Silverman No. 527, ff.

"...Go to the Becker printer & pick up...Emmett Williams...poem. (Printer to paste them) take 100 to Paris 100 to Nice..."
Letter: George Maciunas to Tomas Schmit, [2nd week of July 1963].

"...I have also mailed to you a package which contains ...few rolls of Emmetts...poem...."
Letter: George Maciunas to Tomas Schmit, [late August/ early September 1963].

"...so far of course we can sell only 3 items:...Emmett - rolls..."
Letter: George Maciunas to Tomas Schmit, [October/ early November 1963].

"...In reply to your card & inquiry of Nov. 22nd. the Fluxus boxes can be seen at: 359 Canal St. 2nd floor. Boxes to be seen: Emmett Williams - 6 foot long poem/ long poem - in rolls"
Letter: George Maciunas to Philip Kaplan, November 27, 1963.

FLUXKIT containing following fluxus-publications: (also available separately)...FLUXUS L1 EMMETT WILLIAMS: long poem, 25¢
cc fiVe ThReE (Fluxus Newspaper No. 4) June 1964.

Emmett Williams. abcdefghijklmnopqrstuvwxyz. Detail

BUZZ SILVERMAN

FLUXKIT containing following flux-publications:... long poem,...of Emmett Williams
Second Pricelist - European Mail-Orderhouse. [Fall 1964].

FLUX-PRODUCTS 1961 TO 1969...EMMETT WILLIAMS long poem,... on long scrolls, each: [$] 1
Fluxnewsletter, December 2, 1968 (revised March 15, 1969).

FLUX-PRODUCTS 1961 TO 1970...EMMETT WILLIAMS Long poem... scrolls, each: [$] 1
Flux Fest Kit 2. [ca. December 1969].

COMMENTS: A Fluxus printing of abcdefghijklmnopqrstuvw xyz, also called "Alphabet Poem," was usually included in FLUXUS 1 and Fluxkit. This work was first published by Verlag Kalender, the publishing house of Bernd Ebeling and Hansjoachim Dietrich, Wuppertal, West Germany, ca. 1961. They also published Kalender Rolle, a survey of avant-garde art in 1961, and again in 1962. Printed on a long scroll, their form influenced several Fluxus publications such as Fluxus Preview Review.

ALPHABET POEM see:

abcdefghijklmnopqrstuvwxyz

AN OPERA
Silverman No. 528, ff.

"...It would have been better to have Amsterdam on 29th. & Hague on 30th. so that I would have Fluxus with me for sure, but it's OK. to have Amsterdam on June 23 & Haag on 30th. I will have...Emmett's long opera..."
Letter: George Maciunas to Tomas Schmit, [early June 1963].

"...Go to the Becker printer & pick up...Emmett Williams opera...(Printer to paste them) take 100 to Paris 100 to Nice..."
Letter: George Maciunas to Tomas Schmit, [2nd week of July 1963].

"...I have also mailed to you a package, which contains...few rolls of Emmetts long opera..."
Letter: George Maciunas to Tomas Schmit, [late August/ early September 1963].

"...So far of course we can sell only 3 items:...Emmett - rolls..."
Letter: George Maciunas to Tomas Schmit, [late October/ early November 1963].

"In reply to your card & inquiry of Nov. 22nd. the Fluxus boxes can be seen at: 359 Canal St. 2nd floor. Boxes to be seen: Emmett Williams - 6 foot long poem/ long poem - in rolls"
Letter: George Maciunas to Philip Kaplan, November 27, 1963.

"...Emmett Williams, opera & poem. (Printer to paste them) take 100 to Paris 100 to Nice..."
Letter: George Maciunas to Tomas Schmit, [2nd week of July 1963].

FLUXKIT containing following fluxus-publications: (also available separately)...FLUXUS L2 EMMETT WILLIAMS: opera, 25¢
cc fiVe ThReE (Fluxus Newspaper No. 4) June 1964.

FLUXKIT containing following flux-publications:... opera...of Emmett Williams
Second Pricelist - European Mail-Orderhouse. [Fall 1964].

FLUX-PRODUCTS 1961 TO 1969...EMMETT WILLIAMS...opera...on long scrolls, each: [$] 1
Fluxnewsletter, December 2, 1968 (revised March 15, 1969).

FLUX-PRODUCTS 1961 TO 1970...EMMETT WILLIAMS...opera, scrolls, each: [$] 1
Flux Fest Kit 2. [ca. December 1969].

COMMENTS: An Opera, like "alphabet poem," was included in most assemblings of FLUXUS 1 and Fluxkit. It was also distributed as an individual Fluxus Edition.

Emmett Williams. AN OPERA. Detail

BUZZ SILVERMAN

COMPLETE WORKS

"...past & future works published under one cover or in box - a kind of special fluxus edition...sold separately or as part of fluxus yearbox. I am going to publish such special Fluxus editions containing complete works of...Emmett Williams...This could result in a nice & extensive library or 'encyclopedia' of good works being done these days. A kind of Shosoin warehouse of today"
Letter: George Maciunas to Robert Watts, [December 1962].

FLUXUS SPECIAL EDITIONS 1963-4...FLUXUSe. EMMETT WILLIAMS: COMPLETE WORKS (incl. 1962), in expandable box $8 works from 1963 - by subscription
Fluxus Preview Review, [ca. July] 1963.

[as above]
Daniel Spoerri, L'Optique Moderne. List on editorial page. 1963.

[as above]
La Monte Young, LY 1961. Advertisement page. [1963].

"I am going to publish such 'solo' boxes of...Emmett Williams...so that we can build up a good library of good things being done these days..."
Letter: George Maciunas to Ben Vautier, March 5, 1963.

"...Right now Tomas Schmit stays in my place & puts full time on putting together...Emmett Williams 'Complete works'..."
Letter: George Maciunas to Robert Watts, [March 11 or 12, 1963].

"...By Fall I should have some 6 Fluxus issues:... Emmett Williams Flux..."
Letter: George Maciunas to Robert Watts, [possibly early April 1963].

"...Dec. to March - we should print lots of materials in Dicks shop. (Emmett,..."
Letter: George Maciunas to Tomas Schmit, [before June 8, 1963].

FLUXUS 1964 EDITIONS: FLUXUSe EMMETT WILLIAMS: complete works $8 works from 1964 - by subscription
Film Culture No. 30, Fall 1963.

"...We...are printing now Emmett's complete works..."
Letter: George Maciunas to Willem de Ridder, December 26, 1963.

FLUXUS 1964 EDITIONS: FLUXUSe EMMETT WILLIAMS: complete works $8 works from 1964 - by subscription...Most materials originally intended for Fluxus yearboxes will be included in the FLUXUS ccV TRE newspaper or in individual boxes.
ccV TRE (Fluxus Newspaper No. 1) January 1964.

FLUXUS 1964 EDITIONS: FLUXUS e EMMETT WILLIAMS: complete works $8 works from 1964 - by subscription
cc V TRE (Fluxus Newspaper No. 2) February 1964.

Fe-e EMMETT WILLIAMS complete works (inc. 1962) in expandable box $8
European Mail-Orderhouse: europeanfluxshop, Pricelist. [ca. June 1964].

FE-e EMMETT WILLIAMS works etc. in plastic publication in 1965
Second Pricelist - European Mail-Orderhouse. [Fall 1964].

COMMENTS: *Emmett Williams' Complete Works were never produced by George Maciunas as a Fluxus Edition. Selected Shorter Poems 1950-1970, New Directions, New York, 1975, contains a number of Williams' works associated with Fluxus.*

Emmett Williams. FOUR DIRECTIONAL SONG OF DOUBT FOR 5 VOICES. One page of a five page score

FOUR DIRECTIONAL SONG OF DOUBT FOR 5 VOICES
Silverman No. > 528.II

FLUXKIT containing following fluxus-publications:

(also available separately)...FLUXUS L3 EMMETT WILLIAMS: "Four directional song of doubt for 5 voices," no 2 alike $3
cc fiVe ThReE (Fluxus Newspaper No. 4) June 1964.

FLUXKIT containing following flux-publications:... four directional song of doubt for 5 voices of Emmett Williams
Second Pricelist - European Mail-Orderhouse. [Fall 1964].

COMMENTS: *This score was handmade by the artist, or Maciunas, on graph paper with different colored stickers and holographed words. It had a very small distribution by Fluxus, is rarely included in* Fluxkit *and never in* FLUXUS 1.

LONG POEM see:
abcdefghijklmnopqrstuvwxyz

EMMETT WILLIAMS FLUX see:
COMPLETE WORKS

WORKS FROM 1963 see:
COMPLETE WORKS

WORKS FROM 1964 see:
COMPLETE WORKS

WILLIAM WILSON

"Envelope Event: by Bill Wilson" was published in Fluxus Newspaper No. 1.
see: COLLECTIVE

Y

LA MONTE YOUNG

It was announced in the tentative plans for the first issues of FLUXUS that La Monte Young would contribute a work "to be determined" to FLUXUS NO.1 U.S. ISSUE. Announced in Brochure Prospectus versions A and B, Young's contributions to FLUXUS NO. 1 U.S. YEARBOX were to be: "String Trio" and "Death Chant (scores)." Most early assemblings of FLUXUS 1 contain both "Death Chant" and "Trio for Strings." Trio for Strings was also offered for sale as a separate Fluxus Edition. Remains from Composition 1960 No. 2 rarely appear in FLUXUS 1, and "compositions 1961 No. 4 February 9" is published in Fluxus Newspaper No. 2.
see: COLLECTIVE

COMPLETE WORKS

"...past & future works published under one cover or in box - a kind of special Fluxus edition...sold separately or as part of Fluxus yearbox. I am going to pub-

La Monte Young, ca. 1961. Photograph used as portrait in FLUXUS 1

GEORGE MACIUNAS

thoughts on this.''
Letter: George Maciunas to Robert Watts, [December 1962].

**FLUXUS SPECIAL EDITIONS 1963-4...FLUXUSn.
LA MONTE YOUNG: COMPLETE WORKS (incl.
1963) $4**
Fluxus Preview Review, [ca. July] 1963.

[as above]
*Daniel Spoerri, L'Optique Moderne. List on editorial page.
1963.*

[as above]
La Monte Young, LY 1961. Advertisement page. [1963].

COMMENTS: *Besides many proposed Fluxus anthologies,
perhaps the most ambitious plan that George Maciunas had
for Fluxus was his idea to publish the "complete works" of
those artists that he felt were most central to the movement.
Only a few were actually brought out — George Brecht's*
Water Yam, *Chieko Shiomi's* Events & Games, *and Robert
Watts'* Events. *Some were partially realized, like Takehisa
Kosugi's* Events, *or Milan Knizak's* Complete Works, *which
Maciunas had finished work on but never printed. Some Com-
plete Works were published by the artists themselves. Dick
Higgins self-published* Jefferson's Birthday, *as did Yoko Ono*
Grapefruit *and Ben Vautier* Ben Dieu. *But the "One condi-
tion" Maciunas referred to in his letter to Robert Watts in
1962 must have rubbed some artists the wrong way. Certainly
La Monte Young, an artist who pays scrupulous attention to
each detail in his work, would never consider giving up con-
trol over an individual work, let alone all "future works."
La Monte Young's* Complete Works *were never produced by
George Maciunas as a Fluxus Edition.*

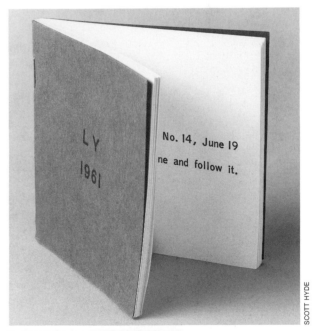

SCOTT HYDE

La Monte Young. COMPOSITIONS 1961

lish such special Fluxus editions containing complete
works of:...La Monte Young...This could result in a
nice & extensive library or 'encyclopedia' of good
works being done these days. A kind of Shosoin ware-
house of today. One condition however. I will finance
& distribute these books, boxes, supply you with a
few 100's. for your own $, BUT — I must have ex-
clusive right to publish them AND ALL YOUR FU-
TURE WORKS. A kind of Faust - Mefisto, Cage -
Peters deal. All works will be copy-righted (inter-
nationally) so no copies will be permitted & no per-
formances without some $ to you. Let me know your

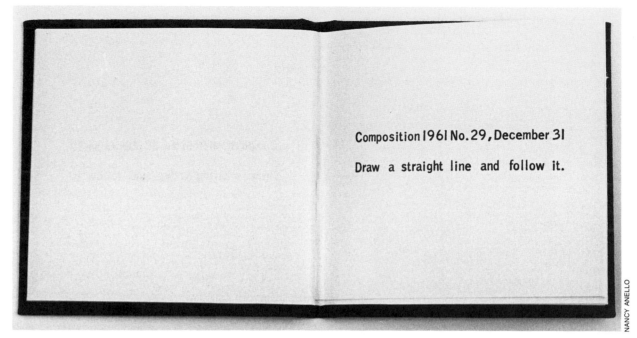

La Monte Young. A page of COMPOSTIONS 1961

Composition 1961 No. 29, December 31

Draw a straight line and follow it.

COMPOSITION 1960 NO. 2 see:
REMAINS FROM COMPOSITION 1960 NO. 2

COMPOSITIONS 1961
Silverman No. 529, ff.

All these lines are by La Monte (his 1961 compositions)

"All these lines are by La Monte (his 1961 compositions)..."
Letter: George Maciunas to Robert Watts, [early April 1963].

"...We shall bring to Nice lots of Fluxus publications (...La Monte Young book of 1961 compositions)..."
Letter: George Maciunas to Ben Vautier, May 26, 1963.

PROPOSED PROPAGANDA ACTION FOR NOV.

FLUXUS IN N.Y.C. (during May - Nov. period)...Propaganda through sale of fluxus publications (fluxus... d.): to be dispatched by end of April to N.Y.C.
Fluxus Newsletter No. 6, April 6, 1963.

"...I will take some 500 of each book...100 books each: London, Amsterdam, Paris, Nice, Florence... this will be quite a load to dispose. (also 100 books in your place.)..."
Letter: George Maciunas to Tomas Schmit, June 1, 1963.

"...I will stay in Weisbaden till Printer completes... La Monte's book - (2 printers are working now). They should have it completed by June 15...."
Letter: George Maciunas to Tomas Schmit, [before June 8, 1963].

"...It would have been better to have Amsterdam on 29th. & Hague on 30th. so that I would have Fluxus with me for sure, but it's OK, to have Amsterdam on June 23 & Haag on 30th. I will have...La Monte Young 1961 book..."
Letter: George Maciunas to Tomas Schmit, [early June 1963].

"...Go to the Becker printer & pick up...La Monte Young book. take 200 to Nice 100 in linen & 100 bound in paper. take 100 to paris (50 linen, 50 in paper...."
Letter: George Maciunas to Tomas Schmit, [2nd week July 1963].

FLUXUS SPECIAL EDITIONS 1963-4...FLUXUS d.
La Monte Young: Compositions 1961, bound in linen $2
Fluxus Preview Review, [ca. July] 1963.

[as above]
Daniel Spoerri, L'Optique Moderne. List on editorial page. 1963.

[as above]
La Monte Young, LY 1961. Advertisement page. [1963].

"...I have also mailed to you a package, which contains...few booklets of La Monte Young 1961 composition. can be sold for 4 DM ea. ..."
Letter: George Maciunas to Tomas Schmit, [late August/ early September 1963].

"You suggest about Fluxus supporting its members - that's ridiculous! The profit we make from selling would not support even a cat and you suggest paying transatlantic fares to all fluxus people who are now in Europe! I did mail out lots of prospecti - Emmett mailed a lot & We did lot of mailing in NYC. So far of course we can sell only 3 items: Brecht box La Monte book & Emmett - rolls - even if we get profit (after selling 200) 50% of it will go to these 3 authors - you know the arrangement."
Letter: George Maciunas to Tomas Schmit, [late October/ early November 1963].

"have mailed a box to you containing: ... few La Monte Young book. 50 cents (U.S.) or less for us will be OK...."
Letter: George Maciunas to Willem de Ridder, [Fall 1963].

FLUXUS 1963 EDITIONS, AVAILABLE NOW FROM FLUXUS P.O. Box 180, New York 10013, N.Y. or FLUXUS 359 Canal St. New York.CO7-9198 ...FLUXUSh LA MONTE YOUNG: Compositions 1961 bound in linen: $3, in paper cover: $1
Film Culture No. 30, Fall 1963.

"...Did you try to sell things I sent you?...La Monte Young 1961 compositions????? I will send you many new things we printed IF you can sell or sold or are selling the things you have...."
Letter: George Maciunas to Willem de Ridder, December 26, 1963.

FLUXUS 1963 EDITIONS, AVAILABLE NOW ... FLUXUS h LA MONTE YOUNG: Compositions 1961 bound in linen: $3, in paper cover: $1...Most materials originally intended for Fluxus yearboxes will be included in the FLUXUSccV TRE newspaper or in individual boxes.
cc V TRE (Fluxus Newspaper No. 1) January 1964.

FLUXUS 1963 EDITIONS, AVAILABLE NOW ...
FLUXUS h LA MONTE YOUNG: Compositions 1961
bound in linen $3, in paper cover: $1
cc V TRE (Fluxus Newspaper No. 2) February 1964.

FLUXUS 1964 EDITIONS, AVAILABLE NOW...
FLUXUS h LA MONTE YOUNG: Compositions 1961
bound in linen: $3, in paper cover: $1
cc Valise e TRanglE (Fluxus Newspaper No. 3) March 1964.

FLUXKIT containing following fluxus-publications:
(also available separately)...FLUXUS h LA MONTE
YOUNG: compositions 1961 $1
cc fiVe ThReE (Fluxus Newspaper No. 4) June 1964.

5F-h LA MONTE YOUNG: Compositions 1961 bound
in linen: $3, in paper cover $1
European Mail-Orderhouse: europeanfluxshop, Pricelist.
[ca. June 1964].

[as above]
Second Pricelist - European Mail-Orderhouse. [Fall 1964].

FLUXKIT containing following flux-publications:...
compositions 1961 of La Monte Young
ibid.

FLUXKIT containing following fluxus-publications:
(also available separately)...FLUXUS h LA MONTE
YOUNG: compositions 1961 $1
Vacuum TRapEzoid (Fluxus Newspaper No. 5) March 1965.

FLUX-PRODUCTS 1961 TO 1969 ... LA MONTE
YOUNG Composition 1961, small booklet, cloth
bound out of print, paper bound: [$] 5
Fluxnewsletter, December 2, 1968 (revised March 15, 1969).

FLUX-PRODUCTS 1961 TO 1970 ... LA MONTE
YOUNG Composition 1961, small booklet [$] 5
Flux Fest Kit 2. [ca. December 1969].

FLUXUS-EDITIONEN... [Catalogue No.] 796 LA
MONTE YOUNG: composition 1961, small booklet
Happening & Fluxus. Koelnischer Kunstverein, 1970.

COMMENTS: *In one respect, these compositions are a sys-*
tematic rewriting of La Monte Young's Composition 1960
No. 10, "draw a straight line and follow it."
 In an interview with Richard Kostelanetz, first published
in The Theatre of Mixed Means, The Dial Press, New York,
1968, La Monte Young discusses Compositions 1961:
La Monte Young - "As we have observed, I have been inter-
ested in the study of a singular event, in terms of both pitch
and other kinds of sensory situations. I felt that a line was
one of the more sparse, singular expressions of oneness, al-
though it is certainly not the final expression. Somebody
might make a point. However, the line was interesting be-
cause it was continuous — it existed in time. A line is a poten-
tial of existing time. In graphs and scores one designates time
as one dimension. Nonetheless, the actual drawing of the line
did involve time, and it did involve a singular event — "Draw

a straight line and follow it. In 1961, I became more and
more interested in the idea of this sort of singular event, and
I decided to polish off my entire output for 1961 in a singu-
lar manner. My book, LY 1961, published by Fluxus, reads
Composition 1961 No. 1 (January 1), 'Draw a straight line
and follow it';
Composition 1961 No. 2 (January 14), 'Draw a straight line
and follow it';
Composition 1961 No. 3 (January 27), 'Draw a straight line
and follow it'.
...what I did was this. On January 6, 1961, I determined the
concept. Then I took a yearly average of the number of pieces
I had completed over a given period of time, and spaced that
number equally throughout 1961, with one composition on
the first day of the year, and one on the last day. It came out
to one every thirteen days, and that night I quite coldly wrote
out the dates....It was Composition 1960 10 written over
and over again. What is also important historically is that I
performed all of them in March, long before many of them
had ever been written according to their dates of composition.
I think that was interesting."
copyright © 1968 La Monte Young. Reprinted with kind
permission of the composer.

LY 1961 see:
COMPOSITIONS 1961

MUSICBOX IN SUITCASE

FLUXUS ha LA MONTE YOUNG: musicbox in suit-
case 18 different movements, $150
Vacuum TRapEzoid (Fluxus Newspaper No. 5) March 1965.

COMMENTS: *In the mid 1960s, Marian Zazeela and La Monte*
Young began to develop ideas for portable music and light
boxes, intending to make objects from their collaboration.
One music and light box was commissioned and built in 1967.
However, a Fluxus Edition of "18 different movements" in a
suitcase, selling for $150, was purely George Maciunas' imagi-
nation, drawn from casual discussions with the artists. Maciu-
nas' idea would have fitted neatly into a roster with other
works he was putting into suitcases. Young and Zazeela's idea
would have required thousands of dollars worth of equip-
ment, as they recently pointed out to me, which was far out
of Maciunas' range. Musicbox in Suitcase was never made.

1962 COMPOSITIONS

In addition to Fluxus Year Boxes the following special
editions [are] planned. These are editions of works
by single composers, poets, artists or what you like ...
La Monte Young 1962 Compositions (to be issued in
1962)...
Fluxus Newsletter No. 4, fragment, [ca. October 1962].

COMMENTS: *By October 1962, George Maciunas probably*
already had La Monte Young's manuscript for Compositions
1961 and was laying plans for future ambitious publishing
ventures. Young's 1962 Compositions were not produced as a
Fluxus Edition.

REMAINS FROM COMPOSITION 1960 NO. 2
Silverman No. > 529.I, ff.

FLUXKIT containing following fluxus-publications:
(also available separately)...FLUXUS hhh LA MONTE
YOUNG: remains from Composition 1960 no. 2, in
jar, $2
cc fiVe ThReE (Fluxus Newspaper No. 4) June 1964.

FLUXKIT containing following flux-publications:...
remains from composition 1960 no. 2 (in jar) of
La Monte Young
Second Pricelist - European Mail-Orderhouse. [Fall 1964].

COMMENTS: *"Composition 1960, No. 2" reads:*
 Build a fire in front of the audience. Preferably, use
 wood although other combustibles may be used as
 necessary for starting the fire or controlling the kind
 of smoke. The fire may be of any size, but it should
 not be the kind which is associated with another ob-
 ject, such as a candle or a cigarette lighter. The lights
 may be turned out.

 After the fire is burning, the builder(s) may sit by and
 watch it for the duration of the composition, however,
 he (they) should not sit between the fire and the audi-
 ence in order that its members will be able to see and
 enjoy the fire.

 The composition may be of any duration. In the event
 that the performance is broadcast, the microphone
 may be brought up close to the fire.
copyright © La Monte Young, 1963. Reprinted from An
Anthology with kind permission of the composer.
 Although probably not authorized by La Monte Young,
the Fluxus Edition of this work is a Maciunas packaging of
burnt matches. Very few examples exist as separate boxed
editions. They also rarely appear in FLUXUS 1. I have never
seen them packaged in a jar.

TRIO FOR STRINGS
Silverman No. > 529.II

FLUXUS 1963 EDITIONS, AVAILABLE NOW
FROM FLUXUS P.O. Box 180, New York 10013,
N.Y. or FLUXUS 359 Canal St. New York. CO 7-9198
...FLUXUShh LA MONTE YOUNG: Trio for strings,
bound in linen: $3, in paper cover: $1
Film Culture No. 30, Fall 1963.

FLUXUS 1963 EDITIONS, AVAILABLE NOW...
FLUXUS hh LA MONTE YOUNG: Trio for strings,
bound in linen: $3, in paper cover: $1...Most materi-
als originally intended for Fluxus yearboxes will be
included in the FLUXUSccV TRE newspaper or in
individual boxes.
cc V TRE (Fluxus Newspaper No. 1) January 1964.

FLUXUS 1963 EDITIONS, AVAILABLE NOW ...

La Monte Young. REMAINS FROM COMPOSITION 1960 NO. 2. see color portfolio

BRAD IVERSON

SCOTT HYDE

La Monte Young. TRIO FOR STRINGS

FLUXUS hh LA MONTE YOUNG: Trio for strings, bound in linen: $3, in paper cover: $1
cc V TRE (Fluxus Newspaper No. 2) February 1964.

FLUXUS 1964 EDITIONS, AVAILABLE NOW...
FLUXUS hh LA MONTE YOUNG: Trio for strings, bound in linen: $3, in paper cover: $1
cc Valise e TRanglE (Fluxus Newspaper No. 3) March 1964.

5F-hh LA MONTE YOUNG: Trio for Strings bound in linen: $3, in paper cover: $1
European Mail-Orderhouse: europeanfluxshop, Pricelist. [ca. June 1964].

[as above]
Second Pricelist - European Mail-Orderhouse. [Fall 1964].

FLUX-PRODUCTS 1961 TO 1969 ... LA MONTE YOUNG... Trio, out of print
Fluxnewsletter, December 2, 1968 (revised March 15, 1969).

COMMENTS: Trio for Strings, a composition dated September 5, 1958, was printed by Fluxus in late 1962 or 1963. The work, always included in early assemblings of FLUXUS 1, is sometimes missing in later copies of that anthology. The Fluxus printed score was distributed as a separate publication by La Monte Young, but not traditionally bound. One example, signed, used George Maciunas' portrait of Young printed on glassine paper from FLUXUS 1 as the front and back covers, and is staple-bound.

GEORGE YUASA

PROJECTION ESEMPLASTIC FOR PIANO-1
Silverman No. > 530.101

Scores available by special order:...George Yuasa: Projection Esemplastic for piano 1, one large sheet, $0.30
Fluxus Preview Review, [ca. July] 1963.

P-7 George Yuasa: Projection Esemplastic for Piano 1 (1 sheet) 30¢
European Mail-Orderhouse: europeanfluxshop, Pricelist. [ca. June 1964].

P-7 GEORGE YUASA: projection esemplastic for piano 1 (1 sheet) 30¢
Second Pricelist - European Mail-Orderhouse. [Fall 1964].

COMMENTS: This score was printed by blueprint and distributed by Fluxus as part of its early publishing activity. I have only seen one example of the score (illustrated), and it does not have the Fluxus copyright on it.

ISAN YUN

It was announced in the tentative plans for the first issues of FLUXUS that Isan Yun would contribute "Stone instruments of Korean court" to FLUXUS NO. 4 HOMAGE TO THE PAST (later called FLUXUS NO. 5).
see: COLLECTIVE

Z

ZAMEK

It was announced in the Brochure Prospectus versions A and B, that the "Zamek" group of concretists in Lublin, Poland, would contribute "works (photographs)" to FLUXUS NO. 7 EAST EUROPEAN YEARBOX.
see: COLLECTIVE

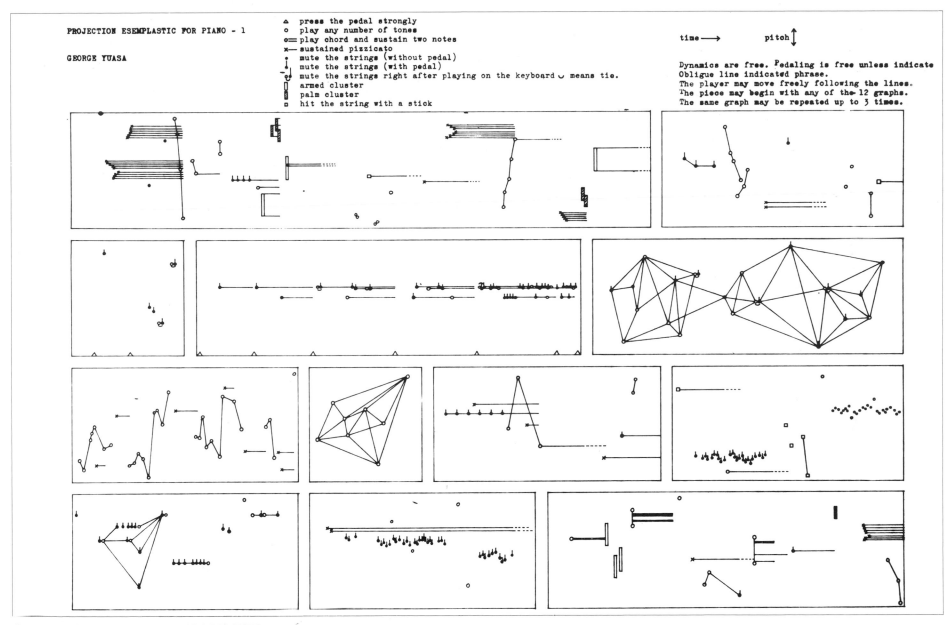

George Yuasa. PROJECTION ESEMPLASTIC FOR PIANO - 1

VYACHESLAV ZAVALISHIN

It was announced in the tentative plans for the first issues of FLUXUS that V. Zavalishin was "being consulted for Abstract sound poetry in Russia 1900-1921: Annenskii, Kruchionych, Shurshun, Klebnikov etc." for FLUXUS NO. 6 EAST EURO-PEAN YEARBOOK (later called FLUXUS NO. 7 EAST EUROPEAN YEARBOX).
see: COLLECTIVE

MARIAN ZAZEELA

It was announced in the Brochure Prospectus version B, that Marian Zazeela would contribute "Scribbles" to FLUXUS NO. 1 U.S. YEARBOX. A drawing titled "message" from 1962 was reproduced in Fluxus Newspaper No. 3.
see: COLLECTIVE

LIST of REFERENCES and
BIBLIOGRAPHIC INFORMATION

This list of references, and the accompanying bibliographic information which we used to prepare **Fluxus Codex,** was compiled by Fatima Bercht and edited by Paula Baxter. In preparing the book we have gathered every known primary Fluxus source which made reference to Fluxus product. In addition to these publications, newsletters, flyers, price lists, catalogues, etc., we have also researched the extensive original correspondence by George Maciunas in the Gilbert and Lila Silverman Fluxus Collection. It will now be possible for future students of Fluxus to apply the system used in **Fluxus Codex** to other Fluxus research material, to expand information on individual pieces and even discover other Fluxus works. Although not every **Fluxus Newsletter** has references to Fluxus product, we have added bibliographic information on all known **Fluxus Newsletters.** The other Fluxus publications can be found in the collective section of this book.

REFERENCE:
Fluxus...Tentative Plan for the Contents of the First
6 Issues. [before February 1962] . version A

BIBLIOGRAPHIC INFORMATION:
Fluxus...Tentative Plan for Contents of the
First 6 Issues... (First preliminary program for
the Fluxus movement). Edited by George
Maciunas. Wiesbaden, West Germany: Fluxus,
[ca. January 1962] .

CONTENTS:
Dictionary definition of fluxus
"Tentative Plan for Contents of the First 6
Issues [of Fluxus] "
"Editors"
"Tentative Programme for the Festival of New
Music": programs for 23 concerts.

REFERENCE:
Fluxus...Tentative Plan for Contents of the First 7
Issues. [before January 18, 1962] . version B

BIBLIOGRAPHIC INFORMATION:
Fluxus...Tentative Plan for Contents of the
First 7 Issues... (Second preliminary program
for the Fluxus movement). Edited by George
Maciunas. Wiesbaden, West Germany: Fluxus,
[before January 18, 1962] .

CONTENTS:
Dictionary definition of fluxus
"Tentative Plan for Contents of the First 7
Issues [of Fluxus] "
"Editorial Committee"
"Subscriptions"
"Tentative Programme for the Festival of New
Music": programs for 22 concerts.

REFERENCE:
Fluxus...Tentative Plan for Contents of the First 7
Issues. [before February 1962] . version C

BIBLIOGRAPHIC INFORMATION:
Fluxus...Tentative Plan for Contents of the
First 7 Issues... (Third preliminary program for
the Fluxus movement). Edited by George
Maciunas. Wiesbaden, West Germany: Fluxus,
[before February 1962] .

CONTENTS:
Dictionary definition of fluxus
"Tentative Plan for Contents of the First 7
Issues [of Fluxus] "
"Editorial Committee"
"Tentative Planned Schedule [for concerts] "
"Temporary Address"
"Tentative Performers (in Europe)"

REFERENCE:
Fluxus Newsletter No. 1, [before May 21, 1962] .

BIBLIOGRAPHIC INFORMATION:
...News-Policy Letter... [Fluxus Newsletter]
no. 1 [Version I] . By George Maciunas. Wies-
baden, West Germany: Fluxus, [May 1962] .

CONTENTS:
"Festival Plans"
"Fluxus Yearbook-Box"
"Tentative Programme for the Festival of Very
New Music"
"Festival Planning Committee"
"Tentative Planned Schedule"
"Tentative Performers (in Europe)"
"Temporary Address"
☞ Reproduced in Jon Hendricks, ed. *Fluxus etc.,*
Addenda I: The Gilbert and Lila Silverman
Collection. New York: Ink &, 1983, pp. 139 -
46.

REFERENCE:
Not used

BIBLIOGRAPHIC INFORMATION:
News-Policy-Letter [Fluxus Newsletter] no. 1
[Version II] . By George Maciunas. Wiesbaden,
West Germany: Fluxus, May 21, 1962.

CONTENTS:
"Distribution"
"Festival Planning Committee"
"Tentative Planned Schedule"
"Tentative Performers (in Europe)"
"Temporary Address"
"Tentative Programme for the Festival of Very
New Music"
"Festival Planning Committee"
"Tentative Planned Schedule"
"Temporary Address"
"Tentative Performers (in Europe)"
"Admission Price"

COMMENTS:
This document is part of the Jean and Leonard Brown
Collection, The Getty Center for the History of Art
and Humanities. Santa Monica, California.
☞ *Reproduced in* Fluxus etc., Addenda I, *pp. 147-53.*

REFERENCE:
Not used

BIBLIOGRAPHIC INFORMATION:
News-Policy-Letter [Fluxus Newsletter] no. 1.
[Version III] . By George Maciunas, Wiesbaden,
West Germany: Fluxus, May 21, 1962.

CONTENTS:
"Distribution"

"Festival Plans"
"Fluxus Yearbook-Box"
"Tentative Programme for the Festival of Very
New Music"
"Festival Planning Committee"
"Tentative Planned Schedule"
"Temporary Address"
"Tentative Performers (in Europe)"
"Admission Price"
"Fluxus -A- Periodical Box"
"Editorial Committee"

COMMENTS:
I have only recently seen this document in the Archiv
Hanns Sohm, Staatsgalerie Stuttgart, and therefore it
has not been included in this book. It is evidently a
complete version of the first Fluxus Newsletter, how-
ever there are significant differences between the three
versions. Page 2 in version II is quite different from
page 8 in version I and page 9 in version III, although
the subjects are the same. Both versions I and II are
missing "Fluxus -A- Periodical Box," pages 10 to 13 in
version III, and the Editorial Committee page. The in-
formation contained in these pages is practically iden-
tical to that found in the Brochure Prospectus for
Fluxus Yearboxes. *[before June 9, 1962] . Version A.*
J.H.

REFERENCE:
Brochure Prospectus for Fluxus Yearboxes. [before
June 9, 1962] . version A

BIBLIOGRAPHIC INFORMATION:
fluxus (Brochure Prospectus for Fluxus Year-
boxes). Edited by George Maciunas. Wiesbaden,
West Germany: Fluxus, [before June 9, 1962] .

REFERENCE:
Advertisement insert in Neo-Dada in der Musik pro-
gram . [ca. June 16, 1962] .

BIBLIOGRAPHIC INFORMATION:
Neo-Dada in der Musik (Program). Duesseldorf:
Kammerspiele, June 16, 1962. Advertisement
insert in program. [ca. June 1962] .
☞ Reproduced in Jon Hendricks, ed. *Fluxus etc.:*
The Gilbert and Lila Silverman Collection.
Bloomfield Hills, Michigan: Cranbrook Acade-
my of Art Museum, 1981, pp. 312-13.

REFERENCE:
Not used

BIBLIOGRAPHIC INFORMATION:
News-Policy-Letter...(Fluxus Festival Only).
[Fluxus Newsletter] no. 2. [By George
Maciunas] . Wiesbaden, West Germany: Fluxus,
July 12, 1962.

CONTENTS:
"Distribution"
"Festival Planning Committee"
Invitation to submit scores, instructions and/
or taped compositions

COMMENTS:
*This document is in the Jean and Leonard Brown
Collection, The Getty Center for the History of Art
and Humanities. Santa Monica, California.*
☞*Reproduced in* Fluxus etc., Addenda I, *p. 154.*

REFERENCE:
Not used

BIBLIOGRAPHIC INFORMATION:
News-Policy-Letter... (Fluxus Festival Only).
[Fluxus Newsletter] no. 3. By George Maciunas.
Wiesbaden, West Germany: Fluxus, August 2,
1962.

CONTENTS:
Festival information
Map of section of Wiesbaden
Performers schedule

COMMENTS:
*The complete four page newsletter is in the Archiv
Hanns Sohm, Staatsgalerie Stuttgart.*
☞*Partially reproduced in Rene Block, comp.* 1962 Wies-
baden Fluxus 1982: Eine kleine Geschichte von Fluxus
in drei Teilen. *Wiesbaden: Harlekin Art and the Ber-
liner Kuenstlerprogramm des DAAD, 1983, p. 358.
J.H.*

REFERENCE:
Brochure Prospectus for Fluxus Yearboxes. [ca. Oc-
tober 1962]. version B

BIBLIOGRAPHIC INFORMATION:
fluxus [Brochure Prospectus for Fluxus Year-
boxes]. Edited by George Maciunas. Ehlhalten,
West Germany: Fluxus, [ca. October 1962].

REFERENCE:
Fluxus Newsletter No. 4, fragment, [ca. October
1962].

BIBLIOGRAPHIC INFORMATION:
[Fluxus Newsletter no. 4. By George Maciunas.
N.p., West Germany: Fluxus, ca. October 1962].

CONTENTS:
"Fluxus Hq. Changed Address & Expanded Ac-
tivities"
Fluxus Yearbox information
Plans for special editions

COMMENTS:
*I have only seen a 2 page fragment of this newsletter
which is on microfilm (Archiv Hanns Sohm, Staats-*

galerie Stuttgart, Roll 1/93) that Maciunas made of
various early Fluxus documents. J.H.

REFERENCE:
Fluxus Newsletter No. 5, January 1, 1963.

BIBLIOGRAPHIC INFORMATION:
Fluxus News Leter [sic] no. 5. By George
Maciunas. Ehlhalten, West Germany: Fluxus,
January 1, 1963.

CONTENTS:
"Distribution"
Proposal for publishing Fluxus Yearboxes as
well as "special collections" and "special items"
Conditions to be met by the authors of above
publications
☞ Reproduced in *Fluxus etc., Addenda I,* p. 155.

REFERENCE:
Photograph of the first Fluxus exhibit, Galerie Parnass.
March 1963.

BIBLIOGRAPHIC INFORMATION:
Black and white photograph by Manfred Leve,
[March 1963]. View of installation of the first
Fluxus exhibit, held in the kitchen of the Gal-
erie Parnass, Wuppertal-Eberfeld, West Germany,
during Nam June Paik's "EXPosition of music
ELectronic television," March 11 - 20, 1963.

REFERENCE:
Nam June Paik, The Monthly Review of the Univer-
sity for Avant-Garde Hinduism. [ca. March 1963].

BIBLIOGRAPHIC INFORMATION:
Nam June Paik, ed. *The Monthly Review of the
University for Avant-Garde Hinduism!* Fluxus
[Special Editions no.] a. Cologne-Muelheim,
West Germany: Fluxus, [ca. March 1963]. In-
cludes Nam June Paik, "Postmusic."
☞ Reproduced in Jon Hendricks, ed. *Fluxus etc.,
Addenda II: The Gilbert and Lila Silverman
Collection.* Pasadena, California: The Baxter Art
Gallery, California Institute of Technology,
1983. pp. 58-9.

REFERENCE:
Fluxus Newsletter No. 6, April 6, 1963.

BIBLIOGRAPHIC INFORMATION:
Fluxus News-Policy Letter no. 6. By George
Maciunas. Ehlhalten, West Germany: Fluxus,
April 6, 1963.

CONTENTS:
"Distribution"
"Proposed Propaganda Action for Nov. Fluxus
in N.Y.C."

"Proposed Preliminary Contents of NYC Fluxus
in Nov."
☞ Reproduced in *Fluxus etc., Addenda I,* pp. 62
and 156.

REFERENCE:
Yam Festival Newspaper, [ca. 1963].

BIBLIOGRAPHIC INFORMATION:
E Newspapayer [Yam Festival Newspaper].
Edited and published by George Brecht and
Robert Watts for Yam Festival Press. [Metuchen,
New Jersey, late 1962 - early 1963].
☞ Reproduced in *Fluxus etc.,* p. 232.

REFERENCE:
Fluxus Newsletter No. 7, May 1, 1963.

BIBLIOGRAPHIC INFORMATION:
Fluxus News Letter no. 7. By George Maciunas.
[Ehlhalten, West Germany]: Fluxus, May 1,
1963.

CONTENTS:
"Distribution"
"Further Proposals for N.Y.C. Fluxus:"
"From Tomas Schmit..."
"From Nam June Paik..."
"From Henry Flynt..."
"From Jackson Mac Low..."
Comments by George Maciunas on Fluxus
Newsletter no. 6
☞ Reproduced in *Fluxus etc., Addenda I,* p. 157.

REFERENCE:
Fluxus Preview Review, [ca. July 1963].

BIBLIOGRAPHIC INFORMATION:
Fluxus Preview Review. Edited by George
Maciunas. Cologne-Muelheim, West Germany:
Fluxus, [ca. July] 1963.
☞ Reproduced in *Fluxus etc.,* p. 229.

REFERENCE:
Daniel Spoerri, L'Optique Moderne. List on editorial
page. 1963.

BIBLIOGRAPHIC INFORMATION:
Daniel Spoerri and François Dufrêne. *L'Optique
Moderne: Collection de lunettes presente par
Daniel Spoerri avec, en regard, d'inutiles notules
par François Dufrêne.* Fluxus [Special Editions,]
no. b. [N.p., West Germany]: Fluxus, 1963.
List on editorial page.
Silverman No. 415

REFERENCE:
La Monte Young, LY 1961. Advertisement page.
[1963].

BIBLIOGRAPHIC INFORMATION:
La Monte Young, *Compositions 1961 (LY 1961).* Fluxus [Special Editions, no.] h. [sic] .
Ehlhalten, West Germany: Fluxus, [Fall 1963] .
List on editorial page.
Silverman No. 529

REFERENCE:
Film Culture No. 30, Fall 1963.

BIBLIOGRAPHIC INFORMATION:
Film Culture (New York) no. 30 (Fall 1963).
List printed on a wrap-around.
Silverman No. 546

REFERENCE:
Sissor Bros. Warehouse Newspaper, [1963] .

BIBLIOGRAPHIC INFORMATION:
Untitled newspaper [Sissor Bros. Warehouse Newspaper]. Published by George Brecht, Alison Knowles and Robert Watts. N.p., [1963] .

REFERENCE:
cc V TRE (Fluxus Newspaper No. 1) January 1964.

BIBLIOGRAPHIC INFORMATION:
Fluxus cc V TRE Fluxus [Fluxus Newspaper no. 1] . Edited by George Brecht and Fluxus Editorial Council. New York: Fluxus, January 1964.
☞ Reproduced in *Fluxus etc.,* pp. 234-37.

REFERENCE:
cc V TRE (Fluxus Newspaper No. 2) February 1964.

BIBLIOGRAPHIC INFORMATION:
Fluxus cc V TRE Fluxus [Fluxus Newspaper no. 2] . Edited by George Brecht and Fluxus Editorial Council. New York: Fluxus, February 1964.
☞ Reproduced in Fluxus etc., pp. 238-41.

REFERENCE:
cc Valise e TRanglE (Fluxus Newspaper No. 3) March 1964.

BIBLIOGRAPHIC INFORMATION:
Fluxus cc Valise e TRanglE [Fluxus Newspaper no. 3] . Edited by Fluxus Editorial Council. [New York] : Fluxus, March 1964.
☞ Reproduced in *Fluxus etc.,* pp. 242-45.

REFERENCE:
Advertisement on Ay-O's Finger Box. [ca. March 1964] .

BIBLIOGRAPHIC INFORMATION:
Ay-O. *Finger Box.* Version used as announcement mailer for exhibition at the Smolin Gallery and for Fluxshop, New York, [ca. March 1964] . Advertisement printed on label of box.
☞ Reproduced in *Fluxus etc.,* p. 65.
Silverman No. 12.

REFERENCE:
cc fiVe ThReE (Fluxus Newspaper No. 4) June 1964.

BIBLIOGRAPHIC INFORMATION:
Fluxus cc fiVe ThReE [Fluxus Newspaper no. 4] . Edited by Fluxus Editorial Council. [New York] : Fluxus, June 1964.
☞ Reproduced in *Fluxus etc.,* pp. 246-49.

REFERENCE:
George Brecht, "Something About Fluxus," cc fiVe ThReE (Fluxus Newspaper No. 4) June 1964.

BIBLIOGRAPHIC INFORMATION:
George Brecht. "Something About Fluxus, May 1964."
Fluxus cc fiVe ThReE [Fluxus Newspaper no. 4] . Edited by Fluxus Editorial Council. [New York] : Fluxus, June 1964, [p.1] .
☞ Reproduced in *Fluxus etc.,* p. 246.

REFERENCE:
Excerpts from Nam June Paik, "Afterlude to the Exposition of Experimental Television," cc fiVe ThReE (Fluxus Newspaper No. 4) June 1964.

BIBLIOGRAPHIC INFORMATION:
Nam June Paik. "Afterlude to the Exposition of Experimental Television 1963, March. Galerie Parnass."
Fluxus cc fiVe ThReE [Fluxus Newspaper no. 4] . Edited by Fluxus Editorial Council. [New York] : Fluxus, June 1964, [p.1] .
☞ Reproduced in *Fluxus etc.,* p. 246.

REFERENCE:
European Mail-Orderhouse: europeanfluxshop, Pricelist. [ca. June 1964] .

BIBLIOGRAPHIC INFORMATION:
European Mail-Orderhouse: european fluxshop ...Pricelist. [Edited by Willem de Ridder] Amsterdam: Fluxus, [ca. June 1964] . Partially re-
☞ produced in *Actie, werklijkheid en fictie in de kunst de jaren'60 in Nederland* (exhibition catalogue). Rotterdam, Netherlands: Museum Boymans-van Beuningen, November 9, 1979 - January 6, 1980, p. 162.

REFERENCE:
European Mail-Orderhouse: europeanfluxshop, Pricelist. With holograph notes from George Maciunas to Willem de Ridder. [ca. Summer 1964] .

BIBLIOGRAPHIC INFORMATION:
European Mail-Orderhouse: european fluxshop ...Pricelist. [Edited by Willem de Ridder] . Amsterdam: Fluxus, [ca. June 1964] . With holograph notes from George Maciunas to Willem de Ridder. [ca. Summer 1964] .

REFERENCE:
Formletter: Lydia Mercedes Luyten for the European Mail Order Warehouse/Fluxshop. ca. August 1964.

BIBLIOGRAPHIC INFORMATION:
Formletter for the European Mail-Order Warehouse/Fluxshop. By Lydia Mercedes Luyten. Amsterdam: Fluxus, ca. August 1964.

REFERENCE:
Second Price list - European Mail-Orderhouse. [Fall 1964] .

BIBLIOGRAPHIC INFORMATION:
Second Pricelist of the European Mail-Orderhouse. [Edited by Willem de Ridder] . Amsterdam: Fluxus, [Fall 1964] .
☞ Partially reproduced in *Actie, werkelijkheid... in Nederland,* p. 162.

REFERENCE:
George Brecht, Water Yam. Advertisement card: "Delivery." 1964.

BIBLIOGRAPHIC INFORMATION:
George Brecht. *Water Yam.* Fluxus [Special Editions] no. c. N.p., West Germany: Fluxus, 1963. New York: Fluxus 1964 - ca. early 1970s. Advertisement card "Delivery," found in some copies assembled from 1964 —.
Silverman No. 35, ff.

REFERENCE:
George Brecht, Water Yam. Advertisement card: "Iced Dice." 1964.

BIBLIOGRAPHIC INFORMATION:
George Brecht. *Water Yam.* Fluxus [Special Editions] no. c. N.p., West Germany: Fluxus 1963. New York: Fluxus 1964 - ca. early 1970s. Advertisement card "Iced Dice," found in some copies assembled from 1964 —.
Silverman No. 35, ff.

REFERENCE:
George Brecht, Water Yam. Advertisement card: "Relocation." 1964.

BIBLIOGRAPHIC INFORMATION:
George Brecht, *Water Yam.* Fluxus [Special Editions] no. c. N.p., West Germany: Fluxus 1963. New York: Fluxus 1964 - ca. early 1970s. Advertisement card "Relocation," found in some copies assembled from 1964—. Silverman No. 35, ff.

REFERENCE:
How to be Satisfluxdecolanti?... [ca. Fall, 1964].

BIBLIOGRAPHIC INFORMATION:
How to be Satisfluxdecolanti?... Edited by Dorothee Meyer. Amsterdam: [Fluxus, Fall 1964].
☞Reproduced in *Actie, werkelijkeid... In Nederland,* pp. 74-5; and partially in *Fluxus etc., Addenda I,* p. 116.

REFERENCE:
Fluxus Offset Printing Negative. [1964].

BIBLIOGRAPHIC INFORMATION:
Offset film negative of lay-outs by George Maciunas for Fluxus works [1964]. Silverman No. < 124.I

REFERENCE:
European Mail-Orderhouse, advertisement for clothes, [ca. 1964].

BIBLIOGRAPHIC INFORMATION:
Photograph with advertisement for clothes printed on verso. Amsterdam: Fluxus [ca. 1964].

REFERENCE:
Vacuum TRapEzoid (Fluxus Newspaper No. 5) March 1965.

BIBLIOGRAPHIC INFORMATION:
Fluxus Vacuum TRapEzoid [Fluxus Newspaper] no. 5. [Edited by George Maciunas]. New York: Fluxus, March 1965.
☞Reproduced in *Fluxus etc.,* pp. 251-54.

REFERENCE:
[Fluxus Newsletter], unnumbered, [ca. March 1965].

BIBLIOGRAPHIC INFORMATION:
A perpetual Fluxus Festival is being planned... [Fluxus Newsletter. By George Maciunas. New York: Fluxus, ca. March 1965].

CONTENTS:
"1. A perpetual Fluxus Festival is being planned at the Cinematheque Theatre in New York...."
"2. We are also planning a second yearbox — Fluxus 2—..."
address

REFERENCE:
fluxus Vaudeville TouRnamEnt (Fluxus Newspaper No. 6) July 1965.

BIBLIOGRAPHIC INFORMATION:
Fluxus Vaudeville TouRnamEnt [Fluxus Newspaper] no. 6. [Edited by George Maciunas]. New York: Fluxus, July 1965.
☞Reproduced in *Fluxus etc.,* pp. 256-58.

REFERENCE:
Fluxorchestra Circular Letter No. 2 [September 1965].

BIBLIOGRAPHIC INFORMATION:
Fluxorchestra Circular Letter No. 2. [Fluxus Newsletter. By George Maciunas. New York: Fluxus, September 1965].

CONTENTS:
Compositions of the entire revised program of Fluxorchestra at Carnegie Recital Hall, New York City, September 25, 1965.
☞Reproduced in *Fluxus etc.,* p. 339 and *Fluxus etc., Addenda I,* p. 160.

REFERENCE:
Not used

BIBLIOGRAPHIC INFORMATION:
Press Release [for Fluxorchestra at Carnegie Recital Hall, September 23, 1965. By George Maciunas. New York: Fluxus, ca. September 1965].

CONTENTS:
Lists works to be performed and announces an exhibition of Fluxus products.

REFERENCE:
Not used

BIBLIOGRAPHIC INFORMATION:
(Fluxus Broadside Manifesto) [By George Maciunas. New York: Fluxus, September 1965].

CONTENTS:
Lists Fluxus artists, publications, festivals and concerts, mass produced works, Fluxshops and Warehouses. A comparative manifesto: Art versus Fluxus Art-Amusement.
☞Reproduced in *Fluxus etc.,* p. 260.

REFERENCE:
Not used

BIBLIOGRAPHIC INFORMATION:
Conditions for Performing Fluxus Published Compositions, Films & Tapes. [Fluxus Newsletter. By George Maciunas. New York: Fluxus,

ca. 1965].
☞Reproduced in *Fluxus etc.,* p. 260 and in *Fluxus etc., Addenda I,* p. 158.

REFERENCE:
Not used

BIBLIOGRAPHIC INFORMATION:
Some hysterical outbursts have recently resulted from... [Fluxus Newsletter. By George Maciunas. New York: Fluxus, ca. 1965].

CONTENTS:
George Maciunas' policy statement regarding the Fluxus Newsletter *Conditions for Performing Fluxus Published Compositions, Films & Tapes,* ca. 1965.
☞Reproduced in *Fluxus etc., Addenda I,* p. 159.

REFERENCE:
3 newspaper eVenTs for the pRicE of $1 (Fluxus Newspaper No. 7) February 1, 1966.

BIBLIOGRAPHIC INFORMATION:
Fluxus 3 newspaper eVenTs for the pRicE of $1 [Fluxus Newspaper] no. 7. [Edited by George Maciunas. New York]: Fluxus, February 1, 1966.
☞Reproduced in *Fluxus etc.,* pp. 262-65.

REFERENCE:
Vaseline sTREet (Fluxus Newspaper No. 8) May 1966.

BIBLIOGRAPHIC INFORMATION:
Fluxus Vaseline sTREet [Fluxus Newspaper] no. 8. [Edited by George Maciunas. New York]: Fluxus, May 1966.
☞Reproduced in *Fluxus etc.,* pp. 266-69.

REFERENCE:
Proposed Program for a Fluxfest in Prague. 1966.

BIBLIOGRAPHIC INFORMATION:
Proposed Program for a Fluxfest in Prague [Fluxus Newsletter. Edited by George Maciunas. New York: Fluxus, 1966].

CONTENTS:
Scores and descriptions for 9 concerts and events
☞Reproduced in *Fluxus etc., Addenda I,* pp. 162-69.

REFERENCE:
Fluxfilms catalogue. [ca. 1966].

BIBLIOGRAPHIC INFORMATION:
Fluxfilms (Catalogue). [Compiled by George

Maciunas] . New York: [Fluxus, ca. 1966] .

COMMENTS:
This undated catalogue of Fluxfilms was probably intended for a wider distribution than most of the Fluxus Newsletters. However, its presentation is consistent with the dissemination of information to Fluxus artists and not a formally designed catalogue to sell or rent Fluxfilms to the public. J.H.
☞ *Reproduced in* Fluxus etc., *p. 105.*

REFERENCE:
Fluxfest Sale. [Winter 1966] .

BIBLIOGRAPHIC INFORMATION:
Fluxfest Sale. (Tabloid publication). [Edited by George Maciunas] . New York: [Fluxus, ca. January 1967] . Simultaneously published in *Film Culture* (New York) no. 43 (Winter 1966): 6-7.
☞ Reproduced in *Fluxus etc.* pp. 270-71.

REFERENCE:
Film Culture, No. 43 (Winter 1966).

BIBLIOGRAPHIC INFORMATION:
Announcement for "Zen for Film," *Film Culture* (New York) no. 43 (Winter 1966): 9.

REFERENCE:
Fluxnewsletter, March 8, 1967.

BIBLIOGRAPHIC INFORMATION:
Fluxnewsletter. By George [Maciunas. New York] : Fluxus, March 8, 1967.

CONTENTS:
"Distribution"
"Past Flux-Projects (realized in 1966)"
"Flux-Projects Planned for 1967"
"Implosions Inc. Projects"
"Fluxhouse Cooperative Building Projects"
"Other News [regarding Flux-West and Flux-East]"
☞ Reproduced in *Fluxus etc., Addenda I,* pp. 172 - 75.

REFERENCE:
Fluxshopnews. [Spring, 1967] .

BIBLIOGRAPHIC INFORMATION:
Fluxshopnews (Advertisement and pricing leaflet). [By George Maciunas. New York: Fluxus, Spring 1967] .
☞ Reproduced in *Fluxus etc.,* p. 279.

REFERENCE:
Flyer for Robert Filliou and Scott Hyde's Handshow. [March 1967] .

BIBLIOGRAPHIC INFORMATION:
Announcement Flyer, for Robert Filliou and Scott Hyde "The Key to Art(?)" exhibition at Tiffany's, New York, March 27 - April 12, [1967] . [Designed by George Maciunas, published in New York, ca. March 1967] .
☞ Reproduced in *Fluxus etc.,* p. 98.
Silverman No. 110

REFERENCE:
Not used

BIBLIOGRAPHIC INFORMATION:
Loft Building Co-operative Newsletter, no. 1. [By George Maciunas. New York, before August 24, 1967] .
☞ Reproduced in *Fluxus etc., Addenda I,* p. 170.

REFERENCE:
Not used

BIBLIOGRAPHIC INFORMATION:
[Loft Building Co-Operative] *Newsletter,* no. 2. [By George Maciunas. New York, before August 30, 1967] .
☞ Reproduced in *Fluxus etc., Addenda I,* p. 171.

REFERENCE:
[Fluxus Newsletter] Proposal for Fluxus Paper Concert. [ca. Fall 1967] .

BIBLIOGRAPHIC INFORMATION:
Proposed "Concert" for Paper Show Opening at Time & Life Bldg. Nov. 15th. [Fluxus Newsletter. By George Maciunas. New York: Fluxus, ca. Fall 1967] .

CONTENTS:
"Basic Proposal" — with two alternatives
"Title"
"Invitations"
"Programs"
"Program"
☞ Reproduced in *Fluxus etc., Addenda I,* p. 187.

REFERENCE:
[Fluxus Newsletter] Supplement I for Fluxus Paper Concert. [ca. Fall 1967] .

BIBLIOGRAPHIC INFORMATION:
Supplement 1. Paper Concert for Paper Show Opening at Time & Life Building. November 15 & 29, 1967. [Fluxus Newsletter. By George Maciunas. New York: Fluxus, ca. Fall 1967] .

CONTENTS:
"Collective Compositions by [various artists]"
"Part I, In memoriam to Adriano Olivetti for paper orchestra"

"Part II, Kill paper not people"
☞ Reproduced in *Fluxus etc., Addenda I,* p. 188.

REFERENCE:
[George Maciunas and Robert Watts] , Proposal for The Greene Street Precinct, Inc. [ca. December 1967] .

BIBLIOGRAPHIC INFORMATION:
Proposal... The Greene Street Precinct, Inc. [By George Maciunas and Robert Watts. New York, ca. December 1967] .

CONTENTS:
'Proposal"
"Concept"
Financial and Organizational Structure
☞ Reproduced in *Fluxus etc., Addenda I,* pp. 177-79.

REFERENCE:
Fluxfurniture, pricelist. [1967] .

BIBLIOGRAPHIC INFORMATION:
Fluxfurniture (Pricelist leaflet). [Compiled by George Maciunas] . New York: [Fluxus, 1967] .

REFERENCE:
Proposed R&R Evenings. [ca. 1967] .

BIBLIOGRAPHIC INFORMATION:
Proposed R&R Evenings. [Fluxus Newsletter. By George Maciunas. New York: Fluxus, ca. 1967] .
☞ Reproduced in *Fluxus etc., Addenda I,* p. 176.

REFERENCE:
Fluxnewsletter, January 31, 1968.

BIBLIOGRAPHIC INFORMATION:
Fluxnewsletter. [By George Maciunas. New York: Fluxus,] January 31, 1968.

CONTENTS:
"Distribution"
"Fluxprojects realized in 1967"
"Fluxprojects for 1968"
"News from Flux-West"
"News from Flux-Houses"
"News from Implosions, Inc."
"Supplement 1: Paper Concert for Paper Show Opening at Time & Life Bldg. Nov. 15th, 1967 & Nov. 29th."
"Proposed Fluxolympiad"
"Proposed R&R Evenings"
"Proposed Structure for Flux-Snowhouse (or Snow-In)"
"Proposed Program for Fluxorchestra Concert at Cinematheque, March"

☞ Reproduced in *Fluxus etc., Addenda I,*
pp. 180-86.

REFERENCE
Fluxnewsletter, December 2, 1968.

BIBLIOGRAPHIC INFORMATION:
Fluxnewsletter. [By George Maciunas. New
York: Fluxus] , December 2, 1968.

CONTENTS:
"Distribution"
"Enclosures"
"Summary of Last Newsletter (Jan. 31, 1968)"
"Fluxprojects for 1969: Products - Publications"
"Flux-Christmas Meal Event"
"Fluxfest"
"Fluxshop"
"Ginger Island Project"
"Proposals Will Be Welcomed for: . . ."
"Flux-Biographies"
"Flux-Mail List"
"Proposed Fluxshow for Gallery 669, Los An-
geles. Opening Nov. 26, 1968"
"1962 Flux-Radio Pieces — 1966 Flux Video
Versions"
"Proposed Fluxolympiad"
"Proposed R&R Evenings"
"Art Notes" from *The New York Times,* June
16, 1968
"Ginger Island, British Virgin Islands [map]"
☞ Reproduced in *Fluxus etc., Addenda I,*
pp. 189-97.

REFERENCE:
Fluxnewsletter, December 2, 1968 (revised March 15,
1969).

BIBLIOGRAPHIC INFORMATION:
*Fluxnewsletter December 2, 1968. (Revised
March 15, 1969).* [By George Maciunas. New
York: Fluxus] , March 15, 1969.

CONTENTS:
"Distribution"
"Fluxfest Information"
"Flux-Members Biographies"
"Proposed Fluxshow"
"Flux-Products 1961 to 1969"
"Flux-Mail List"
"A State of Flux at the Festival" from *The
Guardian,* November 30, 1968.
"Art Notes," from *The New York Times,* June
16, 1968.
☞ Reproduced in *Fluxus etc., Addenda I,*
pp. 198-205.

REFERENCE:
Fluxfest at Stony Brook, Newsletter No. 1, August
18, 1969. version A

BIBLIOGRAPHIC INFORMATION:
Fluxfest at Stony Brook, Newsletter No. 1.
[By George Maciunas. New York: Fluxus] ,
August 18, 1969.

CONTENTS:
"Proposed Categories, Location, Dates, . . ."
"Proposed Flux Drinks & Foods"
"Flux-Olympiad"
Calendar page
☞ Reproduced in *Fluxus etc., Addenda I,*
pp. 215-17.

REFERENCE:
Fluxfest at Stony Brook, Newsletter No. 1, August
18, 1969. version B

BIBLIOGRAPHIC INFORMATION:
Fluxfest at Stony Brook, Newsletter No. 1. [By
George Maciunas. New York: Fluxus] , August
18, 1969.

CONTENTS:
"Proposed Categories, Location, Dates, . . ."
"Flux-Orchestra Concert"
"Flux-Chamber Concert"
"Mechanical Flux-Concert"
"Audience Flux-Concert"
"Slide-Film Flux-Show"
"Flux-Parade"
"Exterior Flux-Events"
"Flux-Olympiad"
"Flux-Radio and TV Pieces, 1965"
"Proposed Flux Drinks & Foods"
Map of Stony Brook
☞ Reproduced in *Fluxus etc., Addenda I,*
pp. 219-27.

REFERENCE:
Not used

BIBLIOGRAPHIC INFORMATION:
Flux Concert [Fluxus Newsletter. Edited by
George Maciunas. New York: Fluxus, ca. Fall
1969] .

CONTENTS:
Scores and descriptions of performances for a
Fluxus concert
☞ Reproduced in *Fluxus etc., Addenda I,* p. 218.

REFERENCE:
[Fluxus Newsletter] Invitation to Participate in New
Year Eve's Flux-Feast. [ca. December 1969] .

BIBLIOGRAPHIC INFORMATION:
*Invitation to Participate in New Year Eve's
Flux-Feast (Food & Drink Event).* [Fluxus
Newsletter. By George Maciunas. New York:
Fluxus, ca. December 1969] .

CONTENTS:
"Distribution"
Instructions
"Flux Drinks & Foods"
☞ Reproduced in *Fluxus etc.,* p. 345 and in
Fluxus etc., Addenda I, p. 228.

REFERENCE:
Flux Fest Kit 2. [ca. December 1969] .

BIBLIOGRAPHIC INFORMATION:
Flux Fest Kit 2 (Tabloid publication). [Edited
by George Maciunas. New York: Fluxus, ca.
December 1969] .
☞ Reproduced In *Fluxus etc.,* p. 285.

REFERENCE:
Not used

BIBLIOGRAPHIC INFORMATION:
Preliminary Offer — This Is Not a Public Offer
[Fluxus Newsletter. By George Maciunas. New
York: Fluxus, 1969] .

CONTENTS:
"General Description — British Virgin Islands"
"Ginger Island — General Description"
"Financial Plan for Purchase of Lots and Their
Development"
"Proposed Improvements"
"Summary of Costs of Improvements"
"Schedule of Work — Services to Lot Owners —
Equipment & Supplies — Cost"
"Ginger Island — Agricultural Development:
Suggested Tropical Fruit Trees & Shrubs"
"Ginger Island, British Virgin Island,
Lat. 18° 23' Long. 64° 29' " [3 maps]
☞ Reproduced in *Fluxus etc., Addenda I,*
pp. 206-14.

REFERENCE:
Fluxnewsletter, January 8, 1970.

BIBLIOGRAPHIC INFORMATION:
Flux Newsletter. [By George Maciunas. New
York: Fluxus] , January 8, 1970.

CONTENTS:
"Flux Mail List Jan. 1970"
George Maciunas editorial requesting documen-
tation from artists
Description of "New Year Eve's Flux-Feast,

Dec. 31, 1969 at Cinematheque''
☞Reproduced in *Fluxus etc.*, p. 347 and *Fluxus etc., Addenda I,* p. 229.

REFERENCE:
Not used

BIBLIOGRAPHIC INFORMATION:
Call for Ideas: Flux Church 11:10 Am. Feb. 17, 1970 at Voorhees Chapel, Douglass College, Rutgers University. [Fluxus Newsletter. By George Maciunas. New York: Fluxus, ca. January 1970] .

CONTENTS:
''Ceremonies or the Seven Sacraments''
''Other Sacraments''
''Liturgical Vestments and Furnishings''

REFERENCE:
Outline of Flux-Mass. [February 17, 1970] .

BIBLIOGRAPHIC INFORMATION:
Outline of Flux-Mass (Performance instructions). [Compiled by George Maciunas. New York: Fluxus, ca. January, 1970] .

CONTENTS:
Sequence of events for performers in the Flux-Mass at Douglass College, New Brunswick, New Jersey. February 17, 1970.
☞Reproduced in *Fluxus etc.*, p. 348 and *Fluxus etc., Addenda I,* p. 230.

REFERENCE:
Poster/program for Flux-Mass, Flux-Sports and Flux-Show. February, 1970.

BIBLIOGRAPHIC INFORMATION:
Poster/program, for ''Flux-Mass, Flux-Sports and Flux-Show,'' at Douglass College, New Brunswick, New Jersey, February 16-20, 1970. [Designed by George Maciunas. New York: Fluxus, ca. February, 1970] .
☞Reproduced in *Fluxus etc.*, p. 349.

REFERENCE:
Schedule of events for Fluxfest presentation of John Lennon and Yoko Ono. [ca. April 1970] . version A

BIBLIOGRAPHIC INFORMATION:
Details of Fluxfest Presentation of John Lennon and Yoko Ono +.* [Fluxus Newsletter. By George Maciunas. New York: Fluxus, ca. April 1970] .

CONTENTS:
Schedule of events with descriptions of environments and exhibits
☞Reproduced in *Fluxus etc., Addenda I,* p. 232.

REFERENCE:
Schedule of events for Fluxfest presentation of John Lennon and Yoko Ono. [ca. April 1970] . version B

BIBLIOGRAPHIC INFORMATION:
Fluxfest Presentation of John Lennon & Yoko Ono +.* (Schedule of events). [By George Maciunas. New York: Fluxus, ca. April 1970] . Included in *Fluxnewsletter.* By George Maciunas. [New York] : Fluxus, April 1973.
☞Reproduced in *Fluxus etc., Addenda I,* p. 240.

REFERENCE:
Schedule of events for Fluxfest presentation of John Lennon and Yoko Ono. April 1, 1970. version C

BIBLIOGRAPHIC INFORMATION:
Press Release - April 1, 1970 Joint Yoko Ono, John Lennon, & Fluxgroup Project Fluxfest Presents Yoko Ono +.* [By George Maciunas. New York: Fluxus] , April 1, 1970.

CONTENTS:
Planned schedule of events and exhibits
☞Reproduced in *Fluxus etc., Addenda I,* p. 231.

REFERENCE:
all photographs copyright nineteen seVenty by peTer mooRE (Fluxus Newspaper No. 9) 1970.

BIBLIOGRAPHIC INFORMATION:
JOHN YOKO & FLUX all photographs copyright nineteen seVenty by peTer mooRE. [Fluxus Newspaper no. 9, misnumbered no. 8. Edited by George Maciunas. New York: Fluxus, ca. June 1970] .
☞Reproduced in *Fluxus etc.*, pp. 280-84.

REFERENCE:
Happening & Fluxus. Koelnischer Kunstverein, 1970.

BIBLIOGRAPIC INFORMATION:
Koelnischer Kunstverein, Cologne. [Hanns Sohm and Harald Szeemann, eds.] *Happening & Fluxus* (Exhibition catalogue and checklist). November 6, 1970 - January 6, 1971.

REFERENCE:
This is Not Here. October 9, 1971.

BIBLIOGRAPHIC INFORMATION:
Yoko Ono, *This Is Not Here* (Tabloid publication). Designed and produced by George Maciunas. Published by Yoko Ono, New York, 1971. Includes catalogue of Yoko Ono one woman exhibition, ''This Is Not Here,'' Everson Museum, Syracuse, New York, October 9 - 27, 1971.

REFERENCE:
[George Maciunas] , Proposed Contents for Fluxpack 3. [ca. 1972] .

BIBLIOGRAPHIC INFORMATION:
Proposed Contents for Fluxpack 3 to Be Published in 1973 by Flash Art (Draft proposal). [By George Maciunas. New York, ca. 1972] .

REFERENCE:
Fluxnewsletter, April 1973.

BIBLIOGRAPHIC INFORMATION:
Fluxnewsletter. By George Maciunas. [New York: Fluxus] , April 1973.

CONTENTS:
Letter from George Maciunas to Giancarlo Politi
General news
''Flux Mail List''
''Fluxproducts Produced in 1972 & 1973''
Letter from George Maciunas to Daniela Palazzoli
''Proposed Fluxanniversaryfest Program 1962 - 1972 Sept. & Oct.''
Plan for Flux Toilet
''Corrections: Some Comments on Structural Film...by George Maciunas...''
''Fluxfest Presentation of John Lennon and Yoko Ono''
☞Reproduced in *Fluxus etc., Addenda I,* pp. 233-40.

REFERENCE:
Flyer for Flux Game Fest. May 1973.

BIBLIOGRAPHIC INFORMATION:
Flux Game Fest, 80 Wooster, May 19, 20, 26 and 27 (Flyer). [Designed by George Maciunas. New York: Fluxus, ca. May 1973] .
☞Reproduced in *Fluxus etc.*, p. 355.

REFERENCE:
George Maciunas, Diagram of Historical Developments of Fluxus... [1973] .

BIBLIOGRAPHIC INFORMATION:
George Maciunas. *Diagram of Historical Development of Fluxus and Other 4 Dimentional [sic] , Aural, Optic, Olfactory, Epithelial and Tactile Art Forms. (Incomplete).* [New York: Fluxus, 1973] .
☞Reproduced in *Fluxus etc.*, pp. 154-56.

REFERENCE:
Not used

BIBLIOGRAPHIC INFORMATION:
Encoded Mailing List. [Fluxus Newsletter.

By George Maciunas. New York: Fluxus, ca. 1973].

CONTENTS:
Fluxus mailing list coded for association with Fluxus or other art activities.
☞ Reproduced in *Fluxus etc., Addenda I,* p. 241.

REFERENCE:
Fluxfilms catalogue. 1974.

BIBLIOGRAPHIC INFORMATION:
Fluxfilms, 1974 version (Catalogue), [Compiled by George Maciunas. New York: Fluxus, 1974].

REFERENCE:
Preliminary Proposal for a Flux Exhibit at Rene Block Gallery. [ca. 1974].

BIBLIOGRAPHIC INFORMATION:
Preliminary Proposal for a Flux Exhibit at Rene Block Gallery, 409 West Broadway. [Fluxus Newsletter]. By George Maciunas. [New York: Fluxus, ca. 1974].

CONTENTS:
"Proposed Date"
"Proposed Participants"
"Flux Amusement Arcade"
"Flux Game Room"
"Budget"
☞ Reproduced in *Fluxus etc., Addenda I,* p. 242.

REFERENCE:
George Maciunas. Preliminary instruction drawing for Flux-Maze [New York, 1974].

BIBLIOGRAPHIC INFORMATION:
George Maciunas. Preliminary instruction drawing for "Flux-Maze." [New York, 1974].
Silverman No. > 297.IV (a)

REFERENCE:
George Maciunas, Plan for Flux-Maze, New York. [1974].

BIBLIOGRAPHIC INFORMATION:
Further Proposal for Flux-Maze at Rene Block Gallery, January 1975. [Fluxus Newsletter. By George Maciunas. New York: Fluxus, late 1974].
Silverman No. > 297.IV (c)

REFERENCE:
George Maciunas, Further Proposal for Flux-Maze at Rene Block Gallery. [ca. Fall 1974].

BIBLIOGRAPHIC INFORMATION:
Further Proposal for Flux-Maze at Rene Block Gallery, January 1975. [Fluxus Newsletter. By

George Maciunas. New York: Fluxus, 1974].
Silverman No. > 297.IV (b)

REFERENCE:
Fluxnewsletter, April 1975.

BIBLIOGRAPHIC INFORMATION:
Flux Newsletter. [By George Maciunas. New York: Fluxus], April 1975.

CONTENTS:
"Flux Mail List, 1974"
Price list of new Fluxus products
☞ Reproduced in *Fluxus etc., Addenda I,* p. 243.

REFERENCE:
Fluxnewsletter, May 3, 1975.

BIBLIOGRAPHIC INFORMATION:
Flux Newsletter. [By] George [Maciunas. New York: Fluxus], May 3, 1975.

CONTENTS:
"Flux New Year Eve, 1973 – Disguises"
"Flux New Year Eve, 1974 – Colored Meal"
"Flux Harpsichord Recital, March 24, 1975..."
"Flux Combat with New York State Attorney (& Police)..."
"New Flux Objects..."
"Fluxfest Presents 12 Big Names, April 21, 1975"
☞ Reproduced in *Fluxus etc.,* p. 160 and in *Fluxus etc., Addenda I,* p. 244.

REFERENCE:
Not used

BIBLIOGRAPHIC INFORMATION:
Newsletter on Sailing Trip [Fluxus Newsletter]. By George Maciunas. [New York: Fluxus, ca. August 1975].

CONTENTS:
"Distribution"
"Departing"
"Supplies"
"Food & Cooking"
☞ Reproduced in *Fluxus etc., Addenda I,* p. 245.

REFERENCE:
[Fluxus price list for a customer]. September 1975.

BIBLIOGRAPHIC INFORMATION:
Pricelist of Fluxus products, published in *Flux Fest Kit 2,* ca. December 1969, with price updates and deletions holographed by George Maciunas, to a customer in Europe. New York, [before September 1975].

REFERENCE:
Proposal for 1975/76 Flux-New Year's Eve Event. [ca. November 1975].

BIBLIOGRAPHIC INFORMATION:
Proposal for 1975/76 Flux-New Year's Event at Clock Tower [Fluxus Newsletter]. By George Maciunas. [New York: Fluxus, ca. November, 1975].

CONTENTS:
"Distribution"
"Some Proposed Objects/Events"
"Foods"
☞ Reproduced in *Fluxus etc., Addenda I,* p. 283.

REFERENCE:
Not used

BIBLIOGRAPHIC INFORMATION:
To Avoid Repeating the Story Endlessly... [Fluxus Newsletter. By George Maciunas. New York: Fluxus, November or December 1975].

CONTENTS:
Description of brutal attack on George Maciunas by "gorillas."
☞ Reproduced in *Fluxus etc., Addenda I,* p. 67.

REFERENCE:
Not used

BIBLIOGRAPHIC INFORMATION:
Met George Brecht while stuck in a revolving door... [Fluxus Newsletter]. By George Maciunas. [New York: Fluxus], December 10, 1975.

CONTENTS.
Spurious descriptions of encounters between George Maciunas and various Fluxus artists.
☞ Reproduced in *Fluxus etc., Addenda I,* p. 284.

REFERENCE:
Not used

BIBLIOGRAPHIC INFORMATION:
Proposed Graphics Study Program. [Fluxus Newsletter]. By George Maciunas. [New York: Fluxus, ca. late 1975].
☞ Reproduced in *Fluxus etc., Addenda I,* p. 285.

REFERENCE:
Not used

BIBLIOGRAPHIC INFORMATION:
Caravan/Expedition to Circumvent the World [Fluxus Newsletter. By George Maciunas. New York: Fluxus, 1975-76].

CONTENTS:
Summary of project
"Equipment"
"Route"
List of locations and monuments to be seen
☞ Reproduced in *Fluxus etc., Addenda I*,
pp. 246-57.

REFERENCE:
Not used

BIBLIOGRAPHIC INFORMATION:
*Circumnavigation of the World with 85 Ft
Schooner, 1976-80* [Fluxus Newsletter. By
George Maciunas. New York: Fluxus, 1975-76].

CONTENTS:
Outline of crew and equipment necessary for
trip
"Preliminary plan of the route"
List of possible crew members
Diagram of boat
☞ Reproduced in *Fluxus etc., Addenda I*,
pp. 258-59.

REFERENCE:
Not used

BIBLIOGRAPHIC INFORMATION:
*Circumnavigation of the World with 145 Ft
Converted Mine Sweeper, 1976-1984.* [Fluxus
Newsletter. By George Maciunas. New York:
Fluxus 1975-76].

CONTENTS:
Outline of crew and equipment necessary for
trip
"Preliminary plan of the route"
List of possible crew members
Map and descriptions of points along the route
☞ Reproduced in *Fluxus etc., Addenda I*,
pp. 260-82.

REFERENCE:
[Fluxus price list for a customer]. January 7, 1976.

BIBLIOGRAPHIC INFORMATION:
Price list from George Maciunas to a customer
in Europe. New York, January 7, 1976.

REFERENCE:
Formletter: George Brecht to Fluxus Artists. January
14, 1976.

BIBLIOGRAPHIC INFORMATION:
Festschrift for George Maciunas (Newsletter).
By George Brecht. [Cologne?, West Germany],
January 14, 1976.
☞ Reproduced in *Fluxus etc., Addenda I,* p. 286.

REFERENCE:
Flux Objects, Price List. May 1976.

BIBLIOGRAPHIC INFORMATION:
Letter with pricelist of Fluxus works from
George Maciunas to Dr. Hanns Sohm, Mark-
groningen, West Germany. May 1, 1976.

REFERENCE:
[Fluxnewsletter] Laudatio Scripta pro George Maciu-
nas. [May 1976].

BIBLIOGRAPHIC INFORMATION:
*Laudatio Scripta pro George Maciunas Concepta
Hominibus Fluxi - May 2, 1976.* [Fluxus News-
letter]. By George [Maciunas. New York: Flux-
us, May 1976].

REFERENCE:
Instruction drawing for Fluxlabyrinth, Berlin.
[ca. August 1976]. version A

BIBLIOGRAPHIC INFORMATION:
George Maciunas. Instruction drawing for *Flux-
labyrinth,* Berlin. [ca. August 1976].
☞ Reproduced in *Fluxus etc. Addenda II,* p. 237.
Silverman No. > 297.V (3).

REFERENCE:
Instruction drawing for Fluxlabyrinth, Berlin.
[ca. August 1976]. version B

BIBLIOGRAPHIC INFORMATION:
George Maciunas. Instruction drawing for *Flux-
labyrinth,* Berlin. [ca. August 1976].
☞ Reproduced in *Fluxus etc., Addenda II,* p. 236.
Silverman No. > 297.V (2)

REFERENCE:
Notes: Larry Miller to George Maciunas concerning
the Fluxlabyrinth, Berlin. [ca. August 1976].

BIBLIOGRAPHIC INFORMATION:
Larry Miller to George Maciunas. Holograph
notes and diagrams regarding the *Fluxlabyrinth,*
Berlin, West Germany. [Berlin, ca. August
1976].
☞ Reproduced in *Fluxus etc., Addenda II,*
pp. 250-67.

REFERENCE:
Plan of completed Fluxlabyrinth, Berlin. [ca. Sep-
tember 1976].

BIBLIOGRAPHIC INFORMATION:
Plan of completed *Fluxlabyrinth.* Berlin, West
Germany, September 1976. [Fluxus Newsletter.
By George Maciunas. New Marlborough, Massa-
chusetts: Fluxus, Fall 1976].

CONTENTS:
Plan of *Fluxlabyrinth* as built in the Art Acade-
my, during the 26th Arts Festival, Berlin, West
Germany. September 1976.
☞ Reproduced in *Fluxus etc., Addenda I,* p. 288.

REFERENCE:
Instructions for Flux-New Year Eve Event. [Decem-
ber 1976].

BIBLIOGRAPHIC INFORMATION:
Instructions for Flux-New Year Eve Event.
[Fluxus Newsletter. By George Maciunas. New
Marlborough, Massachusetts: Fluxus, Decem-
ber 1976].

CONTENTS:
List of participants
Map
Instructions for event
☞ Reproduced in *Fluxus etc., Addenda I,* p. 289.

REFERENCE:
George Maciunas Biographical Data. 1976.

BIBLIOGRAPHIC INFORMATION:
[George Maciunas], "George Maciunas - Bio-
Graphical Data" (Typescript). [New Marlbor-
ough, Massachusetts], 1976.

REFERENCE:
Prospectus for the New Marlborought Centre for the
Arts. [ca. 1976]

BIBLIOGRAPHIC INFORMATION:
*Prospectus for New Marlborough Centre for the
Arts.* [Fluxus Newsletter. By George Maciunas.
New Marlborough, Massachusetts: Fluxus, ca.
1976].

CONTENTS:
Statement of intent
Structure of the Centre
☞ Reproduced in *Fluxus etc., Addenda I,* p. 287.

REFERENCE:
Notes: George Maciunas on objects, [ca. 1976].

BIBLIOGRAPHIC INFORMATION:
George Maciunas. Holograph notations regarding
Fluxus objects and events, ca. 1976.

REFERENCE:
Announcement for Flux Snow Event: January 22-23,
1977.

BIBLIOGRAPHIC INFORMATION:
*Announcement for Flux Snow Event: January
22-23, 1977 at Non-Smoking Marlboro Coun-*

try. [Fluxus Newsletter] . By George Maciunas. New Marlborough, [Massachusetts: Fluxus, ca. December 1976 - January 1977] .

CONTENTS:
List of participants
"Instructions"
☞Reproduced in *Fluxus etc., Addenda I,* p. 290.

REFERENCE:
[George Maciunas] Invitation to Participate in Flux Summer Fest in South Berkshires. March 4, 1977.

BIBLIOGRAPHIC INFORMATION:
Invitation to Participate in Flux Summer Fest in South Berkshires, 1977. [Fluxus Newsletter. By George Maciunas. New Marlborough, Massachusetts: Fluxus] , March 4, 1977.

CONTENTS:
"Distribution"
"Proposed Categories and Locations"
Additional proposals by George Maciunas of works by other artists.
☞Reproduced in *Fluxus etc., Addenda I,* p. 291.

REFERENCE:
Proposal for Flux Fest at New Marlborough. April 8, 1977.

BIBLIOGRAPHIC INFORMATION:
Summary of Proposed Flux Fest at New Marlborough. [Fluxus Newsletter. By George Maciunas. New Marlborough, Massachusetts: Fluxus] , April 8, 1977.

CONTENTS:
Dates
Events
Participants
☞Reproduced in *Fluxus etc., Addenda I,* p. 292.

REFERENCE:
Notes: George Maciunas for the Fluxfest 77 at and/or, Seattle [ca. September 1977] .

BIBLIOGRAPHIC INFORMATION:
George Maciunas. Holograph notations for the "Fluxfest 77," at and/or, Seattle, Washington, [ca. September 1977] .

REFERENCE:
Fluxfest 77 at and/or, Seattle. September 1977.

BIBLIOGRAPHIC INFORMATION:
Calendar for "Fluxfest 77," at and/or, Seattle, Washington, September 24 - October 2, 1977.

CORRESPONDENCE

All original letters or, in a few cases, vintage copies, are in the Gilbert and Lila Silverman Fluxus Collection.

Maciunas, George. Letter to Rene Block. [Summer? 1976] .
☞Reproduced in *Fluxus etc., Addenda II,* pp. 246-47.

Maciunas, George. Complete known correspondence to Willem de Ridder, in Amsterdam, Netherlands. [From ca. July 15, 1963] to March 2, 1965.

Maciunas, George. Letter to Peter Frank, in New York. [ca. March 1977] .

Maciunas, George. Complete known correspondence to Ken Friedman, in California. From August 1966 to [ca. April 1973] .

Maciunas, George. Letter to Dick Higgins, in New York. January 18, 1962.

Maciunas, George. Correspondence to Armin Hundertmark, in Cologne. [From ca. September to late 1976] .
☞Reproduced in *Fluxus etc., Addenda I,* pp. 69-70.

Maciunas, George. Postcards to Philip Kaplan, in New York. [ca. November 19, 1963] and November 27, 1963.
☞Reproduced in *Fluxus etc.,* pp. 157-58.

Maciunas, George. Complete known correspondence to Milan Knizak, in Prague, Czechoslovakia. [From January 1966 to ca. November 15, 1967] .

Maciunas, George. Letter to David Mayor, in England. N.d.
☞Reproduced in David Mayor, ed. *Fluxshoe.* Cullompton, England: Beau Geste Press, 1972, p. 69.

Maciunas, George. Fragment of a letter to Nam June Paik, in West Germany. [ca. February 1963]
☞Reproduced in *Fluxus etc., Addenda II,* p. 144.

Maciunas, George. Letter to Daniela Palazzoli, in Milan. N.d. Included in *Fluxnewsletter.* By George Maciunas. [New York: Fluxus] , April 1973.
☞Reproduced in *Fluxus etc., Addenda I,* p. 236.

Maciunas, George. Letter to Giancarlo Politi, in Milan. N.d. Included in *Fluxnewsletter.* By George Maciunas. [New York: Fluxus] , April 1973.
☞Reproduced in *Fluxus etc., Addenda I,* p. 233.

Maciunas, George. Letter to Takako Saito, in Reggio Emilia, Italy. May 30, 1977.

Maciunas, George. Complete known correspondence to Tomas Schmit, primarily in Cologne, West Germany. [From ca. late December 1961/January 1962 to March 1964] .

Maciunas, George. Complete known correspondence to Paul Sharits, in St. Cloud, Minnesota and Baltimore, Maryland. [From ca. April 6, 1966 to ca. April 1970] .

Maciunas, George. Complete known correspondence to Mieko Shiomi, in Osaka, Japan. [From 1972 to 1975] .

Maciunas, George. Letter to Dr. Hanns Sohm, in Markgroningen, West Germany. ca. late 1972 and November 30, 1975.

Maciunas, George. Complete known correspondence to Ben Vautier, Nice, France. From March 5, 1963 to October 1977.

Maciunas, George. Complete known correspondence to Robert Watts, primarily in Lebanon, New Jersey. [From ca. June 1962] to September 12, 1966.

INDEX